THE GROVE ENCYCLOPEDIA OF
AMERICAN ART

THE GROVE ENCYCLOPEDIA OF
AMERICAN ART

EDITOR IN CHIEF

Joan Marter

VOLUME 1

Aalto–Cutrone

OXFORD
UNIVERSITY PRESS

OXFORD

UNIVERSITY PRESS

Oxford University Press, Inc., publishes works that further
Oxford University's objective of excellence in research,
scholarship, and education.

Oxford New York
Auckland Cape Town Dar es Salaam Hong Kong Karachi
Kuala Lumpur Madrid Melbourne Mexico City Nairobi
New Delhi Shanghai Taipei Toronto

With offices in
Argentina Austria Brazil Chile Czech Republic France Greece
Guatemala Hungary Italy Japan Poland Portugal Singapore
South Korea Switzerland Thailand Turkey Ukraine Vietnam

Published by Oxford University Press, Inc.
198 Madison Avenue, New York, NY 10016
www.oup.com

The Library of Congress Cataloging-in-Publication Data

The Grove encyclopedia of American art / Joan Marter,
editor in chief.
p. cm.
Includes bibliographical references and index.
ISBN 978-0-19-533579-8 (alk. paper) – ISBN 978-0-19-973926-4 (e-book)
1. Art, American–Encyclopedias. I. Marter, Joan M.
N6505.G76 2010
709.73'03–dc22 2010030274
1 3 5 7 9 8 6 4 2
Printed in the United States of America on acid-free paper

CONTENTS

The Grove Encyclopedia of American Art

LIST OF ARTICLES

INTRODUCTION

American art in the 21st century

Where is American art in the new millennium? At the heart of all cultural developments is diversity. No style of art or architecture dominates. No critic dictates. Access through recent technology engenders interaction with artists from Western and Eastern Europe, Central and South America, and all of Asia. There are no boundaries. In the 21st century American art is no longer considered a historical development which ended when "contemporary art" arrived after World War II. The visual arts in the United States are bold—brash even—and pulsating with new ideas. Where American art was once viewed as a provincial "shadow" of European advancements, artists in the United States have now taken a prominent international role in painting, photography, sculpture and architecture. Artists from many countries and ethnicities work within our borders, and contribute to the burgeoning force of America's cultural output. American art has legitimately assumed a principal importance in the global art scene.

Seventy years ago historians characterized American art as a provincial manifestation of Western civilization. American art was typically viewed from a national perspective rather than an international one. In the 21st century, this definition of American art and culture seems both narrow and Eurocentric. Just as American cinema and television have reached remote communities around the world, so has American art had an impact internationally. Particularly after World War II, New York became a vital center for modernism where artists congregated to join a dynamic community of artists. The United States has exported painting and sculpture to eager collectors and museums in far-flung locations. By the 21st century many visual artists have become almost as well known as film

celebrities. American artists make a strong showing at the Venice
Biennale, Documenta and other international art exhibitions. The United
States now attracts artists from all over the globe to create and exhibit
their art in this country. Contemporary artists from Europe and Asia
continue to arrive in the United States to show their works in major
museums, make performances and create installations. Architects of
international renown extend their worldwide production of exemplary
works into American cities.

Unlike previous reference volumes and texts on American art which
begin with the colonial period and end in 1945, this publication encom-
passes the entire history of the cultural development of America. The
United States has always been a country known for diversity resulting
from centuries of welcoming immigrants to her shores. Long before the
early explorers arrived, Native American peoples were engaged in cultural
exchanges through trade and migration. They spoke different languages,
and created pottery, beadwork and other artifacts to trade with neigh-
boring communities. Later, arts in the "New World" were catalyzed by
contacts with people from abroad, the opening of international trade,
changing borders and annexations. Early Spanish, French and English
explorers seeking adventure and fortune interacted with indigenous peo-
ple along the coast before making their way inland. Africans, brought
against their will, nevertheless built a vital visual culture drawn from
memories and creative energies. Migrations from Eastern and Western
Europe and Asia brought people seeking a new life in this young country,
as did later waves from Central and South America. A flowering of
Western-style art was tempered by diverse cultural expressions created
by those on the margins of society. Often these marginalized groups were
not educated according to mainstream standards for art, but nevertheless
had a sustained impact. Although each cultural tradition needs to be
defined specifically, the weaving together of multiple threads forms the
compelling narrative of American art as it comes of age.

In colonial times, the influence of classicism and various European
sources—predominantly English, Italian and French—figured impor-
tantly into the design of country mansions, modified only by local taste,
materials and other practical considerations. In Florida and later in the
Southwest, religious and domestic structures were often based on Span-
ish architectural sources. Likewise, American painting and sculpture in
the 17th and 18th centuries may be viewed as derivative of European
models, although the historical motivation for these images relates to
local patronage. By the 19th century, a growing diversity was to be found
among artists working in this nation, as attested by the number of
paintings and sculptures by African Americans and women, for example.
While Revival styles flourished as a search for a simpler, more innocent

past, new narratives and the dogged rise of industrialism shaped architectural design as well as other arts. Transatlantic exchanges not only brought Realism and Impressionism to America, but generated an emigration of eager American artists to Paris, Rome and other European capitals for first-hand study of new developments and opportunities for immersion in the classical heritage.

As the 20th century unfolded, American artists were drawn to the modernism that was exploding in some of the great cities of Europe. French Cubism, Italian Futurism and German Expressionism were among the new art movements that Americans brought home. Between the two World Wars, although avant-garde art continued in Europe, many artists there were consumed by impending war and economic hardship. For some American painters a pledge to remain isolationists produced an American style of social realism during the 1930s. But by the 1940s, cultural trends changed again, and many young Americans, introduced to abstraction and Surrealism, set aside such previously insular styles.

Cultural nationalism was the mode for reading American art after World War II, but in recent decades the global context of our cultural output has superseded this characterization. Asian and Native American sources, Latino and African American art, and various other indigenous traditions have contributed to the dynamic hybridity of contemporary art in America. Politically and culturally the United States is experiencing an expansionist posture which encourages our artists to seek commissions abroad, while welcoming foreign artists to our shores. With the hyperactivity of the internet as a model, American art has assumed a global reach.

Gender and ethnic studies have done much to revise the prevailing Eurocentrism of previous writings on American art. Since the 1960s and the birth of the women's movement, much attention has been given to women artists' contributions to our cultural heritage. Feminist art historians have introduced many accomplished artists from the past to the national narrative. Gender identity has predicated different circumstances for artistic production. The assumption of white male identity for artistic prowess has been seriously collapsed, not only for women artists, but also for artists from other cultural traditions. Since 1970 women artists have created a dynamic body of work in response to their deep commitment to feminist issues, expanding their bold outreach to include a range of artistic mediums as well as installation, performance and video art.

The project of defining an increasingly diverse American art requires a thorough assessment and the inclusion of many artists who were not considered among the mainstream previously. During the 19th century, African Americans overcame obstacles to receive professional training and establish successful careers. While typically these artists worked

within the stylistic parameters of their period of production, it is also true that they engineered their own artistic revolution. Recalling an American heritage that went back many generations, some black artists of the early 20th century were identified with the Harlem Renaissance, a cultural efflorescence both in literature and the visual arts. Black Americans also emigrated to Paris to form their own response to modernism. By the end of the 20th century, African American sculptors, painters and photographers were being recognized for works that demanded attention to racial issues. At the same time that these works were entering major museum collections in this country, their art addressing the African diaspora was being celebrated abroad.

The design and styles from many cultural traditions have expanded and enriched the vocabulary of American art. Although painted works by Native Americans have not always survived, objects such as pottery, sculptures, hides and stitchery and the remnants of early dwellings reflected their distinctive tribal styles. Exquisite examples of Native American art also served as an inspiration for later artistic developments including abstract art after 1940. Among contemporary Native American artists are those who sustain their own heritage while forging new inroads into recent developments in the visual arts.

Asian art has also been an important source for American artists, from interest in Japonisme in the late 19th century, to the attractions of calligraphy and *sumi-e* painting in the 20th century. Asian artists coming to the United States brought audacious examples of their abstract painting as well as more traditional styles. Asian American artists have been recognized in the United States, particularly after 1950 and the transoceanic exchanges now extend to the Pacific Rim as well as earlier transatlantic connections.

Links with Chicano artists, and the great heritage of Latin American art have greatly enriched the visual arts in the United States. Mural, genre and abstract painters brought their indigenous traditions, the Pre-Columbian and Colonial legacies and contemporary culture to bear on a highly expressive cross-cultural production. The inspiration of Latin American sources, and the creative interaction with Latino artists, is a sustaining aspect of American modernism. Contemporary art of Central and South America blends frequently with other forms of cultural production in this country as artists continue their shared interests in themes of nature and the cycles of life.

The Grove Encyclopedia of American Art is the first comprehensive reference on this subject. Previously one-volume dictionaries have been devoted to American art, but the scope and methodological approach of this publication is new. As the study of cultural achievements in the United States continues in the 21st century, new methodologies and

methods assume greater importance. This is an appropriate juncture to review the history of the visual arts from the perspective of America's position in the global arena. In this publication American art has been reconceptualized from the vantage point of a new millennium. Entries provide a revisionist approach to the investigation of American painting, architecture, sculpture and photography. Many entries are completely new, particularly those devoted to African American artists, Asian American and Latin American artists, and Native American art, both historical and contemporary. The Encyclopedia includes artists, major movements, art institutions, critics and the architecture found in major cities of the United States. New media and methodologies including digital art, performance art and installation art are considered.

In assembling five volumes devoted to cultural manifestations in the United States, the intention is to view the history of American art through various lenses. Rather than seeking a singular "national identity," which was the purpose of dozens of previous studies, this reference foregrounds "hybridity"—that is, the diversity and cultural exchanges that have always been a composite of the American narrative. The decision was made to include pottery, beadwork and other artifacts for Native American art only, as these works are often the few remaining traces of indigenous cultures of great interest. Since Oxford University Press published another reference volume devoted to the decorative arts, no furniture, glassware or other objects in the category of American decorative arts are included here.

How to Use the Encyclopedia

The Grove Encyclopedia of American Art is addressed to many different users. Some readers will be college and high school students; others are scholars and general readers seeking information about American art and culture. Readers may be searching for specific information or may hope to find ideas for research papers. Other users will be interested in the general information to be found in an introduction to American architecture, painting, sculpture, photography or a cultural account of a noted American city.

There are over 2300 entries in *The Grove Encyclopedia of American Art*. These entries are arranged in alphabetical order letter by letter. Composite entries gather together discussions of similar or related topics under one headword. For example under the entry, "Sculpture" a headnote lists the various subentries of "Before World War I," "After World War I," and "Materials and techniques."

The contributors have sought to write in clear language with a minimum of technical vocabulary. The articles give important terms and titles in their original languages, with English translations when needed.

A selective bibliography at the end of each article directs the reader who wishes to pursue a topic in greater detail to primary sources and the most important scholarly works, arranged chronologically.

To guide readers from one article to related discussions elsewhere in the Encyclopedia, end-references appear at the conclusion of many articles. There are cross-references within the body of a few articles. Blind entries direct the user from an alternate form of an entry term to the entry itself. For example, the blind entry for "Frontier art" tells the reader to look under "Wild West and frontier art." Readers interested in finding all the articles on a particular subject (for example Environmental art or Sculpture) may consult the topical outline at the end of volume 5. A comprehensive index at the end of volume 5 lists all the topics covered in the Encyclopedia, including those that are not headwords themselves. The Encyclopedia includes over 150 color plates and over 500 images throughout the text. At the end of volume 5 are the topical outline (which shows how articles relate to one another and to the overall design of the Encyclopedia and the directory of contributors.

Acknowledgments

My heartfelt thanks go to the "area editors" who have been with me since the inception of this project. Pamela H. Simpson has been an invaluable support for her sound judgments on various topics as the plans were unfolding for this publication. I appreciate her willingness to write entries on American sculptors and painters of the 19th century, and to take on some additional assignments in the final days before our deadline. Margaret Barlow, my co-editor of *Woman's Art Journal*, provided essential support for text and bibliographic updates. Wendy Bellion managed the entries on paintings of the 18th and 19th centuries, and contributed a number of important entries. Robert Craig took on the daunting assignment of all of the architectural entries from the Colonial period to the present, and added many architects and topics. Robert Hobbs, a distinguished expert on contemporary art, proposed dozens of living artists to be added to the roster of artists slated for inclusion in this publication. Katherine Manthorne and Nancy Mowll Mathews, two eminent specialists on American painting, wrote articles and located authors who contributed importantly to the publication. Katherine Manthorne also introduced Latin American artists and topics. Paula Wisotzski, a modernist, worked effectively in reviewing entries on contemporary American artists. Douglas Nickel was charged with the photography entries, many of which were new to this publication. Special thanks to James Smalls, who wrote on various African American artists and supervised the addition of many entries on African American painters and sculptors of the past and present. Melissa Chiu, curator at the Asia

Society, organized a list of Asian American artists and found appropriate authors for these entries. Paul Apodaca, a professor of anthropology and American Studies with Navaho heritage, directed the completion of entries on Native American art and introduced contemporary Native American artists to the publication. Sincere thanks also to many colleagues in art history who responded to my request for their expert contributions to this project.

At Oxford University Press, I was privileged to work with Eric Stannard who sustained the project from inception to completion. Amber Fischer was the link with Grove Art Online, another important dimension to this research and writing on American artists. Jenny Doster was an invaluable assistant with the procurement of images and permissions. Thanks to Stephen Wagley for his wise counsel and dedication to the success of these reference volumes. All authors and teachers of American art have countless reasons to thank the Henry Luce Foundation whose generous grant made this new reference possible. On a personal note, I thank my husband Walter for his support over the years of bringing this project to completion.

Joan Marter

A NOTE ON THE USE OF THE ENCYCLOPEDIA

This note is intended as a short guide to the basic editorial conventions adopted in this encyclopedia.

Abbreviations used in this encyclopedia are listed on pp. xli.

Alphabetization of headings, which are distinguished in bold typeface, is letter by letter up to the first comma (ignoring spaces, hyphens, accents and any parenthesized or bracketed matter); the same principle applies thereafter. Abbreviations of "Saint" and its foreign equivalents are alphabetized as if spelled out. Names that include the prefix "de," "van" or "von" are alphabetized under the part of the name following the prefix. Names that begin with the prefix "Mc" or "Mac" are alphabetized at the beginning of the letter M.

Authors' names appear in the Directory of Contributors in Vol. 5, pp. 345.

Bibliographies are arranged chronologically (within section, where divided) by order of year of first publication and, within years, alphabetically by authors' names. Some standard reference books have had their titles abbreviated, as have those of periodicals. The full list of abbreviations used in this encyclopedia begins on p. xli.

Illustrations to an article that are reproduced in black-and-white appear on the same page as the article, and the caption accompanying the illustration identifies the article to which they relate. Color illustrations are indicated in the running text of the article with the citation "see color pl." followed by the volume number, plate number, and illustration number (eg. "see color pl. 4:IX, 2"). Color plates therefore may be several pages away from the source article, but they are generally in the same volume.

ILLUSTRATION ACKNOWLEDGMENTS

We are grateful to all those who granted permission to reproduce copyright illustrative material and to those contributors who supplied photographs or helped us to obtain them. All copyright information can be found in the credit line contained in the caption accompanying each image. Every effort has been made to contact copyright holders and to credit them appropriately; we apologize to anyone who may have been omitted from the acknowledgments or cited incorrectly. Any error brought to our attention will be corrected in subsequent printings.

ABBREVIATIONS USED IN THIS WORK

General

AA	Associate of Arts	Col.	Collection	
AD	Anno Domini	Coll.	College	
add.	addition; additional	CT	Connecticut	
A.G.	Art Gallery	*d*	died	
AIA	American Institute of Architects	DC	District of Columbia	
A. Inst.	Art Institute	DE	Delware	
AK	Alaska	Dec	December	
AL	Alabama	ded.	dedication, dedicated to	
Alta	Alberta	Dept	Department	
a.m.	ante meridiem [before noon]	destr.	destroyed	
AR	Arkansas	diam.	diameter	
ARA	Associate of the Royal Academy	Dip.	Diploma	
artist's col.	artist's collection	diss.	dissertation	
Aug	August	Dr.	Doctor	
AZ	Arizona	E.	East(ern)	
b	born	ed.	editor, edited by	
BA	Bachelor of Arts	edn.	edition	
BArch	Bachelor of Architecture	eds.	editors	
bapt.	baptized	e.g.	*exempli gratia* (for example)	
BC	Before Christ	Eng.	English	
BC	British Columbia	esp.	especially	
BFA	Bachelor of Fine Arts	est.	established	
bibliog.	bibliography	etc.	*etcetera* [and so on]	
Bros.	Brothers	exh. cat.	exhibition catalog	
Bucks	Buckinghamshire	f, ff.	following page(s)	
c.	*circa* [about]	F.A.	Fine Art(s)	
CA	California	facs.	facsimile	
cat.	catalog	Feb	February	
cat. rais.	catalogue raisonné	Fed.	Federation, Federal	
Cent.	Center	fig.	figure (illustration)	
Co.	Company; County	FL	Florida	
CO	Colorado	*fl.*	*floruit* [flourished]	

Fr.	French	MS	Mississippi
ft	foot, feet	MS., MSS	manuscript(s)
GA	Georgia	MSc	Master of Science
Gal., Gals.	Gallery, Galleries	MT	Montana
Ger.	German	Mt	Mount
GI	Government/General Issue	Mus.	Museum
h.	height	N.	North(ern)
ha.	hectare	NC	North Carolina
Herts	Hertfordshire	ND	North Dakota
HI	Hawaii	NE	Nebraska
IA	Iowa	Nfld	Newfoundland
ibid.	*ibidem* [in the same place]	NH	New Hampshire
ID	Idaho	NJ	New Jersey
i.e.	*id est* [that is]	NM	New Mexico
IL	Illinois	Nov	November
illus.	illustrated, illustration	n.p.	no place (of publication)
IN	Indiana	nr.	near
Inc.	Incorporated	NS	Nova Scotia
incl.	including	n. s.	new series
Inst.	Institute	NT	National Trust [UK]
intro.	introduction	NV	Nevada
Jan	January	NY	New York
jr.	junior	NZ	New Zealand
km	kilometre	Oct	October
KS	Kansas	OH	Ohio
KY	Kentucky	OK	Oklahoma
l.	length	Ont.	Ontario
Lancs	Lancashire	OR	Oregon
Ltd	Limited	p., pp.	page(s)
m	meters	PA	Pennsylvania
MA	Master of Arts; Massachusetts	PhD	Doctor of Philosophy
Mag.	Magazine	pl/pls.	plural; plate(s)
MArch	Master of Architecture	Prefect.	Prefecture
MBA	Master of Business Administration	prev.	previous(ly)
MD	Maryland	priv. col.	private collection
ME	Maine	pubd.	published
Mem.	Memorial(s)	pt	part
MFA	Master of Fine Arts	ptgs.	paintings
MI	Michigan	r.	*regit* [ruled]
mm	millimeter(s)	R	reprint
MN	Minnesota	repr.	reprinted; reproduced
MO	Missouri	rest.	restored

rev.	revision, revised		US	United States
Rev.	Reverend; Review		USA	United States of America
RI	Rhode Island		USSR	Union of Soviet Socialist Republics
S.	San; South(ern)		UT	Utah
SC	South Carolina		VA	Virginia
SD	South Dakota		vol., vols.	volume(s)
Sept	September		VT	Vermont
sq.	square		W.	West(ern)
sr.	senior		w.	width
St	Saint		WA	Washington
suppl.	supplement		WI	Wisconsin
S. Yorks	South Yorkshire		Worcs	Worcestershire
TN	Tennessee		wtrcols.	watercolors
trans.	translation, translated by		WV	West Virginia
TX	Texas		WY	Wyoming
U.	University		W. Yorks	West Yorkshire

Locations

Aachen, Neue Gal.	Aachen, Neue Galerie
Aachen, Suermondt-Ludwig-Mus.	Aachen, Suermondt-Ludwig-Museum
Adelaide, A.G. S. Australia	Adelaide, Art Gallery of South Australia
Akron, OH, A. Mus.	Akron, OH, Art Museum
Albany, NY, Inst. Hist. & A.	Albany, NY, Institute of History and Art
Albany, NY State Mus.	Albany, NY, New York State Museum
Albany, SUNY, U. A.G.	Albany, NY, State Univesity of New York, University of Art Gallery
Albuquerque, NM, Mus. A. & Hist.	Albuquerque, NM, Albuquerque Museum of Art and History
Albuquerque, U. NM, A. Mus.	Albuquerque, NM, University of New Mexico, Art Museum
Allentown, PA, Mus. A.	Allentown, PA, Museum of Art
Amherst, MA, Amherst Coll., Mead A. Mus.	Amherst, MA, Amherst College, Mead Art Museum
Amherst, U. MA, U. Gal.	Amherst, MA, University of Massachusetts at Amherst, University Gallery
Amsterdam, Inst. Contemp. A.	Amsterdam, Institute of Contemporary Art
Amsterdam, Rijksmus. van Gogh	Amsterdam, Rijksmuseum Vincent van Gogh
Amsterdam, Stedel. Mus.	Amsterdam, Stedelijk Museum
Anadarko, OK, Southern Plains Ind. Mus.	Anadarko, OK, Southern Plains Indian Museum
Anchorage, AK, Mus. Hist. & A.	Anchorage, AK, Anchorage Museum of History and Art
Andover, MA, Phillips Acad., Addison Gal.	Andover, MA, Phillips Academy, Addison Gallery

Annandale-on-Hudson, NY, Bard Coll., Blum Inst. — Annandale-on-Hudson, NY, Bard College, Edith C. Blum Institute

Ann Arbor, U. MI, Mus. A. — Ann Arbor, MI, University of Michigan, Museum of Art

Asheville, NC, Black Mountain Coll. Mus. & A. Cent. — Asheville, NC, Black College Museum and Art Center

Aspen, CO, A. Mus. — Aspen, CO, Art Museum

Athens, Mus. Cyclad. & Anc. Gr. A. — Athens, Museum of Cycladic and Ancient Greek Art

Athens, U. GA Mus. A. — Athens, GA, University of Georgia Museum of Art

Atlanta, GA, High Mus. A. — Atlanta, GA, High Museum of Art

Atlanta, GA, Hist. Soc. Mus. — Atlanta, GA, Atlanta Historical Society Museum

Atlanta, GA, Mus. Contemp. A. — Atlanta, GA, Museum of Contemporary Art of Georgia

Auckland, C.A.G. — Auckland, City Art Gallery

Augusta, GA, Morris Mus. A. — Augusta, GA, Morris Museum of Art

Austin, TX, Laguna Gloria A. Mus. — Austin, TX, Laguna Gloria Art Museum

Austin, U. TX, A. Mus. — Austin, TX, University of Texas at Austin, University Art Museum [name changed to Huntington A.G. in 1980]

Austin, U. TX, Blanton Mus. — Austin, TX, University of Texas at Austin, Blanton Museum

Austin, U. TX, Huntington A.G. — Austin, TX, University of Texas at Austin, Archer M. Huntington Art Gallery

Austin, U. TX, Ransom Human Res. Cent. — Austin, TX, University of Texas at Austin, Harry Hunt Ransom Humanities Research Center

Baden-Baden, Staatl. Ksthalle — Baden-Baden, Staatliche Kunsthalle Baden-Baden

Baltimore, MD Hist. Soc. Mus. — Baltimore, MD, Maryland Historical Society Museum

Baltimore, MD, Johns Hopkins U. — Baltimore, MD, John Hopkins University

Baltimore, MD, Peabody A. Col. — Baltimore, MD, Peabody Art Collection

Baltimore, MD, Walters A. Mus. — Baltimore, MD, Walters Art Museum

Baltimore, U. MD, Mus. A. — Baltimore, MD, University of Maryland, Museum of Art

Barcelona, Cent. Cult. Fund. Caixa Pensions — Barcelona, Centre Cultural de la Fundació Caixa de Pensions

Barcelona, Cent. Miró — Barcelona, Centro Miró

Basle, Ksthalle — Basel, Kunsthalle

Basle, Kstmus. — Basel, Kunstmuseum

Basle, Mus. Gegenwartskst — Basel, Museum für Gegenwartskunst

Bath, Amer. Mus. Britain — Bath, American Museum in Britain

Bath, Royal Phot. Soc. — Bath, Royal Photographic Society

Baton Rouge, LA State U. — Baton Rouge, LA, Louisiana State University

Bennington, VT, Mus. — Bennington, VT, Bennington Museum

Berkeley, U. CA, A. Mus. — Berkeley, CA, University of California, Art Museum

Berkeley, U. CA, Bancroft Lib. — Berkeley, CA, University of California, Bancroft Library

Berlin, Akad. Kst — Berlin, Akademie der Künste

Berlin, Bauhaus-Archv — Berlin, Bauhaus-Archiv

Berlin, Berlin. Gal. — Berlin, Berlinische Galerie

Berlin, Guggenheim — Berlin, Deutsche Guggenheim

Berlin, Neue Ges. Bild. Kst — Berlin, Neue Gesellschaft für Bildende Kunst

Berlin, Neue N.G. — Berlin, Neue Nationalgalerie

Berlin, Staatl. Ksthalle — Berlin, Staatliche Kunsthalle

Berne, Kstmus. — Berne, Kunstmuseum

Bethlehem, PA, Archv Morav. Church — Bethlehem, PA, Archive of the Moravian Church

Bethlehem, PA, Lehigh U. — Bethlehem, PA, Lehigh University

Bielefeld, Städt. Ksthalle — Bielefeld, Städtische Kunsthalle

Bielefeld, U. Bielefeld, Zentrum für Interdiszip. Forsch. — Bielefeld, Universität Bielefeld, Zentrum für Interdisziplinäre Forschung

Binghamton, SUNY — Binghamton, NY, State University of New York

Birmingham, Ikon Gal. — Birmingham, Ikon Gallery

Birmingham, U. Birmingham, Barber Inst. — Birmingham, University of Birmingham, Barber Institute

Birmingham, AL, Mus. A. — Birmingham, AL, Museum of Art

Black Mountain, NC, Coll., Mus. & A. Cent. — Black Mountain, NC, Black Mountain College, Museum and Arts Center

Boca Raton, FL, Mus. A., Seavest Col. — Boca Raton, FL, Museum of Art, Seavest Collection

Bochum, Mus. Bochum, Kstsamml. — Bochum, Museum Bochum, Kunstsammlung

Bologna, Gal. Com. A. Mod. — Bologna, Galleria Comunale d'Arte Moderna

Bonn, Rhein. Landesmus. — Bonn, Rheinisches Landesmuseum

Bonn, Städt. Kstmus. — Bonn, Städtisches Kunstmuseum Bonn

Bordeaux, Cent. A. Plast. Contemp. — Bordeaux, Centre d'Arts Plastiques Contemporain

Bordeaux, Mus. A. Contemp. — Bordeaux, Musée d'Art Contemporain

Boston, MA, Boston U. A.G. — Boston, MA, Boston University Art Gallery

Boston, MA, Goethe Inst. — Boston, MA, Goethe Institute

Boston, MA Hist. Soc. — Boston, MA, Massachusetts Historical Society

Boston, MA, ICA — Boston, MA, Institute of Contemporary Arts

Boston, MA, Isabella Stewart Gardner Mus. — Boston, MA, Isabella Stewart Gardner Museum

Boston, MA, Mus. Afr.-Amer. Hist. — Boston, MA, Museum of Afro-American History

Boston, MA, Mus. F.A. — Boston, MA, Museum of Fine Arts

Boston, MA, Pub. Lib. — Boston, MA, Public Library

Bregenz, Kstlerhaus Bregenz, Künstlerhaus

Brisbane, Queensland A.G. Brisbane, Queensland Art Gallery

Bristol, Arnolfini Gal. Bristol, Arnolfini Gallery

Bristol, Mus. & A.G. Bristol, City of Bristol Museum and Art Gallery

Brockton, MA, Fuller Mus. A. Brockton, MA, Fuller Museum of Art

Brookville, NY, Long Island U., Hillwood A. Mus. Brookville, NY, Long Island University, Hillwood Art Museum

Brunswick, ME, Bowdoin Coll. Mus. A. Brunswick, ME, Bowdoin College Museum of Art

Budapest, Ludwig Mus. Contemp. A. Budapest, Ludwig Museum of Contemporary Art

Buffalo, NY, Albright–Knox A.G. Buffalo, NY, Albright–Knox Art Gallery

Buffalo, NY, Burchfield A. Cent. Buffalo, NY, Burchfield Art Center

Burlington, U. VT, Robert Hull Fleming Mus. Burlington, VT, University of Vermont, Robert Hull Fleming Museum

Calais, Mus. B.-A. Calais, Musée des Beaux-Arts et de la Dentelle

Calgary, Glenbow–Alta Inst. Calgary, Glenbow–Alberta Institute

Cambridge, Robinson Coll. Cambridge (UK), Robinson College

Cambridge, U. Cambridge, Kettle's Yard Cambridge, University of Cambridge, Kettle's Yard

Cambridge, MA, Busch-Reisinger Mus. Cambridge, MA, Busch-Reisinger Museum

Cambridge, MA, Fogg Cambridge, MA, Fogg Art Museum

Cambridge, MA, Harvard U. A. Museums Cambridge, MA, Harvard University Art Museums

Cambridge, MA, Harvard U., Frances Loeb Sch. Des. Lib. Cambridge, MA, Harvard University, Frances Loeb School of Design Library

Cambridge, MA, Harvard U., Grad. Sch. Des. Cambridge, MA, Harvard University, Graduate School of Design

Cambridge, MA, Harvard U., Houghton Lib. Cambridge, MA, Harvard U., Houghton Library

Cambridge, MA, Inst. Contemp. A. Cambridge, MA, Institute of Contemporary Art

Cambridge, MA, MIT, List Visual A. Cent. Cambridge, MA, Massachusetts Intitute of Technology, List Visual Arts Center

Canajoharie, NY, Lib. & A.G. Canajoharie, NY, Canajoharie Library and Art Gallery

Canton, OH, A. Inst. Canton, OH, Art Institute

Cape Town, N.G. Cape Town, South African National Gallery

Carlisle, PA, Dickinson Coll., Trout A.G. Carlisle, PA, Dickinson College, Trout Art Gallery

Casper, WY, Nicolaysen A. Mus. Casper, WY, Nicolaysen Art Museum

Catanzaro, Mus. A. Catanzaro, Museo delle Arti di Catanzaro

Chadds Ford, PA, Brandywine River Mus. Chadds Ford, PA, Brandywine River Museum

Champaign, U. IL, Krannert A. Mus. Champaign, IL, University of Illinois, Krannert Art Museum

Chapel Hill, U. NC, Ackland A. Mus. Chapel Hill, NC, University of North Carolina, Ackland Art Museum

Charleston, SC, Carolina A. Assoc. — Charleston, SC, Carolina Art Association

Charleston, SC, Gibbes Mus. A. — Charleston, SC, Gibbes Museum of Art

Charlotte, NC, Mint Mus. A. — Charlotte, NC, Mint Museum of Art

Charlottesville, U. VA, Bayly A. Mus. — Charlottesville, VA, University of Virginia, Bayly Art Museum

Chattanooga, TN, Hunter Mus. Amer. A. — Chattanooga, TN, Hunter Museum of American Art

Chicago, IL, A. Club — Chicago, IL, Arts Club

Chicago, IL, A. Inst. — Chicago, IL, Art Institute of Chicago

Chicago, IL, Cent. Comtemp. Phot. — Chicago, IL, Center for Contemporary Photography

Chicago, IL, Hist. Mus. — Chicago, IL, Chicago History Museum

Chicago, IL, Mus. Contemp. A. — Chicago, IL, Museum of Contemporary Art

Chicago, IL, Newberry Lib., Dankmar Adler Archv — Chicago, IL, Newberry Library, Dankmar Adler Archive

Chicago, IL, Sch. A. Inst. — Chicago, IL, School of the Art Institute of Chicago

Chicago, IL, Smart Mus. A. — Chicago, IL, Smart Museum of Art

Chicago, IL, Terra Found. Amer. A. — Chicago, IL, Terra Foundation of American Art

Chicago, IL, Terra Mus. Amer. A. — Chicago, IL, Terra Museum of American Art

Chicago, IL, U. Chicago, Ren. Soc. Gal. — Chicago, IL, University of Chicago, Renaissance Society Gallery

Chicago, IL, Valerie Carberry Gal. — Chicago, IL, Valerie Carberry Gallery

Cincinnati, OH, A. Mus. — Cincinnati, OH, Cincinnati Art Museum

Cincinnati, OH, Contemp. A. Cent. — Cincinnati, OH, Contemporary Art Center

Cincinnati, OH, Union Inst. & U. — Cincinnati, OH, Union Institute and University

Clemson, SC, Clemson U., Lee Gal. — Clemson, SC, Clemson University, Lee Gallery

Cleveland, OH, Cent. Contemp. A. — Cleveland, OH, Cleveland Center for Contemporary Art

Cleveland, OH, Mus. A. — Cleveland, OH, Cleveland Museum of Art

Cody, WY, Buffalo Bill Hist. Cent. — Cody, WY, Buffalo Bill Historical Center

Cold Spring, NY, Putnam County Hist. Soc. — Cold Spring, NY, Putnam County Historical Society

College Park, U. MD A.G. — College Park, MD, University of Maryland Art Gallery

Cologne, Kstver. — Cologne, Kunstverein

Cologne, Mus. Ludwig — Cologne, Museum Ludwig

Cologne, Stadtmus. — Cologne, Kölnisches Stadtmuseum

Cologne, Wallraf-Richartz-Mus. — Cologne, Wallraf-Richartz-Museum

Colorado Springs, CO, F.A. Cent. — Colorado Springs, CO, Fine Arts Center

Columbus, GA, Mus. — Columbus, GA, Columbus Museum

Columbus, OH Hist. Soc. — Columbus, OH, Ohio Historical Society

Columbus, OH, Mus. A. — Columbus, OH, Museum of Art

Columbus, OH, Wexner Cent. A. — Columbus, OH, Wexner Center for the Arts

Cooperstown, Mus. NY State Hist. Assoc.	Cooperstown, NY, Museum of New York State Historical Association
Cooperstown, NY, Fenimore A. Mus.	Cooperstown, NY, Fenimore Art Museum
Coral Gables, FL, U. Miami, Lowe A. Mus.	Coral Gables, FL, University of Miami, Lowe Art Museum
Corpus Christi, A. Mus. S. TX	Corpus Christi, TX, Art Museum of South Texas
Cortland, SUNY, Dowd F.A. Gal.	Cortland, NY, State University of New York, Dowd Fine Arts Gallery
Cragsmoor, NY, Free Lib.	Cragsmoor, NY, Free Library
Dallas, TX, Mus. A.	Dallas, TX, Museum of Art
Dallas, TX, Mus. F.A.	Dallas, TX, Museum of Fine Arts
Dallas, TX, S. Methodist U., Meadows Mus. & Gal.	Dallas, TX, Southern Methodist University, Meadows Museum and Gallery
Dallas, TX, S. Methodist U., Pollock Gals.	Dallas, TX, Southern Methodist University, Pollock Galleries
Davis, U. CA, Nelson A.G.	Davis, CA, University of California, Nelson Art Gallery
Dayton, OH, A. Inst.	Dayton, OH, Art Institute
Deerfield, MA, Mem. Hall Mus.	Deerfield, MA, Memorial Hall Museum
DeLand, FL, Stetson U.	DeLand, FL, Stetson University
Dennis, MA, Cape Mus. F.A.	Dennis, MA, Cape Museum of Fine Arts
Denver, CO, A. Mus.	Denver, CO, Art Museum
Denver, CO, Mus. W. A.	Denver, CO, Museum of Western Art
Denver, CO, Vance Kirkland Mus. & Fdn	Denver, CO, Vance Kirkland Museum and Foundation
Des Moines, IA, A. Cent.	Des Moines, IA, Art Center
Des Moines, IA, Civ. Cent.	Des Moines, IA, Civic Center of Greater Des Moines
Detroit, MI, Hist. Mus.	Detroit, MI, Historical Museum
Detroit, MI, Inst. A.	Detroit, MI, Detroit Institute of Arts
Detroit, MI, Mus. Afr. Amer. Hist.	Detroit, MI, Museum of African-American History
Dortmund, Mus. Kst & Kultgesch.	Dortmund, Museum für Kunst und Kulturgeschichte der Stadt
Dortmund, Mus. Ostwall	Dortmund, Museum am Ostwall
Doylestown, PA, Michener A. Mus.	Doylestown, PA, James A. Michener Art Museum
Dublin, Irish MOMA	Dublin, Irish Museum of Modern Art
Dublin, Trinity Coll., Hyde Gal.	Dublin, Trinity College, Douglas Hyde Galler
Duisburg, Lehmsbruck-Mus.	Duisburg, Lehmsbruck-Museum
Durham, NC, Cent. U., Mus. A.	Durham, NC, North Carolina Central University, Museum of Art
Durham, U. NH, A. Gals	Durham, NH, University of New Hampshire, University Art Galleries

Düsseldorf, Kstsamml. Nordrhein–Westfalen	Düsseldorf, Kunstsammlung Nordrhein–Westfalen
Düsseldorf, Kstver.	Düsseldorf, Kunstverein für die Rheinlande und Westfalen
Düsseldorf, Städt. Ksthalle	Düsseldorf, Städtische Kunsthalle
Duxbury, MA, A. Complex Mus.	Duxbury, MA, Art Complex Museum
East Hampton, NY, Guild Hall Mus.	East Hampton, NY, Guild Hall Museum
Easton, PA, Lafayette Coll. A.G.	Easton, PA, Lafayette College Art Gallery
Eindhoven, Stedel. Van Abbemus.	Eindhoven, Stedelijk Van Abbemuseum
Essen, Mus. Flkwang	Essen, Museum Folkwang
Evanston, IL, Northwestern U., Dittmar Mem. Gal.	Evanston, IL, Northwestern University, Dittmar Memorial Gallery
Evanston, IL, Northwestern U., Mary & Leigh Block Gal.	Evanston, IL, Northwestern University, Mary and Leigh Block Gallery
Fargo, ND, Plains A. Mus.	Fargo, ND, Plains Art Museum
Flint, MI, Inst. A.	Flint, MI, Flint Institute of Arts
Florence, Pitti	Florence, Palazzo Pitti
Fort Lauderdale, FL, Mus. A.	Fort Lauderdale, FL, Museum of Art
Fort Wayne, IN, Mus. A.	Fort Wayne, IN, Fort Wayne Museum of Art
Fort Worth, TX, Amon Carter Mus.	Fort Worth, TX, Amon Carter Museum of Western Art
Fort Worth, TX, A. Mus.	Fort Worth, TX, Fort Worth Art Museum
Fort Worth, TX, Mod. A. Mus.	Fort Worth, TX, Modern Art Museum of Fort Worth
Framingham, MA, Danforth Mus. A.	Framingham, MA, Danforth Museum of Art
Frankfurt am Main, Gal. Neuendorf	Frankfurt am Main, Galerie Neuendorf
Frankfurt am Main, Kstver.	Frankfurt am Main, Kunstverein
Frankfurt am Main, Schirn Ksthalle	Frankfurt am Main, Schirn Kunsthalle
Frankfurt am Main, Städel. Kstinst. & Städt. Gal.	Frankfurt am Main, Städelsches Kunstinstitut und Städtische Galerie
Fremont, CA Sch. Deaf	Fremont, CA, California School for the Deaf
Fresno, CA, A. Mus.	Fresno, CA, Art Museum
Fullerton, CA State U., Visual A. Cent., A.G.	Fullerton, CA, California State University, Visual Arts Center, Art Gallery
Gainesville, U. FL, Mus. Nat. Hist.	Gainesville, FL, University of Florida Museum of Natural History
Gambier, OH, Kenyon Coll., Olin A.G.	Gambier, OH, Kenyon College, Olin Art Gallery
Gera, Kstgal.	Gera, Kunstgalerie
Gettysburg, PA, N. Mil. Park	Gettysburg, PA, National Military Park
Ghent, Stedel. Mus. Actuele Kst	Ghent, Stedelijk Museum voor Actuele Kunst
Giverny, Mus. A. Amér.	Giverny, Musée d'Art Américain
Glasgow, A.G. & Mus.	Glasgow, Art Gallery and Museum
Glasgow, U. Glasgow, Hunterian A.G.	Glasgow, University of Glasgow, Hunterian Art Gallery

Glendale, CA, Forest Lawn Mem. Park — Glendale, CA, Forest Lawn Memorial Park

Godfrey, IL, Lewis & Clark Comm. Coll. — Godfrey, IL, Lewis and Clark Community College

Great Falls, MT, C. M. Russell Mus. — Great Falls, MT, C. M. Russell Museum

Greensboro, U. NC, Weatherspoon A. Mus. — Greensboro, NC, University of North Carolina, Weatherspoon Art Museum

Greenburg, PA, Westmoreland Mus. Amer. A. — Greenburg, PA, Westmoreland Museum of American Art

Greeville, SC, Co. Mus. A. — Greenville, SC, County Museum of Art

Greenwich, CT, Bruce Mus. — Greenwich, CT, Bruce Museum

Greenville, SC, Co. Mus. A. — Greenville, SC, County Museum of Art

Grenoble, Magasin-Cent. N. A. Contemp. — Grenoble, Magasin-Centre National d'Art Contemporain

Grinnell, IA, Grinnell Coll., Faulconer Gal. — Grinnell, IA, Grinnell College, Faulconer Gallery

Groningen, Groninger Mus. — Groningen, Groninger Museum

Hagerstown, MD, Washington Co. Hist. Soc. Mus. — Hagerstown, MD, Washington County Historical Society Museum

The Hague, Fotomus. — The Hague, Fotomuseum Den Haag

The Hague, Gemeentemus. — The Hague, Gemeentemuseum

Halifax, A.G. NS — Halifax, NS, Art Gallery of Nova Scotia

Halifax, NS Coll. A. & Des. — Halifax, NS, Nova Scotia College of Art and Design

Halifax, NS Mus. — Halifax, NS, Nova Scotia Museum

Halle, Landeskstmus. Sachsen-Anhalt — Halle, Landeskunstmuseum Sachsen-Anhalt

Halle, Staatl. Gal. Moritzburg — Halle, Staatliche Galerie Mortizburg

Hamburg, Mus. Kst & Gew. — Museum für Kunst und Gewerbe

Hamilton, NY, Colgate U. — Hamilton, NY, Colgate University

Hampton, VA, U. Mus. — Hampton, VA, Hampton University Museum

Hannover, Kestner-Ges. — Hannover, Kestner-Gesellschaft

Hannover, Sprengel Mus. — Hannover, Sprengel Museum

Hanover, NH, Dartmouth Coll., Hood Mus. A. — Hanover, NH, Dartmouth College, Hood Museum of Art

Harrisburg, PA, State Mus. — Harrisburg, PA, State Museum of Pennsylvania

Harvard, MA, Fruitlands Mus. — Harvard, MA, Fruitlands Museum

Heidelberg, Ruprecht-Karls-U. — Heidelberg, Ruprecht-Karls-Universität

Hempstead, NY, F.A. Mus. Long Island — Hempstead, NY, Fine Arts Museum of Long Island

Hempstead, NY, Hofstra U. Mus. — Hempstead, NY, Hofstra University Museum

Honolulu, HI, Contemp. A. Cent. — Honolulu, HI, Contemporary Arts Center

Houston, TX, Cent. Phot. — Houston, TX, Houston Center for Photography

Houston, TX, Contemp. A. Mus. — Houston, TX, Contemporary Art Museum

Houston, TX, Menil Col. — Houston, TX, Menil Collection

Houston, TX, Rice U. Inst. A., Rice Mus.　　Houston, TX, Rice University Institute for the Arts, Rice Museum

Houston, TX, U. Houston, Sarah Campbell Blaffer Gal.　　Houston, TX, University of Houston, Sarah Campbell Blaffer Gallery

Houston, TX, Rice U. Inst. A.　　Houston TX, Rice University Institute for the Arts

Humlebæk, Louisiana Mus.　　Humlebæk, Louisiana Museum of Modern Art

Huntingdon, PA, Juniata Coll. Mus. A.　　Huntingdon, PA, Juniata College Museum of Art

Huntington, NY, Heckscher Mus.　　Huntington, NY, Heckscher Museum

Huntington, WV, Marshall U.　　Huntington, WV, Marshall University

Indianapolis, IN, Eitelborg Mus. Amer. Ind. & W. A.　　Indianapolis, IN, Eitelborg Museum of the American Indian and Western Art

Indianapolis, IN, Herron A. Inst.　　Indianapolis, IN, John Herron Art Institute [name change to Herron Mus. A. then IN Mus. A.]

Indianapolis, IN, Herron Mus. A.　　Indianapolis, IN, Herron Museum of Art [name changed to IN Mus. A. in 1968]

Indianapolis, IN, Mus. A.　　Indianapolis, IN, Indianapolis Museum of Art

Iowa City, U. IA Mus. A.　　Iowa City, IA, University of Iowa Museum of Art

Irvine, CA, Mus.　　Irvine, CA, Irvine Museum

Ithaca, NY, Cornell U., Dickson White Mus. A.　　Ithaca, NY, Cornell University, Andrew Dickson White Museum of Art

Ithaca, NY, Cornell U., Johnson Mus. A.　　Ithaca, NY, Cornell University, Herbert F. Johnson Museum of Art

Ithaca, NY, Cornell U. Lib.　　Ithaca, NY, Cornell University Library

Jackson, MS Mus. A.　　Jackson, MS, Mississippi Museum of Art

Jackson Hole, WY, N. Mus. Wildlife　　Jackson Hole, WY, National Museum of Wildlife

Jacksonville, FL, Cummer Gal. A.　　Jacksonville, FL, Cummer Gallery of Art

Jersey City, NJ, Mus.　　Jersey City, NJ, Jersey City Museum

Jerusalem, Israel Mus.　　Jerusalem, Israel Museum

Kalamazoo, MI, Inst. A.　　Kalamazoo, MI, Kalamazoo Institute of Arts

Kansas City, MO, Nelson–Atkins Mus. A.　　Kansas City, MO, Nelson–Atkins Museum of Art

Kansas City, MO, W. Rockhill Nelson Gal.　　Kansas City, MO, W. Rockhill Nelson Gallery [now Nelson–Atkins Museum of Art]

Kassel, Kstver.　　Kasseler Kunstverein

Kazan', Mus. F.A. Tatarstan　　Kazan', Museum of Fine Arts of Tatarstan

Keene, NH, State Coll.　　Keene, NH, Keene State College

Knoxville, TN, Mus. A.　　Knoxville, TN, Knoxille Museum of Art

Kyoto, N. Mus. Mod. A.　　Kyoto, National Museum of Modern Art

Labege-Innopole, Cent. Rég. A. Contemp. Midi-Pyrénées　　Labege-Innopole, Centre Régional d'Art Contemporain Midi-Pyrénées

Laguna Beach, CA, A. Mus.　　Laguna Beach, CA, Laguna Beach Art Museum

La Jolla, CA, Mus. Contemp. A.	La Jolla, CA, Museum of Contemporary Art
Laramie, U. WY A. Mus.	Laramie, WY, University of Wyoming Art Museum
Lawrence, U. KS, Spencer Mus. A.	Lawrence, KS, University of Kansas, Spencer Museum of Art
Leeds, C.A.G.	Leeds, City Art Gallery
Lewisburg, PA, Bucknell U.	Lewisburg, PA, Bucknell University
Lewisburg, PA, Packwood House Mus.	Lewisburg, PA, Packwood House Museum
León, Mus. A. Contemp.	León, Museo de Arte Contemporáneo
Liège, Mus. A. Mod.	Liège, Musée d'Art Moderne
Limoges, Fonds Rég. A. Contemp.	Limoges, Fonds Régional d'Art Contemporain
Lincoln, MA, DeCordova & Dana Mus.	Lincoln, MA, DeCordova and Dana Museum and Park
Lincoln, U. NE, Sheldon Mem. A.G.	Lincoln, NE, University of Nebraska, Sheldon Memorial Art Gallery
Linz, Neue Gal.	Linz, Neue Galerie der Stadt Linz
Little Rock AR A. Cent.	Little Rock, AR, Arkansas Art Center
Liverpool, Walker A.G.	Liverpool, Walker Art Gallery
London, ACGB	London, Arts Council of Great Britain
London, Archit. Assoc.	London, Architectural Association
London, Barbican A.G.	London, Barbican Art Gallery
London, BM	London, British Museum
London, Buckingham Pal., Royal Col.	London, Buckingham Palace, Royal Collection
London, Camden A. Cent.	London, Camden Arts Centre
London, Hayward Gal.	London, Hayward Gallery
London, ICA	London, Institute of Contemporary Art
London, N. Mar. Mus.	London, National Maritime Museum
London, N.P.G.	London, National Portrait Gallery
London, RA	London, Royal Academy
London, Richmond Pub. Lib.	London, Richmond Public Library
London, Royal Coll. A.	London, Royal College of Art
London, Royal Soc. A.	London, Royal Society of Arts
London, Saatchi Gal.	London, Saatchi Gallery
London, Serpentine Gal.	London, Serpentine Gallery
London, U. London, Courtauld Inst.	London, University of London, Courtauld Institute
London, V&A	London, Victoria and Albert Museum
London, U. W. Ont., McIntosh A.G.	London, Ont., University of Western Ontario, McIntosh Art Gallery
London, Whitechapel A.G.	London, Whitechapel Art Gallery
Long Beach, CA, Mus. A.	Long Beach, CA, Museum of Art
Long Beach, CA State U., A. Mus.	Long Beach, CA, California State University, University Art Museum

Los Angeles, CA Afr. Amer. Mus. — Los Angeles, CA, California African American Museum

Los Angeles, CA, Co. Mus. A. — Los Angeles, CA, County Museum of Art

Los Angeles, CA, Jap. Amer. N. Mus. — Los Angeles, CA, Japanese American National Museum

Los Angeles, CA, MAK Cent. A. & Archit. — Los Angeles, CA, MAK Center for Art and Architecture

Los Angeles, CA, Mus. Contemp. A. — Los Angeles, CA, Museum of Contemporary Art

Los Angeles, CA, Otis A. Inst. Gal. — Los Angeles, CA, Otis Art Institute Gallery

Los Angeles, CA, Skirball Cult. Cent. & Mus. — Los Angeles, CA, Skirball Cultural Center and Museum

Los Angeles, CA, Southwest Mus. — Los Angeles, CA, Southwest Museum

Los Angeles, UCLA, Hammer Mus. — Los Angeles, CA, University of California, Hammer Museum

Los Angeles, UCLA, Wight A.G. — Los Angeles, CA, University of California, Frederick S. Wight Art Gallery

Louisville, KY, Speed A. Mus. — Louisville, KY, J. B. Speed Art Museum

Lugano, Col. Thyssen-Bornemisza — Lugano, Collection Baron Thyssen-Bornemisza

Lyon, Mus. A. Contemp. — Lyon, Musée d'Art Contemporain

Madison, U. WI, Elvehjem A. Cent. — Madison, WI, University of Wisconsin, Elvehjem Art Center

Madrid, Fund. Caja Pensiones — Madrid, Fundación Caja de Pensiones

Madrid, Mus. N. Cent. A. Reina Sofia — Madrid, Museo Nacional Centro de Arte Reina Sofia

Madrid, Prado — Madrid, Museo del Prado

Malibu CA, Pepperdine U. Weisman Mus. A. — Malibu, CA, Pepperdine University, Frederick R. Weisman Museum of Art

Malmö, Ksthall — Malmö, Konsthall

Manchester, NH, Currier Mus. A. — Manchester, NH, Currier Museum of Art

Manchester, NH, S. NH U., McIninch A.G. — Manchester, NH, Southern New Hampshire University, McIninch Art Gallery

Marugame, Genichiro-Inokuma Mus. Contemp. A. — Marugame, Genichiro-Inokuma Museum of Contemporary Art

Memphis, TN, Brooks Mus. A. — Memphis, TN, Brooks Museum of Art

Mexico City, Inst. N. B.A. — Mexico City, Instituto Nacional de Bellas Artes

Mexico City, Mus. N. Est. — Mexico City, Museo Nacional de la Estampa

Mexico City, Mus. Pal. B.A. — Mexico City, Museo del Palacio de Bellas Artes

Miami Beach, FL, Bass Mus. A. — Miami Beach, FL, Bass Museum of Art

Middletown, CT, Wesleyan U., Davison A. Cent. — Middletown, CT, Wesleyan University, Davison Art Center

Milwaukee, WI, A. Mus. — Milwaukee, WI, Milwaukee Art Museum

Minneapolis, MN, Inst. A. — Minneapolis, MN, Minneapolis Institute of Arts

Minneapolis, MN, Walker A. Cent. — Minneapolis, MN, Walter Art Center

Minneapolis, U. MN, A. Gal. — Minneapolis, MN, University of Minnesota, University Art Gallery

Minneapolis, U. MN, Weisman A. Mus. — Minneapolis, MN, University of Minnesota, Frederick R. Weisman Art Museum

Modena, Gal. Civ. Com. — Modena, Galleria Civica del Comune

Mönchengladbach, Städt. Mus. Abteiberg — Mönchengladbach, Städtisches Museum Abteiberg

Montclair, NJ, A. Mus. — Montclair, NJ, Montclair Art Museum

Monterey, CA, Peninsula Mus. A. — Monterey, CA, Peninsula Museum of Art

Montgomery, AL, Mus. F.A. — Montgomery, AL, Museum of Fine Arts

Montreal, Concordia U., Williams A. Gals — Montreal, Concordia University, Sir George Williams Art Galleries [now Leonard & Bina Ellen Art Gallery]

Montreal, Expo '67, Can. Pav. — Montreal, Expo '67, Canadian Pavilion

Montreal, McGill U., McCord Mus. — Montreal, McGill University, McCord Museum

Montreal, Mus. A. Contemp. — Montreal, Musée d'Art Contemporain

Morago, CA, Hearst A.G. — Morago, CA, Hearst Art Gallery

Moscow, Pushkin Mus. F.A. — Moscow, Pushkin Museum of Fine Arts

Moscow, Tret'yakov Gal. — Moscow, Tret'yakov Gallery

Mountainville, NY, Storm King A. Cent. — Mountainville, NY, Storm King Art Center

Munich, Fotomus. — Munich, Fotomuseum

Munich, Haus Kst — Munich, Haus der Kunst

Munich, Lenbachhaus — Munich, Städtische Galerie im Lenbachhaus

Munich, Neue Kstsalon — Munich, Neue Kunstsalon

Nashville, TN Botan. Gdns & F.A. Cent. — Nashville, TN, Tennessee Botanical Gardens and Fine Arts Center

Nazareth, PA, Whitefield House Mus. — Nazareth, PA, Whitefield House Museum

Neah Bay, WA, Makah Cult. & Res. Cent. — Neah Bay, WA, Makah Cultural and Research Center

Newark, U. DE — Newark, DE, University of Delaware

Newark, NJ, Mus. — Newark, NJ, Newark Museum

New Britain, CT, Mus. Amer. A. — New Britain, CT, Museum of American Art

New Brunswick, NJ, Rutgers U. A.G. — New Brunswick, NJ, Rutgers University Art Gallery

New Brunswick, NJ, Rutgers U., Zimmerli A. Mus. — New Brunswick, NJ, Rutgers University, Zimmerli Art Museum

New Haven, CT, Colony Hist. Soc. Mus. — New Haven, CT, Colony Historical Society Museum

New Haven, CT, Yale U. A.G. — New Haven, CT, Yale University Art Gallery

New Haven, CT, Yale U. Cent. Amer. A. — New Haven, CT, Yale University, Center for American Arts and Material Culture

New Orleans, LA, Contemp. A. Cent. — New Orleans, LA, Contemporary Art Center

New Orleans, LA State Mus. — New Orleans, LA, Louisiana State Museum

New Orleans, Tulane U. LA — New Orleans, LA, Tulane University of Louisiana

Newport, RI, Redwood Lib. Newport, RI, Redwood Library

Newport Beach, CA, Harbor A. Mus. Newport Beach, CA, Harbor Art Museum

Newport Beach, CA, Orange Co. Mus. A. Newport Beach, CA, Orange County Museum of Art

New York, Altern. Cent. Int. A. New York, Alternative Center for International Arts

New York, Amer. A. Assoc. New York, American Art Association

New York, Amer. Acad. A. & Lett. New York, American Academy of Arts and Letters

New York, Amer. Craft Mus. New York, American Craft Museum

New York, Amer. Fed. A. New York, American Federation of Arts

New York, Amer. Folk A. Mus. New York, American Folk Art Museum

New York, Amer. Numi. Soc. New York, American Numismatic Society

New York, Arthur M. Sackler Found. New York, Arthur M. Sackler Foundation

New York, Asian A. Inst. New York, Asian Arts Institute

New York, Asia Soc. Gals. New York, Asia Society Galleries

New York, Bard Grad. Cent. New York, Bard Graduate Center for Studies in the Decorative Arts, Design and Culture

New York, Berry-Hill Gals New York, Berry-Hill Galleries

New York, Bronx Mus. A. New York, Bronx Museum of the Arts

New York, Brooklyn Mus. New York, The Brooklyn Museum

New York, C. Assoc. New York, Century Association

New York, Cent. Int. Contemp. A. New York, Center for International Contemporary Arts

New York, Columbia U., Avery Archit. & F.A. Lib. New York, Columbia University, Avery Architectural and Fine Arts Library

New York, Columbia U., Wallach A.G. New York, Columbia University, Miriam and Ira D. Wallach Art Gallery

New York, Cooper-Hewitt Mus. New York, Cooper-Hewitt Museum, Smithsonian Institution; National Museum of Design

New York, Cult. Cent. New York, Cultural Center

New York, Dia A. Found. New York, Dia Art Foundation

New York, Dintenfass Gal. New York, Terry Dintenfass Gallery

New York, Drg Cent. New York, The Drawing Center

New York, Gal. Mod. A. New York, Gallery of Modern Art

New York, Gen. Theol. Semin. New York, General Theological Seminary

New York, Grey Gal. & Stud. Cent. New York, Grey Gallery and Study Center

New York, Guggenheim New York, Solomon R. Guggenheim Museum

New York, Hudson River Mus. New York, Hudson River Museum at Yonkers

New York, ICA New York, Institute of Contemporary of Art

New York, Inst. Archit. & Urb. Stud. New York, Institute of Architecture and Urban Studies

New York, Int. Cent. Phot. New York, International Center of Photography

New York, Japan Soc. Gal. New York, Japan Society Gallery
New York, Jew. Mus. New York, Jewish Museum
New York, Marlborough Gal. New York, Marlborough Gallery, Inc.
New York, Met. New York, Metropolitan Museum of Art
New York, MOMA New York, Museum of Modern Art
New York, Mus. A. & Des. New York, Museum of Art and Design
New York, Mus. Amer. Flk A. New York, Museum of American Folk Art
New York, Mus. Barrio New York, Museo del Barrio
New York, Mus. City NY New York, Museum of the City of New York
New York, Mus. Contemp. Hisp. A. New York, Museum of Contemporary Hispanic
 Art
New York, Mus. Non-obj. Ptg New York, Museum of Non-objective Painting
New York, N. Acad. Des. New York, National Academy of Design
New York, N. Acad. Mus. New York, National Academy Museum
New York, New Mus. Contemp. A. New York, New Museum of Contemporary Art
New York, New Sch. Soc. Res. New York, New School for Social Research
New York, N. Mus. Amer. Ind. New York, National Museum of the American
 Indian
New York, N. Sculp. Soc. New York, National Sculpture Society
New York, NY Hist. Soc. New York, New-York Historical Society
New York, Paula Cooper Gal. New York, Paula Cooper Gallery
New York, P.S.1 New York, P.S.1 [Project Studio One]
 Contemporary Art Center
New York, Pub. Lib. New York, Public Library
New York, Pub. Lib., Schomburg Cent. New York, Public Library, Schomburg Center for
 Res. Black Cult. Research in Black Culture
New York, Queens Mus. A. New York, Queens Museum of Art
New York, Ronald Feldman F.A. Inc. New York, Ronald Feldman Fine Art, Inc.
New York, Smolin Gallery New York, Smolin Gallery
New York, Spanierman Gal. New York, Spanierman Gallery
New York, Studio Mus. Harlem New York, Studio Museum in Harlem
New York, Tibor de Nagy Gal. New York, Tibor de Nagy Gallery
New York U., Grey A.G. New York, New York University, Grey Art
 Gallery and Study Center
New York, Whitney New York, Whitney Museum of American Art
Nîmes, Gal. Arènes Nîmes, Galerie des Arènes
Nîmes, Mus. A. Contemp. Nîmes, Musée d'Art Contemporain
Norfolk, VA, Chrysler Mus. Norfolk, VA, Chrysler Museum
Normal, IL, State U. Gals. Normal, IL, Illinois State University Galleries
Norman, U. OK, Jones Mus. A. Norman, OK, University of Oklahoma, Fred
 Jones Jr. Museum of Art
North Adams, MA, Mus. Contemp. A. North Adams, MA, Massachusetts Museum of
 Contemporary Art

Northampton, MA, Smith Coll. Mus. A. — Northampton, MA, Smith College Museum of Art

North Miami, FL, Mus. Contemp. A. — North Miami, FL, Museum of Contemporary Art

Norwich, U. E. Anglia — Norwich, University of East Anglia

Norwich, CT, Slater Mem. Mus. — Norwich, CT, Slater Memorial Museum

Notre Dame, IN, Snite Mus. A. — Notre Dame, IN, Snite Museum of Art

Oakland, CA, Mus. — Oakland, CA, Oakland Museum

Oberlin Coll., OH, Allen Mem. A. Mus. — Oberlin, OH, Oberlin College, Allen Memorial Art Museum

Ogunquit, ME, Mus. Amer. A. — Ogunquit, ME, Ogunquit Mus. Amer. A.

Oklahoma City, OK City Mus. A. — Oklahoma City, OK, Oklahoma City Museum of Art

Old Lyme, CT, Florence Griswold Mus. — Old Lyme, CT, Florence Griswold Museum

Omaha, NE, Joslyn A. Mus. — Omaha, NE, Joslyn Art Museum

Oneonta, NY State U. Coll. — Oneonta, NY, New York State University College at Oneonta

Oporto, Mus. Serralves — Oporto, Museu Serralves

Orlando, FL, Mus. A. — Orlando, FL, Orlando Museum of Art

Oshkosh, WI, Paine A. Cent. & Arboretum — Oshkosh, WI, Paine Art Center and Arboretum

Oslo, Astrup Fearnley Mus. Mod. Kst — Oslo, Astrup Fearnley Museet for Moderne Kunst

Oslo, Mus. Samtidkst — Oslo, Museet for Samtidkunst

Oswego, SUNY, Tyler A.G. — Oswego, NY, State University of New York, Tyler Art Gallery

Ottawa, N. Archvs — Ottawa, National Archives of Canada

Ottawa, N.G. — Ottawa, National Gallery of Canada

Otterlo, Rijksmus. Kröller-Müller — Otterlo, Rijksmuseum Kröller-Müller

Oxford, Mod. A. — Oxford, Modern Art [formerly MOMA]

Oxford, MOMA — Oxford, Museum of Modern Art

Oxford, OH, Miami U., A. Mus. — Oxford, Ohio, Miami University, Art Museum

Palm Springs, CA, Desert Mus. — Palm Springs, CA, Desert Museum

Paris, Carnavalet — Paris, Musée Carnavalet

Paris, Gal. France — Paris, Galerie de France

Paris, Grand Pal. — Paris, Grand Palais

Paris, Inst. A. & Archéol. — Paris, Institut d'art et d'archéologie

Paris, Louvre — Paris, Musée du Louvre

Paris, Mus. A. Déc. — Paris, Musée des Arts Décoratifs

Paris, Mus. A. Mod. Ville — Paris, Musée d'Art Moderne de la Ville de Paris

Paris, Mus. Marmottan — Paris, Musée Marmottan

Paris, Mus. N. A. Mod. — Paris, Musée National d'Art Moderne

Paris, Mus. Orangerie — Paris, Musée de l'Orangerie

Paris, Mus. Orsay — Paris, Musée d'Orsay

Paris, Pal. Luxembourg — Paris, Palais du Luxembourg

Paris, Pompidou — Paris, Centre Georges Pompidou

Pasadena, CA, A. Mus. — Pasadena, CA, Pasadena Art Museum [name changed to Norton Simon museum in 1975]

Pasadena, CA, Inst. Tech.	Pasadena, CA, California Institute of Technology
Pasadena, CA, Norton Simon Mus.	Pasadena, CA, Norton Simon Museum
Perth, A.G. W. Australia	Perth, Art Gallery of Western Australia
Philadelphia, PA, A. Alliance	Philadelphia, PA, Art Alliance
Philadelphia, PA Acad. F.A.	Philadelphia, PA, Pennsylvania Academy of the Fine Arts
Philadelphia, PA, Acad. Nat. Sci.	Philadelphia, PA, Academy of Natural Scienes of Philadelphia
Philadelphia, PA, Hist. Soc.	Philadelphia, PA, Historical Society of Pennsylvania
Philadelphia, PA, ICA	Philadelphia, PA, Institute of Contemporary Art
Philadelphia, PA, Indep. N. Hist. Park	Philadelphia, PA, Independence National Historial Park
Philadelphia, PA, Mar. Mus.	Philadelphia, PA, Maritime Museum
Philadelphia, PA, Moore Coll. A. & Des., Goldie Paley Gal.	Philadelphia, PA, Moore College of Art and Design, Goldie Paley Galleri
Philadelphia, PA, Mus. A.	Philadelphia, PA, Museum of Art
Philadelphia, PA, N. Mus. Amer. Jew. Hist.	Philadelphia, PA, National Museum of American Jewish History
Philadelphia, PA, Prt Club Mus.	Philadelphia, PA, Print Club Museum
Philadelphia, PA, Thomas Jefferson U., Medic. Col.	Philadelphia, PA, Thomas Jefferson University, Medical Collection
Philadelphia, PA, Woodmere A. Mus.	Philadelphia, PA, Woodmere Art Museum
Philadelphia, U. PA, ICA	Philadelphia, PA, University of Pennsylvania, Institute of Contemporary Art
Phoenix, AZ, A. Mus.	Phoenix, AZ, Art Museum
Phoenix, AZ, Heard Mus.	Phoenix, AZ, Heard Museum
Pittsburgh, PA, Buhl Sci. Cent.	Pittsburgh, PA, Buhl Science Center
Pittsburgh, PA, Carnegie Inst.	Pittsburgh, PA, Carnegie Institute
Pittsburgh, PA, Carnegie Mus. A.	Pittsburgh, PA, Carnegie Museum of Art
Pittsburgh, PA, Carnegie–Mellon U. A.G.	Pittsburgh, PA, Carnegie–Mellon University Art Gallery
Pittsburgh, PA, Carnegie–Mellon U., Hewlett Gal.	Pittsburgh, PA, Carnegie–Mellon University, Hewlett Gallery
Pittsburgh, PA, Frick A. & Hist. Cent.	Pittsburgh, PA, Frick Art and Historical Center
Pittsburgh, U. PA, A.G.	Pittsburgh, PA, University Pittsburgh, Art Gallery
Pittsfield, MA, Berkshire Mus.	Pittsfield, MA, Berkshire Museum
Ponce, Mus. A.	Ponce, Museo de Arte de Ponce
Portland, ME, ICA	Portland, ME, Portland Institute of Contemporary Art
Portland, ME, Mus. A.	Portland, ME, Museum of Art
Portland, OR, A. Mus.	Portland, OR, Portland Art Museum

Poughkeepsie, NY, Vassar Coll. A.G. — Poughkeepsie, NY, Vassar College Art Gallery

Poughkeepsie, NY, Vassar Coll., Frances Lehman Loeb A. Cent. — Poughkeepsie, NY, Vassar Coll., Frances Lehman Loeb Art Center

Providence, RI, Brown U., Bell Gal. — Providence, RI, Brown University, Bell Gallery

Providence, RI Hist. Soc. — Providence, RI, Rhode Island Historical Society

Providence, RI Sch. Des., Mus. A. — Providence, RI, Rhode Island School of Design, Museum of Art

Provo, UT, Brigham Young U. Mus. A. — Provo, UT, Brigham Young University Museum of Art

Purchase, SUNY, Neuberger Mus. — Purchase, NY, State University of New York, Neugberger Museum

Quito, Mus. Camilo Egas Banco Cent. — Quito, Museo Camilo Egas del Banco Central

Raleigh, NC Mus. A. — Raleigh, NC, North Carolina Museum of Art

Richmond, CA, A. Cent. — Richmond, CA, Richmond Art Center

Richmond, VA Mus. F.A. — Richmond, VA, Virginia Museum of Fine Arts

Ridgefield, CT, Aldrich Mus. Contemp. A. — Ridgefield, CT, Aldrich Museum of Contemporary Art

Rivoli, Castello, Mus. A. Contemp. — Rivoli, Castello di Rivoli, Museo d'Arte Contemporanea

Roanoke, VA, Hollins U., Wilson Mus. — Roanoke, VA, Hollins University, Eleanor D. Wilson Museum

Rochdale, A.G. — Rochdale (Lancashire), Art Gallery

Rochester, NY, Int. Mus. Phot. — Rochester, NY, International Museum of Photography at George Eastman House

Rochester, NY, U. Rochester, Mem. A.G. — Rochester, NY, University of Rochester, Memorial Art Gallery

Rockland, ME, Farnsworth Lib. & A. Mus. — Rockland, ME, Farnsworth Library and Art Museum

Rome, Mus. A. Contemp. — Rome, Museo d'Arte Contemporanea di Roma

Rome, Mus. Andersen — Rome, Museo Hendrik Christian Andersen

Roslyn, NY, Nassau Co. Mus. F.A. — Roslyn, NY, Nassau County Museum of Fine Arts

Rotterdam, Mus. Boymans–van Beuningen — Rotterdam, Museum Boymans–van Beuningen

Rotterdam, Ned. Fotomus. — Rotterdam, Nederlands Fotomuseum

Roxbury, MA, Mus. Afro-Amer. Hist. — Roxbury, MA, Museum of Afro-American History

Roxbury, MA, Mus. N. Cent. Afro-Amer. Artists — Roxbury, MA, Museum of the National Center of Afro-American Artists

Saco, ME, Mus. — Saco, ME, Saco Museum

Sacramento, CA, Crocker A. Mus. — Sacramento, CA, Crocker Art Museum

St Gall, Kstver. — St Gall, Kunstverein

St Louis, MO, A. Mus. — St Louis, MO, Art Museum

St Louis, MO, Boatmen's N. Bank — St Louis, MO, The Boatmen's National Bank of St Louis

St Louis, MO, Brentwood Gal.	St Louis, MO, Brentwood Gallery
St Louis, MO, Mercantile Lib.	St Louis, MO, Mercantile Library
St Louis, U. MO	St Louis, University of Missouri
St Louis, MO, Washington U., Gal. A.	St Louis, MO, Washington University, Gallery of Art
St Paul, MN Mus. A.	St Paul, MN, Minnesota Museum of Art
Saint-Paul-de-Vence, Fond. Maeght	Saint-Paul-de-Vence, Fondation Maeght
St Petersburg, Rus. Mus.	St Petersburg, Russian Museum
St Petersburg, FL, Dalí Found. Mus.	St Petersburg, FL, Dalí Foundation Museum
St Petersburg, FL, Mus. F.A.	St Petersburg, FL, Museum of Fine Arts
Saitama, MOMA	Saitama, Museum of Modern Art
Salem, MA, Peabody Essex Mus.	Salem, MA, Peabody Essex Museum
Salt Lake City, U. UT, Mus. F.A.	Salt Lake City, UT, University of Utah, Museum of Fine Arts
San Antonio, TX, McNay A. Inst.	San Antonio, TX, Marion Koogler McNay Art Institute
San Diego, CA, Mus. A.	San Diego, CA, San Diego Museum of Art
San Diego, CA, Mus. Contemp. A.	San Diego, CA, Museum of Contemporary Art
San Diego, CA, Mus. Man	San Diego, CA, San Diego Museum of Man
San Diego, CA, Timken A.G.	San Diego, CA, Timken Art Gallery
San Francisco, CA, A. Inst. Gals	San Francisco, CA, Art Institute Galleries
San Francisco, CA, de Young Mem. Mus.	San Francisco, CA, M. H. de Young Memorial Museum
San Francisco, CA, F.A. Museums	San Francisco, CA, Fine Arts Museums of San Francisco
San Francisco, CA Hist. Soc.	San Francisco, CA, California Historical Society
San Francisco, CA, MOMA	San Francisco, CA, Museum of Modern Art [formerly Mus. A.]
San Francisco, CA, Mus. A.	San Francisco, CA, Museum of Art [name changed to MOMA in 1976]
San Francisco, CA Pal. Legion of Honor	San Francisco, CA, California Palace of the Legion of Honor
San Gimignano, Mus. Civ.	San Gimignano, Museo Civico
San Jose, CA, Mus. A.	San Jose, CA, San Jose Museum of Art
San Marino, CA, Huntington Lib. & A.G.	San Marino, CA, Huntington Library and Art Gallery
Santa Barbara, CA, Mus. A.	Santa Barbara, CA, Museum of Art
Santa Barbara, U. CA, A. Mus.	Santa Barbara, CA, University of California, University Art Museum
Santa Clara U., CA, De Saisset Mus.	Santa Clara, CA, University of Santa Clara, De Saisset Museum
Santa Fe, NM, Cent. Contemp. A.	Santa Fe, NM, Center for Contemporary Art

Santa Fe, NM Mus. A. Sante Fe, NM, New Mexico Museum of Art
Santa Fe, NM, O'Keeffe Mus. Santa Fe, NM, Georgia O'Keeffe Museum
Santa Fe, NM, Wheelwright Mus. Amer. Ind. Santa Fe, NM, Wheelwright Museum of the
 American Indian
Santa Monica, CA, Mus. A. Santa Monica, CA, Museum of Art
Santiago de Compostela, Cent. Galego A. Contemp. Santiago de Compostela, Centro Galego de Arte
 Contemporanea
Sarasota, FL, Ringling Coll. A. & Des. Sarasota, FL, Ringling College of Art and Design
Sarasota, FL, Ringling Mus. A. Sarasota, FL, John and Mable Ringling Museum
 of Art
Saratoga Springs, NY, Skidmore Coll., Frances Young Saratoga Springs, NY, Skidmore College, Frances
 Tang Teaching Mus. & A.G. Young Tang Teaching Museum and Art Gallery
Scottsdale, AZ, Cent. A. Scottsdale, AZ, Scottsdale Center for the Arts
Scottsdale, AZ, Mus. Contemp. A. Scottsdale, AZ, Scottsdale Museum of
 Contemporary Art
Seattle, WA, A. Mus. Seattle, WA, Seattle Art Museum
Seattle, WA, Cent. Contemp. A. Seattle, WA, Center for Contemporary Art
Seattle, U. WA, Henry A.G. Seattle, WA, University of Washington, Henry
 Art Gallery
Seneca Fall, NY, Hist. Soc. Mus. Historical Society Museum
Sheffield, Mappin A.G. Sheffield, Mappin Art Gallery
Shelburne, VT, Mus. Shelburne, VT, Shelburne Museum
Siegen, Mus. Gegenswartskst Siegen, Museum für Gegenswartskunt
South Hadley, MA, Mount Holyoke Coll. A. Mus. South Hadley, MA, Mount Holyoke College
 Art Museum
Southampton, NY, Parrish A. Mus. Southampton, NY, Parrish Art Museum
South Bend, IN, U. Notre Dame South Bend, IN, University of Notre Dame
Springfield, IL, State Mus. Springfield, IL, Illinois State Museum
Springfield, MA, Mus. F.A. Springfield, MA, Museum of Fine Arts
Springfield, MA, Smith A. Mus. Springfield, MA, George Walter Vincent Smith
 Art Museum
Stanford, CA, U. A.G. & Mus. Stanford, CA, Stanford University Art Gallery
 and Museum
Stanford, CA, U., Cantor Cent. Visual A. Stanford, CA, Stanford University, Iris and B.
 Gerald Cantor Center for Visual Arts
Stockholm, Mod. Mus. Stockholm, Moderna Museum
Stony Brook, SUNY Stony Brook, NY, State University of New York
Stony Brook, SUNY, Staller Cent. A., U. A.G. Stony Brook, NY, State University of New York,
 Staller Center for the Arts University Art
 Gallery
Storrs, U. CT, Benton Mus. A. Storrs, CT, University of Connecticut, William
 Benton Museum of Art

Strasbourg, Mus. A. Mod. & Contemp.	Strasbourg, Musée d'Art Moderne et Contemporain
Stuttgart, Württemberg. Kstver.	Stuttgart, Württembergischer Kunstverein
Sunderland, A. Cent.	Sunderland, Arts Centre
Sunderland, N. Cent. Contemp. A.	Sunderland, National Centre for Contemporary Art
Swansea, Vivian A.G. & Mus.	Swansea, Glynn Vivian Art Gallery and Museum
Sydney, A.G. NSW	Sydney, Art Gallery of New South Wales
Sydney, Mus. Contemp. A.	Sydney, Museum of Contemporary Art
Syracuse, NY, Everson Mus. A.	Syracuse, NY, Everson Museum of Art
Tallahassee, FL State U., F.A. Gal.	Tallahassee, FL, Florida State University, Fine Arts Gallery
Tallahassee, FL State U., Mus. F.A.	Tallahassee, FL, Florida State University, Museum of Fine Arts
Tampa, U. S. FL	Tampa, FL, University of South Florida
Tempe, AZ State U. A. Mus.	Tempe, AZ, Arizona State University Art Museum
Tokyo, Idemitsu Mus. A	Tokyo, Idemitsu Museum of Art
Tokyo, Mus. Contemp. A.	Tokyo, Museum of Contemporary Art
Tokyo, N. Mus. Mod. A.	Tokyo, National Museum of Modern Art
Tokyo, Seibu Mus. A.	Tokyo, Seibu Museum of Art
Toledo, OH, Mus. A.	Toledo, OH, Museum of Art
Toronto, A.G. Harbourfront	Toronto, The Art Gallery at Harbourfront
Toronto, A.G. Ont.	Toronto, Art Gallery of Ontario
Toronto, Power Plant Contemp. A.G.	Toronto, Power Plant Contemporary Art Gallery
Toronto, U. Toronto A. Cent.	Toronto, University of Toronto Art Centre
Tours, Mus. B.-A.	Tours, Musée des Beaux-Arts
Trent, Mus. A. Mod. & Contemp. Trento & Roverto	Trent, Museo d'Arte Moderna e Contemporanea di Trento e Roverto
Trenton, NJ State Mus.	Trenton, NJ, New Jersey State Museum
Tucson, AZ, Mus. A.	Tucson, AZ, Museum of Art
Tucson, AZ State Mus.	Tucson, AZ, Arizona State Museum
Tucson, U. AZ, Cent. Creative Phot.	Tucson, AZ, University Arizona, Center for Creative Photography
Tucson, U. AZ Mus. A.	Tucson, AZ, University of Arizona Museum of Art
Tulsa, OK, Gilcrease Inst. Amer. Hist. & A.	Tulsa, OK, Gilcrease Institute of American History and Art
Tulsa, OK, Philbrook A. Cent.	Tulsa, OK, Philbrook Art Center
Turin, Castello Rivoli, Mus. A. Contemp.	Turin, Castello di Rivoli, Museo d'Arte Contemporanea
University Park, PA State U., Palmer Mus. A.	University Park, PA, Pennsylvania State University, Palmer Museum of Art
Urbana, U. IL, Krannert A. Mus.	Urbana, IL, University of Illinois, Krannert Art Museum

Utica, NY, Munson–Williams–Proctor Inst.	Utica, NY, Munson–Williams–Proctor Institute
Valencia, IVAM Cent. Julio González	Valencia, IVAM Centre Julio González
Valencia, CA, Inst. A.	Valencia, CA, Institute of the Arts
Vancouver, A.G.	Vancouver, Art Gallery
Vancouver, Emily Carr U. A. & Des., Scott Gal.	Vancouver, Emily Carr University of Art and Design, Charles H. Scott Gallery
Vancouver, U. BC, F.A. Gals	Vancouver, University of British Columbia, Fine Arts Gallery
Vienna, Österreich. Mus. Angewandte Kst	Vienna, Österreichisches Museum für Angewandte Kunst
Venice, Guggenheim	Venice, Peggy Guggenheim Collection
Vero Beach, FL, Mus. A.	Vero Beach, FL, Vero Beach Museum of Art
Vienna, Österreich. Mus. Angewandte Kst	Vienna, Österreichisches Museum für Angewandte Kunst
Waltham, MA, Brandeis U., Rose A. Mus.	Waltham, MA, Brandeis University, Rose Art Museum
Washington, DC, Amer. Inst. Architects Found.	Washington, DC, American Institute of Architects Foundation
Washington, DC, A. Mus. Americas	Washington, DC, Art Museum of the Americas
Washington, DC, Armed Forces Inst. Pathology, N. Mus. Health & Medic.	Washington, DC, Armed Forces Institute of Pathology, National Museum of Health and Medicine
Washington, DC, Corcoran Gal. A.	Washington, DC, Corcoran Gallery of Art
Washington, DC, Freer	Washington, DC, Freer Gallery of Art
Washington, DC, Gal. Mod. A.	Washington, DC, Gallery of Modern Art
Washington, DC, Hirshhorn	Washington, DC, Hirshhorn Museum and Sculpture Garden
Washington, DC, Howard U., Gal. A.	Washington, DC, Howard University, Gallery of Art
Washington, DC, Lib. Congr.	Washington, DC, Library of Congress
Washington, DC, N. Col. F.A.	Washington, DC, National Collection of Fine Arts
Washington, DC, N.G.A.	Washington, DC, National Gallery of Art
Washington, DC, N. Mus. Amer. A.	Washington, DC, National Museum of American Art [name changed to Smithsonian Amer. A. Mus. in 2000]
Washington, DC, N. Mus. Women A.	Washington, DC, National Museum of Women in the Arts
Washington, DC, N.P.G.	Washington, DC, National Portrait Gallery
Washington, DC, N. Trust Hist. Preserv.	Washington, DC, National Trust for Historic Preservation
Washington, DC, Phillips Col.	Washington, DC, Phillips Collection
Washington, DC, Renwick Gal.	Washington, DC, Renwick Gallery
Washington, DC, Sackler Gal.	Washington, DC, Arthur M. Sackler Gallery

Washington, DC, Smithsonian Amer. A. Mus. — Washington, DC, Smithsonian American Art Museum [formerly N. Mus. Amer. A.]

Washington, DC, Smithsonian Inst., Archvs Amer. A. — Washington, DC, Smithsonian Institute, Archives of American Art

Watertown, MA, Free Pub. Lib. — Watertown, MA, Free Public Library

Waterville, ME, Colby Coll., Mus. A. — Waterville, ME, Colby College, Museum of Art

Weil am Rhein, Vitra Des. Mus. — Weil am Rhein, Vitra Design Museum

Wellesley Coll., MA, Davis Mus. & Cult. Cent. — Wellesley, MA, Wellesley College, Davis Museum and Cultural Center

Wellesley Coll., MA, Jewett A. Cent. — Wellesley, MA, Wellesley College, Jewett Arts Center

Wellington, NZ, C.A.G. — Wellington, NZ, City Art Gallery

West Palm Beach, FL, Norton Gal. & Sch. A. — West Palm Beach, FL, Norton Gallery and School of Art

Wichita, KS, A. Mus. — Wichita, KS, Wichita Art Museum

Wichita, State U., KS, Edwin A. Ulrich Mus. A. — Wichita, KS, Wichita State University, Edwin A. Ulrich Museum of Art

Wiesbaden, Mus. — Wiesbaden, Museum Wiesbaden

Williamsburg, VA, Rockefeller Flk A. Col. — Williamsburg, VA, Abby Aldrich Rockefeller Folk Art Collection

Williamstown, MA, Clark A. Inst. — Williamstown, MA, Sterling and Francine Clark Art Institute

Williamstown, MA, Williams Coll. Mus. A. — Williamstown, MA, Williams College Museum of Art

Wilmington, DE A. Cent. — Wilmington, DE, Delaware Art Center

Wilmington, DE A. Mus. — Wilmington, DE, Delaware Art Museum

Wilton, CT, The Weir Farm Her. Trust — Wilton, CT, The Weir Farm Heritage Trust

Winnipeg, A.G. — Winnipeg, Art Gallery

Winston-Salem, NC, Mus. Early S. Dec. A. — Winston-Salem, NC, Museum of Early Southern Decorative Arts

Winston-Salem, NC, State U., Diggs Gal. — Winston-Salem, NC, Winston-Salem State University, Diggs Gallery

Winter Park, FL, Morse Gal. A. — Winter Park, FL, Morse Gallery of Art

Winterthur, Kstmus. — Winterthur, Kunstmuseum

Winterthur, DE, Mus. & Gdn Lib. — Winterthur, DE, Winterthur Museum and Garden Library

Wolfsburg, Kstmus. — Wolfsburg, Kunstmuseum

Wooster, OH, Coll. A. Mus. — Wooster, OH, College of Wooster Art Museum

Worcester, MA, A. Mus. — Worcester, MA, Worcester Art Museum

Worcester, MA, Amer. Antiqua. Soc. — Worcester, MA, American Antiquarian Society

Youngstown, OH, Butler Inst. Amer. A. — Youngstown, OH, Butler Institute of American Art

Zagreb, Gal. Contemp. A. — Zagreb, Gallery of Contemporary Art

Zurich, Ksthalle — Zurich, Kunsthalle

Journals

AA Files	AA [Architectural Association] Files	*Amer. Her.*	American Heritage
		América Indíg.	América indígena
A. America	Art in America	*Amer. Ind. A. Mag.*	American Indian Art Magazine
A. & Ant.	Art and Antiques		
A. & Archaeol.	Art and Archaeology	*Amer. Inst. Planners J.*	American Institute of Planners Journal
A. Asia	Arts of Asia		
A. Asia Pacific	Art Asia Pacific	*Amer. J. Archaeol.*	American Journal of Archaeology
A. Bull.	Art Bulletin		
A. CA	Art of California	*Amer. Mag. A.*	American Magazine of Art
A. Crit.	Art Criticism	*Amer. Phot.*	American Photographer
A. & Dec.	Arts and Decoration	*Amer. Q.*	American Quarterly
A. Dig.	Art Digest	*Amer. Scholar*	American Scholar
A. Doc.	Art Documentation	*Amer. Stud.*	American Studies
A. Educ.	Art Education	*A. Mthly*	Art Monthly
Afr. A.	African Arts	*A. News Annu.*	Art News Annual
Afr. Amer. Rev.	African American Review	*A. Newspaper*	Art Newspaper
A. Hist.	Art History	*Anlct. Romana Inst. Dan.*	Analecta Romana Instituti Danici
AIA J.	AIA [American Institute for Architects] Journal		
		Annu. Brit. Sch. Athens	Annual of the British School at Athens
A. India	Art India		
A. Int.	Art International	*Annu. Rev. Anthropol.*	Annual Review Anthropology
A. J.	Art Journal		
A. Libs J.	Art Libraries Journal	*Ant.*	Antiques
A. & Lit.	Art and Literature	*Ant. & F.A.*	Antiques and Fine Art
A. Mag.	Arts Magazine	*Anthony's Phot. Bull.*	Anthony's Photographic Bulletin
Amer. A.	American Art		
Amer. A. & Ant.	American Art and Antiques	*A. Papers*	Art Papers
Amer. A. J.	American Art Journal	*A. Press*	Art Press
Amer. Archit.	American Architect	*A. & Prog.*	Art and Progress
Amer. Architect & Bldg News	American Architect and Building News	*A. Psychotherapy*	The Arts in Psychotherapy
		A. Q.	Art Quarterly
Amer. A. Rev.	American Art Review	*Archit. Actuelle*	Architektur Actuelle
Amer. Artist	American Artist	*Archit. Annu.*	Architectural Annual
Amerasia J.	Amerasia Journal	*Archit. Assoc. J.*	Architectural Association Journal
Amer. Assoc. Archit. Bibliog.: Pap.	American Association of Architectural Bibliographers: Papers		
		Archit. & Bldg News	Architect and Building News
Amerasia J.	Amerasia Journal	*Archit. CA*	Architecture California
Amer. Colr	American Collector	*Archit. & Des.*	Architecture and Design
Amer. Craft	American Craft	*Archit. Des.*	Architectural Design
Amer. Furn.	American Furniture	*Archit. Dig.*	Architectural Digest

Architect & Bldr	Architect and Builder	*Brit. J. Aesth.*	British Journal of Aesthetics
Architect & Contract Rep.	Architect and Contract Reporter	*Brit. J. Phot.*	British Journal of Photography
Architect & Engin.	Architect and Engineer	*Bull. Amer. Assoc. U. Prof.*	Bulletin of the American Association of University Professors
Archit. & Engin. CA	Architect and Engineer of California		
Architecture [USA] [prev. pubd. as *AIA J.*]		*Bull. Amer. Mus. Nat. Hist.*	Bulletin of the American Museum of Natural History
Archit. Forum	Architectural Forum	*Bull. Antiqua. & Landmarks Soc. CT*	Bulletin of the Antiquarian and Landmarks Society Connecticut
Archit. Fr.	L'Architecture française		
Archit. MN	Architecture Minnesota		
Archit. Rec.	Architectural Record	*Bull. Assoc. F.A. Yale U.*	Bulletin of the Associates in Fine Arts at Yale University
Archit. Res. Q.	Architectural Research Quarterly		
Archvs Amer. A. J.	Archives of American Art Journal	*Bull. B.-A. Inst. Des.*	Bulletin of the Beaux-Arts Institute of Design
Archv Amer. A. Q. Bull.	Archives of American Art Quarterly Bulletin	*Bull. Brooklyn Mus.*	Bulletin of the Brooklyn Museum
A. Rev.	Arts Review	*Bull. Cleveland Mus. A.*	Bulletin of the Cleveland Museum of Art
Artforum Int.	Artforum International		
Asian A. News	Asian Art News	*Bull. Detroit Inst. A.*	Bulletin of the Detroit Institute of Arts
A. & Text	Art and Text		
Atlantic Mthly	Atlantic Monthly	*Bull. Fogg A. Mus.*	Bulletin of the Fogg Art Museum
A+U	Architecture and Urbanism	*Bull. Ger. Hist. Inst.*	Bulletin of the German Historical Institute
Austral. J. Anthropol.	Australian Journal of Anthropology	*Bull. Met.*	Bulletin of the Metropolitan Museum of Art
A. VA	Arts in Virginia		
A. Voices	Art Voices		
A. Voices S.	Art Voices South	*Bull. MOMA*	Bulletin of the Museum of Modern Art [later pubd. as *MOMA Bull.*]
A. World	Art World		
Biog. Mem., N. Acad. Sci.	Biographical Memoirs, National Academy of Science	*Bull. Mus. A., RI Sch. Des.*	Bulletin of the Museum of Art, Rhode Island School of Design
Bk & Pap. Grp Annu.	Book and Paper Group Annual	*Bull. NY Acad. Medic.*	Bulletin of the New York Academy of Medicine
Black Amer. Lit. Forum	Black American Literature Forum	*Bull. NY Pub. Lib.*	Bulletin of the New York Public Library
Black Mountain Coll. Bull.	Black Mountain College Bulletin	*Bull.: Philadelphia Mus. A.*	Bulletin: Philadelphia Museum of Art
Bldg Rev.	Building Review		

Burl. Mag.	Burlington Magazine	*Dumbarton Oaks Pap.*	Dumbarton Oaks Papers
Byz. Forsch.	Byzantinische Forschungen	*Early Amer. Lit.*	Early American Literature
CA A. & Archit.	California Arts and Architecture	*Engin. Mag.*	Engineering Magazine
		Engin. Rec., Bldg Rec. & Sanitary Engin.	Engineering Record, Building Record and Sanitary Engineering
CA Hist. Soc. Q.	California History Society Quarterly		
		Eng. Lit. Hist.	English Literary History
Camera Int.	Camera International	*Essex Inst. Hist. Col.*	Essex Institute Historical Collections
Can. Architect	Canadian Architect		
Carib. Rev.	Caribbean Review	*Ethiopian Rev.*	Ethiopian Review
Carnegie Mellon Mag.	Carnegie Mellon Magazine	*Fem. Rev.*	Feminist Review
Cent. Creative Phot.	Center for Creative Photography	*Fem. Stud.*	Feminist Studies
		Flash A.	Flash Art
Center: J. Archit. America	Center: A Journal of Architecture in America	*Folk A.*	Folk Art
		Folk A. Mag.	Folk Art Magazine
Chicago Archit. J.	Chicago Architectural Journal	*Furn. Hist.*	Furniture History
		GA Hist. Q.	Georgia Historical Quarterly
Chicago Hist.	Chicago History		
Cleveland Stud. Hist. A.	Cleveland Studies in the History of Art	*GA Mus. A. Bull.*	Georgia Museum of Art Bulletin
C. Mag.	Century Magazine		
Coll. A. J.	College Art Journal	*Gaz. B.-A.*	Gazette des Beaux-Arts
Colon. Soc. MA	Colonial Society of Massachusetts	*Gdn & Forest*	Garden and Forest
		Gilcrease Mag. Amer. Hist. & A.	Gilcrease Magazine of American History and Art
Colr Newslett.	A Collector's Newsletter		
Communic. A.	Communication Arts		
Conn. A.	Connaissance des arts	*Global Archit. Doc.*	GA [Globa Architecture] Document
Constr. Hist.	Construction History		
Cosmopolitan A. J.	Cosmopolitan Art Journal	*Global Archit. Houses*	GA [Global Architecture] Houses
Creative A.	Creative Art		
CT Antiqua.	Connecticut Antiquarian	*Harper's New Mthly Mag.*	Harper's New Monthly Magazine
CT Hist. Soc. Bull.	Connecticut Historical Society Bulletin		
		Harvard Archit. Rev.	Harvard Architecture Review
Current Biog.	Current Biography		
Current Lit.	Current Literature	*Harvard Des. Mag.*	Harvard Design Magazine
DAB	*Dictionary of American Biography* (New York, 1928–)	*Harvard Mag.*	Harvard Magazine
		Hb. N. Amer. Ind.	Handbook of North American Indians
Daguerreian Annu.	Daguerreian Annual	*Henry James Rev.*	Henry James Review
Des. Bk Rev.	Design Book Review	*Hist. Phot.*	History of Photography
Designers' J.	Designers' Journal	*Hist. Preserv.*	Historic Preservation
Des. Iss.	Design Issues	*Hist. Today*	History Today
Des. Q.	Design Quarterly	*Hogar & Archit.*	Hogar y architectura

Huntington Lib. Q.	Huntington Library Quarterly	*J. Archit. & Planning Res.*	Journal of Architecture and Planning Research
Illus. Tosc.	Illustrazione Toscana	*Jb. Ksthist. Samml. Wien*	Jahrbuch der kunsthistorischen Sammlungen in Wien
Ind. America	Indian America		
Indust. Des.	Industrial Design		
IN Hist. Soc. Prehist. Res. Ser.	Indiana Historical Society Preshistoric Research Series	*J. Can. A. Hist.*	Journal of Canadian Art History
		J. Cincinnati Soc. Nat. Hist.	Journal of the Cincinnati Society of Natural History
Inland Architect & News Rec.	Inland Architect and News Record		
Interior Des.	Interior Design	*J. Contemp. A.*	Journal of Contemporary Art
Int. J. Mus. Mgmt & Cur.	International Journal of Museum Management and Curatorship	*J. Contemp. Afr. A.*	Journal of Contemporary African Art
		J. Dec. & Propaganda A.	Journal of the Decorative and Propaganda Arts
Int. Rev. Afr.-Amer. A.	International Review of African American Art		
		J. Des. Hist.	Journal of Design History
Int. Studio	International Studio	*J. Early Rep.*	Journal of the Early Republic
Irish A. Rev.	Irish Arts Review		
Irish J. Amer. Stud.	Irish Journal of American Studies	*J. Early S. Dec. A.*	Journal of Early Southern Decorative Arts
J. Aesth. & A. Crit.	Journal of Aesthetics and Art Criticism	*J. Gdn. Hist.*	Journal of Garden History
		J. Hist. Col.	Journal of the History of Collections
J. Amer. Cult.	Journal of American Culture		
		J. Hist. Ideas	Journal of the History of Ideas
J. Amer. Hist.	Journal of American History		
		J. Interior Des.	Journal of Interior Design
J. Amer. Inst. Archit.	Journal of the American Institute of Architects	*J. Mar. Res.*	Journal for Maritime Research
J. Amer. Inst. Conserv.	Journal for the American Institute for Conservation	*J. Mus. F.A., Boston*	Journal of the Museum of Fine Arts, Boston
		J. New Haven Colony Hist. Soc.	Journal of the New Haven Colony Historical Society
J. Amer. Inst. Planners	Journal of the American Institute of Planners		
		J. Planning Hist.	Journal of Planning History
J. Amer. Plan. Assoc.	Journal of the American Planning Association		
J. Amer. Soc. Civ. Engin.	Journal of the American Society of Civil Engineers	*J. Planning Lit.*	Journal of Planning Literature
		J. Pop. Cult.	Journal of Popular Culture
J. Archit.	The Journal of Architecture	*J. RIBA*	Journal of the Royal Institute of British Architects [prev. pubd. and continued as *RIBA J.*]
J. Archit. Educ.	Journal of Architectural Education		

J. Soc. Archit. Hist.	Journal of the Society of Architectural Historians	*New England Q.*	New England Quarterly
		Newport Hist.	Newport History
J. Urban Des.	Journal of Urban Design	*Newslett.: NY Landmarks Conserv.*	Newsletter: New York Landmarks Conservancy
J. Urban Hist.	Journal of Urban History	*N.G. Canada Bull.*	National Gallery of Canada Bulletin
Kresge A. Mus. Bull.	Kresge Art Museum Bulletin	*N. Geog.*	National Geographic
Landscape Archit.	Landscape Architecture	*19th C.*	Nineteenth Century
Landscape Des.	Landscape Design	*19th C. A. Worldwide*	Nineteenth-Century Art Worldwide
Lat. Amer. A.	Latin American Art		
Lib. Chron.	Library Chronicle	*19th C. Stud.*	Nineteenth Century Studies
Lib. Congr. Inf. Bull.	Library of Congress Information Bulletin	*NY Hist. Soc. Q.*	New York Historical Society Quarterly
Liturg. A.	Liturgical Arts	*NY Mag.*	New York Magazine
London Mag.	London Magazine	*NY Rev. Bks*	New York Review of Books
Mag. Ant.	Magazine Antiques	*NY Times*	New York Times
MA Rev.	Massachusetts Review	*NY Times Mag.*	New York Times Magazine
Master Drgs	Master Drawings	*NY World Mag.*	New York World Magazine
MD Hist. Mag.	Maryland Historical Magazine	*OH State Archaeol.& Hist. Q.*	Ohio State Archaeological and Historical Quarterly
Met. Mus. A. Bull.	Metropolitan Museum of Art Bulletin	*Oxford A. J.*	Oxford Art Journal
		Oxford Amer.	Oxford American
Met. Mus. J.	Metropolitan Museum Journal	*Oz J.*	Oz Journal [Journal of the College of Architecture, Planning and Design, Kansas State University]
Met. Papers	Metropolitan Papers		
MO Archaeologist	Missouri Archaeologist		
Mod. Painters	Modern Painters		
MOMA Bull.	Museum of Modern Art Bulletin [prev. pubd. as *Bull. MOMA*]	*PAJ: J. Performance & A.*	PAJ: A Journal of Performance and Art
		Palais Mag.	Palais Magazine
MS Valley Hist. Rev.	Mississippi Valley Historical Review	*PA Mag. Hist. & Biog.*	Pennsylvania Magazine of History and Biography
Mus. Stud.	Museum Studies	*Partisan Rev.*	Partisan Review
NACF Rev.	National Art Collections Fund Review	*Persp. Vern. Archit.*	Perspectives in Vernacular Architecture
NC Hist. Rev.	North Carolina Historical Review	*Phot. F.A. J.*	Photographic and Fine Art Journal
NC Mus. A. Bull.	North Carolina Museum of Art Bulletin	*Phot. Forum*	Photographer's Forum
		Pict. Rev.	Pictorial Review
New A. Examiner	New Art Examiner	*Plan. Persp.*	Planning Perspectives
		Pop. Phot.	Popular Photography
New England Mag.	New England Magazine	*Pop. Sci. Mthly*	Popular Science Monthly

Preview: York A.G. Bull. Preview: York Art Gallery Bulletin

Proc. Amer. Antiqua. Soc. Proceedings of the American Antiquarian Society

Proc. Amer. Philos. Soc. Proceedings of the American Philosophical Society

Process: Archit. Process: Architecture

Proc. MA Hist. Soc. Proceedings of the Massachusetts Historical Society

Proc. US N. Mus. Proceedings of the United States National Museum

Prog. Archit. Progressive Architecture

Prog. Educ. Progressive Education

Prt Colr Newslett. Print Collector's Newsletter

Prt Colr Q. Print Collector's Quarterly

Prtg Hist. Printing History

Prt Q. Print Quarterly

Prt Rev. Print Review

Pubns Jesup N. Pacific Expedition Publications of the Jesup North Pacific Expedition

Pubns Mod. Lang. Assoc. Publications of the Modern Languages Association

RACAR RACAR: Revue d'art canadienne

RA: Roy. Acad. Mag. RA: Royal Academy Magazine

Raw Vision: Int. J. Intuit. & Vision. A. Raw Vision: International Journal of Intuitive and Visionary Art

Rec. A. Mus., Princeton U. Record of the Art Museum, Princeton University

Register Spencer Mus. A. Register of the Spencer Museum of Art

Ren. Q. Renaissance Quarterly

Repert. Kstwiss. Repertorium für Kunstwissenschaft

Rev. A. Revue d'art

Rev. Esthét. Revue d'esthétique

RIBA J. Royal Institute of British Architects Journal

Ric. Stor. A. Ricerche di storia dell'arte

Royal Inst. Architects Canada J. Royal Institute of Architects of Canada Journal

San Juan Rev. San Juan Review

Sat. Rev. Saturday Review

Sci. Amer. Scientific American

Scribner's Mag. Scribner's Magazine

Sculp. Mag. Sculpture Magazine

Sculp. Rev. Sculpture Review

S.-E. Coll. Rev. Southeastern College Art Conference Review

Signs: J. Women Cult. & Soc. Signs: Journal of Women in Culture and Society

Smithsonian Stud. Amer. A. Smithsonian Studies in American Art

Southern Q. Southern Quarterly

Stor. A. Storia dell'arte

Stud. Dec. A. Studies in the Decorative Arts

Stud. Hist. A. Studies in the History of Art

Stud. Hist. Gdn & Des. Landscapes Studies in the History of Gardens and Designed Landscapes

Stud. Medievalism Studies in Medievalism

SW A. Southwest Art

Swed.-Amer. Hist. Q. Swedish-American Historical Quarterly

SW Rev. Southwest Review

Technol. & Cult. Technology and Culture

Trans. Amer. Philos. Soc. Transactions of the American Philosophical Society

U. Rochester Lib. Bull. University Rochester Library Bulletin

VA Mag. Hist. & Biog. Virginia Magazine of History and Biography

Wallraf-Richartz-Jb. Wallraf-Richartz-Jahrbuch

W. Architect Western Architect

William & Mary Q.	William and Mary Quarterly		*Medallists*, 8 vols. (London, 1902–30)
Winterthur Port.	Winterthur Portfolio	*Grove Amer. Music*	S. Sadie and H. W. Hitchcock, eds.: *The New Grove Dictionary of American Music*, 4 vols. (London, 1986)
Woman's A. J.	Woman's Art Journal		
Women & Performance	Women and Performance: A Journal of Feminist Theory		
Worcester A. Mus. Bull.	Worcester Art Museum Bulletin	*Grove Instr.*	S. Sadie, ed.: *The New Grove Dictionary of Musical Instruments*, 3 vols. (London, 1984)
World A.	World Art		
World Archit.	World Architecture		
W. PA Hist. Mag.	Western Pennsylvania Historical Magazine	*Grove 6*	S. Sadie, ed.: *The New Grove Dictionary of Music and Musicians*, 20 vols. (London, rev. 6/1980)
Yale Sci. Mag.	Yale Science Magazine		
Yale U. A.G. Bull.	Yale University Art Gallery Bulletin		
Yale U. Lib. Gaz.	Yale University Library Gazette	Gunniss	R. Gunniss: *Dictionary of British Sculptors, 1660–1851* (London, 1951, rev. 2/1968)
Yishu: J. Contemp. Chin. A.	Yishu: Journal of Contemporary Chinese Art		
		Pelican Hist. A.	Pelican History of Art
Z. Ästh. & Allg. Kstwiss.	Zeitschrift für Ästhetik und allgemeine Kunstwissenschaft	*Macmillan Enc. Architects*	A. K. Placzek, ed.: *Macmillan Encyclopedia of Architects*, 4 vols. (New York, 1982)
Z. Kstgesch.	Zeitschrift für Kunstgeschichte	Thieme–Becker	U. Thieme and F. Becker, eds.: *Allgemeines Lexikon der bildenen Künstler von der Antike bis zur Gegenwart*, 37 vols. (Leipzig, 1907–50)

Standard Reference Books and Series

Cent. Creative Phot., Guide Ser.	Center for Creative Photography, Guide Series		
Contemp. Architects	M. Emanuel, ed.: *Contemporary Architects* (London, 1980, rev. 1986)	U. CA, Pubns Amer. Archaeol. & Ethnol.	University of California, Publications in American Archaeology and Ethnology
Forrer	L. Forrer: *Biographical Dictionary of*	World. A.	World of Art

THE GROVE ENCYCLOPEDIA OF
AMERICAN ART

Aalto, Alvar

(*b* Kuortane, 3 Feb 1898; *d* Helsinki, 11 May 1976), Finnish architect and designer, active also in America. His success as an architect lay in the individual nature of his buildings, which were always designed with their surrounding environment in mind and with great attention to their practical demands. (Hugo) Alvar (Henrik) Aalto never used forms that were merely aesthetic or conditioned by technical factors but looked to the more permanent models of nature and natural forms. He was not anti-technology but believed that technology could be humanized to become the servant of human beings and the promoter of cultural values. One of his important maxims was that architects have an absolutely clear mission: to humanize mechanical forms.

Training and Early Years, to 1927. His father was a government surveyor working in the lake district of central Finland and became a counterforce to his son's strong artistic calling. Instead of becoming a painter, which tempted him for a long time, Aalto chose the career of architect as a possible compromise. He never became a planner dominated by technological thinking, however, but always gave his creations an artistic, humanistic character. He studied at the Technical College in Helsinki (1916–21), with one of the foremost proponents of National Romantic architecture, Armas Lindgren, as his principal teacher. This instilled in him not only the national fervor of Lindgren and his colleague Eliel Saarinen but also the tendency of the Art Nouveau school toward live, dynamic forms and a striving to adapt architecture to the natural environment. During his period of study, however, another style became dominant, formally, in Scandinavia, namely a sophisticated Neo-classicism associated with Scandinavia in the 18th century. The chief proponent of this school was the Swedish architect Gunnar Asplund (1885–1940), who soon became an admired model for Aalto and a close personal friend to him. In 1923 Aalto established a modest office in the town where he grew up, Jyväskylä in central Finland. The buildings that he planned there bear the stamp not only of Asplund but also a powerful Italian influence, which he brought back with him from his first trip there in 1924. The early Renaissance of central and northern Italy, with masters such as Filippo Brunelleschi (1377–1446) and urban environments such as Florence, Siena and Venice, remained a frequently visited source of inspiration for Aalto all his life. The most important works from Aalto's "Neo-classical period," which lasted until the summer of 1927, include the Workers' Club in Jyväskylä with the

town's theater of that time (planned in 1924), the Defense Corps building (1926) in the same town, the church in Muurame (1926), reminiscent of an Italian provincial church and the Defense Corps building (1924) in Seinäjoki. He also took part in several of the architectural competitions that are common in Scandinavia and enable young, untried architects to receive imporhtant commissions. Though unsuccessful in the competition in 1923–4 for the Finnish Parliament building, in 1927 he won first prize in the competition for Viipuri City Library; this library was not, however, built until 1934–5, to entirely new plans bearing the stamp of Aalto's change-over to Rationalism. Another competition that Aalto won in 1927 was for a multi-purpose building, the Agricultural Co-operative building in Turku, which housed shops, offices, restaurants, hotels, private dwellings and, in particular, the town theater. This great volume of building work caused Aalto to move his office to Turku in 1927.

Influence of Rationalism, 1927–32. The new architecture launched from the beginning of the 1920s by Le Corbusier (1887–1965) in France, the De Stijl group in the Netherlands and the Bauhaus in Germany reached Scandinavia in the late 1920s. However, in 1927 Aalto and his Swedish colleague Sven Markelius (1889–1972) were drawn along with the new tendency, soon to be followed by Gunnar Asplund. Aalto's Agricultural Co-operative building shows the earliest signs of this innovation. In 1928 he was ready to design Finland's first completely Functionalist building, the newspaper group Turun Sanomat's building in Turku. It was completed in 1930 and fulfilled all of the criteria for a rationalist building that had been formulated by Le Corbusier, even though at that time Aalto knew Functionalism only through books and journals. With Erik Bryggman (1891–1955), he also planned the large open-air exhibition with pavilions, inspired by Soviet Constructivism and by modern typography, which was organized in the summer of 1929 in Turku to celebrate the 700th anniversary of the town. However, it was not so much the formal goals of the new

architecture as its social goals to which Aalto and his Scandinavian colleagues were attracted. The Bauhaus and its program of social reform, therefore, became a more important model for them to follow than the work of the French and Dutch Modernists.

In 1929 Aalto was invited to join CIAM. He went to Frankfurt to attend the second congress and established friendly relations, not only with older colleagues such as Le Corbusier and Walter Gropius but also with László Moholy-Nagy (who was the same age and who gave him important artistic inspiration) and with the group secretary Siegfried Giedion (1888–1968) and the English architectural critic Philip Morton Shand (1888–1960) who became a warm and influential supporter in the international arena. The same year Aalto made an international breakthrough when he won an architectural competition for the large tuberculosis sanatorium in Paimio outside Turku, a building commission that he completed in 1932. In it he broke away from the strict principles of early Rationalism, grouping the various building lengths in a non-geometrical, organic way and giving consideration more to the psychological needs of the users than to the functional aspects and technical and constructional factors. For the Paimio Sanatorium he designed buildings and all of the interior equipment, ranging from furniture and lamps to door handles, glassware and porcelain. His transformation of the newly invented tubular steel furniture into modern wooden furniture, manufactured by compression-molding laminated wood, was particularly significant. In collaboration with master joiner Otto Korhonen (1884–1935) and his furniture factory in Turku, he had already created a chair in 1929, on which the press-molded back and seat of plywood are supported by tubular-steel legs. For the sanatorium he invented a chair without any tubular steel at all, the so-called Paimio Chair, the back and seat of which are supported by a laminated wood frame that provides both arm supports and legs. This creation, perfect in form, competed successfully against Marcel Breuer's famous tubular steel construction, the so-called Wassili

Chair, in realizing the dream of a modern life-style. The cantilevered tubular steel chair that the Bauhaus launched was also matched in 1932 by a corresponding Aalto-style product, the elegant arm-chair of curved wood, which was soon imitated by many other furniture designers but which remained most sought after in its original models with either hard or soft seat and high or low back. The basic design element for Aalto's standard furniture is the chair- or table-leg, which he jokingly called the "column's little sister" and which was designed in three variants, the L-leg, the Y-leg and the X-leg.

International Recognition, 1933–49. Aalto's international reputation was initially founded very much on the furniture that, in contrast to the buildings erected in Finland, could be exhibited to an international public, for example at a show in London in 1933 that attracted attention, and at the Triennale exhibitions in Milan. In 1933 he moved to Helsinki, where two years later he erected his own residential and office building in the district of Munkkiniemi.

An important event for Aalto's career was meeting the factory-owning couple Maire and Harry Gullichsen in 1935. His friendship with them made possible the foundation of the Artek furniture design company, which began to sell Aalto's furniture in Finland and abroad and in general promoted a modern lifestyle, introducing modern international art into the country at the same time. Through Harry Gullichsen, Aalto soon received important large-scale planning and building commissions for Finnish industry. In 1937 he planned extensive residential areas and an industrial complex for the sulfate cellulose mill in Sunila near Kotka. Shortly afterward he planned the paper mill and different types of dwellings for the industrial town of Inkeroinen. After World War II he was commissioned to build a complete industrial community on virgin land in Summa near Hamina on the south coast of Finland.

The commission of 1938 to design a private residence in Noormarkku near Pori for Maire and Harry Gullichsen was even more significant. The result,

Villa Mairea, is one of the young Aalto's major works and shows his revolt against rigid Rationalism. On the one hand, he mixed folk traditions in Finnish building with the classical heritage of architectural history and with the formal concerns of Rationalism, producing a unique collage; on the other, he defined a new spatial concept that is related to both the forest as a felt environment and to the type of spatial openness that Paul Cézanne (1839–1906) introduced and that the Cubist painters developed further. Taking into account the experience of the materials' textures, the ceiling and floor of wood, walls of lime-washed tiles, slabs of natural stone and folkloric textiles, a better understanding is gained of the warm, harmonious atmosphere that characterizes this home, where everything is of exquisite quality without being ostentatious.

The first opportunity for an international public to become aware of Aalto's architecture was in 1937 at the Exposition Internationale des Arts et Techniques dans la Vie Moderne in Paris, where he was responsible for the Finnish Pavilion. Its ground-plan of structures freely grouped around an inner garden gave it a more open character than the Villa Mairea. The success of the pavilion led the Museum of Modern Art (MOMA), New York, to invite Aalto to mount a one-man show there. In the following year (1939) he was given the responsibility for the Finnish Pavilion at the World's Fair in New York, although this involved fitting up a sector of the unit-hall shared by the small countries, in which Finland with her limited resources rented a stand. In the enclosed interior he created one of his most original works, raising a freely curving, forward-leaning "auroral frontage" within the limited space, where the exhibits of Finland, a timber-exporting country, formed an assemblage. At both expositions Aalto also displayed the glassware he created during the 1930s, in particular the Savoy Vase with serpentine curved sides, all of which was influential on the international successes of Finnish arts and crafts during the postwar decades.

In 1940 Aalto was appointed research professor in architecture at the Massachusetts Institute of Technology (MIT), Cambridge, but he managed to teach for only a short time in the USA before he was summoned back to his homeland. He was employed on the reconstruction of Finland's towns and cities after war damage. He had been occupied with urban and regional planning before World War II. Faced with the risk that reconstruction would be based, frighteningly, on a stereotyped technological standardization, he advocated the development of what he called "flexible standardization." It accepted large-scale industrialized building, since only this could remedy the housing shortage, but required the building elements to be made sufficiently flexible to be combined in innumerable different ways in accordance with the possibilities afforded by the environment and the individual users' needs.

In 1945 Aalto was commissioned to draw up a general plan for the province of Lappland and a new city plan for the totally destroyed provincial capital, Rovaniemi. His principles for urban and regional planning amounted to maintaining contact with nature and the countryside, favoring small-scale grouping of dwellings and, if possible, breaking down large industrial plants, office complexes, government departments and shopping centers into smaller interrelated units. For the new town of Imatra (also known as Vuoksenniska), which was founded after the cession of areas of land to the USSR, he drew up a general plan (1947–53; published in book form in 1957) with very sparse grouping of buildings. (For the same town he later, in 1955, designed one of his most notable works, the church of the Three Crosses, which was asymmetrical and with variable dimensions.)

In 1946 Aalto resumed his teaching at MIT but confined his stays there to three or four months in a year. His most important contribution there was the building of Baker House Dormitory (1947–9). This building of red tiles, with its huge serpentine facade facing the river and steps rising in cascade form on the inner frontage, is the realization of Aalto's dream of flexible standardization, based on nature's principle of individualization: all 260 of the students' rooms with a view over the river have different shapes and therefore varied interior fixtures and furniture. However, the death of his wife and collaborator of many years, Aino Aalto (1894–1949), who devoted herself especially to tasks of interior equipment in conjunction with the couple's buildings, caused him deep depression, leading him to abandon all his work in the USA.

Later Years: The 1950s and After. The 1950s became a great, vital creative period in Aalto's life after he met the young architect Elissa Mäkiniemi (1922–94), his wife from 1952. The important monumental buildings that he was commissioned to design include the Kansaneläkelatos (National Pensions Insurance Institute) in Helsinki and the new buildings of the Technical College in Otaniemi outside Helsinki. These were two major tasks, which occupied him for a long time, and they were executed during 1952–6 and 1962–8, respectively. In both of them he used richly textured red tiles for the facades. In order to be able to build even more curved tile surfaces than in Baker House and in the main building of the Technical College in Otaniemi, he invented a triangular tile, which in 1955–8 enabled him to build the auditorium for Helsinki's House of Culture in the form of a gently rounded shell. In addition, the university in Jyväskylä (1951–6), with several buildings grouped around a campus, uses red tile surfaces and offers various free-form interiors with the unlimited space characteristic of Aalto's work.

A key work of Aalto's architecture of the 1950s is the small civic center for the industrial town of Säynätsalo outside Jyväskylä, where the moderate scale and grouping of the cubic structures around a small inner courtyard are reminiscent of Italian small towns such as San Gimignano. The synthesis between old building traditions of the Mediterranean countries and an uncompromising modernism also characterizes the two buildings that Aalto built for himself in the 1950s, namely his summer holiday residence and studio in the wilderness of the island

of Muuratsalo in the lake district of central Finland, rising like a Byzantine monastery on the rock-strewn shore, and his new office building in Munkkiniemi outside Helsinki, which combines the form of an ancient theater auditorium with modern office premises.

It was during the 1950s that Aalto really began to receive commissions outside Finland. In 1953 he won the competition for the Vogelweidplatz sports hall in Vienna, with what was technically a very daring (and therefore unexecuted) project. In 1955 he and a dozen of the world's best-known architects were each invited to design a block of flats in the Hansaviertel in Berlin. When the project was formally opened in 1957 as the *Interbauausstellung*, Aalto's building was one of those that received most attention and praise. In 1959 he won the competition for an opera house in Essen, in which he combined his shell-like, asymmetrical auditorium, known from Helsinki's House of Culture, with a series of three-tiered, serpentine balconies that are mirrored in the tall foyer situated behind them. The opera house was eventually built between 1981 and 1988, but Aalto had already used its basic shape in his project for Helsinki's Finlandiatalo, which was completed in 1971. Between 1958 and 1962 he built a marble-clad, fan-shaped house of culture in Wolfsburg in Germany, where he also erected a church between 1960 and 1963. His Neue Vahr tower block in Bremen, fan-shaped in plan, was completed in 1962. Several of Aalto's best projects remained unrealized unfortunately, including the competition design of 1958 for a town hall in Kiruna in Sweden, which won first prize; his winning proposal from the same year for a museum of art in Ålborg, Denmark, was built ten years later, as was his church in Detmerode (1963–9), Germany.

In 1956 Aalto planned a very lavishly endowed residence in the village of Bazoches-sur-Guyonne outside Paris for the art dealer Louis Carré. The building's sloping roof covered with Normandy slate repeats the rhythm of the surrounding landscape, while every detail of the interior, which offers rooms of varying height, is specially designed. Nordens hus (1964–9) in Reykjavik, Iceland, can also be counted among Aalto's important works abroad. Its outline repeats the rhythm of the surrounding mountain ridges, while the interior, with a library and various assembly rooms, has a cozy, intimate character. For the Mount Angels Monastery in Oregon, USA, he designed in 1964 a small library in the form of a sloping theater auditorium (completed 1968), and in the mountain village of Riola, south of Bologna in Italy, a church based on his designs, with stepped dormer windows and asymmetrical in plan, was built between 1975 and 1980.

One of Aalto's lasting ambitions was to build whole city centers with several public buildings grouped around squares. He planned such centers both for the place where he grew up, Jyväskylä, for Helsinki and for many other towns in Finland and abroad. In many instances he was commissioned to execute only a part of these projects: the town hall in Säynätsalo (1949–52); a theater (1964–86) and a police station (1967–70) in Jyväskylä; the magnificent Finlandiatalo and its conference wing (1962–76) in Helsinki. In only two cases was Aalto's center project fully implemented. Possibly Aalto's most beautiful library was erected around the central square of Rovaniemi between 1961 and 1966, with a crystal-like exterior and a bookpit inside. From 1969 to 1971 the theater and radio building Lapponia was added, and from 1986 to 1988 the town hall, designed in 1963. However, the most richly endowed center by Aalto was built in the town of Seinäjoki in central Finland, where the church (1951–60) was accompanied by a town hall (1958–62), a library (1960–65) and a theater (1961–87), all of them grouped around a series of open spaces, testifying to the fact that Aalto welcomed the principle in the urban environment of unlimited space, more like the countryside than the city or town.

Influence. Aalto was an outgoing and spontaneous person with humor, charm and a great gift for relating to people, which contributed greatly toward his successes. Despite his bohemian living habits,

lack of interest in financial gain and not very efficiently organized architect's bureau, during his career he managed to execute c. 1000 projects, always working with uninhibited pleasure and a wealth of ideas. Over the years he accepted more than 300 young architects from both Finland and abroad (particularly Switzerland, Italy, Scandinavia and the USA) as assistants for short or long periods of time. With his pronounced skepticism of theorizing, he refrained from writing books on architecture and from academic lecturing; however, he loved to converse about architectural matters that were at the same time social and cultural. He thought that the practical work in his office—which he called his "academy"—was the best way to pass on professional knowledge: that is to say, a teaching method corresponding to what Renaissance painters and architects applied in their workshops where they were surrounded by apprentices and assistants.

BIBLIOGRAPHY

S. Giedion: *Space, Time and Architecture* (Cambridge, MA, 1944, rev. 3/1954), pp. 565–604

B. Zevi: *Storia dell'architettura moderna* (Turin, 1950), pp. 283–307

Archit. Aujourd'hui, xxix (1950) [special issue on Aalto]

E. Neuenschwander and C. Neuenschwander: *Finische Bauten: Atelier Alvar Aalto, 1950–51* (Zurich, 1954)

F. Gutheim: *Alvar Aalto*, Masters of World Architecture (New York and London, 1960)

Arquitectura [Madrid], ii (1960) [special issue on Aalto]

Quad. Arquit., xxxix (1960) [special issue on Aalto]

K. Fleig, ed.: *Alvar Aalto*, 3 vols (Zurich, 1963–78)

L. Mosso: *L'opera di Alvar Aalto* (Milan, 1965)

R. Venturi: *Complexity and Contradiction in Architecture* (New York, 1966)

Arkitekten [Stockholm], iv (1969) [special issue on Aalto]

B. Hoesli, ed.: *Alvar Aalto Synopsis: Painting Architecture Sculpture* (Zurich, 1970) [incl. writings, chronological list of works and bibliog., richly illus.; in Fr., Ger. and Eng.]

G. Baird: *Alvar Aalto* (New York, 1971) [photographs by Y. Futugawa]

G. Schildt, ed.: *Alvar Aalto luonnoksia* [Alvar Aalto sketches] (Helsinki, 1972; Eng. trans., 1978) [contains a selection of Aalto's articles and lectures]

C. Jencks: *Modern Movements in Architecture* (New York, 1973), pp. 167–83

C. Cresti: Alvar Aalto, *Maestri del novecento*, 25 (Florence, 1975; Eng. and Sp. trans., 1976)

Arkkitehti/Arkitekten, vii–viii (1976) [memorial issue on Aalto]

Archit. Aujourd'hui, cxci (1977) [special issue on Aalto]

Parametro, lxii (1977)

Prog. Archit., iv (1977) [special issue on Aalto]

Space Des., i–ii (1977) [special issue on Aalto]

A. Gozak: *Arhitektura i gumanizm* [Architecture and humanism] (Moscow, 1978)

P. D. Pearson: *Alvar Aalto and the International Style* (New York, 1978)

B. Zevi: *The Modern Language of Architecture* (Seattle, 1978)

Alvar Aalto, Architectural Monographs and Academy Editions, 4 (London, 1978) [texts by D. Porphyrios and R. L. Heinonen]

Alvar Aalto, 1898–1976 (exh. cat., ed. A. Ruusuvuori; Helsinki, Mus. Fin. Archit., 1978) [incl. writings]

Archit. Des., xii (1979) [special issue on Aalto]

K. Frampton: *Modern Architecture: A Critical History* (New York, 1980), pp. 192–202

L. Rubino: *Aino e Alvar Aalto: Tutto il disegno* (Rome, 1980)

W. Blaser: *Il design di Alvar Aalto* (Milan, 1981)

D. Porphyrios: *Sources of Modern Eclecticism: Studies on Alvar Aalto* (London, 1982)

G. Schildt: *Det vita bordet: Alvar Aaltos ungdom och grundläggande konstnarliga ideer* (Helsinki, 1982); Eng. trans. as *Alvar Aalto: The Early Years* (New York, 1984) [biog. up to 1927]

M. Quantrill: *Alvar Aalto: A Critical Study* (London, 1983)

A & U, v (1983) [special issue on Aalto]

W. C. Miller: *Alvar Aalto: An Annotated Bibliography* (New York, 1984)

J. Pallasmaa, ed.: *Alvar Aalto Furniture*, Helsinki, Mus. Fin. Archit. cat. (Helsinki, 1984)

G. Schildt: *Moderna tider* (Helsinki, 1985); Eng. trans. as *Alvar Aalto: The Decisive Years* (New York, 1986) [biog. 1927–39]

G. Schildt: *Den mänshliga fahtorn* (Helsinki, 1990); Eng. trans. as *Alvar Aalto: The Mature Years* (New York, 1991) [biog. 1940–76]

G. Schildt: *Alvar Aalto: The Complete Catalogue of Architecture, Design and Art* (London and New York, 1994)

Á. Ólafsdóttir: *Le mobilier d'Alvar Aalto dans l'espace et dans le temps: La diffusion internationale du design, 1920–1940* (Paris, 1998)

W. Nerdinger: *Alvar Aalto: Towards a Human Modernism* (Munich and New York, 1999)

E. Ottillinger: *Alvar Aalto: Möbel: Die Sammlung Kossdorff* (Vienna, 2002)

P. Tuukkanen: *Alvar Aalto, Designer* (Helsinki, 2002)

P. Blundell-Jones and others: "Acoustic Form in the Modern Movement," *Archit. Res. Q.,* vii/1 (2003), pp. 75–85

J.V.M. Pallasmaa: "Alvar Aalto, 1938–39," *Lotus International,* cxix (2003), pp. 6–25

E. Vedrenne: "La ligne ondulante d'Alvar Aalto," *Conn. A.,* 611 (Dec 2003), pp. 102–7

S. Menin: "A Gateway to the 'Backwoods':Aalto and the Matter of Rooting Modernity," *Archit. Res. Q,* ix/2 (2005), pp. 145–55

N. Ray: *Alvar Aalto* (New Haven, 2005)

"Master Key," *RIBA J.,* cxiv/2 (Feb 2007), pp. 50–51, 53–6, 58–9 [interview with Shigeru Ban on Alvar Aalto]

S. Dachs, ed.: *Alvar Aalto* (Barcelona, 2007)

S. W. Goldhagen: "Ultraviolet: Alvar Aalto's Embodied Rationalism," *Harvard Des. Mag.,* xxvii (Fall 2007–Winter 2008), pp. 38–52

F. Dal Co: "Un reperto squisito. La maison Carre di Alvar Aalto e Elissa Aalto/An Exquisite Relic: The Maison Carré of Alvar and Elissa Aalto," *Casabella,* lxxii/6 (June 2008), pp. 14–21, 109–10

B. Ramade: "Alvar Aalto: Pas d'architecture sans design," *L'Oeil,* 604 (July–Aug 2008), pp. 138–9

B. Shim: "Nature, Culture of the Local," *A+U,* 458 (Nov 2008), pp. 14–18 [part of special section: Dwelling and the Land]

W. J. Stock: "Aus Linien werden Ideen: Alvar Aalto als Meisterzeicher/From Lines Ideas Develop: Aalto as a Master Draughtsman," *Archit. Actuelle,* 340–41 (July–Aug 2008), pp. 6, 8

Göran Schildt

Abbe, James

(*b* Alfred, ME, 17 July 1883; *d* San Francisco, 11 Nov 1973), photographer. James (Edward) Abbe was self-taught and started to produce photographs by the age of 12. From 1898 to 1910 he worked in his father's bookshop and then worked as a reporter for the *Washington Post*, traveling to Europe in 1910. Having earlier produced photographs of ships and sailors for tourist cards, from 1913 to 1917 he worked as a freelance photojournalist in Virginia. In 1917 he set up a studio in New York, where he produced the first photographic cover for the *Saturday Evening Post* as well as photographs for *Ladies Home Journal*, the *New York Times* and other publications. From 1922 to 1923 he worked as a stills photographer, actor and writer for film studios. Though this was mainly for Mack Sennett in Hollywood, he also worked for D.W. Griffiths as a stills photographer on *Way Down East* (1920) and accompanied Lilian Gish to Italy to provide stills for Griffiths's *The White Sister* (1923). After establishing a studio in Paris in 1924, he had his photographs published in such journals as *Harper's Bazaar*, *L'Illustration*, *New York Herald Tribune*, *The Tatler*, *Vanity Fair*, *Vogue* and *Vu*. He photographed film stars and the Moulin Rouge in Paris and also produced fashion pictures, such as *Natasha Rambova in Fortuny Gown* (*c.* 1924; see Hall-Duncan, p. 41).

From 1929 until 1932 Abbe traveled extensively in Europe, Mexico, the USA and the USSR as one of the first photojournalists, working for the *Berliner illustrierte Zeitung*. During this period he covered the Mexican Revolution of 1932 as well as crime and prohibition in Chicago. He photographed Hitler and Mussolini during their rise to power, and in 1932 he was the first foreign correspondent to photograph Stalin (among other images published in his book *I Photograph Russia*, 1934). In 1934 he returned to the USA, working in Larkspur, CO, as a freelance photojournalist until 1936. In 1936 he went to Spain as a war correspondent for the *Alliance* newspaper, covering the Civil War from General Franco's side. After this he ceased work as a photographer and became, in turn, a rancher, radio broadcaster and television critic.

PHOTOGRAPHIC PUBLICATIONS

I Photograph Russia (New York, 1934)

Stars of the '20s (London, 1975) [text by M. D. Early]

Limelight: Photographs by James Abbe, Antique Collectors Club (Woodbridge, 1995) [text by T. Pepper] [Antique Collectors Club]

BIBLIOGRAPHY

C. Beaton and G. Buckland: *The Magic Image: The Genius of Photography from 1939 to the Present Day* (London, 1975), p. 185

N. Hall-Duncan: *The History of Fashion Photography* (New York, 1979), pp. 41, 43, 224

G. Walsh, C. Naylor and M. Held, eds.: *Contemporary Photographers* (New York, 1982)

James Abbe: Photographer (exh. cat. by B. Johnson and T. Pepper, Norfolk, VA, Chrysler Mus., 2000)

Abbey, Edwin Austin

(*b* Philadelphia, PA, 1 April 1852; *d* London 1 Aug 1911), painter, illustrator and muralist, active also in England. Abbey began his art studies at the age of 14 in his native Philadelphia where he worked with Isaac L. Williams (1817–95). Two years later he enrolled in night classes at the Pennsylvania Academy of Fine Art working under Christian Schussele (1824–1979), but by then Abbey was already a published illustrator. In the 1870s his drawings appeared in numerous publications, but it was his work for Harper & Brothers that proved most important to his career. In 1871 he moved to New York, and in 1878, Harper's sent him on a research trip to England. He found such affinity with the country that he made it his home for the rest of his life. After 1889 he devoted more time to painting, was elected a Royal Academician in 1898, and in 1902 was chosen by Edward VII (*r.* 1901–10) to make his coronation portrait (London, Buckingham Pal.). Abbey's best-known work is the series of murals he did for the Boston Public Library and the Pennsylvania State House.

Basing his distinctive style on his love of the Pre-Raphaelites, English book illustration and English history painting, Abbey did meticulous research for his elegant drawings and paintings. In fact, he was reported to have sometimes spent more on the costumes and props than he could earn from the commissioned work. One reason for his settling in England was not only the general Anglomania of the time, but his particular feeling that history was simply more alive there. His affection for the English countryside as well as his friendship with fellow American expatriate Francis Davis Millet (1846–1912) led to their establishment of an artists' colony in Broadway, Worcs, between 1885 and 1889, where others including John Singer Sargent joined them. Abbey's friendship with English painter Alfred Parson (1847–1920) also led to shared studios, exhibitions, travel and collaboration on several gift-book projects, including *Old Songs* (1889) and *The Quiet Life* (1890).

Abbey is best known as an illustrator, and his many projects included drawings for the *Selections from the Poetry of Robert Herrick* (1882), Oliver Goldsmith's *She Stoops to Conquer* (1887) and *The Deserted Village* (1902), as well as the *Comedies of William Shakespeare* (1899). In the late 1880s, however, Abbey also began exhibiting full-scale watercolor and oil paintings that were often based on subjects from his illustrations, especially Shakespeare's plays. His *Richard, Duke of Gloucester, and the Lady Anne* (1896; New Haven, CT, Yale U. A.G.) in which Richard is proposing to the widow of a man he has just murdered, is typical with its abundant history-telling details and authentic period costumes, including Richard's brilliant red robes. Abbey's murals for McKim, Mead & White's Boston Public Library (1890–1901) were based on the theme of the Quest for the Holy Grail. The 15 panels, which fit beautifully into their architectural space, feature such dramatic narratives as *Sir Galahad Being Led to the Seat Perilous*. Highly praised in their day, they were often compared to Alfred Tennyson's verse on the same theme. The fame of the murals, as well as the fact that Abbey was a native Pennsylvanian, led to his final commission, the murals for the Pennsylvania State House in Harrisburg (1902–11). While most of his murals up to this point had been based on his theatrical narrative style, many of those for the capitol were more symbolic in character. *The Apotheosis of Pennsylvania* for the House Chamber is a case in point with its full-blown architectural setting and centrally enthroned allegorical figure. Abbey died of cancer in 1911 before the final work was done, but his widow Gertrude took over the project and under her administration Abbey's studio assistant Ernest Board (1877–1934), working with the further supervision of John Singer Sargent, completed the last mural and the final installation.

Abbey received most of the recognition and accolades available to artists of his age. In addition to being elected to the Royal Academy in 1898, he was also elected to the National Academy of Design and

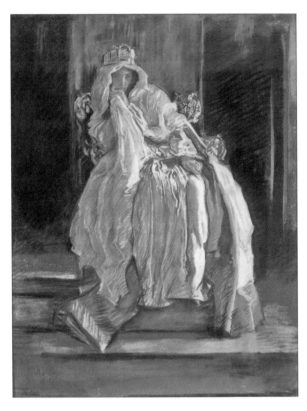

EDWIN AUSTIN ABBEY. *The Queen in "Hamlet,"* pastel on paperboard, 707 × 555 mm, 1895. GIFT OF SEN. STUART SYMINGTON AND REP. JAMES W. SYMINGTON/SMITHSONIAN AMERICAN ART MUSEUM, WASHINGTON, DC/ART RESOURCE, NY

the American Academy of Arts and Letters, and was awarded the Pennsylvania Academy of Fine Arts' Gold Medal of Honor. He was active in the expansion of the British School in Rome, and his widow established a prize and memorial for him there. In 1937, she left a considerable collection of his work to Yale University. While much celebrated in his own day, Abbey has not always been included in more recent histories of American painting. His work as an illustrator, however, made him one of the best-known artists in the period known as the golden age of illustration.

BIBLIOGRAPHY

H. James: "Edwin A. Abbey," *Picture and Text* (New York, 1893), pp. 44–5

E. V. Lucas: *Edwin Austin Abbey, Royal Academician: The Record of his Life and Work*, 2 vols. (London, 1921)

Edwin Austin Abbey (1852–1911) (exh. cat. by K. A. Foster and M. Quick, New Haven, CT, Yale U., 1973)

M. Simpson: "Windows on the Past: Edward Austin Abbey and Francis Davis Millet in England," *Amer. A. J.*, xxii/3 (1990), pp. 62–89

M. Simpson: *Reconstructing the Golden Age: American Artists in Broadway, Worcestershire, 1885–1889* (diss., New Haven, CT, Yale U., 1993)

C. Waring: *"The Quest for the Holy Grail" Murals by Edwin Austin Abbey* (diss., University Park, PA State U., 1999)

Pamela H. Simpson

Abbott, Berenice

(*b* Springfield, OH, 17 July 1898; *d* 9 Dec 1991), photographer. Abbott spent a term at the Ohio State University in Columbus (1917–18) and then studied sculpture independently in New York (1918–21) where she met Marcel Duchamp and Man Ray. She left the USA for Paris in 1921 where she studied at the Académie de la Grande Chaumière before attending the Kunstschule in Berlin for less than a year in 1923. From 1924 to 1926 she worked as Man Ray's assistant and first saw photographs by Eugène Atget in Man Ray's studio in 1925. Her first solo show, at the gallery Le Sacre du Printemps in Paris in 1926, was devoted to portraits of avant-garde personalities such as Jean Cocteau, James Joyce and André Gide. She continued to take portraits, such as that of James Joyce (1927; see *Berenice Abbott: Photographs*, p. 26), until leaving Paris in 1929. After Atget's death (1927) she bought most of his negatives and prints in 1928, and in 1929 she returned to New York. There she began a series of documentary photographs of the city and from 1935 to 1939 directed the "Changing New York" project for the Works Progress Administration Federal Art Project, which resulted in the book of photographs *Changing New York* (1939; *Rockefeller Center, from 444 Madison Avenue*). Like Atget's views of Paris these photographs covered both the people and the architecture of New York in a methodical and detached way. The images in *Greenwich Village Today and Yesterday* (1949) were motivated by a similar spirit. She also

took various portrait photographs in the 1930s and 1940s, such as that of Max Ernst (1941; see O'Neal, p. 182).

From 1947 to 1958 Abbott ran the House of Photography, a firm established to develop and sell her photographic inventions, although it proved a financial failure. At a conference at the Aspen Institute for Humanistic Studies in Colorado (1951) she caused a storm by criticizing the Pictorialism of such photographers as Alfred Stieglitz, Edward J. Steichen and Paul Strand. Instead she advocated a documentary style, exemplified by her images of urban America,

such as *American Shops* (1954; see O'Neal, p. 197). In 1956 she printed and published 100 sets of Atget's photographs in New York as *Eugène Atget Portfolio: Twenty Photographic Prints from His Glass Negatives*. Having experimented with scientific photography since 1939, from 1958 to 1961 she worked for the Physical Science Study Committee of Educational Services, taking photographs to illustrate the laws of physics. These were used in three books, published in Cleveland, OH, with texts by E.G. Valens: *Magnet* (1964), *Motion* (1965) and *The Attractive Universe* (1969). Continuing her championship of

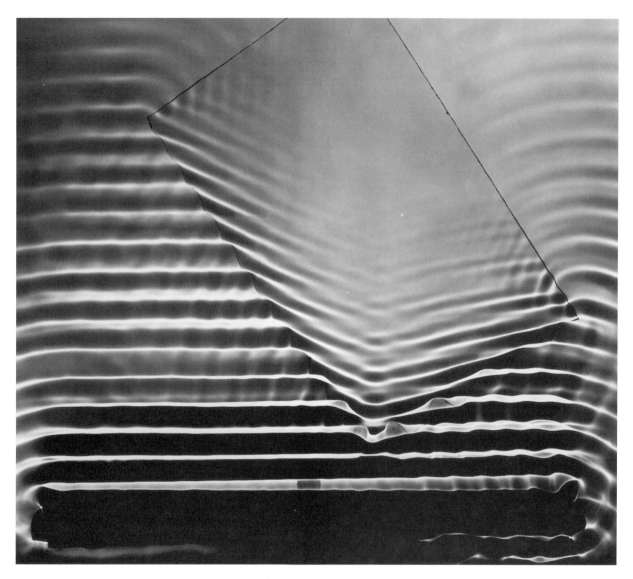

BERENICE ABBOTT. *Wave Pattern with Glass Plate*, 1958–61. COURTESY OF COMMERCE GRAPHICS, NEW YORK CITY

Atget, in 1964 she published *The World of Atget*, writing the text herself. In 1966 she moved to Abbot Village, ME, where she continued producing documentary photographs, such as those for *A Portrait of Maine* (1968). In later life she occupied herself increasingly with organizing and printing her earlier work, and from the late 1970s and into the 1980s several portfolios of earlier photographs were published by the Parasol Press in New York.

[*See also* Photography.]

WRITINGS

A Guide to Better Photography (New York, 1941)

A New Guide to Better Photography (New York, 1953)

PHOTOGRAPHIC PUBLICATIONS

Changing New York, text by E. McCausland (New York, 1939)

Greenwich Village Today and Yesterday, text by H. W. Lanier (New York, 1949)

The World of Atget (New York, 1964)

Berenice Abbott: Photographs, text by D. Vestal and M. Rukeyser (New York, 1970, rev. Washington, DC, and London, 1990)

Berenice Abbott: The Red River Photographs, text by H. O'Neal (Provincetown, MA, 1979)

Photographs (Washington, 1990)

Berenice Abbott & Eugene Atget, text by C. Worswick (Santa Fe, NM, 2002)

BIBLIOGRAPHY

Berenice Abbott: The 20's and 30's (exh. cat. by B. Shissler Nosanow, New York, Int. Cent. Phot.; Washington, DC, N. Mus. Amer. A.; 1981–2)

H. O'Neal: *Berenice Abbott: Sixty Years of Photography*, intro. by J. Canaday (New York and London, 1982)

VIDEO RECORDINGS

K. Weaver and M. Wheelock: *Berenice Abbott: A View of the 20th Century* (1992)

Abele, Julian

(*b* Philadelphia, PA, 29 April 1881; *d* Philadelphia, PA, 23 April 1950), architect. Born and educated in Philadelphia, Julian (Francis) Abele was the chief designer in the firm of Horace Trumbauer. Unknown for most of his life, Julian Abele has become renowned as a pioneer African American architect.

Abele attended the Institute for Colored Youth and Brown Preparatory School before enrolling at the Pennsylvania Museum School of Industrial Art, where in 1898 he earned his Certificate in Architectural Drawing and the Frederick Graff Prize for work in Architectural Design, Evening Class Students. Abele then enrolled at the University of Pennsylvania. Again he distinguished himself in the architectural program, and at his 1902 graduation he was awarded the prestigious Arthur Spayd Brooke Memorial Prize. Abele's work was also exhibited in the Toronto Architectural Club (1901), the T-Square Club Annual Exhibition (1901–2) and the Pittsburgh Architectural Club annual exhibition of 1903.

As an undergraduate Abele worked for Louis C. Hickman (1863–c. 1917), an early president of the T-Square Club, but after earning a Certificate of Completion in Architectural Design in May 1903 from the Pennsylvania Academy of the Fine Arts, and traveling and studying in Europe, in 1906 Abele joined the office of Horace Trumbauer as assistant to chief designer Frank Seeburger (*fl.* 1887–1934). When Seeburger left in 1909, Abele succeeded him, remaining as chief designer until Trumbauer's death. Abele excelled at the Beaux-Arts style and successfully applied it in such notable projects as the Free Library of Philadelphia building (1917), buildings on the Duke University Campus (beginning in 1929), Durham, NC, Whitemarsh Hall (1916) in Chestnut Hill, Philadelphia, for Edward T. Stotesbury and the Philadelphia Museum of Art (1919–28). However, Abele met few of Trumbauer's clients and never saw the buildings at Duke University, which were constructed using his designs. After Trumbauer's death in 1938, Abele and William O. Frank (1887–1968) continued the firm under the name The Office of Horace Trumbauer, but even then few outside of Philadelphia realized that Abele was African American.

In 1925 Julian Abele married Marguerite Bulle, a graduate of the Conservatoire de Musique in Paris, but this marriage lasted only nine years, producing a son and daughter.

[*See also* Trumbauer, Horace.]

UNPUBLISHED SOURCES
Philadelphia, U. PA, Architectural Archives, Abele Col.

BIBLIOGRAPHY

J. T. Maher: *The Twilight of Splendor; Chronicles of the Age of American Palaces* (Boston, 1975)

D. Brownlee: *Building the City Beautiful: The Benjamin Franklin Parkway and the Philadelphia Museum of Art* (Philadelphia, 1989)

M. C. Kathrens: *American Splendor, The Residential Architecture of Horace Trumbauer* (New York, 2002)

D. S. Wilson: "Julian Francis Abele," *African American Architects: A Biographical Dictionary 1865–1945*, ed. D. S. Wilson (New York, 2004), pp. 1–4

S. E. Tifft: "Out of the Shadows," *Smithsonian,* xxxv (Feb 2005), pp. 100–06

Sandra L. Tatman

Abramovic, Marina

(*b* Belgrade, 30 Nov 1946), Yugoslavian performance artist, video artist and installation artist, active also in the USA. She attended the Academy of Fine Arts in Belgrade (1965–70) before completing her post-diploma studies at the Academy of Fine Arts, Zagreb, in 1972. Her early works included sound pieces installed on bridges and paintings of truck crashes. In her first mature performance, *Rhythm 10* (1973; see T. McEvilley and others, pp. 57–61), she stabbed the spaces between her fingers with a variety of knives. Her infamous performance *Thomas Lips* (1975; see T. McEvilley and others, pp. 99–105), in which she cut, flagellated and froze herself, established her practice as one that dramatically explored the physical limits of her body. Like Chris Burden and also like the Viennese artists associated with Aktionismus, she used performance to test the endurance and tolerance of the human body. In 1976 she teamed up with another performance artist, Ulay (*b* 1943) with whom she produced collaborative works until 1988. In these works they explored simple binary oppositions, (male/female, active/passive) in a form of physical theater that involved them shouting at each other, slapping each other, or tying each other's hair together. *Nightsea Crossing* (1981–7; see T. McEvilley and others, pp. 260–93) was their largest project, presented in various spaces around the world. Inspired by Eastern mysticism, the performance consisted of both artists sitting at a table for extended periods of up to 16 days at a time. When their association ended, Abramovic turned to sculptural installations consisting of crystal shoes, pillows or helmets and requiring audience interaction, such as *Black Dragon: Waiting* (performed at Oxford, MOMA, 1990). She also continued to make performances, including *Balkan Baroque* (1997; see T. McEvilley and others, pp. 364–9), where she cleaned bones for four and a half days while singing traditional Yugoslavian folk songs.

BIBLIOGRAPHY

T. McEvilley: "Marina Abramovic/Ulay," *Artforum,* xxii/1 (Sept 1983), pp. 52–5

Modus Vivendi: Ulay & M.A. (exh. cat. by R. Zaugg and others, Eindhoven, Cologne, and Turin, 1985)

Marina Abramovic (exh. cat. by D. von Drathen, Paris, 1992)

B. Pejic and D. von Drathen: *Marina Abramovic* (Stuttgart, 1993)

Marina Abramovic: Objects, Performances, Video, Sound (exh. cat., essays R. Goldberg, T. McEvilley and D. Elliot, Oxford, MOMA, 1996)

J. Fisher: "Interperformance: The Live Tableaux of Suzanne Lacy, Janine Antoni, and Marina Abramovic," *A. J.* (USA), lvi/4 (Winter 1997), pp. 28–33

T. McEvilley and others: *Marina Abramovic: Artist Body: Performances 1969–1998* (Milan, 1998) [cat. rais.]

The Bridge/El puente: Marina Abramovic, exposición retrospectiva (exh. cat. with text by A. Abramovic, P. J. Rico, and T. Wulffen, Valencia, 1998)

J. A. Kaplan: "Deeper and Deeper: Interview with Marina Abramovic," *A. J.* (USA), lviii/2 (Summer 1999), pp. 6–21

C. Green: "Doppelgangers and the Third Force: The Artistic Collaborations of Gilbert & George and Marina Abramovic/Ulay," *A. J.* (USA), lix/2 (Summer 2000), pp. 36–45

Marina Abramovic: Student Body, Workshops, 1979–2003; Performances, 1993–2003 (exh. cat., Milan, 2003)

M. Turim: "Marina Abramovic's Performance: Stress on the Body and Psyche in Installation Art," *Camera Obscura,* liv (2003), pp. 98–117

A. Navakov: "Point of Access: Marina Abramovic's 1975 Performance, 'Role Exchange'," *Woman's A. J.,* xxiv/2 (Fall 2003–Winter 2004), pp. 31–5 [includes bibliography]

A. Moulton: "Marina Abramovic: RE-Performance," *Flash A.*, xxviii/244 (Oct 2005), pp. 86–89

H. Kontova: "Marina Abramovic, Vanessa Beecroft, Shirin Neshat: Modern Nomads," *Flash A.*, xl/255 (July 2007–Sept 2007), pp. 102–7

M. Falconer and C. Iles: "The Life and Death of Marina Abramovic," *Art World*, vii (Oct 2008–Nov 2008), pp. 36–41

J. Santone: "Marina Abramovic's 'Seven Easy Pieces': Critical Documentation Strategies for Preservings Art's History," *Leonardo*, xli/2 (2008), pp. 147–52

Marina Abramovic: The Artist is Present (exh. cat. by K. Biesenbach; New York, MOMA, 2010)

Francis Summers

Abrams, Harry N.

(*b* London, 8 Dec 1904; *d* New York, 25 Nov 1979), publisher and collector. He trained at the National Academy of Design and the Art Students League in New York before working in publishing. In 1950 he set up his own publishing company, Harry N. Abrams, Inc., one of the first American companies to specialize in art books. In 1968 he founded Abbeville Books. His collecting, which began in the mid-1930s, went through three distinct phases: his first interest was in such contemporary American painters as Milton Avery and Raphael Soyer. He continued to purchase such works into the 1950s, but from the mid-1940s his collecting began to be dominated by works by major 20th-century artists; he acquired, among other works, *Clock* (1948) by Marc Chagall (1887–1985), *Motherhood* (1921) by Pablo Picasso (1881–1973) and *Miserere* (1939) by Georges Rouault (1871–1958).

Abrams's most notable period as a collector was the 1960s, when he became known as a major collector of new American art. His interest in this area was fueled by the *New Realists* exhibition of 1962 at the Sidney Janis Gallery in New York, from which he acquired his first example of Pop art. He subsequently acquired such works as Morris Louis's *Pillar of Fire* (1961), a Robert Rauschenberg combine, *Third Time Painting* (1961), Lucas Samaras's *Chairs* (1965) and Wayne Thiebaud's *Football Player* (1963).

BIBLIOGRAPHY

Harry N. Abrams Family Collection (exh. cat., New York, Jew. Mus., 1966)

B. Kurtz: "Interview with Harry N. Abrams," *Arts* [New York], xlvii/1 (Sept–Oct 1972)

A. Deirdre Robson

Abstract art

Art form that conveys a visual message by reducing or eliminating representation of nature (termed nonrepresentational) and objects (termed nonobjective). Abstract art includes both reductive artwork, which starts with observation of nature and distills it, often in successive stages, and artwork which initially refers to ideas or emotions. With images from suggestive to more obscure, abstract art is distinguished from representational art as an independent aesthetic of the 20th century. Abstract art in America from about 1905 to the late 1960s can be grouped in three phases. Modernism from 1905 to 1920 was primarily influenced by the avant-garde European movements of Post-Impressionism, Fauvism, Cubism and Futurism through exchanges with Europe in artists' travel, exhibitions and publications. A second period from 1920 to 1940 saw a retrenchment with critical debate about the social relevance of abstract art in the post-World War I and Depression era. At this time, additional abstract movements from abroad were influential including Suprematism, Constructivism, Neo-plasticism and the more contemporaneous Dada and Surrealism. The American Abstract Artists group formed to educate the public about abstract art and strengthen artists' ties at a time when social realism and naturalism had gained majority. In the third phase, the post-World War II period, the single-minded focus of abstract artists of the 1930s in America along with an influx of artists from Europe, such as Joan Miró (1893–1983), Fernand Léger (1881–1955), Josef Albers and Hans Hofmann, produced the formative milieu for an ambitious generation of artists who were sometimes called the New York school, a term

indicative of a shift in the art world center from Paris to New York. Abstract Expressionism, which gained international prominence, was followed by Post-painterly abstraction and Minimalism.

Modernism 1905–1920, initiation of an American abstract art. Among the American artists who studied in Paris in the early 20th century, Max Weber arrived in 1905, where the influence of Paul Cézanne (1839–1906) affected freer brushstrokes and reduced detail in work that was exhibited at the 1907 Salon d'Automne along with a major Cézanne retrospective. In Paris Weber helped organize a class with the Fauve painter Henri Matisse (1869–1954), and his work gained further simplification and figurative distortion. When he returned to New York in 1909 he absorbed Cubism, employing a web of fractured form, and Futurism in expansive directional lines, executing a series of paintings and drawings of New York City that celebrate the chaos and dynamism of urban life and the modern skyscraper (*Abstraction*, 1913; New Britain, CT, Mus. Amer. A.). Weber's radically simplified figurative sculpture from 1910 and a totally abstract, Cubist-related bronze of 1913, *Spiral Rhythm* (Washington, DC, Hirshhorn), place Weber as one of the innovators of abstract sculpture in America.

Though the work of Arthur Dove owes a debt to Cubism, which he saw along with Cézanne on a European trip (1907–9), his pursuit of the turbulent forces behind natural appearances led him to produce some of the earliest abstractions in Europe or America. The charcoal *Abstraction, Number 2* (c. 1911; New York, Whitney) coalesces energies and sensations from nature through a series of forceful diagonal spikes and radiating overlapping wheels whose cutoff forms extend beyond the page. Georgia O'Keeffe knew the work of Dove from the 1910 exhibition *Younger American Painters* at the Alfred Stieglitz gallery 291, which also included pioneering American modernists Max Weber, John Marin, Marsden Hartley, Arthur Carles and Alfred Maurer. O'Keeffe studied with Arthur Wesley Dow whose unconventional teaching encouraged her, as it had

Weber, to take a freer, nonacademic approach. For O'Keeffe, like Dove, that meant to look beyond a recognizable surface toward elemental mysteries. In 1916 she executed a group of abstract charcoal drawings, shown shortly afterward at 291. The charcoals, along with her abstract watercolors such as *Evening Star VI* (1917; New York, MOMA) introduced a highly personal vocabulary including jagged silhouettes, ovoid shapes and sensate openings, which at times stood alone as intense abstractions and, particularly in the 1920s and later, became an integral part of her interpretation of subjects such as flowers, skulls, doorways and the sky.

The modernist movement, which included developments in abstract art, was catapulted into the consciousness of the American public by the 1913 Armory Show in New York, Chicago and Boston. European Post-Impressionists, Cubists and Fauves were shown along with American artists ranging from Ashcan realists to modernists. Following the Armory Show, significant numbers of modern art galleries opened. Already in existence, Stieglitz's gallery 291 (1908–17) had shown early abstract art, including paintings by the Russian artist Vasily Kandinsky (1866–1944), while the gallery's magazine *Camera Work* had published his theoretical tract "On the Spiritual in Art." The path was open for the earliest American nonobjective movement Synchromism, signifying "with color," to receive international attention. Working in Paris, two Americans, Stanton Macdonald-Wright and Morgan Russell, presented the first Synchromist exhibitions in 1913 in Munich and Paris. Rhythmic arrangements of chromatic Cubist planes in Russell's *Synchromy in Blue Violet* (1913; Minneapolis, MN, Curtis Gals.) and Macdonald-Wright's *"Conception." Synchromy* (1915; New York, Whitney) is intended to elicit a direct, sensuous response analogous to musical compositions. From their study (1903–13) with Percyval Tudor-Hart (1873–1954), a Canadian artist teaching in Paris, Russell and Macdonald-Wright developed their own color system using the basic color wheel to gauge spatial intervals. In their quest to find in

pure chromatic form an equivalent plasticity to Michelangelo's sculpture, they noted their emotional response to color as well as made judgments about what colors advance and which appear to recede. These "chromatic waves," as they called them (1913; Paris, Bernheim-Jeune cat.), were arranged to both visualize form and to be revealed over time, in the vein of contemporary European abstractions by František Kupka (1871–1957), Francis Picabia (1879–1953) and Kandinsky, whose intent was to create analogies to rhythmic structure and tonal variations in music. Another approach to abstract composition using musical analogies was achieved by Man Ray in his oil painting *Symphony Orchestra* (1916; Buffalo, NY, Albright–Knox A.G.) that combined a flattened piano with pure shapes and linear rhythms inspired by musical tones and intervals. Man Ray's experiments with Cubist techniques, which he encountered at the Armory Show in 1913, followed by his close contact with Marcel Duchamp from 1915, led to an extreme abstract simplification seen in his *Revolving Door* series (1916–17) and his masterpiece of compressed space and bold color silhouettes *The Rope Dancer Accompanies herself with her Shadow* (1916; New York, MOMA). From 1917 to 1921, Man Ray produced avant-garde sculptures from found objects such as his chromed and painted bronze made from boards held in a tilted stack by a C-clamp and titled *New York* (1917; New York, Whitney). As a student of Auguste Rodin (1840–1917) in Paris, from *c.* 1912 until Rodin's death in 1917, John Storrs adopted Rodin's partial figure and long planar silhouettes. Storrs combined these with his own smooth, Cubist-influenced, simplifications in his figurative sculpture that included monumental architectural commissions. A parallel pursuit in totally nonobjective sculpture (e.g. *Forms in Space, Number 1*, stainless steel and copper, 1927; New York, Met.) began in 1917. This work was characterized by tubular and flat, recessed and projected planes with vertical, arched and zigzag articulations that won him critical recognition as a sculptor of early modernist spirit and the machine age.

Abstract art 1920–1940, establishment of an independent aesthetic. By 1920 much of the modernist impetus was spent with artists such as Weber, Marsden Hartley, Joseph Stella, Russell and Macdonald-Wright returning to representation. World War I and the Depression of 1929, led to a period when social realism and naturalism suited the national consciousness. American abstraction continued in fewer and diverse channels. The Société Anonyme was founded in 1920 by Katherine Dreier, Duchamp and Man Ray to exhibit, collect and promote an understanding of both American and foreign abstract art. The Society staged its largest exhibition, the International Exhibition of Modern Art, at the Brooklyn Museum in 1926, showing 300 works and featuring on its catalog cover a purist abstract sculpture by John Storrs. From World War I to the early 1930s a generation of artists pursuing abstraction followed a wide choice of inclinations. Early work by Ilya Bolotowsky of the 1930s related to the Surrealist biomorphism of Joan Miró and the Neo-plasticism of Piet Mondrian (1872–1944), while also showing Suprematist and Constructivist influence. In the 1930s to 1941 Bolotowsky participated in Works Progress Administration (WPA) abstract projects (e.g. *Autumn, Study for a Mural*, 1940; New Haven, CT, Yale U.). The mural division was headed by Burgoyne Diller whom Bolotowsky joined in 1936 as a founding member of the American Abstract Artists (AAA), an organization designed to hold exhibitions, provide artist contact and educate the public about abstract art. In the 1940s Bolotowsky's work became more purist with an interpretation of Mondrian's Neo-plasticism that showed his own "counterpoint of colors." In painting and later column sculptures, he eliminated diagonals to concentrate on surface tension through color balance and a proportional push and pull between rectilinear forms (e.g. *Metal Column B*, 1966; Minneapolis, MN, Walker A. Cent.). Other accomplished Neo-plasticists, who were members of the AAA, were Burgoyne Diller and Fritz Glarner while another group of members represented 1930s Cubist styles.

George L. K. Morris, as AAA spokesman and an editor for *Partisan Review* (1937–43), advocated for abstraction, described in the fifth AAA exhibition catalog as: "a direct, untrammeled relationship of the elements of plastic expression . . . concerned with the universal values, the real expressions of art" (R. Guerin, p. 7). Morris's nonobjective work of the mid-1930s (e.g. *Composition*, 1938; Philadelphia, PA, Mus. A.) showed fragmented shapes arranged in a narrow space and related to the style of Jean Hélion (1904–87) at this time. A. E. Gallatin, one of the AAA Synthetic Cubists as well as a collector, made his greatest contribution by founding the Gallery of Living Art in 1927 at New York University to show American and European avant-garde art. Balcomb Greene's Synthetic-Cubist-related abstractions of the 1930s deployed broad curvilinear stenciled sections with cut and overlapping geometries. Around 1943 he started a transition to figurative work that continued to be informed by the distinctive arrangements of his nonobjective period. The abstract collages and painted reliefs made by Gertrude Greene (1904–56) in the 1930s, where shapes hang or overlay one another in unexpected alignments, progressed toward geometrical purity influenced by Constructivism. In Greene's 1940s layered wood reliefs, some have gestural strokes that in later paintings of the 1950s became more expressionistic.

Abstract art 1940–late 1960s: Abstract Expressionism, Post-painterly abstraction and Minimalism. The post-World War II period, beginning with Abstract Expressionism, has been recognized internationally as the most innovative period in the development of American abstract art up to that time. Abstract Expressionism refers to a group of painters working in New York in the 1940s and 1950s who shared a common interest in presenting self-identity, mythic or spiritual content, and process as subject in order to submerge or eliminate representation. In mature work of the 1950s, Jackson Pollock's completely abstract, rhythmic skeins of paint were applied by pouring from all sides onto canvas placed on the floor using a technique that prompted the name action painting by the critic Harold Rosenberg (see color pl. 1:I, 1). This term applies variously to the process of others of the group, among them Willem de Kooning, Franz Kline and Robert Motherwell. Lee Krasner, who in 1937 studied in Hans Hofmann's school, composed her mature work from 1946 using techniques such as layers of dripped color, multiple calligraphic or shaped marks and full gestures of the body. Ibram Lassaw, one of the first abstract sculptors of the 1930s, after World War II, developed an improvisational technique of bending rods, then coating them with different colored alloys to create complex open-form structures. The sculptors Herbert Ferber, Seymour Lipton and David Smith, also associated with Abstract Expressionism, shared in their Surrealist heritage of using automatic writing to manifest psychic and unconscious feelings which in the new art first appeared as biomorphic forms and later were channeled into the urge toward immediacy of self-expression, the acting out of personal destiny in the existentialist sense then current. Barnett Newman as writer/spokesman projected mythic, religious and metaphysical content into totally abstract visual expanses of a single color animated and given scale by generally vertical, narrow strips that he called "zips." His early work was composed of numerous biomorphic elements denoting chaos in cyclical creation arising from destruction. From 1948 his work resolved into unified abstract color fields that addressed subjects such as the *Stations of the Cross* (1958–66) and in his monumental sculpture *Broken Obelisk*, ancient and contemporary civilization. Mark Rothko found new content in ancient myths, painting hybrid creatures that in the mid-1940s he reduced to loose symbolic markings. His work progressed toward "transcendence" as he called his quest to recreate the tragedy of the human condition. In the 1950s Rothko's large, loosely-formed horizontal rectangles, which approach the edges of the canvas, simultaneously float on a single-color area and appear to merge with the painting's surface—works that were recognized as icons of the new radical abstraction.

Newman's and Rothko's compositions as "fields" of color as they were called by the critic Clement Greenberg, became fully adopted by the next generation of artists who otherwise rejected Abstract Expressionist painterly facture and allusion to dramatic or spiritual content. Greenberg organized an exhibition showing 31 artists of the new nonobjective painting in 1964 at the Los Angeles County Museum and called it *Post-painterly Abstraction*. Some critics applied the notion to abstract modalities occurring after Abstract Expressionism that reintroduced a discrete contour to delimit form or spatial interval using the style term hard-edge. Another aspect was the stain painting of Helen Frankenthaler, which she began in 1952, practiced as well by Morris Louis. By pouring thinned paint onto unprimed canvas, a technique that merged color and surface, object versus ground composition became obsolete.

In asserting the primacy of color, a smooth uncomplicated surface and line used in single or systemic configurations, artists of the 1960s such as Ellsworth Kelly, Agnes Martin, Jack Youngerman, Al Held, Larry Poons and Frank Stella imbued formal pictorial elements with total meaning. This self-referring abstract formalism was by 1968 generally understood as Minimalism, a term first applied to recent art by Richard Wollheim in 1965 (Meyer, p. 142) and some months later by Barbara Rose (*ABC Art*, in Fabozzi, pp. 186–201). Working in Paris in 1947–54, then returning to New York, Ellsworth Kelly looked at nature, architecture and art history, appropriating specific elements to invent his isolated shapes, split forms and conjoint sections. In his mature paintings and sculptures, saturated color or flat white are calculated to hold the surface plane or register equally with adjacent panels or three-dimensional shapes. A concordant approach in the use of intuitive sensibility to compose nonhierarchical field structure is presented in the more austere work of Agnes Martin. In paintings and drawings beginning in the late 1950s, small, near equal units are conceived in an allover linear grid. Martin's line of subtly varied

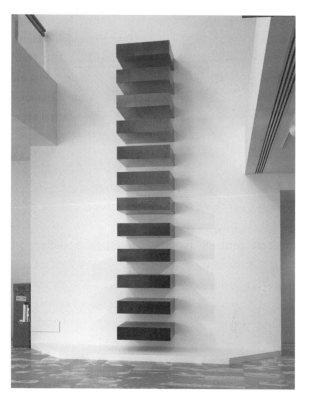

ABSTRACT ART. *Untitled* by Donald Judd, galvanized iron and lacquer, h. 1.02 m, 1967. Helen Achen Bequest (by exchange) and Gift of Joseph Helman. © Judd Foundation, Licensed by VAGA, NY © Museum of Modern Art/Licensed by SCALA/Art Resource, NY

pressure but without noticeable accenting and her barely mutable, uninterrupted tone or color refer to her personal conviction regarding abstraction: "a hint of perfection present—at the slightest hint . . . the work is alive" (Agnes Martin *Reflections*, 1973, in Fabozzi, p. 185). Other artists of the 1960s and 1970s working in variants of reductive geometric abstraction were Robert Ryman, Robert Mangold and Brice Marden.

Sculptors associated with Minimalism, or as it was sometimes called "Object art," were Dan Flavin, Larry Bell, Sol LeWitt, Ronald Bladen, Carl Andre and Robert Smithson, as well as two sculptors also known for their writings on Minimalist polemics Robert Morris and Donald Judd (*Specific Objects*, 1965, in Fabozzi p. 173). Smooth geometric shapes, often fabricated by others, devoid of Abstract Expressionist accident or incident, were to be apprehended at once as self-sufficient presence,

whether a monolith or spatial grouping. Intended to involve the viewer in perceptual process, artists' choices were concerned with interval, proportion and angled facture; materials like ordinary plywood versus new industrial metals, coatings and plastics; and innovative placement—without pedestal, leaning or propped up, or as with André's works, to be walked on.

[*See also* Abstract Expressionism; Action painting; Andre, Carl; Bell, Larry; Bladen, Ronald; Bolotowsky, Ilya; Color field painting; De Kooning, Willem; Diller, Burgoyne; Dove, Arthur; Ferber, Herbert; Flavin, Dan; Frankenthaler, Helen; Gallatin, A. E.; Glarner, Fritz; Hard-edge painting; Held, Al; Judd, Donald; Kelly, Ellsworth; Kline, Franz; Krasner, Lee; Lassaw, Ibram; LeWitt, Sol; Lipton, Seymour; Louis, Morris; Macdonald-Wright, Stanton; Mangold, Robert; Marden, Brice; Minimalism; Morris, Robert; Motherwell, Robert; Newman, Barnett; O'Keeffe, Georgia; Poons, Larry; Post-painterly abstraction; Rothko, Mark; Russell, Morgan; Ryman, Robert; Smith, David; Smithson, Robert; Stella, Frank; Storrs, John; Synchromism; Weber, Max; *and* Youngerman, Jack.]

BIBLIOGRAPHY

International Exhibition of Modern Art (exh. cat., New York, Brooklyn Mus., 1926–7) [assembled by Société Anonyme]

A. Ritchie: *Abstract Painting and Sculpture in America* (New York, 1951)

A. E. Gallatin Collection, "Museum of Living Art," Philadelphia, PA, Mus. A. cat. (Philadelphia, 1954)

C. Greenberg: *Post-Painterly Abstraction* (Los Angeles, 1964)

R. Guerin: *American Abstract Artists, 1936–1966* (New York, 1966)

B. Rose: *American Art Since 1900* (New York, 1967)

Ilya Bolotowsky (exh. cat., New York, Guggenheim, 1974) [includes interview by L. A. Svendsen and M. Poser]

M. Lorenz: *George L. K. Morris, Artist and Critic* (Ann Arbor, 1982)

N. Frackman: *John Storrs* (New York, 1986)

V. Mecklenburg: *The Patricia and Phillip Frost Collection, American Abstraction 1930–1945* (Washington, DC, 1989)

B. Haskell: *The American Century, Art & Culture 1900–1950* (New York, 1999)

J. Meyer: *Minimalism, Art and Polemics in the Sixties* (London, 2001)

P. Fabozzi: *Artists, Critics, Context* (New Jersey, 2002)

T. Kellein: *Donald Judd, 1955–1968* (Bielefeld, 2002)

F. Naumann: *Conversion to Modernism: the Early Work of Man Ray* (New Brunswick, 2003) [includes essay by G. Stavitsky]

Visual Music: Synaesthesia in Art and Music since 1900 (exh. cat. by K. Brougher and others, Los Angeles, CA, Mus. Contemp. A., 2005)

Victoria Thorson

Abstract Expressionism

Term applied to a movement in American painting that flourished in the 1940s and 1950s, sometimes referred to as the New York school or, very narrowly, as action painting, although it was first coined in relation to the work of Vasily Kandinsky in 1929. The works of the generation of artists active in New York from the 1940s and regarded as Abstract Expressionists resist definition as a cohesive style; they range from Barnett Newman's unbroken fields of color to Willem de Kooning's violent handling of the figure. They were linked by a concern with varying degrees of abstraction used to convey strong emotional or expressive content. Although the term primarily denotes a small nucleus of painters, Abstract Expressionist qualities can also be seen in the sculpture of David Smith, Ibram Lassaw and others, the photography of Aaron Siskind and the painting of Mark Tobey, as well as in the work of less renowned artists such as Bradley Walker Tomlin and Lee Krasner. However, the majority of Abstract Expressionists rejected critical labels and shared, if anything, only a common sense of moral purpose and alienation from American society. Abstract Expressionism has nonetheless been interpreted as an especially "American" style because of its attention to the physical immediacy of paint; it has also been seen as a continuation of the Romantic tradition of the Sublime. It undeniably became the first American visual art to attain international status and influence.

Background, Origins and Early Phase. The roots of Abstract Expressionism lie in the social and

artistic climate of the 1920s and early 1930s. Apart from Hans Hofmann, all its major exponents were born between 1903 and 1915 and grew up during a period of American isolationism. Although Europe remained the traditional source of advanced culture, American efforts during the 1920s to develop an aesthetic independence culminated in the direct, homespun realism of Regionalism. Consequently, the development of the art of Willem de Kooning (see *Woman II*, 1952), Arshile Gorky, Jackson Pollock and Clyfford Still, for example, illustrates a complex interaction between tradition, rebellion and the individual talent. European modernism stimulated them deeply, while their desire to retain the impact of personal experience recalled the aims of American Scene painting. Pollock, Still, Smith and Franz Kline were all affected by their native backgrounds in the rural West and in the steel- and coal-producing regions, respectively. In other cases Jewish or European origins contributed to an unusual gamut of ethnic, intellectual and private sources of inspiration.

Between the wars New York offered some notable opportunities to assimilate comparatively recent artistic developments. Its galleries included the Museum of Non-Objective Painting, which housed the impressive Kandinsky collection, and the Museum of Modern Art, which mounted exhibitions throughout the 1930s and 1940s covering many aspects of 20th-century painting.

Much of the creative intellectual ferment of the time was focused in the theories of the Russian émigré painter and writer John Graham, who befriended Gorky, Pollock and others. His book *Systems and Dialectics of Art* (1937) justified abstraction as distilling the essence of reality and traced its roots to primitivism, the unconscious and the painter's empathy with the brushstroke. The younger American artists thus seem to have become highly conscious of their historical position and dictates. Most felt that they had to reconcile Cubist spatial organization with the poetic subject matter of Surrealism and realized that original art would then need to go beyond both.

The development of Arshile Gorky's art from the late 1920s exemplified the cross-currents in the matrix of Abstract Expressionism. He progressively assimilated the main phases of modern European painting in order to explore his own identity until in *The Artist and his Mother* (c. 1926–34; New York, Whitney) the private world of Gorky's Armenian origins merged with his contemporary stance as heir to the space and forms of Synthetic Cubism, Picasso and Miró. This mood of transition is especially apparent in technical paradoxes, such as the strange contrasts of carefully finished areas with unresolved passages of paintwork that make this double portrait appear as if it were suspended in a process of change. By the early 1940s this tendency (which can be traced back to Paul Cézanne and to Futurism) provided new means of incorporating the tensions of the artist's immediate circumstances into the actual picture. De Kooning, for example, deliberately allowed successive efforts to capture volume and contour to overtake the stability of his figures, as in *Queen of Hearts* (c. 1943; Washington, DC, Hirshhorn); such figures typify one aspect of early Abstract Expressionism in retreating into a dense, ambiguous visual fabric.

At an early stage Pollock, Still and Mark Rothko established a similar polarity between the figure (or other signs of existence) and external forces. The "realism" of their early landscapes, interiors and urban scenes undoubtedly reflected the emphasis on locale in American scene painting, but the expressive symbolism was prophetic. A sense of isolation and gloom probably derived in part from the context of the Depression allied with personal factors. They combined highly sensitive, romantic temperaments with left-wing or radical views so that the social circumstances of the period naturally suggested an approach to art that explored the human predicament. This had already been anticipated by some literature of the 1920s and 1930s, notably the novels of William Faulkner (1897–1962), which placed the self against an inimical environment; contemporary American art, however, offered few successful

precedents. On the contrary, the weaknesses of depicting human themes literally had already surfaced in Thomas Hart Benton's anecdotal brand of Regionalism that Pollock, a former pupil of Benton, later described as "something against which to react very strongly." Despite the wagons, cowboy and mules in Pollock's *Going West* (*c.* 1934–5; Washington, DC, Smithsonian Amer. A. Mus.); it remains more elemental than anything by Benton. A feeling of almost cosmic tumult is countered by an overall vortex-like unity.

As Pollock's work became more abstract during the 1930s, it nonetheless retained an underlying conflict between impulsive chaos and the need to impose some overall sense of order. Yet the common problem of the 1930s was not just evolving a formal language for what Rothko subsequently termed "pictures of the human figure—alone in a moment of utter immobility" ("The Romantics were prompted": *Possibilities*, 1 (Winter 1947–8), p. 84) and other contrasting psychological states; the controversy in the USA focused instead upon the definition and priorities of an authentic avant-garde art.

Several future Abstract Expressionists were employed on the Works Progress Administration's Federal Art Project (WPA/FAP). Alongside the practical benefits of financial support and official endorsement, the WPA/FAP allowed opportunities to experiment with new techniques and to tackle the problems of working on a large scale. It also acted as a catalyst for a more cohesive New York community. But the advocacy of Social Realism on the project alerted many to its academic nature, which Gorky summarized as "poor art for poor people." From a visual rather than literary standpoint, the humanitarian imagery of a leading Social Realist such as Ben Shahn seemed as barren as the reactionary equivalents in Regionalism. David Smith's *Medals for Dishonor* series (15 plaster models, 1939; e.g. *No. 9—Bombing Civilian Populations*, ex-artist's priv. col., see G. McCoy, ed.: *David Smith*, New York, 1973, fig.) and the early paintings of Philip Guston not only engaged anti-Fascist ideas but also revealed a legacy

of the radicalism of the 1930s that was never abandoned, despite largely unfounded claims that later the movement was on the whole "de-politicized." Smith and Guston, rather, subsequently sought to show how their respective media could signify and not merely illustrate their beliefs about freedom, aggression and constraint. Similarly, Pollock drew almost nothing from the overt socialism of the Mexican José Clemente Orozco's murals but a great deal from their capacity to embody human strife in the objective pictorial terms of rhythm and surface pattern.

Another alternative in the 1930s was the tradition of "pure" abstraction, stemming from Piet Mondrian and upheld by the American Abstract Artists group (AAA) to which Ad Reinhardt belonged. Reinhardt's eventual divergence from mainstream Abstract Expressionism can be traced to this initial assumption that the liberating potential of non-objective and specifically geometric art lay in its very independence from the social sphere. A more moderate approach was adopted by the painters Hans Hofmann and Milton Avery. Hofmann, born in Bavaria in 1880, provided a link with an earlier phase of European modernism and, through his own school, which he founded in New York in 1934, taught the synthesis of Cubist structure (emphasizing the unity of the picture plane) with the brilliant colors of Fauvism. Avery's more lyrical approach suffused a simple, flat handling of space with light and atmosphere. This inspired Rothko and Adolph Gottlieb with its Matisse-like balance between observation and the artist's feelings. Moreover, the growing popularity among an emergent New York avant-garde of theories originated by Leon Trotsky tended to discourage strict orthodoxy by stressing the autonomy of art over social and political restrictions. Out of this amalgam of diverse sources and beginnings, Abstract Expressionism during the 1940s sought to integrate the inner world of emotions with the realities of the picture-making process.

The 1940s: Paths to Abstraction. The exhibition *Fantastic Art, Dada, Surrealism* (1936–7; New York,

MOMA) heralded a phase when Surrealism and its affinities changed the course of American painting. Furthermore, the arrival of several leading European Surrealists including André Breton, André Masson and Max Ernst in the USA after the outbreak of World War II allowed stimulating personal contacts, Robert Motherwell being one of the first to benefit in this way. This brought an international note to the art scene and reinforced a sense of historical moment: the hegemony of the Ecole de Paris had shifted to New York. As the war continued it also seemed that new subject matter and accompanying techniques were necessary to confront what was perceived as the tragic and chaotic zeitgeist. Surrealism had partly satisfied such needs by unleashing the disruptive forces of the unconscious, but its tendency toward pure fantasy now appeared irrelevant. In a statement made in 1943 in the *New York Times* (13 June, p. 9), Rothko and Gottlieb declared the new gravity of intent: "There is no such thing as good painting about nothing. We assert that the subject is crucial and only that subject-matter is valid which is tragic and timeless."

The pursuit of universal themes continued Surrealist artists' fascination with the omnipotent force of sexuality and explained much apparently Freudian imagery in paintings of the earlier 1940s. Erotic motifs occur in Gorky's *The Liver Is the Cock's Comb* (1944; Buffalo, NY, Albright–Knox A.G.). Interpenetrating or phallic elements characterized Smith's sculptures at times, as well as the paintings of Pollock, Rothko, Still and Theodoros Stamos; the living figure in Motherwell's *Pancho Villa Dead and Alive* (1943; New York, MOMA) is distinguished by his genitalia. Such iconography in fact derived less from Freud than from a more universal symbolism invoking regeneration, fertility and primitive impulses. These themes in twin stemmed from the Abstract Expressionist's overriding concern with subjectivity. To this end the Surrealist use of biomorphism, a formal language of organic curves and similar motifs, was variously exploited. For Gorky it evolved into a metamorphic realm where

tendrils, spikes and softer masses referred simultaneously to nature and to human anatomy. Pollock's version was less specific, and in *Pasiphaë* (1943; New York, Met.) it implied womb-like enclosure versus whirling activity. Even de Kooning, the least sympathetic toward Surrealism, reiterated organic contours in his claustrophobic canvases of the mid-1940s as reminders of a strong yet cryptic eroticism. Thus biomorphism served to bridge the figurative modes of the 1940s with a manifold path to abstraction.

Another catalyst in the 1940s was a preoccupation with the concept of myth, especially as interpreted by the Swiss psychologist Carl Gustav Jung, whose writings had gradually gained an American readership. According to Jung, myths gave universal form to basic human truths and related to a profound level of experience that he identified as the "collective unconscious." These theories helped several Abstract Expressionists attain more reductive styles because myth, Jung claimed, had a dramatic simplicity expressed through "archetypes," that is, primal figures and symbols. Primitive art often dealt with myth and became a secondary source at this stage, particularly in the aftermath of exhibitions at the Museum of Modern Art in New York, ranging from prehistoric rock pictures in Europe and Africa (1937) to American Indian art (1941). The totem was a frequently used primitive motif, aptly fitted to personify the Jungian archetype in the guise of a mysterious, upright entity. In Pollock's *Guardians of the Secret* (1943; San Francisco, CA, MOMA) sentinels at either side of the picture seem to guard a central maze of lines and markings that suggests the chaotic recesses of the collective unconscious. Similarly, Still, Smith and others turned the totem into a visual cipher halfway between a figure and a nonrepresentational emblem.

The great potential of the abstract sign soon became clear: it embodied a kind of terse pictorial shorthand, provocative in itself or, rather like individual script, imbued with the physical impetus of its creator. In 1941 Gottlieb began a series known

collectively as *Pictographs* (e.g. *Voyager's Return*, 1946; New York, MOMA). Enigmatic details, including body parts and geometric motifs, were set within a rough gridwork that recalled an archaic sign system or petroglyph. By 1947 Rothko, Stamos and others had created sparse schematic images marked by a shallow, post-Cubist space and defined in the *Ideographic Picture* exhibition, organized by Barnett Newman for the Betty Parsons Gallery, New York, in 1947, as "a symbol or character painted, written or inscribed representing ideas."

Newman's own works of this period reflected the theory that abstraction could convey awesome meanings. Their breakthrough was analogous to that in Aaron Siskind's contemporary photographs, such as *Iron Work I* (1947; see C. Chiarenza: *Aaron Siskind: Pleasures and Terrors*, Boston, 1982, fig.), which gained impact from a calculated ambiguity. Their syntax of vertical elements, quivering edges and voids retained the dramatic aura associated with figuration but no longer conformed to either a biomorphic style or to the geometry of Mondrian. Rothko's paintings also progressed in a similar direction already anticipated in 1943 when he wrote, "We favor the simple expression of the complex thought" (letter to the *New York Times* Art Editor, Edward Alden, 7 June 1943), which was to be achieved through the "large shape" that could impose its monumentality upon the viewer.

This reduction to essentials had widespread consequences during the 1940s. It shifted attention away from relatively graphic symbolism toward the capacities of color and space to acquire an absolute intensity, not bound to describe events and forms within the picture but free to embody extremes of light and darkness, enclosure, liberation and so on. The dynamics of the act of painting assumed a central role. Gorky's use of very fluid washes of pigment in 1942, under the influence of the Chilean Surrealist Roberto Matta, foreshadowed both tendencies. The resultant veils, billows and liquid runs of color created an unusually complex space, as in *Water of the Flowery Mill* (1944; New York, Met.) that

changed from one area to another with the same spontaneity that had previously been limited to Gorky's organic shapes.

Still, Gottlieb, Stamos and Richard Pousette-Dart pursued a different course in the 1940s by stressing tangible paint layers with heavy or unconventional textures. These methods altered their works from the traditional concept of a discrete easel picture to more palpable images whose presence confronted the actual world of the spectator. Dimensions grew in order to accentuate psychological and physical rapport with the viewer. Inevitably, the search for heightened immediacy, for a charged relationship between surface and viewer, meant that a number of artists would regard the painting as an incarnation of the process—the energy, tensions and gestures—that had created it.

The Surrealist technique automatism again unlocked possibilities for incorporating immediacy with a vivid record of manual activity, and the impulses behind it, into the final work. Automatism had supposedly allowed Surrealists like Miró and Masson to paint without full conscious control and so essentially stimulated the discovery of unorthodox forms. In contrast, Abstract Expressionism elevated automatist procedures into a means of reorganizing the entire composition. Hofmann was among the first to pour and drip paint in the early 1940s in order to achieve increased liveliness, but Pollock took the technique to revolutionary limits. By the mid-1940s he painted with such urgency that the remnants of figures and other symbolic details were almost dismembered and lost within the great arcs and whorls formed by his sweeping gestures, for example *There Were Seven in Eight* (1945; New York, MOMA). A climax came in 1947 when the restrictions of brushes and the upright format of the easel picture were abandoned as Pollock took to working directly on the floor, dripping paint either straight from the can or with the aid of an implement such as a stick or a trowel. Consequently, in works of this period an astonishing labyrinth of paint traces expand, oscillate and hurtle back upon themselves,

resembling, as the artist described it, "energy and motion made visible." Pollock had reconciled two long-standing though divergent impulses, an obsession with chaotic force and the desire for order, into the vibrant unity of a field, for example *Number 2, 1949* (Utica, NY, Munson–Williams–Proctor Inst.) and *Summertime: Number 9A* (1948; London, Tate).

This synthesis was unique at the time, but Abstract Expressionist painting in the late 1940s generally approached a threshold where restlessness and flux predominated. The composition dissolved into a seething field of fragments dispersed with almost equal intensity throughout the picture; hence the term "all-over" was sometimes used to describe this tendency. A type of space evolved that was dense and unstable beyond even that of Analytical Cubism, as in de Kooning's *Painting* (1948; New York, MOMA (see color pl. 1:I, 2)). This probably owed something to the doubt-ridden anxieties of the postwar years and perhaps the pressures of fast-moving urban life. It certainly also stemmed from the consequences of automatism, which took even less overtly Abstract Expressionist painters like Reinhardt and Tobey to the stage where a teeming, calligraphic field of brushstrokes predominated. By the end of the decade the need to reassert meaningful content in unprecedented ways had again become imperative.

The 1950s: Climax, Reaction and Later Work. Newman's essay "The Sublime Is Now," published in the *Tiger's Eye* (i/6, 1948), called for a new art stripped to its formal essentials that still dealt with "absolute emotions." He concluded, "The image we produce is the self-evident one of revelation, real and concrete." Within two years Newman, Rothko and Still fulfilled these aims, primarily through a total concentration on color, a pictorial element loaded with dramatic connotations, simultaneously palpable and metaphysical insofar as its total effect transcends analysis. The deep redness of Newman's *Onement I* (1948; New York, MOMA) no longer describes forms since it comprises an absolute continuum, punctuated, although not broken, by a central vertical band of a brighter hue. Encompassing fields of color

tended to minimize internal pictorial relations and so invite the onlooker's participation, especially when enlarged to the mural scale sometimes adopted in the early 1950s. Small incidents acquired an uncanny prominence; the luminous rifts that escaped from Still's essays in black or the slight haloes around Rothko's rectangles implied the numinous behind the apparently monolithic facades. By "telling little," as Rothko described it in 1958, these works in fact managed to express more.

Color field painting was championed, using narrow stylistic criteria, by the critic Clement Greenberg as a breakthrough in modernist painting's attitude toward space because it superseded the shallow figure–ground relationships found in Cubism. Another interpretation has concentrated upon its elemental conflicts of light and scale, and of void and presence, as extending the Romantic tradition of the Sublime with its predilection for epic revelations. Both readings are valid but overlook the fact that the artists had essentially lifted the symbolic extremes and states of consciousness depicted in their earlier works onto an abstract plane. Moreover, the primal field of color, accentuating the viewer's isolation and sense of self, may equally have reflected a need for strong emotional experience in the barrenness of the Cold War during the late 1940s and the 1950s in the USA. Indeed, its imagery was not confined to Abstract Expressionist painting and recurred in the photographs of Siskind and Harry Callahan as well as in the expanses of space that engulfed the solitary figures painted by Ben Shahn and Andrew Wyeth.

In 1950 de Kooning abruptly abandoned his increasingly hermetic all-over compositions, such as *Excavation* (1950; Chicago, IL, A. Inst.), to begin a number of female subjects, the first being *Woman I* (1950–52; New York, MOMA). Paradoxically, this return to the figure vied with de Kooning's painting style, where the furious tumult of brushstrokes seemed to possess independence and velocity. The poet and critic Harold Rosenberg traced similarities in the work of Pollock, de Kooning and Franz Kline,

who had begun black-and-white abstractions *c.* 1949 that aggrandize the individual brushstroke into enormous vectors appearing to continue beyond the picture's edges. Rosenberg had assimilated the existentialism popular among the New York intelligentsia of the late 1940s and claimed that this art represented the physical traces of its creator's spontaneous working methods. He characterized it as action painting. Subsequent histories have tended to maintain the consequent division into "action" or "gestural" styles and "color field painting," although these rather simplistic critical categories were disowned by the artists and overrode many subtle connections.

Newman's *Onement* paintings (which date from *c.* 1948 to 1953) and de Kooning's *Woman* paintings, a theme to which he repeatedly returned, stand at opposite poles of technique and mood, ranging from the exalted to the grotesque. Both nonetheless juxtapose a centralized presence against an ambience, whether of color or urban chaos. Still's *1957-D-No1* (1957; Buffalo, NY, Albright–Knox A.G.) further demonstrates the shortcomings of critical categories by conferring the graphic contours and energy associated with gestural painting upon grandiose and otherwise almost homogeneous walls of pigment. Alongside Pollock's "drip" paintings and the large, linear steel sculptures by Smith of the late 1940s onward, it established a radical type of Abstract Expressionist work where any static or conventional background ceased to exist and all parts interacted as if galvanized into a network of forces. The viewer's perceptual process had to integrate the pictorial incidents actively, the far-flung extremes of scale, color and focus and, in Smith's sculptures, the great disparities when seen from different viewpoints. This meant that they had a "life" beyond what was contained in any one aspect. The dynamic encounter between the work and its audience became a hallmark of Abstract Expressionism.

National recognition increased during the 1950s. The role of dealers, critics and institutions such as the Museum of Modern Art, New York, in this development encouraged the theory that the movement was promoted at home and abroad as a weapon of Cold War ideology to stress the USA's superior freedom of expression. While the claim may be just, the artists themselves were not actively responsible. In fact several challenged such control by avoiding contact with the art establishment or taking their work to conclusions that almost defied critical commentary, such as the progression toward hypnotic monochrome painting by Reinhardt and Rothko in the 1960s.

While Abstract Expressionism's intensity depended partly on its very stylistic terseness, as in Newman's work, or singularity, as in Pollock's, its latter phases tended to pivot around a search to avoid defined limits or to extract the greatest range of meanings from a strictly limited idiom. The notion of working in series allowed nuances and variations to register most forcefully against a fairly constant visual syntax: Newman's group of 14 paintings, *Stations of the Cross* (1958–66), or Smith's *Cubi* series (1961–5) shows a creative impulse transcending the parameters of a single act. Themes and images from the 1940s also returned on a grandiose scale. Thus Gottlieb's *Bursts* (which he painted from 1957) refashioned pictograph symbols into newfound explosive gestures and calmer fields of color. It was Pollock's last period, however, that encapsulated the movement's overall dilemma. At best he summoned earlier mythic imagery, through methods such as black paint soaked into bare canvas in the remarkable, nightmarish compositions of 1951 and 1952. More often the sheer fusion of audacity and control attained in the drip paintings preempted further innovation, and Pollock's death in 1956 reinforced suspicions that a vanguard was now in decline.

In this later phase a community of younger artists emerged to adopt the tenets of spontaneity, improvisation and the importance of process. They included the painters Helen Frankenthaler and Joan Mitchell, poet Frank O'Hara (1926–66) and the sculptors associated with assemblage. However,

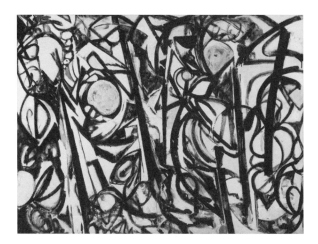

ABSTRACT EXPRESSIONISM. *Gothic Landscape* by Lee Krasner, oil on canvas, 1.77 × 2.39 m, 1961. © 2010 THE POLLOCK-KRASNER FOUNDATION/ARTISTS RIGHTS SOCIETY, NY/TATE GALLERY, LONDON/ART RESOURCE, NY

they replaced the basic urgency and existential vision of their models with a more lyrical and relatively decorative stance (that could indeed suggest a feminist revision of "masculine" premises), characterized for example by Frankenthaler's *Mountains and Sea* (1952; artist's col., on loan to Washington, DC, N.G.A.). By then Abstract Expressionism had nonetheless transformed the fundamentals of painting and sculpture in the mid-20th century, and its influence in terms of style and aesthetics extended over a vast spectrum of subsequent art.

[*See also* Action painting *and* Color field painting.]

BIBLIOGRAPHY

C. Greenberg: *Art and Culture* (Boston, 1961)

H. Rosenberg: *The Tradition of the New* (New York, 1961)

Artforum, iv/1 (1965) [issue ded. to Abstract Expressionism]

M. Tuchman, ed.: *New York School* (Greenwich, NY, 1965)

B. Rose: *Readings in American Art since 1900* (New York, 1968)

W. Rubin: *Dada and Surrealist Art* (London, 1969), pp. 342–410

I. Sandler: *The Triumph of American Painting: A History of Abstract Expressionism* (New York, 1970)

D. Ashton: *The Life and Times of the New York School* (Bath, 1972)

S. Hunter: *American Art of the Twentieth Century* (New York, 1972)

C. Harrison: "Abstract Expressionism," *Concepts of Modern Art* (London, 1974/1988, ed. N. Stangos), pp. 169–211

W. Andersen: *American Sculpture in Process: 1930–1970* (Boston, MA, 1975)

R. Rosenblum: *Modern Painting and the Northern Romantic Tradition* (London, 1975)

K. McShine, ed.: *The Natural Paradise* (New York, 1976)

J. Wechsler: *Surrealism and American Painting* (New Brunswick, 1977)

E. Carmen Jr.: *The Subjects of the Artist* (Washington, DC, 1978)

R. Hobbs and G. Levin: *Abstract Expressionism, the Formative Years* (New York, 1978)

I. Sandler: *The New York School* (New York, 1978)

B. Rose: *American Painting* (London, 1980)

A. Cox: *Art-as-politics: The Abstract Expressionist Avant-garde and Society* (Ann Arbor, 1982)

S. Guilbaut: *How New York Stole the Idea of Modern Art* (Chicago, 1983)

W. Seitz: *Abstract Expressionist Painting in America* (Cambridge, MA, 1983)

M. Baigell: *A Concise History of American Painting and Sculpture* (New York, 1984)

P. Turner, ed.: *American Images: Photography, 1945–80* (London, 1985)

M. Auping, ed.: *Abstract Expressionism: The Critical Developments* (New York, 1987)

D. Shapiro and C. Shapiro, eds: *Abstract Expressionism: A Critical Record* (Cambridge, 1989)

D. Anfam: *Abstract Expressionism* (London, 1990)

C. Ross: *Abstract Expressionism: Creators and Critics* (New York, 1990)

S. Polcari: *Abstract Expressionism and the Modern Experience*, (Cambridge, 1991)

Abstract Expressionism: Works on Paper: Selections from the Metropolitan Museum of Art (exh. cat. by L. M. Messinger, Met Mus. A. and High Mus. A, 1992; publ. New York, 1992)

D. Thistlewood, ed.: *American Abstract Expressionism* (Liverpool, 1993)

E. DeKooning: *The Spirit of Abstract Expressionism: Selected Writings* (New York, 1994)

F. S. Puniello and H. R. Rusak: *The Abstract Expressionist Women Painters: An Annotated Bibliography: Elaine de Kooning, Helen Frankenthaler, Grace Hartigan, Lee Krasner, Joan Mitchell, Ethel Schwabacher* (Lanham, MD, 1996)

The San Francisco School of Abstract Expressionism (exh. cat. by S. Landauer, Laguna Art Mus., Laguna Beach, CA; publ. Berkeley, 1996)

C. Cernuschi: *"Not an Illustration but the Equivalent": A Cognitive Approach to Abstract Expressionism* (Madison, NJ, 1997)

A. E. Gibson: *Abstract Expressionism: Other Politics* (New Haven, CT, 1997)

F. Frasina, ed.: *Pollock and After: The Critical Debate* (London and New York, 2000)

M. Herskovic, ed.: *New York School: Abstract Expressionists: Artists Choice by Artists: A Complete Documentation of the New York Painting and Sculpture Annuals, 1851–1957* (Franklin Lakes, NJ, 2000)

D. Joselit: *American Art since 1945* (London and New York, 2003)

J. Perl: *New Art City* (New York, 2005)

E. G. Landau, ed.: *Reading Abstract Expressionism: Context and Critique* (New Haven and London, 2005)

J. Marter, ed.: *Abstract Expressionism: The International Context* (New Brunswick, NJ, 2007)

Action/Abstraction: Pollock, de Kooning, and American Art, 1840–1976 (exh. cat., ed. N. L. Kleeblatt. Jewish Mus, New York; publ. New Haven, CT, 2008)

I. Sandler: *Abstract Expressionism and the American Experience: A Reevaluation* (Lenox, MA, 2009)

David Anfam

Acconci, Vito

(*b* New York, 24 Jan 1940), poet, performance, video and installation artist and urban designer. Vito (Hannibal) Acconci worked for an MFA degree at the University of Iowa from 1962 to 1964. He initially devoted himself to poetry and writing that emphasized the physicality of the page and then began to produce visual work in real space in 1969. He worked as a performance artist from 1969 until 1974. His performance work addressed the social construction of subjectivity. A central work, *Seedbed* (1972; Sonnabend Gallery, New York), saw Acconci masturbate for six hours a day, hidden under a sloping gallery floor, involving visitors in the public expression of private fantasy. Between 1974 and 1979 he made a series of installations often using video and especially sound, mainly in gallery spaces, examining relations between subjectivity and public space. For *Where We Are Now* (*Who Are We Anyway*) (1976; Sonnabend Gal., New York), a long table in the gallery and recorded voices suggested a realm of public or communal debate, but the table extended out of the window over the street like a diving board,

countering idealism with the realities of city life. In the 1980s Acconci made sculptures and installations, many viewer activated, invoking basic architectural units and domestic space. *Instant House* (1980; La Jolla, CA, Mus. Contemp. A.) saw the four sides of a "house" pulled together, activated by a viewer on a swing: the inside, visible from the swing, was decorated with American flags and the outside with Russian flags, so that private and public symbols were at odds. The exhibition *Public Places* (1988; MOMA, New York) included several sculptures invoking architecture and models and maquettes of projects for indoor and outdoor public spaces. That inaugurated the continuing phase of his career as a designer of public projects in the collaborative enterprise, Acconci Studio. *Extra Spheres for Klapper Hall* (1993–5; Queens College, New York) inserted seven spherical units derived from an architectural detail of Klapper Hall into a campus plaza, providing spaces for various scales of interaction in that conventionally open public context. *Mur Island* (2003; Graz, Austria) is a pedestrian bridge spanning the river, at the center of which is a steel, shell-like structure providing for mixed public uses (including performance space and cafe).

BIBLIOGRAPHY

Vito Acconci: A Retrospective, 1969–1980 (exh. cat. by J. R. Kirshner, Chicago, IL, Mus. Contemp. A., 1980)

Vito Acconci: Domestic Trappings (exh. cat. by R. J. Onorato, La Jolla, CA, Mus. Contemp. A., 1987)

Vito Acconci: Public Places (exh. cat. by Linda Shearer, MOMA, New York, 1988)

K. Linker: *Vito Acconci* (Rizzoli, 1994)

Vito Acconci: Writings, Works, Projects (ed. Gloria Moure, Poligrafa, 2001)

F. Ward, M. C. Taylor and J. Bloomer: *Vito Acconci* (Phaidon, 2002)

Frazer Ward

Action painting

Term applied to the work of Abstract Expressionists such as Jackson Pollock and Willem de Kooning and,

by extension, to the art of their followers at home and abroad during the 1950s. An alternative but slightly more general term is gestural painting; the other division within Abstract Expressionism was color field painting.

The critic Harold Rosenberg defined action painting in an article, "The American Action Painters" (1952), where he wrote: "At a certain moment the canvas began to appear to one American painter after another as an arena in which to act. . . . What was to go on canvas was not a picture but an event." This proposition drew heavily, and perhaps crudely, upon ideas then current in intellectual circles, especially in the wake of Jean-Paul Sartre's essay *L'Existentialisme est un humanisme* (Paris, 1946; Eng. trans., 1948), which claimed that "there is no reality except in action." In the 1940s Herbert Ferber, Barnett Newman, and others had already characterized their creative process in similar terms; Rosenberg was probably also inspired by photographs of Pollock at work (rather than the actual paintings) that emphasized his apparent psychological freedom and physical engagement with materials. "Action painting" became a common critical term to describe styles marked by impulsive brushwork, visible pentiments and unstable or energetic composition, which seemed to express the state of consciousness held by the artist in the heat of creation. Action painting thereby shared the spontaneity of automatism. Although this implicit, direct synthesis of art and consciousness is questionable, the spontaneous methods associated with the concept were paralleled in European movements such as Tachism and Art informel.

[*See also* Abstract Expressionism.]

BIBLIOGRAPHY

H. Rosenberg: "The American Action Painters," *ARTnews*, li/8 (1952), pp. 22–3, 48–50

H. Rosenberg: "The Concept of Action in Painting," *New Yorker*, xliv (25 May 1968), pp. 116–28

F. Orton: "Action, Revolution and Painting," *Oxford A. J.*, xiv/2 (1991), pp. 3–17

Action Painting (exh. cat., Basle, Fondation Beyeler, 2008) [Ger. and Eng. editions]

Action/Abstraction: Pollock, de Kooning, and American Art, 1940–1976 (exh. cat., ed. M. Berger; New York, Jew. Mus., 2009)

David Anfam

Adams, Adeline

(*b* Boston, MA, 24 Oct 1859; *d* Brooklyn, NY, 1 July 1948), critic and author. Adams [née Adeline Valentine Pond] was a vocal proponent of American sculpture during the last decades of civic sculpture's golden age. She expressed her views on the state of the field in two significant publications, *The Spirit of American Sculpture* (1923; reissued in 1929) and a chapter in the 1930 edition of Lorado Taft's *History of American Sculpture*, as well as in regular contributions to the *American Magazine of Art*.

Adams was an artist herself, though writing claimed her full attention. While she was in Paris in 1887, she posed for the sculptor Herbert Adams, whom she married two years later. The resulting marble bust (1889; New York, Hisp. Soc. America) was exhibited at the 1893 Chicago World's Fair, an exposition that Adams hailed for fostering a new ideal of collaboration between architects and sculptors. Adams praised the role that sculpture played in public life and promoted figurative work modeled in the French academic tradition. She admired artists like Daniel Chester French, John Quincy Adams Ward and Augustus Saint-Gaudens, whose sculpture she believed embodied the moral spirit and values of the country. Adams authored studies of French and Ward, as well as of the American Impressionist painter Childe Hassam.

Adams's criticism contributed to the success of women sculptors in the early 20th century. She singled out the work of Laura Gardin Fraser, Evelyn Beatrice Longman, Janet Scudder, Bessie Potter Vonnoh, Abastenia Saint Leger Eberle (1878–1942) and Anna Hyatt Huntington, writing, perhaps optimistically, that women of the 1920s competed on equal footing with their male peers. She also wrote

passionately about memorials, expressing the urgent need for rural and urban communities across the country to eschew mass-produced soldier statues for the more inspired though still conservative designs by professional sculptors. On the whole, Adams did not support modern developments in art, and felt that in the intimate emotional context of commemorative art, the persistence of naturalistic trends was especially appropriate.

[See also Adams, Herbert.]

WRITINGS
John Quincy Adams Ward: An Appreciation (New York, 1912)
"An Exhibition of American Sculpture," *Bull. Met.*, xiii/3 (March 1918), pp. 68–71
The Spirit of American Sculpture (New York, 1923/R 1929)
Daniel Chester French, Sculptor (New York, 1932)

BIBLIOGRAPHY
D. Robbins: "Statues to Sculpture: From the Nineties to the Thirties," *200 Years of American Sculpture* (exh. cat. by T. Armstrong and others, New York, Whitney, 1976)

Jennifer Wingate

Adams, Ansel

(*b* San Francisco, CA, 20 Feb 1902; *d* Carmel, CA, 22 April 1984), photographer. Ansel (Easton) Adams trained as a musician and supported himself by teaching the piano until 1930. He became involved with photography in 1916 when his parents presented him with a Kodak Box Brownie camera during a summer vacation in Yosemite National Park. In 1917–18 he worked part-time in a photo-finishing business. From 1920 to 1927 he served as custodian of the LeConte Memorial in Yosemite, the Sierra Club's headquarters. His duties included leading weekly expeditions through the valley and rims, during which he continued to photograph the landscape. He considered his snapshots of Yosemite and the Sierra Nevada Mountains, taken during the early 1920s, to be a visual diary, the work of an ardent hobbyist. By 1923 he used a 6½×8½-inch Korona view camera on his pack trips, and in 1927

he spent an afternoon making one of his most famous images, *Monolith, the Face of Half Dome, Yosemite National Park* (Chicago, IL, A. Inst.). Adams planned his photograph, waited for the exact sunlight he desired and used a red filter to darken the sky against the monumental cliff. He later referred to this image as his "first true visualization" of the subject, not as it appeared "in reality but how it *felt* to me and how it must appear in the finished print" (*Ansel Adams: An Autobiography*, p. 76).

With the assistance of Albert Bender (1866–1941), one of San Francisco's foremost patrons of the arts, Adams published his first portfolio, *Parmelian Prints of the High Sierras* (San Francisco, 1927), and his first illustrated book, *Taos pueblo* (San Francisco, 1930). In 1930 he met Paul Strand and decided to devote himself to photography. Strand's photographic vision made Adams realize the potential of the medium as an expressive art form. Adams abandoned textured photographic paper, his last vestige of Pictorialism, for glossy stock and experienced a liberation in his creative direction as well. In 1932 he and several San Francisco Bay Area photographers formed Group f.64 to promote "straight" unmanipulated photography.

Adams visited Alfred Stieglitz at his New York gallery, An American Place, in 1933 and exhibited there in 1936, his contact with Stieglitz giving him more confidence in the medium. He wrote his first technical manual, *Making a Photograph* (London and New York, 1935), and subsequently published several others, along with collections of photographs.

Adams used all types of camera and experimented constantly with new techniques. He developed a "zone system," which divided the gradations of light into ten zones from black to white, allowing the photographer, with the help of an exposure meter, to correlate areas of different luminosity in the subject with the approximate value of grey in the final print. Adams's technical mastery, his complete control of the final image, was a necessary stage of development in achieving his full creative vision. His photographs transcend the simple

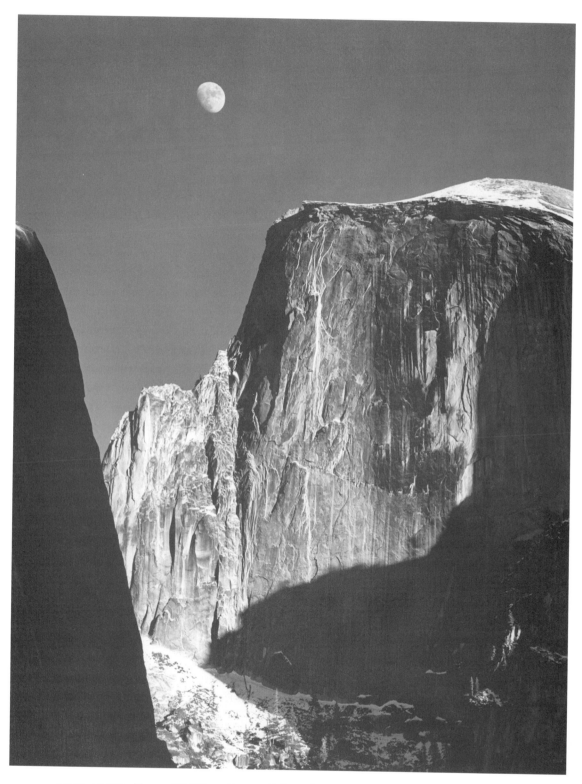

ANSEL ADAMS. *Moon and Half Dome, Yosemite Valley, California*, gelatin silver print, 310 × 238 mm, 1960.

description of objects and landscape: they depict transient aspects of light, atmosphere and natural phenomena (see *Surf Sequence No. 5, 1940*).

In 1940 Adams helped to establish the Department of Photography at the Museum of Modern Art in New York and co-curated its first exhibition. He also established the Department of Photography at the California School of Fine Arts (now the San Francisco Art Institute) in 1946. He moved to Carmel, CA, in 1961 and was one of the founders of the Friends of Photography in 1966.

WRITINGS

with V. Adams: *Illustrated Guide to Yosemite Valley* (San Francisco, 1946, rev. 2/1963) with E. Land, D. McAlpin and J. Holmes: *Ansel Adams: Singular Images* (New York, 1974)

Ansel Adams: An Autobiography (Boston, 1985)

M. Alinder and A. Stillman, eds.: *Letters 1916–1984* (Boston, MA, 2001)

PHOTOGRAPHIC PUBLICATIONS

Sierra Nevada: The John Muir Trail (Berkeley, CA, 1938)

Born Free and Equal: Photographs of the Loyal Japanese-Americans at Manzanar Relocation Center, Inyo County, California (New York, 1944)

Camera and Lens (New York, 1948)

The Negative (New York, 1948)

My Camera in Yosemite Valley (Yosemite, CA, 1949)

My Camera in the National Parks (Yosemite, CA, 1950)

The Print (New York, 1950)

Natural Light Photography (New York, 1952)

Artificial-Light Photography (New York, 1956)

These we Inherit (San Francisco, 1962)

Polaroid Land Photography Manual (New York, 1963, rev. 1978)

Examples: The Making of 40 Photographs (Boston, 1983)

BIBLIOGRAPHY

J. Muir: *Yosemite and the High Sierra* (Boston, 1948)

M. Austin: *The Land of Little Rain* (Boston, 1950)

N. Newhall: *Death Valley* (Redwood City, CA, 1954)

N. Newhall: *Mission San Xavier del Bac* (Redwood City, CA, 1954)

N. Newhall: *The Pageant of History in Northern California* (San Francisco, 1954)

N. Newhall, ed.: *Yosemite Valley* (San Francisco, 1959)

E. Corle: *Death Valley and the Creek Called Furnace* (Los Angeles, 1962)

N. Newhall: *The Eloquent Light*, i of *Ansel Adams* (San Francisco, 1963) [only vol.]

E. Joesting: *An Introduction to Hawaii* (Redwood City, CA, 1964)

N. Newhall: *Fiat Lux: The University of California* (New York, 1967)

N. Newhall: *The Tetons and the Yellowstone* (Redwood City, CA, 1970)

L. de Cock, ed.: *Ansel Adams* (New York, 1972)

W. Stegner: *Ansel Adams: Images, 1923–1974* (Boston, 1974)

L. C. Powell: *Photographs of the Southwest* (Boston, 1976)

J. Szarkowski: *The Portfolios of Ansel Adams* (Boston, 1977)

J. Alinder and M. S. Alinder: *Ansel Adams: A San Francisco Heritage* (San Francisco, 1978)

P. Brooks: *Yosemite and the Range of Light* (Boston, 1979)

J. Alinder: *The Unknown Ansel Adams* (Carmel, 1982)

A. Gray: *Ansel Adams: An American Place, 1936* (Tucson, 1982)

H. M. Callahan, ed.: *Ansel Adams in Color* (Boston and London, 1993)

J. Spaulding: *Ansel Adams and the American Landscape* (Berkeley, 1995)

M. Street: *Ansel Adams: A Biography* (New York, 1996)

In Praise of Nature: Ansel Adams and Photographers of the American West (exh. cat. by A. L. Nyerges, Dayton, OH, A. Inst., 1999)

D. Peeler: *The Illuminating Mind in American Photography: Stieglitz, Strand, Weston, Adams* (Rochester, NY, 2001)

J. Szarkowski: *Ansel Adams at 100* (Boston, MA, 2001)

Reinventing the West: The Photographs of Ansel Adams and Robert Adams (exh. cat., Andover, MA, Phillips Acad., Addison Gal., 2001)

A. Hammond: *Ansel Adams: Divine Performance* (New Haven, 2002)

Ansel Adams (exh. cat., by J. Verhulst, A Coruña, Fundación Barrié de la Maza, 2003)

Georgia O'Keeffe and Ansel Adams: Natural Affinities (exh. cat. by A. Hammond, Santa Fe, NM, Georgia O'Keeffe Museum, 2008)

Richard Lorenz

Adams, Clinton

(*b* Glendale, CA, 11 Dec 1918; *d* Albuquerque, NM, 13 May 2002), painter, printmaker, art historian, writer and teacher. His appointment to the art faculty of the University of California, Los Angeles, in 1942 was interrupted by military service, and it was not until 1946 that he resumed his career as a teacher of the practice and theory of art. This took him to

the universities of Kentucky (Lexington), Florida (Gainesville) and finally New Mexico (Albuquerque), where he served as dean (1961–76). Despite academic demands, Adams always found time to paint and showed his work in over 50 solo exhibitions. Equally at home in oil, acrylic, watercolor and egg tempera, he was initially inspired by the abstracted cityscapes of Stuart Davis. Later he absorbed the lessons of Henri Matisse (1869–1954), achieving particularly radiant paintings during the 1980s. In 1993 he was elected an Academician by the National Academy of Design.

In 1948, at Stanton Macdonald-Wright's suggestion, Adams began to make lithographs with the Los Angeles printer, Lynton Kistler. Early in his use of color, he exhibited at the *1st International Biennial of Color Lithography* (1950) in Cincinnati, OH. During 1960 Adams helped June Wayne set up the Tamarind Lithography Workshop, which transformed printmaking in the USA. When the workshop moved to Albuquerque as the Tamarind Institute, Adams became its director (1970–85).

During the 1970s Adams entered an intensive period as a writer, founding the exemplary research journal *The Tamarind Papers* in 1974, and editing and contributing to it until 1996. The author of more than 100 articles about lithography, he co-authored the "bible" of the process in 1971 and went on to write an outstanding history (1983) of lithography in America. In 1985, Adams received the Governor's Award for "Outstanding Contributions to the Arts of New Mexico." In fact, through his many activities, his impact on the knowledge and practice of lithography has been worldwide.

[*See also* Wayne, June.]

WRITINGS

with G. Antreasian: *The Tamarind Book of Lithography: Art and Techniques* (New York, 1971)

regular contributions to *Tamarind Pap.* (1974–95)

Fritz Scholder Lithographs (Boston, 1975)

"The Prints of Andrew Dasburg: A Complete Catalogue," *Tamarind Pap.*, iv (1980–81), pp. 18–25

American Lithographers, 1900–1960: The Artists and their Printers (Albuquerque, 1983)

"Adolf Dehn: The Lithographs," *The Prints of Adolf Dehn: A Catalogue Raisonné* (St Paul, 1987), pp. 26–42

"The Nature of Lithography," *Lasting Impressions: Lithography as Art*, ed. P. Gilmour (Canberra, London, and Philadelphia, 1988), pp. 24–41

Printmaking in New Mexico, 1880–1890 (Albuquerque, 1991)

Crayonstone: The Life and Work of Bolton Coit Brown, with a Catalogue of his Lithographs (Albuquerque, 1993)

with eds. L. Tyler and P. Walch: *Life and Art in Los Angeles, 1934–1954* (Albuquerque, 2002)

BIBLIOGRAPHY

Tamarind: Homage to Lithography (exh. cat. by V. Allen, New York, MOMA, 1969), pp. 10, 13, 27, 60

Clinton Adams (exh. cat. by V. D. Coke, Albuquerque, U. NM, A. Mus., 1971)

J. Watrous: *A Century of American Printmaking, 1880–1980* (Madison, WI, 1984)

Clinton Adams: Paintings and Watercolours, 1945–1987 (exh. cat. by V. D. Coke and P. Walch, Albuquerque, U. NM, A. Mus., 1987)

P. Gilmour: "Lithographic Collaboration: The Hand, the Head, the Heart," *Lasting Impressions: Lithography as Art*, ed. P. Gilmour (Canberra, London, and Philadelphia, 1988), pp. 264, 344–5, 347–9, 358

Spectrum of Innovation: Color in American Printmaking, 1890–1960 (exh. cat. by D. Acton, Worcester, MA, A. Mus., 1990–91), pp. 33–9, 246–8]

Pat Gilmour

Adams, Herbert

(*b* West Concord, VT, 28 Jan 1858; *d* New York, NY, 21 May 1945), sculptor. Raised in Fitchburg, MA, he trained at the Institute of Technology in Worcester (subsequently Worcester Polytechnic Institute), the Massachusetts Normal Art School in Boston (now the Massachusetts College of Art and Design) and the Maryland Institute of Art in Baltimore, following an artistic path that mirrored that of many of his contemporaries. Arriving in Paris around 1885, he found a mentor in Antonin Mercié (1845–1916), whose accomplished bronzes evoke Italian Renaissance prototypes. He briefly established his own studio in Paris in 1888, and from 1890 to 1895 he taught at the Pratt Institute in Brooklyn.

Adams won important commissions for public monuments in Boston (clergyman *William Ellery Channing*, 1904) and New York (*William Cullen Bryant*, 1911). The latter, located on the grounds of the New York Public Library, features a dignified seated portrait of the poet, editor and advocate of Central Park and the Metropolitan Museum; architect Thomas Hastings designed the elaborate canopy that dwarfs the sculpture.

While most contemporary sculptors achieved success with their Beaux-Arts monuments, Lorado Taft dismissed Adams's public works as commonplace. Instead, Adams excelled in the genre of the female bust, some of which are portraits (notably that of his future wife, author, and art critic *Adeline Valentine*, 1889; New York, Hisp. Soc.), while others are idealizations (*Primavera*, 1890–93; Washington, DC, Corcoran Gal. A., and *La Jeunesse*, c. 1899; New York, Met.). These works, which Taft pronounced both rare and exquisite, fuse highly naturalistic physiognomies with richly modeled, Renaissance-inspired costumes and coiffures. Prized for their aesthetic refinement, several are polychromed terracottas or mixed media sculpture: *La Jeunesse* combines marble, applewood and paste jewels, emulating a contemporary French practice. Beginning in the mid-1890s, Adams summered in the art colony at Cornish, NH, with fellow artists Thomas Wilmer Dewing and Augustus Saint-Gaudens.

Adams skillfully navigated the competitive New York art world: a member of the Society of American Artists, the National Arts Commission, the American Academy of Arts and Letters, the Metropolitan Museum's advisory council on sculpture and a founding member of the National Sculpture Society, he was appointed Academician of the National Academy of Design in 1899 and served as its president from 1917–20.

[*See also* Adams, Adeline.]

BIBLIOGRAPHY

L. Taft: *The History of American Sculpture* (New York, 1903, rev. 1930), pp. 386–93

W. Craven: *Sculpture in America* (Newark, 1968, rev. 1984), pp. 434–7

T. Tolles, ed.: *American Sculpture in the Metropolitan Museum of Art: Volume I. A Catalogue of Works by Artists Born before 1865* (New York, 1991), pp. 360–64

Janet A. Headley

Adams, Mark

(*b* Fort Plain, NY, 27 Oct 1925; *d* San Francisco, 2006), tapestry artist, painter and stained-glass designer. He studied painting at Syracuse University and with Hans Hofmann in New York, where he was influenced by the medieval tapestries in the Cloisters and also by the work of Henri Matisse (1869–1954). In the 1950s Adams was apprenticed to the influential French tapestry designer Jean Lurçat (1892–1966), from whom he learned the bold colors and clear imagery that characterize his work. He also studied at the Ecole Nationale d'Art Décoratif in Aubusson before beginning to use a series of workshops, notably that of Marguerite and Paul Avignon, who wove his first nationally acclaimed tapestry, *Phoenix and the Golden Gate* (1957). *Flight of Angels* (1962) was exhibited at the first Biennale Internationale de la Tapisserie in Lausanne. In 1976 his cartoon of *California Poppies* (San Francisco, CA Pal. Legion of Honor) was woven for the *Five Centuries of Tapestry* exhibition at the California Palace of the Legion of Honor, San Francisco, as a demonstration piece. Later tapestries, for example *White Block* (1977) and *Sunset with Palms* (1979), were woven by the San Francisco Tapestry Workshop, with which he was associated. Public commissions included a series of panels depicting garden scenes for the San Francisco International Airport (1981–3) as well as designs for stained-glass windows, notably two for the Temple Emanu-El in San Francisco (*Fire* and *Water*, 1971–4). He painted a self-portrait in 1982 (artist's col., see Johnson, Mills and Price, p. 25).

BIBLIOGRAPHY

Mark Adams: An Exhibition of Tapestries, Paintings, Stained Glass Windows and Architectural Designs (exh. cat. by W. H. Elsner, San Francisco, CA Pal. Legion of Honor, 1970)

Mark Adams (exh. cat. by H. T. Hopkins, San Francisco, CA, John Berggruen Gal., 1980)

R. F. Johnson, P. Mills and L. Price: *Mark Adams* (San Francisco, 1985)

S. Steinberg: "Mark Adams: Ordinary Elevated to Extraordinary," *SW A.*, xiv/11 (April 1985), pp. 56–9

Mark Adams: A Way with Color (exh. cat. by J. Price, San Francisco, CA, John Berggruen Gallery, 1995)

Courtney Ann Shaw

Adams, Robert

(*b* Orange, NJ, 8 May 1937), photographer. After teaching English literature for several years, Adams turned to photography in the late 1960s, studying with Minor White. In his black-and-white photographs of the American West, such as his series *From the Missouri West* (1980), he emphasized man's presence in nature and the tension between the beauty of the landscape and man's effect upon it. His landscapes include such features as telephone poles and wires, mountains edged by highway guardrails, parking lots and housing complexes. In 1975

ROBERT ADAMS. *Colorado Springs, Colorado*, gelatin silver print, 1970. © ROBERT ADAMS, COURTESY FRAENKEL GALLERY, SAN FRANCISCO AND MATTHEW MARKS GALLERY, NEW YORK

Adams took part in the group exhibition *New Topographics: Photographs of a Man-altered Landscape*. As a photographer and an articulate writer on photography, he has published *Summer Nights* (1985) and important essays on 19th- and 20th-century photography.

[*See also* New Topographics.]

PHOTOGRAPHIC PUBLICATIONS
Cottonwoods; Photographs (Washington, DC, 1994)

Notes for Friends: Along Colorado Roads (Boulder, CO, 1999)

Along Some Rivers: Photographs and Conversations, with foreword by R. Woodward (New York, 2006)

BIBLIOGRAPHY
Mirrors and Windows: American Photography since 1960 (exh. cat., ed. J. Szarkowski; New York, MOMA, 1978)

J. Z. Grover: "The Sublime and the Anachronistic: Robert Adams' American Landscape," *After image* (1981), pp. 6–7

P. Wollheim: "The Aesthetics of Accommodation: Robert Adams," *Vanguard*, xi/7 (Sept 1982), pp. 14–17

Robert. Adams: To Make it Home: Photographs of the American West (exh. cat., Philadelphia, PA, Mus. A., 1989)

California Views by Robert Adams of the Los Angeles Basin, 1978–1983 (exh. cat. by R. Hass, San Francisco, CA, Fraenkel Gallery and New York, Matthew Marks Gallery, 2000)

T. Weski: "Robert Adams," *Camera Austria*, lxxxix (2005), pp. 9–21

C. Mallinson: "Robert Adams: Reformed Formalist," *X-TRA: Contemp. A. Q.*, ix/2 (Winter 2006), pp. 28–35

Mary Christian

AdamsMorioka

Graphic design firm. Founded in 1993 by Sean Adams and Noreen Morioka (*b* Sunnyvale, CA, 6 July 1965). Often described as simple and pure, AdamsMorioka design is distinguished by its clear, pragmatic approach, often joined with optimistic bright color palettes. Morioka studied at the California Institute of the Arts (CalArts) program in 1984 under Lorraine Wild and Lou Danziger. After graduating in 1987 with a BFA in graphic design, she joined Gensler and Associates in San Francisco as a graphic designer. A year later she traveled to Tokyo to work

for Landor and Associates. While there she continued to build on corporate identity skills taught to her by Lou Danziger and was exposed to Landor's rigorous corporate identity system development. Upon returning to the United States in 1991, she joined the design studio of April Greiman. There she collaborated with former CalArts classmate Sean Adams, also working for April Greiman at the time.

In 1993 Adams and Morioka joined forces and launched their own design firm, AdamsMorioka. Based in Beverly Hills, CA, they quickly gained national and international attention. One of their first clients, the Pacific Design Center in Los Angeles, proved their talent, not just as designers, but also as business people. AdamsMorioka were asked to create a new identity for the Pacific Design Center, a furnishings showcase designed by architect Cesar Pelli that was struggling to keep tenants and draw visitors. By understanding the business and growth needs, AdamsMorioka created a cohesive, refreshed identity system for Pacific Design Center, while recommending strategic business changes that could create overall growth for the Center, including events for the public and enhanced environmental graphics. The re-branding of Pacific Design Center created visual continuity while meeting business and growth goals. Their reputation and success drew enough attention that in 1995 they receive an invitation to become fellows of the International Design Conference at Aspen. In 1997 AdamsMorioka was mentioned in ID40, *ID* magazine's annual list of the 40 most influential designers in the world. Their style is conducive to the film and television industry, AdamsMorioka has designed identity systems for The Walt Disney Company, VH1, Nickelodeon, TNN, AMC, ABC, MTV and Sundance International Film Festival. These identities, while all unique, all have interchangeable elements and a cohesive system that at once creates a brand and provides flexibility. Other clients include Gap, Old Navy, Adobe, Appleton Papers, CalArts, UCLA and architectural firm Frank Gehry and Associates.

In 2000 the San Francisco Museum of Modern Art exhibited a solo show of their work. AdamsMorioka design work is included in the permanent collections of The Design Museum in London, Library of Congress, New York's Metropolitan Museum of Art, San Francisco, Museum of Modern Art and the University of California, Los Angeles.

WRITINGS

Logo Design Workbook: A Hands-on Guide to Creating Logos (Gloucester, MA, 2004)

BIBLIOGRAPHY

K. Coupland: "AdamsMorioka Double Vision," *Graphis*, lii/305 (Sept–Oct 1996), pp. 72–9, 126–7, 142–3

M. English: *Designing Identity: Graphic Design as a Business Strategy* (Gloucester, MA, 2000)

Pash: *Inspirability: 40 Top Designers Speak Out about What Inspires* (Cincinnati, 2005)

Amy Fox

Adena Mound

Prehistoric site. It is the largest of several mounds along the Scioto River north of Chillicothe, OH. Although it is the eponym of the Early Woodland-period Adena culture of the Upper Ohio River Valley (*c*. 1000–*c*. 100 BC), the date of the mound itself is unknown. No stylized engraved palettes, characteristic of Adena culture, were found. The mound comprises a penannular earthwork built in several stages to a height of 8 m. A circular structure with sloping sides and double-set wooden post walls was constructed on a floor from which numerous fires had been cleared. Next, burials were placed centrally in rectangular tombs dug into the floor of the structure; a low mound was heaped over them; and the funerary structure was burned. The entire area was then covered by layers of black sand incorporating several new cremations and burials outside the central tombs. For some considerable time after this, additional cremated human remains and extended burials were placed in further layers of sand and gravel. The cremation and inhumation burials, and

occasionally clay-covered bundles of bones, were accompanied by annular and penannular copper bracelets and rings; cut river mussel shell animal effigies; cut mica headbands; expanded center gorgets, ground, polished and drilled, of schist and chlorite; and a human effigy carved in the round on an Ohio pipestone tube.

BIBLIOGRAPHY

W. C. Mills: "Excavation of the Adena Mound," *OH State Archaeol. Hist. Q.*, x (1902), pp. 451–79

W. S. Webb and C. E. Snow: *The Adena People*, University of Kentucky Reports in Anthropology and Archaeology, vi (Lexington, KY, 1945)

W. S. Webb and R. S. Baby: *The Adena People 2* (Columbus, OH, 1957)

D. S. Brose, J. A. Brown, and D. W. Penney: *Ancient Art of the American Woodland Indians* (New York, 1985)

K. B. Farnsworth and T. E. Emerson: *Early Woodland Archaeology*, Center for American Archaeology, Kampsville Seminars in Archaeology, ii (Kampsville, IL, 1986)

M. Korp: *The Sacred Geography of the American Mound Builders* (Lewiston, NY, 1990)

David S. Brose

Adler, Dankmar

(*b* Stadtlengsfeld, nr Eisenach, 3 July 1844; *d* Chicago, 16 April 1900), architect and engineer of German birth. His family moved to the USA in 1854, and he trained in Detroit in the architectural offices of John Schaefer, E. Willard Smith and others. After his family moved from Detroit to Chicago, Adler worked under a German émigré architect Augustus Bauer (1827–94) and gained valuable training in an engineering company during his military service in the Civil War. After the war, he worked with O. S. Kinney (*d* 1868), and later Ashley Kinney, building educational and civic structures in the Midwest. Adler's ability soon brought him to the attention of an established practitioner, Edward Burling (1818–92), who needed assistance in the aftermath of the Chicago fire of 1871. Burling and Adler's many buildings include the First National Bank (1871) and Mercantile (1873) buildings and the Methodist

Church Block (1872), all designed in Chicago by Adler and all demolished. In 1879 he and Burling parted.

Adler's first independent commission was the Central Music Hall (1879; destr. 1900), Chicago, which integrated an office-block, a multipurpose auditorium and shops, a successful formula that Adler later repeated. Other early commissions in Chicago were houses for John Borden (1880; destr. 1955) and Henry Leopold (1882; destr. before 1932) and a number of commercial buildings: the Borden Block (1881; destr. 1916), Jewelers' Building (1882), the Brunswick and Balke Factory (1882–91; destr. 1989) and the Crilly & Blair Complex (1881; destr. c. 1970). By 1881 Adler's employees included Louis Sullivan, as is evident from the style and placement of the ornament on the Borden Block. Adler made Sullivan a full partner in 1883, by which time the office was designing factories, stores, houses, office-blocks and especially theaters. The early success of Adler and Sullivan was due to Adler's planning and engineering innovations and his reputation as a careful builder and businessman of integrity. He could recognize and guide talent in others, and the firm also benefited from his many social connections. A founder of the Western Association of Architects, he led its merger into the American Institute of Architects, of which he was secretary in 1892.

Between 1879 and 1889 Adler executed many commissions for theaters and concert halls, ranging from remodelings to enormous multipurpose complexes. He was recognized as a leading expert in acoustics and served as acoustics consultant during the construction (1890–91) of Carnegie Hall, New York. Adler and Sullivan's records do not survive, and the contribution of the partners and their employees can only be inferred. For the Auditorium Building, Chicago (1886–9), Sullivan, Paul Mueller and Frank Lloyd Wright, who was employed as a draftsman, all contributed to the building complex, but the commission and the overall design were Adler's. Among the innovations Adler adapted for the Auditorium Building were caisson foundations,

huge trusses to support the rooms above the theater space and hydraulic machinery to raise and lower sections of the stage. The plan of the concert hall, with its excellent provision for sight and sound, evolved from early Adler designs; Sullivan was engaged on the ornamental decoration; and Mueller contributed to the engineering. The result was a true synthesis of acoustics, aesthetics and technical innovation, with color and ornament, science and technology harnessed in the service of art. Wright called it "the greatest room for music and opera in the world." Other theater commissions carried out by Adler and Sullivan include the Schiller Theater (1891–3; destr. 1961), Chicago, which—like the Auditorium Theater—was part of a tall office building. Several influential early skyscrapers were also produced by the firm, notably the Wainwright Building, St Louis (1890–91), the Chicago Stock Exchange (1893; destr. 1971) and the Guaranty Building, Buffalo (1894–6).

The financial crash of 1893–4, a shift in architectural taste and irreconcilable aesthetic and economic

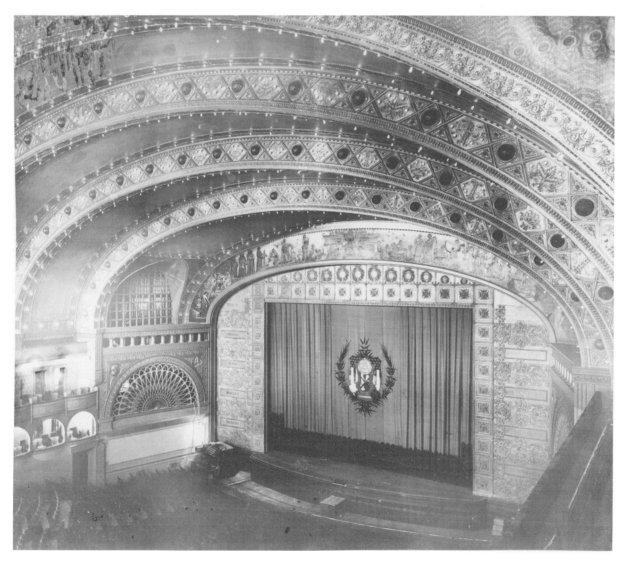

DANKMAR ADLER. Auditorium Building, Chicago, Illinois, 1887–9. Library of Congress Prints and Photographs Division

arguments between Adler and Sullivan led to the partnership being acrimoniously dissolved in 1895. That year Adler became a consultant for a company manufacturing lifts for new skyscrapers, mostly in New York. He left after six months, returning to architecture and to Chicago, taking his son Abraham (1876–1914) into partnership. Adler and Sullivan now became competitors—but not implacable enemies—in a shrinking market. Between 1896 and 1900 Adler's offices in Chicago and New York had fewer than a dozen commissions, whereas in 1886 the firm of Adler and Sullivan had 18 jobs in addition to the Auditorium. Of the edifices built after the split with Sullivan, Adler's Morgan Park Academy dormitories (1896; destr. c. 1970) for a college preparatory school and Isaiah Temple (1898), both in Chicago, were architecturally the most interesting. The temple contains many elements he had used in the Central Music Hall, but the overall style is more historically derived than any Adler and Sullivan designs.

Adler spent much of his later life writing and working successfully for state licensing of architects. He was particularly interested in two causes: recognition for architecture as a learned profession and the education of both the public and the practitioners on how to design for modern society. There were some unbuilt projects, but after his death the firm he left behind did not flourish. The work of this brilliant and conscientious architect and engineer was dominated by the idea of the building as a synthesis, in which "form and function are one" and in which "there must be throughout, from foundation to roof, in the arrangement of all the parts, in the design of every line, the imprint and all-pervading influence of one master mind." He solved practical problems creatively and literally put a firm foundation under the skyscraper and a solid skeleton under its skin. Adler opposed height limitations and slavish obedience to historical precedents, and he was unusual in his willingness to experiment with new materials and relatively untried structural and foundation techniques, as well as in the breadth of building type undertaken. With Sullivan he provided a model for the modern, multi-specialist architectural office, providing also a creative and productive milieu, in which some of the 20th century's leading architects began their careers.

[*See also* Skyscraper *and* Sullivan, Louis.]

UNPUBLISHED SOURCES

Chicago, IL, Newberry Lib., Dankmar Adler Archv [journals, letters, autobiography] Chicago, IL, Richard Nickel Cttee [architectural photographs and archv, 1972]

WRITINGS

"Foundations of the Auditorium Building," *Inland Architect & News Rec.*, xi (1888), pp. 31–2

"The Auditorium Tower," *Amer. Architect & Bldg News*, xxxi (1891), pp. 15–16

"Tall Office Buildings—Past and Future," *Engin. Mag.*, iii (1892), pp. 765–73

"Theater-Building for American Cities," *Engin. Mag.*, vii (1894), pp. 717–30; viii, pp. 814–29

"The Influence of Steel Construction and of Plate Glass upon the Development of Modern Style," *Inland Architect & News Rec.*, xxviii (1896), pp. 34–7

BIBLIOGRAPHY

M. Schuyler: "Architecture in Chicago: Adler & Sullivan," *Archit. Rec. Suppl.*, 3 (1895), pp. 3–48

L. Sullivan: *Autobiography of an Idea* (New York, 1924)

F. Lloyd Wright: *Genius and the Mobocracy* (New York, 1949)

C. Condit: *American Building Art: Nineteenth and Twentieth Century* (New York, 1961)

R. Elstein: *The Architectural Style of Dankmar Adler* (MA thesis, U. Chicago, 1963)

R. Baron: "Forgotten Facets of Dankmar Adler," *Inland Architect & News Rec.*, vii (1964), pp. 14–16

C. Condit: *The Chicago School of Architecture* (Chicago, 1964)

R. Elstein: "The Architecture of Dankmar Adler," *J. Soc. Archit. Historians*, xxvi (1967), pp. 242–9

J. Saltzstein: "Dankmar Adler: The Man, the Architect, the Author," *Wisconsin Architect*, xxxviii (1967): (July), pp. 15–19; (Sept), pp. 10–14; (Nov), pp. 16–19

N. Menocal: *Architecture as Nature: The Transcendentalist Idea of Louis Sullivan* (Madison, 1981) [with complete list of Adler's pubd writings, pp. 206–07]

J. W. Saltzstein: "The Autobiography and Letters of Dankmar Adler," *Inland Architect*, xxvii/5 (Sept–Oct 1983), pp. 16–27

C. Grimsley: *A Study of the Contributions of Dankmar Adler to the Theater Building Practices of the Late Nineteenth Century* (diss., Evanston, IL, Northwestern U., 1984)

L. Doumato: *Dankmar Adler, 1844–1900* (Monticello, IL, 1985)

R. Twombly: *Louis Sullivan: His Life and Work* (New York, 1986) [with full list of Adler & Sullivan commissions]

R. M. Geraniotis: "German Architectural Theory and Practice in Chicago, 1850–1900," *Winterthur Portfolio*, xxi (Winter 1986), pp. 293–306

D. G. Lowe: "Monument of an Age: Louis Sullivan and Dankmar Adler's Colossal Auditorium Building in Chicago," *American Craft*, xlviii (June–July 1988), pp. 40–47

C. Gregersen: *Dankmar Adler: His Theaters and Auditoriums* (Athens, OH, 1990)

J. Siry: "Chicago's Auditorium Building: Opera or Anarchism," *J. Soc. Archit. Hist.*, lvii (1998), pp. 128–59

D. V. Griffin: "Pilgrim Baptist Church," *Preservation*, lx/3 (May–June 2008), p. 82

Rochelle Berger Elstein

Aestheticism

Late 19th-century movement in the arts and literature characterized by the pursuit and veneration of beauty and the fostering of close relationships among the fine and applied arts. According to its major proponents, beauty was found in imaginative creations that harmonized colors, forms and patterns derived from Western and non-Western cultures as well as motifs from nature. Aestheticism gained momentum in England in the 1850s, achieved widespread popularity in England and the USA by the 1870s and declined by the 1890s.

Background, Origins and Early Phase. As a movement, Aestheticism originated in England beginning in the 1850s and consisted of two principal branches: a circle of painters and writers in Chelsea and Oxford who called for an autonomous art with no moral imperative and social utility and a group of reformers in South Kensington who established new approaches to design and its education and promoted the social value of art and its potential to improve industrial society.

Often conflated with Aestheticism, the term "art for art's sake" is usually attributed to the French philosopher Victor Cousin, who first used it in his lectures on *Le Vrai, le beau, et le bien* (1818, published 1836). The phrase, which calls for an art that serves its own ends rather than a moral, religious or ethical purpose, became a slogan during the Aesthetic Movement. In 1832, the French writer Théophile Gautier popularized this sentiment in his "Preface" to *Mademoiselle de Maupin*. Across the channel, the British poet A. H. Hallam in "On Some Characteristics of Modern Poetry" (1833) also praised art devoted solely to the evocation of beauty. The concept of art shared by these like-minded thinkers sought to counter the belief that art must serve a moral purpose, advanced by the British art critic and champion of the Pre-Raphaelites John Ruskin, among others. By the early 1860s, British painters Dante Gabriel Rossetti, Frederic Leighton and Albert Moore, as well as the expatriate American painter James Abbott McNeill Whistler, had initiated the canvases that have come to exemplify "art for art's sake" and the aesthetic style in painting: sensuous depictions of women, usually with natural motifs and decorative objects, subtle harmonies of tone that suggest the interplay of music and art and attention to surface pattern and framing inspired by Japanese prints (see color pl. 1:IV, 1). During the same decade, the principles of Aestheticism appeared in the art criticism, public writing and personal correspondence of key British supporters and proponents, including the art critics Walter Pater and Tom Taylor, the poet Algernon Charles Swinburne and the artist Simeon Solomon.

Following the earlier ideas of A. W. N. Pugin and Owen Jones, British designers including E. W. Godwin, Christopher Dresser and Bruce Talbert favored the embellishment of utilitarian objects and buildings with two-dimensional patterns based on geometric and natural forms. They derived inspiration from Persian, Moorish, Indian, Egyptian and Japanese sources, many drawn from Jones's *The Grammar of Ornament* (1856). Unlike the painters and poets, who divorced the arts from moral or practical purpose, designers, notably William Morris, believed the pursuit of beauty enhanced the conditions of everyday life.

Aestheticism in America. The principal ideologies and practices of British Aestheticism came to the USA through both educational and commercial channels. As early as 1873, the Scottish stained-glass designer, decorator and art dealer Daniel Cottier opened a branch of his interior design shop in New York and played a significant role in introducing aesthetic taste and artifacts to Americans. The Philadelphia Centennial Exposition of 1876, with its extensive display of industrial and decorative arts, showcased British Aestheticism and the Japanese ceramics that influenced it. British art magazines and books, especially Charles Locke Eastlake's *Hints on Household Taste in Furniture, Upholstery, and Other Details* (first published 1868), advanced the Aesthetic doctrine. From 1882 to 1883, Oscar Wilde, the British poet, dramatist and self-proclaimed promoter of Aestheticism, toured the USA, instructing Americans about aesthetic home decoration and dress in a lecture entitled "The Practical Application of the Principles of Aesthetic Theory to Exterior and Interior House Decoration, with Observations upon Dress and Personal Ornaments."

Domestic space was central to Aestheticism's goal to transform everyday life into art. The American market for both antique and newly handcrafted decorative objects flourished. Professional designers, in some cases decorating firms, such as Herter Brothers and Associated Artists, and in others an architect or an artist, worked with wealthy patrons to assemble elaborate interiors. Among the examples of still extant American aesthetic decoration are the Veterans' Room in the Seventh Regiment Armory, New York (1879–80); the Mark Twain house, Hartford, CT (designed 1874; decorated 1881); Frederic Edwin Church's home and studio, Olana, near Hudson, New York (1870–91); and George Peabody Wetmore's former residence, Château-sur-Mer, Newport, Rhode Island (designed 1851–2; remodeled 1871–8). Although many aesthetic interiors no longer exist, they have been documented in photographs and celebrated in illustrated volumes, such as *Artistic Houses*. Americans who could not afford to hire professional designers relied on other resources for learning about the artistic arrangement of houses. Homemakers, mostly women, sought counsel regarding the proper transformation of their homes into tasteful, artistic spaces from decorating advice books and magazines. Illustrated books, including *The House Beautiful* (1878) by Clarence Cook and *Art Decoration Applied to Furniture* (1878) by Harriet Prescott Spofford, instructed readers about assembling furnishings according to aesthetic principles. American editions of British art publications, including *Magazine of Art* and *Art Journal*, were launched, and American periodicals, such as *Art Amateur* and *Art Interchange*, promoted aesthetic-style home decoration.

In contrast to earlier interiors that evoked a dominant style or a particular historical period, the Aesthetic interior was distinguished by its eclectic collection of objects from varying periods and places. Non-Western, especially Asian, artifacts cultivated an exotic atmosphere. Divorced from their original context and function, objects often served a decorative role: Japanese fans and Islamic ceramics hung on the wall like paintings. The elevation of craft to the fine arts was a key aspect of the Aesthetic doctrine. Despite the diversity of its contents, the interior was intended to evoke an overall unity of color and form, achieved through its thoughtful arrangement.

American Artists and the Aesthetic Movement. In 1881, Whistler's celebrated, aesthetic-style painting, *Symphony in White, No. 1: The White Girl* (1862; Washington, DC, N.G.A.) was exhibited for the first time in the USA. It had a far-reaching influence on American artists, and William Merritt Chase, Thomas Wilmer Dewing and John White Alexander, among others, embraced the portrayal of fashionably dressed, leisure class women in elaborately decorated interiors, painted with attention to the harmony of color, line and form. In response to the new interest in the Aesthetic interior and the decorative arts, artists assumed new functions as tastemakers, collectors and professional designers. Their lavishly furnished studios, best exemplified by William Merritt Chase's atelier in the Tenth Street

Studio building in New York, were opened to the public and upheld as models for interior decoration. The painters John La Farge and Louis Comfort Tiffany established their own decorating companies. As shown by the Tile Club (founded in 1877), artists formed art clubs dedicated to decorative work and artistic experimentation.

Aestheticism as a Woman's Movement. American women, the principal consumers of aesthetic objects, played a central role as designers and producers and encouraged the professionalization of handicraft manufacture. Notable female promoters of Aestheticism are Candace Wheeler, who helped to establish the decorating firm Associated Artists (founded in 1879); Mary Louise McLaughlin, a pioneer of china painting and the founder of the Cincinnati Pottery Club (founded 1879); and Celia Thaxter, who organized salons for artists and writers at her home on Appledore Island.

Criticism and Decline of Aestheticism. By the early 1880s, cultural commentators had begun to criticize the movement for being too decadent and too feminine. In Britain, W. S. Gilbert and Arthur Sullivan satirized aesthetic taste and the ultra-refined behavior and dress of its proponents Wilde and Whistler in their comic opera *Patience* (1881), which had an extended run in the USA. George Du Maurier ridiculed it in his cartoons for the British magazine *Punch*. Likewise, the American periodicals *Life* and *Harper's* featured cartoons that mocked the Aesthetic painter's lack of technical skill despite his lavishly decorated studio. Oscar Wilde became the subject of numerous parodies of the self-indulgent, degenerate and overly feminine aesthete, and his imprisonment in England for homosexual behavior marks the decline of Aestheticism and the conservative backlash against it in the 1890s.

BIBLIOGRAPHY

R. B. Stein: *John Ruskin and Aesthetic Thought in America, 1840–1900* (Cambridge, MA, 1967)

T. J. Jackson Lears: *No Place of Grace: Antimodernism and the Transformation of American Culture, 1880–1920* (New York, 1981)

In Pursuit of Beauty: Americans and the Aesthetic Movement (exh. cat. by D. B. Burke and others; New York, Met., 1986)

L. Lambourne: *The Aesthetic Movement* (London, 1996).

S. Burns: *Inventing the Modern Artist: Art & Culture in Gilded Age America* (New Haven, 1996)

M. W. Blanchard: *Oscar Wilde's America: Counterculture in the Gilded Age* (New Haven, 1998)

The Tile Club and the Aesthetic Movement in America (exh. cat. by R. G. Pisano, M. A. Apicella and L. H. Skalet; Stony Brook, NY, Mus., 1999)

E. Prettejohn: *Art for Art's Sake: Aestheticism in Victorian Painting* (New Haven, 2007)

Isabel L. Taube

Affleck, Thomas

(*b* Aberdeen, 1740; *d* Philadelphia, PA, 5 March 1795), cabinetmaker of Scottish birth. Affleck trained as a cabinetmaker in Edinburgh and London. In 1763 he arrived in Philadelphia on the same boat as John Penn, the new Governor of Pennsylvania and future client, to join Quaker friends. He opened a shop on Union Street and eventually moved to Second Street in the Society Hill area. He made stylish mahogany furniture (sold 1788; e.g. Philadelphia, PA, Cliveden Mus.; armchair, Winterthur, DE, Mus. & Gdns.) for the governor's mansion at Lansdowne, PA, and many of the most prominent families in the city owned his work, including the Mifflins, the Whartons and the Chew family at Cliveden. The parlor suite he made for John Cadwalader, carved by James Reynolds and the firm of Bernard and Jugiez in 1770–71, was among the most elaborate ever produced in the colonies (pole screen, Phil. Mus. A.).

A Quaker and Loyalist, Affleck refused to participate in the Revolution (1775–83) and was banished for several months to Virginia in 1777. By the end of the war, however, he was the most prosperous cabinetmaker in the city. His Loyalist sympathies seem to have been forgiven because he was given a number of important commissions, including furniture for Congress Hall and the first Supreme Court Chamber in the City Hall, both in Philadelphia.

The large body of surviving furniture attributed to Affleck, which includes wall-brackets, chairs (New York, Met.), grand chest-on-chests and elaborately carved tallboys or high chests-of-drawers, confirms his reputation as the leading cabinetmaker in Philadelphia in the 18th century. Much of his furniture was derived from designs in his personal copy of *Gentleman and Cabinet-maker's Director* by Thomas Chippendale. He also made furniture in the Neoclassical style. After his death, his son Lewis G. Affleck carried on the business for a short time until he went bankrupt.

[*See also* Philadelphia.]

BIBLIOGRAPHY

B. Garvan: "Thomas Affleck," *Philadelphia: Three Centuries of American Art* (Philadelphia, 1976), pp. 98–100

W. Hornor: *Blue Book, Philadelphia Furniture: William Penn to George Washington* (Philadelphia, 1935/R Washington, DC, 1977)

L. Beckerdite: "Philadelphia Carving Shops," *Ant.*, cxxviii (1985), pp. 498–513

D. M. Price: "Cabinetmaker to the Colonial Stars," *A. & Ant.*, xxii/1 (Jan 1999), pp. 54–60

L. Graves and L. Beckerdite: "New Insights on John Cadwalader's Commode-Seat Side Chairs," *Amer. Furn.*, (2000), pp. 153–168

Oscar P. Fitzgerald

African American art

[*This entry includes six subentries:*
Overview
Abstract sculpture
Murals
Photography in the 19th century
Photography in the 20th century
Vernacular art.]

Overview

Term used to describe art made by Americans of African descent. While the crafts of African Americans in the 18th and 19th centuries continued largely to reflect African artistic traditions, the earliest fine art made by professional African American artists was in an academic western style.

Before c. 1920. The first African American artist to be documented was Joshua Johnson, a portrait painter who practiced in and around Baltimore, MD. Possibly a former slave in the West Indies, he executed plain, linear portraits for middle-class families (e.g. *Sarah Ogden Gustin*, c. 1798–1802; Washington, DC, N.G.A.). Only one of the c. 83 portraits attributed to Johnson is signed, and none are dated. There are only two African American sitters among Johnson's attributions. Among the second generation of prominent 19th-century African American artists were the portrait painter William E. Simpson (1818–72) of Buffalo, NY, Robert Douglass Jr. (1809–87) and Douglass's cousin and pupil David Bowser (1820–1900) of Philadelphia. Douglass, none of whose works survives, started as a sign painter and then painted portraits as a disciple of Thomas Sully. Engravings and lithographs were produced by Patrick Reason (1817–98) of New York, whose parents were from Haiti. His engravings included illustrations for publications supporting the abolition of slavery and also portraits (e.g. *Granville Sharp*, 1835; Washington, DC, Howard U., Gal. A.).

Julian Hudson (*fl c.* 1831–44) was the earliest documented African American painter in the South. Having studied in Paris, he returned to his hometown, New Orleans, where he taught art and painted portraits. Although his quarter-length figures were rigidly conventional, Hudson was a skillful painter of faces. His *Self-portrait* (1839; New Orleans, LA State Mus.) is the earliest surviving self-portrait by an African American artist. Jules Lion (1810–66) also studied and practiced in Paris prior to returning to New Orleans, where he produced paintings and lithographs. He was also credited with introducing the daguerreotype to the city, where he was one of the earliest professional photographers.

Throughout the 19th century African American artists in Louisiana apparently did not experience as much professional discrimination as their peers

in other areas of the USA. However, even in Louisiana there are few examples of work commissioned by African Americans at this time. The Melrose Plantation House, built *c.* 1833 for the mulatto Metoyer family in Melrose, near Natchitoches, LA, is the only surviving plantation manor house built by an African American family in the southern states. It contained portraits of members of the family, probably executed by an unknown mulatto painter before 1830. The brick and timber African House, an outbuilding used in part as a prison for the control of slaves in the plantation at Melrose, was remarkable for the width and height of its roof: it was probably constructed during the early 19th century by African-born slaves owned by the Metoyer family.

Another artist from New Orleans, Eugene Warbourg (1826–59), was among the leading black sculptors of the 19th century. He worked in Rome, developing a Neo-classical style, as did Edmonia Lewis, who trained in Boston before becoming the first professional African American sculptor, producing such works as *Death of Cleopatra* (1876; Washington, DC, Smithsonian Amer. A. Mus.).

The most important African American landscape painters of the 19th century were Robert S. Duncanson, Edward Mitchell Bannister and Grafton Tyler Brown. Duncanson, who worked in Cincinnati and Detroit, was the earliest professional African American landscape painter. He studied in Glasgow and traveled extensively in Italy, France and England, as well as in Minnesota, Vermont and Canada. He was the first African American artist to receive international recognition. Although Duncanson painted portraits and still lifes, he is best known as a Romantic realist landscape painter in the Hudson River school tradition. His largest commission came in 1848, when he painted eight large landscape panels and four over-door compositions in the main entrance hall of Nicholas Longworth's mansion, Belmont (now the Taft Museum), in Cincinnati.

Bannister was the leading painter in Providence, RI, during the 1870s and 1880s. Born in Nova Scotia,

he started by making solar prints and attended an evening drawing class in Boston. He is reported to have taken up painting in reaction to a newspaper statement in 1867 that blacks could appreciate art but not produce it. He was a moderately talented painter of poetic landscapes (e.g. *Landscape, c.* 1870–5; Providence, RI Sch. Des., Mus. A.), influenced by Alexander Helwig Wyant and the Hudson River school. He was the earliest African American artist to receive a national award when he received a gold medal for *Under the Oaks* (untraced) at the Philadelphia Centennial Exposition in 1876. He was also one of the seven founder-members in 1873 of the Providence Art Club, which became the nucleus of the Rhode Island School of Design. He was the only prominent African American artist of the 19th century not to travel or study in Europe.

Brown was the earliest documented professional African American artist in California. He was first employed in San Francisco as a draftsman and lithographer, also printing street maps and stock certificates, before turning to landscape painting. His most productive years were during the 1880s, when he painted many Canadian landscapes and scenes of the American Northwest. He also lived in Portland, OR, and Washington. After 1891 Brown apparently ceased painting and in 1892 moved to St Paul, MN, where he worked as a draftsman.

The most distinguished African American artist who worked in the 19th century was Henry Ossawa Tanner. His early paintings of the 1890s included African American genre subjects and reflect the realist tradition of Thomas Eakins under whom Tanner studied at the Pennsylvania Academy of Fine Arts in Philadelphia. From 1903 he painted religious subjects, portraits and landscapes, primarily in subdued blues and greens. Like the majority of prominent 19th-century African American artists, Tanner went to Europe for further training and to escape racial and professional discrimination: he lived in Paris during most of his career and developed a painterly style influenced by Symbolism. He held his first one-man exhibition of religious paintings, however,

at the American Art Galleries in New York in 1908, and in 1909 he became the first African American to be elected to the National Academy of Design.

In 1907 the Tercentennial Exposition in Jamestown, VA, included among the pavilions a "Negro Building": its exhibits focused primarily on African American crafts, carpentry and inventions. Although there were 484 paintings and drawings, no works by prominent African American painters were included. The most important African American artist to be included in the Jamestown exhibition was the sculptor Meta Vaux Fuller, who had studied in Paris, where she had gained the approval of Auguste Rodin (1840–1917): she exhibited a series of dioramas depicting various aspects of black life in America. Other contemporary exhibitions, however, such as that of the Eight in 1908 and the Armory Show in 1913, both held in New York, had little initial stylistic impact on African American art.

c. 1920–*c.* 1960. The most significant African American stylistic and aesthetic movement of the early 20th century was the Harlem Renaissance or "New Negro" movement of the 1920s. The Harlem district of New York became, during the decade, the "cultural capital of black America." The ensuing Harlem Renaissance drew upon the community's African heritage and was the earliest race-conscious cultural movement by African Americans. Primarily political and literary, the spirit of the Harlem Renaissance was most eloquently expressed by Alain Locke in his book *The New Negro* (New York, 1925). The earliest African American painter consciously to incorporate African imagery in his work was Aaron Douglas, a prominent figure in the Harlem Renaissance and later. Other significant artists who contributed to the movement included Meta Vaux Fuller, Palmer Cole Hayden, who painted satirical images of life in Harlem, William E. Scott (1884–1964) and Malvin Gray Johnson (1896–1934). The most important African American photographer of that period was James Van Der Zee, who photographed people and scenes in Harlem for more than 50 years and also served as the official photographer for the Pan-Africanist Marcus Garvey during his frequent parades and rallies in Harlem.

The artists of the Harlem Renaissance received a great stimulus from the exhibitions of the Harmon Foundation. This was founded in New York in 1922 by William E. Harmon, a white Ohio-born philanthropist and real estate developer, and in 1926 it began promoting African American artistic talents and offering awards in the fine arts. The foundation's first *Exhibit of Fine Arts Productions of American Negro Artists* opened at International House in New York in January 1928. Following the success of the pilot exhibition, the foundation mounted additional shows at International House in 1929 and 1930. In 1931 it moved the location of its exhibitions to the galleries of the Art Center on E. 56th Street in New York. During the early years of the foundation's operation, annual traveling exhibitions were organized that introduced African American art to broad audiences for the first time. The exhibitions included artists working in traditional western, naive and modernist styles. Although some critics felt that the foundation's jurors were not critical enough in their selection procedures, the Harmon Foundation's awards, exhibitions and exhibition catalogs continued to promote African American art until 1966, when it closed. Its files, which formed the most comprehensive single body of materials relating specifically to African American art during the first half of the 20th century, were placed in the Library of Congress and the National Archives in Washington, DC. The large art collection that the foundation amassed was divided between the National Collection of Fine Arts (subsequently the National Museum of American Art of the Smithsonian Institution and now the Smithsonian American Art Museum) in Washington, DC, Fisk University in Nashville, TN, and the Hampton Institute (now Hampton University) in Hampton, VA.

The stock market crash of 1929 brought the golden era of the Harlem Renaissance to an end and plunged the USA into the Great Depression of the 1930s. The Depression paralyzed the nation's

economy, and President Franklin D. Roosevelt established the Federal Art Project (1935–43), a division of the Works Progress Administration, which provided employment for many African American artists. The early school of African American muralists reached its apogee during the 1930s, and numerous murals by African American artists were commissioned to decorate schools, hospitals, banks, post offices and other public buildings.

These murals ranged greatly in style: such artists as Charles White and Hale Woodruff executed historical murals that showed the influence of Mexican social realism, for example the *Amistad* murals (1939) by Woodruff in the Savery Library in Talladega College, Talladega, AL, which depicted a slave mutiny in 1839. Other artists produced mural work in a primitivist style, for example Aaron Douglas, whose murals of African life included elongated, angular figures with stylized features, and Charles Alston, a painter and sculptor. Alston painted mural panels (1937) in the Harlem Hospital, New York, depicting tribal African and modern scientific medicine in a style also characterized by expressively distorted figures. Some murals had themes that were not specific to African Americans, for example the mural panel by Archibald J. Motley Jr. entitled *United States Mail* (1936) in the post office in Wood River, IL. Motley also made easel paintings of scenes from African, American and even Parisian life, employing both a naive and a highly naturalistic style. Murals were also produced by such artists as the painter William E. Scott (1884–1964) and the sculptors Sargent Johnson (1887–1967) and James Richmond Barthé, who carved reliefs with highly formalized figures. Barthé was also an accomplished painter and figure sculptor of black subjects (e.g. *Blackberry Woman*, 1932; New York, Whitney) as well as theatrical characters. The sculpture of Sargent Johnson was characterized by figure studies in various materials such as porcelain, terracotta and lacquered wood (e.g. *Forever Free*, 1936; San Francisco, CA, MOMA).

The most important national commission received by an African American artist during the 1930s went to the sculptor Augusta Savage, who created a large sculpture, *The Harp* (later called *Lift Every Voice and Sing*; painted plaster, h. 4.87 m) for the Negro Pavilion of the New York World's Fair of 1939. It was intended to represent African American music and consisted of a receding line of singing figures arranged in the shape of a harp. The sculpture, cast in plaster and gilded to resemble bronze, never received permanent casting and was destroyed following the fair's closing (see Dover, pl. 72). Selma Hortense Burke was another important African American female sculptor whose career blossomed during the 1930s and 1940s. In 1935 she received a Roosevelt Foundation Fellowship, and in 1943 she participated in a competition sponsored by the Fine Arts Commission of the District of Columbia to depict a bust of President Roosevelt. The bust, which was completed and unveiled in 1945, was adapted in 1946 for use on the American dime.

During and immediately after World War II, there arose to prominence a new school of African American artists, many of whom were the so-called "children of the Harlem Renaissance." Such artists as Selma Burke, Charles White and William H. Johnson, who had attracted attention before the war, continued their achievements, for example in the social realism of the *Contribution of the Negro to American Democracy* (1953) in the Hampton Institute in Virginia. Johnson, who was influenced by Chaïm Soutine (1893–1943), worked in France, Denmark and Norway before returning to the USA in 1938. He painted Expressionist works and naive images of black life in the USA (e.g. *Going to Church*, c. 1940–44; Washington, DC, Smithsonian Amer. A. Mus.). Over 1000 of his works were in the collection of the Harmon Foundation when it closed. The art of African Americans was encouraged by the exhibition of the *Art of the American Negro, 1851–1940*, assembled by Alonso Aden with assistance from the Harmon Foundation and the Works Progress Administration, at the *American Negro Exposition* in Chicago in 1940. Among the artists exhibited was Jacob Lawrence, who painted highly colored naive

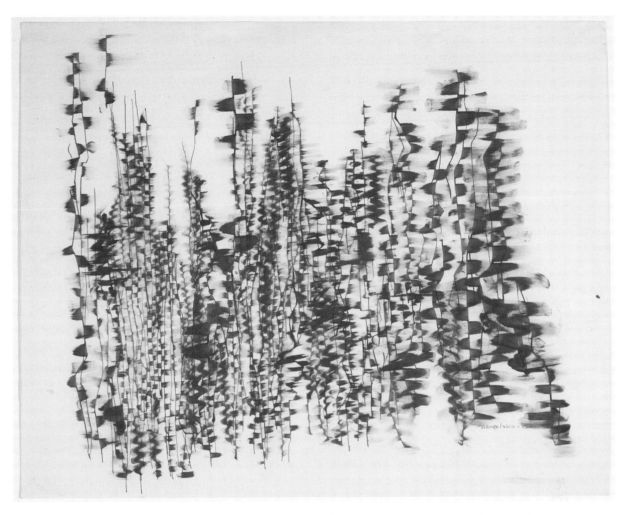

AFRICAN AMERICAN ART. *Echoes* by Norman Lewis, ink on paper, 482 × 613 mm, 1950. EDWARD W. ROOT BEQUEST, MUNSON-WILLIAMS-PROCTOR ARTS INSTITUTE, UTICA, NY/ART RESOURCE, NY

images of black life and history, eschewing perspective (e.g. the 60 gouache panels of the *Migration of the Negro Northwards*, 1941; Washington, DC, Phillips Col. and New York, MOMA). Other prominent African American artists of this time were Elmer Simms Campbell (1906–71), who contributed illustrations for such periodicals as *Esquire*, and the painters Romare Bearden, Eldzier Cortor, Frederick Flemister (1917–76) and Horace Pippin, whose paintings included depictions of figures from the history of black emancipation. Significant figure-sculpture was made by Elizabeth Catlett and William Artis (1914–77); the latter was a pupil of Augusta Savage and produced highly naturalistic portrait busts.

During the 1950s African American art was dominated by two stylistic trends: Abstract Expressionism and Realism. Some artists developed an abstract style that was related to contemporary Abstract Expressionism but also was motivated by a belated interest in Cubism, most noticeable in the works of Charles Alston, Romare Bearden, Hale Woodruff and James Lesesne Wells. This contrasted with the realistic styles championed by Sargent Johnson and William Artis and heralded a new direction in African American art.

c. **1960 and After.** In the 1960s and 1970s new classifications appeared in African American art based on continuing developments in abstract art

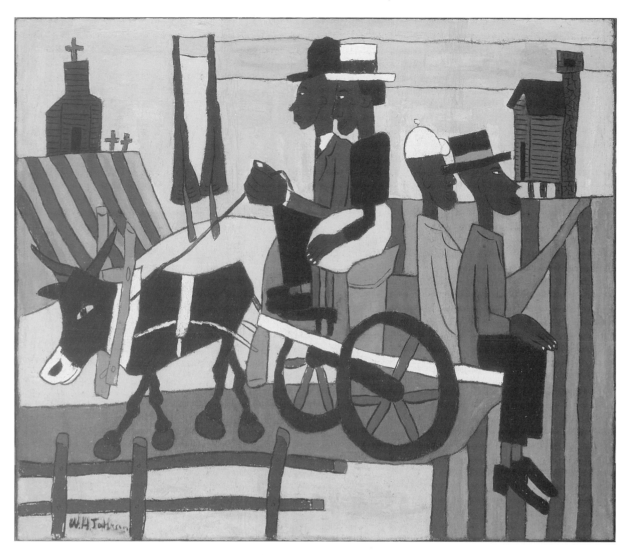

AFRICAN AMERICAN ART. *Going to Church* by William H. Johnson, oil on burlap, 968 × 1121 mm, c. 1940–41. SMITHSONIAN AMERICAN ART MUSEUM, WASHINGTON, DC/ART RESOURCE, NY

and the rise of the figurative style known as Black Expressionism. A new generation of artists came to prominence, influenced by such developments as Abstract Expressionism, color field painting and hard-edge painting. These artists produced large, colorful, non-representational art that was not racially identifiable: such work was more successful commercially and more likely to be included in museums, exhibitions and galleries than that of the Black Expressionists. The most prominent African American abstract painter was Sam Gilliam, based in Washington, DC, whose color field painting

employed folded, draped and hanging canvases as well as other forms of support (e.g. *Abstraction*, acrylic on aluminum-treated paper, 1969; Washington, DC, Evans-Tibbs Col., see 1989 exh. cat., p. 94).

The leading African American abstract sculptor was Richard Hunt from Chicago: in his youth he worked under the Spanish sculptor Julio González (1876–1942), after which he went on to produce elegant welded and cast metal sculpture that included figurative and organic elements. A variety of other abstract styles also appeared in the work of such sculptors as Barbara Chase-Riboud, Martin

Puryear, Daniel Johnson (*b* 1938), Juan Logan (*b* 1946) and Fred Eversley (*b* 1941). Chase-Riboud produced expressive, distorted sculptures using various media (e.g. *Monument III*, bronze and silk, 2134×914×152 mm, 1970; New York, Betty Parsons Gal.). Logan's sculpture, however, was concerned with the formal qualities of geometric shapes and the use of industrial materials (e.g. *Traditional Trap*, galvanized steel, 2.16×1.02×2.35 m, 1972; artist's col., see 1974 exh. cat., fig.), while Eversley's work aimed at producing complex optical effects (e.g. *Untitled*, polyester, 1970; New York, Whitney).

The 1960s and 1970s were also marked by fertile associations between the older and younger generations of abstract painters, such as the Spiral group, founded in New York in 1963 by Hale Woodruff, Romare Bearden and Norman Lewis, which attracted such younger artists as Richard Mayhew (*b* 1934). Mayhew, who was also a jazz singer, expressed his love of music in lyrical, colorful abstractions (e.g. *Vibrato*, 1974; Washington, DC, Evans-Tibbs Col., see 1989 exh. cat., p. 86). Varying degrees of abstraction characterized the paintings of such artists as Norma Morgan (*b* 1928), Alvin Loving (*b* 1935), Bill Hutson (*b* 1936), William T. Williams (*b* 1942) and Robert Reid (*b* 1924). The development of innovative effects of color and space also affected Bob Thompson, who reinterpreted Renaissance themes with flat figures, colors influenced by Fauvism and rich impasto painting techniques (e.g. *Music Lesson*, 1962; Washington, DC, Evans-Tibbs Col., see 1989 exh. cat., p. 92; see also *Descent from the Cross*, color pl. 1:III, 2).

Black Expressionism was a movement that grew out of the political unrest of the 1960s, in particular the struggle for civil rights. It also grew from the outrage of African American artists at the professional discrimination that they faced. As a result, many black artists began producing political art directed primarily toward black audiences. Black Expressionist art was always figurative and often employed bright colors, such as the black, red and green of the Black Nationalists' flag: the works frequently bore slogans and extolled the virtues of black Africa. The racial pride and political radicalism of this art led to regular depictions of such subjects as Angela Davis, the Black Panther Party (e.g. Eliot Knight's mural *Panther Tribute*, 10.97×7.32 m, early 1970s; Roxbury, MA, Warren Street, destr., see 1980 exh. cat., p. 10), Muhammad Ali and anti-Vietnam War slogans. The American flag was a constantly recurring motif and often appeared blood-spattered as a noose around the neck of a lynched black male or with yellow instead of white stripes to indicate the cowardice of the white American political structure.

Among the artists associated with Black Expressionism there was, however, a multiplicity of subjects, styles and techniques, ranging from the threatening images created by Dana Chandler (*b* 1941) even from such subjects as a domestic still life, to the work of Faith Ringgold, who depicted ritualistic African subjects in so-called "soft sculpture," while a preoccupation with unorthodox media is apparent in the collage paintings of Benny Andrews, which contain real pieces of clothing. Other artists representative of the diversity of Black Expressionism included Charles Searles (1937–2004), Murry DePillars (*b* 1939), David Hammons, Joe Overstreet, Melvin Edwards, John Riddle (*b* 1933), Malcolm Bailey (*b* 1947), Gary Rickson (*b* 1942), Phillip Mason (*b* 1942) and Vincent Smith (*b* 1929). Black Expressionism also influenced older artists such as Romare Bearden, Charles White, Elizabeth Catlett, Jacob Lawrence and John Biggers.

One of the most important movements to develop out of Black Expressionism was the Black Neighborhood Mural Movement, which originated in Chicago during the early 1960s. Motivated partly by the fact that African Americans were not primarily museum-oriented and by the belief that American museums had few relevant programs for African Americans, numerous artists transformed drab walls in run-down, predominantly black neighborhoods with brilliant, glowing murals incorporating subject matter with which almost every African American could identify. These served to instill black pride and

a sense of heritage and racial identity. Chicago produced the largest number of murals, followed by Detroit; Boston; San Francisco; Washington, DC; Atlanta and New Orleans. The most famous were the *Wall of Respect and Community as One* in Chicago (1967; see 1989–91 exh. cat., p. 28) and the *Wall of Dignity* in Detroit, completed during the early 1960s: both were lost when the buildings on which they were painted were demolished.

The *Wall of Respect and Community as One*, which took as its general theme black heroes, was executed by the Visual Arts Workshop of the Organization of Black American Culture (OBAC). This included Barbara Jones-Hogu (1938–78) and Jeff Donaldson (1932–2004). They were among a splinter group in Chicago which, after the mural was completed, formed the African Commune of Bad Relevant Artists (AFRICOBRA), "bad" meaning "good" in African American slang. AFRICOBRA artists employed fluorescent colors such as strawberry pink, "hot" orange, lime green and grape purple in their highly rhythmic message-emblazoned art, which, they declared, was produced exclusively for African American audiences. They produced a series of high-quality screenprints that were originally sold very inexpensively to promote the doctrine of "black art for every black home in America" (e.g. *Unite* by Barbara Jones-Hogu, 1969).

Another important group that developed in the 1960s was Weusi Nyumba Ya Sanaa (Swahili: Black House of Art) in Harlem. Founded in 1965, it established an academy and a gallery (1967–78). The Weusi artists incorporated some aspects of African iconography in all of their art: many members abandoned their former "slave" names, officially adopting African names and converting to African religions. Weusi's spokesman was Ademola Olugebefola (*b* 1941), who used traditional African materials such as cowrie shells to create ritualistic images.

Following such reforms as the Public Accommodations Act of 1964, which made racial discrimination in public places illegal, and the Voting Rights Act of 1965, which enforced African Americans' right to vote, there was an increasingly heavy reliance on West African and sometimes Egyptian themes as the militancy of Black Expressionism gradually diminished. The Weusi and AFRICOBRA collaborations continued, however, to produce colorful, message-bearing art for African American audiences. In 1987 AFRICOBRA experienced its first cross-cultural exposure when it was invited to exhibit with Groupe Fromagé in Martinique at the 16th annual Sermac festival of the arts and culture. AFRICOBRA and Groupe Fromagé shared a similar philosophy and an aesthetic based on African, African American and Caribbean forms.

Such artists as Sam Gilliam and Richard Hunt continued meanwhile to explore abstract art, both completing a number of large-scale public commissions. Gilliam's paintings of the 1980s and early 1990s frequently employed metal, fabric and paint in dramatic impasto techniques, as well as using more conventional techniques such as acrylic and screenprinting (e.g. *In Celebration*, 1987). Martin Puryear emerged during the 1980s as a leading African American abstract sculptor, working primarily in wood in a Postminimalist style and frequently incorporating such materials as rope, leather and hide. During the late 1970s and early 1980s Puryear created a number of public projects and wall pieces that were ring-shaped or reflected biomorphic forms and organic materials.

In the 1980s African American art was the subject of a number of pioneering exhibitions. In particular, in 1982 the Corcoran Gallery of Art in Washington, DC, mounted the first major traveling exhibition of African American folk or self-taught artists. The artists, the majority of whom were born and still lived in the southern states of the USA, were frequently elderly when their careers began, following retirement or a work-related injury. Many were self-styled religious ministers, prophets and missionaries. As well as referring to childhood experiences they frequently used bird, animal and reptilian imagery: they also often represented figures associated with emancipation and civil rights, such

as George Washington, Abraham Lincoln, John F. Kennedy and Martin Luther King Jr. Such artists displayed an amazing ingenuity for converting *objets trouvés* and discarded materials, including costume jewelry, bones, bottle caps, chewing gum, foam packing, sawdust, mud, tree trunks, branches and Mardi Gras beads, into unique artifacts. The influence of traditional African culture on African American art was explored in an exhibition organized in 1989 by the Dallas Museum of Art. *Black Art—Ancestral Legacy: The African Impulse in African American Art* was the first major exhibition to bring together the works of African, Caribbean and African American academic and folk artists.

[*See also* African American expatriate artists (Negro Colony); AFRICOBRA; Alston, Charles; Andrews, Benny; Bannister, Edward Mitchell; Barthé, James Richmond; Bearden, Romare; Biggers, John; Brown, Grafton Tyler; Burke, Selma Hortense; Catlett, Elizabeth; Chase-Riboud, Barbara; Cortor, Eldzier; Douglas, Aaron; Duncanson, Robert S.; Edwards, Melvin; Fuller, Meta Vaux; Gilliam, Sam; Hammons, David; Harlem Renaissance; Hunt, Richard; Johnson, Joshua; Johnson, William H.; Lawrence, Jacob; Lewis, Edmonia; Lewis, Norman; Motley, Archibald J., Jr.; New Negro movement; Overstreet, Joe; Pippin, Horace; Puryear, Martin; Reid, Robert; Ringgold, Faith; Savage, Augusta; Spiral; Tanner, Henry Ossawa; Thompson, Bob; Wells, James Lesesne; White, Charles; *and* Woodruff, Hale.]

BIBLIOGRAPHY
J. A. Porter: *Modern Negro Art* (New York, 1943)

The Negro in American Art: One Hundred and Fifty Years of Afro-American Art (exh. cat. by J. A. Porter, Los Angeles, CA, Davis U. CA; San Diego, CA, State U., A. Gal.; Oakland, CA, Mus.; 1966–7)

The Evolution of Afro-American Artists, 1800–1950 (exh. cat., intro. C. Greene Jr.; New York, City Coll. City U., 1967)

M. J. Butcher: *The Negro in American Culture* (New York, 1969)

C. Dover: *American Negro Art* (London, 1969)

Harlem Artists 69 (exh. cat., intro. T. Gunn; New York, Stud. Mus. Harlem, 1969)

S. Lewis and R. Waddy, eds.: *Black Artists on Art*, 2 vols. (Los Angeles, 1969–71)

Afro-American Artists, 1800–1969 (exh. cat. by R. J. Craig, F. Bacon and B. Harmon, Philadelphia, PA, Mus. Civ. Cent., 1970)

Dimensions of Black (exh. cat., ed. J. Teihet; La Jolla, CA, A. Cent., 1970)

J. W. Chase: *Afro-American Art and Craft* (New York, 1971)

E. Fax: *Seventeen Black Artists* (New York, 1971)

Contemporary Black Artists in America (exh. cat. by R. Doty, New York, Whitney, 1971)

R. Bearden and H. Henderson: *Six Black Masters of American Art* (New York, 1972)

A New Vitality in Art: The Black Woman (exh. cat. by G. Garrison and P. Long, South Hadley, MA, Mount Holyoke Coll. A. Mus., 1972)

E. H. Fine: *The Afro-American Artist: A Search for Identity* (New York, 1973)

Blacks: USA: 1973 (exh. cat., intro. B. Andrews; New York, Cult. Cent., 1973)

Directions in Afro-American Art (exh. cat., intro. R. R. Jeffries; Ithaca, NY, Cornell U., Johnson Mus. A., 1974)

E. Fax: *Black Artists of the New Generation* (New York, 1977)

S. Lewis: *Art: African American* (New York, 1978)

Spirals: Afro-American Art of the '70s (exh. cat. by E. B. Gaither, Roxbury, MA, Mus. Afro-Amer. Hist., 1980)

L. M. Igoe: *Two Hundred and Fifty Years of Afro-American Art: An Annotated Bibliography* (New York, 1981)

J. Anderson: *This Was Harlem* (New York, 1982)

D. L. Lewis: *When Harlem Was in Vogue* (New York, 1982)

W. Ferris, ed.: *Afro-American Folk Arts and Crafts* (Jackson, MS, 1983)

R. F. Thompson: *Flash of the Spirit: African and Afro-American Art and Philosophy* (New York, 1984)

M. S. Campbell and others: *Harlem Renaissance: Art of Black America* (New York, 1987)

C. D. Wintz: *Black Culture and the Harlem Renaissance* (Houston, 1988)

African-American Artists, 1880–1987: Selections from the Evans-Tibbs Collection (exh. cat. by G. C. McElroy and others, Washington, DC, Smithsonian Inst. Traveling Exh. Serv., 1989)

Black Art—Ancestral Legacy: The African Impulse in African–American Art (exh. cat., ed. R. V. Rozelle, A. J. Wardlaw and M. A. McKenna; Dallas, TX, Mus. A.; Atlanta, GA, High Mus. A.; Milwaukee, WI, A. Mus.; Richmond, VA Mus. F.A.; 1989–91)

R. Bearden and H. Henderson: *A History of African-American Artists, 1792–1988* (New York, 1992)

Facing the Rising Sun: 150 Years of the African-American Experience, 1842–1992 (exh. cat. by B. A. Hudson, Hartford, CT, Wadsworth Atheneum, 1992–3)

Free within Ourselves: African-American Artists in the Collection of the National Museum of American Art (exh. cat. by R. A. Perry, Hartford, CT, Wadsworth Atheneum and elsewhere, 1992–3)

J. Smalls: "A Ghost of a Chance: Invisibility and Elision in African American Art Historical Practice," *A. Doc.*, xiii/1 (Spring 1994), pp. 3–8

S. Stuckey: *Going through the Storm: The Influence of African American Art in History* (New York, 1994)

S. L. Jones: "A Keen Sense of the Artistic: African American Material Culture in Nineteenth-century Philadelphia," *Int. Rev. Afr.-Amer. A.*, xii/2 (1995), pp. 4–29

Int. Rev. Afr.-Amer. A., xii/3 (1995) [issue dedicated to Nineteenth-century African American fine and craft arts of the South]

G. C. Tomlinson and R. Corpus: "A Selection of Works by African American Artists in the Philadelphia Museum of Art," *Bull.: Philadelphia Mus. A.*, xc/382–3 (1995)

S. F. Patton: *African-American Art* (Oxford and New York, 1998)

R. J. Powell: "Linguists, Poets, and 'Others' on African American Art," *Amer. A.*, xvii/1 (2003), pp. 16–19

L. E. Farrington: *Creating their Own Image: The History of African-American Women Artists* (Oxford and New York, 2005)

D. English: "Post Post-Black: Some Politically Incorrect Thoughts on the Reception and Contemplation of African-American Art," *A. J.*, lxvi/4 (Winter 2007), pp. 112–14

C.-M. Bernier: *African American Visual Arts: From Slavery to the Present* (Chapel Hill, 2008)

Regenia Perry

Abstract sculpture

The roots of American abstract sculpture can be traced to extant pieces—functional, decorative and utilitarian objects—which were crafted in socially challenging circumstances by slaves in northern and middle colonies in the 19th century. The most referenced example of these utilitarian objects is the vessel (h. 210 mm), dubbed the Afro-Carolinian Face Vessel (Washington, DC, N.G.A.). The way in which it meshes abstracted physiognomic features with functionality recalls the spiritual force and deliberative improvisation that are essential features of African sculpture.

This adaptive essence is a characteristic of abstraction in African American art and has manifested itself in several forms. Among artists who took recourse to abstract expressive three-dimensional works are Bessie Harvey; Betye Saar and her daughter Alison Saar. One peculiar trait of these artists is their preference for recycling materials. All of them produced intimate sculptures that are steeped in spirituality. While the two Saars received formal education in art, Harvey was a self-taught artist who, like Thornton Dial, worked in formats such as metal reliefs and freestanding assemblages. Dial gives full reign to the rawness of the very process through which his sculptures are produced. With a fourth grade education, his abstract sculptures and installations are considered unique for two main reasons: the artist's immersion in the culture of the Deep South and the absence of any exposure to formal art training or, for that matter, art establishments. It was not until the 1980s that he first learned of the existence of museums. What Dial lacked in formal education he gained in life-long hands-on training in Bessemer, AL, near Birmingham, where he lived for more than 30 years. It was here that he learned a variety of skills—welding, ironwork, carpentry and cement work—all of which gave him the skills necessary to produce remarkable sculptures.

A pervasive issue in African American abstract sculpture throughout the 19th century and much of the 20th pertained to sustainability and institutional patronage. While African American painters were relatively more visible, abstract sculptors did not fare well: the prevailing political and socio-economic climate severely discouraged the creation of any sculptural pieces that were not utilitarian or were dictated by aesthetic impulses or personal whims. Patronage of three-dimensional art created by African American artists was almost non-existent. This was the prevailing situation up to and, indeed, beyond the Harlem Renaissance.

In the years after the crash of the stock market in 1929, the Federal Art Project, which was part of the Works Progress Administration that President Franklin D. Roosevelt established, produced no remarkable abstract sculptures by African American

artists. The convulsive political environment of the first five decades of the 20th century, during which blacks were discriminated against and denied equal opportunities across a broad spectrum of the social and political strata, gave impetus to the Civil Rights Movement of the 1960s. For African American visual artists, this condition provoked a visual militancy: a desire to identify with an expressive stance that was Afrocentric. Bright colors, highly energized designs and patterns derived from African motifs and symbols that were radically different from the accepted Western canon were incorporated into the visual lexicon of African American art. Known as Black Expressionism, this movement was limited to the two-dimensional domain; it would be several years before African American abstract sculpture would come into its own.

Among the artists who have defined this category is Richard Hunt. His sinuous, organic bronze or welded metal sculptures are characteristic stylistic traits of an artist who grew up with an interest in the visual arts and the biological sciences. He started making sculpture in clay in his father's basement, which he converted into a personal studio when he was just a teenager. When he was in high school, he worked at the zoological laboratory of the University of Chicago and studied at the Art Institute of Chicago. He became fascinated by sculpture, especially the processes entailed in working with welded steel and iron, which he particularly admired in the work of the Spanish artist Julio González (1876–1942). Hunt's abstract sculpture is a synthesis of geometric and organic elements combined to create movement and empathy in space. In creating sinuous, biotic forms, he drew inspiration from his familiarization with biology and his understanding of the processes entailed in working with metals. His stainless steel *Freeform* (1993), which adorns the State of Illinois Building at North LaSalle Street, Chicago, exemplifies Hunt's style.

Among women whose sculptures have had considerable impact for their skillful handling of materials and their cerebral approach to subject matter are Elizabeth Catlett and Barbara Chase-Riboud. While

AFRICAN AMERICAN ART: ABSTRACT SCULPTURE. *Resolved* by Melvin Edwards, welded steel, from the *Lynch Fragments* series, 1986. ESTATE OF GERTRUDE WEINSTACK SIMPSON THE NEWARK MUSEUM/ART RESOURCE, NY

Catlett expressed herself in figurative and abstract styles, her sensitive portrayal of the African American condition, especially in wood, has endeared her to diverse audiences across nations. As a sculptor, Chase-Riboud used abstraction to express nuanced and interconnected artistry at the spiritual, creative and literary levels. She has traveled widely and has earned perhaps more recognition in Europe—in particular in France where she has resided since 1961—than in the United States. Her Tantra series, of which *Tantra I* (1994) is an example, is devoted to exploring the interconnectedness of the spiritual, the poetic and the sexual, using an assortment of media such as bronze, fiber and silk.

One of the most versatile African American sculptors working in the abstract medium is Martin Puryear. Acknowledged for his disciplined and poetic works, which are shorn of any doctrinal or

racial undertones, Puryear capitalizes on his dexterity and craftsmanship. His interest in art was matched only by his love for reading and an irrepressible urge to construct things. He developed an interest in abstract art during his years at Catholic University in Washington, DC, when he came under the influence of Nell Sonneman. Between 1964 and 1966, Puryear was in Sierra Leone after which he traveled to Stockholm. His apprenticeship to local craftsmen in these two diverse environments gave him the skills that informed his graduate studies in sculpture at Yale. He produced a body of work in which the distillation of oppositional or complementary ideas remains a constant theme. Puryear is recognized for his uncanny ability to bend his material, mainly wood, to obey his creative biddings. Among the works that attest to Puryear's sensitivity to medium is *Ladder for Booker T. Washington* (1996), an 11-m-tall ash ladder that meanders its way up until it almost dissolves into the atmosphere.

In terms of the socio-political import of their abstract sculptures, Melvin Edwards appears to operate from the opposite end of Puryear's spectrum. While Puryear deliberately avoids artworks with political tenor, Edwards is direct in using his sculptures to draw attention to the dark history of race in the United States and the extent to which African Americans have been demonized, humiliated and de-humanized. His *Lynch Fragments* series, which he began in 1963 and which now numbers over 200 pieces, is meant to draw attention to the victimization of blacks, many of whom were lynched and hanged. Created often in relief form and meant to be hung as in *Tambo* (1993; Washington, DC, Smithsonian Amer. A. Mus.), Edwards uses composite found objects such as metal extrusions, nails, auto parts, horseshoes, ball bearings and chains to underline the poignancy of his message.

[*See also* Catlett, Elizabeth; Chase-Riboud, Barbara; Dial, Thornton; Edwards, Melvin; Harvey, Bessie; Hunt, Richard; Puryear, Martin; Saar, Alison; *and* Saar, Betye.]

BIBLIOGRAPHY

Black Art Ancestral Legacy: The African Impulse in African American Art (exh. cat., ed. R. V. Rozelle, Dallas, TX, Mus. A., 1989)

R. J. Powell: *Rhapsodies in Black: The Art of the Harlem Renaissance* (Berkeley, 1997)

S. F. Patton: *African-American Art* (New York, 1998)

S. Lewis: *African American Art and Artists* (Berkeley, 3/2003)

M. A. Calo: *Distinction and Denial: Race, Nation, and the Critical Construction of the African American Artist, 1920–40* (Ann Arbor, 2007)

M. Puryear: *Martin Puryear* (New York, 2007)

dele jegede

Murals

Mural painting has played a unique and prominent role in the work of African American artists and within black urban communities across the nation. The earliest evidence of murals painted by an African American artist is the Belmont Murals painted by Robert S. Duncanson. Commissioned in 1850 by Cincinnati abolitionist and banker Nicholas Longworth, these eight murals depict landscapes set in *trompe l'oeil* frames directly on the walls of his private residence. Although African American artists have been painting murals since the mid-19th century, two major periods in the 20th century mark the flourishing of mural production within African American culture: the 1930s through 1940s, and the late 1960s through 1970s.

In the 1930s, murals were funded through the Federal Art Project (FAP) within the Works Progress Administration (WPA) (1935–43) and are owned by the government. Murals were critical to the program's focus on creating easily visible public art that was accessible outside of museum and galleries. The WPA murals were sponsored to boost national morale during the Great Depression and encourage national unity during World War II. These large-scale paintings were made to inspire viewers to labor for the common national goal as a means to strengthen the country during difficult economic times through depictions of industrial and agricultural labor, and to celebrate the history of America's national heritage. Heavily influenced by the exploration of their

African heritage during the Harlem Renaissance (1919–29), and the aesthetic and formal expressions of cultural heritage by three master muralists from Mexico known as Los Tres Grandes—José Clemente Orozco (1883–1949), Diego Rivera (1886–1957) and David Alfaro Siqueiros (1896–1974)—African Americans explored their origins, current political concerns and future contributions to the nation. Their works were displayed in a variety of buildings including hospitals, Historically Black Colleges and Universities (HBCUs) and libraries. African American murals of this period prominently depict images of black people in the public art landscape of America. Some of the African American muralists who excelled during this period are Charles Alston, John Biggers, Aaron Douglas, Charles White and Hale Woodruff.

Douglas is best known for his murals *Pageant of the Negro* (1930), painted for the Cravath Library at Fisk University, in Nashville, TN, and the four part series *Aspects of Negro Life* (1934; see color pl. 1:III, 3), located in the main reading room at the Schomburg Center for Research in Black Culture in Harlem, New York. Douglas's Fisk murals express life in Africa before the transatlantic slave trade and life in America during and after slavery. The murals are organized into two themes: Spirituals and Negro labor. Through the abstraction of Cubist, West and Central African and Art Deco styles, *Aspects of Negro Life* focuses on African American music, song and dance in Africa, forced migration of Africans to the New World, life during slavery and emancipation from slavery.

In 1936, six mural designs by African American artists Charles Alston, Georgette Seabrooke, Vertis Hayes, Sara Murrell, Elba Lightfoot and Selma Day were submitted for execution at Harlem Hospital in New York. The designs, which explored African folklore, traditional African medicine, modern-medicine, community recreation activities and African American progress, were approved by the FAP. However, hospital superintendent L. T. Dermody rejected four of the murals for reasons he revealed in conversation with Alston, including that "the

murals had too much Negro matter . . . and that the hospital was not a Negro hospital but a city institution" (*NY Times*, 22 Feb 1936, p. 13). Eventually the murals were approved and in 2010 remained on view at Harlem Hospital.

Hale Woodruff traveled to Mexico to work with Diego Rivera in 1934. He was the only African American artist to collaborate with one of Los Tres Grandes. He incorporated some of the stylistic aspects of the great Mexican muralists into his three 1939 murals titled collectively *The Amistad Mutiny* and painted for the Savery Library at the Talladega College in Alabama. The panels depict the rebellion of slaves on the Spanish schooner *Amistad*, their trial in the quest for freedom and their return to Sierra Leone. The inspirational story of resistance to slavery was monumentalized as an important part of African American heritage and was intended to educate and encourage contemporary viewers to fight against current forms of racial oppression. In 1949, Alston, together with Woodruff, painted two large murals for the insurance company Golden State Mutual Life in Los Angeles, CA. The murals focus on the history of black settlers in the West with a particular focus on their roles in the founding of Los Angeles.

During the Black Arts Movement of the late 1960s to 1970s, murals were popular in working-class and middle-class black urban neighborhoods across the country. These grassroots collaborative projects claimed space to depict images of shared black cultural heritage, to articulate political aspirations and to express spiritual beliefs. Murals were created to renew hope in communities where unemployment was often high and residents were disenfranchised from political representation and power. The quintessential mural that exemplified and sparked the movement was the ambitious Chicago-based project known as the *Wall of Respect* (1967), spearheaded by painter Jeff Donaldson, co-founder of the Organization of Black American Culture (OBAC), an Afrocentric group formed to engage black American communities with the visual arts. Painted on the side of a two-story building, the mural celebrated

black iconic figures in four thematic sections: rhythm and blues, theater and jazz; religion; statesmen; and political heroes. Photographs taken by black photographers of subjects reflecting these themes were interspersed between the two floors. Over a four-year period, the images and themes were modified as community attitudes shifted. Although the wall was destroyed in a 1971 fire, it inspired other *Wall of Respect* murals in St Louis (1968) and Atlanta (1974). Detroit's *Wall of Dignity* (1968), Chicago's *Wall of Truth* (1969), Philadelphia's *Wall of Consciousness* (1972) and Chicago's *Wall of Community Respect* (1985) are among other riffs on the original theme. Over 200 murals were painted in Chicago alone by 1975. Over 1500 were painted in urban black communities after 1967. Some of these murals adorned churches, alleyways and other community spaces as visual celebrations of jazz, religion, local histories, hometown heroes and critical commentaries on issues of national concern.

In the 1980s and 1990s many murals by African American artists incorporated more brightly colored and expertly drafted compositions than had previously been common in the 1960s and 1970s. Still influenced by study of Los Tres Grandes, these artists also benefited from the earlier generations of African American muralists including Alston, Douglas, Biggers, White and Woodruff. They were also influenced by the visibility of graffiti designs, which had gained respectability as an art form. The abstract quality of these murals and their impressive size made a grand impact by way of their content and execution. Works by Los Angeles-based artist Richard Wyatt exemplify this new wave of murals, for example *Hollywood Jazz 1945–1972* (1990), executed at the Capitol Records building in Hollywood, CA. This mural depicts larger-than-life photorealist portraits of jazz legends. In his mural *Cecil* (1989), located at the Watts Towers Art Center in Los Angeles, Wyatt immortalizes Los Angeles art world icon Cecil Ferguson.

Throughout the 1990s, black urban communities used murals to express appreciation for local and national figures and to articulate political positions such as disdain for drug abuse and police brutality. The success of murals in black urban communities was fostered by corporations such as Coca Cola and Sprite in the 1990s and 2000s. These companies commissioned murals to function as billboards marketed toward youth culture. Despite the commodification of murals in predominantly black neighborhoods, African Americans continue to paint murals to validate the commonalities among African Americans and as a way to announce their identities to a larger public that often dismisses their contributions to the nation.

[*See also* Alston, Charles; Biggers, John; Douglas, Aaron; White, Charles; *and* Woodruff, Hale.]

BIBLIOGRAPHY

A. Locke: *The Negro in Art: A Pictorial Record of the Negro Artist and of the Negro Theme in Art* (New York, 1979)

J. D. Ketner: *The Emergence of the African-American Artist: Robert S. Duncanson, 1821–1872* (Columbia, MO, 1994)

L. Lefalle-Collins: *In the Spirit of Resistance: African American Modernists and the Mexican Muralist School* (New York, 1996)

J. Donaldson: "The Rise, Fall and Legacy of the Wall of Respect Movement," *Int. Rev. Afr. Amer. A.*, xv/1 (1998), pp. 22–6

S. Patton: *African-American Art* (Oxford, 1998)

J. Prigoff and R. J. Dunitz: *Walls of Heritage, Walls of Pride: African American Murals* (San Francisco, 2000)

S. Earle, ed.: *Aaron Douglas: African American Modernist* (New Haven, 2007)

Bridget R. Cooks

Photography in the 19th century

American-born free persons of African descent have been photographers since the medium's inception. In antebellum America, photography was a viable business opportunity for free men of color, and a handful were among the early adopters of the new technology. Despite the successes of this small number of practitioners during the course of the 19th century, the dominant culture quickly and effectively wedded photography to the demands of racial ideology in virtually all of the medium's applications. The standard practices that were established for photography privileged the white subject, normalizing the

concept of the biologically based inherent racial difference and the inferiority of African Americans and all other non-whites. It was not until the turn of century that African American photographers developed a distinctive aesthetic as a conscious strategy to counter the pejorative imagery that pervaded American culture.

Antebellum Era. One of the first people to bring the new daguerreotype technology to the USA was Jules Lion (1810–66), a French artist of African descent. Lion had moved to New Orleans in 1837 but was back in Paris when Daguerre made his discovery public and obtained instruction in the new medium. When he returned to New Orleans in 1840, he was the first to introduce photography to that region. None of his daguerreotypes are known to have survived.

Two other important African American daguerreotypists were Augustus Washington (1820/1–75) and J. P. Ball. Washington, a free man from Trenton, NJ, trying to finance his education at Dartmouth College, opened a studio in Hartford, CT, in 1846. Circumstances prevented him from completing his education, but his studio was a success. Still, pessimistic about prospects for free persons of color in America, Washington migrated to Liberia in 1853 and operated a studio in Monrovia, the capitol. Washington made a series of portraits of fellow colonists who were members of the Liberian government, providing a rare visual record of American-born African Americans who repatriated to Africa. Ball's Great Daguerrean Gallery of the West in Cincinnati, OH, became one of the nation's largest photographic enterprises. Both Hartford and Cincinnati were abolitionist centers with a Euro-American population predisposed to support African American businesses. During the 19th century, African American photographers depended upon a largely Euro-American clientele. Prior to the Civil War, few free African Americans could afford to have their photographs taken, and few such portraits have survived.

Enslaved Africans sometimes appeared in group portraits of a slaveholding household, and nannies were often included in portraits of young children, holding and displaying the child for the camera. The enslaved Africans appeared on the periphery in such images reinforcing the nation's racial hierarchies while simultaneously suggesting the purported intimacy between the races routinely expressed by slaveholders. In 1850, Swiss-born scientist and Harvard University professor Louis Agassiz (1807–73) pioneered the use photography in support of scientific racism despite his insistence on his political neutrality regarding the slavery debate. Hoping to scientifically prove polygenesis (i.e. that Africans constituted a separate species), Agassiz commissioned James T. Zealy, a daguerreotypist in Columbia, SC, to make a series of images of African-born slaves and their American-born children selected from local plantations. Not readily reproducible, the daguerreotypes did not circulate widely but set an important precedent for the coupling of photography and science in the service of racial hegemony. Rediscovered in the storage attic of Harvard's Peabody Museum of Archaeology and Ethnology in 1976, these images have become notorious examples of how photography had been used to denote racial difference.

Civil War. Just prior to the Civil War, less expensive alternatives to the daguerreotype, such as the ambrotype, ferrotype, and tintype, became available as well as a commercially viable negative/positive process that yielded reproducible paper-based prints. The invention of the *carte-de-visite* in France in 1859 helped to popularize the paper-mounted prints. Photographers, like J. P. Ball, embraced the new technologies, and he remained in business until his death at the end of the century.

The ability to mass-reproduce photographic images also established a market of portraits of cultural heroes and celebrities. Former slaves who effected dramatic escapes from bondage and wrote autobiographies in support of the abolitionist cause were popular photographic subjects. Figures like Frederick Douglass and Sojourner Truth were photographed numerous times. They recognized

that the expressive power of the visual image, and especially the photograph, could be an important tool in their arsenal of weapons to abolish slavery. Truth also had an economic incentive and sold signed copies of her photographs as she toured on the lecture circuit to support herself.

The advent of several wars, including the Crimean War in Europe and the Civil War, made cheap, easily mailed photographs desirable. Soldiers constituted a large market for photographers at mid-century, commissioning portraits of themselves to send to their loved ones. African American soldiers comprised a portion of this market. Having a record of themselves in uniform and being able to lay claim to all the established hallmarks of manhood was an additional incentive. White officers sometimes had their African American pageboys included in their portraits, which would have been a sign of elevated status and/or commitment to slavery. Contrabands, or escaped slaves who joined the Union Army, appeared regularly in camp images. A particularly famous pair of images of the former slave Gordon, one showing the keloid scar tissue from whippings on his back and one showing him in uniform, circulated widely as Union propaganda. Images of a liberated plantation's entire complement of slaves were also taken during this period.

From Reconstruction to Jim Crow. Following the War, African Americans were able to commission portraits in greater numbers, though they were still largely limited financially to only obtaining such images on one or two major life occasions such as a marriage. Photographic portraiture increasingly became a means to articulate a distinctive African American identity, but one that adhered closely to Victorian bourgeois norms. The self-presentation of the sitter was the determining factor in reflecting an African American identity, not the racial background of the photographer. Although African American photographers increased in number during this period, they were not necessarily accessible to every African American patron. Few photographers of the period had the financial wherewithal to observe discriminatory practices—photographers of all racial backgrounds had clients of all races.

Scholarship on individual African American photographers of this period is sparse. Archival collections for several photographers have been identified, such as The Goodridge Brothers, Glenalvin (1829–90), Wallace (1840–1922) and William (1846–90), active in Saginaw, MI; Harry Shepard (1856–?), active in St Paul, MN; Thomas E. Askew (1850?–1914), active in Atlanta, GA; and Daniel Freeman (1868–after 1919?), active in Washington, DC. Preliminary research on these figures has been conducted, but much more remains to be done.

As segregation laws became entrenched in the 1890s, the photography market also polarized, and both African Americans photographers and clients found their options restricted by race. By this time not only could most African Americans afford at least one photographic portrait during their lifetime, a prosperous African American elite had emerged who would begin to accumulate a series of portraits of a single individual over the course of their lifespan. Despite racial barriers, African American photographers had a self-sustaining client pool eager for their services. This promoted the emergence of a distinctive African American aesthetic as photographers and sitters collaborated to produce imagery that reflected their group's tastes, values and aspirations.

BIBLIOGRAPHY

D. Willis: *Black Photographers, 1840–1940: An Illustrated Bio-Bibliography* (New York, 1985)

D. Willis: *Black Photographers, 1940–1988: An Illustrated Bio-Bibliography* (New York, 1988)

D. Willis: *Reflections in Black: A History of Black Photographers, 1840 to the Present* (New York, 2000)

J. Wilson: *Hidden Witness: African-American Images from the Dawn of Photography to the Civil War* (New York, 2000)

Committed to the Image: Contemporary Black Photographers (exh. cat., ed. B. Millstein; New York, Brooklyn Mus. A., 2001)

D. Willis and D. Lewis: *A Small Nation of People: W. E. B. DuBois and African American Portraits of Progress* (New York, 2003)

S. Smith: *Photography on the Color Line: W. E. B. DuBois, Race, and Visual Culture* (Durham, NC, 2004)

R. Kelbaugh: *Introduction to African American Photographs: 1840–1950: Identification, Research, Care & Collecting* (Gettysburg, PA, 2005)

Camara Dia Holloway

Photography in the 20th century

The Paris Exposition of 1900 became the catalyst for a significant development in the history of African American photography. W. E. B. DuBois and Thomas J. Calloway, his former roommate at Fisk University in Nashville, TN, were commissioned to create an exhibition about the "American Negro" for the Palace of Social Economy at the Fair. Several of the historically black colleges and universities that were founded following the Civil War were invited to contribute photographs for inclusion in the display.

Photography was viewed as a practical skill with earning potential unlike that of more traditional fine art media and therefore an acceptable part of the curriculum at such institutions. For example, Leigh Richmond Miner (1864–1935), a Euro-American photographer from Connecticut hired to initiate photographic instruction at the Hampton Normal and Agricultural Institute in Hampton, VA, founded a camera club at the school in 1893 with a combined membership of Euro-American instructors and African American students. Some of those students went on to become professional photographers and later teach at these schools as their faculties were integrated. In 1899, the Hampton Institute Camera Club began a series of photographic illustrations for the first of six books of poems by Paul Lawrence Dunbar.

The famed Euro-American photojournalist, Frances Benjamin Johnston was also at Hampton in 1899 having been invited to take a series of images intended for the "American Negro" exhibit. This album was singled out for a special prize in addition to the prize awarded to the entire exhibit. DuBois was responsible for the organization of several albums of photographs, and the vision of African American life he presented was ideologically distinct from Johnston's. Her images were consistent with the gradual and limited assimilation of African Americans into the broader American culture espoused by the educator Booker T. Washington, a graduate of Hampton and founder of the Tuskegee Institute. DuBois, in contrast, favored unequivocal equality and no restriction to the opportunities that African Americans could pursue. Nevertheless, DuBois' albums also received special recognition and prizes. Both sets of photographs demonstrated that African Americans were thoroughly capable human beings making significant contributions to the nation.

Washington, perhaps to counter the attention that DuBois received, published the book, *A New Negro for a New Century*, illustrated with photographic portraits of important African Americans in 1900. The term "New Negro" was coined in 1895 to describe the new elite group of educated and affluent African American professionals who were markedly different from an older generation born under slavery. The "Old Negro" figure was the point of departure for the bulk of the denigrating stereotypes that circulated in the culture. For example, the Aunt Jemima advertising icon had only just debuted at the 1893 Columbian Exposition in Chicago. While African American image-makers consistently created works that venerated the "Old Negro," it was the "New Negro" that captured their imagination and African American leaders, regardless of their ideological stance, embraced photography as the means to envision this new cultural ideal.

Notable photographers from this period include Arthur P. Bedou (1882–1966) who photographed Washington extensively; Cornelius Marion Battey (1873–1927) who was hired to form the Photographic Division at Tuskegee; Battey's students: P. H. Polk, Elise Forrest Harleston (1891–1970), Andrew T. Kelley (circa 1890–1965) and Ellie Lee Weems (1901–83); and Addison Scurlock (1883–1964), the official photographer of Howard University in Washington, DC. They would set the stage for the explosion of African American photography that came after the Great War.

Harlem Renaissance. The Great War galvanized African Americans. The war effort's demand for labor intensified the migration of African Americans from the rural South to urban centers in the North and West resulting in the largest demographic shift of African Americans in the history of the nation. The modernization and urbanization of African Americans during this Great Migration fostered a sense of a national black community with common goals and desires and a defined leadership that articulated this group's views to the larger national community. When African American soldiers were allowed to join the war theater as combatants and performed with exceptional valor, African Americans felt that they had demonstrated the validity of their claims for equality and full citizenship. The New Negro icon gained in importance as a symbol that communicated these ideas to the national audience.

African American photographers played a crucial role in developing the iconography of the modern, urbane African American. African Americans patronized a growing number of African American photographers who operated studios in the segregated urban communities that they found themselves settling in. Larger cities with substantial African American populations, such as New York City's Harlem, the largest and most culturally significant African American community in the nation, provided enough business for multiple photography studios. Despite the existence of snapshot photography, formal studio portraiture was the consumer preference during this period. For African Americans, photographers like James Van Der Zee, Eddie Elcha (active 1900–30s), Paul Poole (1886–c. 1955), Richard S. Roberts (1881–1936) and Florestine Perrault Collins (1895–1987) enabled them to refashion themselves as New Negroes.

The Harlem photographer James L. Allen (1907–77) played a special role in the development of New Negro iconography. He photographed the cultural, intellectual and political elite of the African American community. The men and women of arts and letters who created the cultural products of the so-called Harlem Renaissance, or New Negro cultural movement, and the leaders who advocated on behalf of African Americans, most of whom passed through Harlem during this period, posed for Allen. Allen pursued an artistic career and therefore shared their aesthetic sensibilities and aspirations. Not only did he exhibit his work alongside theirs, Allen's portraits of these figures were widely reproduced in African American periodicals as New Negro exemplars for others to emulate.

Documentary Photography. Like other periodical publications, African American periodicals took advantage of the half-tone printing process that allowed for the mass duplication of photographs alongside text. With the invention of the 35-mm single-lens reflex camera, candid street photography became easier and publishers were able to get those images to their audiences rapidly. Photography became the predominant vehicle for the dissemination of visual information. Since periodicals for the Euro-American audience tended to only include African American topics of the most salacious or pathological nature, African American photojournalists emerged to record a community-based perspective of everyday African American life. Photographers like Allen E. Cole (1893–1970); Charles "Teenie" Harris (1908–98); Robert Scurlock (1916–94) and George H. Scurlock (1919–2005); Moneta J. Sleet (1926–96); Morgan (1910–93) and Marvin Smith (1910–2003); and Ernest C. Withers (1922–2007) supplied an image of African American life that countered the generally negative opinion that held sway in the American imagination.

Photographers interested in recording everyday life also published extended photographic essays in book format. Sometimes they worked independently or were commissioned by both businesses and non-profit organizations to produce projects. Many photographers of all racial heritages found African American life and sites like Harlem a compelling photographic subject. Due to the severe impact of the Great Depression on African

Americans, these so-called documentary photographers, however liberal and sympathetic, tended to approach the African Americans they documented as victims. The Historical Section of the Farm Security Administration, created by the federal government in 1935, which hired many of the leading photographers of the era, set the prevailing tone for documentary photography and encouraged this romanticized "aesthetic of poverty."

It was not until 1942 that Gordon Parks became the first African American photographer hired for the FSA project. Parks would continue to work with Roy Stryker, the project's director, when the FSA was converted to the Office of War Information with the outbreak of World War Two. After the war, Parks would be the first African American hired as a staff photographer for *Life* magazine. Robert H. McNeill (1917–2005) also worked for a New Deal era federal agency, the Federal Writer's Project, which resulted in the publication of *The Negro in Virginia* (1940). Such projects underscored the role that racism played in shaping the lives of African Americans, a perspective that would carry through African American photojournalism during the Civil Rights era and beyond.

Roy DeCarava formed a crucial link between the artistic aspirations of the Harlem Renaissance and contemporary art photography. Born in Harlem, DeCarava studied art at the Cooper Union, the Harlem Community Art Center and the George Washington Carver School. He turned exclusively to photography in 1949 and became the first African American to receive the John Simon Guggenheim Memorial Fellowship in 1952. The fellowship resulted in the publication of *The Sweet Flypaper of Life* (1955), a photographic essay of Harlem that featured a text by famed poet Langston Hughes. Although these early images were similar to street photographs, DeCarava always saw the camera as a means of artistic expression. Using black and white film, available light and exacting printing technique, DeCarava created works like *The Hallway* (1953; Washington, DC, N. G. A) that extend beyond the literal description of places, people and things to make powerful symbolic and emotive statements.

Uncomfortable with the demands of commercial freelance photography, DeCarava switched to teaching in 1975. He was a member of the faculty of Hunter College up until his death. He also constantly strove to promote photography as a fine art. In 1955, he opened "A Photographer's Gallery," one of the first galleries in New York devoted exclusively to fine art photography. From 1963 to 1966, he ran the Kamoinge Workshop for African American photographers. Opposing its approach to photography and African American art, DeCarava declined to participate in the Metropolitan Museum of Art's 1969 exhibition, *Harlem on My Mind*. DeCarava's photographic work has been the subject of many exhibitions, including a retrospective at The Museum of Modern Art in 1996. For his contributions, DeCarava was awarded the National Medal of Arts in 2006.

Contemporary Photography. Important social phenomena led to the most recent developments in African American photography: the impact of desegregation and the social movements of the 1960s and 1970s and the resurgence of a photography market increased availability of photographic instruction and scholarship on photography. Photographers like Dawoud Bey, Albert Chong (*b* 1958), Lorna Simpson (*b* 1960), Pat Ward Williams (*b* 1948) and Carrie Mae Weems (*b* 1950) have paid special attention to the history of photography and how African Americans have been represented in photographs as a key facet of their work. They tend to combine traditional photography with other media and text and make multi-paneled pieces on a large scale to create works that bear much in common with other contemporary art practices. Many photographers have also embraced the use of color and the digital revolution.

BIBLIOGRAPHY

D. Willis: *Black Photographers, 1840–1940: An Illustrated Bio-Bibliography* (New York, 1985)

D. Willis: *Black Photographers, 1940–1988: An Illustrated Bio-Bibliography* (New York, 1988)

D. Willis: *Reflections in Black: A History of Black Photographers, 1840 to the Present* (New York, 2000)

J. Wilson: *Hidden Witness: African-American Images from the Dawn of Photography to the Civil War* (New York, 2000)

Committed to the Image: Contemporary Black Photographers (exh. cat., ed. B. Millstein; New York, Brooklyn Mus. A., 2001)

D. Willis and D. Lewis: *A Small Nation of People: W. E. B. DuBois and African American Portraits of Progress* (New York, 2003)

S. Smith: *Photography on the Color Line: W. E. B. DuBois, Race, and Visual Culture* (Durham, NC, 2004)

R. Kelbaugh: *Introduction to African American Photographs: 1840–1950: Identification, Research, Care & Collecting* (Gettysburg, PA, 2005)

Camara Dia Holloway

Vernacular art

A field of African American visual culture that ranges from popular decorative, commemorative and healing practices to the creative production of individual artists who have gained recognition in the art world as folk, outsider, visionary and self-taught artists. Grounded in the African Diaspora, these practices are culturally syncretic, mixing African signifying practices—from cultures such as those of the Yoruba, Kongo, Fon and Ejagham—with those of European American cultures throughout the Americas and the Caribbean. African American vernacular art flourished initially in the American South, but has spread to major urban centers with significant African American populations. This category may be roughly divided into the following practices that are not mutually exclusive: cemetery decoration, yardwork, rootwork, spirit writing, woodcarving, ceramics and textile work.

Preeminent scholar and pioneering art historian Robert Farris Thompson has contextualized much African American vernacular art within the way of life of the Bakongo people. Tracing ever-changing cultural continuations, from the Kongo culture (in what is now the Democratice Republic of Congo, formerly Zaïre) to the Americas, Thompson identified a central locus of vernacular expression in varied practices of cemetery decoration to both honor and guide the spirits of the dead, such as the use of plates, cups, seashells (predominantly white), carved chickens, trees adorned with empty bottles, found or constructed images of airplanes or other vehicles to signify spirit passage, and the repeated use of circular-shaped objects derived from variations on the Bakongo cosmological map or "cosmogram," or cross within a circle. Another crucial Bakongo tradition related to these practices is that of *nkisi* (pl. *minkisi*), charms or bundles filled with medicinal objects and materials intended to guide the spirit.

These funerary and medicinal practices have been reinvented at the grassroots level by African Americans who practice yardwork, some of whom have been recognized for extraordinary creative inventiveness. One of the first African American yards to receive serious attention was that of Henry Dorsey of Brownsboro, KY. Thompson broke new ground by "reading" Dorsey's elaborate yard according to his knowledge of Kongo culture and philosophy, recognizing spirit-directing messages in his assortment of found objects such as fans, tires, machine parts and carefully displayed dolls. Thompson also devoted serious attention to Gyp Packnett of Centerville, MI, and with the help of art historian Judith McWillie, presented elements from his yard in his exhibition *Face of the Gods: Art and Altars of Africa and the African Americas* (1992) at the Museum for African Art in New York.

Anthropologist Grey Gundaker, a former student of Thompson, has recognized "vernacular literacy" at work in yardwork and has effectively "read" a number of extraordinary African American yards, including that of William Edmondson of Nashville, TN, the first African American to have been given a solo exhibition at the Museum of Modern Art in 1938. Thompson, McWillie and Gundaker have made the case for understanding African American yardwork as more than simply decorative, but rather a continuation of cultural signification that cannot be reduced to the Western notion of artistic expression. Nevertheless, yardwork and discrete assemblages

constructed by means of yardwork strategies, have been received, collected, analyzed and celebrated as works of art.

Lonnie Holly's elaborate yards in Alabama (now destroyed) gained the attention of the folk art and outsider art worlds. His discrete assemblages are now highly valued and are included in the collections of the American Folk Art Museum in New York, the High Museum of Art in Atlanta, GA, and the Smithsonian American Art Museum in Washington, DC, among many others. Another artist whose work began in, but moved away from, the yard context, is Thornton Dial, who has become known not only for his mixed-media assemblages, but also for his major canvases and large-scale, lyrical drawings. Other African American yardworkers who have been recognized as major artists include the Reverend George Kornegay (b 1913) of Brent, AL, David Butler (1898–1997) of Patterson, LA, Nellie Mae Rowe (1900–82) of Atlanta, GA, Joe Minter (b 1935) of Birmingham, AL, T. Smith of Hazlehurst, MS, Joe Light (1934–2005) of Memphis, TN, Robert Howell of Richmond, VA, and Curtis Cuffie (1955–2002) of New York.

Thompson recognized the healing impulse of the *nkisi* tradition as generative of a range of creative practices, including *The Throne of the Third Heaven of the Nations Millennium General Assembly* (c. 1950–64; Washington, DC, Smithsonian Amer. A. Mus.) by James Hampton (1909–64), an extensive throne and altar built of found furniture, mixed-media and tin foil in a garage in Washington, DC. This monument was intended to be housed within a storefront church. Another grouping of artists whose works grew out of *nkisi* are rootworkers—individuals using tree roots as charms within practices known as hoodoo or conjure. Rootworkers who have gained recognition by other artists include Bessie Harvey of Alcoa, TN, and Ralph Griffin (b 1925) of Girard, GA. Both artists used paint and mixed media to transform found roots, branches and stumps into anthropomorphic and zoomorphic works. The healing intention of the *nkisi* continued in Harvey's work,

which she intended to carry properties of spiritual healing literally. Another example of the continuation and reinvention of *nkisi* in African American vernacular art is the legacy of the so-called Philadelphia Wireman, the name given to the anonymous artist responsible for producing two boxes full of small, overwrought, intensely wrapped wire and mixed-media objects, recovered on a street in Philadelphia in 1982.

A dominant, but nevertheless significant category of African American vernacular art has grown out of African diasporic spirit-writing practices. Although diaspora scholars have extended the notion of vernacular literacy to all of African American visual culture—including visual "puns" in yardwork—specific graphic practices derived from *Nsibidi* script and the above-mentioned Kongo cosmographic sign system, or *dikenga*, among many others. Essentially syncretic, diasporic practices have mixed with the European religious notion of glossolalia ("speaking in tongues"). Individuals whose inventive script-writing practices have been received as art included John B. Murray (1908–88) of Glasgock County, GA, whose feather spirit-writing evolved into a painting practice often described as expressionistic; Zebedee Armstrong (1911–93), who painted clocks and timepieces; and Mattie Blackman of Colquit, GA, who surrounded the perimeter of her yard with bottles painted with spirit-script for the purpose of protection.

Ceramic face-vessels (or face-jugs), also probably of Bakongo origin, spread through the African Americas. Predominantly Southern, face-vessels vary widely, but the common thread is a grotesque and often humorous physiognomy. The mixed-media clay skulls of James "Son Ford" Thomas (1926–93) of Leland, MS, represent a particular reinvention of this ongoing genre.

Diasporic carving practices, in both stone and wood, comprise a significant element of African American vernacular art. William Edmondson, mentioned above for his yardwork, carved human figures and animals in limestone. Woodcarvers of note include William Rodgers and Jesse Aaron

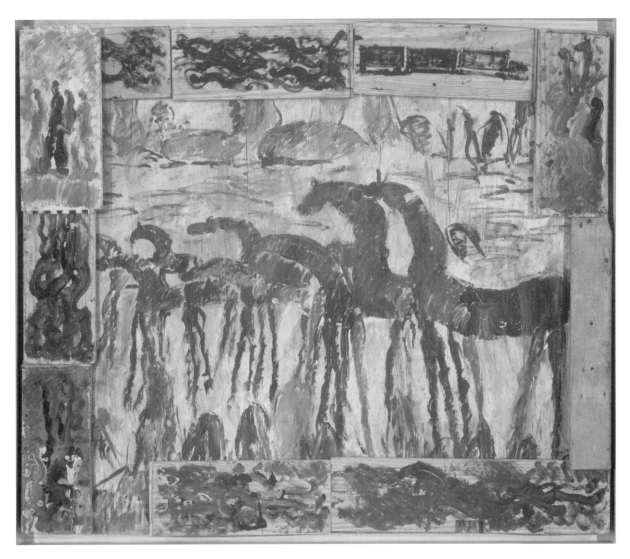

AFRICAN AMERICAN ART: VERNACULAR ART. *Untitled* by Purvis Young, acrylic on plywood with fiberboard, 1029 × 1232 mm, *c.* 1988. COURTESY OF SKOT FOREMAN FINE ART/© SMITHSONIAN AMERICAN ART MUSEUM, WASHINGTON, DC/ART RESOURCE, NY

(1887–1979) of Lake City, FL, who both carved walking sticks; Elijah Pierce (1892–1984) of Columbus, OH, and his student, Leroy Almon Sr. (1938–97) of Tallapoosa, FL, who both crafted relief carvings ranging from moral (Christian) narratives to African American history. An outstanding woodcarver whose work ranged from chairs to enigmatic abstract shapes was Leroy Person (1907–85) of Occoneechee, NC. Although much of Person's work is extant in major collections, much has been lost, including the artist's elaborate carvings on his house

and the surrounding fence. Another carver of great talent was Ulysses S. Davis (1914–90) of Savannah, GA, whose varied wood-carvings ranged from portrait busts of US Presidents to fantastical creatures, to abstract forms.

Maude Southwell Wahlman, another student of Thompson, has argued convincingly for the understanding of African American quiltmaking as a continuation of African textile production. She has identified a number of traits marking continuity in this diasporic continuation of textile-making:

verticality of design, the use of bright colors, large designs, asymmetry, improvisation and symbolic forms, among many others. An early quilter of note was Harriet Powers of Athens, GA, whose "Bible Quilt" (1886) and "Pictorial Quilt" (1889) are outstanding examples of African American narrative in which appliqué is used to present a narrative. Vibrant, brightly colored patchwork quilts from used clothing and other found cloth have gained increasing popularity, especially the quilts made by women in rural Gee's Bend, AL, including Mary Lee Bendolph (*b* 1935), Ruth Mosely, Loretta Pettway (*b* 1942) and Annie Mae Young (*b* 1928), among many others. Although Wahlman and others have exhaustively proven the diasporic context in which these quilts were conceived, there is a push to view these within the purview of modernist abstraction. The debate over whether to view African American quilts within the context of European abstraction or African American vernacular culture continues.

There have been a significant number of exhibitions presenting African American vernacular art in recent years. A short sampling includes: *Black Quilters* (1980; New Haven, Yale U. Sch. A. & Archit. Gal.), *Another Face of the Diamond: Pathways Through the Black Atlantic South* (1989; New York, INTAR Latin American Gallery), *Face of the Gods: Art and Altars of Africa and the African Americas* (1993; New York, Mus. Afr. A.), *The Migration of Meaning* (1992; New York, INTAR Latin American Gallery), *The Quilts of Gee's Bend* (2002, Houston, TX, Mus. F.A.) and *Ancestry and Innovation: African-American Art From the Collection* (2005; New York, Amer. Folk A. Mus.).

[*See also* Dial, Thornton; Harvey, Bessie; *and* Powers, Harriet.]

BIBLIOGRAPHY

The Four Moments of the Sun: Kongo Art in Two Worlds (exh. cat. by R. F. Thompson, Washington, DC, N.G.A., 1981)

"Black American Folk Art: Origins and Early Manifestations," *Black Folk Art in America: 1930–1980* (exh. cat. by R. Perry, Washington, DC, Corcoran Gal. A., 1982)

R. F. Thompson: *Flash of the Spirit: African and Afro-American Art and Philosophy*. (New York, 1984)

Another Face of the Diamond: Pathways Through the Black Atlantic South, (exh. cat. by J. M. McWillie and others, New York, INTAR Latin American Gallery, 1989)

G. Gundaker: *Even The Deep Things of God: A Quality of Mind in Afro-Atlantic Traditional Art* (Pittsburgh, 1990)

The Migration of Meaning (exh. cat. by J. M. McWillie and others, New York, INTAR Latin American Gallery, 1992)

M. S. Wahlman: *Signs and Symbols: African Images in African-American Quilts* (New York, 1993)

Ashe: Improvisation and Recycling in African-American Self-Taught Art (exh. cat. by T. Patterson, Winston-Salem, NC, Diggs Gal., 1993)

Face of the Gods: Art and Altars of Africa and the African Americas (exh. cat. by R. F. Thompson, New York, Mus. Afr. A., 1993)

G. Gundaker: *Keep Your Head to the Sky: Interpreting African American Home Ground* (Charlottesville, 1998)

G. Gundaker: *Signs of Diaspora/Diaspora of Signs: Literacies, Creolization, and Vernacular Practice in African America* (New York, 1998)

P. Arnett and W. Arnett, eds.: *Souls Grown Deep: African American Vernacular Art of the South, Volume I: The Tree Gave the Dove a Leaf* (Atlanta, GA, 2000)

P. Arnett and W. Arnett, eds.: *Souls Grown Deep: African American Vernacular Art of the South, Volume II.* (Atlanta, GA, 2001)

J. Beardsley, A. Wardlaw and P. C. Marzio, eds.: *The Quilts of Gee's Bend* (Atlanta, GA, 2002)

G. Gundaker and J. M. Willie: *No Space Hidden: The Spirit of African American Yard Work* (Knoxville, 2005)

G. Gundaker: "Scriptures Beyond Script: Some African Diasporic Occasions," *Theorizing Scriptures: New Critical Orientations to a Cultural Phenomenon*, ed. V. L. Wimbush (New Brunswick, 2008), pp. 155, 156–66

Jenifer P. Borum

African American expatriate artists

Group of African American artists active in France in the 1920s and 1930s. Between the world wars, Paris became a Mecca for a "lost generation" of Americans. Hundreds of artists, musicians and writers from all over the world flocked to the French capital in search of a sense of community and freedom to be creative. For African Americans, the lure of Paris was enhanced by fear of and disgust with widespread

racial discrimination experienced in the USA. They sought a more nurturing environment where their work would receive serious attention, as well as the chance to study many of the world's greatest cultural achievements. France offered this along with an active black diasporal community with a growing sense of Pan-Africanism. Painters, sculptors and printmakers thrived there, studying at the finest art academies, exhibiting at respected salons, winning awards, seeing choice art collections, mingling with people of diverse ethnic origins, dancing to jazz and fervently discussing art, race, literature, philosophy and politics. Although their individual experiences differed widely, they had much in common, including exposure to traditional European art, African art, modern art and proto-Negritude ideas. As a result of their stay in Paris, all were affected artistically, socially and politically in positive ways and most went on to have distinguished careers.

At least a dozen African American artists went to Paris between 1922 and 1934, and they constituted quite a diverse group. Gwendolyn Bennett (1902–81), Aaron Douglas, William Thompson Goss (b 1894), William Emmett Grant (fl. 1929–31), Palmer Hayden, William H. Johnson, Archibald J. Motley Jr., Nancy Elizabeth Prophet, Augusta Savage, Albert Alexander Smith, Laura Wheeler Waring and Hale Woodruff came from all over the USA. Almost all moved from their small hometowns to attend art schools in larger cities; few, though, enrolled at the same institution. These artists had in common dedicated teachers who had studied in Paris and who urged their students to do the same. In addition, nearly all supported themselves through school by working a variety of odd jobs. All but two of the artists were more than 32 years of age by the time they went to Europe.

The experiences of African American artists in Paris during the interwar years were distinctive, yet they shared some of the same benefits and challenges as other foreign artists there at the same time, such as a loose sense of community and an ambivalence about the city and their place in it. What made them unique was the kind of art they produced and the ways in which they marketed those images. Ever aware of multiple audiences they created diverse works. Their stylistic approaches, although mostly academic and rarely avant-garde, were less exciting than the subjects they tackled. These ranged from conservative landscapes and depictions of French landmarks to Cubist and near-abstract compositions. These artists also explored two main themes that were occupying French artists at the same time, those of modernity and nostalgia. The concept of nostalgia, or more specifically of longing for both an earlier, mythical time in America's folk history and a grand, exotic vision of Africa, is all the more intriguing given the use of stereotypes by these artists. The reliance on, expansion and subversion of black stereotypes were certainly conditioned and affirmed in large part by white American and European patronage. Yet there was considerable agency and choice on the part of the producers as well.

In the first half of the 19th century, most artists in Paris studied at the Ecole des Beaux-Arts. At the turn of the century, many American artists went to the privately operated Académie Julian. They were attracted by the school's live models, critiques by professors, longer studio hours and the lack of an entrance examination. Henry Ossawa Tanner was the first African American artist to study at the Académie Julian; followed by Annie E.A. Walker, William Harper, William Edouard Scott and Gwendolyn Bennett. However, by the late 1920s, the Académie had lost its appeal and rigor, and Woodruff quickly dropped out in favor of the recently founded académies Moderne and Scandinave. Douglas and Savage also attended the latter school. These institutions, along with the Académie de la Grande Chaumière, were attractive because of their smaller classes and more personalized attention. Others preferred the long-standing prestige of national schools; Prophet worked at the Ecole des Beaux-Arts, and Smith studied old master printmaking techniques at the Académie Royale des Beaux-Arts in Brussels.

African American artists depicted famous landmarks, such as the Pont Neuf and Sacré-Coeur (both in Paris), Chartres, Cluny, Versailles and Parisian cafes, markets and street scenes, which sold well. Jazz performer Albert Alexander Smith partially supported himself by offering inexpensive prints of such scenes to the tourist market. The *Indianapolis Star* newspaper paid Woodruff for his sketches of and comments about celebrated landmarks, and Hayden learned that American buyers admired his watercolors of French folk and trade. Images of Parisian nightlife were also popular, and Smith, Hayden, and Motley captured the heady atmosphere of crowded nightclubs.

Few members of the "Negro colony" ever associated with the famous white American community in Paris in the 1920s, which included such literary figures as Ernest Hemingway and F. Scott Fitzgerald. Bennett did go to tea at the homes of Gertrude Stein, Sylvia Beach (owner of the Shakespeare & Company Bookstore), Konrad Bercovoci and even Henri Matisse, while Woodruff met Kay Boyle, Raymond Duncan and George Antheil, but they were never mentioned in the memoirs of these prominent people. While African American artists seemed to have been invisible to this group, their interactions with them were mostly positive.

African American artists depicted other parts of France as well. Hayden traveled throughout Brittany filling his sketchbooks with seascapes and workers in the fishing village of Concarneau. Smith went north to Trouville, the coastal resort so popular among the bourgeois in the late 19th century. Johnson and Woodruff followed painter Chaim Soutine's path south to Cagnes-sur-Mer, an artists' colony on the Riviera.

While few African American artists in France between the world wars worked in a Cubist mode, all were quite conscious of the inspirational role that African sculpture played in the development of this modernist style. Woodruff claimed that after *Les Demoiselles d'Avignon* (1907; New York, MOMA) by Pablo Picasso (1881–1973) clarified the relationship between modern French art and African art for him, he bought his first pieces, a Yoruba Shango staff and a Bemba male figure, at a flea market in Paris. Philosopher Alain Locke, who made his own purchases, accompanied Woodruff on these forays. Locke built a large collection of African art during his European travels and lectured widely on its influence in the works of modern French painters. Like W.E.B. Du Bois, Locke urged African Americans to take pride in and depict their African heritage. In his important anthology of writings by and about young black artists, *The New Negro* (1925), he strongly advised the new generation to "look to the art of the ancestors" for inspiration in creating racially representative art. Not all African American artists heeded Locke's charge, however. Hayden was, in fact, the only African American artist in Paris between the world wars who included a likeness of an African sculpture in his painting *Fétiche et Fleurs* (c. 1923).

As Paris was an international metropolis that was part of the African diaspora, African American artists were able to depict Africans and people of African descent in their art while they were in Paris. Working from live models, Motley painted Senegalese and Martinicans, while Prophet sculptured powerfully meditative portrait busts of black men, and Savage produced a half figure of an African female warrior holding a spear.

Affected by the influence of African sculpture on modern art and jazz, and by the arrival of the singer Josephine Baker in 1925, Parisians were enthralled by black culture between the world wars, and African American artists benefited from the plethora of publications on the subject. However, although the rising popularity of black culture in Paris no doubt contributed to the commercial and exhibition success of some African American artists, for the most part, they earned critical attention solely on artistic merit rather than on racial grounds, and collectively, they demonstrated an impressive exhibition history.

African American artistic activity in Paris peaked between 1922 and 1934. By 1931, however, those African Americans who remained had begun to feel

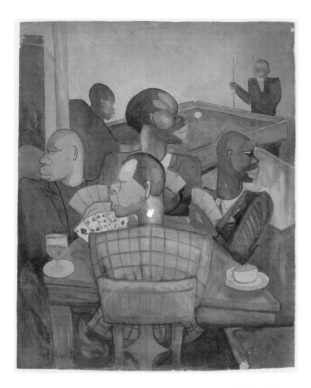

AFRICAN AMERICAN EXPATRIATE ARTISTS. *Nous Quatre à Paris (We Four in Paris)* by Palmer Hayden, watercolor and pencil on paper, 552 × 460 mm, *c.* 1930. GIFT OF THE JOSEPH H. HAZEN FOUNDATION INC., 1975 © THE METROPOLITAN MUSEUM OF ART/ART RESOURCE, NY

the effects of the Great Depression in France. By that year, almost all of the African American artists had returned to America. Study and success in Paris were crucial to African American expatriates and the Negro colony. In this challenging and stimulating environment, they proved their talents and enriched their visions, while in the process forever changing their lives. Although the artists came from disparate backgrounds throughout the USA and their works differed dramatically in style and content, they had much in common in terms of class, origin, education, patronage, experiences, achievements abroad, artistic development and subject matter and careers. Paris provided a formidable and dynamic site for these intersections and fostered a coming of age.

[*See also* Douglas, Aaron; Hayden, Palmer Cole; Johnson, William H.; Motley, Archibald J., Jr.; Prophet, Nancy Elizabeth; Savage, Augusta; Smith, Albert Alexander; Tanner, Henry Osawa; Waring, Laura Wheeler; *and* Woodruff, Hale.]

BIBLIOGRAPHY

T. Leininger-Miller: "Heads of Thought and Reflection: Busts of African Warriors by Nancy Elizabeth Prophet and Augusta Savage, African American Sculptors in Paris, 1922–1934," *Out of Context: American Artists Abroad*, ed. L. Fattal and C. Salus (Westport, 2004), pp. 93–111

T. Leininger-Miller: "Modern Dancers and African Amazons: Augusta Savage's Sculptures of Women, 1929–1930," *The Modern Woman Revisited: Paris Between the Wars*, ed. W. Chadwick and T. T. Latimer (New Brunswick, 2003), pp. 183–97

T. Leininger-Miller: *New Negro Artists in Paris: African American Painters and Sculptors in the City of Light, 1922–1934* (New Brunswick, 2001)

T. Leininger-Miller: "The Transatlantic Connection: New Negro Artists in Paris, 1922–1934," *Harlem Renaissance* (Oklahoma City, 2009), pp. 77–101

Theresa Leininger-Miller

AFRICOBRA (African Commune of Bad Relevant Artists)

African American group of artists. AFRICOBRA was an art movement formed in Chicago in 1968 by a coalition of eight African American artists devoted to celebrating and affirming the legitimacy of black artistic expression. The movement paralleled the black cultural revolution of the 1960s and incorporated elements of free jazz, vibrant color, the spiritual or transcendental and "TransAfricanism." The term TransAfricanism was invented and defined by Jeff Donaldson (1932–2004), one of AFRICOBRA's principal founders, as a transcendent African-based aesthetic that simultaneously defines, directs, and fashions historical evolution. AFRICOBRA sought to develop a new and revolutionary black aesthetic based on African and African American approaches to art, taste and beauty. These aspirations were combined with principles of social responsibility and involvement of artists in their local communities. The goal was to promote and instill pride in black self-identity through a self-defined black visual aesthetic.

Unlike most prior movements within African American art, AFRICOBRA's work was not individualistic, but rather, focused on collectivity and collaboration. AFRICOBRA grew out of the Chicago-based artists' workshop OBAC (Organization of Black American Culture), whose founders included Donaldson, Wadsworth Jarrell (*b* 1929) and Barbara Jones-Hogu (1938–78). These artists collaborated and spearheaded the creation of a public mural on the exterior walls of a building on the Southside of Chicago and called the Wall of Respect (1967; destr. 1971). The mural became a flashpoint of the black cultural nationalist revolutionary and Black Arts movement of the late 1960s. It was highly controversial at the time and displayed themes such as African American heroes, musicians, writers and political leaders that had been collectively chosen by adherents to AFRICOBRA.

The AFRICOBRA collective consisted of painters, photographers, printmakers, textile designers and sculptors. Its aesthetic objectives included five key elements: "awesome energy" that moves the viewer and fuses social and spiritual awareness; "free symmetry" or a poly-rhythmic randomness that is likened to jazz; a compositional inner glow or "shine" that emits a spirituality that is "unassuming, celestial and serene," thus allowing the viewer to connect with the work on a transcendental level. (This "shine" can be derived from or seen in popular icons or symbols of African American culture.) Another element is the use of strong and radiant "Kool-Aid colors" (orange, strawberry, cherry, lemon, lime and grape) that communicate energy and the intensity of African textiles and elaborate and resonate on a conscious and unconscious level characteristic of non-Western, specifically African, aesthetics. Finally, recurrent themes or subject matter, such as the snake, considered "TransAfrican" in nature, and linked to an inherited ancestral aesthetic; or the black dot, signifying blackness and origin, also appear. In some AFRICOBRA paintings Egyptian themes and their relationship to the black community are a significant focus.

The key original AFRICOBRA members included: Napoleon Henderson, Wadsworth Jarrell, Jay Jarrell, Michael Harris, Nelson Stevens, Ron Anderson, Jeff Donaldson, Frank Smith, Barbara Jones-Hogu, Carol Lawrence, Murry De Pillars, Omar Lama and Sherman Beck.

BIBLIOGRAPHY

R. L. Douglas: *Wadsworth Jarrell: The Artist as Revolutionary* (San Francisco, 1996)

S. F. Patton: *African-American Art* (New York, 1998)

J. E. Smethurst: *The Black Arts Movement: Literary Nationalism in the 1960s and 1970s* (Chapel Hill, NC, 2005)

G. Lock and D. Murray, eds.: *The Hearing Eye: Jazz & Blues Influences in African American Visual Art* (New York, 2009)

James Smalls

Agrest, Diana

(*b* Buenos Aires, 1945), architect and theorist of Argentine birth. Agrest received her Diploma of Architecture at the University of Buenos Aires in 1967 and studied further in Paris at the Ecole Pratique des Hautes Etudes and the Centre du Recherche d'Urbanisme (1967–9). She moved to New York in 1971. From 1976 Agrest taught at Cooper Union, New York, and at Columbia, Princeton and Yale universities. In 1980 she went into partnership with her husband, Mario Gandelsonas (*b* 1938), in the firm A & G Development Consultants, Inc., in New York. She also formed her own firm, Diana Agrest, Architect, in New York. Agrest was deeply involved in theoretical research and was a Fellow at the Institute for Architecture and Urban Studies, New York, from 1972 to 1984. She was strongly influenced by semiotics and developed the idea that architecture can refer beyond itself, discussed particularly in her essay on architecture and film (1991). She also argued for a contextual and integrative approach to architecture, as seen in her master plan (1986) for Deep Ellum, Dallas, which proposes a development for a section of downtown Dallas, integrating retail, office and residential spaces.

The visual concerns of the plan are classically orientated toward symmetry and clarity. Surfaces are characterized by unornamented planarity. This severity also appeared in Agrest's designs for *Shingle–Schinkel Holiday House* (1981–2). The shingle siding and roof refer to the traditions of the projected East Hampton location, and they enliven the surfaces of the otherwise severe cubic forms, which include two towers. Agrest and Gandelsonas also designed office and apartment interiors and furniture. These interiors (e.g. Park Avenue apartment, *c.* 1990) can be somewhat playful, combining materials such as pink marble, granite and exotic woods, yet they are still geometrically severe.

WRITINGS

with M. Gandelsonas: "Two Pavilion House" and "Shingle Schinkel," *Lotus Int.*, 44 (1984), pp. 51–4; 55–7

Architecture from Without: Theoretical Framings for a Critical Practice (Cambridge, MA, 1991); review by R. Moore in *Archit. Rev.* [London], cxc/1143 (1992), p. 13

with M. Gandelsonas: *Agrest and Gandelsonas: Works* (New York, 1995)

with S. Allen: *Practice: Architecture, Technique and Representation* (2000)

BIBLIOGRAPHY

"Deep Ellum, Dallas, Texas," *Lotus Int.*, 50 (1986), pp. 47–57

C. Lorenz: *Women in Architecture: A Contemporary Perspective* (New York, 1990), pp. 10–1

"Agrest and Gandelsonas," *Archit. Dig.* (1991), pp. 20–1

Walter Smith

AIA Gold Medal

Established in 1907 the Gold Medal's purposes were several: to commemorate the 50th anniversary of the founding of the American Institute of Architects (AIA), to recognize individuals for their accomplishments and to increase public awareness of architecture. Modeled on European medals such as the Royal Institute of British Architects (RIBA) Gold Medal (established in 1848), Charles McKim (Gold Medal awarded 1909), a leading New York architect and the instigator of the America medal, wanted to demonstrate that the United States and its architecture had come of age.

From the very first presentation to Sir Aston Webb (1907) the medal was intended to be international in its recognition of architects, although those who have practiced in the United States dominate the list. About 20 of the Gold Medalists, such as Alvar Aalto (1963), Kenzō Tange (1966), Tadao Andō (2002) and Glenn Murcutt (2009), have made their primary reputations abroad.

What the Gold Medal has recognized over the years has varied widely. Many of the early Gold Medalists made their mark as classically oriented designers. This was followed by those who practiced in a more Art Deco vein, and then in the mid-1950s Modernism became popular, followed, in more recent years, by those with reputations as Post-modernists.

Style is but one way of understanding the Gold Medal, for while all the medalists are associated with major buildings, they are also recognized for their technological accomplishments, such as Auguste Perret (1952) for his work in concrete, R. Buckminster Fuller (1970) for his experimental structures and Santiago Calatrava (2005) for his suspension systems. Other important areas of Gold Medal recognition include education and theory, honoring Louis Kahn (1971), Josep Lluis Sert (1981) and Samuel "Sambo" Mockbee (2004), while the transformation of architectural practice and the rise of the large firm are reflected in awards to Louis Skidmore (1957), John Wellborn Root II (1958), Wallace K. Harrison (1967), Nathaniel Owings (1983) and William W. Caudill (1985).

The Gold Medal presents an interesting picture of what the professional American architect has seen fit to recognize in built forms, new and innovative use of materials and design processes and ideas.

BIBLIOGRAPHY

R. G. Wilson: *The AIA Gold Medal* (New York, 1983)

N. Solomon, ed.: *Architecture: Celebrating the Past, Designing the Future* (2008)

Richard Guy Wilson

Ain, Gregory

(*b* Pittsburgh, PA, 28 March 1908; *d* 9 Jan 1988), architect. Ain's major contribution was creating modernist medium- and low-cost housing. He received his architectural training at the School of Architecture (1927–8), University of Southern California, Los Angeles. He worked with Rudolph Schindler (1932) and Richard Neutra (1932–5), who both influenced his development greatly. In 1936 he opened his own office in Los Angeles. His principal early work consisted of private houses in the Los Angeles area, but like both Schindler and Neutra, Ain had a marked interest in low-cost housing. One example is his Dunsmuir Flats (1937–9), 1281 South Dunsmuir Avenue, Los Angeles. In 1940 Ain received a Guggenheim Fellowship to explore a system of panel design for such housing. In collaboration with landscape architect Garrett Eckbo (1910–2000) Ain produced setback housing units in garden settings for various locations in the Los Angeles area; most notable were Park Planned Homes (1946), Altadena, CA, and two groups in Los Angeles, the Mar Vista Housing complex and the Avenel Housing complex, 1939–45 Avenel Street, Silver Lake (both 1948; in 2005 the Avenel housing complex was listed in the National Register of Historic Places). In 1950, with Joseph Johnson and Alfred Day, Ain designed an exhibition house for the garden of the Museum of Modern Art, New York. Ain served as Dean of the School of Architecture, Pennsylvania State University, from 1963 to 1967.

[*See also* Arensberg *and* Los Angeles.]

BIBLIOGRAPHY

Contemp. Architects: *Built in the USA since 1932* (exh. cat., ed. E. Mock; New York, MOMA, 1945)

D. Gebhard, H. Von Breton and L. Weiss: *The Architecture of Gregory Ain: The Play Between the Rational and High Art* (Las Angeles, 1980; 2/1997)

E. McCoy: *The Second Generation* (Salt Lake City, 1984)

Leland M. Roth

Airport

From the time of the Wright brothers' first efforts at Kitty Hawk to the wide-body jets of the 21st century, aviation technology has developed rapidly, and along with it has come a demand for a new architectural form, the airport. It is a distinctly 20th-century building type. Soon after World War I, the American government began using planes for mail delivery, but it was not until 1925 that private contractors were allowed to bid on these routes. Once they did, they began to add passenger service as a means to further income. Before this, early airports were called airfields because that is largely what they were—grassy fields with a gas tank and a hangar. The presence of passengers meant the need for spaces to accommodate them: ticket counters, waiting lounges, and baggage handling areas. At first these were modest since the normal seating capacity of the planes was limited to about a dozen or so people, but the history of airports, like the history of planes, is one of rapid growth and quickly changing technologies.

Among the pioneers of airport design was the architectural firm of Delano & Aldrich. Their 1928 Miami terminal for Pan American Airways was a large, hanger-like building in an Art Deco style that evoked Mediterranean associations. Its dramatic two-story space housed a dining terrace; one of the first of what would soon become a key feature of every airport. Two planes at a time could taxi up to the loading area. Delano & Aldrich's 1930 LaGuardia terminals in Queens, New York, one for land and one for marine operations, were also in the Art Deco style, and were noted for their clean lines and modernist associations. The marine terminal survives and is still in use today, but it was the land terminal that was influential in its innovative efforts to offer a covered boarding area and separate levels for embarking and disembarking passengers. Like Washington's National (1941) and Chicago's Midway (1945) airports, LaGuardia's land terminal was a "linear" type where the planes pulled up to the docking side. This type evoked the idea of the train

station with an architecturally distinctive front where the passengers came into the building and a functionalist rear where the passengers boarded the plane. In between was the depot with ticket counters, lounges and restaurants. Midway airport could handle as many as 15 planes at one time when it first opened, but like other airports, it soon had to expand and did so by lengthening the building.

In 1952 a different system called the "satellite" was developed at Idlewild Airport (later renamed JFK International Airport) in New York. Here each airline company had its own building and the planes parked in a circle around its loading area. Each of the nine terminals had its own passenger and baggage systems and its own apron areas. Eero Saarinen famously took up the challenge of designing a distinctive architectural form for the 1956 TWA terminal. Inspired by the dramatically shaped concrete forms of Le Corbusier (1887–1965), Saarinen constructed four intersecting barrel vaults supported by four Y-shaped columns. The result has often been compared to a bird about to take to flight. The building achieved international recognition but faced the problem of nearly every airport design in that it was quickly outdated. As planes grew bigger and could carry more passengers, the airports had to expand and adapt. The biggest change came with the introduction of jets in the late 1950s and early 1960s. Again Saarinen led the way with his design for Washington Dulles International Airport (1958–62).

Washington, DC, had long needed a larger, regional airport, and a site near Chantilly, VA, was chosen for Dulles. Saarinen's design contrasted with the traditional static, Art Deco style of Washington National as he sought to express the movement and excitement of travel. A great concrete roof was suspended between supporting pylons; like a giant wing, it seemed to hover above the ground. It is 19.8 m high on the landside and 12 m high on the airside, with a distinctive, asymmetrically placed control tower soaring above it. It quickly became an architectural celebrity, not only for its dramatic forms, but also for its innovative ideas about how to move the passengers to their

planes. At most airports the planes park at the concourses, so the passengers have to walk to their gates. At places like Chicago's O'Hare Airport, the growing number of gates meant an increasing number of concourses and, as they grew longer and longer, branching out in different directions, they presented the passenger with a considerable walk. The horizontal moving sidewalk system first developed at Dallas's Love Field in 1958 helped to solve the problem at many airports. A fairly slow-moving belt where passengers could either stand or walk, the moving sidewalk lessened the amount of effort required by the individual, but it was still often quite a distance to get to the plane. At Dulles, working with the Chrysler and Budd companies, Saarinen developed a system of mobile lounges that would move the passengers to the planes. It proved remarkably effective for a while, but eventually the development of wide-body jets that could carry hundreds of people made them inefficient. Dulles eventually added new concourses in a far more functionalist style and reverted to the idea of a long building with multiple gates and lots of walking for the passengers.

One of the most imitated plans for addressing the problems of how to accommodate getting the people to the planes was Atlanta's Hartsfield International Airport (ATL). Opened in 1980, ATL has a functionalist terminal building connected to the concourses by means of an underground train. Called the "multiple island pier" solution, it proved efficient for growth and for passenger movement. When more concourses were needed, they were added to the ends and the train tracks extended.

It was this multiple island pier form that was the basis for the Denver International Airport (1995). The first completely new airport designed in the United States since the 1970s, Denver presented a distinctive form with its 34 Teflon-coated, woven fiberglass fabric, tent-like peaks that seemed to echo the mountain skyline behind it. Denver's mayor had said he wanted a "postcard airport" like Dulles, one that would serve as a landmark for the city, and that is what the firm of Fentress Bradburn

gave him. The tent-like roof is similar to Skidmore, Owings & Merrill's 1981 Hajj Terminal in Jiddah, Saudi Arabia, but Denver's is designed to meet the different climate demands. The structure allows so much natural illumination that artificial lights are only needed at nighttime.

Perhaps the most interesting feature of recent airport design is the introduction of art. LaGuardia's Marine Terminal had a Works Progress Administration (WPA) mural by James Brooks, and airports such as Phoenix's Sky Harbor Airport began hanging art by local artists in the 1960s. Many airports, especially in the 1980s and 1990s, added art to already existing spaces, but the challenge was to have art as part of the initial plans. That was

accomplished at Chicago's O'Hare, for example, in a tunnel between two sections of Terminal One. Opened in 1987, the passage, via escalators and moving walkways, is through a dynamic neon-light sculpture complete with changing sounds and colors created by Michael Hayden (b 1943).

At Denver the whole airport was designed to include art from the beginning. Featuring regional artists and themes, the art begins with the *Mustang* (h. 9.14 m), a brightly colored fiberglass sculpture by Luis Jimenez. Inside the terminal, floors, mosaics and wall paintings continue the Native American and Hispanic themes such as the mural *Children of the World Dream of Peace* (1993–5) by Leo Tanguma. Fountains, gardens, paintings and sculpture greet

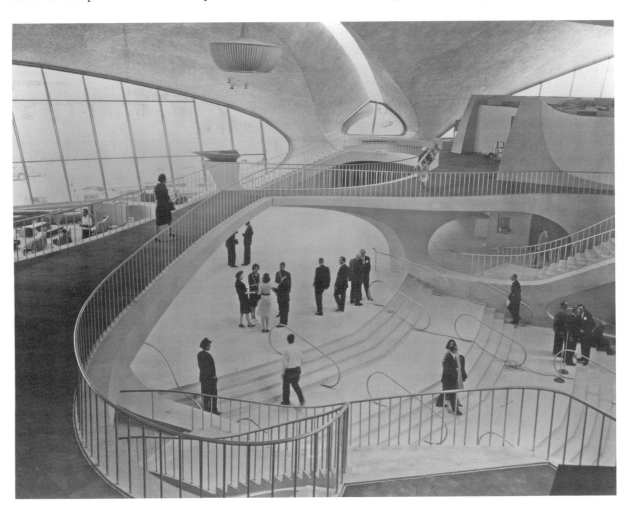

AIRPORT. Trans World Airlines terminal by Eero Saarinen, John F. Kennedy Airport, New York, 1956–62.
EERO SAARINEN COLLECTION, MANUSCRIPT & ARCHIVES, YALE UNIVERSITY

passengers at each concourse. Even the train tunnels have light and sound pieces such as *Kinetic Light Air Curtain* by William Maxwell (*b* 1947) and Antoinette Rosato, where the rushing air of the passing trains sets hundreds of small propellers spinning. The atrium for Concourse C features a 465 sq. m garden by Michael Singer (*b* 1945) that evokes associations with Mayan ruins.

If the airport experience is, as Witold Rybczynski suggested in a 2009 article in *Slate*, essentially a sort of bus stop where anxious passengers are concerned only with making their connections, then the dramatic architectural forms of Saarinen's TWA Terminal and Dulles Airport, and the artistic outpourings at Denver, might seem superfluous. He may be right that in the face of long lines to get through security, the idea that the excitement of travel could be enhanced by architectural beauty is simply a thing of the past. But another argument can be made that today's airports are more like small cities, with retail shops, restaurants and nearby hotels. They are places that passengers often have to linger. Rather than simply rushing blindly to their gate, the people experiencing Denver's art or a space such as Helmut Jahn's 1988 United Terminal at O'Hare Airport, with its light, airy forms and exposed structural members, might at least feel a lightened spirit in such a visually exciting passage.

BIBLIOGRAPHY

J. Wooley and E. Hill: *Airplane Transportation* (Hollywood, CA, 1929)

A. Temko: *Eero Saarinen* (New York, 1962)

R. Bilstein: *Flight in America 1900–1983* (Baltimore, 1984)

W. Hart: *The Airport Passenger Terminal* (New York, 1985)

C. Blow: *Airport Terminals* (Boston, 1996)

J. Zutowsky, ed.: *Building for Air Travel: Architecture and Design for Commercial Aviation* (New York, 1996)

B. Edwards: *The Modern Terminal* (New York, 1998)

A. Gordon: *Naked Airport: A Cultural History of the World's Most Revolutionary Structure* (Chicago, 2004)

W. Rybczynski: "The History and Future of Airport Design," *Slate* (22 July 2009)

<div align="right">Pamela H. Simpson</div>

Albers, Anni

(*b* Berlin, 12 June 1899; *d* Orange, CT, 10 May 1994), textile designer, draftsman and printmaker of German birth. Anni [Anneliese] Albers studied art under Martin Brandenburg (1870–1919) in Berlin from 1916 to 1919, at the Kunstgewerbeschule in Hamburg (1919–20) and at the Bauhaus in Weimar (1922–5) and Dessau (1925–9). In 1925 she married Josef Albers, with whom she settled in the USA in 1933 after the closure of the Bauhaus, and from 1933 to 1949 she taught at Black Mountain College in North Carolina; she became a US citizen in 1937. Her Bauhaus training led her as early as the 1920s to produce rectilinear abstract designs based on color relationships, such as *Design for Rug for Child's Room* (gouache on paper, 1928; New York, MOMA), but it was during her period at Black Mountain College that she began producing her most original work, including fabrics made of unusual materials such as a mixture of jute and cellophane (1945–50; New York, MOMA) or of mixed warp and heavy linen weft with jute, cotton and aluminum (1949; New York, MOMA). She began producing prints in 1963, using lithography, screenprinting, etching and aquatint and inkless intaglio (see exh. cat., pp. 106–30). For illustration, see color pl. 1:II, 1.

[*See also* Albers, Josef *and* Black Mountain College.]

WRITINGS

Anni Albers: On Designing (New York, 1959/R Middletown, CT, 1961)

Anni Albers: On Weaving (Middletown, CT, 1965/R 1972)

Anni Albers: Selected Writings on Design (Middletown, CT and London, 2000)

BIBLIOGRAPHY

The Woven and Graphic Art of Anni Albers (exh. cat. by N. F. Weber, M. J. Jacob and R. S. Field, Washington, DC, N. Mus. Amer. A., 1985)

N. F. Weber and P. T. Asbaghi: *Anni Albers* (New York and London, 1999)

V. G. Troy: *Anni Albers and Ancient American Textiles: From Bauhaus to Black Mountain* (Burlington, 2002)

N. F. Weber: *Josef and Anni Albers: Designs for Living* (London, 2004)

B. Danilowitz and H. Liesbrock: *Anni and Josef Albers: Latin American Journeys* (Ostfildern, 2007)

Nicholas Fox Weber

Albers, Josef

(*b* Bottrop, Ruhr, 19 March 1888; *d* New Haven, CT, 25 March 1976), painter, printmaker, sculptor, designer, writer and teacher of German birth. He worked from 1908 to 1913 as a schoolteacher in Bottrop and from 1913 to 1915 trained as an art teacher at the Königliche Kunstschule in Berlin, where he was exposed to many current art movements and to the work of such Old Masters as Albrecht Dürer and Hans Holbein the younger. His figurative drawings of the next few years, which he kept hidden and which were discovered only after his death (many now in Orange, CT, Albers Found.), show that he applied these influences to his consistent concern with the simplest and most effective means of communicating his subject; he drew rabbits, schoolgirls and the local landscape in as dispassionate and impersonal a manner as possible. After his studies in Berlin he returned to Bottrop and from 1916 to 1919 began his work as a printmaker at the Kunstgewerbeschule in nearby Essen. In 1919 he went to Munich to study at the Königliche Bayerische Akademie der Bildenden Kunst, where he produced a number of nude drawings and Bavarian landscapes (Orange, CT, Albers Found.).

In 1920 Albers attended the preliminary course (*Vorkurs*) at the recently formed Bauhaus in Weimar, where he designed stained glass, furniture, metalwork and typography (see Alviani, pp. 18–21) as well as architecture. He was among the first students to be appointed a master (in 1925) and was one of the most influential teachers of this renowned course. He was deeply involved with technical mastery and with abstract form, particularly in his glass assemblages; the first of these, such as *Untitled (Window Picture)*

(589×553×213 mm, 1921; Washington, DC, Hirshhorn), were made from broken bottle fragments found in the city dump in Weimar, while later works were made from sand-blasted multi-layered glass in precise, right-angled, abstract forms and pure, radiant colors in careful arrangements, for example *Factory* (*c.* 1925; New Haven, CT, Yale U., A.G.).

Albers was the longest-serving member of the Bauhaus when it was closed under pressure from the Nazis in 1933, and he was among the faculty members who agreed with its Director at the time, Ludwig Mies van der Rohe, that the school be shut down. Albers and his wife, Anni Albers, whom he had married in 1925, were asked in the same year to teach art at the newly formed Black Mountain College in North Carolina on the recommendation of Philip Johnson at MOMA in New York; they remained there until 1949, and Albers became one of the best-known and most influential art teachers in the USA. He also continued his foray into printmaking, notably in a series of woodcuts and linoleum cuts of 1933–44 (see Alviani, pp. 30–46), and pursued abstract painting in a highly innovative way. During this period he first developed the idea of producing series of paintings in standard formats but different colors, for example *Bent Black (B)* (1940; Washington, DC, Hirshhorn) and *Bent Dark Gray* (1943; New York, Guggenheim). In 1947 he began a large series of rectangular abstractions entitled *Adobes*, for example *Variant: Inside and Out* (1948–53; Hartford, CT, Wadsworth Atheneum) and *Variant* (1948–52; Bottrop, Albers Mus.), in which he often used equal quantities of five different colors in a precisely calculated geometric arrangement. It was in these and related works that he first developed a rather mechanical, emotionless technique to achieve highly poetic results.

In 1950 Albers was appointed chairman of the Department of Design at Yale University, New Haven, CT, a post he retained until 1958, although he remained there as visiting professor until 1960. His students there and previously at Black Mountain College included Eva Hesse, Robert

Rauschenberg, Kenneth Noland and Richard Anuszkiewicz. His teaching of color at Yale led to the publication of his renowned treatise *Interaction of Color* (1963), a book that was later translated into eight languages as one of the major tools of art teaching throughout the world. In it Albers investigated the properties of color, including the illusory ability of opaque colors to appear translucent and overlapping, which he had begun to explore in 1950 in his best-known series of works, *Homage to the Square* (see color pl. 1:II, 2), on which he was occupied until his death. These were exhibited all over the world and were the basis of the first solo show given to a living artist at the Metropolitan Museum of Art in New York (1971). Works from this series, of which Albers did over 1000, are in the Josef Albers Museum (opened 1983) in Bottrop, Germany, as well as numerous public collections (e.g. New Haven, CT, Yale U., A.G.; New York, Guggenheim; Berlin, N.G.; Paris, Pompidou). Each consists of either three or four squares of solid planes of color nested within one another, in one of four different arrangements and in square formats ranging from 406×406 mm to 1.22×1.22 m. In these paintings, and in related prints and tapestries, Albers explored effects of perception, such as the apparent oscillation between the flat surface design and an illusion of movement across or into space and the interaction of adjacent colors to produce effects of modulation and tonal variation.

Albers painted the *Homages* in a precise arrangement and under laboratory-like conditions, always working on the rough side of Masonite (wood fibreboard) panels, primed with at least six coats of white liquitex. Under a careful arrangement of fluorescent lights (bulbs arranged warm/cool/warm/cool over one work table, warm/warm/cool/cool over another), he worked on each painting in alternate light conditions, applying unmixed paints straight out of the tube with a palette knife, often starting with the center square and working outward. However systematic and even mechanical their execution, these paintings remain mysterious and enormously varied in mood and color.

On his retirement from Yale, Albers continued to live near New Haven and to paint, monitor his own exhibitions and publications, write, lecture and work on large commissioned sculptures for architectural settings, many of which were based on a series of drawings and engravings entitled *Structural Constellations* (see Alviani, pp. 72–84). Such works as *Repeat and Reverse* (stainless steel, 1.98×0.91 m, 1963; New Haven, CT, Yale U., A. & Archit. Bldg) dominate major open spaces in cities as far afield as Sydney and Münster and the insides of such important New York skyscrapers as the Pan Am and Time-Life buildings. Whatever their basis, all of Albers's work points to the beauty of simple geometry and technical proficiency and to "the discrepancy between physical fact and psychic effect," which the artist regarded as one of the major goals of his art.

[*See also* Albers, Anni *and* Black Mountain College.]

WRITINGS

"Concerning Art Instruction," *Black Mountain Coll. Bull.*, ii (1934), pp. 2–7

Zeichnungen: Drawings (New York, 1956)

Interaction of Color (New Haven, 1963, rev. 1975)

"Op Art and/or Perceptual Effects," *Yale Sci. Mag.*, xl/2 (1965), pp. 8–15

Josef Albers: Formulation, Articulation (New York, 1972)

BIBLIOGRAPHY

F. Bucher: *Josef Albers: Despite Straight Lines: An Analysis of his Graphic Constructions* (New York, 1961)

Josef Albers: Homage to the Square (exh. cat. by J.Albers and K. McShine, New York, MOMA, 1964)

Josef Albers: White Line Squares (exh. cat., essays by K. E. Tyler, H. Hopkins, and J. Albers, Los Angeles, Co. Mus. A., 1966)

E. Gomringer: *Josef Albers* (New York, 1968)

W. Spies: *Albers* (New York, 1970)

Josef Albers (exh. cat., essays by W. Hofman and others, Hamburg, Ksthalle, 1970)

Josef Albers (exh. cat., essays by W. Spies and others, Düsseldorf, Städt. Ksthalle, 1970)

J. Miller: *Joseph Albers: Prints, 1915–1970* (New York, 1973)

N. F. Weber: *The Drawings of Josef Albers* (New Haven, 1984)

N. D. Benezra: *The Murals and Sculpture of Josef Albers* (New York, 1985)

G. Alviani: *Josef Albers* (Milan, 1988) [English, German, and Italian]

Josef Albers: A Retrospective (exh. cat. by N. F. Weber and others, New York, Guggenheim, 1988)

N. F. Weber: *Josef and Anni Albers: Designs for Living* (London, 2004)

B. Danilowitz and H. Liesbrock: *Anni and Josef Albers: Latin American Journeys* (Ostfildern, 2007)

E. Diaz: "The Ethics of Perception: Josef Albers in the United States," *A. Bull.*, xc (2008), pp. 260–85

Nicholas Fox Weber

Albright, Ivan

(*b* North Harvey, IL, 20 Feb 1897; *d* Woodstock, VT, 18 Nov 1983), painter, sculptor, printmaker and filmmaker. Ivan (le Lorraine) Albright was brought up in the suburbs of Chicago and was exposed to art at an early age by his father, Adam Emory Albright (1862–1957), a portrait painter. He passed on to his son the interest in careful draftsmanship that he had developed from tuition with Thomas Eakins. Albright's initial field of interest was architecture, which he studied at Northwestern University, Evanston (1915–16), and at the University of Illinois, Urbana (1916–17). During World War I he served with an Army medical unit, making surgical drawings with great precision. He subsequently decided to become a painter and attended the Art Institute of Chicago (1920–23), the Pennsylvania Academy of Fine Arts, Chicago (1923) and the National Academy of Design, New York (1924). Around this time he began to exhibit regularly.

Albright settled in Chicago in 1927, and, isolated from New York circles, he developed his personal, mature style. From 1929 to 1930 he painted his first monumental work, *Into the World There Came a Soul Named Ida* (Chicago, IL, A. Inst.); in this modern *vanitas* painting, Albright transformed an attractive 21-year-old sitter into a withered old woman who looks sorrowfully into a mirror. Agitated light effects, deadened purple tones and microscopic detail emphasize the transitory nature of beauty, as do the burnt paper, wilting flowers and other debris.

In the 1930s Albright fully developed his meticulous technique, which included creating numerous detailed drawings, grinding his own colors and painting with hundreds of tiny brushes, often covering only a tiny area of canvas per day. He devised inconsistencies in perspective by moving objects on rotating stands as he painted. He generated flickering illumination by varying the light in his studio and introducing arbitrary shadows, a technique he used in one of his most renowned paintings, *That which I Should Have Done I Did Not Do (The Door)* (1931–41; Chicago, IL, A. Inst.). A haunting assemblage of memorabilia, including a weathered Victorian door, a cheap funeral wreath and a woman's hand, is depicted with cold, metallic lighting, a scarred paint surface and a warped perspective that makes the door appear coffin-shaped.

Albright continued to work in this same mode for six decades, examining the concept of mortality through portraits and still lifes, including the powerful *Poor Room—There Is No Time, No End, No Today, No Yesterday, No Tomorrow, Only the Forever, and Forever, and Forever, Without End* (1941–62) and

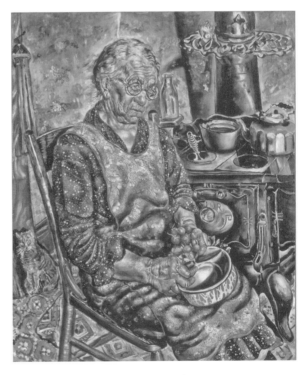

IVAN ALBRIGHT. *The Farmer's Kitchen*, oil on canvas, 915 × 765 mm, *c.* 1933–4. Smithsonian American Art Museum, Washington, DC/Art Resource, NY

If Life Were Life, There Would Be No Death (1966–77, both Chicago, IL, A. Inst.). He experimented, however, with a variety of media besides painting. His sculptures similarly explore tactile values, as evident in the jagged, asymmetrical features of *Adam Emory Albright* (1935; New York, MOMA). His lithographs, for example *Self-portrait at 55 East Division Street* (1947; see Croyden, p. 212), were often inspired by his paintings; their strong tonal patterns, created without the use of color, intensify their expression. Albright also experimented with film, culminating in *Unfinished Portrait of an Artist* (1963). He wrote prolifically and left a series of 31 notebooks in which he investigated the relationship between word and image, reality and illusion.

BIBLIOGRAPHY

Ivan Albright (exh. cat. by F. Sweet and J. Dubuffet, Chicago, A. Inst., 1964)

J. van der Marck: "Ivan Albright: More than Meets the Eye," *A. America*, lxv/6 (1977), pp. 92–9

M. Croyden: *Ivan Albright* (New York, 1978)

Graven Image: The Prints of Ivan Albright, 1931–1977 (exh. cat. by M. Croyden, Lake Forest, Coll., 1978)

S. P. Teller: "The Prints of Ivan Albright," *Prt Rev.*, x (1980), pp. 21–35

M. W. Brown: "Realism in the U.S.A. Between the Wars," *Les Realismes: 1919–1939* (exh. cat., Paris, Pompidou, 1981), pp. 238–50

C. Lyon: "Synthetic Realism: Albright, Golub, Paschke," *A. J.*, xlv/4 (Winter 1985), pp. 330–34

Ivan Albright: The Late Self-Portraits (exh. cat. by P. Floyd, Hanover, NH, Dartmouth Coll., Hood Mus. A., 1986)

"Ivan Albright," *Modern Arts Criticism*, ed. J. Prosyniuk, ii (Detroit, New York, and London, 1992)

M. Duncan: "The Way of All Flesh," *A. America*, lxxxv/7 (July 1997), pp. 82–9

Ivan Albright (exh. cat., Chicago, IL, A. Inst., 1997)

Ivan Albright: Magic Realist (exh. cat., New York, Met., 1997)

G. McDonald: "The Launching of American Art in Postwar France: Jean Cassou and the Musee National D'Art Moderne," *Amer. A.*, xiii/1 (Spring 1999), pp. 40–61

K. Kuh: *The Artist's Voice: Talks with Seventeen Modern Artists* (New York, 2000)

D. Kuspit: *The Rebirth of Painting in the Late Twentieth Century* (Cambridge, 2000)

Janet Marstine

Alexander, Francis

(*b* Killingly, CT, 3 Feb 1800; *d* Florence, 27 March 1880), painter and lithographer. He studied briefly with Alexander Robertson (1768–1841) in New York and copied portraits by John Trumbull and Samuel Waldo. From 1821 to 1825 he painted portraits in Killingly, CT, and Providence, RI. He received encouraging advice from Gilbert Stuart in Boston, probably in 1825, and by 1828 was a prominent portrait painter and lithographer there. Portraits such as *Mrs. Jared Sparks* (1830; Cambridge, MA, Harvard U.) demonstrate a well-developed sense of pattern and design but display some deficiency in draftsmanship, with conventional shapes used to determine the sitter's features.

From 1831 to 1833 Alexander traveled and painted in Italy. After returning to Boston, he exhibited 39 paintings in 1834 at Harding's Gallery, many of which were derived from the Italian trip. His unusually theatrical portrait of *Senator Daniel Webster* (1835; Hanover, NH, Dartmouth Coll., Hood Mus. A.) shows the effect of his exposure to Romanticism; Webster is presented with fiery eyes and wild hair, silhouetted against a dramatic sky. When Charles Dickens visited America in 1842, Alexander aggressively sought him out and depicted him as a slight youth (Dickens was 30) seated casually behind a large table (Boston, MA, Mus. F.A.).

Alexander was made an honorary member of the National Academy of Design in New York in 1840. He returned to Italy in 1853, settling in Florence, where he collected early Renaissance art, gave up painting and became a friend of Hiram Powers, the leader of the city's American art colony. He revisited America only once, in 1868–9. Most of the paintings in his collection, which included works attributed to Perugino, Orcagna and Ghirlandaio, were destroyed while in storage in Boston during the great fire of 1873; the remainder were sold at auction at Leonard & Co., Boston, in 1874. His daughter Esther Frances Alexander (1837–1917), known as Francesca, became a painter, illustrator and poet.

UNPUBLISHED SOURCES

Cole papers, New York, Hist. Soc. [copies of Alexander's corr. etc, comp. E. Parker Lesley (1938–48)]

BIBLIOGRAPHY

W. Dunlap: *History of the Rise and Progress of the Arts of Design in the United States*, iii (New York, 1934, rev. 3/1965), pp. 232–40

C. W. Pierce: "Francis Alexander: Union List of Paintings," *Old-Time New England*, xliv (1953), pp. 29–46

Leah Lipton

Alexander, Henry

(*b* San Francisco, CA, *c.* 1860; *d* New York, NY, 16 May 1894), painter. San Francisco's first native-born artist, he was among the most intriguing of late 19th-century American painters. Little is known about his short life and career, for which there are only four or five reliable dates. He was the second child of an eastern European Jewish immigrant family that settled in San Francisco sometime before 1860. He received his early art training at the California School of Design, where he studied with Toby Rosenthal (1848–1917), probably in 1872–3. A year or two later he left for Europe for prolonged study in Munich. The first definite date of his career is his arrival in New York in 1883 and subsequent return to San Francisco, where he maintained studios in the financial district for about four years. On 15 April 1887, he sailed by way of Panama for New York City, where, seven years later—ill, poverty-stricken and deeply despondent—he took his life by drinking a carbolic acid "cocktail." Most of what is known about Alexander, other than the evidence of some 30 surviving paintings, appears in the newspaper obituaries reporting his suicide at the age of about 35.

Once described in the *New York Herald* as one of the creators of the "modern school of art," Alexander was, in fact, a traditional genre painter in the dark Munich manner, a style made unfashionable by the rise of the brighter, more cosmopolitan Impressionist movement. Along with his friend and fellow student Charles Frederick Ulrich (1858–1908),

Alexander was a representative of the later academic Munich style that emulated the precise rendering and subdued tones of the 17th-century Dutch "little masters." Among his other friends in Germany was fellow San Franciscan Henry Raschen (1854–1937), who later became a noted specialist in the depiction of Native Americans.

Most of Alexander's surviving works are San Francisco subjects depicting identifiable interiors and specific activities of the 1880s. Typical of a series of scientific and trade genre pictures is *The First Lesson* (San Francisco, CA, F.A. Museums), in which taxidermist William Nolte is seen demonstrating his craft to apprentice William J. Hackimer in the former's Golden Gate Avenue studio (identification according to Williams). *The Lost Genius* (Berkeley, U. CA, A. Mus.), showing an aged cobbler in his meticulously detailed storefront shop playing his violin with a black boy listening at the door, brings to mind the work of William Sidney Mount, J. D. Chalfant (1856–1931) or even Eastman Johnson. Alexander is also known for his views of Chinese interiors, including "opium dens." Despite their descriptive realism, these paintings convey an evocative mood both contemplative and mysterious.

Alexander's slightly off-center, enigmatic work never found a comfortable art-historical niche, in spite of his Munich training and clear ambitions to succeed as a genre and portrait painter, first in San Francisco and then in New York. The problem of his posthumous reputation is compounded by several factors, including his short career and the destruction of the majority of his output by fire following the 1906 San Francisco earthquake. The unsold paintings were stored by the family in a warehouse on Sansome Street in anticipation of a major retrospective. It was not until three decades later, however, that the first retrospective of Alexander's work took place, at Gump's Art Gallery, San Francisco (1937). Only two further exhibitions of his paintings have been held, both also in San Francisco: one at the San Francisco Museum of Art (1940) and another at the M. H. de Young Memorial Museum

(1973), which displayed the 20 paintings at the time believed to be the total of his extant oeuvre.

BIBLIOGRAPHY

A. Frankenstein: *After the Hunt: William Harnett and Other American Still-life Painters, 1870–1900* (Berkeley, CA, 1953, 2/1969)

H. W. Williams Jr.: *Mirror to the American Past: A Survey of American Genre Painting, 1750–1900* (New York, 1973)

R. L. Wilson: "Henry Alexander: Chronicler of Commerce," *Archvs Amer. A. J.*, xx/2 (1980), pp. 10–13

W. H. Gerdts: *Painters of the Humble Truth* (Columbia, MO, 1981)

P. J. Karlstrom: "The Short, Hard and Tragic Life of Henry Alexander," *Smithsonian*, xii (March 1982), pp. 108–17

W. H. Gerdts: *Art across America: Two Centuries of Regional Painting, 1720–1920*, iii (New York, 1990)

Revisiting the White City: American Art at the 1893 World's Fair (exh. cat. by C. K. Carr and others, Washington, DC, N. Mus. Amer. A. and N.P.G., 1993)

E. M. Hughes: *Artists in California, 1786–1940* (Sacramento, 3/2002)

Paul J. Karlstrom

Alexander, John White

(*b* Allegheny, PA, 7 Oct 1856; *d* New York, 31 May 1915), painter and illustrator. He began his career in New York in 1875 as a political cartoonist and illustrator for *Harper's Weekly*. In 1877 he went to Paris for his first formal art training, and then to Munich, where he enrolled at the Kunstakademie under Gyuala Benczúr (1844–1920). In 1878 he joined a colony of American painters established by Frank Duveneck in Polling, Bavaria. In 1879 they traveled to Italy, where Alexander formed friendships with James McNeill Whistler and Henry James. In 1881 he returned to New York, working as an illustrator for *Harper's*, as a drawing instructor at Princeton and as a highly successful society portrait painter. He also exhibited at the National Academy of Design. By 1893 his reputation in both Europe and America had soared, and in 1895 he was awarded a prestigious commission for a series of murals entitled the *Evolution of the Book* in the newly established Library of Congress in Washington, DC. After 1901 Alexander became deeply involved with the promotion of the arts in America. He won numerous mural commissions (e.g. Pittsburgh, PA, Carnegie Inst.; from 1905, unfinished) and continued to paint portraits.

Alexander's stylistic development falls into several distinct stages. His early landscapes and genre scenes of the 1870s bear the stamp of the realist style of Munich artist Wilhelm Leibl (1844–1900) as espoused by Duveneck and William Merritt Chase. His fluid brushwork resembled that of Frans Hals (1581/5–1666) and Diego Velázquez (1599–1660), painters he deeply admired. After his return to the USA in 1881 and under the influence of Whistler, he favored a more limited palette and experimented with the evocation of mood through shadow and gesture. His portrait of *Walt Whitman* (1886–9; New York, Met.) is one of his finest works of the 1880s. Many of his later portraits, notably of women, were psychological studies rather than specific likenesses, as in *The Ring* (1911; New York, Met.). His brushwork became less painterly and more concerned with suggesting abstracted shapes. He also adopted a very coarse-weave canvas, the texture of which became an important element in his mature work. By applying thinned-down paint to the absorbent surface, his pictures appear to have been dyed in muted tones, in marked contrast to the glossy, impasted surfaces of his earlier work. Throughout his career Alexander favored compositions with a single figure placed against a sharply contrasting background. The sinuous curvilinear outline of the heroine standing full-length in *Isabella, or the Pot of Basil* (1897; Boston, MA, Mus. F.A.) evokes contemporary Art Nouveau forms. Like the Symbolists, he sought by gesture and strong lighting to intensify the viewer's response to his sensuous treatment of the subject. For illustration, see color pl. 1:V, 2.

[*See also* Duveneck, Frank, *and* Pittsburgh.]

UNPUBLISHED SOURCES

Washington DC, Smithsonian Inst., Archv Amer. A. [John White Alexander papers]

BIBLIOGRAPHY

G. Monrey: "An American Painter in Paris: John W. Alexander," *Int. Studio*, xi (1900), pp. 71–7

Amer. Mag. A., vii (1916) [whole issue]

Catalogue of Paintings: John White Alexander Memorial Exhibition (Pittsburgh, PA, Carnegie Mus. A., 1916)

John White Alexander (1856–1915) (exh. cat. by M. Goley, Washington, DC, N. Col. F. A., 1976)

John White Alexander (1856–1915): Fin-de-siècle American (exh. cat. by S. Leff, New York, Graham Gal., 1980)

M. A. Goley: "John White Alexander's *Panel for Music Room*," *Bull. Detroit Inst. A.*, lxiv/4 (1989), pp. 5–15

M. A. Goley: "John White Alexander: The Art of Still Life," *Amer. A. Rev.*, vii/4 (1995), pp. 148–53

S. J. Moore: *John White Alexander and the Construction of National Identity: Cosmopolitan American Art, 1880–1915* (Newark, DE, 2003)

Eleanor Jones Harvey

Ali, Laylah

(*b* Buffalo, NY, 9 May 1968), painter and draftsman. She studied English and Studio Art at Williams College, Williamstown, MA, graduating with a BA in 1991. Shortly thereafter, she attended the Whitney Museum Independent Study Program, New York, and completed her MFA in 1994 at Washington University, St Louis. Ali became known for her painting series *Greenheads*, in which round-headed characters perform choreographed activities against flat, light-blue backgrounds. These cartoon-styled allegories of American history and culture examine the sublimated or overt aggression inherent in activities such as team sports, ceremonies, military training, court marshaling and lynching. Referencing folk art or hieroglyphs, *Untitled (Greenheads)* (gouache on paper, 1998) depicts a sequence of disputes between uniformed characters and injured figures in athletic apparel. As with most of Ali's oeuvre, the gestures and expressions of the figures communicate a sense of violent intensity, while the exact nature of the interaction remains enigmatic. Addressing the power dynamics of race, religion and gender, her scenarios respond to personal experience as well as

local or world events, yet do not serve to represent them directly. Correspondingly, the single figures that appear in her later drawings and paintings display what initially seem to be specific ethnic tributes or dress codes, subsequently revealed to be invented and constructed by Ali. As it remains up to the viewer to interpret who these characters are or what may distinguish them as individuals, the perspective and biases of the viewer become part of the artwork's meaning. The young, green-faced character in *Untitled* (gouache on paper, 2004) displays a strong personality and a scar, but what he/she is wearing could speculatively be a costume, uniform, ethnic garb or the latest street fashion, and could presumably come from multiple geographies or time frames.

BIBLIOGRAPHY

T. Golden and H. Walker: *Freestyle* (New York, 2001), pp. 20–21

S. Campbell and G. Tawadros: *Fault Lines: Contemporary African Art and Shifting Landscapes* (London, 2003), pp. 98–103

C. Iles, S. Momin and D. Singer, eds: *Whitney Biennial 2004* (New York, 2004), p. 147

S. Sollins: *Art 21: Art in the Twenty-First Century 3* (New York, 2005), pp. 22–33

Laylah Ali: Typology (exh. cat. by A. Baker, Philadelphia, PA F.A., 2007)

Nizan Shaked

Allen, Elsie

(*b* Santa Rosa, CA, 22 Sept 1899; *d* California 31 Dec 1990), basket-weaver. Taken from her family to attend a Native American boarding school in Covelo, CA, Allen's father, George Allen, of the Ukiah Pomo, and her mother, Annie Burke (1876–1962), of the Comanche, allowed Elsie's grandmother Nellie Burke to raise and teach her about Pomo basketry techniques near Cloverdale, CA. A matrilineal skill passed down from mother to daughter, Pomo tradition requires the burial with the deceased of all baskets created during an artist's lifetime. Annie Burke did not want Pomo basket artistry to die out

and demanded that Allen not bury her with her baskets. Allen broke with tradition and kept her mother's baskets.

In 1919 she married Arthur Allen of the Pinoleville Pomo tribe. Over the next 30 years, Allen devoted herself to education and adding baskets to the family collection. In 1980, her grandniece Susie Billy became her apprentice. Studying for five years, Billy developed her Pomo basket weaving knowledge, and increased efforts to preserve Pomo basket cultural traditions. Allen's oldest daughter, Genevieve Allen Aguilar (b 1920), became guardian of the family basket collection, placing 131 baskets on long-term loan with the Mendocino County Museum, subsequently known as the "Elsie Allen Collection." The baskets incorporate brightly colored feathers and tiny glass beads, inviting sensory delight and wonder.

Allen carried out extensive hard work to complete her baskets, gathering willow, sedge roots, bulrush roots and redbud bark, in a process that required years of preparation and curing of materials. Baskets took months or years to complete. At the age of 91 Allen died, after training several younger Pomo women in the arts of Pomo basketry to allow its continuance.

WRITINGS

Pomo Basket Making: A Supreme Art for the Weaver (Happy Camp, 1972)

BIBLIOGRAPHY

S. Abel-Vidor, D. Brovarney and S. Billy: *Remember Your Relations: The Elsie Allen Baskets, Family & Friends* (Oakland, CA, 1996)

G. Lola Worthington

All-over painting

Term coined during the height of Abstract Expressionism in the USA, with particular relevance to the work of painter Jackson Pollock. The "all-over" quality of works such as *Lavender Mist: Number 1, 1950* (Washington, DC, N.G.A.) refers to its lack of compositional structure (no apparent foreground,

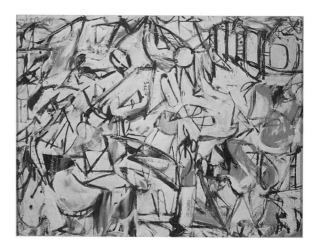

ALL-OVER PAINTING. *Untitled* by Willem de Kooning, 1950. PRIVATE COLLECTION © 2010 THE WILLEM DE KOONING FOUNDATION/ ARTISTS RIGHTS SOCIETY, NY DACS/THE BRIDGEMAN ART LIBRARY INTERNATIONAL

middleground and background) as in traditional representational painting. It also suggests the lack of spatial delineations or focal points of any kind, creating an entirely abstract work that asserts the canvas's flat surface and eschews any attempt at representational or symbolic interpretation. The large scale of Pollock's drip paintings made their all-over quality all the more impressive as the sprawled paint made the viewer survey the entire surface. Though initially used to describe Pollock's drip paintings, the term was later applied to the color field painters of the second generation of Abstract Expressionists. Furthermore, the term "all-over" can be applied to a variety of abstract design strategies.

Critic Clement Greenberg, one of Pollock's most ardent champions, wrote of the triumph of Abstract Expressionism—and particularly of Pollock's drip paintings—as surrendering to the flat surface of the canvas and its rigorous rejection of illusionism or representation. "The history of avant-garde painting is that of a progressive surrender to the resistance of its medium," he wrote in "Towards a Newer Laocoon," an essay that created a teleology placing American painting from the period following World War II at the summit of its medium. While Greenberg championed the Abstract Expressionists'

truth to the medium of painting, Harold Rosenberg would coin the term "action painter" to name the same drip paintings of Jackson Pollock and to the work of other artists such as Franz Kline. Rosenberg found an existential hero in the action painter and read the painting as a truly individual index of the artist's life. All-over painting and the aesthetic of Abstract Expressionism came to signify a triumph in American art in the late 1940s and 1950s.

[See also Abstract Expressionism; Action painting; and Pollock, Jackson.]

BIBLIOGRAPHY

C. Greenberg: "Towards a Newer Laocoon," Partisan Rev., vii/4 (Aug 1940), pp. 296–310

H. Rosenberg: "The American Action Painters," ARTnews (Dec 1952), pp. 22ff

M. Leja: Reframing Abstract Expressionism: Subjectivity and Painting in the 1940s (New Haven, 1993)

Annie Dell'Aria

Allston, Washington

(b Waccamaw, SC, 5 Nov 1779; d Cambridgeport, MA, 9 July 1843), painter. The son of a prominent South Carolina plantation owner of English descent, he began to draw around the age of six, and he moved to his uncle's home in Newport, RI, at the age of eight. While there he came into contact with the portrait painter Samuel King, but it was the exhibited portraits of Robert Edge Pine that offered him inspiring models of glazing and coloring. Dubbed "the Count" by his Harvard College classmates for his way with fashion, Allston explored alternatives to the portrait tradition with landscapes, as well as with depictions of irrational figures, for example Man in Chains (1800; Andover, MA, Phillips Acad., Addison Gal.). After graduating in 1800, he sold his patrimony to fund study abroad.

In 1801 Allston went with Edward Greene Malbone to London, where he frequented the circle of Benjamin West and studied drawing at the Royal Academy. In late 1803 he departed with John Vanderlyn for Paris, where an enthusiasm for heroic landscape temporarily usurped the ideals that he had attached to history painting. Allston exhibited at the Royal Academy in 1802 and 1803, and at the Paris Salon of 1804, but he achieved his first critical success with Diana and her Nymphs in the Chase (1805; Cambridge, MA, Fogg), which he painted in Rome soon after his arrival there in 1805. The monumental canvas presents Classical figures, a chasm rupturing the shore of a crystalline lake and a jagged, gleaming mountain beyond. Allston achieved his brilliant sunlight and strikingly transparent color with a Venetian method of glazing readily learned in London but little known in Paris or Rome; it cast him into the role of an international conduit for ideas about painting technique and consolidated his reputation. While in Rome he painted several portraits, including his Self-portrait (1805; Boston, MA, Mus. F.A.) and one of his friend Samuel Taylor Coleridge (1806; Cambridge, MA, Fogg).

Allston returned to Boston in 1808 and married the next year; during this stay he composed much of the verse that he published as a collection in 1813 and painted a few comic pieces, such as The Poor Author and the Rich Bookseller (1811; Boston, MA, Mus. F.A.). In 1811 he departed for London with his wife and his pupil, Samuel F. B. Morse. At this time he began to depict biblical themes, emphasizing in particular figural and facial expression. Participating in the current English vogue for resurrection imagery, Allston chose a rarely treated Old Testament subject, the Dead Man Restored to Life by Touching the Bones of the Prophet Elisha (1811–14; Philadelphia, PA Acad. F.A.). The prostrate protagonist, inspired by the monument to Gen. William Hargrave (1757; London, Westminster Abbey) by Louis-François Roubiliac (1702–72), unfurls his shroud and thereby illustrates the divine process of reanimation. The other figures' dramatic responses to this miracle exemplify Allston's Romantic historical style. The prize awarded by the British Institution to the Dead Man in 1814 and purchases made by English aristocrats and Americans in London provided

Allston with a decided degree of success. Yet around the time of the sudden death of his wife in 1815, he first met the financial pressures that would plague him for the balance of his career. Despite a first prize at the British Institution in 1818 for *Uriel in the Sun* (1817; U. Boston, MA, Mugar Mem. Lib.), Allston sailed for Boston that year.

Allston thought he had but several months' work remaining on a 3.6×4.8-m canvas that he had begun in London of *Belshazzar's Feast* (1817–18, 1820–28, 1839–43; Detroit, MI, Inst. A.), which, like West's treatment of the subject, emphasizes Daniel's act of interpretation. Allston intended from the outset to exhibit the canvas in America; the subject, a type of both the advent of the millennium and the Last Judgment, was especially potent for American audiences, given the formative role of Jeremiads in American thought. Before his recommencement of the project in 1820, Allston elaborated on the imagery of prophecy and divine vengeance in canvases featuring the Old Testament figures Miriam, Saul and Jeremiah (e.g. *Jeremiah Dictating his Prophecy of the Destruction of Jerusalem to Baruch the Scribe*, 1820; New Haven, CT, Yale U. A.G.), yet it was *Belshazzar's Feast* that he planned as his homecoming masterpiece, hoping it to be worthy of comparison with the great works of the past.

The ceaseless revisions that characterized Allston's work on the composition began with an overhaul of its spatial organization. Among the fruits of the protracted labors of "Belshazzar's slave," as he referred to himself in 1825, were expressive chalk drawings (Cambridge, MA, Fogg) of the King's fear-stricken hands. In the winter of 1825–6 illness interrupted Allston's progress, just as it had in 1813 when work on the *Dead Man* undermined his health. Given Allston's European successes, technical sophistication and intellectualism, such exertions only enhanced for many Americans his identification with the Romantic ideal of the fine arts. By 1827 twelve patrons had created a fund of $10,000 to free Allston from financial pressures; this increased his sense of obligation to complete the canvas,

although the original idea must have been long lost to him. Moving to a smaller studio in 1828, Allston stored the canvas until 1839, when he began a final and unsuccessful period of work on it. Insecurity about his fitness for the task had progressively overwhelmed his aspirations, and he never completed the canvas.

In 1830 Allston married his late wife's cousin and moved to Cambridgeport, MA. While he had painted solitary, idealized women from the time of his first marriage, in his later years he was persistently concerned with depicting the single figure. The shimmering, mist-filled setting of his richly colored and heavily glazed *Spanish Girl in Reverie* (1831; New York, Met.) creates a mood conducive to peaceful reflection, although the figure's poised right hand and the towering peaks beyond contribute dramatic counterpoints. Such cabinet pictures and his late landscapes (e.g. *Italian Landscape*, *c.* 1828–30; Detroit, MI, Inst. A.), exhibited in the major retrospective of his works in Boston in 1839, set the tone for his posthumous reputation as a refined and poetic Romantic genius. Allston inspired numerous American artists, including William Page and the sculptor Horatio Greenough.

[*See also* Boston.]

WRITINGS

R. H. Dana Jr., ed.: *Lectures on Art and Poems* (New York, 1850) [essays composed in the 1830s; the first art treatise by an American]

N. Wright, ed.: *The Correspondence of Washington Allston* (Lexington, KY, 1993) [all letters to and from the painter, 1795–1843]

BIBLIOGRAPHY

J. B. Flagg: *The Life and Letters of Washington Allston* (New York, 1892)

E. P. Richardson: *Washington Allston: A Study of the Romantic Artist in America* (Chicago, 1948, rev. New York, 1967)

K. C. Bolton: *The Drawings of Washington Allston: A Catalogue Raisonée* (PhD diss., Harvard U., 1978)

E. Johns: "Washington Allston's *Dead Man Revived*," *A. Bull.*, lxi (1979), pp. 79–99

"A Man of Genius": The Art of Washington Allston (1779–1843) (exh. cat. by W. H. Gerdts and T. E. Stebbins jr., Boston, MA, Mus. F.A., 1979)

B. J. Wolf: "Romanticism and Self-consciousness: Washington Allston," *Romantic Re-vision: Culture and Consciousness in Nineteenth-century American Painting and Literature* (Chicago and London, 1982), pp. 3–77

D. Bjelajac: *Millennial Desire and the Apocalyptic Vision of Washington Allston* (Washington, DC, 1988)

M. B. Wallace: "Washington Allston's *Moonlit Landscape*," *The Italian Presence in American Art, 1760–1860*, ed. I. B. Jaffe (New York, 1989), pp. 82–94

G. Eager: "Washington Allston's *The Sisters*: Poetry, Painting and Friendship," *Word & Image*, vi/4 (1990), pp. 298–307

J. Hill Stoner: "Washington Allston: Poems, Veils and 'Titian's Dirt'," *J. Amer. Inst. Conserv.*, xxix/1 (1990), pp. 1–12

D. Bjelajac: "Washington Allston's Prophetic Voice in Worshipful Song with Antebellum America," *Amer. A.*, v/3 (1991), pp. 68–87

D. B. Dearinger: "British Travelers' Views of American Art before the Civil War, with an Appendix Listing Travel Books," *Amer. A. J.*, xxiii/1 (1991), pp. 38–69

K. A. P. Lawson: "Washington Allston's *Hermia and Helena*," *Amer. A.*, v/3 (1991), pp. 108–9

D. Bjelajac: "The Boston Elite's Resistance to Washington Allston's *Elijah in the Desert*," *American Iconology: New Approaches to Nineteenth-century Art and Literature* (New Haven and London, 1993), pp. 39–57

D. Strazdes: "Washington Allston's *Beatrice*," *J. Mus. F.A., Boston*, vi (1994), pp. 63–75

D. Strazdes: "Washington Allston: Great Painting as Mute Poetry," *Redefining American History Painting* (Cambridge, 1995), pp. 139–57

D. Bjelajac: *Washington Allston, Secret Societies and the Alchemy of Anglo-American Painting* (Cambridge and New York, 1997)

E. Hirsher: "The Ambassadors," *RA: Roy. Acad. Mag.*, lxxxvii (Summer 2005), pp. 51–3

J. Harris, ed.: *Value, Art, Politics: Criticism, Meaning, and Interpretation after Postmodernism* (Liverpool, 2007)

M. Paley: *Samuel Taylor Coleridge and the Fine Arts* (Oxford and New York, 2008)

David Steinberg

Alston, Charles

(*b* Charlotte, NC, 29 Nov 1907; *d* 27 April 1977), painter, sculptor, graphic artist, muralist and educator. In 1913, Charles (Henry) [Spinky] Alston's family relocated from North Carolina to New York where he attended DeWitt Clinton High School. In 1929, he attended Columbia College and then Teachers College at Columbia University, where he obtained his Master of Fine Arts in 1931. Alston's art career began while he was a student, creating illustrations for *Opportunity* magazine and album covers for jazz musician Duke Ellington.

Alston was a groundbreaking educator and mentor. He directed the Harlem Arts Workshop, and then initiated the influential space known simply as "306," which ran from 1934 to 1938. He taught at the Works Progress Administration's Harlem Community Art Center and was supervisor of the Harlem Hospital Center murals, leading 35 artists as the first African American project supervisor of the Federal Art Project. His two murals reveal the influence of Mexican muralist Diego Rivera (1886–1957). His artwork ranged from the comic to the abstract, while often including references to African art. During World War II, he worked at the Office of War Information and Public Information, creating cartoons and posters to mobilize the black community in the war effort.

Alston was the first African American instructor at the Art Students League of New York (1950–71) and the Museum of Modern Art (1956). He was a member of the Board of Directors of the National Society of Mural Painters and an active member of Spiral, a black artists' collaborative founded in the 1960s. In 1969, he was appointed the painter member of the Art Commission of the City of New York, and he became a full professor at the City University of New York in 1973 (where he taught from 1970 to 1977). His work is in the permanent collections of the Metropolitan Museum of Art, the Whitney Museum of American Art, and the Detroit Institute of Arts.

[*See also* Spiral.]

BIBLIOGRAPHY

G. Coker and C. Jennings: *Charles Alston, Artist and Teacher* (exh. cat., New York, Kenkeleba Gallery, 1990)

A. J. Wardlaw: *Charles Alston*, David C. Driskell Series of American Art, 6 (Petaluma, CA, 2007)

Deborah Cullen

Alternative Museum, The

New York-based nonprofit art institution that was founded in 1975 by Geno Rodriguez, Janice Rooney and Robert Browning as the Alternative Center for International Arts. Like many other alternative institutions, the Alternative Museum was established in the wake of the social movements of the 1960s with the mission of displaying socially and politically charged art and providing a venue that was independent from both the market-oriented gallery system and the prevailing conservatism of New York museums. The museum closed its SoHo location in 2000 and now exists entirely as an online institution.

The museum originated in part as a response to Rodriguez's own experiences with institutional prejudices while attempting to find exhibition venues for his own work during the early 1970s, and it was founded with the pluralist aspiration to show artists that were marginalized or tokenized within dominant institutions. Within their first year, for example, the museum hosted significant exhibitions of art from both Latin America and Japan. Moreover, the museum often adopted a decidedly more political position than even most other nonprofit institutions in New York, particularly in reference to questions of racism and sexism. Although the institution hosted a number of significant solo exhibitions, including notable shows of work by Dennis Adams (b 1948), Enrique Chagoya (b 1953), Les Levine (b 1935) and Adrian Piper, its impact was felt most decisively in a series of group exhibitions that addressed political issues and attempted to challenge the limits of political expression within the art world. In the 1986 show *Disinformation: The Manufacture of Consent*, for example, the museum exhibited a number of artists who addressed the media's role in shaping public opinion and furthering political consent, a case that was made in a catalog essay by Noam Chomsky. The 1989 exhibition *Prisoners of Image: Ethnic and Gender Stereotypes Yesterday and Today* followed this example by displaying historical artifacts of racism and sexism alongside works by contemporary artists that addressed the legacy of these attitudes.

Between 1975 and 1985, the museum also hosted a large concert program directed by Browning that made the museum an important venue for world music in New York. In 1985, Browning left the museum to found the World Music Institute, and the museum's concert program then focused primarily on American experimental and jazz music. In subsequent years, particularly during the 1990s, there was a growing receptivity in the art world to both multiculturalism and, to a lesser degree, politically-oriented exhibitions, and the museum found that its mission was increasingly adopted by established museums and commercial galleries. At the same time, the institution also began focusing on new media with exhibitions such as *The Luminous Image* in 1996, which featured a catalog available only in CD-ROM format. In light of these developments and in the face of increasing difficulty raising funds, the museum shut its physical location in 2000 and re-established itself as a web-based institution. Since this transition, the museum has offered some virtual residencies and commissions for artists working within digital media. It has also hosted a number of online exhibitions, but the website exists today primarily as an archive for the museum's earlier activities.

BIBLIOGRAPHY
J. Kastner: "Uncertain Alternatives," *ARTnews*, xcv/6 (June 1996), pp. 120–23
J. Ault, ed.: *Alternative Art New York, 1965–1985* (Minneapolis, MN, 2002)

Tom Williams

Alternatives spaces

Exhibition spaces that are not run by institutions or commercial organizations. The phenomenon of alternative spaces in the USA is usually tied with the blooming of numerous not-for-profit, artist-run spaces in the 1970s, although important precedents can be found as far as in 1862, when the Art Building

Gallery in Chicago was founded to provide free exhibition space to artists. Providing fees and decision-power to artists, promoting conceptual and video, installation or action art, collective practices and social and political commitment, alternative spaces radically contributed to redefine the position of the artist and the form of the exhibition in the USA. Since then, the acceptance of the term has shifted to a more general opposition to mainstream institutions, such as museums and commercial galleries.

Generally considered the first small nonprofit organizations initiated by and for visual artists, 98 Greene Street, Apple and 112 Workshop (now White Columns) opened in New York in 1969–70. Grants from the National Endowment for the Arts (founded in 1965) and the increase of art school graduates in the late 1960s contributed to the creation of spaces such as the Kitchen (1971), Artists Space (1973), Franklin Furnace and P.S.1 (1976), all in New York; NAME Gallery (1973–97) in Chicago; Washington Project for the Arts (1975–96) in Washington, DC; and LACE (1978) in Los Angeles, among others. In the 1980s, the diminution of public funding due to the "Culture Wars," the increasing rates of real estate and a rejection of conceptually based practices led many alternative spaces to redefine their status and mission: Randolph Street Gallery (1979–98) in Chicago moved to a more traditional board-structure and San Francisco Artists' Television Access, founded in 1983, included cable television as a distribution system. The 1990s saw the closing of numerous alternative spaces due to bankruptcy, while in New York Franklin Furnace and The Alternative Museum started operating as Web sites in 2000. Some were absorbed by bigger institutions, which had diversified their activities since the 1970s under the influence of the same alternative spaces, such as New York P.S.1, which was taken over by the Museum of Modern Art in 2000. At the end of the 2000s, the economic recession questioned the future of these spaces in the United States, although new venues such as Brooklyn Cleopatra's (2008) remained open.

[*See also* Alternative Museum, The; Artists Space; *and* Franklin Furnace.]

BIBLIOGRAPHY
K. Larson: "Rooms with a Point of View," *ARTnews*, lxxvi (Oct 1977), pp. 32–8

P. Patton: "Other Voices, Other Rooms: The Rise of the Alternative Space," *A. America*, lxv (July–Aug 1977), pp. 80–89

J. Apple and M. Delahoyd: *Alternatives in Retrospect* (exh. cat., New York, The New Museum, 1981)

L. Lippard: *Get the Message? A Decade of Art for Social Change* (New York, 1984)

L. Warren: *Alternative Spaces: A History in Chicago* (Chicago, 1984)

A. Moore and M. Miller: *ABC No Rio Dinero: The Story of a Lower East Side Art Gallery* (New York, 1985)

R. Atkins: "On Edge: Alternative Spaces Today," *A. America* (Nov 1998), pp. 57–61

C. Gould and V. Smith, ed.: *5000 Artists Return to Artists Space: 25 Years* (New York, 1998)

L. Bovier and C. Cherix: *Les Espaces Indépendants/Independent Spaces* (Geneva, 1999)

B. Wallis, M. Weems, and P. Yenawine, eds.: *Art Matters: How the Culture Wars Changed America* (New York, 1999)

J. Ault, ed.: *Alternative Art New York 1965–1985* (exh. cat., New York, The Drawing Center, 2002)

R. Kostelanetz: *Soho: the Rise and Fall of an Artists' Colony* (New York, 2003)

Phonebook: An Annual Directory for Alternative Art Spaces (Chicago, 2008)

Virginie Bobin

Altman, Benjamin

(*b* New York, 12 July 1840; *d* New York, 7 Oct 1913), merchant and collector. He was the son of Bavarian Jewish immigrants who ran a small dry goods business in New York before the Civil War. About 1863 he entered into a business partnership with his brother; after Morris Altman's death in 1876, Benjamin re-established the business and quickly developed it into a highly profitable enterprise. Altman's aesthetic interests extended from European and Oriental decorative arts to Old Master paintings. A self-educated connoisseur, Altman depended a great deal on the advice of dealers such as Duveen,

Agnew, Gimpel and Wildenstein, but also developed a fine discrimination as a result of a few short trips to Europe and the accumulation of a valuable art library. As he became more deeply involved in art, he began to devote his entire time to its study. Although never a recluse, he did not participate actively in New York society, never married and insisted on privacy.

During the 1880s and 1890s Altman collected mainly American and Barbizon school paintings. From 1905, when he moved to a new Fifth Avenue home, he turned to Old Masters, particularly of the Dutch and Flemish schools, expensive porcelain, Oriental rugs and 18th-century furniture. From the Rodolphe and Maurice Kann collections he acquired Vermeer's *Girl Asleep*, three Rembrandts and paintings by Nicolaes Maes, Pieter de Hooch, Meindert Hobbema and Aelbert Cuyp. Later he acquired Jacob van Ruisdael's *Wheatfields*, Rembrandt's *Toilet of Bathsheba*, Velázquez's *Christ and the Pilgrims of Emmaus*, Fra Angelico's *Crucifixion*, Francesco Francia's *Federigo Gonzaga*, Titian's *Portrait of a Man* and Botticelli's *Last Communion of St Jerome*. (All works mentioned are in New York, Met.) His collection of simple but dignified portraits of bankers and merchants from the Low Countries and Germany are among the finest examples of Flemish and German painting of their period: for example, Hans Memling's *Tommaso Portinari* and Hans Maler I's *Ulrich Fugger of Augsburg*. Haskell has concluded that Altman's collection constituted his "gallery of ancestors" (1970, p. 261).

By bequeathing his 51 pictures, Chinese porcelain, works in gold, crystal and enamel, tapestries, sculptures, Japanese lacquer and rugs to the Metropolitan Museum, New York, Altman paid homage to the city responsible for his success, but he also hoped his collection would benefit mankind.

BIBLIOGRAPHY
"The Benjamin Altman Bequest," *Bull. Met.*, viii (1913), pp. 226–41

F. Monod: "La Galerie Altman au Metropolitan Museum de New York," *Gaz. B.-A.*, n.s. 5, viii (1923), pp. 179–98, 297–312, 367–77

Handbook of the Altman Collection (New York, 1928)

F. Haskell: "The Benjamin Altman Bequest," *Met. Mus. J.*, iii (1970), pp. 259–80; repr. in *Past and Present in Art and Taste* (New Haven, 1987), pp. 186–206

Merchants and Masterpieces: Great Collectors of the Metropolitan Museum of Art [videorecording, c. 1995]

Lillian B. Miller
Revised and updated by Margaret Barlow

Alvarez Bravo, Manuel

(*b* Mexico City, 4 Feb 1902; *d* Mexico City, 19 Oct 2002), Mexican photographer. Alvarez Bravo's interest in photography began in his adolescence while living in Mexico City in the 1910s, the years of the Mexican Revolution. He left school at the age of 13 to help support his family but pursued his creative interests by studying foreign photography magazines and receiving instruction from the German photographer based in Mexico, Hugo Brehme (1882–1954). Alvarez Bravo's earliest images, made with a large-format Graflex camera, reflected the romantic pictorialist mode identified with Brehme's generation. By 1925, however, he turned to a modernist aesthetic inspired by the photographs Edward Weston made in Mexico in the mid-1920s as well as those of Tina Modotti, who accompanied Weston and remained in the country until 1930. During this era Alvarez Bravo came to know Modotti as well as the artists who led Mexico's cultural renaissance of the 1920s and 1930s, including Diego Rivera (1886–1957), Frida Kahlo (1907–57) and Rufino Tamayo (1899–1991). Also central to this circle was Lola Alvarez Bravo (1907–93), whom he married in 1924 and who eventually became a significant photographer in her own right (they separated in 1934 and divorced several years later).

Alvarez Bravo produced essentially all his work in Mexico. His first mature photographs in the late 1920s include spare, composed scenes of common forms like a stack of books, tools, or rolls of accounting paper. His classic images of the 1930s meld a keen sense of observation with a seemingly uncanny ability to infuse the everyday with metaphorical value, and often, with a sense of poetic possibility.

Optic Parable (1931), a reversed image of an optician's storefront filled with pictures of eyes, express vision as a physical, spiritual, and creative entity. It is one of many photographs by Alvarez Bravo highlighting the cultural incongruities visible amidst the urban landscape of Mexico City, then a rapidly modernizing city but one a large peasant population and ancient indigenous roots. Alvarez Bravo also depicted anonymous everyday people, who acted as much as symbols for the Mexican cultural heritage he cherished as nuanced studies in human behavior.

In 1935 Alvarez Bravo exhibited with Henri Cartier-Bresson (1908–2004) and Walker Evans at the Julien Levy Gallery in New York; he subsequently traveled to Chicago where he taught and exhibited at Hull House. When André Breton (1896–1966) visited Mexico, he featured Alvarez Bravo in the 1940 Exposition of Surrealism, held in Mexico City. Although Alvarez Bravo did not consider himself a Surrealist, he created one of his most iconic images, *Good Reputation Sleeping* (1939), as a result of a "surrealist impulse." This enigmatic composition of a reclining woman whose feet and upper thighs are wrapped with lengths of bandage evinces Alvarez Bravo as a photographer of enormous psychological depth. The female nude was one of his abiding themes, particularly later in his life.

Alvarez Bravo worked as a still photographer in Mexico's film industry in the 1940s and 1950s, decades known as the nation's Golden Age of cinema. He continued to photograph in this period, often picturing arid landscapes, workers, and simply, people walking along city streets framed by tall walls. His long career also encompassed teaching, filmmaking, publishing and curating.

PHOTOGRAPHIC PUBLICATIONS

Manuel Alvarez Bravo: Fotografías (Mexico City, 1945)

Photographs by Manuel Alvarez Bravo (Geneva, 1977)

Sol (Mexico City, 1989)

Luz y tiempo: Catálogo de la colección fotográfica formada por Manuel Alvarez Bravo para la Fundación Cultura Televisa, 3 vols (Mexico City, 1995)

Instante y Revelación (Mexico City, 1982) [photographs accompany poems by Octavio Paz]

BIBLIOGRAPHY

Manuel Alvarez Bravo (exh. cat. by J. Livingston, Washington, DC, Corcoran Gal. A., 1978)

A. D. Coleman: *Manuel Alvarez Bravo* (Millerton, NY, 1987)

Manuel Alvarez Bravo (exh. cat. by S. Kismaric, New York, MOMA, 1997)

C. Monsiváis: *Manuel Alvarez Bravo: 100 Years, 100 Days* (Mexico, 2001)

Elizabeth Ferrer

Ambasz, Emilio

(*b* Resistencia, June 1943), architect, industrial designer and museum curator of Argentine birth. He received a Master of Fine Arts degree in architecture from Princeton University, NJ, and then taught at Princeton, at Carnegie Institute of Technology in Pittsburgh and at the Hochschule für Gestaltung in Ulm, Germany. From 1969 to 1976 he was Curator of Design for the Museum of Modern Art (MOMA) in New York. In 1972 he produced the exhibition *Italy: The New Domestic Landscape* and a related book for MOMA. The exhibition offered historical background and a presentation of contemporary Italian avant-garde work and theory. His architectural works include the Lucille Halsell Conservatory at San Antonio, TX (1987); Banque Bruxelles Lambert offices in Milan (1981), Lausanne (1983) and New York (1984); and offices for the Financial Guaranty Insurance Company in New York (1986), for which he won the International Interior Design Award. An innovative designer, Ambasz sought to reinterpret the poetic aspects of Modernism and the relationship between architecture and the landscape. As an industrial designer, he developed furniture, lighting, a diesel engine and packaging and graphic designs. His work has won many honors and awards.

WRITINGS

with others: *Emilio Ambasz: The Poetics of the Pragmatic* (New York, 1989)

"The Green and the Gray," *Kenchiku bunka*, l/585 (July 1995), pp. 57–90

"Interroga se stello/I ask Myself," *Ottagono*, xxx/114 (March–May 1995), pp. 80–87 [answers to questions about design]

"Paesaggio domestico 1972–1997/Domestic Landscape 1972–1997," *Ottagono*, xxxii/122 (March–May 1997); special issue featuring "1972–1997, Italy: The New Domestic Landscape," with essays by E. Ambasz and others and samples of work by *c.* 70 designers

BIBLIOGRAPHY

P. Buchanan: "Curtains for Ambasz," *Archit. Rev.* [London], clxxxi/1083 (1987), pp. 73–7

M. Bellini and others: *Emilio Ambasz: The Poetics of the Pragmatic: Architecture, Exhibit, Industrial and Graphic Design* (New York, 1988)

P. Buchanan and others: *Inventions: The Reality of the Ideal/ Emilio Ambasz* (New York, 1992)

"Emilio Ambasz, 1986–1992/Emirio Ambātsu," *A+U*, special issue (April 1993)

Emilio Ambasz: Arquitectura y diseño: 1973–1993 (exh. cat., with intro. by T. Riley, Tokyo, Tokyo Station Gallery, 1993)

"Emilio Ambasz: Worldbridge Trade and Investment Center, Fukuoka Prefectural International Hall, Nichii Obihiro Department Store," *Perspecta*, xxix (1998), pp. 42–9

T. Ando and others: *Emilio Ambasz: Natural Architecture: Artificial Design* (Milan, 2001)

M. Alassio: "Casa par viaggio interior/House for an Inner Voyage," *Domus*, 875 (Nov 2004), pp. 20–29

J. Dodds and others: *Emilio Ambasz* (New York, 2004)

F. Irace: *Emilio Ambasz: Una Arcadia technologica* (Milan, 2004)

F. Scott: "On the 'Counter-Design' of Institutions: Emilio Ambasz's Universitas Symposium at MoMA," *Grey Room*, xiv (Winter 2004), pp. 46–77

M. Alassio: *Emilio Ambasz: Casa de retiro esspiritual/photography/fotografia* (Milan, 2005)

"Casa del Retiro Espiritual, El Ronquillo, Sevilla/House of Spiritual Retreat, El Ronquillo, Sevilla," *ON Diseño*, 272 (2006), pp. 174–99

John F. Pile

Amelung, John Frederick

(*b* Hettlingen, Germany, 26 June 1741; *d* Baltimore, MD, 1 Nov 1798), glass manufacturer of German birth. John Frederick [Johann Friedrich] Amelung was associated with his brother's mirror-glass factory in the town of Grünenplan before his venture to make table wares and utility glass in America began in 1784. With backing from investors in Bremen, Germany, Amelung brought 68 glass craftsmen and furnace equipment to the USA. He purchased an existing glasshouse near Frederick, MD, along with 2100 acres. The factory, which he named the New Bremen Glassmanufactory, had been founded by glassmakers from Henry William Stiegel's defunct operation in Manheim, PA. It was well situated in western Maryland, not far from Baltimore, which offered a fast-growing market. Many settlers in the area were Germans, who were expected to be supportive of the enterprise. During the following decade Amelung built housing for his 400–500 workers. It is believed that he built four glasshouses.

Although Amelung's craftsmen made window glass, bottles and table glass, the most important group of objects associated with the factory are the high-quality, wheel-engraved presentation pieces (e.g. sugar bowl, 1785–95; Winterthur, DE, Du Pont Winterthur Mus.) made as gifts for friends and for such politicians as President George Washington, whom Amelung hoped to impress. These wares shared some of the *Waldglas* lily-pad decoration associated with Caspar Wistar's earlier glassworks, but Amelung's products are more spectacular in conception and execution. They are significant for often being signed and dated; Amelung's was the only American factory doing this at the time.

In 1787 Amelung published a pamphlet entitled *Remarks on Manufactures, Principally on the New Established Glass-house, near Frederick-Town in the State of Maryland*, in which he related the founding of his enterprise and speculated on its future. Its progress, he argued, would be greatly facilitated and the public interest best served by official support of American manufacturers through tax exemptions and interest-free government loans. Although the State of Maryland loaned him £1000 in 1788, additional state or federal government support was not forthcoming. Furthermore, a flood in the autumn of 1786 that damaged one glasshouse, a strong wind in the spring of 1790 that caused the collapse of several houses and mills, and shortly thereafter a fire that destroyed one of his factories and a warehouse, all combined to undermine an operation that was already overextended. Amelung's petition to the US

Congress for help after the fire was denied for lack of security on a loan. In a second petition he further proposed to build glasshouses in Virginia and the Carolinas to serve the southern USA. Although the second request was rejected, his suggestion that duties be raised on imported glass was executed in several installments between 1790 and 1794. Amelung's operations virtually ceased following his stroke in 1794, and he went bankrupt in 1795. His son, John Frederick Magnus Amelung, continued to make glass in the glasshouse given to him in 1795 by his father (the site was not included in his father's bankruptcy), but in 1799 he transferred the property to his partners Adam Kohlenberg and George Christian Gabler.

[*See also* Federal Style.]

WRITINGS

Remarks on Manufactures, Principally on the New Established Glass-house, near Frederick-Town in the State of Maryland (Frederick-Town, 1787)

BIBLIOGRAPHY

E. S. Delaplaine: *John Frederick Amelung, Maryland Glassmaker* (Frederick, MD, 1971)

D. P. Lanmon, A. Palmer Schwind, and others: *John Frederick Amelung: Early American Glassmaker* (London, 1990)

Ellen Denker

American Abstract Artists

American group of painters and sculptors formed in 1936 in New York. The aim of American Abstract Artists [A.A.A.] was to promote American abstract art. Similar to the Abstraction–Création group in Europe, this association introduced the public to American abstraction through annual exhibitions, publications and lectures. It also acted as a forum for abstract artists to share ideas. The group, whose first exhibition was held in April 1937 at the Squibb Galleries in New York, insisted that art should be divorced from political or social issues. Its aesthetics were usually identified with Synthetic Cubism, and the majority of its members worked in a geometric Cubist-derived idiom of hard-edge forms, applying flat, strong colors. Although the group officially rejected Expressionism and Surrealism, its members actually painted in a number of abstract styles. Almost half of the founding members had studied with Hans Hoffmann and infused their geometric styles with surreal, biomorphic forms, whereas others experimented with Neo-plasticism.

The first president was Balcomb Greene (1904–90). Among the early members were Ilya Bolotowsky, Willem de Kooning, Burgoyne Diller, A. E. Gallatin, Carl Holty (1900–73), Harry Holtzman (*b* 1912), Lee Krasner, Ibram Lassaw, Ad Reinhardt, David Smith and Albert Swinden (1901–61). The group also included a number of European artists living in the USA, among them Josef Albers, Jean Hélion, László Moholy-Nagy and Piet Mondrian.

The group, which never dissolved, had its heyday from 1937 to 1942, when it established a suitable climate for the formation of Abstract Expressionism.

[*See also* Eames; Reinhardt, Ad; *and* Sculpture, *subentry on* After World War I.]

WRITINGS

American Abstract Artists, Three Yearbooks (1938, 1939, 1946) (New York, 1969)

BIBLIOGRAPHY

G. McNeil: "American Abstractionists Venerable at Twenty," *Art News*, lv/3 (1956), pp. 34–5, 64–6

J. Elderfield: "American Geometric Abstraction in the Late Thirties," *ARTFORUM*, 11/4 (1972), pp. 35–42

S. C. Larsen: "The American Abstract Artists: A Documentary History, 1936–1941," *Arch. Am. A. J.* 14/1 (1974), pp. 2–7

S. C. Larsen: "The American Abstract Artists Group: A History and Evaluation of Its Impact upon American Art" (diss., Evanston, IL, Northwestern U., 1975)

E. Slobodkina: *American Abstract Artists: Its Publications, Catalogs and Membership* (Great Neck, NY, Urquhart-Slobodkina, *c.* 1979)

Abstract Painting and Sculpture in America, 1927–1944 (exh. cat., ed. J. R. Lane and S. C. Larsen; Pittsburgh, PA, Carnegie Mus. A., 1983)

V. M. Mecklenburg: (preface by) Broun, Elizabeth, *The Patricia and Phillip Frost Collection: American Abstraction 1930–1945* (exh. cat., Washington, DC: N. Mus. Amer. A. (8 Sept 1989–11 Feb 1990)

Ilene Susan Fort

American Academy of Fine Arts

New York–based institution and art school promoting fine art that was active between 1802 and 1841. The Academy was founded in 1802 as New York Academy of the Fine Arts by its first president, mayor Edward Livingston, and his brother Robert R. Livingston, president from 1804 to 1813. The Academy's first task was to procure plaster casts from antique statues in the Louvre, Paris. With the exception of this permanent exhibition, however, the institution largely languished. In 1804 it changed its name to the American Academy of the Arts, finally being incorporated in 1808.

After his return to the United States in 1815, John Trumbull became a main force behind the Academy's reactivation. In 1816, its first exhibition in new rooms was highly successful. Succeeding DeWitt Clinton as president in 1817, Trumbull promoted many changes mostly modeled on the Royal Academy in London. The institution consisted of 20 professional artists as Academicians with an equal number of Associates, and was managed by a board of 11 mostly non-artist directors.

During the following years the Academy organized annual exhibitions and cultivated a civic art community. Its collection and prestige grew, exemplified by the acquisition of Thomas Lawrence's portrait of *Benjamin West* (1818–21; Hartford, CT, Wadsworth Atheneum), which became the focal point of the Academy's gallery. However, Trumbull's administration of the art school led to the Academy's disintegration. The training of young artists consisted mainly of the privilege to copy plaster casts and paintings between 6 a.m. and 9 a.m.; otherwise they were largely left on their own and consequently felt increasingly alienated. In 1825, some of them, including Samuel F. B. Morse, Asher B. Durand and Thomas Cole, formed the New York Drawing Association and finally the National Academy of Design. In the following years several proposals for a union of the two institutions were put forward, but the question whether an academy should be governed exclusively by artists or also by non-artist stockholders frustrated these efforts.

In 1836, Trumbull resigned as president. The last presidents, Rembrandt Peale and Alexander E. Hosack (from 1839), could not revive the institution to its former vigor. In 1837 and 1839, fires damaged the premises of the Academy, which was finally dissolved in 1841.

[*See also* Trumbull, John.]

BIBLIOGRAPHY

The Charter and By-Laws of the American Academy of the Fine Arts, Instituted February 12, 1802, Under the Title of American Academy of the Arts: With an Account of the Statues, Busts, Paintings, Prints, Books, and Other Property Belonging to the Academy (New York, 1817)

W. E. Howe: *A History of the Metropolitan Museum of Art with a Chapter on the Early Institutions of Art in New York* (New York, 1913)

T. Sizer: "The American Academy if the Fine Arts," *American Academy of Fine Arts and American Art-Union*, ed. M. Bartlett Cowdrey, i (New York, 1953), pp. 3–93

I. B. Jaffe: *John Trumbull. Patriot Artist of the American Revolution* (Boston, 1975)

C. Rebora: "Sir Thomas Lawrence's 'Benjamin West' for the American Academy of the Fine Arts," *Amer. A. J.*, xxi/3 (1989), pp. 19–47

Grischka Petri

American Artists' Congress

Organization founded in 1936 in the USA in response to the call of the Popular Front and the American Communist Party for formations of literary and artistic groups against the spread of Fascism. In May 1935 a group of New York artists met to draw up the "Call for an American Artists' Congress"; among the initiators were George Ault (1891–1948), Peter Blume, Stuart Davis, Adolf Dehn (1895–1968), William Gropper, Jerome Klein, Louis Lozowick (1892–1973), Moses Soyer, Niles Spencer and Harry Sternberg (1904–2001). Davis became one of the most vociferous promoters of the Congress and was not only the national executive secretary but

also the editor of the organization's magazine, *Art Front*, until 1939.

The dual concerns of the American Artists' Congress were the economic distress of artists resulting from the depressions of the 1930s and the effect of Fascism in terms of the use of art as war propaganda and the censorship of art. The Congress endorsed the Works Progress Administration's Federal Art Project (WPA/FAP) based on the economic needs of artists and lobbied for permanent governmental sponsorship of the arts. In 1939 a book of *Twelve Cartoons Defending WPA by Members of the American Artists' Congress* was published. The Congress supported a policy of museums paying rental fees to artists and called for an exhibition boycott of the Olympic Games in Berlin in 1936.

The first American Artists' Congress against War and Fascism was held in New York at the Town Hall and the New School for Social Research on 14–16 February 1936. About 400 delegates attended, including "leading American artists, academicians and modernists, purists and social realists" (*American Artists' Congress against War and Fascism*), as well as visiting delegations from Mexico, Cuba, Peru and Canada. The opening address was delivered by Lewis Mumford, then chairman of the American Writers' League, which had been organized in April 1935.

Membership of the American Artists' Congress declined in 1940, when a number of members, concerned at the apparent support by the Communist-orientated organization for the Russians' attack on Finland, seceded to form the politically independent Federation of Modern Painters and Sculptors. By 1943 the Congress was defunct.

[*See also* Davis, Stuart.]

WRITINGS

American Artists' Congress against War and Fascism: First American Artists' Congress (New York, 1936)

M. Baigell and J. Williams, eds.: *Artists against War and Fascism: Papers of the First American Artists' Congress* (New Brunswick, 1986)

M. Sue Kendall

American Federation of Arts

Not-for-profit organization founded in 1909 that initiates and organizes art exhibitions and provides educational and professional programs in collaboration with the museum community. Established by an act of Congress in 1909, after former Secretary of State and US Senator Elihu Root called for the founding of an organization "whose purpose is to promote the study of art, the cultivation of public taste, and the application of art to the development of material conditions in our country," the American Federation of Arts (AFA) is one of the oldest art organizations in the country and serves nearly 300 museum members in the USA and abroad. Root's then revolutionary proposal was unanimously endorsed by representatives of 80 American art institutions in attendance. Among the 35 founders, in addition to Root, were presidents Theodore Roosevelt and William Taft, as well as artist William Merritt Chase and businessmen Andrew W. Mellon and J. P. Morgan.

Originally based in Washington, DC, the AFA moved to New York in 1952. In 1912 it merged with the National League of Handicraft Societies and later, in 1987, with the Art Museum Association of America (AMAA). From 1909 to 1953 it published a monthly magazine, *Art and Progress,* renamed *The American Magazine of Art* in 1916 and *The Magazine of Art* in 1937.

Since its founding, the AFA has organized over 1000 exhibitions that have traveled to hundreds of art museums and galleries across America and internationally. Its exhibitions encompass a wide range of mediums, artists, historical periods and cultural traditions, from Roman portraiture and Native American artifacts to American Impressionism and contemporary art and sculpture. It also collaborates with institutions around the world to tour important aspects of their collections. To further engage and inform museum visitors and art enthusiasts, it produces innovative educational components and richly illustrated catalogs introducing original scholarship.

In 1993 the AFA inaugurated an annual Directors Forum, a three-day conference for art museum directors, and donated the bulk of its records to the Archives of American Art. In 2003 it launched ArtTalks, a public lecture series featuring prominent figures in the art community.

BIBLIOGRAPHY

AFA, http://www.afaweb.org (accessed 15 April 2010)

Klaus Ottmann

Ames, Ezra

(*b* Framingham, MA, 5 May 1768; *d* Albany, NY, 23 Feb 1836), painter and craftsman. After working briefly in Worcester, MA (1790–93), painting miniatures, chimney-pieces, signs and sleighs, he settled permanently in Albany, NY. There he practiced various crafts, including framemaking and painting ornamental clock faces. Active in the Masonic Temple, he held a high position in the New York chapter from 1802 to 1826. For the Masons he made signs, aprons, urns and carpet designs. Entries in his account books indicate that by 1813 he was primarily painting portraits, improving his technique by copying works by John Singleton Copley and Gilbert Stuart. His first major success was the sale of a portrait of *George Clinton*, Governor of New York and vice president of the USA, to the Pennsylvania Academy of Fine Arts (1812; destr. 1845). Laudatory reviews generated requests for replicas, including an ambitious but somewhat awkward full-length version (*c.* 1813; Albany, NY, State Capitol). Ames also painted the official portrait of George Clinton's nephew, *DeWitt Clinton as Governor of New York* for the city of Albany (1817–18; on dep. Albany, NY, Inst. Hist. & A.). It is a half-length portrait and demonstrates his straightforward, factual style. Ames was elected to the American Academy of Fine Arts in 1824 but never exhibited in New York. Nearly 500 of his works, mainly portraits of people in New York state, have been recorded.

BIBLIOGRAPHY

T. Bolton and I. F. Cortelyou: *Ezra Ames of Albany* (New York, 1955)

I. F. Cortelyou: *A Supplement to the Catalogue of Pictures by Ezra Ames of Albany* (New York, 1957)

Leah Lipton

Ammann, Othmar Hermann

(*b* Schaffenhausen, Switzerland, 1879; *d* New York, 1965), civil engineer of Swiss origin and education. Amman was born in Schaffhausen, Switzerland, and educated at the Swiss Federal Polytechnic Institute in Zurich, from which he graduated in 1902. After brief employment in Swiss and German steel and bridge construction firms, his ambition led him to move to the USA in 1904.

Arriving in New York, Ammann quickly found work in the office of consulting engineer Joseph Mayer, for whom he would work for only six months. Between 1904 and 1907, Ammann worked for the Pennsylvania Steel Company, in Harrisburg, and Chicago bridge engineer Ralph Modjeski, before settling in Philadelphia as consultant for the engineering firm of Kunz and Schneider. Ammann's trajectory put him in contact with leading designers of long-span bridges and the most important steel construction problems of his time. At Pennsylvania Steel, Ammann worked on the construction of engineer Gustav Lindenthal's Queensboro Bridge in New York, and his first job for Kunz and Schneider was to study the failure of the Quebec Bridge in 1907.

Ammann's political activities and proposal for the future George Washington Bridge's design led to his appointment as Chief Engineer of the Port Authority of New York and New Jersey in 1925. In this capacity, he designed a series of important bridges and tunnels in the New York region: The Goethals and Outerbridge crossings, completed in 1928, the Bayonne Bridge and George Washington Bridge, completed in 1931, the Triborough (now Robert F. Kennedy) Bridge (1936), the Lincoln Tunnel (1937)

and the Bronx Whitestone Bridge (1939). As Ammann was now considered a leading authority on long-span bridge design, he also consulted for engineer Joseph B. Strauss on the construction of the Golden Gate Bridge in San Francisco (1937).

Ammann left the Port Authority for private practice in 1939 and opened an office with the concrete expert Charles S. Whitney in 1946. Their combined expertise, and Ammann's high-profile projects for the Port Authority, allowed the firm to pursue important commissions across the United States and internationally. Ammann & Whitney built two more bridges in New York City: The Throgs Neck Bridge, completed in 1961, and the Verrazano Narrows Bridge, completed in 1964. Important architectural projects also include the Pittsburg Civic Arena (1963), the dramatic retractable dome of the University of Illinois at Urbana's Assembly Hall (1963) and architect Eero Saarinen's TWA Terminal at New York's Idlewild Airport (1962).

BIBLIOGRAPHY

F. C. Kunz and O. H. Ammann: *Design of Steel Bridges.* (New York, 1915)

O. H. Ammann: "The Hudson River Bridge," *Eng. News* (Feb 1928)

O. H. Ammann: *Proc Amer. Inst. Consult. Eng.* (4 Nov. 1931)

O. H. Ammann: "Bridges of New York," *J. Boston Soc. Civil Eng.* (July 1937)

O. H. Ammann: "Planning the Lincoln Tunnel Under the Hudson," *Civil Eng.* (June 1937)

O. H. Ammann: "Verrazano-Narrows Bridge: Conception of Design and Construction Procedure," *J. Const. Div. ASCE* (Mar 1966)

E. Cohen: "The Engineer and His Works: A Tribute to Othmar Hermann Ammann," *An. NY Acad Sci* 136 (Sept 1967)

F. Stüssi: *Othmar H. Ammann: Sein Beitrag zur Entwicklung des Brückenbaus* (Basel, 1974)

E. Cohen: "Long-Span Bridges," *O.H. Ammann Centennial Conference, An. NY Acad. Sci.* 352 (Dec 1980)

D. P. Billington: *The Tower and the Bridge* (New York, 1983)

C. Szoradi: "Ammann & Whitney," in Joseph A. Wilkes, ed., *Encyclopedia of Architecture, Design, Engineering & Construction* (New York, 1988)

J. W. Doig: "Politics and the Engineering Mind," in David Perry, ed., *Building the Public City* (1995)

D. Rastorfer: *Six Bridges: The Legacy of Othmar H. Ammann* (New Haven, 2000)

D. P. Billington and J. W. Doig: *Art of Structural Design: A Swiss Legacy* (Princeton, NJ, 2003)

C. Dicleli: "Ingenieurporträt: Othmar Ammann, Brückenbauer des 20. Jahrhunderts in den USA," in *Deutsche Bauzeitung,* 2 (2006)

Matico Josephson

Amos, Emma

(*b* Atlanta, GA, 16 March 1938), painter, printmaker and weaver. Amos studied fine arts and textile weaving at Antioch College at Yellow Springs, OH, where she received her BFA in 1958. She went on to study etching and painting at the Central School of Art, London (1958–9), and the following year she moved to New York, where she began working at two printmaking studios: Robert Blackburn's workshop and that of Letterio Calapai (an outpost of Stanley William Hayter's Atelier 17). She completed her MA at New York University in 1966. Through Hale Woodruff, an art professor at NYU and family friend, she was invited to exhibit with Spiral, an all-male art group founded by Woodruff and Romare Bearden and featuring recognized African American artists. Spiral, closely allied with the Civil Rights movement, dissolved in 1967, and subsequently Amos had trouble exhibiting her work. In 1974, after the birth of her two children, Amos found a position as an instructor in textile design at the Newark School of Fine and Industrial Arts. She continued her own weaving in New York and benefited from the revival of interest in women's traditional art forms in the early years of the feminist art movement.

In 1980 Amos became a professor of art at the Mason Gross School of the Arts, Rutgers University, NJ. She began teaching drawing, painting and intaglio printmaking. Her own work included a series of etchings and aquatints of women of color. The *Water Series* a synthesis of Amos's interest in painting, printmaking and weaving, began shortly

after she was awarded tenure at Rutgers in 1985. The vivid, semi-abstract works include bathers, Olympic swimmers and creatures of the sea. Conveying both tension and exuberance, the human subjects are captured in dramatic positions to emphasize their sense of movement through space. The series includes passages in acrylic combined with borders of Kente cloth, woven linen or batik. The *Falling series*, begun in 1988, was exhibited at the Bronx Museum of the Arts, New York, in 1991. Amos developed the dynamic effect of her figures falling through space, calling it "absolute movement." The series has been associated with the difficulties of the time for the underprivileged, but Amos also portrayed the triumph of certain African Americans, including Jackie Joyner-Kersee (*b* 1962), the Olympic gold medalist, whose dynamic form seems to rise upward or leap forward. Amos went on to explore the construction of beauty in visual cultures. Her models included herself, as well as historical portrayals of royal women, such as images from Benin culture, and more recent conceptions of female beauty. Amos uses cloth to deconstruct the idea of African art and magical powers. Often she introduces historical references that reveal gender issues or racial tensions. Other "heroes" appeared in later works, such as a portrait of Picasso emblazoned on an apron and surrounded by African herdsmen, sculptures from Africa and Amos's own portrait. After the death of her husband in 2005, Amos took a new direction in her art, introducing more subtle passages of color. The forms, previously clearly delineated, became more abstract, introducing richly symbolic content. Later paintings by Amos replace ancestor worship with a focus on self-analysis and self-reference, including self-portraits and images of friends.

Amos's works have been shown in numerous solo exhibitions, and her works have been exhibited in museums throughout the USA. She has also received fellowships from the Rockefeller Foundation and the National Endowment for the Arts. For illustration, see color pl. 1:VII, 1.

WRITINGS
"Some Do's and Don'ts for Black Women Artists," *Heresies*, xv (1982)

BIBLIOGRAPHY
Emma Amos: Drawings and Prints, 1982–1992 (exh. cat., Wooster, OH, Coll. A. Mus., 1993)
J. Isaak: *Looking Forward, Looking Black* (Geneva and New York, 1999)
L. E. Farrington: "Emma Amos: Art as Legacy," *Woman's A. J.*, xxviii (Spring–Summer 2007), pp. 3–11

Joan Marter

Anasazi

Term applied to the prehistoric "basketmakers" (*fl* to *c.* AD 750) of the southwestern USA and their successors, the Pueblo tribes, who still live in the region in the early 20th century. The Anasazi (Navajo for "the ancient ones") are famous for their communal buildings, many now ruined, which were known as "pueblos" by the first Spanish explorers. The most celebrated of these stone and adobe structures were multi-room, multi-family dwellings built atop mesas and in natural caves found at the base of canyons. Built *c.* 1100–*c.* 1300, they are located at various sites, including Mesa Verde in southwest Colorado and Chaco Canyon in northwest New Mexico. The Anasazi also produced painted pottery, basketry and weaving.

[*See also* Native North American Art, *subentry on* Dwellings and Other Structures.]

BIBLIOGRAPHY
D. G. Pike: *Anasazi: Ancient People of the Rock* (New York, 1974)
W. M. Ferguson and A. H. Rohn: *Anasazi Ruins of the Southwest in Color* (Albuquerque, 1986)
L. S. Cordell and G. J. Gumerman, eds.: *Dynamics of Southwest Prehistory* (Washington, DC, 1989/R 1993)
D. E. Stuart: *Anasazi America: 17 Centuries on the Road from Center Place* (Albuquerque, 2000)

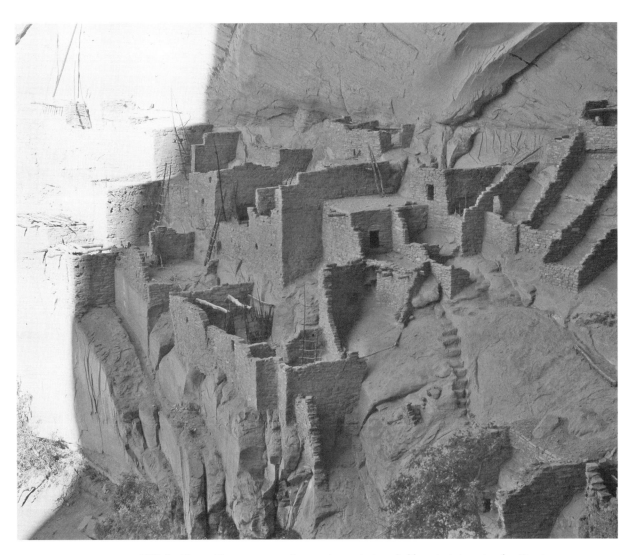

ANASAZI. Cliff dwelling with 135 rooms, former Anasazi stronghold against invasion by Navajo and Apache Athapascan nomads, near Betakin, Arizona, abandoned by AD 1300. WERNER FORMAN/ART RESOURCE, NY

Anderson, Alexander

(*b* New York, 21 April 1775; *d* Jersey City, NJ, 17 Jan 1870), wood-engraver. Anderson was the first important American wood-engraver. He was self-taught and made woodcuts for newspapers at the age of 12. Between *c.* 1792 and 1798, when he studied and practiced medicine, he engraved wood as a secondary occupation, but following the death of his family in the yellow fever epidemic of 1798, he abandoned medicine and worked as a graphic artist. He was an early follower of Thomas Bewick's white-line style. He usually engraved the designs of others, such as Benjamin West, but he was a skillful and original draftsman, as can be seen in his illustrations for Durell's edition of Homer's *Iliad* (New York, 1808). He exhibited frequently at the American Academy and was a founder-member of the National Academy of Design (1825). Anderson spent his long and prolific career in New York, engraving mainly for book publishers and magazines but also producing pictorial matter for printed ephemera. He worked steadily until the late 1850s, cut his last blocks in

1868 and was described by Linton as "the father of American wood engraving." His reputation rests on his solid craftsmanship rather than his artistic abilities. A large collection of his proofs is in the New York Public Library, and his tools and some of his blocks are kept by the New York Historical Society.

BIBLIOGRAPHY

W. J. Linton: *History of Wood Engraving in America* (Boston, 1882), pp. 1–9

F. M. Burr: *Life and Works of Alexander Anderson, M.D., the First American Wood Engraver* (New York, 1893)

H. Knubel: "Alexander Anderson and Early American Book Illustration," *Princeton U. Lib. Chron.*, i (April 1940), pp. 8–18

A. Gardner: "Doctor Alexander Anderson," *Bull. Met.*, ix/x (1950–52), pp. 218–24

J. R. Pomeroy: "Alexander Anderson's Life and Engravings before 1800," *Amer. Ant. Soc. Proc.*, c (1990), pp. 137–230

J. R. Pomeroy: "A New Bibliography of the Work of Wood Engraver and Illustrator Alexander Anderson," *Proc. Amer. Ant. Soc.*, 115/2 (2005), pp. 317–40

David Tatham

Anderson, Laurie

(*b* Chicago, 5 June 1947), performance artist, sculptor, musician, draftsman and writer. Anderson completed her BA in art history at Barnard College, New York, in 1969 and had her first one-woman show there in 1970, exhibiting sculptures and drawings, among other works. She then trained as a sculptor at Columbia University, New York, receiving her MFA in 1972. Much of her work has built on her childhood instruction as a classical violinist, and she achieved popular notoriety in 1981 when her song "O Superman" became a popular hit in England. Her first performance piece, *Automotive*, took place in 1972 at Town Green in Rochester, VT, and involved a concert of car horns. In 1974, she staged another music-based performance entitled *Duets on Ice*, in which she appeared at four different locations on New York sidewalks wearing a pair of ice skates with their blades frozen in blocks of ice, and she proceeded to play one of several altered violins until the ice melted into water. In subsequent years, she has continued to work primarily as a performance artist, using projected photographs, films, texts and music to create technologically sophisticated and elaborately staged events. Many of these performances have featured instruments of her own invention. The most famous of these was a violin with a recording head on its body and a strip of audio tape in the place of the hairs on its bow. This piece allowed her to play the human voice as an instrument by changing its speed and cadence with the movements of her arm. The most complex and spectacular of her performances, *United States*, first realized in full at the Brooklyn Academy of Music in New York in 1983, was a four-part compendium of spoken texts and songs in which she addressed themes such as the use and abuse of language and political power. She has often returned to and expanded on these concerns in subsequent years, but her work has also developed in other directions. In her performance *The Nerve Bible* (1995), for example, she took up, among other things, the events of the Gulf War in 1991, and in *Songs and Stories from Moby Dick* (1999), she used the novel by Herman Melville to address themes of obsession and the search for meaning at the end of the 20th century.

WRITINGS

United States (New York, 1984)

Stories from the Nerve Bible: A Retrospective 1972–1992 (New York, 1994)

"Control Rooms and Other Stories: Confessions of a Content Provider," *Parkett* 49 (1997), pp. 127–35

Night Life (Göttingen, 2006)

BIBLIOGRAPHY

Laurie Anderson: Works from 1969 to 1983 (exh. cat. by J. Kardon, Philadelphia, U. PA, Inst. Contemp. A., 1983)

J. Howell: *Laurie Anderson* (New York, 1992)

J. McKenzie: "Laurie Anderson for Dummies," *The Drama Review* 41/2 (Summer 1997), pp. 30–50

Laurie Anderson: Dal vivo (exh. cat. by Germano Celant; Milan: Fondazione Prada, 1998)

R. Goldberg: *Laurie Anderson* (New York, 2000)

The Record of the Time: Sound in the Work of Laurie Anderson (exh. cat.; Lyon: Museé d'art contemporain de Lyon, 2002)

VIDEO RECORDINGS

Talk Normal: The Laurie Anderson Anthology (Los Angeles, 1982, 2002) [compact disc]

Andre, Carl

(*b* Quincy, MA, 16 Sept 1935), sculptor. Andre attended the Phillips Academy, Andover, MA, from 1951 to 1953, and in 1954 he visited England, where he was greatly impressed by Stonehenge. From 1955 to 1956 he served in the US Army; in 1957 he moved to New York, where he began to write poetry. He also made drawings and sculpture in Perspex (Plexiglass) and wood. He met Frank Stella in 1958, and in 1959 he shared his studio where he made large sculptures, such as *Last Ladder* (wood, 2.14×1.55×1.55 m; 1959; London, Tate). The *Black Paintings* on which Stella was working had a considerable influence on Andre both for their non-referentiality and for their symmetrical and non-hierarchic compositions, in which no part was given more emphasis than any other. Andre's totemic wooden sculptures, such as *Ladder No. 2* (wood, 2.1×0.15×0.15 m, 1959; London, Tate), are indebted to Constantin Brancusi (1876–1957) but were cut rather than carved. Many of them were constructed according to what Andre called structural building principles, in which elements were stacked and interlocked.

In 1965, however, after spending four years working as a freight brakeman and then a conductor on the railway, Andre abandoned this manner of working and began to look for new materials. "The railway completely tore me away from the pretensions of art, even my own, and I was back on the horizontal lines of steel and rust and great masses of coal and material, timber, with all kinds of hides and glue and the burdens and weights of the cars themselves" (exh. cat. 1978). Andre's sculpture after 1965, central to the movement labeled Minimalism, consisted of series of similar units placed together in a manner reminiscent of coupled railway trucks. As each unit is replaceable by another, all units are equally important, thereby obeying the principle of what Andre called "axial symmetry," where the whole is the same on each side of a central axis.

After 1965 Andre's sculptures were made to be placed directly on the floor and were constructed out of common building materials. These included aluminum, lead and magnesium plates, as well as common building bricks, each sculpture comprising one material only, as in *144 Aluminum Squares* (1967; Pasadena, CA, Norton Simon Mus.). These floor pieces were intended not only to be looked at but also to be walked on, so that the material difference between the floor and the sculpture could be physically experienced. In terms of structure these works were composed simply by placing the elements alongside each other in shapes that were suggested by the elements themselves. Thus the configuration of a work was to a great extent self-determined and logical. The structure of the sculpture would be immediately apparent. In this sense Andre was concerned to retain the identity of each of his building materials in a way that he had not been earlier by his action of cutting into wood. The artist's hand would not be visibly apparent.

Such sculptures were often meant to be seen not in isolation but in the context of an entire installation that articulated the architecture of the gallery. The titles of individual works such as *Equivalent VIII*, made of building bricks (1966, destr.; remade 1969; London, Tate), drew attention to the fact that the work was part of a whole just as each work was composed of standard elements. Another characteristic of Andre's sculpture after 1965 was its sense of weight and mass, another product of the artist's experience on the railway. He experimented with sculpture in wood but rejected it as an unsuitably light material for the floor pieces, as he felt that they were likely to move, and that the shape of the sculpture would therefore be difficult to maintain.

In the early 1970s Andre made some major wood sculptures, such as *Henge on Threshold (Meditation of the Year 1960)* (1971; Otterlo, Kröller-Müller). After 1975 he again began to use wood, but this time as unaltered blocks reminiscent of the sleepers on the railway, as in *The Way North, East, South, West (Uncarved Blocks)* (western red cedar, 0.91×1.5×1.5 m, 1975; New York, Agnes Gind priv. col.; see 1987 exh. cat., pl. 66).

For Andre a sculpture had no meaning outside of its existence, and for this reason he did not consider

himself in any way to be a conceptual artist. The idea cannot be divorced from the object for it must be physically experienced. Its creation arises out of a desire "to make something to be in the world," and its importance lies in the effect it has on its environment and on the viewer's perception of space.

[*See also* Mendieta, Ana, *and* Minimalism.]

BIBLIOGRAPHY

P. Tuchman: "An Interview with Carl Andre," *Artforum*, viii/10 (1970), pp. 55–61

D. Waldman: *Carl Andre* (New York, 1970)

Carl Andre: Sculpture, 1959–1978 (exh. cat., ed. N. Serota; London, Whitechapel A.G., 1978)

Carl Andre: 12 Dialogues 1962–1963 with Hollis Frampton (Halifax, NS, and New York, 1980)

Carl Andre (exh. cat., ed. P. de Jonge; The Hague, Gemeentemus.; Eindhoven, Stedel. Van Abbemus.; 1987) [includes catalogue raisonné]

Carl Andre and The Sculptural Imagination (exh cat., ed. I. Cole; Museum of Modern Art, Oxford; 1996)

Carl Andre Sculptor (exh. cat., Krefeld, Haus Lange and Haus Esters; Wolfsburg, Kunstmuseum; 1996)

Jeremy Lewison

Andrews, Benny

(*b* Plainview, GA, 13 Nov 1930; *d* Brooklyn, New York, 10 Nov 2006), painter, collagist, printmaker and art advocate. Benny Andrews grew up under segregation in the rural South, one of 10 children in a sharecropper's family. After graduating from high school, he served in the US Air Force. Afterward, under the GI Bill of Rights, Andrews studied at the School of the Art Institute of Chicago, where he received his BFA. In 1958, he moved to New York. Andrews received a John Hay Whitney Fellowship (1965–6) as well as a CAPS award from the New York State Council on the Arts (1971). From 1968 to 1997, he taught at Queens College, City University of New York, and created a prison arts program that became a national model. In 1969, Andrews co-founded the Black Emergency Cultural Coalition (BECC), an organization that protested against the *Harlem on my Mind* exhibit at the Metropolitan Museum of Art, New York.

Between 1982 and 1984 he served as director of the Visual Art Program for the National Endowment for the Arts. In 1983 he was instrumental in the creation of The National Arts Program. Andrews served on the Board of the MacDowell Colony, New Hampshire, among others.

Andrews was committed to social change in addition to continually developing his own eloquent pictorial vision. A figurative artist whose oil paintings, prints and collages depict a diverse range of American scenes, his narrative regionalist style celebrates the experiences of ordinary people's lives with dignity. His work is in the permanent collections of the Metropolitan Museum of Art, the Museum of Modern Art and the Studio Museum in Harlem, all in New York; the Hirshhorn Museum, Washington, DC; the Art Institute of Chicago; and the High Museum of Art, Atlanta, GA.

BIBLIOGRAPHY

Introduction, Icons and Images in the Work of Benny Andrews (exh. cat. by R. Andrews; Atlanta, GA, Southern Arts Federation, 1984)

The Collages of Benny Andrews (exh. cat., New York, Studio Mus. Harlem, 1988)

S. Cash: "Benny Andrews, 1930–2006," *A. America*, xcv/1 (Jan 2007)

Benny Andrews: A Georgia Artist Comes Home, An Exhibition in Two Parts (exh. cat. by L. McIntosh; Atlanta, GA, Mus. Contemp. A., 2007)

Deborah Cullen

Annapolis

Capital city of the state of Maryland. Annapolis is situated on a peninsula in the Severn River and had a population of *c.* 36,000 in 2010. It was founded as state capital in 1694. Originally called Providence, it was then named after Princess, later Queen, Anne, although it was also known at that time as Anne Arundeltown. Following the English Glorious Revolution of 1688, which brought William III and Mary II to the English throne, the formerly largely Catholic state of Maryland was divided into Anglican parishes by its new governor, Francis Nicholson. Although

land had been set aside before 1694 on Annapolis's site, little development had occurred. The city plan (1695) is attributable to Nicholson, and while several towns in the English colonies, including New Haven (founded 1638) and Philadelphia (founded 1682), had adhered earlier to formal design principles, none was as obviously Baroque as his plan. Although the original was lost, another exists from 1743, which retraced a survey made in 1718; the original layout is believed to have been faithfully drawn but with additional streets to the north. Its Baroque character, with streets radiating out from two circles, affirms Nicholson's awareness of the plans by Christopher Wren (1632–1723) and John Evelyn (1620–1706) for rebuilding London after the Great Fire of 1666.

The firm connection between Church and State that the Glorious Revolution meant to effect is strongly expressed through the dominating Church Circle and Public Circle in the city plan. Nicholson intended each circle to house the Anglican church of St Anne and the statehouse respectively. Linking the two circles is the short School Street, on which was built King William's School (chartered 1696). Other features of the plan included Bloomsbury Square to the west of the circles and a market square to the east, neither of which survives. The main street, Church Street, led from Church Circle to the dock and harbor. Because of its constricted peninsular site and because Baltimore had surpassed Annapolis as Maryland's major town shortly after the Revolution, Annapolis never became a metropolis, and much of the character of the original town survives; government buildings lie to the west of the colonial city without destroying its intimacy. Although its first statehouse and churches are gone, the existing Statehouse or Capitol, begun in 1772 by Joseph H. Anderson, remains the oldest in continuous use in the USA. Its wooden dome, begun in 1785 by Joseph Clark, is distinctive for its construction without nails. An unusual church was built to replace the first church in 1775–92, but it was destroyed by fire in 1858; a print of c. 1800 shows it as a two-story brick rectangular structure with a pedimented roof and single bell-tower, the first story ornamented with a series of blind arcades. A third significant colonial building in Annapolis was the house begun c. 1742 by Governor Thomas Bladen, intended to equal the Williamsburg Governor's Palace; due to its inordinate cost, however, funding was stopped, and it became known as Bladen's Folly. It was later remodeled on the campus of St John's College.

Annapolis has many high-quality houses dating from the mid to late 18th century, at least five of which were worked on by William Buckland, who settled in Annapolis after 1771. These include the Chase-Lloyd House (1771), the James Brice House (c. 1772) and, the finest of all, the Hammond-Harwood House (1773–4). The last comprises five sections, with two end pavilions with octagonal bays. The United States Congress met in Annapolis in 1783–4, following the signing of the Peace of Paris (1783) in the Statehouse, and the city, with its central location, bid unsuccessfully to become the United States capital. Indeed, with nearby Baltimore's emergence as the USA's fifth largest city in 1790, Annapolis, with only 2000 inhabitants, had to fight to remain state capital. In 1808 the circular Fort Severn was built by the government at the tip of the peninsula to the northeast of the town; the site was later selected for the United States Naval Academy (1845). While the rate of restoration of the city's buildings may not have been as fast as in the colonial city of Williamsburg, a number of Victorian buildings that overshadowed important 18th-century sites have been removed, enabling the reconstruction of sites of interest.

[*See also* Buckland, William.]

BIBLIOGRAPHY

E. S. Riley: *"The Ancient City": A History of Annapolis, in Maryland, 1649–1887* (Annapolis, 1887)

W. B. Norris: *Annapolis: Its Colonial and Naval Story* (New York, 1925)

D. Davis: *Annapolis Houses, 1700–1775* (New York, 1947)

M. L. Radoff: *Buildings of the State of Maryland at Annapolis* (Annapolis, 1954)

H. C. Forman: *Maryland Architecture—A Short History* (Cambridge, MD, 1968)

J. W. Reps: *Tidewater Towns: City Planning in Colonial Virginia and Maryland* (Williamsburg and Charlottesville, 1972)

E. B. Anderson and M. P. Parker: *Annapolis: A Walk Through History* (Centreville, MD, 1984; rev. 2003)

B. Paca-Steele: "The Mathematics of an Eighteenth Century Wilderness Garden: William Paca Garden, Annapolis," *J. Gdn. Hist.*, vi (1986), pp. 299–320

M. P. Leone and others: "Power Gardens of Annapolis: Landscape Archaeology of the American Revolution," *Archaeology*, xlii (1989), pp. 34–9

M. P. Leone and B. J. Little: "Seeds of Sedition: Jonas Green's Printshop, Annapolis," *Archaeology*, xliii (1990), pp. 36–40

K. McCormick: "Buried Treasures: William Paca House, Annapolis," *Hist. Preserv.*, xlv (1993), p. 68

J. A. Headley: "The Monument without a Public: The Case of the Tripoli Monument," *Winterthur Port.*, xxix (1994), pp. 247–64

E. Kryder–Reid: "The Archaeology of Vision in Eighteenth Century Chesapeake Gardens," *J. Gdn. Hist.*, xiv (1994), pp. 42–54

P. A. Shackel, P. R. Mullins, and M. S. Warner, eds.: *Annapolis Pasts: Historical Archaeology in Annapolis, Maryland* (Knoxville, 1998)

M. Letzer and J. B. Russo, eds.: *The Diary of William Faris: The Daily Life of an Annapolis Silversmith* (Baltimore, 2002)

M. P. Leone: *The Archaeology of Liberty in an American Capital, Excavations in Annapolis* (Berkeley, CA, 2005)

James D. Kornwolf
Revised and updated by Margaret Barlow

Anshutz, Thomas

(*b* Newport, KY, 5 Oct 1851; *d* Fort Washington, PA, 16 June 1912), painter and teacher. In 1872 Thomas (Pollock) Anshutz moved to New York, where he enrolled at the National Academy of Design. By 1875 he had advanced to the life class but found the Academy "a rotten old institution." Moving to Philadelphia, Anshutz entered a life class taught by Thomas Eakins at the Philadelphia Sketch Club and transferred to the Pennsylvania Academy of the Fine Arts when it opened its new building in 1876. Continuing to study under Eakins and Christian Schussele (1824/6–79), Anshutz soon became Eakins's assistant demonstrator for anatomy courses taught by the surgeon William Williams Keen.

Anshutz's style quickly progressed from a tight linearity toward an emphasis on solid form, expressed through simplified modeling and a thorough knowledge of anatomy. For his first mature works he sought subjects in the active lives around him, whether in the lush pastoral setting of *The Father and his Son Harvesting* (1879; New York, Berry-Hill Gals) or the cruder homestead of *The Way They Live (Cabbages)* (1879; New York, Met.). The factual, yet measured depiction of both outdoor setting and human activity in these works also characterizes Anshutz's finest painting, *The Ironworkers' Noontime* (1880; San Francisco, CA, F.A. Museums), a scene of factory workers at their midday break. Masterful in the arrangement and description of human form and industrial setting, the painting was groundbreaking for the choice of subject and the objectivity of the artist's approach. Curiously, Anshutz never attempted another work so bold or important, perhaps because his duties at the Academy were increasingly demanding of his energies.

By 1881 Anshutz had become Chief Demonstrator for life-class dissections at the Academy; two years later he became Assistant Professor in Painting and Drawing to Eakins. In 1884 he assisted Eakins and Eadweard Muybridge with their experiments in motion photography at the University of Pennsylvania. Yet by 1886 Anshutz had joined the students and faculty who charged Eakins with misconduct of the life class; after Eakins resigned, Anshutz succeeded him as Professor of Painting and Drawing. Thereafter teaching dominated his activities.

In 1892 Anshutz married and combined his honeymoon with a year's study at the Académie Julian, Paris. On his return, he began working more in pastels and watercolor, showing a greater interest in light and color, even while basing his compositions on photographic sources. He resumed teaching at the Academy in 1893; five years later he joined Hugh Breckenridge (1870–1937) in establishing a

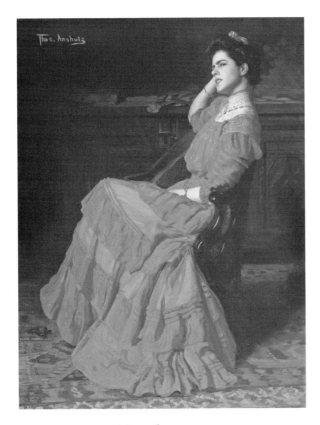

THOMAS ANSHUTZ. *A Rose*, oil on canvas, 1473 × 1114 mm, 1907. MARGUERITE AND FRANK A. COSGROVE JR. FUND, 1993 © THE METROPOLITAN MUSEUM OF ART/ART RESOURCE, NY

summer school for landscape painting. In 1909 Anshutz succeeded William Merritt Chase as Director of the Academy; the next year he was elected President of the Philadelphia Sketch Club. Anshutz's portraits and figural paintings from these later years demonstrate his characteristic concern for modeling and form, yet works such as *The Tanagra* (1911; Philadelphia, PA Acad. F.A.) also display more fluid brushwork and a hint of decorative flatness, suggesting the influence of Chase as well as study in Paris.

One of the most influential American teachers of the 19th century, Anshutz transmitted Eakins's emphasis on careful observation, solid form and comprehension of anatomy. While insisting on fundamentals, he encouraged individual expression. His instruction formed a bridge between the analytical realism of Eakins and the more expressive, experimental styles of the early 20th century. Anshutz's most successful students included the Pennsylvania landscape painter Edward Redfield (1869–1965), such members of the Ashcan school as Robert Henri and John Sloan, and artists who drew inspiration from European modernism, such as Charles Sheeler and John Marin.

[*See also* Eakins, Thomas; Muybridge, Eadweard; *and* Philadelphia.]

BIBLIOGRAPHY

F. Zeigler: "An Unassuming Painter: Thomas P. Anshutz," *Brush & Pencil*, iv (1899), pp. 277–84

R. Bowman: "Nature, the Photograph and Thomas Anshutz," *A. J.* [New York], xxxiii/1 (1973), pp. 32–40

Thomas P. Anshutz, 1851–1912 (exh. cat. by S. D. Heard, Philadelphia, PA Acad. F.A., 1973)

L. Goodrich: *Thomas Eakins*, i (Cambridge, MA, 1982)

Thomas Anshutz: Artist and Teacher (exh. cat. by R. C. Griffin, Huntington, NY, Heckscher Mus., 1994)

G. McCoy: "*The Ironworkers' Noontime*: Documents of Ownership of the Painting," *Archvs Amer. A. J.*, xxxv/1–4 (1995), pp. 83–6

R. C. Griffin: *Homer, Eakins & Anshutz: The Search for American Identity in the Gilded Age* (University Park, PA, 2004)

Sally Mills

Antin, Eleanor

(*b* New York, 27 Feb 1935), performance artist. In the mid-1950s Eleanor Antin [née Fineman] studied acting at the Tamara Daykarhanova School for Stage, New York, and creative writing at the College of the City of New York. Her performances can be seen as autobiographical, with invented roles based partly on historical characters. Set-pieces recurring in performances from the early 1970s included the *King of Solana Beach*, inspired by a portrait of Charles I, King of England, by Anthony van Dyck (1599–1641); *Eleanor Antinova*, giving the recollections of a black dancer in Serge Diaghilev's Ballets Russes; and the *Angel of Mercy*, Florence Nightingale in the Crimea. Antin considered her performances as a means of self-definition as an artist and woman in the late

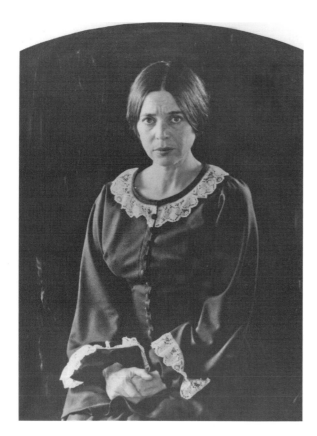

ELEANOR ANTIN. Myself 1854, *The Angel of Mercy* tinted gelatin silver print mounted on paperboard, 457 × 330 mm, 1977. Courtesy of Ronald Feldman Fine Arts, New York

20th century. The presentations incorporated pithy commentaries on contemporary social and political issues. The spontaneous nature of her activity can be linked to the early years of American filmmaking, when participants devised dramatic scenarios in an ad hoc sequence. By interspersing her personal experience and vision with episodes from the past, Antin attempted to redefine traditional boundaries associated with women, power and art. For *The Last Days of Pompeii* (2001) and *Historical Takes* (2008), Antin staged elaborate tableaux of imagined scenes from ancient history and mythology. Photographed in the Southern California landscape, she used wit to suggest ways in which historic corruption and abuse mirror contemporary events. From 1975 she was Professor of Visual Arts at the University of California, San Diego.

BIBLIOGRAPHY

Contemp. A.

Eleanor Antin, "The Angel of Mercy" (exh. cat., La Jolla, CA, Mus. Contemp. A., 1977) [essays by J. Crary and K. Levin]

M. Roth, ed.: *The Amazing Decade: Women and Performance Art in America, 1970–1980* (Los Angeles, 1983)

K. Iwamasa: *David and Eleanor Antin* (Boulder, CO, 1994) [videotape]

Eleanor Antin (exh. cat. by L. Bloom and H. N. Fox; Los Angeles, CA, Co. Mus. A., 1999)

S. Sollins: *Art 21: Art in the Twenty-First Century 2* (New York, 2003)

Art 21, seasons 1 and 2 (2003) [videotape]

Eleanor Antin: Historical Takes (exh. cat. by B. S. Hertz, San Diego, CA, Mus. A., 2008)

Antonakos, Stephen

(*b* Saint Nicholas, Greece, 1 Nov 1926), sculptor and installation artist of Greek birth. Known for his neon environments, he has used light over five decades to explore spatial and temporal relationships. Settling with his family in New York in 1930, he graduated from the Brooklyn Community College in 1947. Through the 1950s, he experimented with assemblage and was interested in Abstract Expressionism as well as Arte Povera. In 1960, he began to design neon configurations for interior spaces. While the geometry of his forms recalls emerging Minimalism, the richly glowing colors in such works as *Red Box over Blue Box* (1973; La Jolla, CA, Mus. Contemp. A.) are sensuous and emotionally evocative, thus differentiating Antonakos from his strictly Minimalist contemporaries. He uses incomplete geometric forms, suggesting Gestalt shapes, to invite the viewer to participate imaginatively in their completion. Since 1973, Antonakos has created nearly 50 permanent public works in America, Europe and Japan, such as *Neons for Stadtsparkasse* (1993; Cologne), in which light is used to redefine architectural spaces and express the dynamism of modern life. Simultaneously, he has executed an extensive body of drawings in colored pencil on vellum and collages that explore the effects of light and shape on a more intimate scale.

In 1980, after decades-long contact with Greek religious art and architecture, he created the *Panels* series, which remained the center of his practice. The shaped panels, with gold leaf or painted surfaces, are suspended from the wall with neon behind the surfaces. Instead of a visible light source, the illumination is reflective and ephemeral, referencing traditional icon painting and highlighting the meditative character of his art. In a related impulse, Antonakos began in 1989 to design *Chapels* and *Meditation Rooms*. Twenty models exist, and a dozen chapels have been constructed full scale. Referencing simultaneously modern architecture of the International Style and simple whitewashed Greek chapels, these structures utilize light and geometry in manners aligned to his neon constructions.

BIBLIOGRAPHY

I. Sandler: *Antonakos* (New York, 1999)

Stephen Antonakos: A Retrospective (Athens, 2007–8)

R. S. Mattison: *Stephen Antonakos: The Power of Light* (exh. cat., Allentown, PA, A. Mus., 2008–9)

Robert Saltonstall Mattison

Antoni, Janine

(*b* Freeport, Bahamas, 19 Jan 1964), performance artist and sculptor. Antoni studied sculpture at the Rhode Island School of Design in Providence. She drew attention to herself in 1993 during a performance (*Loving Care*) at the Anthony d'Offay Gallery in London where, dressed in a black catsuit, she dipped her long hair repeatedly into a bucket filled with hair dye and, using her hair as a paint brush, mopped the gallery floor on her hands and knees. Her performance was reminiscent of Yves Klein's 1960s *Anthropometries*, his performative paintings created by using nude female models as paint brushes, as well as a series of the early feminist performative works by the Japanese artist Shigeko Kubota (*b* 1937), the so-called *Vagina Paintings* of 1965 in which Kubota painted on a horizontal surface using a brush that extended from her vagina.

In 1993 Antoni exhibited the photographic gender-reversing triptych *Mom and Dad*, which depicted her actual parents cross-dressing and disguised by prosthetic make-up. But Antoni is perhaps best known for her sculptures made of chocolate or lard, which she creates by gnawing into them with her teeth, such as *Gnaw* (1991) and *Lick and Lather* (1993–4), an installation of 14 classically styled self-portrait busts, half of them molded in chocolate licked by the artist, the other half in soap that she repeatedly washed. In *Slumber* (1994), her most elaborate work, she slept during the night hours in a bed at the gallery attached to an EEG machine that recorded her rapid eye movements, while during the day she wove a strip torn from her nightgown into the blanket she slept under at night, following the REM patterns that indicated her dream period. She continued to perform *Slumber* in museums and galleries, and her "dream blanket" became more than 60 m long. In her later series, *Up Against* (2009), consisting of photographs and sculpture, Antoni extended her exploration of the female body into architecture by photographing her own body within miniature architectural models and by creating a small copper device modeled in the form of a gargoyle to be used for women to urinate standing up.

In 1998 Antoni was the recipient of a John D. and Catherine T. MacArthur Fellowship, and in 1999 she received the Larry Aldrich Foundation Award.

BIBLIOGRAPHY

A. Capellazzo and others: *Janine Antoni* (Ostfildern-Ruit, 2000)

The Girl Made of Butter (exh. cat. by H. Philbrick, Ridgefield, CT, Aldrich Mus. Contemp. A., 2001)

Klaus Ottmann

Anuszkiewicz, Richard

(*b* Erie, PA, 23 May 1930), painter, printmaker and sculptor. He trained at the Cleveland Institute of Art in Cleveland, OH (1948–53), and under Josef Albers at the Yale University School of Art and Architecture in New Haven, CT (1953–5). In his paintings of the late 1940s and early 1950s he depicted everyday city

life, as in *The Bridge* (1950; artist's priv. col., see Lunde, pl. 66). In 1957 he moved to New York, where from 1957 to 1958 he worked as a conservator at the Metropolitan Museum of Art and from 1959 to 1961 as a silver designer for Tiffany and Co. During this period he began to produce abstract paintings, using either organic or geometric repeated forms, as in *Winter Recipe* (1958; New York, Mr. and Mrs. David Evins priv. col., see Lunde, pl. 100). These led in the early 1960s to asymmetric and imperfectly geometric works, such as *Fluorescent Complement* (1960; New York, MOMA), and then to more rigidly structured arrangements, for example *In the Fourth of Three* (1963; New York, Whitney), which consists of blue and green squares on a red ground. He often incorporated geometrical networks of colored lines, thus exploring the phenomenon of optical mixtures in these mature works, with which he made his contribution to Op art, as in *Iridescence* (1965; Buffalo, NY, Albright–Knox A.G.), although these sometimes extend only a little way in from the edge of the picture. The strong internal structure of each work is the result not of a rigid system, however, but of a trial-and-error approach to composition; from the early 1960s he applied these methods also to screenprints, lithographs and prints made by intaglio techniques, still within the terms of Op art. In the late 1960s he turned to sculpture, characteristically making painted wooden cubes, sometimes on a mirror base, as in *Spiral* (1967; artist's priv. col., see Lunde, pl. 29). In his later works he remained faithful to the approach he established in the 1960s while developing more subtle color modulations and sophisticated geometries. These were extended into low relief, with a new monumentality, in the mid-1980s. His main concern continued to be with the perception of colors and with the exploration of a variety of effects.

[*See also* Op art.]

BIBLIOGRAPHY

L. Lunde: *Anuszkiewicz* (New York, 1977)

Richard Anuszkiewicz: Prints and Multiples, 1964–79 (exh. cat. by D. Brooke and G. Baro, Williamstown, MA, Clark A. Inst.; New York, Brooklyn Mus.; 1979–80)

Richard Anuszkiewicz (exh. cat. by A. Stewart and E. H. Varian, Tallahassee, FL State U., F.A. Gal., 1981)

T. Buchsteiner: *Anuszkiewicz: Op Art* (Ostfildern, 1997)

Kenneth W. Prescott

Apartment

Term used to describe a set of rooms within a residential building that usually contains four or more such units for rent rather than purchase. The apartment building, during the past 150 years, has evidenced numerous changes in layout, style, scale and identifying terminology.

Introduction. In the 16th century an "apartement" was a suite of rooms in a European palace, townhouse or country house, in which chamber, antechamber, bedchamber and cabinet were laid out in a sequence of increasing privacy. As an architectural type, apartment buildings containing multiple units are distinguished from many other collections of joined residential units, including row housing, terrace houses, residential circuses, townhouse crescents and similarly conjoined townhouses as developed in 18th-century Bath, in Georgian Edinburgh and in the London terraces of John Nash (1752–1835), or in the 19th century urban plans by Baron Haussmann (1809–91) for Paris and in the crescents and rows in Boston designed by Charles Bulfinch. All these evidence multi-family, linked residential units that predate, and are distinct from, what is traditionally considered an apartment building.

The modern "apartment building," designed as a multi-family rental edifice, was developed for 19th- and 20th-century city dwellers in Europe, where the English and others call them "flats," in France where the French relevant terms are *immeubles* or *maisons de rapport* and in the USA where the building type was initially called a "French flat" and later referred to as an apartment house or simply apartments. "Four-plexes" (two up and two down) or "triple deckers" (3 stories) were early variants with fewer units in pre-elevator buildings. "Tenements" or "tenement apartments" usually implies, in the USA,

a plainer multi-unit building, even a slum residential block, at the other end of the socio-economic scale from a "luxury apartment." Many tenements and simpler apartment buildings, usually three, four or five stories, were "walk-ups" without an elevator, and some had shared bathing facilities.

The apartment building seeks to provide its multiple residents and families all the amenities of domestic life, in a shared edifice owned by an individual who is responsible for the building maintenance and upkeep and who collects rent from tenants for the leased premises. Individual apartments that are owned by respective individuals are "condominiums," some of whose owners, in turn, may rent their condominium units to others. A monthly fee is assessed for condominium building maintenance and other shared assessments. The "co-op" or cooperative apartment acts as a corporation in which all tenants are shareholders in the corporation and thus jointly and proportionately own the building without owning their individual apartment and with shared responsibility—covered by assessed fees—for maintenance.

History and Development. Although apartment buildings are known to have been built by the Romans (e.g. *insulae* in Ostia Antica dating from the 2nd century AD, for example, where commercial businesses and retail shops known as *tabernas* occupied the ground floor and residential dwellings were grouped above), it was not until the rise of towns in Europe (and later with increasing populations in the industrial city), and the rising cost of land, together with other economic pressures, that urban dwellers were increasingly encouraged to occupy multi-unit structures, that is, to live under one roof with others in tenements or apartment blocks. However, the ideal of independent, rather than collective, living prevailed in the USA (with the exception of such 19th-century utopian or communist communities as the Shakers). Nevertheless, by the mid-19th century, the apartment building emerged as an increasingly acceptable option for urban living.

The apartment block was introduced in New York at the Stuyvesant Building (1869–70; destr.) designed by architect Richard Morris Hunt, who had recently returned to America from Paris, and who adapted the French-style flat to its pioneer American use in New York. In 1876, Alfred T. White formed The Improved Dwellings Company to build and manage model tenements for the poor, and the first unit was built in Brooklyn as the Home Building in 1877. The following year, the *Sanitary Engineer* sponsored a competition for the design of tenement houses, and the winning entry, by James E. Ware, introduced the "dumbbell apartment" whose layout of rooms, on 25×100-ft (7.6×30.5 m) lots, called for narrower center lobbies, stairhalls and small bedrooms in order to allow space for courtyards, an apartment plan which would open tightly-aligned tenement units to light and air. Finally, in 1890, The Improved Dwellings Company erected the Riverside Apartments covering a full city block in Brooklyn and representing one of the earliest instances of "public housing" in the USA.

At the other end of the socio-economic scale, the first luxury apartment building in the USA is generally considered to be The Dakota (1880–84), built in New York by architect Henry Janeway Hardenbergh, a noted hotel designer whose later works in New York include the Waldorf-Astoria (1893 and 1897) and the Plaza (1905–7) hotels, as well as The Willard Hotel (1901) in Washington, DC. The Dakota adopted an eclectic Northern European Renaissance vocabulary to its square courtyard plan. A porte-cochère opened the court to the street, allowing access by horse-drawn carriages to the multi-story stable building beyond. The French-inspired layout of The Dakota grouped major rooms enfilade so that they were both connected and accessible from a corridor, allowing a convenient flow of occupants and guests between major rooms as well as separate servant access for service. Principal rooms faced the street, while the kitchen and auxiliary rooms faced the courtyard, an arrangement providing cross ventilation for each apartment. A level of luxury was

assured by the use of ceilings over 4 m high, 15 m-long drawing rooms and rich inlay and stylish appointments.

In the transition from private urban mansions to luxury apartments, McKim, Mead & White's Villard Houses (1885) provided a significant step. Designed to resemble a single, monumental Roman High Renaissance palazzo, the Villard Houses were actually six elegant five-story houses joined horizontally to form a U-shaped classical courtyard, rather than stacked vertically as a proto-skyscraper. In this arrangement, it shared more with Nash's London terraces and other sophisticated row houses than with future apartment towers. Publisher Henry Villard (1835–1900) reserved the largest house for himself and intended the others for his friends. Significantly, the building offered the wealthy an acceptable example of magnificent living under a common roof shared by other families.

The "cooperative apartment" dates from about the same period; it appeared in New York in the early 1880s as Hubert Home Clubs. An early example was the Rembrandt (1881), a 17 m-wide six-story building intended for artists and designed for eight families, each provided with 204 sq. m in ten rooms.

Following further developments in the luxury hotel in the 1890s, the heyday of the traditional "luxury apartment" was the early 20th century. High-styled urban apartment towers were repeatedly dressed as vertical urban palaces, and urban life embraced collective apartment living. Apartment architect J. E. R. Carpenter (1867–1932) changed the face of Fifth Avenue in New York and influenced the building of large apartment buildings there and elsewhere. As Elizabeth Hawes has noted of New York, "in 1869, all respectable New Yorkers lived in private houses; in 1929, 98% of that same population had been stacked up in multiple dwellings," as "the apartment house transformed the life of the city."

At the suburban edge of American cities, the "garden apartment" further extended apartment development between the world wars. Garden apartments grouped two-story wings to form enclosed courtyards, U-plans or parallel blocks incorporating open landscaping and gardens, and were especially popular in such southern cities as Atlanta.

Following World War II, tower apartments and modern "superblocks," inspired by German *siedlungs* or by the *unité d'habitation* or "ville contemporaine" drawings of Le Corbusier (1887–1965), grouped even larger numbers of units into skyscraper towers and dense modernist blocks. "Megastructural" forms were increasingly evidenced in large American cities for both public housing and middle-class apartment dwellings. Examples include the Alfred E. Smith Housing (Eggers & Higgins, 1948) in New York, Pruitt Igoe (Minoru Yamasaki, 1952–5, destr.) in St Louis, and Co-op City (Herman J. Jessor, 1968) in the Bronx. In 1952 Ludwig Mies van der Rohe brought a modernist and minimalist elegance to the apartment tower in his 860–880 Lake Shore Drive Apartments in Chicago, by which time the modern apartment building was displacing traditionally-styled apartments in the modern city, and the glass tower was becoming an iconic image of the modern urban workplace as well as residence.

At the same time, the apartment building returned to its mixed use roots, echoing the Roman *insula*'s combination of retail and residential dwelling in a single structure. Postwar apartment buildings had reached a prodigious scale in the mid-20th century city, with the result that extensive urban amenities and multiple uses increasingly characterized their recent development. Bertrand Goldberg's Marina Towers (1959–64) in Chicago, for instance, brought to its design not only the distinction of its paired 65-story circular towers but also the innovation of incorporating parking on the first 19 floors and stacked apartments above. A "city within the city," Marina Towers provided on site such recreational facilities as a gym, swimming pool, ice rink and bowling alley, as well as a theater, commercial stores and restaurants, with the whole building cantilevered over defunct railroad tracks at the edge of the river where a marina was also included in the apartment tower design. In the same city, the John

Hancock Tower (1966–8) by Skidmore, Owings & Merrill positioned upper apartments above lower floors of offices and retail in a tapered, multi-use urban skyscraper of 100 stories. To an extent, the apartment building, with retail below, had come full circle.

[*See also* Hardenbergh, Henry Janeway; Hunt, Richard Morris; *and* Tenement building.]

BIBLIOGRAPHY

R. W. Sexton: *American Apartment Houses of Today: Illustrating Plans, Details, Exteriors and Interiors of Modern City and Suburban Apartment Houses Throughout the United States* (New York, 1926)

S. Paul: *Apartments: Their Design and Development* (New York, 1967)

E. C. Cromley: *Alone Together: A History of New York's Early Apartments* (Ithaca, NY, 1990)

E. Hawes: *New York, New York: How the Apartment House Transformed the Life of the City 1869–1930* (New York, 1993)

O. R. Ojeda, ed.: *The New American Apartment: Innovations in Residential Design and Construction: 30 Case Studies* (New York, 1997)

Robert M. Craig

Applebroog, Ida

(*b* New York, 11 Nov 1929), painter. Applebroog attended the New York State Institute of Applied Arts and Sciences (1947–50) and in 1958 moved to Chicago, where she was a student at the School of the Art Institute of Chicago (1966–8). In 1974 she moved to New York. Applebroog's paintings were best known for their collision of imagery based on specific everyday experiences, news items and endemic social ills. She first became known in the 1970s for small books, such as *Galileo Works* (1977), in which her own "narratives," consisting of leaps and jumps between ideas and images, represent a disjunction associated with social critique and a questioning of the ideologies implicit in representation. She sent them to friends and people in the art world. They were the precursors to larger sequential works such as *Sure I'm Sure* (ink and Rhoplex on vellum, 2.56×1.72 m, 1980; artist's col.), comprising six panels, much like sinister comic strips combining irony and intense

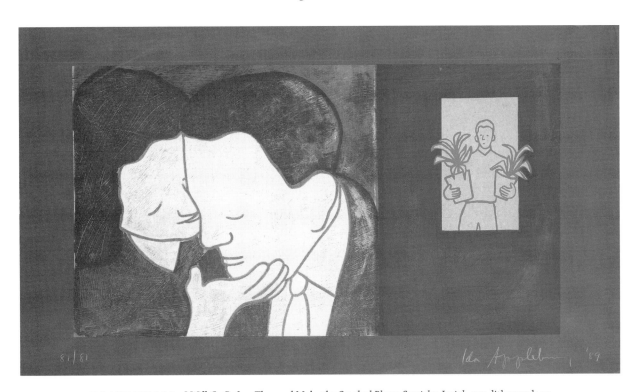

IDA APPLEBROOG. *I Will Go Before Thee and Make the Crooked Places Straight, Isaiah 45:2,* lithograph on paper, 537 × 953 mm, 1989. COURTESY OF IDA APPLEBROOG STUDIO/COMMISSION VERA G. LIST/NEW YEAR'S GRAPHIC FUND © THE JEWISH MUSEUM/ART RESOURCE, NY

tenderness. She is best known for her multi-partite paintings that, as part of the legacy of feminist practice in the 1970s, deal with the "trivial details" of everyday life as if they had the scale and weight of subject matter of traditional history painting. By giving prominence to ordinary events or to groups of people whom she saw as victimized or marginalized, she attempted to empower such groups, especially women, by revealing those elements in their experience that she saw as common to all (e.g. *Pull Down the Shade*, oil on canvas, 2.18×1.52 m, 1985). Her paintings place the viewer in an uncomfortable moral position, as they demonstrate Applebroog's moral outrage and social conscience.

WRITINGS

with B. Reinhardt and B. Gross: *Ida Applebroog: Bilder* (Ostfildern, 1991)

BIBLIOGRAPHY

Applebroog (exh. cat. by R. Feldman and others, New York, Ronald Feldman F.A. Inc., 1987)

Art at the Edge: Ida Applebroog (exh. cat. by S. Krane, Atlanta, GA, High Mus. A.; Pittsburgh, PA, Carnegie–Mellon U. A.G.; 1989)

Ida Applebroog: Happy Families: A Fifteen Year Survey (exh. cat. by M. A. Zeitlin, Houston, TX, Contemp. A. Mus., 1990)

Ida Applebroog (exh. cat. by M. Schor, Londonderry, Orchard Gal.; Dublin, Irish MOMA; 1993)

Ida Applebroog: Nothing Personal, Paintings 1987–1997 (exh. cat. by A. Danto and others, Washington, DC, Corcoran Gal. A., 1998)

B. Lignel, ed.: *Ida Applebroog 1976–2002: Are You Bleeding Yet?* (New York, 2002)

Appropriation art

Term that refers to a tendency in contemporary art in which artists adopt imagery, ideas or materials from pre-existing works of art or culture. The act of appropriation is usually an acknowledged component within the works, and it is typically deployed to call attention either to the source material or to the act of borrowing itself. The term came into common usage during the late 1970s and early 1980s in reference to the work of artists such as Troy Brauntuch (*b* 1954), Jack Goldstein, Barbara Kruger, Sherrie Levine, Robert Longo, Richard Prince and Cindy Sherman, but it has subsequently been applied more generally to any artistic practice that makes use of existing cultural material.

Although the antecedents of appropriation art have been traced back to the art historical allusions in works by Edouard Manet (1832–83) or Gustave Flaubert's *Dictionnaire des idées reçues* (1913), its origins have often been found in early 20th-century avant-garde practices such as collage, photomontage and, especially, the ready-made. These procedures involved the use of found objects as the raw materials or the final form of the work of art. Among these, Marcel Duchamp's development of the ready-made in 1913 was particularly important for later manifestations of appropriation art. In his famous *Fountain* from 1917, for example, he adopted the pseudonym R. Mutt and submitted a urinal for an exhibition of the Society of Independent Artists in New York. After its rejection, he published a brief article entitled "The Richard Mutt Case" that defended the work as the revaluation of a utilitarian object and a subversion of its conventional meanings. This work, and others like it, became the basis for further developments in appropriation during the 20th century, and subsequent commentators have cited this work as a challenge to prevailing notions of originality and aesthetic autonomy in the work of art.

During the early 1960s, Pop artists such as Roy Lichtenstein, James Rosenquist and Andy Warhol revived a form of the ready-made by adopting images from advertisements, comic strips and popular magazines. Warhol's famous silkscreen paintings, in particular, featured repeated images of celebrities or commodities in grid arrangements that replicated the logic of mass production and seemed to anticipate the wholesale dissolution of art into the prevailing mass culture. Moreover, his work shifted from ready-made objects to ready-made images at a moment when postwar culture was increasingly dominated by media representations.

Critics have long debated whether Pop art critiqued or celebrated consumer culture, but it nonetheless took that culture as the horizon for future artistic practice in anticipation of the modes of appropriation that emerged during the late 1970s and early 1980s.

A decidedly more critical mode of appropriation emerged in France during the late 1950s and early 1960s under the auspices of an organization of radical artists and intellectuals known as the Situationist International. In texts such as Guy Debord's *The Society of the Spectacle*, the group advocated a form of cultural praxis that included, among other things, a method of critical appropriation that they referred to as *détournement*. The term derived from the verb *détourner*, which means "to divert" or "to turn around," and the practice often involved attempts to hijack images and advertisements from the existing "society of the spectacle" and reorient them toward a revolutionary goal. They introduced new texts into comic strips, recaptioned advertisements and re-edited footage from Hollywood films in order to disrupt their normal operations and direct them against the society that they typically affirmed. These practices were formative for subsequent developments in critical appropriation, particularly as they became more widely disseminated in the 1980s and 1990s.

Aspects of both Pop and Situationist practices are discernable in the kinds of appropriation art that emerged in New York during the late 1970s and early 1980s. The term itself entered into circulation in the wake of a 1977 exhibition entitled *Pictures* that was organized by Douglas Crimp for Artists Space in New York. This exhibition included works by Brauntuch, Goldstein, Levine, Longo and Philip Smith (*b* 1952), and although Crimp's essay in the accompanying catalog did not use the term, the show did help establish appropriation as an important practice in contemporary art. These artists, he claimed, along with others in their generation, adopted images in ways that addressed the structures of representation at a moment in which experience was increasingly

"governed by pictures, pictures in newspapers and magazines, on television and in the cinema." This exhibition proved so influential that these artists and many of their contemporaries have often been referred as the "Pictures Generation," and their ascendance marked a shift from the dominance of modernism in postwar art.

In subsequent years, this generation was championed under the banner of appropriation by a group of critics associated with the journal *October* such as Benjamin Buchloh, Hal Foster and Craig Owens. These critics frequently described appropriation as a form of allegory that applied new layers of meaning to existing cultural materials, and they often suggested that such practices represented an attack on either conventional notions of artistic originality or on the ideological operations of images within contemporary media culture. Levine's unaltered appropriations of photographs by Walker Evans or Edward Weston, for example, were described as attacks on modernist notions of artistic creativity and innovation, and Sherman's various cinematic self-portraits (her *Untitled Film Stills*) were described as deconstructing the conventions of Hollywood cinema, particularly in its representations of women. Along similar lines, Barbara Kruger made a series of images that attached agit-prop captions to appropriated images and recalled John Heartfield's antifascist photomontages from the 1920s and 1930s. In her work, however, his acerbic texts were typically replaced with ambiguous declarations in the first or third person such as "I shop therefore I am" or "Your gaze hits the side of my face." These photomontages supplanted the overt political messages of Heartfield's work with a politics of representation and an investigation of the operations of images within a consumer society.

A number of artists in this generation were as interested in the semiotics of visual images as they were in their ideological implications or their purported originality. Richard Prince, for example, produced a series of works, such as his *Untitled (four women looking in the same direction) #1–#4* from

1977 to 1979, in which he arranged images of fashion models from unrelated magazines that assumed nearly identical poses. These works emphasized the similarities of these pictures and thereby the conventions of representation over the subjects represented. They were exercises in the syntax of popular culture as much as in the semantics of the image. Like much of appropriation art, these works called attention to the formal operations of the prevailing media culture, but they often remained ambiguous in their disposition toward that culture and toward the society that it sustained.

During the early 1980s, a number of critics began to respond to these ambiguities and suggest that the criticality of appropriation could no longer be taken for granted. In a 1982 essay entitled "Appropriating Appropriation," for example, Crimp argued that the normalization of the practice marked a historical shift toward Postmodernism in the cultural sphere rather than an unequivocal challenge to the society in which this shift was occurring. "Appropriation, pastiche, quotation," he wrote, "these methods extend to virtually every aspect of our culture," including both cynical commercialism and social critique. In subsequent decades, the practice became increasingly central to contemporary art and evident in the work of artists as varied as Mike Kelley, Jeff Koons, Vik Muniz (b 1961), Kara Walker and Fred Wilson. During the 1990s, French critic and curator Nicolas Bourriaud attempted to restore an element of criticality to the notion by championing a new generation of appropriation artists that included Liam Gillick (b 1964), Douglas Gordon (b 1966), Pierre Huyghe (b 1962), Philippe Parreno (b 1964) and others. In his influential book *Postproduction*, Bourriaud described how an ever-increasing number of "artists interpret, reproduce, re-exhibit, or use works made by others or available cultural products." In Gordon's *24 Hour Psycho*, for example, he slowed a projection of Alfred Hitchcock's classic film to a period of 24 hours, and Huyghe and Parreno purchased an animated character named Annlee from a Japanese production company to use in their own work and to lend to other artists. In Bourriaud's account, such works represented a fundamentally new moment in which appropriation became something more than a conceptual exercise or an abstract challenge to aesthetic categories. Artists such as Levine, he claimed, had sustained categories of originality, authorship and innovation as the conditions for critiquing them, and the subsequent generation dispensed with such notions by treating the work of art as a site for the subversive combination and reorganization of existing cultural properties. "We must stop interpreting the world," he declared, "stop playing walk-on parts in a script written by power. We must become its actors or co-writers." While many commentators have questioned this claim for agency, it has nonetheless offered a new account of appropriation's subversive potential by aligning it with popular practices such as sampling, disc jockeying, web surfing and hacking.

[*See also* Duchamp, Marcel; Goldstein, Jack; Kelley, Mike; Koons, Jeff; Kruger, Barbara, Levine, Sherrie; Lichtenstein, Roy; Longo, Robert; Pop art; Prince, Richard; Rosenquist, James; Sherman, Cindy; Situationism; Walker, Kara; Warhol, Andy; *and* Wilson, Fred.]

BIBLIOGRAPHY

Pictures (exh. cat. by D. Crimp, New York, Artists Space, 1977)

B. Buchloh: "Allegorical Procedures: Appropriation and Montage in Contemporary Art," *Artforum*, xi/1 (Sept 1982), pp. 43–56

H. Foster: *Recodings: Art, Spectacle, and Cultural Politics* (Port Townsend, WA, 1985)

D. Crimp: *On the Museum's Ruins* (Cambridge, MA, 1993)

C. Owens: *Beyond Recognition: Representation, Power, and Culture* (Berkeley, 1994)

J. Welchman: *Art after Appropriation: Essays on Art in the 1990s* (New York and London, 2001)

N. Bourriaud: *Postproduction: Culture as Screenplay: How Art Reprograms the World* (New York, 2002)

R. Nelson: "Appropriation," *Critical Terms for Art History*, ed. R. Nelson and R. Shiff (Chicago, 2003), pp. 160–73

D. Bowen: "Imagine There's No Image (It's Easy If You Try): Appropriation in the Age of Digital Reproduction," *A Companion to Contemporary Art Since 1945*, ed. A. Jones (Malden, MA, 2006), pp. 534–56

D. Evans, ed.: *Appropriation* (London and Cambridge, MA, 2009)

Pictures Generation, 1974–1984 (exh. cat. by Douglas Eklund, New York, Met., 2009)

Tom Williams

Arai, Tomie

(*b* New York, 16 Aug 1949), printmaker and installation artist. Born and raised in New York City, Tomie Arai, a third-generation Japanese American printmaker, mixed-media artist, public artist and cultural activist, studied art at the Philadelphia College of Art and The Printmaking Workshop in New York. Since the 1970s, her diverse projects have ranged from individual works to large-scale public commissions. She has designed permanent public works, including an interior mural commemorating the African burial ground in lower Manhattan and an outdoor mural for Philadelphia's Chinatown. Other works include *Wall of Respect for Women* (1974), a mural on New York's Lower East Side, which was a collaboration between Arai and women from the local community. Her art has been exhibited in such venues as the Bronx Museum of the Arts, the Whitney Museum of American Art, the Museum of Modern Art, International Center for Photography, P.S.1 Museum, the Brooklyn Museum, the Museum of Contemporary Hispanic Art, all New York and the Library of Congress, Washington, DC. She is the recipient of awards and fellowships from National Endowment for the Arts, New York Foundation for the Arts and Joan Mitchell Foundation.

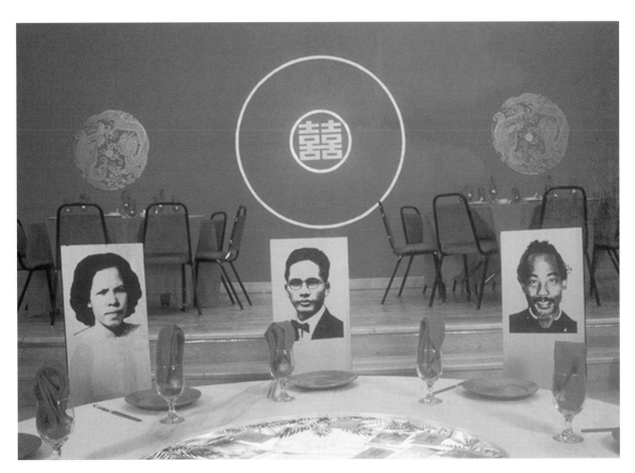

TOMIE ARAI. *Double Happiness*, mixed media installation, 1998. © TOMIE ARAI PHOTOGRAPH BY DANIEL MIRER © BRONX MUSEUM OF THE ARTS, NY

Growing up in New York's ethnically mixed environment, she came to conceive of the local Asian presence as part of an extended "third world" culture. Reflecting a deep investment in art as social practice, Arai's work is anchored in US race politics, immigration, family and labor history, influenced by her early engagement with the public art and mural movement, as well as with grassroots Asian American arts groups.

Her evocative works, typically incorporating photoscreenprinted portraits, have melded poignant tributes to individual lives, with visualizations of global migratory flows, points of settlement in this nation and forms of hybridity arising from the mixing of cultures and peoples, such as *Laundryman's Daughter* (1988), a screenprint that featured the dual image of a mother and daughter taken from archival sources of immigrants' photos. Seeking common cause in the histories and struggles of Asians and other minoritized groups, a number of her pieces have integrally involved collaborations with members of different communities, whose lived realities and historical experiences she seeks to portray.

BIBLIOGRAPHY

E. Cockcroft, J. P. Weber and J. Cockcroft: *Toward a People's Art* (New York, 1977, rev. Albuquerque, 1998), pp. 127–30

D. Wye: *Committed to Print* (exh. cat., New York, 1988), pp. 89, 100

(dis)ORIENTED: Shifting Identities of Asian Women in America (exh. cat. by M. Machida, New York, Abrons Art Center, 1995)

There to Here (exh. cat. by K. Sakamoto, Easton, PA, Lafayette Coll. A.G., 1995)

L. Weintraub, A. Danto and T. McEvilley, eds.: *Art on the Edge and Over* (Litchfield, 1996), pp. 103–8

J. Prigoff and R. Dunitz, eds.: *Walls of Heritage/Walls of Pride African American Murals* (Petaluma, CA, 2000), pp. 234–5

E. H. Kim, M. Machida and S. Mizota, eds.: *Fresh Talk/Daring Gazes: Conversations on Asian American Art* (Berkeley, 2003), pp. 87–90

J. Marquand and S. Eskilon: *Frames of Reference: Art, History, and the World* (London, 2003), pp. 347–8

K. Carlin: *Art/Vision/Voice: Cultural Conversations in Community* (Chicago, 2005), pp. 123–30

K. Hallmark: *Encyclopedia of Asian American Artists* (Westport, 2007), pp. 10–13

A. Chang: *Envisioning Diaspora* (Beijing, 2008)

M. Machida: *Unsettled Visions: Asian American Artists and the Social Imaginary* (Durham, 2008), pp. 98–112

Margo Machida

Arakawa, Shusaku

(*b* Nagoya, 6 July 1936; *d* New York, 18 May 2010), Japanese painter, performance artist and filmmaker active in the USA. Arakawa studied medicine and mathematics at Tokyo University (1954–8) and art at the Musashino College of Art in Tokyo, holding his first solo exhibition at the National Museum of Modern Art in Tokyo in 1958 and contributing to the Yomiuri Independent exhibitions from 1958 to 1961. In 1960 he took part in the "anti-art" activities of the Neo-Dadaism Organizers in Tokyo and produced his first Happenings and a series of sculptures entitled *Boxes*, which consisted of amorphous lumps of cotton wads hardened in cement; many of these were put in coffin-like boxes, although one entitled *Foetus* was laid on a blanket. In pointing to the sickness of contemporary society, these works caused a great scandal in Tokyo.

In 1961 Arakawa settled in New York, where soon afterward he addressed himself to the idea of a work being "untitled." In taking as his subject this apparent lack of subject, he emphasized the areas of the picture surface where the subject "ought to be" by means of a few well-placed colored framing marks, as in *Untitledness No. 2* (1961–2; see 1979 exh. cat., pl. 1). These were followed by another series of paintings entitled *Diagrams*, which consist of the sprayed silhouettes of banal objects such as tennis rackets, combs and gloves (e.g. *A Card Becomes a Foot*, 1964; see 1979 exh. cat., pl. 7). After thus alluding to the shadows cast by objects, he moved even further away from actual objects by replacing them with their names and cursory outlines, as in *Alphabet Skin No. 2* (1966; see 1979 exh. cat., pl. 23). Arakawa continued to explore the interrelationship between

different forms of representation in a series of drawings and paintings entitled *Webster's Dictionary* (1965–6; see 1979 exh. cat., pls. 13, 14 and 18), in which reproductions of dictionary pages were altered so that only the initial word was legible. The definitions were scribbled out in various colors, paradoxically suggesting both that words were meaningless and that they might have an equivalent in color.

Since 1963 Arakawa made many of his works in collaboration with the American poet Madeline H. Gins (*b* 1943). A set of reproductions of their series *The Mechanism of Meaning*, published in book form in 1971, presented Arakawa's concentrated treatment of the nature of thought, language and representation. Real objects and stenciled texts were incorporated in some works of this period, often suggesting that the viewer engage in an apparently nonsensical activity; one instruction, for instance, found beneath a piece of cloth attached to the canvas, demands, "Before lifting this decide whether you have ever seen what is underneath." Arakawa also experimented with film making, producing *Why Not* in 1969 and *For Example (A Critique of Never)* in 1971. Soon after *The Mechanism of Meaning* his paintings settled into a more consistent style characterized by intricate networks of lines, stenciled words and pale, transparent colors. These have the rational look of technical drawings and, like his previous works, defy complete understanding, as in the diptych *Afternoon and Evening* (1974; see 1979 exh. cat., pls. 43–4), which on the afternoon panel contains the faint words "THE AFTERNOON OF/EACH CLEAVING AIR/ EVERY AIR OF CLEAVING/ON THE SAME AFTERNOON/OF 'TO CLEAVE'/SHAPE AS 'A NOTHING'/OR SHAPE IN NOTHING." After producing other works, sometimes very large in scale, in a similar style, in the late 1970s and early 1980s he again investigated the idea of blankness, this time using arrows and fragments of street maps, as in *Blank Dots* (1982; New York, Met.). By the 1990s Arakawa and Gins had developed a philosophy of life and art called "reversible destiny" aimed at "outlawing" aging and mortality. Turning to

architecture as most able to fully express their philosophy, they designed and oversaw the construction of the Bioscleave House (Lifespan Extending Villa; completed 2008), whose multiple, oddly angled levels at varying heights forced inhabitants to move in unexpected ways to maintain their equilibrium, at the same time stimulating rejuvenating effects.

[*See also* Neo-Dada.]

WRITINGS

with M. H. Gins: *Mechanismus der Bedeutung (Werk im Entstehen: 1963–1971)* (Munich, 1971), intro. L. Alloway; rev. as *The Mechanism of Meaning: Work in Progress (1963–1971, 1978)* (New York, 1978)

with M. H. Gins: *Architecture: Sites of Reversible Destiny* (New York, 1994)

with M. Gins: *Architectural Body* (Tuscaloosa, AL, 2002)

BIBLIOGRAPHY

Arakawa (exh. cat. by M. H. Gins, Düsseldorf, Städt. Ksthalle, 1977)

Shusaku Arakawa (exh. cat. by M. H. Gins, Tokyo, Seibu Mus. A., 1979)

Arakawa (exh. cat. by D. Rice, Chicago, A. Club, 1981)

Arakawa: Bilder und Zeichnungen, 1962–1981 (exh. cat. by A. Zweite, Munich, Lenbachhaus; Hannover, Kestner-Ges.; 1981–2)

Arakawa (exh. cat. by J.-F. Lyotard, Milan, Padiglione A. Contemp., 1987)

G. Lakoff and M. Taylor: *Reversible Destiny: Arakawa/Gins* (New York, 1997)

Arbus, Diane

(*b* New York, 14 March 1923; *d* New York, 26 July 1971), photographer. Diane [née Nemerov] Arbus was educated at the Ethical Culture School and Fieldston School until 1940. In 1940 she married Allan Arbus with whom she formed a successful partnership in fashion photography. She studied photography with Alexey Brodovitch (*c.* 1954) and Lisette Model (*c.* 1955–7). Model encouraged Arbus as an artist and particularly as a maker of powerfully individualistic portraits. In 1963 Arbus visited a nudist camp for the first time. *Retired Man and His Wife at Home in a Nudist Camp One Morning, NJ*

(1963; see Arbus and Israel, 1972, p. 27) juxtaposes the domestic, furnished environment with a middle-aged couple whose only clothing is their footwear, enhancing the overall air of incongruity.

In 1963 and 1966 Arbus received Guggenheim fellowships for a project entitled *American Rites, Manners, and Customs*. A group of images from this work was featured in the exhibition of 1967 at the Museum of Modern Art, New York, entitled *New Documents*, alongside work by Lee Friedlander and Garry Winogrand.

Arbus's apparent interest in what the exhibition curator, John Szarkowski, referred to as society's "frailties" aroused great controversy and debate. Some saw Arbus as characterizing to perfection the disinterested, amoral voyeur potentially lurking in every photographer, taking pictures of, for example, transvestites, as in *Young Man with Curlers at Home on West 20th Street, New York City* (1966; see Arbus and Israel, 1972, p. 21). Others lauded her for her psychological authenticity and her evident empathy with disadvantaged subjects, such as the mentally handicapped, in the *Untitled* series (1970–71; see Arbus and Israel, 1972, pp. 165–74). Arbus was troubled by the notoriety her work achieved. She often felt that her imagery was misunderstood, excessively praised or vilified.

A very successful posthumous retrospective (New York, MOMA) confirmed Arbus's reputation as one of the most important photographers of the 1960s. Not only did her work extend notions of acceptable subject matter and violate canons of "decent" distance between photographer and subject, but also it was characterized by a psychological intensity rare in photographic portraiture and an obvious awareness of the photographer on the part of the subject.

Arbus exemplified clearly the shift during the 1960s from objectivity to subjectivity in documentary photography. Her portraits are an exposition of her personal fascination with American mores as seen through outsiders such as dwarfs, giants, twins and the elderly. Arbus did exploit her subjects in that she used them as metaphors of her own sense of what it was to be an individual, but her self-searching was not mere self-indulgence; her *cri de coeur* was a collective one that encompassed not only the stigmatized members of society but also the "normal."

Although Arbus captured an emotional rawness and undoubted aggression in her work, she was a highly intelligent photographer. Subtleties and sly ironies appear in works such as *House on a Hill, Hollywood, CA* (1963; see Arbus and Israel, 1972, p. 163), in which an elegant, abandoned false mansion front is seen in an overgrown setting. There is an ineffable sense of falling short in life and in society too—the grim gap between what is given and what is intended.

In her dark and compelling works Arbus created a memorable gallery of American characters, perhaps perverse but certainly not perverted. On a much narrower yet comparably intense scale, her imagery echoes August Sander's epic characterization of Weimar Germany. Arbus was dealing primarily with a psychological rather than overtly societal profile. Nevertheless, she encapsulated a remarkably vivid sense of the *Zeitgeist* of the 1960s.

[*See also* Kruger, Barbara, *and* Photography.]

BIBLIOGRAPHY

D. Arbus and M. Israel, eds.: *Diane Arbus: A Monograph* (Millerton, NY, 1972)

I. Jeffrey: "Diane Arbus and American Freaks," *Studio Int.*, clxxxvii/964 (1974), pp. 133–4

I. Jeffrey: *Diane Arbus: Magazine Work* (Millerton, NY, 1984)

G. Badger: "Notes from the Margin of Spoiled Identity: The Art of Diane Arbus," G. Badger and P. Turner: *Phototexts* (London, 1988), pp. 162–73

S. S. Phillips and others: *Diane Arbus: Revelations* (New York, 2003)

Diane Arbus: Family Albums (exh. cat. ed. by A. W. Lee and J. Pultz; Lawrence, U. KS, Spencer Mus. A. and South Hadley, MA, Mount Holyoke Coll. A. Mus., 2003)

P. Bosworth: *Diane Arbus: A Biography* (New York, 2005)

Stud. Gender Sexual., 8/4 (Fall 2007) [Special issue devoted to Diane Arbus]

Gerry Badger

Arcega, Michael

(*b* Manila, the Philippines, 19 Aug 1973), installation artist. Arcega was born in Manila and immigrated to the USA when he was ten years old. He received a Bachelor of Fine Arts degree from San Francisco Art Institute and, in 2009, earned a Master of Fine Arts degree from Stanford University, California. While Arcega has worked with a variety of media, including sculpture and installation, he mainly focuses on language and creates visual and linguistic puns and satires that expose various social and political conflicts and problems resulting from globalization.

A tongue-in-cheek approach as an effective conceptual strategy has been used by a number of artists since Marcel Duchamp. In Arcega's case, however, it relates more closely to the "format of jokes" that plays on unintended cultural misunderstandings between native English speakers and those for whom English is a second language. Ultimately, Arcega's humor exposes the dark side of reality with frequent references to political and social issues. His installation *Tanks A Lot* (2003), for instance, consisted of numerous bug-size miniature tanks made of wood glued onto walls. With an army of cockroach-like vehicles occupying the space, the title became a double entendre, insinuating heavily accented foreigners thanking the global military presence of the United States army.

In addition, materials often add an essential aspect to Arcega's visual puns. In *SPAM/MAPS: Oceania* (2007) he created realistic relief maps of the South Pacific using preserved canned meat, Spam. Arcega not only referred to the historical use of this lunchmeat by the US Army during World War II but also literally mapped out the postwar emergence of unique cultures under the influence of the US military bases in the regions of Asia.

His more ambitiously scaled installation *Eternal Salivation* (2006) conflated the story of deluge from the Old Testament and the disaster of Hurricane Katrina in 2005. Arcega meticulously constructed a 4.5-m-long Noah's Ark out of veneered wood and placed dried meats of various animals inside. The ship rested precariously on makeshift wooden pedestals. Arcega deployed his tactful use of parody in this installation, poignantly satirizing the ill-managed rescue efforts of the Federal Emergency Management Agency (FEMA).

Miwako Tezuka

Archipenko, Alexander

(*b* Kiev, Ukraine, 30 May 1887; *d* New York, 25 Feb 1964), Ukrainian sculptor, active in Paris and in the USA. Alexander [Aleksandr] Archipenko began studying painting and sculpture at the School of Art in Kiev in 1902 but was forced to leave in 1905 after criticizing the academicism of his instructors. In 1906 he went to Moscow, where, according to the artist, he participated in some group exhibitions (Archipenko, p. 68). In 1908 he established himself in Paris, where he rejected the most favored contemporary sculptural styles, including the work of Rodin. After only two weeks of formal instruction at the Ecole des Beaux-Arts he left to teach himself sculpture by direct study of examples in the Musée du Louvre. By 1910 Archipenko was exhibiting with the Cubists at the Salon des Indépendants, and his work was shown at the Salon d'Automne from 1911 to 1913.

A variety of cultural sources lie behind Archipenko's work. He remained indebted throughout his career to the spiritual values and visual effects found in the Byzantine culture of his youth and had a strong affinity for ancient Egyptian, Gothic and primitive art that coexisted with the influence of modernist styles such as Cubism and Futurism.

The decade following Archipenko's arrival in Paris was his most inventive and includes works produced during his residence at Cimiez, near Nice (1914–18), and throughout a period of extensive travel in Europe (1918–21). His first sculptures, such as *Woman with Cat* (1911; Düsseldorf, Kstmus.), in their stress on

solid mass, showed the impact of Pre-Columbian art. By 1912 he had opened his own art school in Paris, and works such as *Walking Woman* (1912; Denver, CO, A. Mus.), a bronze female figure made up of interlocking convex and concave pieces on a flat supporting shape, were more directly related to Cubism. Influenced by the Cubist notion of integrating the figure with surrounding space, by 1914 Archipenko had begun to interchange solids and voids by incorporating effects of light in his sculpture, so that protruding elements seemed to recede and internal features to advance. In *Woman Combing Her Hair* (bronze, 1914; New York, MOMA), the massive head is pierced by a hole, an absolute reversal of solid and void that took one step further Archipenko's characteristic exchange of concave and convex forms. His use of voids as positive forms, in doing away with the traditional monolithic concept of sculpture, had broad-ranging implications for other artists. *Boxing Match* (painted plaster, 1914; New York, Guggenheim) is one of Archipenko's most renowned sculptures of the Cubist years. It is nearly abstract in form, but, as the title suggests, its subject is the tension and struggle of opposing forces; depending on the viewpoint, the cylindrical shapes look like the heads and torsos of two combatants or like silhouetted fighters engaged in dynamic opposition.

Further sculptural innovations were initiated by Archipenko in his first constructions in painted materials, influenced both by the collages of Picasso and Braque and by the Futurist concepts published in Boccioni's *La Scultura Futurista* (1912). *Medrano II* (1914; New York, Guggenheim) describes the volumes of a figure in articulated planes. The circus clown represented here is attached to a colored back panel that serves to clarify the composition. The main volumes of the body are represented by intersecting planes, curving planar forms and wedge- and cone-shape elements. Color articulates structure and helps to distinguish the varying materials. In 1914 Archipenko developed a form that he called sculpto-painting, which he defined as "a new

character of art, due to its specific interdependencies of relief, concave or perforated forms, colours, or textures" (Archipenko, p. 40). He felt that this art form was more adaptable to artistic invention than traditional painting and sculpture in that it emphasized the inherent qualities of form and color, bringing pictorial surfaces and sculptural volumes into a dynamic unity and exploiting new technical means and materials. He made almost 40 sculpto-paintings before 1920 (see *In the Boudoir*, 1915; Philadelphia, PA, Mus. A.), and another concentration of these works appeared in the late 1950s. In *The Bather* (1915; Philadelphia, PA, Mus. A.) a woman holds a towel in her upraised arms as she steps from a tub. The figure is composed mainly from wooden and metal elements and is integrated with the surrounding drawn and painted space through conic sections, Archipenko's idiosyncratic version of Cubist facets.

Archipenko was represented in the New York Armory Show of 1913 and in many international Cubist exhibitions. In 1921 he moved to Berlin and opened an art school. In 1923 he settled in the USA and established a school in New York City. He initiated a summer program in Woodstock, New York, in 1924, which continued until his death. In 1927 he was granted a patent for his invention of the "peinture changeante" (or Archipentura), a motorized mechanism for the production of variable images in sequence. This machine (which in his view combined the scientific with the emotional), as well as his incorporation of electric light and actual movement into his work, revealed his continued attraction to the Futurist urge to represent the dynamism of the modern era.

In the 1930s and 1940s Archipenko's style changed to a classicizing naturalism, and he turned to traditional sculptural materials such as bronze, marble and ceramics to produce more restrained and elegant works. Bronze sculptures included his *Torso in Space* (1935; Jerusalem, Israel Mus.), and ceramic works included the terracotta *The Bride* (1937; Seattle, WA, A. Mus.). During this period he also lectured and taught art at numerous colleges and universities

throughout the USA and Canada. In the 1950s he again concentrated on industrial materials, in which he demonstrated his taste for dazzling polychromy, for example in the series of reliefs initiated in 1957 in polychrome wood and bakelite, including works such as *Oval Figure* (1957; artist's estate, see Karshan, 1974, p. 153). Notable features of work of his late years were his indebtedness to his cultural origins and a deep spirituality. In recent years more attention has been given to Archipenko by Ukrainian scholars, and his work has been acknowledged in various museums of Ukrainian art. It is, however, for the freshness of his explorations of sculptural mass and space and for his innovative multimedia constructions that Archipenko received his greatest acclaim.

WRITINGS
Archipenko: Fifty Creative Years, 1908–1958 (New York, 1960)

BIBLIOGRAPHY
H. Hildebrandt: *Alexander Archipenko* (Berlin, 1923)

D. Karshan: *Archipenko: International Visionary* (Washington, DC, 1969)

K. Michaelsen: *Archipenko: A Study of the Early Works, 1908–1920* (New York, 1977)

D. Karshan: *Archipenko: Sculpture, Drawings, Prints, 1908–1964* (Danville, KY, 1985)

J. Marter, R. Rosenblum and L. Weintraub: *Archipenko: Drawings, Reliefs and Constructions* (New York, 1985)

K. Michaelsen and N. Guralnik: *Alexander Archipenko: A Centennial Tribute* (Washington, DC, 1987)

Alexander Archipenko; Vision and Continuity (exh.cat. Ukrainian Mus., 2005)

Alexander Archipenko Revisited, an International Perspective, Proceedings of the Archipenko Symposium, Cooper Union, New York, Sept 17, 2007 (Bearsville, NY, Archipenko Found., 2008)

<div style="text-align:right">Joan Marter</div>

Architecture

Colonial era architecture adapted to the needs of the local environment. The Governor's Palace at Santa Fe, NM, begun in 1610, utilized adobe, a material used by the Pueblo Indians for centuries. Florida's major Spanish monument, the Castillo de San Marcos, begun in 1672 and attributed to Cubans Juan Síscara (*fl* 1664–91) and Ignacio Daza, was built of a local shell-limestone, which enabled it to withstand three British sieges.

In the British Colonies the majority of 17th century buildings were built of wood. In Puritan New England the central building of each community was the meetinghouse, serving both religious and secular functions; earlier versions were indistinguishable from dwellings. The Old Ship Meeting-house (1681; enlarged 1729 and 1755), Hingham, MA, with its square plan and hipped roof, contrasts significantly with the Old Brick Church (*c.* 1660), Isle of Wight County, VA, whose Gothic features also can be seen in English churches of the time.

Domestic architecture demonstrated marked regional differences. The New England middle-class house was two stories, with a central chimney and never more than one room deep, although extra rooms might be added at the rear. Its equivalent in the South was of one or one-and-a-half stories, with end chimneys and two rooms (hall and parlor) on the ground floor. While the New England type first appeared in England in the 16th century, the Southern type had no English antecedents. Grander Southern houses, such as Bacon's Castle, Surry County, VA, designed by Arthur Allen in 1664–5, remained purely English. An innovative house type was built where Dutch influence was prominent. This was a single-story or one-and-a-half-story house with end chimneys and a gently sloping roof with flared eaves. The Swedes made an invaluable contribution to the settling of the continent in bringing the log cabin, built with horizontal logs notched at the corners. Another log-building technique, with vertical logs trimmed flat on two sides, was employed by the French in the Mississippi Valley.

In the 18th century, outside New Mexico, where the indigenous 17th century style continued unchanged, Spanish Colonial architecture followed Mexican precedents. Thus the unfinished facade of S Antonio de Valero (1744–after 1777; now Church of the Alamo), San Antonio, TX, is an imitation of Durango

Cathedral; that of S José y S Miguel de Aguayo (1768–77), near San Antonio, by Pedro Huizar belongs to the Mexican Baroque; and that of S Xavier del Bac (1775–97), near Tucson, AZ, is a belated example of the *estípite* style. In Louisiana the French developed a type of house well suited to the climate, with a hipped roof spreading out to shelter a *galerie* surrounding the principal rooms on the first floor; Parlange (1750), Pointe Coupée Parish, is an early example. In the British colonies porches of any kind were absent. In the early 18th century the influence of Christopher Wren became evident in the church of St Philip (1711–23; destr. 1835), Charleston, SC. The Governor's Palace, Williamsburg, VA, 1706–20 (destr. 1781; reconstructed 1931–4), was the grandest early 18th-century double pile. The typical Virginian plantation house of *c.* 1720–*c.* 1760, five bays wide, of two or two-and-a-half stories with a hipped roof, had antecedents in the brick vernacular of southeastern England. Exceptional houses of the second quarter of the century include Stratford Hall (1725–30), Westmoreland County, VA; Westover (*c.* 1730) and Carter's Grove (1750–3), both James River plantations, Charles City, VA; and Drayton Hall (1738–42), Charleston, SC, which has a two-story portico, making it the first Palladian house in British America. Other Anglo-Palladian, mid-Georgian examples include the Miles Brewton House (*c.* 1765–9), Charleston, SC, and Mt Pleasant in Fairmount Park (1761–2), Philadelphia, PA.

By mid-century architectural books from England began to make an impact. Peter Harrison, a rich merchant with a gift for design, was an exceptional figure in the Colonial scene. His King's Chapel (1749–58), Boston, MA, influenced by James Gibbs, proved Harrison to be adept in the intelligent use of printed sources. Gibbs's St Martin-in-the-Fields, London, influenced many 18th-century American church designs, seen especially in The First Baptist Meeting House (1774–75), Providence, RI. Most of those named as architects of Colonial buildings, such as Robert Smith in Philadelphia and William Buckland in Virginia and Maryland, had craft training. Thanks to them and the books they used, British Colonial architecture prior to Independence, although very rarely original, attained a high level of competence.

The Federalist Period and Eclectic Revivalism. After the Revolution, architects sought to establish an independent American style. A seat for the new government was required, so in 1791 the site for a capital was selected midway between the northern and southern states. Appointed to plan the new city, Pierre-Charles L'Enfant employed radiating diagonals (inspired by Versailles). The two principal government buildings were designed by William Thornton, a self-trained amateur, and an Irish emigrant, James Hoban. Thornton's US Capitol (begun 1793) incorporated a Classical Roman rotunda, and Hoban's presidential residence, later known as the White House (1792–1803), was modeled on 18th-century Irish country houses.

After 1795 New England architecture developed its own identity, although indebted to English practitioners such as William Chambers. Samuel McIntire was typical of the early 19th century self-taught architects. Trained as a wood-carver and cabinetmaker, he designed such residences as the John Gardner House (1804–5), Salem, which have a characteristic linearity of ornament. Charles Bulfinch pursued architecture as a gentlemanly avocation until forced to make his living by designing buildings. Bulfinch is perhaps best known for his domed, brick-built Massachusetts State House (1795–8), Boston, based on William Chambers's Somerset House (1776–1801), London.

In the more southerly states, designers attempted to develop an architecture appropriate to the new nation. Thomas Jefferson, last of the gentlemen amateur architects, was well known for his hilltop home, Monticello (begun 1770). In 1785 Jefferson, in collaboration with Charles-Louis Clérisseau, designed the Virginia State Capitol at Richmond—the earliest American Neo-classical building—based on the ancient Roman Maison Carrée, Nîmes.

Jefferson sponsored one of the first professional architects to arrive in the USA, Benjamin Henry

Latrobe, obtaining for him the commission for the Virginia State Penitentiary (1797–8). Like Jefferson, Latrobe advocated Neo-classicism, as seen in his Greco-Roman Bank of Pennsylvania (1798–1800; destr.), Philadelphia. Like John Soane, Latrobe used the stark geometries of ancient Greece and Rome as a point of departure for the creation of an original and consciously modern idiom. The USA had only a few trained professionals trying to meet the needs of a burgeoning westward-moving population. Aimed at builders, inexpensive architectural manuals such as Asher Benjamin's *The American Builder's Companion* (1806) were published to meet the challenge.

American architecture entered an increasingly nationalist phase *c.* 1815 with the beginnings of revivalism ranging from ancient Egyptian through medieval to Italian Renaissance. Americans saw a parallel between their struggle for freedom and the struggle of the Greeks to free themselves from Turkish domination. Ancient Greek temples were reproduced almost exactly, seen in the Second Bank of the United States (1818–24) in Philadelphia, by William Strickland. With the recently published restoration drawings of the Parthenon by James Stuart and Nicholas Revett, the Greek Revival established itself as the style for public and government buildings, for example Alexander Parris's Quincy Market (1825–6) in Boston, MA.

The adaptation of the Greek temple for white-painted wood-frame houses was uniquely American. One example is the Boody House, called Rose Hill (*c.* 1835), outside Geneva, NY. The popularity of such houses was encouraged in the new pattern books produced by Minard Lafever. His most influential book, *The Modern Builder's Guide* (1833), contains designs for a simpler Grecian house that could be built with plain wooden boards. The Greek Revival spread throughout the USA, especially in the antebellum South. In his two books, *Cottage Residences* (1842) and *The Architecture of Country Houses* (1850), A. J. Downing, a horticulturist, advocated the fusion of building and landscape, with similar irregularity and roughness. The houses illustrated in his books often had L-shaped plans, elaborate medieval details, and broad porches from which to survey the surrounding landscape. One example is the Nicholls–McKim House (1858–9), Llewellyn Park, West Orange, NJ, located on a rolling hillside where the streets were laid out to follow the topography.

Various historical styles developed associational meanings: Roman or Greek classicism for public and commercial buildings, and Downing's medievalism for country residences. The churches of Richard Upjohn, an advocate of 14th and 15th century English Gothic, were more "correctly" medieval. His best-known application, Trinity Church (1839–46), New York, is reminiscent of A. W. N. Pugin's work.

John Haviland promoted a more generic medievalism in his Eastern State Penitentiary (1821–5), Philadelphia, PA. The arrangement of individual cells in radiating arms for easier central control was radically new and established a system of prison design named after Haviland used around the globe. Egyptian motifs were also used for prisons, though they were more commonly used for cemeteries, for example Henry Austin's massive pylon gate (1845–8) for the Grove Street Cemetery, New Haven, CT. Early 19th century examples of new building types include the round-arched Romanesque Revival used in James Renwick's Smithsonian Institution (1847–55) in Washington, DC.

Industrialization had a major influence on American architecture, and manufacturers quickly turned to building with cast iron. Entire facades were assembled from identical prefabricated pieces of cast iron bolted together. One example is the Haughwout Building (1856–7), New York, also notable for containing the first steam-operated passenger lift, which made feasible the construction of higher commercial buildings. Mechanization made a dramatic impact on house construction. Standardized, machine-cut pieces of timber were assembled rapidly into a complete house frame held together by cheap, machine-made nails. A carpenter could hammer together such a balloon frame in the space of one day, needing none of the skills of a traditional joiner.

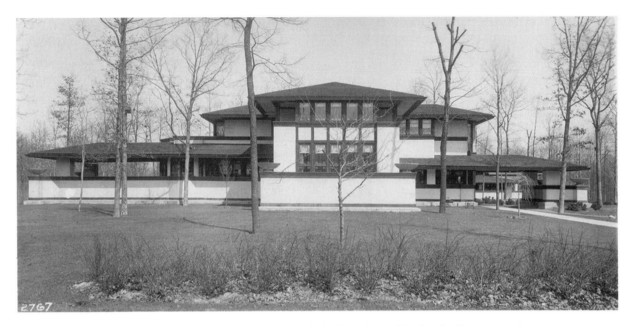

ARCHITECTURE. Ward W. Willits House by Frank Lloyd Wright, Highland Park, Illinois, 1902. © 2010 THE FRANK LLOYD WRIGHT FOUNDATION, SCOTTSDALE, AZ/ARTISTS RIGHTS SOCIETY, NY © ART RESOURCE, NY

The Civil War and Late 19th-century Eclecticism. By 1850 the limits of literal replication gradually had became apparent. After the Civil War, the French Second Empire style and the English High Victorian Gothic appeared. The Second Empire style, inspired by the 1852–7 additions to the Musée du Louvre in Paris, was characterized by pavilions with mansard (gambrel) roofs connected by lower wings, compositions that allowed for large irregular sites. One example is the Philadelphia City Hall (1871–1901) by John McArthur Jr.

High Victorian Gothic developed from the writings of John Ruskin, who advocated the development of a new Gothic idiom suited to modern needs. This was boldly irregular and colorful Gothic architecture, freed of archaeological dependence. One example illustrating the use of variously colored materials is the Memorial Hall (1870–8) at Harvard University, Cambridge, MA, by William Robert Ware and Henry Van Brunt. This style allowed for an unprecedented margin for invention, and Frank Furness was perhaps the most successful, particularly his Pennsylvania Academy of the Fine Arts (1871–6), Philadelphia. Furness was one of a new group of

architects who began to redirect the course of American architecture. Their extensive formal training was strongly influenced by the academic program of the Ecole des Beaux-Arts in Paris. Furness's teacher, Richard Morris Hunt, had been a student at the Ecole for nine years and supervised construction of the additions to the Louvre under Lefuel. Hunt established a studio in New York where he trained some of the most important architects at the end of the century.

Stylistic experimentation in domestic architecture increased. The New Jersey coast and Newport, RI became settings for the creation of new informal residential styles. The Stick style (c 1870–80) developed out of High Victorian Gothic, with intersecting steep roofs, prominent gables, and exposed timbers, as seen in the Jacob Cram House (1872) of Middletown, RI. The spiky appearance of the Stick style soon gave way to the stylistic unity of the Shingle style (c 1880 to 1895), which exploited long sweeping roofs and wall surfaces covered with wooden shingles. A particularly good example is the Isaac Bell House (1881–3), Newport, RI, by McKim, Mead & White, who were leading practitioners. Although

these styles were at first used in houses for the very wealthy, they soon appeared in ubiquitous pattern books such as those of Paliser & Paliser.

In the major commercial centers architectural emphasis was on size and height. In New York height records were set quickly with Richard Morris Hunt's *New York Tribune* Building (1873–6; destr.), which rose to 260 ft. The most influential architect of this period, H. H. Richardson, developed a highly individual style by 1872 that employed great masses of solid masonry with stylized Romanesque ornament. It was not a Romanesque Revival, but rather the result of careful analysis. Richardson's buildings had a monumental quality, such as Trinity Church (1875–7), Boston, MA, but his best were later works such as the Marshall Field Wholesale Store (1885–7; destr. 1930), Chicago.

A detailed knowledge of history, honed by training in Paris studios, marked the last phase of eclecticism in the 19th century. Perhaps the most important creation during this period was the metal-framed skyscraper. The traditional load-bearing wall construction of early skyscrapers limited their height; in Chicago William Le Baron Jenney was the first to substitute an internal metal skeleton in his Home Insurance Building (1883–5; destr. 1931). The technology was quickly perfected, resulting in frames made entirely of steel in such towers as Daniel H. Burnham and John Wellborn Root's Reliance Building (1889–95). Louis Sullivan and Dankmar Adler's Wainwright Building (1890–91), St Louis, MO, used continuous vertical lines to emphasize height.

In the face of industrial expansion during the 1870s, architects sought cultural continuity, admiring the balance and repose of Colonial and Federal style architecture. The result was a resurgence of academic classicism in the form of Colonial revival. Leading advocates were McKim, Mead & White, who introduced the Colonial Revival in their 18th-century-style house (1883–5; destr. 1952) at Newport, RI, for H. A. C. Taylor. They also developed a generic Italian Renaissance classicism, seen in the magisterial Boston Public Library (1887–95). By the

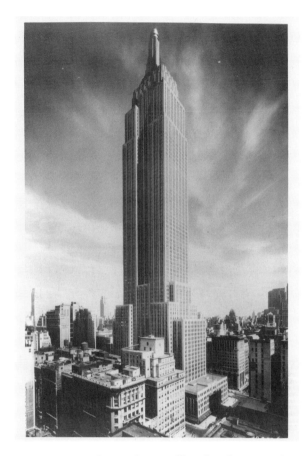

ARCHITECTURE. Empire State Building by Shreve, Lamb & Harmon, New York, 1929–31. © Museum of the City of New York/The Bridgeman Art Library

mid-1890s academic classicism had become the preferred language for urban buildings across the country. The white plaster, Renaissance style buildings of the Columbian Exposition (1893), Chicago, spurred the City Beautiful Movement, which swept the USA and led to the creation of scores of Neo-classical civic centers.

The Chicago School, the Prairie School, Academic Eclecticism and the Rise of Modernism. Among the most potent agents shaping American architecture in the early 20th century were the progressive architects now labeled the Chicago school, including incisive thinker, Louis Sullivan. The firm of Holabird & Roche developed a standardized form for their office towers, and the younger partners of Burnham & Root carried on the further development

of the Chicago skyscraper. Chicago architects likewise focused on the suburban family house, the most revolutionary changes made by Frank Lloyd Wright. For his own house in the Chicago suburb of Oak Park (1889), Wright drew on the Shingle style. Wright's goals of ridding the house of applied ornament and opening up its spaces were realized in a series of houses, particularly in the expansive Willits House (1902–6) in the suburb of Highland Park. Houses relating to the flat Midwestern prairie, emphasizing the horizontal line, established a Prairie school.

Part of the Arts and Crafts Movement, whose chief American proponent was Gustav Stickley, is the work of the brothers Greene and Greene of Pasadena, CA. Their masterwork, the David B. Gamble House (1908), Pasadena, synthesizes elements of the Stick style, the Shingle style, and Japanese influence, with Arts and Crafts interiors and furnishings. Other noteworthy works of the Arts and Crafts movement include those of Bernard Maybeck and the Bay Region Tradition in northern California, as well as those of Irving Gill in San Diego, CA.

The metal frame for skyscrapers was quickly adopted in New York, where by 1900 office towers were being built higher than those in Chicago, such as Cass Gilbert's Woolworth Building (1910–3), whose 55 stories rose 761 ft. After World War I there flourished an academic eclecticism that paralleled American political isolationism, seen in Pennsylvania Station (1902–11; destr. 1963–5), New York, by McKim, Mead & White. The Gothic Revival was championed by Ralph Adams Cram together with Bertram Goodhue and is well represented in St Thomas's (1905–14), Fifth Avenue, New York.

In city centers the continuing City Beautiful Movement inspired classical city halls, courthouses, and public libraries until the mid-1930s, but the spirit of American inventiveness focused on office skyscrapers. Some of these office towers had historical trappings, such as the Gothic competition-winning design for the Tribune Tower (1922–5), Chicago, by John Mead Howells and Raymond Hood. Eliel

Saarinen's unrealized design, which won second prize, had an even stronger influence, with its many subtle setbacks and use of abstracted ornament. Late 1920s office tower designs drew on European Art Deco to create bold geometric and colored patterns. One example is the Chrysler Building (1928–30), New York, by William Van Alen, soon overtopped by the Empire State Building (1929–31) by Shreve, Lamb & Harmon, whose height was unsurpassed until 1965. With the strong recovery of business in the 1920s, architects designed stately suburban homes for the wealthy, characterized by the residence for Edsel Ford (1927), Grosse Pointe, MI, by Albert Kahn. Similar houses were built in suburbs outside every major city, in styles inspired by medieval, Italian Renaissance or English Baroque models.

Another new building type was the cinema, rich in inventive escapism and fantasy, such as the Chicago Theater (1920–1), by Cornelius and George Rapp. While many buildings were treated with elaborate ornament, factories and other utilitarian buildings were designed in lean, functional modernism. A leading architect in this field was Albert Kahn, admired by Walter Gropius and Le Corbusier, designing concrete-frame factories for car manufacturers in Detroit, such as the Packard and Ford plants of 1905 and 1908–10. Kahn pioneered new methods such as wide-span steel trusses in his Dodge Half-Ton Truck Plant (1937), Detroit. During the Depression of the 1930s, functional utilitarianism was also employed in public works projects, such as the Kentucky Dam (1938–44), designed by Roland Wank. Bringing disparate elements together, Bertram Goodhue designed the competition-winning Nebraska State Capitol (1919–32), Lincoln, with a broad cross-in-square plan (reminiscent of Beaux-Arts schemes) and a metal-framed skyscraper tower rising from its center—an example that is at once both traditional and modern.

In 1936 a new phase in Frank Lloyd Wright's career was inaugurated by two designs: the cantilevered floor-trays at Fallingwater (1936–9) in

western Pennsylvania, and the spacious central office of the Johnson Wax Administration Building (1936–9), Racine, WI. Rejecting the idea of the traditional city, Wright envisioned individual prefabricated Usonian houses spread across the landscape in "Broadacre City" (early 1930s).

After World War II: Modernism, Neo-expressionism, Postmodernism. In 1910 when Wright started a trend of radically new architecture, publication of his designs attracted two Viennese architects to the USA: Rudolph Schindler and Richard Neutra. Both worked briefly for Wright and then settled in Los Angeles, where they developed their own variants of Modernism. Another immigrant was Pietro Belluschi, who worked in the office of A. E. Doyle (*d* 1928) in Portland, OR, moving away from the academic eclecticism practiced by Doyle and developing his own variant of modern functionalism, signaled by the Portland Art Museum (1931–8). The greatest European influence on American architecture began with the flight of artists from Nazi Germany. By 1938 Walter Gropius had left the Bauhaus and was head of the Graduate School of Design at Harvard University, Cambridge, MA, training young architects in a new curriculum, which spearheaded the abandonment of the Beaux-Arts method.

Ludwig Mies van der Rohe gave definitive form to the postwar American office skyscraper, coming to the USA in 1937 and accepting the position of Director of Architecture at the Armour (later Illinois) Institute of Technology. Mies's austere buildings were reduced to a bare minimum of metal frame and glass, beginning with the Lake Shore Drive Apartments (1948–51), Chicago. Philip Johnson modeled his own Glass House (1949) at New Canaan, CT, on Mies's design for a residence for Dr. Edith Farnsworth (executed 1945–50), Plano, IL. Eero Saarinen sought the single most expressive form for each of his commissions. Eero began practice in partnership with his father, Eliel Saarinen, and together in 1948 they won the competition for the Jefferson National Expansion Memorial in St Louis, MO, a gigantic reverse catenary arch. Two of Eero's

most expressive designs were for airports, including the wing-like cantilevered concrete shells for the Trans World Airlines Terminal (1956–62), in New York. As domestic buildings spilled into the rapidly expanding suburbs, the now-labeled Mid-Century Modern home design flourished.

Louis Kahn sought to reconcile Beaux-Arts didactic forms with the modernist insistence on structural precision and expression, finding success in the Salk Institute for Biological Studies (1959–65) at La Jolla, CA, where elements were expressively articulated. Kahn's concern with manipulating natural light can be seen in his Kimbell Art Museum (1966–72), Fort Worth, TX. Around 1965 a reaction began against the strictures of the International Style. Architect Robert Venturi celebrated the multiple and ambiguous meanings of architecture and criticized the absence of understandable imagery of international Modernism, demonstrated in his Vanna Venturi House (1962), Chestnut Hill, PA.

The principal agent in spreading International Style worldwide was the firm Skidmore, Owings & Merrill (SOM), based in Chicago, with 47 partners and more than 1400 architects by the mid-1980s. SOM introduced a new scale to office buildings, seen in the Sears Tower (1970–4), in Chicago, employing nine bundled vertical cantilevered tubes to withstand enormous wind pressure. A number of alternative approaches emerged; the Miesian glass-box tower was replaced with experiments to find recognizable images for office towers, like those of the Art Deco skyscrapers of the 1920s, giving form to corporate identities. Philip Johnson was among the first to play with form in this way in his classically inspired AT&T company headquarters (1983) in New York, with its so-called "Chippendale" pediment.

The most austere reaction was the minimalism espoused by Peter D. Eisenman, who created an ascetic architecture of pure geometry. A more derivative approach was taken by Richard Meier, whose geometrically abstract residences of the early 1970s, rendered in pure white, drew heavily from Le Corbusier's designs of the late 1920s. Meier's

Geometries became more complex and historical references more inclusive, developments that are well illustrated in his High Museum of Art (1980–4), Atlanta, GA.

A new emphasis to contextual response is seen in the work of Charles W. Moore. The stylized Second Empire style massing of his firm's Citizens' Federal Savings and Loan Association (1962), San Francisco, reiterated the principal forms of the original bank next door. At Sea Ranch condominium complex (1965–72), wind-tunnel models were studied to find the optimum environmental living conditions; the result was rugged wood siding and sharply angled shed roofs. In the late 1980s Moore used another Post-modern response, either inventing ornamental patterns when none prevailed or deriving motifs from local sources to maintain contextualism. Venturi's shingled Trubeck and Wislocki homes (1970), Nantucket Island, MA, show his high regard for local early 19th-century vernacular models; and Moore, in his proposal for the Beverly Hills Civic Center (1982), made reference to long-popular Spanish Renaissance historicist themes.

Designing meaningful public architecture became more challenging, particularly because of the high cost of elegant durable materials such as marble and bronze, the high cost of artisans to shape these materials and a public unwilling to regard architecture as a long-term investment. In the Portland Building (1978–82), Portland, OR, Michael Graves won the design competition partly because it met the tight city budget. Creativity dominated the late 20th century with architecture that seemed at times more conceptual than physical: the seemingly physics-defying, undulating works of Frank Gehry, seen in his Walt Disney Concert Hall (1999–2003), Los Angeles, CA, and the explorations of shape and reflection by Zaha Hadid, seen in her early work, the Lois and Richard Rosenthal Center for Contemporary Art (2001–3), Cincinnati, OH. American architects were struggling to frame a coherent view of their art and the direction it should take. Critical participants, both USA-born and otherwise,

in shaping late 20th-century architectural expression include Thom Mayne, Jon Pickard, John Portman, I. M. Pei, Renzo Piano and the innovative firm, Arquitectonica. Their works embody a playful approach and a plastic or sculptural expression of three-dimensional forms, aided by the use of computer-based design software.

Nearing the close of the 20th century, architects turned their attention to sustainability through "Green" design, and, beginning in 1998, achieving Leadership in Energy and Environmental Design accreditation of their buildings. On the eve of the millennium American architecture became more global in practice and influence, seemingly blurring the definition of a uniquely American style.

BIBLIOGRAPHY

S. F. Kimball: *Domestic Architecture of the American Colonies and of the Early Republic* (New York, 1922/R 1966)

G. H. Edgell: *The American Architecture of Today* (New York, 1928)

F. Lloyd Wright: *An Autobiography* (New York, 1932, R 4/1977)

G. Kubler: *The Religious Architecture of New Mexico in the Colonial Period and since the American Occupation* (Colorado Springs, 1940/R Albuquerque, 1972)

T. Hamlin: *Greek Revival Architecture in America* (New York, 1944/R 1966)

E. Mock, ed.: *Built in the USA since 1932* (New York, 1945)

J. M. Fitch: *American Building: The Historical Forces that Shaped it* (Boston, MA, 1948, 2/1966)

T. T. Waterman: *The Dwellings of Colonial America* (Chapel Hill, NC, 1950)

H.-R. Hitchcock and A. Drexler, eds: *Built in the USA: Post-war Architecture* (New York, 1952)

H. Morrison: *Early American Architecture, from the First Colonial Settlements to the National Period* (New York, 1952)

L. Mumford: *Roots of Contemporary American Architecture* (New York, 1952)

W. Andrews: *Architecture, Ambition and Americans* (New York, 1955, 2/1964)

V. J. Scully Jr.: *The Shingle Style and the Stick Style* (New Haven, CT, 1955, 2/1971)

H.-R. Hitchcock: *Architecture, Nineteenth and Twentieth Centuries* (Harmondsworth, 1958, 4/1977)

E. McCoy: *Five California Architects* (New York, 1960)

V. J. Scully Jr.: *Frank Lloyd Wright* (New York, 1960)

J. Burchard and A. Bush-Brown: *The Architecture of America: A Social and Cultural History* (Boston, 1961, 2/1967)

W. von Eckardt, ed.: *Mid-century Architecture in America* (New York, 1961)

H. W. Rose: *The Colonial Houses of Worship in America* (New York, 1963)

P. Heyer, ed.: *Architects on Architecture: New Directions in Architecture* (New York, 1966)

C. W. Condit: *American Building* (Chicago, 1968, 2/1982)

M. C. Donnelly: *The New England Meeting House of the Seventeenth Century* (Middletown, 1968)

P. B. Stanton: *The Gothic Revival and American Church Architecture: An Episode in Taste, 1840–1856* (Baltimore, 1968)

V. J. Scully Jr.: *American Architecture and Urbanism* (New York, 1969)

R. A. M. Stern: *New Directions in American Architecture* (New York and London, 1969, R 1977)

W. H. Pierson Jr.: "The Colonial and Neo-Classical Styles," i of *American Buildings and their Architects* (Garden City, NY, 1970)

W. H. Jordy: "The Impact of European Modernism in the Mid-twentieth Century," iv of *American Buildings and their Architects* (Garden City, NY, 1972)

W. H. Jordy: "Progressive and Academic Ideals at the Turn of the Century," iii of *American Buildings and their Architects* (Garden City, NY, 1972)

L. Cummings: *The Framed Houses of Massachusetts Bay, 1625–1725* (Cambridge, MA, 1974)

C. Robinson and R. Haag Bletter: *Skyscraper Style: Art Deco in New York* (New York, 1975)

W. H. Pierson Jr.: "Technology and the Picturesque, the Corporate and Early Gothic Styles," ii of *American Buildings and their Architects* (Garden City, NY, 1978)

G. Ciucci and others: *The American City: From the Civil War to the Deal* (Cambridge, MA, 1979, 2/London, 1980)

A. L. Cummings: *The Framed Houses of Massachusetts Bay, 1625–1725* (Cambridge, MA, 1979)

L. M. Roth: *A Concise History of American Architecture* (New York and London, 1979, 2/1988)

M. Whiffen and F. Koeper: *American Architecture, 1607–1976* (Cambridge, MA, 1981)

L. M. Roth: *America Builds: Source Documents in American Architecture and Planning* (New York, 1983)

D. P. Handlin: *American Architecture* (London and New York, 1985)

D. D. Reiff: *Small Georgian Houses in England and Virginia: Origins and Development through the 1750s* (London, 1986)

L. Ford: *Cities and Buildings: Skyscrapers, Skid Rows, and Suburbs* (Baltimore, 1994)

A. H. Ameri: "Housing Ideologies in the New England and Chesapeake Bay Colonies, *c.* 1650–1700: Expression of Puritan and Anglican Communities," *J. Soc. Archit. Hist.*, lvi (1997), pp. 6–15

R. B. St-George: Afterthoughts on Material Life in America, 1600–1860: Household Space in Boston, 1670–1730, *Winterthur Port.*, xxxii (Spring 1997), pp. 1–38

D. Upton: *Architecture in the United States* (Oxford, 1998)

G. E. Kidder Smith: *Source Book of American Architecture: 500 Notable Buildings from the 10th Century to the Present* (Princeton, 2000)

M. Gelernter: *A History of American Architecture: Buildings in Their Cultural and Technological Context* (Lebanon, NH, 2001)

D. D. Reiff: *Houses from Books: Treatises, Pattern Books, and Catalogs in American Architecture, 1738–1950: A History and Guide* (University Park, PA, 2001)

L. M. Roth: *American Architecture: A History* (Boulder, CO, 2001)

D. Kelbaugh: *Repairing the American Metropolis: Common Place Revisited* (Seattle, 2002)

S. Conn and M. Page, eds.: *Building the Nation: Americans Write about their Architecture, their Cities, and their Landscape* (Philadelphia, 2003)

M. C. Donnelly and L. M. Roth, ed: *Architecture in Colonial America* (Eugene, OR, 2003)

K. Eggener, ed.: *American Architectural History: A Contemporary Reader* (New York, 2004)

S. Guy and S. A. Moore, eds.: *Sustainable Architectures: Cultures and Natures in Europe and North America* (London, 2005)

H. Davis: *The Culture of Building* (Oxford, 2006)

L. Asquith and M. Vellinga, eds.: *Vernacular Architecture in the Twenty-first Century: Theory, Education and Practice* (London, 2006)

Marcus Whiffen
Leland M. Roth

Architecture, Pre-Columbian sources in

America's interest in Pre-Columbian culture began to take tangible form in the 19th century. American explorer John Lloyd Stephens (1805–52) and artist Frederick Catherwood (1799–1854) journeyed to Chiapas and the Yucatán peninsula in 1839 to describe and document Mayan ruins. Their research was published in 1841 as *Incidents of Travel in Central America, Chiapas and the Yucatan*. An expanded two-volume version, *Incidents of Travel in the Yucatan*, was published in 1843 and contained over 120 woodcut illustrations, and provided the first pictorial views of ancient Mesoamerica.

The ancient sites of Mitla, Palenque, Izamal, Chichén Itzá and Uxmal were first photographed

by French photographer and explorer Désiré Charnay (1828–1915) between 1858 and 1860. The resulting images were collected into a book published in 1863 entitled *Cités et ruines américaines*, which later included an essay by the influential French architect and theorist Eugène-Emmanuel Viollet-le-Duc (1814–79). Charnay made a second trip to the region from 1880 to 1882 that resulted in another publication entitled *Les anciennes villes du Nouveau monde*, which contained over 214 illustrations. Both publications were translated into English in 1888 and published as *The Ancient Cities of the New World*.

An American archaeologist named Edward H. Thompson made several expeditions to Mesoamerica between 1885 and 1910, and his research proved useful to archaeologist Frederick W. Putnam. As the head of archaeology at the 1893 World's Columbian Exposition in Chicago, Putnam enhanced the visitors' experience by commissioning life-size reconstructions of the Arch at Labná and facades of the Nunnery at Uxmal as well as numerous other castings from Thompson, producing reproductions of sculptures cast by Charnay and borrowing actual Aztec and Mayan artifacts from the Peabody and Berlin museums.

The influences the publications mentioned above and the Mesoamerican exhibit at the World's Columbian Exposition had on architects practicing in the United States took many forms. American architect Frank Lloyd Wright is often cited as being directly influenced by Aztec and Mayan motifs and many have made correlations between his projects and Mesoamerican archaeology. His quests for an American architectural iconography borrowed discreetly from Native America and Mesoamerica and led him beyond the aesthetic of the Prairie school as evidenced by Chicago's Midway Gardens (1913, destr.) and the Imperial Hotel (designed 1913; built 1919–21) in Tokyo. However, the fonts from which he derived inspiration remain unclear. Explicit, albeit loosely interpreted, Mayan references appear in his work from 1915 with the A. D. German

Warehouse (1915) in Richland Center, WI, the Bogk House (1916) in Milwaukee, WI, and the Barnsdall House (1916–22) in Los Angeles whose plan recalls ancient Mayan quadrangles. The strongest Pre-Columbian references materialize in four concrete textile-block houses he designed in the Los Angeles area. In their abstraction and surface ornament, the Millard House (1923), Pasadena, CA, and the Freeman, Ennis and Storer houses (all 1924), Los Angeles, reflect Wright's interest in the monumentality and decorative richness of Mayan and Aztec structures.

Architectural revivalists embraced Mesoamerican motifs in an attempt to establish an all-American decorative language. In the Pan American Union in Washington, DC, designed in 1908 by Albert Kelsey (1870–1950) and Paul Cret, Mayan and Aztec inspired ornament is most evident in the mosaics, patio fountain and the Aztec garden. The 1920s brought about a renewed interest in Mesoamerican archaeology among revival-style architects thanks to new publications such as George Oakley Totten's *Maya Architecture* (1926) and Sylvanus G. Morley's essays for *National Geographic*. In 1923, a British-born architect named Robert Stacy-Judd (1884–1975) relocated to Southern California. Shortly after his arrival, he purchased Stephens and Catherwood's two-volume publication, which inspired his design for the Aztec Hotel (1924–5) in Monrovia, CA. The hotel is an L-shaped structure of cast concrete dressed in imaginative Mayan motifs. Decorative elements and other forms derived directly from Stephens and Catherwood are better evidenced in his designs for the First Baptist Church in Ventura, the Wise residence in Oceano and the Masonic Temple in North Hollywood, all in California. Stacy-Judd visited the Yucatán peninsula in the early 1930s and published an account of his travels entitled *The Ancient Mayas; Adventures in the Jungles of the Yucatan* in 1934. Stacy-Judd advocated the Mayan Revival as the only "truly American" style.

Other notable revival-style structures include the Mayan Theater in Los Angeles by Morgan, Walls & Clements, the Mayan Theater in Denver by Montana

Fallis and the Mayan Theater in Detroit. Archaeologist Sylvanus G. Morley collaborated on and authenticated the Mayan-inspired decoration of the latter theater, designed by the firm Gravan and Mayger in Albert Kahn's Fisher Building. Morley also composed an article about Mayan civilization for the opening day program.

The search for an American architectural language through the study of ancient Pre-Columbian cultures would also have a notable influence on Art Deco architecture and decoration which borrowed heavily from the geometric patterns and monumental forms of America's indigenous cultures, including Mesoamerica.

BIBLIOGRAPHY

R. Stacy-Judd: *The Ancient Mayas: Adventures in the Jungles of the Yucatan* (Los Angeles, 1934)

D. Tselos: "Frank Lloyd Wright and World Architecture," *J. Soc. Archit. Hist.*, xxviii/1 (1969), pp. 58–72

M. Ingle: *Mayan Revival Style: Art Deco Modern Fantasy* (Salt Lake City, 1984)

A. Alofsin. *Frank Lloyd Wright: The Lost Years 1910–1922* (Chicago, 1993)

D. Gebhard: *Robert Stacy-Judd: Maya Architecture and the Creation of a New Style* (Santa Barbara, 1993)

Anne Blecksmith

Arensberg

Art collectors and patrons. Walter (Conrad) Arensberg (*b* Pittsburg [now Pittsburgh], PA, 4 April 1878; *d* Los Angeles, CA, 29 Jan 1954) and his wife, Louise [née Mary Louise Stevens] (*b* Dresden, 15 May 1879; *d* Los Angeles, CA, 25 Nov 1953), lived in New York from 1914 to 1921. During this period their apartment at 33 W. 67th Street was an unofficial salon for the American Dada movement, where French expatriate artists such as Marcel Duchamp and Francis Picabia mingled with American writers, artists, musicians and others. Although Walter Arensberg enjoyed financial comfort for a while, owing to financial assistance from his father, this soon ended. Walter's support of such journals as

Others and *Blind Man* and of the Marius de Zayas Gallery was short lived and ended in financial failure. In contrast, his wife, Louise (whom he had married in 1907), had inherited substantial wealth from her parents, which provided the means to acquire the majority of works the couple amassed from the 1920s.

While the Arensbergs lived in New York, their entire holdings of art, furniture and rugs comprised fewer than 70 items but grew to over 1500 items by the time of their deaths. The expansive display of these works in their apartment in New York was dramatically altered in their house in Hollywood, CA, where they settled permanently in 1927: paintings were hung frame to frame, floor to ceiling, on the staircases and even in the bathrooms; oriental and Middle Eastern rugs were piled three to four on top of one another; Shaker furniture, purchased with the assistance of Charles Sheeler, was displayed with Chippendale and other types. In May 1933 an extension designed by Richard Neutra and Gregory Ain was completed in an attempt to relieve the overcrowding.

The Arensbergs' collection comprised two main sections, avant-garde art and non-Western artifacts, a pattern of acquisition begun in the 1910s. The majority of modern works, most dated between 1910 and 1914, were centered around the aesthetic impact of European modernism, in particular Cubism, first seen in the USA at the Armory Show (1913). The Arensbergs felt that this art heralded a new perception, and with singular commitment they sought particular works that they believed demonstrated its effect on the very premise and process of art. Their collection was dominated by Cubist works, the works of forerunners of Cubism and works by artists influenced by the movement, including paintings, prints and drawings by Georges Braque, Paul Cézanne, Marc Chagall, Robert Delaunay, Albert Gleizes, Juan Gris, Fernand Léger, Henri Matisse, Jean Metzinger, Francis Picabia, Pablo Picasso, Henri Rousseau and Jacques Villon. One of the Armory Show's most notorious works, Duchamp's

Nude Descending a Staircase No. 2 (1912), was eventually acquired with ten other works from the show. Duchamp's art became the focus of the collection, which contained over 35 of his works. (Among the other artists who were substantially represented were Constantin Brancusi and Paul Klee.) From the 1930s the Arensbergs expanded this initial concentration in Cubist works to acquire works by Klee, Surrealist paintings, including those by such artists as Max Ernst, Joan Miró and Salvador Dalí, and contemporary Mexican artists such as Diego Rivera.

Of more than 65 modern artists represented in the collection, only a small number were American. Most of these works were produced in the mid-1910s by members of the Arensbergs' circle in New York, such as Walter Arensberg's cousin John R. Covert (1882–1960), Charles Demuth, Charles Sheeler and Morton Livingston Schamberg. Their small photographic collection was dominated by the works of such Americans as Sheeler and Edward Weston.

The section devoted to ethnic artifacts, which eventually included more than 300 items, changed after the Arensbergs moved to California. They ceased buying wooden African works in favor of Pre-Columbian objects (primarily of stone), Mexican retables, Native American items (baskets, rugs, spearheads) and some Asiatic and Indian works. The display of the large number of items in this section in their homes in New York and Hollywood continued the aesthetic interrelationships and cultural juxtaposition of "primitive" to modern promoted in the 1910s by such dealers in New York as Alfred Stieglitz and Marius de Zayas.

Although the Arensbergs purchased directly from individuals, their major dealer and art adviser was Marcel Duchamp, whom they met upon his arrival in the USA in 1915. Not including gifts such as *Boîte-en-valise*, Duchamp sold the Arensbergs approximately 50 works, the majority by either him or Brancusi. Duchamp and the Arensbergs also made a conscious effort to have the majority of Duchamp's works in their collection, including *The Bride Stripped Bare by Her Bachelors, Even* (*The Large Glass*; Philadelphia,

PA, Mus. A.), which they sold to Katherine S. Dreier in 1921, and *Sad Young Man on a Train* (Venice, Guggenheim).

The Arensbergs were committed to the public dissemination and display of modern art, especially in the Los Angeles area, which at that time lacked both a museum devoted solely to art and in particular a museum devoted to the modern period. They supported the Modern Institute of Art and American Arts in Action, Inc., both public galleries of modern art. Their activities in Los Angeles were, however, more isolated and restricted than they had been in New York. Entrance to their Hollywood home was by invitation and recommendation, although apparently no one interested in seeing the collection was refused access. Their collection had little impact, however, on art life in Los Angeles, beyond shared interests with other modern collectors such as Ruth Maitland.

The Arensbergs' original intention was for their collection to remain in the Los Angeles area. An initial offer made to the County Museum of Art in 1938 was never acknowledged, however. Negotiations took place with over 30 institutions in the USA, including the University of California at Los Angeles and Stanford University, CA, as well as with institutions in Paris and Mexico City. The primary negotiating problems were twofold. The Arensbergs insisted that a research institute be part of the bequeathal of the art collection. The institution established by them in 1937 as The Francis Bacon Foundation (in Claremont, CA, from the 1960s), its aim being to promote Walter Arensberg's theory that the English statesman and philosopher Francis Bacon (1561–1626) wrote the plays and poems attributed to William Shakespeare, was the immediate beneficiary of the art collection. The other criterion was that the entire art collection be displayed as a unit for a substantial period. After almost three years of discussions, and after relinquishing the idea of such a research institute from the negotiations, the Board of Trustees of The Francis Bacon Foundation approved the offer made by the

Philadelphia Museum of Art (bequeathed 1950). In 1954, a total of 22 galleries housing the collection in the Philadelphia Museum of Art opened to the public.

Walter Arensberg also received recognition as a writer and took an active role in promoting modernism in the USA. His early sporadic writings on art were on established artists or movements, but by the mid-1910s he was writing articles on Dada artists for various journals and joined the literary vanguard of Imagist writers with the publication of two books of poetry (*Poems*, 1914; *Idols*, 1916). By the time the Arensbergs moved to the Los Angeles area, Walter Arensberg was less actively involved in writing or commenting publicly about art. The only occasions on which he expressed any view were when he considered publicity a necessity for demonstrating the importance of the collection, in particular during the Art Institute of Chicago's exhibition of a major portion of their 20th-century holdings (1949), and shortly after its bequeathal to the Philadelphia Museum of Art.

UNPUBLISHED SOURCES

Philadelphia, PA, Mus. A., Arensberg Archv

San Marino, CA, Huntington Lib. & A.G., Arensberg Archv

WRITINGS

"Mr. Pennell's Etchings of London," *Evening Post* (1 March 1906); *R* in book form (New York, 1906)

W. C. Brensberg [*sic*]: "Art in America: The Art Season in New York," *Burl. Mag.*, x/46 (1907)

"The National Academy of Design," *Burl. Mag.*, x/47 (1907), p. 336

"Partie d'échecs entre Picabia et Roché," 391, vii/7 (1917), p. 3

BIBLIOGRAPHY

A. Norton: "Walter's Room," *The Quill* (June 1919), pp. 20–21 [describes the Arensbergs' salon in New York]

H. McBride: "Modern Forms (The Arnsbergs) [*sic*]," *Dial* (July 1920), pp. 61–4

J. T. Soby: "Marcel Duchamp in the Arensberg Collection," *View*, v/1 (1945), pp. 11–12

J. Langsner: "The Arensberg Riches of Cubism," *Artnews*, xlvii/7 (1949), pp. 24–5, 61–2 [incl. quotes from interviews with Walter Arensberg]

20th-century Art from the Louise and Walter Arensberg Collection (exh. cat., Chicago, IL, A. Inst., 1949)

"The Louise and Walter Arensberg Collection," *Modern Artists in America*, 1st ser. (1950–51), pp. 124–31 [contains phot. of the col. in the Arensbergs' home in Los Angeles]

The Louise and Walter Arensberg Collection, 2 vols (Philadelphia, 1954)

F. Kimball: "Cubism and the Arensbergs," *ARTnews Annu.*, xxiv (1955), pp. 117–22, 174–8 [contains personal reminiscences of the Arensbergs by their friends]

W. H. Higgins: *Art Collecting in the Los Angeles Area, 1910–1960* (diss., Los Angeles, U. CA, 1963), pp. 621–81

K. Kuh: "Walter Arensberg and Marcel Duchamp," *The Open Eye: In Pursuit of Art* (New York, 1971), pp. 56–64

L. H. Lincoln: *Walter Arensberg and his Circle* (MA thesis, New York U. DE, 1972)

A. d'Harnoncourt: "A. E. Gallatin and the Arensbergs: Pioneer Collectors of Twentieth-century Art," *Apollo*, n.s., xclx/149 (1974), pp. 52–61

F. M. Naumann: "Walter Conrad Arensberg: Poet, Patron, and Participant in the New York Avant-garde," *Bull. Philadelphia Mus. A.*, xxvi/328 (1980), pp. 2–32

R. E. Kuenzli, ed.: "Bibliography on Dada, 1978–1983," *Dada Surrealism*, xiii (1984), pp. 164–93 [contains section on Walter Arensberg's writings and works about him and the art col.]

R. E. Kuenzli and T. Shipe, eds.: "Bibliography on New York Dada," *Dada Surrealism*, xiv (1985), pp. 126–64

F. M. Naumann, ed.: "Marcel Duchamp's Letters to Walter and Louise Arensberg, 1917–1921," *Dada/Surrealism*, xvi (1987), pp. 203–57; also in *Marcel Duchamp: Artist of the Century*, R. E. Kuenzli and F. M. Naumann, eds. (Cambridge and London, 1989)

N. Sawelson-Gorse: *"For the Want of a Nail": The Disposition of the Louise and Walter Arensberg Collection* (MA thesis, Riverside, U. CA, 1987)

N. Sawelson-Gorse: "Hollywood Conversations: Duchamp and the Arensbergs," *West Coast Duchamp*, B. Clearwater, ed. (Miami, 1991), pp. 24–45

R. Crunden: *American Salons: Encounters with European Modernism, 1885–1917* (Oxford and New York: Oxford University Press, 1993)

N. Sawelson-Gorse: *Marcel Duchamp's "Silent Guard": A Critical Study of Louise and Walter Arensberg* (Ph.D. dissertation, Santa Barbara, U. CA, 1994)

M. Nesbit and N. Sawelson-Gorse: "The Concept of Nothing: New Notes by Marcel Duchamp and Walter Arensberg," *The Duchamp Effect: Essays, Interviews, Round Table*, M. Buskirk and M. Nixon (Cambridge and London, 1996), pp. 131–75

J. Moffitt: "Cryptography and Alchemy in the Work of Marcel Duchamp and Walter Arensberg," *Aries*, I/1 (2001), pp. 38–61

Naomi Sawelson-Gorse

Armajani, Siah

(*b* Tehran, 10 July 1939), sculptor of Iranian birth. Armajani studied in Iran at the University of Tehran before immigrating to the United States in 1960 to complete his studies in philosophy at Macalester College in Saint Paul, MN, where he settled permanently. He became a naturalized US citizen in 1967. Armajani uses the language of vernacular architecture in his sculpture to create spaces into which the viewer moves, sometimes being literally surrounded by the sculpture. Cellar doors, back stairways, loading docks, benches, bridges, porches, gazebos and other such homely architectural elements are the inspiration for his sculptures and installations. Early in Armajani's career he was on the faculty of the Minneapolis College of Art and Design, where he lectured on philosophy and conceptual art, but he left teaching in 1975 to concentrate exclusively on his sculpture.

Armajani has stated repeatedly that it is his intention to create a "neighborly" space, that is, a space that brings people together. His public sculpture is perhaps best thought of as social sculpture, in the sense meant by postwar German artist Josef Beuys (1921–86): a community-seeking, politically progressive, public art. Armajani's many commissions include the Irene Hixon Whitney Bridge in Minneapolis (1988) and a garden and waterfront sculpture designed in collaboration with Scott Burton and Cesar Pelli for Battery Park in the southern tip of Manhattan (1988). He was asked to design a sculpture for the 1996 centennial of the modern Olympics in Atlanta, GA, his largest work to date, which included a bridge spanning a highway as well as a sculptural cauldron to contain the Olympic torch. His international public commissions include works in Germany, France, the Netherlands and Spain, where he is perhaps better known than in the United States.

Armajani considers himself a populist and advocates a breakdown between the art object and the viewing subject into one unitary experience, which links his work to the aesthetics of early 20th-century pragmatist John Dewey. Although he has virtually no formal training as an artist, his training in philosophy was a major influence in his work. Besides Dewey, his mature sculpture owes a great intellectual debt to German philosophers Martin Heidegger and Walter Benjamin (particularly his *Arcades Project*, which inspired Armajani's later glass sculptures), as well as the more recent neo-pragmatism of Richard Rorty and Cornel West.

For a number of years Armajani worked intermittently on what appear to be small, roughly constructed three-dimensional "sketches." He titled these collectively the *Dictionary for Building* (1965–85). They are small works made of cardboard, balsa wood, little boxes, spools, scraps of plastic or other humble materials; the pieces number in the hundreds (all are now in the collection of Museé d'art Moderne et Contemporain, Geneva). These served as the prototypes from which most of his later work was derived.

Armajani's early experiences under the repressive regime of the Shah of Iran gave the artist a lifelong disdain for monarchs and demagogues. This disdain also drew him to the philosophy of anarchism, and several of his sculptural installations made during the late 1980s and 1990s have been dedicated to obscure Italian-American anarchists from the first decades of the 20th century. In fact, many of his works are dedicated to his intellectual heroes, who, besides the anarchists, include people as diverse as Thomas Jefferson, Ralph Waldo Emerson, El Lizzitsky, Edgar Allan Poe, Rumi and Noam Chomsky. Many of his sculptures and installations are dedicated to these heroes in their titles, linking his work, at least conceptually, to the traditional function of sculptural monuments of the past.

After 1999 Armajani expanded his range with large two-dimensional work in colored pencil inspired by traditional Persian miniatures and the painting of early 20th-century proto-Surrealist Giorgio de Chirico (1888–1978). At the same time, he developed a series of large, enigmatic studio

sculptures characterized by walls of transparent glass, giving the viewer visual access to the interior but barring him from entering the sculpture, as was often the case in his earlier work. In these somber, almost haunted sculptures, Armajani addressed his feelings of alienation, especially in works made since the terrorist attacks of September 11, 2001, on the USA. His *Glass Room for an Exile* (2002) or *One Car Garage* (2003) expressed his sense of feeling uprooted and are in marked contrast with his earlier, more optimistic public sculptures. In *Fallujah* (2007), the largest and most ambitious work in the series, he expressed his outrage at the massacre of Iraqi civilians by US troops during the siege of Fallujah in 2004.

BIBLIOGRAPHY

J. Kardon: *Siah Armajani: Bridges, Houses, Communal Spaces, Dictionary for Building* (exh. cat., Philadelphia, U. PA, ICA, 1985)

N. Princenthal: "The Sculpture/Constructions of Siah Armajani," *A. America*, lxxiv (March 1986), pp. 126–33

C. Tompkins: "Profiles: Siah Armajani: Open, Available, Useful," *New Yorker*, lxvi (19 March 1990), pp. 48–72

Siah Armajani (exh. cat., Madrid, Mus. N. Cent. A. Reina Sofia, 1999)

D. Raverty: "Locale, Memory and Exile in Recent Work of Siah Armajani," *Art Papers*, xxviii (Sept 2004), pp. 28–33

K. Bradley: "Collateral Damage: Siah Armajani's *Fallujah* Employs Some of His Signature Architectural Vocabulary in a New, Darkly Pessimistic Tone," *A. America*, xcvi (June–July 2008), pp. 152–3, 210

Dennis Raverty

Arman

(*b* Nice, 17 Nov 1928; *d* New York, 22 Oct 2005), sculptor and collector of French birth. Arman [Armand Fernandez] lived in Nice until 1949, studying there at the Ecole des Arts Décoratifs from 1946 and in 1947 striking up a friendship with the artist Yves Klein (1928–62), with whom he was later closely associated in the Nouveau Réalisme movement. In 1949 he moved to Paris, where he studied at the Ecole du Louvre and where in an exhibition in 1954 he discovered the work of Kurt Schwitters

(1887–1948), which led him to reject the lyrical abstraction of the period. In 1955 Arman began producing *Stamps*, using ink-pads in a determined critique of *Art informel* and Abstract Expressionism to suggest a depersonalized and mechanical version of all-over paintings. In his next series, the *Gait of Objects*, which he initiated in 1958, he took further his rejection of the subjectivity of the personal touch by throwing inked objects against the canvas.

Arman's willingness to embrace chance was indicated by his decision in 1958 to change his name in accordance with a printing error, having already stopped using his surname in 1947. The attitude was consistent with that of his work, which by the late 1950s had moved away from traditional painting and sculpture in favor of the object and specifically of the ready-made as defined in the Dada movement by Marcel Duchamp. In his *Accumulations* he piled up identical salvaged objects, modifying their meaning by repetition and giving the construction an ironic title, as with the accumulation of gas masks, *Home Sweet Home* (1960; Paris, Pompidou). He continued this aesthetic of detritus and scrap in another particularly provocative group of works, the *Dustbins*, transparent containers in which he placed either rubbish he had collected or objects that had belonged to a friend, as in *Robot-portrait of Yves Klein, The Monochrome* (1960; Paris, priv. col., see 1986 exh. cat., p. 117).

In response to Yves Klein's installation of an empty room, *The Void* (Paris, Gal. Iris Clert, 1958), Arman exhibited *Fullness* (Paris, Gal. Iris Clert, 1960), a gigantic accumulation of refuse that filled the same space from floor to ceiling; both works were important early examples of environmental art. He soon widened his vocabulary by choosing both to cut the objects into thin strips, revealing their internal structure, and to destroy them violently during *Rages* held in public as a kind of performance art. The objects used by Arman were extremely diverse, but they were always familiar things collected in considerable quantities. Among those he favored were those deriving from domestic consumption, such as coffee grinders and beer glasses, as well as

musical instruments, which he subjected to all kinds of violence and destruction, as in *Chopin's Waterloo*. In 1963 he began another series, *Combustions*, using fire as his basic material. Arman's ill-treatment of objects, especially in his early work, was due less to a systematically destructive will than to a desire to provoke new aesthetic effects. The subsequent development of his art largely confirms this view, as in his *Inclusions*, such as *Venus of the Shaving Brushes* (1969; London, Tate), which consist of transparent polyester containers holding objects embedded in resin; this became a standard form for many of his works. In the mid-1960s he used tubes of paint dribbling color as a parody of abstract painting, especially of the impasto effects of Tachism, and he also began using polyester to preserve perishable rubbish for a new series of *Dustbins*.

From the mid-1960s Arman made numerous visits to New York, and he soon came to regard the USA as his second home, taking American citizenship in 1972. The stocks of new objects that he discovered there directed him toward new and more abstract accumulations (see *Fagot de clarinettes*, 1976; Paris, Pompidou). These culminated in 1967–8 in the *Renault Accumulations* (e.g. *Renault Accumulation No. 106*, 1967; see 1986 exh. cat., p. 221), highly sculptural works made from separate pieces supplied by the Renault car factory, and in large-scale commissioned monuments such as *Long Term Parking* (h. 18 m, 1982–3; Jouy-en-Josas, Fond. Cartier Mus.), a gigantic tower consisting of 60 cars embedded in concrete. In his later work he also recast some of his earlier *Rages* and *Combustions* in bronze, and in another series, *Armed Objects*, he used concrete as a base in which to fix the object, somewhat in the way he had previously used transparent plastic. He broadened his imagery to include tools while remaining faithful above all to objects symbolizing the excesses of the consumer society. Arman was also an avid collector of objects, artifacts and works of art, including watches, radios, cars, European pistols, African carved sculpture (especially Kota guardian figures) and Japanese armor.

BIBLIOGRAPHY

O. Hahn: *Arman* (Paris, 1972)

H. Martin: *Arman* (New York, 1973)

Arman, Parade der Objekte (exh. cat., Hannover, Sprengel Mus., 1982)

J. van der Marck: *Arman* (New York, 1984)

1960: Les Nouveaux Réalistes (exh. cat. by B. Cotenson and others, Paris, Mus. A. Mod. Ville Paris, 1986)

B. Lamarche-Vadel: *Arman* (Paris, 1987/R 1998)

Arman 1955–1991: A Retrospective (exh. cat., Houston, TX, Mus. F.A., 1991)

P. Cabanne: *Arman* (Paris, 1993)

F. Bonnefoy and S. Clément: *Arman* (exh. cat., Paris, Mus. Jeu de Paume, 1998)

T. Reut: *Arman: La liberté en peinture/Arman: Freedom in Painting* (exh. cat., Paris, Galerie Piltzer, 1999)

Arman: Passage à l'acte (exh. cat., Nice, Mus. A. Mod. & Contemp., 2001)

Alfred Pacquement
Revised and updated by Virginie Bobin

Armory Show

Exhibition of art held between 17 February and 15 March 1913 in New York at the 69th Regiment Armory, Lexington Avenue, Manhattan, from which it derived its nickname. The Armory Show [International Exhibition of Modern Art] then traveled to the Art Institute of Chicago (24 March–16 April) and Copley Hall, Boston (28 April–19 May). This first large-scale show of modern art held in the USA resulted from the independent campaign of the Association of American Painters and Sculptors, a group of progressive artists formed in 1912 to oppose the National Academy of Design and to broaden exhibition opportunities for American artists. Arthur B. Davies, the president of the group, and Walt Kuhn were determined to present an international survey for the first in what was to have been a series of exhibitions. The Armory Show was modeled on the *Sonderbund* exhibition in Cologne (1912) and on the two Post-Impressionist exhibitions organized by Roger Fry in London. In 1912 Kuhn traveled to Cologne, The Hague,

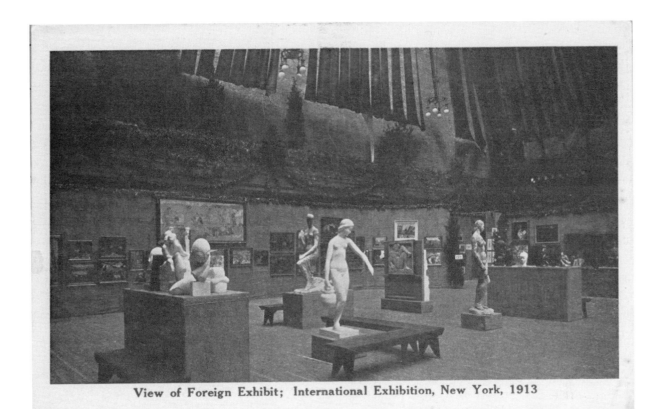

View of Foreign Exhibit; International Exhibition, New York, 1913

ARMORY SHOW. Postcard view of the Armory Show (International Exhibition of Modern Art) in the Armory of the 69th Regiment, 1913. SRAPBOOK COMPILED BY CHARLES A. SMITH (GIFT OF NELSON A. ROCKEFELLER). © MUSEUM OF MODERN ART/LICENSED BY SCALA/ART RESOURCE, NY

Amsterdam, Berlin and Munich to make selections and was joined by Davies in Paris and London. Assisted in Paris by Walter Pach, who was instrumental in shaping the European selections, they succeeded in borrowing significant Impressionist, Post-Impressionist, Fauve and Cubist works from leading European artists and dealers. The entire project would have been impossible without the efforts of the Association's legal counsel, attorney John Quinn, who successfully lobbied Congress to repeal tariff restrictions on the importation of contemporary art from abroad. Although two thirds of the 1300 works included in the exhibition were by American artists, the European selections attracted the greatest attention and defined public perceptions of the show.

The organizers intended to trace the development of modern art from the 19th century to contemporary work. Featured artists ranged from Jean-Auguste-Dominique Ingres to Post-Impressionists such as Paul Cézanne, Paul Gauguin and Vincent van Gogh, as well as Pablo Picasso, Georges Braque, Henri Matisse, Vasily Kandinsky and Marcel Duchamp. The European selections reflected Davies's preference for French art and Pach's intimate knowledge of the Parisian art world. German Expressionism was not adequately represented, and the Italian Futurists refused to participate. American entries ranged from the late Impressionism of Childe Hassam to the Ashcan realism of John Sloan and the Post-Impressionist modernism of Arthur B. Carles, Alfred H. Maurer and Joseph Stella.

The Association's publicity campaign aimed to attract broad public attendance and interest. The show's organizers adopted the pine-tree flag from the American Revolution as their emblem and

"The New Spirit" as their motto, and, aided by journalist Frederick James Gregg, they produced posters, badges, postcards and educational brochures to promote the event. Around 300,000 people attended the exhibition during its three-city tour. Revenues from the sale of works to a new class of adventurous collectors, notably Quinn and Arthur Jerome Eddy, amounted to $44,148.75. The Metropolitan Museum of Art acquired Cézanne's *The Poorhouse on the Hill* for $6700. Despite its success, the Association of American Painters and Sculptors did not survive to sponsor other exhibitions, but its principal organizers—Davies, Kuhn, Pach and Quinn—all remained active in promoting modern art in the aftermath of the show.

Although the Armory Show was not the first exhibition of modern art in the USA, it was unmatched in its scope and significance. Although few American artists, such as Stuart Davis, converted to modernism as a direct result of the exhibition, the event marked a watershed in American cultural history. The Armory Show effectively transformed the New York art market by generating the emergence of galleries and collectors of modern art. The Daniel, Bourgeois, Carroll, and Coady galleries in New York joined the Modern Gallery and Alfred Stieglitz's Little Galleries of the Photo-Secession to present and promote vanguard European and American work. Such was the impact of the exhibition that older firms such as M. Knoedler & Co. and N. E. Montross began to display modern art. The Armory Show and its parent organization proved to be the first in what became a series of antiacademic exhibitions and organizations, such as the Society of Independent Artists and the Société Anonyme, which challenged the genteel tradition and championed the cause of modernism in the USA in the early 20th century.

UNPUBLISHED SOURCES

New York, NY, New York Pub. Lib., Astor, Lenox, and Tilden Foundations. John Quinn Memorial Collection

Washington, DC, Archives of American Art, Walt Kuhn Papers; Walter Pach Papers

Washington, DC, Hirshhorn Mus. Sculpt. Gdn, Elmer MacRae Papers

BIBLIOGRAPHY

Association of American Painters and Sculptors: *For and Against: Anthology of Commentary on the Armory Show* (New York, 1913)

A. & Déc., iii (March 1913) [special issue]

M. Schapiro, "Rebellion in Art," in D. Aaron, ed. *America in Crisis* (New York, 1952), pp. 203–42

Armory Show: 50th Anniversary Exhibition, 1913–1963 (exh. cat. Utica, NY, Munson–Williams–Proctor Inst., 1963)

M. Brown: *The Story of the Armory Show* (New York, 1963/ R 1988)

The Armory Show: International Exhibition of Modern Art, 3 vols (New York, 1972) [anthol. of primary doc.]

J. Zilczer: "'The World's New Art Center': Modern Art Exhibitions in New York City, 1913–1918," *Archv Amer. A. J.*, xvi/3 (1974), pp. 2–7

R. Tarbell: "The Impact of the Armory Show on American Sculpture," *Archv Amer. A. J.*, xviii/2 (1978), pp. 2–11

J. Zilczer: "The Armory Show and the American Avant-garde: A Re-evaluation," *Arts Magazine [prev. pubd as Arts [New York]; A. Dig.]*, liii/1 (1978), pp. 126–30

G. McCoy, ed.: "The Seventy-fifth Anniversary of the Armory Show," *Archv Amer. A. J.*, xxvii/2 (1987), pp. 2–33

M. Green: *New York, 1913: The Armory Show and the Paterson Strike Pageant* (New York, 1988)

C. I. Oaklander: "Clara Davidge's Madison Art Gallery: Sowing the Seed for the Armory Show," *Archvs Amer. A. J.*, xxxvi/3–4 (1996), pp. 20–37

L. McCarthy, "The 'Truths' about the Armory Show: Walter Pach's Side of the Story," *Arch. Amer. A. J.* 44 (2004), no.3/4, pp. 2–13

M. Leja, "Art and Class in the Era of Barnum," *Vis. Res.*, xxii (2006), no. 1, pp. 53–62

Judith Zilczer

Arneson, Robert

(*b* Benicia, CA, 4 Sept 1930; *d* Benecia, CA, 2 Nov 1992), ceramic sculptor. Arneson was an influential artist of the Bay Area from the 1960s until his death. He was identified with Funk art in the 1960s and expanded his creation of witty ceramic sculpture by focusing on self-portraits and political subjects. He spent his youth in a small working-class town and worked as a cartoonist for the local paper. Arneson received an undergraduate degree in 1954 from the California College of Arts and Crafts in Oakland and

taught in a local high school. His master's degree was awarded in 1958 by Mills College. In 1962 he began teaching at the University of California, Davis, and he continued there as head of the ceramics department for 30 years. Also on the faculty were Wayne Thiebaud, William Wiley and Roy De Forest. Graduates from UC Davis include renowned clay artists David Gilhooly (b 1943) and Richard Shaw (b 1941).

In his early career Robert Arneson was inspired by the ceramics of Peter Voulkos. After seeing the work of his fellow Californian in 1957, Arneson departed from the creation of decorative or utilitarian objects. By 1961 he was producing gestural sculptures based in part on Asian ceramics and the clay works of Joan Miró (1893–1983). His rough, non-functional clay pieces challenged conventional ideas about the medium. When one of his pieces cracked in the kiln, he began exploring the use of such accidents as a technical liberation from the preciousness of materials. By 1965 Arneson was working with the expressive possibilities of glazes as a form of painting. His dialogue with Abstract Expressionisn also verged on Pop art as he introduced everyday objects into his art. *Typewriter* (1966; Berkeley, U. CA, A. Mus.) features fingertips with brightly colored nails that substitute for the keys. Combining elaborate glazes with red nail polish that was applied after firing the piece, this work demonstrates Arneson's skill with glazes as well as his interest in painting.

Soon he was creating a series of humorous self-portraits based on expressionistic preliminary drawings. As a source for many ideas, the self-portraits include a hipster with sunglasses, a chef and the artist with a protruding tongue.

Among Arneson's most controversial works is a 1981 bust of George Moscone, mayor of San Francisco. Moscone and Supervisor Harvey Milk were assassinated in 1978 by Dan White, a former municipal supervisor. In Arneson's memorial sculpture, the base includes text and images describing events in Moscone's life. The words "Bang Bang Bang Bang" and "Harvey Milk Too" can be found on the front of the pedestal. Intended as a focal point for the new Moscone Convention Center, the Art Commission of San Franciso rejected the monumental sculpture that featured a smiling head of Mayor Moscone. At the dedication of the building, the sculpture was draped so that the pedestal was not in view. Later Arneson withdrew the sculpture and returned the fee he was paid for this commission.

In his later years Arneson suffered from cancer, and a somber tone appeared in his art. In 1982 Arneson produced *Holy War Head* (priv. col.), which is inscribed with a description of the effects of radiation at Hiroshima. In the 1980s he focused attention on the threat of nuclear weapons and the resultant dangers of radiation poisoning. *General Nuke* (1984; Washington, DC, Hirshhorn) is a satirical, anti-war statement.

Arneson's works can be found in many public collections around the world, including the Metropolitan Museum of Art in New York, the Chicago Art Institute, the Whitney Museum of American Art in New York and the Museum of Contemporary Art in Kyoto, Japan. The Nelson Gallery at UC Davis owns 70 of Arneson's works.

BIBLIOGRAPHY

Robert Arneson, War Heads and Others (exh. cat. by J. Fineberg, New York, Allan Frumkin Gal., 1983)

Robert Arneson, a Retrospective (exh. cat. by N. Benezra, Des Moines, IA, A. Cent., 1985)

Robert Arneson and Politics (exh. cat. by S. Nash, San Francisco, CA, F.A. Museums, 1993)

Fired at Davis: Figurative Ceramic Sculpture by Robert Arneson (exh. cat., Stanford, CA, U., Cantor Cent. Visual A., 2005)

Joan Marter

Arnheim, Rudolf

(b Berlin, 15 July 1904; d Ann Arbor, MI, 9 June 2007), psychologist and writer of German birth. He studied with Gestalt psychologists at the University of Berlin in the 1920s. His secondary studies in art history and musicology, together with Gestalt psychology, were the basis for his subsequent research into the mechanisms of perception. During the

1930s he studied film, finding in the silent film's unadorned method of reproduction an artistic interpretation of perceptible reality. He wrote film reviews and published the book *Film als Kunst* (Berlin, 1932). In 1940, he settled in the USA, where he taught psychology and the psychology of art at Sarah Lawrence College, Bronxville, NY; in 1968 he was appointed professor at the Harvard University Carpenter Center of Visual Arts, Cambridge, MA.

Arnheim was responsible for the revision of the prevailing opinion that perception was a primary, physiological function and thought a secondary, interpretative one; he did this by discovering an inseparable mutual interaction between perception and thought. Arnheim considered pictorial art the highest expression of visual thought, or thought in images, and, using Pablo Picasso's sketches for *Guernica* (1937; Madrid, Prado), he demonstrated that the visual thought was the beginning of the creative process, and that its power persisted into the completed work of art. Taking perceptual psychology as a point of departure, Arnheim strove, on a broader basis, to establish a comparative vision of art by characterizing the basic perceptual structures of works of art. In this way he made a contribution to the development of a historical morphology that supplemented the research methods of art history.

WRITINGS

Art and Visual Perception: A Psychology of the Creative Eye (Berkeley, CA, 1954; rev. 1974 and 2004)

The Genesis of Painting: Picasso's Guernica (Berkeley, CA, 1962)

Visual Thinking (Berkeley, CA, 1969; rev. 1997)

The Power of the Center: A Study of Composition in the Visual Arts (Berkeley, CA, 1982; rev. 1988)

New Essays on the Psychology of Art (Berkeley, CA, 1986)

Parables of Sun Light: Observations on Psychology, the Arts, and the Rest (Berkeley, CA, 1989)

To the Rescue of Art: Twenty-Six Essays (Berkeley, CA, 1992)

The Split and the Structure: Twenty-Eight Essays (Berkeley, CA, 1996)

BIBLIOGRAPHY

"Visual Thinking: On Rudolf Arnheim," *Salmagundi*, pp. 78–9 (Spring–Summer 1988), pp. 43–143 [special issue]

R. Rothman and I. Verstegen: "Arnheim's Lesson: Cubism, Collage and Gestalt Psychology," *J. Aesth. & A. Crit.*, lxv (2007), pp. 287–98

Anneke E. Wijnbeek

Arquitectonica

Architectural firm incorporated in 1977 by Bernardo Fort-Brescia (*b* Lima, Peru, 19 Nov 1950), Laurinda Hope Spear (*b* Rochester, MN, 23 Aug 1950), Hervin Romney (*b* Havana, Cuba, 9 Feb 1941), Andres Duany (*b* New York, 7 Sept 1949) and Elizabeth Plater-Zyberk (*b* Bryn Mawr, PA, 10 Dec 1950). The latter two members of the firm left in 1980 to start their own practice, as did Romney in 1984. Arquitectonica's modernism was youthful, unpredictable and slightly rebellious and essentially displaced the polemical and elitist high Modern with a populist, chic and jazzy Modernism. The firm continued the colorism of Miami's "tropical art deco," but its roots remained in the Latin culture of Peru, Cuba and Miami: ultimately their commercially hot architecture called to mind the nonacademic character of Pop art, the nonconformity and pizzazz of youth and the cultural flare and brassy musicality of Brazil 66, Tijuana Brass and the Miami Sound Machine.

The firm's early sketches displayed an interest in the surrealistic place-making of Giorgio de Chirico, which Arquitectonica transformed to exercises in geometric abstraction at the layered and orderly Spear house (1977–8), Miami, FL. In its first decade of practice Arquitectonica transformed speculative housing developments, office buildings and shopping centers—normally banal architectural projects—into dramatic, expressive "high tech" forms marked by flashy, sensual and commercially attractive styling. It single-handedly transformed the Biscayne Bay–Brickell Boulevard skyline in Miami with its Helmsley Palace (1979–80), Babylon (1979–82) and Imperial (1979–83). In the especially witty housing block Atlantis (1980–82), Arquitectonica married Mondrian's primary De Stijl colors and Le Corbusier's *unité d'habitation*

to create a vibrant, high tech, tropical housing block, made famous by a large void punched out of its mid-section.

Work in other cities included the Horizon Hill Center (1981–2), San Antonio, TX, which echoed the theatrical scale of the Soviet Constructivists' images of the 1920s, whereas the Casa Los Andes (1988), Lima, employed freer forms inspired by Matisse collages. At the Rio Shopping Mall (1988–9, now razed), Atlanta, GA, Arquitectonica ornamented a brightly colored corrugated metal skin with elements of structural steel framing, a geodesic dome and, just for fun, a parade of adoring frogs in formation in a pond. The firm's other work in the city is Philip's Arena (1996–9), which they built in association with Hellmuth, Obata and Kassabaum (HOK Sports Facilities Group, Kansas City, MO); the building's facade spells out "Atlanta" in superscaled structural graphics.

Functionalism remained the underlying catalyst informing such late 1980s work as the Banco de Credito (1988), La Molina, Lima, whose independent forms for foyer, boardroom, auditorium and cafeteria slice through or slide under the four-story courtyard block. Arquitectonica's 1999 American Airlines Arena (for basketball and multi-purpose events) is sited on Biscayne Bay in Miami as a grand civic monument, and it was announced in April 2009 that the arena had been awarded L.E.E.D. certification, which recognizes green, energy-efficient and high-performing buildings.

Airport expansions include work in Lima and Miami, and a successful competition entry landed a major Performing Arts Center project (1991–8) for the city of Dijon, France. Other cultural projects are notable: the firm built the Miami Beach Headquarters for the Miami City Ballet (2000), and recent and ongoing work for the Bronx Museum of the Arts (2004–6) and the Miami Children's Museum (2001–3) continued the architects' use of unorthodox and playful architectural forms. In much of their best work, Arquitectonica adapted the universality of Modernist abstraction to the local climate of time and place, especially in Miami where its chic, late-Modernist

buildings reflected both the optimism of the 1980s and the regional color and festive unconventionality of subtropical south Florida cultivated ever since.

The firm has designed high rises in Shanghai, Hong Kong and New York; in the latter city, the 57-floor Westin Hotel (2002) brought their witty aesthetic to the Time's Square redevelopment program. Increasingly a global practice, Arquitectonica at its height employed a professional staff of more than 400 and maintained offices in Miami, New York, Los Angeles, Paris, Madrid, Buenos Aires, Sao Paulo, Lima, Hong Kong, Manila and Shanghai. Some of the firm's most recent and current work includes The Four Seasons Resort in Dubai, City of Dreams in Macau, The Gate at Al Reem Island in Abu Dhabi and Orchards Scott residences in Singapore, the latter reminiscent of the 1980s Biscayne Boulevard work of their early years.

[*See also* Miami.]

BIBLIOGRAPHY

"Romantic Modernism," *Process: Archit.*, 165 (1986) [issue dedicated to Arquitectonica]

W. McQuade: "Glamour, Inc. Architecture with the Latino Flash, by Arquitectonica," *Connoisseur*, ccxviii (1988), pp. 146–55

B. Dunlap: *Arquit.* (New York, 2004)

Robert M. Craig

Art & Language

Group of conceptual artists. Art & Language was founded in Coventry, England, in 1968 by Terry Atkinson (*b* 1939), David Bainbridge (*b* 1941), Michael Baldwin (*b* 1945) and Harold Hurrell (*b* 1940). Their name reflected their early aspiration to eliminate the accepted distinctions between artistic practice and critical discourse, and, in 1969, they pursued this aspiration by founding the theoretical journal *Art-Language*. During that same year, the group invited the conceptual artist Joseph Kosuth to serve as the journal's American editor, and, in 1971, the art historian and critic Charles Harrison (1942–2009) joined the group and assumed editorial

responsibility after leaving a position as editor at *Studio International*. During the same year as Harrison's arrival, the group was also joined by Mel Ramsden (*b* 1944) and Ian Burn (1939–93) of the Society for Theoretical Art and Analysis in New York (although their collaboration had pre-dated this moment by a couple of years), and, until 1977, Art & Language had members in both England and the United States. This transatlantic collaboration ended when disputes, particularly those involving Kosuth, led to the dissolution of the New York division. Although the group counted as many as 30 members during the mid-1970s, from 1977 it consisted of Baldwin, Harrison and Ramsden.

In many respects, Art & Language was one manifestation of a larger tendency toward conceptualism during the late 1960s and early 1970s, when art was increasingly discussed in terms of ideas and immateriality, but their practice had its own distinctive set of concerns and its own formulations. In particular, their work attempted to bring together the languages of artistic production and critical reception that were previously positioned at opposite extremes of an institutional continuum. As Ramsden later noted, the criticism that surrounded modern art had become so central in determining its course that they decided to make this discourse the object of discussion. Accordingly, the early activities of the group were centered on establishing their journal and writing criticism and theory over the production of conventional art objects. This tendency in their work was illustrated quite strikingly in their well-known 1972 project *Index 01* at the Documenta 5 exhibition at Kassel in Germany. In this piece, they exhibited a catalog of their writings in eight filing cabinets that they placed on four gray plinths at eye level. In addition, they wallpapered the gallery with enlargements of a complex index that listed these texts in alphabetical order and cross-referenced them according to their compatibility. In this presentation, the group substituted discursive for aesthetic experience, and they also displayed both their common intellectual effort and the plurality of voices. As Harrison would later write in his book *Essays on Art & Language*, the index was not simply a presentation of their various positions and ideas, but also an attempt "to map and to represent relations within a conversational world." In this sense, the work was a demonstration of the group's shared activities and of the increasingly discursive character of their practice. Moreover, by putting these efforts on display, the group attempted to activate the public as an interlocutor or participant in this shared endeavor.

Although the group sustained a strongly discursive component throughout its history, this approach was most central to their activities during the 1970s when they sustained both a large membership and presence in both England and the United States. During the period between 1975 and 1976, the New York-based Art & Language Foundation, Inc. also published Kosuth's journal *The Fox*. While this periodical was ostensibly dedicated to voicing the distinct concerns of the New York community, its publication was also indicative of a growing rift within the transatlantic organization. In 1977, after a series of complicated disagreements, the New York group disbanded, and many of the artists involved, such as Burns and Terry Smith (*b* 1944), relocated. Ramsden moved to England early in 1977, however, and he continued the collaboration with Baldwin and Harrison. Their subsequent work has been notable for its return to painting and for its appropriations and transformations of a number of art historical sources. Of this work, their series of paintings depicting V. I. Lenin in the style of Jackson Pollock have been particularly significant. In these works, Baldwin and Ramsden applied paint using Pollock's drip technique over a series of stencils that were produced from images of Lenin. While many of the resulting paintings are easily legible as images, in others, the portraits are barely discernable except as vague contours within the dense skeins and splashes of paint. As Harrison noted in *Essays on Art & Language*, by combining the style of American Abstract Expression and the imagery of Soviet

Realism, these compositions endeavored to achieve "an ironic stylistic *détente* between supposedly incompatible aesthetic and ideological worlds." The paintings adopted the style most associated with the artistic individualism and applied it to an emblem of collective revolutionary aspirations. While these compositions may have rehearsed some of the issues of individualism and collectivity that surrounded the group's own divisions in 1977, they also spoke to the larger questions of representation in the context of the Cold War. In subsequent works, the group continued these experiments and made, for example, an interpretation of *Guernica* (1937; Madrid, Cent. A. Reina Sofia) by Pablo Picasso (1881–1973) in the style of Pollock and a large-scale recreation of *A Burial at Ornans* (1849–50; Paris, Mus. Orsay) by Gustave Courbet (1819–77) based on one of Pollock's drawings. In the case of the latter, the painting was divided into three parts and accompanied by a poster that appeared to discuss each section in passages that were a mishmash of appropriated texts and pastiches of art critical writing. The text, then, mirrored the operations of the work and seemed to imply that both painting and the discourse that surrounded it could be revived only under the conditions of quotation and parody. The group's subsequent work continued this investigation of painting from a characteristically conceptualist perspective, and their later paintings have delved into other artistic mythologies by focusing on both the studio and the museum. Although this work represents a significant departure from the conceptual works of the 1970s in both formal composition and technique, it nevertheless has maintained the group's commitment to overcoming the distinctions between critical discourse and artistic practice.

BIBLIOGRAPHY
C. Harrison and F. Orton: *A Provisional History of Art & Language* (Paris, 1982)
C. Harrison: *Essays on Art & Language* (Cambridge, MA, 1991)
Art & Language in Practice (exh. cat. by M. Baldwin, M. Ramsden, and C. Harrison; Barcelona, Fundació Antoni Tàpies, 1999)
C. Green: *The Third Hand: Collaboration in Art from Conceptualism to Postmodernism* (Minneapolis, 2001)
C. Harrison: *Conceptual Art and Painting: Further Essays on Art & Language* (Cambridge, MA, 2003)
C. Gilbert: "Art & Language and the Institutional Form in Anglo-American Collectivism," *Collectivism after Modernism: The Art of Social Imagination after 1945* (Minneapolis, 2007), pp. 77–93

Tom Williams

Art Deco

A stylistic term applied to architecture and decorative arts of the 1920s and 1930s whose origin partially lies with the 1925 Exposition Internationale des Arts Décoratifs et Industriels Modernes held in Paris. The term was invented in 1966 and initially applied just to French 1920s design but shortly thereafter grew to encompass a wide variety of modernist architecture and design that displayed decorative traits that stood in contrast to the more austere Modern style sometimes known as Functionalism, Bauhaus style or International Style. Synonyms for Art Deco have included Style Moderne, Art Moderne, Modernistic, Cubistic, Manhattan style, skyscraper style, setback style, zigzag style, streamlined, stripped Classicism, Greco Deco and others.

French and European Sources. The Exposition Internationale des Arts Décoratifs et Industriels Modernes held in Paris in 1925 was a lavish spectacle of pavilions and exhibits that showcased the latest modern tendencies in French and foreign design. Originally scheduled for 1915 but postponed until 1925 because of the war, its program stipulated that everything must be "modern," although in many cases traditional French handicrafts and luxury goods were shown along with machine-made products. The contrast could be seen in different pavilions such as Le Corbusier and Pierre Jeanneret Pavilion de Esprit Nouveau, which was a rectilinear white box with no ornament, filled with machine-made austere furniture. Against this stood most of the other pavilions such as those for the Parisian department stores, which were highly decorated and

colored on the exterior and filled with lavish, very expensive and craftsman-made furniture and items by Paul Follot (1877–1941), Süe and Mare, Jacques-Emile Ruhlmann (1879–1933), Jean Dunand (1877–1942) and others.

Stylistically the Exposition Internationale contained many different motifs, but the dominant elements could be seen in the entrance gates by Henri Favier (*b* 1899) and André Ventre (1874–1951) with metal work by Edgar Brandt (1880–1960), sculpture by Navarre and glasswork by René Lalique (1860–1945). Abstracted fluted columns were topped by setback forms, and the sculpture was low relief and geometric. Some of the roots for the style can be traced back to the earlier Art Nouveau, although it focused more on floral forms. Also important as a source was the Viennese decorative arts, the Wiener Werkstätte and the Ballets Russes, with its exoticism and strong vibrant colors, which had made its debut in Paris in 1909. Forms and motifs strongly resembling Art Deco could also be found in the work of other architects and designers throughout Europe, such as Eliel Saarinen in Helsinki, who immigrated to the United States in the 1920s.

American Sources and Reactions. In addition to the foreign influence of Art Deco, an American origin can be seen in the designs of Frank Lloyd Wright and Bertram Goodhue. Wright's work of the period 1900–24, whether in buildings or in decorative details, contained interlocking geometrical forms and vivid colors similar to those of the French. Goodhue began his career as a medieval revivalist, but by 1920 his designs, such as that for the Nebraska State Capitol, Lincoln, NE (1920–31), or the Liberty Memorial competition in Kansas City, MO (1918), displayed a simplified interlocking geometry, low-relief sculpture and high coloration. Additionally, Americans were captivated by machinery in the 1920s and 1930s and incorporated mechanical details and forms in buildings.

Other countries were asked to participate in the Paris Exposition, but the United States Secretary of Commerce, Herbert Hoover, declined, claiming that America had no modern art. A protest developed and a commission of editors, artists, decorators and manufacturers was appointed to visit the fair and issue a report. The American press reported extensively on the Exposition, with some, such as the Brooklyn critic Helen Appleton Read, claiming the "cubistic shapes and futurist colors" recalled "a Picasso abstraction." A few months later she summarized: "The whole trend of modern design toward the geometric and the unadorned had its inception through the omnipresence of the machine."

Furniture and other items went on display at an exhibition at the Metropolitan Museum of Art in New York in 1926, and within the next year department stores such as Lord & Taylor were holding exhibits of both French-made items and American derivatives. In 1928 Macy's, B. Altman's, Abraham & Straus and Lord & Taylor held exhibits of furniture and other items. Other stores and cities followed, such as Marshall Field's in Chicago and Shilloto's in Cincinnati. In Los Angeles the high-end store Bullocks commissioned a new building on Wilshire Boulevard (1929) from the firm of Parkinson & Parkinson, and its tower, forms, motifs and details all recalled the 1925 Paris Exposition.

Helping to spur the new design were a group of foreign-born designers such as Joseph Urban, Kem Weber (1889–1963) and Paul Frankl (1886–1958), all of whom came from or were heavily influenced by Viennese Wiener Werkstätte or German Secessionism. Urban arrived in 1911 and designed stage sets, theaters and furniture along with importing Seccessionist-inspired goods, which he sold in his New York store starting in 1923. Weber immigrated to Los Angeles where he taught and also produced designs initially in the setback mode, but by the 1930s he was producing chromium tubular furniture with a swept wing or streamlined shape. He was the primary designer for the original Walt Disney Studios in Burbank, CA (1937). Frankl arrived in 1914 and opened a gallery in New York; he produced furniture such as the "Skyscraper" bookcase (1928). Frankl became one of the major promoters of the

new modernism with his books, and he established the American Union of Decorative Artists and Craftsmen, which held a very influential exhibit. In the 1930s Frankl moved to Hollywood, and his rectilinear geometry gave way to more streamlined shapes, as can be seen in his chairs.

Skyscraper Style. Skyscrapers are one of the building types most identified with Art Deco because of their setback shapes, which emerged in the 1920s, and also their elaborate decorative elements on the exterior and in the lobbies. In 1916 New York passed a zoning ordinance that required tall buildings to set back the upper floors to allow light to penetrate the streets below. By 1922 and the *Chicago Tribune* competition, the setback form was in full swing among American architects. Hugh Ferriss, an important architectural delineator, published designs showing the possibilities of the setback form and skyscraper cities. The first Art Deco skyscraper was the New York Telephone Company–Barclay–Vesey Building in New York (1920–26) designed by Ralph Walker of McKenzie, Voorhees & Gmelin. Dramatic setback forms were enlivened by intertwining floral details. Other skyscrapers followed: William Van Alen's Chrysler Building (1930), with its decorative stainless-steel sunburst at the top and the automobile imagery at the setbacks and the lobby with its expensive marbles and richly decorated elevator doors with an inlaid design in the form of a papyrus flower, or the Empire State Building (1931, Shreve, Lamb & Harmon), with its conical tower and mast at the top and much more restrained and abstract geometrical imagery in the window spandrels. In New York the epitome of the Art Deco skyscraper was Rockefeller Center (1929–37, Raymond Hood and others), a complex of buildings festooned with sculpture on the exterior and colorful details on the interior, with the high point being Radio City Music Hall designed by Donald Deskey. A skyscraper mania caught the country and cities partook in a race to erect tall buildings, sometimes in various colors. Tulsa, OK, a petroleum center, sprouted a series of lavishly decorated

skyscrapers including the Boston Avenue Methodist Church (Rush, Endacott & Rush, 1926) with Bruce Goff as the lead designer. Every city constructed skyscrapers, even for civic buildings such as the 18-story St Paul City Hall and Ramsey County Courthouse, St. Paul, MN (1929–32), designed by the leading Chicago firm of Holabird and Root. On the exterior Lee Lawrie (1877–1963) provided modern sculptural panels; the interior has murals by John Norton (1876–1934) in the council chambers and the elevator doors, created by Albert Stewart Co. of New York, contain inset mechanical imagery. Dominating the marble-lined 3-story main hall is a 38-foot-tall creamy white onyx Indian God of Peace by Carl Milles (1877–1955) that rotates.

Stylistic and Regional Variations. Beginning about 1930 (and coinciding with the Great Depression) a more curvilinear or swept wing image, sometimes called "Streamlined Deco," began to impact design. Greatly influenced by the idea of aerodynamic efficiency as seen in automobile, train and plane design, curved forms appeared on buildings from movie theaters to expositions such as the Century of Progress, Chicago (1933–34), and chairs. Ornament still played a major role as buildings such as Texaco Service Stations (Walter Dorwin Teague, 1936) were united by flowing horizontal bands. Mirroring the age were the more than 100 Greyhound Bus Depots designed by W. S. Arrasmith (c. 1895–1965) of Louisville, KY, which began in the later 1920s as very zigzag types of facades and evolved into streamlined shapes with a tall vertical entrance motif by the later 1930s as in the Evanston, IN, depot (1938). The architectural details designed by Gordon B. Kaufmann (1888–1949) on the Hoover Dam (Bureau of Reclamation Engineers, 1930–36) on the Colorado River between Arizona and Nevada included both setback-shaped towers and streamline-shaped flood gates and power houses.

Native American imagery such as Navajo rugs and pottery contained interlocking geometrical forms that could easily be adopted as decorative details

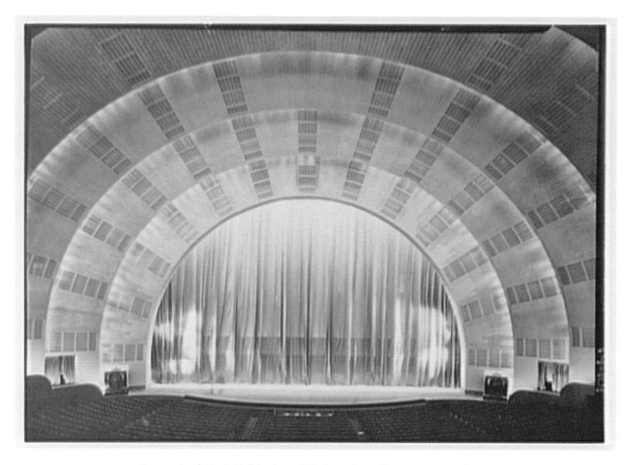

ART DECO. International Music Hall by Samuel H. Gottscho, Radio City, New York, 1932. LIBRARY OF CONGRESS PRINTS AND PHOTOGRAPHS DIVISION

for buildings and furniture. A Pueblo Deco style emerged in the Southwest along with a Mayan Deco style. Frank Lloyd Wright had explored elements of this style with his Ennis house in Los Angeles (1924), but other architects such as Robert Stacy-Judd (1884–1975) carried it further with cinemas and other buildings in Southern California such as the Aztec Hotel in Monrovia, CA (1924–25), and film sets.

Movies were an extremely important vehicle in the dissemination of Art Deco to the general public as Hollywood became the center of the American film industry. Metro–Goldwyn–Mayer led the way with the Irish-born architect and designer Cedric Gibbons (1893–1960), who as art director created modernist sets for movies such as *Women Love*

Diamonds (1927), *Our Dancing Daughters* (1928) and *The Kiss* (1929). Gibbons created perhaps the most widely known Art Deco design, the Oscar (1928).

Movie theaters depended for their draw not just on films but also on the environment in which they were shown. Initially movie theaters drew upon historical styles, but beginning in the later 1920s with Joseph Urban's Ziegfeld, New York (1926–27), or the Pantages Theater (Marcus B. Priteca, 1929–30) in Los Angeles, Art Deco made an appearance. In the 1930s the leading theater designers such as Thomas Lamb (1871–1942) combined horizontal streamlined shapes with vertical signage as in the Trans-Lux (1936), Washington, DC.

Even classically derived architecture fell under the influence of Art Deco, for example, the Folger

Shakespeare Library (Paul Cret), Washington, DC. In buildings like these classical elements are simplified; column capitals are either eliminated or abstracted; and the sculptural details could have come from the 1925 Exposition. Sometimes called stripped Classicism or Greco Deco, this type of design appeared in courthouses and other public buildings across the country.

Although the Depression severely restricted much building activity, in some places such as the developing resort of Miami Beach, FL, a tremendous amount of architecture did appear. Architects such as C. Murray Dixon and Henry Hohauser (1896–1963) created hotels and apartment buildings that frequently combined the interlocking geometry of the 1920s and the horizontal streamline of the 1930s.

Broadly interpreted, Art Deco design impacted almost every area of American life in the 1920s and 1930s from the kitchen and bathroom to the most public of buildings. However, to some critics and designers the decorative quality meant that it was not a true modernism; it lacked the austerity of the International Style that was promoted by the Museum of Modern Art. Although some traces of Art Deco can be found in the post-World War II years, for the most part the more restrained modernism became the new American style.

BIBLIOGRAPHY

Encyclopédie des arts décoratifs et industriels modernes au XXe siècle, 12 vols (Paris, 1932/R New York and London, 1977) [official edition for the Paris *Exposition Internationale des arts décoratifs et industriels modernes*, 1925]

H. A. Reed: "The Exposition in Paris," *Int. Studio* 82 (Nov. 1925), p. 96

H. A. Reed: "Creative Design in Our Industrial Art," *Int. Studio*, 83 (March 1926), p. 56

P. Frankl: *New Dimensions; The Decorative Arts of Today in Words & Pictures* (New York, 1928)

P. Frankl: *Form and Re-form* (New York, 1930)

American Union of Decorative Artists and Craftsmen Annual of American Design (New York, 1931)

Musee des Arts Decoratifs: *Les Annees "25": Art Deco/Bauhaus/Stijl/Esprit Nouveau* (Paris, 1966)

B. Hillier: *Art Deco of the 20s and 30s* (London, 1968)

G. Veronesi: *Style 1925: Triomphe et chute des "Arts-Déco"* (Lausanne and Paris, 1968)

Y. Brunhammer: *The Nineteen-twenties Style* (London, 1969)

D. Gebhard and Kem Weber: *The Moderne in Southern California 1920 through 1941* (Santa Barbara, 1969)

C. Robinson and R. H. Bletter: *Skyscraper Style: Art Deco, New York* (New York, 1975)

Musee des Arts Decoratifs: *Cinquantenaire de l'Exposition de 1925* (Paris, 1976)

L. Kreisman: *Art Deco Seattle* (Seattle: 1979)

C. Gambino and D. Halpern: *Tulsa Art Deco* (Tulsa, 1980)

V. Arwas: *Art Deco* (London, 1980/R 1992)

A. Duncan: *Art Deco Furniture: The French Designers* (London, 1984)

P. Cabanne: *Encyclopédie Art Déco* (Paris, 1986)

A. Duncan: *American Art Deco* (London, 1986)

P. Kery: *Art Deco Graphics* (London, 1986)

R. G. Wilson, D. Pilgrim, and D. Tashjian: *The Machine Age in America, 1918–1941* (New York, 1986)

P. Bayer, *Art Deco Source Book* (Oxford, 1988)

R. H. Bletter and others: *Remembering the Future: The New York World's Fair from 1939–1964* (New York, 1989)

D. Gebhard: *Los Angeles in the Thirties, 1931–1941* (Los Angeles, 1989)

P. Bayer: *Art Deco Interiors: Decoration and Design Classics of the 1920s and 1930s* (New York, 1990)

C. Breeze: *Pueblo Deco* (New York, 1990)

Y. Brunhammer and S. Tise: *French Decorative Art, 1900–1942* (Paris, 1990)

M. Dufrene, ed.: *Authentic Art Deco Interiors* (Woodbridge, Suffolk, 1990)

C. Breeze: *L.A. Deco* (New York, 1991)

M. L. Solera: *Miami Beach during the Streamline Decade and L. Murray Dixon* (1991)

P. Bayer: *Art Deco Architecture: Design, Decoration, and Detail from the Twenties and Thirties* (New York, 1992)

C. Breeze: *New York Deco* (New York, 1993)

D. Gebhard and Robert Stacy Judd: *Maya Architecture, the Creation of a New Style* (Santa Barbara, 1993)

D. Gebhard: *The National Trust Guide to Art Deco in America* (New York, 1996).

B. Hillier and S. Escritt: *Art Deco Style* (London, 1997)

J-F. Lejeune: *The Making of Miami Beach, 1933–1942: The Architecture of Lawrence Murray Dixon* (Miami Beach, 2000)

L. Cerwinske: *South Beach Style* (New York, 2002).

M. Dufrène: *Authentic Art Deco Interiors: From the 1925 Paris Exhibition* (Woodbridge, 2002)

A. Tinniswood: *The Art Deco House* (London, 2002)

C. Benton, T. Benton and G. Wood: *Art Deco 1910–1939* (Boston, 2003)

C. Breeze: *American Art Deco: Architecture and Regionalism* (New York, 2003)

L. Fischer: *Designing Women: Cinema, Art Deco, and the Female Form* (New York, 2003)

K. Wilson: *Livable Modernism: Interior Decorating and Design during the Great Depression* (New Haven, 2004)

T. Benton: *The Modernist Home* (London, 2006)

C. Long: *Paul T. Frankl and Modern American Design* (New Haven, 2007)

K. Wilson: *The Modern Eye: Stieglitz, MoMA, and the Art of the Exhibition, 1925–1934* (New Haven, 2009)

Richard Guy Wilson

Art Deco architecture

Term generally applied to architecture and design movements between 1925 and 1945. Derived from the title of the international exhibition of industrial and decorative arts held in Paris in 1925, "Art Deco" was coined in 1968 by British historian Bevis Hillier to describe the architecture and design arts of the 1920s and 1930s, known at the time as Art Moderne. In actuality, Art Deco is a catchall term for different developments in the design arts and architecture between the World Wars. In some circles, Art Deco is considered an outgrowth of French Art Nouveau, the German *Jugendstil* and the Arts and Crafts Movement. Architectural historian David Gebhard distinguished three styles within Art Deco architecture: "Zigzag Moderne," "Streamline Moderne" and the more classically restrained "PWA Moderne" or "Federal Moderne." These same three, Robert Craig labels "Art Deco," "Streamlined Moderne" and "Modern Classic." Design historian Jeffrey L. Meikle refers to varying Art Deco styles as "exposition style," "modernistic" and "streamlined," avoiding using the phrase "streamline[d] moderne" as it suggests a strong connection with the French Moderne style.

Zigzag Moderne refers to angular geometric patterns, such as those borrowed from Native American motifs, or structural elements such as architectural or sculptural setbacks. Streamlined Moderne architecture employs horizontal lines, curved forms and surface decoration and color palates are restrained. PWA Moderne, Federal Moderne or Modern Classic are terms often applied to the style of projects sponsored by the Public Works Administration and thus are mostly limited to post offices, courthouses and city halls.

Art Deco flourished in the United States for several reasons. The influential Exposition Internationale des Arts Décoratifs et Industriels Modernes of 1925 in Paris left an impression on many American patrons, architects and designers seeking a break from prevailing historical tastes of the Beaux-Arts movement and the historicism of the 19th century. Additionally, America was seeking a versatile means of artistic and decorative expression that could successfully incorporate indigenous themes derived from Pre-Columbian and Native American cultures as well as modern forms of inspiration such as industry, machines and the skyscraper. Many American Art Deco architects and designers were highly versatile and worked in more than one discipline, including industrial design and graphic art.

Although disquieting at first, the bright colors, geometric configurations and such whimsical motifs as sunbursts, zigzags, chevrons and mythical creatures ornamenting the architecture and objects displayed at the Paris exposition influenced American Art Deco styles. The Art Deco structures at the exposition were, for the most part, embellished Beaux-Arts constructions as demonstrated by the pavilion for Galleries Lafayette, the Pavilion de la Revue and the Gate of Honor. The eclectic, modern tendencies of the Paris exposition were actively promoted in America, where, beginning in 1926, those who did not travel to Paris were able to visit exhibits of French decorative arts from the exposition; these exhibits traveled to various museums in the USA such as the Metropolitan Museum of Art and featured the work of French furniture maker Jacques-Emile Ruhlmann (1879–1933) and renowned French glassmaker René Lalique (1860–1945). Four major domestic expositions held in the 1930s would also

become showcases of American Art Deco architecture: Chicago's Century of Progress Exhibition in 1933–4 which featured the streamlined, futuristic General Motors Pavilion by Norman Bel Geddes and the Electrical Pavilion by Raymond M. Hood; the Dallas Centennial Exhibition in 1936 on which architect Paul Cret was a design consultant; and the New York World's Fair, known for the iconic Trylon and Perisphere by Wallace K. Harrison and J. André Fouilhoux (1879–1945), and San Francisco's Golden Gate International Exposition, both held in 1939.

From Beaux-Arts to Art Deco. One of the earliest Art Deco structures in America is considered to be the Nebraska State Capitol in Lincoln, by Bertram Goodhue. Designed in 1919, it technically pre-dates Art Deco; however, it exhibits Art Deco characteristics in its primitive monumentality, ornament and abstraction. Intended to resemble a Mesopotamian edifice, Goodhue's design united a lantern-topped skyscraper with a lower, horizontal structure. The building's decorative themes were derived from European history as well as the Native American cultures of the Great Plains region and were expressed through relief carvings, grillwork and mosaic. The Nebraska State Capitol influenced many structures in the United States; including the Louisiana State Capitol (1930–32) in Baton Rouge and the Los Angeles City Hall (1926–8), both of which are almost identical in their outward appearance. Soon after completing the Nebraska Capitol, Goodhue collaborated with Carleton M. Winslow (1876–1946) on the similarly influential Los Angeles Public Library (1922–6), with its mosaic-covered, pyramid-topped tower. Its design motifs were inspired by Pre-Columbian, ancient European, Persian and Egyptian themes. The main rotunda featured stylized narrative murals of California history by Dean Cornwell (1892–1960). Even though neither of these structures fit neatly into the categories described by Gebhard, both exemplify the transition from the predominating Beaux-Arts style to the modern construction prototypes and decorative influences of Art Deco.

In 1928, another hybrid Beaux-Arts and Art Deco structure was competed in Los Angeles—not far from the library—for exclusive haberdashers Frank Alexander and James Oviatt. What began as an Italian Romanesque multi-level department store by architects Albert Walker (1881–1958) and Percy Eisen (1886–1946) took an exposition-style design direction after Oviatt visited Paris in 1925 and was taken with Art Deco's bold, luxurious style. At his direction, the Oviatt Building (1927–8) was decorated by French artisans including Lalique himself who designed 30 tons of glass for the building's zigzag lightbox marquee and lobby forecourt as well as the building's elevator doors, mailboxes and directories.

Zigzag Styles of the 1920s. Zigzag structures were often vertical in form and decorated in polychrome colors and metallic accents. The Bullock's Wilshire Department Store in Los Angeles, completed in 1929 by architects John Parkinson (1861–1935) and Donald Parkinson (1895–1946), was inspired by the modern luxury of the Paris exposition. The building consists of a central tower set on top of a five-story horizontal structure and was constructed in reinforced concrete and clad in buff terracotta. Its vertical window bands and pinnacle are accented with sunken copper verdigris decorative paneling and grillwork with zigzag patterns. The porte-cochère featured murals by Herman Sachs (1889–1940) entitled *Speed of Transportation* and elevators as well as interiors were designed by Jock D. Peters.

Another prominent example of Zigzag Moderne in Los Angeles is the polychrome Eastern Columbia Building (1929) by Claude Beelman (1883–1963), which is clad in turquoise terracotta and gold trimming and topped by a four-sided clock and a buttressed smokestack. Other Art Deco landmarks in Los Angeles include the Wiltern Theater and Pellissier Building (1930), clad in bright turquoise tile with gold accents, by Morgan, Walls & Clements and the Atlantic Richfield Oil Company Building (1929) by Stiles Clements. Covered in jet black ceramic tile with gold accents and with its radio

tower pinnacle spelling out "Richfield" in vertical neon letters, the building was one of the nation's premier Art Deco landmarks but was demolished to make way for new construction in the late 1960s.

The phrase "skyscraper moderne" is sometimes used to describe architecture and decorative art objects with towered, setback profiles. Paul Frankl's skyscraper case furniture series and other decorative objects such as Norman Bel Geddes cocktail service were inspired by such skyscraper forms. Built or designed in New York during the 1920s, tall buildings with setbacks are said by Rosemarie Haag Bletter to constitute an Art Deco "skyscraper style." The 102-story Empire State Building, designed by Shreve, Lamb & Harmon Associates and completed in 1931, is a classic Art Deco landmark built on an unprecedented scale.

The first Art Deco skyscraper is considered to be the Barclay-Vesey Telephone Building, designed by architect Ralph Walker and built between 1923 and 1926. The building emphasizes its height by placing a tower on top of a lower base structure, and its height is made visible from the street through setbacks. The use of alternating pilasters and recessed window and spandrel panels add to its verticality. Decorative themes range from floral patterns to animals and even marine motifs. The Chrysler Building designed by William Van Alen is one of America's most recognizable Art Deco landmarks (for illustration, see Skyscraper and Van Alen, William). Capped with a stepped, radiating zigzag motif with a pinnacle that is an abstract reference to the Statue of Liberty's crown, the Chrysler Building's exterior decoration features ornaments that reference the automobile, including brickwork patterns and gargoyles in the form of radiator caps, car fenders and hood ornaments. Its interiors feature ceiling murals by Edward Turnbull, elevator doors of exotic inlaid woods and flooring of different types of polished marble. Clad in terracotta tiles, the RCA Victor Building, designed by Cross & Cross and completed in 1931, integrates stylized Gothic influences with an electricity theme

expressed in its design with radiating zigzags at the base of the building and barbed terracotta open work at the crown of the building.

Art Deco's Transition to the Streamline Styles of the 1930s and 1940s. In New York, the Rockefeller Center (1931–40) carries the skyscraper style to the scale of a coordinated urban ensemble, adorned with sculptural panels and ornamental motifs. Radio City Music Hall at the Rockefeller Center, an amalgam of Art Deco styles, combines modernistic and streamlined styling on the exterior where the vertically banded building meets the curved marquee, and streamlining is especially discernible within. In the lobby and auditorium, designer Donald Deskey created smooth surfaces of aluminum foil wallpaper, glass, chrome and warm woods, and formed the renowned radiating concentric arcs resembling a streamlined sunburst—a popular Art Deco motif. Finally, in his McGraw Hill Building (1930), Raymond Hood synthesized modern ribbon windows, Art Deco color and streamlining, in a progressive skyscraper design of the period.

Throughout the 1930s, streamlining became a universal aesthetic for what Donald Bush has called "the streamlined decade." In America, industrial designers employed streamlining in such classic designs as Raymond Loewy's Sears Coldspot refrigerator in 1931 and Henry Dreyfuss's iconic Twentieth Century Limited passenger train (1938) for the New York Central Railroad. In architecture, streamlined structures are usually low, of few stories, and do not bear the same vertical monumentality of the skyscraper or the zigzag surface patterning of Art Deco architectural ornament. In Los Angeles, the Sunset Tower Apartments (1928) by Leland A. Bryant is a transitional structure that blends elements of zigzag and streamline style. Other examples include the Wilshire/Fairfax and Crenshaw Boulevard May Company department stores designed by Albert C. Martin; the aerodynamic Pan-Pacific Auditorium of 1935 by Wurdeman and Becket; and the Coulter's department store (1938) by Stiles O. Clements.

Several streamlined apartment structures made of straight and curved-edge components were also built in Los Angeles in the 1930s by Milton J. Black. The streamlining phase of Art Deco was well suited to the design of various drive-thru roadside buildings as well as movie theaters, the latter illustrated by the S. Charles Lee's Academy Theater of 1939 with its spiraling tower, curved marquee and cylindrical volumes of varying heights.

A notable amalgam of Art Deco and streamlining in a remarkable coordination of designs among various architects is evidenced in the hotel and apartment district of Miami Beach, FL, that developed between 1930 and 1942. Principally situated on Ocean Drive and Collins Avenue, most "South Beach" structures display a restrained Art Deco aesthetic expressed in white or pastel colors and enhanced by streamlined details, sometimes almost nautical in form, and replete with "tropical deco" decorative detail and clean modern graphics, often in neon.

The PWA Moderne or Federal Moderne style. PWA Moderne is an architectural style applied to structures commissioned and built between 1933 and 1944 by the Public Works Administration, a New Deal program formed during the Great Depression. PWA Moderne draws from traditional styles such as Beaux-Arts classicism and new movements such Art Deco. Structures such as courthouses, schools, libraries and post offices built in what is referred to as the PWA Moderne style borrow from classical organization as well as Art Deco decoration and geometry. The pinnacle of PWA Moderne is the concrete Hoover Dam on the border between Arizona and Nevada, by Gordon Kaufmann. The dam is comprised of a sweeping curve, dramatic spillways and four Moderne towers. The dam's restrained decoration was inspired by both Native American cultures and classical influences. The exterior of the Folger Shakespare Library designed by Paul Cret, widely considered a successful practitioner of the PWA Moderne style, in 1932 as well as the 1939

Library of Congress Annex in Washington, DC, are other examples of PWA Moderne. Both library buildings use alternating pilasters and window bands, and the library annex features a stepped-back upper story that lends verticality to an otherwise low structure. Although Art Deco decoration is restrained on the exterior of the library annex and a smooth classicism prevails, elements inspired by the Exposition des Arts Décoratifs held in Paris in 1925 are present on the annex's interiors. The history of the written word, for example, is depicted in sculptured figures by Lee Lawrie on the bronze doors at the entrances. On the fifth floor, the north reading room is decorated by murals by renowned artist Ezra Winter, who previously produced murals for Radio City Music Hall, that illustrate the characters in Geoffrey Chaucer's *Canterbury Tales*. Other motifs on the interior are derived from floral motifs and Pre-Columbian archeology.

Too numerous to describe here, Art Deco monuments can be found in cities and towns all across the USA. While many embodied a more singular and unified ornamental Art Deco style, variations on Art Deco, from zigzag to streamlining, were often evidenced in combined form within one structure. Though it was a popular style, Art Deco would be largely superseded by the minimalist International Style after World War II.

[*See also* Modern Classic *and* Streamlined Moderne.]

BIBLIOGRAPHY

B. Hillier: *The World of Art Deco* (Minneapolis and New York, 1971)

J. Meikle: *Twentieth Century Limited: Industrial Design in America 1929–1935* (Philadelphia, 1979)

H. Wirz and R. Striner: *Deco: Art Deco Design in the Nation's Capital* (Washington, DC, 1984)

R. G. Wilson, D. H. Pilgrim and D. Tashjian: *The Machine Age in America, 1918–1941* (New York, 1986)

B. Baer Capitman: *Deco Delights: Preserving the Beauty and Joy of Miami Beach Architecture* (New York, 1988)

P. Bayer: *Art Deco Architecture: Design, Decoration and Detail from the Twenties and Thirties* (London, 1992)

R. M. Craig: *Atlanta Architecture: Art Deco to Modern Classic, 1929–1959* (Gretna, LA, 1995)

D. Gebhard: *The National Trust Guide to Art Deco in America* (New York, 1996)

A. Duncan: *American Art Deco* (New York, 1999)

C. Breeze: *American Art Deco: Architecture and Regionalism* (New York, 2003)

J. Meikle: *Design in the USA* (New York, 2005)

Anne Blecksmith

Art Front

Art journal published from 1934 to 1937. In 1934, the Artists' Union joined with the Artists' Committee of Action, which had been organized to protest against the destruction of Diego Rivera's mural *Man at the Crossroads* in Rockefeller Center, New York, to publish *Art Front*, a journal of news and opinion for artists. The first issue appeared in November 1934 with an editorial committee consisting of eight members of the Artists' Committee of Action (Hugo Gellert (1892–1985), Stuart Davis, Zoltan Hecht (1890–1968), Abraham Harriton (1893–1986), Rosa Pringle, Hilda Abel, Jennings Tofel (1891–1959) and Harold Baumbach (1903–2002)) and eight from the Artists' Union (Ethel Olenikov, Boris Gorelick (1912–84), Robert Jonas (*b* 1907), Max Spivak (1906–81), Michael Loew (1907–85), Katherine Gridley (1898–1940), Herbert Kruckman (1904–98) and C. Mactarian). Herman Baron served as the Managing Editor. The opening statement announced:

> Many art magazines are being published in America today. Without one exception, however, these periodicals support outworn economic concepts as a basis for the support of art which victimize and destroy art. The urgent need for a publication which speaks for the artist, battles for his economic security and guides him in his artistic efforts is self-evident. ART FRONT is the crystallization of all the forces in art surging forward to combat the destructive and chauvinistic tendencies which are becoming more distinct daily. It calls upon those who are interested in a sane and logical foundation for

the best interests of art and artists to rally to its support. A new art frontier is being created. Help to extend it.

By April 1935, it was the official publication of the Artists' Union. Issues appeared almost monthly until December 1937, when it ceased publication. Not until the seventh issue (November 1935) was the editorial board again noted. By this time Stuart Davis was the editor and served until March 1936, when Joseph Solman (1909–2008) took over. Clarence Weinstock became Managing Editor in January 1937.

Art Front contained items of news about government funding for the arts, reviews of exhibitions and books, and announcements of meetings and rallies for the membership of the Artists' Union; it also included polemical essays on political and aesthetic issues significant to artists. Reproductions of paintings, drawings and prints enlivened the pages. Many of the major critics and intellectuals of the 1930s wrote for the magazine, including Irwin Edman, F. D. Klingender, Elizabeth McCausland (under the pseudonym "Elizabeth Noble"), William Phillips, Samuel Putnam, Kenneth Rexroth, Harold Rosenberg and Meyer Schapiro. Among the artists writing were Gwendolyn Bennett (1902–81), Stuart Davis, Fritz Eichenberg (1901–90), Philip Evergood, Balcomb Greene (1904–90), Jacob Kainen (1909–2001), Chet La More (1908–80), Fernand Léger (1881–1955), Louis Lozowick (1892–1973), Isamu Noguchi, James Porter, Joseph Solman, Moses Soyer, Charmion von Wiegand, Lynd Ward (1905–85) and Max Weber. The issues and projects supported by *Art Front* included: a federal art bill that would give relief to unemployed artists by setting up a federal agency to hire them as artists; a nonprofit municipal art gallery and center to show the works of artists; rental fees to artists from museums borrowing their works for exhibition; the first and second American Artists Congress; the Harlem Artists Guild; and support for the loyalists in the Spanish Civil War. The issues of *Art Front* present the best venue for understanding the concerns of radical artists during the 1930s.

[*See also* Artists' Union *and* Davis, Stuart.]

BIBLIOGRAPHY

Art Front, vols. 1–3 (Nov 1934–Nov 1937)

G. M. Monroe: "Art Front," *Archvs Amer. A. J.*, xiii/3 (1973), pp. 13–19

F. Tyler: *Artists Respond to the Great Depression and the Threat of Fascism: The New York Artists' Union and Its Magazine* Art Front (1934–1937) (PhD thesis, New York U., 1991)

V. H. Marquardt: "Art on the Political Front in America: From *The Liberator* to *Art Front*," *A. J.*, lii/1 (Spring 1993), pp. 72–81

Patricia Hills

Artists' Caucus of Visual AIDS

Artists' convention within the larger AIDS activist organization Visual AIDS. This group is best known for the famous Ribbon Project in 1991 in which artists and activists encouraged people to wear red ribbons to raise consciousness about the AIDS crisis within the broader population. Along with the efforts of such artist–activist groups as Gran Fury and Group Material, Visual AIDS represented an important aspect of the art world's response to the AIDS crisis during the late 1980s and early 1990s. The Artists' Caucus comprised a diverse and changing group of artists that included Penny Arcade, Allen Frame, Michael Goff, Nan Goldin, Paul H-O, Frank Moore, Joe Rudy and Leslie Sharpe.

Visual AIDS was established in New York in 1989 by curators Gary Garrels, William Olander and Thomas Sokolowski and by the art critic Robert Atkins in order to mobilize art world institutions in the fight against AIDS and to increase public awareness of the crisis. Among their early interventions, the most important was the first annual "Day Without Art" in which museums and galleries were encouraged to memorialize AIDS deaths on 1 December 1989 (which was also World AIDS Day) by dimming their lights, draping their galleries, or by closing their doors completely. Figures such as Frame, Golden, H-O and Moore founded the Artists' Caucus during this period, and the group was subsequently involved in a number of exhibitions and public interventions. In 1990, the caucus marked the Day Without Art by projecting a four-hour slide show entitled *Electric Blanket* onto the exterior walls of the Cooper Union building in New York. This presentation interspersed text slides featuring political slogans, AIDS statistics and the statements of politicians with photographs of the disease's victims and protests by groups such as ACT-UP (AIDS Coalition to Unleash Power). In subsequent years, the presentation was repeated in an expanded and revised form, and it later toured the USA and a number of other countries, including England, Germany, Hungary, Japan, Norway, Russia and Scotland. Among the group's other significant activities, the Ribbon Project had the largest impact and public profile. Although the conception of this project has often been attributed entirely to Frank Moore, it was actually developed as a collaborative effort by the Artists' Caucus as a whole. The group developed this idea in response to the yellow ribbons that were prevalent emblems of patriotism during the first Gulf War, and it was almost immediately adopted by a number of other AIDS organizations as a modest symbol of the struggle against the disease. The project achieved widespread visibility after Jeremy Irons and other celebrities wore the ribbons at the 1991 Tony Awards, the 1992 Academy Awards and other prominent media events. Wearing the ribbons subsequently became a trend within socially conscious circles and a popular phenomenon during much of the 1990s. Along with the pink triangle adopted by Gran Fury, they eventually became a ubiquitous emblem of the global AIDS crisis. Although a number of critics objected to the ribbons as a trivialization of the crisis, they are often credited with occasioning a broader public discussion about the disease and individuals suffering from it.

BIBLIOGRAPHY

M. H. Stolbach: "A Day without Art," *Social Text*, xxiv (1990), pp. 182–6

From Media to Metaphor (exh. cat., New York, Independent Curators, Inc., 1991)

H. Cotter: "The Stuff that Life Is Made Of," *A. America*, lxxxv/4 (April 1997), pp. 50–5

D. Deitcher, ed.: "What Does Silence Equal Now?" *Art Matters: How the Culture Wars Changed America*, ed. B. Wallis, M. Weems and P. Yenawine (New York, 1999), pp. 93–125

T. Finkelpearl: "Interview: Frank Moore on the AIDS Ribbon," *Dialogues in Public Art*, ed. T. Finkelpearl (Cambridge, MA, 2000), pp. 419–37

Tom Williams

Artists for Victory, Inc.

Non-profit organization formed to put the special training and technical skills of artists at the service of the US government during World War II. Emulating the Central Institute of Art and Design, which aided the British government with war-related projects, the National Art Council for Defense and Artists Societies for Defense were formed in New York in 1941. Complying with a federal request that there be only one such US organization, these merged in January 1942 to form Artists for Victory, Inc., with the intent "to render effective the talents and abilities of artists in the prosecution of World War II and the protection of this country."

With their headquarters on Park Avenue, New York, by early 1943 Artists for Victory had a national individual membership of over 10,000 painters, sculptors, designers and printmakers. Taking as their symbol the *Nike* of Samothrace (*c.* 200 BC; Paris, Louvre) and, as a basis for their philosophy, Franklin Delano Roosevelt's State of the Union message of 6 January 1942 emphasizing the Four Freedoms as a moral foundation for the nation's role in world affairs, Artists for Victory pledged a minimum of five million hours to the war effort. Its main task was to act as liaison between members and the federal, state and local government agencies and private industries needing artistic jobs done for war purposes. Artists across the country were cross-indexed according to training and capabilities and matches were made with job openings. Artists for Victory also acted as a clearinghouse for providing temporary studio space for servicemen in New York, sent artists for portrait sketching or to work as recreational instructors in service hospitals and provided muralists to decorate United Service Organizations' (USO) centers and service mess halls.

To encourage aesthetic activity when cultural values were not a priority, Artists for Victory held weekly radio shows on WINS-NY and published a bi-monthly bulletin in *ARTnews*. The group sponsored competitive exhibitions: the first opened the anniversary of Pearl Harbor Day, 7 December 1942, at the Metropolitan Museum of Art, New York. The second, *America in the War*, was limited to printmakers. A contribution to the national observance of Four Freedoms Days, it opened on 20 October 1943 in 26 museums, the first such synchronized presentation in the USA. Four subject categories were featured: Heroes of the Fighting Front, Action on the Fighting Front, Heroes of the Home Front, The Enemy and The Victory and Peace to Follow, but any print conveying the impact of the war on the life of Americans was eligible. Subsequently, *America in the War* circulated to USO centers, army camps and other museums including the National Gallery of Canada, Ottawa.

Additional shows sponsored by Artists for Victory included a national war-poster competition, a greeting card design competition to interpret the spirit of Christmas in terms of hope for global peace, several "Portraits of America" in collaboration with Pepsi-Cola, and a British–American Goodwill exhibition. Artists for Victory's service to the nation was praised by Roosevelt and Congress, and the group received a medal of commendation for services rendered to the US Army. After its continuation as a peacetime organization was considered in 1945, the corporation phased out of existence in February 1946 due to lack of interest.

BIBLIOGRAPHY

"10,000 Artists United for Victory," *A. Dig.* (1 Feb 1942), pp. 32–3

"Artists for Victory Exhibition Issue," *ARTnews* (1–14 Jan 1943)

"Whither Victory?" *A. Dig.* (15 Jan 1944), p. 10

Artists for Victory: An Exhibition Catalog (exh. cat. by E. G. Landau; Washington, DC, 1983)

E. G. Landau: "'A Certain Rightness': Artists for Victory's 1943 *America in the War* Show," *A. Mag.* (Feb 1986), pp. 43–54

Ellen G. Landau

Artists in Residence (A. I. R. Gallery)

Founded in 1972 in New York, Artists in Residence, or A. I. R. Gallery, was the first artist-run, not-for-profit gallery dedicated to women artists in the USA. Encouraged by the burgeoning Women's Movement, a group of women artists wanted to create meaningful opportunities to show their art and have it seen and discussed. There were few options for women creating art to show it since few of the commercial galleries would show work by women. Women artists might occasionally have a single work included in a group show at a commercial gallery, but it was rare, and solo exhibitions of women artists were rarer still. So, women artists had to develop their own occasions to show their art.

A. I. R. Gallery's mission is "to advance the status of women artists by exhibiting quality work by a diverse group of women artists and to provide leadership and community to women artists." The gallery was founded by a group of artists—Dotty Attie (*b* 1938), Maude Boltz (*b* 1939), Mary Grigoriadis (*b* 1942), Nancy Spero, Susan Williams and Barbara Zucker (*b* 1940)—seeking opportunities to show their work and gain an audience. They asked a group of 14 other artists to join them as original members. This group included Rachel bas-Cohain (1937–82), Judith Bernstein (*b* 1942), Blythe Bohnen (*b* 1940), Agnes Denes, Daria Dorosh (*b* 1943), Loretta Dunkelman (*b* 1937), Harmony Hammond, Laurace James (*b* 1936), Nancy Kitchell, Louise Kramer (*b* 1923), Anne Healy, Rosemary Mayer (*b* 1943), Patsy Norvell (*b* 1942) and Howardena Pindell. They incorporated as a not-for-profit corporation and opened a gallery space at 97 Wooster Street in New York's Soho district.

The first show opened on 16 September 1972 with a group exhibition of ten of the gallery artists. The show received considerable press attention from the *New York Times* and *Ms. Magazine*, among other publications. The gallery continues to support a range of public and community programs, including an internship, performances, panels, a biennial exhibition and invitational exhibitions. The gallery has a core membership of 20 artists and in the mid-1980s they began a category of membership called National Artists to engage women artists from around the country in their activities. The gallery moved twice within Soho, then to Chelsea and is currently located in Brooklyn.

[*See also* Denes, Agnes; Hammond, Harmony; Pindell, Howardena; Spero, Nancy; *and* Williams, Susan.]

BIBLIOGRAPHY
T. Gouma-Peterson and P. Mathews: "The Feminist Critique of Art History," *A. Bull.*, lxix/3 (Sept 1987), pp. 326–57

M. Schor and others: "Contemporary Feminism: Art Practice, Theory, and Activism—An Intergenerational Perspective," *A. J.*, lviii/4 (Winter 1999), pp. 8–29

A.I.R. Gallery: The History Show (exh. cat., essays by S. Bee, K. Griefen, C. Lovelace and D. Muller, New York U., 2008–9)

Anne K. Swartz

Artists Space, New York

Alternative exhibition space established by Irving Sandler and Trudie Grace in 1972–3 for the exhibition of "unaffiliated artists" in New York. It was founded under the auspices of the New York State Council on the Arts (NYSCA) to provide artists with a non-profit alternative to the commercial gallery system in New York. The stated mission of the space was to provide a venue for artists without gallery representation and to give them greater control over the exhibition of their work. In accordance with this mission, artists have frequently played a key role in administering the space and determining its exhibition schedule. A number of notable figures

exhibited at Artists Space early in their careers, including Laurie Anderson, Robert Longo, Richard Prince, Cindy Sherman and Laurie Simmons.

In 1972, Sandler was acting as a consultant to NYSCA, and Grace was the director of its Visual Arts Program, and they established the space to provide financial resources and exhibition opportunities for unaffiliated artists living in New York. In accordance with this mission, artists often curated their own exhibitions and those of other artists, and in the 1970s and 1980s, the space became a crucial site of artistic independence and experimentation. During its early years, a pattern was established in which well-known artists would select someone from the younger generation for exhibition, but when Helene Winer followed Grace as director between 1975 and 1980, the space became more associated with emerging trends in appropriation art. In 1977, she arranged to have the art historian Douglas Crimp curate the important exhibition *Pictures,* and the show inaugurated both the return to representation and the media-based practices of the 1980s.

During much of its history, Artists Space has been recognized as a showcase for young and talented artists who have later been recruited by commercial galleries, and in this sense, it has often functioned as an incubator for emerging artists rather than an alternative to established institutions. Artists Space has, however, often attempted to foster artistic independence through a number of ancillary programs that have provided funds to artists exhibiting at other non-commercial venues, including the Emergency Materials Fund, the Independent Exhibitions Program, and the Independent Project Grants. In 1974, the space began maintaining a collection of resumes and slides for artists who were not represented by commercial galleries. The Unaffiliated Artists File (now online and referred to as the Irving Sandler Artists File) also served as a curating resource for many of the gallery's exhibitions. Over the course of its history, the space has hosted a number of important and influential shows, including both *Pictures* and the series of new media exhibitions entitled *Dark Rooms* that were curated by Valerie Smith during the 1980s. Several exhibitions at Artists Space have also been subjects of controversy. In 1979, for example, the white artist Donald Newman touched off a firestorm when he titled his exhibition *Nigger Drawings* (a name that was unrelated to the content of his work). A decade later, the photographer Nan Goldin used a grant from the National Endowment for the Arts to organize the show *Witnesses: Against Our Vanishing* as a response to the AIDS crisis, and it prompted an outcry over public funding for the arts. Most of the exhibitions at Artists Space have, however, been significantly less controversial, and it has continued on into the 21st century with more or less the same mission that it had at the time of its founding.

BIBLIOGRAPHY

C. Gould and V. Smith, eds.: 5000 *Artists Return to Artists Space: 25 Years* (New York, 1998)

J. Ault, ed.: *Alternative Art New York, 1965–1985* (Minneapolis, MN, 2002)

I. Sandler: *From Avant-Garde to Pluralism* (Lenox, MA, 2006)

Tom Williams

Artists' Union

Organization created in 1934 to improve the economic conditions for artists during the Great Depression. In September 1933 a group of 25 artists, then working for the government's Emergency Work Bureau in New York, met to discuss the pending discontinuance of the bureau. One of the artists was Bernarda Bryson, who had helped organize the Unemployed Councils for the Communist Party. Calling themselves the Emergency Work Bureau Artists Group, they changed their name to the Unemployed Artists Group. In December they petitioned the federal relief administrator Harry L. Hopkins to set up a jobs program for all unemployed artists, to include teaching, mural painting, easel painting and commercial and applied art jobs. In response the Public Works of Art Project (PWAP) was set up,

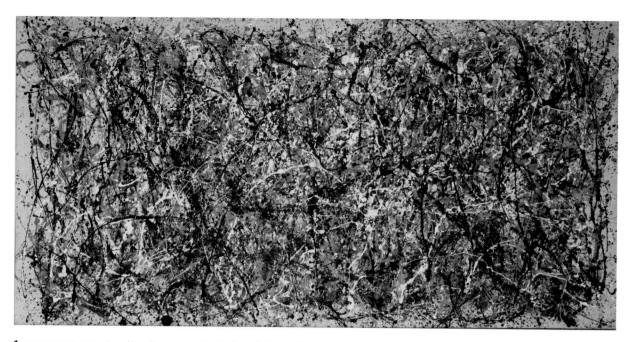

1. ABSTRACT ART. *One (Number 31, 1950)* by Jackson Pollock, oil and enamel on unprimed canvas, 2.69 × 5.31 m, 1950. Sidney and Harriet Janis Collection Fund (by exchange) © 2010 The Pollock–Krasner Foundation/Artists Rights Society, New York Digital Image © Museum of Modern Art/Licensed by SCALA/Art Resource, NY

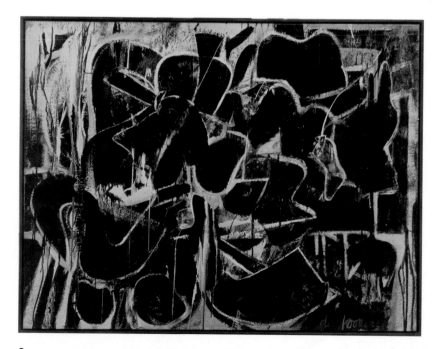

2. ABSTRACT EXPRESSIONISM. *Painting* by Willem de Kooning, enamel and oil on canvas, 1.08 × 1.43 m, 1948. © 2010 The Willem de Kooning Foundation/Artists Rights Society (ARS), New York. Digital image © The Museum of Modern Art/Licensed by SCALA/Art Resource, NY

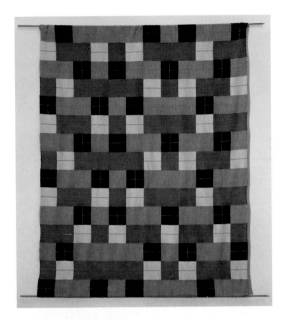

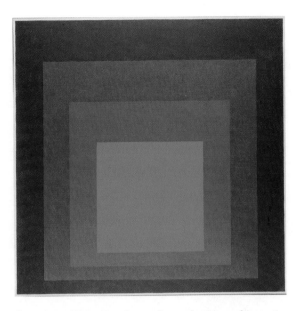

1. ANNI ALBERS. Wall hanging, cotton and silk, 148 × 121 mm, 1927. GIFT OF THE DESIGNER IN MEMORY OF GRETA DANIEL, 1965 © 2010 THE JOSEF AND ANNI ALBERS FOUNDATION/ARTISTS RIGHTS SOCIETY, NY DIGITAL IMAGE © MUSEUM OF MODERN ART/ LICENSED BY SCALA/ART RESOURCE, NY

2. JOSEF ALBERS. *Open Outward*, from the series *Homage to the Square*, oil on hardboard, 1.22 × 1.22 m, 1967; Berlin, Neue Nationalgalerie. © 2010 THE JOSEF AND ANNI ALBERS FOUNDATION/ARTISTS RIGHTS SOCIETY, NY. PHOTOGRAPH BY JOERG P. ANDERS. © BILDARCHIV PREUSSISCHER KULTURBESITZ/ART RESOURCE, NY

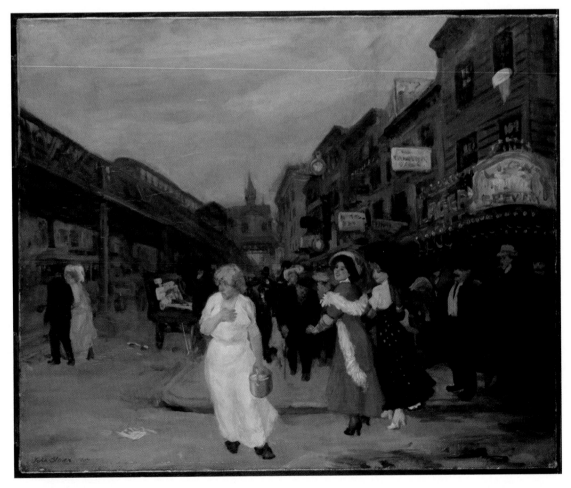

3. ASHCAN SCHOOL. *Sixth Avenue and Thirtieth Street, New York City* by John Sloan, oil on canvas, 616 × 813 mm, 1907. GIFT OF MEYER P. POTAMKIN AND VIVIAN O. POTAMKIN, 2000. THE PHILADELPHIA MUSEUM OF ART/ART RESOURCE, NY

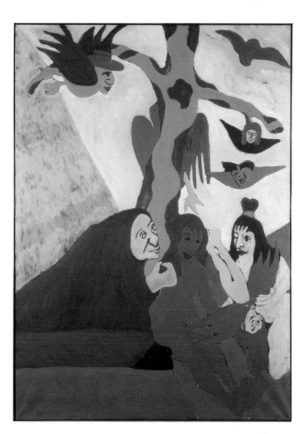

1. ROSS BLECKNER. *Memorial II,* oil on linen, 2.44 × 3.05 m, 1994. © Ross Bleckner. Courtesy Mary Boone Gallery, NY/The Museum of Modern Art

2. AFRICAN AMERICAN ART. *Descent from the Cross* by Bob Thompson, oil on canvas, 2.13 × 1.52 m, 1963. Smithsonian American Art Museum, Washington, DC/Art Resource, NY. Courtesy of Michael Rosenfeld Gallery, LLC, New York, NY

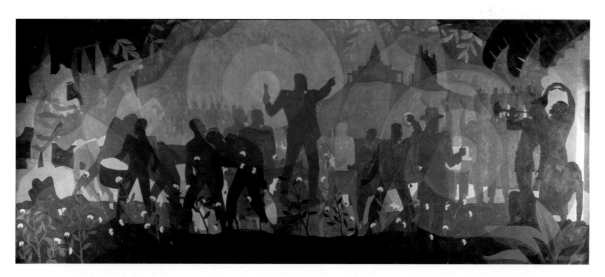

3. AFRICAN AMERICAN ART: MURALS. *Aspects of Negro Life: From Slavery through Reconstruction* by Aaron Douglas, oil on canvas, 1.52 × 3.53 m, 1934. © Schomburg Center for Research in Black Culture, The New York Public Library/Art Resource, NY. Courtesy The Aaron and Alta Sawyer Douglas Foundation

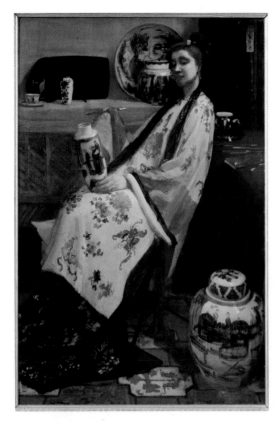

1. AESTHETICISM. *Purple and Rose* by James McNeill Whistler, 1864; Philadelphia Museum of Art. ERICH LESSING/ART RESOURCE, NY

2. MILTON AVERY. *Sea Grasses and Blue Sea*, oil on canvas, 1.53 × 1.84 m, 1958. © 2010 MILTON AVERY TRUST/ARTISTS RIGHTS SOCIETY, NY GIFT OF FRIENDS OF THE ARTIST. DIGITAL IMAGE © MUSEUM OF MODERN ART/LICENSED BY SCALA/ART RESOURCE, NY

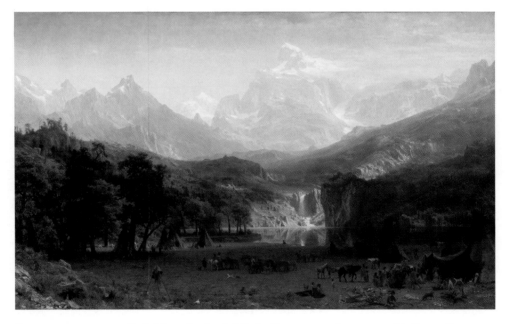

3. ALBERT BIERSTADT. *Rocky Mountains, Lander's Peak*, oil on canvas, 1.87 × 3.07 m, 1863. ROGERS FUND, 1907. IMAGE COPYRIGHT © THE METROPOLITAN MUSEUM OF ART/ART RESOURCE, NY

1. LYNDA BENGLIS. *Fallen Painting*, pigmented latex rubber, l. 9.07 m, 1968. GIFT OF MICHAEL GOLDBERG, LYNDA BENGLIS AND PAULA COOPER, 1992 © LYNDA BENGLIS/LICENSED BY VAGA, NEW YORK, NY © VAGA/ALBRIGHT-KNOX ART GALLERY, BUFFALO, NY/ART RESOURCE, NY

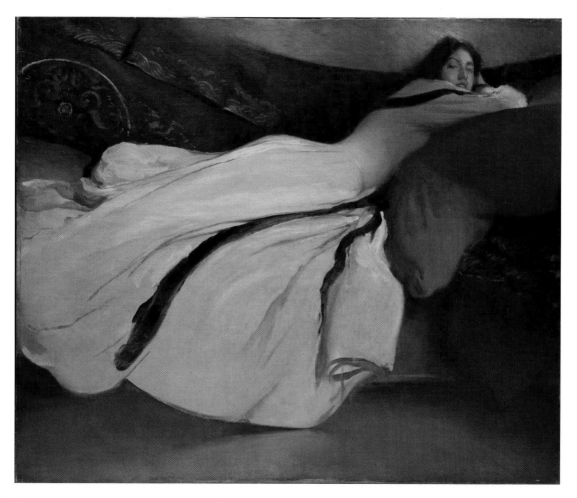

2. JOHN WHITE ALEXANDER. *Repose*, oil on canvas, 1.3 × 1.6 m, 1895. ANONYMOUS GIFT, 1980. IMAGE COPYRIGHT © THE METROPOLITAN MUSEUM OF ART/ART RESOURCE, NY

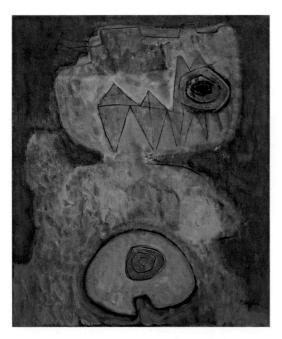

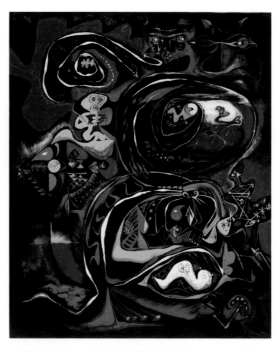

1. WILLIAM BAZIOTES. *Dwarf*, oil on canvas, 1.07 × 0.92 m, 1947. © Estate of the artist/A. Conger Goodyear Fund/ Digital Image © Museum of Modern Art/Licensed by SCALA/Art Resource, NY

2. AUTOMATISM. *Meditation on an Oak Leaf* by André Masson, tempera, pastel and sand on canvas, 1016 × 838 mm, 1942. Given anonymously. © 2010 Artists Rights Society (ARS), New York/ADAGP, Paris/Digital image © The Museum of Modern Art/Licensed by SCALA/Art Resource, NY

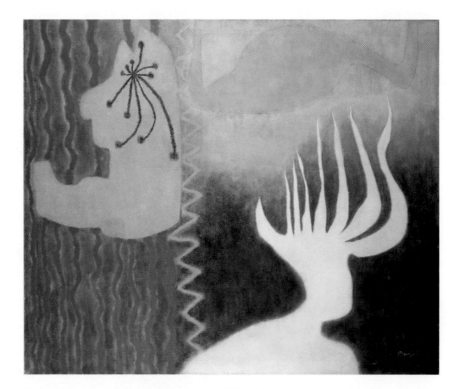

3. BIOMORPHISM. *The Flesh Eaters* by William Baziotes, oil and charcoal on canvas, 1.52 × 1.83 m, 1952. Purchase, George A. Hearn Fund, Arthur Hoppock Hearn Fund, and Hearn Funds, Bequest of Charles F. Iklé, and gifts of Mrs. Carroll J. Post and Mrs. George S. Amory, by exchange, 1995. Image copyright © The Metropolitan Museum of Art/Art Resource, NY

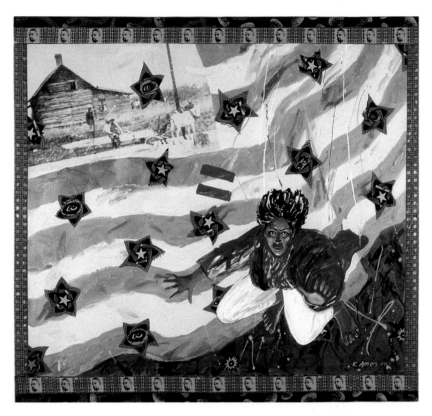

1. **EMMA AMOS.** *Equals*, acrylic on canvas, photo transfer and African fabric borders, 1992.
© Emma Amos/Licensed by VAGA, New York, NY

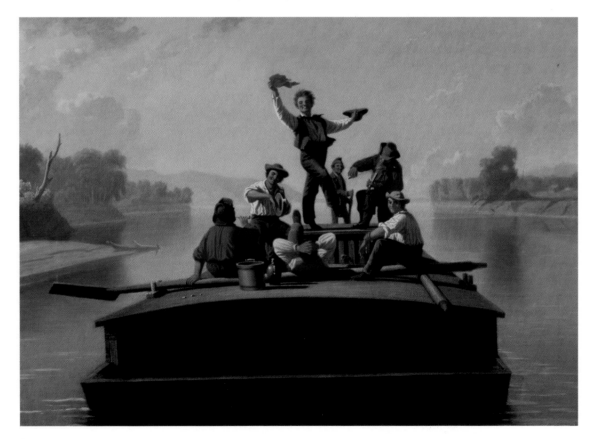

2. **GEORGE CALEB BINGHAM.** *The Jolly Flatboatmen*, oil on canvas, 662 × 924 mm, 1877–8. Daniel J. Terra Collection, Terra Foundation for American Art, Chicago/Art Resource, NY

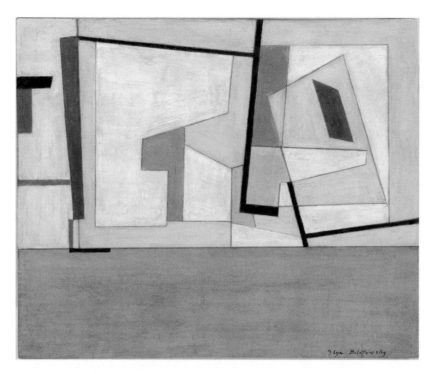

1. ILYA BOLOTOWSKY. *Autumn*, pencil and tempera on cardboard, study for mural at Men's Day Room, Chronic Diseases Hospital, Welfare Island, New York, 133 × 160 mm, 1940. © ESTATE OF ILYA BOLOTOWSKY/LICENSED BY VAGA, NEW YORK, NY . GIFT FROM THE ESTATE OF KATHERINE S. DREIER/YALE UNIVERSITY ART GALLERY/ART RESOURCE, NY

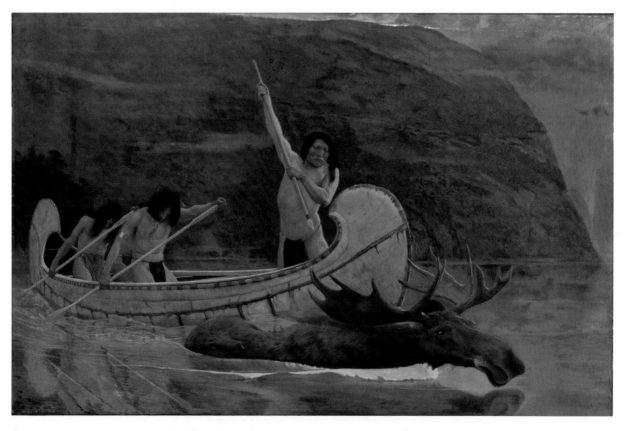

2. GEORGE DE FOREST BRUSH. *The Moose Chase*, oil on canvas, 948 × 1457 mm, 1888. SMITHSONIAN AMERICAN ART MUSEUM, WASHINGTON, DC/ART RESOURCE, NY

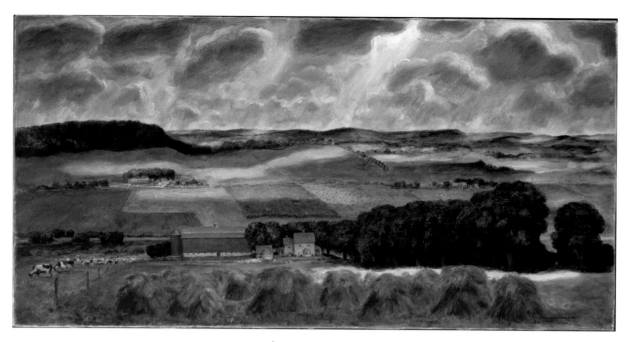

1. JOHN STEUART CURRY. *Wisconsin Landscape*, oil on canvas, 1.07 × 2.13 m, 1938–9. GEORGE A. HEARN FUND, 1942 IMAGE COPYRIGHT © THE METROPOLITAN MUSEUM OF ART/ART RESOURCE, NY

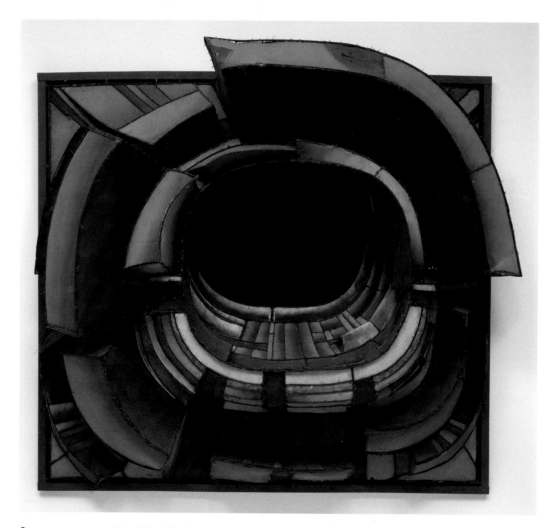

2. LEE BONTECOU. *Untitled*, welded steel, canvas, black fabric, copper wire and soot, h. 2.04 m, 1961. © LEE BONTECOU. KAY SAGE TANGUY FUND DIGITAL IMAGE © MUSEUM OF MODERN ART/LICENSED BY SCALA/ART RESOURCE, NY

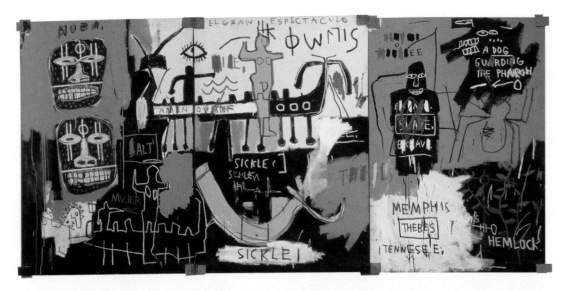

1. JEAN-MICHEL BASQUIAT. *El gran espectaculo (History of black people),* acrylic and pencil on canvas, 1.73 × 3.58 m. © 2010 THE ESTATE OF JEAN-MICHEL BASQUIAT/ ARS, NEW YORK. PRIVATE COLLECTION/BANQUE D'IMAGES, ADAGP/ART RESOURCE, NY

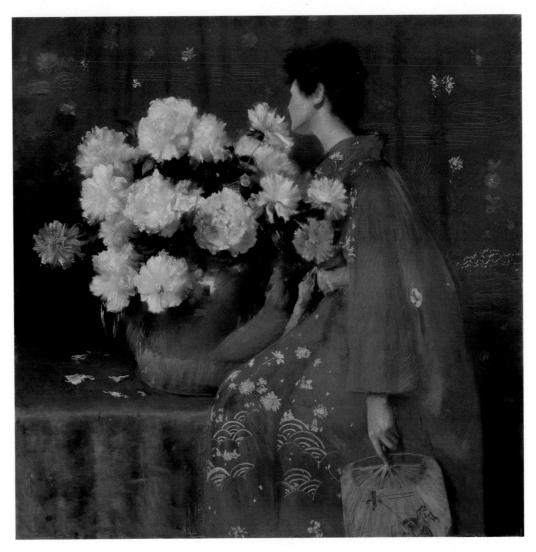

2. WILLIAM MERRITT CHASE. *Spring Flowers (Peonies),* pastel on paper, 1.22 × 1.22 m, before 1889. DANIEL J. TERRA COLLECTION, TERRA FOUNDATION FOR AMERICAN ART, CHICAGO/ART RESOURCE, NY

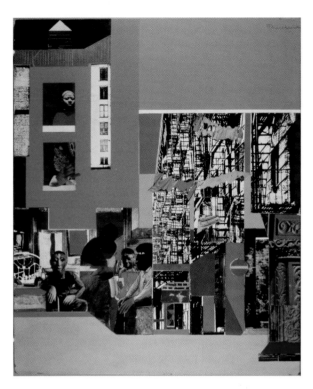

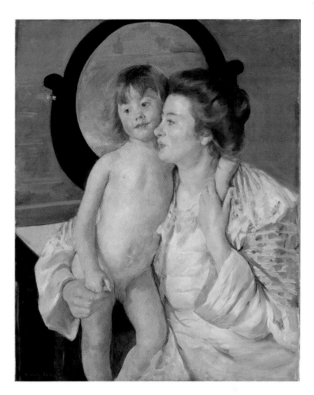

1. ROMARE BEARDEN. *Black Manhattan*, collage paper and polymer paint on board, 647 × 540 mm, 1969. © ROMARE BEARDEN FOUNDATION/LICENSED BY VAGA, NEW YORK, NY. SCHOMBURG CENTER FOR RESEARCH IN BLACK CULTURE, THE NEW YORK PUBLIC LIBRARY/ART RESOURCE, NY

2. MARY CASSATT. *Mother and Child (The Oval Mirror)*, oil on canvas, 816 × 657 mm, *c.* 1899. H.O. HAVEMEYER COLLECTION, BEQUEST OF MRS. H.O. HAVEMEYER, 1929 © THE METROPOLITAN MUSEUM OF ART/ART RESOURCE, NY

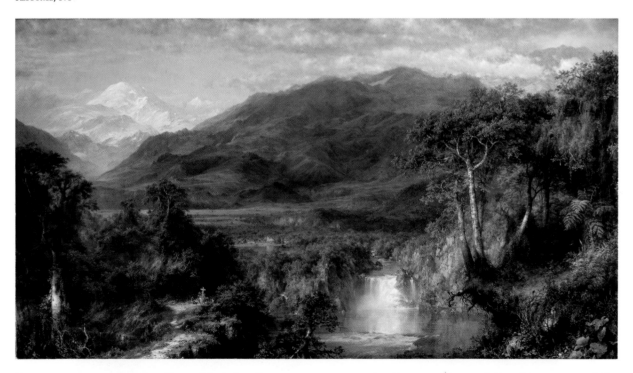

3. FREDERIC EDWIN CHURCH. *Heart of the Andes*, oil on canvas, 1.7 × 3.0 m, 1859. BEQUEST OF MARGARET E. DOWS IMAGE COPYRIGHT © THE METROPOLITAN MUSEUM OF ART/ART RESOURCE, NY

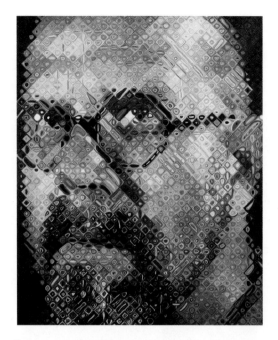

1. CHUCK CLOSE. *Self-portrait*, oil on canvas, 2.59 × 2.13 m, 1997. GIFT OF AGNES GUND, JO CAROLE AND RONALD S. LAUDER, DONALD L. BRYANT, JR., LEON BLACK, MICHAEL AND JUDY OVITZ, ANNA MARIE AND ROBERT F. SHAPIRO, LEILA AND MELVILLE STRAUSS, DORIS AND DONALD FISHER, AND PURCHASE © CHUCK CLOSE, COURTESY OF THE PACE GALLERY, NY © MUSEUM OF MODERN ART/LICENSED BY SCALA/ART RESOURCE, NY

2. JAMES BROOKS. *Rasalus*, oil on canvas, 1.67 × 2.03 m, 1959. PURCHASE, WITH FUNDS FROM THE FRIENDS OF THE WHITNEY MUSEUM OF AMERICAN ART © ESTATE OF JAMES BROOKS/LICENSED BY, NEW YORK, NY. PHOTOGRAPH BY PETER ACCETTOLA. PHOTOGRAPH COPYRIGHT © 1996: WHITNEY MUSEUM OF AMERICAN ART, NEW YORK

ROBERT COLESCOTT. *Big Bathers, Another Judgement*, acrylic on canvas, New York, NY. Photograph by Peter Accettola. Photograph copyright © 1996: Whitney Museum of American Art, New York. F.V. DuPONT ACQUISITION FUND, DELAWARE ART MUSEUM/THE BRIDGEMAN ART LIBRARY

1. ARTHUR B. CARLES. *Blue Abstraction*, oil on canvas, 1022 × 843 mm, c. 1929. COURTESY OF THE ARTIST'S ESTATE AND MARK BORGHI FINE ART INC. GIFT OF MR. AND MRS. ROBERT MCLEAN, 1977./THE PHILADELPHIA MUSEUM OF ART/ART RESOURCE, NY

2. CECILIA BEAUX. *The Dreamer*, oil on canvas, 819 × 622 mm, 1894. MUSEUM PURCHASE 1929. © BUTLER INSTITUTE OF AMERICAN ART, YOUNGSTOWN, OH/THE BRIDGEMAN ART LIBRARY

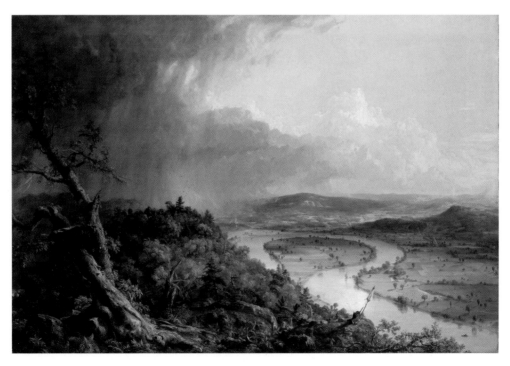

3. THOMAS COLE. *Oxbow on the Connecticut River (View from Mount Holyoke, Northampton, Massachusetts, after a Thunderstorm, The Oxbow)*, oil on canvas, 1.30 x 1.93 m, 1836. GIFT OF MRS. RUSSELL SAGE, 1908. IMAGE COPYRIGHT © THE METROPOLITAN MUSEUM OF ART/ART RESOURCE, NY

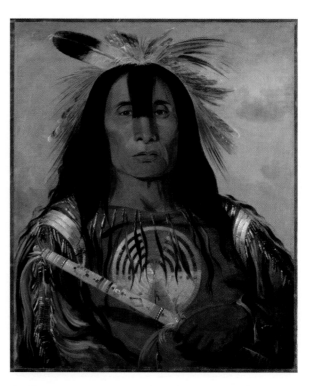

1. COLOR FIELD PAINTING. *Turnsole* by Kenneth Noland, synthetic polymer paint on unprimed canvas, 2.39 × 3.05 m, 1961. BLANCHETTE ROCKEFELLER FUND © ESTATE OF KENNETH NOLAND/ LICENSED BY VAGA, NEW YORK, NY. DIGITAL IMAGE © MUSEUM OF MODERN ART/LICENSED BY SCALA/ART RESOURCE, NY

2. GEORGE CATLIN. *Stu-mick-o-súcks, Buffalo Bull's Back Fat (Blackfoot), Head Chief, Blood Tribe*, oil on canvas, 737 × 609 mm, 1832. SMITHSONIAN AMERICAN ART MUSEUM, WASHINGTON, DC/ART RESOURCE, NY

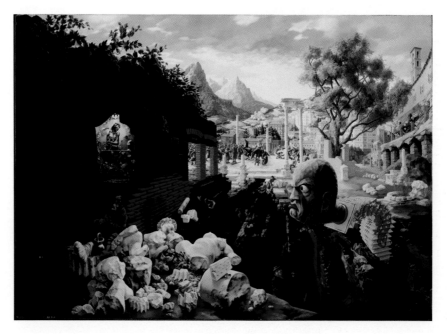

3. PETER BLUME. *Eternal City*, oil on canvas, 864 × 1216 mm, 1934–7. MRS. SIMON GUGGENHEIM FUND © THE EDUCATIONAL ALLIANCE, INC./ESTATE OF PETER BLUME/LICENSED BY VAGA, NEW YORK, NY. DIGITAL IMAGE © MUSEUM OF MODERN ART/LICENSED BY SCALA/ART RESOURCE, NY

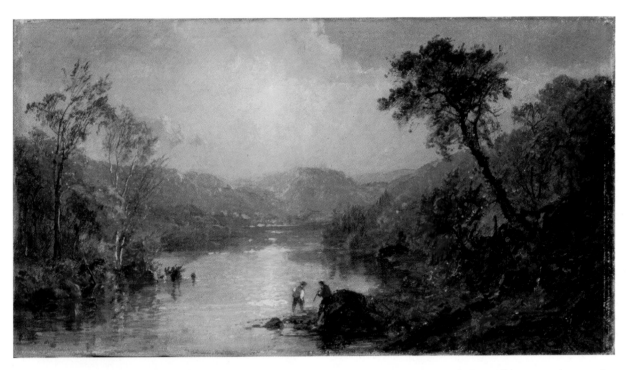

1. JASPER F. CROPSEY. *Indian Summer,* oil on canvas, 179 x 330 mm, 1886. Bequest of Martha L. Loomis/Smithsonian American Art Museum, Washington, DC/Art Resource, NY

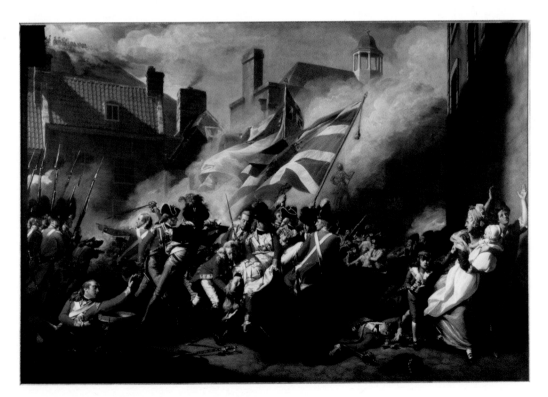

2. JOHN SINGLETON COPLEY. *The Death of Major Peirson, January 6, 1781,* oil on canvas, 2.51 × 3.65 m, 1782–4. Tate Gallery, London/Art Resource, NY

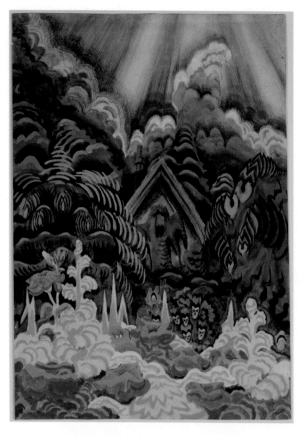

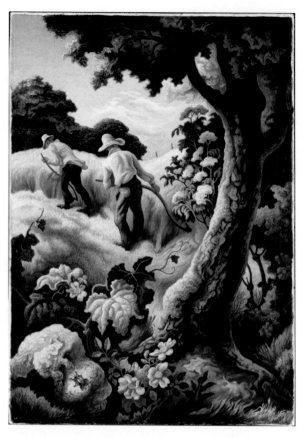

1. CHARLES BURCHFIELD. *Childhood's Garden*, watercolor on paper, 686 × 481 mm, 1917. EDWARD W. ROOT BEQUEST MUNSON–WILLIAMS–PROCTOR ARTS INSTITUTE, UTICA, NY/ART RESOURCE, NY

2. THOMAS HART BENTON. *July Hay*, egg tempera, methyl cellulose and oil on masonite, 965 × 679 mm, 1943. GEORGE A. HEARN FUND © T.H. BENTON AND R.P. BENTON TESTAMENTARY TRUSTS/UMB BANK TRUSTEE/LICENSED BY VAGA, NEW YORK, NY. IMAGE COPYRIGHT © THE METROPOLITAN MUSEUM OF ART/ART RESOURCE, NY

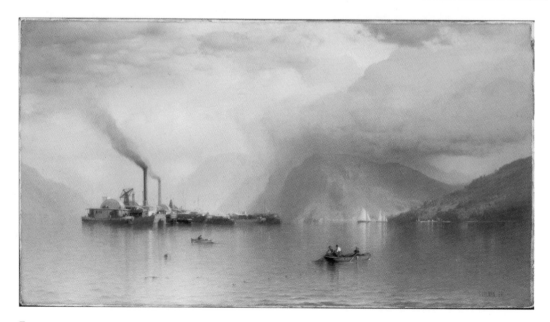

3. SAMUEL COLMAN. *Storm King on the Hudson*, oil on canvas, 816 × 1520 mm, 1866. SMITHSONIAN AMERICAN ART MUSEUM, WASHINGTON, DC/ART RESOURCE, NY

with Julianna Force, director of the Whitney Museum of American Art, administering the program in New York. Not satisfied with the limited number of artists being placed in PWAP roles, the Unemployed Artists Group protested; the group also renamed itself the Artists' Union (AU) in 1934 to designate itself as clearly representing both the recently employed and unemployed artists. When the government set up the Federal Art Project (FAP) in August 1935, under the administration of the Works Progress Administration (WPA), and put artists on the payroll, the ranks of the AU swelled. The AU organized a large sit-down strike in December 1936 at the FAP headquarters in New York to protest cutbacks and in January 1937 a massive demonstration in New York was followed by a march on Washington. Subsequently, art unions sprang up in other cities of the country. The New York AU hoped to affiliate with the American Federation of Labor (AFL), at that time the only large, viable union organization; the artists thought the AFL would give them economic clout as well as official visibility.

Talks dragged on with the AFL, which hesitated to take on the artists, although the AFL did grant a charter to the Commercial Artists and Designers Union (CADU). By 1937, the Congress of Industrial Organization (CIO) had emerged to challenge the AFL. The CIO was receptive to the artists, and talks between the CIO and Philip Evergood, then president of the AU, began in earnest in the fall of 1937. In January 1938 a charter was drawn up and the AU became the United American Artists, Local 60 of the United Office and Professional Workers of America (UOPWA), a CIO affiliate. With the phasing out of government art programs in the early 1940s, the various artists' unions in New York and other cities dwindled in membership.

BIBLIOGRAPHY

"History of the Artists Union," *Art Front*, i (Nov 1934), p. 4

G. M. Monroe: The Artists Union of New York (PhD thesis, New York U., 1971)

Patricia Hills

Arts and Crafts Movement

Informal movement in architecture and the decorative arts that championed the unity of the arts, the experience of the individual craftsman and the qualities of materials and construction in the work itself.

In the USA there was the same mixture of social concern and dilettantism and the rejection of historical styles in favor of a traditional simplicity. Many of the same groups of people, too, were involved: social reformers, teachers and women's organizations, as well as architects and designers. Ruskin and Morris were the prophets of craftsmanship for Americans as for Britons, although Thoreau, Ralph Waldo Emerson and Walt Whitman provided a sympathetic intellectual climate. Morris was influential in book design and Voysey and Baillie Scott in architecture and furniture, and French artist–potters influenced their American counterparts. The Americans, however, were bolder than the British in making and selling large quantities. "The World of Commerce," wrote Elbert Hubbard, "is just as honorable as the World of Art and a trifle more necessary" (see 1987 exh. cat., p. 315). Compared with Europe, the American Arts and Crafts Movement was much less influenced by Art Nouveau. There was a sturdy, four-square quality about much American Arts and Crafts that appealed, as Theodore Roosevelt appealed, to an American ideal of strong, simple manliness.

The movement in craftsmanship started in the 1870s and 1880s in response to a demand from such architects as H. H. Richardson. The art pottery movement began in Cincinnati, OH, in the 1880s; in quantity and quality the work of the Rookwood Pottery, the Van Briggle Pottery and the Grueby Faience Co., among others, claims pride of place alongside furniture in American Arts and Crafts. The East Coast was always more aware of British and European developments, and the first Arts and Crafts exhibition in America was held at Copley Hall in Boston in 1897. This was followed by the foundation of the Society of Arts and Crafts, Boston, which

sponsored local exhibitions, sale-rooms and work-shops with great success. The Society's Handicraft Shop produced fine silverware, but it was in printing that Boston excelled: the city's tradition of fine printing fostered outstanding Arts and Crafts presses, notably the Merrymount Press run by Daniel Berkeley Updike. In Philadelphia the architects of the T-Square Club looked particularly to England and exhibited Arts and Crafts work in the 1890s; in 1901 the architect William L. Price founded an idealistic and short-lived craft colony at Rose Valley, outside Philadelphia, devoted to furniture, pottery and amateur theatricals.

Upper New York State was another important center of the Arts and Crafts, partly perhaps because of the attractions of the Catskill Mountains. At the Byrdcliffe Colony in Woodstock, for example, pottery, textiles, metalwork and furniture were produced in a romantic backwoods setting; the Arts and Crafts shared some of the pioneering mystique of the log cabin for Americans. The most important figure in the area, and arguably in American Arts and Crafts as a whole, was Gustav Stickley, a furniture manufacturer in Eastwood, Syracuse, NY, who began producing simple Mission furniture about 1900. The design of Stickley's furniture was not as important as the scale of his operations and his power of communication. From 1901 he published *The Craftsman* magazine, which became the mouthpiece of the movement in America, and in 1904 he started the Craftsman Home-Builders Club, which issued plans for self-build bungalows; by 1915 it was estimated that $10 million worth of Craftsman homes had been built. The furniture, house plans and magazine together presented the Arts and Crafts as a way of life instead of a specialist movement. Simple, middlebrow, traditional, slightly masculine and slightly rural, it appealed to a large American market. The most flamboyant figure in New York State was Elbert Hubbard. At his Roycroft works in East Aurora, he produced metalwork, printed books and furniture very like Stickley's and published *The Philistine* magazine. Hubbard, too, created a powerful image for his craft enterprise, a slightly ersatz blend of bonhomie and culture, which made him seem almost a parody of Stickley or, more subtly, of himself.

In Chicago the focus of the movement was at first at Hull House, the settlement house run by the social reformer Jane Addams (1860–1935), where the Chicago Society of Arts and Crafts was founded in 1897. Here immigrants were encouraged to practice their native crafts, such as spinning and weaving, less to perfect the craft than to soften the shock of the new city. There were more Arts and Crafts societies and workshops in Chicago than in any other American city, a witness to its aspiring culture. Perhaps the most distinguished of the workshops were those of the metalworkers and silversmiths, such as the Kalo Shop, which was started in 1900 and continued production until 1970. It was in Chicago also that the Arts and Crafts made one of its most important contributions to American architecture: Arts and Crafts influence can be seen in the work of the Prairie School architects Walter Burley Griffin, George Washington Maher (1864–1926), Purcell & Elmslie and most notably Frank Lloyd Wright. In their sense of materials, their creation of a regional style echoing the horizontals of the prairies and their interest in designing furniture, metalwork and decorative details in their interiors, they continued the Arts and Crafts tradition.

Arts and Crafts workshops and activities in California began only in the early 1900s and were often stimulated by architects and designers from the east settling in California. Although Californian Arts and Crafts showed a debt to the beauty of the landscape and to the building traditions of the Spanish Mission, it had no single stylistic character. It ranged from the richly carved and painted furniture made by Arthur F. Mathews and his wife Lucia in San Francisco, through the simple, almost monumental, copper table-lamps of Dirk Van Erp (1859–1933), to the outstanding work of the architects Charles Sumner Greene and Henry Mather Greene. Between c. 1905 and 1911 Greene & Greene designed a number of large, expensive, wooden bungalows in and

around Pasadena and equipped them with fine hand-made furniture. These houses lie along the contours of their sites, inside and outside merging in the kindness of the climate. Their timber construction, paneling and fitted and movable furniture all show the gentle and authoritative ways in which the Greene brothers could make one piece of wood meet another, with Japanese and Chinese jointing techniques transformed into a decorative Californian *tour de force*. Although most products of the American Arts and Crafts are strong and simple in character, the Greenes' finest houses, the masterpieces of American Arts and Crafts architecture, are delicate and exquisite.

In 1936 Nikolaus Pevsner published *Pioneers of the Modern Movement*, in which he traced the origins of Modernism among various European movements of the late 19th and early 20th centuries, including the Arts and Crafts. Pevsner's book has influenced the study of the Arts and Crafts Movement more than any other, and much writing on the subject has concentrated on the movement's progressive elements, the tentative acceptance of machine production by some Arts and Crafts writers and the simpler designs that seem to reject ornament and historical styles in favor of functionalism. The Modernist view has subsequently come to seem incomplete; it ignored the fact that Arts and Crafts designs, without being any less modern in spirit, are almost always informed by a sense of the past, that ornament is central to much Arts and Crafts designing and that, whatever some theorists may have said, the practical bias of the movement, with its little workshops set apart from the world of industry, was anti-industrial. If the Arts and Crafts Movement is seen in its own time and context and not just as part of the story of Modernism, it appears as a deeply Romantic movement with its roots in the 19th century, a movement that belongs as much to the history of anti-Modernism as to that of Modernism.

The most distinctive feature of the Arts and Crafts Movement was its intellectual ambition. Ruskin's attack on factory work uncovered a fundamental malaise in modern industrial society, which Karl Marx identified as alienation. When Morris tried to make art more accessible, giving as much attention to a table and a chair as to an easel painting, he challenged the whole esoteric tendency of modern art. Arts and Crafts objects carry special, idealistic meanings; they tell the viewer about the value of art versus money, about how they are made, about nature or modernity or the satisfactions of hand work. Such idealism is incompatible with the world of manufacture, and if the Arts and Crafts Movement flourished it did so at the price of compromise and contradiction. In Britain the element of contradiction, or at least of inconsistency, was strongest. Arts and Crafts workers drew strength from Ruskin's words, which applied to all kinds of mechanized and factory work, but their own efforts were confined to the small (and relatively unmechanized) world of the decorative arts. In the USA compromise was sometimes the price that was paid. Stickley operated on so large a scale and Hubbard with such crude salesmanship that it is sometimes hard to distinguish them from the enemy, from the industrial and commercial world that Ruskin denounced. The Arts and Crafts Movement was not always as radical as it aspired to be; it is perhaps best understood, at the end of the day, as simply another movement of taste in the history of the decorative arts.

BIBLIOGRAPHY
Primary sources
J. Ruskin: *The Seven Lamps of Architecture* (London, 1849)
J. Ruskin: *The Stones of Venice*, 3 vols (London, 1851–3)
Catalogues, Arts and Crafts Exhibition Society (London, 1888–)
W. R. Lethaby: *Architecture, Mysticism and Myth* (London, 1891)
W. Crane: *The Claims of Decorative Art* (London, 1892)
Arts and Crafts Essays, Arts and Crafts Exhibition Society (London, 1893)
The Studio (1893–)
H. Van de Velde: *Déblaiement d'art* (Brussels, 1894/R 1979)
H. Van de Velde: *Aperçus en vue d'une synthèse d'art* (Brussels, 1895)
The Philistine (1895–)
Art and Life and the Building and Decoration of Cities, Arts and Crafts Exhibition Society (London, 1897)
Dek. Kst (1897–)

Dt. Kst & Dek. (1897–)

Kst & Ksthandwk (1898–)

H. Muthesius: *Die englische Baukunst der Gegenwart* (Leipzig, 1900)

D. Cockerell: *Bookbinding and the Care of Books* (London, 1901)

H. Van de Velde: *Die Renaissance in modernen Kunstgewerbe* (Berlin, 1901)

The Craftsman (1901–16)

H. Wilson: *Silverwork and Jewellery* (London, 1903)

The Artsman (1903–7)

H. Muthesius: *Das englische Haus* (Berlin, 1904)

T. J. Cobden-Sanderson: *The Arts and Crafts Movement* (London, 1905)

C. Whall: *Stained Glass Work* (London, 1905)

M. H. Baillie Scott: *Houses and Gardens* (London, 1906)

W. Crane: *An Artist's Reminiscences* (London, 1907)

C. R. Ashbee: *Craftsmanship in Competitive Industry* (London and Chipping Campden, 1908)

E. Johnston: *Writing and Illuminating and Lettering* (London, 1909)

T. Raffles Davison, ed.: *The Arts Connected with Building* (London, 1909)

H. Waentig: *Wirtschaft und Kunst* (Jena, 1909)

W. Morris: *Collected Works*, ed. M. Morris, 24 vols (London, 1910–15)

W. Crane: *From William Morris to Whistler* (London, 1911)

W. R. Lethaby: *Form in Civilization: Collected Papers on Art and Labour* (London, 1922)

W. R. Lethaby, A. H. Powell and F. L. Griggs: *Ernest Gimson: His Life and Work* (London, 1924)

W. Rothenstein: *Men and Memories*, 2 vols (London, 1931)

W. R. Lethaby: *Philip Webb and His Work* (London, 1935)

H. J. L. J. Massé: *The Art-Workers' Guild, 1884–1934* (Oxford, 1935)

Secondary sources

G. Naylor: *The Arts and Crafts Movement: A Study of Its Sources, Ideals and Influence on Design Theory* (London, 1971)

R. J. Clark: *The Arts and Crafts Movement in America, 1876–1916* (Princeton, 1972)

The Arts and Crafts Movement in America, 1876–1916 (exh. cat., ed. R. J. Clark; Princeton U., NJ, A. Mus., 1972)

California Design, 1910 (exh. cat., ed. T. J. Andersen, E. M. Moore and R. W. Winter; Pasadena, A. Mus., 1974)

N. Pevsner: *Pioneers of the Modern Movement: From William Morris to Walter Gropius* (London, 1936); rev. as *Pioneers of Modern Design: From William Morris to Walter Gropius* (Harmondsworth, 1974)

P. Vergo: *Art in Vienna, 1898–1918* (London, 1975)

S. O. Thompson: *American Book Design and William Morris* (New York, 1977)

A. Callen: *Angel in the Studio: Women in the Arts and Crafts Movement, 1870–1914* (London, 1979)

P. Davey: *Arts and Crafts Architecture: The Search for Earthly Paradise* (London, 1980)

J. Sheehy: *The Rediscovery of Ireland's Past: The Celtic Revival, 1830–1930* (London, 1980)

The Arts and Crafts Movement in New York State, 1890s–1920s (exh. cat., ed. C. L. Ludwig; Oswego, SUNY, Tyler A.G., 1983)

M. Richardson: *Architects of the Arts and Crafts Movement*, RIBA Drawings Series (London, 1983)

A. Crawford, ed.: *By Hammer and Hand: The Arts and Crafts Movement in Birmingham* (Birmingham, 1984)

The Glasgow Style, 1890–1920 (exh. cat., Glasgow, A.G. & Mus., 1984)

P. Stansky: *Redesigning the World: William Morris, the 1880s, and the Arts and Crafts* (Princeton, 1985)

E. Boris: *Art and Labor: Ruskin, Morris and the Craftsman Ideal in America* (Philadelphia, 1986)

F. Borsi and E. Godoli: *Vienna, 1900: Architecture and Design* (London, 1986)

J. Heskett: *Design in Germany, 1870–1918* (London, 1986)

"The Art that is Life": The Arts and Crafts Movement in America, 1875–1920 (exh. cat., ed. W. Kaplan; Boston, Mus. F.A., 1987)

E. Cumming and W. Kaplin: *The Arts and Crafts Movement* (London, 1991)

K. Trapp, ed.: *The Arts and Crafts Movement in California: Living the Good Life* (Oakland and New York, 1993)

M. Conforti, ed.: *Art and Life on the Upper Mississippi, 1890–1915* (Newark, 1994)

B. Denker, ed.: *The Substance of Style: Perspectives on the American Arts and Crafts Movement* (Winterthur, 1996)

M. Boyd Meyer, ed.: *Inspiring Reform: Boston's Arts and Crafts Movement* (Wellesley, 1997)

W. Kaplan and P. Bayer: *The Encyclopedia of Arts and Crafts* (London, 1998)

P. Todd: *The Arts & Crafts Companion* (New York, 2004)

International Arts and Crafts (exh. cat. ed. by Karen Livingstone and Linda Parry; London, V&A, 2005)

R. Blakesley: *The Arts and Crafts Movement* (London, 2006)

Alan Crawford

Artschwager, Richard

(*b* Washington, DC, 26 Dec 1924), sculptor and painter. He studied art in 1949–50 under Amédée Ozenfant (1886–1966) in New York. During the 1950s he designed and made furniture in New York, but after a fire that destroyed most of the contents

RICHARD ARTSCHWAGER. *Table and Chair*, melamine laminate and wood, h. 755 mm, 1963–4. © 2010 RICHARD ARTSCHWAGER/ ARTISTS RIGHTS SOCIETY, NEW YORK © TATE GALLERY, LONDON/ART RESOURCE, NY

of his shop in 1958 he turned again to art, initially painting abstract pictures derived from memories of the New Mexican landscape.

Artschwager continued to produce furniture and, after a commission to make altars for ships in 1960, had the idea of producing sculptures that mimicked actual objects while simultaneously betraying their identity as artistic illusions. At first these included *objets trouvés* made of wood, overpainted with acrylic in an exaggerated wood-grain pattern (e.g. *Table and Chair*, 1962–3; New York, Paula Cooper priv. col., see 1988–9 exh. cat., p. 49), but he soon developed more abstract or geometrical versions of such objects formed from a veneer of Formica on wood (e.g. *Table and Chair*, 1963–4; London, Tate). His preference for synthetic materials considered to be in debased taste together with his references to everyday objects were central to his response to Pop art. Similarly his blocklike sculptures had much in common formally with Minimalism.

From 1962 Artschwager also painted gray acrylic monochrome pictures, basing his images on black-and-white photographs, characteristically of modern buildings as shown in property advertisements, as in *Apartment House* (1964; Cologne, Mus. Ludwig).

Gradually his paintings became more complex and mysterious, the surface subsumed in a pattern of flickering light, for example in *The Bush* (1.22×1.79 m, 1971; New York, Whitney). His emphasis, however, remained on ambiguities of perception—on the interaction of observation and illusion—especially in sculptures conceived as hybrids of recognizable objects, such as *Book III (Laokoon*; Formica on wood with metal handles and vinyl cushion, 1981; Paris, Pompidou), part lectern and part pew.

[*See also* Pop art.]

BIBLIOGRAPHY
E. C. Baker: "Artschwager's Mental Furniture," *A. News*, 66 (1968), pp. 48–9, 58–61

Richard Artschwager's Theme(s) (exh. cat., essays R. Armstrong, L. C. Cathcart, and S. Delehanty; Buffalo, Albright–Knox A.G.; Philadelphia, U. PA, Inst. Contemp. A.; La Jolla, CA, Mus. Contemp. A.; Houston, TX, Contemp. A. Mus.; 1979)

Artschwager, Richard (exh. cat. by R. Armstrong, New York, Whitney; San Francisco, CA, MOMA; Los Angeles, CA, Mus. Contemp. A.; 1988–9)

Marco Livingstone

Art Students League

One of the oldest and largest artist-run schools of art instruction in the USA. The Arts Students League (ASL) was founded in New York in 1875 by and for art students, many of whom were women. It opened largely in response to student dissatisfaction with the classes and conservative leadership at the National Academy of Design (NAD), then the predominant school of art instruction. The Academy had been founded in 1825 by artists including Samuel F. B. Morse, Asher B. Durand and Thomas Cole. Faced with financial difficulty, it was rumored that live-figure drawing classes were to be canceled at the Academy, and therefore students and concerned teachers called for a meeting to initiate a new program of art instruction. The Art Students League was independently funded by tuition fees and vowed that life drawing would always be available. The mission of the ASL remains to emphasize the importance of

artistic creativity, to maintain the greatest respect for artists who devote their lives to art and to educate students in the process of making art in an environment where anyone who wishes to pursue an art education can realize their full potential.

Lemuel E. Wilmarth (1835–1918), a former NAD instructor, served as the ASL's first president when the school opened on the top floor of a building on the corner of Fifth Avenue and 16th Street. In the period after the Civil War, New York was becoming the nation's cultural capital, and it was felt the Academy was not sufficiently receptive to European modern art. The ASL eagerly included artists as teachers upon their return from European sojourns, thereby aligning itself with modern art ideas from Europe from its inception. The ASL was in fact modeled on the French atelier system, in which various teachers ran continuous courses in their own manner, unrestricted by administration, in loosely affiliated studios that offered a range of technical and intellectual methodologies. The ASL continues to follow this model, without set curricular programs, degrees or diplomas.

The school received its charter from the State of New York and was incorporated on 31 January 1878. From the beginning, the school was open to anyone of "acceptable moral character" who could pay dues of $5 per month, including many foreign students. The school expanded throughout the 1880s and 1890s. In 1882, the ASL moved to 38 West 14th Street, between Fifth and Sixth Avenues, where it occupied the upper three floors of a building; in 1887 it moved to 143–147 East 23 Street. In 1892, the Art Students League joined with other arts organizations under the umbrella, the American Fine Arts Society, and became permanently headquartered at 215 West 57th Street, between Broadway and Seventh Avenue, in its own building. This landmark designed by Henry J. Hardenbergh offers studios for life drawing, painting, printmaking and sculpture and storage for the collection of 1600 works, as well as exhibition galleries.

Noted instructors of the late 19th century and early 20th century include William Merritt Chase (who broke away to found the Chase school, later Parsons The New School for Design, in 1896), Frank Vincent DuMond (1865–1951), Robert Henri, George Bellows, George Luks, John Sloan (president 1931–2), Everett Shinn, Julian Alden Weir, Walter Shirlaw, Frederick Dielman (1847–1935), John H. Twachtman, Kenyon Cox, Augustus Saint-Gaudens, Daniel Chester French, Thomas Eakins, Childe Hassam, Frank Duveneck, Thomas W. Dewing and Arthur Wesley Dow. Other, later, well-known artists have been instructors, lecturers and students: George Bridgman (1865–1943) and Kenneth Hayes Miller as well as Thomas Hart Benton, Alexander Calder, Helen Frankenthaler, Georgia O'Keeffe, Barnett Newman, Norman Rockwell, Winslow Homer, Man Ray, Jackson Pollock, Lee Krasner, Robert Rauschenberg, James Rosenquist, Louise Nevelson, Reginald Marsh, Romare Bearden, Red Grooms, Donald Judd, Roy Lichtenstein, Mark Rothko, Ben Shahn and Cy Twombly.

BIBLIOGRAPHY

M. E. Landgren: *Years of Art: The Story of the Art Students League of New York* (New York, 1940)

R. J. Steiner: *The Art Students League of New York: A History* (New York, 1999)

Deborah Cullen

Asawa, Ruth

(b. Norwalk, CA, 24 Jan 1926), sculptor, painter and draftsman. Ruth (Aiko) Asawa was born the fourth of seven children to Japanese immigrants, and her childhood on a thriving truck farm formed her work ethic. During World War II, the Asawas were separated into different internment camps. At the Rohwer Relocation Center in Arkansas, Asawa was able to learn drawing from interned Japanese American illustrators. In 1943 a scholarship allowed her to leave the camp to study at Milwaukee State Teachers College. However, when she realized that she could never find a teaching position in Wisconsin because

of her Japanese ancestry, she headed to Black Mountain College in North Carolina in 1946. The Black Mountain College community, including illustrious teachers such as Josef Albers and Buckminster Fuller, nurtured Asawa's artistic foundation and philosophy. There she started on looped-wire sculpture after discovering the basket crocheting technique in Mexico in 1947. Upon graduation, she married her classmate, the architect Albert Lanier (1927–2008), in San Francisco, where they raised six children.

Although Asawa's wire sculpture with its organic repetitive patterns was not readily accepted by art establishments due to its unconventional hanging format and its close ties to crafts, her exhibition opportunities dramatically increased once her hanging sculptures adorned the cover of *Arts & Architecture* in 1952 and *Vogue* the following year. By 1955, the year after her first exhibition in New York, the Rockefellers and Philip Johnson, among others, were purchasing her sculptures. While continuing to create hanging looped-wire sculpture, Asawa started experimenting with tied-wire sculpture in the early 1960s. Resembling bonsai trees or snowflakes, they are made by tying all the intersections of multiple wires. From 1963, Asawa received numerous commissions to create large public sculptures in the San Francisco area and served as a public art advocate, promoting her belief of "art for everybody." In 1968 she co-founded Alvarado School Arts Workshop and ran its volunteer-based community arts program until 1973. The de Young Museum holds a permanent collection of Asawa's sculpture. Her major retrospective exhibition was held there in 2006 and traveled to the Japanese American National Museum, Los Angeles.

BIBLIOGRAPHY

Asawa, http://www.ruthasawa.com/ (accessed 21 October 2009)

Ruth Asawa: A Retrospective View (exh. cat. by G. Noland; San Francisco, CA, Mus. Art, 1973)

The Sculpture of Ruth Asawa: Countours in the Air (exh. cat. by D. Cornell; San Francisco, CA, F. A. Museums, 2006)

Midori Yoshimoto

Ashcan school

Term first used by Holger Cahill and Alfred Barr in *Art in America* (New York, 1934) and loosely applied to American urban realist painters. In particular it referred to those members of the Eight who shortly after 1900 began to portray ordinary aspects of city life in their paintings, for example George Luks's painting *Closing the Café* (1904; Utica, NY, Munson–Williams–Proctor Inst.). Robert Henri, John Sloan, William J. Glackens, Everett Shinn and George Luks were the core of an informal association of painters who, in reaction against the prevailing restrictive academic exhibition procedures, mounted a controversial independent exhibition at the Macbeth Galleries, New York (1908).

Sloan, Glackens, Shinn and Luks had all worked for the *Philadelphia Press*. It was in Philadelphia, where Henri had trained at the Academy of Fine Arts, that he convinced them to leave their careers as newspaper illustrators to take up painting as a serious profession. In an explicit challenge to the "art for art's sake" aesthetic of the late 19th century, Henri proposed an "art for life," one that would abandon the polished techniques and polite subject matter of the academicians; it would celebrate instead the vitality that the painter saw around him in everyday situations.

In 1904 Henri set up his own school in New York in a Latin quarter on Upper Broadway. He was joined there by Sloan, Glackens, Luks and Shinn; George Bellows, Glenn O. Coleman (1887–1932) and Jerome Myers also associated themselves with Henri's new urban realism. Henri and his followers were initially referred to as the "revolutionary black gang," a term that alluded to the dark subdued palette that characterized much of the group's early paintings. They drew subject matter from life in the Bowery, Lower Sixth Avenue and West 14th Street. Among the typical works of the Ashcan school were images of street urchins, prostitutes, athletes, immigrants and boxers, as in Bellows's *Stag at Sharkey's* (1909; Cleveland, OH, Mus. A. for illustration, see Bellows, George) and

Dempsey and Firpo (1924; New York, Whitney). Such figure studies, together with street scenes such as *Hairdresser's Window* by Sloan, convey a vivid impression of life in New York in the early years of the century. For illustration, see color pl. 1:II, 3.

Their choice of such picturesque contemporary motifs was generally considered bold, but as William B. McCormick, writing in the *New York Press* in 1908, observed, there were clear precedents in European art:

> Surely it is not 'revolutionary' to follow in the footsteps of the men who were the rage in artistic Paris twenty years ago. Nor is it 'a new departure in American art' to paint after the manner of Manet, Degas, and Monet.

[*See also* Bellows, George; Eight, the; Glackens, William J.; Henri, Robert; Luks, George; Myers, Jerome; Shinn, Everett; *and* Sloan, John.]

BIBLIOGRAPHY

I. Forrester: "New York Art Anarchists," *N Y World Mag.* (10 June 1906), p. 6

B. B. Perlman: *The Immortal Eight, American Painting from Eakins to the Armory Show, 1870–1913* (New York, 1962)

W. I. Homer: "The Exhibition of 'The Eight': Its History and Significance," *Amer. A. J.*, i/1 (1969), pp. 53–64

W. I. Homer: *Robert Henri and his Circle* (Ithaca, 1969)

M. S. Young: *The Eight* (New York, 1973)

B. B. Perlman: "Rebels with a Cause—The Eight," *ARTnews*, lxxxi/18 (1982), pp. 62–7

J. Zilczer: "The Eight on Tour, 1908–1909," *Amer. A. J.*, xvi/64 (1984), pp. 20–48

B. B. Perlman: *Painters of the Ashcan School: The Immortal Eight* (New York, 1988)

E. H. Turner: *Men of the Rebellion: The Eight and their Associates at the Phillips Collection* (Washington, DC, *c*.1990)

Painters of a New Century: The Eight and American Art (exh. cat. by E. Milroy, Milwaukee, WI, A. Mus.; Denver, CO, A. Mus.; New York, Brooklyn Mus. and elsewhere; 1991–2)

V. M. Mecklenburg: "New York City and the Ashcan School," *Antiques*, cxlviii (Nov 1995), pp. 684–93

Metropolitan Lives: The Ashcan Artists and their New York (exh. cat. by R. Zurier, R. W. Snyder, and V. M. Mecklenburg, Washington, DC, N. Mus. Amer. A., 1995–6)

B. Fahlman: "Realism: Tradition and Innovation," *American Images: The SBC Collection of Twentieth-century American Art*, ed. E. Whitacre, L. C. Martin and W. Hopps (New York, 1996)

V. A. Leeds: *The Independents: The Ashcan School and their Circle from Florida Collections* (Winter Park, FL, 1996)

R. Zurier: *Picturing the City: Urban Vision and the Ashcan School* (Berkeley, CA, 2006)

M. Sue Kendall

Ashkin, Michael

(*b* Morristown, NJ, 29 Oct 1955), sculptor. He studied Oriental and Middle Eastern cultures and languages before later graduating in Painting and Drawing from the School of the Art Institute of Chicago (MFA 1993). Ashkin gained international recognition in the mid-1990s for his tabletop dioramas of inhospitable, often deserted, American landscapes. Influenced by Robert Smithson's interest in the concept of entropy as well as more traditional landscape discourses such as Romanticism and the Sublime, Ashkin's work has often suggested vast inhuman wastelands, although their real scale might only be a few square feet. His earliest works concentrated on semi-arid deserts, but soon the dominant motif switched to semi-stagnant marshes. *No. 33* (1996; see exh. cat.), typical of the numerical nomination of his work, depicts a long, thin freeway in a swampy wilderness; a single truck drives along and telegraph wires line the road, suggesting vast distances. *No. 15* (1996; see exh. cat.) is smaller in size, though again the tiny scale of the trucks that pass in convoy over a swampy, pock-marked landscape suggest great expanse. Ashkin expanded his practice into video and photography exploring the Sublime in the early 21st century. *Proof Range* (1999; see *Artforum*, May 2000) is a three-screen video installation showing a landscape of eroding concrete bunkers, ramps and stairways; the purpose of the architecture, which is shown from various angles, is left obscure. While obviously referencing the discourse of landscape painting, the scale of his sculptures also suggests an interest in the open compositional forms of Abstract Expressionist painting.

BIBLIOGRAPHY

A. Perchuk: "Michael Ashkin," *Artforum*, xxxvi/10 (Summer 1998), p.129

G. Volk: "Michael Ashkin at Andrea Rosen," *A. America*, lxxxvi/11 (Nov 1998), p. 129

Young Americans 2: New American Art at the Saatchi Gallery (exh. cat., essay by L. Liebmann and B. Adams, London, Saatchi Gal., 1998)

F. Richard: "Michael Ashkin," *Artforum*, xxxviii/9 (May 2000), p. 176

Morgan Falconer

Asian American Arts Centre

Multi-ethnic arts organization based in New York's Chinatown. The Asian American Arts Centre (AAAC) and its predecessors, the Asian American Dance Theatre (1974–93) and the Asian Arts Institute (1981–8), emerged from the milieu of the Basement Workshop, the first working group of the Asian American Movement on the East Coast, whose mouthpiece was the journal *Bridge* (1970–81). After the closing of the Basement Workshop in 1987, the Dance Theatre and the Asian Arts Institute were consolidated as the AAAC.

Directed by Eleanor S. Yung, the Dance Theatre was at the core of the organization's activities from the 1970s through the early 1990s, performing traditional dances from several Asian cultures alongside modern and postmodern forms. In the early 1980s, the Asian Arts Institute began to hold exhibitions and collect slides of artists' work and documentation of their activities, working primarily with artists involved in the downtown art scene. Early programs included open studio events for artists working in Chinatown and exhibitions of the work of Arlan Huang (*b* 1948), Bing Lee, Charles Yuen, Colin Lee (*b* 1953), Toshio Sasaki (*d* 2007), Martin Wong, Tomie Arai, Kwok Mang Ho (*b* 1947), Anna Kuo and downtown photographer Tseng Kwong Chi, among others.

After consolidating as the AAAC, the organization, directed by Robert Lee, continued to sponsor exhibitions and organize educational programs and folk art demonstrations. Exhibitions include, *Public Art in Chinatown* (1988), *CHINA: June 4, 1989*, a response to the Tiananmen Square Massacre (1989), *From "Star Star" to Avant Garde: 10 Artists from China* (1991), which featured the work of Xu Bing, Gu Wenda (*b* 1955) and Zhang Hongtu (*b* 1943), *We Count! The State of Asian Pacific America* (1992) and *Three Generations: Towards a History of Asian American Art* (1997). In the 1980s and 1990s, the Centre's energies remained directed toward the community involvement that had characterized the Basement Workshop, including performances at Lunar New Year festivals, programs in New York's public schools and Saturday art classes for children. The slide archive and collection of ephemera, which opened in 1982, became an increasingly important aspect of the Centre's program and was digitized and made available on the internet in 2009.

BIBLIOGRAPHY

In the Spirit of Dunhuang: Studies (exh. cat. by Zhang Hongtu, New York, Asian Arts Institute, 1984)

Chihung Yang, Works on Paper (exh. cat. by J. Yau and others, New York, Asian Arts Institute, 1984)

Fathers (exh. cat., New York, Asian Arts Institute, 1986)

Orientalism: Exhibition of Paintings by Margo Machida and Charles Yuen (exh. cat., New York, Asian Arts Institute, 1986)

The City: Exhibition of Works by Y.J. Cho, Jerry Kwan, and Ming Murray (exh. cat., New York, Asian Arts Institute, 1986)

The Mind's I. Part 1: Exhibition of Works by Benny Andrews, Raphael Soyer, Chiu Ya-Tsai, and Martin Wong (exh. cat., New York, Asian Arts Institute, 1987)

The Mind's I. Part 2: Exhibition of works by Luis Cruz Azaceta, Robert Colescott, and Margo Machida (exh. cat., New York, Asian Arts Institute, 1987)

The Mind's I. Part 3: Exhibition of Works by William Jung, Charles Parness and Jorge Tacla (exh. cat., New York, Asian Arts Institute, 1987)

The Mind's I. Part 4: On the Concept of Self in Transition: Exhibition of Works by Albert Chong, Linda Peer, Alison Saar and Patti Warashina (exh. cat., New York, Asian Arts Institute, 1987)

Public Art in Chinatown: Sculpture, Drawings, Models, Plans (exh. cat. by R. Lee and others, New York, Asian American Arts Centre, 1988)

W. Wei: *The Asian American Movement* (Philadelphia, 1993)

"Asian American Arts Centre," "Basement Workshop" and "Asian American Dance Theatre," *The Asian American Encyclopedia* (New York, 1995)

J. Ault, ed. *Alternative Art New York, 1965–1985: A Cultural Politics Book for the Social Text Collective* (Minneapolis, 2002)

G. Oldham: "Asian American Dance Theatre," *Asian American History and Culture: An Encyclopedia* (Armonk, NY, 2007)

Matico Josephson

Assemblage

Term that typically refers to sculpture made through the additive combination of found objects and materials. It was first coined by Jean Dubuffet (1901–85) in reference to his collages, but later was taken up by William Seitz for his important 1961 exhibition *The Art of Assemblage* at the Museum of Modern Art in New York. In the accompanying catalog, Seitz presented assemblage as any form of artistic or literary juxtaposition, but it has subsequently been applied primarily to sculpture. The practice was developed by Pablo Picasso (1881–1973) around 1912, and it became a central component of movements such as Cubism, Constructivism, Dada and Surrealism as well as Neo-Dada, Nouveau Réalisme, Funk art and other trends during the postwar period. During the early 1960s, the term was often used almost interchangeably with "Junk art" to describe the work of figures such as Arman, John A. Chamberlain, Bruce Conner, Edward Kienholz, Robert Rauschenberg, Richard Stankiewicz and Jean Tinguely (1925–91). In recent years, it has also been applied to the work of artists such as Isa Genzken (*b* 1948), Rachel Harrison (*b* 1966), Thomas Hirschhorn (*b* 1957) and Jessica Stockholder.

Although assemblage-type practices have vernacular precedents throughout the world, they became a key component of the early 20th-century avant-garde with Picasso's famous *Guitar* (1912; New York, MOMA). In this piece, he assembled the rough contours of the musical instrument using wire and pieces of sheet metal. This initial gesture of repurposing found materials was elaborated in the work of other artists as a challenge to accepted notions of sculpture as the transformation of raw materials.

After encountering Picasso's sculptures in 1914, for example, the Ukrainian artist Vladimir Tatlin (1885–1953) began making assemblages from materials such as wood, glass, asphalt and metal. Although the earliest of these were still lifes, he quickly began making non-representational constructions that he often hung in corners to disrupt the illusionism typically characteristic of relief sculpture. These works became the basis for later developments in the Soviet avant-garde, including works by El Lissitzky (1890–1941) and Aleksandr Rodchenko (1891–1956), and demonstrated the Constructivist principle of *faktura* or the derivation of the finished work from the physical properties of its materials.

Dada artists also embraced assemblage as a form of anti-art or as a means of disrupting the separation of art from life. Kurt Schwitters (1887–1948), for example, attempted to revitalize painting through collages and assemblages made from the detritus he gathered in the streets of Hanover. His works in particular provided an important model for practitioners of Junk art during the postwar period. The "assisted ready-mades" of Marcel Duchamp and Man Ray, on the other hand, endeavored to repudiate rather than revitalize painting by rejecting both artisanship and aesthetic experience. Although their found objects were often altered or modified, they usually retained an element of independence within the finished work. In one of his early ready-mades from 1913, Duchamp mounted an inverted bicycle wheel onto the seat of a bar stool, and Man Ray glued a row of tacks to the face of a flatiron in his ominous readymade *Cadeau* of 1921.

During the 1930s, a number of Surrealists similarly took up assemblage as mode of poetic juxtaposition that approximated the logic of dreams. *Object* (sometimes called *Le Déjeuner en fourrure* or *Lunch in Fur*, 1936; New York, MOMA) by Meret Oppenheim (1913–85), for example, featured a fur-covered teacup, saucer, and spoon and *Objet poétique* (1936) by Joan Miró (1893–1983) juxtaposed a stuffed parrot, a hat and a doll's leg in a vertical columnar

arrangement. Along similar lines, the American Joseph Cornell made dioramas featuring suggestive combinations of objects and images that evoked reliquaries or dream spaces. Like much of Surrealist assemblage, these compositions extended the practices of montage and free association into three dimensions.

The Dada revival of the 1950s also brought a reinvigoration of assemblage in the work of artists such as Rauschenberg, Kienholz and Conner. These artists often embraced Junk art assemblage as an answer to the prevailing aestheticism and purism of modernist painting. Their intent was to confound the easy distinctions between art and life that this tradition affirmed. Rauschenberg's so-called "combine paintings," for example, featured objects such as bed sheets, car tires, street signs and taxidermied animals that he salvaged from the streets and shops of downtown New York. These works inspired the critic Leo Steinberg's famous description of the "flatbed picture plane" in which canvas became a surface for the accumulation of ordinary objects instead of a window or a "worldspace" distinct from everyday life. Between 1957 and 1964, the California-based Conner made a series of assemblages by entangling assortments of bric-à-brac and rubbish in webs of women's hosiery. These works lent the practice a distinctly fetishistic and personal character that recalled aspects of Surrealist assemblage but followed a formal logic more akin to the work of Schwitters. During the same period, artists such as Chamberlain and Stankiewicz made "heavy metal" sculptures from industrial refuse and scrapyard debris that operated on a distinctly formalist register. Chamberlain became famous for colorful sculptures comprised of the crushed parts of automobiles, and Stankiewicz welded assemblages from the rusted scrap metal and car parts that he salvaged from junkyards. The work of these artists retained, as Seitz noted, a sense of the "discarded or purloined" in the finished work that seemed to comment on the throwaway culture of postwar America. The French Nouveau Réalistes such as Jean Tinguely and Arman embraced a similar junk aesthetic and cultivated a comparable sense of obsolescence and decay. In his famous *Homage to New York* from 1960, Tinguely took the anti-art sensibility of Neo-Dada assemblage to new lengths in a massive kinetic contraption that self-destructed in the Museum of Modern Art's sculpture garden and emerged as an ironic paean to the "planned obsolescence" in a postwar manufacturing. Arman, on the other hand, displayed "accumulations" of nearly identical objects such as paintbrushes or typewriters, or he piled debris into vitrines that he dubbed "*poubelles*" (garbage cans). Like their counterparts in the United States, these artists challenged the aestheticism and expressionism of postwar painting by turning to what Seitz called the "collage environment" of the postwar consumer society.

In subsequent years, assemblage has been a nearly ubiquitous practice in contemporary art, frequently reflecting the aesthetic and political demands of the moment. During the 1980s and 1990s a number of identity artists embraced assemblage in ways that often suggested vernacular forms and suffused everyday objects with political and social significance. In David Hammons's *High Falutin'* (1990; New York, MOMA), for example, he improvised a basketball-hoop-cum-altarpiece out of found materials and adorned it with light bulbs from a broken chandelier, bicycle inner tubes and wire. In so doing, he provocatively conflated spiritualism and athletics as some of the more salient tropes of African American culture.

The work of Swiss artist Hirschhorn has also recalled the postwar Junk art. Rather than emphasizing material refuse for its own sake, however, he has made large-scale "monuments" or installations that have celebrated intellectual heroes such as Gilles Deleuze, Baruch Spinoza and Georges Bataille or addressed contemporary social and political struggles. These makeshift constructions often enact complex allegories of the current political situation or showcase the most luminous stars of the intellectual constellations of contemporary critical theory.

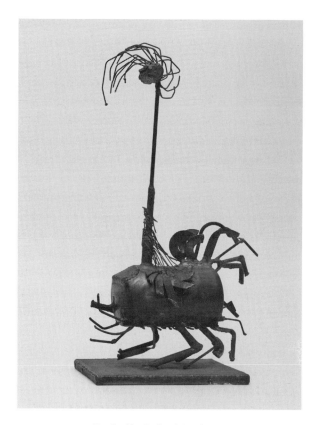

ASSEMBLAGE. *City Bird* by Richard Stankiewicz, iron and steel, h. 659 mm, 1957. PHILIP JOHNSON FUND © MUSEUM OF MODERN ART/ LICENSED BY SCALA/ART RESOURCE, NY

At the same time, artists such as Stockholder in the United States and Genzken in Germany have replaced the predilection for obsolescence and decay with an affinity for pristine, synthetic materials that exude a strikingly formalist preoccupation with color, texture and space. In such works, a new form of aestheticism has displaced the anti-art associations that assemblage once carried. At the same time, both Stockholder and especially Genzken often push the limits of formal coherence and structural cohesion in their work, suggesting that disintegration and decomposition are as much aesthetic as material processes. More generally, however, this broad diversity in present-day assemblage points to everyday experience as the horizon of contemporary artistic practice, and the resulting works suggest that the found object has become a condition for subjective expression in a world defined by material overproduction and consumer excess.

[*See also* Arman; Chamberlain, John A.; Conner, Bruce; Cornell, Joseph; Duchamp, Marcel; Kienholz, Edward; Man Ray; Rauschenberg, Robert; Stankiewicz, Richard; *and* Stockholder, Jessica.]

BIBLIOGRAPHY

L. Alloway: "Junk Culture as a Tradition," *New Forms–New Media* (exh. cat., New York, Martha Jackson Gal., 1960)

The Art of Assemblage (exh. cat. by W. Seitz, New York, MOMA; Dallas, TX, Mus. A.; San Francisco, CA, Mus. A.; 1961–2)

W. Seitz: "Assemblage: Problems and Issues," *A. Int.*, vi (Feb 1962), pp. 26–34

A. Kaprow: *Assemblage, Environments, and Happenings* (New York, 1966)

L. Steinberg: *Other Criteria: Confrontations with Twentieth-Century Art* (Chicago and London, 1972)

J. Elderfield, ed.: *Essays on Assemblage* (New York, 1992)

D. Waldman: *Collage, Assemblage, and the Found Object* (New York, 1992)

Unmonumental: The Object in the 21st Century (exh. cat., New York, New Mus., 2007)

A. J., lxvii/1 (Spring 2008) [Special issue devoted to assemblage]

Tom Williams

Association of American Painters and Sculptors

Group of artists founded in New York in 1911 with the aim of finding suitable exhibition space for young American artists. After preliminary meetings between the painters Jerome Myers (1867–1940), Elmer MacRae (1875–1955), Walt Kuhn (1877–1949) and others, a meeting was held at the Madison Gallery on 16 December 1911, for the purpose of founding a new artists' organization. At a subsequent meeting on 2 January 1912 they elected officers and began to discuss exhibition plans. The president, Julian Alden Weir, who had been elected *in absentia*, resigned, however, and the leadership passed to Arthur B. Davies.

Davies, Walt Kuhn and Walter Pach soon took the lead and developed the plan for a major international exhibition, much to the disapproval of the American Realists associated with Robert Henri; the latter group was interested in gaining broader

exposure to a public that knew only of the major figures associated with the National Academy of Design and saw no reason to include foreign modernists. Davies and his allies, contemptuous of their provincialism, ignored their wishes. The result of the Association of American Painters and Sculptors' plans was the International Exhibition of Modern Art, known as the Armory Show (1913), which introduced European modernism to the art-viewing public and which in the eyes of both the public and the artists stripped the National Academy of Design of its importance. The Association disbanded shortly afterward.

[*See also* Armory Show.]

BIBLIOGRAPHY

M. Brown: *American Painting from the Armory Show to the Depression* (Princeton, 1955)

M. Brown: *The Story of the Armory Show* (New York, 1963/R 1988)

David M. Sokol

Atlanta

Capital city of Georgia. The city of Atlanta, situated in the foothills of the Appalachians, was established in 1837 and has been the capital of the state of Georgia since 1868; the urban area remains today the most populous metropolitan region of the southeastern USA. The city has historically always been linked to transportation and has served as the hub in the Southeast of, successively, the regional railroad system, the interstate highway system and (with one of the busiest international airports in the world) the global air transportation system.

In 1836 few whites had yet settled in the land of the Creek and Cherokee Indians when the Georgia General Assembly voted to build a state railroad linking the Midwest to the Georgia coast (and through the port of Savannah to the Atlantic). The proposed Western and Atlantic Railroad ran from the Tennessee state line to the bank of the Chattahoochee River, and from there connected to branch

rail lines. A small community, initially named Terminus, and in 1847 renamed Atlanta, developed near the river. The "zero milepost," which marked the city's foundation in 1837, is commemorated today by a plaque in Underground Atlanta, positioned at the point where the Indian trails and Atlanta's Piedmont ridges converge.

As a rail center, Atlanta was critical to the Southern Confederacy during the American Civil War (1860–65). The city was burned by General William T. Sherman in July 1864, but was rapidly rebuilt, marking the start of a period of extraordinary development and growth that made Atlanta more the leading city of the New South than a representative city of the rural Old South. Its historic architecture is Victorian and eclectic, with academic classical and Tudor Revival styles predominating.

The late 19th-century city was characterized by the government district near the Italian Renaissance-style State Capitol (1885–9 by W. J. Edbrooke and Franklin P. Burnham) and by the business district that developed south of Central City Park. "Streetcar suburbs" emerged in West End and in Inman Park, the latter occurring after 1889 and where some of the city's best Queen Anne houses remain today. Another streetcar line extended northward from downtown into Midtown to the Peters estate, where Edward C. Peters built the still extant Ivy Hall (1883), designed by Gottfried L. Norrman and recently restored as a cultural arts and writing center by the Savannah College of Art and Design (SCAD). A substantial residential development north of the Peters mansion was characterized by large turn-of-the-century houses along Piedmont Avenue and later middle-class houses and bungalows on parallel streets.

Along the railway line connecting Atlanta to the nearby town of Decatur, two small communities developed: Edgewood (now Candler Park) and Kirkwood, both annexed by Atlanta in 1908. These districts maintain the architectural character of their early years, with large, late Victorian residences and cottages, as well as Craftsman bungalows, the latter

are also evidenced extensively throughout the Virginia Highlands neighborhood and are typical of middle-class housing throughout the USA in the second and third decades of the 20th century.

In Druid Hills, an area designed in the 1890s by Frederick Law Olmsted, larger houses were built after 1908 in the eclectic historicist styles of the American "Academic" tradition: Tudor Revival manor houses, Mediterranean-style villas, Georgian Revival houses based on 18th-century colonial mansions, and various Federal, Colonial Revival, and Neo-classical buildings, all with ample plots of land. With its system of parks and natural landscaping, Druid Hills represents one of Olmsted's finest and most complete designs.

During these same years, many of Atlanta's most wealthy families established even larger-scaled country houses in the Buckhead area, encouraging the continuing growth of the city northward. The houses lining the Peachtree Battle Parkway (1911) by Carrère and Hastings are not unlike many built in Druid Hills, but the country houses of Cooper and Cooper (Glenridge Hall, 1926–9), Pringle and Smith (Villa Juanita, 1922–4), Neil Reid (McDuffie House, 1922) and Philip Shutze (Calhoun House, 1922–3, and Swan House, 1926–8) introduced a new scale of elegance and new dimensions of historicism. In Druid Hills only the Candler Mansions (Callanwolde, 1917–21 by Henry Hornbostel, and Lullwater House, 1925–6, by Ivey and Crook) compare. At a smaller scale, houses built in the 1920s and 1930s filled automobile suburbs, such as Morningside and Garden Hills, where model houses designed by local architects inspired a host of derivative, so-called "dream houses" constructed by developers and anonymous builders.

The late 1920s and 1930s witnessed the first populist phase of Modernism in Atlanta in the city's few Art Deco skyscrapers built by P. Thornton Marye (Southern Bell Telephone Company Building, 1929) and Pringle and Smith (William Oliver Building, 1930). A more functionalist Modernism emerged in the late 1940s and 1950s in work by Paul M. Heffernan, FABRAP and Stevens and Wilkinson.

However, the modern image of Atlanta was essentially formed in the 1960s and after, particularly in the work of entrepreneurial developer–architect John C. Portman Jr. Portman designed the series of buildings constituting Peachtree Center, a mixed-use complex built over four decades beginning with his 1960 project for the Atlanta Merchandise Mart, and eventually including office towers, apparel and computer marts and three major hotels. The Hyatt Regency (1966–7) was his archetypal atrium hotel, built around a pioneering 22-story lobby conceived as a festival courtyard space and accented by jet-age styled elevator cars rising dramatically up the inner edge of the atrium. This work established Portman's, as well as Atlanta's, international reputation for architecture. He followed the Hyatt project with the Westin Peachtree (1976), a 70-story cylindrical glass hotel, which was the world's tallest hotel at the time, and in 1985 with the Marriott Marquis, where a 50-story atrium offered even more theatrical spatial excitement. These hotels and other developments of convention and trade facilities, most notably Thompson Ventulett and Stainback's Omni International (1975–6) and the Georgia World Congress Center (1975–2002; built in four phases), made Atlanta one of the leading convention centers of the United States.

The cultural life of Atlanta is enhanced by the presence of a number of museums, including the Emory University Museum of Art and Archaeology (1984, 1995) by Michael Graves and the High Museum of Art (1980–83) by Richard Meier, with a notable expansion (2000–05) by Renzo Piano. Other prominent architects with work in Atlanta include Paul Rudolph (William Cannon Chapel, Emory University, 1979–81), Philip Johnson (IBM Tower, 1985–7, and 191 Building, 1987–90), I. M. Pei (Gulf Oil Building, 1950–51 and Wildwood Plaza, 1991) and Arquitectonica (Philips Arena, 1996–9). In 1996 the city was the focus of international attention when it hosted the summer Games of the XXVI Olympiad.

[*See also* Craftsman Movement.]

BIBLIOGRAPHY

Atlanta: A City of the Modern South (New York, 1942)

Atlanta Architecture: The Victorian Heritage (exh. cat. by E. A. M. Lyon, Atlanta, GA, Hist. Soc. Mus., 1976)

E. Stanfield and others: *From Plantation to Peachtree: A Century and a Half of Classic Atlanta Homes* (Atlanta, 1987)

E. Dowling: *American Classicist: The Architecture of Philip Trammell Shutze* (New York, 1989)

P. Riani, P. Goldberger and J. Portman: *John Portman* (Milan, 1990)

W. Mitchell Jr.: *Classic Atlanta: Landmarks of the Atlanta Spirit* (New Orleans, 1991)

R. M. Craig: *Atlanta Architecture: Art Deco to Modern Classic, 1929–1959* (Gretna, LA, 1995)

R. Koolhaas and others: *Atlanta* (Barcelona, 1996)

F. Allen: *Atlanta Rising* (Atlanta, 1996)

A. Ambrose: *Atlanta: An Illustrated History* (Athens, GA, 1996)

R. Hartle Jr.: *Atlanta's Druid Hills: A Brief History* (Charleston, SC, 2008)

Robert M. Craig

Atnafu, Elisabeth Tariqua

(*b* 8 Dec 1956), Ethiopian painter, installation artist, graphic designer and writer, active in the USA. She grew up in Addis Ababa in a family of painters before moving to the USA. She graduated from Howard University, Washington, DC, with a BFA in painting (1975), returning in 1994 for an MFA. Her early works, based on dreams or visions, have richly textured surfaces. In the 1980s she abandoned her early palette of reds, ochres and greens for one of purples and blues. Later paintings depict an urban environment and frequently evoke the feeling of dislocation and nostalgia that comes from living in a country not one's own. Her use of themes and motifs from myriad cultures (including those of Ethiopia and Latin America) comes out of her experiences as a diasporic subject as well as the lives of the women around her. Her pieces often tell their stories, as in the *Dream Dancers* series (1999), in which animated figures are depicted in a loose, linear style inspired by New York

women seeking treatment for drug addiction. Although still producing mixed-media paintings, in the mid-1990s Atnafu began creating shrine-like installation pieces emphasizing the importance of personal experiences for understanding the world. She received the United Nations Women's Artists Award (1976). Her works appear on the album covers of Ornette Coleman and Charles Hayden and are owned by the Paris Museum of Prints and Photography and the Museum of Modern Art in Mexico.

BIBLIOGRAPHY

J. Kennedy: *New Currents, Ancient Rivers: Contemporary African Artists in a Generation of Change* (Washington, DC, 1992), pp. 126, 138–9

S. Hassan: "Magical Realism: Art as Ritual in the Work of Elisabeth Tariqua Atnafu," *Gendered Visions: The Art of Contemporary Africana Women Artists*, ed. S. Hassan (Trenton, NJ, 1997), pp. 39–43

E. Harney: *Ethiopian Passages: Contemporary Art from the Diaspora* (London; Washington, DC: N. Mus. Afr. A., Smithsonian, 2003), pp. 38–40, 72–5

Carol Magee

Atterbury, Grosvenor

(*b* Detroit, MI, 7 July 1869; *d* Southampton, NY, 18 Oct 1956), architect, urban planner and writer. Atterbury studied at Yale University, New Haven, CT, and traveled in Europe. He studied architecture at Columbia University, New York, and worked in the office of McKim, Mead & White before completing his architecture studies at the Ecole des Beaux-Arts in Paris. Atterbury's early work consisted of suburban and weekend houses for wealthy industrialists, such as the Henry W. de Forest House (1898) in Cold Springs Harbor on Long Island, NY. De Forest was a leader in the philanthropic movement to improve workers' housing, an interest that Atterbury shared; through him Atterbury was given the commission for the model housing community of Forest Hills Gardens, NY, begun in 1909 under the sponsorship of the Russell Sage Foundation; the co-planners and landscape designers were the brothers

John Charles Olmsted (1852–1920) and Frederick Law Olmsted Jr. (1870–1957), the sons of Frederick Law Olmsted. Atterbury developed a system of pre-cast concrete panels to build a varied group of multiple units and town houses suggesting an English country hamlet. He continued his research into prefabrication largely at his own expense throughout his life.

An active writer on planning, housing and industrialized methods of construction, Atterbury put his views into practice on two other projects: Indian Hill (1915–16), a community of 58 single-family houses for employees of the Norton Company, Worcester, MA, and the new railway town of Erwin, TN, planned for an eventual population of 40,000 and begun in 1916. In his work for these and other housing groups, Atterbury used a traditional architectural idiom and a level of craftsmanship that matched that of his residences for the wealthy.

WRITINGS
Model Towns in America (New York: National Housing Association, 1913/R from Scribner's Magazine, 52 (July 1912): 20–35)
The Economic Production of Workingmen's Homes (New York, 1930)

BIBLIOGRAPHY
DAB Suppl.
J. L. Chamberlain: "Atterbury, Grosvenor: Yale B.A. 1891," *Universities and Their Sons; History, Influence and Characteristics of American Universities.* (Boston, 1898–1900, v. 4)
"The Work of Grosvenor Atterbury," *Amer. Archit.*, xliv (Aug/Sept 1908), pp. 68–72, 76–80
L. Doumato: *Grosvenor Atterbury: A Bibliography* (Monticello, IL, 1989)
M. Crawford: *Building the Workingman's Paradise: The Design of American Company Towns* (London, 1995)
P. Pennoyer, A. Walker and J. Wallen: *The Architecture of Grosvenor Atterbury* (New York, 2009)

Leland M. Roth

Atwood, Charles B.

(*b* Charlestown, MA, 18 May 1849; *d* Chicago, IL, 19 Dec 1895), architect. Atwood received his architectural training in the offices of Eldridge Boyden (1819–96) in Worcester, MA, and Ware & Van Brunt in Boston, with a year's study (1869–70) in the Lawrence Scientific School at Harvard University, Cambridge, MA. In 1872 he set out on his own, designing the State Mutual Assurance Building (1872) in Worcester, MA, and the Holyoke City Hall (1874–5), MA. In 1875 he settled in New York, working for Christian Herter's firm of decorators, Herter Brothers, and perhaps also for McKim, Mead & White. Between 1879 and 1881 he assembled a small team of draftsmen to execute the design of the William Henry Vanderbilt house on Fifth Avenue (destr.), in collaboration with Herter Brothers and the architect John Butler Snook. After the death of John Wellborn Root in January 1891, Root's partner Daniel H. Burnham engaged Atwood as chief architect of the World's Columbian Exposition in Chicago, which opened on 1 May 1893, and then made him a 27% partner in his firm, D. H. Burnham & Co. In these capacities he produced his most admired designs: the Fine Arts Building at the Exposition (rebuilt as the Museum of Science and Industry), the annex of the Marshall Field Store (1892–3; interior altered) in Chicago, the Reliance Building (1891–5), Chicago and the Ellicott Square Building (1894–5), Buffalo, NY. His designs were not particularly original but rather in whatever style was practical or popular at the time; a crude Néo-Grec for the Vanderbilt houses, Beaux-Arts classical for the Fine Arts Building, Gothic Revival for the Reliance Building and Renaissance Revival for the Field annex and Ellicott Square Building. His use of drugs caused him to be dismissed from Burnham's on 10 December 1895 and to commit suicide nine days later.

[*See also* Burnham, Daniel H.]

BIBLIOGRAPHY
D. H. Burnham: "Charles Bowler Atwood," *Inland Architect & News Rec.*, xxvi (1906), pp. 56–7
A. L. Van Zanten: "The Marshall Field Annex and the New Urban Order of Daniel Burnham's Chicago," *Chicago Hist.*, xi/3 (1982), pp. 130–41

David van Zanten

Audubon, John James

(b Les Cayes, Santo Domingo [now Haiti], 26 April 1785; d New York State, 27 Jan 1851), naturalist, painter and draftsman of French–Creole descent. Brought up in a French village near Nantes, Audubon developed an interest in art and natural science, encouraged by his father and the naturalist Alcide Dessaline d'Orbigny. He is thought to have moved to Paris by 1802 to pursue formal art training; although the evidence is inconclusive, Audubon claimed to have studied in the studio of Jacques-Louis David.

In 1803 Audubon traveled to the USA to oversee Mill Grove, an estate owned by his father on the outskirts of Philadelphia, PA. Uninterested in practical affairs, he spent his time hunting and drawing birds. His drawings (many in Cambridge, MA, Harvard U., Houghton Lib.) from this period are executed primarily in pencil and pastel. They are conventional specimen drawings that define individual birds in stiff profile with little or no background. A number of these works, however, bear notations from Mark Catesby's *Natural History of Carolina, Florida and the Bahama Islands* (1731–47). Catesby's etchings, which were some of the first natural history illustrations to stress the interaction between organisms and their habitats, clearly impressed Audubon, and soon his work began to address the complex relations that exist between birds and their environments. He also began to use watercolor, the medium he employed most regularly as a mature artist.

In 1807 Audubon moved to Louisville, KY, where his passion for the study and depiction of birds accounted, at least in part, for the failure of a series of business ventures. In 1810 he was visited by the Philadelphia naturalist–artist Alexander Wilson, who was looking for subscribers for his illustrated *American Ornithology* (1808–14). Audubon, who believed himself the better artist, did not subscribe, but Wilson's work undoubtedly inspired him to begin his own large-scale publication on American birds.

Having been declared bankrupt in 1819, Audubon moved to Shippingsport, KY, where he began to draw portraits in chalk. The following year he briefly ran a drawing school in Cincinnati, OH, and also worked for the Western Museum at Cincinnati College (now the Museum of Natural History), where he stuffed animal specimens and drew landscape backgrounds for museum displays. It was during this time that he dedicated himself to the publication of his own watercolors of American birds. In October 1820, accompanied by his student, Joseph Mason (1807–83), Audubon left for a three-month collecting and drawing expedition down the Ohio River and the Mississippi River. At the end of this trip, in 1821 he explored the Louisiana bayous in search of birds; he painted each new species, and Mason supplied detailed backgrounds for over 50 of the watercolors. In 1824 Audubon attempted to publish his pictures in Philadelphia, but he met with a disappointing reception from the scientific community there, due partly to his own arrogance and partly to the community's loyalty to Wilson. For the next two years he continued to observe and paint the birds of the southern states.

In May 1826 Audubon left for England, where he exhibited his watercolors at the Liverpool Royal Institution to great acclaim. To increase his income, he sold a number of copies of his works in oil. He also exhibited at the Royal Society of British Artists, London, the Royal Scottish Academy and the Royal Institution of Edinburgh. In November 1826 Audubon entered into an agreement with the engraver William Home Lizars to publish his watercolors as hand-colored engravings. After several months, however, with only ten plates completed, the contract was terminated, and Audubon was compelled to find a new publisher. The engraver Robert Havell Jr. undertook the project, and by the autumn *The Birds of America* was under way.

While overseeing the production of the plates for *The Birds of America*, Audubon worked on his accompanying text, the *Ornithological Biography* (1831–8). He also commissioned Joseph Bartholomew Kidd (1808–89) to copy his watercolors in oil.

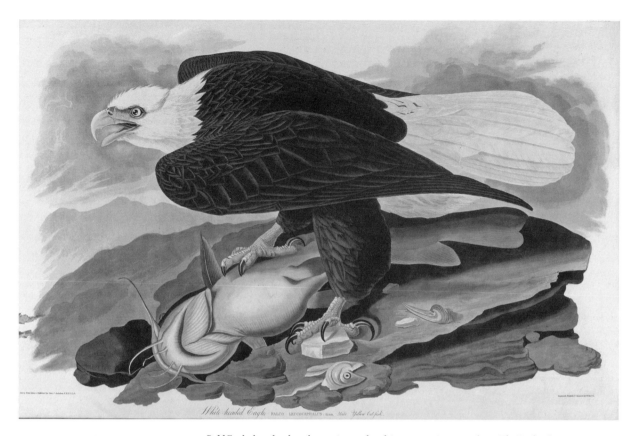

JOHN JAMES AUDUBON. *Bald Eagle*, hand-colored aquatint and etching, 970 × 648 mm, from *The Birds of America*, vol. 1, 1827–30. Daniel J. Terra Collection, 1984, Terra Foundation for American Art, Chicago/Art Resource, NY

From 1831 to 1833 Audubon received from Kidd at least 94 copies of watercolors for the first and second volumes of *The Birds of America*. These, however, were unsigned, and have consequently been difficult to distinguish from copies painted by Audubon himself and by his sons Victor Gifford Audubon (1809–62) and John Woodhouse Audubon (1812–60), both accomplished artists.

Audubon returned to America to seek new subjects, in 1829–30 in New Jersey and Pennsylvania and in 1831 in the Florida Keys, accompanied by the artist George Lehman (*d* 1870). In Charleston, SC, he befriended the Rev. John Bachman (1790–1874), a naturalist whose sister, Maria Martin (*d* 1863), provided watercolors of plants and insects for the backgrounds of approximately 35 plates. Audubon continued his explorations in Labrador, Newfoundland, with his son John, returning to England in 1834.

The Birds of America was completed in early 1839 as a double elephant folio. Issued by subscription in 87 parts, the set contains 435 hand-colored prints of 1065 life-sized birds representing 489 species. Havell produced these prints by a complex process of engraving, etching and aquatint. The original watercolors for the set belong to the New York Historical Society, New York. The watercolors and the prints reflect the growing interest of naturalists to define species not only according to anatomical traits but also according to characteristic behavioral patterns. Audubon's works generally present several birds from the same species engaged in such typical group activities as hunting, feeding, courting or caring for their young. Foreshadowing Darwinism, many of Audubon's most dramatic images openly challenge the traditional conception of a benevolent Creation by pitting predators against prey and even

showing members of the same species confronting one another in a violent struggle for survival.

Between 1840 and 1844 a seven-volume octavo version of *The Birds of America* was produced by the Philadelphia firm of J. T. Bowen. This publication, overseen by John Woodhouse Audubon, contains 500 lithographs of the original prints, as well as prints of several new birds. In 1842 Audubon settled on the Hudson River, at an estate called Minnie's Land, and began work on *The Viviparous Quadrupeds of North America* (150 plates, 1845–8). His sons assisted, with John Woodhouse Audubon producing more than half the studies for the 150 hand-colored lithographs. Seeking new specimens for this publication, Audubon made his last extended expedition along the upper Missouri and Yellowstone rivers in 1843, accompanied by John Bachman and the young naturalist Isaac Sprague (1811–95). Bachman wrote all of the text that accompanied the plates for *The Viviparous Quadrupeds* in the volumes that appeared between 1846 and 1854.

[*See also* New Orleans.]

WRITINGS AND PRINTS

The Birds of America, from Original Drawings Made during a Residence of 25 Years in the United States, 4 vols (London, 1827–39); rev. in 7 vols (Philadelphia and New York, 1840–44/R 1967)

My Style of Drawing Birds (MS, 1831); intro. M. Zinman (New York, 1979)

Ornithological Biography, 5 vols (Edinburgh, 1831–8) [text to accompany *The Birds of America*]

with J. Bachman: *The Viviparous Quadrupeds of North America* (New York, 1845–8 [pls], pp. 1846–54 [text] /R 3/1856)

L. Audubon, ed.: *The Life of John James Audubon, the Naturalist* (New York, 1869)

H. Corning, ed.: *Letters of John James Audubon, 1826–1840* (Boston, 1930)

A. Ford, ed.: *The 1826 Journal of John James Audubon* (New York, 1987)

BIBLIOGRAPHY

M. Audubon: *Audubon and His Journals*, 2 vols (New York, 1897/R 1972)

W. Fries: "Joseph Bartholomew Kidd and the Oil Paintings of Audubon's *Birds of America*," *A. Q. [Detroit]*, xxvi (1963), pp. 339–49

A. Ford: *John James Audubon* (Norman, OK, 1964)

A. Coffin: "Audubon's Friend: Maria Martin," *NY Hist. Soc. Q.*, xlix (1965), pp. 29–51

A. Adams: *John James Audubon: A Biography* (New York, 1966)

W. Fries: *The Double Elephant Folio: The Story of Audubon's "Birds of America"* (Chicago, 1973)

J. Chancellor: *Audubon: A Biography* (New York, 1978)

John James Audubon and His Sons (exh. cat., ed. G. Reynolds; New York U., Grey A.G., 1982)

C. E. Jackson: *Bird Etchings: The Illustrators and Their Books, 1655–1855* (Ithaca and London, 1985), pp. 230–46

A. A. Lindsey: *The Bicentennial of John James Audubon* (Bloomington, IN, 1985)

J. Burroughs: *John James Audubon* (New York, 1987)

A. Ford: *John James Audubon: A Biography* (New York, 1988)

R. Tyler: *Nature's Classics: John James Audubon's Birds and Animals* (Orange, TX, 1992)

A. Blaugrund and R. F. Snyder: "Audubon: Artist and Entrepreneur," *Mag. Ant.*, cxliv (1993), pp. 672–81

A. S. Blum: *Picturing Nature: American Nineteenth-century Zoological Illustration* (Princeton, 1993), pp. 88–118

T. E. Stebbins: "The Birds of America: John James Audubon," *F.A. & Ant. Int.*, vi/6 (1993), pp. 30–5

John James Audubon: The Watercolors for the Birds of America (exh. cat., ed. H. Hotchner and others; Washington, DC, N.G.A., 1993); review by E. Gibson in *New Criterion*, xii (1993), p. 59

B. Galimard Flavigny: "Les Livres d'oiseaux," *Obj. A.*, cclxxix (1994), pp. 34–43

S. May: "John James Audubon: Sojourn in Texas," *Southwest A.*, xxiv (1994), pp. 80–84

M. Welch: *The Book of Nature: Natural History in the United States, 1825–1875* (Boston, 1998)

Amy Meyers

Augur, Hezekiah

(*b* New Haven, CT, 21 Feb 1791; *d* New Haven, CT, 10 Jan 1858), sculptor. Although as a youth Augur showed talent for handling tools, his father, a joiner and carpenter, discouraged him from becoming a wood-carver. After opening a fruit shop in New Haven, he began carving musical instruments and furniture legs for a local cabinetmaker. With his invention of a lace-making machine, he was able to settle his business debts and devote himself entirely to sculpture.

About 1825 Samuel F. B. Morse encouraged Augur to try working in marble. Among his earliest attempts in this medium was a bust of *Professor Alexander Metcalf Fisher* (c. 1825–7; New Haven, CT, Yale U. A.G.), which was exhibited in 1827 at the National Academy of Design in New York. The impact of the Neo-classical style is clearly evident in his most ambitious work, *Jephthah and His Daughter* (c. 1828–30; New Haven, CT, Yale U. A.G.), a pair of free-standing half life-size marble figures. The treatment of the heads shows Roman influence, which Augur must have absorbed from engravings; this is borne out by the detailed work on Jephthah's armor. The bold handling of the hair and drapery reveals his experience as a wood-carver. In 1834 Augur received a commission to execute a marble bust of Chief Justice Oliver Ellsworth (completed 1837) for the Supreme Court Room in the US Capitol, Washington, DC. Four years later he was commissioned to design bronze medals for the bicentennial of New Haven's settlement; this is his last known work.

BIBLIOGRAPHY

H. W. French: *Art and Artists in Connecticut* (New York, 1879), pp. 47–9

G. Heard Hamilton: *Hezekiah Augur: An American Sculptor, 1791–1854* (MA thesis, New Haven, CT, Yale U., 1934)

O. Larkin: "Early American Sculpture: A Craft Becomes an Art," *Antiques*, lvi (1949), pp. 178–9

W. Craven: *Sculpture in America* (Newark, 1968/R New York, 1984), pp. 92–4

Donna J. Hassler

Aust, Gottfried

(*b* Heidersdorf, 5 April 1722; *d* Lititz, PA, 28 Oct 1788), potter of German birth. Although originally trained as a weaver, Gottfried was apprenticed to a potter in Herrnhut, Germany, where the Moravian Brethren were centered. In 1754 he arrived in Bethlehem, PA, the Brethren's first colonial outpost. After ten months' work at the pottery there under master Michael Odenwald, Aust went to the new settlement in Bethabara, NC, where he established its first pottery. In 1768 the pottery was moved to another new settlement at Salem, NC. All the wares necessary for daily life were made in Aust's potteries, including large stoves. Aust's most distinctive work is found on decorative plates embellished with floral or geometric ornament delineated in green, red, brown, white and dark brown slips (e.g. earthenware dish used by Aust as a trade sign, diam. 555 mm, 1773; Winston-Salem, NC, Old Salem; see Bivins, p. 224). He trained a number of apprentices who worked in the Piedmont region, thereby creating a "school" of his style that is associated with the area.

[*See also* Ceramics.]

UNPUBLISHED SOURCES

Raleigh, NC, North Carolina Department of Archives and History [MS of *The Ceramic Types and Forms of the Potter, Gottfried Aust of Bethabara, North Carolina, 1755–1771* by S. A. South, 1966]

BIBLIOGRAPHY

J. F. Bivins: "Slip-decorated Earthenware in Wachovia: The Influence of Europe on American Pottery," *Amer. Cer. Circ. Bull.*, i (1970–71), pp. 93–106

J. F. Bivins: *The Moravian Potters in North Carolina* (Chapel Hill, NC, 1972)

M. Hewitt: "Stuck in the Mud: The Folk Pottery of North Carolina," *Cer. Rev.*, cli (Jan–Feb 1995), pp. 30–33

S. A. South: *"Historical Archaeology in Wachovia"* Excavating Eighteenth-Century Bethabara and Moravian Pottery (New York, 1999)

Ellen Denker

Austen, Alice

(*b* Rose Bank, Staten Island, NY, 17 March 1866; *d* New York, 9 June 1952), photographer. Introduced to photography in 1876 by her uncle, Oswald Muller, (Elizabeth) Alice Austen (Munn) quickly learned the complexities of working with a variety of cumbersome cameras, dry-plate negatives and contact printing. As an avid amateur photographer, she documented a social history of a bygone era. Her work, dating between the 1880s and 1930s, recorded a charming portrait of the genteel activities of upper

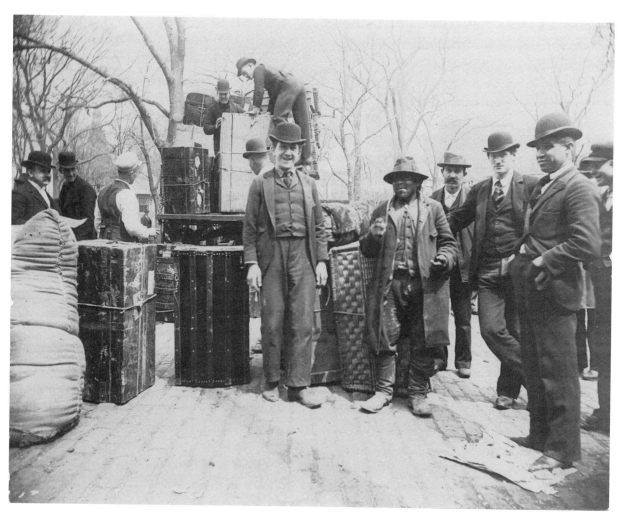

ALICE AUSTEN. *Immigrants*, gelatin silver print, 93 × 118 mm, 1896. Miriam and Ira D. Wallach Division, Photography Collection © The New York Public Library/Art Resource, NY

middle-class society on Staten Island. Although her photographs primarily documented the everyday life of the wealthy inhabitants and friends of her home, Clear Comfort, which overlooked New York's Upper Bay, she also produced a challenging series of images of New York's Lower East Side. These "street types" were published as a portfolio by the Albertype Company in 1896.

Unlike those of Jacob A. Riis and Lewis W. Hine, Austen's images of immigrants revealed no concern for social reform, but evidenced a hesitancy and curiosity experienced by both photographer and subject. Her life of stability was abruptly ended by the Stock Market Crash of 1929. She was eventually forced to sell all of her possessions and ended up living in the City Farm Colony, a local poorhouse. With the aid of the Staten Island Historical Society, which had preserved her negatives and prints, and researcher Oliver Jensen, her photographs were sold to several publications, particularly *Life* and *Holiday*, bringing her fame at the age of 85.

BIBLIOGRAPHY

"The Newly Discovered Picture World of Alice Austen: Great Woman Photographer Steps Out of the Past," *Life* (24 Sept 1951), pp. 137–44

H. Humphries and R. Benedict: "The Friends of Alice Austen: With a Portfolio of Historical Photographs," *Infinity* (July 1967), pp. 4–31

A. Novotny: *Alice's World: The Life and Photography of an American Original: Alice Austen, 1866–1952* (Old Greenwich, CT, 1976)

S. Khoudari: *Looking the Shadows: The Life and Photography of Alice Austen* (diss., New York, Sarah Lawrence College, 1993)

M. Kreisel: *American Women Photographers: A Selected and Annotated Bibliography* (Westport and London, 1999)

J. L. Roscio: *Unpacking a Victorian Woman: Alice Austen and Photography of the Cult of Domesticity in Nineteenth Century America* (diss., Buffalo, NY, State U., 2005)

Fiona Dejardin

Austin, Henry

(*b* Hamden, CT, 12 April 1804; *d* New Haven, 12 Nov 1891), architect. Austin was based in New Haven, from where his work and influence spread over much of Connecticut, with two major forays out of state: a speculative development (*c.* 1840) in Trenton, NJ, and the lavish Morse–Libby house (1859) in Portland, ME. After neglect in the Colonial Revival period, he was later recognized as Connecticut's foremost 19th-century architect. His work is mainly associated with the Villa style of the 1840s and 1850s in its many variations, Grecian, Italian, Tuscan, Renaissance and Oriental, but continuing, with less intensity, through the Victorian Gothic and French Empire styles of the 1860s and 1870s. To these popular fashions of his day, Austin brought a personal interpretation and a sometimes startling imagination, distorting and exaggerating familiar proportions with long, dripping brackets and excessively broad, flat eaves, modeling surfaces with the deep shadows of strangely jutting pediments and short, square columns and breaking the skyline with roof structures topped by exotic little finials from the Orient.

Austin trained as a carpenter in the environs of New Haven and in the 1820s moved to the city, where he acted as agent for the New York firm of Ithiel Town and Alexander Jackson Davis while trying to start a practice of his own. Davis had a strong influence on his first attributed building, a Grecian villa of *c.* 1840 (destr.), and on his first major commission, a Gothic library (1842; now Dwight Chapel, Yale University, New Haven) for Yale College. The library was followed in 1845 by another major commission, the monumental Egyptian Revival style gate for the Grove Street Cemetery, New Haven. With these two projects, both highly visible and both in the vanguard of fashion, Austin's reputation was established. Over the next 20 years his output was enormous. Outstanding works include villas for the old New Haven gentry on Hillhouse Avenue and for the new manufacturing class around Wooster Square; three brownstone banks in the 1850s (all destr.); the Moses Beach House (1850; destr.) in Wallingford, CT, and New Haven City Hall (1861), a precocious High Victorian Gothic design praised by critics then and since (destr. 1977 except for facade and tower; stairwell and cast-iron stair restored 1994). The Willis Bristol House (1845) is a rare example of an oriental villa, while the Dana House (1848), New Haven, uses such exotic decorations as Indian plant columns and fringed cornices to embellish the basic cube of the Italian villa style, a formula that became an Austin trademark. The climactic building of this period is the New Haven Railroad Station (1848–9, destr. 1894), considered one of the most fanciful buildings ever erected in New England—a long, slim structure suggesting the proportions of a train, set directly over the tracks and topped with bizarre stupa-like forms.

After the American Civil War, patronage declined and Austin's work became tamer. However, he retained his old verve in two late projects: Trinity Home (1868; mostly destr.), New Haven, an urban compound consisting of town houses framing the entrance to a tree-planted court containing chapel, school and home; and his swansong, the J. W. Clark seaside cottage at Stony Creek, Branford, CT (1879), with a high red-roof tower that is one of the landmarks on the Connecticut shore.

Austin was among the first architects in Connecticut to establish a home-grown professional practice employing numerous draftsmen, which affected the

next generation of architects, including David R. Brown, Rufus G. Russell (1823–96) and Leoni Robinson (1852–1923). His office exemplifies the transition from the builder–architects at the start of the 19th century to the local professional firms at its end.

[*See also* Architecture.]

BIBLIOGRAPHY
Macmillian Enc. Archit.
E. M. Brown: *New Haven: A Guide to Architecture and Urban Design* (New Haven, 1976)
James F. O'Gorman: *Henry Austin: In Every Variety of Architectural Style* (Middletown, CT, 2009)

Elizabeth Mills Brown

Automatism

Term applied to manual and psychological techniques in painting and drawing that flourished in the 1940s and 1950s. André Breton (1896–1966), the founder of the Surrealist movement in France, defined psychic automatism in his *First Surrealist Manifesto* (1924) as a form of free association where artists could express thoughts free of the control of reason, aesthetic or moral considerations. It was this aspect of Surrealism that was to have such a lasting impact on New York painters and sculptors. When Surrealists Breton, Roberto Matta (1911–2002), Gordon Onslow Ford (1852–1901), André Masson, Max Ernst and others arrived in New York during World War II to escape the Nazi onslaught, their ideas had a great impact on New York school artists, including Jackson Pollock, William Baziotes, Robert Motherwell, Arshile Gorky and David Hare. Automatism became a key to their artistic practices. Although many American artists knew about automatism in the 1930s, the concept grew in significance subsequent to the arrival of the Europeans. On a deep level, automatism meant the ability to approach the canvas without preconceived ideas, like a magic mirror, to use a common title of the 1940s, and allow the automatic process itself to generate images. It was

seen in Freudian and Jungian terms as a key to the unconscious and was a powerful tool for inspiration.

When the Surrealists arrived in New York they met the American artists in different venues. Peggy Guggenheim, for example, opened her gallery, Art of This Century, in the fall of 1942 where she showed both Surrealist and American artists such as Pollock, Baziotes and Motherwell. Other loci of contact involved gatherings with Matta and Ford. While Ford delivered well-attended lectures at the New School in 1941, Matta decided to organize his own Surrealist group in 1942 highlighting the role of automatism. He enlisted Baziotes and Motherwell to help with this endeavor and Pollock, Gerome Kamrowski (1914–2004) and Peter Busa (1914–85) joined the ranks. They met for several afternoons and worked together in Matta's studio. Although Gorky did not join the group, he too was reportedly influenced by Matta's notions on automatism. In one often-cited exchange, Matta accused him of painting too thickly to which Gorky rejoined that it was Matta who painted too thin. Nonetheless, Gorky's art moved in the direction of looser application of paint while still retaining nature references. In the 1940s the effects of Surrealist automatism could also be seen in the works of Mark Rothko and Adolph Gottlieb, although they did not take part in Matta's gatherings.

Automatism was a broad concept, but many Americans translated it into the employment of automatic techniques. It was Motherwell who was to coin the term "plastic automatism" to highlight the importance of the artist's medium; a preference which separated them from the Surrealists and led to the breakthroughs in abstraction associated with Abstract Expressionism. American artists invented various practices to experiment with automatism. Jackson Pollock's methods of dripping and pouring paint are perhaps the most well known and were inspired by automatism as well as accidental methods of pouring and spraying paint learned in 1936 at the experimental workshop run by David Alfaro Siqueiros (1896–1975) in New York. Pollock also knew of

Navajo sand painting and watched Native American painters pouring sand in the creation of their ceremonial art at the 1941 Museum of Modern art exhibition, *Indian Art of the United States*. He tried out variations of these techniques in the winter of 1940 in a collaborative painting with Baziotes and Kamrowski produced in Kamrowski's studio

Other New York artists tried their hands at automatism. Jimmy Ernst, for example, used a technique, which he called "sifflage," to blow webs of thin oil paint onto the canvas. A devotee of jazz, he often related automatism to the improvisatory component of the music. Boris Margo (1902–95), who had emigrated from Russia to America, had in the 1930s used a process called decalcomania, which entailed laying paper over a thickly painted wet canvas, and then pulling it off, leaving an encrusted and provocative surface. Whereas many of the Surrealist artists used these techniques, notably Ernst with decalcomania or Masson who dripped paint and sand, most often the Europeans turned their forms into recognizable imagery and used automatism as a vehicle for their expression of the marvelous. They often populated their paintings with fantastical creatures embedded in a deep space analogous with the unconscious. The Americans, however, moved more and more into the direction of abstraction and automatism engendered a form of dynamic energy.

Paint was the natural media for automatism given the potential ease of its application. Pencil or crayon fit this rubric as well. Artists, however, found ways of engaging automatism when working in printmaking, photography and sculpture. The English artist S. W. Hayter was renowned for furthering automatic techniques in printmaking. He was devoted to pushing the boundaries of printmaking through the use of technical experimentation. He reopened his famous Atelier 17 in New York in 1940 where automatic practices were developed, such as pressing fabrics or leaves into the soft ground to create surprising textures in etchings or applying ink with various levels of pressure. Among the Americans who worked there were Baziotes, Motherwell, Pollock, Ernst, Gottlieb and Alexander Calder. Hayter struggled to make printmaking into an intuitive process. His workshop, with its inspirational techniques, had a widespread effect on American printmaking for decades to follow.

As the editor of *VVV*, the Surrealist magazine in New York, David Hare was perhaps the closest of the Americans to the Surrealists and most passionate in his application of their ideas to his photographic and sculptural practices. In photography he developed a technique called "heatage," where accidental forms arise from the process of melting negatives. In his sculptural activity Hare engaged automatism but he always considered the practice to be less about techniques than about a creative process that sought the free play of the imagination. He worked intuitively and allowed the sculptural forms to change accordingly, in a metamorphic process that he referred to as a "magician's game." The resulting works had moving parts and in that sense were "living creatures," as close to Surrealism as they were to the existential philosophy of his friend and advocate, the philosopher Jean-Paul Sartre.

The Surrealist automatic process with its rich association of contradictory ideas naturally engendered syncretic forms and conflated imagery, which the New York artists connected to what they saw as a totemic primitive world. Concomitant with an evolutionary model, automatism became a metaphor for growth as a microscopic/macroscopic world of germination. Automatism in the 1940s also entailed an atavistic component that conflated the depths of the mind with the works of early man, hence the artists' frequent visits to the prehistoric collection of the Museum of Natural History in New York and the ubiquity of titles referring to the primordial or mythic world. Unfortunately, this led to an outmoded anthropological and Jungian discourse popular in the 1940s on the "primitive" as representing the ancestral nature of humanity accessible to the artist through an instinctual process.

Alternative scholarship has discussed more transgressive sides of Surrealism in relation to the writings of Georges Bataille or to an unconscious that is more conflicted and less liberating than Breton's Surrealism. Pollock's drippings are paired with drooling, a war-shattered city, nuclear holocaust or Warhol's urine paintings. In these controversial readings Pollock's poured paintings have less to do with the free play of the unconscious than the aggressiveness and formlessness of the repressed. For illustration, see color pl. 1:VI, 2.

[*See also* Abstract Expressionism; Baziotes, William; Ernst, Jimmy; Gorky, Arshile; Hare, David; Hayter, S. W.; Motherwell, Robert; Pollock, Jackson; *and* Surrealism.]

BIBLIOGRAPHY

S. Simon: "Concerning the Beginnings of the New York School, An Interview with Peter Busa and Matta, December, 1966," *A. Int.*, xi/6 (Summer 1967), pp. 17–20

S. Simon: "Concerning the Beginnings of the New York School, An Interview with Robert Motherwell, January, 1967," *A. Int.*, xi/6 (Summer 1967), pp. 20–23

M. Hadler: "William Baziotes: Four Sources of Inspiration," *William Baziotes: A Retrospective Exhibition* (exh. cat. by M. Preble, Newport Beach, CA, Harbor A. Mus., 1978), pp. 77–100

M. Hadler: "David Hare: A Magician's Game in Context," *A. J.*, xlvii/3 (Fall 1988), pp. 196–201

S. Polcari: *Abstract Expressionism and the Modern Experience* (Cambridge, 1991)

R. E. Krauss: *The Optical Unconscious* (Cambridge, MA, 1993), pp. 243–308

M. Sawin: *Surrealism in Exile and the Beginnings of the New York School*, (Cambridge MA, 1995)

R. Hobbs: "Surrealism and Abstract Expressionism: From Psychic to Plastic Automatism," *Surrealism USA*, ed. I. Dervaux (New York, 2004), pp. 56–66

Mona Hadler

Avedon, Richard

(*b* New York, 15 May 1923; *d* San Antonio, TX, 1 Oct 2004), photographer. Avedon studied philosophy at Columbia University, New York (1941–2), and from 1942 to 1944 served in the photography department of the US Merchant Marine, taking identity photographs of servicemen. He then studied photography under Alexey Brodovitch at the New School for Social Research, New York, from 1944 to 1950; from 1945 to 1965 he worked under Brodovitch and Carmel Snow for *Harper's Bazaar*, contributing fashion photographs. As a young boy he had seen various fashion magazines and had been particularly impressed by the photographs of Martin Munkacsi. This influence remained in evidence in his own fashion work for *Harper's Bazaar*, because he, too, photographed the models outside and in motion to arrive at dramatic, sometimes blurred, images. From 1950 he also contributed photographs to *Life*, *Look* and *Graphis* and in 1952 became Staff Editor and photographer for *Theatre Arts*. Toward the end of the 1950s he became dissatisfied with daylight photography and open-air locations and so turned to studio photography, using strobe lighting. In 1965 he left *Harper's Bazaar* to work for *Vogue* under Diana Vreeland and Alexander Liberman. Avedon presented fashion photography as theater, and his innovative style greatly influenced other photographers; his work of the 1960s hinted at the energy and sexual explicitness of the period.

Concurrent with his commercial assignments, Avedon produced portrait photographs of both celebrities and ordinary Americans. In his book *Nothing Personal* (1964), which includes portraits of figures such as the philosopher Bertrand Russell together with images of prisoners, the mentally ill and the poor, he created a disturbingly contrasting picture of society. In 1976 he photographed American businessmen and political leaders for a portfolio in *Rolling Stone*. His portraits, made with a view camera and often printed larger than life, are stark images with plain white backdrops, with the sitter generally looking directly at the camera. The unflinching quality of such works is especially evident in a series of portraits of his dying father exhibited in 1974 at the Museum of Modern Art in New York. He adapted this style for *In the American West*, a series of portraits produced from 1979 to 1984

for the Amon Carter Museum in Fort Worth, TX. The harsh realism of these portraits of miners, oil workers and slaughterhouse workers provides a powerful, if bleak, record of working life in the region. A major retrospective exhibition of Avedon's photographs was mounted in 1994 at the Whitney Museum of American Art in New York.

[*See also* Photography.]

PHOTOGRAPHIC PUBLICATIONS

Nothing Personal, text J. Baldwin (New York, 1964)

Portraits, text H. Rosenberg (New York, 1976)

"The Family," text R. Adler, *Rolling Stone*, 224 (21 Oct 1976), pp. 50–97

Photographs, 1947–1977, text H. Brodkey (New York and Toronto, 1978)

In the American West: 1979–1984, text L. Wilson (New York, 1985)

An Autobiography: Richard Avedon (New York, 1993)

Evidence, 1944–1994: Richard Avedon, text by J. Livingston and A. Gopnik (New York, 1994)

The Sixties, text by D. Arbus (New York, 1999)

Richard Avedon: Made in France, text by J. Thurman (San Francisco, 2001)

Woman in the Mirror, text by A. Hollander (New York, 2005)

Performance, text by J. Lahr (New York 2008)

BIBLIOGRAPHY

Avedon (exh. cat. by A. Clarke and C. Hartwell, Minneapolis, MN, Inst. A., 1970)

C. Beaton and G. Buckland: *The Magic Image: The Genius of Photography from 1839 to the Present Day* (London and Boston, 1975)

Avedon: Retrospective, 1946–1980 (exh. cat. by D. Ross; Berkeley, U. CA, A. Mus., 1980)

Richard Avedon Portraits (exh. cat. by M. Hambourg, M. Fineman and R. Avedon; New York, Met. 2002)

Richard Avedon Photographs, 1946–2004 (exh. cat. by Michael Juul Holm; Humlebæk, Denmark, Louisiana MOMA, 2007)

Richard Avedon: Portraits of Power (exh. cat. by R. Adler, P. Roth, and F. Goodyear; Washington, DC, Corcoran Gal. A., 2008)

Martha A. Sandweiss

Avery, Milton

(*b* Altmar, NY, 7 March 1893; *d* New York, 3 Jan 1965), painter and printmaker. He spent his childhood in Hartford, CT, where he remained until 1925, attending art school from 1911 to 1919 and thereafter painting in the surrounding countryside. His works from this period are characterized by shiny, enamel-like surfaces, created by applying colors with brushes and a palette knife and blending them with his fingers. After moving to New York in 1925 and his marriage, he replaced the light-drenched palette of his Hartford paintings with somber tones. He also stopped using an impastoed, palette-knife technique and began to brush pigment onto his canvases in thin layers. His figurative and genre subjects resembled those of the realists, but his technique of dispensing with illusionistically modeled shapes in favor of simplified forms and flat colors derived from European artists such as Henri Matisse (1869–1954) and Pablo Picasso (1881–1973) (e.g. *Harbor at Night*, 1932; Washington, DC, Phillips Col. and *The Steeplechase, Coney Island*, 1929; New York, Met.). During the 1930s, this simplification of form, coupled with Avery's luminous color harmonies, provided a model for a group of younger artists including Adolph Gottlieb and Mark Rothko. He also had the support of the Valentine Gallery from 1935 to 1943 and of the Paul Rosenberg Gallery from 1943 to 1950.

In 1944 Avery precipitously abandoned the anecdotal detailing and brushy paint application of his earlier endeavors for dense, more evenly modulated areas of flattened color contained within crisply delineated forms (e.g. *Pink Tablecloth*, 1944; Utica, NY, Munson–Williams–Proctor Inst.). This mature style was heralded by a one-man exhibition at the Phillips Memorial Gallery in Washington, DC, in 1944. In June 1949 he suffered a major heart attack. While recuperating in Florida in autumn 1950 he began making monotypes, for example *Leaves* (1951; see Johnson, no. 41). Over the next two years he produced nearly 200 prints.

Avery's paintings underwent a subtle shift following his heart attack: quieter, more muted color harmonies replaced the vibrant hues of earlier work, while thin washes of paint, applied one over another, created veiled, slightly mottled fields of color. A further reduction of compositional elements

and heightened color effects occurred when Avery enlarged his paintings in summer 1957 while in Provincetown on Cape Cod. By mottling his color and tinting his paint with white pigment, he created shimmering rhythms of color that were simultaneously opulent and pastel. In paintings such as *Dunes and Sea No. 2* (1960; New York, Whitney) and *Sea Grasses and Blue Sea* (1958; New York, MOMA; see color pl. 1:IV, 2) he pushed toward the farthest limits of pure abstraction without abandoning his commitment to working from nature. Serenity and harmony had prevailed in all of Avery's work. Yet this work, more than ever, exuded a world of low-key emotions from which anger and anxiety were absent. These large canvases, perhaps because of their greater parity between abstract and recognizable shapes, elicited an enthusiastic critical response. As Avery's reputation began to grow, however, his physical condition worsened to the extent that he could not attend the opening of his retrospective at the Whitney Museum of American Art, New York, in 1960. In autumn 1961 he had a second heart attack from which he never fully recovered.

BIBLIOGRAPHY

Milton Avery (exh. cat., New York, Whitney, 1960)

U. E. Johnson: *Milton Avery: Prints and Drawings, 1930–1964*, essay by M. Rothko (New York, 1966)

Milton Avery (exh. cat., Washington, DC, Smithsonian Inst.; New York, Brooklyn Mus.; Columbus, OH, U. Gal. F.A.; 1970)

B. L. Grad: *Milton Avery*, foreword by S. Michel Avery (Strathcona, 1981)

M. Price: *Milton Avery: Early and Late* (Annandale-on-Hudson, NY, 1981)

B. Haskell: *Milton Avery* (New York, 1982)

R. C. Hobbs: *Milton Avery* (New York, 1990)

R. C. Hobbs: *Milton Avery: The Late Paintings* (New York, 2001)

Barbara Haskell

Avery, Samuel P.

(*b* New York, 17 March 1822; *d* New York, 11 Aug 1904), wood-engraver, art dealer, collector and philanthropist. Avery's career as a wood-engraver and his involvement with the New York publishing trade began in the early 1840s. He worked for, among others, *Appleton's*, the *New York Herald* and *Harper's* and produced illustrations for trade cards, religious tracts, adventure stories and children's books. By the early 1850s Avery had begun compiling humorous books and commissioning drawings from such artist–illustrators as Felix Octavius Carr Darley, John Whetten Ehninger, Augustus Hoppin (1827–96), Tompkins Harrison Matteson and John McLenan (1827–66). His business contacts led to close relationships with such artists as Frederick Church, John F. Kensett and William Trost Richards.

By the late 1850s Avery had begun to collect drawings and small cabinet pictures by local artists. Other art collectors, notably William T. Walters, asked Avery's advice when commissioning works of art. In 1864 he turned his engraving practice over to Isaac Pesoa, his former apprentice, and became one of the first art dealers in the USA. In 1867 Avery was appointed commissioner for the American section at the Exposition Universelle in Paris. Before leaving New York, he liquidated his collection to buy works of art abroad. With the assistance of George A. Lucas, Avery commissioned paintings from such artists as William-Adolphe Bouguereau, Jules Breton, Jean-Léon Gérôme and Ernest Meissonier. He made annual buying trips to Europe during the 1870s; his diaries provide insight into the European art market and record information about contemporary Dutch, English, French and German artists. Avery auctioned his acquisitions in New York, although some works were selected for specific collectors, such as William Henry Vanderbilt. Avery's opinions were central in forming the Metropolitan Museum of Art in New York, of which he was a founder in 1872 and a lifelong trustee and to which he donated some of his American pictures.

Avery bought books with exceptional bindings, and he encouraged contemporary designers by commissioning examples of their craftsmanship. He was instrumental in establishing a separate print room at the New York Public Library in December 1899, presenting it in 1900 with a gift of over 19,000 prints.

Avery remained active in numerous art societies. His son, Samuel P. Avery Jr. (1847–1920), assisted in his gallery, resumed the business in 1888 and left his collections mainly to the Brooklyn Museum, New York, and the Wadsworth Atheneum, Hartford, CT, where the Avery Wing was opened in 1934. Another son, Henry Ogden Avery (1852–90), studied at the Ecole des Beaux-Arts in Paris (1872–9) and worked as an architect. In 1887 he designed some exhibition rooms and a gallery in New York for his brother. Avery Sr. endowed the Avery Architectural Library at Columbia University, New York, in memory of Henry, bequeathing it part of his book collection.

[*See also* Collecting and dealing; Lucas, George A.; *and* Museums.]

WRITINGS

The Diaries 1871–1882 of Samuel P. Avery, Art Dealer, ed. M. Fidell-Beaufort, H. L. Kleinfield and J. K. Welcher (New York, 1979)

BIBLIOGRAPHY

R. Sieben-Morgan: *Samuel Putnam Avery (1822–1904), Engraver on Wood: A Bio-bibliographical Study* (MLS diss., New York, Columbia U., 1940, additions 1942)

D. Sutton: *Paris–New York, a Continuing Romance* (London, 1977); preface *RApollo*, cxxv (1987), pp. 122–31

M. Fidell-Beaufort: "Whistling at One's Ruskins," *Confrontation* (Spring–Summer 1979), pp. 58–63

M. Fidell-Beaufort: "Jules Breton in America: Collecting in the 19th Century," *Jules Breton and the French Rural Tradition* (exh. cat., Omaha, Joslyn A. Mus., 1982), pp. 51–61

M. Fidell-Beaufort and J. K. Welcher: "Some Views of Art Buying in New York in the 1870s and 1880s," *Oxford A. J.*, v/1 (1982), pp. 48–55

K. M. McClinton: "Letters of American Artists to Samuel P. Avery," *Apollo*, cxx (1984), pp. 182–7

I. Léon y Escosura: *Letters & Sketches: Addressed to Samuel Putnam Avery, 1884–1899*. ed. M. F. Beaufort, R. P. Welcher and J. K. Welcher (Ann Arbor, 2004)

Madeleine Fidell-Beaufort

Awatovi

Site in North America, in northeastern Arizona. A Hopi village was established there by *c.* 1250 and destroyed in 1700. During excavations (1935–9) by the Peabody Museum, Harvard University, almost 150 wall paintings were discovered in 11 *kivas* (subterranean ceremonial structures). The wall paintings were first executed *c.* 1375 using the *fresco secco* technique and continued up to Spanish contact in the early 17th century. Except for black, inorganic pigments were used, including red, yellow, blue, green, pink, orange, brown, gray and white. Plant, animal and anthropomorphic forms are portrayed, as well as clouds, lightning, water symbols and geometric designs. The subject matter is religious, depicting parts of ceremonies, events and creatures of Hopi oral history and altars used to perform ceremonies. Later compositions convey a feeling of movement, many showing symbolic combat between two figures. The sudden appearance of elaborate *kiva* wall paintings seems to coincide with the development of *kachina* religion, and *kachina* figures (spirits of the benevolent dead) can be identified in the paintings. The construction of a Spanish mission at Awatovi in 1630 ended the painting of *kiva* murals; the mission was destroyed during the Pueblo Revolt of 1680 and the pueblo was destroyed in 1700 through actions of other Hopi villages.

[*See also* Kiva.]

BIBLIOGRAPHY

R. Montgomery, W. Smith and J. O. Brew: *Franciscan Awatovi: The Excavations and Conjectural Reconstruction of a 17th-century Spanish Mission Establishment at a Hopi Indian Town in Northeastern Arizona*, Pap. Peabody Mus. Amer. Archaeol. & Ethnol., xxxvi (Cambridge, MA, 1949)

W. Smith: *Kiva Mural Decorations at Awatovi and Kawaika-a, with a Survey of Other Wall Paintings in the Pueblo Southwest*, Pap. Peabody Mus. Amer. Archaeol. & Ethnol., xxxvii (Cambridge, MA, 1952)

E. C. Adams: *Homol'ovi: An Ancient Hopi Settlement Cluster* (Tucson, 2002)

E. C. Adams and A. I. Duff, eds.: *The Protohistoric Pueblo World: A.D. 1275–1630* (Arizona, 2002)

H. A. Davis: *Remembering Awatovi: The Story of an Archaeological Expedition in Northern Arizona, 1935–1939* (Cambridge, MA, 2008)

E. Charles Adams

Aycock, Alice

(*b* Harrisburg, PA, 20 Nov 1946), sculptor, draftsman, installation and environmental artist. She studied liberal arts at Rutgers University, New Brunswick, NJ (1964–8), and obtained an MA in studio art at Hunter College, City University of New York (1968–71), where she worked under Robert Morris and became familiar with systems theory. From the 1960s Aycock developed phenomenologically site-orientated works to include metaphor and simile, referring to machinery and construction sites, archaeological sites, models, children's play areas and funfairs and other public or social settings. For example in a *Simple Network of Underground Wells and Tunnels* (1975) six concrete wells (1.62 sq. m) with connecting tunnels were sunk into an area of ground *c*. 6.1×12.2 m at Merriewold West, Far Hills, NJ (destr.). The curious sense of authority within her sophisticated, well-made structures is simultaneously articulated and undermined by a nonsensical, nonfunctional and fantastical element. Her works are often a synthesis of diverse elements. The imagery of the *Game of Flyers* (wood, steel, fire, water, birds, 1979–80; Washington, DC, Project A.) derives equally from tantric drawings, the problem of designing and constructing a machine for human flight and thoughts about World War II.

In the 1990s and early 2000s, Aycock produced elaborate gallery installations and site-specific public art works. A vortex of stainless steel, aluminum and motorized parts, *Star Sifter* (1993; New York, JFK International Airport, Terminal One) brings into play imagined experiences of cosmic travel with the realities of airway and airport regulations. Lit by neon components, *Ghost Machine for the East Bank*

ALICE AYCOCK. *Studies for a Town*, wood, h. 3.04 m, 1977. Courtesy of the artist/Gift of the Louis and Bessie Adler Foundation, Inc., Seymour M. Klein, President © The Museum of Modern Art/Licensed by SCALA/Art Resource, NY

Machineworks (2005–7; Nashville, TN) at once acknowledges the site's industrial past and engages with the city's rising profile. Examples of her work are housed in the Australian National Gallery, Canberra, the Museum Ludwig, Cologne, and the Whitney Museum of American Art, New York.

[*See also* Sculpture, *subentry on* After World War I.]

BIBLIOGRAPHY

Alice Aycock Projects (exh. cat., essay by E. F. Fry, Tampa, U. S. FL, 1979–81)

J. Fineberg and others: *Alice Aycock: Retrospective of Projects and Ideas (1972–1983)* (Stuttgart, 1983) [in Ger. and Eng.]

Complex Visions: Sculpture and Drawings by Alice Aycock (exh. cat., Mountainville, NY, Storm King A. Cent., 1990)

North Fork/South Fork (exh. cat. by A. G. Longwell; Southampton, NY, Parrish A. Mus., 2004)

R. C. Hobbs: *Alice Aycock: Sculpture and Projects* (Cambridge, MA, 2005)

Babb, Cook & Willard

American architectural partnership formed in 1884 by George Fletcher Babb (*b* New York, 1836; *d* Holden, MA, 1915), Walter Cook (*b* Buffalo, NY, 22 July 1846; *d* New York, 25 March 1916) and Daniel Wheelock Willard (*b* Brookline, MA, 1849; *d* California, after 1902). Babb trained in the office of T. R. Jackson in the late 1850s before going into partnership (1859–65) with Nathaniel G. Foster. He then joined the office of Russell Sturgis, becoming senior draftsman in 1868. Cook graduated from Harvard in 1869 and then studied architecture at the Polytechnikum (1871–3) in Munich and the Ecole de Beaux-Arts (1873–6), Paris, where he joined the atelier of Emile Vaudremer. He returned to America in 1877, when he went into partnership with Babb, their first major commission being a warehouse (or loft; 1877–80) on Duane Street, New York. This had a brick facade of deeply cut arcades, an arcuated parapet and cast terracotta details, suggesting 15th-century Italian influences. Willard, who had trained as an engineer, joined the firm in 1884 to help with the design of the De Vinne Press Building (1885–6), 309 Lafayette Street, New York. This building developed the design of the Duane Street warehouse and was articulated with six large arches, framed by rows of smaller arched windows, with further ornamentation of Renaissance inspiration. Later commercial commissions included two important office buildings for the New York Life Insurance Company in St Paul (1888–9; destr.), MN, and Minneapolis (1890–91; destr.), MN. Their domestic work included the Atwater-Ciampoline house (1890–91), New Haven, CT, in the Shingle style, and the Andrew Carnegie residence (1899–1901; now the Cooper-Hewitt Mus.) on Fifth Avenue, New York. This is a stately four-story classical mansion. Other buildings designed wholly or primarily by Cook are the Mott Haven branch (1905) of the New York Public Library and the Choir School (1915) of the Cathedral of St John the Divine, New York.

[*See also* Hardy Holzman Pfeiffer Associates.]

BIBLIOGRAPHY
DAB; Macmillan Enc. Archit.

R. A. Cram: Obituary [Cook], *J. Amer. Inst. Architects*, iv/6 (1916), pp. 231–3

T. Hastings: Obituary [Cook], *Amer. Architect*, cix/2104 (1916), p. 257

V. J. Scully Jr.: *The Shingle Style: Architectural Theory and Design from Richardson to the Origins of Wright* (New Haven, 1955); rev. as *The Shingle Style and the Stick Style* (New Haven, 1971)

S. B. Landau: "The Tall Office Building Artistically Reconsidered: Arcaded Buildings of the New York School,

c. 1870–90," *In Search of Modern Architecture: A Tribute to Henry-Russell Hitchcock*, ed. H. Searing (Cambridge, MA, and London, 1982), pp. 136–64

"Carnegie Residence, Fifth Avenue, New York City," *Archit. Rec.* [New York], ix/1 (1988), pp. 77–81

M. G. Broderick: *Long Island Country Houses and Their Architects, 1860–1940*, Society for the Preservation of Long Island Antiquities (New York, 1989)

Mosette Glaser Broderick and Walter Smith

Baca, Judith

(*b* East Los Angeles, CA, 20 Sept 1946), artist, activist and professor. Born to Mexican American parents, Judy Baca is recognized as one of the leading muralists in the USA. She was involved from a young age in activism, including the Chicano movement, the antiwar protest and women's liberation. She studied art at California State University, Northridge, where she received Bachelor's and Master's degrees. Baca started teaching art in 1970 in East Los Angeles for the Los Angeles Department of Recreation and Parks and became interested in the ways murals could involve youth, allowing them to express their experiences. She founded the City of Los Angeles Mural Program in 1974, which evolved into the Social and Public Resource Center, a community arts organization, where she serves as artistic director. She held five summer mural workshops from 1976 through 1983 for teenagers and community artists to help her paint a huge mural on the ethnic history of Los Angeles, called the *Great Wall of Los Angeles*, a half mile (750 m) long on a 4 m wall of a flood control channel, located below street level. This particular mural showcases the history of California from prehistory to the present, particularly from the perspective of non-Anglos. In 1977, she studied mural painting at the Taller Siqueíros, or Siqueíros Workshop, in Cuernavaca, Mexico. Baca has held faculty positions at University of California, Irvine, California State University, Monterey Bay, and University of California, Los Angeles, where she co-founded the Cesar Chavez Center for Interdisciplinary Studies. In 1986, she originated an ongoing portable mural *The World Wall: A Vision of the Future without Fear*, consisting of eight 3×9 m panels on canvas displayed in a 100-foot semi-circle, exhibited in the USA and internationally. In 1988, she created the Neighborhood Pride Program, commissioned by Tom Bradley, the mayor of Los Angeles, which employed over 1000 youths and resulted in more than 80 murals in the city. In 2008, she completed the *Cesar Chavez Monument Plaza*, located at San Jose State University, comprising a 7.6 m arch containing six digital murals, plaza with mosaic tiles and six benches in *metate* forms. In her various capacities she has spearheaded hundreds of murals.

BIBLIOGRAPHY

Judy Baca (exh. cat., Wadsworth Atheneum, Hartford, CT, 1982)

P. Blum: *Other Visions, Other Voices: Women Political Artists in Greater Los Angeles* (Ann Arbor, 2008)

G. Latorre: *Walls of Empowerment: Chicana/o Indigenist Murals of California* (Austin, 2008)

Anne K. Swartz

Bache, Jules Semon

(*b* New York, 9 Nov 1861; *d* Palm Beach, FL, 24 March 1944), collector and businessman. Having founded a major banking house in New York, Bache continued the interest in collecting that had begun when he was young. While living in Paris before World War I he had bought fine antique furniture for his home. After the war he specialized in collecting paintings of Renaissance and Baroque Italian, Flemish, French, Dutch, German and English artists. He often used the services of art dealers René Gimpel (1881–1945) and Joseph Duveen, through whom he purchased such paintings as Jean-Honoré Fragonard's *Billet-doux*, Vermeer's *Young Woman Reading* and Rembrandt's *Standard-bearer* (all New York, Met.). Bache bought *Billet-doux* for £250,000 in 1919 from Gimpel and, with the help of Duveen, bought the *Standard-bearer* in 1924 for £60,000.

In 1937 he established a foundation to manage the collection for public viewing in his home at 814 Fifth Avenue in New York. In January 1944 he made a will bequeathing the collection to the Metropolitan Museum of Art, New York, for permanent viewing.

BIBLIOGRAPHY
DAB
E. Jewell: "Museums: The Bache Collection," *The New York Times* (June 20, 1943), p. sm20
"The Bache Collection," *Time Mag.*, xliii (10 April 1944), p. 15
R. Gimpel: *Diary of an Art Dealer* (New York, 1966), pp. 99, 309
C. Simpson: *Artful Partners: The Secret Association of Bernard Berenson and Joseph Duveen* (New York, 1986), pp. 203–17

Darryl Patrick

Bacon, Henry

(*b* Watseka, IL, 28 Nov 1866; *d* New York, 16 Feb 1924), architect. The son of a distinguished civil engineer, Bacon studied architecture at the Illinois Industrial University, Urbana, in 1884–5. In 1885 he moved to Boston to become a draftsman for the architectural firm of Chamberlin & Whidden, known for its buildings in the Colonial Revival style, but in 1888 he moved to McKim, Mead & White, working as a draftsman and perspectivist. In 1889 Bacon won the Rotch Traveling Scholarship, which enabled him to go to France, Italy, Greece and Turkey for two years. Influenced by his brother, Francis Henry Bacon (1856–1940), an architect and furniture designer who assisted in the excavations at the Greek site of Assos in 1881–3, he became attracted to ancient, especially Greek, architecture. He returned to the McKim, Mead & White office in 1891 and became McKim's chief design assistant. The following year he represented the firm on the construction site of the World's Columbian Exposition in Chicago. Among other projects, he worked on the design of McKim's Rhode Island State House (1891–1903) in Providence.

In 1897 Bacon formed a partnership with James Brite (1865–1942), a colleague from the McKim office with whom he had traveled in Europe. Brite & Bacon specialized in the design of public buildings; they entered many competitions, including those for the Philadelphia Art Museum in 1895 and the New York Public Library in 1897, and executed designs for public libraries in Jersey City, NJ (1898–1900), and Madison, CT (1899–1900). Their domestic architecture is in a variety of styles. An outstanding example in the Federal Revival style is Chesterwood (*c.* 1900), near Stockbridge, MA, the summer home and studio of the sculptor Daniel Chester French, which is now a museum. The partnership ended in 1903, after which Bacon practiced alone, running a small office and maintaining close personal control over all designs. Among his principal projects were the Danforth Memorial Library (1903–6), Paterson, NJ, the mausoleum to *Marcus Alonzo Hanna* (1904–6), Cleveland, OH, the Union Square Bank (1905–7), New York, the Halle Brothers Department Store (1910, addition 1914), Cleveland, OH, and the general plan for Wesleyan University (1912–13), Middletown, CT, where he also designed the Van Vleck Observatory (1914–16), the Clark Hall dormitory (1915–16) and a memorial library (1923; unexecuted). Bacon was also responsible for the design of many kinds of urban amenity, such as lampposts for Central Park, New York (1907), and Washington, DC (1923), the Whittemore Memorial Bridge (*c.* 1910–14), Naugatuck, CT, and the DuPont Memorial Fountain (1917–21), Washington, DC. His most ambitious project of this kind was the highly acclaimed Court of the Four Seasons (destr.) at the Panama–Pacific Exposition of 1915 in San Francisco.

Bacon is principally remembered for his collaboration with sculptors in the design of monuments and memorials. He collaborated with Augustus Saint-Gaudens on several schemes, including the memorial to *James McNeill Whistler* (1903–7), US Military Academy, West Point, NY, the monuments to *Charles Stewart Parnell* (1900–11), Dublin, and *Marcus Alonzo Hanna* (1905–8), Cleveland, OH, and the *Christopher Lyman Magee* fountain-stele (1905–8), Pittsburgh, PA. He worked most often and harmoniously with

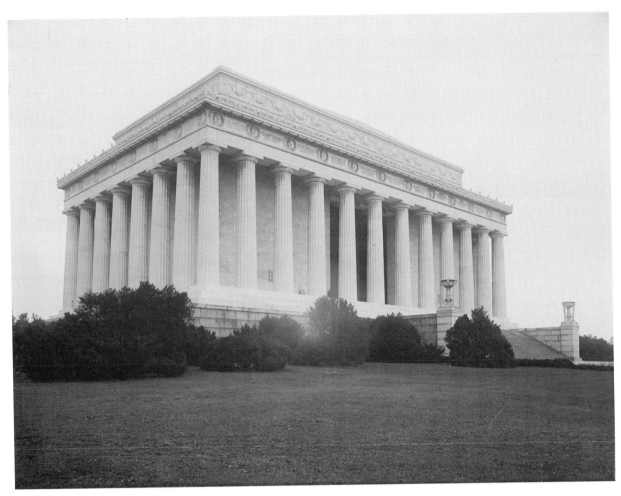

HENRY BACON. Lincoln Memorial, Washington, DC, 1923. Library of Congress Prints and Photographs Division

French, producing many memorials, including those to the Melvin brothers (*Mourning Victory*, 1897–1907), Concord, MA; Spencer Trask (*The Spirit of Life*, 1913–15), Saratoga Springs, NY; *Abraham Lincoln* (1909–12), Lincoln, NB; *Henry Wadsworth Longfellow* (*c.* 1913), Cambridge, MA; and the *Marquis de Lafayette* (1916–17), Brooklyn, NY, as well as a monument (1921–4; unexecuted) to those from Massachusetts who died in World War I, at St-Mihiel, Meuse, France. Bacon also collaborated, though less frequently, with the sculptors Karl Bitter, James Earle Fraser, Henry Hering (1874–1949), Evelyn Beatrice Longman, Charles Niehaus (1855–1935) and John Massey Rhind (1858–1936).

Bacon's major work resulted from the invitation in August 1911 to prepare a design for a national memorial to Abraham Lincoln at the west end of the Mall by the Potomac River in Washington, DC. This was the site recommended a decade earlier by the McMillan Commission. Bacon designed a classical structure in white marble on a podium, with a Doric peristyle and high attic, open to the east and containing a statue of heroic size and two tablets engraved with the texts of Lincoln's *Gettysburg Address* and *Second Inaugural*. His design, with modifications, was finally accepted by Congress in early 1913, but construction was delayed because of a change of administration as well as the outbreak of World War I, and the memorial was not completed until 1922. With French's marble statue of the seated *Abraham Lincoln* (1914–20) as its centerpiece, this was the largest federal project of the kind since the

erection of Robert Mills's Washington Monument (1884) and was hailed as a triumph by the press, the public and traditional architects. In May 1923 the American Institute of Architects awarded Bacon its gold medal in a night-time ceremony on the steps of the memorial. Since its completion, the Lincoln Memorial has become a primary site for public rallies and demonstrations, particularly in the cause of justice for racial and other minorities.

[*See also* Mills, Robert.]

UNPUBLISHED SOURCES
Washington, DC, 62nd Congress, 3rd session, Senate Doc. no. 965 (serial set no. 6347) [Lincoln Memorial Commission Report]

BIBLIOGRAPHY
Macmillan Enc. Archit.

G. Brown: *The Development of Washington, with Special Reference to the Lincoln Memorial* (Washington, 1911)

The Architecture and Landscape Gardening of the Exposition (San Francisco, 1915), pp. 124–37

R. A. Cram: "The Lincoln Memorial," *Archit. Rec.*, liii (1923), pp. 478–508

Obituary, *Amer. Architect*, cxxv (1924), pp. 195–6

Obituary, *Amer. A. Annu.*, xxi (1924–5), p. 282

Obituary, *Amer. Mag. A.*, xv (1924), pp. 190–93

Obituary, *Archit. Rec.*, lv (1924), pp. 273–6

Obituary, *New York Times* (17 Feb 1924), p. 23

Obituary, *Wesleyan U. Alumnus* (March 1924)

F. S. Swales: "Henry Bacon as a Draftsman"; "Master Draftsmen, v: Francis H. Bacon"; *Pencil Points*, v (1924), May, pp. 42–62; Sept, pp. 38–54

C. A. Platt: "Henry Bacon," *Commemorative Tributes*, American Academy of Arts & Letters, 50 (New York, 1925), pp. 21–4

E. F. Concklin: *The Lincoln Memorial, Washington*, US Office of Public Buildings and Public Parks of the National Capital (Washington, DC, 1927)

H. F. Withey and E. R. Withey: *Biographical Dictionary of American Architects (Deceased)* (Los Angeles, 1956/R 1970) [separate entries on Bacon and Brite]

R. R. Selden: *Henry Bacon and His Work at Wesleyan University* (MA thesis, Charlottesville, U. VA, Sch. Archit., 1974)

B. Lowry: *The Architecture of Washington, DC*, i (Washington, DC, 1976), pp. 83–6, pls 96–106

Daniel Chester French: An American Sculptor (exh. cat. by M. Richman, New York, Met., 1976)

M. Richman: "Daniel Chester French and Henry Bacon: Public Sculpture in Collaboration," *Amer. A. J.*, xii (1980), pp. 46–64

R. G. Wilson: *The AIA Gold Medal* (New York, 1984), pp. 150–51

L. Doumato: *Henry Bacon's Lincoln Memorial* (Monticello, IL, 1985) [Vance bibliographies]

P. Scott and A. J. Lee: *Buildings of the District of Columbia* (New York, 1993), pp. 103–4 [Buildings of the United States]

S. A. Sandage: "A Marble House Divided: The Lincoln Memorial, the Civil Rights Movement, and the Politics of Memory, 1939–1963," *J. Amer. Hist.*, lxxx (June 1993), 135–67

C. A. Thomas: "The Marble of the Lincoln Memorial: 'Whitest, Prettiest, and . . . Best,'" *Washington History*, v (Fall/Winter, 1993–4), pp. 42–63

C.A. Thomas: *The Lincoln Memorial & American Life* (Princeton, NJ, 2002)

Christopher A. Thomas

Bacon, Peggy

(*b* Ridgefield, CT, 2 May 1895; *d* Kennebunk, ME, 4 Jan 1987), printmaker, caricaturist, illustrator, painter and author. Peggy [Margaret] (Frances) Bacon's artist parents, Elizabeth and Charles Roswell Bacon, met at the Art Students League around 1890. Bacon lived in Cornish, NH (1903), and in Montreuil-sur-Mer, France (1904–6), and learned French, Latin, Greek, drawing and writing from tutors before attending the Kent Place School in Summit, NJ (1909–13). She then attended the School of Applied Design for Women briefly and the New York School of Fine and Applied Arts. In 1914 and 1915, landscape artist Jonas Lie (1880–1940) taught her oil painting. At the Art Students League (1915–20), she took the "Woman's Life Class" with Kenneth Hayes Miller, portraiture with George Bellows and painting with John Sloan, studied briefly with George Bridgman (1864–1943) and Max Weber and received critiques in printmaking from Mahonri Young. She then studied modern painting with Andrew Dasburg (1887–1979) in Woodstock (1919). In her early prints, she depicted herself, her art classes and the free-spirited camaraderie among Miller's students, including sculptor Dorothea Greenbaum (1893–1986) and painters Katherine Schmidt (1898–1978), Reginald Marsh and Alexander Brook, who continued as lifelong friends. All were charter members of the

Whitney Studio Club organized by Gertrude Vanderbilt Whitney in 1918. During summers in Provincetown, Bacon studied painting with Impressionists Charles Hawthorne (1915) and Ambrose Webster (1917) and with modernist printmaker B. J. O. Nordfeldt (1916). While a student, she had three solo exhibitions and published her first book. She was a prolific artist and author who published and exhibited her work extensively.

Although Bacon did not study printmaking with Sloan, their intaglio prints of their urban environments share a reportorial candor and ingenious anatomical exaggeration for humorous purposes. Sara Meng wrote that Sloan was a detached observer of the masses, while Bacon concentrated on people she knew in her bohemian art world. Bacon's first drypoints (1918), including *The Bridge Party* and *The Bellows Class*, are her most modern works, characterized by large flat and geometricized planes and abstracted figures. Her later realist signature style depends on expressively exaggerated line.

During her marriage (1920–40) to the modernist painter Alexander Brook, Bacon traveled in Europe, and they were both active in, US artist organizations and group exhibitions, including the Woodstock Artist Association, Maverick, Whitney Studio Club and Museum and Society of Independent Artists. Bacon had solo exhibitions at Joseph Brummer, Montross, Alfred Stieglitz's Intimate Gallery and Weyhe (1920s). Solo shows at museums include the Corcoran Gallery of Art, Washington, DC (1938 and 1943), the Ogunquit Museum of Art in Maine (1973) and the National Collection of Fine Arts, Smithsonian Institution in Washington, DC (1975).

Among the subjects of the 35 satirical polychrome pastel portraits that Bacon drew between 1927 and 1935 are artists Marsden Hartley, Charles Sheeler, Louis Bouché, Miller and Marsh; gallery proprietors Edith Gregor Halpert and E. Weyhe; writer and curator Lloyd Goodrich; Whitney Director Juliana Force; and critics Henry McBride, Royal Cortissoz and Forbes Watson. She caught squinting, short-sighted Cortissoz in profile—a burning cigar's length from the picture he is examining. During her Guggenheim Fellowship in 1934 she created 200 charcoal caricatures and published 39 of them in *Off with Their Heads!* She described *Georgia O'Keeffe* and *Alfred Stieglitz* (both Lincoln, U. NE A. Gals.) with velvety blacks and masterfully executed line. Holger Cahill claimed that Bacon was the most talented caricaturist in the USA (*America as Americans See It*, New York, 1932, p. 295). Bacon's goal was humor, in contrast to William Gropper, who believed in the persuasive power of his political cartoons.

The bite of her wit softened after 1950. She resumed painting and incorporated lyricism and fantasy into her New England landscapes. Bacon illustrated over 40 books by such authors as George Ade, Carl Sandburg and Louis Untermeyer, plus 19 mainly satirical poems and children's short stories, which she had written. She taught in New York at the Fieldston Ethical Culture School (1930s), the Art Students League (1935, 1949–51) and at Birch Wathen (1942–4); in Washington, DC, at the School of the Corcoran Gallery of Art (1942–4); and in Philadelphia at Moore College of Art (1963–4).

WRITINGS
Off with their Heads! (New York, 1934)
Starting from Scratch (New York, 1945)

BIBLIOGRAPHY
Peggy Bacon: Personalities and Places (exh. cat. by R. K. Tarbell and J. Flint, Washington, DC, N. Col. F.A., 1975)
R. K. Tarbell: "Peggy Bacon's Pastel and Charcoal Caricature Portraits," *Woman's A. J.*, ix (1988), pp. 32–7
S. Meng: *Caricature, Modernity, and Artistic Identity: Peggy Bacon between the World Wars* (diss., Cleveland, OH, Case Western Reserve U., 2000)
S. Meng: "Peggy and John Sloan: Their Urban Scenes, 1910–1928," *Woman's A. J.*, xxv (2004), pp. 18–25

Roberta K. Tarbell

Badger, Daniel D.

(*b* Badger's Island, Portsmouth, NH, 15 Oct 1806; *d* Brooklyn, New York, 17 Nov 1884), iron

manufacturer and builder in cast iron. Beginning as a blacksmith's apprentice, Badger was in Boston by 1830 making decorative wrought ironwork at his own smithy. In 1842 he built Boston's first example of an iron-fronted shop, a one-story combination of iron columns and lintels that allowed large glass display windows. The following year, he began producing rolling security shutters that fitted into grooves in the iron columns, having bought the patent from Arthur L. Johnson (1800–60). The "Badger front" design was sold and copied across the USA, winning a gold medal at the American Institute Fair (1847).

In 1846 Badger moved to New York City, where he continued to manufacture his "fronts." Soon afterward he began producing the new form of iron building, commonly called "cast-iron architecture," promoted by James Bogardus: structures with self-supporting, multi-story exterior iron walls, constructed of cast-iron panels and columns bolted together. From 1852 Badger employed the English architect George H. Johnson (1830–79) as his designer and began producing ornate multistory iron facades that were much admired. Four years later he incorporated his firm as Architectural Iron Works, which developed into one of the largest and most versatile of the time, producing high-style prefabricated iron for commercial structures, small bridges and warehouses. Cast-iron architecture became immensely popular, especially for commercial buildings, and was supplanted by steel-frame structures only toward the end of the 19th century.

Some of Badger's finest works were commercial buildings constructed in the 1850s, such as the Haughwout Building and the Cary Building (both 1856) in New York and the Lloyd and Jones Building (1857; destr. 1871) in Chicago. Two years before the Civil War began in 1861 he won a commission from the US government to build the all-iron Watervliet Arsenal (1859), Albany, NY. Badger also built two ornamented iron ferry terminals in Manhattan, NY: the Fulton (1863) and South Ferry (1864; both

destr.). In 1865 Badger issued an illustrated catalog for Architectural Iron Works. Through it he became the best-known builder in cast iron in the USA. Commissions for large structures included the eight-story Gilsey Hotel, New York, and the large Powers office building in Rochester, NY (both 1869). In 1871 he completed an iron-and-glass train shed (destr.) in New York for railway magnate Cornelius Vanderbilt's Grand Central Depot, the largest interior space then seen in the USA (replaced in 1913 by Grand Central Station). The last of Badger's large structures, the huge Manhattan Market (1872), with a vaulted roof almost as high as that at Grand Central, was destroyed by fire in 1880. Badger also built many small-scale iron-fronted buildings and warehouses, such as the Boston Post Building in Boston and 90 Maiden Lane in New York (both 1872), built for the Roosevelt family. He retired in 1873 due to ill health. Without his dynamic leadership his company rapidly faded, and Architectural Iron Works closed in 1876.

Many Badger buildings in New York have been designated by the City's Landmarks Preservation Commission as fine examples of the era of cast-iron architecture.

WRITINGS

Illustrations of Iron Architecture Made by the Architectural Iron Works of the City of New York (New York, 1865); repr. in *The Origins of Cast Iron Architecture in America, Including Illustrations of Iron Architecture Made by the Architectural Iron Works of the City of New York*, intro. W. K. Sturges (New York, 1970); and *Badger's Illustrated Cast-iron Architecture*, intro. M. Gayle (New York, 1981)

BIBLIOGRAPHY

Obituary, *New York Times* (19 Nov 1884), p. 2

W. K. Sturges: "Cast Iron in New York," *Archit. Rev.* [London], cxiv (1953), pp. 232–7

A. L. Huxtable: "Store for E. V. Haughwout & Co., 1857," *Prog. Archit.*, xxxix/2 (1957), pp. 133–6

M. Gayle: *Cast-iron Architecture in New York: A Photographic Survey* (New York, 1974)

M. Gayle and C. Gayle: *Cast-Iron Architecture in America: The Significance of James Bogardus* (New York, 1998)

Margot Gayle and Carol Gayle

Badger, Joseph

(*b* Charlestown, MA, 14 March 1708; *d* Boston, MA, 11 May 1755), painter. Badger was part of a small, active group of portrait painters who worked in Boston in the mid-18th century. Although he was well known in his own time, his work was rediscovered only in the early 20th century. Badger appears to have been a competent artisan with some artistic talent. The few documents that deal with his early life refer to him as a "painter" and "glazier," indicating that his primary profession was house and ship painting. He is described as a "limner" and "faice painter" only toward the end of his life. Badger moved to Boston around 1733 and began painting portraits about ten years later. He became Boston's principal portrait painter after the death of John Smibert in 1751, but his career was eclipsed shortly thereafter by the more accomplished and stylish portraits of John Singleton Copley. Unlike other Colonial artists, Badger was not an itinerant painter: most of his subjects lived in Boston, and many were related or attended the same church. He painted likenesses of three of his children and one grandchild (*James Badger*, 1760; New York, Met.)

Badger's oeuvre appears to be substantial: more than 150 unsigned portraits have been attributed to him. The documented portraits of *Timothy Orne*, his wife, *Rebecca Orne* (both priv. col., see Dresser, pp. 2–3), two of their children, *Rebecca and Lois Orne* (all 1756; Worcester, MA, A. Mus.), and the portrait of *Rev. Ellis Gray* (*c*. 1750; Boston, MA Hist. Soc.) express the basic characteristics of Badger's style and his approach to portrait painting. The poses rely heavily on published English mezzotints. The portrait of Ellis Gray, for example, follows the convention of depicting a minister dressed in his robes, in a bust-length format. Badger painted Timothy Orne standing, three-quarter length, with one hand resting on his hip and the other holding letters, indicating his occupation as a merchant. The pendant portrait of Rebecca Orne shows her seated, holding a rose in one hand. She wears a white cap and a simple, solid-color dress.

Unlike Copley and Robert Feke, Badger paid little attention to the rich patterns and textures of cloth. The Orne children are charmingly painted as miniature adults, holding objects associated with childhood; the smaller child grasps a rattle, while her older sister pets a squirrel. These portraits illustrate a characteristic aspect of Badger's work: nearly one third of the attributed works are portraits of children.

In contrast to the sparse backgrounds and plain clothing, Badger gave character to his sitters' faces, defining their features with strong lines. Almond-shaped eyes invariably focus on the viewer, and a heavy shadow is cast by the nose. A thin red line separates the tightly closed lips of most subjects. In many pictures the minimal facial modeling has been removed by cleaning: most of Badger's work has suffered from overcleaning. This has resulted in a poor impression of his artistic ability and the attribution to him of portraits by less competent painters.

[*See also* Boston.]

BIBLIOGRAPHY

L. Park: "An Account of Joseph Badger, and a Descriptive List of His Work," *Proc. MA Hist. Soc.*, ii (1917), pp. 158–201

L. Park: "Joseph Badger of Boston, and His Portraits of Children," *Old-time New England*, xiii (1923), pp. 99–109

L. Dresser: "The Orne Portraits by Joseph Badger," *Worcester A. Mus. Bull.*, n. s., i/2 (1972), pp. 2–3

R. C. Nylander: *Joseph Badger, American Portrait Painter* (diss., Oneonta, NY State U. Coll., 1972)

Phelps Warren: "Badger Family Portraits," *Antiques*, cxviii/5 (1980), pp. 1043–7

A. Millspaugh Haff and R. Urquhart: "Paintings in the Massachusetts Historical Society," *Antiques*, cxxviii (1985), pp. 960–71

Richard C. Nylander

Badlam, Stephen

(*b* Milton, MA, 1751; *d* Dorchester Lower Mills, MA, 25 Aug 1815), cabinetmaker. Badlam's father, also Stephen Badlam (1721–58), was a part-time cabinetmaker and tavern keeper. Orphaned at a young

age, Badlam was trained both as a surveyor and as a cabinetmaker. Soon after the outbreak of the American Revolution he was commissioned as a major in the artillery. He resigned within a year because of illness but after the war was made a general in the Massachusetts militia. On his return to Dorchester Lower Mills, he opened a cabinetmaking shop in his house and became active in civic affairs. He built up a substantial business, which included participation in the thriving coast trade, and even sold furniture through the warehouse of Thomas Seymour in Boston. He also provided turning for other cabinetmakers in the neighborhood and sold picture-frame materials and window glass. Several chairs in the Federal style with characteristic carved and stopped fluted legs are stamped with his mark, but his fame rests on the monumental mahogany chest-on-chest (1791; New Haven, CT, Yale U. A.G.) that he made for Elias Hasket Derby (1739–99), a Salem merchant and one of the wealthiest men in the country, who ordered it as a wedding present for his daughter, Anstis Derby. Ionic columns flank the upper case, and carved chamfered corners resting on ogee bracket feet border the lower, serpentine section. John Skillin and Simeon Skillin executed the extraordinary figures of *Virtue* flanked by the reclining goddesses of *Peace* and *Plenty* that surmount the pitched pediment. At his death Badlam's estate was valued at over $24,000, a considerable sum for the time and an indication of the position he enjoyed.

[*See also* Skillin.]

BIBLIOGRAPHY

Appleton's Cyclopedia (New York, 1888)

M. Swan: "General Stephen Badlam: Cabinet and Looking-glass Maker," *Antiques*, lxv (1954), pp. 380–83

G. Ward: *American Case Furniture in the Mabel Brady Garvan and Other Collections at Yale University* (Boston, 1988), pp. 171–7

D. Levison and H. Sack: "Identifying Regionalism in Sideboards: A Study of Documented Tapered-leg Examples," *Ant.*, cxli (1992), pp. 820–33

Oscar P. Fitzgerald

Baer, Jo

(*b* Seattle, WA, 7 Aug 1929), painter. Josephine Gail Baer [née Kleinberg] was educated at the University of Washington, Seattle. She worked during the spring and summer of 1950 in a kibbutz in Israel before moving to New York City, where she studied with the Graduate Faculty at the New School for Social Research from 1950 to 1953. In 1953, she married television writer Robert Baer and moved to Los Angeles. Her son Joshua was born in 1955. By the late 1950s, she was working in an abstract painting style inspired by Abstract Expressionism, which she later rejected, and was peripherally associated with the activities of the avant-garde Ferus Gallery in Los Angeles.

In 1959, Baer began living with the artist John Wesley, whom she married in 1960 before moving back to New York City with him; they divorced in 1969. By 1960, her painting became more hard-edged and reductive. Two years later, she met Donald Judd and Dan Flavin and began painting in a more geometric style. Her art started being shown with other artists working in a Minimalist style, including the 1964 group show *Eleven Artists*, organized by Flavin at the Kaymar Gallery in New York. She had her first solo exhibition in New York City at the Fischbach Gallery in 1966, the same year she participated in the landmark *Systemic Painting* show at the Solomon R. Guggenheim Museum in New York, curated by Lawrence Alloway. During the mid-1960s, one of the main changes in her painting style involved her use of diptych and triptych formats as a way to expand her use of minimal compositions. She had her first international gallery exhibition at Galerie Ricke, Cologne, in 1968. In 1975 she left the New York art world for Europe and in the same year her work was the subject of a solo exhibition at the Whitney Museum of American Art, New York, regarded as the high point of her career. By the end of the 1970s, Baer had become more lyrical in her imagery, largely rejecting the structured images for which she had been known. In 1984 she relocated permanently

to Amsterdam, regularly exhibiting her art in the USA and internationally.

[*See also* Wesley, John.]

BIBLIOGRAPHY

Systemic Painting (exh. cat., intro. by L. Alloway; New York, Solomon R. Guggenheim Foundation, 1966)

W. Insley: "Jo Baer," *A. Int.*, xiii (Feb 1969), pp. 26–8

Five Artists: A Logic of Vision (exh. cat., Chicago, IL, Mus. Contemp. A., 1974)

Jo Baer (exh. cat., essay by B. Haskell; New York, Whitney, 1975)

J. Meyer: *Minimalism: Art and Polemics in the Sixties* (New Haven, 2004)

Anne K. Swartz

Baggs, Arthur Eugene

(*b* New York, 27 Oct 1886; *d* Columbus, OH, 15 Feb 1947), potter. As a student of Charles Fergus Binns at Alfred University, Alfred, NY, Baggs was introduced to the practical aspects of running a pottery, and in 1904 Binns sent him to help Dr. Herbert James Hall (1870–1923) to establish a pottery for occupational therapy at his sanatorium in Marblehead, MA. In 1908 the Marblehead Pottery was reorganized on a commercial basis. Baggs designed the wares, which were mostly simply shaped vases covered with muted matte glazes and contrasting stylized decorations. In 1915 Baggs purchased the pottery and continued to be associated with it until its closure in 1936. Between 1925 and 1928 he developed brilliant blue and green glazes while working as a glaze chemist at R. Guy Cowan's Cowan Pottery Studio in Cleveland, OH. In 1928 he became professor of ceramic arts at Ohio State University in Columbus. During the 1930s he revived interest in salt-glazing stoneware, and his "Cookie Jar" (1938) is considered a key work in the use of this method for studio ceramics.

[*See also* Ceramics.]

BIBLIOGRAPHY

R. S. Persick: *Arthur Eugene Baggs, American Potter* (n.p., 1964)

H. Hawley: "Cowan Pottery," *Studio Potter*, xix (June 1991), pp. 70–80

Ellen Paul Denker

Bakewell & Brown

Architectural partnership formed in 1905 by John Bakewell Jr. (*b* Topeka, KS, 28 Aug 1872; *d* San Francisco, CA, 19 Feb 1963) and Arthur Brown Jr. (*b* Oakland, CA, 21 May 1874; *d* Burlingame, CA, 7 July 1957). Both architects studied at the University of California, Berkeley, and then at the Ecole des Beaux-Arts in Paris, where they met. They then returned to the USA and went into partnership in San Francisco, with Brown in charge of design and Bakewell responsible for the daily running of the business and technical operations. The partnership's early projects reflect late 19th-century French work, with large-scale elements, lavish sculptural decoration and, in some cases, theatrically rusticated surfaces. Such exuberant features remained a trademark, but by 1912 they were beginning to be tempered by a strong, rectilinear compositional frame. At its best, the expression fuses the dynamism and expansiveness of French Baroque with the elegant orderliness of designs by Anges-Jacques Gabriel and other 18th-century French Neo-classical architects.

All these attributes are evident in the firm's best known and most admired work, the San Francisco City Hall (1912–16). The building is a hollow rectangle lined with offices and bisected by a ceremonial core that sets public rooms and corridors around a great rotunda. These dual aspects are expressed on the exterior by a monumental five-part composition, dominated by the central block and capped by a massive dome. Other works by the partnership possess the same rigor and clarity, while offering solutions more reflective of California's salubrious climate and associational ties to the Mediterranean basin. The Santa Fe railway station (1914–15), San Diego, CA, presents an arcaded court to the street. Behind, the main block has the twin towers of a Spanish church, divided by an enormous portal, with the concourse and train shed forming the "nave." Other major works included a number of buildings for Stanford University (from 1922) and such public edifices as the Berkeley Town Hall (1909) and Pasadena City Hall (1925–7), one of the

firm's most original designs. Its entrance (part triumphal arch, part *barrière*) leads to a tranquil, lushly foliated court. Its huge tiered dome soars above to command the environs. The rest of the building serves as a foil, being long, low and with little ornament. Elsewhere, with great élan Brown evoked images of ancient Roman ruins, Romanesque monasteries and the vernacular architecture of northern Italian hill towns. In each case, historical references demonstrate the architects' sensitivity to site no less than to function, and the image complements a strong, underlying compositional order. However, the partnership's numerous residences and smaller-scale projects seem dull or contrived in comparison with their monumental projects.

The partnership of Bakewell & Brown was dissolved in 1927, when Bakewell went into partnership with Ernest Weihe (1893–1968), a former employee. Brown continued to practice independently and remained an ardent champion of classicism, designing two buildings in the center of San Francisco that formed an ensemble with the City Hall: the War Veterans' Memorial Building and the War Memorial Opera House (1932; with G. Albert Lansburgh). In 1933 he became architect for the Department of Labor and Interstate Commerce Commission buildings, part of a vast group of academically conceived classical-style office buildings in Washington, DC. He was also a member of various government committees dealing with architectural matters and received numerous honors and awards.

[*See also* San Francisco.]

WRITINGS

J. Bakewell Jr: "The San Francisco City Hall Competition," *Architect & Engin. CA*, xxix/3 (1912), pp. 46–78

J. Bakewell Jr: "The Pasadena City Hall," *Architect & Engin. CA*, xciii/3 (1928), pp. 35–9

A. Brown Jr: "Is Modern Architecture Really Necessary?," *Architect & Engin. CA*, cx/vii/1 (1941), pp. 27–9

BIBLIOGRAPHY

"Some of the Work of Bakewell & Brown, Architects," *Architect & Engin. CA*, xvi/1 (1909), pp. 35–43

B. J. S. Cahill: "The New City Hall, San Francisco," *Archit. & Engin. CA*, xlvi/2 (1916), pp. 38–77

"The San Francisco City Hall," *Amer. Archit.*, cxii (1917), pp. 375–8

H. Allen: "Three Country Houses by Bakewell & Brown," *Bldg Rev.*, xxi (1922), pp. 1–6

H. H. Reed: *The Golden City* (New York, 1959)

M. E. Vetrocq: "Stanford before 1945: The Fate of the Olmsted Plan," *The Founders and the Architects: The Design of Stanford University*, P. Turner and others (Stanford, 1976), pp. 83–98

J. Draper: *The San Francisco Civic Center: Architecture, Planning, and Politics* (diss., U. Berkeley, CA, 1979)

G. Gurney: *Sculpture and the Federal Triangle* (Washington, DC, 1985)

J. T. Tilman: *Arthur Brown, Jr.: Progressive Classicist* (New York, 2006)

Richard Longstreth and John F. Pile

Baldessari, John

(*b* National City, CA, 17 July 1931), conceptual artist. After studying art at San Diego State College (1949–53) and the Otis Art Institute (1957–59), among other institutions, Baldessari began to develop his painting style, soon incorporating letters, words and photographs in his works. By 1966 he was using photographs and text, or simply handlettered text, on canvas as in *Semi-close-up of Girl by Geranium . . .* (1966–8; Basle, Kstmus.). From 1970 he worked in printmaking, film, video, installation, sculpture and photography. His work is characterized by a consciousness of language evident in his use of puns, semantics based on the structuralism of Claude Lévi-Strauss and the incorporation of material drawn from popular culture. All are apparent in *Blasted Allegories* (1978; New York, Sonnabend Gal.), a series combining polaroids of television images captioned and arranged to suggest an unusual syntax. Baldessari differed from other conceptual artists in his humor and commitment to visual images, often obscured by flat, brightly colored geometric and organic shapes including round forms that he likened to bullet holes. He dramatized the ordinary, although beneath the apparent simplicity of his words and images lie multiple connotations.

WRITINGS

Ingres and Other Parables (London, 1971)

Four Events and Reactions (Florence, 1975)

Close Cropped Tales (Buffalo, 1981)

with H. U. Obrist: *Conversation Series 18: John Baldessari, Hans Ulrich Obrist* (Cologne, 2009)

with Jessica Morgan: "Somebody to Talk to," *Tate Etc*, xvii (Autumn 2009), pp. 74–85

BIBLIOGRAPHY

John Baldessari (exh. cat., essays by M. Tucker and R. Pincus-Witten, interview N. Drew; New York, MOMA, 1981)

J. T. D. Neil: "John Baldessari," *Art Rev.* (London), xvii (Autumn 2008), pp. 52–7

S. C. Hurowitz and Wendy Weitman: *John Baldessari: A Catalogue Raisonné of Prints and Multiples 1971–2007* (Manchester, VT, 2009)

John Baldessari: Pure Beauty (exh. cat. by Marie de Brugeroll, Bice Curiger, David Salle and others, Los Angeles, CA, Co. Mus. A., 2009)

Elisabeth Roark

Ball, James Presley

(*b* Virginia, 1825; *d* Honolulu, HI, 3 May 1904), photographer. Ball's parents, William and Susan Ball, were freeborn Americans of African descent. James Presley (J. P.) Ball learned how to make daguerreotypes from a black Bostonian, John P. Bailey. He opened his first photographic enterprise in Cincinnati, OH, in 1845. Black-owned businesses seemed viable in this abolitionist stronghold and key conduit to the West. After a failed first venture and time as an itinerant photographer, he returned and opened Ball's Great Daguerrean Gallery of the West in 1849, which became one of the largest and most successful photographic studios in the region with an enthusiastic multi-racial clientele. Ball hired other African Americans as operators, including his brother, Thomas Ball, his brother-in-law, Alexander Thomas, and the African American landscape painter, Robert S. Duncanson.

An activist for abolition, Ball produced a painted panorama that illustrated the history of African enslavement in 1855 and authored the accompanying pamphlet to great acclaim. With a national reputation and important portrait commissions from such cultural icons as Frederick Douglass and Jenny Lind, Ball expanded with a second studio operated by his brother-in-law who had become a favorite with clients. Together they started an additional studio, the Ball & Thomas Photographic Art Gallery. Ball's Cincinnati enterprises survived well into the 1880s in the hands of Thomas and other Ball relatives since they remained current with photographic technologies.

Ball became itinerant again in 1871, working as a photographer with extended sojourns in Minneapolis, MN, and Helena, MT. In 1900, Ball moved to Seattle, WA, to join his son and namesake who operated a photography studio while building his law practice. Seeking relief from rheumatism, Ball moved again to Hawaii where he died in 1904. With a body of work spanning six decades, he left an important record of Western settlement communities, particularly of those African Americans who had been migrating westward since the mid-19th century.

[*See also* Duncanson, Robert S.]

PHOTOGRAPHIC PUBLICATIONS

Ball's Splendid Mammoth Pictorial Tour of the United States Comprising Views of the African Slave Trade; Of Northern and Southern Cities; of Cotton and Sugar Plantations; of the Mississippi, Ohio and Susquehanna Rivers, Niagara Falls, & C. (Cincinnati, 1855)

BIBLIOGRAPHY

D. Willis, ed.: *J. P. Ball: Daguerrean and Studio Photographer* (1993)

D. Willis: *Reflections in Black: A History of Black Photographers, 1840 to the Present* (New York, 2000)

Camara Dia Holloway

Ball, Thomas

(*b* Charlestown, MA, 3 June 1819; *d* Montclair, NJ, 11 Dec 1911), sculptor. Active in the mid-19th

century, and for much of his career an expatriate in Italy, Ball is noted for his bronze portrait statues. Largely self-taught, he began as a painter in New England before turning to sculpture. In 1854, he settled in Italy and became an important part of the American expatriate community. He returned to Boston in 1857, but went back to Italy in 1865, where his house and studio became important stops for American artists and visitors. His pupils included Daniel Chester French and Martin Milmore (1844–83). Ball's naturalistic style was little influenced by the Neo-classicism of contemporaries such as Hiram Powers. A pioneer in the popularization of mass-produced statuettes, he is best known for his public monuments, especially the equestrian statue of *George Washington* in the Boston Public Gardens and the *Emancipation Group* in Washington, DC.

Ball's father was a sign painter, and both his parents were interested in music, a gift he shared. He supplemented his income early in his career by singing professionally. After his father's death, he left school and worked at various jobs including cutting silhouettes and painting miniature portraits. His first sculpture success was with a cabinet-sized portrait of the Swedish soprano, *Jenny Lind* (1851; NY Hist. Soc.), which he copyrighted and sold in plaster copies. Other cabinet busts followed of musicians and politicians, including Daniel Webster, a man he greatly admired. In 1853 he made a statuette of *Webster* (Washington, DC, US Senate) that was reproduced in multiple copies, as was a companion piece of *Henry Clay* (1858; Washington, DC, US Senate). These are important early experiments with mass-produced sculpture.

Ball married in 1835 and went to Italy, where he became an important member of the expatriate community in Florence. While many of his early portrait busts were in marble, he is best known for his bronzes, especially a series of public monuments done from the late 1850s to the 1870s. The first of these was the equestrian statue of *George Washington* (1858–69) for the Boston Public Gardens. He had

returned to Boston in 1857, where he worked on it, but went back to Florence in 1865. Probably his best-known work is the *Emancipation Group*, also called the Freedman's Memorial, for Washington, DC (1874). A memorial to Lincoln, it was started with the donations of freed slaves. At its dedication in 1875, Frederick Douglas gave the oration. Other important works include statues of *Charles Sumner* (1868; Boston Public Gardens) and *Daniel Webster* (1876; New York, Central Park).

In 1870, Ball built his family home, the Villa Ball, in Florence next door to Hiram Powers. For 20 years, it was a center for American artists and visitors. In 1892 Ball published his autobiography, *My Three Score Years and Ten*, and in 1900, he updated it as *My Fourscore Years*. Both are important resources for the sculpture of the period. He retired to New Jersey in 1897 to live with his daughter and her husband, William Couper (1853–1942), a sculptor and Ball's former pupil. Ball died there in 1911.

BIBLIOGRAPHY

W. Partridge: "Thomas Ball," *New England Mag.* (1895), pp. 292–304

L. Taft: *The History of American Sculpture* (New York, 1925), pp. 141–9

W. Craven: *Sculpture in America* (New York, 1968), pp. 219–28

W. Craven: "The Early Sculptures of Thomas Ball," *NC Mus. A. Bull.* (1964–5), pp. 2–12

K. Savage: *Standing Soldiers, Kneeling Slaves, Race, War and Monument in Nineteenth-Century America* (Princeton, 1997)

M. Hatt: "Making a Man of Him: Masculinity and the Black Body in Mid-Nineteenth-Century American Sculpture," *Re-Racing Art History*, ed. K. Pinder (New York, 2002), pp. 191–213

Pamela H. Simpson

Baltimore

Largest city in Maryland, with a population of just under 650,000 (and a wider metropolitan population of 2.7 million). Situated on the Patapsco River at the northern edge of Chesapeake Bay, Baltimore was named after the baronial title of the Calvert family.

Established in 1729 as a tobacco port, it was incorporated as a city in 1797 and by 1800 was the third largest city in the country.

Baltimore's architecture is a distinguished reflection of the city's importance. Only a few buildings survive from the 18th century, including Mount Clare (1757–87) and Fort McHenry (1799–1805) designed by Jean Foncin (enlarged 1813–57), the defense of which in 1814 inspired the national anthem. The Federal period saw an outpouring of impressive buildings, especially the Roman Catholic Cathedral (1805–21; now Basilica of the Assumption) by Benjamin Henry Latrobe, a major example of international Neo-classicism. Also active here was Maximilian Godefroy, whose works include the Neo-classical First Unitarian Church (1817–18) and the Battle Monument (1815–22), as well as St Mary's Chapel (1806–8), an early example of the Gothic Revival in America. Latrobe's former pupil, Robert Mills, was responsible for the nation's first Washington Monument (1814–29), as well as the demolished Waterloo Row (1816–19), one of the series of row or terrace houses for which Baltimore is famous. There were also prolific local architects, such as Robert Cary Long Sr. (1770–1833).

During the middle third of the 19th century, the city thrived, with major examples of impressive architecture. In the Greek Revival style were such structures as the McKim Free School (1833) by William F. Small and William Howard; St Peter the Apostle Church (1843–4) by Robert Cary Long Jr.; and Evergreen (1857–8), a grand country house. In the Gothic Revival style were such churches as Long's St Alphonsus (1842–5) and the polychromed Mt. Vernon Place Church (1872) by Thomas Dixon (1819–86), along with Dixon's Baltimore City Jail (1859) and Long's Gatehouse (c. 1845–6), and Niernsee & Neilson's Chapel (1851–57) at Greenmount Cemetery, part of the flourishing rural cemetery movement. The palazzo version of the Italianate style could be found in the Peabody Institute (1859–66 and 1875–8) by Edmund G. Lind (1829–1909), with the later part housing the six-story Peabody Library with its dramatic iron

interior. For the Italian villa mode, there was the demolished Wyman Villa (1851–3), inspired by Richard Upjohn.

Baltimore's dramatic growth continued during the last third of the century, characterized by industrial expansion, as evident in railroad structures from Camden Station (1855–64) by Niernsee & Neilson and Joseph Kemp to the B & O Roundhouse (1884) and Mt. Royal Station (1896), the last two by Baldwin and Pennington. But Baltimore also witnessed a number of other trends, from the Second Empire City Hall (1875) by George A. Frederick (1842–1924) and the Queen Anne style of Johns Hopkins Hospital (1875–89) by Niernsee and Cabot and Chandler, to the Richardsonian Romanesque of Lovely Lane Methodist Church (1883–8) and the Beaux-Arts academicism of the Garrett-Jacobs Mansion (1884–93), both by McKim, Mead & White. There was also the flourishing of the planned garden suburb, epitomized by Roland Park (begun 1891), laid out by George Kessler and the Olmsted Brothers, and its Tudor Revival shopping center (1895) by Wyatt & Nolting.

A disastrous fire in 1904 destroyed much of the central business district, but the city recovered quickly with a building boom, which included a number of steel-framed skyscrapers, including the Romanesque Revival Bromo-Seltzer Tower (1910–1) by Joseph E. Sperry and the Art Deco Baltimore Trust Building (1924–9, now Bank of America) by Taylor & Fisher and Smith & May. Other popular styles ranged from Beaux-Arts classical (e.g. US Custom House, 1903–7; Hornblower and Marshall) to Georgian Revival (e.g. Johns Hopkins' Gilman Hall, 1913–5; Parker and Thomas).

After World War II, the construction of freeways and growing car ownership encouraged migration beyond the city, resulting in a declining urban population. Nevertheless, urban renewal brought new planned development to the old center with Charles Center and its series of modern skyscrapers, including Mies van der Rohe's One Charles Center (1960–3), as well as John Johansen's Brutalist

Mechanic Theater (1967). The downtown waterfront was revitalized with the construction of Harborplace (1979–80) by Benjamin Thompson, developed by the Rouse Co., supplemented by a series of major buildings from I. M. Pei's World Trade Center (1968–77) to Oriole Park at Camden Yards (1992) by Hellmuth, Obata & Kassabaum. Subsequent development of Inner Harbor East extended revitalization with a series of tall buildings, including Legg Mason Building (2007–9) by Hill Glazier. Surrounding all of this are the many neighborhoods that retained their traditional red-brick row houses in a variety of styles.

Among the many cultural organizations and museums are the Walters Art Museum (formerly the Walters Art Gallery), with its Beaux-Arts classical building (1904–8) by Delano & Aldrich, with collections ranging from ancient sculpture to 19th-century painting; and the Baltimore Museum of Art, also with a Beaux-Arts building (1927–9 and 1935–7) by John Russell Pope, and later additions, with collections of American and European painting, sculpture and decorative arts, including the Cone Collection of modern art. Also noteworthy for its American collections is the Maryland Historical Society.

BIBLIOGRAPHY

H. A. Williams: *Baltimore Afire* (Baltimore, 1979)

S. H. Olson: *Baltimore, the Building of an American City* (Baltimore, 1980)

L. H. Nast, L. N. Krause and R. C. Monk: *Baltimore, a Living Renaissance* (Baltimore, 1982)

J. Dorsey and J. D. Dilts: *A Guide to Baltimore Architecture* (Centreville, MD, 3rd ed., 1997)

M. E. Hayward and C. Belfoure: *The Baltimore Rowhouse* (New York, 2001)

J. Elfenbein, J. R. Breihan and T. L. Hollowak, eds.: *From Mobtown to Charm City: New Perspectives on Baltimore's Past* (Baltimore, 2002)

M. E. Hayward and F. R. Shivers, eds.: *The Architecture of Baltimore* (Baltimore, 2004)

E. L. Holcolm, ed.: *The City as Suburb: A History of Northeast Baltimore Since 1660* (Santa Fe, 2008)

Damie Stillman

Baltz, Lewis

(*b* Newport Beach, CA, 12 Sept 1945), photographer. He was a major force in the New Topographics movement in American photography and devised a technique that is cool, subtly considered, surgically executed and ironic. His principal photographic series, *The New Industrial Parks near Irvine, California*, *Park City* and *San Quentin Point*, together comprising the Industrial Trilogy, fuse Minimalist art conventions with cultural observation reminiscent of novelist Norman Mailer (1923–2007) in such works as *The Executioner's Song*. His apparently expressionless but obsessive recording of industrial deserts takes on metaphorical overtones as a representation of an American wasteland. Baltz's bleak vision of "landscape as real estate" has found echoes in the work of many later photographic artists around the world. His work in the 1990s reflected his interest in surveillance and cybernetics. In 2003 Baltz became a Professor of Art at the University IUAV in Venice, Italy.

[*See also* New topographics.]

PHOTOGRAPHIC PUBLICATIONS

The New Industrial Parks near Irvine, California (New York, 1974)

Park City (New York, 1980)

San Quentin Point (New York, 1986)

Rule without Exception (Des Moines and Albuquerque, 1990)

Candlestick Point, text by G. Blaisdell. (Tokyo, 1989)

Giochi di Simulatzione (Italy, 1991)

Rule Without Exception, text by M. Fukugawa. (Japan, 1992)

Lewis Baltz: 5 Projects, text by H. Visser. (Amsterdam, 1992)

Lewis Baltz, text by B. Lamarche-Vadel. (Paris, 1993)

Regle Ohne Ausnahme, text by U. Stahel. (Zurich and Berlin, 1993)

Lewis Baltz, text by D. Baudier and S. Morten. (Humlebaek, Denmark, 1995)

Lewis Baltz: Politics of Bacteria, Docile Bodies, Ronde de nuit, text by C. Butler. (Los Angeles, 1998)

Lewis Baltz, text by J. Rian. (London, 2001)

The Prototypes (New York; Los Angeles; Göttingen; 2005)

The Tract Houses, text by S. Conkleton. (New York; Los Angeles; Göttingen, 2005)

89-91: *Sites of Technology*, text by A. Frongia. (Modena and Göttingen, 2007)

CONTACT: Lewis Baltz (Paris)

Geschichten von Verlangen und Macht, text by S. Perkovic. (Zurich and New York)

BIBLIOGRAPHY

J. Green: *American Photography: A Critical History 1945 to the Present* (New York, 1984)

Mark Haworth-Booth

Banham, Reyner

(*b* Norwich, 2 March 1922; *d* London, 18 March 1988), English architectural historian, critic, teacher, writer and journalist, active in the USA. Banham spent the years 1939–45 as an apprentice in the Bristol Aeroplane Company. In 1946 he married Mary Mullet, an art teacher, and for a few years thereafter wrote art reviews for local journals in Norwich, lectured to local organizations and worked as a stage manager at the Norwich theater workshop. In 1949 he moved to London to read art history at the Courtauld Institute, graduated in 1952 and immediately joined the editorial staff of the *Architectural Review*. His regular Sunday-morning open house was by then already attracting the coterie of artists, architects and critics who joined with others at the Institute of Contemporary Arts to form the Independent Group, the first full meeting of which Banham convened in 1952. It has been asserted that at this time his "real muse was [Filippo Tommaso] Marinetti, and in his polemic, motor cars vied with buildings" (see Wilson), but he was also active in the Independent Group in 1954–5 when the ideas of Pop art were initiated and the concepts of a Pop urban culture formulated (Jencks).

During the 1950s Banham published several substantial and groundbreaking critical articles, notably on the Italian Futurists and Neo-Liberty movement, in the *Architectural Review* and other journals; in parallel he developed his racy critical style in the "Not Quite Architecture" column (1958–64) of the

Architects' Journal and a series of articles (1958–65) for the *New Statesman and Nation*. In 1958 he completed a part-time PhD under Nikolaus Pevsner. His first book (and for many his most influential), *Theory and Design in the First Machine Age* (1960), which was based on his dissertation, is a detailed and scholarly exposition of the origins and development of the Modern Movement. In 1960 he became a part-time lecturer at the Bartlett School of Architecture, London. After two years on a research fellowship in Chicago (1964–6) he returned to London to lecture full time at the Bartlett, published *The New Brutalism* (1966) and settled into a series of popular articles (1965–85) in *New Society*. He was appointed to the Chair of Architectural History at the Bartlett—the first in any British university—in 1969, when his Chicago studies were published as *The Architecture of the Well-Tempered Environment*.

Increasing contact with the USA in the early 1970s produced *Los Angeles: The Architecture of Four Ecologies* and his edited version of *The Aspen Papers*, a record of 20 years of design conferences at Aspen, CO. In 1977 he moved to the USA to become Professor and Chairman of Design Studies at the University of New York, Buffalo, subsequently taking up the Chair of Art History at the University of California, Santa Cruz, in 1980. His *Scenes in America Deserta* (1982) approached the English literary tradition, its title deliberately echoing Charles Montagu Doughty's *Travels in Arabia Deserta* (1888). The last book published in Banham's lifetime, *A Concrete Atlantis: US Industrial Building and European Modern Architecture, 1900–1925* (1986), appeared little more than a year before he accepted a Chair of Architectural History and Theory that was specially created for him at the University of New York, but he died a month before his inaugural lecture. Banham was a gifted, natural teacher, combining a populist attitude to theory and design with an enthusiasm for and understanding of the role of technology, and he was an endless fund of informal anecdote about the celebrated architects of the recent past, many of whom he had met as a student or journalist. As a

critic and writer he sought and promoted a nonrhetorical, technically advanced and progressive architecture, far removed from the myths and dogmas of the early Modern Movement.

WRITINGS

Theory and Design in the First Machine Age (London, 1960)

Guide to Modern Architecture (London, 1962); rev. as *Age of the Masters: A Personal View of Architecture* (London, 1975)

The New Brutalism: Ethic or Aesthetic? (London, 1966)

The Architecture of the Well-Tempered Environment (London, 1969/R 2/1984)

Los Angeles: The Architecture of Four Ecologies (London, 1971, 2/1982)

The Aspen Papers: Twenty Years of Design Theory from the International Design Conference in Aspen (London, 1974)

Megastructures: Urban Futures of the Recent Past (London, 1977)

Scenes in America Deserta (Layton, UT, 1982)

ed.: *Buffalo Architecture: A Guide* (London, 1983)

A Concrete Atlantis: US Industrial Building and European Modern Architecture, 1900–1925 (Cambridge, MA, 1986)

The Visions of Ron Herron (London, 1994)

BIBLIOGRAPHY

W. Ellis: "On Reyner Banham's Los Angeles: The Architecture of Four Ecologies," *Oppositions*, 2 (1974), pp. 71–80

S. Lyall: "Banham's Background," *J. RIBA*, 3rd ser., lxxxviii (1981), 10, pp. 3–5 [suppl.]

P. Sparke, ed.: *Reyner Banham: Design by Choice* (London, 1981)

C. Jencks: *Modern Movements in Architecture* (London, 1985), pp. 270–98

S. Richardson: *Reyner Banham: A Bibliography* (Monticello, 1987)

C. St. J. Wilson: Obituary, *Archit. J.*, clxxxvii (1988), 12, pp. 19–21

G. Naylor: "Theory and Design: The Banham Factor," *J. Des. Hist.*, 10 (1997), 3, pp. 241–52

C. S. Wright: *The New Brutalism: Reyner Banham's Definition and Its Application to 1950's Sculpture* (M.A. thesis, 1998)

J. E. Farnham: "Pure Pop for Now People. Reyner Banham, Science Fiction and History," *Lotus Int.*, 104 (1999), pp. 112–31

N. Whiteley: *Reyner Banham: Historian of the Immediate Future* (Cambridge, MA, 2002)

V Michael: "Reyner Banham: Signs and Designs in the Time without Style," *Des. Iss.*, 18 (2002), 2, pp. 65–77

Anthony Vidler: *Histories of the Immediate Present: Inventing Architectural Modernism* (Cambridge, MA, 2008)

A. Vinegar and M. J. Golec, eds: *Relearning from Las Vegas* (Minneapolis, 2009) ["Los Angeles and Reyner Banham," Nigel Whiteley]

John Musgrove

Bannister, Edward Mitchell

(*b* St Andrews, NB, 1833; *d* Providence, RI, 9 Jan 1901), painter of Canadian birth. Bannister grew up in St Andrews, a small seaport in New Brunswick, Canada. His interest in art was encouraged by his mother, and he made his earliest studies, in drawing and watercolor, at the age of ten. After working as a cook on vessels on the Eastern seaboard, he moved in 1848 with his brother to Boston, where he set up as a barber serving the black community. During the 1850s and 1860s he learned the technique of solar photography, a process of enlarging photographic images that were developed outdoors in daylight, which he continued to practice while working in Boston and New York. Documented paintings from this time include religious scenes, seascapes and genre subjects, for example, the noted *Newspaper Boy* (1869; Washington, DC, Smithsonian Amer. A. Mus.), a rare study of urban black experience.

In 1870 Bannister and his wife moved to Providence, RI, where his work flourished and his paintings were collected by such patrons as George T. Downing (1819–1903), a wealthy local entrepreneur, and the black soprano Matilda Sissieretta Jones (1868–1933). In 1876 he became the first African American artist to win a national award, when he received first prize in the Philadelphia Centennial Exposition for *Under the Oaks* (untraced); in 1876 a contemporary described this as a "simple composition, quiet in tone but with strong oppositions" ("Reminiscences of George Whitaker," *Providence Magazine*, Feb 1914). He drew inspiration from Millet and the French Barbizon School. Although he was conscious of his rights as an American citizen, Bannister did not bring politics into his art but aimed to win recognition for his achievement in landscape painting. The last part of his life was marked by ill health and declining patronage, which did not deter him from maintaining a productive output, with 27 paintings dating from the 1890s.

[*See also* African American art.]

BIBLIOGRAPHY

Edward Mitchell Bannister (exh. cat. by L. R. Hartigan, Washington, DC, N. Mus. Amer. A., 1985)

G. B. Opitz: *Dictionary of American Painters, Sculptors and Engravers* (New York, 1986)

Edward Mitchell Bannister, 1833–1901 (exh. cat. by C. Jennings, New York, Whitney, 1992–3)

J. M. Holland: "To Be Free, Gifted and Black: African American Artist Edward Mitchell Bannister," *Int. Rev. Afr. Amer. A.*, xii/1 (1995), pp. 4–25

Edward M. Bannister 1828–1901: A Centennial Retrospective (exh. cat. by C. Boisseau, Newport, RI, Roger King Gal. A., 2001)

Baptists and Congregationalists

Christian nonconformist denominations, basically Calvinist in theology. The Baptist tradition has roots in 16th-century Swiss Anabaptism and among the English Baptists of the 17th century. Their distinctive beliefs include baptism by immersion of self-professed believers, the separation of church and state, the priesthood of all believers and a stress on biblical authority. Congregationalists, related to the European Reformed tradition and English separatists, are distinguished by the congregational form of church government and freedom for all believers using the church and commonwealth as instruments of a theocratic society. Churches were established in North America in the early 17th century: the Congregationalists (Pilgrims and Puritans) in 1611 and 1623 and the Baptists in 1638–9. Both traditions made missionary inroads in Africa and the East, while Baptists also found converts in Europe, notably in 19th-century Russia. By the second half of the 20th century there were more than 50 groups of Baptists in the USA. American Congregationalists became part of the United Church of Christ in 1961; in England and Wales the United Reformed Church was created in 1972 through union with the Presbyterians.

Both Baptists and Congregationalists began as countercultural movements, separating themselves from the artistic tradition of Western Christianity. Early Netherlandish Anabaptists included the glass-painters Jan Woutersz, and Rommenken, who were both martyred in 1572, and David Jorisz., who fled to Basel. Initially members were responsible for considerable iconoclasm, justified by the proscription against images (Exodus 20:4). Their major arts were literary rather than visual, as exemplified by *The Saint's Everlasting Rest* (London, 1650) by the Puritan Richard Baxter (1615–91) and *The Pilgrim's Progress* (London, 1678) by the Baptist John Bunyan (1628–88). Their traditions of craftsmanship are represented by the Anabaptist Habán potters, who were driven from Moravia *c.* 1620 and retained their Baptist identity until recent times.

The arts of glass painting and Fraktur lettering survived through the German and Dutch Mennonites and the American Puritan heritage, illustrating biblical and moralistic themes in a naive style. Examples of early American Baptist and Puritan folk art and crafts (e.g. New York, Mus. Amer. Flk A.) parallel those of the Mennonite, Amish, Lutheran and Shaker traditions. Churches in a simplified Williamsburg style, adapted from the English churches of Christopher Wren, dot the New England landscape. In Britain there is no single characteristic Baptist or Congregationalist style of church architecture, although Welsh Baptist chapels in particular emphasize the interior focus on the pulpit.

Since the 18th century both denominations have established painting traditions. Congregationalists concentrated on portraits of divines and primitive paintings of biblical scenes, while Baptist artists commonly depicted scenes of baptism by immersion, such as Gustaf Cederström's *Baptists* (1886; Stockholm, Baptist Seminary, Chapel), a poignant rural portrayal. Paolo Paschetto (*d* 1963), the son of a Baptist minister, was trained and taught at the Accademia di Belle Arti, Rome. His works in Rome include the interior design of the Waldensian church and a series of paintings based on *Psalm 23* (1956) in the offices of the Italian Baptist Convention. Both denominations support institutions of higher education concentrating on the visual arts.

The principal art form in adult baptism congregations in America consisted of baptistery paintings often done by congregation members. These paintings or murals, executed on the back wall of the baptistery, are called Jordans because the scenes depict the Jordan River, or the artist's imaginative reconstruction of it. At the end of the 20th century such scenes were being replaced by other items of decoration and were becoming a passing folk art form of the Free Churches. Some artisans painted these scenes as an avocation: commercial artist Phil Preddy (*b* 1899) of New Orleans, LA, painted more than 150 baptistery scenes, and Cassius Clay Sr. painted Jordans for African American churches in Louisville, KY, some of which survive.

BIBLIOGRAPHY

H. C. Vedder: *A Short History of the Baptists* (Philadelphia, 1907)

W. W. Sweet: *The Baptists, 1783–1830: A Collection of Source Material* (New York, 1931)

W. W. Sweet: *The Congregationalists: A Collection of Source Materials* (Chicago, 1939)

C. C. Goen: *Revivalism and Separatism in New England, 1740–1800: Strict Congregationalist and Separate Baptists in the Great Awakening* (New Haven, 1962)

R. G. Torbet: *A History of the Baptists* (London, 1965)

W. R. Estep: *Anabaptist Beginnings, 1523–1533: A Source Book* (Nieuwkoop, 1976)

J. Lipman and T. Armstrong, eds: *American Folk Painters of Three Centuries* (New York, 1980)

R. Kennedy: *American Churches* (New York, 1982)

C. K. Dewhurst, B. MacDowell and M. MacDowell: *Religious Folk Art in America: Reflections of Faith* (New York, 1983)

J. Dillenberger: *The Visual Arts and Christianity in America: From the Colonial Period to the Present* (New York, 1989)

W. L. Hendricks: "Southern Baptists and the Arts," *Rev. & Expositor*, lxxxvii (1990), pp. 553–62

J. W. T. Youngs: *The Congregationalists* (Westport, CT, 1990)

B. J. Leonard, ed.: *Dictionary of Baptists in America* (Downers Grove, 1994)

W. H. Brackney: *Historical Dictionary of the Baptists* (Lanham, 1999)

W. H. Brackney: *Baptists in North America: An Historical Perspective* (Malden, 2006)

William L. Hendricks

Baranik, Rudolf

(*b* Lithuania, 1920; *d* New York, 6 March 1998), painter and teacher of Lithuanian birth. Baranik migrated to the USA in 1938 and served in the US Army in World War II. He studied at the Art Institute of Chicago (1946–8) and at the Art Students League in New York, where he met painter May Stevens, whom he later married. Baranik and Stevens lived in Paris from 1948 until the end of 1951, initially studying at the Académie Julian; Baranik then studied in the atelier of Fernand Léger (1881–1955).

In 1952, Baranik first showed at the ACA Gallery in New York, which represented prewar Realist school painters. He left the gallery in 1955, joining the Roko Gallery by 1958. Through contact with the Abstract Expressionists, and especially with fellow Lithuanian Ad Reinhardt, Baranik moved away from the rough materiality of his Parisian work. In the 1960s, figural elements appear on large canvases that he treated like color field paintings.

Involved in protest movements and a committed leftist, he found source material in the imagery of the Vietnam War. His best-known works, including *Napalm Night* (1964) and *Napalm Elegies* (1967–74), are connected to this theme. Although these have been read as statements of political sympathy, Baranik also intended them as meditations on the signifying power of painting: "Socialist formalism" was the designation that he preferred for his position between the older realists and the Abstract Expressionists.

Throughout the 1960s and 1970s, Baranik was engaged in political actions with friends Nancy Spero and Leon Golub, including "Artists and Writers Protest Against the War in Vietnam," the "Art Workers' Coalition" and "Artists Meeting for Cultural Change," which began in his loft in 1975. In the 1980s, Baranik returned to the literary and poetic classicism that inspired his earlier work. His son's suicide in 1982 led to a series of figurative works titled after works by Shakespeare

and T. S. Eliot. Baranik taught at the Pratt Institute in Brooklyn from 1966 to 1991.

After distancing himself from the practice of political art in the 1950s, but refusing to exclude the political from his life and work, it is ironic that Baranik has been represented in historical texts primarily as a political artist.

[*See also* Stevens, May.]

BIBLIOGRAPHY

Rudolf Baranik: Elegies: Sleep Napalm Night Sky (exh. cat., essay by D. Kuspit, Columbus, OH, U. Gal. F.A., 1987)

D. Craven: *Rudolf Baranik: Art and Ideas* (Cortland, NY, 1988)

D. Craven: *Poetics and Politics in the Art of Rudolf Baranik* (Atlantic Highlands, NJ, 1997)

R. Smith: "Rudolf Baranik Dies at 77; Artist and a Political Force," *NY Times* (15 March 1998), p. 42

Rudolf Baranik (exh. cat., essay by L. Lippard, Tucson, U. AZ Mus. A., 2001)

Rudolf Baranik: The Napalm Elegies (exh. cat. by D. Craven and others, Jersey City, NJ, Mus., 2003)

Matico Josephson

Barnard, George Grey

(*b* Bellefonte, PA, 24 May 1863; *d* New York, 24 April 1938), sculptor and collector. Son of a Presbyterian minister, Barnard grew up in the Midwest and began studying at the Chicago Academy of Design in 1880 under Douglas Volk and David Richards. Here he was first introduced to plaster casts of Michelangelo's works and to the casts of Abraham Lincoln made by Leonard Volk in 1860, both clearly influential on his subsequent career. In 1883, he went to Paris, where he enrolled in the Ecole des Beaux-Arts and worked with Pierre-Jules Cavelier (1814–94). Barnard's sculptures are noted for their spiritual, allegorical and mystical themes and were done in the expressive modeling style of the period.

Alfred Corning Clark, wealthy heir to the Singer fortune, became Barnard's patron in 1886. Through Clark and his Norwegian companion Lorentz Severin Skougaard, Barnard was introduced to Nordic themes. Clark commissioned important marble pieces including *Boy* (1884) and *Brotherly Love* (1886–7), a homoerotic composition of two male nude figures that was destined for Skougaard's grave in Langesund, Norway. Another nude composition, *The Struggle of the Two Natures with in Man*, was based on a heroic theme from Victor Hugo. Clark had it carved in marble (1891–4) and presented it to the Metropolitan Museum. Another Clark commission, *The Great God Pan*, was cast in bronze in 1898, and though originally intended for a fountain in Clark's Dakota Hotel in New York, it eventually went to Columbia University.

The early high point of Barnard's Parisian career was in 1894, when a number of his pieces commissioned by Clark were exhibited at the Salon de Champs-de-Mars to wide acclaim, including Rodin's. Barnard left Paris in 1894 to return to the USA, and in 1895 he married the sculptor Edna Monroe. They settled in New York. Clark died the following year. Barnard taught for two terms at the Art Students League in New York.

His first important American commission was for sculptural groups to adorn the new Pennsylvania Capitol at Harrisburg (1902–11). He returned with his family to France to work on the project, but charges of corruption in Harrisburg led to delays in payment until a group of wealthy patrons organized to support Barnard and allowed him to complete the marble figures. They were finally unveiled in Harrisburg in 1911. The sculptures comprise two groups of heroic nudes representing *Love and Labor: The Unbroken Law* and *The Burden of Life: The Broken Law*. The themes reflected his life-long interest in the heroic dignity of ordinary laborers.

In 1911 Charles P. Taft, brother of the president, commissioned Barnard to create a monumental bronze statue of Abraham Lincoln for Cincinnati. Displayed in New York in 1916 and installed in Lytle Park, Cincinnati, in 1917, the 13-foot colossus was hailed by President Taft and Theodore Roosevelt but derided in the press for its deliberately homely, awkward, unidealized appearance. A copy

commissioned by Taft in 1917 for London ended up in Manchester due to the critical uproar. London received a cast of the more acceptable Augustus Saint-Gaudens *Lincoln* (1887) instead. A third cast, privately commissioned by Isaac W. Bernheim, was erected in Louisville, Kentucky, in 1922. This was to be Barnard's last major completed commission. In the years after World War I he worked on an elaborate project for a National Peace Memorial. The *Rainbow Arch*, composed of some fifty heroic figures, was completed in plaster in 1933, but was never erected. His early marble sculptures and the Lincoln statues remain his best-known works.

Barnard was also a significant collector of medieval art and the founder of what would become the Cloisters Museum in New York. In 1905 he began collecting French medieval antiquities, including architectural remnants. Although he sold some to the Louvre, his goal was to sell his collection to the Metropolitan Museum of Art in New York. Although he had support from Roger Fry, who was then working at the Metropolitan, negotiations led nowhere.

In 1913 Barnard managed to export his collection, including most of the cloister of Saint-Michel-de-Cuxa, from France to New York and set it up as a private museum on Fort Washington Avenue. Inspired by the Cluny Museum in Paris, he thought medieval art should be displayed in a medieval setting. His first Cloisters museum, opened in 1914, was a romantic medieval stage, complete with hooded escorts, music and incense. John D. Rockefeller Jr., himself a collector of medieval antiquities, bought some of Barnard's collection, and negotiations resulted in Rockefeller obtaining the Barnard Cloisters museum and presenting it to the Metropolitan Museum of Art in 1925. In 1938, the Cloisters museum was opened to the public in Fort Tryon Park. Designed by Charles Collens and underwritten by Rockefeller, it incorporated both Barnard's and Rockefeller's collections.

Barnard continued to collect medieval art and architecture and created a new museum called the Abbaye, which he opened in New York in 1937. Most

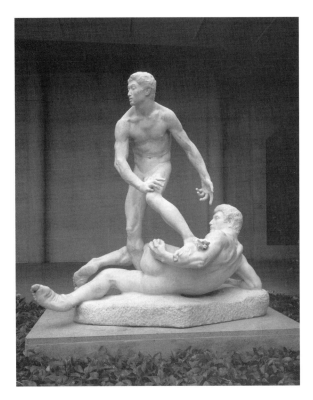

GEORGE GREY BARNARD. *The Struggle of the Two Natures in Man*, marble, h. 2.6 m, 1892–4. GIFT OF ALFRED CORNING CLARK, 1896 © THE METROPOLITAN MUSEUM OF ART/ART RESOURCE, NY

of that collection was acquired by the Philadelphia Museum of Art in 1945, along with an important group of his papers. In 1936 he donated his collection of studio plaster casts to Kankakee Central School, most of which are now in the Kankakee County Museum. He died in New York in 1938.

ARCHIVAL COLLECTIONS

Archives of American Art, Smithsonian Institution, Washington, DC; Philadelphia Museum of Art; Kankakee County Historical Society, Kankakee, Illinois; Bellefonte Historical Society, Bellefonte, Pennsylvania; Pennsylvania State Archives, Harrisburg, Pennsylvania.

BIBLIOGRAPHY

W. A. Coffin: "A New American Sculptor: George Grey Barnard," *C. Mag.*, liii (1897), pp. 877–82

H. E. Dickson, "Barnard's Sculptures for the Pennsylvania Capitol," *A. Q.*, 22 (1959), pp. 126–47

George Grey Barnard: Centenary Exhibition, 1863–1963 (exh. cat., intro. H. E. Dickson; University Park, PA State U., Palmer Mus. A., 1964)

"George Grey Barnard's Controversial Lincoln," *A. J.*, 27 (1967), pp. 8–15.

"Origin of the Cloisters," *A. Q.*, 28 (1965), pp. 252–75.

J. L. Schrader, "George Grey Barnard: The Cloisters and the Abbaye," *Bull. Met.*, xxxvii (1979), pp. 3–52

E. B. Smith: "George Grey Barnard: Artist, Collector, Dealer, Curator," *Medieval Art in America: Patterns of Collecting, 1800–1940* (exh. cat., University Park, PA State U., Palmer Mus. A., 1996), pp. 133–42

F. C. Moffatt, *Errant Bronzes: George Grey Barnard's Statues of Abraham Lincoln* (Newark and London, 1998).

Lawrence E. Butler

Barnard, George N.

(*b* CT, 23 Dec 1819; *d* Cedarville, NY, 4 Feb 1902), photographer. Barnard began to take photographs *c.* 1842 and opened a daguerreotype studio in Oswego, NY, in 1843. His two views of a fire at Ames Mills, *Burning Mills at Oswego, NY, [5 July] 1853* (Rochester, NY, Int. Mus. Phot.), are remarkable examples of early daguerreotype reportage. In the same year he was secretary of the New York State Daguerrean Association. After purchasing Clark's Gallery, Syracuse, in 1854, he began to produce ambrotypes; in the latter half of the decade he learned the collodion process.

Barnard took photographs in Cuba in 1860, but these works are untraced. Shortly before the American Civil War (1861–5), he was employed by Mathew Brady in New York and, possibly, Washington, DC. Barnard made some of his earliest known collodions with J. B. Gibson at Bull Run, VA, the site of the first major land battle of the Civil War (e.g., *Ruins of Stone Bridge, Bull Run*, 1862; see Gardner, i, pl. 7); many were wrongly credited to Brady. He was briefly employed as a photographer at Gray's Gallery, Oswego, in 1862. From 1863 to 1865 he was official Army photographer, Chief Engineer's Office, Division of Mississippi. Afterward he published *Photographic Views of Sherman's Campaign* (New York, 1866/R 1977, with preface by B. Newhall), a landmark portfolio of albumen prints made from collodion negatives, showing the aftermath of war, with a separate prospectus explaining its human aspect. He returned to Syracuse, NY, *c.* 1866 and is known to have run a studio at Charleston, NC (before 1869 and after 1871), where he produced and published notable series of stereographs of black street vendors (*c.* 1875; see *Photographic Views of Sherman's Campaign*, 1977, p. vii). Between 1869 and 1871 he ran a studio in Chicago and photographed the aftermath of the Great Fire (1871). In 1883 he promoted gelatin dry plates for George Eastman of Rochester, and he had his last studio in Plainsville, OH (1884–6).

[*See also* Photography.]

WRITINGS

"Taste," *Phot. F.A. J.*, viii/4 (May 1855), pp. 158–9

BIBLIOGRAPHY

A. Gardner: *Gardner's Photographic Sketchbook of the War*, 2 vols (Washington, DC, 1866/R 1959 as *Gardner's Photographic Sketchbook of the Civil War*, intro. E. F. Bleiler)

Obituary, *Anthony's Phot. Bull.*, xxxiii/4 (1902), pp. 127–8

R. Taft: *Photography and the American Scene: A Social History, 1839–1889* (New York, 1938/R 1964), pp. 128, 230–32, 486

A. M. Slosek: "George N. Barnard: Army Photographer, with Photographs by Barnard," *Oswego County, New York, in the Civil War* (Oswego, 1964), pp. 39–59

K. F. Davis: "Death and Valor," *Register Spencer Mus. A.*, vi/5 (1988), pp. 12–25

A. Trachtenberg: *Reading American Photographs: Images as History: Mathew Brady to Walker Evans* (New York, 1989)

K. F. Davis: *George N. Barnard: Photographer of Sherman's Campaign* (Kansas City, 1990)

R. L. Harley Jr.

Barnes, Albert C.

(*b* Philadelphia, PA, 2 Jan 1872; *d* Chester County, PA, 24 July 1951), chemist and collector. Barnes made his fortune after discovering the drug Argyrol in 1902. By 1907 he had become a millionaire. He and his wife moved to the suburb of Merion on Philadelphia's affluent Main Line and with his new income began to collect paintings of the Barbizon school. In 1910 he renewed contact with a former school friend, William J. Glackens, who introduced him to the works of Maurice Prendergast, Alfred

H. Maurer and Charles Demuth and who encouraged Barnes to collect Impressionist and Post-Impressionist paintings instead of Barbizon works. In 1912 Barnes gave Glackens £20,000 to go to Paris and buy whatever art he saw fit. Glackens, with the help of Maurer, acquired for Barnes works by Renoir, Degas, van Gogh, Cézanne, Monet, Gauguin, Pissarro, Sisley and Seurat. In Paris, Glackens introduced Barnes to Gertrude and Leo Stein, through whom he became familiar with the work of Picasso and Matisse.

By 1913 Barnes had returned to Europe to acquire paintings for himself. By 1915 he owned 50 works by Renoir, 14 by Cézanne, several by Picasso and some Fauvist paintings. He purchased widely among the leading Post-Impressionists. He is credited with being the first to appreciate the work of Chaïm Soutine, which he began to buy in Paris in 1923, and he was among the first to collect Modigliani's paintings. He also acquired works of early American modernists such as Andrew Dasburg (b 1887), Hartley, Maurer, Sheeler, Carles and Demuth. His collection of Impressionist and Post-Impressionist works was later considered one of the most important. It comprised more than 1000 paintings, antique furniture and other art objects, including c. 175 works by Renoir, 66 by Cézanne, 65 by Matisse (among them a mural designed especially for the gallery window lunettes) and other works by Picasso, Soutine, Modigliani, Demuth, Rouault, Degas, Seurat, Rousseau, Courbet and others. It also included Old Master paintings, African sculpture and a large array of Pennsylvania Dutch wooden chests and ironmongery.

In 1923 an exhibition of Barnes's collection was held at the Pennsylvania Academy of Fine Arts, Philadelphia. The response from local art critics was very negative, some saying that the paintings could have been done by children or by the mentally ill. This led to a feud between Barnes and the Philadelphia art establishment that had lasting effects. Barnes proceeded with plans to build a small museum to house his collection. The Barnes Foundation, founded in 1922 as an educational institution, opened in 1925 in Merion, with 22 rooms in a limestone mansion located in a 12-acre arboretum. Barnes's tendency to nurture a grudge against art critics was rivaled by his resentment of high society; over the years he became infamous for the number of notable people to whom he refused a chance to view his collection.

Works of art at the Barnes Foundation were not displayed according to traditional museum categories such as style, school or period. Instead the paintings, antique furniture and a sizable collection of ornamental ironwork were arranged and composed in such a manner that an overall decorative effect was created, demonstrating the aesthetic kinship of the works' plastic values. The "wall pictures," as they were called, were intended to be both decorative and expressive; one wall was arranged to express power, others to express drama, simplicity or delicateness. A "wall picture" might also be arranged to express the harmony of compositional organizations of individual paintings within the arrangement. One might find a triangular arrangement composed of objects that each, individually, exhibit triangular or diagonal composition. It was this totally formal, ahistorical approach to gallery design that resulted in sometimes curious juxtapositions.

Barnes died in a car accident in 1951, and the following year newspaper publisher Walter Annenberg took up the cause to force the Barnes Foundation to make its collection available to visitors. An editor of Annenberg's paper, the *Philadelphia Inquirer*, took legal proceedings to demand that the gallery be opened to the public or lose its tax-exempt status as a non-profit educational institution. After a decade of angry editorials in the *Philadelphia Inquirer* and a prolonged legal battle, in 1961 the Barnes Foundation was obliged by the state to open to the public. Barnes had stipulated in his will that the paintings should remain in exactly the same places that they were at the time of his death, but he also stipulated that the foundation's buildings should be kept in first-class condition. In a highly controversial ruling in 1991, a Montgomery County judge ruled

that to fulfill the latter stipulation the foundation could, exceptionally, overlook the first one and allow a traveling exhibition of some 80 paintings to several venues to renovate the physical facility. The exhibition opened at the National Gallery in Washington, DC, on 9 May 1993 and traveled to Paris, Tokyo, Fort Worth and Toronto, ending in Philadelphia in 1995. The catalog accompanying the exhibition presented the first-ever color pictures of most of the collection, as the foundation had until then refused to allow color reproductions.

WRITINGS

The Art in Painting (Merion, 1925)

with V. de Mazia: *The Art of Henri Matisse* (New York, 1933)

V. de Mazia: *The Art of Renoir* (Merion, 1935)

V. de Mazia: *The Art of Cézanne* (New York, 1939)

BIBLIOGRAPHY

G. M. Cantor: *The Barnes Foundation: Reality vs Myth* (Philadelphia, 1963)

W. Schack: *Art and Argyrol: The Life and Career of Dr Albert C. Barnes* (New York, 1963)

V. de Mazia: "The Barnes Foundation: The Display of Its Art Collection," *Vistas* (1983), pp. 107–20

H. Greenfeld: *The Devil and Dr Barnes: Portrait of an American Art Collector* (New York, 1987)

A. Decker: "Future Shock at the Barnes," *ARTnews* (Summer 1992), pp. 106–11

P. Glatzer: "The Secret Life of Dr Barnes," *Life* (April 1993), p. 76

R. Hughes: "Opening the Barnes Door," *Time* (10 May 1993), pp. 61–4

Great French Paintings from the Barnes Foundation: Impressionist, Post-Impressionist, and Early Modern (exh. cat., New York, 1993)

P. Chisholm: "A Moveable Feast," *Maclean's*, cvii (1994), p. 62

J. Anderson: *Art Held Hostage: The Battle over the Barnes Collection* (New York, 2003)

M. A. Meyers: *Art, Education, and African-American Culture: Albert Barnes and the Science of Philanthropy* (New Brunswick, NJ, 2004)

M. Sue Kendall

Barnes, Edward Larrabee

(*b* Chicago, IL, 15 April 1915; *d* Cupertino, CA, 21 Sept 2004), architect. Barnes studied architecture at Harvard University, Cambridge, MA (1938–42), where his teachers included Marcel Breuer and Walter Gropius. After military service he opened his own office in New York (1949). His subsequent large and varied practice adhered to no specific style doctrine, although the simple forms and choice of materials of most of his work are Modernist. His special ability was in organizing interior spaces and groups of buildings. This can be seen at small scale in his set of 23 shingled, pitch-roofed studio buildings (1961) on a steep site above the sea for the Haystack Mountain School at Deer Isle, ME, and in the Heckscher house (1974) on Mount Desert Island, ME, where four small shingled buildings are set on a wooden platform. On a larger scale his organization of interior spaces in the Walker Art Center (1969), Minneapolis, MN, and the Scaife Gallery (1975), Pittsburgh, PA, demonstrated his versatility.

Barnes's planning abilities were applied to several university master plans, notably that for the State University of New York campus at Purchase (1968)—the organizing principle of which was derived from Thomas Jefferson's plan for the University of Virginia at Charlottesville. Although the glass winter garden of his IBM office building (1983), New York, continued his rational Modernism, his Equitable Tower West (1987), New York, is in a distinctly Postmodern style. He was consistently active in architectural education, serving at various times on the faculties of Pratt Institute, New York, Yale University, New Haven, CT, and Harvard University.

[*See also* Dallas; Minneapolis; *and* Museums.]

WRITINGS

"The Design Process," *Perspecta*, 5 (1959), pp. 20–8

"Remarks on Continuity and Change," *Perspecta*, 9–10 (1965), pp. 291–8

BIBLIOGRAPHY

Contemp. Architects

P. Heyer, ed.: *Architects on Architecture: New Directions in America* (New York, 1966), pp. 324–35

R. B. Harmon: *The Architecture of Restraint in the Works of Edward L. Barnes: A Selected Bibliography* (Monticello, 1981)

J. M. Dixon: "Art Oasis," *Progr. Archit.*, 65/4 (1984), pp. 127–36

M. Gaskie: "Bowing to the East," *Archit. Rec.*, 172/2 (1984), pp. 122–7

M. F. Schmertz: "A Skyscraper in Context," *Archit. Rec.*, 172/ (1984), pp. 146–52

P. Papademetriou: "Dallas Museum of Art: Extending the Modernist Tradition of E. L. Barnes," *Texas Architect*, 35/1 (1985), pp. 36–47

P. Papademetriou: "E. L. Barnes in Retrospect," *Texas Archit.*, 35/1 (1985), pp. 48–51

"Less Is More: 1950, Salisbury, Connecticut," *Abitare*, 245 (1986), pp. 106–11

"Less Is More: 1957, Pound Ridge, New York," *Abitare*, 245 (1986), pp. 112–9

S. Stephens: "An Equitable Relationship?," *Art Amer.*, LXXIV/5 (1986), pp. 116–23

E. L. Barnes: *Edward Larrabee Barnes, Architect* (New York, 1994)

H. N. Cobb: "Edward Larrabee Barnes, March '42, 1915–2004," *Harvard Des. Mag.*, 22 (2005), pp. 135–6

<div align="right">Cervin Robinson</div>

Barney, Matthew

(*b* San Francisco, CA, 25 March 1967), sculptor, installation artist, filmmaker and video artist. Barney

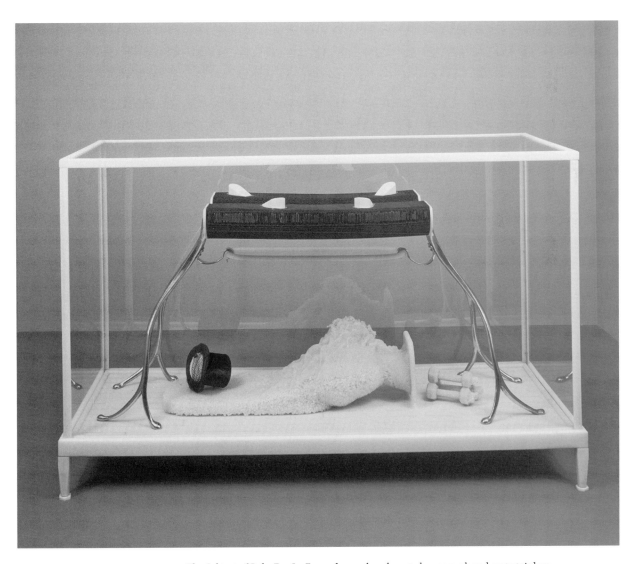

MATTHEW BARNEY. *The Cabinet of Baby Fay La Foe*, nylon, polycarbonate honeycomb and cast stainless steel, h. 1.54 m, 2000. COMMITTEE ON PAINTING AND SCULPTURE FUNDS © THE MUSEUM OF MODERN ART/LICENSED BY SCALA/ART RESOURCE, NY

emerged in the early 1990s to considerable fanfare, based on the reputation of works made while still an undergraduate at Yale University (he graduated with a BA in 1989) and early exhibitions in New York galleries. Exhibitions such as *Field Dressing* (1989; New Haven, CT, Yale, U., Payne Whitney Athletic Complex) and early works in the series *Drawing Restraint* (begun in 1987) established characteristics of Barney's work: striking imagery drawn from an idiosyncratic range of sources (sport-oriented in the earliest works), sculptural objects in signature materials (e.g. petroleum jelly, "self-lubricating plastic") and athletic performances by the artist, in the service of arcane personal mythology. These characteristics are most fully expressed in the *Cremaster* cycle of five films (1994–2003, released out of order, beginning with *Cremaster 4* [1992]). Elaborate and expensive productions featuring lush imagery, drawing on both marginal and mainstream histories (performance art and Hollywood cinema), Celtic and Masonic lore, popular cultural references (Harry Houdini, Gary Gilmore) and anatomical metaphors (the Cremaster is the muscle by which the testicles are raised and lowered), the *Cremaster* films represent a series of narratives of ascent and descent supposedly grounded in the biological process of sexual differentiation. These culminate in the quest narrative of *Cremaster 3* (2002), in which Barney's "Entered Apprentice" overcomes a series of tests in order to achieve the status of "Master Mason" (an adventure that includes scaling the interiors of both the Guggenheim Museum and the Chrysler Building). Each of the films generated a set of sculptural objects and other materials (photographs, drawings), giving rise to discussion about the relative status of the various media Barney employs.

In 2004, Barney returned to live performance for *De Lama Lamina*, a Brazilian carnival procession in collaboration with musician Arto Lindsay. Imagery referring to ecoactivist Julia Butterfly Hill and Candomblé deities informed what was perhaps an allegory of deforestation (the performance was also filmed). *Drawing Restraint 9* (2005), a feature-length 35 mm film, saw more of Barney's hermetic imagery in exoticized contexts, drawing on the history of whaling, Shinto ritual and Japanese tea ceremony, in a mysterious and disjunctive romance narrative set on a Japanese whaling ship in Nagasaki Bay.

BIBLIOGRAPHY

C. Tomkins: "His Body, Himself," *New Yorker* (27 Jan 2003)

Matthew Barney: The Cremaster Cycle (exh. cat. by N. Spector, New York, Guggenheim, 2003)

A. Keller and F. Ward: "Matthew Barney and the Paradox of the Neo-Avant-Garde Blockbuster," *Cinema Journal*, xlv/2 (2006)

Frazer Ward

Barr, Alfred H.

(*b* Detroit, MI, 28 Jan 1902; *d* Salisbury, CT, 15 Aug 1981), art historian and museum director. Barr's career is linked to the history of the Museum of Modern Art (MOMA) in New York and its often controversial role in the promotion of modern art and culture.

Barr graduated in art and archaeology from Princeton University in 1922. The following year he received his MA with a thesis on Piero di Cosimo. At Princeton he studied modern art with Frank Jewitt Mather Jr. (1868–1953), but the synthetic methodology that he learned from the medievalist Charles Rufus Morey proved more influential in his development as a scholar and as the future director of MOMA. Morey presented students with a cross section of the principal medieval visual arts, architecture, sculpture, wall painting and manuscript illumination, as well as minor arts and crafts. After graduate school, Barr traveled in Europe (1923). He returned to the USA and taught art history, first at Vassar College (1923–4), where he mounted an exhibition of Kandinsky's work; at Harvard University (1924–5), where he completed his doctoral courses; at Princeton (1925–6); and finally at Wellesley College (1926–7).

At Wellesley, Barr began to direct his energies specifically toward modern art, and he taught the first undergraduate modern art course ever offered at an American college. Adapting and expanding

Morey's methodology, Barr introduced his students to a panorama of modern culture, giving lectures on painting, sculpture, architecture, graphic arts, film, photography, industrial design, machine art, music, drama and literature. In addition Barr and his students looked at the architecture of H. H. Richardson in Boston, visited a Necco Wafer factory and selected mass-produced objects as examples of modern design. At the end of the academic year Barr went abroad to conduct research on his dissertation, "The Machine in Modern Art." He spent four days in Dessau visiting the Bauhaus and interviewing its members. He was impressed by the fact that in this large, new, modern building the major arts as well as crafts, typography, theater, cinema, photography and industrial design were all studied and taught together, as they were in his experimental modern art course at Wellesley. He changed his dissertation to "Cubism and Modern Art" but did not complete it until 1946.

In July 1929 Barr became director of the newly founded Museum of Modern Art, a post he retained until retirement in 1967. Public appreciation and scholarly study of modern art in the USA were in their infancy in 1929. After the Armory Show (1913), Stieglitz and Steichen's 291 gallery became the sole venue for exhibitions of contemporary avant-garde European and American art. Barr worked to reverse this situation by forming a permanent collection of modern masterpieces and by sponsoring a series of daring temporary exhibitions. His policies as director of MOMA were conditioned by his synthetic approach to the arts. He inaugurated a multi-departmental organization at MOMA, encompassing not only painting, sculpture and the graphic arts but also all modern visual phenomena. He is credited with the development of MOMA's dual role as a repository of established modern art and as a ground for the experimental avant-garde.

Although he left academia permanently, Barr never renounced his role as a teacher and regarded the museum as an educational institution. He organized exhibitions in a pedagogical manner, grouping objects together to elucidate important art-historical and -cultural relationships and providing long and informative labels. The first exhibition, *Cézanne, Gauguin, Seurat and van Gogh* (1929–30), was followed by *Modern Architecture: International Exhibition* (1932; curators Philip Johnson and Henry-Russell Hitchcock); *Machine Art* (1934; curator Philip Johnson); *Cubism and Abstract Art* (1936); *Fantastic Art, Dada, Surrealism* (1936) and numerous others. Barr staged major retrospectives for Matisse (1931) and Picasso (1939). He traced the ancestral tribal roots of modernism in *American Sources of Modern Art (Aztec, Mayan, Incan)* (1933); *African Negro Art* (1935); and *Indian Art of the United States* (1941). One of Barr's most controversial exhibitions was *Artists of the People* (1941), in which he featured the works of contemporary amateur artists. Many of these exhibitions at MOMA were accompanied by books or catalogs written by Barr. Scholarly in approach yet written in a style accessible to the layman, these works have been recognized as model museum publications. Some of the best known of a list of at least 339 items are *Picasso: Fifty Years of his Art* (1946) and *Matisse: His Art and his Public* (1951); *What Is Modern Painting?* (1943) has been published in 11 English editions and in Japanese, Portuguese and Spanish.

Although Barr received high praise from many, he was a controversial figure. In the *New York Times* of 25 September 1960 John Canaday (1907–85), that paper's art critic, described him as "the most powerful tastemaker in American art today and probably in the world." Barr was sensitive to the criticism that MOMA influenced rather than reflected the course of modern art; he responded as follows: "The artists lead; the Museum follows, exhibiting, collecting and publishing their work. In so doing it tries to act with both wisdom and courage, but also with awareness of its own fallibility" (Sandler and Newman, p. 237). An ardent defender of artistic freedom, identifying censorship in the arts with Nazi Germany and Soviet Russia, Barr likewise resisted Clement Greenberg's view that art progresses in only one direction. "The truth is," wrote Barr, "that modern art cannot be

defined with any degree of finality either in time or in character and any attempt to do so implies a blind faith, insufficient knowledge, or an academic lack of realism" (Sandler and Newman, p. 83).

PUBLISHED WRITINGS

Painting and Sculpture in the Museum of Modern Art, 1929–1967 (New York, 1977)

I. Sandler and A. Newman, eds: *Defining Modern Art: Selected Writings of Alfred H. Barr, Jr.* (New York, 1986)

BIBLIOGRAPHY

D. MacDonald: "Action on West Fifty-Third Street—I," *New Yorker* (12 Dec 1953), pp. 49–82; (19 Dec 1953), pp. 35–72

S. Hunter: *The Museum of Modern Art, New York: The History and the Collection* (New York, 1984)

A. G. Marquis: *Alfred H. Barr, Jr. Missionary for the Modern* (Chicago and New York, 1989)

S. G. Kantor: *Alfred H. Barr, Jr. and the Intellectual Origins of the Museum of Modern Art* (Cambridge, MA, 2002)

Roger J. Crum

Barry, Judith

(*b* Columbus, OH, 1949), installation artist and video artist. Barry graduated from the University of Florida in 1972, having studied finance, architecture and art; in 1986 she received an MA in Communication Arts from New York Institute of Technology. Barry's work was consistently guided by an interest in the ways in which lived social relations are translated into built form in architecture and public space. *Casual Shopper* (1980–81; see 1988 exh. cat., p. 14) is typical of her early video pieces in examining these issues through a narrative about a couple in a Californian shopping mall; in it, Barry shows how the realms of private fantasy blend into the fantastical confections of the mall's architecture. The slide and film installation *In the Shadow of the City . . . Vamp r y . . .* (1982–5) points to her related interests in subject formation, states of mind and the way in which power is exercised through the gaze: bringing together a series of domestic and urban spaces, the images show a number of figures looking out of a window and a woman watching a man sleep.

Imagination, Dead Imagine (1991; see 1997 exh. cat., pp. 26–30) explores subjectivity in more detail: taking the form of an oversized Minimalist cube, the sculpture is lit up by internal projections showing an androgynous head being assailed by dirt, insects and ugly fluids, an allegory of the instability of subjectivity and the self. Barry's interests in critical theory and her use of film and video media place her alongside a number of artists working in the USA in the 1980s such as Krzysztof Wodiczko, Hans Haacke and Jenny Holzer.

WRITINGS

I. Blazwick, ed.: *Public Fantasy* (London, 1991)

BIBLIOGRAPHY

Judith Barry: Through the Mirror of Seduction (exh. cat., essay by J. Fisher; Dublin, Trinity Coll., Hyde Gal., 1988)

Judith Barry: Projections: Mise en Abyme (exh. cat., essays by B. Wallis and interview by B. Wallis and M. Wigley, Vancouver, Presentation House Gal., 1997)

Judith Barry: 8th International Cairo Biennale 2001 (exh. cat., essay by G. Sangster; Baltimore, MD, Contemp. Mus., 2001)

Fate of Alien Modes (exh. cat. by C. Ruhm and others; Vienna, Sezession, 2003) [German and English]

Morgan Falconer

Barthé, James Richmond

(*b* Bay St Louis, MS, 28 Jan 1909; *d* Pasadena, CA, 6 March 1989), sculptor and painter. James Richmond Barthé was raised a devout Roman Catholic Creole. He was also the only African American artist of his generation to consistently portray the black male nude. Although closeted throughout his life, sensual figures such as *Stevedore* (1937; Hampton, VA, U. Mus.) expose his homosexuality. Barthé's elementary education ended in 1914. As an adolescent, he skillfully copied magazine illustrations, especially figures. Barthé worked for the wealthy New Orleans Pond family, who summered on the Bay, and in 1917, he moved to New Orleans to become their live-in servant. Barthé had access to the Pond library and art collection, and while in their employment,

he began to paint in oil. In 1924, his head of Jesus prompted the Rev. Harry F. Kane to fund the first of four years at the Art Institute of Chicago School, where Barthé studied painting with Charles Schroeder and sculpture with Albin Polasek (1879–1965). He also worked with Archibald J. Motley Jr. in Chicago and Arthur Lee at the Art Students League, New York, in 1929.

The Negro in Art Week exhibition (1927) at the Art Institute of Chicago included Barthé's student sculpture. Critical attention from such respected men as Alain Locke changed his focus to sculpture. With a 1929 Rosenwald fellowship, Barthé worked temporarily in Harlem on portraits and figures inspired by black urban popular culture as well as Italian Renaissance masterworks for a Chicago solo show in 1930. The following year, Barthé moved permanently to Manhattan, beginning two decades that marked the height of his productivity.

Beginning in 1932 with the Whitney Museum of American Art's purchase of *The Blackberry Woman*, Barthé's emotive black figures entered important collections such as the Metropolitan Museum (*Boxer*, 1942) and numerous private collections. Barthé designed an outdoor frieze for the Harlem River Houses while on the Treasury Relief Art Project (1936–9). His major solo show took place in 1939 at the Arden Gallery, New York. The strength of his mature figurative work such as *Feral Benga* (1935; Newark, NJ, Mus.), a sensitive portrait of the Senegalese dancer, afforded him the first of two consecutive Guggenheim fellowships in 1940. Barthé was also sponsored by the Harmon Foundation.

After completing public monuments for Haiti, Barthé expatriated to Jamaica in 1951 to paint. With limited success at the easel, inspired figures such as *Inner Music* (1961; Los Angeles, CA, Co. Mus. A.) mark his return to sculpture in the 1960s and the culmination of his oeuvre.

In 1975, following a short residency in Florence, Italy, Barthé returned to the USA and settled in Pasadena, CA, where the actor James Garner was his benefactor until his death.

BIBLIOGRAPHY

M. R. Vendryes: *Barthé: A Life in Sculpture* (Jackson, MS, 2008)

P. C. Black: *American Masters of the Mississippi Gulf Coast: George Ohr, Dusti Bongé, Walter Anderson, Richmond Barthé* (Jackson, MS, 2009)

Margaret Rose Vendryes

Bartholomew, Harland

(*b* Stoneham, MA, 14 Sept 1889; *d* St Louis, MO, 2 Dec 1989), city planner. Raised in New Hampshire and New York, Bartholomew studied civil engineering for two years at Rutgers University. His path to become one of the most influential city planners of the 20th century and to leave permanent marks on the design of American cities began in 1912, when he was assigned by the civil engineering firm where he was employed designing harbors and bridges to work on a comprehensive city plan for Newark, NJ. In 1914, he was hired as the "planning engineer" in Newark, the first full-time city planner in the USA. His publication of the Newark Plan (1915) led to broad recognition and to his appointment in 1916 as planning engineer in St Louis, a position he held until 1952. He served as non-resident professor of civic design at the University of Illinois from 1918 to 1952. In 1919, he formed a consulting firm, Harland Bartholomew and Associates, remaining chairman of the firm until his retirement in 1965. Rutgers University awarded him honorary degrees, including Civil Engineer in 1922 and Doctor of Science in 1955.

Bartholomew made major contributions to federal urban programs. As a leading advocate of slum clearance and public housing, President Roosevelt appointed him to the National Slum Clearance Advisory Committee. His role in this committee and other venues helped to shape the US Housing Acts of 1937 and 1949, which established federal public housing and urban renewal. In 1941, Roosevelt appointed him to the Interregional Highway Committee, with Bartholomew writing the recommendations for locating and designing the future interstate highway system within cities and downtowns. He played

the leading role consolidating city planning into a profession based on a specialized body of knowledge derived from his planning practice. His research, published in two books, *Urban Land Use* and *Land Uses in American Cities*, played a primary role shifting city planning from the civic design of streets and public spaces to a focus on land use and zoning of private property. Bartholomew's ideas for the planning and design of American cities—slum clearance, public housing, highways and segregated land uses and zoning districts—have been the subject of debate and criticisms since the 1960s.

WRITINGS

Comprehensive Plan for Newark (Newark, 1915)

The Problems of St. Louis (St Louis, 1917)

Urban Land Uses, Harvard City Planning Studies Series, vol. 4 (Cambridge, MA, 1932)

Land Uses in American Cities (Cambridge, MA, 1955)

BIBLIOGRAPHY

N. J. Johnson: "Harland Bartholomew: Precedent for the Profession," *The American Planner: Biographies and Recollections*, ed. D. A. Krueckeberg (Urbana, 1983)

E. Lovelace: *Harland Bartholomew: His Contribution to American Planning* (Urbana, 1992)

Richard Dagenhart

Bartlett, Jennifer

(*b* Long Beach, CA, 14 March 1941), installation artist, painter, printmaker and sculptor. Bartlett studied at Mills College, Oakland, CA (1960–63), and at the Yale School of Art and Architecture, New Haven, CT (1964–5). The progressive approach to modern art taught at Yale and the nearby thriving art scene of New York were instrumental in her early development (1963–early 1970s). Bartlett's first one-person exhibition was in New York (1970) in the loft of the artist Alan Saret. *Nine-point Pieces* (1973–4), a later work, was shown at the Paula Cooper Gallery in New York and was experimental both conceptually and materially. Her ambivalent use of systems to establish an order and to oppose it allowed her to explore the material and the conceptual process of making images and objects. *Rhapsody* (1975–6; priv. col., see exh. cat., p. 21), one of her best-known installations, consists of 988 steel plates covered with screenprint grids and hand-painted Testors enamel and hung on a wall (2.28×47.86 m). Each plate exists individually and in relation to its adjoining plate and may be read vertically or horizontally, creating a mesh of stylistic variability exploring both figurative and non-figurative motifs. Another work of the 1970s is *Graceland Mansion* (1978–9), a five-part print of drypoint, aquatint, screenprint, woodcut and lithography. During the 1980s her works included *In the Garden* (1980–81), which comprises 197 drawings from memory, photographs and models in a variety of materials such as pencil, pen and ink, brush and ink, conté, oil pastel, gouache and others. Her most important installations exploring the relationship between the painted image and the object include *White House* and *Yellow and Black Boats* (both 1985; London, Saatchi Col.).

WRITINGS

"Falling in Love," *Tracks*, iii/3 (1977), pp. 64–98

History of the Universe (New York, 1985)

BIBLIOGRAPHY

Jennifer Bartlett: In the Garden, intro by J. Russell (New York, 1982)

Rhapsody: Jennifer Bartlett, intro. by R. Smith (New York, 1985) [notes by the artist]

Jennifer Bartlett: Recent Work (exh. cat., intro. D. Sobel; Milwaukee, WI, A. Mus., 1988–9)

Evolutions in Expression: Minimalism and Postminimalism (exh. cat., Stamford, CT, Whitney, 1994)

Powder (exh. cat. by F. Bonami, J. Graham and M. Friedrich; Aspen, CO, A. Mus., 1999)

B. Richardson, *Jennifer Bartlett: Early Plate Work* (exh. cat., Andover, MA, Addison Gal. Amer. A., Phillips Acad., 2006)

Cecile Johnson

Bartlett, Paul Wayland

(*b* New Haven, CT, 24 Jan 1867; *d* Paris, 29 Sept 1925), sculptor. Bartlett spent much of his life in France, but like the Beaux-Arts style in which he worked, his life and career represent the rich interchange between

the two countries in the late 19th and early 20th centuries. His father, Truman H. Bartlett (1835–1923), was a sculptor, art critic and teacher, and the younger Bartlett began modeling in his father's studio at an early age. Bartlett's family divided their time between America and France and his early education and training took place in Paris, with his formal study beginning in 1880, at the age of 15, under Pierre-Jules Cavelier (1814–94) at the Ecole des Beaux-Arts. He also worked with Emmanuel Fremiet (1824–1910) at the Jardin des Plantes and was an assistant to the animalier sculptor Joseph-Antoine Gardet (1861–91). His early work often dealt with animal and ethnographic themes, but he eventually became well known for his monumental figurative and symbolic work, providing sculpture for several of the world's fairs and some of the major buildings of the period. A much respected leader in his profession, he served as the president of the National Sculpture Society and was a vocal critic of modernism.

Although Bartlett's early education took place in Paris, and that is where he started his career, he always considered himself an American and, in the late 1890s, he actively sought American commissions. He worked in the popular Beaux-Arts style with its lively, impressionistic surfaces, and also experimented with lost wax casting techniques in his own studio. His small animal studies were noted for their rich patinas. One of his first major works was the *Bear Tamer* (1885–7; alternative title, *Bohemian Bear Tamer*, New York, Met.), a charming genre piece of a nearly nude man training two young bear cubs, which won him an honorable mention at the Paris Salon in 1887. Bartlett exhibited it along with the *Indian Ghost Dancer* (1888–9; Washington, DC, Smithsonian Amer. A. Mus.) at the 1893 Chicago Columbian Exposition, and together they helped establish his reputation in America.

In the late 1890s Bartlett secured several important figurative commissions including *Michelangelo* and *Columbus* (1897–8) for the Library of Congress, Washington, DC, and the allegorical figures of *Philosophy*, *Romance*, *Religion*, *Poetry*, *Drama*, and *History* for the attic frieze of the New York Public Library (1909–15). But his most important figurative sculpture was the equestrian statue of the *Marquis de Lafayette* (1898–1908; Paris, Louvre), which was a gift to France from the American people to mark the long friendship between the two countries. While his work was much admired for its robust character, active compositions and surface modeling, he was also a perfectionist who sometimes taxed his patrons' patience with long delays. The *Marquis de Lafayette* was unveiled in a plaster version on 4 July 1900, but it took another seven years of revision before the final bronze was cast. In a humorous acknowledgement of his own slowness, Bartlett added a turtle to the base.

The high point of Bartlett's career was the commission for the pediment sculpture for the US Capitol's House of Representatives wing (1908–16) in Washington, DC. The Capitol had been expanded in the 1850s and Thomas Crawford had made sculptures for the Senate wing (1853–63), but the House of Representatives side had remained blank. Many sculptors had vied for a chance to fill it, but the commission came to Bartlett largely because of the recommendation of John Quincy Adams Ward, with whom Bartlett had worked on the New York Stock Exchange pediment (1901–4). Bartlett's design for the Capitol illustrated the theme of America flourishing under a peaceful democracy.

Bartlett was awarded the Légion d'honneur in 1895; he was elected to the National Academy in 1917, and in 1918 became president of the National Sculpture Society. An outspoken critic of the avant-garde art coming out of Paris, Bartlett warned against the "subversive tendencies of the newer art movements" where "theories take the place of talent" (*NY Times*, 9 Feb 1913). He died in 1925 at the age of 60 as the result of blood poisoning from a minor injury he had received in a fall.

UNPUBLISHED SOURCES
Washington, DC, Libr. Congr. [Bartlett Family Papers]

BIBLIOGRAPHY

E. Bartlett: "Paul Bartlett: An American Sculptor," *New England Mag.* (Dec 1905), pp. 369–82

P. Bartlett: "American Sculpture and French Influence Upon Its Development," *NY Times* (9 Feb 1913), section 6, p. 13

C. Wheeler: "Bartlett," *Amer. Mag. A.* (Nov 1925), pp. 573–85

W. Craven: *Sculpture in America* (New York, 1968)

M. E. Shapiro: *Bronze Casting and American Sculpture, 1850–1900* (Newark, DE, 1985)

T. Somma: "The Myth of Bohemia and the Savage Other: Paul Wayland Bartlett's 'Bear Tamer' and 'Indian Ghost Dancer'," *Amer. A.* (Summer 1992), pp. 14–35

T. Somma: *The Apotheosis of Democracy, 1908–1916, The Pediment for the House Wing of the United States Capitol* (Newark, DE, and London, 1995)

T. Somma: "Sculpture as Craft: Two Female Torsos by Paul Wayland Bartlett," *Perspectives on American Sculpture Before 1925*, ed. T. Tolles and M. H. Hecksher (New Haven and London, 2003), pp. 82–95

Pamela H. Simpson

Bartram, William

(*b* Kingsessing, PA, 9 Feb 1739; *d* Kingsessing, 22 July 1823), naturalist and draftsman. The son of the Pennsylvania naturalist John Bartram (1699–1777), William Bartram executed his first drawings in the 1750s as illustrations to his father's observations on the flora and fauna of North America. Bartram accompanied his father on numerous collecting trips in the northeastern colonies and on an expedition to Florida in 1765. His drawings were disseminated to European naturalists by his father's friend and colleague, Peter Collinson (1694–1768), an English merchant who was an important promoter of natural science in the 18th century. Compositionally, Bartram's early works were structured after etchings by the English naturalists Mark Catesby and George Edwards (1694–1773). These artists were among the first to present organisms as part of their larger physical habitats—a practice that Bartram carried forward in his own work, challenging the traditional notion that organisms can be defined solely according to their own physical attributes. Through his drawings Bartram explored the complex interchange that occurs between animals and plants and their environmental contexts, defying the notion that individual organisms fall naturally into an abstract, hierarchical chain of being. He characteristically employed an undulating line that imparts energy to all the elements of a scene, suggesting that the whole of organic creation is united by a single, animated spirit.

Bartram's works were greatly admired by European naturalists, and he won the patronage of Margaret Cavendish-Bentinck (1715–85), 2nd Duchess of Portland, and the botanist Dr. John Fothergill (1712–80). In March 1773, with Fothergill's support, Bartram set out alone on an expedition to Florida that ultimately took him 3900 km across the South, collecting seeds and making drawings. The detailed journals that Bartram kept of his explorations served as the basis for his *Travels through North and South Carolina, Georgia, East and West Florida, the Cherokee Country, the Extensive Territories of the Muscogulges, or Creek Confederacy, and the Country of the Chactaws* (1791). Like his drawings, this highly poetic work creates a picture of a spiritually unified cosmos that came to influence English and American Romantic thinkers, from William Wordsworth and Samuel Coleridge to Ralph Waldo Emerson and Henry David Thoreau.

After his return from the South, Bartram was approached by the recently established University of Pennsylvania, Philadelphia, to serve as the first Professor of Botany; he was also approached several times by the federal government to accompany expeditions into unexplored regions of the country. Bartram preferred, however, to work quietly in his father's experimental garden, tutoring the next generation of Philadelphia naturalists who visited him there and for whom he served as an essential model; his students included Benjamin Smith Barton (1766–1815), who took the professorial post Bartram had rejected and who commissioned him to draw illustrations for the first textbook on American plants, *Elements of Botany* (Philadelphia, 1803). Bartram also served as a mentor to Charles Willson Peale and his children. Bartram encouraged Alexander Wilson to

begin to draw birds and joined with Peale in helping Wilson to produce his *American Ornithology* (Philadelphia, 1808–14), the first study devoted entirely to American birds.

[*See also* Peale, Charles Willson.]

WRITINGS

Proposals for Printing by Subscription, on Fine Paper, with a New and Elegant American Letter, Cast by John Baine & Co. Travels through North and South Carolina, Georgia, East and West Florida, the Cherokee Country and through the Extensive Territories of the Muscogulges, or Creek Confederacy, and the Country of the Chactaws: Containing an Account of the Soil and Natural Productions of Those Regions, Together with Observations on the Manners of the Indians (Philadelphia, 1791/R 1996)

BIBLIOGRAPHY

W. Darlington, ed.: *Memorials of John Bartram and Humphrey Marshall* (Philadelphia, 1849) [correspondence by and about W. Bartram]

N. Fagin: *William Bartram: Interpreter of the American Landscape* (Baltimore, 1933)

E. Earnest: *John and William Bartram: Botanists and Explorers, 1699–1777, 1739–1823* (Philadelphia, 1940)

J. Herbst: *New Green World* (New York, 1954)

W. Sullivan: *Towards Romanticism: A Study of William Bartram* (Salt Lake City, 1969)

J. Ewan, ed.: *William Bartram, Botanical and Zoological Drawings, 1756–1788: Reproduced from the Fothergill Album in the British Museum (Natural History)* (Philadelphia, 1978)

Bartram Heritage: A Study of the Life of William Bartram, Including a Report to the Heritage Conservation and Recreation Service, United States Department of the Interior: Bartram Trail Conference: Montgomery, AL, 1979

E. Berkeley and D. Berkeley: *The Life and Travels of John Bartram from Lake Ontario to the River St. John* (Tallahassee, 1982) [material on W. Bartram's early professional life]

T. Vance: *William Bartram and the Age of Sensibility* (n.p., 1982)

E. Berkeley and D. Berkeley, eds.: *The Correspondence of John Bartram, 1734–1777* (Gainesville, FL, 1992)

William Bartram on the Southeastern Indians (Lincoln, NE, 1995)

J. T. Fry: "An International Catalogue of North American Trees and Shrubs: The Bartram Broadside, 1783," *J. Gdn Hist.*, xvi (1996), pp. 3–21

T. P. Slaughter: *The Natures of John and William Bartram* (New York, 1996)

Amy Meyers

Basement Workshop

Community-based arts and activist group in New York that flourished from 1971 to 1986. Basement Workshop (Inc.) evolved during the Asian American art movement, inspired by the Black Power and the Third World Liberation movements of the late 1960s. The group of artists, writers, performers and social activists initially met in a leaky basement at 54 Elizabeth Street located in New York's Chinatown. Basement moved successively to 22 Catherine Street, 199 Lafayette Street, expanded to include spaces at 7 Eldridge Street and 32 East Broadway, and finally returned to 22 Catherine Street during the collective's existence from 1971 to 1986.

Basement was co-founded by Danny Yung (*b* 1943), Eleanor Yung, Peter Pan, Frank Ching (*b* 1943) and Rocky Chin. Its activities grew from the "Chinatown Report of 1969," which was headed by Danny Yung and funded by the Ford Foundation. Basement was formally incorporated in 1971 and served as an umbrella organization for activities including *Bridge Magazine* (1971–8), Amerasia Creative Arts, the Asian American Dance Workshop (which would be renamed the Asian American Arts Centre in 1976), Community Planning Workshop (which became Asian Americans For Equality), Asian American Resource Center (which would eventually become the Museum of Chinese in America) and the Catherine Gallery.

Artists who also showed at the Catherine Gallery include John Allen, Tomie Arai, Arlan Huang (*b* 1948), Keiko Bonk (*b* 1954), Eric Chan (*b* 1975), Amy Cheng (*b* 1956), Jean Chiang, Janice Chiang (*b* 1955), Alex Chin, Lei-Sanne Doo, Ming Fay (*b* 1943), Sheila Hamanaka, Colin Lee, Corky Lee (*b* 1947), Lanie Lee, David de Silva, William Jung, Nina Kuo, Margo Machida, Kenji Nakahashi (*b* 1947), Mine Okube (*b* 1913), Cissy Pao (*b* 1950), Richard Whitten, John Woo and Charles Yuen.

In the fall of 1971, Basement artists and writers came together to create *Yellow Pearl*, a boxed set of 57 prints on heavy yellow paper of artwork, music and writings

inspired by folksingers Chris Iijima, Nobuko Miyamoto and Charlie Chin. Songs from their album *Grain of Sand* were also reprinted in *Yellow Pearl*. The works of many artists who would pass through the doors of Basement Workshop were included in this collection, which was distributed in 1972. Like much of the collective's activities, the *Yellow Pearl* boxed set emphasized a unified Asian America during a time when the term "Asian American" was just coined.

Artist and writer Fay Chiang was the Executive Director at Basement from 1974 to 1986 after serving as the collective's Assistant Director. Chiang took the helm of Basement during a time of intense political factionism in Chinatown. She continued at Basement as the Executive Director until the collective dissolved in 1986, expanding the group's membership and heading the Catherine Gallery exhibitions.

BIBLIOGRAPHY

F. Chiang, ed.: *Basement Yearbook 1986* (New York, 1986)

L. R. Lippard: *Mixed Blessings: New Art in a Multicultural America* (New York, 1990)

W. Wei: *The Asian American Movement* (Philadelphia, 1994)

Alexandra Chang

Baskin, Leonard

(*b* New Brunswick, NJ, 15 Aug 1922; *d* Northampton, MA, 3 June 2000), sculptor, illustrator and print-maker. Baskin studied at the New York University School of Architecture and Allied Arts (1939–41), the School of Fine Art (1941–3) and New School for Social Research (1949). He also studied at the Académie de la Grande Chaumière in Paris (1950) and the Accademia delle Belle Arti in Florence (1951). Inspired by the iconic, monolithic imagery

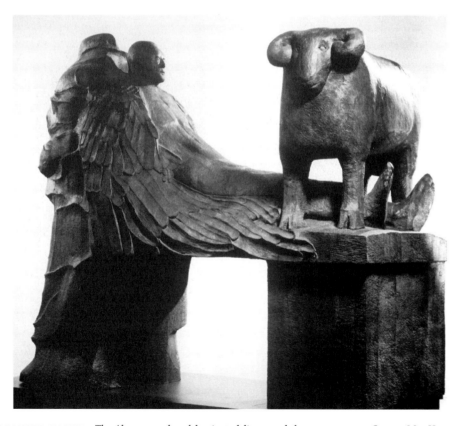

LEONARD BASKIN. *The Altar*, carved and laminated limewood, h. 1.54 m, 1977. Gift of Mr. Herman Tenenbaum and the Saul and Suzanne Mutterperl Bequest, by exchange, in honor of Mildred and George Weissman © Photograph by John Parnell /The Jewish Museum/Art Resource, NY

of Ancient Egyptian and Sumerian art and the similar stylistic qualities of Romanesque and Italian Gothic, he consistently and inventively made use of the archaic mode in such prints as the powerful woodcut *Man of Peace* (1952; see Fern and O'Sullivan, p. 61) as well as in his sculpture. A traditionalist, he carved in wood and stone and modeled in clay, taking the human figure as his subject. He firmly believed that painting and sculpture should mediate between artist and viewer some moral insight about human experience, and he was convinced that abstract art could not do this. Throughout his career he rejected spatial penetration of form, preferring the holistic look of such works as the *Dead Men* series (bronze, 1951–5) and *The Unnoticed* (1982). His monumental wood-carving *The Altar* (1977; New York, Jew. Mus.) is considered among his greatest works. His wide reading of the Bible, Ancient Greek literature and modern Western poetry and fiction is evident from the themes of his sculpture, for example, *Pelle the Conqueror* (bronze, before 1949; Ardsky, NY, Dr and Mrs. Tulipan priv. col.) and *Judith with the Head of Holofernes* (bronze, 1972; West Hartford, CT, Mr. and Mrs. Greenburg priv. col.). Many of his sculptures and prints are tributes to his pantheon of heroes, the great artists whom he saw as his spiritual predecessors. Baskin's private Gehenna Press published more than a hundred fine-art illustrated editions of works ranging from bawdy 16th-century poems to the poetry of Wilfred Owen.

BIBLIOGRAPHY

R. Spence: "Leonard Baskin: The Artist as Counter-Decadent Leonard Baskin," *A. J.*, 22/2 (1962–1963), pp. 88–91

S. Kaplan and L. Baskin: "The Necessary Image: From the Iconologia of Leonard Baskin," *MA Rev.*, 5/1 (1963), pp. 90–112

Trinity College Library: *A Catalogue of Gehenna Press Books and Other Works by Leonard Baskin* (Hartford, 1964)

I. B. Jaffe: *The Sculpture of Leonard Baskin* (New York, 1980)

A. Fern and J. O'Sullivan: *The Complete Prints of Leonard Baskin: A Catalogue Raisonné, 1948–1983* (Boston, 1984)

L. U. Baskin and others: *The Gehenna Press: The Work of Fifty Years, 1942–1992* (exh. cat., Dallas, 1992)

Irma B. Jaffe

Basquiat, Jean-Michel

(*b* New York, 22 Dec 1960; *d* 12 Aug 1988), painter, sculptor and draftsman. He showed an early interest in drawing, and he was encouraged by his mother's interest in fashion design and sketching and by his father's gifts of paper brought home from his office. From as early as 1965 Basquiat's mother took him to the Brooklyn Museum, the Metropolitan Museum of Art and the Museum of Modern Art, and from 1966 he was a Junior Member of the Brooklyn Museum. Early influences on Basquiat's art include his avid reading of French, Spanish and English texts, his interest in cartoon drawings, Alfred Hitchcock films, cars and comic books, such as *MAD* magazine and its main character, Alfred E. Neuman. While attending the City-as-School (1976–8), an alternative high school, he encountered the Upper West Side Drama Group and the Family Life Theatre and invented "SAMO" (Same Old Shit), a fictional character who earns a living selling "fake" religion. He also met, collaborated with and became a close friend of Al Diaz, a graffiti artist from the Jacob Riis Projects on the Lower East Side. Basquiat and Diaz generated much interest in their graffiti art, which took the form of spray-painted aphorisms that were targeted at the D train of the "IND" (subway) line and around Lower Manhattan. SAMO appeared in these graffiti: in 1978 a favorable article about SAMO was printed in the *Village Voice*, and when the collaboration ended in 1979, "SAMO© IS DEAD" could be read on walls in SoHo.

In the late 1970s Basquiat's socializing in clubs frequented by artists and musicians resulted in his introduction into the art world of collectors and dealers through the artist and filmmaker Diego Cortez. During this period Basquiat was making T-shirts, postcards, drawings and collages that developed from his earlier graffiti art and his interest in painting. He focused on such events as the Kennedy assassination or took such motifs as baseball players and the American confectionery called Pez. Basquiat's first public exhibition was in the group *The Times Square*

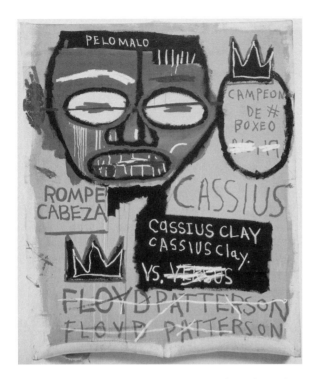

JEAN-MICHEL BASQUIAT. *Cassius Clay*, acrylic and pencil on canvas, 1220 × 1015 mm, 1982. PRIVATE COLLECTION © 2010 THE ESTATE OF JEAN-MICHEL BASQUIAT/ARTISTS RIGHTS SOCIETY, NY/BANQUE D'IMAGES, ADAGP/ART RESOURCE, NY

Show (with David Hammons, Jenny Holzer, Lee Quinones, Kenny Scharf and Kiki Smith among others), held in a vacant building at 41st Street and Seventh Avenue, New York. His first solo exhibition was in 1982 at the Annina Nosei Gallery, New York.

Basquiat's use of drawn and painted references includes imagery and symbolism from African, Aztec, Greek and Roman cultures, as well as that of his own Puerto Rican and Haitian heritage and black and Hispanic cultures. His childhood influences remained evident throughout his work and can be seen in early paintings, for example *Cadillac Man* (acrylic and crayon on canvas, 1980–81; Zurich, Gal. Bruno Bischofberger): in this work his iconography includes cars, television, the letter "A," circles and chains holding up cars; it is painted in a direct, childlike and unhindered manner. In such works as *Untitled (Rinso)* (acrylic and oil paintstick on canvas with exposed wood supports, 1982; artist's estate), in which a drawing of a man lifting a small weight

is accompanied by the words "NO SUH, NO SUH," "THEM SHOVELS," "WHITEWASHING ACTION" and "GREATEST DEVELOPMENT IN SOAP HISTORY," Basquiat made biting commentary, stemming from his identification with historical and contemporary black figures and events, cartoons and graffiti art (see *All Colored Cast Part II*, 1982; private col.). He brought a bicultural perspective to the new figuration of the 1980s, atypical for including black culture and popular street-based imagery. In 1983 Basquiat met Andy Warhol, with whom he became a close friend, sometimes collaborating on work with him; Warhol's untimely death deeply disturbed Basquiat, who also died prematurely. For illustration see color pl. 1:X, 1.

[*See also* Clemente, Francesco; Graffiti; Haring, Keith; SAMO©; *and* Warhol, Andy.]

BIBLIOGRAPHY

Jean-Michel Basquiat: Paintings, 1981–4 (exh. cat., essay by M. Francis; Edinburgh, Fruitmarket Gal.; London, ICA; Rotterdam, Mus. Boymans–van Beuningen; 1984–5)

M. Enrici: *Jean-Michel Basquiat* (Paris, 1989)

Jean-Michel Basquiat (exh. cat. by R. Marshall, New York, Whitney; Houston, TX, Menil Col.; Des Moines, IA, A. Cent.; Montgomery, AL, Mus. F.A.; 1992–4)

M. Angelou: *Life Doesn't Frighten Me* (New York, c. 1993), illustrated by Basquiat

L. Walsh, ed.: *Jean-Michel Basquiat: The Notebooks* (New York, 1993)

L. Emmerling: *Jean-Michel Basquiat: 1960–1988* (Cologne and London, c. 2003)

Basquiat (exh. cat., ed. M. Mayer; New York, Brooklyn Mus., c. 2005)

G. Mercurio, ed.: *The Jean-Michel Basquiat Show* (Milan, 2006)

Bassman, Lillian

(*b* New Haven, CT, 15 June 1917), graphic designer and photographer. After attending Textile High School in Manhattan, Bassman worked briefly on mosaic murals for the World's Fair in New York. In 1935 she married photographer Paul Himmel (*b* 1914), whom she had known since childhood. After briefly taking night classes in fashion illustration at Pratt Institute of Art, she became a student

of Alexey Brodovitch, the Russian émigré art director of *Harper's Bazaar*, at the New School, New York. Bassman worked as an assistant to Elizabeth Arden (1878–1966), but was soon asked to become Brodovitch's first paid assistant at *Harper's Bazaar*. In 1945 Hearst Magazines, the publisher of *Harper's Bazaar*, launched *Junior Bazaar* and Bassman and Brodovitch became its co-art directors, responsible for the overall vision of the magazine. *Junior Bazaar* ran as a stand-alone magazine from November 1945 until May 1948. It was the incubation ground for numerous talented young artists, designers and writers, many of whom went on to high-profile jobs in the industry. Bassman's bold use of color and asymmetrical compositions gave the magazine pages a lively attitude that was quite different in character from the more sophisticated and conservative layouts in *Harper's Bazaar*. During her career she was employed by both *Junior Bazaar* and *Harper's Bazaar* as a designer, photographer and art director.

After several years of working on *Junior Bazaar*, Bassman was offered freelance photography work from Brodovitch and Richard Avedon's loaned studio, and Bassman began to experiment with making her own images. She eventually turned to photography as her primary artistic medium. Although she took jobs photographing both products and fashion, it is her fashion work for which she received critical acclaim. Her clients included *Seventeen*, *Harper's Bazaar*, Chanel and Balenciaga. She became particularly successful at photographing models in lingerie. Her photos made the hard lines of rigid corsets and structured underwear appear soft and ethereal through her use of dark backgrounds and soft lighting. In these photographs the subject's face is often blurred or cropped, making them seem more like allies and cohorts than objects of desire.

Bassman and Himmel closed their studio in 1971 to pursue more personal work. In addition to making and exhibiting fine art photography and designing her own line of clothing, Bassman taught part-time at Parson's School of Design. In 1992 negatives from the 1940s that were thought to have been destroyed were rediscovered by Bassman's neighbor. She "reinterpreted" and reprinted much of this new-found material. The result was a traveling exhibition of her photographs, numerous articles on her work and a monograph in 1997.

PHOTOGRAPHIC PUBLICATIONS
Lillian Bassman, text by M. Harrison and others (New York, 1997)

BIBLIOGRAPHY
M. Harrison: "The Female Eye," *The Independent on Sunday* (6 Sept 1992), pp. 36–8

T. Gett: "Still in Good Shape," *Brit. J. Phot.*, cxl/6931 (1993), p. 29

M. Harrison: "Capturing the Intimate Gesture," *Graphis*, li/298 (1995), pp. 30–9

M. Harrison: *Lillian Bassman: Photographs* (Boston, 1997)

J. Bell: "Lillian Bassman," *Phot. Forum*, xx/2 (1998), pp. 26–9

M. Harrison: *Paul Himmel: Photographs* (New York and Paris, 1999)

J. Crump: "Master: Lillian Bassman: A Fashion Icon's Long-Lost Images Are Revived," *Amer. Photo*, 19/5 (2008), pp. 26–8

D. Solomon: *Lillian Bassman: Women* (New York, 2009)

Aaris Sherin

Baudouine, Charles A.

(*b* New York, 1808; *d* New York, 1895), cabinetmaker. Baudouine opened his first cabinetmaking shop in Pearl Street, New York, about 1830. Ten years later he moved to a four-story "furniture warehouse" on Broadway, near his competitor, John Henry Belter, whose work, in particular the laminated rosewood chairs, Baudouine is claimed, perhaps unjustly, to have imitated. Baudouine's production was huge; he employed up to 200 workers, including 70 cabinetmakers. He favored the Rococo Revival style based on simplified versions of Louis XV designs and frequently traveled to France to purchase upholstery material, hardware and trim. He also brought back furniture made in France, which he sold in his shop along with his own stock. Anthony Kimbel (*d* 1895) was Baudouine's designer in the years before the shop closed about 1856.

In 1842 William Corcoran, wealthy banker friend of Mrs. James K. Polk, ordered 42 carved, rosewood chairs for the State Dining Room in the White House from Baudouine. These balloon back chairs with cabriole legs upholstered in purple velvet were part of the White House renovation that Congress funded soon after Polk was elected president (1842, Side Chair, the White House). The documented "multiform" table (actually a pair of card tables) (Utica, NY, Munson–Williams–Proctor Inst.), two parlour *tête-à-têtes* and six chairs (Utica, NY, Munson–Williams–Proctor Inst.) that lawyer James Watson Williams purchased from Baudouine in 1852 for his new home at Fountain Elms in Utica, NY, are also in rosewood. Earlier Williams had bought his fiancée, Helen Munson, a Baudouine rosewood worktable "of the most approved French pattern." Baudouine used little mahogany, no cheap walnut and only a limited amount of oak, mainly for dining-room furniture. His business success is reflected in the fortune of between $4 million and $5 million he left at his death.

BIBLIOGRAPHY

E. Ingerman: "Personal Experiences of an Old New York Cabinetmaker," *Ant.*, lxxxiv (1963), pp. 576–80

B. Franco: "New York City Furniture Bought for Fountain Elms by James Watson Williams," *Ant.*, civ (1973), pp. 462–7

T. D'Ambrosio: *Masterpieces of American Furniture from the Munson-Williams-Proctor Institute* (Utica, 1999)

Art and the Empire City: New York 1825–1861 (exh. cat. by C. H. Voorsanger and J. K. Howat; New York, Met., 2000)

B. C. Monkman: *The White House: Its Historic Furnishings and First Families* (New York, 2000)

Oscar P. Fitzgerald

Baum, Dwight James

(*b* Little Falls, NY, 24 June 1886; *d* New York City, NY, 23 Dec 1939), architect, developer, city planner and author. Baum enrolled in the architectural program at Syracuse University in 1905, graduating in 1909 and winning an architectural fellowship and membership of the architectural fraternity Tau Sigma Delta. After graduating, Baum married and moved to New York City, opening an office in the Fieldston section of Riverdale in the Bronx in 1915. With his outstanding achievements in residential design, Baum, at age 37, received a Gold Medal in 1923 from the Architectural League of New York, becoming the youngest architect to receive this prestigious honor. At a reception at the White House in 1931, President Herbert C. Hoover presented Baum with a Gold Medal, awarded by the American Institute of Architects for the best design for a two-story house built in America from 1926–30. Known best for his outstanding country homes designed for an affluent clientele, Baum created over 200 homes in the Riverdale on Hudson and Fieldston areas of New York. His work reached far beyond New York State, with private residences and public buildings designed for Sarasota, Temple Terrace, Clewiston and Fort Pierce, all in Florida, with many developed as complete planned communities. Baum's largest and most challenging private commission came in 1923 for John and Mable Ringling. The massive Venetian-Gothic mansion (over 3345 sq m), seated on the very edge of Sarasota Bay, was designed with 56 rooms and a 25-m-high tower inspired by the Giralda Tower in Seville. Both the mansion and its matching gatehouse were decorated with thousands of glazed terracotta tiles made by O. W. Ketchum of Philadelphia.

During the Great Depression, Baum became an architectural consultant to *Good Housekeeping* magazine, designing their exhibit at the *Century of Progress Exposition* at Chicago in 1933–4. In 1934 he was awarded an honorary doctorate of Fine Arts from Syracuse University and in 1939 he served on the committee for the New York World's Fair. The outstanding contribution of Dwight James Baum still lives through the hundreds of public and private buildings that demonstrate his great skill and refinement as a designer.

BIBLIOGRAPHY

"Developing a Regional Type with Particular Reference to the Work of Dwight James Baum," *Amer. Architect* (20 Aug 1926), pp. 144–8, pls. 193–200

R. Stern, G. Gilmartin and J. Massengale: *New York 1900: Metropolitan Architecture and Urbanism 1890–1915* (New York, 1983)

W. Morrison and R. McCarty: *The Work of Dwight James Baum, The American Architect Series* (New York, 2008)

Ronald R. McCarty

Bay Area figurative school

Term applied to artists active in San Francisco from 1950 to the mid-1960s who forged a vibrant brand of figurative Expressionism. Originating in the studios and art schools of postwar San Francisco, the movement transcended its regional identity to attain national recognition as a major trend in mid-20th-century American art.

Around 1950, painters David Park, Elmer Bischoff, Richard Diebenkorn, and James Weeks (1922–98) adapted the gestural style and painterly techniques of Abstract Expressionism to create luminous canvases devoted to recognizable subjects including genre scenes, figure paintings and the local landscape of the Bay Area. These four "founders" were soon joined by slightly younger artists—Nathan Oliveira, Paul Wonner (1920–2008) and Theophilus Brown (*b* 1919), as well as former students Joan Brown (1938–90), Bruce McGaw (*b* 1935), and the lone sculptor, Manuel Neri (*b* 1930). Although Park and his fellow artists would deny they had created a new movement, their shared sensibilities resulted in the cohesive style and widespread influence of the Bay Area figurative school.

That the principal artists involved in the movement were united by a common aesthetic outlook and a network of social and professional support became apparent to Oakland Museum curator Paul Mills, who, in 1957, organized the first exhibition devoted to the group under the rubric,

Contemporary Bay Area Figurative Painting. Mills's exhibition focused critical attention on the emerging Bay Area school. In the late 1950s and early 1960s, the increasingly idiosyncratic quality of the work of the younger members of the movement revealed a kinship with Beat poetry and the growing Funk aesthetic of the San Francisco underground. By the mid-1960s, the Bay Area figurative movement had begun to wane: Diebenkorn resumed abstract painting with his *Ocean Park* series in 1967. Only Elmer Bischoff continued working in the Bay Area figurative tradition into the 1970s. Nonetheless, over a 15-year period, the Bay Area figurative school encompassed a diverse range of work from Park's vigorous expressionism to Diebenkorn's cooler classicism and Joan Brown's quirky, yet intense painterliness. Such diverse vitality earned the movement an enduring place in the history of postwar American art.

[*See also* Beat movement; Bischoff, Elmer; Diebenkorn, Richard; Funk art; Oliveira, Nathan; *and* Park, David.]

BIBLIOGRAPHY

H. Crehan: "Is There a California School?" *ARTnews* (Jan 1956), pp. 32–5, 64–5

Contemporary Bay Area Figurative Painting: An Introduction to New Works by a Number of Bay Area Painters (exh. cat. by P. Mills, Oakland, CA, Mus., 1957)

The Figurative Mode: Bay Area Painting, 1956–1966 (exh. cat., New York U., Grey A.G., 1984)

T. Albright: *Art in the San Francisco Bay Area, 1945–1980: An Illustrated History* (Berkeley and Los Angeles, 1985)

C. A. Jones: *Bay Area Figurative Art, 1950–1965* (exh. cat., San Francisco, CA, MOMA, 1989)

Bay Area: Fresh Views (exh. cat., San Jose, CA, Mus. A., 1989)

Judith Zilczer

Bayer, Herbert

(*b* Haag, Austria, 5 April 1900; *d* Santa Barbara, CA, 30 Sept 1985), painter, designer, photographer and

typographer, of Austrian birth. After serving in the Austrian army (1917–18), Bayer studied architecture under Professor Schmidthammer in Linz in 1919 and in 1920 worked with the architect Emanuel Margold in Darmstadt. From 1921 to 1923 he attended the Bauhaus in Weimar, studying mural painting (with Vasily Kandinsky) and typography; it was at this time that he created the Universal alphabet, consisting only of lowercase letters. In 1925 he returned to the Bauhaus, then in Dessau, as a teacher of advertising, layout and typography, remaining there until 1928. For the next ten years he was based in Berlin as a commercial artist: he worked as art manager of *Vogue* (1929–30) and as director of the Dorland advertising agency. Shortly after his first one-man exhibitions at the Galerie Povolotski, Paris, and at the Kunstlerbund März, Linz (both 1929), he created photomontages of a Surrealist nature, such as *Hands Act* (1932; see Cohen, p. 270).

In 1938 Bayer immigrated to the USA. Until 1945 he worked in New York as a commercial artist, exhibition designer, painter, sculptor and maker of environments. He became the leading art adviser for John Wanamaker and J. Walter Thompson and director of art and design for Dorland International. His first one-man show in the USA took place at Black Mountain College, NC, in 1939, and he was represented in a number of important exhibitions at MOMA, New York, including *Fantastic Art, Dada, Surrealism* (1936), *Bauhaus: 1919–28* (1938) and *Art and Advertising Art* (1943). In 1946 he moved to Aspen, CO, where he worked as design consultant for the development of Aspen, responsible for architectural projects such as the Walter Paepcke Memorial building, Aspen Institute for Humanistic Studies (1963; see Cohen, p. 322). He also worked for the Container Corporation of America (CCA) in Chicago, first as consultant designer (1945–56) and then as Chairman of the Department of Design (1956–65). He designed and edited the *World Geographic Atlas* for the CCA between 1948 and 1953 and was art and design consultant for the Atlantic Richfield Company in 1966. He moved to Montecito, CA, in 1976.

Although Bayer considered himself primarily a painter, it was only in the early 1960s that he began to exhibit more consistently. Throughout his career he combined geometric and organic abstract forms in an imaginatively suggestive way in works such as *Colorado* (oil mural, 1948–67; Denver, CO, A. Mus.). In his photography his approach was similarly anti-narrative, focusing on the geometric abstract formations to be found in the real world, seen for example in *Shadows on the Steps* (1928; see Cohen, p. 259). The same geometric forms of spheres and cones that appeared frequently in his painting and photography were used in designs for environments, such as the white marble forms of *Anaconda* (1978; Denver, CO, Anaconda Tower). In his constant belief in the need to integrate all aspects of artistic creativity into the modern industrial world, Bayer was a true spokesman for the Bauhaus ethos, as well as its last surviving master. He was Visiting Artist at the Jerusalem Foundation in 1977 and Artist in Residence at the American Academy in Rome in 1978. For illustration, see also Photomontage.

BIBLIOGRAPHY

A. Dorner: *The Way beyond "Art": The Work of Herbert Bayer* (New York, 1947)

Herbert Bayer: Beispiele aus dem Gesamtkunstwerk (exh. cat., ed. P. Baum; Linz, Neue Gal., 1976)

Jan Van Der Marck: *Herbert Bayer: From Type to Landscape: Designs, Projects & Proposals, 1923–73* (1977)

Herbert Bayer: Das künstlerische Werk, 1918–1938 (exh. cat., ed. M. Droste; Berlin, Bauhaus-Archv, 1982)

A. A. Cohen: *Herbert Bayer: The Complete Work* (Cambridge, MA, 1984)

Herbert Bayer: Kunst und Design in Amerika, 1938–1985 (exh. cat., ed. E. Neumann; Berlin, Bauhaus-Archv, 1986)

G. F. Chanzit: *Herbert Bayer and Modernist Design in America* (Ann Arbor, 1987)

C.-K. Anhold: *The Imagery of Herbert Bayer's European Years, 1920–1938* (diss., 1988)

G. F. Chanzit: *Herbert Bayer: Collection and Archive at the Denver Art Museum* (Denver, 1988)

M. Neumeier: "The Last Paintings of Herbert Bayer," *Communication Arts Magazine*, 30 (Sept/Oct 1988), pp. 94–112

K. M. Burnett: *Word Becomes Image: Herbert Bayer, Pioneer of a New Vision in Book Design* (diss., 1989)

K. Burnett: "Communication with Visual Sound: Herbert Bayer and the Design of Type," *Vis. Lang.*, 24/3–4 (1990), pp. 298–333

C. Wayne: *Dreams, Lies, and Exaggerations: Photomontage in America* (College Park, 1991)

R. Sachsee: "Herbert Bayer: Out of Austria," *Cam. Austr.*, 46 (1994), pp. 3–11

P. Baum: *Harbert Bayer 1900–1985: Austellung und Katalog* (Linz, 2000)

Monica Bohm-Duchen

Baziotes, William

(*b* Pittsburgh, PA, 11 June 1912; *d* New York, 6 June 1963), painter. Baziotes was brought up in Reading, PA, by his Greek immigrant parents. When his father's business failed in the mid-1920s, he was exposed to poverty and the life of illegal gambling dens and local brothels, all of which later contributed to the spirit of evil lurking in his paintings. In the early 1930s he worked briefly for a company specializing in stained glass for churches, which may have affected the mysterious and translucent painted environments in his later canvases. His early interest in poetry was heightened by his close friendship with the Reading poet Byron Vazakas, who introduced him to the work of Charles Baudelaire and the French Symbolists; these writers soon became an important source for Baziotes's own search to communicate strong emotions and bizarre states of mind. Themes from Baudelaire's poetry are suggested in Baziotes's treatment of twilight, water, the color green and mirrors, while *The Balcony* (1944; Santa Barbara, CA, Wright Ludington priv. col., see Sandler, p. 75) is among the paintings to derive its title from a specific poem.

In 1933 Baziotes moved to New York, where he studied at the National Academy of Design until 1936. There he produced traditional drawings of heavy-set nudes, which anticipate the ponderous and distorted figures that appeared in later paintings such as *Cyclops* (1947; Chicago, IL, A. Inst.). Baziotes worked on the Works Progress Administration Federal Arts Project as a teacher at the Queens Museum, New York (1936–41), yet he felt alienated from the current social concerns.

Baziotes was more sympathetic to the exiled European Surrealists based in New York from 1938 to 1944, especially to Roberto Matta, whom he met in the spring of 1940. The irrational spatial webs and gaseous atmospheres of Matta's paintings were reflected in early works by Baziotes such as the *Butterflies of Leonardo da Vinci* (1942; artist's estate, see Sandler, p. 73). The Surrealists encouraged Baziotes's sense of fantasy and introduced him to the concept of "psychic" Automatism by which marks made spontaneously were thought to release subconscious associations. Baziotes modified this idea into a painting method that one critic called "slow automatism." Although he worked over his pictures many times in rich translucent glazes, he attempted to begin each painting session without preconceptions.

Two exhibitions at the Museum of Modern Art, New York, of works by Picasso (1939) and Miró (1941) were also influential in Baziotes's development. He was struck by the bizarre distortions of Picasso's figures and by Miró's fluid environments and primitivist signs. He also admired the rich colors of Persian miniatures and was fascinated by the grotesque aspects he perceived in science (particularly natural history) and also in popular culture. In 1941 he met Robert Motherwell, whose interests as a painter also included Symbolist literature and Surrealism. Through his friendship with Motherwell and other artists such as Jackson Pollock and Lee Krasner, all of whom shared an interest in automatism, he became associated with Abstract Expressionism, and his first one-man exhibition (1944) was at the gallery most closely involved with the nascent movement, Peggy Guggenheim's Art of This Century. His work always remained at a tangent, however, to that of his colleagues, even during the 1940s, when they shared concerns with dreams, primitive ritual, mystery and terror.

Baziotes's mature style was announced in works such as *The Dwarf* (1947; New York, MOMA; see color pl. 1:VI, 1), in which he applied thin layers of paint with dappled brushstrokes, suggesting simultaneously a watery environment, stained glass and jewels. Inhabiting this dream world is a clumsy green monster, described by the artist as both horrible and humorous, which combines the deadly eye of a lizard with the jagged teeth of a crocodile. The strangely inactive creature, like so many in Baziotes's work, evokes moods of reverie, fear and pity.

In his subsequent work, Baziotes recoiled from the more extreme developments of Abstract Expressionism, shunning its emphasis both on gesture and on dramatic large scale in favor of a less overtly emotional style that elaborated the sense of fantasy of his early pictures. His paintings of the 1950s, such as *Pompeii* (1955; New York, MOMA), were dominated by a mood of stillness, by meandering shapes suggestive of simple organisms, and by classical references prompted by his investigation of his Mediterranean heritage. He taught at the Brooklyn Museum Art School from 1949 to 1952 and at Hunter College, New York, from 1952 until his death. For illustration see also color pl. 1:VI, 3.

BIBLIOGRAPHY

William Baziotes: A Memorial Exhibition (exh. cat., ed. L. Alloway; New York, Guggenheim, 1965)

I. Sandler: *Abstract Expressionism: The Triumph of American Painting* (New York, 1970), pp. 72–8

B. Cavaliere: "An Introduction to the Method of William Baziotes," *A. Mag. [prev. pubd as Arts [New York]; A. Dig.],* li (1977), pp. 124–30

M. Hadler: "William Baziotes: A Contemporary Poet-painter," *A. Mag. [prev. pubd as Arts [New York]; A. Dig.],* li (1977), pp. 102–10

William Baziotes: A Retrospective Exhibition (exh. cat., Newport Beach, CA, Harbor A. Mus., 1978)

M. Preble: *William Baziotes* (Milan, 2005)

D. Anfam: "William Baziotes," *Burl. Mag.,* 222 (2005), pp.62–3

Robert Saltonstall Mattison

Beal, Jack

(*b* Richmond, VA, 25 June 1931), painter. Beal studied at the College of William and Mary, Norfolk, VA, before going on to the School of the Art Institute of Chicago and the University of Chicago. In 1965, he began having solo exhibitions at the Allan Frumkin Gallery, later Frumkin/Adams Gallery and then George Adams Gallery, which had venues in New York City and Chicago, continuing to exhibit with them into the 21st century. Like many artists working in the 1960s, he repudiated the abstract, then so current in the art world, and favored instead the kind of "New Realism" being espoused by artists such as Philip Pearlstein, among others. His art focuses on the figure indoors, usually rendered up-close in a compact interior environment. The colors are usually vivid and the lines often dominant.

Beal is known primarily as a painter, but in addition to painting and prints, Beal produced two major public art monuments. The first was a series of four murals titled *The History of American Labor* (1974–7), installed in the United States Department of Labor Building in Washington, DC. They each focus on a different theme and century: the 17th century and colonization; the 18th century and settlement; the 19th century and industry; and the 20th century and technology. A second major public commission was two mosaic murals for the Metropolitan Transit Authority's Arts in Transit at the Times Square–42nd Street station at 41st Street, New York. These murals are *The Return of Spring* (1999) and *The Onset of Winter* (2003) in which the artist used the classical mythological story of Persephone, who has to live underground for half a year, as an apt metaphor for subway travelers who ascend and descend below the ground. Beal received honorary doctorates from the Art Institute of Boston (1992) and Hollins College (1994). His work is in numerous major public and private collections such as the Whitney Museum of American Art in New York. Additionally, he has also been the recipient of major grants including one from the National Endowment of the Arts.

[*See also* New Realism.]

WRITINGS

foreword in N. Goodstein: *Figure Drawing: The Structure, Anatomy, and Expressive Design of Human Form* (Upper Saddle River, NJ, 6/2004)

BIBLIOGRAPHY

F. Goodyear: *Seven on the Figure* (exh. cat., Philadelphia, PA Acad. F.A., 1979)

E. Shanes: *Jack Beal* (New York, 1993)

Anne K. Swartz

Bearden, Romare

(*b* Charlotte, NC, 2 Sept 1911 or 1912; *d* New York City, 12 March 1988), painter, collagist and author. Bearden is best known for his collages, which often addressed urban themes. He was a founding member of Spiral, a group of African American artists who started meeting at his downtown New York studio in 1963. He also published essays and cartoons, designed book jackets, magazine and album covers, and is widely regarded as the first African American artist to successfully enter the mainstream of the contemporary art world. The posthumously published book he co-authored with Harry Henderson, *A History of African-American Artists: From 1792 to the Present* (1993), in a very short time became an almost canonical text in the field.

Bearden's family moved permanently to Harlem, a predominantly black neighborhood of New York City, in 1920. His mother, Bessye Bearden, was the New York correspondent for the *Chicago Defender*, an African American newspaper, and through her Bearden was introduced to many of the artists, writers and intellectuals associated with the New Negro movement (often referred to as the Harlem Renaissance). He studied at Boston University in the early 1930s and graduated from New York University in 1935 with a degree in education. He also studied for a time at the Art Students League with the German artist George Grosz (1893–1959), who probably introduced him to the photomontages of his fellow Berlin Dadaists, John Heartfield (1891–1968)

and Hannah Höch (1889–1978), influences that would resurface decades later in Bearden's collages.

In 1935 he became a case worker for the Harlem office of the New York City Department of Social Services, a position he maintained on and off throughout most of his career to supplement his uneven income as an artist. In 1940, he had his first solo exhibition at 306, a well-known African American artist's and writer's enclave and gallery located in a former stable on 141st Street in Harlem. In 1945, after a brief stint in the army, he joined the Samuel Kootz Gallery, one of the few avant-garde commercial galleries in New York at that time. His painting from that period was in an expressionistic, linear, semi-abstract style. He often addressed biblical or mythic themes in the work from these years (themes that also attracted Mark Rothko, Adolph Gottlieb and others at that time).

In 1950 he traveled to Paris on the GI Bill, where he studied philosophy with Gaston Bachelard at the Sorbonne and later traveled throughout Europe visiting artists, including Pablo Picasso (1881–1973), with letters of introduction from Kootz. Over the next few years, Bearden tried his hand at writing lyrics in collaboration with composer and musician Dave Ellis while maintaining a regular presence in group exhibitions; but in 1961 Bearden joined the stable of the Cordier and Ekstrom Gallery in New York City, the gallery which was to represent him for the rest of his career.

It was in 1963 or 1964 that Bearden began making the collages for which he has since become well known. The collages comprise images snipped from popular magazines and arranged, along with colored papers, which were often abraded with sandpaper or bleach or enhanced with graphite or paint; these small compositions were then blown up through the Photostat process onto full-sized sheets of paper. The Photostat enlargement reduced the diverse finishes and textures of the printed, pasted and abraded papers of the collage to an even, continuous, smooth matte surface, and in this way the fragmented quality of the collages was reduced and

a new overall unity was achieved. The relatively large size of the Photostats added to their visual impact.

After a well-received exhibition of the Photostats at the Cordier and Ekstrom gallery in 1964, Bearden was invited to mount a solo exhibition of his collages and enlarged Photostats at the Corcoran Gallery of Art, a major museum in Washington DC. Following this, his visibility increased with one successful show after another, culminating in a retrospective exhibition at the Museum of Modern Art in New York City in 1971, when Bearden was in his late 50s. In his later work, he incorporated enlarged Photostats of various photographic images cut and pasted directly, as well as large sheets of silk-screened, colored paper and even fragments of billboards in creating large collages, at first on canvas, then later on fiberboard. For illustration see color pl. 1:XI, 1.

WRITINGS

"The Negro Artist and Modern Art," *Opportunity: Journal of Negro Life*, xv (Dec 1934), pp. 371–2

"Rectangular Structure in My Montage Paintings," *Leonardo*, ii (Jan 1969), pp. 11–19

with H. Henderson: *A History of African-American Artists: From 1792 to the Present* (New York, 1993)

BIBLIOGRAPHY

The Prevalence of Ritual (exh. cat., New York, MOMA, 1971)

The Art of Romare Bearden (exh. cat., Washington, DC, N.G.A., 2003)

Dennis Raverty

Beat Movement

Literary, musical and artistic movement that arose in the 1950s and 1960s. The term is applied to the primarily urban, intellectual and sub-cultural phenomenon that emerged in the aftermath of World War II. It was motivated by writers (especially poets), musicians (mostly jazz practitioners) and visual artists reacting against the rampant conformism and Cold War paranoia of 1950s America. The Beat Movement developed contemporaneously in New York City, Los Angeles and San Francisco. According to poet and critic John Clellon Holmes (1926–88), "Beat" described an alienated state wherein the

individual, "pushed up against the wall of [his] own consciousness," felt compelled to rebel against the strictures of "straight" society. Alternatively, Jack Kerouac (1922–69), author of the archetypal Beat novel, *On the Road* (1957), emphasized the "beatific" aspects of Beat inspiration, prioritizing spirituality over materialism. East and West Coast Beat practitioners shared a number of features, although the art, literature and music produced were not identical in tenor, style or theme. A few participants moved back and forth between locations and, for some, alcohol and drug use, Zen Buddhism and alternate forms of sexuality played an important creative role.

While the Beat Movement in visual art cannot be classified as explicitly as its predecessor Abstract Expressionism, the shared characteristics of many artworks produced during the 1950s with Beat writing and jazz, especially bebop, encouraged analogous categorization, especially in the popular media. These traits included emphasis on improvisation, instinct and spontaneity; intersubjectivity; raw grittiness versus purity of form (a junk aesthetic); random juxtapositions meant to subvert aesthetic expectations (a collage aesthetic); the synergy of boundary crossing between artistic media as well as high and low forms of culture; emphasis on process, direct experience and energy; confessional structure; high value placed on the immediacy of "sketching"; asymmetry or allover composition.

Beat stylists of all kinds admired gestural Abstract Expressionism, extending its implications in a more performance direction. Jackson Pollock was esteemed by Beat poets who sought parallel ways to tap his reliance on bodily movement to create form; for instance, by projecting verse on the writer's breathing patterns, a practice of Allen Ginsberg (1926–97) and Charles Olson (1910–70). According to Holmes, the Beats believed only art that "cried out" for expression because of its unalterable truth to the sayer was truly valid. Such statements, perhaps neither typically artistic nor poetic, should "burst out" of their creator, defining a unique structure through this method. In addition to Pollock, saxophonists

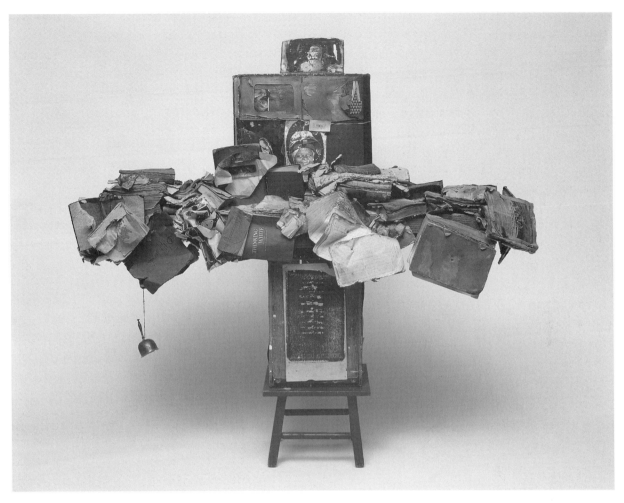

BEAT MOVEMENT. *The Librarian* by George Herms, assemblage made from wooden box, papers, books, loving cup and painted stool, h. 1.45 m, 1960. GIFT OF MOLLY BARNES/NORTON SIMON MUSEUM

Charlie "Bird" Parker (1920–55) and Ornette Coleman (*b* 1930) were likewise important models of no-holds-barred, instinctive spontaneity. Many Beat authors frequented the Cedar Tavern, a popular bar in Greenwich Village, New York, interacting with Pollock (until his early death), Willem de Kooning, Franz Kline and other Abstract Expressionists congregating there. Art critic Harold Rosenberg (1906–78), in his essay "The American Action Painters" (*ARTnews*, Dec 1952), summarized a new situational aesthetic, in which the canvas had become an "arena in which to act," which profoundly influenced Beat practice.

In "The Legacy of Jackson Pollock" (*ARTnews*, Oct 1958), artist Allan Kaprow analyzed the further consequences of Pollock's process orientation, identifying it as a primary inspiration for the new generation's greater desire to integrate art and life. The Beat implications of Pollock's dance-like movements around his canvas placed on the floor, exposed publicly by Hans Namuth in films and photographs of the artist at work made during 1950, were extended in Happenings, the improvisatory theatrical mode Kaprow promoted. The random energy of Happenings stimulated a number of younger painters and sculptors, including Red Grooms, Robert Whitman (*b* 1935), Jim Dine and Claes Oldenburg, to adopt a more experiential and participatory manner of expression from 1957 to 1966.

Other New York artists often categorized as partaking of aspects of the Beat aesthetic are Swiss-born

photographer Robert Frank and painters Robert Rauschenberg and Jasper Johns. Beyond incorporating non-art materials into paintings and sculpture—Rauschenberg called his hybrid assemblages of 1955–62 "combines"—a related Beat tendency to which he and Johns subscribed was the foregrounding of prosaic subject matter. Their vernacular aesthetic of inclusion was strongly influenced by the ideas of composer John Cage, a pioneer of music based on Duchampian chance principles. Although Johns ultimately took the Beat tendency to valorize found objects in a more intellectual direction, Rauschenberg's key goal was to "act in the gap between art and life." Frank's 1955 photo series, *The Americans*, executed on a series of road trips around the USA, and his 1959 short film, *Pull My Daisy*, based on one section of a play by Kerouac, starring Ginsberg and some of his Beat poet friends as well as painters Alice Neel and Larry Rivers, are considered exemplary Beat visual statements.

Members of the Beat sub-culture on the West Coast produced somewhat more oddball, often riskier, and more mystical and collaborative visual and verbal output than New York counterparts. Poets such as Lawrence Ferlinghetti (*b* 1919), co-founder of City Lights Bookstore and Publishers in San Francisco, Michael McClure (*b* 1932) and Gary Snyder (*b* 1930) interacted creatively with Ginsberg as well as each other. (Ginsberg's paradigmatic Beat poem, *Howl*, first performed at the Six Gallery in San Francisco in 1957, was published by City Lights, which was then accused of peddling pornography.) Assemblages by Edward Kienholz, Wally Hedrick (1928–2003), Jay DeFeo, George Herms (*b* 1935) and Bruce Conner at times incorporated political commentary (as on the notorious Black Dahlia murder in Los Angeles by the latter) not evident in the works of Rauschenberg or sculptor Richard Stankiewicz in the east. Wallace Berman mined Jewish mysticism for subject matter used in verifax collages and published a hand-printed mail art journal, *Semina* (1955–64; named after a gallery he started in Los Angeles), in which the major West Coast Beat proponents in art and poetry were featured. Another gallery important for this cohort was the Ferus Gallery on La Cienaga Boulevard (1957–66) founded by Kienholz and curator Walter Hopps (1932–2005).

[*See also* Abstract Expressionism; Berman, Wallace; Cage, John; Conner, Bruce; DeFeo, Jay; De Kooning, Willem; Dine, Jim; Frank, Robert; Grooms, Red; Happenings; Johns, Jasper; Kienholz, Edward; Kline, Franz; Oldenburg, Claes, Pollock, Jackson, Rauschenberg, Robert; *and* Stankiewicz, Richard.]

BIBLIOGRAPHY

J. Clellon Holmes: "This Is the Beat Generation," *NY Times Mag.* (16 Nov 1952), pp. 10–22

K. Rexroth: "Disengagement: The Art of the Beat Generation," *New World Writing*, xi (New York, 1957), pp. 28–41

J. Clellon Holmes: "The Philosophy of the Beat Generation," *Esquire* (Feb 1958), pp. 35–8

A. Kaprow: "The Legacy of Jackson Pollock," *ARTnews* (Oct 1958), pp. 24–6, 55–6

L. Alloway: "Junk Culture as a Tradition," *New Forms/New Media I* (exh. cat., New York, Martha Jackson Gallery, 1960)

The Americans: Photographs by Robert Frank, intro. J. Kerouac (New York, 1969)

Poets of the Cities: New York and San Francisco, 1950–1965 (exh. cat., ed. N. Chassman; Dallas, TX, Mus. F.A. and S. Methodist U., Pollock Gals; San Francisco, CA, Mus. A.; Hartford, CT, Wadsworth Atheneum; 1974)

W. T. Lhamon Jr.: *Deliberate Speed: The Origins of a Cultural Style in the American 1950s* (Washington, DC, 1990)

R. Solnit: *Secret Exhibition: Six California Artists* (San Francisco, 1991)

Hand-Painted Pop: American Art in Transition, 1955–62 (exh. cat., ed. R. Ferguson; Los Angeles, 1993)

Beat Culture and the New America, 1950–1965 (exh. cat., ed. L. Phillips; New York, Whitney, 1995)

D. Belgrad: *The Culture of Spontaneity: Improvisation and the Arts in Postwar America* (Chicago and London, 1998)

J. Fineberg: "The Beat Generation: The Fifties in America," *Art Since 1940: Strategies of Being* (New York, 2/2006), pp. 172–201

Ellen G. Landau

Beatty, Chester

(*b* New York, 7 Feb 1875; *d* Monaco, 19 Jan 1968), mining consultant and collector. Beatty was educated

at the Columbia School of Mines and at Princeton University; by the age of 28 he was the consulting engineer and assistant general manager of the Guggenheim Exploration Company. In 1913, two years after the death of his first wife, he settled in London and became established as a mining consultant. He married Edith Dunn and bought Baroda House in Kensington Palace Gardens. With one of his associates, Herbert Hoover, later president of the USA (1929–33), he reorganized the Kyshtin mine in the Urals. The Selection Trust Ltd., which he established in 1914 to develop and finance profitable mines throughout the world, made great headway after World War I, and he remained its chairman until 1960. He was naturalized as a British citizen in 1933. In his youth he began collecting a range of items, including Western manuscripts and Chinese snuff bottles, but his main passion was collecting Islamic manuscripts and paintings, early Bibles and rare books, Impressionist paintings, French and Russian gold snuffboxes, 18th-century watches, clocks and stamps. His interest in the Islamic arts of the book, particularly manuscripts of the Koran, was stimulated by frequent visits to Cairo, where he wintered between the wars. Although he had no knowledge of Arabic, Persian or Turkish, he was keen to give scholars access to his collection and loaned manuscripts to many exhibitions. In 1950 he moved from Baroda House to Dublin and spent his remaining years between Dublin and the south of France. Knighted in 1954, he became an honorary citizen of the Irish Republic, giving over 80 Impressionist paintings to the National Gallery, Dublin, and his library as a gift to the people of Ireland. He chose the site for his library, which was dedicated in 1953 and extended in 1974.

BIBLIOGRAPHY

ODNB; Enc. Iran: "Chester Beatty Library"

H. J. Polotsky: *Manichäische Handschriften der Sammlung A. Chester Beatty*, i (Stuttgart, 1934)

T. W. Arnold and J. V. S. Wilkinson: *The Library of A. Chester Beatty: A Catalogue of the Indian Miniatures*, 3 vols (London, 1936)

C. R. C. Allberry: *Manichaean Manuscripts in the Chester Beatty Library*, ii (Stuttgart, 1938)

A. J. Arberry: *The Chester Beatty Library: A Handlist of the Arabic Manuscripts*, 8 vols (Dublin, 1955–66)

S. Der Nersessian: *The Chester Beatty Library: A Catalogue of the Armenian Manuscripts* (Dublin, 1958)

V. Minorsky and J. V. S. Wilkinson: *The Chester Beatty Library: A Catalogue of the Turkish Manuscripts and Miniatures* (Dublin, 1958)

A. J. Arberry and others: *The Chester Beatty Library: A Catalogue of the Persian Manuscripts and Miniatures*, 3 vols (Dublin, 1959–62)

B. van Regemorter: *Some Oriental Bindings in the Chester Beatty Library* (Dublin, 1961)

R. J. Hayes: *The Chester Beatty Library* (Dublin, 1963)

A. J. Arberry: *The Koran Illuminated: A Handlist of Korans in the Chester Beatty Library* (Dublin, 1967)

Obituary, *The Times* (22, 27 Jan 1968)

D. L. Snellgrove and C. R. Bawden: *A Catalogue of the Tibetan Collection and a Catalogue of the Mongolian Collection* (Dublin, 1969)

S. Sorimachi: *Japanese Illustrated Books and Manuscripts in the Chester Beatty Library, Dublin, Ireland* (Tokyo, 1979)

D. James: *Qur'āns and Bindings from the Chester Beatty Library* (London, 1980)

A. J. Wilson: *Life and Times of Sir Chester Beatty* (London, 1985)

S. Giversen, ed.: *Manichaean Coptic Papyri in the Chester Beatty Library*, 4 vols (Geneva, 1987–8)

B. P. Kennedy: *Alfred Chester Beatty and Ireland, 1950–1968: A Study in Cultural Politics* (Dublin, 1988)

L. Y. Leach: *Mughal and Other Indian Paintings from the Chester Beatty Library* (Buckhurst Hill, Essex, 1991)

B. P. Kennedy: "The Collecting Technique of Sir Alfred Chester Beatty," *Art Is My Life: A Tribute to James White* (1991)

K. Robinson: "Sir Alfred Chester Beatty and His Library," *Irish Arts Review Yearbook* (1993), pp. 153–62

M. Ryan and others: *The Chester Beatty Library* (London, 2001)

S. J. Vernoit

Beaux, Cecilia

(*b* Philadelphia, PA, 1 May 1855; *d* Gloucester, MA, 17 Sept 1942), painter. Cecilia Beaux's paintings of upper-class men, women and children represent the finest examples of grand manner portraiture from the turn of the 20th century. Known for her bravura brushwork, lush color and consummate ability to

combine likeness and genre, Beaux's paintings garnered awards and accolades at the exhibitions where she regularly showed her work. By the 1890s her portraits were often compared with those of John Singer Sargent, and she was as well known as Mary Cassatt.

Beaux was sixteen years old when an uncle arranged private art lessons with a distant relative and artist, Catharine Ann Drinker (1871–72). Beaux did copy work with her and then took two more years of training at the art school of Francis Adolf Van Der Wielen (1872–74). Beaux later studied china painting at the National Art Training School with Camille Piton (1879). Her earliest Philadelphia training prepared her for a career in the decorative arts. A few of Beaux's early commissions include her lithograph, *The Brighton Cats* (1874; priv. col.), and her china plate, *The Bruce Child* (1880; New York, Met.). Such work perfected Beaux's drawing skills and helped her identify a broad interest in portraiture.

Beaux also attended the Pennsylvania Academy of the Fine Arts (1876–78) and took a class with William Sartain (1881–83). It was with Sartain that she learned to paint, producing her first major portrait, *The Last Days of Infancy* (1883–84; Philadelphia, PA Acad. F.A.), for which she was awarded the Pennsylvania Academy's Mary Smith Prize (1885). Her Philadelphia clientele developed from the success of such portraits as *George Burnham* (1886; Philadelphia, PA, Mus A.).

Beaux sealed her artistic credentials studying in France for a year and a half (1888–89). At the Académies Julian and Colorossi in Paris, she executed life drawings such as *Figure Study, Standing Male* (1888–89; priv. col.). During the summer of 1888 she painted in a *plein-air* style at the art colony in Concarneau, and her palette lightened in paintings such as *Twilight Confidences* (1888; priv. col.). Before returning to Philadelphia she completed commissions in England, including the pastel *Maud (Du Puy) Darwin* (1889; priv. col.).

Beaux solidified her reputation as a grand manner portraitist in the 1890s with paintings of her family, such as *Cecil* (1892; Philadelphia, PA, Mus. A.), and with commissions such as *Mrs. Clement A. Griscom and Daughter Frances Canby* (1898; Philadelphia, PA Acad. F.A.), for which she was awarded a first class gold medal from the Carnegie Institute in 1899.

After the turn of the century, Beaux lived in New York and Gloucester, Massachusetts, where she built her summer home and studio, "Green Alley." Her clientele broadened nationally and internationally, and she fulfilled such commissions as *Mrs. Theodore Roosevelt and Daughter Ethel* (1902; priv. col.), painted in the White House, and *Premier Georges Clemenceau* (1920; Washington, DC, Smithsonian Amer. A. Mus.), executed in Paris for the US War Portraits Commission.

Beaux's painting career ostensibly ended in 1924 when she broke her hip. She then penned an autobiography, *Background with Figures* (Houghton, Mifflin, 1930). For illustration see color pl. 1:XIII, 2.

[*See also* Philadelphia.]

WRITINGS

"Why the Girl Art Student Fails," *Harper's Bazaar*, XLVII/5 (May 1913), pp. 221, 249

"Professional Art Schools," *A. Progr.*, VII/1 (Nov 1915), pp. 3–8

"What Should the College A.B. Course Offer to the Future Artist?," *Amer. Mag. A.*, VII/12 (Oct 1916), pp. 479–84

UNPUBLISHED SOURCES

Cecilia Beaux Papers, American Academy of Arts and Letters Library, New York

Cecilia Beaux Papers, Archives of American Art, Smithsonian Institution, Washington, DC

Cecilia Beaux Papers, Archives, Pennsylvania Academy of the Fine Arts, Philadelphia, Pennsylvania

Tappert Collection of Cecilia Beaux Research Materials, Archives, Pennsylvania Academy of the Fine Arts, Philadelphia, Pennsylvania

BIBLIOGRAPHY

H. S. Drinker: *The Paintings and Drawings of Cecilia Beaux* (Philadelphia, 1955)

C. D. Bowen: *Family Portrait* (Boston, 1970)

Cecilia Beaux, Portrait of an Artist (exh. cat. by F. H. Goodyear Jr. and E. Bailey, Philadelphia, PA Acad. F.A., 1974)

S. Burns: "The 'Earnest, Untiring Worker' and the Magician of the Brush: Gender Politics in the Criticism of Cecilia Beaux and John Singer Sargent," *Oxford A., J.*, XV (1992), pp. 36–53

Cecilia Beaux and the Art of Portraiture (exh. cat. by T. L. Tappert, Washington, DC, N.P.G., 1995)

Cecilia Beaux: American Figure Painter (exh. cat. by S. Yount and others, Atlanta, GA, High Mus. A., 2007)

T. L. Tappert: *Out of the Background: Cecilia Beaux and the Art of Portraiture* (1994), http://www.tfaoi.org/aa/9aa/9aa211.htm

<div align="right">Tara Leigh Tappert</div>

Beaux-Arts classicism

The term Beaux-Arts classicism has several interrelated meanings in connection with American architecture. Frequently it is employed as a stylistic label with reference to the vast array of buildings with classical details constructed in the USA between the 1880s and the 1940s such as the Henry G. Villard houses (1882–6), New York, by McKim, Mead & White and the Thomas Jefferson Memorial (1937–43), Washington, DC, by John Russell Pope and Eggers & Higgins. Details on these and similar buildings employ forms and details from Greek, Roman and Renaissance sources. Beaux-Arts classicism can also refer to buildings with Georgian details that can also be labeled Colonial or Georgian Revival, along with the French château style as popularized in the William K. Vanderbilt house (1879–82), New York, by Richard Morris Hunt. The Court of Honor at the 1893 World's Columbian Exposition in Chicago brought the Beaux-Arts approach to prominence and impacted city planning as reflected in the McMillan Plan for Washington, DC (1901–2).

The term also refers to the overwhelming dominance of French educational methods from the Ecole des Beaux-Arts in Paris on American schools of architecture between the 1860s and the 1930s. Beginning with Richard Morris Hunt in 1847–54, aspiring American architects flocked to the French school and then imported the teaching methods and theory back to the USA. The Massachusetts Institute of Technology architecture program was founded by William R. Ware, a student of Hunt, and it became the model for most schools for the next half-century. The division of teaching between academic subjects (materials, history, etc.) on one side and then studio with juries on the other was standard practice along with methods of composition such as central axis, form follows plan and hierarchy of parts, and a reliance upon classical precedent drawn from either firsthand study in Rome or books became the norm. Many books were written, and a national Beaux-Arts Society and the Beaux-Arts Institute of Design were established that ran competitions and sponsored study abroad. By the mid-1920s a small rebellion began to emerge against the strictures of the Beaux-Arts approach, and the advent of modernism in the 1930s and 1940s meant its stylistic end. However, the academic/studio division of teaching remained, and indeed many post-World War II modernist buildings, while lacking classical details, still adhere to Beaux-Arts planning methods.

[*See also* Colonial Revival *and* Georgian style (Georgian Revival).]

BIBLIOGRAPHY

"The Ecole des Beaux-Arts Number," *Archit. Rec.* (Jan 1901)

W. R. Ware: *The American Vignola* (1901/R 1994)

A. D. F. Hamlin: "The Influence of the Ecole des Beaux-Arts on our Architectural Education," *Archit. Rec.*, xxiii (April 1908), pp. 241–7

J. F. Harbeson: *The Study of Architectural Design, with Special Reference to the Program of the Beaux-Arts Institute of Design* (New York, 1926)

J. P. Noffsinger: *The Influence of the Ecole des Beaux-Arts on the Architects of the United States* (Washington, DC, 1955)

A. Drexler, ed.: *The Architecture of the Ecole des Beaux-Arts* (New York and Cambridge, MA, 1977)

The American Renaissance, 1879–1917 (exh. cat. by R. G. Wilson; New York, Brooklyn Mus., 1979)

R. G. Wilson: "Modernity and Tradition in Beaux-Arts New York," *Paris/New York: Design/Fashion/Culture/1925–40*, ed. D. Albrecht (2008), pp. 50–65

<div align="right">Richard Guy Wilson</div>

Beaux-Arts Institute of Design

National organization dedicated to improving the quality of American architectural education. Incorporated

in 1916 by the architect Lloyd Warren (1867–1922), the Beaux-Arts Institute of Design (BAID) was an outgrowth of the Society of Beaux-Arts Architects (SBAA; 1894–1942) established by his brother Whitney Warren (1864–1943) with Thomas Hastings and Ernest Flagg, all of whom had studied at the Ecole des Beaux-Arts in Paris and were nationally recognized American Architects. BAID was dedicated to the improvement of architectural education by providing a centralized location for the distribution and judging of design problems. Architecture schools and private ateliers located throughout the United States developed projects based on the programs created by BAID. The student work was then sent to the headquarters in New York to be judged. An award system of medals and mentions cited the work considered most deserving by the jury of distinguished architects. The award-winning projects published in *The Bulletin* provided a means of comparing the quality of student design work on a national basis. The most prestigious award associated with BAID was the Paris Prize in Architecture; founded by Lloyd Warren along with numerous distinguished Americans in 1903, it was first offered in 1904. In 1904, Warren obtained permission from the French government allowing the prize-winner to enter the first class level of the Ecole des Beaux-Arts. After Lloyd Warren's accidental death in 1922, permanent funds were raised by 1926 to continue the prize in his memory as the Lloyd Warren Fellowship–Paris Prize in Architecture (last awarded in 1996). In the early years, the prize offered a two-and-a-half-year fellowship at the Ecole.

As architectural style changed through the 20th century, so too did the name of BAID. In 1956 BAID was renamed the National Institute of Architectural Education (NIAE), indicating the growth in influence of modernism over the original Beaux-Arts principles of the founding organization. NIAE survived until 1995, at which time it was renamed in honor of William Van Alen, winner of the 1908 Paris Prize and architect of the Chrysler Building in New York. The Van Alen Institute continues to sponsor competitions and promotes education through lectures, exhibitions and publications.

BIBLIOGRAPHY
Bull. B.-A. Inst. Des. (1925–56)

J. Harbeson: *The Study of Architectural Design, with Special Reference to the Program of the Beaux-Arts Institute of Design* (New York, 1927)

Winning Designs, 1904–1927, Paris Prize in Architecture, Lloyd Warren Memorial, intro. by J. Harbeson (New York, 1928)

J. Harbeson, J. Blatteau and S. Tatman: *The Study of Architectural Design* (New York, 2008)

Elizabeth Meredith Dowling

Beaux-Arts style

Term applied to a style of classical architecture found particularly in France and the USA that derived from the academic teaching of the Ecole des Beaux-Arts, Paris, during the 19th and early 20th centuries. The style is characterized by its formal planning and rich decoration. The term is also found in writings by detractors of the Ecole's teaching methods and results: Frank Lloyd Wright, for example, called its products "Frenchite pastry" ("In the Course of Architecture," *Archit. Rec.*, xxiii [1908], p. 163). For Paris-trained architects, however, issues of style were in general secondary to the more permanent tenets of the doctrine put forward by the Ecole.

Beaux-Arts style is at its most spectacular in large public commissions. On the main facades, monumentality is conveyed by colossal orders and coupled columns, dynamism by marked wall projections and decorative details in high relief, such as swags, garlands and medallions. Well detached from the elaborate rooflines, figure sculptures often terminate the main and secondary vertical axes. Overscaling (a device that characterizes Baroque more than classical architecture) prevents the Hôtel de Ville (1897–1904) in Tours by Victor Laloux from being a mere pastiche of a 17th-century *hôtel de ville*; the atlantids framing the main entrance are truly awe-inspiring, almost surrealistic. Less ornate is the facade on 42nd

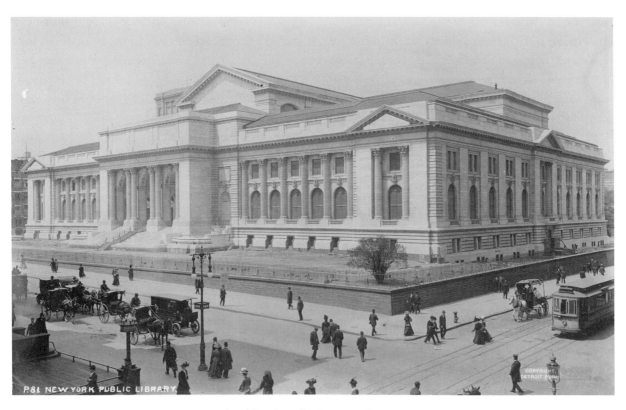

BEAUX-ARTS STYLE. New York Public Library by Carrère & Hastings, 1897–1911. LIBRARY OF CONGRESS PRINTS AND PHOTOGRAPHS DIVISION

Street of Grand Central Station (1903–13), New York, by Warren & Wetmore (with Reed and Stem); motifs, which are maximized against large areas of unadorned smooth stone, successfully address the scale and communal spirit of this area of Manhattan. While the best known and most ridiculed examples of the Beaux-Arts style are major pavilions at the World's Columbian Exposition in Chicago (1893) and the Exposition Universelle of 1900 in Paris, its characteristic features may also be found in Parisian blocks of flats and offices, Manhattan townhouses and sky-scrapers, Long Island and Newport country estates and London department stores.

When the Ecole des Beaux-Arts opened in 1819, amalgamating the special schools of architecture, painting and sculpture, it was unrivaled as a national training center for artists of these disciplines. (Its official denomination changed slightly according to political regimes and bureaucratic reforms.) The architecture section was the descendant of the pre-revolutionary school of the Académie Royale d'Architecture, suppressed in 1793, and the curriculum remained virtually unchanged until 1968. Credits were attributed through a highly competitive system of the Concours d'Emulation; a major tenet of the design-orientated pedagogy was the practice of the *esquisse*, a preliminary sketch defining a *parti* (design orientation), to which competitors had to remain faithful. The teaching also emphasized the logical arrangement of programmatic requirements and the implementation of a suitable "character" over stylistic and structural expression, social relevance and contextualism; projects for a specific site were exceptional. A basic rule for a successful composition was that visitors could find their way around any building without verbal orientation. Designs therefore represented carefully orchestrated sequences of circulation and transitional spaces; hierarchical arrangements of rooms according to their ceremonial and/or functional significance; and the expression of

the axis and cross-axis in elevation section and plan by advancing and receding planes, flights of steps, floor markings etc. According to Egbert, students were required to give their design a general character, which was conveyed by principles of form regarded as universally valid, such as a "monumental," a "public" or a "French" character, as well as a "type character," which was suggested by the particular program of the building. Thus, far from being decorative, ornamentation was supposed to be symbolic in its suggestion of the appropriate character or characters.

The use of a classical heritage as a source for Beaux-Arts architecture was due to the stress given at the school on a thorough knowledge of the architecture of antiquity, the Renaissance and 17th- and 18th-century France. Students' interpretation of this evolved dramatically in the first half of the 19th century, from the uncompromising Neo-classicism promoted by Antoine Quatremère de Quincy to Henri Labrouste's unconventional synthesis of historical references. A major impetus for multiplying the design precedents within this classical range and for the departure from Vitruvian canons of proportions was given by Charles Garnier's Opéra in Paris (1860–75). Among Garnier's junior collaborators on this spectacular project were Henri-Paul Nénot, Jean-Louis Pascal and Julien Azais Guadet, soon to become prominent *patrons*, leaders of large studios at the Ecole.

During the Second Empire the Beaux-Arts style developed, as the school experienced an increase in the number of projects focusing on interior design and the decorative arts, which gave freer rein to personal expression and imagination. As heir to the Second Empire style, Beaux-Arts eclecticism peaked in the 1880s, and it was quickly disseminated worldwide, as the student body at the school became increasingly cosmopolitan. Over 400 Americans studied architecture in Paris between 1846 and 1918, and many more followed a French-inspired curriculum in the USA, where the Beaux-Arts style had its greatest impact outside France. It was associated with the City Beautiful movement. The style made less impact in England, although a number of major buildings were erected by, among others, J. J. Burnet and Thomas Tait. Around 1900, critics of Beaux-Arts style adopted anti-doctrinaire positions, which were best expressed in Guadet's *Eléments et théorie de l'architecture* (1907), but they were in marked contrast with the emerging theories of the Modern Movement. As the traditional Beaux-Arts style became obsolete after 1918, French academic methods seemed to lose touch with contemporary lifestyles and production methods. The late 20th-century rehabilitation of the style originated in the exhibition *The Architecture of the Ecole des Beaux-Arts*, organized by Arthur Drexler in New York, and many thereafter considered its monumentality, clarity, impeccable craftsmanship and attention to detail as a valid alternative to the International Style.

[*See also* Architecture.]

BIBLIOGRAPHY

J. A. Guadet: *Eléments et théorie de l'architecture* (Paris, 1907)

J. P. Noffsinger: *The Influence of the Ecole des Beaux-Arts on the Architects of the United States* (Washington, 1955)

L. Hautecoeur: *Histoire de l'architecture classique en France*, vii (Paris, 1957)

The Architecture of the Ecole des Beaux-Arts (exh. cat., ed. A. Drexler; New York, MOMA, 1975–6)

A. Drexler, ed.: *The Architecture of the Ecole des Beaux-Arts* (New York, 1977)

D. Drew Egbert: *The Beaux-Arts Tradition in French Architecture* (Princeton, 1980)

R. Middleton, ed.: *The Beaux-Arts and Nineteenth-century French Architecture* (Cambridge, MA, 1982)

R. B. Harmon: *Beaux Arts Classicism in American Architecture: A Brief Style Guide* (Monticello, IL, 1983)

Isabelle Gournay

Bechtle, Robert

(*b* San Francisco, CA, 14 May 1932), painter. Native of the San Francisco Bay Area, known for careful observation and explicit use of snapshot-like photographic source material for paintings of family, cars and residential neighborhoods. The artist rose to

national and international prominence in early 1970s as part of the Photorealist movement.

Since the 1960s, Robert Bechtle has pursued a quiet realism based on the things he knows best, translating what seem to be ordinary scenes of middle-class American life into paintings. Following an early childhood in the Bay Area and Sacramento, his family settled in 1942 in Alameda, an island suburb adjacent to Oakland where his mother would occupy the same house for almost 60 years. The neighborhood appears in many of Bechtle's paintings.

Bechtle earned both his BFA (1954) and his MFA (1958) at Oakland's California College of Arts and Crafts, where he studied graphic design and then painting. During his student years and into the 1960s, Bechtle was influenced by Pop art's precedent for the use of commercial subject matter and techniques. He was likewise interested in Bay Area figuration, especially the subjects and structure of paintings by Richard Diebenkorn. Bechtle resisted the gestural paint handling of the figurative artists, however, and simply aimed to paint what he saw, without interpretation.

Bechtle began using photographs as part of his painterly process in 1964, when he snapped an image to further a scene that included his wife, Nancy Dalton, whom he had married in 1963, without requiring her to pose for hours on end (*Nancy Sitting*, 1964; CA priv. col.). For outdoor scenes, he found photographs useful in recording his favorite still-life prop—the car—before it was driven away. While the artist made occasional use of true snapshots for his paintings (*'46 Chevy*, 1965; Lisbon, Berardo col.), most of his source material came from photographs that he took with the idea of eventual paintings in mind. By 1966, Bechtle settled on his long-term studio practice. Once selecting an image to paint, he would project a slide directly onto canvas to lay in the composition. He then worked from a reference print of the slide over the course of several months to translate the photographic image, stroke by stroke, into a painting.

The artist's use of photographic source material as a fundamental part of his practice is something he shared with a number of artists working on both coasts—Richard Estes, Chuck Close, Duane Hanson, Ralph Goings and Richard McLean—who became identified with Photorealism. *'61 Pontiac* (1968–9; New York, Whitney) was one of three of Bechtle's paintings shown in the Whitney Museum of American Art's 1970 exhibition *Twenty-two Realists*. The large, three-panel painting of the bearded artist and his family posed frontally with the family station wagon became problematic of his early interests in depicting suburban scenes with what appeared to be deadpan objectivity. *'61 Pontiac* was shown again in Documenta 5, in Kassel, Germany, in 1972. Compared to the dazzling imagery of the work of peers such as Estes or Audrey Flack, however, Bechtle's paintings remained markedly understated.

In many of his works from the early to mid-1970s, single cars dominate the compositions. Artist Charles Ray, known for uncanny realist sculpture, considered *Alameda Gran Torino* (1974; San Francisco, CA, MOMA) one of his favorite works of art. In writing for Bechtle's San Francisco MOMA 2005 retrospective catalog, Ray noted the work's capacity to shift between its emphasis on structure and subject and its emotional familiarity. The emphasis in his work shifted to figurative canvases and neighborhood scenes where cars did not figure as centrally in the compositions, such as *Watsonville Olympia* (1977; San Francisco, CA, MOMA) or *Frisco Nova* (1979; San Francisco International Airport).

Upon separation from his first wife, Bechtle moved in 1980 to San Francisco's Potrero Hill district. In 1982, he married art historian Whitney Chadwick, a colleague at San Francisco State. The two lived in Soho in New York for brief periods in the mid-1980s, with paintings such as *Broom Street Zenith* (1987; TN priv. col.), harking back to 1960s interiors. In recent decades he has continued to paint interiors, although a primary focus has been exterior views of San Francisco residential neighborhoods at different times of day and night, with many paintings set on the very hilly streets of Potrero Hill. His first major retrospective was organized and

circulated by San Francisco MOMA in 2005; since then his work has been actively shown nationally and internationally.

UNPUBLISHED SOURCES
Washington, DC, Smithsonian Inst., Archvs Amer. A.

BIBLIOGRAPHY
Robert Bechtle: A Retrospective Exhibition (exh. cat., essays by I. Karp and S. McKillop, Sacramento, CA, Crocker A. Mus., 1973)
L. K. Meisel: *Photorealism*; *Photorealism Since 1980*; *Photorealism at the Millenium* (New York, 1980/R 1989, 2002)
Robert Bechtle: A Retrospective (exh. cat. by J. Bishop and others, San Francisco, CA, MOMA, 2005)
Robert Bechtle (exh. cat., essay by L. Nochlin, New York, Gladstone Gal., 2006)
Robert Bechtle, Plein Air, 1986–1999 (exh. cat., essay by B. Berkson, San Francisco, CA, Gal. Paule Anglim, 2007)

Janet Bishop

Beck, Rosemarie

(*b* New York, 3 July 1923; *d* New York, 13 July 2003), painter. Born of Hungarian parents, Beck grew up in Westchester County, NY, and attended high school at New Rochelle, where her chief interests were music and drama. She began studying violin at the age of ten and continued with music at Oberlin College, OH, where she majored in art history. After graduation Beck moved to New York City, where she continued to study art history at the Institute of Fine Arts, as well as attending life-drawing classes at the Art Students League. Beck belonged to the second generation of New York school artists—artists generally born between 1915 and 1925—who began their careers when Abstract Expressionism was gaining momentum in the late 1940s. Like others among her contemporaries, Beck came under the influence of abstract art at an early stage, then turned gradually to representational painting while retaining the structural principles of abstract art.

Beck and her husband, writer and literary critic Robert Phelps, moved to Woodstock, NY, in 1947, where she became close friends with Philip Guston and Bradley Walker Tomlin, both of whom influenced her early shimmering abstract paintings. After her son Roger was born in 1949, she worked in the studio of Robert Motherwell and began to exhibit her work in New York galleries, including a *Young Talent* show at the Kootz Gallery, selected by Clement Greenberg, the annual exhibitions of the New York School at the Stable Gallery and the Whitney Museum's *Young America 1957* exhibition and its *Nature in Abstraction* show in 1958.

Beck's painting went through a crisis in 1957 as figurative subject matter forced its way into her abstract canvases. By the early 1960s she was working entirely from the model and painting large dramatic compositions, often taken from classical Greek or Shakespearean plays staged in modern dress. Her early grounding in abstraction continued to make itself felt in the underlying structure of her work while the gestural paint handling characteristic of Abstract Expressionism was reflected in the vigorous, clearly articulated brushstrokes with which she applied small patches of color. Although an injury to her hand forced Beck to stop playing the violin in 1970, her musical training played a distinct role in the way she thought about rhythms, tempo and intervals in her painting. She achieved the difficult goal of portraying profound aspects of human experience by appropriating themes from classical drama—Antigone before Creon, the death of Phaedra—while maintaining a rhythmic flow of light and color that energizes the paintings' surfaces. Also important in her oeuvre are large, complex still lifes of studio paraphernalia: books, her violin, plaster figures, reproductions of favorite art works, vases of flowers; sometimes the imposing figure of the artist herself looms out of the clutter of the studio interior.

Her paintings were seen regularly in one-person shows at the Peridot Gallery and, after it closed, at the Ingber Gallery through 1990. In 1957 Beck began a teaching career that was to last the rest of her life, first at Vassar College and Middlebury College, then at Queens College, City University of New York,

from 1972 to 1990. She was still on the faculty of the New York Studio School when she was diagnosed with an inoperable brain tumor in 2003.

BIBLIOGRAPHY

T. B. Hess: "U.S. Painting: Some Recent Directions," *A. News Annu.* (1956)

L. Finkelstein: "Painterly Representation," *A. News Annu.* (1956)

M. Sawin: "Rosemarie Beck," *Woman's A. J.*, xxvi/1 (Spring–Summer, 2005) [reprinted and expanded from *Rosemarie Beck*, exh. cat., Dayton, OH, Wright State University, 2002]

Martica Sawin

Becket, Welton

(*b* Seattle, WA, 8 Aug 1902; *d* Los Angeles, CA, 16 Jan 1969), architect. Although Becket was based in the Los Angeles area, he also had an international reputation. His work was in the Modernist mode and he was important in popularizing the style in public buildings throughout southern California and elsewhere.

Becket studied architecture at the University of Washington (1927) and for a short time at the Ecole des Beaux-Arts in Paris. His early work was for established architecture firms in Seattle and then Los Angeles, where he joined the firm of Charles F. Plummer, and, when Plummer died, he teamed up with his classmate Walter Wurdeman to form the firm of Wurdeman and Becket.

Their first major building was the Pan-Pacific Auditorium (1935) in North Hollywood, CA, an assertive structure in the Streamlined Moderne style. It was enormously successful and led to further commissions. One of the best was Bullock's department store (1944) in Pasadena, again in the Streamlined Moderne (then called "modernistic") style. It is now partially obscured by a harmonious recent building erected in its former parking lot. The interior, though remodeled several times, retains a great deal of its original décor, including a tapestry by Jean Lurçat (1892–1966) opposite the first-floor elevators.

After Wurdeman's death in 1949 the firm was re-titled Welton Becket and Associates. It continued to work in the Moderne manner and then moved toward a loose and somewhat glitzy version of the International Style. Its most famous, even iconic, commission was the Capitol Records Tower (1954–6) in Hollywood, which resembled a monumental stack of phonograph records capped by a gigantic tone arm. Even Becket and Associates' work at the University of California, Los Angeles, and the Los Angeles International Airport could not surpass its sense of fun.

Becket, along with his contemporaries Albert C. Martin (1879–1960), William L. Pereira (1909–85) and Skidmore, Owings & Merrill stamped southern California with a Modernist image. Significantly, most of his work was in large buildings; he left residential work in the hands of more talented Modernists and of practitioners of the historic styles.

After his death in 1969 the firm eventually merged with Ellerbe Associates and became Ellerbe Becket Associates.

BIBLIOGRAPHY

W. D. Hunt Jr.: *Total Design: Architecture of Welton Becket and Associates* (New York, 1972)

Robert Winter

Beeby, Thomas

(*b* Oak Park, IL, 12 Oct 1941), architect and professor. Born in Oak Park, Illinois (home of numerous early works by Frank Lloyd Wright), Beeby moved with his family to Philadelphia before they relocated to England, where he completed high school. Beeby returned to the USA to attend Cornell University, earning a Bachelor of Architecture in 1964. The following year he received his Master's of Architecture from Yale University and took a position in the Chicago office of C. F. Murphy, leaving in 1971 to join James Wright Hammond (a former partner at Skidmore Owning & Merrill) in creating Hammond Beeby & Associates, which would eventually become the modern-day firm of Hammond Beeby Rupert

Ainge. In 1973 Beeby began teaching at the Illinois Institute of Technology, serving as an associate professor from 1978 through 1980, when he assumed the directorship of the School of Architecture at the University of Illinois at Chicago. He left this post to become dean of the Yale University School of Architecture from 1985 through 1991. After his time as dean, he remained affiliated with Yale as an adjunct professor while maintaining an active architectural practice.

Throughout his career as architect and professor, Beeby actively engaged with the architectural community. Beginning in 1976, Beeby and six other architects took part in exhibitions and conferences dedicated to the critical appraisal of contemporary architecture, investigating alternatives to Miesian architectural tenets that tended to dominate Chicago's architectural thought and production. Organized by Stanley Tigerman, the group of architects responsible for this discourse became known as "the Chicago Seven"—an ironic nod to the antiwar activists prosecuted in 1970.

In 1987, Beeby and his firm (then Hammond, Beeby & Babka) formed part of the winning team to design and build the new central branch of the Chicago Public Library, the Harold Washington Library Center (1987–91). The resulting building reflects Beeby's interest in contextual architecture, in this case the rich commercial and Neo-classical traditions of late 19th- and early 20th-century Chicago. With its grand arched windows, overhanging cornice and ornate Neo-classical details such as swags and towering finials, the Library Center formed a controversial contribution to Chicago's architectural landscape.

BIBLIOGRAPHY
"Hammond Beeby and Babka," in *A+U*, 200/5 (1987), pp. 17–80
H. Baldauf and G. Schafer, eds.: *Rap Sheets Interviews: Thomas H. Beeby* (New Haven, 1988)
Chicago Oral History Project, "Oral History of Thomas Hall Beeby," interview by Betty J. Blum (Chicago, 1998); found online at http://www.artic.edu/aic/libraries/research/specialcollections/oralhistories/beeby.html

A. Krista Sykes

Beecher, Catherine

(*b* East Hampton, NY, 6 Sept 1800; *d* Elmira, NY, 12 May 1878), writer. Catherine (Esther) Beecher was the daughter of the influential Presbyterian minister, Lyman Beecher (1775–1863), and one of eight children. The education of women was her mission; she focused on making them better writers and speakers, but especially, more efficient household managers and homemakers. Her books included works on improving domestic design. In *The Elements of Mental and Moral Philosophy* (1831) she advanced her view of the superiority of women, and the following book, *A Treatise on Domestic Economy* (1841), was enormously popular. The house designs she began to publish in 1841 were conventional spatially and technically. She rapidly improved her architectural knowledge and in 1869 published with her sister, Harriet Beecher Stowe (1811–96), her most influential book, *The American Woman's Home*. Included were plans for a model house arranged to maximize functional use and to minimize housekeeping drudgery. The latest inventions were incorporated, including water-closets, indoor plumbing, ventilation systems, central heating, and gas illumination. Beecher also reproduced plans for a tenement house and settlement houses for the urban poor, as well as schemes for a suburban church, schoolhouse and a residence for two female missionary teachers. There is also discussion of a Model Christian Neighborhood, in which ten to twelve families share a common bakehouse and laundry with mechanized washing equipment.

WRITINGS
The Elements of Mental and Moral Philosophy (n.p., 1831)
A Treatise on Domestic Economy, for the Use of Young Ladies at Home and at School (Boston, 1841)
"A Model Village," *The Revolution*, i (April 1868), p. 1
with H. Beecher Stowe: *The American Woman's Home: Or, Principles of Domestic Science, Being a Guide to the Formation and Maintenance of Economical, Healthful, Beautiful, and Christian Homes* (New York, 1869); rev. as *The New Housekeeper's Manual* (New York, 1873)
with H. Beecher Stowe: *Principles of Domestic Science* (New York, 1871)

N. Tonkovich, ed.: *The American Woman's Home* (New Brunswick, NJ, 2002)

BIBLIOGRAPHY

D. Cole: *From Tipi to Skyscraper: A History of Women in Architecture* (Boston, 1973)

K. K. Sklar: *Catherine Beecher: A Study in American Domesticity* (New Haven, 1973)

D. Hayden: "Catherine Beecher and the Politics of Housework," *Women in American Architecture: A Historic and Contemporary Perspective*, ed. S. Torre (New York, 1977)

D. Hayden: *The Grand Domestic Revolution: A History of Feminist Designs for American Homes, Neighborhoods, and Cities* (Cambridge, MA, 1981)

L. M. Roth: *America Builds: Source Documents in American Architecture and Planning* (New York, 1983), pp. 57–68

T. B. Dykeman, ed.: *The Social, Political, and Philosophical Works of Catherine Beecher* (Bristol, 2002)

Leland M. Roth

Beecroft, Vanessa

(*b* Genoa, 25 April 1969), Italian performance artist active in the USA. Beecroft's work is largely performance based, using a number of professional models in formation rather than the body of the artist herself. Originating in journals in which she had documented her anorexia, her performances deal with the contemporary striving for perfection in one's body image. Her first performances featured almost identically dressed women in wigs, standing, sitting or moving in slow formation, as in *VB08* (exh. Long Island City, NY, P.S.1, see N. Bryson and others, p. 113). Beecroft developed these performances into "tableaux vivants," turning the female performers into something between an object and an image. Always taking place in a gallery setting and taking full advantage of the voyeuristic possibilities, her performances are defined by an almost exclusive dependence on beautiful semi-clad female models arranged in a highly formal choreography. Over the years the amount of clothes worn by the models has steadily decreased until they have been left sporting only high-heel shoes. A spectacular and very public performance called *Show* (exh. New York,

Guggenheim, 23 April 1998, see *Artforum* Summer, 1998, pp.23–4) featuring 15 bikini-clad models and 5 wearing only high heels standing absolutely still in front of a huge audience, placed Beecroft's work firmly in the spotlight of the art world. She subsequently also used male models, notably US Army SEALs, as in the performance *VB39* (1999; exh. San Diego, CA, Mus. Contemp. A., see N. Bryson and others, pp. 82–7). Beecroft's work is deceptively simple in its execution, provoking questions around identity politics and voyeurism in the complex relationship among viewer, model and context.

BIBLIOGRAPHY

ID: An International Survey on the Notion of Identity in Contemporary Art (exh. cat., Eindhoven, Stedel. Van Abbesmus., 1996)

Vanessa Beecroft, Shirin Neshat (exh. cat., Bologna, Gal. Com. A. Mod. 1998) [text in Italian]

Examining Pictures (exh. cat., essays J. Nesbitt and F. Bonami, Chicago, IL, Mus. Contemp. A.; London, Whitechapel A.G.; 1999)

N. Bryson and others: "Vanessa Beecroft," *Parkett*, 56 (1999), pp. 76–118

C. Coombes: *Gucci Heels and Naked Chicks?: The Performance of Vanessa Beecroft* (MA thesis, 2000)

Vanessa Beecroft Performances, 1993–2003 (exh. cat. by M. Beccaria; Rivoli, Castello, Mus. A. Contemp., 2003)

M. Bianchi: *Permission to Stare: A Study of Alternative Strategies in the Performance-Art Installation Show by Vanessa Beecroft* (MA thesis, 2003)

Vanessa Beecroft: Photographs, Films, Drawings (exh. cat. by T. Kellein; Bielefeld, Städt. Ksthalle, 2004)

C. Sherman and V. Beecroft: *Her Bodies: Cindy Sherman & Vanessa Beecroft* (Chungnam, 2004)

J. Doyle: *Sex Objects: Art and the Dialectics of Desire* (Minneapolis, 2006)

J. Steinmetz, H. Cassils and C. Leary: "Behind Enemy Lines: Toxic Titties Infiltrate Vanessa Beecroft," *Signs: J. Women Cult. & Soc.*, 31/3 (Spring 2006), pp. 753–83

H. Kontova and M. Gioni: "Vanessa Beecroft: Skin Trade," *Flash A.*, 41/261 (2008), pp. 210–13

Francis Summers

Begay, Harrison

(*b* White Cone, AZ, *c.* 15 Nov 1917), painter. Begay was a prolific artist for over 50 years and his work is

familiar through paintings, book illustrations and screenprints, making him perhaps the best known contemporary Native American painter. In 1934 he entered the Santa Fe Indian School and joined the "Studio" of Dorothy Dunn (1903–1990), where he was one of Dunn's star students. In 1939, the year of his graduation, he painted one of the murals on the facade of Maisel's trading post in Albuquerque, NM. With a scholarship from the Indian Commission, he went on to study architecture at Black Mountain College, NC. Due to the public's ready acceptance of his paintings, after his return from military service in World War II he became one of the first Native American artists to support himself by painting full time. Widely exhibited, he was a consistent award winner at exhibitions, and his work has been included in every important public and private collection of Native American art. In recognition of his contributions to Native American art he was awarded the French government's Palmes Académiques in 1954. Begay painted a timeless, peaceful and gentle world, recognizing only the beauty in the Navajo way of life. His genre scenes, rendered in soft tones, speak of peace and serenity. Although his prodigious output included facile minor works tending toward sentimentality, his major work is characterized by inventiveness, originality, refinement and delicacy. At his best he was a keen observer, and his drawings of horses and deer are sensitive and expressive.

[See also Native North American art, subentry on Painting.]

BIBLIOGRAPHY

A. N. Clark, illus. H. Begay: *The Little Indian Basket Maker* (Chicago, 1957)

A. Crowell, illus. H. Begay: *A Hogan for the Bluebird* (New York, 1969)

C. L. Tanner: *Southwest Indian Painting: A Changing Art* (Tucson, 1957/R 1973)

D. Dunn: *American Indian Painting of the Southwest and Plains Areas* (Albuquerque, 1968)

Arthur Silberman
Revised and updated by Margaret Barlow

Bel Geddes, Norman

(*b* Adrian, MI, 27 April 1893; *d* New York, 9 May 1958), designer and writer. Bel Geddes studied at the Cleveland School of Art, OH, and the Art Institute of Chicago, and by 1914 he had established a reputation as an illustrator, making portraits of operatic luminaries for the *New York Times*. After producing plays in Los Angeles (1917), he joined the Metropolitan Opera in New York (1918) and became a leading stage designer; he invented the high-wattage spotlight and developed modern theatrical productions that blended the play, its lighting, its performers and their costumes into a cohesive whole. He gained international attention for his stage set (1921; unexecuted) for Dante's *Divine Comedy*, which revolutionized theatrical and operatic productions; it was conceived as a single, massive set with lighting coming first from below, signifying Hades, and then, as the play progressed, from high above, signifying Paradise. This led Max Reinhardt, the distinguished German producer, to commission him to design the settings for a production of *The Miracle* in New York (1923), and for this Bel Geddes transformed the entire interior of the Century Theater into the nave of a Gothic cathedral, with pews replacing seats to make the audience part of the cast.

In 1925 Bel Geddes went to Paris to design a production of the play *Jeanne d'Arc*. There he was attracted by the new forms of art shown at the Exposition Internationale des Arts Décoratifs et Industriels Modernes (1925), and he determined to leave the world of the theater for industrial design. Criticized for his change of direction, he responded that industry was the driving force of the age. In 1929 he collaborated with Otto Koller on the design (unexecuted) of an airliner as a massive "flying wing" that would provide accommodation for 400 passengers in the style of ocean liners. He became one of the main exponents of streamlining, the "Moderne" style inspired by speed and dynamism, and he produced designs and patents for a streamlined train (1931), ocean liner (1932) and buses and automobiles

(1932), whose forms foreshadowed the Volkswagen Beetle. His influential book *Horizons* (1932) predicted that design in the environment and for machines and objects of daily use would dominate the modern era.

Bel Geddes saw the Depression of the 1930s as a challenge rather than a threat and he responded by designing dramatic theaters and restaurants for Chicago's *Century of Progress Exposition* (1933). Although none was built, his proposal for a revolving, aerial restaurant later became a familiar sight in many cities. In 1937 he designed and built a scale model of *Metropolis*, "the city of tomorrow," for a series of Shell Oil advertisements, which incorporated many advanced ideas for traffic control. This led to his masterpiece, the design for the *Futurama* exhibit that was the central attraction of the General Motors Pavilion at the World's Fair (1939) in New York, introducing thousands of visitors to the super-highways, gleaming cities and tower blocks of the future. During World War II he was involved in building scale models of enemy terrain for military purposes.

Bel Geddes was as well known for his unrealized projects as for his completed works. His vision ranged from the practical design of typewriters, radios, refrigerators and stoves to the redesign of the Ringling Brothers Barnum & Bailey circus and a project for a floating airport in New York Harbor that would rotate to keep its single runway facing into the wind. He also carried out interior design commissions. Bel Geddes was one of the first professional industrial designers in the USA, and he was the first American to respond to the cultural challenge of the Machine Age, approaching every design problem with a penetrating curiosity and conviction that the laws of design were constant. Several prominent designers, including Henry Dreyfuss and Eliot Noyes, received their first exposure to design practice in his office in New York.

[*See also* Design *and* Wright, Russel.]

WRITINGS

A Project for a Theatrical Presentation of the Divine Comedy of Dante Alighieri (New York, 1924)

Horizons (Boston, 1932)

"Streamlining," *Atlantic Mthly*, cliv/5 (1934), pp. 553–63

Magic Motorways (New York, 1940)

W. Kelley, ed.: *Miracle in the Evening* (Garden City, NY, 1960)

BIBLIOGRAPHY

H. Dreyfuss and G. Seldes: "Norman Bel Geddes, 1893–1958," *Indust. Des.* (Dec 1958), pp. 49–51

A. J. Pulos: "The Restless Genius of Norman Bel Geddes," *Archit. Forum*, cxxxiii/1 (1970), pp. 46–51

F. J. Hunter: *Catalogue of the Norman Bel Geddes Theater Collection* (Boston, 1973)

J. D. Roberts: *Norman Bel Geddes: An Exhibition of Theatrical and Industrial Designs* (Austin, 1979)

J. L. Meikle: "Norman Bel Geddes and the Popularization of Streamlining," *Lib. Chron.* 13 (1980), pp. 91–110

A. J. Pulos: *The American Design Ethic* (Cambridge, MA, 1983)

J. Preddy: "Costumes and Clowns: Bizarre Projects of Norman Bel Geddes," *J. Pop. Cult.*, 20/2 (1986), pp. 29–39

R. Marchand: "The Designers Go to the Fair, II: Norman Bel Geddes, the General Motors 'Futurama,' and the Visit to the Factory Transformed," *Des. Iss.* 8/2 (1992), pp. 22–40

F. Engler and C. Lichtenstein: *Norman Bel Geddes, 1893–1958* (Bologna, 1994)

C. Cogdell: "The Futurama Recontextualized: Norman Bel Geddes's Eugenic *World of Tomorrow*," *Amer. Q.* 52/2 (2000), pp. 193–245

A. Morshed: "The Aesthetics of Ascension in Norman Bel Geddes's Futurama," *J. Soc. Archit. Hist.*, lxiii/1 (March 2004), pp. 74–99

C. D. Innes: *Designing Modern America: Broadway to Main Street* (New Haven, 2005)

Arthur J. Pulos

Bell, Larry

(*b* Chicago, IL, 6 Dec 1939), painter and sculptor. Bell attended the Chouinard Art Institute in Los Angeles from 1957 to 1959. After experimenting with geometrically shaped paintings, he turned to constructed paintings made of mirrored and transparent glass and canvas, for example *Untitled (Magic Boxes)* (canvas, acrylic, glass, 1964; Los Angeles, CA, Co. Mus. A.). The optical ambiguities created by the reflections of the viewer's image and the ambient space became the hallmark of Bell's work. Dissatisfied with

the limitations of two-dimensional art, he began making faceted boxes of mirrored and transparent glass, the reflecting and refracting surfaces of which greatly extended the optical complexities and ambiguities of his earlier glass and canvas paintings. By late 1964 he had abandoned faceted, mirrored boxes in favor of pure glass cubes, whose sides he coated with various metals to create fields of elusive, evanescent color, for example *Untitled* (1965; artist's col., see 1982 exh. cat., p. 25). The environmental space seen through and reflected by the glass optically merged with the cube and became an intrinsic part of it.

In 1966 Bell's purchase of a vacuum-coating machine allowed him to produce larger cubes 900 mm square whose transparency and placement on top of clear Plexiglas bases created the illusion of weightless, hovering objects. By 1968 he was working on free-standing glass walls placed at right angles to each other or in other combinations, for example *Untitled* (coated glass, 1971; London, Tate), made of ten units placed in two parallel zigzag rows of five. By varying the density of the coatings, Bell caused the glass to assume different degrees of reflection, transparency and opacity. The result was a complex illusionism. From 1972 he expanded his range to include outdoor, site-specific sculptures made of coated glass.

BIBLIOGRAPHY

Larry Bell (exh. cat. by B. Haskell, Pasadena, CA, A. Mus., 1972)
Larry Bell: New Work (exh. cat., intro. R. Creeley; Yonkers, NY, Hudson River Mus., 1980)
Larry Bell: The Sixties (exh. cat., Santa Fe, Mus. NM, 1982)
Zones of Experience: The Art of Larry Bell (exh. cat., Albuquerque, NM, Albuquerque Mus., 1997)

Barbara Haskell

Bellamy, Richard

(*b* Cincinnati, OH, 3 Dec 1927; *d* Long Island City, New York, 29 March 1998), art dealer, gallery owner, artist advocate and famed promoter of 1960s avant-garde art. An only child, Richard Hu Bellamy's Chinese mother instilled in her son a love of music and literature, which he credited with helping to shape his early conceptions of art and beauty. Upon completing his first semester at the University of Ohio, Cincinnati, Bellamy dropped out and moved east to explore the collegial arts community of Provincetown, MA. After working a string of seasonal jobs, Bellamy uprooted himself yet again and relocated to New York City, where he began a remarkable career in the gallery world. By the early 1950s, Bellamy began an affiliation with the Hansa Gallery arts cooperative, where he soon took on the position of director, overseeing such artists as Wolf Kahn, Allan Kaprow, Jan Muller, George Segal, Richard Stankiewicz and Robert Whitman.

When the Hansa Gallery closed its doors in 1959, Bellamy secured funding from arts supporter and financier Robert Scull to open the now legendary Green Gallery. From 1960 to 1965 the Green Gallery debuted some of the most important rising artists of the decade. Well before critics and scholars had the chance to coin the movements that would define the period, Bellamy's exhibitions were important moments in the careers of Mark Di Suvero (an artist Bellamy would represent his entire life), Donald Judd, Dan Flavin, Robert Morris, Claes Oldenburg, Lucas Samaras, James Rosenquist and Tom Wesselmann. Bellamy's decision to champion emerging artists and the resulting exhibitions were met with much critical acclaim and helped shape the conversations surrounding both the Pop and Minimalist art aesthetics. Unfortunately, that ongoing dialogue often came at the expense of commercial sales. The Green Gallery closed in 1965 but Bellamy's selfless dedication to his favorite avant-garde artists continued long after. Under his guidance, many of the artists he represented went on to find representation with Sidney Janis or Leo Castelli, where their rapid rise to fame resumed.

Bellamy became an independent dealer and consultant, renting a space within the Noah Goldowsky gallery, and turned his attention to those artists who were not easily placed at other galleries, or whose works were not suited to traditional exhibition spaces. He began arranging exhibitions for such artists as

Richard Artschwager and Keith Sonnier, and became Richard Serra's first dealer. In 1980, Bellamy opened the Oil & Steel Gallery in Chambers Street—one of the first in Tribeca in New York. He organized several exhibitions at the Chambers Street gallery and continued to show a preference for the artists and friends whom he began exhibiting in the 1960s. In the early 1980s he mounted shows for Michael Heizer and Neil Jenney and regularly exhibited works by Mark Di Suvero, whose 1983 exhibition at Oil & Steel was the artist's first in the city since his show at the Whitney Museum of American Art in 1975. (Bellamy also arranged for a 1985 retrospective of Di Suvero's work at the Storm King Art Center, Mountainville, NY, and another in 1995.) Motivated by his growing focus on Di Suvero's sculpture and career, Bellamy relocated Oil & Steel to Di Suvero's studio complex in Long Island City, where he maintained until his death a small, by-appointment-only gallery space and devoted himself to representing Di Suvero full-time.

[*See also* Di Suvero, Mark.]

BIBLIOGRAPHY

Richard Bellamy Papers at MOMA, http://moma.org/exhibitions/2008/bellamy/index.html (accessed 21 Oct 2009)

R. Smith: "Richard Bellamy, Art Dealer, Is Dead at 70," *NY Times* (3 April 1998)

J. Meyer: *Minimalism: Art and Polemics in the Sixties* (New Haven, 2001)

Richard Bellamy, Mark Di Suvero (exh. cat., Mountainville, NY, Storm King A. Cent., 2006)

Mary M. Tinti

Bellocq, E. J.

(*b* New Orleans, LA, 15 March 1873; *d* New Orleans, 1949), photographer. E(rnest) J(ames) Bellocq is known to have worked as a commercial photographer in New Orleans from 1895 to 1940 and to have photographed for local shipbuilders and in the Chinese sector of New Orleans, although none of this

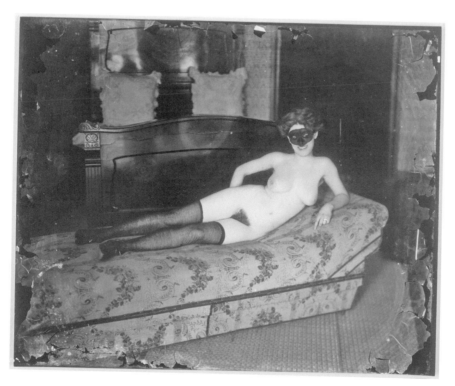

E. J. BELLOCQ. *Untitled*, 201 × 250 mm, *c.* 1911–13. PHOTOGRAPH BY JACQUES FAUJOUR/CENTRE GEORGES POMPIDOU, MUSÉE NATIONAL D'ART MODERNE/CNAC/DIST. RÉUNION DES MUSÉES NATIONAUX/ART RESOURCE, NY

work apparently survives. His photography is known only through prints made by Lee Friedlander from the 89 gelatin dry plate negatives found after Bellocq's death. These negatives date from *c.* 1912 and are sympathetic portraits of prostitutes of New Orleans and interior views of their workplaces. Known as the *Storyville Portraits*, 34 were shown by the Museum of Modern Art (MOMA), New York, in a traveling exhibition in 1970–71. Bellocq's life was the subject of *Pretty Baby* (1978), a film by Louis Malle.

BIBLIOGRAPHY

E. J. Bellocq: *Storyville Portraits: Photographs from the New Orleans Red-light District, circa 1912* (exh. cat. by J. Szarkowski and L. Friedlander, New York, MOMA, 1970)

G. Badger: "Viewed," *Brit. J. Phot.*, mxxv/6158 (1978), pp. 664–7

P. Roegiers: "Bellocq," *Cimaise*, xxxv/197 (Nov–Dec 1988), pp. 25–44

J. Szarkowski, ed.: *Bellocq: Photographs from Storyville, the Red-light District of New Orleans* (London, 1996)

N. Goldin: "Bellocq Époque," *Artforum*, 35/9 (1997), pp. 88–91, 142

P. Everett: *Bellocq's Women* (London, 2000)

M. Panzer: "Bellocq's Obsession: The Storyville Portraits, Reconsidered," *Amer. Photo*, 13/2 (2002), pp. 74–6

Amy Rule

Bellows, George

(*b* Columbus, OH, 12 Aug 1882; *d* New York, 8 Jan 1925), painter and lithographer. George (Wesley) Bellows was the son of George Bellows, an architect and building contractor. He displayed a talent for drawing and for athletics at an early age. In 1901 he entered Ohio State University, where he contributed drawings to the school yearbook and played on both the basketball and the baseball teams. In the spring of his third year he withdrew from university to play semi-professional baseball until the end of summer 1904; this, and the sale of several of his drawings, earned him sufficient money to leave Columbus in September to pursue his career as an artist.

Bellows studied in New York under Robert Henri at the New York School of Art, directed by William Merrit Chase. He initially resided at the YMCA on 57th Street. In 1906 Bellows moved to Studio 616 in the Lincoln Arcade Building on Broadway; over the following years the other tenants at this location included the urban realist painter Glenn O. Coleman (1887–1932), Rockwell Kent and the playwright Eugene O'Neill. Across from Bellows's studio was the Sharkey Athletic Club, the setting for one of Bellows's most famous paintings, *Stag at Sharkey's* (1909; Cleveland, OH, Mus. A.), two fighters painted from the memory of a bout Bellows had witnessed there.

Although prizefighting where admission was charged was illegal in New York at this time, certain "prizefighting clubs" such as Sharkey's circumvented the law by charging a club membership fee to view the fights. The promoter's way around the illicit nature of prizefighting is satirized in the title of another of Bellows's early paintings on this theme, *Both Members of this Club* (1909; Washington, DC, N.G.A.). His early paintings are executed in a tonal palette of primarily creams and browns scumbled by streaks of white, with the vigorous broadly stroked brushwork characteristic of the work of Henri and his students. They evoke the smoky, dark, illicit crowded space of the ring and capture the tawdry underworld flavor associated with these "prizefighting clubs" at the turn of the century.

Prizefighting was finally legalized and the New York Boxing Commission was established as a regulatory agency. By 1923 it was considered not only respectable but also fashionable to attend the supposedly more civilized sport of boxing (as opposed to prizefighting). The *New York Evening Journal* commissioned Bellows to paint the heavily publicized boxing match between Dempsey and Firpo. In the 15 years between *Both Members of this Club* and Bellows's painting of *Dempsey and Firpo* (1924; New York, Whitney), radical changes had occurred both in the public acceptance of boxing and in the style Bellows used to portray it. Bellows's earlier slashing brushstrokes had given way to

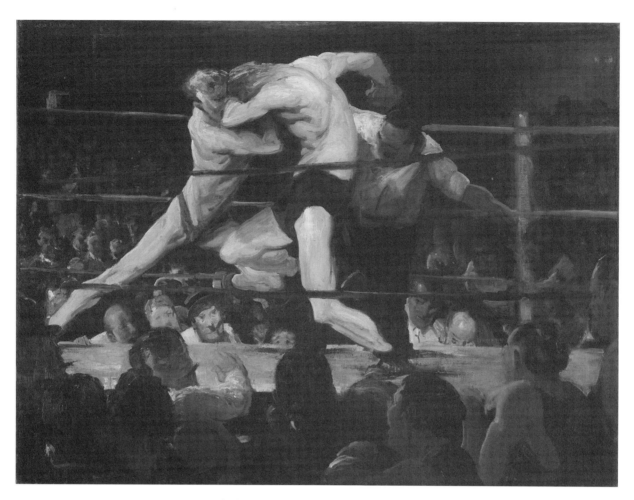

GEORGE BELLOWS. *Stag at Sharkey's*, oil on canvas, 920 × 1226 mm, 1909. Hinman B. Hurlbut Collection © The Cleveland Museum of Art

smoothly contoured, geometricized human figures carefully arranged in a coherent compositional scheme governed by an underlying geometric pattern of intersecting diagonals, which is also evident in his painting *Ringside Seats* (1924; Washington, DC, Hirshhorn).

In 1916 Bellows installed a lithography press in his studio and began producing lithographs with the printer George C. Miller (1892–1964). He became less interested in brushwork and more interested in pictorial structure (see *Stag at Sharkey's*, 1909). In some of his lithographs he satirized the physical improvement concerns of white-collar businessmen,

at a time when President Roosevelt was promoting the "strenuous life" for American males, for example *Businessmen's Class, YMCA* (lithograph, 1916; Ann Arbor, U. MI Mus. A.) and *Shower Bath* (lithograph, 1917; Cleveland, OH, Mus. A.). He began to treat the human figure more simply and geometrically and to experiment with composition. In 1917 he attended a series of lectures by Jay Hambridge, who proposed elaborate geometrical formulas for pictorial composition using a system he called "dynamic symmetry." In 1918 Bellows and Henri undertook serious study of Hambridge's theories, and Bellows was so profoundly converted to the

method that he later professed to Henri that dynamic symmetry was probably of more value than anatomical study. Hambridge's theories were edited and posthumously published in 1924 as *The Elements of Dynamic Symmetry*.

Bellows was associated with the Ashcan school of painting. An example of his early Ashcan work is the painting *Steaming Streets* (1908; Santa Barbara, CA, Mus. A.). Although he was not a member of The Eight, he did show work at the Exhibition of Independent Artists in 1910. He was awarded a prize by the National Academy of Design in 1908 and in 1909 was elected an associate member, the youngest member ever elected. He also exhibited at and helped to organize the Armory Show (1913). Bellows was considered a quintessential American artist, one of the few who did not study abroad. In the years leading up to his death, caused by complications arising from an operation, he executed a number of landscapes and a group of figure compositions ranging from a crucifixion to boxing to nudes in idyllic landscapes. There is also a group of intimate portraits of his friends and family.

[*See also* Ashcan school *and* Eight, The.]

BIBLIOGRAPHY

F. Weitenkampf: "George W. Bellows, Lithographer," *Prt Connoisseur*, iv (1924), pp. 224–44

E. L. Bellows and T. Beer: *George W. Bellows: His Lithographs* (New York, 1927, rev. 1928)

P. Boswell Jr.: *George Bellows* (New York, 1942)

F. Sieberling Jr.: *George Bellows, 1882–1925: His Life and Development as an Artist* (diss., U. Chicago, 1948)

C. H. Morgan: *George Bellows: Painter of America* (New York, 1965)

K. M. Davis: *Bellows: Stylistic and Thematic Development* (diss., OH State U., 1968)

M. S. Young: "George Bellows: Master of the Prizefight," *Apollo*, 89 (1969), pp. 132–41

D. Braider: *George Bellows and the Ashcan School of Painting* (New York, 1971)

C. H. Morgan: *The Drawings of George Bellows* (Alhambra, 1973)

M. S. Young: *The Paintings of George Bellows* (New York, 1973)

L. Mason: *The Lithographs of George Bellows: A Catalogue Raisonné* (New York, 1977, revised 1992)

E. A. Carmean and others: *Bellows: The Boxing Pictures* (Washington, DC, 1982)

Portraits of George Bellows (exh. cat., Washington, DC, N.P.G., 1982)

E. Tufts: "Realism Revisited: Goya's Impact on George Bellows and Other Responses to the Spanish Presence in Art," *A. Mag.*, lvii/6 (1983), pp. 105–13

R. Haywood: "George Bellows's *Stag at Sharkey's*: Boxing, Violence, and Male Identity," *Smithsonian Stud. Amer. A.*, ii/2 (1988), pp. 3–15

J. Myers and L. Ayres: *George Bellows: The Artist and his Lithographs, 1916–1924* (Fort Worth, TX, 1988)

M. Doezema: *George Bellows and Urban America* (New Haven, CT, 1992)

M. Quick and others: *The Paintings of George Bellows* (New York, 1992)

D. Stetford and J. Wilmerding: *George Bellows: Love of Winter* (exh. cat., West Palm Beach, FL, Norton Mus. A., 1997)

D. S. Atkinson and C. S. Engel: *An American Pulse: The Lithographs of George Wesley Bellows* (exh. cat., San Diego, CA, San Diego Mus. A., 1999)

R. Conway: *The Powerful Hand of George Bellows: Drawings from the Boston Public Library* (exh. cat., Boston, Boston Pub. Lib., 2007)

M. S. Haverstock: *George Bellows: An Artist in Action* (Columbus, OH, 2007)

J. Fagg: *On the Cusp: Stephen Crane, George Bellows, and Modernism* (Tuscaloosa, AL, 2009)

M. Sue Kendall

Belluschi, Pietro

(*b* Ancona, 18 Aug 1899; *d* Portland, OR, 14 Feb 1994), architect of Italian birth. Belluschi graduated in civil engineering from the University of Rome (1922), went to Cornell University, Ithaca, NY (1924), and remained in the USA, moving to Portland, OR. His career falls into four distinct phases. He joined the firm of A. E. Doyle Associates as a draftsman in 1925 and upon Doyle's death in 1928 became chief designer, remaining an associate of the firm until 1942. His first major commission was for extensions to the Portland Art Museum (1929), which brought

him national acclaim. Completed in 1932, the design was remarkably modern in its crisp, unornamented brick and innovative use of natural daylighting. Belluschi was invited to design additions to the museum over a period of more than 40 years. In 1936 Belluschi designed his own house, the first of a series of private residences demonstrating his commitment to the Modern Movement and bearing the influence of Frank Lloyd Wright and the influence of Japanese architecture. Eschewing the fashionable historicizing trends in favor of simple, unpainted wooden buildings with gently pitched roofs, integrated with their natural sites, he drew inspiration from the simple vernacular.

The second phase of Belluschi's career began when he set up his own practice (1942). His work from this time demonstrated his belief in the validity of a simple, logically designed functional modern architecture and in his own ability to combine clarity of expression with practical technological solutions. Belluschi's international reputation was enhanced with a number of strikingly modern urban buildings: offices, banks, shops and a series of simple, elegant churches such as the St Thomas More Chapel (1941), the Zion Lutheran Church (1950), both in Portland, and the Church of the Redeemer (1958), Baltimore. Perhaps the most celebrated of the office blocks was the Equitable Building (1945–8), Portland, one of the first major tall office buildings to be built in the postwar era. Constructed in reinforced concrete, it was widely acclaimed for its sleek, clean-lined, wholly unornamented aluminum-clad form. The 12-story slab helped to establish a new direction in American corporate architecture.

Belluschi's practice was acquired by Skidmore, Owings & Merrill (SOM). In 1951 Belluschi became Dean of Architecture and Urban Planning at the Massachusetts Institute of Technology in Cambridge, a position he held until 1965, when he set up a consultancy practice in Boston and Portland. From the time of his tenure at MIT Belluschi continued to practice as a design consultant, usually in conjunction with architectural firms in the vicinity of the project. Among the most significant of his later buildings are the Portsmouth Abbey Church and Monastery (1959; with Anderson, Beckwith and Haible), RI; the Pan Am building (1962; with Walter Gropius and Emery Roth), New York; the Juilliard School (1970; with Catalano, Westman and Associated Architects), Lincoln Center, New York; Bank of America World Headquarters (1970; with Wurster, Bernardi & Emmons, and SOM), San Francisco; and St Mary's Cathedral (1973; with Pier Luigi Nervi), also in San Francisco. A key apologist for the Modern Movement, awarded the prestigious AIA Gold Medal in 1972, Belluschi believed that every architectural problem represented a new challenge, namely to create a building suited to its purpose that satisfies emotionally as well as practically.

[*See also* Harrison & Abramovitz.]

BIBLIOGRAPHY

J. Stubblebine, ed.: *The Northwest Architecture of Pietro Belluschi* (New York, 1953)

M. D. Ross: "The 'Attainment and Restraint' of Pietro Belluschi," *AIA J.*, lviii/1 (1972), pp. 17–25

E. K. Thompson: "Pietro Belluschi, the 1972 Gold Medallist," *Archit. Rec.*, cli (April 1972), pp. 119–26

C. Gubitosi and A. Izzo: *Pietro Belluschi, edifici e progetti, 1932–1973* (Rome, 1973)

L. Doumato: *Pietro Belluschi* (Monticello, IL, 1980) [bibliog.]

M. L. Clausen: *Spiritual Space: The Religious Architecture of Pietro Belluschi* (Seattle and London, 1992)

M. L. Clausen: *Pietro Belluschi. Modern American Architect.* (Cambridge, MA, and London, 1994)

Meredith L. Clausen

Belter, John Henry

(*b* Hilter, nr Osnabrück, 1804; *d* New York, 15 Oct 1863), cabinetmaker of German birth. Belter arrived in New York in 1833 and became a naturalized American citizen in 1839. He was established as a cabinetmaker by 1844 and showed an ebony and ivory table at the New York Exhibition of the Industry of

All Nations in 1853. In the following year he opened a five-story factory on 76th Street near Third Avenue. In 1856 Belter's brother-in-law, John H. Springmeyer, joined the firm. William Springmeyer and Frederic Springmeyer joined in 1861, and in 1865 the firm's name was changed to Springmeyer Bros; it went bankrupt in 1867. Belter's fame is for technical innovation, reflected in four patents: the first, in 1847, was for a device to saw openwork patterns into curved chair backs; the second, in 1856, was for a two-piece bedstead of laminated construction; the third, in 1858, was for a refinement to his process for achieving laminated construction with three-dimensional curves; and the fourth, in 1860, was concerned with laminated construction and central locking. Belter's furniture—curvaceous rosewood chairs, sofas, tables, étagères, beds etc.—is in a coarse and exuberant Rococo Revival manner, characterized by elaborate open crestings and aprons, decorated with C and S scrolls, leaves, flowers and grapes, partly in high relief, where extra sections were glued to the laminated base. His imitators included Charles A. Baudouine, J. and J. Meeks & Co. (1797–1868) and Charles Klein of New York, and George J. Henkels of Philadelphia. Although his innovations in curved and laminated construction were, like those of Michael Thonet, firmly rooted in the Rococo Revival, Belter has been seen as a precursor of Charles Eames and other 20th-century users of laminate technology.

BIBLIOGRAPHY

C. Vincent: "John Henry Belter: Manufacturer of All Kinds of Furniture," *Technical Innovation in the Decorative Arts*: 19th Annual Winterthur Conference, March 1973, pp. 207–34

E. P. Douglas: *Rococo Roses: A Series of Articles Describing the Nineteenth Century American Furniture in the Rococo Revival Style Produced by John Henry Belter, J. and J. W. Meeks, and Others* (Pittsford, 1979–80)

E. P. Douglas: "The Rococo Revivial Furniture of John Henry Belter," *A. & Ant.*, 3/4 (1980), pp. 34–43

D. A. Hanks: *Innovative Furniture in America from 1800 to the Present* (New York, 1981)

E. Dubrow and R. Dubrow: *American Furniture of the 19th Century, 1840–1880* (Exton, 1983)

S. G. Norman and M. S. Podmaniczky: "Belter Furniture, 1840–1860: A Man Who Lent His Name to a Style," *Fine Woodworking*, lxxi (1988), pp. 65–7

C. Greenberg: "High Style in Old Gotham: New York City's Nineteenth-century Cabinetmakers," *A. & Ant.*, xix (1996), pp. 68–74

M. D. Schwartz, E. J. Stanek and D. K. True: *The Furniture of John Henry Belter and the Rococo Revival: An Inquiry into the Nineteenth-Century Furniture Design through a Study of the Gloria and Richard Manney Collection* (Edina, MN, 2000)

A. V. Conkling: *Courting John Henry Belter: Decoding his Decorative Carvings on American Furniture 1840–1860* (MA thesis, 2008)

Simon Jervis

Beman, Solon S.

(*b* Brooklyn, NY, 1 Oct 1853; *d* Chicago, IL, 23 April 1914), architect. Although famous for his model industrial towns of Pullman (1880–95), IL, and Ivorydale (1883–8), OH, Beman contributed substantially to the first-generation achievement of the Chicago school of architecture in the USA. Apprenticed to the firm of Upjohn & Upjohn, New York, he practiced primarily in the Midwest, executing a large and important range of commercial, ecclesiastic and domestic projects in a variety of styles. Beman designed the Mines and Mining and Merchant Tailors pavilions for the World's Columbian Exposition (Chicago, 1893), a crucial turning point in his career. Thereafter, he abandoned his former playful eclecticism and took on the sobriety and unity of the Renaissance and classical styles.

Five important projects in Chicago summarize and distinguish Beman's long and prolific career. He planned the industrial suburb of Pullman with a factory complex, civic center, landscaped grounds and housing for 10,000 residents. His house for W. W. Kimball (1890), patterned after the flamboyant, early 16th-century courtyard facade of the Château de Josselin in Brittany, is regarded as his masterpiece. The iron and glass Grand Central Railway Station, New York, with its huge single-span balloon train shed, came closest of all 19th-century

American stations to synthesizing engineering and architecture. His Studebaker (now Brunswick) Building of 1895, often compared with Louis Sullivan's Gage Building (1898–9), Chicago, was a brilliant exercise in the idiom of the delicately articulated curtain wall, albeit with Gothic detailing. Finally, Beman's First Church of Christ Scientist (1897), Chicago, a design derived from the Erechtheion in Athens, provided a model for many early churches of that denomination.

[See also Burnham, Daniel H.; Chicago school; and International Exhibition.]

BIBLIOGRAPHY

C. Jenkins: "Solon S. Beman," Archit. Rev., xxi/7 (1898), pp. 47–99

T. J. Schlereth: "Solon Spencer Beman: The Social History of a Midwest Architect," Chicago Archit. J., v (1986), pp. 9–31

C. K. Laine: "Renewing a Remarkable Planned Community: Pullman, South Chicago," Archit., lxxvi (1987), pp. 60–65

T. J. Schlereth: "A High Victorian Gothicist as Beaux-Arts Classicist: The Architectural Odyssey of Solon Spencer Beman," Stud. Medievalism, iii/2 (1990), pp. 128–52

J. S. Garner: "S. S. Beman and the Building of Pullman," Midwest in American Architecture, ed. J. S. Garner (Urbana, IL, 1991), pp. 231–50

Thomas J. Schlereth

Benbridge, Henry

(b Philadelphia, PA, 20 Oct 1743; d Philadelphia, bur 25 Jan 1812), painter. Benbridge was educated at the Academy of Philadelphia (1751–8). He was likely acquainted with John Wollaston (who painted Benbridge's stepfather Thomas Gordon in 1758). Benbridge's first portraits, of his mother, stepbrother, half-sister and a large family group, show Wollaston's influence in composition and color. Benbridge's early attempts at history painting, Achilles among the Daughters of Lycomedes and the Three Graces (Philadelphia Mus. A.), are based on European prints after Rubens.

In 1765 Benbridge moved to Rome, where he shared rooms with the Irish sculptor Christopher Hewetson. In his years in Rome he studied the works of antiquity, the Old Masters and contemporary Neo-classical artists, including Pompeo Batoni in whose academy Benbridge was enrolled. He remained in Italy until December 1769, when he moved to London, lodging in Panton Square and taking his meals with Benjamin West, to whose wife he was distantly related. It has been suggested that Benbridge studied with West, but it appears that their relationship was more of fellow countryman and colleague than one of pupil and student. While in Italy he had painted the portrait of Pascal Paoli (San Francisco, CA, F.A. Mus. San Francisco), which was well received when shown in London at the Free Society of Artists exhibition in May 1769. He then exhibited his portraits of Benjamin Franklin (untraced) and the Rev. Thomas Coombe (ex-James Abernathy, Christ Church, PA, 1816) at the Royal Academy in 1770. His work was well received, but rather than remain in London as a portrait painter, he decided instead to return to America in 1770.

Benbridge was back in Philadelphia by 14 October 1770 and married Esther (Hetty) Sage, described as a painter of miniatures, although no known works by her survive. In 1772 they settled in Charleston, SC, where the artist quickly became the city's resident portraitist, largely supplanting the aging Jeremiah Theus. Most of Benbridge's surviving paintings are portraits and miniatures of South Carolinians and display the diverse range of his work. He was able to adapt the lessons of European Grand Tour portraiture to his patrons' tastes, displaying a diverse range of influences from Benjamin West to Raphael Mengs and Pompeo Batoni.

Benbridge's European style was particularly attractive to Charleston's wealthy elite. One of the most important early commissions is that of Charles Cotesworth Pinckney (Washington, DC, N.P.G.). Although he overpainted the uniform when Pinckney threw in his lot with the Revolutionaries, the picture displays Benbridge's virtuosity with glazes and color and his adaptation of European poses and manner. In the companion portrait, Mrs. Charles

Cotesworth Pinckney (Charleston, Gibbes Mus. A.), Benbridge displays his European training as classicism pervades the image in pose, costume and dress. Most of his portraits of women employ fictive portrait dress, while his portraits of men rarely do.

When Charleston fell to the British (12 May 1780), Benbridge, a patriot, was imprisoned on the ship Torbay and exiled to St Augustine, FL, with other outspoken patriot sympathizers. Released in Philadelphia in 1783, he made his way back to Charleston the following year. The most important works from his later years in Charleston are a series of portraits of Revolutionary War heroes, such as Major Benjamin Huger (Winterthur, DE, Winterthur Mus. & Gdn Lib.). These portraits, which are "in-the-small" (full-length works painted on a small scale), are mostly memorial works of fallen patriots. Several other works "in-the-small" were multi-figure family portraits including the *Enoch Edwards Family* (c. 1783; Philadelphia, Mus. A.). His portrait of the mother of Washington Allston, *Rachel Moore Allston Flagg* (c. 1784; Winston-Salem, NC, Mus. Early S. Dec. A.), suggests that Benbridge's work may have been known to the young Allston. Despite working in Charleston for about two decades, fewer than 50 works (paintings and miniatures) can be firmly attributed to this period.

On 1 May 1788 Benbridge represented the limners of Charleston in a parade celebrating the adoption of the Federal Constitution of the United States, and he was listed in the city directory for 1790. It is not certain when he left Charleston. In 1801 the portrait painter Thomas Sully received some instruction from Benbridge in Norfolk, VA. Here Benbridge painted his "in-the-small" family group *Mr. and Mrs. Francis Stubbs Taylor and Children* (Winston-Salem, NC, Mus. Early S Dec. A.), but little is known of his years in Norfolk. He probably made his home with his son Henry, who was there until 1806. The record of Benbridge's burial gives his age as 70.

BIBLIOGRAPHY

A. W. Rutledge: "Henry Benbridge (1743–1812?): American Portrait Painter," *Amer. Colr*, xvi/9 (1948), pp. 8–10, 23; xvi/10 (1948), pp. 9–11, 23

Henry Benbridge (1743–1812): American Portrait Painter (exh. cat. by R. G. Stewart, Washington, DC, N.P.G., 1971)

C. J. Weekly: "Henry Benbridge: Portraits from Norfolk," *J. Early S. Dec. A.*, iv/2 (1978), pp. 50–64

R. G. Stewart: "An Attractive Situation: Henry Benbridge and James Earl in the South," *Southern Q.*, xxvi (1987), pp. 39–56

S. E. Patrick: "I Have at Length Determined to Have my Picture Taken: An Eighteenth-century Young Man's Thoughts about his Portrait by Henry Benbridge," *Amer. A. J.*, xxii/4 (1990), pp. 68–81

Henry Benbridge: Charleston Portrait Painter (1743–1812) (exh. cat. with essays by Maurie McInnis and others; curated by A. D. Mack, Charleston, Gibbes Mus. A., 2000)

A. D. Mack, "Henry Benbridge: Charleston Portrait Painter," *Mag. Ant.* (Nov 2000)

Maurie D. McInnis

Benglis, Lynda

(*b* Lake Charles, LA, 25 Oct 1941), sculptor. She studied art and philosophy at McNeese College in Lake Charles (1959–63) before moving to New York and studying art at the Brooklyn Museum School of Art (1964–5). Benglis admired and was influenced by the work of Abstract Expressionists, such as Franz Kline. Her first exhibitions were at the Bykert Gallery, New York (1968 and 1969), showing wax paintings and poured-latex sculptures. In 1969 she began working with polyurethane foam and made *Brünhilde*, her first projecting foam piece, as a performance at the Galerie Müller, Cologne, in 1970. She began to collaborate with Robert Morris in 1971, which resulted in her video *Mumble* (1972) and Morris's video *Exchange* (1973).

Benglis ran a controversial advertisement in an issue of *Artforum* (Nov 1974), in which she appeared nude in an aggressively provocative pose. This image was poised between showing an overt, active sexuality and other images showing nude women being objectified. This balance between multiple readings would continue to characterize her work. Also in 1974 Benglis showed at the Paula Cooper Gallery, New York, exhibiting the metalized knots that she had begun a few years earlier. From the mid-1970s she worked in various media but still continued to

produce her metalized forms, creating baroque forms in bronze and aluminum (e.g. *Eclat*, aluminum on stainless steel mesh, 1990; New York, Paula Cooper Gal.).

Benglis became best known for her continual questioning of the traditional designations of "feminine" through her particular choice and use of materials, using both their physical qualities and their associations. It was not until the 1980s that a theoretical framework was established that confirmed the validity of her art and dismissed any uneasiness associated with the exuberant physicality, sensuality and decorative nature of her work. For illustration see color pl. 1:V, 1.

[*See also* Feminism *and* Morris, Robert.]

BIBLIOGRAPHY

R. Pincus-Witten: "Lynda Benglis: The Frozen Gesture," *Artforum*, xiii/3 (1974), pp. 54–9; repr. in *The New Sculpture, 1965–75: Between Geometry and Gesture* (exh. cat., ed. R. Armstrong, J. G. Hanhardt and R. Pincus-Witten; New York, Whitney, 1990), pp. 310–13

A. Jinkner-Lloyd: "Materials Girl: Lynda Benglis in Atlanta," *Arts Magazine* [prev. pubd as *Arts* [New York]; *A. Dig.*], lxv (May 1991), pp. 52–5

Lynda Benglis: Dual Natures (exh. cat., text S. Krane; Atlanta, GA, High Mus. A.; New Orleans, LA, Contemp. A. Cent.; San Jose, CA, Mus. A.; 1991)

More than Minimal: Feminism and Abstraction in the 70s: 19th Annual Patrons and Friends Exhibition (exh. cat. by S. L. Stoops, Waltham, MA, Brandeis U., Rose A. Mus., 1996)

C. Chattopadhyay: "Lynda Benglis at Remba Gallery," *Artweek*, xxxii/4 (April 2001), pp. 23–4

Lynda Benglis: Soft Off (exh. cat., essay by C. Ratcliff; Philadelphia, PA, Locks Gal., 2002)

S. Richmond: "The Ins and Outs of Female Sensibility: A 1973 Video by Lynda Benglis," *Camera Obscura*, lxix (2008), pp. 80–109

Clair Joy

Bengston, Billy Al

(*b* Dodge City, KA, 7 June 1934), painter. Bengston studied at City College, Los Angeles (1953–5), California College of Arts and Crafts, Oakland, CA (1955–6) and Otis Art Institute, Los Angeles (1956–7). Between 1961 and 1973 he lectured at various art colleges.

After initially studying ceramics, Bengston began to concentrate on painting in 1956 and participated in the first group show at the Ferus Gallery in Los Angeles in 1957, which put him at the center of the region's new avant-garde, alongside such figures as Ed Kienholtz and Ed Moses. He is best known for the elegiac, Dada-esque tone of his work in the 1960s, when he was heavily influenced by the motorbike and car culture of southern California, from which he drew motifs such as chevrons, Draculas and love hearts. *Mr. Britt* (1960; see 1988 exh. cat, pl. 3) is typical in its placement of sergeant stripes in a square in the center, surrounded by a flat covering of forest green. *Gas Tank and Tachometer II* (1961; see 1968–9 exh. cat., fig.), which employs an image of the handlebars of a motorbike, is well known, although in its depiction of a physical object rather than a motif it is less representative. In the 1970s his work became increasingly romantic, with more spontaneous, expressionistic execution; he also started to produce furniture and watercolors. This stylistic development culminated in a series of paintings of Hawaii in the early 1980s. *Ka'ao* (1984; see 1988 exh. cat., pl. 51) is typical in its blend of watercolor and collage: an airplane, a shark and a palm tree are the central motifs, painted in bright, watery tones.

BIBLIOGRAPHY

Billy Al Bengston (exh. cat., essay by J. Monte; Los Angeles, CA, Co. Mus. A.; Washington, DC, Corcoran Gal. A.; Vancouver, A.G.; 1968)

Billy Al Bengston: Paintings of Three Decades (exh. cat., essays by J. Livingston and others; Houston, TX, Contemp. A. Mus.; Oakland, CA, Mus.; 1988)

Billy Al Bengston (exh. cat., essay by K. Tsujimoto, Frankfurt am Main, Gal. Neuendorf, 1993)

Morgan Falconer

Benjamin, Asher

(*b* Hartland, CT, 15 June 1773; *d* Springfield, MA, 26 July 1845), architect and writer. Benjamin was one of the most influential architect–writers of the first half of the 19th century in the USA and was

trained as a carpenter in rural Connecticut between 1787 and 1794. Two of his earliest commissions, the carving of Ionic capitals (1794) for the Oliver Phelps House in Suffield, CT, and the construction of an elliptical staircase (1795) in Charles Bulfinch's Connecticut State Capitol at Hartford, reveal an exceptional ability with architectural geometry that was to help to determine the direction of his career. Benjamin worked as a housewright in a succession of towns along the Connecticut River during the 1790s. In 1797, dissatisfied with the publications of William Pain, an English popularizer of the Neoclassical style of Robert Adam, Benjamin wrote *The Country Builder's Assistant*, a modest handbook for carpenters that was the first such work by an American writer. In 1802 he attempted to establish an architectural school in Windsor, VT, but may not have succeeded as he moved away that August and settled in Boston in the same year, probably drawn by the possibility of greater opportunities for work and a more settled existence. He continued to identify himself as a housewright and worked in relative obscurity until the publication of his second book, *The American Builder's Companion*, in 1806. This book, written in collaboration with Daniel Raynerd, a stuccoist, is larger, better organized and richer in information and decorative plates than *The Country Builder's Assistant*. These attributes and its clear debt to the work of Charles Bulfinch ensured its popularity through six subsequent editions during the following two decades.

Benjamin's architectural practice in Boston flourished between 1806 and 1810 when he designed the West Church, the Charles Street Meetinghouse, the Chauncey Street Church, the Exchange Coffee House and several fine town houses on Beacon Hill. Bulfinch's influence is apparent in the massing and detailing of these buildings, but Benjamin's work, although strong, lacks Bulfinch's characteristic restraint and refined sense of proportion.

Despite his successes, Benjamin curtailed his practice in 1810 to run a paint store. He published five further editions of *The American Builder's Companion*,

as well as *The Rudiments of Architecture*, a book for students. The paint store did not succeed, and in 1824 Benjamin was forced to declare bankruptcy. He then took a position as a mill agent in Dunstable, NH, about 30 miles from Boston. Three years of hard work enabled him to regain solvency and return to Boston, but significant changes had taken place in architecture during his absence.

Led by Alexander Parris and Solomon Willard, who were inspired by the example of Benjamin Henry Latrobe and his followers, the Neo-classical style was rapidly giving way to the Greek Revival in New England. Asher Benjamin's resilience and skill as a popularizer of style enabled him to absorb the changes and to embark on a substantial second career. The sixth edition of his *American Builder's Companion* (1827) included a new section entitled "Grecian architecture" that was urged on Benjamin by his editor and other eminent architects and builders. By 1830, however, he had created his own simplified version of a Grecian decorative idiom, based on the rectilinear fret, for *The Practical House Carpenter*, his most popular and influential book. Two more books followed, *The Practice of Architecture* and *The Builder's Guide*, both of which show the influence of Minard Lafever, whose elegant *Modern Builder's Guide* of 1833 introduced a new level of sophistication to architectural book engraving. Benjamin's final book, *The Elements of Architecture* (1843), placed a new emphasis on technology, theory and architectural history, a reflection of developments within the profession itself.

Benjamin's Greek Revival books and his post-1830 buildings reveal a reluctance on his part to embrace the Greek Revival fully. He included almost no buildings in these four publications, but preferred to present the Greek Revival as a new kind of decoration, a position that won favor with his vast country-builder readership. In practice, his town houses and detached houses tended to adhere to conservative plan forms, while in his churches and public buildings (including the Fifth Universalist Church, Boston, the Third Religious Society, Unitarian,

in Dorchester, MA, and the Town Hall, Cambridgeport, MA) the temple form was *in antis* or prostylar.

[*See also* Federal style.]

WRITINGS

The Country Builder's Assistant (Greenfield, MA, 1797/R 1972)

with B. Raynerd: *The American Builder's Companion* (Boston, 1806/R 1972)

The Rudiments of Architecture (Boston, 1814/R 1972)

The Practical House Carpenter (Boston, 1830/R 1972)

The Practice of Architecture (Boston, 1833/R 1972)

The Builder's Guide (Boston, 1838/R 1972)

The Elements of Architecture (Boston, 1843/R 1972)

BIBLIOGRAPHY

F. T. Howe: "Asher Benjamin: Country Builder's Assistant," *Ant.*, xl (1941), pp. 364–6

H. W. Congdon: "Our First Architectural School?," *J. Amer. Inst. Archit.*, xiii (1950), pp. 139–40

F. T. Howe: "More about Asher Benjamin," *J. Soc. Archit. Hist.*, xiii (1954), pp. 16–19

J. Tomlinson: "Asher Benjamin: Connecticut Architect," *CT Ant.*, vi (1954), pp. 26–9

H. Kirker: "The Boston Exchange Coffee House," *Old-Time New England*, lii (1961), pp. 11–13

J. Quinan: "Asher Benjamin as an Architect in Windsor, Vermont," *VT Hist.*, lxii (1974), pp. 181–94

J. Quinan: "Asher Benjamin and American Architecture," *J. Soc. Archit. Hist.*, xxxviii (1979), pp. 244–56

J. Quinan: "The Boston Exchange Coffee House," *J. Soc. Archit. Hist.*, xxxviii (1979), pp. 256–62

J. Quinan: "Asher Benjamin and Charles Bulfinch: An Examination of Baroque Forms in Federal Style Architecture," *New England Meeting House and Church: 1630–1850* (exh. cat., ed. P. Benes and P. Zimmerman; Manchester, NH, Currier Gal. A., 1979), pp. 18–29

W. N. Hosley Jr.: "Living with Antiques: Windsor House in Southern Connecticut," *Antiques*, cxxx (1986), pp. 106–15

J. K. Bibber: "The Pattern Books of Asher Benjamin," *Landmarks Observer*, 17/2 (Summer 1992), pp. 10–11

K. Hafertepe: "Asher Benjamin Begins the Samuel and Dorothy Hinckley House," *Old-Time New England*, 77/266 (Spring–Summer 1999), pp. 5–22

K, Hafertepe and J. O'Gorman: *American Architects and Their Books to 1848* (Amherst, MA, 2001)

J. Quinan: "The Exchange Artist: A Tale of High-Flying Speculation and America's First Banking Collapse," *J. Soc. Archit. Hist.*, 68/1 (Summer 2009), pp. 116–7

Jack Quinan

Benjamin, Samuel G. W.

(*b* Argos, Greece, 13 Feb 1837; *d* Burlington, VT, 19 July 1914), writer and artist. Private lessons in painting led Benjamin to illustrate many of his writings on art and travel. After graduating from Williams College, Williamstown, MA, in 1859 he served as assistant librarian in the New York State Library. He wrote his first book on art, *What Is Art or Art Theories and Methods Concisely Stated*, in 1877, followed by three articles published in *Harper's Monthly Magazine* concerning art in Europe. These articles, addressing English, French and German contemporary art, formed the basis of *Contemporary Art in Europe*, also published in 1877. Thereafter he wrote *Our American Artists* (1879) and *Art in America: A Critical and Historical Sketch* (1880), as well as several articles for *Harper's New Monthly Magazine*. Benjamin's writings tended to champion recent art. The second series of *Our American Artists*, written for young people, provided a helpful critical approach to, as well as much information on, contemporary artists. Besides illustrating many of his articles he enjoyed some success as a marine painter.

WRITINGS

Contemporary Art in Europe (Boston, MA, 1877)

What Is Art or Art Theories and Methods Concisely Stated (Boston, MA, 1877)

Our American Artists, 2 vols (Boston, MA, 1879)

Art in America: A Critical and Historical Sketch (New York, 1880)

Our American Artists: Painters, Sculptors, Illustrators, Engravers and Architects for Young People (Boston, 1881)

BIBLIOGRAPHY

National Cyclopedia of American Biography

C. Clement Waters: *Artists of the Nineteenth Century and Their Works* (Boston, 1879) pp. 54–5

E. Johns: "Histories of American Art: The Changing Quest," *A. J.* [New York], xliv (1984), pp. 339

P. Falk: *Who Was Who in American Art, 1564–1975*, vol. I (Madison, CT, 1999), p. 280

Darryl Patrick

Benson

Pomoan basket-weavers. William Benson (1862–1937) was Eastern Pomo and his wife, Mary Benson

(1878–1930), was Central Pomo. Both had Euro-American fathers. After marriage in 1894, they lived at the Central Pomo settlement of Yokaya, CA. Their first promoter was John Hudson (1857–1936), Ukiah medical doctor and amateur anthropologist, who took them to the fair in St Louis, MO, in 1904. Accustomed to dealing with Euro-Americans, William served as informant for the anthropologists Edwin M. Loeb and Jaime de Angulo and became the local agent for Grace Nicholson, a noted Pasadena basketwork dealer, for whom he made ceremonial costumes and implements and wrote down Pomo myths. In 1906 Nicholson acquired exclusive rights to baskets woven by both William and Mary in return for a monthly maintenance fee plus costs for materials and payment for the baskets. Nicholson promoted and publicized the Bensons and brought them to spend the winter of 1906–7 in Pasadena, where they constructed a large granary basket in front of her gallery on North Robles. Both weavers strove continually to increase the fineness of their weaving, decreasing the size of their baskets. Although they cooperated in the completion of some works, William tended to specialize in miniature and feathered, coiled baskets, while Mary made both small twined baskets and monumental coiled works like those of the Washoe weaver Dat So La Lee (Louisa Keyser), in one case copying one of her designs. Nicholson attempted to sell the Benson collection as a unit, but, after a lengthy loan, Frederic Douglas of the Denver Art Museum refused its purchase. At Nicholson's death in 1948, the collection passed to her secretary, Thyra Maxwell, who sold it in 1968 to the Museum of the American Indian, Heye Foundation, NY, through Frederick J. Dockstader. In the same year Maxwell donated the Nicholson papers, including William Benson's notebooks of myths, to the Huntington Library in San Marino, CA.

[*See also* Native North American art.]

BIBLIOGRAPHY

S. McLendon and B. S. Holland: "The Basketmaker: The Pomoans of California," *The Ancestors: Native Artisans of the Americas*, ed. A. C. Roosevelt (New York, 1979), pp. 103–29

S. McLendon: "Pomo Baskets: The Legacy of William and Mary Benson," *Native Peoples*, iv (1992), pp. 26–33

The Language of Native American Baskets from the Weaver's View (exh. cat., N. Mus. Amer. Ind., New York, 2003)

Marvin Cohodas

Benson, Frank W.

(*b* Salem, MA, 24 March 1862; *d* Salem, 15 Nov 1951), painter, etcher and teacher. Benson attended the School of the Museum of Fine Arts, Boston, from 1880 to 1883 as a student of Otto Grundmann (1844–90) and Frederick Crowninshield (1845–1918). In 1883 he traveled with his fellow student and lifelong friend Edmund C. Tarbell to Paris, where they both studied at the Académie Julian for three years with Gustave Boulanger and Jules Lefebvre. Benson traveled with Tarbell to Italy in 1884 and to Italy, Belgium, Germany and Brittany the following year. When he returned home, Benson became an instructor at the Portland (ME) School of Art, and after his marriage to Ellen Perry Peirson in 1888 he returned to his birthplace, Salem, MA. Benson taught with Tarbell at the Museum School in Boston from 1889 until their resignation over policy differences in 1913. Benson rejoined the staff the next year and taught intermittently as a visiting instructor until 1930.

In style and subject Benson's paintings closely resemble those of Tarbell, with whom he is often paired as a leader of the "Boston School." His early paintings were primarily portraits and figure studies in interiors. About 1898 he began the series by which he is best known, paintings in an Impressionist style of young women and children in bright sunny landscapes, which he sometimes based on photographs. After 1901, Benson and his family summered on Penobscot Bay, ME, and their holidays provided inspiration for many of those works. In such paintings as *My Daughters* (1907; Worcester, MA, A. Mus.) and *Eleanor* (1907; Boston, MA, Mus. F.A.), women clothed in white or pastel colors relax outside in a

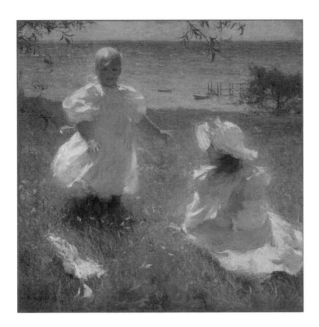

FRANK W. BENSON. *The Sisters*, oil on canvas, 1016 × 1016 mm, 1899. Daniel J. Terra Collection, Terra Foundation for American Art, Chicago/Art Resource, NY

seemingly endless summer of sunlit leisure. His interior scenes such as *Rainy Day* (1906; Chicago, IL, A. Inst.) and *Open Window* (1917; Washington, DC, Corcoran Gal. A.) are more directly influenced by Tarbell, since they depict young women in the still interiors favored by that artist. In other paintings such as *Black Hat* (1904; Providence, RI Sch. Des., Mus. A.), Benson's figures are more monumental and the compositions more decorative than those of Tarbell.

Benson was involved in the decoration of the Library of Congress in Washington, DC, one of the major American mural projects of the late 19th century. His octagonal panels of the *Three Graces* and circular lunettes of the *Four Seasons* were completed in 1896. Executed in a bright Impressionist palette, these murals of half-length young girls were often cited as symbolic of the hope and optimism of the American spirit in the 1890s.

Benson was elected to the Society of American Artists in 1888 but resigned in 1898 to become a founder-member of the Ten American Painters ("the Ten"), who grouped together to exhibit in a supportive and congenial atmosphere. He was made an academician

at the National Academy of Design in 1905. Benson was versatile in his use of many media, including watercolor, pastel, engraving and aquatint. In 1912 he turned to etching as a hobby and quickly gained critical acclaim after an exhibition of his etchings in 1915 at the Guild of Boston Artists. Always an avid sportsman and hunter, he specialized in wildlife scenes, especially in etching but also in watercolor and oil (e.g. *Salmon Fishing*, oil, 1927; Boston, MA, Mus. F.A.). Benson taught until 1931 and continued to exhibit until shortly before his death.

[*See also* Boston *and* Ten American Painters.]

UNPUBLISHED SOURCES
Salem, MA, Essex Inst. [Benson Papers]

BIBLIOGRAPHY
Two American Impressionists: Frank W. Benson and Edmund C. Tarbell (exh. cat., ed. S. F. Olney; Durham, U. NH, A. Gals, 1979)

J. T. Ordeman: *Frank W. Benson: Master of the Sporting Print* (Brooklandville, MD, 1983)

The Bostonians: Painters of an Elegant Age, 1870–1930 (exh. cat., ed. T. J. Fairbrother; Boston, MA, Mus. F.A., 1986)

Frank W. Benson: The Impressionist Years (exh. cat., New York, Spanierman Gal., 1988)

F. A. Bedford: *Frank W. Benson, American Impressionist* (New York, 1994)

The Art of Frank W. Benson, American Impressionist (exh. cat, Salem: Peabody Essex Mus., 1999)

F. A. Bedford: *The Sporting Art of Frank W. Benson* (New York, 2000)

Bailey Van Hook

Benton, Thomas Hart

(*b* Neosho, MO, 15 April 1889; *d* Kansas City, MO, 19 Jan 1975), painter, illustrator and lithographer. One of the most controversial personalities in American art, both in his lifetime and today, Thomas Hart Benton was a key figure in the American Regionalist movement of the 1930s, when he focused on working-class American subject matter and was outspoken in his denunciation of European modern painting. Today he is best remembered for this phase of his

life, and much criticized because of it. But Benton's long career is not easily reduced to a single moment or achievement: his legacy was more complex. As a young struggling artist in Paris and New York, he was a leading American modernist and abstractionist, and in his early maturity he became the teacher and life-long father figure for Jackson Pollock, the most famous of the Abstract Expressionists. He was also a major American writer, who wrote on art and whose autobiography of 1936 became a best-seller. He was also a notable figure in American music who collected American folk songs and devised a new form of harmonica notation that is still in use.

Named for his great-uncle, the first senator from west of the Missouri, Thomas Hart Benton was the son of a lawyer and politician, Maecenas Benton, who was elected to the US Congress on a populist platform in 1896. From that time onward, Benton's childhood was split between his hometown of Neosho, MO, and Washington, DC. In Washington he attended private schools and learned the niceties of social etiquette; in Neosho he associated with farmboys and hillbillies. Both experiences helped shape his adult character.

Benton's talent for drawing was evident at a very early age and was encouraged by his mother but discouraged by his father, who thought that law and politics were the only proper professions for a Benton. While still in high school, Benton landed a high-paying job in Joplin, MO, as a newspaper cartoonist, and pressured his father to send him to art school. Unpersuaded, his father sent him to a military school in Illinois, but then relented and allowed him to attend the Art Institute of Chicago. In Chicago, Benton proved an aggressive student, forcing his way into advanced classes and once pushing a rival down a coal chute. But his talent in pen and ink and watercolor commanded attention, and he became the star student in Frederic Oswald's watercolor class. Before long, however, he had set his eyes on even higher goals and, with Oswald's encouragement, had become determined to conquer Paris. In 1908, funded by a small legacy from an uncle, he embarked for France.

Up to this time, Benton had thought of art as a form of illustration. Indeed, to a large degree his knowledge of art had come not from paintings but from book illustrations and prints. In Paris, he quickly learned that such an approach was out-of-date. Modern art was in the air, and Benton fairly quickly abandoned the deadening academic routine of drawing from studio models and plaster casts, and began to experiment with modern styles, starting with Impressionism, and moving on to modes of painting influenced by the Post-Impressionists, the Fauves and Paul Cézanne (1839–1906). During this period, he formed a close friendship with the California painter Stanton Macdonald-Wright, who was soon to become a co-founder (with Morgan Russell) of Synchromism, a form of modernist painting that combined Cubist fracturing of forms with brilliant prismatic colors.

Benton, however, missed out on the creation of Synchromism, since in 1910 his mother arrived unexpectedly in Paris, discovered that he had a French mistress and took him home. After several aimless months in Neosho, Benton persuaded his parents to let him move to New York, where he took a studio in the Lincoln Arcade. For the next decade, he struggled to find his bearings, supporting himself through various expedients, including working as a set designer for the movie director Rex Ingram. During this period he reconnected with Stanton Macdonald-Wright, who after introducing Synchromism to Paris, and failing to sell his work there, hoped to find a more enthusiastic reception for is paintings in New York. For a brief time, under Macdonald-Wright's tutelage, Benton made Synchromist canvases, which he exhibited in the *Forum Exhibition of Modern American Painters* in 1916. He also participated in the long discussions which led to the book *Modern Painting*, written by Macdonald-Wright's brother, Willard Huntington Wright. Thus, in this period, Benton was exposed to the latest movements in French modern art, such as Cubism and Orphism, and to the notion that a painting should be, above all, a well-organized

composition of abstract forms. Benton was particularly entranced with the notion of creating a rhythmic flow of design, which led the eye, in a sort of interlace, through every sector of the composition. With this in mind, in 1919, he began producing clay models to plan his paintings, first creating purely abstract arrangements and then moving on to rhythmic figure compositions.

During this period Benton was universally regarded as a modernist, and was patronized by modern art collectors such as Dr. Albert Barnes. With the encouragement of Barnes, he wrote a lengthy essay on the principles of abstract composition, which was finally published in *Arts* magazine in 1926–7 under the title "The Mechanics of Form Organization in Painting."

In the 1920s, however, Benton's attention shifted to the American scene. During summer visits to Martha's Vineyard, he began to paint studies of colorful local characters; he also conceived the ambition of creating a large mural painting of American history, which would combine modern form with a modern, Marxist presentation of American history. A defining event was his return to his home state of Missouri in 1924 to visit his father, who was dying. After his father's death, he was struck by a powerful urge to reconnect with the world of his childhood. In 1926 he made a trip back to the Ozarks, during which he made many sketches. In 1928, he made a more ambitious journey of over six months around the USA, focusing particularly on the South, the Midwest and the Southwest, and making hundreds of sketches of American characters and the American scene.

Benton hoped to use these drawings for the American history series he planned, but in 1930 he received a better opportunity to use them: a commission to create a large mural for the New School for Social Research in New York. The resulting mural program, *America Today*, a panorama of every region in the United States, was the first major mural in America to combine working-class subject matter with a distinctly modern handling of form. While dismissed as vulgar by many critics, it made Benton famous and led to a series of other major projects, including murals for the Whitney Museum of American Art, the State of Indiana and the Missouri State Capitol. As America slipped into the Great Depression, Benton's fame rose, and in 1934 he achieved a level of recognition never before achieved by an American artist, when he was featured on the cover of *Time* magazine, the first artist to be so honored. Along with Grant Wood and John Steuart Curry, he was hailed as the leader of a new movement in American art, the "American Scene" movement, later also often termed "Regonalism." At the time, Americans were startled by the notion that the Midwest, always previously viewed as a cultural wasteland, could be the subject of serious art.

Controversy swirled around Benton throughout the 1930s. Benton's murals were filled with social criticism. For example, he included a Ku Klux Klan rally in his Indiana mural and a likeness of Kansas City's notorious political boss, Tom Pendergast, in his Missouri mural. Such irreverence invariably upset local boosters, and in Missouri a bill was even introduced into the state legislature to have his mural whitewashed. In addition, Benton's frank treatment of the American working man also angered Communists and Leftists. In 1933, when he attempted to give a talk at the John Reed Club in New York, the affair ended in a chair-throwing brawl. These controversies, heated enough due to the work itself, were heightened by the writings of Benton's former room-mate, Thomas Craven, who in a series of articles and best-selling books combined praise of Benton with denunciations of other American painters.

In 1935 Benton moved from New York to Kansas City, where he took up a teaching job at the Kansas City Art Institute. In the late 1930s he painted two nearly life-sized nudes, which translated the biblical story of Susanna and the Greek myth of Persephone in a modern American setting. These were widely denounced by preachers and self-appointed moralists. Nonetheless, Benton's retrospective in New York in 1939, which opened the new paintings

galleries of Associated American Artists, was both critically acclaimed and a near sellout. Just two years later, Benton was fired from the Art Institute after a newspaper interview in which he made negative comments about homosexuals at the Nelson–Atkins Museum of Art. Nonetheless, the early 1940s were one of Benton's most financially successful periods, in large part due to the skillful promotion of his work by the art dealer Reeves Lowenthal.

In the late 1940s, however, Benton's career went into sudden eclipse. Artistic taste turned towards abstract art and, in a vicious review of 1946, the noted art historian H. W. Janson condemned him (as well as his friend Grant Wood) as a reactionary and a Fascist. Just a year later, Benton broke with his art dealer Reeves Lowenthal, which ended representation of his work in New York.

During this period, Benton's former pupil Jackson Pollock became the most famous painter in America. In public statements, Pollock and Benton often denounced each other, but they remained in close personal contact until Pollock's death. While he clearly had mixed feelings about Pollock's work, Benton also took pride in his success, and in one late interview he even commented, "Jack never made a painting that wasn't beautiful." Recent scholarship has shown that Pollock's method of composition, and even the deeper messages imbedded in his work, were profoundly indebted to Benton's teaching and writings on abstract art, which in turn were largely based on what Benton had learned from the Synchromists.

Benton survived through the 1950s and 1960s by selling his work locally and by painting murals for the Truman Library and the New York Power Authority. But he ceased to be regarded as a figure of national significance. In the 1970s, there was a modest revival of his work and of the Regionalist movement of the 1930s. "Old age is a wonderful thing," Benton declared at the time. "You outlive your enemies." Active until the end, Benton died in his studio in January 1975 while completing a last mural, *The Sources of Country Music*, for the Country Music Hall of Fame in Nashville, TN.

Along with his work as an easel painter, muralist and book illustrator, Benton wrote two autobiographies, *An Artist in America* (1937), which described his travels in the hinterlands of the United States, and *An American in Art* (1969), which provides a technical account of his development as an artist. A gifted musician and collector of folk tunes, he also performed on the harmonica in a record released by Decca in 1941, *Saturday Night at Tom Benton's*. For illustration see color pl. 1:XVI, 2.

[*See also* Regionalism; Scene painting; *and* Synchromism.]

WRITINGS
"Mechanics of Form Organization in Paintings," *Arts* (Nov 1926), pp. 285–9; (Dec 1926), pp. 240–42; (Jan 1927), pp. 43–4; (Feb 1927), pp. 95–6; (March 1927), pp. 145–8
An Artist in America (New York, 1937)
An American in Art (Lawrence, KS, 1969)

BIBLIOGRAPHY
M. Baigell: *Thomas Hart Benton* (New York, 1974)
H. Adams: *Thomas Hart Benton: An American Original* (New York, 1989)
H. Adams: *Tom and Jack: The Intertwined Lives of Thomas Hart Benton and Jackson Pollock* (New York, 2009)

Henry Adams

Berenson, Bernard

(*b* Butrimonys, Alytus County, Lithuania, 26 June 1865; *d* Settignano, Italy, 6 Oct 1959), art historian, critic and connoisseur of Italian Renaissance art. Berenson was perhaps the single most influential art historian in the USA for much of the 20th century. As the leading scholar and authority on Italian Renaissance art, his opinion greatly influenced American art museums and collectors, whom he guided in the purchase of many important works of art. His pupils and disciples became the curators of many of the world's great museums. His dealings with art galleries also made him a highly controversial figure.

Born to Albert and Julia Valvrojenski in Lithuania, Berenson immigrated to Boston, MA, with his family in 1875, at which time his surname was changed to

Berenson. Later called "BB" by friends and family, he dropped the "h" from his first name around 1915. Jewish by birth, he converted to Christianity and was baptized in 1885. He attended Boston Latin School, Boston University and finally Harvard University, where he studied under Charles Eliot Norton and received a BA in 1887. Following graduation, with funds from supporters including the wealthy Bostonian Isabella Stewart Gardner, he went on a Grand Tour of Europe and studied the famous art collections of Oxford, Paris, Berlin and Florence. In Europe he became inspired to pursue a career in art history and trained his eye to recognize styles and techniques of the masters.

In 1900 he took up residence at Villa I Tatti, a hilltop estate situated in Settignano on the outskirts of Florence, Italy, consisting of an 18th-century mansion, formal gardens and farmlands. He continued to live there until his death. The villa became a gathering place for an international élite and was a humanist sanctuary with a vast library and rooms decorated with Italian Renaissance and oriental art. He was visited there by many of the important art historians and intellectuals of his day, including Edith Wharton and Marcel Proust.

On a return trip to Oxford, England, in 1900, he married Philadelphia-born Mary Costelloe. Under Berenson's tutelage, she became a connoisseur in her own right. Beginning in 1894, Berenson had books and articles published that established a new appreciation for Italian Renaissance art in England and America: *The Venetian Painters of the Renaissance* (partially written by his wife Mary; 1894), *Lorenzo Lotto* (1895), *The Florentine Painters* (1896) and *The Central Italian Painters* (1897). In 1901 and 1902 collections of his articles were printed in *The Study and Criticism of Italian Art*, and in 1903 his monumental work *The Drawings of the Florentine Painters* was published in two volumes. The latter, updated in 1938, is considered by many art historians to be the primary reference book on the subject and one of Berenson's most important achievements.

By his mid-30s, the widely traveled Berenson was considered the greatest living expert on Renaissance art, and his opinion concerning the authorship of Italian paintings was eagerly sought after by collectors and buyers. Helping wealthy Americans build great art collections became an avocation and provided a good source of income. Among his most famous clients was Isabella Stewart Gardner, whom he helped between 1894 and 1903 to purchase more than 40 paintings (on which she spent more than one million dollars) for her villa in Boston.

He was eventually drawn into the lucrative world of art dealers. The most prominent person to enlist his services was Joseph Duveen, head of the Duveen Brothers, leading international art dealers with offices in London, New York and Paris. In 1906 Berenson and Duveen entered into a secret partnership that proved highly profitable and lasted for about 30 years. Their clients were American millionaire collectors such as John D. Rockefeller, J. Pierpont Morgan, Collis Huntington, Andrew Mellon, Henry Clay Frick and Samuel H. Kress. Berenson is said to have received at least $100,000 a year from the partnership. As his biographers have discussed, there was a conflict of interest in Berenson's relationship with Duveen: the art historian's attributions for works of art greatly affected the price at which they could be sold by the dealer.

In 1957 Berenson explained his method of attributing works: "Identity of characteristics indicates identity of origin. What distinguishes one artist from another is the characteristics he does not share with others. . . . To isolate the characteristics of an artist, we take all his works of undoubted authenticity, and we proceed to discover those traits that invariably recur in them, but not in the works of other masters." Among the forgotten artists that Berenson resurrected through his scholarship was the Sienese painter Sassetta (c. 1400–40), about whom he wrote a monograph (1909). Since Berenson's day, research on these works as well as advances in conservation techniques have resulted in changes in some of Berenson's attributions.

During World War II, when Berenson was a virtual prisoner in I Tatti, he wrote a series of remarkable works that later gained him recognition as a philosopher, scholar and humanist: *Sketch for a Self-Portrait* (1949), *Aesthetics and History in the Visual Arts* (1948) and a half dozen scholarly essays in art criticism. Always the conservative and passionate believer in representational art, Berenson did not approve of modern art and argued against it in his volume *Seeing and Knowing* (1953).

In his later years, Berenson studied aesthetics and ancient art, published his memoirs and diaries and supervised the publication of revised editions of several of his important early volumes on art. He also received numerous awards, medals and honorary degrees from learned institutions in Europe and America, including membership in the American Academy of Arts and Letters and an honorary Doctor of Letters and Philosophy degree from the University of Florence (1956).

Upon his death, he bequeathed his estate Villa I Tatti, as well as his collection of books, photographs and some 120 works of Renaissance and oriental art, to Harvard University. Berenson wished I Tatti to be established as a center of scholarship that would advance humanistic learning throughout the world, and he particularly wanted to give young scholars, at critical points in their careers, the opportunity to develop and expand their talents—hence the founding of The Harvard University Center for Italian Renaissance Studies at Villa I Tatti, devoted to the advanced study of all aspects of the Italian Renaissance. Over the decades a roster of world-renowned scholars have served as I Tatti Fellows and made important contributions to Italian Renaissance studies.

WRITINGS
Sketch for a Self-Portrait (1949)

BIBLIOGRAPHY
"Bernard Berenson Dies in Italy; Renaissance-Art Expert Was 94," *NY Times* (8 Oct 1959)
E. Samuels: *Bernard Berenson: The Making of a Connoisseur* (Cambridge, MA, and London, 1979)
C. Simpson: *Artful Partners: Bernard Berenson and Joseph Duveen* (New York, 1986)
E. Samuels: *Bernard Berenson: The Making of a Legend* (Cambridge, MA, and London, 1987)

Margaret Moore Booker

Berman, Wallace

(*b* Staten Island, NY, 18 Feb 1926; *d* Los Angeles, CA, 18 Feb 1976), collagist and poet. After a short period in the US Navy, Berman studied briefly in Los Angeles at the Chouinard Art School and the Jepson Art School in 1944. Later he was associated with the Beat artists and writers and with experimental art on the West Coast. In 1955 he started *Semina* magazine, a hand-printed poetry journal produced in very limited editions until 1964. This contained poems by many Beat writers, including his own works under the *nom de plume* Pantale Xantos. In 1956 Berman began making "parchment paintings," thin paper inscribed with random Hebrew letters mounted on canvas, perhaps making reference to the vogue for ancient writings inspired by the discovery of the Dead Sea Scrolls in 1947. Twelve such works were exhibited at his first solo exhibition, at the Ferus Gallery, Los Angeles (1957). This exhibition resulted in his arrest and the gallery's temporary closure, as well as the destruction of the exhibited works on the grounds of pornography. After a period of disenchantment, Berman began in the early 1960s to make works using a Verifax, a primitive photo-reproductive machine that produced sepia-toned images. Many of the Verifax works used the repeated image of a hand holding a transistor radio with an image pasted over it as if it were a small television. The use of serial imagery in others suggests the influence of Andy Warhol, who had his first solo exhibition at the Ferus Gallery in 1962. The Verifaxes were shown at the Robert Fraser Gallery in London in the exhibition *Los Angeles Now* (1966), which signaled Berman's reemergence on the art scene and international recognition. In 1968 the exhibition *Assemblage in California*, at the University of California at Irvine,

acknowledged his position as a central figure on the West Coast. He has also been cited as an important influence on Correspondence Art and artists' books and on the development of Pop and Beat sensibilities.

BIBLIOGRAPHY

Wallace Berman: Support the Revolution (exh. cat., Amsterdam, Inst. of Contemp. A., 1992)

M. Duncan and K. McKenna: *Semina Culture: Wallace Berman and his Circle* (exh. cat., Santa Monica, CA, Mus. A., 2005)

John-Paul Stonard

Bernstein, Theresa

(*b* Philadelphia, PA, 1 March 1890; *d* New York, NY, 12 Feb 2002), painter. Raised in Philadelphia, she studied at the Philadelphia College of Design for Women (now Moore College of Art & Design) under Elliott Daingerfield (1859–1932), Daniel Garber (1880–1958), Samuel Murray (1869–1941), Harriet Sartain (1873–1957) and Henry B. Snell and graduated in 1911. With her mother, she toured Europe in 1905 and 1912. After returning from her second trip to Europe she settled in New York where her father had recently relocated the family. She lived at home and studied briefly at the Art Students League, taking life and portrait classes with William Merritt Chase. She eventually established her own studio in Manhattan and married William Meyerowitz (1898–1981), a painter and etcher. She was associated with the members of The Eight and part of the Ashcan school. She was an original member of the Philadelphia Ten—a group of female painters and sculptors schooled in Philadelphia who exhibited together annually, sometimes more often, from 1917 to 1945. Additionally, she founded the Society of Independent Artists in 1919 along with John Sloan and her husband.

As a Realist painter in the style of the Ashcan school, Bernstein produced sensitive and sympathetic interpretations of everyday life, best described as urban genre scenes with a narrative component. With heavy brushstrokes and little detail—comparable to Frank Duveneck and the Munich school—she chronicled the life around her in New York (e.g. *In the Elevated*, 1918; priv. col.) and the art colony at Gloucester, MA, where she and Meyerowitz spent their summers. Her compositions were informally paralleling the gritty city life and colorful beach scenes, respectively. Whether New York City or the beaches of Coney Island and Gloucester, her chosen subject matter consisted of throngs of people in public places, specifically the middle class working or enjoying themselves. Bernstein's palette was adventurous, often contrasting salmon-colored skies with the muddy landscapes that surrounded her heavily peopled scenes. Her career was long, lasting almost seven decades, but her style hardly deviated. Her handling of paint became freer, but she never ventured to pure abstraction. She was keenly aware of the abstract movement through attending the Armory Show and traveling abroad in 1923 with her husband, but she remained true to Realism.

As early as 1919 she received such praise as "a woman painter who paints like a man." To further confound potential buyers and critics, she signed her works either simply Bernstein or T. Bernstein to conceal her gender.

In 1992 she was awarded an honorary doctorate by the Moore College of Art & Design in Philadelphia.

[*See also* Society of Independent Artists.]

BIBLIOGRAPHY

P. Burnham: "Theresa Bernstein," *Woman's A. J.*, ix/2 (1988–9), pp. 22–7

Theresa Bernstein (1890–): An Early Modernist (exh. cat., essay by P. Burnham, New York, Joan Whalen Fine Art, 2000)

Marisa J. Pascucci

Bertoia, Harry

(*b* San Lorenzo, nr Reggio di Calabria, 10 March 1915; *d* Barto, PA, 6 Nov 1978), sculptor and furniture designer of Italian birth. After settling in the USA in 1930, Bertoia studied at the Society of Arts and Crafts, Detroit (1936), and the Cranbrook Academy of Art in Bloomfield Hills, MI (1937–9), where he

taught metalworking and produced abstract silver jewelry and color monoprints. In 1943 he moved to California to assist in the development of the first of a series of chairs designed by Charles O. Eames. His first sculptures date from the late 1940s. In 1950 he established himself in Bally, PA, where he designed the Bertoia chair (1952), several forms of which were marketed by Knoll Associates Inc. His furniture is characterized by the use of molded and welded wire; in the case of the Bertoia chair, the chromium-plated steel wire is reshaped by the weight of the sitter. Bertoia also worked on small sculptures, directly forged or welded bronzes. The first of his many large architectural sculptures was a screen commissioned in 1953 for Eero Saarinen's General Motors Technical Center in Detroit; subsequent commissions included the bronze mural (1963) at the Dulles International Airport, Chantilly, VA, and the fountain (1967) at the Civic Center, Philadelphia. Bertoia's work, both graphic and sculptural, shows a combination of strong, organic shapes and intricately textured details.

From 1960 he began to concentrate on making sound sculptures, which have the generic title *Sonambient* and are visually simpler. Most of them consist of vertical bunches of metal rods mounted on a base; when caused to strike against each other the rods produce sounds ranging from delicate rustlings to bell-like peals. Bertoia also constructed chime-like "swinging bars" and circular or rectangular "gongs" in various sizes; the largest of these (diam. 2.5 m) stands over his grave.

[*See also* Saarinen, Eliel]

BIBLIOGRAPHY

Grove Instr.: "Sonambient," "Bertoia, Harry"

F. Bertoia: *Chairs by Harry Bertoia* (New York, 1969)

J. K. Nelson: *Harry Bertoia: Sculptor* (Detroit, 1970)

Harry Bertoia (exh. cat., ed. B. H. Twitchell; Huntington, WV, Marshall U., 1977)

J. Theobald: "Harry Bertoia," *Ear Mag.*, v/6 (1980), p. 9 [assessment of sound sculp.]

J. Stern: "Striking the Modern Note in Metal," *Craft in the Machine Age, 1920–1945* (J. Kardon, ed., with essays by R. H. Bletter and others, New York, 1995), pp. 122–34

W. Moritz: "Visual Music and Film-as-an-Art Before 1950," *On the Edge of America: California's Modernist Art, 1900–1950* (P. Karlstrom, ed., Berkeley, CA, 1996), pp. 210–41

N. Schiffer and V. O. Bertoia: *The World of Harry Bertoia* (Atglen, 2003)

Hugh Davies

Bethune, (Jennie) Louise (Blanchard)

(*b* Waterloo, NY, 21 July 1856; *d* Buffalo, NY, 18 Dec 1913), architect and early advocate for women in the profession. Louise Bethune was the daughter of Dalson Wallace Blanchard, a mathematician and principal of the local school, and Emma Melona Williams Blanchard, also an educator. Her only sibling, a younger brother, died as a child. She was educated at home until she was 11, a year after the family moved to Buffalo, where Louise graduated from high school in 1874. Between 1874 and 1876, she taught school, traveled and studied with the aim of entering the recently opened architectural program at Cornell University.

Instead, at the age of 20, she accepted a position with Buffalo architect Richard A. Waite (1848–1911), where she learned drafting and architectural design, read widely in Waite's architectural library and met her future husband, Robert Armour Bethune (1855–1915), with whom she opened an office in October 1881 and whom she married on 10 December 1881. Their only child, Charles William Bethune, was born in 1883 and became a doctor. The firm of R. A. and L. Bethune designed factories, stores, a women's prison and 18 Buffalo public schools. Their most celebrated commission, and one for which Louise Bethune seems to have been personally responsible, was the 225-room, fireproof Hotel Lafayette in Buffalo, which opened in 1904 and is now on the National Register of Historic Places.

Even more important than Bethune's buildings was her role as the leading woman in the profession. She joined the Western Association of Architects in 1885 and, in 1886, was a founder of the Buffalo Society of Architects. Two years later, she was

elected to the American Institute of Architects (AIA) as its first woman member. In 1889, she became the first AIA female fellow. Bethune declined to enter the competition for the Woman's Building at the 1893 World's Columbian Exposition in Chicago both because she disapproved of competitions in principle and because the premium for the winner would be substantially less than the commissions awarded to men. To suggestions that women specialize in residential architecture, she responded, as quoted in *Inland Architect*: "The dwelling is the most pottering and worst-paid work an architect ever does."

Bethune's professionalism set an example for all future women architects.

[*See also* Woman's Building.]

UNPUBLISHED SOURCES
Buffalo, NY, Buffalo and Erie County Historical Society

WRITINGS
"Women and Architecture," *Inland Architect & News Rec.*, xvii/2 (March 1891), pp. 20–21 [Portions of a talk given by Bethune to the Women's Educational and Industrial Union, Buffalo, March 6, 1891]

BIBLIOGRAPHY
"Mrs. Louise Bethune," *A Woman of the Century: Fourteen Hundred- Seventy Biographical Sketches accompanied by Portraits of Leading American Women in All Walks of Life*, ed. F. E. Willard and M. A. Livermore (Buffalo, 1893), pp. 80–81

M. B. Stern: *We the Women: Career Firsts of 19th-Century America* (New York, 1963), pp. 61–7

M. B. Stern: "Louise Blanchard Bethune," *Notable American Women, 1607–1950: A Biographical Dictionary*, ed. E. T. James and J. W. James, i (Cambridge, MA, 1971), pp. 140–41

A. M. Fox: "Louise Blanchard Bethune: Buffalo Feminist and America's First Woman Architect," *Buffalo Spree* (Summer 1986)

A. Barbasch: "Louise Blanchard Bethune: The AIA Accepts Its First Woman Member," *Architecture: A Place for Women*, ed. E. P. Berkeley and M. McQuaid (Washington, DC, and London, 1989), pp. 15–25

E. G. Grossman and L. B. Reitzes: "Caught in the Crossfire: Women and Architectural Education, 1880–1910," *Architecture: A Place for Women*, ed. E. P. Berkeley and M. McQuaid (Washington, DC, and London, 1989), pp. 27–39

J. Hays: *Louise Blanchard Bethune: Architect Extraordinaire and First American Woman Architect, Practiced in Buffalo, New York (1881–1905)* (diss., Auburn, AL, 2007)

S. Allaback: *The First American Women Architects* (Urbana, 2008), pp. 45–53 [with list of buildings]

C. Blank: "Can Buffalo's Lafayette Hotel Be Saved?," *Counterpunch* (13 Sept 2008)

C. Zaitzevsky: *Long Island Landscapes and the Women Who Designed Them* (New York, 2009)

Cynthia Zaitzevsky

Betty Parsons Gallery

Art gallery in New York. The Betty Parsons Gallery opened in 1946 on East 57th Street. It was the legacy of one of the mid-20th century's most respected artist–dealers and the namesake of Betty Parsons (1900–82), a New York socialite whose contemporary art gallery became the epicenter for post-World War II New York school, Abstract Expressionist art and ideals. Demonstrating a commitment to several generations of post-Abstract Expressionist artists and movements, Parsons kept her gallery an important, viable showcase for modern American art until her death in 1982.

When Peggy Guggenheim closed her Art of This Century gallery in 1947 and left New York for Venice, Parsons stepped in and offered to show the modern American artists suddenly left without representation in an art world that had yet to embrace their Abstract Expressionist visions. Previous gallery jobs had introduced her to the works of Mark Rothko, Hans Hofmann and Ad Reinhardt, all of whom—in addition to Jackson Pollock, Barnett Newman and Clyfford Still—decided to show with Parsons. Newman (a great personal friend) was instrumental in helping mount the gallery's premiere: an exhibition of Northwest Coast Indian art, which was the first of its kind to showcase American Indian artifacts (borrowed from the American Museum of Natural History) for their visual and aesthetic significance rather than their cultural importance. This exhibition, and the clean, white walls of the loft-like space, signaled that the Betty Parsons Gallery was going to be a very different and most influential place.

Parsons's gallery not only showed the New York School artists, it became their home away from home. She gave them total freedom to hang each others shows, put up new walls and to use the gallery as a gathering place. Parsons so believed in the new American art they were creating that she encouraged their growing canvas sizes and allowed their creativity to flourish without too much concern for the salability of their paintings or the negative press surrounding their styles. She represented a range of artists that grew to include Alfonso Ossorio (1916–90), Richard Pousette-Dart and Bradley Walker Tomlin. By the 1950s her gallery was synonymous with the new face of modern art in America and she continued to change the scope of the artists she showed. Artists she had originally represented, such as Pollock and Rothko, thought Parsons should be more focused on them and reluctantly sought new representation elsewhere. Despite this loss and the subsequent departure of Still and Newman, Parsons was adamant about not limiting her gallery to a specific style, and she subsequently took on new artists of such varying styles as Paul Feeley (1910–66), Herbert Ferber, Perle Fine (d 1988), Ellsworth Kelly, Lee Krasner, Alexander Liberman, Richard Lindner, Seymour Lipton, Agnes Martin, Kenzō Okada, Eduardo Paolozzi (1924–2005), Robert Rauschenberg, Leon Polk Smith (1906–96), Hedda Sterne, Richard Tuttle, Ruth Vollmer (1903–82), Jack Youngerman and John Walker (b 1939).

By all accounts, the way that Parsons shaped her gallery practice was influenced by her own experiences as a working artist and collector. She understood the value of taking risks and she encouraged those she represented to do the same. These qualities are what drove Parsons to champion new artists rather than remain focused solely upon the careers and works of the Abstract Expressionists she initially helped launch. Hers was a gallery not tied to any one specific style, trend or movement, but to a spectrum of important American talent of which she felt the art world should take note.

[*See also* Parsons, Betty.]

BIBLIOGRAPHY

A. B. Louchheim: "Betty Parsons: Her Gallery, her Influence," *Vogue* [New York] (1 Oct 1951), pp. 141, 142, 194, 196, 197

R. Constable: "The Betty Parsons Collection," *ARTnews*, lxvii/1 (1968), pp. 48, 58–60

C. Tomkins: "A Keeper of the Treasure," *New Yorker* (9 June 1975), pp. 44–69

L. de Coppet and A. Jones: *The Art Dealers: The Powers behind the Scene Talk about the Business of Art* (New York, 1984), pp. 20–31

J. K. C. van Wagner: *Women Shaping Art: Profiles of Power* (New York, 1984), pp. 57–64

A. D. Robson: *The Market for Modern Art in New York in the 1940s and 1950s* (diss., U. London, 1988), pp. 164–86

L. Hall: *Betty Parsons: Artist, Dealer, Collector* (New York, 1991)

A. Gibson: "Lesbian Identity and the Politics of Representation in Betty Parsons' Gallery," *Gay and Lesbian Studies in Art History*, ed. W. Davis (New York, 1994), pp. 245–70

Mary M. Tinti

Bey, Dawoud

(*b* Queens, NY, 25 Nov 1953), photographer. Dawoud Bey [David Edward Smikle] was born and raised in the neighborhood of Jamaica, Queens, New York City. His interest in photography was cemented by viewing the now infamous exhibition, *Harlem on My Mind*, at the Metropolitan Museum of Art in 1969. He studied at the School of Visual Arts during 1976–8, later earning his BFA from Empire State College, State University of New York in 1990, followed by his MFA from Yale University School of Art in 1993.

Bey launched his career in 1975 with the *Harlem, USA* series, following in the footsteps of street photographers who found the predominantly African American community a compelling subject. This series of black-and-white portraits became the subject of Bey's first solo exhibition at the Studio Museum in Harlem in 1979.

During the 1980s, Bey continued making portraits, expanding his terrain beyond Harlem. Sensitive to the politics of representing African Americans, he developed strategies to equalize the photographic encounter. Bey began using a large-format view

camera on a tripod that he set up in the street. He established a dialogue with his sitters and gifted them with a print of their portrait. This was facilitated by his discovery of 4×5 Polaroid positive/negative Type 55 film that yielded virtually instant prints.

During a residency at the Addison Gallery of Art in 1992, Bey was afforded the opportunity to use one of five large-format 20×24 color Polaroid cameras created by the Kodak company. He held a workshop with teenagers from a local public high school, instructing them in the history and process of photography, thus allowing these often overlooked and marginalized youths access to the means of representation. Students posed for Bey and wrote statements about themselves to accompany their portraits. The result was large-scale compositions consisting of multiple prints featuring parts of the sitter's body arranged in a grid pattern making a cohesive whole that still disrupted the traditional seamlessness of the visual field. Bey also began to photograph groups at this time.

Bey continued to work in this manner, holding combined residency/workshop projects at over 20 venues. He began teaching at Columbia College in Chicago in 1998.

BIBLIOGRAPHY

Dawoud Bey: Portraits, 1975–1995 (exh. cat., ed. A. D. Coleman; Minneapolis, MN, Walker A. Cent., 1995)

Dawoud Bey: The Chicago Project (Chicago, 2003)

Class Pictures: Photographs by Dawoud Bey (New York, 2007)

Camara Dia Holloway

Bickerton, Ashley

(*b* Barbados, 26 May 1959), sculptor and painter. Bickerton studied at the California Institute of the Arts (1982) and the Whitney Independent Studies Program, New York (1985). He had his first solo exhibition at Artists Space, New York (1984), and subsequently showed regularly in America and Europe. Bickerton emerged in New York in the early 1980s as part of the group of artists "'Neo-Geo," along with Jeff Koons, Peter Halley and Meyer Vaisman. Their work was characterized by a rejection of the Neo-Expressionist trends in painting and, in Bickerton's case, by the appropriation of images and labels from consumer culture. His use of popular imagery, although most obviously indebted to Pop art, was influenced also by conceptual and Minimal art; because of its critique of consumer society, it has also been termed "commodity art." In the early 1980s Bickerton made paintings on masonite boards that contained single words, such as "Susie" and "God," in extravagantly ornate lettering as ironic reflections that foreshadowed his later criticisms of American society. These developed into the works for which he became known: wall-mounted black containers, riveted together and covered with corporate logos. Labeled either *Self-portraits (Commercial Pieces)* or *Anthropospheres*, they looked like survival or time capsules containing elements to be preserved in the face of social and economic collapse. *Tormented Self-portrait (Susie at Arles)* (1987–8; New York, MOMA) consists of a box with heavy wall attachments, covered in the type of corporate logos that are seen at sporting events, the suggestion being that identity is formed by brand allegiance. For these works Bickerton created his own logos, "culture lux" and "susie," and the motto, "The best in sensory and intellectual experiences." In the early 1990s his focus moved to the deleterious effects of capitalism (especially in the form of leisure activities) on the natural environment. His decision to leave the USA to settle in Bali was closely related to these concerns. His leitmotif of consumption was also continued in a series of paintings that show the effects of social corruption on the body.

BIBLIOGRAPHY

E. Heartney: "Ashley Bickerton: Visions Apocalyptiques," *A. Press* (April 1991), pp. 30–4

American Art of the 80s (exh. cat., Trent, Mus. A. Mod. & Contemp. Trento & Rovereto, 1992)

Some Went Mad, Some Ran Away (exh. cat., essay R. Shone, London, Serpentine Gal., 1994) [exhibition curated by Damien Hirst]

I. Sandler: *Art of the Postmodern Era: From the Late 1960s to the Early 1990s* (New York, 1996)

John-Paul Stonard

Bidlo, Mike

(*b* Chicago, IL, 20 Oct 1953), painter, sculptor and performance artist. Bidlo was educated at the University of Illinois and at Teachers College at Columbia University in New York. He shot to notoriety in 1982 with his first solo show, *Jack the Dripper at Peg's Place* (Long Island City, NY, P.S.1). Part exhibition, part performance, it was based on Hans Namuth's film of Jackson Pollock painting in 1950. Bidlo exhibited a series of remarkably accurate copies of Pollock's drip paintings and, alongside these, restaged the painter's famous gesture of peeing into Peggy Guggenheim's fire grate. Subsequently, Bidlo mounted a number of performances that led to him being understood by some as a performance artist, yet he is now more widely known for his exact replicas of art central to the modernist canon, a project he began in 1982. Copying work to exact dimensions, using only reproductions for reference, Bidlo commonly chose works central to the mythology of creation of individual genius. *Not Brancusi (Mlle Pogany, 1913)* (1985; see 1989 exh. cat.) reproduced Brancusi's famous ovoid portrait, while *Not Matisse (The Dance, Second Version, 1910)* 1984; see 1989 exh. cat.) tackled another master admired for his supposedly inimitable touch. Bidlo has been received with understandable outrage, but many have been attracted to his strategy, seeing it as an interrogation of the myths of originality, genius and creativity in a culture now swamped by reproductions of many kinds. Bidlo, who casts himself as something of a populist and a crusader, was part of the fashionable East Village art scene of New York in the 1980s and was central to that decade's "appropriationist" art movement, which also included Sherrie Levine. In 1984 he recreated Warhol's Factory, and in 1988 he exhibited 80 copies of Picasso's paintings of women.

BIBLIOGRAPHY

Mike Bidlo: Picasso's Women, 1901–1971 (exh. cat., essays R. Pincus-Witten, B. Jakobson and R. Rosenblum; New York, Leo Castelli Gal., 1988)

Mike Bidlo: Masterpieces (exh. cat., essay R. Rosenblum and interview by C. McCormick, Zurich, Gal. Bruno Bischofberger, 1989)

Mike Bidlo, Manuel Ocampo, Andres Serrano: The Saatchi Collection (exh. cat., essays S. Kent, London, Saatchi Gal., 1991)

Morgan Falconer

Biederman, Charles

(*b* Cleveland, OH, 23 Aug 1906; *d* Red Wing, MN, 26 Dec 2004), painter and theorist. Biederman worked as a graphic designer for several years before studying art at the School of the Art Institute of Chicago from 1926 to 1929. A week after his arrival he saw a painting by Cézanne that greatly influenced his subsequent thought. He lived in New York from 1934 to 1940, except for a nine-month period in 1936–7 when he lived in Paris. He began to make reliefs in 1934. His visits in Paris to the studios of Mondrian, Georges Vantongerloo, César Domela and Antoine Pevsner made him aware of De Stijl, Neo-plasticism, Abstraction-Création and Constructivism. He also met Léger, Miró, Arp, Kandinsky, Robert Delaunay, Alberto Giacometti, Picasso and Brancusi.

Shortly before returning to New York in 1938, Biederman made his first abstract reliefs, which he termed "non-mimetic." In the same year, while visiting Chicago, he attended a seminar given by the Polish-born writer Alfred Korzybski, founder of the General Semantics Institute, which strongly influenced his later theories about history as an evolutionary process. He moved to Red Wing, near Minneapolis, MN, in 1942 to work on an army medical project. Although he did not make art again until 1945, when he returned to painted aluminum reliefs of geometric elements (e.g., *Structurist Relief, Red Wing No. 20*, 1954–65; London, Tate), he began work on his first book, *Art as the Evolution of Visual Knowledge* (1948), in which he explained how art could reflect the structure of nature without imitating its outward appearances. His beliefs, formally referred to as Structurism, were espoused in other books and influenced other Constructivist artists such as Victor Pasmore, Kenneth Martin, Mary Martin and Anthony Hill.

WRITINGS

Art as the Evolution of Visual Knowledge (Red Wing, 1948)

Letters on the New Art (Red Wing, 1951)

The New Cézanne: From Monet to Mondrian (Red Wing, 1958)

An Art Credo (Lanark, 1965)

Search for New Arts (Red Wing, 1979)

Art–Science–Reality (Red Wing, 1988)

The End of Modernism, Figurative or Abstract (Red Wing, 1994)

BIBLIOGRAPHY

G. Rickey: *Constructivism: Origins and Evolution* (New York, 1967), pp. 59, 86, 100, 118–21, 243, 275

Charles Biederman: A Retrospective Exhibition with Especial Emphasis on the Structurist Works of 1936–69 (exh. cat., foreword R. Denny, essay J. van der Marck; London, ACGB, 1969)

Charles Biederman (exh. cat., essays by S. C. Larsen and P. McDonnell; Minneapolis, U. MN, Weisman A. Mus., 2003)

Roy R. Behrens

Bierstadt, Albert

(*b* Solingen, Germany, 7 Jan 1830; *d* New York, 18 Feb 1902), painter of German birth. In a career spanning the entire second half of the 19th century, Bierstadt emerged as the first technically sophisticated artist to travel to the Far West of America, adapt European and Hudson River school prototypes to a new landscape and produce paintings powerful in their nationalistic and religious symbolism.

Bierstadt spent his early years in New Bedford, MA, where his family settled two years after his birth. Lacking funds for formal art instruction, he spent several years as an itinerant drawing instructor before departing in 1853 for Düsseldorf, Germany, where he hoped to study with Johann Peter Hasenclever, a distant relative and a celebrated member of the Düsseldorf art circle. Hasenclever's death shortly before Bierstadt's arrival altered the course of his study, for rather than finding German mentors, he responded to the generous assistance offered by fellow American artists Emanuel Gottlieb Leutze and Worthington Whittredge. After four years of study and travel in Germany, Switzerland and Italy, he had achieved a remarkable level of technical expertise. In 1857, his apprenticeship complete, he returned to New Bedford. The following year he made his New York début contributing a large painting, *Lake Lucerne* (1858; Washington, DC, N.G.A.), to the annual exhibition at the National Academy of Design.

The turning point in his career came in 1859 when he obtained permission to travel west with Frederick W. Lander's Honey Road Survey Party. Bierstadt accompanied the expedition as far as South Pass, high in the Rocky Mountains, not only making sketches, but also taking stereoscopic photographs of Indians, emigrants and members of the survey party. On his return east, Albert gave his negatives to his brothers Charles Bierstadt (1819–1903) and Edward Bierstadt (1824–1906), who shortly thereafter opened their own photography business. Albert himself, after taking space in the Tenth Street Studio Building in New York, set to work on the first of the large western landscapes on which he built his reputation. In 1860 he exhibited *Base of the Rocky Mountains, Laramie Peak* (untraced) at the National Academy of Design and thereby laid artistic claim to the landscape of the American West. Of all the paintings he produced following his first trip west, none drew more attention than *The Rocky Mountains, Lander's Peak* (1863; New York, Met.; see color pl. 1:IV, 3). A huge landscape combining distant mountain grandeur with a close-up view of Native American camp life, *The Rocky Mountains* was seen by some as the North American equivalent of Frederic Edwin Church's *Heart of the Andes* (1859; New York, Met.).

In 1863 Bierstadt made his second trip west, accompanied by the writer Fitz Hugh Ludlow. Traveling by stagecoach and on horseback, the pair reached San Francisco in July, spent seven weeks in Yosemite Valley and then rode north as far as the Columbia River in Oregon before returning east. Following this trip, Bierstadt produced a series of paintings that took as their subject the awesome geography and spiritual power of Yosemite Valley. Such images of undisturbed nature served as welcome antidotes to the chaos and carnage of the Civil

War then ravaging the eastern landscape. In 1865 Bierstadt sold *The Rocky Mountains* to James McHenry, an English railroad financier, for $25,000. The sale marked not only the artist's economic ascendancy but also his entry into European and American society. At the peak of his fame and wealth, Bierstadt built a magnificent home, Malkasten, on the banks of the Hudson River. He continued to produce large paintings of western mountain scenery, including *Storm in the Rocky Mountains, Mt Rosalie* (1866; New York, Brooklyn Mus.; see color pl. 2:XVI, 1.) and *Domes of the Yosemite* (1867; St Johnsbury, VT, Athenaeum).

In June 1867 Bierstadt and his wife departed for Europe, where they spent two years traveling and mixing with potential patrons among the wealthy and titled. In Rome during the winter of 1868 he completed *Among the Sierra Nevada Mountains, California* (Washington, DC, Smithsonian Amer. A. Mus.), a key example of the mythic rather than topographical paintings that would occupy much of his time during the 1870s. In 1871 he returned to California and Yosemite, but the transcontinental railroad had flooded the valley with tourists, and he turned his attention to less accessible and still pristine areas such as Hetch Hetchy Valley, Kings River Canyon and the Farallon Islands. Returning east in 1873, he began work on a new series of paintings of California, as well as a commissioned work for the US Capitol, the *Discovery of the Hudson* (1875; *in situ*). In 1877, when his wife's health required a warmer climate, he began regular trips to Nassau. The island's lush landscape and tropical light offered new subject matter and encouraged him to adopt a brighter palette. In the following decade he traveled constantly, returning to Europe, California, Canada and the Pacific Northwest. In 1881 he visited Yellowstone Park and eight years later Alaska and the Canadian Rockies.

The growing American taste for paintings exhibiting French mood rather than German drama, on an intimate rather than a panoramic scale, had begun to affect Bierstadt's reputation as early as the mid-1870s,

but the most painful blow came in 1889 when his ambitious western canvas, the *Last of the Buffalo* (1888; Washington, DC, Corcoran Gal. A.), was rejected by an American selection committee for the Paris Exposition Universelle. Declaring the canvas too large and not representative of contemporary American art, the committee reinforced the view that Bierstadt was an outmoded master. The revival of interest in Bierstadt's work in the 1960s was sparked not by the large studio paintings celebrated during the 1860s and 1870s, but rather by the fresh, quickly executed sketches done as preparatory works for the larger compositions.

BIBLIOGRAPHY

R. Trump: *Life and Works of Albert Bierstadt* (diss., Columbus, OH State U., 1963)

E. Lindquist-Cock: "Stereoscopic Photography and the Western Subjects of Albert Bierstadt," *A.Q.*, xxxiii (1970), pp. 360–78

G. Hendricks: *Albert Bierstadt: Painter of the American West* (New York, 1973)

M. Baigell: *Albert Bierstadt* (New York, 1981)

G. Carr: "Albert Bierstadt, Big Trees, and the British: A Log of Many Anglo-American Ties," *Arts*, lx (1986), pp. 60–71

N. K. Anderson: "The European Roots of Albert Bierstadt's Views of the American West," *Mag, Ant.*, cxxxix (1991), pp. 220–33

W. H. Truettner: "Reinterpreting Images of Westward Expansion, 1820–1920," *Antiques*, cxxxix (1991), pp. 542–55

L. Buckley: *"The Sierras near Lake Tahoe* by Albert Bierstadt," *Porticus*, xiv–xvi (1991–3), pp. 42–51

Albert Bierstadt: Art & Enterprise (exh. cat. by N. Anderson and L. Ferber, New York, Brooklyn Mus.; San Francisco, CA, F.A. Museums; Washington, DC, N.G.A.; 1991–2); review by B. Nixon in *Artweek*, xxii (1991), p. 1; A. Wilton in *Apollo*, cxxxv (1992), p. 56

The West as America: Rethinking Western Art (exh. cat. by W. Truettner and others, Washington, DC, N. Mus. Amer. A., 1991); review by S. May in *SW A.*, xxi (1991), pp. 100–9

A. Blaugrund: "The Old Boy Network in Rome: Tenth Street Studio Artists Abroad," *Italian Presence in American Art, 1860–1920*, ed. I. B. Jaffe (Rome, 1992), pp. 229–39

F.-B. Oraezie Vallino: "Alle radici dell'etica ambientale: Pensiero sulla natura, wilderness e creatività artistica negli Stati Uniti del XIX secolo, pt. 2," *Stor. A.*, lxxix (1993), pp. 355–410

J. Hines: "Land of Extremes: Mythological Romanticism Associated with the West," *SW A.*, xxvi (1996), p. 40

A. C. Harrison: "Bierstadt Paintings in the Haggin Museum," *Ant.*, 156/5 (Nov 1999), pp. 682–91

N. K. Anderson and others: "Albert Bierstadt: A Letter from New York," *Archit. Amer. A. J.*, 40/3–4 (2000), pp. 28–31

Primal Visions: Albert Bierstadt Discovers America (exh. cat., by D. P. Fischer, Montclair, NJ, Montclair A. Mus., 2001)

Nancy Anderson

Biggers, John

(*b* Gastonia, NC, 13 April 1924; *d* Houston, TX, 25 Jan 2001), painter, draftsman, printmaker and sculptor. John (Thomas) Biggers, the youngest of seven children, grew up in segregated Gastonia, NC. Upon the death of his father in 1937, his mother sent him away to Lincoln Academy to receive a high-quality education. While there, he learned a great deal about African art and the value of African culture; these were lessons he would carry with him throughout his career. Although African influences were most noteworthy in his works, he also managed to synthesize elements from American Regionalism, the African American figurative tradition and Native American sources. In 1941, Biggers entered the Hampton Institute (later renamed Hampton University) in Virginia, where he studied art. In 1943, his mural *Dying Soldier* was featured in the landmark exhibition *Young Negro Art*, organized for the Museum of Modern Art, New York. In that same year, he was drafted into the United States Navy. After receiving an honorable discharge three years later, he enrolled at the Pennsylvania State University. He received his BA and MA degrees in 1948 and a PhD in 1954.

In 1949, Biggers moved to Houston, TX, where he chaired the nascent art department at Texas State University for Negroes (later renamed Texas Southern University) and remained there as a faculty member until his retirement in 1983. While there, he established an obligatory mural program for art students. In 1957, Biggers won a UNESCO fellowship and became among the first black American artists to travel to Africa. He described his trip to Ghana and Nigeria as "a positive shock" and as "the most significant of my life's experiences." His African sojourn had such a profound impact on his world view and on his art that, in 1962, he published a book that he himself illustrated and titled *Ananse: The Web of Life in Africa* (1962) about the art, social life and customs of West Africa.

Over the course of his long career, Biggers moved from creating works that were overtly critical of racial and economic injustice, such as *Victim of the City Streets #2* (1946) and *The Garbage Man* (1944), to more allegorical works such as *Birth from the Sea* (1964) and *Shotguns: Third Ward* (1987). In the latter work, African and African American women function as allegories of creativity, life, hope and the survival of community and culture. As well, the work features one of Biggers's recurring symbols—the shotgun house, a popular style of housing found in rural areas of the South. The combining of African women with the shotgun house was intended to express the importance of social and cultural ties important to African American life.

BIBLIOGRAPHY

A. Wardlaw: *The Art of John Biggers: View from the Upper Room* (Houston, 1995)

O. J. Theisen: *A Life on Paper: The Drawings and Lithographs of John Thomas Biggers* (Denton, TX, 2006)

James Smalls

Billops, Camille

(*b* Los Angeles, CA, 12 Aug 1933), filmmaker, sculptor, printmaker and archivist of African American culture. Camille Billops received her BA from California State College and her MFA from the City College of New York. A visual artist, filmmaker and archivist, Billops's darkly humorous prints and sculpture have been exhibited internationally, including at the Cooper-Hewitt Museum of Design, the New Museum, and the Bronx Museum, New York; the Library of Congress, Washington, DC; Clark College, Atlanta University; the Chrysler Museum of Art, Norfolk, VA; Museo de Arte Moderno La Tertulia, Cali, Colombia; Gallerie Akhenaton, Cairo, Egypt; the American Center, Karachi, Pakistan; and the American Cultural Center, Taipei, Taiwan. Billops received a Percent for Art

commission in New York, and was a long-time member of Robert Blackburn's Printmaking Workshop (PMW), traveling to establish the first summer printmaking workshop in Asilah, Morocco, with the PMW delegation.

As a filmmaker, Billops earned a National Endowment for the Arts award. Her films have been shown on public television and at the Museum of Modern Art, New York. She collaborated with photographer James Van Der Zee on *The Harlem Book of the Dead* (1978). Her award-winning autobiographical film *Finding Christa* (1991), which recounts how Billops was reunited with her daughter 18 years after she was given up for adoption as a young child, won the Grand Jury Award at the Sundance Film Festival, and was screened at film festivals around the world. Her family trilogy also includes *Suzanne, Suzanne* (1982) and *A String of Pearls* (2002). Other films offer perspectives on slavery and racism, such as *The KKK Boutique ain't Just Rednecks* (1994) and *Take Your Bags* (1998), or views on age and sexuality in *Older Women and Love* (1987).

With her husband, theater director and historian James V. Hatch, she founded The Hatch–Billops Collection in New York City. Established in 1975 to preserve primary and secondary resource materials in the black cultural arts, the archive now includes an extensive slide and photographic collection, an oral history library of over 1500 taped interviews and a reference library. Since 1981, they have published the journal *Artist and Influence.*

BIBLIOGRAPHY

K. Blood: "A Printmaking Workshop in Morocco: Artist Camille Billops on Her Work with Robert Blackburn," *Lib. Congr. Inf. Bull.*, lxii/7 (July–Aug 2003)

M. D. Harris: *Colored Pictures: Race and Visual Representation* (Chapel Hill, NC, 2003)

C. Winston: "Through the Looking Glass; An Interview with Camille Billops and James Hatch," *Black Masks* (1 May 2004).

Deborah Cullen

Bing, Ilse

(*b* Frankfurt am Main, 23 March 1899; *d* New York, 10 March 1998), German photographer, active in France and the USA. Self-taught, Bing used the small-format Leica camera for most of her career, earning the nickname "Queen of the Leica." She produced photographic essays for German magazines. Inspired by the photographer Florence Henri, she went to Paris in 1930 where she worked as a fashion photographer for *Vu* and *Harper's Bazaar* and garnered a reputation as a photojournalist, publishing in *Le Monde Illustré* and others. Bing incorporated photojournalist techniques into all of her artistic work and enlivened many of her images with motion. Influenced by abstract painting and by Surrealism, she built up geometric compositions using ordinary objects. After some time in an internment camp in 1939–40, she moved to New York in 1941. Bing worked with the larger Rolleiflex camera and experimented with night photography, solarization, cropping and enlarging and, briefly, with color before she gave up photography completely in 1959. In the late 1970s interest in her work renewed; she was featured in many exhibitions, and in 1985 she was given a retrospective at the New Orleans Museum of Art.

BIBLIOGRAPHY

Ilse Bing: Three Decades of Photography (exh. cat. by N. Barrett, New Orleans, LA, Mus. A., 1985)

Ilse Bing: Paris 1931–1952 (exh. cat., Paris, Carnavalet, 1987)

Fotographien 1929–1956 (exh. cat., Aachen, Suermondt-Ludwig Mus., 1996)

Ilse Bing: Vision of a Century (exh. cat., New York, Edwynn Houk Gal., 1998)

S. Kennel, "Fantasies of the Street—Émigré Photography in Interwar Paris," *History of Photography*, 29/3 (Autumn 2005), pp. 287–300

S. Louth, "The Looking Glass Woman," *Brit. J. Phot.*, 153/7590 (5 July 2006), p. 9

L. Dryansky: *Ilse Bing: Photography through the Looking Glass* (New York, Abrams, 2006).

Victoria & Albert Museum: http://www.vam.ac.uk/collections/photography/past_exhns/bing/index.html [Biography and images]

San Francisco MOMA: http://www.sfmoma.org/artists/2518/artwork [Images]

Sheryl Conkelton

Bingham, George Caleb

(*b* Augusta County, VA, 20 March 1811; *d* Kansas City, MO, 7 July 1879), painter. Raised in rural Franklin County, MO, Bingham experienced from an early age the scenes on the major western rivers, the Missouri and the Mississippi, that inspired his development as a major genre painter. During his apprenticeship to a cabinetmaker, he met the itinerant portrait painter Chester Harding, who turned Bingham's attention to art. Teaching himself to draw and compose from art instruction books and engravings, the only resources available in the frontier territories, Bingham began painting portraits as early as 1834. The style of these works is provincial but notable for its sharpness, clear light and competent handling of paint.

Bingham traveled in 1838 to Philadelphia, where he saw his first genre paintings. He spent the years 1841 to 1844 in Washington, DC, painting the portraits of such political luminaries as *Daniel Webster* (Tulsa, OK, Gilcrease Inst. Amer. Hist. & A.). His roster of impressive sitters later enabled him to attract many portrait commissions. He settled back in Missouri at the end of 1844, and, although portraits would always form the greater portion of his work, it was over the next seven years that he made the outstanding contribution of his era to American genre painting. On the East Coast, Bingham's slightly older contemporary William Sidney Mount had been exhibiting genre scenes of farmers since 1830. In the 1840s, however, the major focus of national concern shifted to westward expansion and its meaning for American society. Bingham's work stunningly interpreted these concerns with three major motifs.

The first was that of the fur trader, which he developed in his painting *Fur Traders Descending the Missouri* (1845; New York, Met.). Against an imposingbackground of golden light and towering clouds, he placed a fur trader and his half-breed son (so identified in the original title of the painting), along with their chained bear cub, in a canoe floating downstream. Looking out at the viewer, the men seem thoughtful and cleanly dressed—not at all the uncivilized creatures described in contemporary literature. The surface of the water is mirror-like; reflections of the canoe, the oar and other details lock the scene into place. It is a romantic vision, transforming into a peaceful idyll the very terms of commercial gain in which the continent had been explored. The painting pays tribute to a vanishing phenomenon, for soon after the Panic of 1837 the market for pelts dropped disastrously and never recovered. As such, it epitomizes Bingham's role in preserving, and reinterpreting, the vanishing West. *Fur Traders* is moreover characteristic of his style. His clearly delineated figures derive from character studies of frontier people that he had sketched on paper. He created a formal design, which conveyed an ordered, inviolate world (there exist no studies for his works other than drawings of individual figures); he painted smoothly, with an absence of brushstroke; and his tonalities were light, dominated by areas of bright color and often, as in this painting, luminous.

Bingham's second motif explored the life of the Mississippi raftsman. His *Jolly Flatboatmen* (1846; Detroit, MI, Manoogian priv. col.), again dominated by a clear light, is even more tightly organized than *Fur Traders*, with a number of figures balancing one another. This predilection for order, fundamental to Bingham's very energies as an artist, contributed crucial meanings to his renderings of the West. These are often ironic meanings. No group of men on the western rivers seemed less responsible to society than the violent, fun-loving, gambling flatboatmen. He painted the flatboatmen in several versions, including scenes of dancing and cardplaying, for example *Raftsmen Playing Cards* (1847; St Louis, MO, A. Mus.), attracting audiences in St Louis and other western cities as well as in the East (for illustration see color pl. 1:VII, 2). His paintings transformed the terms in which frontier life had been understood, negating the threat of the rough frontiersman to civilized life. The American Art-Union, acting on a demand for this vision in the East during a period in which the nation was aggressively expanding westward, became Bingham's major

patron. In 1847 it engraved *Jolly Flatboatmen* for an audience of about 10,000 subscribers.

The final motif that Bingham explored was that of the election. No longer near the river (and the river's associations with commerce and movement), these scenes take place in a village. Clearly influenced by Hogarth, but inspired by his own experience in politics, they show politicians arguing their point in *Stump Speaking* (1854), citizens casting their vote in *County Election* (1851 and 1852; one version in St Louis, MO, A. Mus.) and the electorate gathered to hear election results in *Verdict of the People* (1855; all three in St Louis, MO, Boatmen's N. Bank). In each painting Bingham showed the wide range of social class, economic standing and apparent intellectual capability in the electorate; he chronicled political abuses as well—such as drinking at the polls and electioneering at the ballot box. Bingham exhibited *County Election* widely and painted a second version that was engraved by the Philadelphia engraver John Sartain (1808–97). Although the genre scenes are Bingham's major achievement, he also painted landscapes. His *Emigration of Daniel Boone* (1851; St Louis, MO, Washington U.), while inspired by the popularity of the theme rather than his own experience, pictured the early Western scout leading a caravan of settlers over the Cumberland Gap. In 1857 Bingham went to Düsseldorf, where he painted several large historical portraits on commission, notably one of *Thomas Jefferson* (destr. 1911). His angry historical painting protesting against the imposition of martial law in Missouri during the Civil War, *Order No. 11* (1865–8; Cincinnati, OH, A. Mus.), is full of quotations from earlier works of art. Although Bingham was increasingly involved in state and local politics, he continued his work as a portrait painter. The major repositories for his paintings and drawings are the St Louis Art Museum and the Boatmen's National Bank of St Louis.

[*See also* Kansas City.]

BIBLIOGRAPHY

C. Rollins, ed.: "Letters of George Caleb Bingham to James S. Rollins," *MO Hist. Rev.*, xxxii (1937–8), pp. 3–34, 164–202, 340–77, 484–522; xxxiii (1938–9), pp. 45–78, 203–29, 349–84, 499–526

J. F. McDermott: *George Caleb Bingham: River Portraitist* (Norman, OK, 1959)

J. Demos: "George Caleb Bingham: The Artist as Social Historian," *Amer. Q.*, xvii/2 (1965), pp. 218–28

E. M. Bloch: *George Caleb Bingham: The Evolution of an Artist*, 2 vols (Berkeley, 1967) [with cat. rais.]

R. Westervelt: "Whig Painter of Missouri," *Amer. A. J.* [New York], ii/1 (1970), pp. 46–53

E. M. Bloch: *The Drawings of George Caleb Bingham* (Columbia, MO, 1975)

B. Groseclose: "Painting, Politics, and George Caleb Bingham," *Amer. A. J.*, x/2 (1978), pp. 5–19

George Caleb Bingham (exh. cat. by M. Shapiro and others; St Louis, MO, A. Mus.; and Washington, DC, N.G.A.; 1990)

E. Johns: *American Genre Painting: The Politics of Everyday Life* (New Haven and London, 1991)

N. Rash: *The Painting and Politics of George Caleb Bingham* (New Haven and London, 1991)

The West as America: Reinterpreting Images of the Frontier (exh. cat. by W. Truettner and others, Washington, DC, N. Mus. Amer. A.; Denver, CO, A. Mus.; St Louis, MO, A. Mus.; 1991–2); review by A. Trachtenberg in *A. Amer.*, lxxix (1991), pp. 118–23

D. M. Lubin: *Picturing a Nation: Art and Social Change in Nineteenth-century America* (New Haven and London, 1994)

N. Rash: "New Light on George Caleb Bingham and John Sartain," *Prt Colr Newslett.*, xxv (1994), pp. 135–7

P. Nagel: *George Caleb Bingham: Missouri's Famed Painter and Forgotten Politician* (Columbia, 2005)

Elizabeth Johns

Biomorphism

Term derived from the classical concept of forms created by the power of natural life, applied to the use of organic shapes in 20th-century art, particularly within Surrealism. It was first used in this sense by Alfred H. Barr Jr. in 1936. The tendency to favor ambiguous and organic shapes in apparent movement, with hints of the shapeless and vaguely spherical forms of germs, amoebas and embryos, can be traced to the plant morphology of Art Nouveau at the end of the 19th century; the works of Henry Van de Velde, Victor Horta and Hector Guimard are particularly important in this respect.

From 1915 biomorphic forms appeared in wood reliefs, ink drawings and woodcuts by Hans Arp. By representing ovoid forms shifting into one another, he indicated the unity of nature in conscious opposition to the mechanization and dislocation of modern life. Biomorphic forms were also featured in the *Improvisations* painted around the beginning of World War I by Vasily Kandinsky, who had met Arp while living in Munich. At the end of the 1920s, apparently stimulated by the work of Yves Tanguy, Arp began to use more rounded and modeled shapes. He remained committed to biomorphism throughout his life, using it to express metaphors of cyclical transformation, cosmic harmony and the mystical union of human beings with the form-giving powers of nature.

Joan Miró was also influential in promoting the concept of biomorphism in his work, particularly from the mid-1920s, when he came into contact with Surrealism. He developed arabesque contours and a flux of colored spaces, from which the shapes seem to surface, to convey a sense of creation and evolution and a range of human archetypes, by turns humorous and aggressive. Similar strategies of deformation were developed in the mid-1920s by Picasso, for instance in his *Three Dancers* (1925; London, Tate) and in his series of bathers of the late 1920s. In these and related works he explored ideas of perpetual movement, and through human and animal associations he used the formal language of biomorphism to suggest psychological truths. The application of biomorphism to the human figure in the sculpture of Henry Moore from the early 1930s was, in principle, also rooted in formal concerns linked to Surrealism. In his case abstract rhythms and an organic interdependence of form and space were used to express the relationship between human and landscape forms.

The example of these artists, and especially the impersonal, pantheistic biomorphism of Miró and Moore, had a liberating effect on many others in the 1930s and 1940s. In particular Miró's use of biomorphism stimulated Alexander Calder, Isamu Noguchi, Willi Baumeister and painters associated with Abstract Expressionism, notably Willem de Kooning, Arshile Gorky, Jackson Pollock and Robert Motherwell. While biomorphism never resulted in a style as such, it remained an important tendency through the 1940s in unifying otherwise diverse stylistic innovations. For illustration see color pl. 1:VI, 3.

[*See also* Surrealism.]

BIBLIOGRAPHY

L. Glózer: *Picasso und der Surrealismus* (Cologne, 1974)

S. Poley: *Hans Arp: Die Formensprache im plastischen Werk* (Stuttgart, 1978)

C. Lichtenstern: *Picasso "Tête de Femme": Zwischen Klassik und Surrealismus* (Frankfurt am Main, 1980)

C. Lichtenstern: "Henry Moore and Surrealism," *Burl. Mag.*, cxxiii/944 (1981), pp. 645–58

B. Rose: "Miró aus amerikanischer Sicht," *Joan Miró* (exh. cat. by R. S. Lubar and others, Zurich, Ksthaus; Düsseldorf, Städt. Ksthalle; New York, Guggenheim; 1986)

J. Mundy: *Biomorphism* (diss., U. London, Courtauld Inst., 1987)

Christa Lichtenstern

Birch, Thomas

(*b* Warwicks, 26 July 1779; *d* Philadelphia, PA, 14 Jan 1851), painter of English birth. He was one of the most important American landscape and marine painters of the early 19th century. He moved to America in 1794 with his father William Birch (1755–1834), a painter and engraver from whom he received his artistic training. The family settled in Philadelphia, where William, armed with letters of introduction from Benjamin West to leading citizens of that city, became a drawing master. Early in their American careers both Birches executed cityscapes, several of which were engraved. Thomas contributed a number of compositions to *The City of Philadelphia in the State of Pennsylvania, North America, as it Appeared in the Year 1800* (1800), a series of views conceived by the elder Birch in obvious imitation of comparable British productions. An English sensibility is also apparent in the many paintings of country

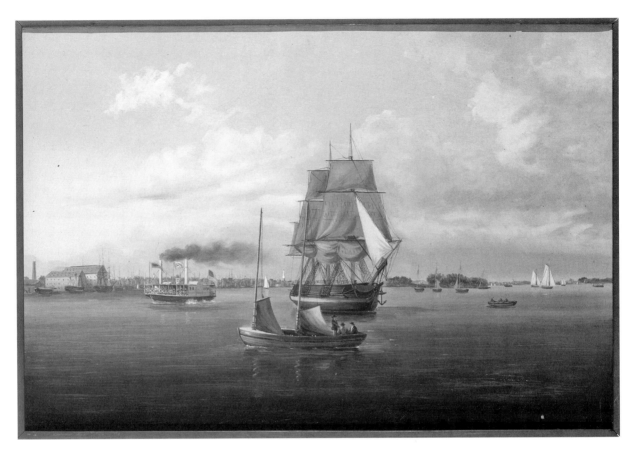

THOMAS BIRCH. *View of the Harbor of Philadelphia from the Delaware River*, oil on canvas, 508 × 768 mm, circa 1835. THE NEWARK MUSEUM NJ/ART RESOURCE, NY

estates executed by father and son in the early 19th century (e.g. *Eaglesfield*, 1808; priv. col., see 1986 exh. cat., p. 26). These compositions, along with such portrayals of important public edifces in and near Philadelphia as *Fairmount Waterworks* (1821; Phila-delphia, PA Acad. F.A.), emphasize the cultural pro-gress and commercial prosperity of the young United States as well as its almost Edenic natural beauty. Birch is also known for his representations of winter landscapes (examples in Shelburne, VT, Mus.)

Among Birch's most accomplished landscapes from the 1810s are his two views of Point Breeze, the country seat of Joseph Bonaparte outside Bordentown, NJ. The sweeping view of the Delaware River as seen from the elegant terrace of this villa, decorated with classical sculpture and populated with fashionably dressed men and women (1818; priv. col., see 1986 exh. cat., p. 146), is perhaps unique in American art

of this period. Its pronounced French flavor seems particularly appropriate for a composition probably commissioned by Napoleon's brother or by one of the Prince's admirers. The collection of Old Masters and contemporary European works at Point Breeze was a major artistic attraction and a source of inspi-ration to many American painters, including Birch.

At the time of the War of 1812 with Britain, Birch took up marine painting. Although he continued to paint landscapes, particularly with river views (e.g. *View on the Delaware*, 1831; Washington, DC, Corcoran Gal. A.) and country estates, many of his works from the second half of his career are naval scenes that reflect his familiarity with the Anglo-Dutch tradition of marine painting. While these compositions frequently depict shipping on the Del-aware and in New York Harbor (several in Boston, MA, Mus. F.A.), he also executed a series of

important canvases chronicling major naval engagements of the war (Philadelphia, PA, Hist. Soc.; New York, NY Hist. Soc.). His seascapes with shipping along rocky coasts buffeted by storms, such as *Shipwreck* (1829; New York, Brooklyn Mus.), recall the compositions of Joseph Vernet, whose work Birch knew first hand and through prints, and those of Vernet's followers in England, such as Philippe de Loutherbourg. Birch was a frequent exhibitor at the Pennsylvania Academy, where he served as keeper from 1812 to 1817, as well as at other artistic institutions in Philadelphia and New York.

BIBLIOGRAPHY

D. J. Creer: *Thomas Birch: A Study of the Condition of Painting and the Artist's Position in Federal America* (MA thesis, Newark, U. DE, 1958)

Thomas Birch (exh. cat. by W. H. Gerdts, Philadelphia, Mar. Mus., 1966)

J. Wilmerding: *A History of American Marine Painting* (Boston, 1968), pp. 102–18

M. Hutson: "The American Winter Landscape, 1830–1870," *Amer. A. Rev.*, ii (Jan–Feb 1975), pp. 60–78

Views and Visions: American Landscape before 1830 (exh. cat. by E. J. Nygren and others, Washington, DC, Corcoran Gal. A., 1986)

J. G. Sweeney: "The Nude of Landscape Painting: Emblematic Personification in the Art of the Hudson River School," *Smithsonian Stud. Amer. A.*, iii/4 (1989), pp. 42–65

Edward J. Nygren

Birnbaum, Dara

(*b* New York, 29 Oct 1946), video and installation artist. Birnbaum received her BA in architecture from Carnegie Institute of Technology, Pittsburgh, PA, in 1969 and a BFA in painting from the San Francisco Art Institute in 1973. She first engaged with video at the New School of Social Research in New York and in 1976 she received a certificate in Video and Electronic Editing from the New School's Video Study Center of Global Village. Considered a second-generation video artist, her production critically responds to and expands upon the theory and practice of first-generation video artists such as Nam

June Paik, Bruce Nauman and Dan Graham. The work of Birnbaum and her contemporaries was especially informed by their predecessors' experimentation with the Kodak PortaPak (*c.* 1967) and the types of video art that emerged from the first generation's exploration of the media in the late 1960s and early 1970s. Of these types, two of the most prevalent were videos rooted in performance art, which focused on the self and the body, and work that assessed the actual media of television by attempting to create less commercial, alternative forms of it such as public access cable television. The latter was explored in the writing of people such as Paul Ryan (*b* 1943) from Radical Software, who encouraged artists' use of video as a social teaching tool for communicating ideas to the masses. Birnbaum's work from the late 1970s to the early 1980s demonstrates an acknowledgment of such utopian ideals as well intentioned but flawed. Understanding much of the video and cable work of the early 1970s as coded, and therefore exclusive of certain people and ideologies, she sought a means to deconstruct standard industry programming that would better motivate participation by an unedited, diverse audience. Her answer was to turn television on itself. Birnbaum infiltrated existing images and narratives from mass media instead of translating her subject into a new or alternative form.

One of Birnbaum's most recognized methods is to alter popular television programs by repeating frames and incorporating new sound and text to interrupt viewer passivity and challenge meaning manufactured by network television executives, especially as it relates to gender and politics. Her modification of familiar narratives jolts viewers into a mode of active reception that requires them to interpret what they are watching. In *Technology/Transformation: Wonder Woman* (1978–9), which was first shown on a cable station opposite the broadcast of the actual *Wonder Woman* television series, Birnbaum appropriated imagery from the original series, focusing on the moment when the character transforms into a super-hero/super-woman, to question the motivation behind identifying this pop icon as a

model for a strong woman. In the work's opening moments, Wonder Woman spins incessantly, stuck in her own metamorphosis. Eventually, the character is shown in action, but her activities do not progress smoothly. They are instead presented as repeated fragments interrupted further by the inclusion of audio and textual excerpts from the song *Wonder Woman in Discoland* (1978, Wonderland Disco Band).

In the mid-1980s Birnbaum moved outside of the physical form of the television frame into installation work. *Rio Videowall* (1989) is a permanent, interactive, outdoor video installation with 25 monitors located at the Rio Shopping Complex, Atlanta, GA. The screens, triggered by the motion of shoppers, show a mixture of news from CNN's Atlanta headquarters and video documentation of the land on which the complex is built, as it existed prior to development. In this work Birnbaum blurs the boundaries between commerce and art, art and media, nature and progress. *Erwartung/Expectancy* (1995), commissioned by the Kunsthalle in Vienna, exhibits a break from television content to explore another form of popular entertainment: opera. Using strategies from her earlier works, such as appropriation and context shifts, Birnbaum produced a multimedia installation based on Arnold Schoenberg's *Erwartung* (1909) and the opera's original libretto, written by Marie Pappenheim. In addition to her solo work, Birnbaum has also collaborated on numerous projects in the USA and abroad. She has participated in three *Documenta* (VII, VIII and IX) and has exhibited nationally and internationally. She has also received grants from the National Endowment for the Arts and the American Film Institute, among others, and is an accomplished teacher.

WRITINGS
Rough Edits: Popular Image Video Works, 1977–1980/Dara Birnbaum, H. D. Buchloh, ed. (Halifax, NS, 1987)
Every TV Needs a Revolution (Ghent, 1992) [artist's book]

BIBLIOGRAPHY
D. Graham: "Essay on Video, Architecture and Television," *Video—Architecture—Television: Writings on Video and Video Works 1970–1978*, ed. B. H. D. Buchloh (New York, 1979)
B. H. D. Buchloh: "Dara Birnbaum: Allegorical Procedures," *Medij v Mediju/Media in Media* (Ljubljana, 1997), pp. 46–55
N. Guagnini: "Cable TV's Failed Utopian Vision: An Interview with Dara Birnbaum," *Cabine*, ix (Winter, 2002–3)
First Generation: Art and the Moving Image, 1963–1986 (exh. cat., by Berta Sichel, Madrid, Mus. N. Cent. A. Reina Sofia, 2007)
J. Jacobs: "Moving Image: When Video was Young," *A. Amer.*, 5 (May 2007), pp. 119–21
K. Kelley and B. Schröder: "Dara Birnbaum," *Bomb*, 104 (Summer 2008), pp. 66–73
Dara Birnbaum–Retrospective: The Dark Matter of Media Light (exh. cat., Ghent, Stedel. Mus. Actuele K, 2009)

Courtney Gerber

Bischoff, Elmer

(*b* Berkeley, CA, 9 July 1916; *d* Berkeley, CA, 2 March 1991), painter and teacher. One of the founders of the Bay Area figurative art movement along with Richard Diebenkorn and David Park, Bischoff worked figuratively but with a strong abstract notion and a broadly defined sense of realism. Bischoff began painting in a purely abstract manner, changed to his signature figurative style then returned to abstract acrylics in his final years.

Bischoff received a Master of Arts degree in 1939 from the University of California, Berkeley. In 1942 he served as a non-combatant in the United States Air Force stationed in Europe. Although he only produced occasional sketches while abroad, he was able to visit Paris often. He left the Air Force in 1945 and began his long and influential teaching career at the California School of Fine Arts (now San Francisco Art Institute), where he taught until 1963. His fellow instructors included Mark Rothko and Clyfford Still, both of whom made him keenly aware of the theories of Abstract Expressionism. It was also at this hotbed of artistic creation that he met Diebenkorn and Park. In 1963 he moved to the University of California, Berkeley, where he remained until retiring in 1985. Upon his retirement Bischoff received the Berkeley Citation for his distinguished teaching career at the university and an Honorary Doctorate of Fine Art from the San Francisco Art Institute.

Bischoff moved from bold abstraction in the manner of Pablo Picasso (1881–1973) and Joan Miró (1893–1983) in the late 1940s to large-scale and vividly colored figure paintings and landscapes that combined recognizable imagery with a surface energy and size on the level of Abstract Expressionism in the 1950s and 1960s. He went back to pure abstraction in the 1970s and 1980s (e.g. #66, 1982; New York, Met.). The figurative abstract paintings (e.g. *Girl Wading*, 1959; New York, MOMA) were the first to bring Bischoff national and international acclaim and, when grouped with the work of Diebenkorn and Park, revealed an important and loosely defined West Coast school of painting. This body of work included nudes, beach scenes, domestic interiors and landscapes with a sense of spontaneity and emotion and most often also possessed a pearly light suggestive of Berkeley's overcast skies.

UNPUBLISHED SOURCES
Berkeley, U. CA, Bancroft Lib., Regional Oral History Office [S. Riess: "Two Conversations with Elmer Bischoff"]

BIBLIOGRAPHY
Elmer Bischoff: 1947–1985, A Retrospective (exh. cat. by R. Frash; Laguna Beach, CA, A. Mus., 1985)
Elmer Bischoff: The Ethics of Paint (exh. cat. by S. Landauer; Oakland, CA, Mus., 2002)

Marisa J. Pascucci

Bischoff, Franz A.

(*b* Bomen, Austria, 14 Jan 1864; *d* Pasadena, 5 Feb 1929), painter and porcelain painter of Austrian birth. He began his artistic training at a craft school in his native Bomen. In 1882 he went to Vienna for further training in painting, design and ceramic decoration. He came to the USA in 1885 and obtained employment as a painter in a ceramic factory in New York City. He moved to Pittsburgh, PA, then to Fostoria, OH, and finally to Dearborn, MI, continuing to work as a porcelain painter. In 1906 he moved his family to the Los Angeles area. Two years later he built a home along the Arroyo Seco in South Pasadena, which included a gallery, ceramic workshop and painting studio. Once in California, Bischoff turned to landscape painting, in addition to continuing his flower paintings and his porcelain work. Through the 1920s, he painted the coastal areas of Monterey and Laguna Beach, the Sierra Nevada Mountains and the desert near Palm Springs. In 1928 he and his friend John Christopher Smith traveled to Utah, where they painted in Zion National Park.

One of the leaders of the California *plein-air* style, Bischoff was also one of the foremost porcelain painters of his day. He founded the Bischoff School of Ceramic Art in Detroit and New York City and formulated and manufactured many of his own colors. His porcelain works were exhibited at the 1893 World's Columbian Exposition in Chicago and at the 1904 Louisiana Purchase Exposition in St Louis.

BIBLIOGRAPHY
J. Stern: *The Paintings of Franz A. Bischoff* (Los Angeles, 1980)
California Light, 1900–1930 (exh. cat. by P. Trenton and W. H. Gerdts, Laguna Beach, CA, A. Mus., 1990)
California Impressionists (exh. cat. by S. Landauer, D. D. Keyes, and J. Stern, Athens, U. GA Mus. A., 1996)

Jean Stern

Bishop, Isabel

(*b* Cincinnati, 3 March 1902; *d* New York, 19 Feb 1988), painter, draftsman and etcher. Bishop moved to New York in 1918 to study at the New York School of Applied Design for Women and from 1920 at the Art Students League under Guy Pène du Bois and Kenneth Hayes Miller. During these years she developed lifelong friendships with Reginald Marsh, Edwin Dickinson and other figurative painters who lived and worked on 14th Street, assimilating these influences with those of Dutch and Flemish painters such as Adriaen Brouwer and Peter Paul Rubens, whose work she saw in Europe in 1931.

From the early 1930s Bishop developed an anecdotal and reportorial Realist style in pictures of life on the streets of Manhattan such as *Encounter*

(1940; St Louis, MO, A. Mus.), in which an ordinary-looking man and woman are shown meeting under a street lamp. Throughout her long career Bishop concentrated on the subtleties of fleeting moments in the daily routine of people who lived and worked in and around Union Square, giving these simple occasions a sense of timelessness: shopgirls seated at a lunch counter, tramps gathered under the horse's tail of the equestrian statue of *George Washington*, travelers waiting on a subway platform, children scrambling at play or students walking quietly through the park. She worked in a cautious and painstaking manner, often spending a year or more on a single picture and thus producing fewer than 175 paintings over a period of nearly 60 years. She also produced drawings and, from 1925, etchings on related subjects, for example *Office Girls* (1938) and *Encounter* (1941; both London, BM), the latter based directly on the painting of the same name.

[*See also* Miller, Kenneth Hayes, *and* Scene painting.]

BIBLIOGRAPHY

Isabel Bishop: Prints and Drawings, 1925–1964 (exh. cat., New York, Brooklyn Mus., 1964)

Isabel Bishop (exh. cat., essay S. Reich; Tucson, U. AZ Mus. A., 1974)

K. Lunde: *Isabel Bishop* (New York, 1975)

S. Teller: *Isabel Bishop: Etchings, Engravings and Aquatints: A Catalogue Raisonné* (New York, 1981, rev. San Francisco 3/2000)

H. Yglesias: *Isabel Bishop* (New York, 1988)

Isabel Bishop (exh. cat., Washington, DC, N. Mus. Women A.; New York, Bronx Mus. A.; Little Rock, AR A. Cent.; 1989)

E. W. Todd: *The "New Woman" Revised: Painting and Gender on Fourteenth Street* (Berkeley, CA, and Oxford, 1993)

Between Heaven and Hell: Union Square in the 1930s (exh. cat., Wilkes-Barre, PA, Sordoni Art Gallery, 1996)

S. C. Larsen: "New England," *Arch. Amer. A. J.*, 42/3–4 (2002), pp. 52–4

M. Consolini: "The Skowhegan Lecture Archive: An Historical Survival Story," *A. Lib. J.*, 31/1 (2006), pp. 17–21

MARTIN H. BUSH

Bitter, Karl

(*b* Vienna, Austria, 6 Dec 1867–*d* New York, 9 April 1915), Austrian sculptor active in America. The sculptor Karl Bitter is best remembered for his contributions to the late 19th-, early 20th-century City Beautiful Movement. He thereby left a lasting imprint on New York City. Examples of his public sculpture grace not only streets and squares from Bowling Green to Morningside Heights but also numerous other urban sites in Philadelphia, Cleveland, Madison and Minneapolis. Born, raised and educated in Vienna, he no sooner completed his formal training at the Kunstgewerbeschule and Kunstakademie than he was conscripted into the army of the Austro-Hungarian Empire. Refusing to serve an obligatory second year, he escaped to New York via Berlin in 1888 with little more than his sack of tools. His arrival marked the beginning of a prolific career lasting 25 years.

He was immediately discovered by the leading Beaux-Arts architect, Richard Morris Hunt, who put him to work producing allegorical figures for major, ongoing commissions. These included two Vanderbilt mansions: *The Breakers* on Newport Beach, Rhode Island, and better still, *Biltmore* in Asheville, North Carolina. His rich variety of works for the latter includes a lengthy mantelpiece relief, *Return from the Chase* (1893–5), carved in marble for the triple fireplace in the Banquet Hall, five oak relief panels depicting scenes from Wagnerian operas for the balustrade of its organ gallery (1893–5) and a bronze fountain figure of a nude boy stealing a struggling goose. Hunt and Bitter also collaborated on the central edifice of Chicago's 1893 Columbian Exposition, the *Administration Building*, for which Bitter created four "colossal" plaster-of-Paris groups: *Elements Controlled* and *Elements Uncontrolled*, visually exploding from the corners of the rooftop at the base of its dome.

In 1896 Bitter moved into a uniquely designed house and studio overlooking the Hudson River in Weehawken, New Jersey, and from there continued to pursue primarily public works. Foremost among these is another major architectural commission consisting of two narrative pediments and four freestanding groups representing *Strength*, *Faith*, *Prosperity* and *Abundance* (1910–12) high on the Wisconsin State Capitol Building in Madison, Wisconsin. Its architect,

George B. Post, a Hunt student, had earlier contracted Bitter to provide giant *Atlantes* (1896) figures for his skyscraper, or so-called "elevator building," the St Paul Building, in New York City.

While these conformed stylistically to the classic Baroque tradition of most academic sculpture, Bitter ultimately progressed toward an early Modern style anticipating Art Moderne. As may be witnessed in various details of his low-relief accessory figures for the 1913 Carl Schurz Monument in Morningside Heights, New York City, and somewhat less in his innovatively recessed *Planting* and *Harvesting* figures for the 1915 Thomas Lowry Monument in Minneapolis, he accomplished this progressive change in view of a widespread interest in ancient Greek Archaic sculpture that he enthusiastically shared. Newly discovered 6th-century BC examples in Athens motivated him to travel to Greece in 1909, the year he returned momentarily to Vienna to receive an amnesty from the court of Emperor Franz Joseph I.

Thus, Bitter's major stylistic phases evolved dramatically. In contrast to his narrative relief panels for the bronze doors of Trinity Church on lower Broadway in 1891- he created the enormous, super high-relief frieze, *Spirit of Transportation*, for Frank Furness's large expansion of Pennsylvania Station in Philadelphia four years later. From his two gigantic equestrian *Standard Bearers* lifting draped flags over the Triumphal Bridge pylons leading into Buffalo's Pan-American Exposition in 1901- his career culminated with the 1915 Pulitzer Fountain gracing New York City's Plaza between 58th and 60th streets.

The Plaza resulted from a collaboration with Thomas Hastings, the architect of the New York Public Library at 42nd Street. Initially laid out by Bitter, the Plaza was designed to cross 59th Street as a grand entrance to the Corso of Central Park paralleling Fifth Avenue. Its final plan called for moving Augustus Saint-Gaudens' equestrian Sherman Monument in line with Bitter's *Pomona* surmounting the fountain. Both she and the *Victory* figure leading Sherman's horse were inspired by the famous life-model, Audrey Munson, who posed for numerous artists at the time. Also proto-modern in its degree of abstraction, the contrapposto *Pomona* existed only as a wax maquette when Bitter was struck by a runaway car as he and his wife Marie were leaving the Metropolitan Opera. He died the next morning.

Bitter's sudden death prevented him from completing his direction of sculpture for the 1915 Panama-Pacific Exposition in San Francisco as he had done for the 1901 Pan-American Exposition in Buffalo and the 1904 St Louis Exposition. He was replaced by Alexander Stirling Calder, who also finished the design and execution of his Depew Memorial Fountain (1915–16) for University Park, Indianapolis.

BIBLIOGRAPHY

F. Schevill: *Karl Bitter: A Biography* (Chicago, 1917)

J. Dennis: *Karl Bitter, Architectural Sculptor (1867–1915)* (Madison, WI, 1967)

S. Rather: "Toward a New Language of Form: Karl Bitter and the Beginnings of Archaism in American Sculpture," *Portfolio* 25 (Spring 1990), pp. 1–19

James M. Dennis

Black Aesthetic

The Black Arts Movement spans the period from the mid-1960s to the mid-1970s. Inherently and overtly political in content, it was an artistic, cultural and literary movement in America promoted to advance African American "social engagement." In a 1968 essay titled "The Black Arts Movement," African American scholar Larry Neal (1937–81) proclaimed it as the "artistic and spiritual sister of the Black Power concept." The use of the term "Black Power" originated in 1966 with Student Nonviolent Coordinating Committee (SNCC) civil rights workers Stokely Carmichael and Willie Ricks. Quickly adopted in the North, Black Power was associated with a militant advocacy of armed self-defense, separation from "racist American domination" and pride in and assertion of the goodness and beauty of "Blackness."

In addition to "Black Power," the slogan "Black Is Beautiful" also became part of the Black Arts

Movement and the Black Cultural Movement (also known as Black Aesthetics). The aim of these maxims was to counter and dispel the widespread notion throughout Western cultures that black people's natural features, such as skin color, facial characteristics and hair, were inherently ugly. The central purpose was to subvert decades of anti-black rhetoric and "to make African Americans totally and irreversibly proud of their racial and cultural heritage." Black Arts Movement cultural theorists and artists reasoned that promotion of a black aesthetic was mandatory to help the African American community perceive itself as not only beautiful, but also as proud of the legacy of African American achievement, self-determinacy and self-identification with all black peoples throughout the African diaspora. The tone was militant and separatist, not conciliatory and assimilationist, and resulted in a call for a revolutionary art that spoke to a definable black aesthetic. In 1971, literary critic Addison Gayle edited the anthology *The Black Aesthetic* (1971) in which the agenda of this new approach to art was clearly delineated. Gayle insisted that work produced by African American artists should reflect political struggle and strive for racial uplift through acknowledgment of an African heritage. Art should cater to black, not white, audiences and interests.

Conceived as the "aesthetic and spiritual sister" of the Black Power concept, the Black Arts Movement arose in the mid-1960s to develop a body of art that would provide "a change of vision" in the perception of African American identity. Like the New Negro Movement of the 1920s, the Black Arts Movement was a flourishing of artistic endeavor among African American writers, poets, playwrights, musicians and visual artists who believed that artistic production could be the key to revising deeply ingrained stereotypes of African Americans. The underlying philosophy of Black Power was not confined to the visual and literary arts, but was also of relevance to theater, music and black vernacular forms of cultural expression.

Unlike the goal established by "New Negro" writers such as Langston Hughes or cultural theorists such as Alain Locke, the Black Arts, Black Aesthetic and Black Power movements set up a departure from the agenda of African American artists of the early 20th century. Rather than creating artwork that would appease white America, Black Arts artists were exclusively interested in improving black Americans' perception of themselves. These movements directed African Americans to separate themselves from mainstream (understood as white) society as the only means to determine who and what black people were and what was their relationship to America and the rest of the world. African American artists were directed to produce socially relevant and original work collectively so to develop a black aesthetic for each field of art. African American artists in all fields were charged with visualizing an empowered black identity that challenged American mainstream artistic expression.

The year 1968 was a volatile and watershed date in the evolution of the Black Arts and Black Power movements. This was a period of social upheaval in America, with proclamations of war, political insurgency and racial strife. Many African Americans who had supported the peaceful civil rights struggle led by the Reverend Dr. Martin Luther King Jr. became more radicalized in their demands and more aggressive in their tactics, viewing themselves as under attack by the dominant white culture. Optimism turned to anger, frustration and hopelessness. Black membership in radicalized political and religious organizations such as the Black Panther Party and the Nation of Islam increased at a brisk rate. Student coalitions were formed to combat racism, segregation and the Vietnam War. Earlier, in 1964, rebellions in Harlem and Rochester, NY, initiated four years of long hot summers. Watts, Detroit, Newark, Cleveland and many other cities went up in flames, culminating in nationwide explosions of resentment and anger following Martin Luther King Jr.'s assassination in April 1968. Younger artists became more sympathetic to a black separatist and black nationalist mindset and produced such images as *Separate but Equal* (1969–70) by Malcolm Bailey

(b 1947) and *Memorial to Fred Hampton* (1970) by Dana Chandler (b 1941). Works such as Faith Ringgold's *Die Nigger* (1969), David Hammons's *Injustice Case* (1970), Betye Saar's *Liberation of Aunt Jemima* (1972), Elizabeth Catlett's *Homage to My Young Black Sisters* (1968), Barbara Chase-Riboud's *Malcolm X, no. 3* (1970) and Melvin Edwards's *Lynch Fragments* series (begun in 1963) employed subject matter and timely themes that spoke directly to the contemporary predicament and struggles of African Americans.

By 1970, the emphasis on racial pride had stimulated the germination of black arts and cultural centers that became active throughout America. A central theme of the Black Arts, Black Aesthetic and Black Power movements was the notion of group identity in which members of organizations defined themselves and their objectives. Artistic activities were community-based and artists were committed to bringing the arts to black urban neighborhoods. Artists' groups, such as Weusi (Swahili for "people"), OBAC (Organization of Black American Culture) and AFRICOBRA (African Commune of Bad Relevant Artists), developed around this philosophy and avoided attempting to integrate with the mainstream art community or to exhibit in white-owned and -operated art museums. In all of these artists' groups, the reclaiming of African culture for cultural and political reasons was motivated by a revival of pan-Africanism throughout the world. The formal elements of art, exemplified by the works of Ben Jones (b 1942), Jeff Donaldson (1932–2004), Wadsworth Jarrell (b 1929) and Barbara Jones-Hogu (1938–78), embraced styles and motifs that appeared African by way of appropriated forms, symbols, colors and rhythmic design compositions.

During this period of black self-affirmation, African American writers, as well as performing and visual artists, made black culture and the political struggles of black peoples worldwide their *raison d'être*. Slogans such as "Black Is Beautiful" and "Black Power," as well as jazz and soul music, became the foundational basis for works by painter Murry

DePillars (1938–2008), mixed-media artist Ben Jones and muralist Dana Chandler. Jeff Donaldson, a co-founder of the Chicago-based black artist collective AFRICOBRA, not only added to this environment with his own jazz and African textile-inspired and mixed-media works, but he also wrote influential art manifestos and helped organize international expositions of black artists in Africa and North America.

It was also during these turbulent years of the Black Arts Movement that many artists whose careers extended back to the 1930s and 1940s resurfaced with a renewed sense of racial solidarity and political engagement. Painters Lois Jones, John Biggers and sculptor and printmaker Elizabeth Catlett all aligned themselves with the younger generation of black artists, creating works that underscored their shared interest in African sensibilities, the black figure and the continuing struggle for civil rights.

[*See also* AFRICOBRA; Biggers, John; Catlett, Elizabeth; Chase-Riboud, Barbara; Edwards, Melvin; Hammons, David; Jones, Lois; New Negro movement; Ringgold, Faith; *and* Saar, Betye.]

BIBLIOGRAPHY

S. Patton:, *African-American Art* (New York, 1998)

J. E. Smethurst: *The Black Arts Movement: Literary Nationalism in the 1960s and 1970s* (Chapel Hill and London, 2005)

L. G. Collins and M. N. Crawford, eds.: *New Thoughts on the Black Arts Movement* (New Brunswick, NJ, 2006)

James Smalls

Blackburn, Joseph

(b c. 1730; d after 1778), English painter, active in the American colonies. Blackburn first appeared in Bermuda in August 1752, and in a matter of months he had painted many of the island's leading families. Approximately 25 of these portraits survive (e.g. *Mrs. John Harvey*, Paget, Bermuda, priv. col.); these demonstrate considerable skill in the painting of lace and other details of dress. Because of these abilities, it is thought that he probably began his career in one of the larger studios in London as a drapery specialist.

By the end of 1753 Blackburn set out for Newport, RI. His portrait of *Mrs. David Chesebrough* (New York, Met.), signed and dated 1754, is the earliest mainland portrait to survive. In the following year he proceeded to Boston where, with John Smibert dead and Robert Feke and John Greenwood departed, only two younger painters, Nathaniel Smibert (1735–56) and John Singleton Copley, were in competition. Blackburn's grandest picture, *Isaac Winslow and his Family* (1755; Boston, MA, Mus. F.A.), a stylish and sizeable group portrait, indicates the level of success Blackburn achieved in Boston; however, not accustomed to painting group compositions, he employed three single portrait formats, tentatively linked by outstretched hands.

Over the next four years Blackburn painted more than 30 portraits for the upper levels of Boston society. He used a light, pastel palette that recalled that of Joseph Highmore, although Blackburn's handling of paint is not as fresh. He was not concerned with expressing the character of his sitters, but rather their chalky flesh tones with fashionably rouged cheeks, artful gestures and exquisite trappings. Part of Blackburn's overt success may be attributable to his willingness to enhance his sitters' appearance. His attention to meticulously rendered lace, diaphanous neckerchiefs and delicate bows, in addition to attractive likenesses, enchanted his female sitters. Unfortunately for Blackburn, John Singleton Copley was a fast learner and within a year was skillfully emulating the visitor's success with such portraits of his own as *Ann Tyng* (Boston, MA, Mus. F.A.). By 1758 Copley was threatening Blackburn's pre-eminence, which may have influenced the latter's decision to move to Portsmouth, NH, that year. After five years there, Blackburn returned to England. His signed and dated English portraits range from 1764 to 1778. A Mr. Blackburn, possibly the same artist, exhibited three history pictures at the Free Society of Artists in 1769.

[*See also* Boston.]

BIBLIOGRAPHY

L. Park: *Joseph Blackburn: A Colonial Portrait Painter with a Descriptive List of his Works* (Worcester, MA, 1923)

J. H. Morgan and H. W. Foote: "An Extension of Lawrence Park's Descriptive List of the Work of Joseph Blackburn," *Proc. Amer. Antiqua. Soc.*, xlvi (1936), pp. 15–81

C. H. Collins Baker: "Notes on Joseph Blackburn and Nathaniel Dance," *Huntington Lib. Q.*, ix (1945), pp. 33–47

W. B. Stevens Jr.: "Joseph Blackburn and his Newport Sitters, 1754–1756," *Newport Hist.*, xl (1967), pp. 95–107

A. Oliver: "The Elusive Mr. Blackburn," *Colon. Soc. MA*, lix (1982), pp. 379–92

W. Craven: *Colonial American Portraiture* (Cambridge, 1986), pp. 296–304

A Brush with History: Paintings from the National Portrait Gallery (exh. cat. by C. K. Carr and E. G. Miles, Washington, DC, N.P.G., 2001)

Richard H. Saunders

Blackburn, Robert

(*b* Summit, NJ, 10 Dec 1920; *d* New York, NY, 21 April 2003), printmaker and educator. Robert Blackburn's family moved to Harlem when he was six years old. Blackburn attended meetings at "306" and learned lithography in 1938 at the Harlem Community Art Center. He earned a scholarship to the Art Students League from 1940 to 1943 and worked for the Harmon Foundation in the mid-1940s. In 1948, he opened the Printmaking Workshop (PMW) in Chelsea, a cooperative where he and his friends could pursue experimental fine art lithography. By 1955, students from S. W. Hayter's Atelier 17, an experimental intaglio workshop, were in attendance. Blackburn earned his living by teaching lithography and printing editions for artists. He became one of the first black technicians at Cooper Union. From 1952 to 1953, Blackburn went to Paris on a John Hay Whitney traveling fellowship, where he worked at the Jacques Desjobert Workshop and then traveled around Europe. He returned to New York and his Printmaking Workshop in 1957 and was hired by Tatyana Grosman as the first Master Printer at the newly founded Universal Limited Art Editions (ULAE) in West Islip, Long Island. Blackburn worked

at ULAE until 1962. While there, he printed ULAE's first 79 lithographic editions with the artists Jim Dine, Helen Frankenthaler, Grace Hartigan, Jasper Johns, Robert Motherwell, Robert Rauschenberg and Larry Rivers.

Blackburn incorporated the PMW as a nonprofit organization in 1971. He exhibited, lectured and taught internationally, including at Columbia University, New York. Blackburn has been a recipient of a MacArthur Award (1992), among many other honors, and the PMW (now a program of the Elizabeth Foundation for the Arts) remains the oldest and largest nonprofit print workshop in the USA.

Blackburn continued to work until his death in 21 April 2003, completing a major series of mosaics for New York's MTA "Arts for Transit Program" in the 116th Street and Lexington Avenue 6 train subway stop.

[*See also* Universal Limited Art Editions.]

UNPUBLISHED SOURCES

Washington, DC, Smithsonian Inst., Archvs Amer. A. [transcript of interview of Robert Blackburn by Paul Cummings, 4 Dec 1970; audiotape of interview of Robert Blackburn by Karl Fortess, 10 June 1972]

BIBLIOGRAPHY

Through A Master Printer: Robert Blackburn and the Printmaking Workshop. (exh. cat. by N. Parris and H. Green, Columbia, SC, Mus. A., 1985)

Will Barnet-Bob Blackburn: An Artistic Friendship in Relief (exh. cat. by B. Lekatsas, LaGrange, GA, Cochran Collection, 1997)

D. Cullen: *Robert Blackburn: American Printmaker* (PhD diss., New York, City U., 2002)

Deborah Cullen

Black Mountain College

Experimental liberal arts college at Black Mountain, NC, open from 1933 to 1957. In the 1940s and early 1950s Black Mountain College was a center for a group of painters, architects, musicians and poets associated particularly with the development of abstract art and performance and multimedia work, crossing many disciplines. It was founded by John Andrew Rice (1888–1968) and a group of students and faculty from Rollins College, Winter Park, FL. It was located in the Blue Ridge Assembly Buildings, *c*. 29 km east of Asheville, NC, until 1941, when it moved to nearby Lake Eden until its closure. The progressive ideas of John Dewey influenced the integration of formal education with community life, the absence of conventional grades and credits and the central importance accorded to the arts. The college was owned and administered by the faculty. The setting was modest, and fewer than 1200 students attended in 24 years.

In the founding year Josef Albers, the first of many European refugees to teach at Black Mountain, came from Germany to teach art. Through his activities the college disseminated Bauhaus teaching methods and ideas into American culture. The visual arts curriculum included courses in design and color that later became a standard part of art education, as well as workshops in weaving, wood-working, printing, photography and bookbinding. Anni Albers, a former Bauhaus student, developed a weaving course that emphasized designing for industrial production. Xanti Schawinsky (1904–79), who studied with Oskar Schlemmer at the Bauhaus, taught art and stage studies from 1936 to 1938 and directed *Spectodrama: Play, Life, Illusion*, one of the earliest performances of abstract theater in the USA.

In 1944 Black Mountain College sponsored the first of its annual summer arts programs, which attracted many major artists for intense periods of teaching and participation in concerts, exhibitions, lectures and drama and dance performances. Among the European artists who taught were Lyonel Feininger, Walter Gropius, Leo Lionni (1910–99), Amédée Ozenfant (1886–1966), Bernard Rudofsky (1905–88) and Ossip Zadkine (1890–1967). Other summer staff included Leo Amino (1911–89), John Cage, Mary Callery (1903–77), Merce Cunningham, Willem de Kooning, Buckminster Fuller,

Jacob Lawrence, Barbara Morgan and Robert Motherwell. Ilya Bolotowsky taught from 1946 to 1948.

After Josef Albers left in 1949, the central figure in the community was the poet and critic Charles Olson (1910–70), who taught at the college in 1948–9 and returned in 1951. Under his direction the college became a center for the formulation of a new poetics based on open form and "projective verse." The *Black Mountain Review*, edited by Robert Creeley (1926–2005), was one of the most influential small-press journals of the period, and the college played a formative role in the revival of the small-press movement in the USA. Creeley, Joseph Fiore (1925–2008), M. C. Richards (1916–99) and Robert Duncan (1919–88) were among the members of the young American staff. A ceramics course was added to the curriculum and the faculty included Robert Turner (1913–2005), Karen Karnes (*b* 1925) and David Weinrib (*b* 1924). The summer sessions in the arts brought many artists to the campus, including Harry Callahan, Shōji Hamada (1894–1978), Franz Kline, Bernard Leach (1887–1979), Ben Shahn, Aaron Siskind, Jack Tworkov and Peter Voulkos.

Albers and the other European refugee artists brought the spirit of modernism to the progressive, experimental spirit of the founders, and the fusion of these dynamic movements culminated in a creative atmosphere and an intense, intellectual community, receptive to experimental ventures in the arts. It was at Black Mountain College that Buckminster Fuller attempted to raise his first dome in 1948, that John Cage staged his first work of performance art using chance procedures in 1952 and that the Cunningham Dance Company was founded in 1953. Through the work of its students, among them Ruth Asawa, John Chamberlain, Ray Johnson, Kenneth Noland, Robert Rauschenberg, Dorothea Rockburne, Kenneth Snelson, Cy Twombly, Stanley Vanderbeek (1927–84) and Jonathan Williams (1929–2008), the college played a formative role in the definition of an American aesthetic and identity in the arts during the second half of the 20th century.

[*See also* Cage, John; Cunningham, Merce; *and* Design.]

UNPUBLISHED SOURCES

The papers of Black Mountain faculty and students are located in archives throughout the USA and Europe. The North Carolina State Archives have the most extensive collection, including the official college papers.

Asheville, NC. Black Mountain College Museum + Arts Center [Papers of BMC faculty and students]

New York, NY. Black Mountain College Project [Papers of BMC faculty and students]

Raleigh, NC State Archvs [Black Mountain College Papers; Black Mountain College Research Project Papers; 1933–73; Theodore and Barbara Loines Dreier Papers, 1925–88 (P.C. 1956); Martin Duberman Collection, 1933–80 (P.C. 1678); and other private collections.]

Storrs, CT. University of Connecticut. Thomas J. Dodd Research Center [Charles Olson Research Collection]

BIBLIOGRAPHY

A. Lovejoy and A. Edwards: "Academic Freedom and Tenure: Rollins College Report," *Bull. Amer. Assoc. U. Prof.*, 19 (Nov 1933), pp. 416–39

J. A. Rice: "Black Mountain College," *Prog. Educ.* 11 (April–May 1934), pp. 271–4

L. Adamic: "Education on a Mountain: The Story of Black Mountain College," *Harper's* 172 (April 1936), pp. 516–30. Uncut version in L. Adamic, *My America* (New York, 1938); condensed in *Reader's Digest* (June 1936)

J. A. Rice: "Fundamentalism and the Higher Learning," *Harper's* 174 (May 1937), pp. 587–96

R. Creeley, ed.: *The Black Mountain Review*, vols. 1–7 (Black Mountain, NC, 1954–7)

F. Dawson: *The Black Mountain Book* (New York, 1970)

M. E. Harris: *The Arts at Black Mountain College* (Cambridge, MA, 1987)

M. Lane, ed.: *Black Mountain College: Sprouted Seeds, An Anthology of Personal Accounts* (Knoxville, 1990)

Remembering Black Mountain College (exh. cat., ed. M. E. Harris; Black Mountain, NC, Coll., Mus. & A. Cent., 1996)

Black Mountain College: Experiment in Art (exh. cat., ed. V. Katz; Black Mountain, NC, Coll., Mus. & A. Cent., 2003)

M. Rumaker: *Black Mountain Days* (Asheville, NC, 2004)

Starting at Zero: Black Mountain College 1933–57. (exh. cat. by C. Collier and M. Harrison; Bristol, Arnolfini Gal.; and Cambridge, U. Cambridge, Kettle's Yard, 2005)

The Shape of Imagination: Women of Black Mountain College (exh. cat. by C. Bostic, Black Mountain, NC, Coll., Mus. & A. Cent., 2008)

C. D. Zommer and N. House: *Fully Awake* (Elon, 2008)

M. Duberman: *Black Mountain College: An Exploration in Community* (New York, 1972/R 2009)

Mary Emma Harris

Bladen, Ronald

(*b* Vancouver, BC, 13 July 1918; *d* New York, 3 Feb 1988), painter and sculptor of Canadian birth. Bladen's large-scale, seemingly austere black sculptures helped launch the Minimalist movement and influenced such artists as Carl Andre, Donald Judd, Robert Morris and Sol LeWitt. Beginning his career in the arts at the Vancouver School of Art in 1937, (Charles) Ronald (Wells) Bladen moved to San Francisco in 1939 and continued his academic training at the California School of Fine Arts. Like many whose first foray in the arts took place in the late 1940s and early 1950s, Bladen began working under the influence of Abstract Expressionism and focused predominantly on drawing and painting. His works on paper were swirling, symbolist charcoal gestures derived from the musings of Beat generation philosophers, poets and friends. His paintings were spiritually inspired, intensely colored and thickly textured abstractions reminiscent of the mythical ideals of Clyfford Still.

In 1956, Bladen moved to New York City where he helped found the Brata Gallery artist cooperative. By the beginning of the next decade, Bladen's work underwent a major shift: sculpture replaced drawing and painting and, on the surface, stark Minimalism appeared to replace Romantic Expressionism. Gigantic black forms became his trademark; geometric sculptures that could occupy entire gallery spaces and yet appear weightless and playful, rather than precarious and foreboding. Bladen's monumental sculptural transformation debuted with much fanfare in 1966 with *Three Elements* (1965), part of the decisive Minimalist exhibition, *Primary Structures*, at the Jewish Museum. *Three Elements* was a trio of 10-ft-tall, freestanding, identical, rhomboid structures,

each slanted at an angle just short of 90°. The critical buzz continued in 1968 as a result of *X* (1967), a two-story piece installed as part of *Scale as Content* exhibition at the Corcoran Gallery of Art in Washington, DC. Other important works from the period include *Curve* (1969) and *The Cathedral Evening* (1969).While the two-toned, U-shaped *Curve* has often been cited as a precursor to Richard Serra's lilting steel forms, *The Cathedral Evening* was noteworthy for its gravity-defying, cantilevered V-shape that dynamically suggests the path of a sharply thrown boomerang launched from, and returning toward, two sturdy trapezoidal blocks on the gallery floor.

Unlike the sculptures of Tony Smith, to which those of Bladen are often compared, Bladen's works were not as physically heavy or psychologically weighty as traditional Minimalist pieces—they soared. Full of personality, exaltation and rapture, Bladen's sculptures were spirited and emotional and invited the viewer to feel the same. While his sculptures appeared simple and streamlined, or looked to be fabricated from industrial materials, their appearances were deceiving. They were in fact highly engineered wooden frames, covered in a bolted-down plywood skin and painted black, with trace evidence of cracks and brush stokes still visible. Thus, a close examination of Bladen's works (and countless renderings, models and maquettes) reveals—quite literally—a sculptor more interested in the sense of drama and presence his sculptures could produce than in their materiality, or in disguising his own hand. By pursuing his own brand of sculpture, Bladen paradoxically created a body of work that inspired a generation of Minimalists and yet remained remarkably true to his Expressionist origins.

BIBLIOGRAPHY

W. Berkson: "Ronald Bladen: Sculpture and Where We Stand," *A. & Lit.*, xii (Spring 1967), pp. 139–50

S. Ellis: "Expanded Pictograms," *A. America*, lxxv (1987), pp. 204–9

S. Westfall: "Ronald Bladen at Washburn," *A. America*, lxxvii (1989), p. 141

Ronald Bladen: Early and Late (exh. cat., San Francisco, CA, MOMA, 1991)

Ronald Bladen, 1918–1988: Drawings and Sculptural Models (exh. cat., Greensboro, NC, The Gallery, 1996)

T. Kellein, ed.: *Ronald Bladen Sculpture* (New York, 1998)

Mary M. Tinti

Blake, Nayland

(*b* New York, NY, 5 Feb 1960), multimedia artist, curator and writer. Blake received a BA from Bard College, Annadale on Hudson, NY, in 1982 and an MFA from the California Institute of Arts in Valencia in 1984. Upon graduation he moved to San Francisco where he worked as a curator at New Langton Arts, San Francisco, until his return to New York in 1996. Most notable of his curated exhibitions was *In A Different Light*, at the University Art Museum, Berkeley, in 1995, the first museum exhibition to examine the influence of lesbian and gay artists on contemporary art. In 2003 Blake became the founding Chair of the International Center of Photography/Bard Masters Program in Advanced Photographic Studies at the International Center for Photography in New York.

Blake's performances, installations and curated exhibitions have consistently tackled issues relating to sexuality, race and representation. In his youth the artist was influenced by Joseph Cornell, and early sculptures such as *Magic* (1991) are assemblages in this spirit. Blake's works have always exuded an element of theatricality through the inclusion of props, costumes, puppets and stages. Not least of all is Blake's use of his own body in his performances and video installations, which frequently blur the line between care and punishment. *Gorge* (1998) is a video work that depicts the artist sitting bare-chested in an empty room. As the clock on the wall behind him keeps time, the artist is continually fed for the duration of an hour by a similarly bare-chested African American man. This act simultaneously sets up reciprocal dichotomies of dominance and servitude, pain and pleasure between the two men. *Feeder*, an installation also from 1998, comprised a life-sized house composed of gingerbread. The two works were initially installed alongside each other so that the pervasive smell of gingerbread overwhelmed the viewer as they experienced the video. Another video piece, *Starting Over* (2000), documents the artist in a bunny suit, weighted to equal his then lover, Philip Horvitz's, body weight. Blake is recorded laboriously performing a tap dance directed offstage by Horvitz. Rabbits appear as a reoccurring motif within Blake's visual vocabulary and alternately signify sexual stereotypes of gay men as sexually promiscuous and Brer Rabbit as a symbol of African American representation (Blake's father was African American), both in relation to his self-identification as a bi-racial gay artist.

BIBLIOGRAPHY

Nayland Blake (exh. cat., Berkeley, U. CA, A. Mus., 1989)

Nayland Blake: Hare Attitudes (exh. cat., Houston, TX, Contemp. A. Mus., 1996)

Nayland Blake: Some Kind of Love: Performance Video 1989–2002 (exh. cat. by I. Berry, Saratoga Springs, NY, Skidmore Coll., Frances Young Tang Teaching Mus. & A.G., 2003)

Michelle Yun

Blakelock, Ralph Albert

(*b* New York, 15 Oct 1847; *d* Elizabethtown, NY, 9 Aug 1919), painter. One of the most important visionary artists in late 19th-century America, Blakelock was self-taught as a painter. From 1867 he was exhibiting landscapes in the style of the Hudson River school at the National Academy of Design in New York. Rather than going abroad for advanced training, like most of his contemporaries, he spent the years 1869–72 in the western USA. Back in New York, Blakelock evolved his personal style during the 1870s and 1880s. Eschewing literal transcriptions of nature, he preferred to paint evocative moonlit landscapes such as *Moonlight* (Washington, DC, Corcoran Gal. A.). These paintings, almost never dated, often included campfires or solitary figures, but such elements were absorbed into the setting rather than being the painting's focus, as in *Moonlight Indian Encampment*

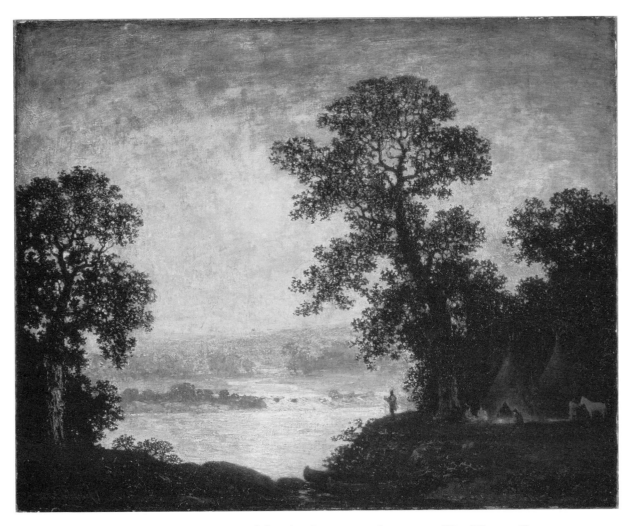

RALPH ALBERT BLAKELOCK. *Moonlight Indian Encampment*, oil on canvas, 688 × 868 mm, 1885–9.
SMITHSONIAN AMERICAN ART MUSEUM, WASHINGTON, DC/ART RESOURCE, NY

(Washington, DC, Smithsonian Amer. A. Mus.). Blakelock's images, imbued with a melancholy that had been evident even in his early work, drew on his deeply felt response to nature.

Blakelock's technique was as individual as his subject; the surfaces, sensuously textured, were built up of layers of thick pigment, although his use of bitumen has disfigured some of his work. Blakelock's unconventional paintings were not well received, and he sold them for meager sums to a few private patrons and through minor New York auction houses and art dealers to support his nine children. Financial distress led to mental breakdown, and in 1899 Blakelock was confined to a mental institution, where he spent most of the rest of his life. Ironically, Blakelock's unique artistry soon gained appreciation and brought substantial prices, from which neither he nor his family benefited. The popularity of his work has also encouraged numerous forgeries.

BIBLIOGRAPHY
E. Daingerfield: "Ralph Albert Blakelock," *A. America*, ii (Dec 1913), pp. 55–68; rev. as *Ralph Albert Blakelock* (New York, 1914); rev. *A. America*, li (Aug 1963), pp. 83–5

Ralph Albert Blakelock Exhibition (exh. cat. by L. Goodrich, New York, Whitney, 1947)

Ralph Albert Blakelock, 1847–1919 (exh. cat. by N. A. Geske, Lincoln, U. NE, Sheldon Mem. A.G.; Trenton, NJ State Mus., 1975)

D. Evans: "Art and Deception: Ralph Blakelock and his Guardian," *Amer. A. J.*, xix/1 (1987), pp. 39–50

A. Theroux: "Artists who Kill and Other Acts of Creative Mayhem," *A. & Ant.* (Summer 1988), pp. 95–8

A. A. Davidson: "Art and Insanity, One Case: Blakelock at Middletown," *Smithsonian Stud. Amer. A.*, iii/3 (1989), pp. 54–71

E. Tebow: "Ralph Blakelock's *The Vision of Life/The Ghost Dance: A Hidden Chronicle*," *Mus. Stud.*, xvi/2 (1990), pp. 166–72

A. A. Davidson: *Ralph Albert Blakelock* (University Park, PA, 1996)

Ralph Albert Blakelock, 1847–1919: Paintings (exh. cat. by P. Auster, F. Bancroft and F. Skloot, New York, Salander-O'Reilly Gals, 1998)

Landscape at the Millennium (exh. cat., by D. Dreishpoon and J Pfahl, Buffalo, NY, Albright-Knox A. G., 1999)

R. L. McGrath: *Gods in Granite: The Art of the White Mountains of New Hampshire* (Syracuse, NY, 2001)

G. Vincent: *The Unknown Night: The Madness and Genius of R. A. Blakelock, An American Painter* (New York, 2003)

N. A. Geske: *Beyond Madness: The Art of Ralph Blakelock, 1847–1919* (Lincoln, NE, 2007)

The Unknown Blakelock (exh. cat., K. Janovy, ed., Lincoln, NE, Sheldon Mem. A. G., 2008)

Lauretta Dimmick

Blashfield, Edwin Howland

(*b* Brooklyn, New York, 15 Dec 1848; *d* South Dennis, MA, 12 Oct 1936), painter and writer. Although born in New York, Edwin Blashfield was raised and educated in Massachusetts, where he attended Boston Latin School and the Massachusetts Institute of Technology. On the advice of William Morris Hunt, Blashfield abandoned engineering and traveled to Europe, where he resided from 1867 to 1871. Two years later he returned to Paris, where he studied with the academic painter Léon Bonnat (1833–1922) and began to exhibit at the annual Salon. He married Evangeline Wilbour in 1881 shortly before returning to New York. He would later collaborate with his wife on *Italian Cities* (1900) and a new edition of Vasari's *Lives of Seventy of the Most Eminent Painters . . .* (1897). His first wife died in 1918; ten years later he married Grace Hall.

Blashfield is best known for the contribution he made to the development of American mural painting and municipal art beginning with his murals for George B. Post's Manufacturer's and Liberal Arts Building at Chicago's 1893 World's Columbian Exposition. He continued to collaborate with Post on the New York residence of Collis P. Huntington (1894, removed to Yale University Art Gallery in 1926), the Great Hall of City College, New York (1907–8), and the Wisconsin State Capitol (1908) in Madison. He also worked for Cass Gilbert contributing mural paintings to the Minnesota State Capitol (1904) in St Paul, the Essex County Courthouse, Newark, NJ, and the Detroit Public Library (1921–2). Other civic work included murals for the Library of Congress's main reading room (1896–7), New York's Appellate Division Courthouse (1899), and two other state capitols: Des Moines, IA (1905), and Pierre, SD (1910).

His murals often refer to local history as in *Minnesota Granary of the World* and *The Discoverers and Civilizers of the Mississippi*, both painted for Minnesota's state capitol. Marked by the use of personification and allegory combined with historical figures, Blashfield in his mural programs sought to communicate the dignity and timelessness of a community's past. His linear, academic style, first learned in France, was greatly influenced by the art of the Italian Renaissance, although in his work at the Library of Congress there can be found the impress of English book illustration and the hieratic design of Byzantine mosaics.

Blashfield was a founding member of New York's Municipal Art Society (1893) and the National Society of Mural Painters (1895) and president of the latter institution in 1914. He also served as president of the Society of American Artists (1895–6) and the National Academy of Design (1920–26). He was a member of the Royal Academy in London, the American Academy of Arts and Letters, the American Federation of Arts and the National Commission of Fine Arts. He received a medal of honor from the New York Architectural League and was awarded the Carnegie Prize by the National Academy of Design in 1911.

WRITINGS

Mural Painting in America (New York, 1913)

BIBLIOGRAPHY

R. Cortissoz: *The Works of Edwin Howland Blashfield* (New York, 1937)

L. Amico: *The Mural Decorations of Edwin Blashfield* (Williamstown, MA, 1978)

Sally Webster

Bleckner, Ross

(*b* New York City, May 13, 1949), abstract painter. Bleckner received a BA in 1971 from New York University, where he studied with Chuck Close. He completed the MFA in 1973 at the California Institute of Arts. There Minimalism and conceptual art dominated among the instructors. In 1974 he returned to New York and set up a studio in SoHo. In 1975, he was included in a group show at Paula Copper Gallery and in the Whitney Biennial. In 1978, he joined fellow artists David Salle and Julian Schnabel by exhibiting at the Mary Boone Gallery. At the time he was producing striped paintings that were very different from the luminous paintings he produced later.

When his work is non-representational it often incorporates visual optical effects with themes related to loss and sadness. Another aspect of his work has been the use of identifiable forms that function as non-objective elements. His work has often related to investigations of light combined with emotionality and Romanticism. Floral paintings represent the transience of beauty and the ephemeral nature of life. Since the 1980s his work has been related to themes of loss and memory. Often he addresses the subject of AIDS but not through direct representation. Bleckner favors symbolic imagery and forms that seem to change focus. He noted, "Whether it's anatomical, medical, illustrational, or metaphoric, I'm trying to figure out some plausible way that things work or don't work, to look for some meaning through the language that I've chosen to speak." His signature works have been likened to cellular forms in mutation and glimpses of images that remain elusive. By blurring the painted surfaces, his subjects appear indistinct. For example, allusion to protein molecules can result from a ring of flowers. In *Small Count* of 1980, phosphorescent creatures or a starry firmament could actually refer to white blood cells depleted by AIDS. After 1990 Bleckner became more explicit in his depiction of cancerous cells, based on microscopic images or medical illustrations. The contemplation of mortality remains at the core of his art.

Solo exhibitions of Ross Bleckner's paintings have been held at San Francisco Museum of Modern Art, Carnegie Museum of Art, Kunsthalle Zurich, Milwaukee Art Museum, Astrup Fearnley Museet for Moderne Kunst in Norway, Lehman Maupin Gallery, I.V.A.M. Centre Julio Gonzalez (Spain), Cais Gallery in Seoul, Galerie Ernst Beyeler in Switzerland and many others. In 1995, the Guggenheim Museum in New York held a major respective of his work.

His work is in major collections including the Museum of Modern Art in New York City, the Whitney Museum of American Art, Museo National Centro de Arte Reina Sofia, Astrup Fearnley Museet, Albright-Knox Art Gallery, St Louis Art Museum and Museum of Fine Arts Boston as well as in many private and corporate collections.

Besides being a highly respected artist, Bleckner has been involved with philanthropic activities including serving as president of the Aids Community Research Initiative of America. In 2009, Ross Bleckner became the first artist to be appointed as a United Nations Goodwill Ambassador. For illustration see color pl. 1:III, 1.

BIBLIOGRAPHY

Ross Bleckner (exh. cat., New York, Guggenheim, 1995)

R. Bleckner: *Ross Bleckner: Watercolor* (Santa Fe and New York, 1998)

R. Milazzo: *The Paintings of Ross Bleckner* (Brussels, 2007)

Charles J. Semowich

Blegen, Carl

(*b* Minneapolis, 27 Jan 1887; *d* Athens, 24 Aug 1971), archaeologist. From 1911 to 1927 Blegen held posts at the American School of Classical Studies, Athens; from 1927 onward he was Professor of Classical

Archaeology at the University of Cincinnati. Early surveys and soundings around Corinth led to excavations at Korakou (1915–6), which established a full Bronze Age sequence for the Greek mainland, a sequence then confirmed at Zygouries (1921–2). Excavations at Nemea (1924–6) and Acrocorinth (1926) dealt mainly with classical periods. But at Prosymna in the Argolid (1925–8) Blegen exposed a large Middle and Late Helladic cemetery. Further study of burial customs and of the distribution of prehistoric sites convinced him that Greek-speakers entered Greece c. 1900 BC, a view long influential but now doubted. His excavations at Troy (1932–8) greatly refined previous findings by Heinrich Schliemann and Wilhelm Dörpfeld and suggested that Troy VIIa, not VI, was destroyed in the Trojan War. Study of the Mycenaean pottery here and elsewhere helped him, with A. J. B. Wace, to overturn (1939) Sir Arthur Evans's theory of a Cretan colonization of the mainland. During World War II he lived in Washington, DC (1942–5), and then became US cultural attaché to Athens (1945–6). His excavations at Pylos (1939, 1952–64) yielded a full picture of a late 13th-century BC Mycenaean palace, fine but fragmentary frescoes and Linear B tablets, which helped confirm Michael Ventris's simultaneous decipherment. His meticulous excavations, wide knowledge and cautious judgments laid much of the basis for the study of Greek prehistory.

WRITINGS

with A. J. B. Wace: "Pre-Mycenaean Pottery of the Mainland," *Annu. Brit. Sch. Athens*, xxii (1916–8), pp. 175–89

Korakou: A Prehistoric Settlement near Corinth (Boston and New York, 1921)

Zygouries: A Prehistoric Settlement in the Valley of Cleonae (Cambridge, MA, 1928)

Acrocorinth: Excavations in 1926 (1930), III/i of *Corinth* (Cambridge, MA, and Princeton, NJ, 1929–)

Prosymna: The Helladic Settlement Preceding the Argive Heraeum, 2 vols (Cambridge, 1937)

Troy: Excavations Conducted by the University of Cincinnati, 1932–1938, 4 vols (Princeton, NJ, 1950–58)

The Palace of Nestor at Pylos in Western Messenia, 3 vols (Princeton, NJ, 1966–73)

BIBLIOGRAPHY
Obituary, *Gnomon*, xlv (1973), pp. 222–4
Obituary, *The Times* (26 Aug 1971)

Donald F. Easton

Bliss

Collectors. Robert Woods Bliss (*b* St Louis, MO, 5 Aug 1875; *d* Washington, DC, 19 April 1962) and his wife, Mildred Bliss (née Barnes) (*b* New York City, Sept 1879; *d* Washington, DC, 17 Jan 1969), developed their interest in art while living abroad, where Robert Bliss served as a diplomat until his retirement in 1933. They were particularly concerned with the then neglected areas of Pre-Columbian and Byzantine art. Their Byzantine collection included coins, icons, ivories, mosaics, jewelry and textiles; their Pre-Columbian collection was similarly wide ranging. In 1920 Robert and Mildred Bliss purchased Dumbarton Oaks, a large house in the Georgetown area of Washington, DC. Although they lived there intermittently for only seven years, they extensively renovated the house and 16-acre garden. Frederick H. Brooke (*d* 1960) was the architect responsible for removing the Victorian accretions and adding the music room; from 1922 to 1933 the landscape architect Beatrix Jones Farrand worked on the garden. Robert Bliss was a Harvard graduate, and in 1940 the couple donated Dumbarton Oaks and their collection to Harvard University. They continued to enrich the collection until Robert Bliss's death. Dumbarton Oaks became a center for Byzantine studies and also serves as a research facility in the areas of landscape architecture and Pre-Columbian civilization.

[*See also* Farrand, Beatrix Jones.]

BIBLIOGRAPHY
H. Cairns: *Robert Woods Bliss* (Washington, DC, 1963)
Handbook of the Robert Wood Bliss Collection of Pre-Columbian Art (Washington, DC, Dumbarton Oaks, 1963)
W. Whitehill: *Dumbarton Oaks* (Cambridge, MA, 1967)
E. H. Boone, ed.: *Andean Art at Dumbarton Oaks* (Washington, DC, 1996)
L. Lott: *Garden Ornament at Dumbarton Oaks* (Washington, DC, 2001)

Anne McClanan

Bliss, Lillie P.

(*b* Boston, MA, 11 April 1864; *d* New York, 12 March 1931), collector, museum founder and patron. Lillie [Lizzie] P(lummer) Bliss was born into an affluent family and discovered modern art through her friendship with the painter Arthur B. Davies. In 1907 she purchased her first painting by Davies and eventually had the largest private collection of his work. Bliss toured galleries with Davies and at the Armory Show (1913) purchased, on his advice, two paintings by Redon, two by Renoir and an oil and a pastel by Degas. She later turned to more avant-garde modernism, acquiring 27 works by Cézanne, and became a great supporter of modern art during the next 15 years, although she was asked by her family not to display her collection in public.

Bliss was one of the co-founders of the Museum of Modern Art (MOMA), New York, in 1929, and was vice-president at the time of her death. She bequeathed paintings to the Metropolitan Museum of Art, New York, and the Corcoran Gallery, Washington, DC, but principally to MOMA, which celebrated the acquisition of over 150 works with a memorial exhibition. Her collection became the core of the museum's extensive holdings of works by Cézanne, Matisse and other pioneering French modernists.

[*See also* Prendergast, Maurice.]

BIBLIOGRAPHY

Memorial Exhibition of the Collection of the Late Miss Lizzie P. Bliss, Vice-President of the Museum (exh. cat., New York, MOMA, 1931)

Modern Masters from the Collection of Miss Lizzie P. Bliss (exh. cat., Indianapolis, John Herron A. Inst., 1932)

M. W. Brown: *The Story of the Armory Show* (New York, 1963)

S. Klos: "Dumbarton Oaks Research Library: A 21st Century Transformation," *A. Lib. J.*, 32/4 (2007), pp. 4–10

David M. Sokol

Bloom, Barbara

(*b* Los Angeles, CA, 11 July 1951), sculptor. Bloom studied at the California Institute of the Arts, Los Angeles, with John Baldessari, Robert Irwin and James Lee Byars. In 1974 Bloom moved to Amsterdam; she later divided her time between New York and Berlin. She became known for her installations, through which she questioned the relationship between vision and desire. In several groups of works she uses photographic images of parapsychological events to bring issues of the uncanny and unconscious into the realm of the viewers' perception and reception of art. Absence, which establishes the conditions for desire, is symbolized by photographs of séances, UFOs or infra-red images. The photographic medium enhances the effect of historical record, while highlighting the absence inherent in the attempt to document events and objects that do not exist. In a well-known work, *The Collection: The Reign of Narcissism* (mixed-media installation, 1989), Bloom meticulously recreated a very bourgeois interior with furnishings and accessories to examine the home and how it structures our understanding of ourselves and the world. Also, in an ironic take on artistic identity, the space was filled with objects self-glorifying the person and accomplishments of a fictive "Barbara Bloom." In dealing with the home, the familiar or the native (*heimlich*), it complements other work exploring the uncanny (*unheimlich*) and also questions how identity is created. Bloom was known as an artist who questioned and explored how the fictions of identity and desire are created. A 2008 retrospective, *The Collections of Barbara Bloom*, showcased photographs of works both made and found that reflected not a summing up of the artist's ouevre so much as works displaying her tastes and cultural aplomb.

BIBLIOGRAPHY

Ghost Writer (exh. cat., Berlin, Daad Gal., 1988) [incl. essays and stories by Bloom and others]

D. Rimanelli: "Barbara Bloom and her Art of Entertaining," *Artforum*, xxviii/2 (1989), 142–6

Barbara Bloom: Never Odd or Even (exh. cat. by D. Goldmann; Munich, Kstver., 1992)

The Collections of Barbara Bloom (exh. cat., by D. Hickey, New York, Int. Cent. Phot., 2008)

Bloom, Hyman

(*b* Brinoviski, Latvia, 29 March 1913; d. Nashua, NH 26 August 2009), painter of Latvian birth. Bloom went to the USA when he was seven and received his early artistic training at the West End Community Center in Boston. He studied art with Denman Ross (1853–1935) of Harvard University, as a fellow pupil of Jack Levine. Among the paintings that he saw at the Museum of Fine Arts in Boston, he was particularly attracted to the thickly painted and richly colored works of Georges Rouault and Chaïm Soutine. The first recognition of his expressionistic canvases came with his inclusion in the *Americans 1942* exhibition at the Metropolitan Museum of Art, New York.

Although superficially similar to Abstract Expressionism in their use of strong colors, thickly applied paint and large scale, Bloom's paintings took as their subject the human form, as a means of commenting on the human condition, for example, *Apparition of Danger* (1951; Washington, DC, Hirshhorn). His interest in mysticism was influenced by William Blake and by the philosophy of Spinoza, Kant and Ouspensky. He also produced paintings of Judaic religious life, such as *Synagogue* (1940; New York, MOMA). In later years his work became much brighter and richer in color, his interest in aspects of Abstract Expressionism more clearly grafted onto recognizable forms.

[*See also* Boston.]

BIBLIOGRAPHY

Contemporary American Painting (exh. cat. by A. Weller, Urbana, U. IL, 1952)

Hyman Bloom (exh. cat. by F. Wight, Buffalo, Albright–Knox A.G., 1954)

Four Boston Masters: Copley, Allston, Prendergast, Bloom (exh. cat., Wellesley, MA, Jewett A. Cent., 1959)

P. Halasz: "Figuration in the '40s: The Other Expresssionism," *A. America*, 70/11 (Dec 1982), pp. 110–19, 145, 147

Hyman Bloom: Paintings and Drawings (exh. cat., New York, Kennedy Gals, 1986)

Hyman Bloom: Overview, 1940–1990 (exh. cat., New York, Terry Dintenfass Gal., 1990)

H. Cotter: "Metaphor and Representation," *A. America*, 79/2 (Feb 1991), pp. 138–41, 161

Hyman Bloom: Paintings and Drawings (exh. cat., with essays by H. Cotter and D. A. Thompson, Durham, U. NH, New Hampshire, 1992)

Hyman Bloom: The Spirits of Hyman Bloom, The Sources of His Imagery (exh. cat., Brockton, MA, Fuller Mus. A., 1996)

Color and Ecstasy: The Art of Hyman Bloom (exh. cat. by Isabelle Dervaux and others, New York, N. Acad. Des., 2002)

M. Duncan: "Bloom's Way," *A. America*, 91/4 (Apr. 2004), pp. 124–9

Hyman Bloom: A Spiritual Embrace (exh. cat. by K. French, forward by Rabbi D. Sears, Framingham, MA, Danforth Mus. A., 2006)

David M. Sokol

Bluemner, Oscar

(*b* Prenzlau, Germany, 21 June 1867; *d* South Braintree, MA, 12 Jan 1938), painter and architect of German birth. Oscar [Florianus] Bluemner immigrated to the USA in 1892 after receiving his diploma and an award for a painting of an architectural subject from the Königliche Technische Hochschule, Berlin. He first worked as a draftsman at the World's Columbian Exposition, Chicago, and later designed New York's Bronx Borough Courthouse (1903). Around 1910 his professional focus moved to painting under the aegis of Alfred Stieglitz, who gave him a one-man exhibition at the 291 gallery in 1915, published his writings in *Camera Work* and recommended his inclusion in the *Forum Exhibition of Modern American Painters* (1916).

Bluemner's prismatically structured early landscapes (e.g. *Expression of a Silktown*, 1915; Trenton, NJ State Mus.) reflected his lasting interest in color theory and familiarity with the work of Paul Cézanne and Vincent van Gogh and with Neo-Impressionism. During the 1920s he concentrated on watercolors (e.g. *Eye of Fate*, 1927; New York, MOMA), whose dramatic forms and enriched palette followed his study of oriental art, Symbolist painting and such thinkers as Johann Wolfgang von Goethe, Arthur Schopenhauer, Henri Bergson and Oswald Spengler. His late pictures, painted in oil or casein, were produced in part while he was employed by the Public

Works of Art Project and were conceived as a series of *Compositions for Color Themes* (e.g., *Situation in Yellow*, 1933; New York, Whitney); they were formally inspired by classical music and iconographically influenced by Freud's ideas on the subconscious. After 1933 Bluemner signed his paintings "FLORIANUS," a Latin idealization of his own surname.

[*See also* Stieglitz, Alfred.]

WRITINGS

"Audiator et Altera Pars: Some Plain Sense on the Modern Art Movement," *Camera Work* (June 1913), pp. 25–38

BIBLIOGRAPHY

Oscar Bluemner: American Colorist (exh. cat. by C. Coggins, M. Holsclaw and M. Hoppin, Cambridge, MA, Fogg, 1967)

F. Gettings: "The Human Landscape: Subjective Symbolism in Oscar Bluemner's Painting," *Archv Amer. A. J.*, xix/3 (1979), pp. 9–14

Oscar Bluemner (exh. cat. by J. Zilczer, Washington, DC, Hirshhorn, 1979)

J. Hayes: "Oscar Bluemner's Late Landscapes: The Musical Color of Fateful Experience," *A. J.*, xxxxiv/4 (1984), pp. 352–60

Oscar Bluemner: Landscapes of Sorrow and Joy (exh. cat. by J. Hayes, Washington, DC, Corcoran Gal. A., 1988)

J. Hayes: *Oscar Bluemner* (Cambridge, 1991)

O. Bluemner: *A Daughter's Legacy* (exh. cat. by R. Favis, DeLand, FL, Stetson U., 2004)

Bluemner on Paper (exh. cat. by J. Hayes, New York, NY, B. Mathes Gal., 2005)

Oscar Bluemner: A Passion for Color (exh. cat. by B. Haskell, New York, NY, Whitney, 2005)

Jeffrey R. Hayes

Blum, Robert Frederick

(*b* Cincinnati, OH, 9 July 1857; *d* New York, 8 June 1903), painter and illustrator. The son of German American parents, he probably became interested in magazine illustration while an apprentice at Gibson & Co. lithographers in Cincinnati during 1873 and 1874. He began drawing lessons at the McMicken School of Design (now the Art Academy of Cincinnati) *c.* 1873, transferring to the Ohio Mechanics Institute in 1874. Blum visited the Centennial Exposition (1876) in Philadelphia and was impressed with paintings by Giovanni Boldini (1842–1931) and Mariano Fortuny y Marsal (1838–74) and by Japanese art. He remained there for about nine months, studying at the Pennsylvania Academy of the Fine Arts.

In 1878 Blum moved to New York, where he contributed illustrations to such magazines as *St Nicholas* and *Scribner's Magazine*. Two years later he took the first of numerous trips to Europe. In Venice he met James McNeill Whistler and Frank Duveneck and under their influence took up etching. He traveled frequently with William Merritt Chase, with whom he founded the Society of Painters in Pastel, New York, which held four exhibitions, the first in 1884. Sketchy pastels made in the Netherlands (1884) and relatively large, detailed and compositionally intricate paintings such as *Venetian Lacemakers* (1887; Cincinnati, OH, A. Mus.) demonstrate his stylistic range. The latter work was initiated during the first of three visits that Blum made to Venice between June 1885 and spring 1889. These artistically productive trips were marked by extended interaction with the American colony there, including, among others, Duveneck, John H. Twachtman, Otto Bacher (1856–1909), G. Ruger Donoho (1857–1916), William Gedney Bunce (1840–1916), Charles F. Ulrich (1858–1909) and Charles Grafly.

In May 1890 Blum was sent to Japan by *Scribner's Magazine* to make illustrations for articles by Sir Edwin Arnold. He remained there for about two years, making both small sketches and ambitious works such as *The Ameya* (1892; New York, Met.), which depicts a crowded Japanese street scene. While there he twice met with Ernest F. Fenollosa, the American expert on Japanese art who was then serving as manager of the art department of the Imperial Museum and the Tokyo Fine Arts Academy before returning in the mid-1890s to become Curator of Oriental Art at the Museum of Fine Arts in Boston.

In New York in 1893 Blum began the large murals for Mendelssohn Hall, *Mood to Music* and the *Vintage Festival* (both New York, Brooklyn Mus.). He was

working on murals for the New Amsterdam Theater when he died of pneumonia.

WRITINGS

"Technical Methods of American Artists, vi: Pen and Ink Drawing," *The Studio*, iii (3 May 1884), pp. 173–5

"An Artist in Japan," *Scribner's Mag.*, xiii (April–June 1893), pp. 399–414, 624–36, 729–49

BIBLIOGRAPHY

Robert F. Blum, 1857–1903: A Retrospective Exhibition (exh. cat., ed. R. J. Boyle; Cincinnati, OH, A. Mus., 1966)

B. Weber: *Robert Frederick Blum (1857–1903) and his Milieu* (diss., New York, City U., 1985)

After Whistler: The Artist and His Influence on American Painting (exh. cat. by L. Merrill, Atlanta, GA, High Mus. A., 2003)

Whistler and his Circle in Venice (exh. cat. by E. Denker, Washington, DC, Corcoran Gal. A., 2003)

Carolyn Kinder Carr

Blume, Peter

(*b* Smorgon, Russia, 27 Oct 1906; *d* New Milford, CT, 30 Nov 1992), painter and sculptor of Russian birth. His parents immigrated to the USA and settled in Brooklyn, New York, *c.* 1912. He studied art from the age of 13 at evening classes, then at the Educational Alliance, the Beaux-Arts Institute of Design and the Art Students League. By 1926 he had a studio in New York. Blume's admiration for Renaissance technique largely inspired his working method: making drawings and compositional cartoons and then painstakingly transferring the images to canvas, a craftsmanlike approach that resulted in a surprisingly small body of work.

Blume's early work shows the influence of the Precisionists and was exhibited by Charles Daniel (one of the first to exhibit modernist American painting). In 1934 Blume won first prize at the Carnegie International Exhibition with the surreal *South of Scranton* (1930–31; New York, Met.). A year in Italy on a Guggenheim grant (1932) inspired his only political painting, *Eternal City* (1934–7; New York, MOMA; see color pl. 1:XIV, 3), in which Mussolini is characterized as a garish jack-in-the-box.

The figurative and literary elements of Blume's work continued into his later career despite the ascendancy of Abstract Expressionism. His pervading themes deal with discontinuity caused by destruction, distance, time and chance, and with man's attempt to unite, repair and rebuild from the fragments that remain. Stones, rocks and girders recur as iconographic motifs, for instance in *Tasso's Oak* (1956; New York, Dintenfass Gal.). *Recollection of the Flood* (1969; New York, Dintenfass Gal.) shows victims of the floods in Florence (1966) seeking shelter in a hall where restorers are already at work. This painting was followed by Blume's first sculpture, *Bronzes about Venus* (1970; New York, Dintenfass Gal.), whose deliberate references to antiquity and Mannerist art are reiterated in the painting *From the Metamorphoses* (1979; New York, Dintenfass Gal.). The latter depicts the legend of Deucalion and Pyrrha, who repopulated the world by throwing stones that turned into men, a further indication of Blume's preoccupation with the role of the artist in restoring the world through the ability to transform materials.

BIBLIOGRAPHY

Peter Blume: Paintings and Drawings in Retrospect, 1925–1964 (exh. cat., intro. C. E. Buckley; Manchester, NH, Currier Gal. A., 1964)

Peter Blume: A Retrospective Exhibition (exh. cat. by D. Adrien and P. Blume, Chicago, IL, Mus. Contemp. A., 1976)

F. Trapp: *Peter Blume* (New York, 1987)

R. Brown: "Interview with Peter Blume," *Archvs Amer. A. J.*, xxxii/3 (1992), pp. 2–13

J. Mellby: "Letters from Charles Daniel to Peter Blume," *Archvs Amer. A. J.*, xxxiii/1 (1993), pp. 13–26

M. A. White and M. Andrew: "Slicing and Dionysian: Peter Blume's Vegetable Dinner," *Amer. A.*, xiv/1 (2000), pp. 80–91

Rina Youngner

Blumenfeld, Erwin

(*b* Berlin, 26 Jan 1897; *d* Rome, 4 July 1969), photographer of German birth. In 1918, in exile in the Netherlands, Blumenfeld met George Grosz, Howard Mehring and Paul Citroen. Working already as a photographer, painter and writer, he set up a

photographic business in Paris in 1936 after the bankruptcy of his leather-goods shop in the preceding year. In 1941 he immigrated to the USA, and within two years he was one of the best paid freelance photographers, working for *Vogue*, *Life* and *Harper's Bazaar*. In 1955 he began the text of his autobiography, *Blumenfeld: Meine 100 Besten Fotos* (1979), on which he worked for the rest of his life. Blumenfeld's personal photography showed the influence of Dada. He experimented unflaggingly with the technical possibilities of photography: solarization, multiple exposures, distortions. The dominant themes throughout his work were women and death. His international reputation was based not only on his experimental photography but also on his fashion photography, which he had begun as early as 1936 in France and with which he very quickly established himself in the USA. He did not, however, choose any of his fashion or glamour photographs for the 100 in his autobiography. The images that were important to him were those in which he tried to "realize visions and penetrate unknown transparencies." The laboratory work, at which he was supremely skilled, helped him to enhance the refinement of the chosen visual angle in order to achieve a state of suspension of the real and the unreal.

PHOTOGRAPHIC PUBLICATIONS AND WRITINGS

Meine 100 Besten Fotos (Bern, 1979; trans. by P. Garner with L. Carne-Ross, with text by H. Teicher: *Blumenfeld: My One Hundred Best Photos*, New York, 1981)

Eye to I: The Autobiography of a Photographer, trans. by M. Mitchell and B. Murdoch (London, 1999)

BIBLIOGRAPHY

Contemp. Phot.

P. Mahassen: "Les Collages de Blumenfeld," *Tribune A.* (13 June 1981)

Blumenfeld: Dada Collages, 1916–1931 (exh. cat. trans. by D. Maisel, Jerusalem, Israel Mus., 1981)

Erwin Blumenfeld (exh. cat. by F. C. Gundlach and P. Weiermair, Frankfurt am Main, Kstver., 1988)

Blumenfeld: A Fetish for Beauty (exh. cat. by W. A. Ewing, in coll. with M. Schinz, London, Barbican A.G., 1996)

Y. Bluemenfeld: *The Naked and the Veiled: The Photographic Nudes of Blumenfeld* (London, 1999)

M. Métayer: *Erwin Blumenfeld* (London, 2004)

Erwin Blumenfeld: His Dutch Years, 1918–1936 (exh. cat., W. van Sinderen, with texts by H. Adkins and others, The Hague, Fotomus, 2006)

Erwin Blumenfeld: Paintings, Drawings, Collages & Photographs (exh. cat., San Francisco, CA, Mod. Gal., 2006)

Erwin Blumenfeld: I Was Nothing But a Berliner: Dada Montages 1916–1933 (exh. cat. by Helen Adkins, Berlin, Berlin. Gal. and other locations, 2008)

<div style="text-align: right">Erika Billeter</div>

Blumenschein, Ernest

(*b* Pittsburgh, PA, 25 May 1874; *d* Albuquerque, NM, 6 June 1960), painter and illustrator. Raised in Dayton, OH, Blumenschein showed an early aptitude for music, art and sports. Upon graduating from high school, he began training as a musician on a violin scholarship at the Music Academy of Cincinnati. Blumenschein left the Academy after a year and enrolled in the Art Academy of Cincinnati, where he received a prize for illustration in Fernand Lungren's class. In 1893, he moved to New York City and enrolled at the Art Students League, where his instructors included John Twachtman and Kenyon Cox. Over the course of the next 15 years, he moved back and forth between New York and Paris, periodically visiting other locales, including Taos, NM, Italy and Giverny. He twice enrolled at the Académie Julian (1894–6 and 1899), where he studied with Jean-Paul Laurens (1838–1921) and Benjamin Constant (1845–1902). In 1905, he married artist Mary Shepard Greene (1869–1958), and with the birth of their daughter in 1909, they settled in Brooklyn.

During the first decade of his career, Blumenschein supported himself as an illustrator, receiving commissions from magazines such as *Scribner's*, *McClure's*, *Harper's Weekly* and *Century* to create images for texts by some of the period's most renowned authors, including Rudyard Kipling, Stephen Crane, Hamlin Garland and Jack London. He also illustrated short stories and books by Willa Cather, Joseph Conrad, Dr Charles Eastman and Edgar

Allan Poe. Through the 1910s, he continued to support himself with illustrative work, while also establishing himself as a painter. In 1917, his wife's inheritance allowed him to turn his focus to painting. Nevertheless, he returned to illustration periodically throughout his career; for example, in 1931 he created illustrations for Erna Fergusson's *Dancing Gods: Indian Ceremonials of New Mexico and Arizona*.

Blumenschein is most well known for his images of Native American populations living in the American Southwest. An 1897 *McClure's* commission to execute drawings of Navajos first brought him to the region. Accompanied by his friend, Bert Geer Phillips, he returned to New Mexico a year later. The two were headed from Colorado to Mexico when a wagon wheel malfunction forced them to stop outside of Taos, where they decided to settle for the summer and fall. Ellis Parker Butler, Phillips and Blumenschein subsequently set in motion a plan to establish a colony of artists and writers in Taos. Blumenschein visited Taos sporadically between 1901 and 1909, at which time he became a seasonal resident. He settled there permanently around 1920.

Blumenschein's artistic output is dominated by paintings of Taos's Pueblo Indian inhabitants. He was also an accomplished painter of landscapes, portraits and figurative works, many of which featured the region's Anglo and Hispanic residents. His representations of Native Americans from the 1910s, such as *The Peacemaker* (1913; Denver, CO, Anschutz Col.), are indicative of his academic training. These works often feature heroically posed Native American figures set in a shallow foreground, standing in front of a sweeping, distant landscape. His style and subject matter were in keeping with that of a group of academically trained artists who had gathered in Taos, including E. Irving Couse, Joseph Sharp and Walter Ufer. Seeking to market their paintings of the region nationwide, these artists were among the founding members of the Taos Society of Artists, established in 1915.

During the late 1910s, Blumenschein's paintings underwent a significant stylistic shift, as is seen in

The Gift (1922; Washington, DC, Smithsonian Amer. A. Mus.). Through the 1920s and 1930s, he experimented with Post-Impressionist derived aesthetics. He intensified his palette, emphasized pattern through the flattening and repetition of forms and often restricted pictorial space by denying illusionistic perspective. He was sympathetic toward modernist trends, however, long before his paintings evidenced this influence. In 1914, he published a defense of the modernist works displayed at the 1913 Armory Show in *Century* magazine. In this article, he was particularly laudatory of paintings by Vincent van Gogh (1853–90) and Paul Gauguin (1848–1903), the two artists whose work most affected his shift in style. Blumenschein's experimentation with Post-Impressionist aesthetics manifests itself around the same time a substantial community of progressive artists, including John Sloan, Robert Henri, Stuart Davis, B. J. O. Nordfeldt and Marsden Hartley, traveled to New Mexico to paint.

Blumenschein maintained a high level of visibility on the national art scene throughout the 1940s. In 1924, he executed three murals for the Missouri State Capitol in Jefferson City. His first solo show at Grand Central Art Galleries, New York, came in 1927, the same year that he was elected Academician at the National Academy of Design. As his health declined, he spent more time in Albuquerque, NM, where he painted urban scenes during the early 1950s and where he died in 1960.

Blumenschein's career is marked by major academy prizes, the most notable of which included: Isidor Medal for best figure composition, National Academy of Design, 1912; Silver Medal, Panama–Pacific Exposition, 1916; Potter Palmer Gold Medal, Art Institute of Chicago, 1917; First Altman Prize, National Academy of Design, 1921; Ranger Fund Purchase Prize, National Academy of Design, 1923; Second Altman Prize for landscape, National Academy of Design, 1925; US Silver Medal, Sesquicentennial International Exposition in Philadelphia, 1926; Ranger Fund Purchase Prize, National Academy of Design, 1929; First Logan Price, National Academy of

Design, 1931; and Silver Medal, National Academy of Design, 1937. Blumenschein won other awards at the Carnegie International, the National Arts Club and the Salmagundi Club.

UNPUBLISHED SOURCES

Santa Fe, NM, Palace of the Governors, Fray Angélico Chávez History Library, Blumenschein Collection

Washington, DC, Smithsonian Inst., Archvs Amer. A., Ernest L. Blumenschein Papers

BIBLIOGRAPHY

V. D. Coke: *Taos and Santa Fe: The Artist's Environment, 1882–1942* (Albuquerque, NM, 1963)

Ernest L. Blumenschein Retrospective (exh. cat. by W. T. Henning, Colorado Springs, CO, F.A. Cent., 1978)

M. C. Nelson: *The Legendary Artists of Taos* (New York, 1980)

Art in New Mexico, 1900–1945: Paths to Taos and Santa Fe (exh. cat. by C. Eldredge, Washington, DC, N. Mus. Amer. A. 1986) [with essays by J. Schimmel and W. Truettner]

J. Moore: "Ernest Blumenschein's Long Journey with Star Road," *Amer. A.*, ix/3 (Fall 1995), pp. 6–27

Taos Artists and Their Patrons, 1898–1950 (exh. cat. by D. Porter and others, Notre Dame, IN, Snite Mus. A.; Tulsa, OK, Gilcrease Inst. Amer. Hist. & A.; 1999) [with essays by T. H. Ebie and S. Campbell]

C. Eldredge: "Ernest Blumenschein's *The Peacemaker*," *Amer. A.*, xv/1 (Spring 2001), pp. 34–42

Painters and the American West: The Anschutz Collection (exh. cat. by J. C. Troccoli, Denver, CO, A. Mus., 2001)

D. Witt: *Modernists in Taos: From Dasburg to Marin* (Santa Fe, 2002)

D. Porter: *Enchanted Visions: The Taos Society of Artists and Ancient Cultures* (Spokane, WA, 2005)

In the Contemporary Rhythm (exh. cat. P. Hassrick and E. Cunningham, Denver, CO, A. Mus.; Albuquerque, NM, Mus. A. & Hist.; Phoenix, AZ, A. Mus.; 2008)

Sascha Scott

Blumenthal, George

(*b* Frankfurt am Main, 7 April 1858; *d* New York, 26 June 1941), financier, collector, museum official and philanthropist of German birth. He entered banking in Germany and immigrated to New York as a young man, becoming a partner in 1893 in Lazard Frères. He retired in 1925 to devote his time to art collecting and philanthropy, favoring causes connected with the arts, medicine and Jewish social services. His wife Florence, née Meyer (1872–1930), whose family were noted philanthropists, was his partner in these activities. After World War I they formed a foundation for the support of French artists, a model for 20th-century arts funding. A longtime finance officer of the Metropolitan Museum in New York, Blumenthal became its seventh president in 1934, guiding it through the Depression. He and his wife maintained collections in their château near Grasse and in a sizeable home in Paris. Their showplace mansion at 50 E. 70th Street (destr. 1943) housed their New York collections. Its central feature was a 16th-century Spanish castle courtyard (now New York, Met., Blumenthal Patio); particularly notable objects from the collection were Justus of Ghent's *Adoration of the Magi*, the Charlemagne tapestry (*c.* 1500) and a 10th-century Ottonian carved ivory altarpiece.

UNPUBLISHED SOURCES

Washington, DC, Smithsonian Inst., Archvs Amer. A. [Blumenthal's correspondence with Jacques Seligman, dealer]

BIBLIOGRAPHY

Catalog of the Collection. . .Blumenthal, New York (Paris, 1926)

"Blumenthal Collection," *Bull. Met.* (Oct. 1941), pp. 193–8 [house described]

"In Memoriam: George Blumenthal 1858–1941," *Bull. Met.*, xxxvi (1941), pp. 146–7

Masterpieces from the Collection of George Blumenthal (exh. cat., New York, Met., 1943)

M. Gauthier: *La fondation americaine Blumenthal pour la pensée et l'art français* (Paris, 1974)

Gretchen G. Fox

Blyth, Benjamin

(*bapt* Salem, MA, 18 May 1746; *d* ?1787), painter. Blyth began his professional career in the 1760s and may have been encouraged by his older brother, Samuel, who was a heraldic and commercial painter. He worked primarily in pastels, or "crayons," as he advertised in the *Salem Gazette* (May 1769), and he capitalized on their increasing popularity around Boston during this decade.

Approximately 30 pastels are now attributed to Blyth, the best known of which is *John Adams*, the earliest portrait of the diplomat and second president of the USA, together with a pendant of his wife, *Abigail Smith Adams* (both 1766; Boston, MA Hist. Soc.). The Adams pastels are typical of Blyth's works: smoothly drawn, restrained in color and highly finished. They are slightly lighter than their counterparts by John Singleton Copley but possess neither the dramatic lighting nor the masterful foreshortening of that artist's work. Blyth's sitters are frequently stiff and have a fixed, impenetrable gaze.

The Salem diarist Rev. William Bentley dismissed Blyth as a "wretched dauber" but noted he had "much employment from the money of the privateer men." Despite this criticism, Blyth was able to remain in Salem completing pastels and oil portraits until 1786, at which point he moved to Richmond, VA.

[*See also* Salem.]

BIBLIOGRAPHY

R. Townsend Cole: "Limned by Blyth," *Ant.*, lxix (1956), pp. 331–3

H. W. Foote: "Benjamin Blyth, of Salem: Eighteenth-century Artist," *Proc. MA Hist. Soc.*, lxxi (1959), pp. 82–102

N. F. Little: "The Blyths of Salem: Benjamin, Limner in Crayons and Oil, and Samuel, Painter and Cabinetmaker," *Essex Inst. Hist. Coll.*, 108/1 (Jan 1972) p. 49–57

Richard H. Saunders

Blythe, David Gilmour

(*b* Wellsville, OH, 9 May 1815; *d* Pittsburgh, PA, 15 May 1865), painter and sculptor. An artistic jack-of-all-trades, Blythe is recognized today as the foremost satirical painter of the mid-19th century. At a time when most American genre painters depicted idyllic, sentimental pictures of American life, Blythe's images were unique, often highlighting the social and political ills of post-Jacksonian America.

The son of Scottish–Irish Presbyterian immigrants, Blythe grew up on a farm in East Liverpool, OH. His strict upbringing informed his sense of moral righteousness and his staunch commitment to individual rights and liberty. In 1831 Blythe went to Pittsburgh to apprentice with the woodcarver Joseph Woodwell and, after a stint in the Navy, returned to his hometown in 1840 and began his artistic career.

Between 1841 and 1852 he worked as an itinerant portraitist, painting stiff likenesses of the local gentry along the Ohio River. He also carved a monumental wood sculpture of the *Marquis de Lafayette* (1850) for the dome of the Uniontown Courthouse and produced a 300-ft (91-m) panorama of the Allegheny Mountains (1851, destr.). His wife's untimely death in 1850 and the commercial failure of his panorama in 1852 left Blythe embittered and disillusioned. After several years of wandering, he returned to East Liverpool in 1854 and painted such portraits as *James McDonald* (1855; Youngstown, OH, Butler Inst. Amer. A.), which are more polished in draftsmanship and painterly technique than his earlier work, and he also experimented with early genre paintings.

In 1856 Blythe relocated to Pittsburgh and turned to the images that made his reputation: moralizing and satirical genre paintings of urban life and political institutions. Pittsburgh in the 1850s—a rapidly growing industrial metropolis with a stagnant economy, rising immigration and unemployment and an inept municipal government—offered a host of subjects. Blythe depicted some of the harsh realities—vagrants, unemployed laborers, a corrupt legal system—as well as seemingly more benign subjects such as the pretensions of the middle class, the new Post Office and children. Children were his most frequent motif—not the usual optimistic depictions of children as the promise of American democracy, but the homeless children who roamed the city streets. One of his best known works on this theme, *Street Urchins* (1856–60; Youngstown, OH, Butler Inst. Amer. A.), depicts a young denizen of the Pittsburgh streets kneeling to light a giant firecracker with his cigar while his companions in crime look on. Blythe's critique is directed both at the

young hoodlums and at the Pittsburgh educational and social institutions that failed them. This painting also demonstrates Blythe's mature style, in which he used distorted anatomy, a muted palette, sharp dark-light contrast and fluid brushwork to call attention to unflattering aspects of urban life. Besides his genre scenes, Blythe also produced a number of paintings relating to the Civil War. A Republican sympathizer, Blythe supported Lincoln and the Union, but in such paintings as *The Higher Law* (1861; Pittsburgh, PA, Carnegie Mus. A.), he castigated extremists in both camps—the abolitionists and southern slaveholders. His mature pictures drew from a multiplicity of sources, including 17th-century Dutch and Flemish genre paintings, the caricatures of William Hogarth (1697–1764), Thomas Rowlandson (1756/7–1827) and George Cruikshank (1792–1878), the lithographs of Honoré Daumier (1808–79) and popular graphic art.

During his Pittsburgh years Blythe was indifferent to financial profit or praise. He exhibited his work mainly in the windows of J. J. Gillespie's art store, where it found patronage among Pittsburgh's rising merchant class but sold for paltry sums. Blythe led an intemperate life and died of complications from alcoholism.

BIBLIOGRAPHY

D. Miller: *The Life and Work of David G. Blythe* (Pittsburgh, 1950)

Works by David Blythe, 1815–1865 (exh. cat., Columbus, OH, Mus. A., 1968)

B. W. Chambers: *The World of David Gilmour Blythe* (exh. cat., Washington, DC, N. Col. F.A., 1980)

S. Burns: "The Underground Man," *Painting the Dark Side: Art and the Gothic Imagination in Nineteenth-Century America* (Berkeley, 2004), pp. 44–74

S. Burns: "Cartoons in Color: David Gilmour Blythe's Very Uncivil War," *Seeing High and Low: Representing Social Conflict in American Visual Culture*, ed. P. Johnston (Berkeley, 2006), pp. 66–83

R. C. Youngner: "David Gilmour Blythe and His Critique of Industry," *Industry in Art: Pittsburgh, 1812 to 1920* (Pittsburgh, 2006), pp. 41–56

Gina M. D'Angelo

Boas, Franz

(*b* Minden, Westphalia, July 1858; *d* New York, 21 Dec 1942), anthropologist and art historian of German birth. Trained as a physical scientist at the University of Kiel, he became interested in anthropology soon after receiving his doctorate in 1881. He immigrated to the USA in 1888 and became curator of ethnology at the American Museum of Natural History in New York in 1895. The following year he also began to teach at Columbia University, where he worked full-time from 1905 until his retirement in 1936.

Boas's first publications on art consisted largely of descriptions of artifacts made by the native population of the northwest coast of North America, but by 1888 he had begun to reconstruct the history of this art. Between 1896 and 1900 he demonstrated the inadequacy of the then-prevalent evolutionistic theory that art degenerated from realism to abstraction and proposed that conventionalization in the art of the northwest coast resulted from attempts to represent as many characteristics of an animal as possible even if this resulted in a distortion of the image, as, for example, when an animal was split down the middle and flattened out so that both sides could be depicted in a two-dimensional medium. After 1900 he began to use examples from other regions in his attempt to substitute history for evolutionism and to show that the psychology of the individual artist was as important in primitive art as it was in Western art: whatever differences there were between the two were not due to the inferiority of the primitive artist but to the constraints imposed on him by his culture. Boas's research culminated in his book *Primitive Art*, in which he dealt with African and Asian as well as Native American art.

[*See also* Native North American art, *subentries on* Archaeology *and* Historiography.]

WRITINGS

"The Development of Culture of Northwest America," *Science*, xii (1888), pp. 194–6

"The Decorative Art of the Indians of the North Pacific Coast," *Bull. Amer. Mus. Nat. Hist.*, ix (1897), pp. 123–76

"Facial Paintings of the Indians of Northern British Columbia," *Pubns Jesup N. Pacific Expedition*, i (1898), pp. 13–24

"The Decorative Art of the North American Indians," *Pop. Sci. Mthly*, lxiii (1903), pp. 481–98

"Decorative Designs of Alaskan Needlecases: A Study in the History of Conventional Designs, Based on Materials in the U.S. National Museum," *Proc. US N. Mus.*, xxxiv (1908), pp. 321–44

"Representative Art of Primitive Peoples," *Holmes Anniversary Volume* (Washington, DC, 1916), pp. 18–23

Primitive Art (Oslo, 1927)

BIBLIOGRAPHY

G. W. Stocking Jr., ed.: *The Shaping of American Anthropology, 1883–1911: A Franz Boas Reader* (New York, [1974])

A. Jonaitis: *A Wealth of Thought: Franz Boas on Native American Art* (Seattle, 1995)

G. W. Stocking Jr., ed.: *Volksgeist as Method and Ethic: Essays on Boasian Ethnography and the German Anthropological Tradition* (Madison, WI, 1996)

V. Williams: *Rethinking Race: Franz Boas and his Contemporaries* (Lexington, 1996)

D. Cole: *Franz Boas: The Early Years, 1858–1906* (Vancouver and Seattle, 1999)

Aldona Jonaitis

Bochner, Mel

(*b* Pittsburgh, PA, 23 Aug 1940), conceptual artist, draftsman, painter and writer. He studied painting at the Carnegie Institute of Technology, Pittsburgh (BFA, 1962). In 1964 Bochner moved to New York. His first exhibition (1966), described by Benjamin Buchloch as the first conceptual art exhibition, was held at the Visual Arts Gallery, School of Visual Arts, New York, and titled *Working Drawings and Other Visible Things on Paper Not Necessarily Meant To Be Viewed as Art*. In his work he investigated the relation between thinking and seeing. In his first mature works (1966), which are both conceptual and perceptual in basis and philosophical in content, he was interested to eliminate the "object" in art and to communicate his own feelings and personal experience, and he did not wish to accept established art-historical conventions. He also experimented with word-drawings and number systems. For his *Measurement* series (late 1960s) he used black tape and Letraset to create line drawings accompanied by measurements directly on to walls, effectively making large-scale diagrams of the rooms in which they were installed. Bochner continued to make series of installational line drawings into the 1970s and 1980s, but from 1983 he made paintings on irregular-shaped canvases that can be interpreted as meditations on drawing and the interrelation between the mind, eye and hand. They display vigorously made marks, all tracing the hand's movement across specific surfaces.

From the 1990s he was dealing with the visual and perceptual systems of perspective. Later he used words and language as the subjects through which his objects projected meaning. He was a senior critic in painting and printmaking at Yale University from 1979, and an adjunct professor from 2001.

[*See also* Conceptual art.]

WRITINGS

with R. Smithson: "Domain of the Great Bear," *A. Voices*, v/4 (1966), pp. 44–51

Ten Misunderstandings: A Theory of Photography (New York, 1970)

BIBLIOGRAPHY

Mel Bochner: Number and Shapes (exh. cat. by B. Richardson, Baltimore, MD, Mus. A., 1976) [excellent essay on development of Bochner's work]

Mel Bochner, 1973–1985 (exh. cat., essay by E. A. King; Pittsburgh, PA, Carnegie–Mellon U. A.G., 1985) [incl. interview with Bochner]

B. Buchloch: "Conceptual Art, 1962–1969," *October*, lv (1991), pp. 105–43

R. Kalina: "Measure for Measure," *A. America*, lxxxiv (1996), pp. 88–93

Mel Bochner: Language 1966–2006 (exh cat. by J. Burton, Chicago, IL, A. Inst., 2007)

Mel Bochner: Solar System & Rest Rooms, Writings and Interviews, 1965–2007 (Cambridge, MA, 2008)

Revised by Margaret Barlow

Bock, Vera

(*b* St Petersburg, 4 April 1905; *d* New York, 1973), illustrator, graphic designer and painter of Russian birth. Vera Bock moved to the USA in 1917 during

the height of the Russian Revolution, arriving in San Francisco. The daughter of an American banker and a Russian-born concert pianist, she studied woodcutting, manuscript illumination, printing and photogravure in England for a year, supplementing her training in painting and drawing. Her book illustration career began in 1929 with Elle Young's *The Tangle-Coated Horse* and Waldemar Bonsels' *The Adventures of Maya the Bee*. During the Great Depression of the 1930s she was employed by the Federal Art Project (FAP) through the Works Progress Administration (later Works Projects Administration; WPA) of the US government. During 1936–9 she illustrated and designed posters for the FAP New York City poster division. Most noted posters from this period are *History of Civic Service Poster* series (1936) and *WPA Kills Rumor* (1939–41); both show the influence of book illustration and design. In *WPA Kills Rumor*, she used the strong lines of a woodcut illustration to clearly convey power and force. In the 1940s she also worked as a magazine illustrator for *Life* and *Coronet* and over the course of her life also painted murals in private homes. She is also credited with illustrating many children's books. The lyrical, playful and loose illustrations of *Arabian Nights* (1946) make the characters dance around the page, bringing to life the stories and characters. Some of the most notable book illustrations include: *Arabian Nights*, *King of the Cats*, *Little Magic Horse* (1949), *A Ring and a Riddle* (1944) and *The Oak Tree House*. For adults her most notable book illustrations include *The Koran*, *Critical History of Children's Literature* (1953) and *Phantom Victory*. Many of her illustrated books are included in library collections such as the Kerlan Collection of Children's Literature at the University of Minnesota and the Library of Congress, Washington, DC. Her works have been included in exhibitions at the New York Public Library (1942), Art Directors Club (1946), International Exhibition of Illustrated Books at the Pierpont Morgan Library (1946), *Ten Years of American Illustration* at the New York Public Library (1951) and the William Farnsworth Museum, Rockland, ME (1952).

UNPUBLISHED SOURCES

Washington, DC, Lib. Congr. [Works Progress Administration posters]

BIBLIOGRAPHY

Illustrators of Children's Books (Boston, 1947)

C. Denoon: *Posters of the WPA* (New York, 1987)

The Artist and the Child (exh. cat., Boston, MA, Pub. Lib., 1990)

Amy Fox

Bodmer, Karl

(*b* Riesbach, Switzerland, Feb 1809; *d* Barbizon, Seine-et-Marne, 30 Oct 1893), Swiss painter and graphic artist, active in the USA and France. Bodmer's earliest exposure to art probably came from his uncle, the landscape painter and engraver Johann Jakob Meyer (1787–1858). When he was 22, Bodmer moved to Paris, where he studied art under Sébastien Cornu. In Paris he met his future patron, Prince Maximilian of Wied-Neuwied, who was planning an ambitious scientific expedition to North America. Bodmer was engaged to accompany the expedition and to provide sketches of the American wilderness. After touring the East Coast, the party made their way westward via the Ohio and Mississippi rivers to St Louis, MO, and in 1833 traveled up the Missouri River into country scarcely inhabited by white men. On the journey north to Fort MacKenzie, WY, Bodmer recorded the landscape and the groups of Indians they encountered. Having wintered in Fort Clark, ND, they returned to New York and then Europe in 1834.

Bodmer's paintings of Indians are full of carefully observed anthropological detail. His delicate, linear style and subdued palette give a savage splendor to such works as *Péhriska-Rúhpa, Hidatsa Man*, also known as *Two Ravens* (Omaha, NE, Joslyn A. Mus.). In his masterpiece, *Bison Dance of the Mandan Indians* (known only in engraving), Bodmer shows a skill in dramatic composition unmatched by his contemporary George Catlin. His watercolor sketches were exhibited in Europe to admiring audiences. The journals of the expedition were published in 1839 with aquatint illustrations based on Bodmer's

watercolors. In 1849 he established himself in the Barbizon colony in France, where he painted such works as *Forest Scene* (1850; Paris, Pal. Luxembourg), exhibited regularly at the Paris Salons and was associated with Jean-François Millet. The Joslyn Art Museum, Omaha, NE, has an important collection of Bodmer's paintings.

[*See also* Wild West and frontier art.]

BIBLIOGRAPHY

F. Weitenkampf: "A Swiss Artist among the Indians," *Bull. NY Pub. Lib.*, lii (1948), pp. 554–6

America through the Eyes of German Immigrant Painters (exh. cat., ed. A. Harding; Boston, MA, Goethe Inst., 1975)

H. Läng: *Indianer waren meine Freunde: Leben und Werk Karl Bodmers (1809–1893)* (Berne, 1976)

Pictures from an Expedition: Early Views of the American West (exh. cat. by M. A. Sandweiss, New Haven, CT, Yale U., Cent. Amer. A., 1978–9)

Views of a Vanishing Frontier (exh. cat. by J. C. Ewers and others, Omaha, NE, Joslyn A. Mus., 1984); review by M. V. Gallagher in *Amer. Ind. A. Mag.*, ix (Spring 1984), pp. 54–61

J. Hines: "History Painting, Meeting of Minds," *SW A.*, xxi (1991), p. 36

W. Rawls: "Audubon, Bodmer and Catlin: Facsimile Editions from the Editorial Side," *Imprint*, xvi/1 (1991), pp. 2–10

The North American Indian Portfolios from the Library of Congress, intro. by J. Gilreath (New York, 1993)

Karl Bodmer's Eastern Views: A Journey in North America (exh. cat. by M. V. Gallagher and J. F. Sears, Omaha, NE, Joslyn A. Mus., 1996)

R. J. Moore: *American Indians: The Art and Travels of Charles Bird King, George Catlin, and Karl Bodmer* (Vercelli, Italy, 1997)

P. von M. Wied: *Travels in the Interior of North America During the Years 1832–1834* (Cologne, London and New York, 2001)

Karl Bodmer's North American Prints (exh. cat. by R. Tyler and B. K. Rund, Omaha, NE, Joslyn A. Mus., 2004)

Leslie Heiner

Body art

Movement in performance art that took shape in the 1960s and 1970s in which artists use their own bodies or those of their audience as the basis for their work. Body art performances have frequently involved transgression and occasionally violence, and they have often entailed extreme acts of

BODY ART. *Meat Joy*, performance by Carolee Schneemann, 1964. © CAROLEE SCHNEEMANN/ARTISTS RIGHTS SOCIETY, NY

endurance on the part of the artists. This term is typically in used in reference to artists such as Vito Acconci, Chris Burden, Valie Export, Gina Pane (1939–90), Carolee Schneemann, the Vienna Actionists, Hannah Wilke, Marina Abramovic and her former collaborator Ulay, as well as Brazilian artists in the Neo-Concrete movement such as Hélio Oiticica (1937–80) and Lygia Clark (1922–80).

Although the emergence of body art is often traced back to early 20th-century trends in performance art, recent accounts have pointed to Hans Namuth's famous photographs of Jackson Pollock in the act of painting as a particularly important precedent. This practice was taken up by a number of performance artists during the late 1950s and early 1960s, including artists involved in Happenings such as Allan Kaprow and the Japanese group Gutai. The latter, in particular, was known for energetic events in which artists such as Kazuo Shiraga (1924–2008) painted with his feet or Shigeko Kubota (*b* 1937) painted with a brush that projected from her vagina. Other precedents included Yoko Ono's 1964

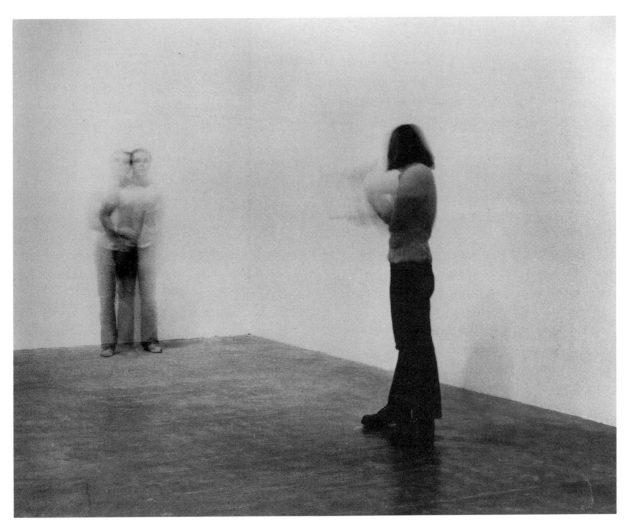

BODY ART. *Shoot*, performance by Chris Burden at F Space, Santa Ana, California, 19 November 1971.
At 7:45 p.m. I was shot in the left arm by a friend. The bullet was a copper-jacketed .22 from a long rifle.
My friend was standing about fifteen feet from me. © CHRIS BURDEN/COURTESY GAGOSIAN GALLERY

Cut Piece in which she enjoined the audience to cut the clothes from her body or Schneemann's *Meat Joy*, from the same year, where she staged a writhing semi-orgiastic scene in which the performers' bodies mingled with pieces of meat.

During the late 1960s, a number of artists engaged in bodily actions that were often more dramatic and confrontational and defied the conventional relationship between the performer and the audience. The New York-based performance artist Acconci, for example, became well known for a series of performances in which he subjected himself and the audience to unsettling disruptions of social norms. In his

notorious 1972 action *Seedbed*, for instance, he concealed himself under a ramp at one end of the gallery and masturbated. The audience was able to discover this by reading a small sign that was posted at the top of the ramp or, less directly, by hearing the artist's vocalizations projected on a speaker throughout the gallery. The actions of other artists often proved to be even more dangerous and extreme than this exhibitionist exercise. In Burden's 1971 piece *Shoot*, for example, he had a friend shoot him in the arm with a rifle in a performance at a gallery in Santa Ana, CA. During this same period, he also staged performances in which he squirmed on his

belly through broken glass, crucified himself to the back of a Volkswagen, and lived in a locker for five days. In her 1974 performance *Rhythm O* at a gallery in Naples, Italy, the Serbian artist Marina Abramovic placed a number of instruments of pain and pleasure on a table next to her and instructed an audience to use them on her as they wished. Members of the audience responded by assaulting her with razor blades and other objects, and one individual placed a gun in her hand before others rose to protect her and effectively stopped the performance.

The Brazilian Neo-Concrete artists, on the other hand, engaged in performances that were concerned more with Eros than Thanatos. Clark, for instance, organized a series of performances beginning in the mid-1960s in which she more or less eliminated the distinction between the audience and performers and staged erotically charged encounters that made bodily sensation the basis for the work. During the 1970s, many similar performances were rooted in feminist aspirations to reclaim the female body from patriarchal categories. Schneemann's 1975 performance *Inner Scroll*, for example, culminated when she unfurled a long, thin paper scroll from her vagina as she read aloud from it a personal narrative that recounted the marginalization of her work as sentimental, emotive and feminine.

Many recent contributions to the genre have focused on the social and cultural significance of the body. In a series of performances during the 1990s by the French artist Orlan (*b* 1947), for example, she gradually modified her appearance through successive plastic surgeries in an effort to model herself on the figures featured in works of Western art. In this extreme case of life imitating art, she engaged in an ambiguous parody of both standards of the ideal beauty and the lengths people go to attain them. In a very different manner, Andrea Fraser (*b* 1965) also challenged the conventions of the genre with *Untitled* (2003). In this piece, she asked her dealer to broker a hotel liaison between herself and an unidentified collector, and a DVD that documented the sexual encounter was subsequently sold as an edition by her gallery. This piece, in particular, raises questions about the sensationalism and exhibitionism of body art by situating it in relation to the art market. At the same time, however, it suggests that the body continues to be an important medium for artists addressing the relationship between the work of art, its audience, and the broader society.

[*See also* Acconci, Vito; Burden, Chris; Ono, Yoko; Performance art; Schneemann, Carolee; *and* Wilke, Hannah.]

BIBLIOGRAPHY

A. Jones: *Body Art: Performing the Subject* (Minneapolis, 1998)

K. O'Dell: *Contract with the Skin: Masochism, Performance Art, and the 1970s* (Minneapolis, 1998)

Out of Actions: Between Performance and the Object, 1949–1979 (exh. cat., ed. P. Schimmel and R. Ferguson; Los Angeles, CA, Mus. Contemp. A., 1998)

R. Goldberg: *Performance: Live Art Since the 1960s* (London and New York, 2004)

T. Warr, ed.: *The Artist's Body* (London, 2006)

Tom Williams

Bogardus, James

(*b* Catskill, NY, 14 March 1800; *d* New York, 13 April 1874), inventor, engineer, designer and manufacturer. Bogardus trained as a watchmaker's apprentice in Catskill, NY, and worked as an engraver in Savannah, GA, and again in Catskill. About 1830 he moved to New York City to promote his inventions. He secured many patents for various devices, including clocks, an eversharp pencil, a dry gas meter and a meter for measuring fluids. His most remunerative invention was a widely useful grinding mill (first patented 1832), which provided steady income throughout his life. During years spent in England (1836–40) he was granted an English patent for a postage device and won £100 in a competition with his proposal for a pre-paid postal system. He also observed the extensive use of iron in the construction of British factories, bridges and large buildings. After a trip to Italy, he conceived the idea of erecting prefabricated multi-story structures with cast-iron

exterior walls that reproduced classical and Renaissance architectural styles. Returning to New York in 1840, Bogardus became an apostle for cast-iron architecture.

In 1847 Bogardus displayed a small model of an all-iron factory, attracting a financial backer, Hamilton Hoppin, whose support allowed him to begin construction of an actual factory at Duane and Centre streets in Manhattan. He suspended work on it to erect what became the first iron front, an ornamental five-story iron facade (1848; destr.) modernizing the pharmacy of the distinguished Dr John Milhau (1785–1874) on lower Broadway in Manhattan. By May 1849 Bogardus had completed the five unified iron-fronted Laing Stores (destr.) in Manhattan. Later in the same year he finished his own factory (destr.), constructed of iron throughout—frame, roof, walls and floors. A US patent was granted to him in 1850 for his construction system. In 1850–51 he erected a large five-story publishing plant for the *Sun* newspaper in Baltimore, MD (destr.). During the next decade he erected prefabricated structures in New York City, Albany, NY, Baltimore, Charleston, SC, Chicago, Philadelphia, Washington, DC, and even Cuba. After a fire in late 1853 destroyed the Manhattan offices and printing plant of America's largest publisher, Harper & Brothers, Bogardus and others built on its site a large iron-frame structure. It had exposed ornamental interior cast-iron columns and trusses and also a non-flammable floor system incorporating America's first successful roll of lengthy wrought-iron beams, employed to support brick jack arches. The stately Harper Building, with its elaborate 130-ft (nearly 40 m) cast-iron facade, was regarded as the first example of a new fire-proof building type. In 1856 Bogardus published a pamphlet extolling the merits of cast-iron architecture (R 1858). His two largest structures were both completed in 1860: in Manhattan, the three-story Tompkins Market and 7th Regiment Armory (destr.), virtually all iron; and near Havana, Cuba, a huge iron-frame sugar warehouse (destr.). Only four iron-fronted buildings unquestionably by Bogardus

survive. Three in lower Manhattan are official landmarks: the handsome 254 Canal Street (1856–7), erected for the inventor–printer George Bruce, 75 Murray Street (1857) and 85 Leonard Street (1861). The fourth is the last structure Bogardus erected, a large iron front in Cooperstown, NY, affectionately called the Ironclad Building (1863).

Bogardus also utilized the strength of cast iron to build unprecedented tall, skeletal iron-frame towers. Two fire watch-towers (1851 and 1853; both destr.) built for the City of New York rose to heights of 100 and 125 ft (30.5 and 38.1 m). A lighthouse (1853; destr.) in the Dominican Republic was 75 ft (22.85 m). He erected two even taller towers in lower Manhattan for manufacturing lead shot (1855 and 1856; both destr.), which soared to heights of 170 and 217 ft (51.8 and 67 m). Brick infill walls were added to the shot towers to keep out the wind; these formed curtain walls that were carried by the iron frame, an early demonstration of the principle that would later be used for skyscraper construction. With Daniel D. Badger, Bogardus was a pioneer in iron construction; his innovative structural use of metal led to its employment in ever-larger buildings and introduced what was to become a widespread building type for American commerical architecture in the 19th century.

[*See also* Badger, Daniel D.]

WRITINGS

"Construction of the Frame, Roof, and Floor of Iron Buildings: Specification of Letters Patent No. 7,337, dated May 7, 1850"; repr. in *The Literature of Architecture: The Evolution of Architectural Theory and Practice in Nineteenth-century America*, ed. D. Gifford (New York, 1966)

with J. W. Thomson: *Cast Iron Buildings: Their Construction and Advantages* (New York, 1856, 2/1858); repr. in *The Origins of Cast Iron Architecture in America, Including . . . Cast Iron Buildings: Their Construction and Advantages*, intro. W. K. Sturges (New York, 1970)

BIBLIOGRAPHY
DAB

T. C. Bannister: "Bogardus Revisited," *J. Soc. Archit. Hist.*, xv/4 (1956), pp. 12–33; xvi/1 (1957), pp. 11–19

J. G. Waite: "The Edgar Laing Stores (1849)," *Iron Architecture in New York City*, ed. J. G. Waite (Albany, 1972)

W. R. Weismann: "Mid-19th-century Commercial Building by James Bogardus," *Monumentum*, ix (1973), pp. 63–75

M. Gayle: *Cast-Iron Architecture in New York: A Photographic Survey* (New York, 1974)

J.-B. Ache: "The Heroic Age: Metallic Construction in the 19th Century," *Archit. Fr.*, 36/394 (Dec 1975), pp. 54–7

D. M. Kahn: "Bogardus, Fire, and the Iron Tower," *J. Soc. Archit. Hist.*, xxxv/3 (1976), pp. 190–201

M. Gayle and C. Gayle: *Cast-Iron Architecture in America: The Significance of James Bogardus* (New York, 1998)

Margot Gayle and Carol Gayle

Boime, Albert

(*b* St Louis, MO, 17 March, 1933; *d* Los Angeles, CA, 18 Oct 2008), art historian. Albert Boime, a leading social art historian in the 20th century, received his education at the University of California Los Angeles (UCLA) (BA in Art History, 1961) and Columbia University (MA 1963; PhD 1968). He taught at the State University of New York (SUNY) at Stony Brook (1968–72), SUNY Binghamton (1972–8), and at UCLA (1978–2008). Boime's publications focus primarily on 19th-century European art, interpreted from a political, social and cultural perspective. Boime also published in the areas of 19th- and 20th-century American art. Central to his scholarship is the historical and socio-political expression of the aesthetic object. His research highlights previously unknown or unrecognized artists and subjects, such as the French academic painter Thomas Couture (1980) or the representation of blacks in 19th-century art (1990). Boime offers radically new readings for major artists, monuments and movements, with a focus on the historical value of the aesthetic object. In his first book, *Nineteenth Century Painting and the Academy* (1971), Boime argued that the 19th-century avant-garde movement was deeply rooted in academic practice. The development of an aesthetic based on the sketch, as practiced by the Impressionists, was fundamentally tied to the Academy's teaching where the sketch constituted a distinctive step within the production of a painting. The role of academic doctrine in the definition of modern painting is further discussed in his book on Thomas Couture (1815–79), the academic history painter and teacher of Edouard Manet. Boime's publications triggered a renewed interest in academic art by scholars and museums. Boime's investigation of the Paris Commune and the rise of Impressionism demonstrates how political forces shaped artistic language (1995). Impressionist artists adhered to their conservative, bourgeois patrons and reconstructed Paris as a place of the bourgeoisie, eliminating the memory of a socialist presence and the destruction caused as a result of the 1871 Commune. A major contribution to the studies of 19th-century art is Boime's series on the *Social History of Modern Art* (1987–2007) that covers artistic movements from 1750 to 1871 in which he combined careful formal analyses with discussions of political, social, scientific and literary movements to define artistic production in Europe and the USA.

Boime's discussion in *The Art of Exclusion* (1990) aligns the artistic representation of blacks in fine art and popular imagery to contemporary racist politics and cultural contentions regarding slavery. Defining and reflecting national identity is the focus of Boime's publications on 19th-century sculpture (1987, 1998) and American landscape painting (1991). In his last collection of essays, *Revelation of Modernism* (2008), Boime attempted to provide new interpretations of Post-Impressionist paintings; reaching to provide a contextual reading that takes into account contemporary cultural ideologies and projections of utopias.

Boime's research is characterized by its thoroughness and expansive reach. His writing is clear, thought-provoking and at times polemic. He engages in critical historical analysis with an emphasis on the interconnection of the artistic, cultural, social and political discourse. Key in his interpretation is the attempt to define the historical context and to read a work of art in a manner that reflects the cultural framework in which and for which it has been created. Boime's research has revamped the art historical discourse by firmly placing the aesthetic

debate within the sociopolitical context. His importance as a teacher and mentor of a generation of young scholars can be demonstrated by the influential scholarship of his students at UCLA.

Boime has been recognized internationally, and his work has been translated into French, Spanish, German, Italian and Japanese.

WRITINGS

The Academy and French Painting in the Nineteenth Century (London and New Haven, 1971, 2/1986; trans. into Japanese, 2004)

Thomas Couture and the Eclectic Vision (London and New Haven, 1980)

Art in an Age of Revolution, 1750–1800 (1987), i of *A Social History of Modern Art* (Chicago and London, 1987–2007; trans. into Spanish, 1994)

Hollow Icons: The Politics of Nineteenth Century French Sculpture, (Kent, OH, 1987)

Art in an Age of Bonapartism, 1800–1815 (1990), ii of *A Social History of Modern Art* (Chicago and London, 1987–2007; trans. into Spanish, 1994)

The Art of Exclusion: Representing Black People in the Nineteenth Century (Washington, DC, and London, 1990)

Manifest Destiny and the Magisterial Gaze in Nineteenth Century American Painting (Washington and London, 1991)

Art and the French Commune, Imaging Paris after War and Revolution (Princeton, 1995)

The Unveiling of the National Icons. A Plea for Patriotic Iconoclasm in a Nationalist Era (Cambridge and New York, 1998)

Art in and Age of Counterrevolution, 1815–1848 (2004), iii of *A Social History of Modern Art* (Chicago and London, 1987–2007)

Art in an Age of Civil Struggle, 1848–1871 (2007), iv of *A Social History of Modern Art* (Chicago and London, 1987–2007)

Revelation of Modernism. Responses to Cultural Crises in Fin-de-Siècle Painting (Columbia and London, 2008)

Susanne Anderson-Riedel

Bolling, Leslie

(*b* Dendron, Surry County, VA, 16 Sept 1898; *d* New York, 27 Sept 1955), sculptor. Educated at Hampton Institute and Virginia Union University, Leslie Garland Bolling supported himself through a number of jobs, working as a porter and as a schoolteacher, while perfecting his skill at carving wood into sculpture. Between 1926 and 1943 Bolling created over 80 wood sculptures consisting of portrait busts, nudes and figures illustrating African American life. His work was recognized by local art critics and supported by exhibition through the Richmond Academy of Arts (now the Virginia Museum of Fine Art) and New York's Harmon Foundation, as well as important venues across the country.

Bolling's technique consisted of drawing the figure from two angles on paper, tracing the cutout onto wood along two faces, then roughing out the shape with a scroll saw and carving the details using one of several ordinary pocketknives. The figures were generally finished with a light wax and sometimes painted. Although never self-consciously political, Bolling carved sculptures that celebrated the integrity of everyday African American life, and thus challenged prevailing class and racial stereotypes. Moreover, his work contributed to contemporary discourses of modern American art, blurring the arbitrary distinctions between "folk art" and "fine art," while combining a keen sense of realism and abstraction. His nude figures were clearly individualized yet observed an abstract interpretation of African aesthetics with their overemphasized, physical proportions.

Eschewing the economic attraction of New York's Harlem art scene, Bolling remained in Richmond, VA, supporting other African American artists through teaching and exhibiting at the integrated Works Progress Administration-funded Craig House Art Center. By 1955, Bolling had been forgotten, only to be rediscovered in the 1990s.

BIBLIOGRAPHY

B. C. Batson: *Freeing Art From Wood: the Sculpture of Leslie Garland Bolling* (Richmond, VA, 2006)

Jacqueline S. Taylor

Bolotowsky, Ilya

(*b* St Petersburg, Russia, 1 July 1907; *d* New York, 22 Nov 1981), painter and sculptor of Russian birth.

His early years were marked by a series of moves, first to Constantinople (now Istanbul) in 1921–3, and then to New York in 1923, where he studied at the National Academy of Design (1924–30). Inspired both by Surrealist biomorphic forms and geometric abstraction, he painted his first non-objective work in 1933 when he saw paintings by Piet Mondrian (1872–1944) in the Gallatin Collection and works by Joan Miró (1893–1983) in the Pierre Matisse Gallery exhibition, both in New York. During the Depression of the 1930s he painted numerous abstract murals under the auspices of government-sponsored programs, such as the Works Progress Administration's Federal Art Project (WPA/FAP) for which he created numerous murals. His *Williamsburg Housing Project Mural* of 1936 was one of the first abstract murals in America and demonstrates this style. In 1936 he was a founder-member of the American Abstract Artists. In 1946–8 he taught at Black Mountain College, concentrating on a coloristically diverse variant of Piet Mondrian's Neo-plasticism, the style that characterized both the painted columns Bolotowsky began to make in the 1960s (e.g. *Metal Column 1966*, 1966; Minneapolis, MN, Walker A. Cent.) and the paintings of the rest of his career. He continued to create his own variations on geometric abstraction until the end of his career, and used a variety of shaped canvases: round, elliptical and diamond. In 1961 he took the sculptural and architectural possibilities of Neo-plasticism further and began painting columns. In 1974 the Solomon R. Guggenheim Museum in New York presented a retrospective of his work. For illustration see color pl. 1:VII, 1.

WRITINGS

"On Neoplasticism and my Own Work," *Leonardo*, ii (1969), pp. 221–30

BIBLIOGRAPHY

Ilya Bolotowsky (exh. cat., New York, Guggenheim, 1974) [includes interview by L. A. Svendsen and M. Poser]

S. Larsen: "Going Abstract in the Thirties: An Interview with Ilya Bolotowsky," *A. America*, lxiv/5 (1976), pp. 70–79

Homage to Bolotowsky, 1935–1981 (exh. cat., Stony Brook, SUNY, Staller Cent. A., U.A.G., 1985)

American Modernism (1920–1945): From Realism to Abstraction (exh. cat., London, Crane Kalman Gal., 1996)

Rina Arya

Bond, Richard

(*fl* 1820–50), architect. There is evidence that Bond was trained by Solomon Willard. Certain of Bond's designs suggest the Greek Revival approach that Willard brought from Washington, DC. Bond's style moved between Gothic Revival and a Neo-classical heaviness. In the Salem City Hall of 1836–37 the two-story Greek Revival facade shows his carefully proportioned details. An example of Gothic Revival is St John's Episcopal Church and Rectory (1841), Devens Street, Boston, which has a rather heavy granite facade dominated by a square tower with a battlemented roof line; there are large quatrefoil windows in the walls below. In the same year Bond was called to Oberlin College in Ohio to design First Church, which had to be a Greek Revival design. He worked on Lewis Wharf (1836–40; later remodeled), Boston, where certain walls reflect his attraction to boldly massed granite surfaces. Bond's best-known buildings during his life were at Harvard University, Cambridge, MA. These included Gore Hall (1838; destr. 1913), alterations to Harvard Hall (1842; later remodeled) and Lawrence Hall (1847; much modified). As a representative architect from Boston, Bond was present at a meeting in New York in 1838, which resulted in the formation of the National Society of Architects, the first professional architectural organization in the USA.

BIBLIOGRAPHY

B. F. Tolles Jr., C. Tolles and P. F. Norton: *Architecture in Salem* (Lebanon, NH, 2004)

B. M. G. Linden: *Library of American Landscape History*, photos by R. Cheek and C. Betsch (Amherst, MA, 2007)

Darryl Patrick

Bonnafé, A. A.

(*fl.* mid-19th century), French draftsman and lithographer active in the USA and Peru. He lived briefly

in the USA, where in 1852 he published a book containing 32 woodcuts depicting American working-class figures. Later he moved to Lima, the capital of Peru, where he published two albums of hand-colored lithographs, *Recuerdos de Lima* (1856–7), depicting the city's people, clothing and customs.

PRINTS

Recuerdos de Lima (Lima, 1856–7)

BIBLIOGRAPHY

L. E. Tord: "Historia de las artes plásticas en el Perú," *Historia del Perú*, ix (Lima, 1980)

C. Milla Batres, ed.: *Diccionario histórico y biográfico del Perú: Siglos XV–XX*, ii (Lima, 1986)

Luis Enrique Tord

Bonnin & Morris

Porcelain manufacturer. Gousse Bonnin (*b* ?Antigua, *c.* 1741; *d c.* 1779) moved in 1768 from England to Philadelphia, where he established the first porcelain factory in America with money from an inheritance and with investments from George Morris (1742/5–73). The land was purchased late in 1769 and in January 1770 the first notice regarding the enterprise was published. The first blue-decorated bone china wares were not produced until late in 1770. Newspaper advertisements noted "three kilns, two furnaces, two mills, two clay vaults, cisterns, engines and treading rooms" and listed such wares as pickle stands, fruit baskets, sauce boats, pint bowls, plates, plain and handled cups, quilted cups, sugar dishes in two sizes, cream jugs, teapots in two sizes and breakfast sets. Well-established foreign competition, however, was too formidable for the new business, which had to charge high prices to meet large expenses; production ceased by November 1772.

BIBLIOGRAPHY

G. Hood: *Bonnin and Morris of Philadelphia: The First American Porcelain Factory, 1770–1772* (Chapel Hill, NC, 1972)

E. H. Gustafson: "A Rare Pair," *Mag. Ant.*, clxi/4 (April 2002), pp. 40–42

R. Hunter, ed.: *Ceramics in America* (Milwaukee, WI, 2007)

R. Hunter and A. A. Kirtley: "Recent Scholarship on the American China Manufactory of Bonnin and Morris," *Mag. Ant.* 173 (Feb 2008), pp. 66–71

Ellen Paul Denker

Bontecou, Lee

(*b* Providence RI, 15 Jan 1931), sculptor and print-maker. Best known for constructed reliefs. Bontecou grew up during the war years with a mother who worked in a factory wiring submarine parts and a father who, along with her uncle, had invented the first all-aluminum canoe. Due to her mother's Canadian roots, she spent her summers in Nova Scotia where she grew to love the landscape and especially its marine life. Bontecou studied at the Art Students League in New York from 1953 to 1958 where she quickly shifted from painting to sculpture working in plaster, clay and cement under William Zorach. In the summer of 1954, at the Skowhegan School in Maine, she learned welding, which she continued to use in Italy where she lived from 1956 to 1957 after receiving a Fulbright scholarship. Back in New York, her large metal and canvas constructions caused a sensation when they were shown at the prestigious Leo Castelli Gallery, New York, in 1960. Bontecou continued to exhibit at Castelli, holding solo shows in 1962, 1966 and 1971. She was lionized by Europeans and Americans alike. By 1964 she was exhibiting in Paris, Germany and New York. In the early 1970s Bontecou joined the faculty at Brooklyn College, moved out of New York City and worked privately for decades. The public at large became relatively unaware of her ongoing work, particularly her powerful late production, until a major retrospective opened to rave reviews in 2003 and traveled between New York, Chicago and Los Angeles.

In Rome in the late 1950s Bontecou invented a technique that was to have profound consequences for her production. She began making soot drawings using an acetylene torch with the oxygen turned down which produced residues of velvety blacks on the paper. Back in New York in 1958–9 she began

transforming the imagery and formal properties of the drawings into sculptures. Like other assemblage artists of the day (she was included in the *The Art of Assemblage* held at the Museum of Modern Art, New York, in 1961) she collected discarded materials from the streets of the city, in particular worn-out canvas conveyor belts, which she sooted black with the torch. She proceeded to fasten this material to metal frames which she had welded into asymmetrical arrangements that allowed for a rich spatial play (for illustration see color pl. 1:IX, 2). These works, which grew in power and intensity, were heralded by critics such as Donald Judd, who praised her ability to make the structure of the work coextensive with its total shape. By 1964 she produced a commanding 6.4-m construction for the New York State Theater at Lincoln Center. Conjuring natural and mechanical notions of flight, this vital work spreads magisterially across the expanse of the wall.

Bontecou maintained that world politics and events, more than artistic models, inspired her soot drawings and the relief sculptures that followed. Awed by Sputnik, which was launched during her stay in Italy, Bontecou coined the term "worldscape" to express the scope of the outer limits. The blackness of the drawings and deep recesses of her work were aligned with poetic notions of cavernous space or the vastness of heaven. She opened the surface of her sculpture with darkness as Constantin Brancusi (1876–1957) had done with light on his reflective surfaces. Other works that she produced were menacing, with threatening saw blades and war equipment embedded into the orifices of her structures. She called one group of small striated metal pieces her "prison" series. All these constructions expressed her darker moods and anger at war, the memory of the bloodshed, and the menace of the Cold War with its threat of nuclear devastation.

The poetic use of black in drawings and printmaking became a strong outlet for her visionary and emotional production. Beginning in 1962, Bontecou worked at Universal Limited Art Editions with Tatyana Grossman and produced a startling body of graphic work. Blacks give rise to floating eyes, in the manner of such 19th-century symbolists as Odilon Redon (1840–1916), or form swirling masses inspired by early notions of black holes as frightening magnetic forces in the cosmos. While sculptors often have important two-dimensional productions, Bontecou's are particularly effective. Not only do her sculptures break down distinctions between two- and three-dimensional production but the imagery and techniques blend seamlessly between the two endeavors.

In 1971 Bontecou did a startling about-face by exhibiting a group of fish and flowers that were new in their frank illusionism and overt use of plastic. The works had been shaped from a homemade vacuum-forming machine and expose sections that had been bolted together or glued together with epoxy resin. Although this production looked quite different from her earlier work in its verisimilitude, its affect heralded back to earlier concerns. Often ominous or strange in appearance, her extra-large translucent flowers with hanging tentacles or rapacious fish with prey inside harkened back to the threat of her 1960s work with menacing saw blades and gas masks. Just as her early works shifted from the poetry of space to the fear of war, she continued to produce sculpture that conjoined the horrible and the beautiful, the ordinary and the fantastic, the abstract and the real. Bontecou's illusionary work in plastic was a brief experiment, but its spirit continued into late welded steel and porcelain sculptures with sharp teeth and demonic grins.

Her late oeuvre, which hangs from the ceiling, was revealed for the first time in the 2003 retrospective. Created over a 25-year period in a secluded setting, they are constructed with a handmade welded frame and embellished with numerous small porcelain elements all made by hand. These works have an expansive and calming effect. They are both galactic and terrestrial. The world of natural forms was never far from her formal imagination. She drew on imagery from her early years in Canada, her frequent trips to the Museum of Natural History

and her later seclusion in nature where she watched wildlife with a naturalist's zeal. Such morphologies enliven and inform the many ceramic elements of the hanging production. Freed from the wall the works realize her cosmic vision begun in the worldscapes of her youth and expressed in her graphic work. These sculptures form the apex of a lifelong visionary search and have had been inspirational to a generation of younger artists.

Bontecou's work has had a sustained impact on the art world. Exhibiting in the noted Castelli Gallery and in 1964 in Kassel, Germany, at *Documenta 3*, she was a major figure in the 1960s and an important woman artist to receive acclamation before the advent of the women's movement. Bontecou herself never took an active feminist stance and disliked a reductionistic reading of the holes in her work as body imagery. She preferred to see them equally in the context of the poetry of space. Nevertheless, her work has been influential to other women artists from Eva Hesse to the present for different reasons, ranging from her provocative use of materials to her visionary and meditative late production.

Bontecou's powerful constructions broke down distinctions between sculpture and painting and found an expressive formal language to confront the social ills of her time. Included in the *Assemblage* show, championed by Judd, and influential for Hesse and others, her labor-intensive production anticipated the process artists of her day, while the stranger elements merited her inclusion in Lucy Lippard's 1966 *Eccentric Abstraction* show and continue to fascinate artists in their grotesque and transgressive sensibility. The extent of the influence of her varied production has yet to be assessed. Her decision to remove herself from a successful exhibiting career in order to pursue a private, contemplative practice has its adherents as well. Heir to the Abstract Expressionist commitment to the primacy of artistic engagement and sublime expressivity, she has worked alone in her studio without assistants for decades in rural Pennsylvania struggling to express the transcendent and menacing components of her vision.

BIBLIOGRAPHY

D. Judd: "Lee Bontecou," *A. Mag.*, xxxix/7 (April 1965), pp. 17–21

Lee Bontecou (exh. cat. by R. Wederer, Berlin, Deutsche Gesellschaft für Bildende Kunst, 1968)

T. Towle: "Two Conversations with Lee Bontecou," *Prt Colr Newslett.*, ii/2 (May–June 1971), pp. 25–8

M. Hadler: "Lee Bontecou's 'Warnings'," *A. J.*, liii/4 (Winter 1994), pp. 56–61

Lee Bontecou, A Retrospective (exh. cat. by E. A. T. Smith, Chicago, IL, Mus. Contemp. A., 2003/R 2008)

J. Applin: "'This Threatening and Possibly Functioning Object': Lee Bontecou and the Sculptural Void," *Art History*, 29/3 (June, 2006), pp. 476–502

M. Hadler: "Lee Bontecou: Plastic Fish and Grinning Saw Blades," *Woman's A. J.*, xxviii/1 (Spring–Summer 2007), pp. 12–18

Mona Hadler

Book illustration, 19th-century

The first quarter of the 19th century brought great advances in the art of illustration and printing of books with the technology becoming more sophistication with newly invented processes. Many of the illustrated books of 1800 to 1850 were topographical, but there were also volumes on architecture and design, medicine, natural history, botany, zoology, ornithology and Americana. Novels were printed with a small number of illustrations, usually on inferior paper stock. Edgar Allan Poe (1809–49) published *The Conchologist's First Book* in 1839, which had a relatively uninspired engraved cover illustration. When the American classic, *Moby Dick*, by Herman Melville was published in 1851, it came with a compelling image of sperm whales in combat. The use of imagery brings an immediate reaction, catching the customer's attention and becoming an important aspect to the marketing and sales of books. As the market expanded, so did the size of the printing presses and techniques used on them. At the end of the 19th century Robert Louis Stevenson published his mystery, *The Strange Case of Dr. Jekyll and Mr. Hyde*, released by the American publisher

Charles Scribner's and Sons, publishing the work before the British editions were released. The Schreiber's edition sold for $1, with a reprinted edition for the Seaside Library selling for 10 cents and having a cover illustration engraved with an Aesthetic Movement design. In the mid-century magazines and newspapers began using illustrations on popular culture with portraits of government officials, battle scenes, science and travel. Artists were trained with the new technologies, allowing them to draw directly on the plate, therefore creating a more consistent line for the reproduction of the image.

Intaglio engraving was used and advanced with several types of processes to achieve the desired effect for the illustration. Wood engraving was used for the earliest part of the 19th century where the design was drawn on the wood block then cut across the grain giving more strength to the surface. The surface was cut with a tool called a burin, which had a sharp steel point to create the design. The British engraver Thomas Bewick (1753–1828) set the standard in the late 18th century with artists continuing the process even today. Hand-coloring the engraved plates was a method that greatly enhanced the black-and-white illustrations at the beginning of the 19th century. The design was first printed in black ink, pressed to a paper surface using a metal or copper plate, with the final process having an artist apply transparent watercolor washes over the printed designs. The quality of craftsmanship varied dramatically, with early examples showing a primitive flat wash to the later edition having a much more sophisticated blending of colors and shading to the finished work of art. The hand-colored volumes were very expensive to produce and usually required selling a subscription for the collection in advance, funding the expedition or project. These volumes not only documented nature, with illustrations of birds or mammals, but also gave master artists the opportunity to make their work available to hundreds of collectors in America and Europe. The subject matter ranges from lavishly painted botanical illustrations to ornithological or scientific and medical publications. William Barton (1786–1856) was a

professor of medicine at the University of Pennsylvania and produced a series of botanical studies using his illustrations drawn from life, with his wife hand-coloring the engraved plates. One of the most important studies of American bird life was by John James Audubon with his collection of 435 life-sized aquatints illustrating *The Birds of America* (1827–39). His later work on native mammals, *The Viviparous Quadrupeds of North America* (1846–54), was ambitious work produced using early lithographic techniques. Audubon's work epitomizes the highest quality of printed books, showing how a collaboration between an artist and a master printmaker can allow the artist to control the quality of the final product. The study of entomology produced publications with thousands of depictions of insects, showing the detailed anatomy in various positions. Cornelius Tiebout produced examples of hand-colored stippled engravings of insects from renderings by Titian Ramsay Peale in the 1820s. Tiebout was the first American to study the art of engraving in Europe, returning with refined techniques that were equal to the European engravers. His portraits of George Washington and Thomas Jefferson are some of the finest examples of engraving of the early 1800s. Many scientific institutions commissioned artists to illustrate not only their scholarly publications, but also to document newly discovered species. Philadelphia became the leading center for publishing, establishing a large market for artists to illustrate all the sciences. Titian Ramsay Peale lived in Philadelphia and was a great supporter of the natural sciences along with his famous family. He worked as an artist and entomologist, traveling on expeditions as an illustrator for Thomas Say's *American Entomology* from 1824 to 1828, and then for Charles Lucien Bonaparte's *American Ornithology* from 1825 to 1833. Philadelphia was not only known for publishing but was to become the nation's mint, creating work for the finest engravers to illustrate the presidents and the architectural monuments of America on bank notes. The process of printing an illustration for a newspaper in the

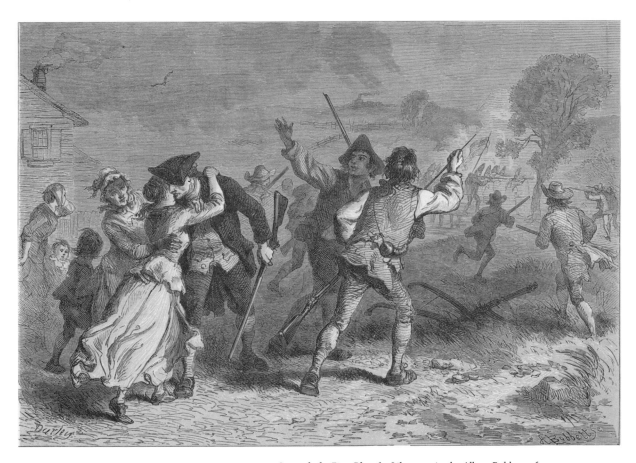

BOOK ILLUSTRATION, 19TH-CENTURY. *Concord, the First Blow for Liberty*, print by Albert Bobbett after a design by Felix Octavius Carr Darley, from *Our Country* by Benson John Lossing, 1877. THE NEW YORK PUBLIC LIBRARY PICTURE COLLECTION/ART RESOURCE, NY

mid-19th century involved sending artists to the site location to prepare quick sketches of the event that was then drawn onto small wood blocks made of boxwood. The blocks were cut onto the surface with exceptional precision and then joined together with screws for printing. If a large illustration was needed, it could involve as many as 15 artists carving small wood blocks to be assembled as a larger image. One of the most important American artists commissioned to travel to these locations to provide illustrations for newspapers was Winslow Homer. The engravers used a flat hand tool in four to five sizes, a steel engraver in two sizes, tint tools, a scraper and a chisel with a bag of sand into which the wood block would be set as the artist worked.

Lithography created another printing process offering a greater application of color to the printed illustration. Invented by Alois Senefelder (1771–1834) in Germany in 1798, the process was called "chemical printing." The technology is based on drawing the image with ink or lithographic chalk directly onto a limestone plate, which absorbs the water and grease in equal amounts. Areas are covered in gum arabic and acid voids areas from receiving ink as it is applied. This process revolutionized the printing industry, creating colorful depictions that could be reproduced hundreds of times. The earliest lithography sometimes required watercolor to be washed over the printing, but as the technology advanced, so did the quality of the publication. Senefelder devoted his entire life to the lithography process and designed a printing press that featured automatic dampening and inking of the printers plates. Chromolithography was popular from the 1880s where the printing process was applied with

separate blocks, each having a single color that was added to the illustration in layers, achieving spectacular effects to the image. This process was greatly used with children's books and printed toys of the period.

Howard Pyle became one of the leading components on the period known as The Golden Age of Children's Illustration. His earliest illustrations were published in 1873 for the *St Nicholas*, a popular children's magazine. He continued his work with several book commissions in 1881, *Yankee Doodle* and *Lady of Shalott*. One of his most famous books, *The Merry Adventurers of Robin Hood*, was written and illustrated in 1883 by Pyle. He left a teaching position at Drexel Institute of Art, Science and Industry to teach his own principles of illustration and start his own school. Howard Pyle's School of American Illustration was established in 1898, later renamed the Brandywine School of American Illustration, where he instructed such artists as Maxfield Parrish, Jesse Willcox Smith (1863–1935) and N. C. Wyeth. His passion for art and teaching revolutionized the art of illustration, introducing the most important illustrators of the early 20th century.

[*See also* Audubon, John James; Chromolithography; Hower, Winslow; Peale, Titian Ramsay; Pyle, Howard; *and* Tiebout, Cornelius.]

BIBLIOGRAPHY

C. M. Hovey: *Fruits of America; Containing Richly Colored Figures and Full Descriptions of All the Choicest Varieties Cultivated in the United States* (Boston, MA, and New York, 1856)

H. T. Peters: *America on Stone* (1931/R 1973)

N. B. Wainwright: *Philadelphia in the Romantic Age of Lithography* (Philadelphia, 1958)

P. C. Marzio: *The Democratic Art, Pictures for a Nineteenth-Century America, Chromolithography, 1840–1900* (1979)

P. B. Meggs: *A History of Graphic Design* (1998)

Ronald R. McCarty

Borglum, Gutzon

(*b* Ovid, ID, 25 March 1867; *d* Chicago, IL, 6 March 1941), sculptor and painter. Born into a Mormon family practicing plural marriage, (John) Gutzon Borglum suffered the loss of his mother when his father separated from the religion. Reared mostly in Fremont and Omaha, NE, he studied briefly at St Mary's Academy in Kansas City, KS (1882). Some time later (*c.* 1884), he worked as an engraver for an Omaha newspaper. Interested in a career in art, he next went to Los Angeles. There he apprenticed himself to a lithographer, then turned to fresco painting and etching; *c.* 1885 he met Elizabeth Janes Putnam (1848–1922), a divorcee and accomplished painter many years his senior, who became his wife (1889). Before that, however, encouraged by her, he traveled to San Francisco and studied at the California School of Design (*c.* 1885–6) under Virgil Williams (1830–86) and received criticism from William Keith. On his return to Los Angeles, while sharing a studio with Putnam, Borglum was working on *Staging over the Sierra Madre Mountains* (1889; Omaha, NE, Joslyn A. Mus.), which caught the eye of Jessie Benton Fremont, who became a benefactor. Other works followed, including a portrait of *General John C. Fremont* (1888; Los Angeles, CA, Southwest Mus.).

With his new bride, Borglum made two trips to Europe (1890–93 and 1896–1901). During the interlude, he acquired land in Sierra Madre, CA, on which the couple built a home, and he became deeply involved in the art life of Los Angeles. On their first stay abroad, Borglum studied in Paris at the Académie Julian and the Ecole des Beaux-Arts. In 1891 he was made an associate of the Société Nationale des Beaux-Arts for his first public display of a sculpture, *Death of a Chief* (Glendale, CA, Forest Lawn Mem. Park), at the Salon of that year. On their second visit, spent mostly in London, he received some important commissions, but failed to gain the recognition he desired.

Amazed by the acclaim received by his younger brother, Solon Borglum (1868–1922), for a display of sculptures of Western subjects at the Exposition Universelle in Paris (1900), Borglum decided to specialize in sculpture as well. Returning to the USA

in 1901, he obtained a studio in New York City and, in 1910, following a second marriage in 1909, a home and studio in Stamford, CT ("Borgland"). During the next 40 years, while remaining a controversial figure involved not only in differences with the art establishment of New York City but also in political and social issues, he produced an astounding number of sculptures, many of heroic and monumental sizes. Noteworthy among them are the *Mares of Diomedes* (New York, Met.), which was a gold medal winner at the Louisiana Purchase International Exposition in St Louis (1904); the heroic *Wars of the Americas* group in Veteran's Park, Newark, NJ, counting forty-three figures and two horses (1926); and his famous Mount Rushmore carvings in granite of the heads of American presidents *George Washington, Thomas Jefferson, Abraham Lincoln and Theodore Roosevelt* in the Black Hills of South Dakota (1941).

UNPUBLISHED SOURCES

Washington, DC, Smithsonian Inst., Archvs Amer. A., reel 3056 [Gutzon Borglum papers]

Washington, DC, Smithsonian Inst., Archvs Amer. A., reels N69–98, 1054 [Solon Borglum papers]

BIBLIOGRAPHY

Obituary, *Chicago Daily Tribune*, 7 March 1941, 16:1

R. J. Casey and M. Borglum: *Give the Man Room: The Story of Gutzon Borglum* (Indianapolis, 1952)

W. Price: *Gutzon Borglum: Artist and Patriot* (Chicago, 1961)

A. M. Davies: *Solon H. Borglum: "A Man Who Stands Alone"* (Chester, CT, 1973)

H. Shaff and A. K. Shaff: *Six Wars at a Time: The Life and Times of Gutzon Borglum, Sculptor of Mount Rushmore* (Sioux Falls, 1985)

Phil Kovinick

Borofsky, Jonathan

(*b* Boston, MA, 1942), sculptor, painter and draftsman. As a child he accompanied his mother, a trained architect, to weekly painting classes, where he was encouraged to draw freely and not in a traditional manner. He studied at Carnegie–Mellon University, Pittsburgh, PA (BFA, 1962), and at Yale School of Art and Architecture, New Haven, CT (MFA, 1966), where his work was mainly sculptural. From the early 1970s his central concern was to diminish the boundaries between life and art. From 1973 he made use of dreams, in drawings, paintings, sculptures, projected images, prints, and finally combinations of these in multi-media installations. Borofsky first exhibited at the Artists Space, New York (1973), showing *Counting* (1969–), a serial project comprising a stack of sheets of graph paper (220×280 mm), on which numbers from 1 to *c.* 1,800,000 were written in pencil and ink. An ongoing project, it continued to reappear in later shows under a tailor-made Perspex (Plexiglass) box; by September 1993 the numbers reached 3,200,000 and the stack *c.* 1.28 m high. These characteristic numbers also appeared on the back of *Flags* (exh. 1988, New York, Paula Cooper Gal.), for which Borofsky painted the flags of the world, with the name of each country printed under its flag; the work also included a large (h. 3.65 m) sculpture of a man with a beating red Perspex heart, his singularity contrasting with the numerous flags. One of his best-known images is the *Hammering Man*, which appeared in both two- and three-dimensional works, including a 3.65-m-high sculpture with a motorized hammering arm.

Later large-scale sculptures were found on three continents. *Walking to the Sky* (2005, Dallas, TX, Nasher Collection; 2006, Pittsburgh, PA Carnegie–Mellon U.; 2008, Seoul, Korea) features life-size figures walking up a 30-m pole. For other series such as *Human Structures with the Light of Consciousness* (exh. 2009, New York Deich Projects; installed 2009 Meijer Park, Grand Rapids, MI), Borofsky linked colorful polycarbonate or metal figures into large groupings. Like his *Tower of People* (h. 19.8 m), created for the 2008 Beijing Olympics, these works focused on portraying his belief that "everything is connected."

BIBLIOGRAPHY

J. Simon: "An Interview with Jonathan Borofsky," *A. America*, lxix/9 (Nov 1981), pp. 162–7

Jonathan Borofsky (exh. cat., essays by M. Rosenthal and R. Marshall; Philadelphia, PA, Mus. A.; New York, Whitney;

Berkeley, U. CA, A. Mus., and elsewhere; 1984–5) [good photos of installations, some related by artist's notes to dreams]

Horizons: Jonathan Borofsky (exh. cat., with an essay by D. E. Scott; Kansas City, MO, Nelson–Atkins Mus. A., 1988)

"Jonathan Borofsky: Nobody Knows His Name, Everybody Has His Number," *Carnegie Mellon Mag.*, xx/3 (Spring 2002), pp. 12–21 (interview with Ann Curran)

M. Klein: "Jonathan Borofsky on a Grand Scale," *Sculpture*, xxiii/10 (Dec 2004), pp. 34–9

Revised by Margaret Barlow

Boston

City and capital of Massachusetts. Boston was established in 1630 as a self-governing Puritan community situated on the Shuwmut Peninsula, a hilly parcel of land surrounded by tidal flats known as the Back Bay and joined by an isthmus to the mainland. It rapidly became a thriving commercial center due to its deep harbor and multiple waterways that enabled easy transport of goods, the largest of which are the Mystic and Charles Rivers. By 1790 the city of Boston was named the capital of the Massachusetts Bay Colony, remained capital after statehood and rapidly became one of the largest manufacturing centers in America. The city was not formally planned, but evolved as a series of neighborhood districts, and by the early 19th century growth in commercial trade propelled developments along the waterfront resulting in the infilling of the tidal flats and areas near wharves to reclaim land for new development. The Big Dig project, begun in 1984 as the relocation underground of the elevated central artery, is considered as America's largest public works project, costing nearly 15 billion dollars.

Boston's historic architecture mirrored English design in the colonial and later periods. Surviving landmarks include Faneuil Hall (1740–42), designed by John Smibert in the Georgian style and displaying elaborately detailed brick work with Tuscan and Doric pilasters and a tall central cupola. The hall was restored and enlarged by Charles Bulfinch in 1805 after being damaged by a fire in 1761. The Anglican churches, Kings Chapel (1749–58) in Boston and Christ Church (1761–73) in nearby Cambridge, both designed by Peter Harrison, were inspired by City of London churches and exhibit fine Georgian-styled interiors. With the rise of Boston as a mercantile center, with strong trade links with England, the city's early national architecture also began to mirror contemporary London architectural styles. Boston architects such as Charles Bulfinch designed many fine examples of Georgian and Neo-classical architecture, including the State House (1795–7), which recalls Somerset House (1776) in London by William Chambers (1723–96), and the three Harrison Gray Otis Houses (1796, 1800 and 1806). In town planning Bulfinch also left his imprint on Boston, designing new residential neighborhoods such Louisburg Square in the Mt Vernon area of Beacon Hill (1795), which has large lots surrounded by landscaped gardens. Later in the 19th century, architect H. H. Richardson influenced the spatial form of Boston through his designs for Trinity Church Copley Square (1872), which dominated the monumental public plaza, and for buildings at Harvard University in Cambridge, such as Sever Hall (1878–80) and Austin Hall (1881–4). Richardson's Stoughton house on Brattle Street (1882–3) is an important surviving Shingle-style residence.

The "Emerald Necklace" park system (1878) is an intact linear park designed by Frederick Law Olmsted to connect the Boston Common to Franklin Park; it encompasses the Charles River and connects a number of streams and ponds within a coordinated park plan.

The Boston Symphony Hall (designed in 1892 and built 1900–01) and the first steel-frame building, the Winthrop Building (1893–4) by Clarence H. Blackall, defined the innovative character of the city at the end of the 19th century. In 1907 the Museum of Fine Arts (founded in 1876) moved into a classical revival building designed by Guy Lowell; the museum hosts a world-renowned collection spanning early

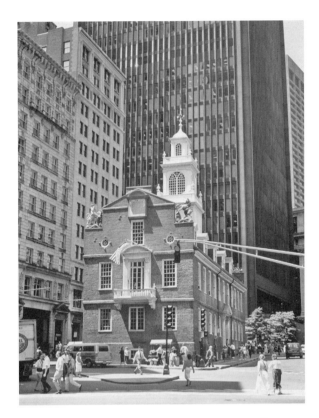

BOSTON. Old State House, 1713. HIP/ART RESOURCE, NY

American art through to contemporary artworks. The Isabella Stewart Gardener Museum (1909) integrates multiple European Gothic and Renaissance architectural elements to evoke a Venetian palazzo. Renzo Piano's design for a new museum building (2012) will enable further expansion.

Modern architects executed significant buildings in Boston during the mid-20th century. In 1945 Walter Gropius founded The Architects Collaborative (TAC) and in 1949 he designed the Harvard Graduate Center. Other notable campus buildings include Alvar Aalto's Baker House dormitory block (1947–9), Eero Saarinen's Chapel (195861) and Kresge Auditorium (1955), all at the Massachusetts Institute of Technology (MIT), and Le Corbusier's Carpenter Center for the Visual Arts (1961–4) at Harvard (the architect's only constructed American project). Paul Rudolph's design for the state Health, Education and Welfare Service Center in the government complex (1962–71) and Kallman, McKimmell & Knowles's Boston City Hall (1968) are notable public buildings at mid-century. The John Hancock Tower (1976) designed by I. M. Pei and Henry N. Cobb was Boston's tallest skyscraper for over 30 years. Frank Gehry's design for the MIT STATA Center (2004) and Steven Holl's award-winning project for the MIT Simmons Hall residences (2003) are recent contemporary architectural additions.

The Institute of Contemporary Art (founded in 1936) relocated to a new building in the South Boston Seaport District designed by Diller Scofidio + Renfro (2006).

BIBLIOGRAPHY

W. Kilham: *Boston After Bulfinch: An Account of its Architecture 1800–1900* (Cambridge, MA, 1946)

W. M. Whitehill: *Boston: A Topographical History* (Boston, 1963/R Cambridge, MA, 3/ 2000)

M. D. Ross: *The Book of Boston: The Victorian Period 1837–1901 (New York, 1964)*

B. Bunting: *Houses of Boston's Back Bay, An Architectural History, 1840–1917* (Cambridge, MA, 1967)

R. Campbell: *City Scapes of Boston: An American City through Time* (Boston, 1992)

Deborah A. Middleton

Boston Society of Architects

Founded in 1867, the Boston Society of Architects (BSA) is the oldest of the three Massachusetts chapters of the American Institute of Architects, established in 1857. Dominated by Edward Clark Cabot as its president for the first three decades, the Boston Society of Architects reflected the nature of the expanding practice in the city at that moment. Opened in the same year as the BSA was the nation's first academic program in architecture at the Massachusetts Institute of Technology (MIT). In addition to the MIT courses, the BSA was soon joined by the first substantial professional journal in the country, *The American Architect and Building News*, which began publication in Boston in 1876. The Society

served as both a professional and a social organization in its early years, allowing members to meet and learn from their fellow practitioners. A parallel organization, open to non-architects as well, was the Architecture Association created in 1883, which was replaced by the more successful Boston Architectural Club in 1889. Eventually, the Boston Architectural Club became the Boston Architectural Center in 1944 and the Boston Architectural College in 2006. Also in 1883, Boston architect Arthur Rotch (1850–94) and his brother and sisters created the Rotch Traveling Fellowship and invited the BSA to establish a process to select the most deserving architecture student who wished to "pursue studies in foreign countries." The first such traveling architectural fellowship in the USA, the Rotch awards have allowed generations of architects to benefit from study abroad. In 1921, the Society also created the Harleston Parker Prize, awarded annually for "the most beautiful piece of architecture" in the metropolitan region of Boston. It is now one of 16 annual awards made by the society to recognize excellence in design. In 1984, the Boston Foundation for Architecture was established by the society to fund public education projects in design and the built environment. Located in the historic Architects Buildings at 52 Broad Street, in Boston, the BSA, with approximately 4000 members, remains a vital focus of the educational activities for architects, affiliated professionals, students and others interested in design from throughout eastern Massachusetts.

BIBLIOGRAPHY

M. H. Floyd: *Architectural Education and Boston* (Boston, 1995)

Keith N. Morgan

Bottomley, William Lawrence

(*b* Richmond, VA, 24 Feb 1883; *d* Glen Head, Long Island, NY, 1 Feb 1951), architect, preservationist, author and editor. His wealthy patrician family provided the opportunity for a fine education and connections to future clients. In 1906 he received a Bachelor of Architecture degree from Columbia University. His education continued in Rome at the American Academy through receipt of the McKim Fellowship in Architecture in 1907. In 1908 he passed the entrance examination for the Ecole des Beaux-Arts and remained in Paris until 1909.

Best known for his residential work, Bottomley combined his extensive knowledge of architectural history with his own observations to produce personal interpretations of past styles. Of his approximately 186 commissions, 90 were located in New York and 51 in Virginia. His most recognized residential commissions are found on Monument Avenue in Richmond, VA. Produced during the 1920s and 1930s, these residences, like many of his other projects, have exteriors inspired by nearby 18th-century James River Georgian mansions. Their interiors deviate from the Georgian models with creatively arranged plans that display a particular delight in the use of curving stairs within a variety of different shaped foyers.

Among his important publications are *Spanish Details* (1924) and the significant two-volume *Great Georgian Houses of America* (1933, 1937), for which he served as editor. The latter book was produced during the Great Depression under the auspices of the Architects' Emergency Committee and remains in print. Although his architectural production was limited, he designed a variety of building types including high schools, a city hall, an immigration station, apartment houses, a church, nightclubs, hotels and a tomb. His largest and most complex project, River House, was designed in the firm name of Bottomley, Wagner and White from 1929 to 1932. The 25-story skyscraper apartment building located on the East River in Manhattan included simplex, duplex and triplex apartments, a club with entertainment and athletic facilities, and arrival accommodations for cars and boats. In 1934 he received the Apartment House Medal of the New York chapter of the American Institute of Architects for River House and the Silver Medal of Honor of the Architectural League of New York for his work in

restoration of historic Virginia houses and as an editor. In 1944 he was honored with the distinction of Fellow in the AIA.

WRITINGS

Spanish Details (New York, 1924)

ed.: *Great Georgian Houses of America*, 2 vols. (New York, 1933–7; rev. 2/1970)

BIBLIOGRAPHY

W. B. O'Neal and C. Weeks: *The Work of William Lawrence Bottomley in Richmond* (Charlottesville, VA, 1985)

S. H. Frazer: *The Architecture of William Lawrence Bottomley* (New York, 2007)

Elizabeth Meredith Dowling

Bourgeois, Louise

(*b* Paris, 25 Dec 1911; *d* New York, 31 May 2010), sculptor, painter and printmaker of French birth. Her parents ran a workshop in Paris restoring tapestries, for which Bourgeois filled in the designs where they had become worn. She studied mathematics at the Sorbonne before turning to studio arts. In 1938, after marrying Robert Goldwater, an American art historian, critic and curator, she went to New York, where she enrolled in the Art Students League and studied painting for two years with Václav Vytlačil (1892–1984). Bourgeois's work was shown at the Brooklyn Museum Print Exhibition in 1939. During World War II she worked with Joan Miró (1893–1983), André Masson and other European expatriates.

Although Bourgeois exhibited with the Abstract Expressionists—and, like them, drew from the unconscious—she never became an abstract artist. Instead, she created symbolic objects and drawings expressing themes of loneliness and conflict, frustration and vulnerability, as reflected in her suite of engravings and parables, *He Disappeared into Complete Silence* (1947).

In 1949 Bourgeois had her first sculpture exhibition, including *Woman in the Shape of a Shuttle* (1947–9; New York, Xavier Fourcade), at the Peridot Gallery; this work proved typical of her wooden

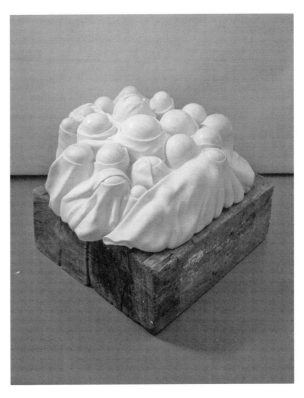

LOUISE BOURGEOIS. *Cumul I*, marble, h. 51 cm 1968. © LOUISE BOURGEOIS/LICENSED BY VAGA, NY/POMPIDOU, MUSÉE NATIONAL D'ART MODERNE, CENTRE GEORGES POMPIDOU, PARIS/CNAC/DIST. RÉUNION DES MUSÉES NATIONAUX/ART RESOURCE, NY

sculpture and foreshadowed her preoccupations of the following years. Her first sculptures were narrow wooden pieces, such as *Sleeping Figure* (1950; New York, MOMA), a "stick" figure articulated into four parts with two supporting poles. Bourgeois soon began using non-traditional media, with rough works in latex and plaster contrasting with her elegantly worked pieces in wood, bronze and marble. In the 1960s and 1970s her work became more sexually explicit, as in the *Femme Couteau* group (1969–70; King's Point, NY, J. and E. Spiegel priv. col.) and *Cumul I* (1969; Paris, Pompidou). The psychological origins of her work are particularly evident in *Destruction of the Father* (1974; New York, Xavier Fourcade). Bourgeois's work was appreciated by a wider public in the 1970s as a result of the change in attitudes wrought by feminism and Postmodernism.

BIBLIOGRAPHY

W. Anderson: "American Sculpture: The Situation in the Fifties," *Artforum*, v (1967), pp. 60–67

L. R. Lippard: "Louise Bourgeois: From the Inside Out," *From the Center: Feminist Essays on Art* (New York, 1976)

Louise Bourgeois (exh. cat. by D. Wye, New York, MOMA, 1982) [with many pls., chronology and bibliog.]

C. Never-Thess: *Louise Bourgeois: Designing for Free Fall* (Zurich, 1992)

The Prints of Louise Bourgeois (exh. cat. by D. Wye; New York, MOMA, 1994)

M.-L. Bernadac: *Louise Bourgeois* (Paris and New York, 1996)

R. Crone and P. Schaesberg: *Louise Bourgeois: The Secret of the Cells* (Munich, London and New York, 1998)

Louise Bourgeois: Life as Art (exh. cat., ed. A. Kold and A. M. Lund; Humlebæk, Louisiana Mus., 2003)

M.-L. Bernadac and H.-U. Obrist, eds.: *Destruction of the Father, Reconstruction of the Father: Writings and Interviews, 1923–1997* (Cambridge, MA, and London, 1998)

R. Storr: *Louise Bourgeois* (London and New York, 2003)

M. Nixon: *Fantastic Reality: Louise Bourgeois and a Story of Modern Art* (Cambridge, MA, 2005)

Rina Youngner

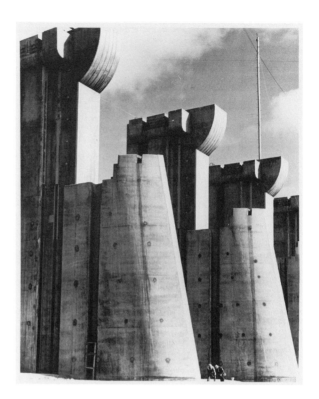

MARGARET BOURKE-WHITE. *Fort Peck Dam, Montana*, gelatin silver print, 330 × 260 mm, 1947. © ESTATE OF MARGARET BOURKE-WHITE/LICENSED BY VAGA, NY/GIFT OF *LIFE MAGAZINE* THE MUSEUM OF MODERN ART/LICENSED BY SCALA/ART RESOURCE, NY

Bourke-White, Margaret

(*b* New York, 14 June 1904; *d* Darien, CT, 27 Aug 1971), photographer. Bourke-White (née White) studied at Columbia University, New York (1921–22), where she was influenced by Clarence H. White's photography course. After attending a number of colleges she decided in 1927 to pursue a career in photography and moved to Cleveland, OH, where she set up a photographic studio. Her industrial images caught the attention of Henry Luce (1898–1967), the founder of *Time* and *Fortune* magazines, and he invited her to become the first staff photographer for *Fortune* in 1929.

In 1930 *Fortune* paid Bourke-White to photograph German industry, for example, *Workmen in the AEG Plant* (1930; see Silverman, p. 39). Although the editors were interested in a project on the USSR, they doubted that the Soviet authorities would grant permission to photograph industry there. Bourke-White decided to pursue the matter and photographed subjects such as *Dam at Dnieperstroi* (1930; see Silverman, p. 42). Her experience was recorded in *Eyes on Russia* (New York, 1931). In 1930 she established a photographic studio in the Chrysler building in New York. She visited Russia again in 1931 and in 1932 and then in 1941.

Although both Paul Strand and Charles Sheeler had created classic machine-age compositions, Bourke-White brought new drama and action to her industrial work for *Fortune*. In 1934, however, the magazine commissioned her to photograph the area of the American Midwest known as the Dust Bowl. It was this story documenting the great drought and rural exodus that changed her attitude toward the role of the photographic essay, which she pioneered as a medium to examine social issues from a humanitarian perspective.

When Luce launched *Life* magazine in 1936 Bourke-White joined the staff, and her *Fort Peck Dam, Montana* (Chicago, IL, A. Inst.) appeared on the first cover. Also in the late 1930s she collaborated with the writer Erskine Caldwell (1903–87), her husband from 1939 to 1942, on four projects: *You Have Seen Their Faces* (New York, 1937), which included such photographs as *Maiden Lane, Georgia* (1936; see Callahan, p. 93), *North of the Danube* (New York, 1939), a photographic study of the conflict in the Sudetenland, *Say, Is This the USA* (New York, 1941) and *Russia at War* (London, n.d.).

From 1942 to 1945 Bourke-White was a war correspondent, accredited first to the US Army Air Force. On assignment for *Life*, she worked in Britain, Germany, North Africa and Italy. She photographed images such as *Harbour of Naples* (1944; see Silverman, p. 143) and in 1945 the concentration camps of *Erla* (see Silverman, pp. 164–5) and *Buchenwald* (see Silverman, p. 166). Visits to India (1946 and 1947–8) and South Africa (1949–50) produced two of her most penetrating and renowned images: *Mahatma Gandhi Spinning* (1946; Chicago, IL, A. Inst., see 1985 exh. cat., no. 8), and *A Mile Underground* (1950; see 1985 exh. cat., no. 9), from a series on the Kimberley Diamond Mine, South Africa. In 1969 Parkinson's disease forced her to retire.

[*See also* Photography.]

WRITINGS

Portrait of Myself (New York, 1963)

BIBLIOGRAPHY

S. Callahan, ed.: *The Photographs of Margaret Bourke-White* (New York, 1972)

J. Silverman: *For the World to See: The Life of Margaret Bourke-White*, preface A. Eisenstaedt (London and New York, 1983)

A Collective Vision: Clarence H. White and His Students (exh. cat., ed. L. Barnes, C. Glenn and J. Bledsoe; Long Beach, CA State U., A. Mus., 1985)

V. Goldberg: *Margaret Bourke-White: A Biography* (New York, 1986)

Bourke-White (exh. cat. by V. Goldberg; New York, Int. Cent. Phot., 1988)

M. A. McEuen: *Seeing America: Women Photographers between the Wars* (Lexington, KY, 2000)

S. B. Philips: *Margaret Bourke-White: The Photography of Design, 1927–1936* (New York, 2002)

R. Ostman and H. Littell: *Margaret Bourke-White: The Early Work, 1922–1930* (New York, 2005)

Constance W. Glenn

Bowdoin, James, III

(*b* Boston, MA, 22 Sept 1752; *d* Buzzard's Bay, MA, 11 Oct 1811), diplomat and collector. He was born into a prominent New England mercantile family of broad political and intellectual interests. Using the fortune garnered by his grandfather, a sea captain and merchant, he built on the collection, one of the first in the USA, begun by his father James Bowdoin II (1726–90), eventually bequeathing it to Bowdoin College, Maine, which was named after his father. The collection includes 70 paintings—mainly copies after Old Masters, the first Old Master drawings to arrive in America, and several prints, the latter probably collected by James II. It is likely that James III purchased at least 34 of the paintings in Europe, where he studied, later traveled, and was Minister Plenipotentiary to Spain under President Thomas Jefferson between 1805 and 1808. From the Scottish-born portrait painter John Smibert, he likely acquired additional copies but also, more significantly, two portfolios totaling 141 drawings. Most notable among them are a landscape traditionally attributed to Pieter Bruegel I and a Domenico Beccafumi fresco study. The painting collection is distinguished by portraits of *Thomas Jefferson* and *James Madison* by Gilbert Stuart, as well as by family portraits by Joseph Blackburn, Smibert and Robert Feke, which James III's widow Sarah Bowdoin Dearborn (1761–1826) added to the bequest. According to Wegner, James III may have been influenced in his collecting intentions both by the display of masterpieces he saw in Napoleon's Paris and by Jefferson's own accumulation of portraits of ancient and modern worthies who represented an ethical and cultivated life.

BIBLIOGRAPHY

M. S. Sadik: *Colonial and Federal Portraits at Bowdoin College* (Brunswick, 1966)

Governor Bowdoin and his Family (exh. cat. by R. L. Voltz, Brunswick, ME, Bowdoin Coll. Mus. A., 1969)

D. P. Becker: *Old Master Drawings at Bowdoin College* (Brunswick, 1985)

S. E. Wegner: "The Collection of James Bowdoin III (1752–1811)," *College Art Association Sessions* [abstracts] (New York, 1991), pp. 192–3

The Legacy of James Bowdoin III (exh. cat., with essays by L. Docherty and others, Brunswick, ME, Bowdoin Coll. Mus. A., 1993); review by P. Anderson in *A. New England*, xv (1993–4), pp. 52–3

Diane Tepfer

WRITINGS

Gournia, Vasiliki and Other Prehistoric Sites on the Isthmus of Hierapetra, Crete (Philadelphia, 1908)

C. H. Hawes and H. Boyd Hawes: *Crete, the Forerunner of Greece* (New York, 1909)

BIBLIOGRAPHY

Obituary, *Amer. J. Archaeol.*, xlix (1945), p. 359

R. Higgins: *The Archaeology of Minoan Crete* (London, 1973)

M. Allsebrook: *Born to Rebel: Life of Harriet Boyd Hawes* (Oxford, 1992)

V. Fotou and A. Brown: "Harriet Boyd Hawes, 1871–1945," *Breaking Ground: Pioneering Women Archaeologists*, ed. G. Cohen and M. Joukowsky (Ann Arbor, 2006), pp. 198–273

J. Lesley Fitton

Boyd, Harriet

(*b* Boston, MA, 11 Oct 1871; *d* Washington, DC, 31 March 1945), archaeologist. Harriet (Ann) Boyd was a pioneer of the archaeological excavation of Minoan Crete, first traveling in the island in 1900 as a fellow of the American School of Classical Studies in Athens. Adventurous and intrepid, she explored the area of east Crete around the Isthmus of Hierapetra, covering the rough terrain on mule-back. At the suggestion of Sir Arthur Evans, then beginning his investigation of Knossos, she excavated at Kavousi on the eastern side of the Gulf of Mirabello, revealing remains of an early Iron Age site. On her return to Crete in 1901 information from a local peasant led to her most remarkable discovery, the prosperous Minoan town of Gournia, where she directed excavations in 1901, 1903 and 1904, often employing a workforce of more than a hundred. She succeeded in unearthing virtually the whole town, and the evidence, which she published with exemplary speed, provided useful comparisons with that from the grander palace sites at Knossos and Phaistos. She married the English anthropologist Charles Henry Hawes in 1906 and, after doing relief work during World War I and raising a family, became a lecturer in pre-Christian art at Wellesley College, MA, from 1920 to 1936.

Boyle, John

(*b* New York, 1851; *d* New York, 10 Feb 1917), sculptor. Born in New York, but raised in Philadelphia, John J. Boyle trained initially as a stonecutter before studying at the Pennsylvania Academy of the Fine Arts under Thomas Eakins. In 1877 he went to Paris to study at the Ecole des Beaux-Arts where he remained for three years. His early commissions were dominated by aboriginal themes, but like most of the Beaux-Arts-trained sculptors of his day, he also did important portrait statues and contributed to the architectural sculpture at the international fairs.

Boyle's first success was with a group called *The Alarm* (1884; Chicago, IL, Lincoln Park), which depicted a Native American family with a powerful man and his dog listening while his wife and baby huddle beside him. This led to the *Stone Age in America* (1886–8) for Philadelphia's Fairmount Park. In the initial design, a Native American woman protected her children by killing an attacking eagle, but having the national bird as the victim was considered inappropriate, and Boyle was forced to change the dying animal to a small bear. His aboriginal themes also included *The Savage Age of the East* and *The Savage Age of the West* for the 1901 Pan-American Exposition in Buffalo, NY, where marauding ancient warriors illustrate the barbaric customs of the past. Another

piece was his unusual New York 42nd Infantry Monument (1891) at Gettysburg, PA, which depicted the figure of Chief Tammany in front of a teepee. His portrait statues include a seated *Benjamin Franklin* (1899), now at the University of Pennsylvania, Philadelphia, which Lorado Taft praised as one of the finest ever done. For the rotunda of the Library of Congress, Washington, DC, Boyle contributed statues of *Plato* and *Bacon* (1898), for Philadelphia's City Hall Plaza, *John Christian Bullitt* (1907), and for Washington, DC, *Commodore John Barry* (1914). The bronze portrait statue supported by a stone base adorned with an allegorical female figure, typifies the Beaux-Arts combination of the real and the ideal.

Boyle moved to New York in 1902 and died there in 1917. He was a charter member of the National Sculpture society, an associate of the National Academy, and served on the New York Art Commission.

BIBLIOGRAPHY

Obituary, *NY Times* (11 Feb 1917), p. 23

L. Taft: *The History of American Sculpture* (New York, 1925), pp. 404–10

W. Craven: *Sculpture in America* (New York, 1968), pp. 481–3

Pamela H. Simpson

Bradford, William

(*b* Fairhaven, MA, 30 April 1823; *d* New York, 25 April 1892), painter and photographer. Bradford became a full-time artist about 1853, after spending a few years in the wholesale clothing business. In 1855 he set up a studio in Fairhaven, MA, and made a living by painting ship portraits. At the same time he studied with the slightly more experienced marine painter Albert van Beest (1820–60), and they collaborated on

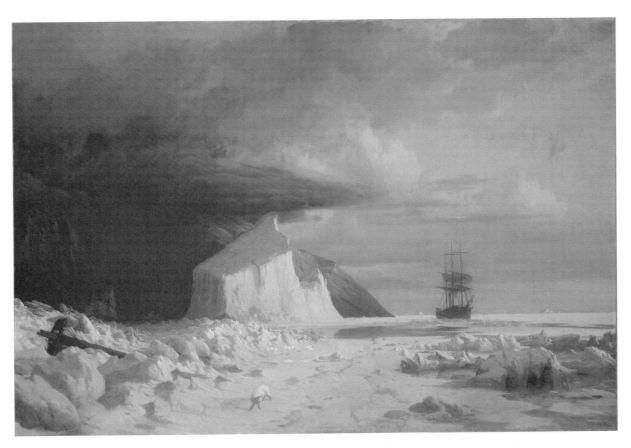

WILLIAM BRADFORD. *An Arctic Summer: Boring through the Pack in Melville Bay*, oil on canvas, 1314 × 1981 mm, 1871. GIFT OF ERVING AND JOYCE WOLF, 1982. © THE METROPOLITAN MUSEUM OF ART/ART RESOURCE, NY

several works. By 1860 Bradford had moved to New York and was starting to gain a reputation for such paintings of the coast of Labrador as *Ice Dwellers Watching the Invaders* (c. 1870; New Bedford, MA, Whaling Mus.) and Greenland, which were based on his own photographs and drawings. From 1872 to 1874 he was in London, lecturing on the Arctic and publishing his book *The Arctic Regions* (1873). Queen Victoria commissioned him to paint an Arctic scene that was shown at the Royal Academy in 1875. On his return to the USA, Bradford was elected an associate member of the National Academy of Design. In later years his tight, realistic style went out of favor as French Impressionism became increasingly popular.

WRITINGS
The Arctic Regions (London, 1873)

BIBLIOGRAPHY
William Bradford, 1823–1892 (exh. cat., ed. J. Wilmerding; Lincoln, MA, DeCordova & Dana Mus., 1969)

F. Horch: "Photographs and Paintings by William Bradford," *Amer. A. J.*, v (1973), pp. 61–70

A.-M. A. Kilkenny: *"Life and Scenery in the Far North:* William Bradford's 1885 Lecture to the American Geographical Society," *Amer. A. J.*, xxvi/12 (1994), pp. 106–8

R. Kugler: *William Bradford: Sailing Ships and Arctic Seas* (Seattle, 2003)

Mark W. Sullivan

Brady, Mathew B.

(*b* Warren County, NY, 1823; *d* New York, 15 Jan 1896), photographer. At the age of 16 he left his home town and moved to nearby Saratoga. There he learned how to manufacture jewelry cases and met William Page, who taught him the techniques of painting. Impressed by his ability, Page took Brady to New York in 1841 to study with Samuel F. B. Morse at the Academy of Design and to attend Morse's school of daguerreotypy; there Brady learned the details of photographic technique. After experimenting with the medium from 1841 to 1843, Brady set up his Daguerrean Miniature Gallery in New York (1844), where he both took and exhibited daguerreotypes. Very soon he established a considerable reputation and in 1845 won first prize in two classes of the daguerreotype competition run by the American Institute. He concentrated on photographic portraits, especially of famous contemporary Americans, such as the statesman *Henry Clay* (1849; Washington, DC, Lib. Congr.). In 1847, with his business flourishing, he opened a second studio, in Washington, DC, and in 1850 published his *Gallery of Illustrious Americans* (New York). These were lithographic portraits of eminent Americans, such as General Winfield Scott and Millard Fillmore, taken from Brady's original daguerreotypes.

In 1851 Brady contributed a number of daguerreotypes to the Great Exhibition in London, which included the largest photographic display so far held. The Americans took all the top awards, Brady himself winning first prize. While in London, he also learned of the new wet collodion or "wet plate" process and met one of its leading practitioners, Alexander Gardner. Soon after his return to New York in 1852, the ambrotype (a collodion glass positive with black backing) became his dominant medium. In 1853 he opened a larger gallery in New York and in 1858 added a gallery to his studio in Washington. In 1856, persuaded by Brady, Gardner came to New York, where he was put in charge of the new gallery. He brought with him the details of a process enabling the production of enlargements from wet plate negatives, which allowed Brady to make large "Imperial"-size portraits. In 1860 Brady opened the largest of his galleries in New York, called the National Portrait Gallery, and that year he took his famous photograph of *Abraham Lincoln* (1860; Washington, DC, Lib. Congr.), the first of many, on the occasion of Lincoln's speech to the Cooper Union. Lincoln, who was elected president the following year, attributed his success to a Brady *carte-de-visite*.

In 1861, at the outbreak of the American Civil War, Brady gave up his lucrative career as a portrait photographer and decided to devote himself to

documenting the events of the war. During the first few months of the following year, he organized and equipped at his own expense several teams of cameramen to send to the numerous sites of conflict. Among the photographers he employed, apart from himself and Gardner, were Timothy O'Sullivan, William R. Pyell, J. B. Gibson, George Cook, David Knox, D. B. Woodbury, J. Reekie and Stanley Morrow. Though working in extremely difficult conditions, Brady and his team were able to cover virtually all the battles and events of the war. Those photographs taken by Brady himself included portraits of the protagonists, such as *Robert E. Lee* (1865; Washington, DC, Lib. Congr.), taken after his defeat, and numerous images of its horrors, such as

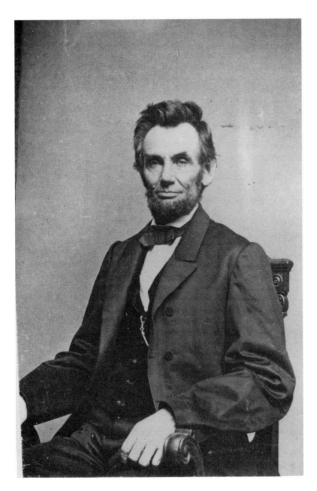

MATTHEW B. BRADY. *Abraham Lincoln*, albumen silver print, 83 × 53 mm, *c.* 1864. NATIONAL PORTRAIT GALLERY, SMITHSONIAN INSTITUTION, WASHINGTON, DC/ART RESOURCE, NY

On the Antietam Battlefield (1862; Washington, DC, Lib. Congr.). Some of his photographs, such as *Dead Confederate Soldier with Gun* (1863; Washington, DC, Lib. Congr.), were stereoscopic views.

Brady had embarked on this vast enterprise in the belief that both private individuals and, more importantly, the state would be interested in purchasing the photographs after the war. In fact, the trauma and destruction it caused led to a general desire to forget. Burdened by huge debts, he tried to persuade the government to buy his collection for the archives. It was not until 1875 that it finally did so, after a vote in Congress. The purchase came too late, however: Brady had been forced to sell all his properties except for the one in Washington, which was run by his nephew Levin Handy. Though reduced to poverty, he produced a few further portrait photographs, such as *Chiefs of the Sioux Indian Nations* (1877; Washington, DC, Lib. Congr.). He sold the last of his galleries in 1895.

[*See also* Gardner, Alexander, *and* Photography.]

BIBLIOGRAPHY

R. Meredith: *Mr. Lincoln's Cameraman* (New York, 1946)

J. D. Horan: *Mathew Brady: Historian with a Camera* (New York, 1955)

P. Pollack: *The Picture History of Photography* (New York, 1977), pp. 56–9

D. M. Kunhardt and P. B. Kunhardt Jr.: *Mathew Brady and his World* (Alexandria, VA, 1977)

G. Hobart: *Mathew Brady* (London, 1984)

A. Trachtenberg: *Reading American Photographs: Images as History, Mathew Brady to Walker Evans* (New York, 1989); review by N. Rosenblum in *A. J.* [New York], xlix (1990), pp. 178–81

Photography in Nineteenth-century America (exh. cat., ed. M. A. Sandweiss; Fort Worth, TX, Amon Carter Mus., and Amherst, U. MA, U. Gal., 1991–2)

H. von Amelunxen: "Von der Vorgeschichte des Abschieds: Bilder zum Zustand des Kriegerischen in der Fotografie," *Fotogeschichte*, xii/43 (1992), pp. 27–38

T. R. Kailbourn, ed.: "'Still Taking Pictures': An Interview with Mathew Brady in April, 1891," *Daguerreian Annu.* (1992), pp. 109–17

G. Gilbert: "Brady's Four New York City Galleries, Not Three!," *Daguerreian Annu.* (1993), pp. 74–9

Mathew Brady and the Image of History (exh. cat. by M. Panzer, Washington, DC, N.P.G; Cambridge, MA, Fogg; New York, Int. Cent. Phot.; 1997–8)

M. Panzer: *Mathew Brady* (London and New York, 2001)

Revised and updated by Margaret Barlow

Brecht, George

(*b* New York, 27 Aug 1926; *d* Cologne, 5 Dec 2008), sculptor, performance artist and writer. A proto-conceptual artist, Brecht emerged as part of the group of avant-garde composers and artists surrounding John Cage in the late 1950s. His model of the "event score," a short textual proposition meant to activate the experience between subject and object, was a pivotal contribution to the conceptual strategies of art in the 1960s. A member of Cage's Experimental Composition courses at New York's New School for Social Research (1956–60), he wrote chance-based, indeterminate scores, first for music, and eventually for *events in all dimensions*. His first solo exhibition, *Toward Events: An Arrangement* (Reuben Gallery, NYC, Oct. 1959)-featured constellations of ready-made objects in familiar "frames," such as a regular medicine cabinet or a suitcase, with instructions indicating how they could be perceived as "events" via suggested (but open) time-based encounters. Between 1959 and 1962 Brecht wrote several hundred event scores, which he often mailed out to friends and colleagues to realize however they wished. In his own practice, he gave object-based realizations to the scores (e.g. "Three Chair Events," 1961), which were presented in landmark exhibitions of this period such as *New Forms, New Media I & II* (June and Sept, 1960), and *Environments, Situations, Spaces* (April, 1961), at the Martha Jackson Gallery, New York; *Art in Motion* at the Stedelijk Museum, Amsterdam (March–April, 1961); and *The Art of Assemblage* at the Museum of Modern Art, New York (Oct–Nov 1961). From 1962 onward, event scores entered Fluxus performance, the context in which they were best known and, perhaps until recently, best understood.

Brecht completed a BS degree and worked as a research chemist for Mobil Oil, Pfizer and Johnson & Johnson (1951–65), registering five US patents and two co-patents for his inventions. Through the 1950s his art was focused on chance-based experiments. Concerned with amplifying the radical aspects of Jackson Pollock's process, he made "chance paintings" and wrote a paper called "Chance-Imagery" (1957), which charted the history of chance in art from Duchamp and Dada to Surrealism, Pollock and Cage. In 1958–59, Brecht attended Cage's classes and developed his model of events from the Cagean score model: composed by chance methods and indeterminate as to performance. Building on the way in which the musical score structures the experience of sound for a listener, Brecht wrote his first scores for music, gradually expanding their parameters to incorporate everyday objects and experiences beyond the purely aural. In 1959 he wrote *Time-Table Music*, the very first short textual score. Many would follow in the year ahead, by Brecht, La Monte Young and others (and from 1961–2 onward by Fluxus artists). Cage class members performed *Time-Table Music* at Grand Central Station, using ready-made timetables to frame all observable occurrences in the station for the given period (e.g. 7:16 would be 7 minutes and 16 seconds).

Brecht's scores were explored extensively *as performance* in the context of Fluxus. The concept of openness, and the inherent removal of the author, is evident in the wide range of interpretations played out. "Piano Piece" (1962), whose notation simply states: "center," has included moving the piano into the center of the room, as well as it can be determined by the performer, to sitting at the piano with each hand at either end of the keyboard, striking each key, and ending at the center. George Maciunas's various interpretations of "Drip Music"—dramatically releasing the water from jug to bucket atop a high ladder at the Fluxus concert in Düsseldorf and reverently dripping in Amsterdam (both 1962)—are well documented. Brecht's own realization of his "Solo for Violin, Viola, Cello, or

their neutral use of language and the fundamental concept that they can be realized as an object, a performance or simply a thought. The event score thus stands as a critique of conventional artistic representation, handing over the power of observation to everyone. A landmark conceptual matrix, with language replacing the art object, Brecht's events anticipated the linguistic strategies of conceptual art by almost a decade.

[*See also* Conceptual art *and* Fluxus.]

BIBLIOGRAPHY

G. Brecht: *Chance Imagery* [1957] (New York, 1966)

G. Brecht: *Water-Yam 1961–1986* (Hamburg, Brussels, 1986)

J. Marter, ed.: *Off Limits: Rutgers University and the Avant-Garde, 1957–63* (New Brunswick, NJ and London, 1999), pp. xii, xvii, 1, 14, 21, 27, 38–41, 47, 49, 63, 65, 75, 77, 90–4, 96, 97, 111–7, 133–4. 144

J. E. Robinson: "In the Event of George Brecht," *George Brecht Events: A Heterospective*, ed. A. Fischer (Cologne, 2005), pp. 16–181

Julia Robinson

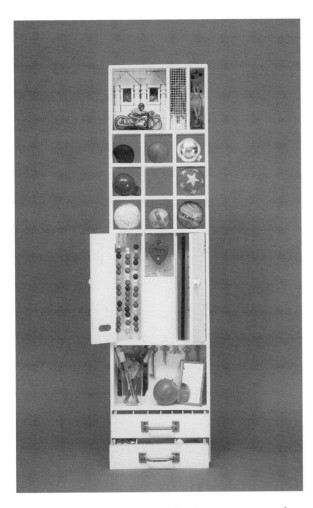

GEORGE BRECHT. *Repository*, wall cabinet containing *objets trouvés,* h. 1.03 m, 1961. LARRY ALDRICH FOUNDATION FUND © 2010 ARTISTS RIGHTS SOCIETY, NY/VG BILD-KUNST, BONN/THE MUSEUM OF MODERN ART/LICENSED BY SCALA/ART RESOURCE, NY

Contrabass" (1962), with the cue "polishing," involved gently applying lemon oil to a violin, occasionally emitting sounds. "Two Durations" (red, green) can be contemplated sitting at a traffic light but in Fluxus it has been realized in combination with Brecht's "Two Umbrellas": one red and one green, opened and closed. Fluxus concerts often used Brecht's 1961 "Word Event" (EXIT) to end performances, indicating to the audience that it was time to leave. Beyond Fluxus, Brecht's work has been shown in the context of Pop art, Minimalism and conceptual art. To grasp the scope and significance of his event scores, it is critical to appreciate

Breitz, Candice

(*b* Johannesburg, 1972), South African multi-media artist. Breitz lives in Berlin, Germany. She received a BA in fine arts (University of Witwatersrand, 1993), an MA in art history (University of Chicago, 1995) and an MPhil in art history (Columbia University, New York, 1997). She was a fellow of the Whitney Independent Studio Program, New York (1996–7). Her work is regularly included in biennials (including among others Johannesburg 1995, São Paulo 1998 and Venice 2005). Her work has been shown extensively in international solo and group exhibitions and is owned by museums and private collectors throughout the world. In 2007, she was awarded the *Prix International d'Art Contemporain* by the Fondation Prince Pierre de Monaco. In photography, video and installation, Breitz turns an insightful, playful and critical eye toward issues of representation, identity, media, global capital, consumerism, celebrity, fandom and language. Her work stretches

from the problem of the cult of the individual to the question of how cultural and other forms of identity are established and maintained. Employing techniques of quotation, appropriation and montage Breitz represents primarily American-produced popular culture in ways that ask viewers to consider the global circulation of visual culture and its impacts on people's lives. Paying particular attention to language and both its possibility and its impossibility in communicating across differences, Breitz makes the familiar unfamiliar and posits the act of translation as a subject in and of itself.

BIBLIOGRAPHY

Y. Dziewior: "Candice Breitz: The 'Surrogate Portrait' Series," *Artforum* (1999)

Candace Breitz: Re-animations (exh. cat., Oxford, Mod. A., 2003)

J. Morgan: "A Scripted Life," curator & ed. O. Zaya, *Candice Breitz, Exposición Múltiple/Multiple Exposure* (Barcelona & New York, 2007)

T. J. Demos: "(In)voluntary Acting: The Art of Candice Breitz," *Candice Breitz, Mother + Father* (Monaco, 2007)

Carol Magee

Brenner, Victor D.

(*b* Schavli, Kovno [now Kaunas], 12 June 1871; *d* New York, 5 April 1924), medalist of Lithuanian origin. Brenner trained as a seal-engraver under his father and worked as a jewelry engraver and type cutter. In 1890 he went to New York, where he worked as a die engraver of badges, and in 1898 to Paris to study at the Académie Julian and later with Oscar Roty. He first exhibited medals in the early years of the 20th century. The influence of Roty is apparent in the low relief and soft-edge naturalism and also in the inclusion of flat expanses of metal in his designs. He occasionally ventured into sculpture, as in the Schenley Memorial Fountain (bronze; Pittsburgh, PA, Schenley Park), but he was best known for his medals and plaquettes, both struck and cast, and his sensitive portraits assured his popularity. The powerful head of President Roosevelt on the Panama Canal medal (bronze, 1908) and the tender

Shepherdess plaquette (electrotype, 1907) demonstrate his range. He executed coins for the Republic of San Domingo and designed the American cent coin with the head of Abraham Lincoln first used in 1909.

BIBLIOGRAPHY

DAB; Thieme–Becker

L. Forrer: *Biographical Dictionary of Medallists* (London, 1902–30), i, pp. 277–9; vii, pp. 117–22; viii, p. 320

International Exhibition of Contemporary Medals, 1910 (exh. cat., intro. A. Baldwin; New York, Amer. Numi. Soc., 1911), pp. 26–34

Exhibition of American Sculpture (exh. cat., preface H. A. MacNeil; New York, N. Sculp. Soc., 1923), p. 30

D. Taxay: *The US Mint and Coinage* (New York, 1966), pp. 330–9

The Beaux-Arts Medal in America (exh. cat. by B. A. Baxter, New York, Amer. Numi. Soc., 1988)

Philip Attwood

Bretteville, Sheila (Levrant) de

(*b* Brooklyn, NY, 4 Nov 1940), graphic designer, installation artist and design educator. De Bretteville attended Abraham Lincoln High School in Brooklyn, NY, and was included in the school's Art Squad by teacher and artist Leon Friend, who submitted his students' work to national competitions. She received a prestigious Alex Award, named after the designer Alex Steinweiss, also a former member of the Art Squad. She received a BA in art history from Barnard College, New York, in 1962 and received her MFA in the graphic design program at Yale University's School of Art in 1964. She joined the faculty of the California Institute of the Arts (CalArts) and founded the first design program for women in 1970. In 1981 she founded the communication design program at the Otis Art Institute in Los Angeles (now the Otis College of Art and Design), which was at the time affiliated with the Parsons School of Design in New York. In 1973 de Bretteville co-founded, with Judy Chicago and Arlene Raven (1944–2006), the Woman's Building,

a public center for female culture in downtown Los Angeles. For more than 20 years the space was home to projects such as the Womanspace gallery, the Feminist Studio Workshop, the offices of the National Organization for Women and the Women's Graphic Center of Typesetting and Design, a full-service, for-profit design studio run by women designers. The building and its exhibits and programming were internationally recognized until it closed in 1991.

Through her work at CalArts and the Woman's Building, de Bretteville became a major figure in both design and the women's movement, infusing visual culture with feminist principles, which was alternatively called "feminist design" and "person-centered design." She portrayed subjective thinking and multiple perspectives in her work and instructed her students to filter their assignments through personal experience, incorporating meaning and reason for their design that went beyond simply making messages. She also attached a social responsibility to design, calling for user participation and for design to connect with audiences by addressing community issues and cultural improvement. Empowered by these feminist and activist principles, de Bretteville held design to a higher standard, a position that was criticized and celebrated by designers worldwide. A poster for CalArts that she produced in 1969 epitomized her beliefs: "If the designer is to make a deliberate contribution to society, he must be able to integrate all he can learn about behavior and resources, ecology and human needs; taste and style just aren't enough." In 1990, when she was appointed director of studies for the graphic design program at Yale University, legendary designer and faculty member Paul Rand resigned in protest at her personal design mandate.

De Bretteville created award-winning environmental design, graphic design, signage, public art installations, publication design and exhibits for the New York City Metropolitan Transportation, *The Motown Album* (St Martin's Press, 1990), *The Los Angeles Times*, *American Cinematographer*, *Arts in Society*, the cities of Los Angeles, Flushing, NY, and New Haven, CT, and various educational and cultural institutions. De Bretteville approached her design with an academic rigor, conducting extensive community research, even recording the voices of her audience. Her best known work brought culturally significant public art projects to impoverished neighborhoods. *Biddy Mason: Time & Place* (1990) is a mural that chronicles the life of an African American midwife who lived in downtown Los Angeles. In *Path of Stars* (1994), in a New Haven neighborhood, de Bretteville immortalized ordinary citizens with granite stars in the pavement. Her work is featured in the Museum of Modern Art, New York, and the Victoria and Albert Museum, London. She received honorary degrees from California College of Arts and Crafts and Moore College of Art. She was awarded the highest recognition for graphic design, the AIGA Medal, in 2004.

BIBLIOGRAPHY

D. Stermer: "Sheila de Bretteville," *Communic. A.* (May–June 1982), p. 45

At Home (exh. cat. by A. Raven; Long Beach, CA, Mus. A., 1983)

E. Lupton: "Sheila Levrant de Bretteville: Dirty Design and Fuzzy Theory," *Eye* (1992)

E. Lupton: "Colophon: Women Graphic Designers," *Women Designers in the USA 1900–2000: Diversity and Difference*, ed. P. Kirkham (London, 2000)

Alissa Walker

Breuer, Marcel

(*b* Pécs, Hungary, 21 May 1902; *d* New York, 1 July 1981), furniture designer and architect of Hungarian birth. In 1920 Marcel Lajos Breuer took up a scholarship at the Akademie der Bildenden Künste, Vienna, but he left almost immediately to find a job in an architect's office. A few weeks later he enrolled at the Bauhaus at Weimar on the recommendation of the Hungarian architect Fred Forbat (1897–1972). Breuer soon became an outstanding student in the carpentry workshop, which he led in its endeavors to find radically innovative forms for

modern furniture. In practice, this meant rejecting traditional forms, which were considered symbolic of bourgeois life. The results of these experiments were initially as idiosyncratic as those of other workshops at Weimar, including the adoption of non-Western forms, for example the African chair (1921; see Rowland, 1990, p. 66) and an aggressively castellated style inspired by Constructivism.

Breuer was impressed by De Stijl, whose founder Theo van Doesburg (1883–1931) made his presence felt in Weimar in 1921–2. Breuer interpreted the De Stijl aesthetic in his designs, which were characterized by asymmetry, discrete elements and a tendency to view the design of a chair, for example, as an architectural experiment. The Red–Blue chair (1917; New York, MOMA) by Gerrit Rietveld (1888–1964) taught Breuer to distinguish between the frame of a chair and the supports for the sitter. Encouraged by Walter Gropius to think in terms of standardization, he used elements of the same width to facilitate manufacture. From 1923 he also turned to less expensive woods such as plywood, particularly in his children's furniture. After a brief period working as an architect in Paris (1924), Breuer rejoined the Bauhaus in Dessau as leader of the carpentry workshop. By 1925 he insisted on the complete rejection of formalism: if an object was designed in such a way that it fulfilled its function clearly, it was finished. Suitability for a particular function was not, however, enough in itself; there was also the quality factor. Ornamentation was not necessary to form a coherent set of furniture: a good chair would go with a good table.

In spring 1925 Breuer began to experiment with tubular steel, beginning with his Wassily chair, which was allegedly inspired by the lightness and strength of his new Adler bicycle. Next he developed a side chair with sled-like runners instead of legs. The following crucial stage was the cantilevered side chair, first developed by Mart Stam (1899–1986), although Breuer claimed that he had conceived the idea on turning one of his nesting stools on its side and subsequently confided it to Stam. Breuer's best-known side chair is the B32 (1928; New York, MOMA) in chrome-plated steel, wood and cane, which is still mass-produced. He also produced tables, for example in steel tube and wood. Breuer negotiated privately to secure marketing by Standard-Möbel, which in April 1929 was bought up by the manufacturer Thonet. These chairs and the glass-topped tables that accompanied them were intended to be light, transparent and non-specific in function. Thus, for example, his small stacking stools could also be used as occasional tables. He also developed a range of modular furniture (cabinets, desktops, shelving) that could be assembled according to need (examples in New York, MOMA). The interiors that he designed in conjunction with Gropius's architectural office, such as the theater director and producer Erwin Piscator's flat, have a beauty that Breuer liked to consider impersonal, arising not from ornament but from what he called the tools of living themselves and from the contrast of textures and surfaces.

Breuer was too much of an individualist to remain at the Bauhaus under Hannes Meyer; from 1928 to 1931 he worked for Gropius's office in Berlin and became increasingly involved in architectural projects. These were initially informed by an enthusiastically American style: his multi-level traffic scheme for the Potsdamer Platz of 1928, for example, was based on the flow diagrams of an American assembly line. A constructivist phase followed, for example the Khar'kov Theater project (1931). Finally he arrived at a Corbusian purism, exemplified in the Harnismacher house (1932), Wiesbaden, a piece of humanly made perfection in white stucco set against the natural landscape. From 1932 to 1935 Breuer led a nomadic existence, traveling around the Mediterranean and in North Africa and admiring what he saw as the impersonality and rationality of the vernacular architecture. In 1933 he won the International Aluminum Competition in Paris for aluminum furniture by exploiting the material's lightness and flexibility. In October 1935 he followed Gropius to England and on his suggestion designed a plywood

version of his aluminum lounge chair for Jack Pritchard's Isokon Company. The Isokon long chair (1935; New York, MOMA), an early example of biomorphic design, was followed by plywood nesting tables and stacking chairs. With his partner and architect Francis Reginald Stevens Yorke (1906–62) he designed a pavilion for the Royal Show at Bristol in 1936, using stone and wood in the slab and panel forms favored by the Modern Movement. The ambitious design for a Civic Centre of the Future for the British Cement Industries (1936) contains elements of all their favorite projects such as Y-shaped blocks of flats, which Breuer was later to implement.

In 1937 Breuer joined Gropius as a professor at Harvard University, Cambridge, MA, and together they created the Harvard school of third-generation modernists. Ironically, when Breuer finally arrived in the USA he was impressed not by large-scale American industry but by New England vernacular architecture. In their domestic architecture he and Gropius, who were partners (1937–41), successfully assimilated its use of wood and mortared rubble to the demands of the new architecture, and they delighted in the contrast between rough stonework and smooth white surfaces. In 1946 he formed his own partnership in New York. Although he experimented with wooden prefabricated housing and with the idea of the H-shaped house, he largely worked on ambitious projects for substantial industrial concerns and institutions in North and South America. In Europe he also designed resort buildings and housing, although his best-known building there is the Y-shaped UNESCO headquarters (1953–8) in Paris.

In 1963–6 he designed the Whitney Museum of American Art, New York, a massive, granite-faced building on Madison Avenue, designed to stand out from the surrounding office buildings. The facade is punctuated by obliquely angled windows, intended to prevent direct sunlight reaching the works of art housed inside. Breuer maintained his interest in textural contrast and his fondness for Corbusian pilotis; however, after World War II he suffered a loss of direction, and his work was at times overblown and

MARCEL BREUER AND HAMILTON SMITH. Whitney Museum of American Art, 945 Madison Avenue, New York, 1963–6. PHOTOGRAPH BY JERRY L. THOMPSON

unconvincing. His religious buildings, such as the St Francis de Sales church (1961–7), Muskegon, MI, are often strenuously modern, relying on feats of engineering to create excitement. His designs for private houses, and in particular his interiors, were generally much more successful. His great achievement lay in devising furnishings, appropriate for the modern interior, which retained their refreshingly clear and modern appearance over time. Among the most renowned of Breuer's pupils are I. M. Pei, Philip Johnson and Paul Rudolph.

WRITINGS
"Form Funktion," *Junge Menschen*, v/8 (1924) [issue devoted to the Bauhaus]
Architektur, Möbel, Design (Berlin, 1975)

BIBLIOGRAPHY
P. Blake: *Marcel Breuer: Architect and Designer* (New York, 1949)
P. Blake, ed.: *Marcel Breuer: Sun and Shadow* (New York, 1955)
C. Jones, ed.: *Marcel Breuer: Buildings and Projects, 1921–61* (London and Stuttgart, 1962; 2/New York, 1963)
H. M. Wingler: *Das Bauhaus* (Bramasche and Cologne, 1969; Eng. trans., Cambridge, MA, and London, 1969, rev. 1976)
D. Sharp, T. Benton and B. Campbell Cole: *Pel and Tubular Steel Furniture of the Thirties* (London, 1977)

L. Doumato: *Marcel L. Breuer: Architect and Designer* (Monticello, IL, 1979)

R. B. Harmon: *The Architecture of Marcel Lajos Breuer: A Selected Bibliography* (Monticello, IL, 1980)

C. Wilk: *Marcel Breuer: Furniture and Interiors* (London, 1981)

A. Rowland: *The Bauhaus Source Book* (Oxford, 1990)

J. Driller: *Breuer Houses* (London, 2001)

I. Hyman: *Marcel Breuer, Architect: The Career and the Buildings* (New York, 2001)

Marcel Breuer: Design and Architecture (exh. cat. by A. von Vegesack and others, Weil am Rhein, Vitra Des. Mus., 2003)

Anna Rowland

Brewster, John, Jr.

(*b* Hampton, CT, 30 or 31 May 1766; *d* Buxton, ME, 13 Aug 1854), painter. John Brewster Jr. was the son of Dr John Brewster, a prominent physician in Hampton, CT, and his first wife, Mary Durkee. Born a deaf–mute, Brewster was taught at an early age to communicate through signs and writing. In addition he received instruction in painting from Rev. Joseph Steward (1753–1822), a successful local portrait painter. Essentially self-taught, Steward painted portraits in the manner of Ralph Earl, who inspired a regional portrait style in Connecticut in the 1790s. Brewster began painting full-length likenesses of his family and friends in the mid-1790s, such as the double portrait of his parents (Sturbridge, MA, Old Sturbridge Village), which includes a regional landscape view in the background, a characteristic of Connecticut portraiture of the period.

Brewster began a successful career as an itinerant artist in 1796, when he followed his brother Royal to Buxton, ME. Buxton became Brewster's permanent home between his extensive trips, throughout the northeastern states, during which he painted portraits and miniatures. His portraits are executed in a flat, decorative style, with realistic likenesses of his subjects, elements related to folk art. Brewster's strong characterizations of his subjects are portrayed with great sensitivity. His finest works are the double portraits of 1799, *Comfort Starr Mygatt and his Daughter Lucy* (priv. col.) and *Lucy Knapp Mygatt and her Son George* (University Park,

PA State U., Palmer Mus. A.). After 1805 he often signed and dated his work on the stretcher in pencil.

In 1817, at the age of 51, Brewster enrolled in the first class of the Connecticut Asylum for the Deaf and Dumb in Hartford, where he studied for three years. He returned to Buxton in 1820 and continued painting until his death.

BIBLIOGRAPHY

N. F. Little: "John Brewster Jr., 1766–1854," *CT Hist. Soc. Bull.*, xxv/4 (1960), pp. 97–129

N. F. Little: "John Brewster Jr.," *American Folk Painters of Three Centuries*, ed. J. Lipman and T. Armstrong (New York, 1980), pp. 18–26

B. T. Rumford, ed.: *American Folk Portraits* (Boston, 1981), pp. 65–7

J. Hill: "Miniatures by John Brewster Jr.," *The Clarion* (Spring–Summer 1983), pp. 49–50

Ralph Earl: The Face of the Young Republic (exh. cat. by E. M. Kornhauser and others, Hartford, CT, Wadsworth Atheneum, 1991), pp. 242–5

H. Lane: *A Deaf Artist in Early America: The Worlds of John Brewster, Jr.* (Boston, 2004)

A Deaf Artist in Early America: The Worlds of John Brewster Jr. (exh. cat. by P. D'Ambrosio, Cooperstown, NY, Fenimore A. Mus.; and elsewhere; 2005–6)

Elizabeth Mankin Kornhauser

Bricher, Alfred Thompson

(*b* Portsmouth, NH, 10 April 1837; *d* New Dorp, Staten Island, NY, 30 Sept 1908), painter. A landscape painter who primarily painted seascapes, he was the son of an Englishman who had moved to the USA in 1820. While working in business, Bricher took art lessons at the Lowell Institute in Boston, MA, and by 1859 was able to set himself up as a painter in Newburyport, MA. His subject matter derived from sketches made during his summer travels along the Maine and Massachusetts coasts and to the Bay of Fundy; during the winter he worked these into finished paintings. In 1869 Bricher moved to New York, where a lucrative arrangement with the chromolithography firm of Louis Prang & Co. gave his work wide exposure through commercial reproduction.

Bricher exhibited annually at the National Academy of Design in New York. A fine watercolor

ALFRED THOMPSON BRICHER. *Castle Rock, Marblehead,* oil on canvas, 663 × 1275 mm, 1878. SMITHSONIAN AMERICAN ART MUSEUM, WASHINGTON, DC/ART RESOURCE, NY

painter, he was also an active member of the American Society of Painters in Water-Colors. His watercolor *In a Tide Harbour* (untraced) was shown at the Exposition Universelle in Paris in 1878. A steady stream of buyers brought him financial and popular success, enabling him to own homes in Staten Island and Southampton, NY. Bricher's work reflected the Luminist aesthetic of sharply defined panoramic views suffused with crisp, clear light. He was particularly partial to low tide scenes (e.g. *Fog Clearing, Grand Manan, c.* 1898; Hartford, CT, Wadsworth Atheneum). His work lacked variety, though it was invariably painted with a high degree of finish.

BIBLIOGRAPHY

J. D. Preston: "Alfred T. Bricher, 1837–1908," *A. Q.,* xxv (1962), pp. 149–57

Alfred Thompson Bricher, 1837–1908 (exh. cat. by J. R. Brown, Indianapolis, IN, Mus. A., 1973)

Domestic Bliss: Family Life in American Painting, 1840–1910 (exh. cat. by L. M. Edwards, New York, Hudson River Mus., 1986), pp. 92–6

Lee M. Edwards

Brito, María

(*b* Havana, 10 Oct 1947), Cuban sculptor, active in the USA. María Brito (Avellana) arrived in the USA during the 1960s and in 1979 obtained an MFA at the University of Miami. She worked primarily in three formats: wall-hanging constructions, free-standing sculpture and installations situated in corners like stage props. Using mixed-media, often wood and found objects, she focused on the objective representation of personal dreamed images, reminiscent of the assemblages of Joseph Cornell and Marisol (e.g. *Next Room [Homage to R.B.],* mixed-media, 1986; see 1987–8 exh. cat., p. 259). Brito exhibited widely throughout the USA, in both solo and group exhibitions.

BIBLIOGRAPHY

P. Plagens: "Report from Florida: Miami Slice," *A. America,* lxxiv/11 (Nov 1986), pp. 26–39

R. Pau-Llosa: "The Dreamt Objectivities of María Brito Avellana," *Dreamworks,* v/2 (1986–7), pp. 98–104

Outside Cuba (exh. cat. by I. Fuentes-Pérez, G. Cruz-Taura, and R. Pau-Llosa, New Brunswick, NJ, Rutgers U., Zimmerli A. Mus.; New York, Mus. Contemp. Hisp. A.; Oxford, OH, Miami U., A. Mus.; and elsewhere; 1987–9), pp. 258–61

C. S. Rubenstein: *American Women Sculptors: History of Women Working in Three Dimensions* (Boston, 1990), pp. 564–5

L. M. Bosch: "Metonomy and Metaphor: María Brito," *Lat. Amer. A.*, v/3 (1993), pp. 20–23

J. Lukac: "Lydia Rubio, Cesar Trasobares, Ricardo Zulueta, Ricardo Viera, Maria Brito, Maria Lino," *A. Papers*, xvii/1 (Jan–Feb 1993), pp. 17–20

Islands in the Stream: Seven Cuban American Artists (exh. cat. by L. Bosch, Cortland, SUNY, Dowd F.A. Gal., c. 1993)

. . . my magic pours secret libations (exh. cat. by M. Love and others, Tallahasse, FL State U., Mus. F. A., 1997)

Maria Brito: Rites of Passage: Sculpture and Painting, 1988–1998 (exh. cat.; Fort Lauderdale, FL, Mus. A., 1998)

R. Henkes: *Latin American Women Artists of the United States* (Jefferson, NC, 1999)

K. G. Congdon and K. K. Hallmark: *Artists from Latin American Cultures: A Biographical Dictionary* (Westport, CT, 2002)

Ricardo Pau-Llosa

Broadacre City

Theoretical housing and development plan by Frank Lloyd Wright. Broadacre City embodied architect Frank Lloyd Wright's ideals of housing and development for 20th-century America. It is a utopian plan in which Wright proposed that every American family should own, occupy and cultivate one acre of land, evenly distributed across the entire country. Its basic premise is the decentralization of urban areas, enabled by universal automobile ownership. Wright's own "organic" architecture was to supply all the built needs for this society. Wright first published his ideas for Broadacre City in a book entitled *The Disappearing City* (1932), and he worked on the concept until his death in 1959, publishing a total of three books on the subject, the first followed by *When Democracy Builds* (1945) and *The Living City* (1958).

The Disappearing City appeared the same year as Wright's autobiography, both written in a Depression-Era lull in the architect's career. The autobiography contained a section subtitled "The Usonian City." "Usonia," a portmanteau word derived from "United States" and "utopia," was Wright's name for his idealized vision for America. This project included autonomous dwellings for all working-class families, and Wright worked in the 1930s on the modest "Usonian" homes that were his answer to this ideal. Examples of Usonian homes include the first Herbert Jacobs House in Madison, WI (1936), and the Pope-Leighey House in Alexandria, VA (1939).

The intellectual underpinnings of Broadacre City were political, social and economic as well as architectural, and were in part a reaction to the devastations of the Great Depression. Wright decried the "have" and "have-not" relationship of landlord to tenant, maintaining that the system of tenancy, rent and mortgaging was anti-democratic. He felt that the crowding and verticality of dense urban cores was unnatural, and believed that centralization, brought about by industrialization and increased bureaucracy, was the antithesis of human individuality and freedom. He argued that technologies such as electricity, communication, food preservation, mass production and, above all, the automobile made urbanism irrelevant.

Wright's answer to the artificiality of the large American city was decentralization, based on Jeffersonian agrarian individualism. The Broadacre City model proposed fracturing the urban enterprise into smaller economic units, and then redistributing these units over the entire national landscape. Every family would have a minimum of one acre to live on and to farm, and no home would be more than 10 miles from the workplace. Factories would be broken up to be small enough to allow proximity to their workers. Offices, too, would be smaller and decentralized; telecommunication would allow many to work from home. Wright proposed that in addition to home gardens, farmers would work small farms of three, five or ten acres. Small town centers would answer communal needs such as education, healthcare, commerce, entertainment, culture and worship. This low-density fabric would be woven together via a vast roadway system and universal personal transportation in the form of automobiles and personal helicopters he dubbed "aerotors."

Wright's architecture played the defining aesthetic role in the development of Broadacre City. His lifelong commitment to an "organic" architecture dictated the architectural approach to building within Broadacre City. He banished all historicizing ornament and focused instead on architectural integration: the site with the building, the materials with the landscape and the people with their environment. In this architectural utopia, the highest civil authority was the county architect.

From 1934, Wright brought the theories first published in 1932 in *The Disappearing City* into more concrete form when the patrons of Fallingwater, Edgar and Lillian Kaufmann, visited their son at Wright's home and studio, Taliesin, and were persuaded to provide financial support to develop a model for Broadacre City. By 1935, Wright and the Taliesin fellows had built a 12×12 ft wooden model on a scale of 75 ft per inch. The model represented four square miles of development, capable of housing and employing 1400 families. In theory, these four square miles could represent any place in Wright's "Usonia."

Broadacre City has received mixed critical and historical reception. Wright accurately predicted many of the aspects in which modern life has been affected by universal car ownership. He foresaw increased traffic congestion in urban centers, and the superhighways he proposed have more or less come into being. His preference for horizontality and his proposal to build outwards rather than upwards have been realized in what is now termed "sprawl." Contemporary population trends and theories of New Urbanism have led to the revitalization of city centers and a distaste for suburban sprawl that has, to some extent, discredited the Broadacre City vision.

[*See also* Wright, Frank Lloyd.]

BIBLIOGRAPHY
F. L. Wright: *The Disappearing City* (New York, 1932)
F. L. Wright: *When Democracy Builds* (Chicago, 1945)
F. L. Wright: *The Living City* (New York, 1958)
S. Grabow: "Frank Lloyd Wright and the American City: The Broadacres Debate," *Amer. Inst. Planners J.*, xliii (April 1977), pp. 115–23
A. Alofsin: "Broadacre City: The Reception of a Modernist Vision," *Center: J. Archit. America*, v (1989), pp. 5–43
A. Rosenbaum: *Usonia: Frank Lloyd Wright's Design for America* (Washington, DC, 1993)
A. C. Nelson: "The Planning of Exurban America: Lessons from Frank Lloyd Wright's Broadacre City," *J. Archit. & Planning Res.*, xii (Winter 1995), pp. 337–56
P. K. Zygas and L. N. Johnson, eds.: *Frank Lloyd Wright: The Phoenix Papers Volume 1: Broadacre City* (Tempe, AZ, 1995)
P. Zellner: "'The Big City Is no Longer Modern': Frank Lloyd Wright," *Daidalos*, lxix–lxx (Dec 1998–Jan 1999), pp. 68–75
M. Deheane: "Broadacre City: The City in the Eye of the Beholder," *J. Archit. & Planning Res.*, xix (Summer 2002), pp. 91–109
D. L. Johnson: "Frank Lloyd Wright's Community Planning," *J. Planning Hist.*, iii (Feb 2004), pp. 3–28

Ingrid Steffensen

Brodovitch, Alexey

(*b* Ogolitchi, nr St Petersburg, 1898; *d* Le Thor, Vaucluse, 15 April 1971), typographic designer, art director and photographer. After settling in the USA in 1930, Brodovitch established a reputation as one of the most influential art directors of the 20th century. He was best known for his 24-year career (1934–1958) at *Harper's Bazaar* and for his Design Laboratory, operated first under the auspices of the Philadelphia Museum School (1936–40) and then (1941–59) of the New School for Social Research and the American Institute of Graphic Arts, both in New York. Through his work at *Harper's*, Brodovitch revolutionized modern magazine design by forging a greater integration of typography, text and photography. His innovative layouts and numerous cover illustrations for the magazine popularized the techniques of montage, full-bleed paging and strategic sequencing of photographs that fostered interactive readership. In 1945 Brodovitch published *Ballet*, an influential book featuring his own photographs of the Ballets Russes de Monte Carlo taken between 1935 and 1939. The book's blurred, fast-paced, almost

Surrealist photographs suggest Brodovitch's preference for unconventional framing and juxtaposition, while its sequencing demonstrated for many the fundamental principles underlying his art direction and instruction. During his years teaching the Design Laboratory courses in New York, Brodovitch directly affected the careers of several important photographers, including Diane Arbus, Richard Avedon, Irving Penn and Lisette Model. His influence on graphic design and photography continued to be manifest in magazine and book publishing at the end of the 20th century.

[*See also* Frank, Robert.]

PHOTOGRAPHIC PUBLICATIONS
Ballet (New York, 1945)

BIBLIOGRAPHY
A. Grundberg: *Brodovitch* (New York, 1989)
J. Livingston: *The New York School: Photographs, 1936–63* (New York, 1992), pp. 36–51

James Crump

Brookes, Samuel Marsden

(*b* Newington Green, Middlesex, England, 8 March 1816; *d* San Francisco, CA, 21 Jan 1892), painter of English birth. He immigrated with his family to the USA in 1833, settling in Chicago, where in 1841 he received his only art training from two itinerant painters. Essentially self-taught, he spent two years (1845–6) in London copying Old Master paintings; forgoing an anticipated sojourn in Rome, he returned to the USA, at his wife's request, to launch his career in Chicago and Minneapolis. In 1862 he settled permanently in San Francisco, where he built up a highly successful art practice—his income averaging $300 per month and paintings selling for as much as $2000—while establishing a national reputation as perhaps the finest American still-life painter of the 19th century. Thomas Hill and even Albert Bierstadt reportedly acknowledged Brookes's pre-eminent ability to render the iridescence of fish scales, a skill abundantly evident in *Steelhead Salmon* (1885; Oakland, CA, Mus.).

When he arrived in San Francisco, Brookes offered art lessons from his studio, and among his students was the young William Keith. His many patrons included Edwin Bryant Crocker and Mrs. Mark Hopkins, who commissioned Brookes's *tour-de-force* study of a peacock (1880; Los Angeles, CA, priv. col.) for her Nob Hill mansion. Many of the artist's paintings were lost in the1906 earthquake, when the Mark Hopkins Institute of Art (the mansion had been donated to the California School of Design after Mrs. Hopkins's death) was consumed by fire, but *Peacock* appears to have been among the survivors. A founder of both the Bohemian Club (1872) and San Francisco Art Association (1871), Brookes shared his Clay Street studio during the 1870s with fellow Bohemian Edwin Deakin (1838–1923), who painted several portraits of his colorful friend at work. By the 1880s Brookes had become a well-known San Francisco figure, described as short and stocky with a large head, long hair and flowing beard, always with a cigar clenched between his teeth. His picturesque studio was for years a favorite gathering place for artists, of whom several prominent ones— among them Keith and Norton Bush (1834–94)— served as pallbearers at Brookes's funeral.

Brookes's work was shown at the Mechanics Institute Industrial Exhibitions, San Francisco (1864– 90); the San Francisco Art Association (*c.* 1872–86); the Philadelphia Centennial Exposition (1876); the World's Columbian Exposition, Chicago (1893); and the California Midwinter International Exposition, San Francisco (1894). Posthumous exhibitions included a retrospective (1962–3) shown at the California Historical Society, San Francisco, and the Oakland Museum.

BIBLIOGRAPHY
L. A. Marshall: "Samuel Marsden Brookes," *CA Hist. Soc. Q.*, xxxvi (Sept 1957), pp. 193–203
Samuel Marsden Brookes (1816–1892) (exh. cat. with essay by J. A. Baird jr., San Francisco, CA Hist. Soc., and Oakland, CA, Mus., 1962–3)

W. H. Gerdts: *Art across America: Two Centuries of Regional Painting, 1720–1920*, iii (New York, 1990)

Beautiful Harvest: Nineteenth-century California Still-life Painting (exh. cat. by J. T. Dreisbach, Sacramento, CA, Crocker A. Mus., 1991)

K. Starr: *The Visual Arts in Bohemia: 125 Years of Artistic Creativity in the Bohemian Club* (San Francisco, 1997)

Paul J. Karlstrom

Brooks, James

(*b* St Louis, MO, 18 Oct 1906; *d* Long Island, New York, 9 March 1992), painter. Brooks moved in 1916 to Dallas, TX, where he studied at Southern Methodist University from 1923 to 1925, majoring in art, and from 1925 to 1926 at the Dallas Art Institute. In 1926 he moved to New York, where he studied at the Art Students League from 1927–30 while earning his living as a commercial artist. In the 1930s he painted in the prevailing social realist style, usually taking the rural West and Midwest as his subject matter. From 1936 to 1942 he participated in the Works Progress Administration's Federal Art Project, executing murals in public buildings; the most important of these, including the *Acquisition of Long Island* (1937–8; New York, Woodside Lib.; destr. 1963, with few remaining fragments) and the vast *Flight* (3.65 × 99 m, 1938–42; for detail, see I. Sandler, *Abstract Expressionism: The Triumph of American Painting*, New York, 1970, p. 234) at La Guardia Airport in New York, were later destroyed. Even in these representational works, with their meticulously organized spaces, a tendency to formal and abstract concerns is in evidence.

After serving as an artist correspondent during World War II, Brooks returned to painting, evolving a style characterized by freer and looser forms through variations on Cubism. Influenced first by the work of Picasso, by the late 1940s he developed a preference for fluid colors as used by Jackson Pollock, with whom he became close friends from 1946. In this mature period, during which he became associated with Abstract Expressionism, he demonstrated his mastery and control of color and gesture, allowing the paint to whirl and blot freely in paintings such as *Boon* (oil on canvas, 1.8 × 1.73 m, 1957; London, Tate), with color and space in harmonious balance. His preference for subtle tonalities and calm, lyrical moods distinguished his work from the more aggressive tone of the branch of Abstract Expressionism sometimes referred to as action painting. In later paintings such as *Cooba* (2.03 × 1.88 m, 1963; Buffalo, NY, Albright–Knox A.G.) he introduced elegant linear elements as a decorative counterpoint to the flat irregular shapes against which they were placed. For illustration, see color pl. 1:XII, 2.

[*See also* Abstract Expressionism.]

BIBLIOGRAPHY
Twelve Americans (exh. cat., ed. D. C. Miller, New York, MOMA, 1956)

James Brooks (exh. cat., foreword J. I. H. Baur, essay S. Hunter; New York, Whitney, 1963)

Recent Paintings by James Brooks (exh. cat., New York, Martha Jackson Gal., 1968)

James Brooks (exh. cat., New York, Martha Jackson Gal., 1971)

James Brooks (exh. cat., intro. M. Rueppel; Dallas, TX, Mus. F.A., 1972)

James Brooks: Paintings 1952–1975, Works on Paper 1950–1975 (exh. cat., New York, Martha Jackson Gal., 1975)

D. Seckler: "James Brooks: Interview," *Archvs Amer. A. J.*, 16/1 (1976), pp. 12–20

James Brooks, A Quarter-Century of Work (exh. cat. by L. M. Messinger; Huntington, NY, Heckscher Mus., 1988)

James Brooks: The Early 1950's (exh. cat.; New York, Berry-Hill Gals, 1989)

A. Abeles: *James Brooks: From Dallas to the New York School* (diss., City U. of New York, 2001)

Alberto Cernuschi

Brooks, Romaine

(*b* Rome, 1 May 1874; *d* Nice, 7 Dec 1970), painter and draftsman. Romaine Brooks [née Goddard] grew up in various European and American cities, including Paris, Rome, Geneva and New York, living in a disturbing family atmosphere. When she was seven, her mother abandoned her in New York, and

her Irish laundress, Mrs. Hickey, took her into her home, where they lived in severe poverty until Brooks's grandfather's secretary collected her. Brooks was allowed and encouraged to draw by Mrs. Hickey. In 1896–7 Brooks went to Rome, studying at the Scuola Nazionale by day and the Circolo Artistico by night. The only woman at the Scuola, she was one of the first to be allowed to draw from a nude male model. In summer 1899 she studied at the Académie Colarossi, Paris. A substantial fortune inherited from her grandfather (1902) markedly altered the quality of her life. Following a brief marriage, Brooks moved to London (1902–4), made her earliest mature portrait paintings of young women and returned to Paris. Her first solo exhibition was at the Galerie Durand-Ruel (1910), of 13 portraits, including those of noted members of the intelligentsia and Parisian society. These and later works for which she is renowned, such as portraits of Russian

ROMAINE BROOKS. *Ida Rubinstein*, oil on canvas, 1191 × 940 mm, 1917. GIFT OF THE ARTIST/SMITHSONIAN AMERICAN ART MUSEUM, WASHINGTON, DC/ART RESOURCE, NY

ballerina *Ida Rubenstein* (1917; Washington, DC, Smithsonian Inst.), writer *Gabriele D'Annunzio* (1912; Paris, Mus. N. A. Mod.) and her companion of 50 years, writer and salonist *Natalie Clifford Barney* (*L'Amazon*, c. 1920; Paris, Mus. Carnavalet), have a characteristic boldness that sets the figures apart from their environments. She was also known for portraits of androgynous women in masculine dress (*Self-portrait*, 1923; Washington, DC, Smithsonian Inst.). Her drawings are more imaginary, exploring personal and fanciful themes. Brooks's style suggests an interest in Symbolism and Art Nouveau. Interest in Brooks was reawakened by two major exhibitions: one at the National Collection of Fine Arts, Washington, DC, in 1971, and one at both the University of California Berkeley, CA, and National Museum of Women in the Arts, Washington, DC, in 2000.

BIBLIOGRAPHY

A. Breeskin: *Romaine Brooks, Thief of Souls* (Washington, DC, 1971)

M. Secrest: *Between me and my Life: A Biography of Romaine Brooks* (London, 1976)

B. Elliott and J. Wallace: "Fleurs du Mal or Second-Hand Roses?: Natalie Barney, Romaine Brooks, and the 'Originality of the Avant-Garde'," *Fem. Rev.*, xl (Spring 1992), pp. 6–30

C. M. Chastain: "Romaine Brooks: A New Look at Her Drawings," *Woman's A. J.*, xvii/2 (Fall 1996–Winter 1997), pp. 9–14

Amazons in the Drawing Room: The Art of Romaine Brooks (exh. cat., essays by W. Chadwick and J. Lucchesi; Washington, DC, N. Mus. Women A.; Berkeley, U. CA, A. Mus., 2000)

T. T. Latimer: *Women Together/Women Apart: Portraits of Lesbian Paris* (New Brunswick, NJ, 2005)

Revised and updated by Margaret Barlow

Broome, Isaac

(*b* Valcartier, Qué., 16 May 1836; *d* Trenton, NJ, 4 May 1922), sculptor, ceramic modeler and teacher of Canadian birth. Broome received his artistic training at the Pennsylvania Academy of Fine Arts in Philadelphia, where he was elected an Academician in 1860 and taught (1860–63) in the Life and Antique department. In 1854 he assisted Thomas Crawford with the statues on the pediment of the Senate wing

of the US Capitol in Washington, DC, and tried unsuccessfully to establish a firm for architectural terracotta and garden ornaments in Pittsburgh and New York.

From 1875 Broome was employed as a modeler by the firm of Ott & Brewer in Trenton, NJ. The parian porcelain sculpture he created for their display at the Centennial International Exhibition of 1876 in Philadelphia won him medals for ceramic arts. Following his success at the Exhibition and at the Exposition Universelle of 1878 in Paris, for which he was Special Commissioner from the USA, he was active as a teacher and lecturer and was keenly interested in educational, political and industrial reforms. He also continued as a modeler for potters in Ohio and Trenton, including the Trent Tile Co. and the Providential Tile Co., producing major work as late as 1917, when he modeled a parian portrait bust of Walter Scott Lenox (Lawrenceville, NJ, Lenox Inc.).

BIBLIOGRAPHY

Who Was Who in America, i (Chicago, 1943)

A. C. Frelinghuysen: *American Porcelain 1770–1920* (NY: Met., 1989)

Ellen Paul Denker

Brown, A. Page

(*b* Ellisburg, NY, 1859; *d* Burlingame, CA, 21 Jan 1896), architect. Despite his tragically brief career and six Neo-classical buildings, Arthur Page Brown will be remembered for his Ferry Building, the centerpiece of San Francisco's waterfront; that city's Swedenborgian Church with its Mission-style chairs, both icons of the American Arts and Crafts Movement; and his Mission-style California building for the 1893 Chicago Exposition, a structure that helped establish Mission and Mediterranean styles as appropriate for both domestic and commercial designs throughout the Southwest.

After briefly attending Cornell University, Brown spent three years with the New York architectural firm of McKim, Mead & White. By December 1884, after two years studying European architecture, he opened his own New York practice. Commissions in San Francisco from the Crocker family in 1889 led him to open a West Coast office. He supervised the completion of the first Grace Cathedral (1890, replaced), designed the city's second skyscraper and, in February 1892, his Mission Revival-style design won the competition for the California State Building for the 1893 World's Columbian Exposition in Chicago, helping to launch this style. For the 1894 Midwinter Fair held in Golden Gate Park, Brown's office designed the Administration and the Manufactures and Liberal Arts Buildings.

In 1892 the Rev. Joseph Worcester (1836–1913), an amateur architect, commissioned Brown to design the San Francisco Swedenborgian Church, a collaborative effort involving several regional designers: Worcester suggested supporting the sanctuary with Madrone trees; artist Bruce Porter (1865–1953) designed the stained-glass windows; William Keith contributed four pastoral paintings; Bernard Maybeck was probably Brown's draftsman assigned to the building; and A. C. Schweinfurth, Willis Polk and Ernest Coxhead may all have contributed ideas. The church's natural features captivated proponents of the American Arts and Crafts Movement, and *The Craftsman* published two articles on it. The church's maple chairs (1894) are now recognized as prototypes for America's Mission-style furniture, influencing the work of Joseph P. McHugh, Gustav Stickley and others.

Social connections also brought commissions at Princeton University: the Clio and Whig Halls, "Greek" temples (1890–93); the Museum of Historic Art (1887–92; destr.); and the Class of 1877 Biological Laboratory in the rugged Richardson Romanesque style (1887–8). In Chicago he designed the Richardsonian Fowler Hall for the McCormick Seminary, erected buildings in South Carolina and Tennessee, designed upper-class residences in New York, New Jersey and Toronto, and built several houses in San Francisco (e.g. the Alban Towne house, 1890,

of which only the portico remains, and the extant Richard E. Queen house, 1895, with its semi-circular Neo-classical portico and Palladian window).

Brown's contributions to the California Shingle and Mission styles were made more notable by the numerous design assistants who moved in and out of his firm at various times, including Willis Polk, Bernard Maybeck and A. C. Schweinfurth, a collaborative circle that also benefited from its friendship with the influential Joseph Worcester.

UNPUBLISHED SOURCES

A. P. Brown: Sketchbook, *Winterthur, folio 68 (furniture designs)*

BIBLIOGRAPHY

K. Starr: *Inventing the Dream: California through the Progressive Era (Americans & the California Dream)* (New York, 1985)

R. Longstreth: *On the Edge of the World: Four Architects in San Francisco at the Turn of the Century* (Los Angeles, London and Berkeley, 1998)

R. P. Rhinehart: *Princeton University: The Campus Guide* (New York, 2000)

L. Mandelson Freudenheim: *Building with Nature: Inspiration for the Arts & Crafts Home* (Salt Lake, 2005)

Leslie Freudenheim

Brown, Arthur, Jr.

(*b* Oakland, CA, 21 May 1874; *d* Burlingame, CA, 7 July 1957), architect. Brown was the West Coast's preeminent practitioner of classical architecture in the first decades of the 20th century. Renowned for his buildings for the San Francisco Civic Center, his City Hall for Pasadena, CA, and for the Labor-ICC block of the Federal Triangle in Washington, DC, Brown also contributed many significant buildings for the campuses of Stanford University and the University of California at Berkeley and participated in the design of three World's Fairs.

In 1896 Brown earned a degree in civil engineering from the University of California, where he took classes in architecture from Bernard Maybeck. That same year Brown went on to the Ecole des Beaux-Arts in Paris, where he had unprecedented success for an American. After his return to San Francisco in 1904, Brown teamed up with John Bakewell to form Bakewell & Brown, where he served as the firm's design partner. The young architects were well positioned after the earthquake and fire of 1906, as they had mastered concrete construction very early in their practice, as demonstrated by their Berkeley Town Hall of 1908 and their work for Stanford University.

Brown's rise to national prominence came with his win in the competition of 1912 to build a new San Francisco City Hall. Brown's design integrated the working and ceremonial functions of the building with a soaring dome over a central four-story-high rotunda. Brown was commissioned to design several other buildings for the Civic Center: in 1932 he completed the twin buildings of the War Memorial Opera House and the Veterans' Building; a few years later he also designed the San Francisco Federal Building on United Nations Plaza.

Perhaps Bakewell & Brown's most celebrated work was the Mediterranean Revival Pasadena City Hall, completed in late 1927. Another competition win, Brown's design organized the various departments of the program around an open landscaped court that celebrated Pasadena's glorious weather with classical elements borrowed from Spain, France and Italy. Although the building looked like a fantastical Hollywood stage set, it was most renown at its construction for its demonstration that the full expression of the classical orders could be executed in reinforced concrete.

Except for a few buildings at Stanford University, including the Hoover Tower of 1942, Brown practiced alone after 1927. His primary achievement in these years was his buildings for the Federal Triangle in Washington, DC, where his liberal use of sculpture in the pediments and in the public interiors brightened up an otherwise sober French classicism. Brown worked with several of the Triangle architects at the 1933 Century of Progress

Exposition in Chicago and the 1939 Golden Gate International Exposition in San Francisco; his buildings for these world's fairs attempted to adapt his classical design sensibilities to the emerging Modern Movement. Brown's Coit Tower of 1933, a blunt fluted concrete shaft rising from the rocky crown of Telegraph Hill in San Francisco, is now considered an iconographic monument of the city.

Brown's architecture became synonymous with the power of the federal government. The State Department chose Brown's buildings at the San Francisco Civic Center to be the setting for the founding of the United Nations, and Brown's Labor Auditorium in Washington, DC, was used for the ceremonies that founded NATO. Brown's classicism was intended to communicate the authority of the institutions it housed, and his buildings still carry this gravitas today.

[*See also* Bakewell & Brown.]

BIBLIOGRAPHY

J. P. Noffsinger: *The Influence of the Ecole des Beaux-Arts on the Architects of the United States* (Washington, DC, 1955)

H. H. Reed: *The Golden City* (New York, 1971)

P. V. Turner: *The Founders and Their Architects: The Design of Stanford University* (Stanford, 1976)

M. R. Corbett: *Splendid Survivors: San Francisco's Downtown Heritage* (San Francisco, 1979)

R. G. Wilson: "California Classicist," *Prog. Archit.* (Dec 1983), pp. 64–71

D. Gebhard: "Civic Presence in California Cities," *Archit. Des.*, lvii (Sept–Oct 1987), pp. 74–80

S. K. Tompkins: *A Quest for Grandeur* (Washington, DC, 1991)

J. T. Tilman: *Arthur Brown, Jr., Progressive Classicist* (New York, 2006)

M. Zakheim: *Coit Tower, San Francisco: Its History and Art* (Volcano, CA, 2/2007)

Jeffrey Tilman

Brown, Benjamin C.

(*b* Marion, AR, 14 July 1865; *d* Pasadena, CA, 19 Jan 1942), painter, draftsman and etcher. Brown studied at the St Louis School of Fine Arts. In 1886 he traveled to California with his parents, who were considering moving to Pasadena. While in California, he made numerous pencil sketches of landmarks. He returned to St Louis, where he continued his studies and then opened his own art school in Little Rock, AR, while specializing in portrait painting. In 1890 he went to Europe with his friends and fellow artists William A. Griffith (1866–1940) and Edmund H. Wuerpel (1866–1958). In Paris, Brown studied at the Académie Julian for one year. After returning to the USA, he moved to Pasadena in 1896. He continued to do portraiture but, finding few patrons for his works, began also to paint the landscape. He was also an etcher and, along with his brother, Howell Brown (1880–1954), founded the Print Makers Society of California. A prolific and well-respected artist, Benjamin Brown received numerous awards, including a bronze medal at the Portland World's Fair in 1905, a silver medal at the Seattle World's Fair in 1909 and a bronze medal for etching from the Panama–Pacific International Exposition in San Francisco in 1915.

BIBLIOGRAPHY

Impressionism: The California View (exh. cat., Oakland, CA, Mus.; Laguna Beach, CA, Mus. A.; Sacramento, CA, Crocker A. Mus.; 1981)

R. L. Westphal: *Plein-air Painters of California: The Southland* (Irvine, CA, 1982)

California Impressionists (exh. cat. by S. Landauer, D. D. Keyes and J. Stern, Athens, U. GA Mus. A., 1996)

Jean Stern

Brown, George Loring

(*b* Boston, MA, 2 Feb 1814; *d* Malden, MA, 25 June 1889), painter and illustrator. Brown was apprenticed at about age 14 to the Boston wood-engraver Alonzo Hartwell and had produced scores of illustrations by 1832, when he turned to painting and sailed to Europe for further training. After brief stays in Antwerp and London, he settled in Paris, where he was admitted to the atelier of Eugène Isabey. Returning to America in 1834, Brown

GEORGE LORING BROWN. *Italian Scenery*, oil on canvas, 1038 × 1376 mm, 1846. MUSEUM PURCHASE/VICTOR D. SPARK/SMITHSONIAN AMERICAN ART MUSEUM, WASHINGTON, DC/ART RESOURCE, NY

produced illustrations, portraits and landscapes. He traveled throughout the northeastern USA, sketching in watercolor and in oil. His work was admired by Washington Allston, who assisted him in a second visit to Europe.

Brown and his wife settled in Florence from 1841 to 1846. At first he painted copies from Old Masters for American and British tourists, but gradually, as his technique and composition improved, he began to create original Italian landscapes with strong chiaroscuro and impasto. He became closely involved with American expatriates and many artists and writers. He moved to Rome in 1847 and for the next 12 years produced colorful and attractive landscapes such as a *View of Amalfi* (1857; New York, Met.).

When American tourism waned during the financial crisis in 1859, Brown returned home. His bold, colorful style shocked American eyes, but he determined to "fight with my brush" to revitalize American art. At first he succeeded, selling Italian and American scenes, such as a *View of Norwalk Islands* (1864; Andover, MA, Phillips Acad., Addison Gal.), for high prices, but the Civil War intervened and tastes altered to embrace Ruskinian idealism and the Barbizon school. Brown's popularity gradually declined.

[*See also* Metcalf, Willard Leroy.]

BIBLIOGRAPHY

H. T. Tuckerman: *Artist-life, or Sketches of American Painters* (New York, 1847), pp. 229–31

George Loring Brown: Landscapes of Europe and America, 1834–1880 (exh. cat. by W. C. Lipke, Burlington, U. VT, Robert Hull Fleming Mus., 1973)

T. W. Leavitt: "Let the Dogs Bark: George Loring Brown and the Critics," *Amer. A. Rev.*, i/2 (1974), pp. 87–99

A. Golahny: "George Loring Brown and the Bay of Naples," *Nineteenth Century* 25/1 (Spring 2005), pp. 12–7

<div align="right">Thomas W. Leavitt</div>

Brown, Glenn

(*b* Fauquier County, VA, 13 Sept, 1854; *d* Newport News, VA, 22 April 1932), architect. The son of an Alexandria, VA, physician and grandson of a US senator, Brown was educated as an architect by means of both academic training and office apprenticeships. He attended Washington and Lee University for two years (1871–3) before apprenticing with a Washington, DC, architect. In 1875 Brown entered the special course in architecture at the Massachusetts Institute of Technology. He completed one year of the non-degree program before working as the clerk of the works on H. H. Richardson's Cheney Building in Hartford before opening an office in Washington, DC, in 1880.

During the next two decades, while he built up a substantial practice as a designer of upper middle class houses influenced by, but not imitative of, Richardson's work, Brown developed an expertise both in sanitary systems and public health and in Colonial architecture. By the turn of the century his conversion to classicism was complete. His best surviving buildings are the Renaissance-inspired Mrs. Joseph Beale House (1907; now the Egyptian Embassy) and the curved Dumbarton Street Bridge (1913–5).

Although one of Washington's best architects, Brown's most consequential contributions were as an organizer of architectural professionalism in America, as a prime promoter and then supporter of the Senate Park Commission Plan that revolutionized Washington's monumental core, and as the historian of the US Capitol. In 1898 the American Institute of Architects (AIA) relocated its headquarters to William Thornton's Octagon House a block from the President's House. Brown was named its secretary (1899–1913) and worked with the nation's most important architects to interact with other professional arts organizations and government officials to establish both standards and fees for architects. He authored dozens of articles and edited several compilations of essays on the history of early American architecture and contemporary urban planning. Brown's study of the Octagon led to his identification of Thornton as the original designer of the Capitol and publication of his two-volume *History of the United States Capitol* (1900–4), the most in-depth examination of any American building yet undertaken.

Brown coordinated the AIA's 1900 annual meeting held in Washington to commemorate the centenary of the federal government's move to the federal city. He collaborated with Charles Follen McKim and Frederick Law Olmsted Jr. to rescue the Mall from its Victorian incarnation by reviving the original, but never built, Neo-classical vision of Pierre-Charles L'Enfant sanctioned by Washington and Jefferson. Their collaborative efforts led to the formation in 1901 of the Senate Park Commission, and Brown worked assiduously through the AIA and the commission's members to publicize its plan nation-wide, thus insuring its implementation.

BIBLIOGRAPHY

W. B. Bushong: *Glenn Brown, The American Institute of Architects, and the Development of the Civic Core of Washington, D.C.* (PhD. thesis, Washington DC, George Washington U., 1988)

W. B. Bushong: *Glenn Brown's History of the United States Capitol* (Washington, DC, 1998)

T. P. Wrenn: "The American Institute of Architects Convention of 1900: Its Influence on the Senate Park Commission Plan," *Designing the Nation's Capital*, ed. S. Kohler and P. Scott (Washington, DC, 2006)

<div align="right">Pamela Scott</div>

Brown, Grafton Tyler

(*b* Harrisburg, PA, 22 Feb 1841; *d* St Paul, MN, 2 March 1918), painter and lithographer. Grafton Tyler Brown was the first African American artist

to portray California and the Pacific Northwest. One of many artists who migrated West in the years after the Gold Rush, Brown began his career in San Francisco in the 1860s as a commercial lithographer, and made his mark in the 1880s as a landscape painter of the Pacific Northwest.

The son of freed slaves, Brown probably began his career working at the lithographic firm of P. S. Duval in Philadelphia, and in the late 1850s followed C. C. Kuchel, a Duval lithographer and his soon-to-be employer, to San Francisco. From 1861 to 1867 he worked as a draftsman and lithographer at the Kuchel & Dressel firm in San Francisco, and in 1867 established his own firm, G. T. Brown & Co. His most celebrated project, *The Illustrated History of San Mateo County* (1878), featured 72 city views whose sensitive topographical style would influence his paintings. Brown sold his firm in 1879, and began to redefine himself as an artist.

In 1882 he left San Francisco for Victoria, BC, to join the Amos Bowman Geological Survey of the Cascade Mountains. Working as a draftsman, Brown made sketches from which he later composed such paintings as *Goldstream Falls, British Columbia* (1883), which won critical praise for its fidelity to nature when exhibited in Victoria in 1883. Brown returned to America the following year, traveling through Oregon, Wyoming and Washington, where he painted Mt Tacoma (now Mt Rainier). In 1866 he settled in Portland, OR, to paint most of his wilderness landscapes, including such well-known sites as Yellowstone and Yosemite. *View of Lower Falls, Grand Canyon of the Yellowstone* (1890; Washington, DC, Smithsonian Amer. A. Mus.), with its emphasis on factual description of place and careful attention to detail is characteristic of Brown's representational landscape style.

Brown moved to St Paul, MN, in 1893 to work as a draftsman for the US Army Corps of Engineers (1893–7), and for the city's Civil Engineering Department (1897–1910). He continued to list himself as an artist, but no works from this period are known.

BIBLIOGRAPHY

Grafton Tyler Brown, Nineteenth Century American Artist (exh. cat., Washington, DC, The Evan-Tibbs Collection, 1988)

L. Lefalle-Collins: "Grafton Tyler Brown: Selling the Promise of the West," *Int. Rev. Afr.-Amer. A.,* xii (1995), pp. 26–44

Grafton Tyler Brown: Visualizing California and the Pacific Northwest (exh. cat. by L. Lefalle-Collins, Los Angeles, CA Afr. Amer. Mus., 2003)

Gina M. D'Angelo

Brown, Henry Kirke

(*b* Leyden, MA, 24 Feb 1814; *d* Balmville, NY, 10 July 1886), sculptor. Of the many sculptors to study in Italy, Brown was the first to eschew a career as an expatriate artist, choosing instead to establish his studio in the USA. To this end Brown depicted subjects of national relevance in a realist style that was accessible and appealing to his audience. His monuments to *De Witt Clinton* (1853) in the Green-Wood Cemetery, Brooklyn, and *George Washington* (1856) in Union Square, Manhattan, cast at the Ames Manufacturing Company—a firearms factory in Chicopee, MA—were among the first bronze monuments successfully cast in the USA and paved the way for other American sculptors to cast their work in this county.

Born on a farm in Massachusetts, Brown studied painting in Boston in 1832 with noted portraitist Chester Harding and in the mid-1830s learned anatomy at the Woodstock Medical College in Vermont. By 1836 he was painting in Cincinnati. It was here that Brown experimented with modeling clay, probably at the suggestion of his friend the sculptor Shobal Clevenger (1812–43).

In 1839 Brown married Lydia Louise Udall of Vermont and moved to Boston, though he made extended trips to Albany and Troy, NY, where he modeled as many as 40 portrait busts of local civic officials. The technical obstacles entailed in producing marble and bronze sculpture in the USA at this time led Brown to cast most of these busts in

plaster. Hoping to execute them in marble, he moved to Florence, Italy, with his wife in 1842. The Browns became prominent in the Anglo-American expatriate community in Florence, remaining there until 1843 when they moved to Rome, where they lived until 1846. Brown rounded out his largely autodidactic training by sketching numerous drawings after antique sculptures he saw in Rome, Tivoli, Naples, Sorrento and Pompeii (examples in the Library of Congress, Washington, DC). While abroad he received commissions from important American patrons, including Charles M. Leupp (*d* 1859), for whom he sculpted the marble composition *Chi Vinci Mangia* (1844–6; New York, NY Hist. Soc.), depicting a boy holding a dog on a leash.

In the fall of 1846 Brown arrived in New York and became a key figure in the city's burgeoning cultural scene, serving as a founding member of the Century Club and sculpting busts of the prominent cultural figures Asher B. Durand, Thomas Cole and William Cullen Bryant. His solo exhibition, the first such show by an American sculptor in New York, opened in November 1846 at the National Academy of Design, to which he earned associate membership the following year. In the summer of 1848 Brown established a studio and makeshift foundry in Brooklyn, where he modeled and cast *Choosing of the Arrow* (1849; version New York, Met.) and *Filatrice* (1850; version New York, Met.), which were distributed nationally by lottery through the American Art-Union and were among the first editions of statuettes issued in America. Shortly after this, Brown's monuments to *De Witt Clinton* and *George Washington* earned him a national reputation.

In 1856 Brown moved his studio and home to Balmville, near Newburgh, NY. Around this time he made several attempts but failed to secure a coveted federal commission for the House pediment of the Capitol. As a consequence he became active with the Washington Art Association, a national organization then lobbying Congress to distribute commissions for the Capitol to American artists.

Brown's fellow artists chose him as their spokesperson, which led to his appointment to the National Art Commission by President James Buchanan in 1859. This commission advising Congress on decorations for the Capitol was terminated at the onset of the Civil War. Brown's models (1860–61) for a 100-ft-long pediment for the State House, Columbia, SC, were also destroyed during the war.

In the last two decades of his life Brown sculpted numerous public monuments, including two statues of Abraham Lincoln (1869, Prospect Park, Brooklyn; 1870, Union Square, Manhattan) and two federally commissioned equestrian statues: *General Winfield Scott* (1874), Scott Circle, Washington, DC, and *Nathanael Greene* (1877), Stanton Park, Washington, DC. He received four commissions for statues for the Capitol's National Statuary Hall (*Nathanael Greene*, 1870; *George Clinton*, 1873; *Philip Kearney*, 1888, *Richard Stockton*, 1888), the last two of which were completed by Henry Kirke Bush-Brown (1857–1935), his nephew and adopted son.

In 1876 Brown served as a judge for the Centennial Exposition in Philadelphia. Shortly thereafter his realist style was superseded by that of American sculptors trained at the Ecole des Beaux-Arts in Paris, who would dominate portrait sculpture and public art of the last quarter of the 19th century. His apprentices John Quincy Adams Ward and Larkin Mead (1835–1910) both became notable American sculptors.

UNPUBLISHED SOURCES
Washington, DC, Libr. Congr. [Brown archives]

BIBLIOGRAPHY
W. Craven: *Sculpture in America* (New York, 1968, rev. Newark, 2/1984), pp. 144–58
W. Craven: "Henry Kirke Brown in Italy, 1842–1846," *Amer. A. J.*, i/1 (1969), pp. 65–77
W. Craven: "Henry Kirke Brown: His Search for an American Art in the 1840s," *Amer. A. J.*, iv/2 (Nov 1972), pp. 44–58
K. Lemmey: *Henry Kirke Brown and the Development of American Public Sculpture in New York City, 1846–1876* (diss., New York, City U., 2005)

Karen Lemmey

Brown, John George

(*b* Durham, England, 11 Nov 1831; *d* New York, 8 Feb 1913), painter. A popular painter of rural and urban genre scenes, he spent his youth in England, where he served an apprenticeship as a glasscutter. By 1853 he was employed in Brooklyn, NY. After serious study he became, in 1860, a fully fledged member of the New York artistic community, with a studio in the Tenth Street Studio Building and participating regularly in National Academy of Design exhibitions.

Brown's first genre scenes focused on rural children out of doors. Often sentimental, these exhibited a clarity of light and drawing attributable to his early interest in the Pre-Raphaelite painters. The *Music Lesson* (1870; New York, Met.), a courtship scene set in a Victorian parlor, reveals his debt to English painting. In 1879 Brown painted the *Longshoreman's Noon* (Washington, DC, Corcoran Gal. A.), an affectionate but sober rendering of the variety of ages and physical types in the urban working class. About 1880 he found a new type for his genre scenes in the urban street-boys in such occupations as newsboy, bootblack and fruit vendor. *Tuckered out—the Shoeshine Boy* (*c.* 1890; Boston, MA, Mus. F.A.) is characteristic; the boy is scrubbed, his clothes patched and ragged but clean, and he appeals to the viewer's sympathy. The motif, which perhaps served as a palliative to the urban poverty and numbers of abandoned children on the streets, was enormously popular, and Brown had many patrons.

BIBLIOGRAPHY

John George Brown, 1831–1913: A Reappraisal (exh. cat., Burlington, U. VT, Robert Hull Fleming Mus., 1976)

N. Spassky, ed.: *American Paintings in the Metropolitan Museum of Art*, ii (Princeton, 1985)

S. Burns: "Barefoot Boys and Other Country Children: Sentiment and Ideology in Nineteenth-Century American Art," *Amer. A. J.*, xx/1 (1988), pp. 25–50

Country Paths and City Sidewalks: The Art of J. G. Brown (exh. cat., Springfield, MA, Smith A. Mus., 1989)

K. S. Placidi: "Beyond Bootblacks: The Boat Builder and the Art of John George Brown," *Bull. Cleveland Mus. A.*, lxxvii (1990), pp. 366–82

M. J. Hoppin: "The 'Little White Slaves' of New York: Paintings of Child Street Musicians by J. G. Brown," *Amer. A. J.*, xxvi/1–2 (1994), pp. 4–43

Elizabeth Johns

Brown, Joseph

(*b* Providence, RI, 3 Dec 1733; *d* Providence, 3 Dec 1785), architect. Brown was from one of the leading families of Providence. Primarily a mathematician and astronomer, he became Professor of Experimental Philosophy at Rhode Island College (now Brown University). In 1770 he served, with Robert Smith, on the building committee for the College Edifice (now University Hall), which is modeled on Nassau Hall at Princeton University, NJ (architects Robert Smith and William Shippen, 1754).

Brown was an amateur architect who never developed a personal style. The Providence Market House, built to his design in 1772–7, was of a plainness that makes all the more surprising the Baroque swagger of the curved pediment crowning the facade of his own house in South Main Street, Providence (1774). The design of his biggest building, the First Baptist Meeting House (1774–5), Providence, was assembled from plates in James Gibbs's *Book of Architecture* (1728); its beautiful spire is from one of the alternative designs for the spire of St Martin-in-the-Fields, London, while the underscaled portico comes from the Oxford Chapel (now St Peter's) in Vere Street, London. The substantial house of his brother John in Power Street, Providence, begun in 1786 after Brown's death but nonetheless attributed to him, is in a mid-18th-century style, updated with a projecting porch with columns.

BIBLIOGRAPHY

Macmillan Enc. Archit.

A. F. Downing: *Early Homes of Rhode Island* (Richmond, VA, 1937)

H. R. Hitchcock: *Rhode Island Architecture* (Providence, 1939/R New York, 1968)

J. H. Cady: *The Civic and Architectural Development of Providence, 1636–1950* (Providence, 1957)

Marcus Whiffen

Brown, Mather

(*b* Boston, 7 Oct 1761; *d* London, 25 May 1831), painter. Brown was descended from four generations of New England religious leaders; John Singleton Copley painted portraits of his mother (New Haven, CT, Yale U., A.G.) and his maternal grandfather (Worcester, MA, Amer. Antiqua. Soc.; Halifax, NS, U. King's Coll.). John Trumbull was his friend and Gilbert Stuart "learnt me to draw" at age 12. At 16 Brown walked 640 km (398 miles) to Peekskill, NY, and back, selling wine and painting miniature portraits; from these pursuits he earned enough to pay for three years of study in Europe. In London, on Benjamin Franklin's recommendation, Benjamin West accepted him as a free student. Brown was admitted as a student to the Royal Academy in January 1782 and exhibited four paintings the following year. He showed 80 paintings there in all. In 1785–6 he painted much admired portraits of *Thomas Jefferson* (Charles Francis Adams priv. col., see Meschutt, p. 48) and *John Adams* (untraced; second version, 1788; Boston, MA, Athenaeum) and several of his family. He painted two full-length portraits in 1788 of *Frederick Augustus, Duke of York* (Waddesdon Manor, Bucks, NT) and the *Prince of Wales*, later George IV (London, Buckingham Pal., Royal Col.), and in the same year he was appointed historical and portrait painter to the Duke of York.

Brown's portrait style was influenced by that of Gilbert Stuart, under whom he worked in West's studio, with the result that his unsigned portraits have often been confused with those of Stuart. Evans, however, revealed an impressive body of portraiture in which Brown relied on superior drawing and developed his own freer techniques of high

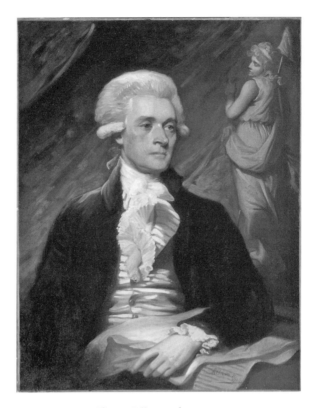

MATHER BROWN. *Thomas Jefferson*, oil on canvas, 908 × 724 mm, 1786. Bequest of Charles Francis Adams/National Portrait Gallery, Smithsonian Institution, Washington, DC/Art Resource, NY

coloring and longer, sweeping brushstrokes. Despite his phenomenal early success, Brown fell on hard times. He was disinherited by his father, and an obsession drove him to concentrate on large unsalable religious and historical subjects. Typical of these works are *Richard II Resigning his Crown to Bolingbroke* (London, BM), the *Baptism of Henry VIII* (1.83×2.70 m; Bristol, Mus. & A.G.), *Lord Cornwallis Receiving as Hostages the Sons of Tippo Sahib* (2.75×2.14 m; London, Stratford House [Oriental Club]) and *Lord Howe on the Deck of the "Queen Charlotte"* (London, N. Mar. Mus.). In 1809 Brown left London to live and work in Bath, Bristol and Lancashire. He returned to London in 1824 and died there in poverty, in a room crowded with unsold paintings.

BIBLIOGRAPHY

W. Dunlap: *A History of the Rise and Progress of the Arts of Design in the United States* (New York, 1834/R 1969), i, pp. 228–9

F. A. Coburn: "Mather Brown," *A. Amer.*, xi (1923), pp. 252–60

W. T. Whitley: *Artists and Their Friends in England, 1700–1799* (London, 1928), ii, pp. 97–100

D. Evans: "Twenty-six Drawings Attributed to Mather Brown," *Burl. Mag.*, cxiv (1972), pp. 534–41

D. Evans: *Benjamin West and His American Students* (Washington, DC, 1980)

D. Evans: *Mather Brown: Early American Artist in England* (Middletown, CT, 1982); review by R. H. Saunders in *Winterthur Port.*, xix (Winter 1994), pp. 304–6; B. Allen in *Burl. Mag.*, cxxvi (1984), p. 366

D. Meschutt: "The Adams–Jefferson Portrait Exchange," *Amer. A. J.*, xiv/2 (1982), pp. 47–54

Robert C. Alberts

Revised and updated by Margaret Barlow

Brown, Roger

(*b* Hamilton, AL, 10 Dec 1941; *d* Atlanta, GA, 22 Nov 1997), painter, printmaker and collector. American painter raised in Alabama, where his religious upbringing and interest in folk and material culture, comics aesthetics and vernacular and Art Deco architecture were formative. He moved to Chicago in 1962 and earned a certificate in commercial design prior to studying at the School of the Art Institute of Chicago (SAIC), where he gravitated to pre-Renaissance Italian art, Surrealism, artists Edward Hopper, Grant Wood and Georgia O'Keeffe, and tribal art. Painter Ray Yoshida and art historian Whitney Halstead were seminal influences at SAIC. Both included folk, popular and self-taught art within the scope of their teaching.

Brown earned his BFA (1968) and his MFA (1970) at SAIC. Works by Brown and fellow students were recognized by curator Don Baum, who organized spirited "Chicago School" exhibitions at the Hyde Park Art Center (HPAC) from 1966 to 1971; Brown's work was shown there with the group False Image (1968, 1969). From these early HPAC exhibits, a loosely associated group of artists became known as Chicago Imagists, a term coined by art critic Franz Schulz (1972). They did not become a formal group, adopt the name or have a shared ideology, but they worked independently of New York contemporary art trends and incorporated imagery from popular culture into their works, although less cerebrally than New York Pop artists. Brown's first solo exhibit (1971) at Phyllis Kind Gallery, Chicago, began his 26-year representation at Phyllis Kind in Chicago and, later, New York. Although known as an Imagist throughout his career, Brown's work evolved beyond the indeterminate definition of that "school."

Brown developed a mature visual vocabulary in the late 1960s, engaging silhouetted figures, nocturnal cityscapes, and theater facades and interiors. In the early 1970s he received acclaim for paintings of stylized landscapes and city scenes as stark backdrops for aspects of contemporary life and the *Disasters* series, paintings of exploding buildings (1972), followed by a procession of iconic, flat-patterned landscape paintings. As his renown grew in the 1980s and 1990s, Brown addressed a range of subjects including architecture, natural and urban landscapes, the dichotomy of nature and culture, disasters of all types, current and political events, social, religious and popular culture, sensational events and banal commonplaces, autobiographical, personal and sexual issues, the art world in many guises, cosmology, mortality, history, mythology and more. He used the weather as a grand, allegorical backdrop for the larger physical and metaphysical forces that dwarf human endeavor. Brown created a sequence of ominous clouds, followed by the *Virtual Still Life* series: 27 paintings with projecting shelves holding ceramic objects—meditations on the dialogue between painting and object, and the nature of reality. His final sequence was a metaphorical exploration of bonsai, in which giant trees tower over miniature figures.

Throughout his career Brown intended his works to have the clarity and accessibility of folk art while expressing the conceptual depth and complexity of 20th-century life. He presented temporal events with uncanny prescience, giving his work fresh relevance when viewed against the ongoing progression of current events.

extensive collections and gardens. Plans for two additional sites were unrealized, and he was creating a final home–studio in Beulah, AL, at the time of his death. Brown gave two homes and three collections to SAIC, which became the representative of his estate. SAIC preserves his Chicago home as the Roger Brown Study Collection, a house museum and archive.

BIBLIOGRAPHY

R. Bowman: "An Interview with Roger Brown," *A. America*, lxvi (Jan–Feb 1978), pp. 106–11

Roger Brown (exh. cat. by M. D. Kahan, R. Bowman and D. Adrian, Montgomery, AL, Mus. F.A., Houston, TX, Contemp. A. Mus., Chicago, IL, Mus. Contemp. A., 1980)

D. Adrian: "Roger Brown and the Chicago Context: An Appreciation," *Sight out of Mind: Essays and Criticism on Art* (Ann Arbor, 1985), pp. 43–52

Roger Brown (exh. cat. by S. Lawrence and J. Yau, Washington, DC, Hirshhorn, 1987)

Roger Brown: A Different Dimension (exh. cat. by M. Pascucci and others, Montgomery, AL, Mus. F.A., 2004)

Roger Brown: The American Landscape (exh. cat. by R. Storr, New York, DC Moore Gal., 2008)

Lisa Stone

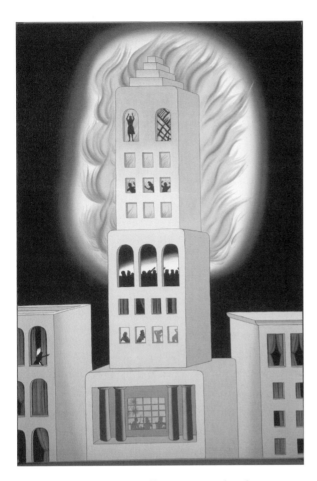

ROGER BROWN. *World's Tallest Disaster*, oil and magma on canvas, 1831 × 1220 mm, 1972. Smithsonian American Art Museum, Washington, DC/Art Resource, NY

Brown had numerous solo and group exhibitions in the US and abroad. Traveling retrospectives were organized by the Montgomery Museum (1980) and the Hirshhorn Museum (1987), Washington, DC.

Best known as a painter, Brown also made prints, sculpture, sets and costumes for theater and opera, and murals for public spaces, including four Italian glass mosaic murals (Chicago, New York). Collecting art and objects was integral to his artistic practice. His interest in traditional folk art developed into a sustained exploration of self-taught art, which he collected prodigiously and championed as equal or superior to works from the academic mainstream. He created three homes and studios (Chicago, Michigan, California), with

Bruce, Patrick Henry

(*b* Long Island, VA, 25 March 1881; *d* New York, 12 Nov 1936), painter. Bruce studied in New York under William Merritt Chase (1901) and Robert Henri (1903). In 1903 he went to Paris and was organizer, with Sarah Stein, of Matisse's school. From 1912 he was closely associated with Sonia Delaunay and Robert Delaunay. He remained in Paris until 1936, when he returned to New York, where he committed suicide a few months later.

Bruce destroyed much of his own work: only *c.* 100 of his paintings remain. His oeuvre can be divided into four periods. The first, lasting until *c.* 1907, reflects the influence of Henri in the bravura brushwork and deep tonalities of such portraits as *Littleton Maclurg Wickham* (1903; Julia Wickham Porter priv. col., see Agee and Rose, p. 14). In the second period, from 1907 to 1912, Bruce painted

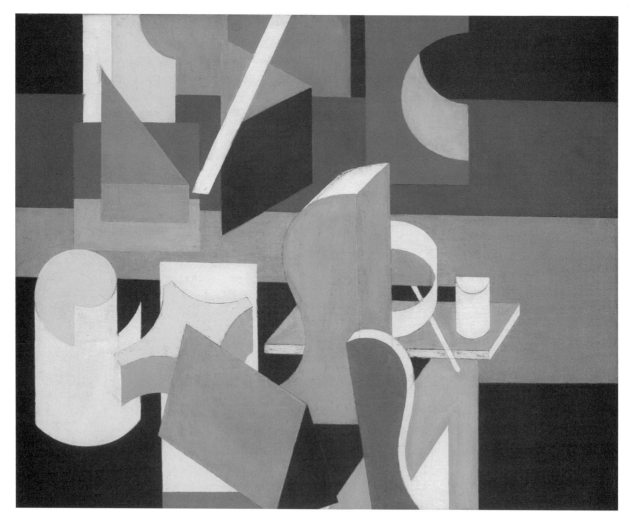

PATRICK HENRY BRUCE. *Peinture*, oil and graphite on canvas, 256 × 321 mm, 1917–18. Daniel J. Terra Collection, Terra Foundation for American Art, Chicago/Art Resource, NY

a few landscapes and portraits, but predominant in this period are still lifes in a style reflecting an interest in Cézanne and his study with Matisse. In these works, for example *Still-life of Red-cheeked Pears* (1912; B. F. Garber priv. col., see Agee and Rose, p. 16), Bruce combined the bright colors of Fauvism with the structure of Cubism. From his third phase, which lasted until *c.* 1920, several Orphist-like, hard-edge compositions remain, including *Composition II* (1916; New Haven, CT, Yale U. A.G.), in which colors are unmodulated and angled forms are flat and unmodeled. In the final phase of his oeuvre Bruce produced geometric Cubist still lifes based on architectural themes, such as *Painting/Still-life* (*c.* 1925–6; Washington, DC, Hirshhorn).

Although Bruce never identified himself with any school, he has often been labeled a *Synchromist.* His works became more widely known in the USA through an exhibition on Synchromism organized by William C. Agee at M. Knoedler and Co., Inc. in 1965.

BIBLIOGRAPHY

W. D. Judson III: *Patrick Henry Bruce, 1881–1936* (diss., Oberlin Coll., OH, 1968)

T. M. Wolf: "Patrick Henry Bruce," *Marsyas*, xv (1970–72), pp. 73–85

W. C. Agee and B. Rose, eds: *Patrick Henry Bruce: American Modernist* (New York, 1979) [cat. rais.; also used as catalog for exhibitions at New York, MOMA, and Houston, TX, Mus. F.A., 1979]

A. A. Davidson: *Early American Modernist Painting, 1910–1935* (New York, 1981)

M. Sue Kendall

Bruehl, Anton

(*b* Hawker, Port Augusta, S. Australia, 11 March 1900; *d* San Francisco, CA, 10 Aug 1983), photographer, of Australian birth. Bruehl trained as an electrical engineer in Melbourne, but in 1919 he immigrated to the USA. He developed his interest in photography while working for the Western Electric Company, New York. In 1923 he attended an exhibition by students of Clarence H. White, who was then considered America's most prominent Pictorialist photographer. White agreed to teach him privately, but by 1924 Bruehl had become both a regular student at White's New York school and a member of his summer faculty in Canaan, CT. White encouraged the individualism shown by his students. Among them, Bruehl, Paul Outerbridge and Ralph Steiner became known for a crisp, graphic style that would distinguish the best commercial photography in the 1920s and 1930s.

In 1927 Bruehl opened his own studio, which prospered in New York until 1966. The photograph *Untitled* (Riverside, U. CA, Mus. Phot., see 1985 exh. cat., no. 20) of an apple, camera and lamp exemplifies his use of high contrast with black background and is an example of the table-top still lifes that appeared in such magazines as *Vanity Fair*, *House and Garden* and *Vogue* along with his glamorous portraits of international society figures and stars, including *Peter Lorre* (1935; see 1985 exh. cat., no. 18). Bruehl's appointment as chief of color photography at Condé Nast publishers in the early 1930s led to his most influential work. In collaboration with Fernand Bourges, a French color technician, he set the standard for commercially printed color work of the period. Bruehl did not, however, give up working in black and white, as seen in his most important publication, *Mexico* (1933), a collection of 25 sensitive portraits of Mexican villagers.

[*See also* White, Clarence H.]

PHOTOGRAPHIC PUBLICATIONS
Mexico (New York, 1933)

BIBLIOGRAPHY
J. Deal: "Anton Bruehl", *Image*, xix/2 (1976), pp. 1–9

N. Hall-Duncan: *The History of Fashion Photography* (New York, 1979), pp. 99, 120–1, 225

Photography Rediscovered (exh. cat. by D. Travis, New York, Whitney, 1979)

A Collective Vision: Clarence H. White and His Students (exh. cat., ed. L. Barnes, J. Bledsoe and C. Glenn; Long Beach, CA State U., A. Mus., 1985)

O. Debroise: *Mexican Suite: A History of Photography in Mexico*, trans. by Stella de Sá Rego (Austin, TX, 2001)

Constance W. Glenn

Bruguera, Tania

(*b* Havana, 1968), Cuban installation and performance artist, active in the USA. In Havana Bruguera attended the Escuela de Artes Plasticas San Alejandro (1983–7) and completed her first degree at the Instituto Superior de Arte (1987–92). Bruguera is part of a generation of artists who emerged during Cuba's "special period" (1989–94), the period of extreme economic hardship brought about by the country's sudden isolation from trade and aid following the collapse of the Soviet Bloc. In 1993 and 1994 she published two issues of an underground newspaper entitled *Memoria de la postguerra* ("Memory of the Postwar Era"), containing texts by Cuban artists, both those still in Cuba and those in exile. The paper displayed an interest in the affective power of information as it is circulated and withheld, a common theme of her later work.

Bruguera's use of performance from the mid-1990s onward brought her work to wider critical attention. In an early piece, *Lo que me corresponde*

("What Is Rightfully Mine"), performed at the artist's home in Havana in 1995, she positioned herself, her naked body feathered with cotton wool, on a plinth. Forcing the viewer's gaze upward, this work established an ambiguous relationship of power between herself and her audience, and her performance work continued to explore the dynamics between ideological control and individual submission and resistance. This relationship is frequently evoked by bringing the pervasive presence of political signs and speeches into contact with silent but visceral performances that mutely allude to untold truths regarding Cuban history or contemporary social conditions. In *El peso de la culpa* ("The Weight of Guilt"), first performed in her home during the 1997 Havana Biennale, Bruguera stood in front of a Cuban flag woven from human hair, eating soil with a lamb carcass draped over her neck (Fusco, pp. 152–3). The act of eating dirt was a ritual re-enactment of the actions of Taino Indians who had taken their own lives rather than submitting to Spanish rule in Cuba in the 16th century.

Between 1995 and 1998 Bruguera completed artist-in-residency program in Canada, the UK, the USA and Venezuela. In 1998 she was awarded a Guggenheim Fellowship and in 1999 a Merit Scholarship that allowed her to complete an MFA in performance at The School of the Art Institute of Chicago (1999–2001). After 2000 her work displayed an increasing emphasis on participation; creating ambiguous environments in which viewers can be immersed and their movements restricted or manipulated. At the 2000 Havana Biennale she created an untitled installation in a tunnel at the Fortaleza, formerly used as a penitentiary cell. Disorientated by darkness and by the effort of trudging through a floor covered with fermenting sugarcane, viewers of the work were drawn toward a dim glow at the end of the tunnel that transpired to be a television, silently projecting looped images of Fidel Castro. Reaching the end of the tunnel, four figures standing naked in rows of two and making silent repetitive gestures also came into the spectators' field of vision.

In 2002 Bruguera founded the Catedra Arte de Conducta, a department for the study of performance and time-based art at the Instituto Superior de Arte, Havana, and in 2004 she became a faculty member at The School of the Art Institute of Chicago.

BIBLIOGRAPHY

L. Camnitzer: *New Art of Cuba* (Austin, 1994)

J. Birrenger: "Art in America (the Dream)," *Performance Research 3*, i (1998), pp. 24–31 [interview]

C. Fusco, ed.: *Corpus Delecti: Performance Art of the Americas* (London and New York, 1999)

J. Muñoz: "Performing Greater Cuba: Tania Bruguera and the Burden of Guilt," *Women & Performance 11/2*, (2000), pp. 251–65

H. Block: *Art Cuba: The New Generation* (New York, 2001)

A Little Bit of History Repeated (exh. cat., ed. J. Hoffman; Berlin, Kunst-Werke, 2001)

J. Beverley: "Tania Bruguera: Untitled, Havana, 2000," *Boundary 2*, xxix/3 (Fall 2002), pp. 34–47

T. Bruguera: "Postwar Memories," *By Deart/De Memoria: Cuban Women's Journeys in and Out of Exile*, ed. M. de los Angeles Torres (Philadelphia, 2003), pp. 169–89

A. Ledo: "Huellas íntimas/ Intimate Traces," *Lapiz* 23/207 (Nov 2004), pp. 48–63

R. Goldberg: "Tania Bruguera: Dreaming in Cuban," *Parkett 73* (2005), pp. 148–60

Isobel Whitelegg

Bruguière, Francis

(*b* San Francisco, CA, 16 Oct 1880; *d* London, 8 May 1945), photographer. Bruguière studied painting in Europe and trained as a photographer in New York with Frank Eugene. In 1905, after meeting Alfred Stieglitz and the photographers associated with the 291 gallery in New York, he became a member of the Photo-Secession. From then until 1918 he experimented with photography in San Francisco; some of his photographs appeared in *Camera Work* in 1916. In 1919 he opened his own photographic studio in New York. He became well known for his images of alienation—reminiscent of the Cubists— which he achieved by photographing subjects with

the help of mirrors. He was an important pioneer of theater photography, collaborating with Norman Bel Geddes and making an important contribution to the latter's edition of Dante's *Divine Comedy* in 1924. His preoccupation with light led him to create abstract photographs from elements of light, some of which were exhibited at the Sturm-Galerie in Berlin in 1928, on the strength of which he was elected an honorary member of the German Secessionists. The images were also featured in his book *Beyond This Point* (1929). Another product of his experiments with light was his 1930 film *Light Rhythms*. He experimented with multiple exposures, taking a series of photographs of France's cathedrals and Manhattan's skyscrapers. These fascinated his contemporaries from the way in which reality dissolved into abstract patterns. In the 1930s he concentrated on technical experiments and after 1940 devoted himself to painting.

[*See also* Cunningham, Imogen.]

PHOTOGRAPHIC PUBLICATIONS

with N. Bel Geddes: *Divine Comedy* (New York, 1924)

with L. Sieveking: *Beyond This Point* (London, 1929)

BIBLIOGRAPHY

J. Enyeart: *Bruguière: His Photographs and His Life* (New York, 1977)

Erika Billeter

Brumidi, Constantino

(*b* Rome, 26 July 1805; *d* Washington, DC, 19 Feb 1880), painter of Italian birth. Brumidi is primarily known for the murals he painted in the US Capitol, Washington, DC, over a 25-year period. Son of coffee shop owner Stauros Brumidi from Greece and Anna Bianchini of Rome, he studied at the Accademia di S Luca in Rome for 14 years from the age of 13. His training and artistic vision was inspired by the wall paintings and sculpture of ancient Rome and Pompeii and by the Renaissance revival of classical art. He mastered all of the painting and mural media, including true fresco. His knowledge of sculpture,

the human figure, and of light and shadow enabled him to paint forms that appear to be three-dimensional.

Brumidi, who was considered one of the best painters in Rome, began getting important private commissions. From 1836, he painted murals in Prince Alessandro Torlonia's palace on the Piazza Venezia (demolished in 1900). He filled the Clifford-Weld Chapel under the church of S Marcello al Corso with marble reliefs (1837) and he painted the saints in the Gothic Revival family chapel in the Palazzo Torlonia (1842–4). At the Villa Torlonia on the Via Nomentana, Brumidi was in charge of decorating the new theater (1844–5). The walls of the theater's numerous rooms are covered with *trompe l'oeil* architectural forms and classical motifs that he would later bring to the US Capitol.

Brumidi also worked extensively for the church. From 1840 to 1842, for Pope Gregory XVI (*r.* 1831–46), he restored frescoes in the third Loggia in the Vatican Palace painted by followers of Raphael. He painted the official portrait of Pope Pius IX (*r.* 1846–78) and portraits of popes used as models for mosaics at S Paolo fuori le Mura. His last commission in Rome was for the murals in the tiny church of the Madonna dell'Archetto dedicated in 1851.

Brumidi was also a captain in the civic guard authorized by Pius IX in 1847. Romans became caught up in the revolutionary spirit pervading Europe, and after the pope fled the city, a republic was declared in 1849. During the ensuing war, Brumidi worked to protect art and property. After the pope was restored to power, Brumidi was among many arrested and accused of serious crimes (1851). After 13 months in prison and despite many testimonies in his favor, he was sentenced to 18 years. Pius IX agreed to pardon him with the understanding that he would be leaving for America, where he had potential church commissions.

Arriving in New York in September 1852, Brumidi immediately applied for citizenship and found private portrait work. The first of his many important New World church commissions was an altarpiece for the Mexico City Cathedral (1854). The next year,

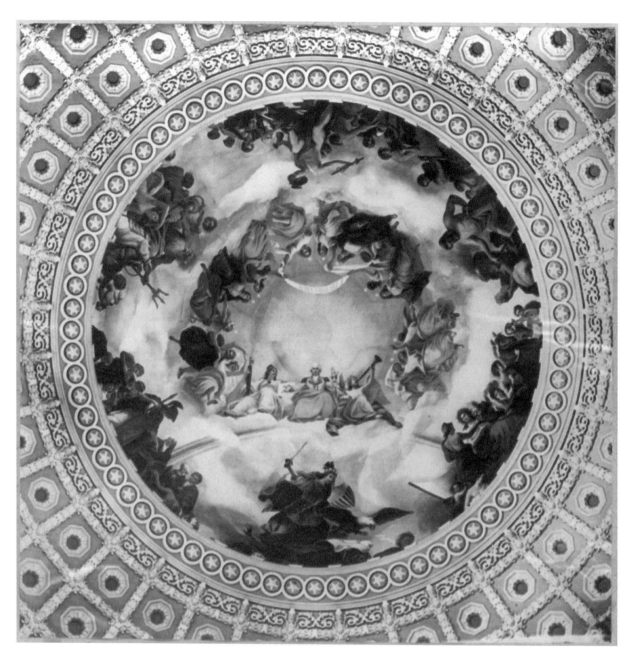

CONSTANTINO BRUMIDI. *The Apotheosis of Washington*, canopy fresco in US Capitol dome, Washington, DC, 1865. Library of Congress Prints and Photographs Division

he painted an altarpiece for the new church of St Stephen's in New York, where he returned to paint murals (1866 and 1871–2). He painted altarpieces and murals for St. Ignatius in Baltimore (1856) and St Aloysius in Washington, DC (1859) and frescoes in the Cathedral of SS Peter and Paul in Philadelphia (1864). At a time when imposing Catholic cathedrals and churches were being constructed in many cities, Brumidi provided dramatic images inspired by the Baroque masters, which have served as the focus of worship for many generations of Americans.

Brumidi's contributions to the US Capitol began with his 1854 introduction to Captain Montgomery C. Meigs, who was in charge of the construction

and decoration of the Capitol extension and dome designed by Thomas U. Walter. Meigs asked Brumidi to paint a sample fresco in his Capitol office to be used by the House Agriculture Committee (H-144). When it was well received, Brumidi was put on the payroll and asked to complete the decoration of the entire room in fresco and to make designs for important rooms in the Senate wing. During the 1850s, he worked with teams of artists of varied national origins to carry out his designs, executing all of the major figurative work and true frescoes himself. Brumidi worked intensively at the Capitol through the mid-1860s and continued to add scenes in the 1870s. His murals throughout the building combine classical and allegorical subjects with portraits and scenes from American history and tributes to American inventions. Brumidi designed and executed murals in the first-floor Senate corridors, now called the Brumidi Corridors, the House of Representatives Chamber, the Senate Library (S-211), the Senate Military Affairs Committee (S-128), the office of the Senate Sergeant at Arms (S-212), and the President's Room (S-216). He was never allowed to complete his designs in many rooms; blank spaces still remain, for example, in the room for the Senate Committee on Naval Affairs (S-127), the Senate first-floor corridors, and the Senate Reception Room (S-213), one of the most lavishly decorated spaces in the Capitol. Brumidi's murals continue to provide the setting for legislative work and ceremonies of the United States Congress.

Brumidi's most viewed and most ambitious contributions to the art of the Capitol are the monumental canopy fresco, the *Apotheosis of George Washington* (1865), and the frieze of *American History* under the new Capitol dome. Brumidi began painting the frieze in fresco to resemble a carved relief in 1878, but died with it less than half finished. His designs were carried out by Filippo Costaggini (1837–1904) between 1881 and 1889, although the entire frieze was only completed in 1953.

At the time of Brumidi's death in 1880, he was compared to Michelangelo, but his Neo-classical style was no longer in fashion, and proposals were made to redecorate the Rotunda. Brumidi's legacy was carried on by Costaggini, who painted in churches around the country, by one of his assistants, Joseph Rakemann, who returned to paint many murals in the Capitol at the turn of the century, and by his son, Laurence S. Brumidi (1861–1920). In the 1970s, Allyn Cox (1896–1982), who had completed Brumidi's frieze and worked on the canopy fresco, painted classical-style murals in the House corridors intended to complement those by Brumidi. The beauty and impact of Brumidi's murals was lost over the decades after they were obscured by grime and overpainting. Ongoing conservation carried out by the Architect of the Capitol since 1985, as well as more recent conservation efforts in Rome, has revealed Brumidi's original designs and rich color and has allowed a renewed appreciation for the high quality and impact of his work.

UNPUBLISHED SOURCES

Vatican City, Archivio Segreto Vaticano

Washington, DC, Montgomery C. Meigs Papers, Manuscript Division, Library of Congress

Washington, DC, Records of the Architect of the Capitol

Washington, DC, Records of the Department of the Interior, National Archives and Records Administration

Washington, DC, Mildred Thompson Papers, United States Senate Collection

BIBLIOGRAPHY

S. D. Wyeth: *The Federal City* (Washington, DC, 1865)

G. Hazleton Jr.: *The National Capitol* (Washington, DC, 1897)

C. E. Fairman: *Art and Artists of the Capitol of the United States of America* (Washington, DC, 1927)

M. C. Murdock: *Constantino Brumidi: Michelangelo of the United States Capitol* (Washington, DC, 1950)

Architect of the Capitol, Art in the United States Capitol (Washington, DC, 1978)

A. Campitelli and B. Steindl: "Costantino Brumidi da Roma a Washington. Vicende e opere di un artist romano," *Ric. Stor. A.*, xlvi (1992), pp. 49–50

A. Campitelli: *Villa Torlonia* (Rome, 1997)

B. A. Wolanin: *Constantino Brumidi: Artist of the Capitol* (Washington, DC, 1998)

W. Wolff, ed.: *Capitol Builder: The Shorthand Journals of Montgomery C. Meigs* (Washington, DC, 2001)

Barbara A. Wolanin

Brush, George de Forest

(*b* Shelbyville, TN, 28 Sept 1855; *d* Hanover, NH, 24 April 1941), painter. He began his formal training at the National Academy of Design in New York and in 1873 entered the atelier of Jean-Léon Gérôme (1824–1904) in Paris, studying there and at the Ecole des Beaux-Arts for almost six years. Soon after his return to the USA in 1880, he was elected to the Society of American Artists. Thereafter he spent much time on both sides of the Atlantic, beginning in the American West and including lengthy stays in Paris, Florence, New York and Dublin, NH, where he purchased a farm in 1901.

Brush first attained prominence as a painter of Indian life, which he observed while living in Wyoming and Montana in 1881. His pictures (completed in the studio but frequently based on studies done *in situ*) focus on everyday life and domestic tribal customs, with strict attention paid to documentary detail, a trait adopted from Gérôme and exemplified in the *Moose Chase* (1888; Washington, DC, Smithsonian Amer. A. Mus.; see color pl. 1:VII, 2.). In the 1890s Brush painted his first family group, the theme for which he is best known. Invariably his own wife and children posed for these works, for example *Mother and Child* (1894; New York, Met.). Brush imbued this and similar works with a feeling of holiness without the use of Christian iconography.

WRITINGS
"An Artist among the Indians," *C. Mag.*, xxx (May 1885), pp. 54–7

BIBLIOGRAPHY
N. D. Bowditch: *George de Forest Brush: Recollections of a Joyous Painter* (Peterborough, NH, 1970) [by the artist's daughter]

J. B. Morgan: *George de Forest Brush: Painter of the American Renaissance* (New York, 1985)

B. Van Hook: "'Milk White Angels of Art': Images of Women in Turn of the Century America," *Woman's A. J.*, xi/2 (Fall 1990–Winter 1991), pp. 23–9

George de Forest Brush: The Indian Paintings (exh. cat. by N. K. Anderson, Washington, DC, N.G.A., 2008)

Ross C. Anderson

Brutalism

New Brutalism, or simply Brutalism, is a term applied to a range of architecture built between the late 1950s and 1970s. The term gained currency both as a description of architects' fealty to a particular building material—*béton brut* (Fr.: "raw concrete")—and of a broader cultural disposition within which designers and critics situated the social practice of architecture. In appearance New Brutalism is characterized often, but not exclusively, by rugged and dramatic concrete surfaces and monumental sculptural forms.

Two early monuments highlight the often overlooked heterogeneity of New Brutalism: Le Corbusier's Unité d'Habitation (Marseille, France, 1952) and Alison and Peter Smithson's Hunstanton School (Norfolk, England, 1954). The former is an apartment block composed of aggressively modeled concrete with exposed formwork patterns that would inspire imitators far and wide of wildly divergent quality. The latter is a school complex where orthogonal, Miesian proportions and symmetry are materialized in steel, glass and brick (with its particular class associations). Nikolaus Pevsner described Hunstanton's formal qualities as "ruthlessly perfect," but for the Smithsons Brutalism was "an ethic, not an aesthetic."

In the context of the USA, Brutalism flourished on college campuses (Sert, Jackson & Gourley, Peabody Terrace, Married Student Housing, Harvard University, Cambridge, MA, 1963 or Caudill, Rowlett & Scott, Graduate School of Education, Harvard University, Cambridge, MA, 1965), in government buildings (Marcel Breuer, HUD Headquarters, Washington, DC, 1968 and Kallman, McKimmell & Knowles, New City Hall, Boston, 1968), cultural institutions (Breuer's Whitney Museum of American Art, New York, 1966), churches (Breuer again with St John's Abbey Church, Collegeville, MN, 1961) and as the favored architectural style of major transportation infrastructure projects (exemplified by

Harry Weese's Washington, DC, Metrorail stations and many stations for Atlanta's MARTA, various architects).

Perhaps not surprisingly, given its association with Le Corbusier and his influence on architecture in the three decades after World War II, New Brutalism was a popular choice to house many schools of architecture and related design-oriented disciplines in the USA (most famously with Paul Rudolph's Art & Architecture Building, Yale University, New Haven, CT, 1964, but also Esherick, Olsen, & DeMars, Wurster Hall, College of Environmental Design, University of California, Berkeley, 1964). The affection of many architects for New Brutalism was not matched in much of the general public, who regarded the term and many of its buildings with some skepticism. Today many New Brutalist buildings are at risk of demolition in cities across the country, often with little public outcry over their demise (see Araldo Cossutta's *Third Church of Christ*, Scientist, Washington, DC, 1971).

BIBLIOGRAPHY

R. Banham: *The New Brutalism: Ethic or Aesthetic?* (London, 1966)

Benjamin Flowers

Bry, Theodor de

(*b* Liège, 1528; *d* Frankfurt am Main, 29 March 1598), engraver, printmaker, publisher and goldsmith. De Bry's engravings after John White established the normative representation of North American Native Americans for centuries. He was trained in Liège as a goldsmith and engraver, but possibly due to his Reformed religious convictions he left for Strasbourg, where in 1560 he married Katharina Esslinger (*d* 1570) and where his sons and eventual collaborators Johan Theodor (*b* 1563) and Johan Israel (*b* 1565) were born. He was married a second time, in 1570, to Katharina, daughter of the Frankfurt goldsmith Hans Rötlinger. De Bry came under the stylistic influence of the Parisian Huguenot Etienne

Delaune, who had fled to Strasbourg in 1572. Because Strasbourg's Lutherans increasingly restricted the religious freedom of the Reformed church, de Bry, like many Calvinists, emigrated to Antwerp after the Pacification of Ghent in 1576. He was active as both a goldsmith and an engraver in Antwerp for approximately eight years but left just prior to the recapturing of the city by Spanish troops in 1585. From 1585 until 1588 he worked in London as an illustrator for English clients. In 1588 de Bry moved permanently to Frankfurt and with his sons established a successful humanist publishing house that became famed for its series of Protestant voyages, the *India Occidentalis* (14 vols., 1590–1634) and the *India Orientalis* (13 vols., 1597–1628). The first volume of the *India Occidentalis* and the first volume published by the de Bry firm was Thomas Harriot's *Briefe and True Report of the New Found Land of Virginia* (1590), illustrated with engraved copies after the watercolors of John White of scenes from the New World. Similar works by Jacques Le Moyne de Morgues provided visual material for the second volume on Florida (1591), and in subsequent volumes of the *India Occidentalis* de Bry published and illustrated travel accounts by Hans Staden, Jean de Léry, Girolamo Benzoni and others. De Bry tended to emphasize the cruelty of the Spanish conquerors toward the natives they encountered in America, and his landscape and figure formulae were made to conform to European standards (the de Brys based some compositions directly upon works by well-known engravers like Hendrick Goltzius). These engravings were the medium through which most Europeans came to view the customs and habits of the American Indians, and they became the source of illustrations for many later travel accounts. De Bry also published emblem books, antiquarian texts and a series of portraits of famous men—including Gerard Mercator (1512–94) and Copernicus (1473–1543)—engraved after drawings by Jean-Jacques Boissard (*Icones quinquaginta vivorum illustrium doctrine et eruditione praestantium*

ad vivum effectae, Frankfurt am Main, 1597–9). The engravings, by a number of different artists, form an important precedent for van Dyck's *Iconographie* of 1632–44. The de Bry imprint survived until 1626, when the contents of the publishing house were inherited by the Swiss publisher Matthaeus Merian and the English publisher William Fitzer.

BIBLIOGRAPHY

The European Vision of America (exh. cat. by H. Honour, Washington, DC, N.G.A.; Cleveland, OH, Mus. A.; Paris, Grand Pal.; 1975–7)

The New Golden Land: European Images of America from the Discoveries to the Present Time (New York, 1975) [based on 1975–7 exh. cat.]

B. Bernadette: *Icon and Conquest: A Structural Analysis of the Illustrations of De Bry's Great Voyages* (Chicago, 1981)

H. Keazor: "Theodore De Bry's Images for America," *Prt Q.*, 15 (June 1998), pp. 131–49

S. Burghartz, ed.: *Inszenierte Welten. Die west- und ostindischen Reisen der Verleger de Bry, 1590–1630 / Staging New Worlds. De Bry's illustrated travel reports, 1590–1630* (Basel, 2004)

M. Gaudio: *Engraving the Savage: The New World and Techniques of Civilization* (Minneapolis, 2008)

M. van Groesen: *The Representations of the Overseas World in the de Bry Collection of Voyages* (Leiden, 2008)

Jane Campbell Hutchison

Bryant, Gridley J. F.

(*b* Boston, MA, 29 Aug 1816; *d* Boston, 8 June 1899), architect. Gridley J(ames) F(ox) Bryant was the son of the engineer and railway pioneer Gridley Bryant. He trained in the Boston office of Alexander Parris and Loammi Baldwin in the 1830s and was practicing on his own by the autumn of 1837. In the 1840s he designed railway stations and commercial buildings, for example the Long Wharf Bonded Warehouse (1846; destr.) in Boston. During the next decade he also designed schools and court-houses and was involved in no fewer than 30 asylum projects following the design of his influential Charles Street Jail (1848–51), Boston, in conjunction with the prison reformer, the Rev Louis Dwight. This adaptation of the Auburn System of prison discipline to a

cruciform plan became the first executed American project to be published in the British architectural periodical *The Builder* (vii/326, 1849). When the great fire of 1872 devastated Boston's central business district, destroying 152 buildings designed by Bryant, he received commissions to rebuild 111 of them. He was also responsible for 19 state capitol and city hall projects, 95 court-houses, asylums and schools, 16 custom-houses and post offices and eight churches. He worked extensively with Arthur Delavan Gilman, who seems to have been responsible for design, while Bryant supervised the construction of such projects as the former Boston City Hall (1862–5), School Street. Primarily remembered as a great commercial architect and a leading figure in the latter stages of the Boston "granite school," Bryant was also an innovator in an emerging profession. He was one of the first American practitioners to use labor-saving standardized plans, to specialize in particular building types, to develop a large office and to introduce new styles. In the middle decades of the 19th century he presided over a practice that was regional if not quite national in scope.

BIBLIOGRAPHY

Macmillan Enc. Archit.

H. T. Bailey: "An Architect of the Old School," *New England Mag.*, xxv (1901), pp. 326–48

W. H. Kilham: *Boston after Bulfinch* (Cambridge, MA, 1946)

B. Bunting: *Houses of Boston's Back Bay* (Cambridge, MA, 1967)

H. R. Hitchcock and W. Seale: *Temples of Democracy: The State Capitols of the USA* (New York, 1976)

R. B. MacKay: *The Charles Street Jail: Hegemony of a Design* (diss., U. Boston, MA, 1980)

R. G. Reed: *Building Victorian Boston: The Architecture of Gridley J. F. Bryant* (Amherst, MA, 2007)

Robert B. MacKay

Buchloh, Benjamin

(*b* Cologne, 1941), art historian, critic and teacher of German birth. The significance of Buchloh's work

lies in its expansion of the modern art canon, demonstration of a critical potential of art and straddling of micro and macro levels of history. Buchloh's scholarship on art made in postwar Europe or from unconventional media has broadened previous, particularly American, understandings of modern art. While a committed historian, Buchloh always also assumes the role of critic, insisting on the critical responsibility of art *vis à vis* history and the present while cautious about its limits. He maintains that one core function of art is to present the illusion, if not the realization, of a suspension of power (*Neo-Avantgarde*, p. xxiv). In keeping with this, Buchloh often writes on artists of his own generation whose practice and thinking he knows intimately, and on artists who share his commitment, most importantly conceptual artists of the late 1960s and 1970s. Buchloh's combined roles as historian and critic spearheaded the merger of art history and art criticism that today defines writing on postwar art. Finally, Buchloh's thinking interweaves macro and micro perspectives on art, anchoring broad historical arguments in formal and material details, or demonstrating, as in his writings on the "neo-avantgarde," historical and hermeneutic differences between seemingly similar artistic practices and similarities between ones seemingly different. Buchloh, in short, demonstrates to many why art matters.

Buchloh's intellectual formation pushed him in these directions. Born in Cologne in 1941 and sheltered during the war in Switzerland, he came of age during postwar German reconstruction. After briefly studying art history in Cologne and Munich, he eventually received an MA in German literature with a minor in art history from the Freie Universität Berlin in 1969, amidst the country's hotbed of student protests. The West German student movement had galvanized not only around the brutalities of Vietnam, and increasingly repressive tendencies of its own government, but also around continuities with the National Socialist regime and the nation's inability to work through its Fascist past. Against this background, student and public discussion questioned the social and political relevance of cultural and artistic expression, fueled by the Frankfurt School's Critical Theory, the mounting political influence of the news media, an omnipresent culture industry and the market for American painting.

Following two years spent in London writing fiction to dissociate himself from the anarchist left in Berlin, Buchloh entered the German art world in 1971. He worked as an editor, notably on the last two issues of *Interfunktionen*, a leading postwar European art magazine. He worked as a teacher; from 1975 to 1977 he was lecturer on contemporary art history and criticism at the Staatliche Kunstakademie in Düsseldorf, where his students included Isa Genzken (b 1948), Thomas Schütte (b 1954) and Thomas Struth (b 1954). He also worked as a (co-)curator of one-man shows (Marcel Broodthaers, Dan Graham and Gerhard Richter at the Rudolf Zwirner Gallery in Cologne), a survey of art exhibitions in Europe since 1946, and the first retrospective of Sigmar Polke, both at Düsseldorf's Städtische Kunsthalle in 1976. A year later Buchloh moved to North America. Eager to leave the "strictures of the highly overdetermined cultural identity of postwar Germany," the new continent promised a welcome "model of a postnational cultural identity" (*Neo-Avantgarde*, p. xvii). Buchloh produced the majority of his writing on art following this move. Its significance extends beyond postwar European art and, from the perspective of American art, is centered on conceptual art and the "neo-avantgarde."

Buchloh's writings on conceptual art and artists practicing Institutional Critique demonstrate the critical potential of art while also attending to its problems. His seminal essay "Conceptual Art 1962–1969" lays out a historical genealogy of the term and practice and argues that an aesthetic vocabulary of administration initially employed by proto-Conceptualists and Conceptualists was transformed into a critique of the institutional frameworks of art in the hands of other artists. The former replaced the transcendental, visual and material foundations of art

making with a set of aesthetic strategies related to the vernacular realm of administration. Examples include: the linguistic turn in the art of Sol LeWitt, who worked with contradictions between visual and verbal signs; legal documents in/as works of art such as Robert Morris's *Statement of Aesthetic Withdrawal*; vernacular forms of distributing art such as Dan Graham's publication of *Homes for America* in *Arts* magazine; arbitrary and abstract methods of quantification in Ed Ruscha's commercially produced books; and the architectural determination of art in Robert Barry's square canvas to be placed in the exact center of the display wall. Artists practicing Institutional Critique furthered the critical potential of this aesthetic of administration by using it to critique the social and artistic institutions which are themselves based on the logic of administration. Such artists as Lawrence Weiner and Hans Haacke demonstrate that art—its making, materials and display—is "always already inscribed within institutional power and ideological and economic investment" (p. 136) and turned by these institutions into a "tool of ideological control and cultural legitimation" (p. 143).

The concept of the neo-avantgarde features prominently in Buchloh's thinking and in his hands becomes a powerful tool for thinking across the full span of 20th-century art while simultaneously tending to individual artists and works. The term originates in literary theorist Peter Bürger's book *Theorie der Avantgarde* (1972), where the avantgarde of the late 1910s and 1920s, with its critique of artistic autonomy, is contrasted with a postwar "neo-avantgarde," which merely institutionalizes the original critique. Buchloh deems Bürger's reading faulty and reductive. In fact, all of his writings on postwar art in one way or another demonstrate more complex and concrete ways in which it can be thought of in relation to prewar art, ways in which the re-emergences of earlier pictorial strategies like the grid, the monochrome, the ready-made, collage and photomontage are not merely repetitions. In "The Primary Colors for the Second Time," he

argues that historical context, especially reception histories, are essential in understanding postwar art beyond influence, imitation and authenticity. Reference points over the course of 30 years shifted from bourgeois art to a corporate state. In other cases, Buchloh stresses similarities between pre- and postwar art to reveal unexpected continuities in meaning. In "Figures of Authority, Ciphers of Regression," he posits that the link between traditional modes of representation in European 1920s and 1930s art and the rise of Fascism reveals a new authoritarian attitude and politically oppressive climate underlying the return to figuration in 1980s Neo-Expressionism.

In the introduction to *Neo-Avantgarde and Culture Industry*, Buchloh discusses problems with his earlier work ranging from its exclusion of women artists to efforts to elevate artists to canonical stature. Such self-critique may be the true mark of critical competence.

In 2005 Buchloh became professor of modern art at Harvard University and co-editor of its art journal *October*.

[*See also* Institutional critique.]

WRITINGS

"Figures of Authority, Ciphers of Regression," *October* (Spring 1981)

"The Primary Colors for the Second Time: A Paradigm Repetition of the Neo-Avantgarde," *October* (Summer 1986)

"Conceptual Art 1962–1969: From the Aesthetics of Administration to the Critique of Institutions," *October* (Winter 1990)

Neo-Avantgarde and Culture Industry: Essays on European and American Art from 1955 to 1975 (Cambridge, MA, 2000)

BIBLIOGRAPHY

T. Crow: "Committed to Memory," *Artforum* (Feb 2001)

C. Mehring: "Continental Schrift: The Magazine *Interfunktionen*," *Artforum* (May 2004)

Christine Mehring

Buckland, William

(*b* Oxford, 14 Aug 1734; *d* Annapolis, MD, between 16 Nov and 19 Dec 1774), architect. In 1748 Buckland

was apprenticed to his uncle James Buckland, a London joiner; in 1755, after completing his articles, he became an indentured servant to Thomson Mason, who had been studying law in London and had been asked by his brother George Mason (author of the Virginia Bill of Rights) to find a joiner to finish his house in Virginia. Buckland bound himself to serve "Thomson Mason, his Executors or Assigns in the Plantation of Virginia beyond the Seas, for the Space of Four Years," and thus came to be responsible for all the woodwork, indoors and out, of Gunston Hall (1755–60), Fairfax County, VA. Gunston Hall served as a showpiece for Buckland. The two porches, one an adaptation of the Palladian motif and the other a half-octagon combining a Doric pilaster order with ogee arches, were the first of their kind in Colonial America, as was the chinoiserie decoration in the dining room. In designing it, he drew on several books from his own library: *The British Architect* (1745, 1750, 1758) and *A Collection of Designs in Architecture* (1757) by Abraham Swan, *The Gentleman and Cabinet-maker's Director* (1754) by Thomas Chippendale and *The Builder's Companion* (1758) by William Pain.

When Gunston had been completed, Buckland moved to Richmond County, VA, where in 1765 he bought a farm. He moved to Annapolis, MD, in 1771. Buckland's most important work in his Richmond County period was the interior woodwork of Mount Airy (begun 1758, largely destr. 1844), where he was working in 1762. Although documentary evidence is scarce and it is difficult to be precise about his contribution to the architecture of the period, Buckland is known to have built the county prison and the Lunenburg Parish glebe house. Work in various houses in northern Virginia, including Nanzatico (1767–9), King George County, Menokin (1769–71), Richmond County, and Blandfield (?1769–?72), Essex County, and in Maryland (e.g. Whitehall (begun 1764), Anne Arundel County) has been attributed to him. He was undoubtedly responsible for much of the interior woodwork for the Chase–Lloyd House (1771), Annapolis. The interior has a stately staircase, rising to a half-landing and dividing into two flights with their serpentine underside visible. The dining room has much elaborate carving, mahogany doors with silver handles and paneled window shutters carved with octagonal medallions and rosettes. Buckland was also architect of the Hammond–Harwood House (1773–4), Annapolis, a five-bay house flanked by pavilions with octagonal bays. Although the detail derives from James Gibbs and Swan, the house is an outstanding example of Colonial domestic architecture. The interior woodwork is intricately carved, notably in the dining room and ballroom above, with beads, acanthus leaves and scrolls.

At his death, Buckland was recorded as leaving a substantial estate, including 15 books on architecture and closely related subjects.

BIBLIOGRAPHY

Macmillan Enc. Archit.

S. F. Limball: "Gunston Hall," *J. Soc. Archit. Hist.*, xiii (1954), pp. 3–8

R. R. Beirne and J. H. Scarff: *William Buckland, 1734–74: Architect of Virginia and Maryland* (Baltimore, 1958)

W. H. Pierson Jr.: "The Hammond–Harwood House: A Colonial Masterpiece," *Antiques*, cxi (1977), pp. 186–93

G. B. Tatum: "Great Houses from the Golden Age of Annapolis," *Antiques*, cxi (1977), pp. 174–85

C. Lounsbury: "An Elegant and Commodious Building: William Buckland and the Design of the Prince William County Courthouse, Dumfries, VA," *J. Soc. Archit. Hist.*, xlvi (1987), pp. 228–40

L. Beckerdite: "Architect-designed Furniture in Eighteenth-century Virginia: The Work of William Buckland and William Bernard Sears," *Amer. Furn.* (1994), pp. 28–42

Marcus Whiffen

Bucklin, James C.

(*b* Pawtucket, RI, 26 July 1801; *d* Providence, RI, 28 Sept 1890), architect. Bucklin's early training in architecture was as apprentice to John Holden Greene. When he was 21 he formed a partnership with William Tallman, a builder and timber

merchant, and they remained associates until the early 1850s. Russell Warren worked with them between 1827 and the early 1830s, as did Thomas Tefft between 1847 and 1851.

Tallman & Bucklin was a prolific firm. It engaged in speculative residential construction and was awarded some choice local commissions between the late 1820s and 1850s. Most of these were Greek Revival, including the Providence Arcade (1828), a monumental covered shopping mall; Westminster Street Congregational Church (1829; destr.); Rhode Island Hall, Brown University (1840); the Washington Row (1843–5; destr.); the Providence High School (1844; destr.); and Athenaeum Row (1845), all in Providence. The Tudor-style Butler Hospital (1847), Providence, is probably by Tefft, the architectural prodigy who was working for the firm while a student at Brown University.

After 1851 Bucklin practiced alone, but the influence of Tefft remained strong. His Renaissance Revival buildings often imitate Tefft's in both detail and format, as in the Third Howard Building (1859; destr.), Providence, and he adapted Tefft's *Rundbogenstil* brickwork for his mills, such as the Monohasset Mill (1868), Providence. The Thomas Davis House (1869; destr.), Providence, a Gothic Revival villa, recalls some of the designs of Tefft, who left his papers to Bucklin on his death in 1859.

Bucklin's late work demonstrates his desire to keep up to date in his designs. The Néo-Grec Hoppin Homestead Building (1875; destr.) and the high Victorian Gothic Brownell Building (1878; destr.), both in Providence, were conservative interpretations of current styles.

[*See also* Providence *and* Warren, Russell.]

BIBLIOGRAPHY

D.-B. Nelson: *The Greek Revival Architecture of James C. Bucklin* (diss., Newark, U. DE, 1969)

Buildings on Paper: Rhode Island Architectural Drawings, 1825–1945 (exh. cat., ed. W. H. Jordy and C. P. Monkhouse; Providence, RI, Brown U., Bell Gal., 1982)

W. McKenzie Woodward

Buffalo

American city and seat of Erie County in the state of New York. Buffalo is situated at the eastern end of Lake Erie, where the lake flows into the Niagara River, and has a population of *c.* 328,000. Designed as a village for the Holland Land Co. in 1803 by Joseph Ellicott (1760–1826), the settlement grew rapidly after the opening of the Erie Canal in 1825, developing into a major port, rail center, livestock and grain market and becoming known as the gateway to the Midwest. The migration to the suburbs in the 1950s was detrimental to architectural development. The city's notable buildings include St Paul's Episcopal Cathedral by Richard Upjohn (spire 1870; church rebuilt after the fire of 1888 by R. W. Gibson (1854–1927)); the State Hospital (1872–7) by H. H. Richardson; and the Guaranty (1894–6; now Prudential) Building by Dankmar Adler and Louis Sullivan, which is considered one of their finest buildings. In 1904 Frank Lloyd Wright designed the offices of the Larkin Soap Co. (1903–6; destr. 1950) and the Darwin Martin House (1903–6), an example of his "Prairie Houses." Pilot Field, stadium for the Bisons, was designed by Hellmuth, Obata & Kassabaum in 1988. Buffalo has two significant art museums. The Albright–Knox Art Gallery (1900–05) was designed by Edward B. Green (1855–1950), and an extension by Skidmore, Owings & Merrill was added in 1962. The museum is best known for its collection of American and European contemporary art and also contains 18th-century English and 19th-century French and American paintings. The Burchfield Art Center (previously Rockwell Hall), founded in 1966 at State University College of New York at Buffalo, is noted mainly for its collection of 77 paintings by Charles Burchfield.

[*See also* Burchfield, Charles, *and* Sullivan, Louis.]

BIBLIOGRAPHY

M. Goldman: *High Hopes: The Rise and Decline of Buffalo, New York* (Albany, 1983)

S. Doubilet: "In the Empire State," *Prog. Archit.*, xi (1984), pp. 88–94

S. Webster: "Pattern and Decoration in the Public Eye," *A. Amer.*, lxxv (Feb 1987), pp. 118–25

E. Lica: "Burchfield and Friends," *ARTnews*, lxxxix (1990), p. 62

P. M. Kenny: "A McKim, Mead and White Stair Hall of 1884," *Ant.*, cxli/2 (1992), pp. 312–19

J. Cigliano and S. B. Landau, eds: *Grand American Avenue, 1850–1920* (Washington, DC, 1994); review by J. E. Draper in *J. Soc. Archit. Hist.*, liv (1995), pp. 478–9

J. Siry: "Adler and Sullivan's Guaranty Building in Buffalo," *J. Soc. Archit. Hist.*, lv (1996), pp. 6–37

W. Holloway: "City of Parks: The Buffalo Olmsted Parks, Buffalo, NY," *Clem Labine's Traditional Building*, 19/5 (Oct 2006), pp. 28–30

Ann McKeighan Lee

Buffalo Meat

(*b* Southern Plains, USA, *c.* 1847; *d* nr Kingfisher, OK, 2 Oct 1917), artist, of Southern Cheyenne Native American descent. In his younger years, Buffalo Meat lived the ordinary life of the buffalo-hunting Plains Indians. He married *c.* 1867. On 3 April 1875 he was arrested at the Cheyenne Agency, Indian Territory, OK, with the charge of participating in the murder of a Euro-American immigrant family. He was sentenced to imprisonment without a trial or hearing, along with 71 other Native Americans. They arrived at Fort Marion, FL, on 21 May 1875. Encouraged by the fort's commander, 26 of the younger prisoners started to produce an enormous amount of pencil, ink and crayon drawings depicting their former lives. It became known as "ledger book art" and soon a white market developed for it. Buffalo Meat made his first known drawings during this imprisonment, although he probably produced some art before his arrest. He departed for the reservation on 11 April 1878, where he became a policeman, laborer for the agent and then a worker and deacon in the Baptist church. There is no record of his artistic occupation after his homecoming. In 1917 he died of tuberculosis. Among the 44 drawings assigned to him, the attribution of 16 drawings (before 1878; Washington, DC, Smithsonian Inst., Archvs Amer. A.), "BAEC," is uncertain, although these are definitely the work of a Kiowa artist. A set of eight pages of drawings (before 12 March 1878; Fort Worth, TX, Amon Carter Mus.) depicts scenes of Native American life. The other set, of six drawings, includes his best known work, *Buffalo Meat in His Sunday Clothes* (crayon and colored inks, 160×110 mm, before 12 March 1878; Oklahoma City, OK Hist. Soc.), which shows an attempt to represent spatial depth.

[*See also* Native North American art.]

BIBLIOGRAPHY

K. D. Petersen: *Plains Indian Art from Fort Marion* (Norman, 1971)

P. J. Powell: "Artists and Fighting Men: A Brief Introduction to Northern Cheyenne Ledger Book Drawings," *Amer. Ind. A.*, 1/1 (Autumn 1975), pp. 44–8

M. F. Harris: *Between Two Cultures* (St Paul, 1989)

J. M. Szabo: "Chief Killer and a New Reality: Narration and Description in Fort Marion Art," *Amer. Ind. A.Mag.*, 19/3 (1992), pp. 50–7

J. M. Szabo: *Howling Wolf and the History of Ledger Art* (Albuquerque, 1994)

Plains Indian Ledger Art [electronic resource] (La Jolla, CA, University of California San Diego Plains Indian Ledger Art Project, 1994–ongoing; http://plainsledgerart.org]

J. C. Berlo, ed.: *Plains Indian Drawings, 1865–1935: Pages from a Visual History* (New York, 1996)

H. Viola: *Warrior Artists: Historic Cheyenne and Kiowa Indian Ledger Art Drawn by Making Medicine and Zotom* (with commentary by J. D. and G. P. Capture, Washington, DC, 1998)

J. R. Lovett and D. L. DeWitt: *Guide to Native American Ledger Drawings and Pictographs in the United States Museums, Libraries, and Archives* (Westport, CT, 1998)

F. K. Pohl: *Framing America: A Social History of American Art* (New York, 2002)

A Kiowa's Odyssey: A Sketchbook from Fort Marion (exh. cat., P. Earenfight, ed., with contributions by J. C. Berlo and others, Seattle, The Trout Gallery, 2006)

Imre Nagy

Buffington, Leroy Sunderland

(*b* Cincinnati, OH, 22 Sept 1847; *d* Minneapolis, MN 6 Feb 1931), architect. The son of a mechanical engineer, Buffington was trained, after graduating from high school, in several Cincinnati offices, most

notably that of [Edwin] Anderson and [Samuel] Hannaford. He was also a student and later a teacher at the Ohio Mechanics' Institute, and in the late 1860s he worked as a draftsman in Terre Haute, IN, and Cleveland, OH. He was a founding member of the Cincinnati Chapter of the American Institute of Architects in 1870. Moving to St Paul, MN, in 1871, he served as the local superintendent of construction for the new US Customs House designed by the office of the supervising architect of the treasury in Washington, DC. In 1872 he formed a partnership with Abraham Radcliffe (1827–86) and two years later established an independent practice in Minneapolis. Within a few years he was known as the best architect in the state and was certainly one of the busiest. He produced dozens of residential, commercial, civic and church designs.

Buffington's early designs included the Boston Block (1880–4; destr.), the Pillsbury "A" Mill (1881–3), the West Hotel (1881–4; destr.), the Tribune building (1883–4; destr.), the Mechanic Arts Building (1885–6, now Eddy Hall) at the University of Minnesota, all in Minneapolis, and the North Dakota State Capitol (begun 1880; destr.) in Bismarck. Subsequent designs in the Romanesque Revival style of Henry Hobson Richardson, such as the Science Building (1886–7, now Pillsbury Hall) at the University of Minnesota, the Charles Pillsbury residence (1887), the Samuel Gale residence (1888), all in Minneapolis, and the Mabel Tainter Memorial (1889) in Menomonie, WI, propelled the Buffington office to national fame because of the publication of their perspective renderings in *American Architect and Building News* and *Inland Architect*. These Richardsonian designs and renderings, and many others in the same vein, were not done by Buffington but by his employees, especially Harvey Ellis, Edgar Eugene Joralemon (1858–1934) and Francis W. Fitzpatrick (1864–1931).

Buffington's unpublished *Memories*, written near the end of his life, claimed that he had invented skyscraper construction, which was a skeletal metal framing system for tall buildings, between the winters of 1880–1 and 1883–4. On 22 May 1888 the US Patent Office granted him patent no. 383170 for his "cloudscraper," as he called it, although it used an iron construction that was essentially standard at the time (it was one of about two dozen patents he eventually acquired). In 1892 he founded the Buffington Iron Building Company to license use of his system. When his practice declined after 1893, Buffington began to gain notoriety because of his repeated legal attempts, which were unsuccessful except in the instance of the Foshay Tower (1926–9, Minneapolis, by [Gottlieb] Magney & [Wilbur] Tusler), to collect royalties from other architects who were designing tall buildings.

[*See also* Ellis, Harvey.]

UNPUBLISHED SOURCES

L. S. Buffington: *Memories* (1931, ed. M. B. Christison as MA thesis, U. MN, 1941)

E. Manning: *The Architectural Designs of Harvey Ellis* (MA thesis, U. MN, 1953), pp. 19–26, 35–43

Minneapolis, U. MN Libs, NW Archit. Archvs [drawings and memorabilia, including *Memories*]

BIBLIOGRAPHY

"Appreciation," *Architectural Record*, lxix, (1931), p. 92

"Buffington, Leroy Sunderland," *The National Cyclopedia of American Biography*, xxii (New York, 1932), p. 384

E. M. Upjohn: "Buffington and the Skyscraper," *A. Bull.*, xx (1935), pp. 48–70

M. B. Christison, "How Buffington Staked His Claim," *A. Bull.*, xxvi (1944), pp. 267–76

D. Tselos: "The Enigma of Buffington's Skyscraper," *A. Bull.*, xxvi (1944), pp. 3–12

D. R. Torbert: "Buffington, Leroy Sunderland," *Macmillan Encyclopedia of Architects* (New York and London, 1982), pp. 320–1

E. M. Michels: *Reconfiguring Harvey Ellis* (Minneapolis, 2004), pp. 89–123, 173–82

W. Langham: "Buffington, Leroy Sunderland," *Biographical Dictionary of Cincinnati Architects, 1788–1940* (Cincinnati, 2008)

Eileen Michels

Bulfinch, Charles

(*b* Boston, MA, 8 August 1763; *d* Boston, 15 April 1844), architect. Bulfinch was a leading architect of

the Federal period in America, but had no formal architectural training.

Before 1795. Born to an aristocratic Boston family, Bulfinch graduated from Harvard College in 1781. In 1785 he embarked on a two-year tour of Italy, France and England, during which he developed a special enthusiasm for the Neo-classical style of Robert Adam. On his return, he married a wealthy cousin and, by his own account, spent the following eight years "pursuing no business but giving gratuitous advice in architecture." Bulfinch designed approximately 15 buildings during this early period, including three churches, a theater, a state house for Connecticut, seven detached houses and a group of row houses. The style derives clearly from Adam, but it is notably shallow and linear, owing perhaps to the American use of wood and brick rather than stone and to Bulfinch's probable reliance on sketches and engravings of the English models. It is also likely that, at this stage of his career, Bulfinch did not supervise his buildings but merely provided elevations and floor plans to builders who constructed them. Notable among his early works are two churches for Pittsfield and Taunton, MA (both begun in 1790), in which Bulfinch placed a belfry at the join of the principal roof of the building and the lower gable of the entrance porch so as to interlock the three principal masses, an innovation that became a popular standard for New England churches for many decades.

In 1793 Bulfinch designed the Tontine Crescent, a sweeping arc of connected town houses (destr.), which derived its general configuration from John Wood II's Royal Crescent (1767–c. 1775) at Bath and its detailing from Robert Adam's Adelphi Terrace (1768–72) in London. The failure of this venture, which was Bulfinch's first attempt at large-scale improvement to the Boston townscape, eradicated his fortune, forced him to declare bankruptcy and concluded his amateur status in architecture.

1795–1816. Bulfinch's commission (1795) for the Massachusetts State House in Boston was second only to the US Capitol as the largest and most

complex building in America in the 1790s. The elevation of his seven-bay projecting center is reworked from the design for the center of the main range to the river of Somerset House (1776–86), London, by Sir William Chambers. It has a tall arched arcade at ground level, a first-floor colonnade with the outer bay to either side emphasized by coupled columns and a five-bay pedimented attic story with the dome surmounted by a cupola. The building has a slight awkwardness of proportion, characteristic of Bulfinch's large-scale commissions. Documents indicate that he was paid about $600 over a three-year period as supervising architect of the building, a sum that provided only marginal subsistence to the Bulfinch family. In 1799 Bulfinch was made Chairman of the Board of Selectmen and Superintendent of Police of the Town of Boston, a position similar to that of mayor, which he held for nearly 20 years.

With this assurance and a modicum of economic stability (the position paid $600 per year, later raised to $1000), Bulfinch designed approximately 5 churches, 21 houses and 23 civic and commercial buildings between 1799 and 1817, many in Boston. India Wharf (1803), Faneuil Hall (1906) and Boylston Hall and Market (1809), with inadequate decorative elements on a scale more appropriate to domestic buildings, show again his awkward

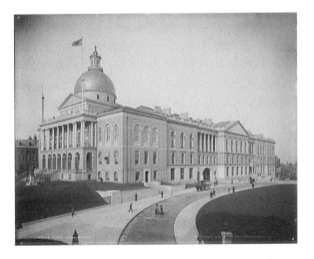

CHARLES BULFINCH. State House, Boston, MA, 1795–7. LIBRARY OF CONGRESS PRINTS AND PHOTOGRAPHS DIVISION/DETROIT PUBLISHING COMPANY COLLECTION

handling of large buildings. He was most confident with domestic architecture, his refined sense of proportion and restrained use of Neo-classical detail culminating in the three houses designed for Harrison Gray Otis between 1795 and 1805. His third house for Otis (1805), on Beacon Street, has a superbly proportioned symmetrical facade, with cast-iron balconies in a handsome fretwork design; behind the facade lies an unexpectedly varied plan. His New South Church, Boston (1814; destr.), was an elegant Neo-classical restatement of one of James Gibbs's alternative designs for St Martin-in-the-Fields, London. His finest work, the Church of Christ in rural Lancaster, MA (1816), is a red brick building with white wooden Neo-classical detail, but its distinction lies in the daringly overscaled massing of the portico with its three tall arches divided by pilasters, attic block and tall cupola, which nearly hide the main hall with a powerful design of abstract shapes.

Despite his active involvement in architecture and the financial support given by the town of Boston, Bulfinch's financial situation remained tenuous, and in 1811 he was again forced to declare bankruptcy and spent a brief period in jail.

1817–29. Bulfinch finally achieved full professional status as an architect in 1817, when President James Monroe summoned him to Washington, DC, and appointed him Architect of the US Capitol at an annual salary of $2500. Bulfinch was initially daunted by the prospect of carrying out the work begun by Benjamin Henry Latrobe, whose training and abilities were so clearly superior to his own, but he persevered and brought the building to completion in 1829, contributing the old Library of Congress (destr. 1851), the dome (replaced) and the west front. The Capitol building was Bulfinch's crowning achievement in its scale, but it is not his finest work. Under pressure from members of the President's Cabinet, he raised the central dome considerably higher than he wanted, and the west front, which is on a falling site and a full story taller than the east front, is marred by fussy detail.

Bulfinch returned to Boston in 1829; he lived there in retirement until his death. His last commission, the State House for Augusta, ME, of 1829, follows the general configuration of the Massachusetts State House of 1795, but the details are thickened in response to the developing Greek Revival.

[*See also* Boston *and* Federal style.]

BIBLIOGRAPHY

C. A. Cummings: "Architecture in Boston," *The Memorial History of Boston*, ed. J. Winsor, iv (Boston, 1881), pp. 465–88

A. R. Willard: "Charles Bulfinch, the Architect," *New England Mag.*, iii (1890), pp. 272–99

S. E. Bulfinch: *The Life and Letters of Charles Bulfinch* (Boston, 1896)

A. S. Roe: "The Massachusetts State House," *New England Mag.*, xix (1899), pp. 659–77

C. A. Place: *Charles Bulfinch: Architect and Citizen* (Boston, 1925)

W. Kilham: *Boston after Bulfinch* (Cambridge, 1946)

A. L. Cummings: "Charles Bulfinch and Boston's Vanishing West End," *Old-Time New England*, lii (1961), pp. 31–47

A. L. Cummings: "The Beginnings of India Wharf," *Proceedings of the Bostonian Society: Boston, 1962*, pp. 17–24 [annual meeting]

H. Kirker and J. Kirker: *Bulfinch's Boston: 1787–1817* (New York, 1964)

H. Kirker: *The Architecture of Charles Bulfinch* (Cambridge, 1969)

B. Pickens: "Wyatt's Pantheon, the State House in Boston and a New View of Bulfinch," *J. Soc. Archit. Hist.*, xxix (1970), pp. 124–31

W. Pierson: *American Buildings and their Architects: The Colonial and Neo-classical Styles* (New York, 1970), pp. 240–85

E. S. Bulfinch, ed.: *The Life and Letters of Charles Bulfinch, with Other Family Papers* (with intro. by C. A. Cummings, New York, 1973)

R. Nylander: "First Harrison Gray Otis House," *Ant.*, cvii (1975), pp. 1130

F. C. Detwiller: "Thomas Dawes's Church in Brattle Square," *Old-Time New England*, lxix (1979), pp. 1–17

J. F. Quinan: "Asher Benjamin and Charles Bulfinch: An Examination of Baroque Forms in Federal Style Architecture," *New England Meeting House and Church: 1630–1850* (Boston, 1980), pp. 18–29

J. Frew: "Bulfinch on Gothic," *J. Soc. Archit. Hist.*, xlv (1986), pp. 161–3

R. Nylander: "The First Harrison Gray Otis House, Boston, Massachusetts," *Ant.*, cxxix (1986), pp. 618–21

On the Boards: Drawings by Nineteenth-century Boston Architects (exh. cat. by J. F. O'Gorman, Wellesley Coll., MA, Mus., 1989)

L. Koenigsberg: "Life-writing: First American Biographers of Architects and their Works," *Stud. Hist. A.*, xxxv (1990), pp. 41–58

J. F. O'Gorman: "Bulfinch on Gothic, Again," *J. Soc. Archit. Hist.*, l/2 (1991), pp. 192–4

Temple of Liberty: Building the Capitol for a New Nation (exh. cat. by P. Scott, Washington, DC, Lib. Congr., 1995); review by D. Stillman in *J. Soc. Archit. Hist.*, liv (1995), pp. 461–4

D. Shand-Tucci: *Built in Boston: City and Suburb, 1800–2000* (Amherst, MA, 1999)

D. R. Kennon: *The United States Capitol: Designing and Decorating a National Icon* (Athens, OH, 2000)

K. Hefertepe and J. F. O'Gorman, eds.: *American Architects and Their Books to 1848* (Amherst, MA, 2001)

H. H. Reed: *The United States Capitol: Its Architecture and Decoration* (New York, 2005)

H. Howard: *Dr. Kimball and Mr. Jefferson: Rediscovering the Founding Fathers of American Architecture* (New York, 2006)

Jack Quinan

Bullock, Wynn

(*b* Chicago, IL, 18 April 1902; *d* Monterey, CA, 16 Nov 1975), photographer. Bullock was brought up in South Pasadena, CA, and he moved to New York in the early 1920s to attend Columbia University and study singing and music. He was a professional tenor before moving in 1928 to Paris, where he lived for two years, and became increasingly interested in the visual arts and photography. He bought his first camera to document his intermittent tours around the continent. Returning to the USA in 1931, Bullock briefly considered a career in real estate or law before enrolling in the Los Angeles Art Center School in 1938. There he studied photography with Edward Kaminski (1895–1964), who encouraged the creative use of the medium, in particular surrealistic experimentation.

Bullock's early work reflected the experimental approach of his teacher. He developed a solarization technique, patenting it in 1948, which photographically produced a line drawing of the outlines of objects rather than a conventional continuous tone image. He also worked in the carbro color print process, a complex technique used to produce brilliant, highly focused color prints. His first solo show was held in 1941 at the Los Angeles County Museum, where he exhibited his Art Center School photographs. In 1940–41 he also studied with the semanticist Alfred Korzybski (1879–1950), who stressed the principle that words as labels interfere with perception. Bullock became increasingly concerned with the philosophical aspects of photography and the meaningfulness of his photographs as symbols.

In 1946 Bullock settled in the coastal town of Monterey, CA, and opened a commercial photography studio. After meeting the photographer Edward Weston in 1948, Bullock radically changed his artistic direction and decided to explore natural imagery. The Californian coastline provided him with an abundance of richly textured environments for solitary nature studies and as backgrounds for his provocative nudes. Edward Steichen, as Director of the Department of Photography at the Museum of Modern Art in New York, was an early enthusiast of Bullock's work and featured his *Child in the Forest* (1951; Tucson, U. AZ, Cent. Creative Phot.) in the Museum's landmark exhibition, the *Family of Man*, in 1955.

Bullock claimed that he was always an intuitive photographer, who only much later developed the concepts to substantiate his work. He believed that the principles of "space-time" and "opposites" were important visual tools with which we could better perceive the world. These beliefs are illustrated in his juxtaposition of nude flesh against foliage and timber and in his time exposures, which juxtapose static and mobile elements such as trees and creeping mist and were achieved using filters, small lens aperture sizes and lengthy exposures. His finest prints impart a mystical connotation within the framework of a straight photograph.

[*See also* Photography.]

WRITINGS

The Photograph as Symbol (Capitola, 1976)

with E. Lewis, ed., and others, *Darkroom* (New York: 1977)

The Concepts and Principles of Wynn Bullock (Chicago, 1979)
[lecture of 1970, ed. by E. Bullock, 1973]

BIBLIOGRAPHY

B. Bullock: *Wynn Bullock* (San Francisco, 1971)

Wynn Bullock: 20 Color Photographs/Light Abstractions (exh. cat.,
Santa Clara U., CA, De Saisset Mus., 1972)

L. DeCock, ed.: *Wynn Bullock: Photography, A Way of Life* (Dobbs
Ferry, 1973)

D. Fuess: *Wynn Bullock* (Millerton, 1976)

H. Jones, ed.: "Wynn Bullock: American Lyric Tenor," *Cent.
Creative Phot.*, 2 (Sept 1976) [whole issue]

C. H. Dilley: *The Photography and Philosophy of Wynn Bullock*
(PhD dissertation, U. New Mexico, 1980)

C. Lamb and C. Ludlow, eds: *Wynn Bullock Archive*, Cent. Crea-
tive Phot., Guide Ser., 6 (Tucson, 1982)

B. Bullock-Wilson and E. Bullock, eds: *Wynn Bullock:
Photographing the Nude* (Salt Lake City, 1984)

B. Bullock-Wilson and E. Bullock, eds.: *Wynn Bullock:
Photographing the Nude: The Beginnings of a Quest for Mean-
ing*, with intro. by B. Bullock-Wilson (Salt Lake City, 1984)

Wynn Bullock: The Enchanted Landscape (with bio. essay by
R. Shevelev and poems by U. K. LeGuin, New York, 1993)

D. Fuess: *Wynn Bullock* (New York, 1999) [with bibliographic
references]

C. Johnson and B. Bullock-Wilson: *Wynn Bullock* (London and
New York, 2001)

Wynn Bullock: Listening with the Eyes, Seeing with the Heart (exh.
cat., Chicago, Stephen Daiter Gal., 2002)

Wynn Bullock: Realities and Metaphors (exh. cat., New York,
Laurence Miller Gal., 2002)

Wynn Bullock: Let There Be Light (exh. cat., Yamanashi, Japan,
Kiyosato Museum of Photographic Arts, 2006)

Richard Lorenz

Bungalow

The term "bungalow," outside the USA, connotes a
generic, one-story, vernacular dwelling. The building
type developed into one of the most frequently
adapted house forms in the world—it is the most
popular residential style in American architecture
(rivaled only by the ranch house)—and it is probably
the only type of dwelling known, by name and form,
on every continent of the world. The term derives
from a simple structure of mud, thatch and bamboo:
a Bengalese hut or "banggolo." Its Anglo-American

roots spring from a simple peasant cottage of the
17th century and from later colonial permutations
of indigenous dwellings at the far reaches of the
empire: the Anglo-Indian hut, for instance. The
early bungalow was a square dwelling surrounded
by a verandah, which might be partially enclosed,
that developed into rural or suburban domestic
forms. The bungalow eventually took on symbolic
associations with a freer or simpler way of life,
increasingly employed for summer cottages, beach
houses and country or suburban residences.

In American culture the term has come to connote
both a type of house and an architectural move-
ment; an historical development in domestic design
associated with the Arts and Crafts Movement as
well as an early suburban residential development.
Stylistically, an early 20th-century American bunga-
low differed from a 1930s "period house," or even a
mid-century ranch house, in the bungalow's empha-
sis on craftsmanly display of construction materials
and methods, and its avoidance of both explicit
historicism and abstracted images of progressivism.
As a symbol, the bungalow preferred other "signs"
or images representing home and domestic life, and
it retained traditional forms, such as the gable and
porch, and a homey character that included values
thought to be embodied in the very fabric of the
bungalow.

The term bungalow is often coupled with refer-
ences to "craftsmanship" or the artisan craftsman,
associating the house type with values attributed to
the very making of the work as an exemplar of the
builder's art: hence "Craftsman bungalow" connotes
in American architecture both the stylistic residen-
tial building and the "domestic revival" movement
which sprang from the English Arts and Crafts
Movement. The American bungalow was the prod-
uct of pre-industrial craft during a pre-machine age
when artisan handiwork informed a simpler life and
when art more directly expressed itself as a product
of labor.

The Craftsman bungalow is typically one story,
or one and a half stories, with front gable(s),

prominent porch and a straightforward use of construction materials. One or more gables extend frontally to the street, or prominently present broad roof surfaces spanning the house and running parallel to the sidewalk. The front porch is open, broad and spacious. Masonry piers serving as plinths are topped with tapered wood piers or columns to support the broad entablature of a frontal gable over a wide porch, the brick or stone base connoting strength and a greater duty of support than that performed by the tapered and wood piers above. Foundations are similarly solidly built, expressing themselves as well grounded by employing natural materials rooting the house to the earth. Rafter ends are exposed beneath sloping roof eaves, and other evidence of wood framing and masonry directly expresses the fabrication of the building, the art of joinery and the labor of the artisan or builder. The bungalow, as a sociological expression, is honest, democratic, middle class and simple, in all, appropriate for an American clientele.

Interiors of bungalows display freer, more open plans and evidence artisan details that find aesthetic merit in the display of natural materials and structural features. Furniture is frequently built in— whether employing settles to enframe fireplaces and to convey the bungalow's association of hearth and home, or providing built-in book cases as room dividers or at room's edge in order to free up usable space for family activities. Living rooms are oriented to fireplaces, window seats or library inglenooks; dining-rooms are large, providing communal space emphasizing the meal as the occasion for conversation, culture and an engaged family life.

Through the pages of *The Craftsman* magazine (1901–16), furniture maker Gustav Stickley advanced the popularity of the bungalow when he published "Craftsman homes" as proper settings for his simple and "well wrought" furniture. Mail order catalogs from Sears Roebuck & Company, Montgomery Ward and other commercial companies reflected the popularity of the bungalow at the turn of the 20th century by including in their pages numerous model homes in variations on bungalow themes. Pattern books available to contractors and builders further spread the residential building form. In California, architects Greene and Greene built "ultimate bungalows" for such wealthy clients as David Gamble (1908) and Robert Blacker (1907) in Pasadena, demonstrating that the bungalow could manifest itself as an exemplar of "architecture as a fine art" in which the artistry of stained glass, wood joinery, fireplace tile work and furniture design was in evidence.

Middle-class bungalows aspired to similar expressions of the "artistic home" but within their more limited means as "simple homes," an appellation adopted by Charles Keeler in Berkeley, CA, to describe the kind of hillside houses built by Bernard Maybeck at the turn of the century in the San Francisco Bay region. The everyday American bungalow, symbolized in the drawing by Grant Wood entitled *Main Street Mansion* (1936–7; Chattanooga, TN, Hunter Mus. A.), became the ubiquitous house form during the first quarter of the 20th century, and its features and character quintessentially shaped the values of the New Urbanism movement decades later. As new generations returned to live in renovated neighborhoods of the inner city, it is the way of life, psychic comfort, substantiality, economy and practicality of the bungalow which continue to attract.

[*See also* Arts and Crafts Movement; Craftsman Movement; Maybeck, Bernard; *and* Stickley, Gustav.]

BIBLIOGRAPHY

The Craftsman (1901–16)

C. Keeler: *The Simple Home* (San Francisco, 1904)

G. Stickley: *Craftsman Homes: Architecture and Furnishings of the American Arts and Crafts Movement* (New York, 1909/R 1979)

G. Stickley: *More Craftsman Homes* (New York, 1912)

G. Stickley: *The Best of Craftsman Homes* (Santa Barbara and Salt Lake City, 1979)

C. Lancaster: *The American Bungalow, 1880–1930* (New York, 1985)

A. D. King: *The Bungalow: The Production of a Global Culture* (New York, 1995)

Robert M. Craig

Bunker, Dennis Miller

(*b* New York, 6 Nov 1861; *d* Boston, MA, 28 Dec 1890), painter. He was a founder-member of the Boston school of painters and was the first artist to bring the Impressionist style to New England. From *c.* 1878 to 1881 he studied with William Merritt Chase, and from 1881 he studied in Paris with Jean-Léon Gérôme (1824–1904), returning to America in the autumn of 1885 to teach at the Cowles Art School in Boston. Although he held this post for only five years, he influenced many Bostonians (among them Isabella Stewart Gardner, founder of the Gardner Museum in Boston) to be more open to European ideas in art. After spending the summer of 1888 at Calcott, Salop, England, painting *plein-air* landscapes with John Singer Sargent, who was working closely with Claude Monet (1840–1926) at the time, he altered his style, his colors becoming brighter and his brushwork looser. However, he always maintained the careful drawing he had learned from Gérôme. Bunker's best-known works date from the last year or two of his life, such as *Jessica* (1890; Boston, MA, Mus. F.A.) and the *Roadside Cottage: Medfield* (1890; Duxbury, MA, A. Complex Mus.). Bunker, whom Sargent once called the most gifted young American, died at 29 of influenza, just a few years after his first solo exhibition.

BIBLIOGRAPHY
R. H. I. Gammell: *Dennis Miller Bunker* (New York, 1953)

Dennis Miller Bunker (1861–1890) Rediscovered (exh. cat., ed. C. Ferguson; New Britain, CT, Mus. Amer. A., 1978)

E. A. Porat: "Dennis Miller Bunker: A Tribute to an American Impressionist," *Amer. A. Rev.*, vii/2 (1995), pp. 104–13, 156–7

Dennis Miller Bunker, American Impressionist (exh. cat. by E. E. Hirshler and D. P. Curry, Boston, MA, Mus. F.A.; Chicago, IL, Terra Mus. Amer. A.; Denver, CO, A. Mus.; 1995); review by W. H. Gerdts, *Apollo*, cxli (1995), pp. 61–2

Dennis Miller Bunker and his Circle (exh. cat. by E. E. Hirshler, Boston, MA, Isabella Stewart Gardner Mus., 1995)

Like Breath on Glass: Whistler, Inness, and the Art of Painting Softly (exh. cat. by M. Simpson and others; Williamstown, MA, Clark A. Inst., 2008)

Mark W. Sullivan

Bunshaft, Gordon

(*b* Buffalo, NY, 9 May 1909; *d* New York, 6 Aug 1990), architect. He graduated in architecture at the Massachusetts Institute of Technology, Cambridge (BArch, 1933; MArch, 1935). In 1935–7 he was in Europe and North Africa on the Rotch Traveling Scholarship. On his return to New York in 1937 he joined the firm of Skidmore, Owings & Merrill (SOM). In 1938, with Robert A. Green (*b* 1910), he submitted a design in the well-known Wheaton College Art Center (IL) competition, which aimed at bringing Modernism to the American campus. The scheme, which won an Honorable Mention, derived from Impington Village College (1936–9) by Walter Gropius and E. Maxwell Fry in Cambs, England, and the Bunshaft and Green design confirmed their acceptance of the International Style idiom. Bunshaft was thus among the first American architects to embrace European Modernism, but unlike others, such as Edward Durrell Stone, Philip Johnson and Eero Saarinen, he never rejected its machine-age imperatives. More pragmatic and vernacular in his approach, he never entered the arena of architectural theory, history or criticism.

Bunshaft served during World War II, returning to SOM in 1946 and becoming a partner in 1949. He remained a major designer in the firm until his retirement in the 1980s. His greatest success came with the construction of Lever House (1950–52), New York, one of the first completely Modernist high-rises in any American city. It became the precedent for literally hundreds of similarly designed and constructed high-rises that characterize most American cities and many around the world. Its prefabricated aluminum and plate-glass curtain walls hang shorn of any hint of the craftsmanship necessary with walls of brick, stone or terracotta. Its specially designed movable scaffolding enables its sheath to be regularly and mechanically washed with Lever Brothers' products. Such a design quickly won support from the country's aggressive, expanding corporate establishment. The building's

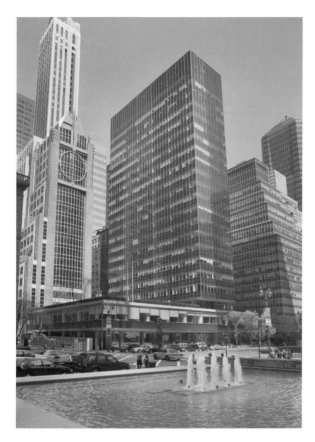

GORDON BUNSHAFT AND SKIDMORE, OWINGS & MERRILL.
Lever House, New York, 1950–52. Vanni/Art Resource, NY

stilts are also significant since they open up much space at ground-level. Pedestrians are thereby enabled to abandon the gridiron flow pattern of New York's streets and freely cut across the space, a concept that was widely imitated. The 24-story building was later threatened by a scheme to build a yet higher structure on its site; many Post-modernists were in favor of demolishing the building that symbolized the "less is a bore," glass-box type of Modernist architecture. However, the new scheme was rejected.

The success of Lever House brought Bunshaft and the firm many corporate commissions, to such an extent that offices were opened in Chicago and San Francisco in order to handle the volume of work, and with over 2000 staff the firm reached a size hitherto unprecedented. With the design of the Connecticut General Life Insurance complex (1957), Bloomfield, Bunshaft produced another design option for corporate architecture: sited on *c.* 250 acres, landscaped in the picturesque mode, the scheme was widely influential on firms wanting suburban or rural locations.

Among the urban buildings credited to Bunshaft are the Pepsi-Cola (subsequently Olivetti, now Amro Bank) Building (1960), Chase Manhattan Bank (1962), Marine Midland Bank (1967) and the W. R. Grace Building (1973), 1114 Avenue of the Americas, all in New York. The last of these pioneered the concave sloped facade as a solution to the setback requirements of the city's zoning laws. Bunshaft also had international commissions: Banque Lambert (1965), Brussels; the Haj Terminal (1982) at King Abdul Aziz International Airport, near Mecca, Saudi Arabia; and the National Commercial Bank (1982), Jiddah, Saudi Arabia. His monumental commissions included the Lyndon Baines Johnson and Sid W. Richardson Library (1971), University of Texas at Austin, and the Hirshhorn Museum and Sculpture Garden (1974), Washington, DC.

In 1988 he was a co-recipient (with Oscar Niemeyer) of the Pritzker Architecture Prize, honored for creating "a rich inventory of projects that set a timeless standard for buildings in the urban/ corporate world," demonstrating "an understanding of contemporary technology and materials in the making of great architecture that is unsurpassed." For illustration, see also International Style.

[*See also* Skidmore, Owings & Merrill.]

BIBLIOGRAPHY
"Wheaton College Art Center," *Archit. Forum*, lxix/2 (1938), p. 155

D. Jacobs: "The Establishment's Architect-plus," *NY Times Mag.* (23 July 1972), pp. 12–23

S. Stephens: "Big Deals and Bitter Endings," *Artforum*, xiii/6 (1975), pp. 56–62

S. Stephens: "Museum as Monument," *Prog. Archit.*, lvi/3 (1975), pp. 42–7

C. Stoloff: "Art Gallery and Sculpture Garden, Washington, DC," *Architect & Bldr*, xxv (March 1975), pp. 18–20

S. Abercrombie: "Twenty-five Year Award Goes to Lever House," *AIA J.*, lxix/3 (1980), pp. 76–9

C. H. Krinsky: *Gordon Bunshaft of Skidmore, Owings & Merrill* (Cambridge, MA, 1988)

James D. Kornwolf
Revised and updated by Margaret Barlow

Burchfield, Charles

(*b* Ashtabula Harbor, OH, 9 April 1893; *d* West Seneca, NY, 10 Jan 1967), painter. At five Burchfield moved with his family to Salem, OH, where he spent his youth. From 1912 to 1916 he studied at the Cleveland School of Art, OH. He was awarded a scholarship to the National Academy of Design, New York, where he went in October 1916 but left after one day of classes. He returned to Salem in November, where he supported himself by working at a local metal-fabricating plant and painted during his lunch hours and on weekends.

Between 1915 and 1918 Burchfield painted small watercolors marked by their fantasy and arbitrary color; see color pl. 1:XVI, 1. In these he often painted either visual equivalents of sounds in nature, as in *The Insect Chorus* (1917; Utica, NY, Munson–Williams–Proctor Inst.), or re-created childhood emotions, such as fear of the dark in *Church Bells Ringing, Rainy Winter Night* (1917; Cleveland, OH, Mus. A.). For these works he invented symbols in a sketchbook entitled *Conventions for Abstract Thoughts* (New York, Kennedy Gals) in which he identified his motifs with such labels as "Fear," "Dangerous Brooding" and "Fascination of Evil." Other watercolors from this period reflect his deep love of nature, as in *Dandelion Seed Balls and Trees* (1917; New York, Met.). All Burchfield's early watercolors have a strong decorative quality derived in part from oriental art, which he had admired at the Cleveland Museum of Art during his student days. However, his use of expressive color and distortion of form were achieved independently of the example of European modernism, with which he was not familiar until much later.

In July 1918 Burchfield was drafted into the US Army, from which he was released in January 1919.

In 1921 he became a designer for the wallpaper firm of M. H. Birge & Sons in Buffalo, NY, and in 1922 he married Bertha L. Kenreich. In 1925 he moved to a small house in Gardenville, a suburb of Buffalo, where he spent the rest of his life. In 1929 he left Birge to paint full time. The period 1919 to 1929 was an interlude of experiment and change in Burchfield's work. In 1924 Guy Pène du Bois referred to Burchfield as depicting "the American scene" in his paintings of provincial America. From 1929 to 1943 he developed a predominantly Realist style, in which he largely abandoned fantasy and concentrated on urban subjects. The paintings were larger in scale and more realistically handled than his earlier works on paper. He occasionally painted in oil, for example *Old House by Creek* (1932–8; New York, Whitney), but his preferred medium was always watercolor. He developed a distinctive watercolor technique using heavy, overlapping brushstrokes that gave the medium a notable weight and density rather than its customary transparency and sparkle. His subject matter was the architecture and industry of Buffalo: its grim Victorian houses, the facades of which he painted to evoke faces of corresponding mood, for example *Rainy Night* (1929–30; San Diego, CA, Mus. A.); its industrial scenes, such as *Black Iron* (1935; New York, Mrs. John D. Rockefeller III priv. col.); and its piles of rusty debris, which can be seen in *Scrap Iron* (1929; Lockport, NY, Charles Rand Penney priv. col.). Between 1936 and 1937 *Fortune* magazine commissioned him to paint railway yards in Pennsylvania and coal mines in Texas and West Virginia. By 1943 Burchfield felt he had exhausted this style and made a conscious effort to revive the imaginative quality of his early work on a larger scale.

Burchfield's late, Expressionist period lasted from 1943 to 1967. He enlarged some early watercolors by pasting strips of paper around them in a style consistent with their fantasy, for example *Sun and Rocks* (1918, enlarged 1950; Buffalo, NY, Albright-Knox A.G.). Other watercolors followed that were not reconstructions but the result of a direct approach to

nature. In these, he adapted the broad, solid technique of his middle period to Expressionist rather than Realist ends. By freely distorting form and color he interpreted the moods he felt in all the changing aspects of the landscape in different seasons, light and weather. The large watercolors of this last period (often over 1.25 m wide) were the clearest expression of his faith in the ultimate spiritual meaning of nature. Outstanding examples are *An April Mood* (1946–55; New York, Whitney), *Arctic Owl and Winter Moon* (1960; Montgomery, AL, Blount Col.), *Orion in Winter* (1962; Lugano, Col. Thyssen–Bornemisza) and *Dandelion Seed Heads and the Moon* (1961–5; Wayne, NJ, Irwin Goldstein priv. col., see Trovato, p. 311). In these Burchfield affirmed unmistakably the pantheism that had informed so much of his work. He was one of the last of many American pantheists and belonged to a tradition that began in the 19th century with writers such as Ralph Waldo Emerson and painters of the Hudson River school and later embraced the Luminists and even natural historians, including John Burroughs (1837–1921) and John Muir (1838–1914).

[*See also* Scene painting.]

UNPUBLISHED SOURCES

Oral history interview with Charles Burchfield, 19 Aug 1959 (conducted by J. D. Morse for the Arch. Amer. A.) [transcript available on the Arch. Amer A. website at http://www.aaa.si.edu/collections/oralhistories/transcripts/burchf59.htm]

WRITINGS

Charles Burchfield's Journals: The Poetry of Place (J. G, Townsend, ed., Albany, NY, 1993)

BIBLIOGRAPHY

J. I. H. Baur: *Charles Burchfield* (New York, 1956)

J. S. Trovato: *Charles Burchfield: Catalogue of Paintings in Public and Private Collections* (Utica, 1970)

M. Baigell: *Charles Burchfield* (New York, 1976)

J. I. H. Baur: *The Inlander: Life and Work of Charles Burchfield, 1893–1967* (East Brunswick, NJ, 1982)

Charles E. Burchfield: The Sacred Woods (exh. cat. by N. Weekly, Buffalo, NY, Burchfield A. Cent., 1993)

G. Davenport: *Charles Burchfield's Seasons* (San Francisco, 1994) [pomegranate]

C. L. Makowski: *Charles Burchfield: An Annotated Bibliography* (Lanham, MD, 1996)

The Paintings of Charles Burchfield: North by Midwest (exh. cat. by N. V. Maciejunes and M. D. Hall, Columbus Mus of A., OH and Nat. Mus of America A., Smithsonian Washington DC, 1997) (contr. by H. Adams, K. L. Ames, M. Kammen and D. Kuspit.) [publ. NY by Abrams, 1997]

John I. H. Baur
Revised and updated by Margaret Barlow

Burden, Chris

(*b* Boston, MA, 11 April 1946), performance and installation artist. Burden received a BA from Pomona College, Claremont, CA, and an MFA from the University of California, Irvine, in 1971. Burden made Minimalist sculptures, then viewer-activated sculptural works, before abandoning object-based

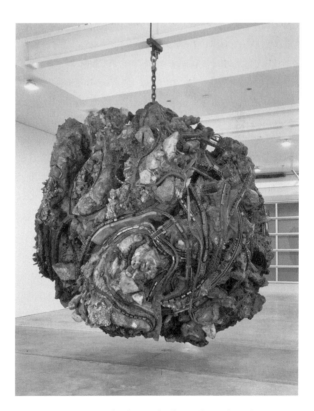

CHRIS BURDEN. *Medusa's Head*, plywood, steel, rock, cement, diam. 4.27 m (14 ft), 1989–92. © CHRIS BURDEN/COURTESY GAGOSIAN GALLERY

work in favor of performance for his MFA thesis exhibition, *Five Day Locker Piece* (26–30 April, 1971), when he was locked for five days in a conventional locker, 60 cm high, 60 cm wide, 60 cm deep (the locker above containing five gallons of water, the locker below an empty five-gallon bottle). Burden's performances, from the 1970s into the early 1980s, frequently involved situations that were apparently dangerous to himself, notoriously so in *Shoot* (19 Nov 1971, F Space, Santa Ana, CA; see Body art), in which he arranged to be shot in the left arm by a friend using a .22 gauge rifle from a distance of about 4.5 m—a work that took place in the context of the Vietnam War and tested its invited audience's relationship to violence and its representation. Other performances tested audience reactions by more passive means, as in *Doomed* (11 April, 1975, Museum of Contemporary Art, Chicago, IL), when Burden set a clock to 12, then lay down under a sheet of glass (1.5×2.5 m) leaning against the gallery wall, leaving no further instruction: 45 hours and 10 minutes later, Burden smashed the clock face with a hammer to record the time when a museum staff member placed a container of water under the glass. In the mid-1970s, Burden also returned to objects with *B-Car* (24 Aug–26 Oct 1975), when he constructed a lightweight, fast, fuel-efficient, single-passenger car. His installations since then have often featured kinetic elements, as in *The Big Wheel* (1979), in which a motorcycle was used to set an 2.5-m-diameter, cast-iron flywheel (weighing over 2.7 tons) in motion, or *The Flying Steamroller* (1996, Österreichisches Museum für Angewandte Kunst, Vienna), in which a 12-ton steamroller, suspended from a pivoting structure and balanced by a counterweight, "flies" in a circle around a gallery space when driven at full speed. Other works have addressed forms of power in different ways: *Samson* (1985, Henry Art Gallery, University of Washington, Seattle) was an oversized jack pushing large timbers against the supporting walls of a museum space, geared so that each visitor passing through the turnstiles moved the timbers infinitesimally; *Tower of*

Power (12–20 Jan 1985, Wadsworth Atheneum, Hartford, CT), consisted of 100 one-kilogram gold bricks, the value of which was at that time $US 1,000,000 (a related project using 100 kilograms of gold bricks, *One Ton One Kilo*, was canceled in March 2009 because the gold had been bought by Burden's gallery from a subsidiary of Stanford Financial Group, whose assets were frozen while Securities and Exchange Commission investigations proceeded). Burden was a professor of new media at the University of California, Los Angeles, from 1978 until 2005, when he resigned in protest against the university's handling of an incident concerning a student's work that invoked *Shoot*, and which might have involved a loaded gun.

BIBLIOGRAPHY

Chris Burden: A Twenty Year Survey (exh. cat. by P. Schimmel and others, Newport Beach, CA, Harbor A. Mus., 1988)

Chris Burden: Beyond the Limits (exh. cat. by P. Noever, Vienna, Österreich. Mus. Angewandte Kst, 1996)

F. Ward: "Gray Zone: Watching Shoot," *October*, xlv (Winter 2001)

Frazer Ward

Burke, Selma Hortense

(*b* Mooresville, NC, 1 Jan 1907; *d* New Hope, PA, 29 Aug 1995), sculptor, teacher and writer. Burke initially trained as a nurse at the Women's Medical College, NC, before studying philosophy at Columbia University, New York (1936–41). During the 1930s she became one of a few prominent black American sculptors participating in the Works Progress Administration's Federal Art Projects. She also became an instructor in sculpture at the Harlem Community Art Center and a frequent contributor to periodicals and newspapers, and she worked with Aristide Maillol in Paris and Hans Reiss (*b* 1885) in New York. In 1940 she was awarded a Rosenwald Fellowship and in 1943–6 was director of the Student's School of Sculpture, New York. Her sculpture is characterized by an idealistic intent in sensitively molded stone carvings on humanistic themes, for example *Lafayette* and *Salome*, exhibited at the

McMillen Galleries, New York, in November 1941. In later works the artist evoked the timeless spirit of such universal subjects as *Mother and Child* (1968; Los Angeles, CA, Co. Mus. A.), in which the smooth surfaces of intertwined figures play against rhythmic drapery. Her relief sculpture rendering of Franklin Delano Roosevelt was the source of the profile image on the US dime. There were major exhibitions in 1945 held at the Carlen Galleries, Philadelphia, and the McMillen Galleries and Modernage Gallery, New York. Works are held in the New York Public Library, New York Public School, Bethune College, New York, Teachers College, Winston-Salem, NC, and the Recorder of Deeds Building, Washington, DC.

[*See also* African American art.]

BIBLIOGRAPHY

Two Centuries of Black American Art (exh. cat. by D. D. Driscoll, Los Angeles, CA, Co. Mus. A., 1976)

G. B. Opitz, ed.: *Dictionary of American Painters, Sculptors and Engravers* (New York, 1986)

P. Chiarmonte: *Women Artists in the United States* (Boston, 1990)

G. Jackson: *Selma Burke, Artist* (Cleveland, 1994)

Burnham, Daniel H.

(*b* Henderson, NY, 4 Sept 1846; *d* Heidelberg, Germany, 1 June 1912), architect, urban planner and writer. The most active and successful architect, urban planner and organizer in the years around 1900, Daniel H(udson) Burnham, with his partner John Wellborn Root, created a series of original and distinctive early skyscrapers in Chicago in the 1880s. Burnham's urban plans, particularly those for Washington, DC (1901–2), and Chicago (1906–9), made a crucial contribution to the creation of monumental city centers with a great emphasis on parks.

Architectural Work to 1892. In 1854 Burnham's established New England family settled in Chicago. His father, ambitious for his son, sent him for tutoring and to a preparatory school in Waltham, MA (1863). He failed the entrance examinations for both Harvard University, Cambridge, MA, and Yale University, New Haven, CT, before returning in 1867 to Chicago, where his father placed him temporarily in the office of the engineer and architect William Le Baron Jenney. After two years of fruitless adventures in the West (1869–70), he worked for other architects in Chicago, and in 1872 he was presented by his father to Peter Bonnett Wight of Carter, Drake & Wight (*fl* 1872–4). There he met Root, who was chief draftsman, and in 1873 they set up their own firm of Burnham & Root, with Burnham in charge of business and planning and Root of design. Initially they received only house commissions, the first being that in 1874 (destr.) for the businessman and organizer of the Union Stock Yards, John B. Sherman, whose daughter Burnham married in 1876. The firm's domestic commissions for a fashionable clientele were executed in an accurate Ruskinian Gothic Revival style, which Root had learned from Wight.

From 1880 Burnham & Root emerged as the principal designers of the new ten-story skyscraper office buildings, especially with the Montauk Block (1881–2; destr.), Chicago. Here and in some two dozen subsequent structures in the city, the firm perfected "raft" foundations to support tall buildings on the muddy Chicago soil, iron (and eventually steel) skeletal frames to lighten and expedite their construction, and a frank, unfussy treatment of facades in red brick, terracotta and sandstone to express this new technological creation. The Rookery Building (1885–8) was their next prominent work, at the southeast corner of La Salle and Adams Streets, followed by the Rand–McNally Building (1888–90; destr.) with a complete steel frame lightly clad only in terracotta, the Monadnock Building (1889–92) at the southwest corner of Dearborn and Jackson Streets, with a brick exterior ornamented only by the elegant batter of its walls and cavetto cornice, and finally the steel and terracotta Masonic Temple (1890–92; destr.), at 22 stories then the tallest building in the world.

Urban Plans for the World's Columbian Exposition, 1890–93. In 1890 Burnham & Root were appointed consulting architects to the World's

Columbian Exposition, a world fair in commemoration of the discovery of America in 1492. The fair was snatched away from New York by Chicago and held a year late, in 1893, because of construction time. Preliminary plans were worked out in late 1890 by Burnham & Root and the landscape partnership of Frederick Law Olmsted and Henry Sargent Codman (1867–93). In December 1890 it was decided that detailed designs for the pavilions were to be executed by a board of five of the most prestigious architectural firms in the country: Richard Morris Hunt, George Browne Post and McKim, Mead & White, all from New York; Peabody & Stearns of Boston; and Van Brunt & Howe of Kansas City. In the face of local dismay that no Chicago architects were included, an equal number of Chicago practices were added: Adler & Sullivan, Solon S. Beman, Henry Ives Cobb, Jenney & Mundie and Burling & Whitehouse (fl 1880s). The board of architects met in Chicago in January 1891 to divide the work. The first five firms and Beman were given the task of designing the pavilions around the monumental Court of Honor, sketched out by Root and Olmsted, and they agreed to adhere to common facade and cornice lines and to adopt a consistent Greco-Roman style, executed in a kind of plaster known as staff. The Chicago firms were mostly assigned structures behind the Court of Honor, and they produced freer designs, especially Louis Sullivan's Transportation Building and Cobb's Fisheries Building. Root died unexpectedly of pneumonia just after the first meeting of the board of architects, but Burnham carried the project through with legendary assiduousness as Director of Construction, employing Charles B. Atwood of New York to design structures not envisioned in the initial plans, most notably the celebrated Fine Arts Building. Although Burnham did not design the complex, he was responsible for its execution, deciding such important secondary questions as the painting of the buildings in a uniform ivory white and their illumination at night.

The opening of the Exposition on 1 May 1893 was a triumph for Burnham. The monumental harmony, the classical nostalgia and the white cleanliness of the Court of Honor made a tremendous impression on Americans as a vision of what a great orderly city might be.

Architectural Work, 1893 and After. In the light of all of the activity after Root's death, Burnham's day-to-day practice of architecture as the senior partner of one of the largest firms in the country is easily forgotten. He had virtually closed his practice during the erection of the World's Columbian Exposition buildings. When he reopened it in 1893, he organized it around his Exposition staff, with Atwood in charge of design (until 1895), a 27% interest in the partnership, and Ernest Graham controlling the drafting room and Edward Shankland (1854–1924) responsible for engineering, both with a 10% interest.

Atwood withdrew in December 1895 and Shankland in January 1900, after which Graham and Burnham split the firm 40:60. In 1900 Peirce Anderson (1870–1924) returned from the Ecole des Beaux-Arts, Paris, to take charge of design and in 1908 he became a partner. In 1910 Burnham's sons Hubert Burnham (1887–1974) and Daniel Hudson Burnham Jr. (1886–1961) also entered the firm. After Burnham's death in 1912, the firm was reorganized as Graham, Burnham & Co.; in 1917, when Burnham's sons left the practice, it took the name Graham, Anderson, Probst & White.

It is easy to imagine that Burnham had little impact on the artistic production of the firm, but his contemporaries were vehement in denying this. "When a man has no time to make large drawings," wrote Peter Bonnett Wight in *Construction News* on Burnham's death, "he has to make small ones, and he has to reduce the size of his sheets as the demands upon his time increase. That is what Burnham did. He could lay out the plan for a large office building on sheets six inches square; and he would not only make one plan but would use sheets enough to lay it out according to every arrangement he could conceive of until he found the best one to recommend to his client."

The production of the firm after 1893 was almost exclusively office buildings and department stores, particularly the large and expensive sort: the Reliance Building (lower stories, 1889–91; upper stories, 1894–5), 32 North State Street, Chicago; the Ellicott Square Building (1894), Buffalo, NY; the Frick Building (1901), Pittsburgh, PA; the Flatiron Building (1903), intersection of Broadway and Fifth Avenue, New York; the Railway Exchange (1903) and People's Gas buildings (1910), both Chicago; and the department stores Selfridge's (1906), London, and Wanamaker's (1909), Philadelphia. Although widely scattered, these buildings displayed a remarkably consistent vocabulary of a few classical motifs applied over a clearly expressed steel skeleton, small variations in the costliness of materials and extensiveness of ornament responding to the budget and pretences of particular cases. The designs of Burnham & Co. were considered practical and fashionable, the "latest thing" from Chicago. The firm's few monumental commissions included the Union Station (1907) in Washington, DC, of which Peirce Anderson was in charge. It is a remarkably spacious and successful composition of characteristic volumes without, however, any individuality or "punch" in its details.

Urban Plans, 1901 and After. The World's Columbian Exposition ultimately inspired a movement that supported monumental municipal planning in New York, Philadelphia and elsewhere. Burnham and his new friend McKim were honored and consulted, and Burnham was awarded honorary degrees from Yale, Harvard and Northwestern universities. In 1901–2 Senator James McMillan, chairman of the congressional committee administering the national capital, the District of Columbia, commissioned a new plan for the city, based on the 18th-century Baroque scheme of Pierre-Charles L'Enfant. Burnham, McKim and Frederick Law Olmsted Jr. (1870–1957) were appointed to a three-man planning commission and, in collaboration with government authorities, they worked out a scheme of low Greco–Roman masses set in broad parks along L'Enfant's monumental axes, which was followed in the rebuilding of Washington during the next half century. In 1902–3 Burnham headed a commission to advise on the rebuilding of the center of Cleveland, a project promoted by the mayor Tom Johnson, who supported municipal reform. In 1905 Burnham produced an elaborate plan for San Francisco; however, the plan was not adopted when the city was rebuilt after the earthquake of 1906, although small fragments of it appeared, as in a portion of Telegraph Hill. In 1904–5 the US government dispatched him to the newly pacified Philippines to redesign Manila and to lay out a summer capital at Baguio. Finally, and most importantly, between 1906 and 1909 Burnham, together with Edward H. Bennett (1874–1954), oversaw a plan for the rebuilding and expansion of Chicago, which they published as *Plan of Chicago* (1909), a magnificent volume with architectural designs by the Frenchman Fernand Janin (1880–1912) and renderings by the American Jules Guerin (1866–1946). The Chicago plan was Burnham's last as well as his greatest work. It provided for streets laid out on a grid with radial and concentric boulevards, monumental civic buildings and efficient transport systems, a greater number of parks and a lakefront park system stretching 20 miles along Lake Michigan. The drawings were displayed around the world, with Burnham himself presenting them at the Town Planning Conference held in London in 1910.

Burnham consolidated his increasing reputation as a planner with a number of professional posts, some of which were created for him. In 1884 he was a founder and officer of the Western Association of Architects. After it amalgamated with the American Institute of Architects (AIA; 1889), he served as the AIA's President in 1894 and 1895, pushing for application of the Tarsney Act of 1893, which provided for the competitive award of public commissions. In 1894 Burnham and McKim were the prime movers in the founding of the American School of Architecture in Rome (later the American Academy). In 1910 he was appointed Chairman of the National Council

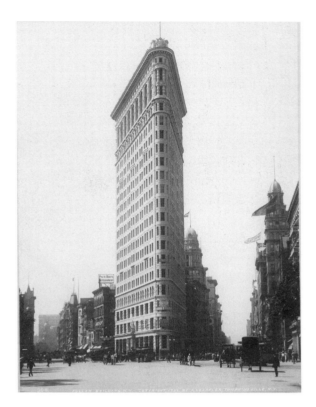

DANIEL H. BURNHAM. Flatiron Building, New York, 1902. Photograph by A. Loeffler/Library of Congress Prints and Photographs Division

of Fine Arts to oversee all public building and art in Washington, DC.

Critical Reception and Posthumous Reputation. Burnham's critical reputation, both as an architect and as a planner, has fluctuated over time. His contemporaries depicted him as a brilliant planner who conceived initial layouts of buildings in consultation with the clients and as an omnipresent and incisive critic who controlled his battalion of draftsmen with great effectiveness. He is often remembered for the words his associate Willis Jefferson Polk attributed to him: "Make no little plans, they have no magic to stir men's blood. . . . Make big plans . . . remembering that a noble, logical diagram once recorded will never die but long after we are gone will be a living thing asserting itself with ever growing intensity." His older professional contemporary Wight summarized his accomplishment more succinctly: "For the practice of the profession

of architecture, he did this: he made [his profession] known and respected by millions who had never heard of an architect in all their lives."

Burnham was tremendously admired at the time of his death, although as a planner rather than as an artist. His initial schemes for Washington and Chicago determined urban development in both cities until the 1950s: the Mall and Federal Triangle projects in Washington and the Lakefront parks and Chicago River quays and bridges in Chicago. In the 1920s advocates of the European International Style praised Burnham's reticent skyscrapers, especially the Reliance Building, while decrying the formality of his urban plans. Today the harmony and expressiveness of his great schemes—the Court of Honor, the Washington Mall, Grant Park in Chicago—have come to seem preferable to the starkness and individuality of postwar Modernism. Yet as early as 1924 concern was expressed by Louis Sullivan in his *Autobiography of an Idea* and later by Thomas Hines in his *Burnham of Chicago* (1974) that Burnham sought a least common denominator and that, for all the efficiency of his execution, his building designs and city plans remain uncommitted either socially or aesthetically.

[*See also* Atwood, Charles B.; Chicago school; Cincinnati; Graham, Anderson, Probst White; Hunt, Richard Morris; Jenney, William Le Baron; L'Enfant Plan; McKim, Mead & White; Polk, Willis J.; Root, John Wellborn; Skyscraper; *and* Washington, DC.]

UNPUBLISHED SOURCES
Chicago, IL, A. Inst. [Daniel H. Burnham Papers]

WRITINGS
The Final Report of the Director of Works of the World's Columbian Exposition (1894; Chicago, IL, A. Inst., Burnham Lib./R New York and London, 1989); review by C. E. Gregersen, *J. Soc. Archit. Hist.*, l (1991), pp. 219–21
The Improvement of the Park System of the District of Columbia (Washington, DC, 1902)
with J. M. Carrere and A. Brunner: "The Grouping of Public Buildings at Cleveland," *Inland Archit. & News Rec.*, xlii (Sept 1903), pp. 13–15
Report on a Plan for San Francisco, ed. E. F. O'Day (San Francisco, 1905)

with E. H. Bennett: *Plan of Chicago* (Chicago, 1909, R New York, 1970/1993)

"A City of the Future under a Democratic Government," *Trans. of the Town Planning Conference, Royal Institute of British Architects: London, 1910*, pp. 368–78

BIBLIOGRAPHY

H. Monroe: *John Wellborn Root: A Study of his Life and Work* (Boston, 1896)

C. Moore: *Daniel H. Burnham: Architect, Planner of Cities*, 2 vols (Boston, 1921)

L. H. Sullivan: *The Autobiography of an Idea* (New York, 1924)

T. Tallmadge: *Architecture in Old Chicago* (Chicago, 1941)

C. Condit: *The Rise of the Skyscraper* (Chicago, 1952)

D. Hoffmann: *The Architecture of John Wellborn Root* (Baltimore, 1973)

T. Hines: *Burnham of Chicago* (Chicago, 1974)

J. E. Draper: "Paris by the Lake: Sources of Burnham's Plan of Chicago," *Chicago Architecture, 1872–1922: Birth of a Metropolis*, ed. J. Zakowsky (Munich, 1987)

D. E. Gordon and M. S. Stubbs: "The Rebirth of a Magnificent Monument: Washington's Union Station Restoration," *Archit.*, lxxvii (1988), pp. 68–75

J. C. Lawrence: "Steel Frame Architecture versus the London Building Regulations: Selfridges, the Ritz and American Technology," *Constr. Hist.*, vi (1990), pp. 23–46

D. van Zanten: "Chicago in Architectural History," *Stud. Hist. A.*, xxxv (1990), pp. 91–9

T. S. Hines: "The Imperial Mall: The City Beautiful Movement and the Washington Plan of 1901–1902," *Stud. Hist. A.*, xxx (1991), pp. 78–99

D. Dunster: "The City as Autodidact: The Chicago Plan of 1909," *AA Files*, xxiii (1992), pp. 32–8

G. Ive: "Urban Classicim and Modern Ideology," *Architecture and the Sites of History: Interpretations of Buildings and Cities*, ed. I. Borden and D. Dunster (Oxford, 1995), pp. 38–52

D. H. Burnham and Mid-American Classicism (exh. cat., Chicago, IL, A. Inst., 1996); review by E. Keegan in *Architecture*, lxxxv (1996), p. 30

C. S. Smith, *The Plan of Chicago; Daniel Burnham and the Remaking of the American City* (Chicago, 2006)

David van Zanten

Burton, Scott

(*b* Greenboro, AL, 23 June 1939; *d* New York, 29 Dec 1989), sculptor, installation artist and performance artist. Walter Scott Burton studied art under Leon

SCOTT BURTON. *Pair of Rock Chairs*, gneiss, h. 1.25 and 1.11 m, 1980. © 2010 ESTATE OF SCOTT BURTON/ARTISTS RIGHTS SOCIETY, NY/ ACQUIRED THROUGH THE PHILIP JOHNSON, MR. AND JOSEPH PULITZER, JR. AND ROBERT ROSENBLUM FUNDS © THE MUSEUM OF MODERN ART/ LICENSED BY SCALA/ART RESOURCE, NY

Berkowitz (1919–87) in Washington, DC, and Hans Hofmann in Massachusetts, before moving to New York to study literature, gaining a BA from Columbia University, New York (1962), and an MA from New York University (1963). He first earned a reputation with performance and installation work in the 1970s. His series of *Behaviour Tableaux* and *Chair Tableaux* had a dramatic quality, the former actually involving actors in staged confrontations. *Pastoral Chair Tableaux* (see 1986–7 exh. cat., p. 34) is typical of the latter series: a simple arrangement of chairs on artificial grass in front of a sky-blue curtain, it suggested narrative without making one apparent. Burton's chair sculptures emerged out of these works in the late 1970s, and it is these for which he became most famous in the subsequent decade. Initially the work represented a humorous take on popular, conventional types of household furniture, but in 1980 he began the *Rock Chair Series* which comprised much more monumental, sculpted objects, carved as if from a single boulder with two simple cuts. Following these Burton's work demonstrated a closer engagement with the history of furniture, his *Sling Chair* (1982–3; see 1986–7 exh. cat. p. 44) finding a new interpretation of chairs by Ludwig

Mies van der Rohe, Mart Stam and Marcel Breuer's tubular chairs. Toward the mid-1980s Burton also began a series of interlocking granite chairs, which demonstrated his continuing debt to Minimalism.

BIBLIOGRAPHY

Scott Burton: Chairs (exh. cat., essay C. Stuckey, Cincinnati, OH, Contemp. A. Cent.; Minneapolis, MN, Walker A. Cent.; Fort Worth, TX, A. Mus.; Houston, TX, Contemp. A. Mus.; 1983–4)

Scott Burton (exh. cat., essay B. Richardson, Baltimore, U. MD, Mus. A., 1986–7)

Burton on Brancusi (exh. cat., New York, MOMA, 1989)

Scott Burton (exh. cat., essays R. Smith, and others, Düsseldorf, Kstver., 1989)

Scott Burton: Chaise Longings (exh. cat., essay N. Princenthal, New York, Max Protetch Gal., 1996)

Morgan Falconer

Butler, Howard Crosby

(*b* Croton Falls, New York, 7 March 1872; *d* Paris, 13 Aug 1922), archaeologist and teacher. After receiving his MA in 1893 from Princeton University with a fellowship in archaeology, Butler studied architecture at Columbia University. From 1895 until his death he held various appointments at Princeton in architecture, archaeology and art; his teaching of architecture as one of the fine arts led to the creation of the Princeton School of Architecture, of which he became the founding director in 1922. He was one of the most influential American archaeologists of his time, owing to his discoveries in Syria and at Sardis. His work in Syria was inspired by Melchior de Vogüé's explorations there in the 1860s. Butler organized and led an American expedition in 1899 with the intention of verifying, photographing and adding to the list of de Vogüé's sites. His work in Syria continued until 1909 and resulted in several important publications on the early Christian architecture. In 1910 he began excavating at Sardis, uncovering the Artemis Temple and a number of important Lydian objects, until 1914, when the outbreak of World War I halted work. He was occupied with his commitments at Princeton and the American Institute of Archaeology until 1922, when he returned to Sardis for a season of excavating. He died unexpectedly on his journey home, leaving his greatest dream, the excavation of Palmyra, unrealized. Archeological work at Sardis, including reconstruction of the Gymnasium and Synagogue, has been carried out since 1958 by teams from Harvard University Art Museums and Cornell University.

WRITINGS

The Story of Athens: A Record of the Life and Art of the City of the Violet Crown, Read in Its Ruins and in the Lives of Great Athenians (New York: Century, 1902/R Boston, 2000)

Architecture and Other Arts (New York, 1903)

Ancient Architecture in Syria, 2 vols (Leiden, 1919–20)

Sardis I: The Excavations, Part I: 1910–1914 (Leiden, 1922)

Sardis II: Architecture, Part I: The Temple of Artemis (Leiden, 1925)

E. Baldwin Smith, ed.: *Early Churches in Syria: Fourth to Seventh Centuries* (Princeton, 1929/R Amsterdam, 1969)

BIBLIOGRAPHY

Howard Crosby Butler, 1872–1922, Princeton University (Princeton, 1923)

H. S. Leach: *A Bibliography of Howard Crosby Butler, 1872–1922* (Princeton, 1924)

Lawrence E. Butler

Butterfield, Deborah

(*b* San Diego, CA, 7 May 1949), sculptor. Butterfield attended the University of California at Davis where she received a BA in 1972; after spending the summer of the same year at the Skowhegan School of Painting and Sculpture in Maine, she received an MFA from UC Davis in 1973, studying with such artists as William T. Wiley, Robert Arneson, Manuel Neri and Roy De Forest. In 1977 she received an Honorary Doctorate of Fine Arts from Rocky Mountain College in Billings, MT, and in 1978 she received the same distinction from Montana State University in Bozeman. Butterfield taught sculpture at the University of Wisconsin, Madison, first as a lecturer (1974–5) and then as an assistant professor (1975–7), before joining the staff at Montana State University,

Bozeman, as a visiting artist (1977–9), adjunct professor (1979–83) and then adjunct assistant professor and graduate student consultant (1984–6). Butterfield is well known for her sculptures of horses in various materials and compositions, which explore the dynamic relationship among humans, animals and nature.

In the 1970s Butterfield began creating sculptures of horses using plaster over a steel armature, describing these early works as self-portraits. She then moved to more ephemeral and natural materials such as mud, clay, leaves and sticks, which she collected on her farm in Montana and around her studio in Hawaii. These sculptures, which are partly influenced by her admiration of Asian, African and Native American art, merge the horses with their environment (e.g. *Horse #7* (*Bonfire*), 1978; Napa, CA, di Rosa Preserve). Butterfield's horses are tame and quiet animals, usually mares, standing with their heads gently lowered or lying on the ground—a posture she relates to the often reclining and seductive female nude prevalent in Western art. This early decision to create docile female horses was also based on her reaction to the popularity of sculptures that depicted giant horses, usually stallions, carrying generals and soldiers off to war. Butterfield's

sculpted horses vary in size from about one meter high—usually presented on a pedestal so it can be viewed at eye-level—to slightly larger than life-size; both placement and size reflect the artist's love for these animals. In the 1980s she began collecting scrap metal she found in dumps and on her ranch. She shaped the pieces into horses by hammering, bending and welding these discarded and colorful car, machine and metal signage parts (e.g. *Riot*, 1990; Wilmington, DE A. Mus.). Critics have described her work as a reflection on the replacement of horses by cars and the subsequent impact of this change on our environment (e.g. *Horse #2–85*, 1985; Tempe, AZ, State U. A. Mus.), which uses a tire to define the horse's body. In the late 1980s she began casting horses in bronze from models of wood and applying a patina, which made the sculpture appear as if it were made of wood (e.g. *Monekana*, 2001; Washington, DC, Smithsonian Amer. A. Mus. and *Shannon*, 2004; Col. Kim Lyford Bishop). Butterfield's decision to use bronze not only stems from a desire to make her sculptures more sturdy and long-lasting, but also reflects her interest in materials that are vulnerable and fragile as well as strong and permanent—noting that the medium of bronze is also transformed by rust throughout time.

Part of Butterfield's fascination with horses arose from her day-to-day interaction with these animals. Active in dressage, the art of training horses to execute precise movements on command, she was interested in the way humans communicate with other species and the structure of language in general. She also compared dressage to the physical and emotional act of creating art. While her sculptures exhibit mass and materiality, the horses are internally animated, with their actions, movements and gestures contained within their bodies. Butterfield's horses conjure feelings of both freedom and domestication, suggesting that her works are more about human nature and experiences than the animals themselves.

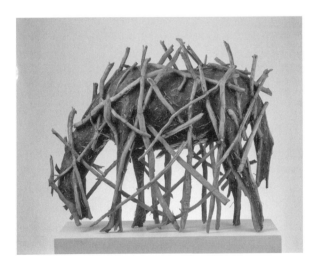

DEBORAH BUTTERFIELD. *Horse*, twigs. © Deborah Butterfield/ Licensed by VAGA, NY/Private collection/Edward Owen/Art Resource, NY

BIBLIOGRAPHY
Deborah Butterfield: Jerusalem Horses (exh. cat. by M. Weyland and S. Rachun, Jerusalem, Israel Mus., 1981)

M. Tucker: "Equestrian Mysteries: An Interview with Deborah Butterfield," *A. Amer.*, lxxvii/6 (June 1989), pp. 153–6, 203

Making Their Mark: Women Artists Move into the Mainstream, 1970–85 (exh. cat. by R. Rosen and C. C. Brawer and others, Cincinnati, OH, 1989)

Horses: The Art of Deborah Butterfield (exh. cat., with essay by D. Kuspit and interview by M. Tucker, Coral Gables, Lowe A. Mus., 1992)

Deborah Butterfield (exh. cat. by M. Stofflet; San Diego, CA, Mus. A., 1996)

D. Kuspit: *Idiosyncratic Identities: Artists at the End of the Avante-Garde* (Cambridge, 1996)

R. Gordon and others: *Deborah Butterfield* (New York, 2003)

J. Smiley: "Horse Sense," *SW Art*, 33/3 (Aug 2003), pp. 116–20, 200–04

L. Delk: "For the Love of Horses: A Conversation with Deborah Butterfield," *Sculpture*, xxiv/10 (Dec 2005), pp. 42–7

Mary Chou

Byars, James Lee

(*b* Detroit, 10 May 1932; *d* Cairo, Egypt, 23 June 1997), sculptor, performance artist and installation artist. James Lee Byars spent his formative years in Japan (1958–1968), where he learned to appreciate the ephemeral as a valued quality in art and embrace the ceremonial as a continuing mode in his life and work. He adapted the highly sensual, abstract and symbolic practices found in Japanese Noh theater and Shinto rituals to Western science, art and philosophy. One of his most important works of that period is *Untitled Object (Runcible)* (1962–64), also known as *The Performable Square*, an 18×18×18 inch cube consisting of 1000 sheets of white flax paper that unfold into a 50×50 foot white plane divided by 32 parallel strips connected at the top with paper hinges. It was first exhibited, folded, in 1964 at the National Museum of Modern Art, Kyoto, in the center of the museum floor, placed on a sheet of glass, but not "performed" (e.g. unfolded) until 14 years later, in March 1978, during Byars's exhibition at the University Art Museum in Berkeley, California.

He is best known for his later luxurious and enigmatic objects made of glass, gold, exotic stone or rare marble, such as *The Perfect Death of James Lee Byars*, consisting of a single room covered in gold leaf, five diamonds and a gold-leaf sarcophagus; *The Red Angel of Marseilles* (1993), featuring 1000 red glass spheres; or *Concave Figures* (1994), five life-size columns carved from white Thassos marble. Largely ignored in his native country after his return from Japan in 1968, he was immediately embraced by European artists and curators as one of their own, but is now recognized as a major figure in 20th-century American art.

BIBLIOGRAPHY

The Perfect Thought: Works by James Lee Byars (exh. cat. by J. Elliot, C. Ratcliff and G. Vattimo, Berkeley, U. CA, A. Mus., 1980)

The Palace of Good Luck (exh. cat. by R. Fuchs and G. Vattimo, Turin, Castello Rivoli, 1989)

The Perfect Moment (exh. cat. by H. Heil and others, Valencia, Generalidad, 1995)

James Lee Byars—The Epitaph of Con. Art Is Which Questions Have Disappeared? (exh. cat., ed. C. Haenlein; Hannover, Kestner Ges., 1999)

James Lee Byars: Life, Love, and Death (exh. cat. by K. Ottmann, Frankfurt am Main, Schirn Ksthalle; Strasbourg, Mus. A. Mod. & Contemp.; 2004–5)

Klaus Ottmann

Byrne, Barry

(*b* Chicago, IL, 19 Dec 1892; *d* Chicago, 17 Dec 1967), architect. Byrne was apprenticed to Frank Lloyd Wright from 1902 to 1909 and then spent a year in Seattle, WA. During a brief period in 1913 in California, he met the sculptor Alfonso Ianelli (1888–1965), who later provided ornament for several of Byrne's buildings. Byrne took over Walter Burley Griffin's American practice from 1913 to 1922, after the latter's departure to Australia. Later he founded his own building company (1922–9) and a small practice in Wilmette, IL (1930–32). From 1932 until his return to Chicago in 1945 he had an office in New York, where in addition to practicing architecture he published articles and reviews on architectural aesthetics and church design.

Byrne's secular work shows his individual synthesis of the Prairie school, Expressionism and Modernism in libraries, schools and private dwellings, notably the Kenna Apartments, 2214 East 69th Street (1916), Chicago, where the brick is used in a planar way, and Immaculata High School, Irving Park Road and Marine Drive (1922), Chicago, with its special attention to the edges where the masonry planes join. Byrne's churches are particularly expressive of his architectural ideas. By integrating the nave and sanctuary spaces he devised new spatial environments to express the liturgical reform movement in the Roman Catholic Church, anticipating by 40 years the changes that followed the Vatican II Councils of the 1960s. The church of St Thomas the Apostle at 55th and Kimbark (1922), Chicago, is the beginning of this development, which continued in the church of Christ the King (Tulsa, OK, 1926) and in a concrete church also called Christ the King (Cork, Ireland, 1929).

In his later churches in the USA Byrne showed a continuing sensitivity to light and color as well as to space, giving architectural expression to the ideas of peace and fulfillment that he felt were appropriate to the spiritual expression embodied in the Mass.

[*See also* Prairie school.]

WRITINGS

"Plan for a Church," *Liturg. A.*, x (May 1942)

"On Training for Architecture," *Liturg. A.*, xiii (May 1945)

"This Modernism," *Liturg. A.*, xix (Feb 1951)

"From These Roots," *Amer. Benedictine Rev.*, ii (Summer 1951)

BIBLIOGRAPHY

S. A. Kitt Chappell: *Barry Byrne: Architecture and Writings* (diss., Evanston, Northwestern U., 1968; microfilm, Ann Arbor, 1969)

S. A. Kitt Chappell and A. Van Zanten: *Barry Byrne and John Lloyd Wright: Architecture and Design* (Chicago, 1982) [incl. a select bibliog. of articles and reviews by Byrne]

H. A. Brooks: "La Prairie School nella storia dell'architettura—The Prairie School in the History of Architecture," *Rassegna*, 20/74 (1998), pp. 16–31

V. Michael: "Barry Byrne: The Prairie School Goes to Church," *Chicago Archit. J.*, 9 (2000), pp. 16–19

Sally A. Kitt Chappell

Cadmus, Paul

(*b* New York, 17 Dec 1904; *d* Weston, CT, 12 Dec 1999), painter. Cadmus studied in New York at the National Academy of Design (1919–26) and at the Art Students League (1928). With the painter Jared French (1905–88), he traveled in Italy from 1931 to 1933. His deep admiration for Italian Renaissance painting, for skilled draftsmanship and classical composition led him to learn the technique of egg tempera, which he often combined with oil. His

PAUL CADMUS. *Bar Italia*, tempera on wood, 952 × 1150 mm, 1953–5. © JON F. ANDERSON, ESTATE OF PAUL CADMUS/LICENSED BY VAGA, NY/SMITHSONIAN AMERICAN ART MUSEUM, WASHINGTON, DC/ ART RESOURCE, NY

social concerns informed his often critical view of contemporary life as in *Sailors and Floosies* (1938; New York, Whitney). Sexually ambiguous themes, which were often satirical and affectionate, pervade works such as *Bar Italia* (1952–5; Washington, DC, Smithsonian Amer. A. Mus.).

BIBLIOGRAPHY

Paul Cadmus, Yesterday and Today (exh. cat. by P. Eliasoph, Oxford, OH, Miami U., A. Mus., 1981) [retrospective exhibition]

L. Kirstein: *Paul Cadmus* (New York, 1984)

The Drawings of Paul Cadmus (intro. by G. Davenport; New York, 1989)

Collaboration, the Photographs of Paul Cadmus, Margaret French and Jared French (Santa Fe, *c.* 1992)

D. Leddick: *Intimate Companions: A Triography of George Platt Lynes, Paul Cadmus, Lincoln Kirstein, and their circle* (New York, 2000)

J. Spring: *Paul Cadmus: The Male Nude* (New York, 2002)

Emmanuel Cooper

Cage, John

(*b* Los Angeles, CA, 5 Sept 1912; *d* New York, 12 Aug 1992), composer, philosopher, writer and printmaker. He was educated in California and then made a study tour of Europe (1930–31), concentrating on art,

architecture and music. On his return to the USA he studied music with Richard Buhlig, Adolph Weiss, Henry Cowell and Arnold Schoenberg; in 1934 he abandoned abstract painting for music. An interest in extending the existing range of percussion instruments led him, in 1940, to devise the "prepared piano" (in which the sound is transformed by the insertion of various objects between the strings) and to pioneer electronic sound sources.

Cage's studies of Zen Buddhism and Indian philosophy during the 1940s resulted in a decision to remove intention, memory and personal taste from music, based on the Oriental concern with process rather than result. According equal status to both structured sound and noise, he treated silence (the absence of intentional sounds) as an element in its own right. In the early 1950s he began his close collaboration with the pianist David Tudor and, with the composers Morton Feldman, Earle Brown and Christian Wolff, they worked on his Project of Music for Magnetic Tapes (1951–3). In the winter of 1950–51 Wolff gave Cage a copy of his father's publication of the *Yi jing* (*I Ching*), the Chinese Book of Changes, which he used in his work thereafter as a source of "chance operations" to obtain numerical values (for which Cage had earlier devised mathematical charts) that could be applied to any facet of musical or artistic composition. In the following year Cage produced his *4'33"* (shortly after Robert Rauschenberg's "white canvases"), in which the performer(s) make no sounds but only delineate the work's three movements.

Also in 1952 Cage organized an untitled event at Black Mountain College, which foreshadowed the Happenings of the following decade and initiated an approach to performance in collaboration with the dancer and choreographer Merce Cunningham, in which music and movement were conceived separately and performed simultaneously. Many later works make use of concurrent layers of independent musical or non-musical activities. Cage also pioneered aspects of live electronic music and offered the performer greater creative freedom.

Cage was influential not only as a composer but also as a thinker, profoundly influencing artists working in other media. He was a friend of visual artists such as Mark Tobey, Morris Graves, Max Ernst, Richard Lippold, Willem de Kooning, Robert Motherwell, Rauschenberg, Jasper Johns, Joan Miró (1893–1983) and, in particular, Marcel Duchamp, and wrote about and collaborated with most of them. In his own scores after 1950 Cage frequently incorporated visual elements, such as superimpositions of transparent sheets covered with straight and curved lines, circles and dots; colored wavy lines to represent melodic outlines; and graphlike notations. In some scores he determined the positioning of pitches on a more or less conventional staff by the superimposition of star charts, or he based it on observations of imperfections in the paper. During the 1950s Cage also worked for a time as art director for a textile company.

From 1949 Cage began to introduce new elements into the presentation of lectures, beginning with *Lecture on Nothing*, by juxtaposing passages of text and sometimes also of music with silences and physical gestures. This was extended in the mid-1960s by the exploratory use of non-syntactical texts and texts printed in a variety of different typefaces. From 1963 Cage developed a new poetic form that he called the "mesostic," in which new words were formed vertically by highlighting one character within each line of the horizontal text. An example of this is the score of a composition for unaccompanied, amplified voice, *62 Mesostics re Merce Cunningham* (1971), which uses more than 700 different Letraset typefaces and sizes. A new visual element—the fragmentary drawings from nature scattered throughout Henry David Thoreau's *Journal*—is included in the published text of Cage's *Empty Words* and in the compositions *Score (40 Drawings by Thoreau) and 23 Parts* (1974) and *Renga* (1976; based on 361 paintings), for any instruments or voices.

Cage's increasing involvement in the graphic presentation of his work also led him to create purely

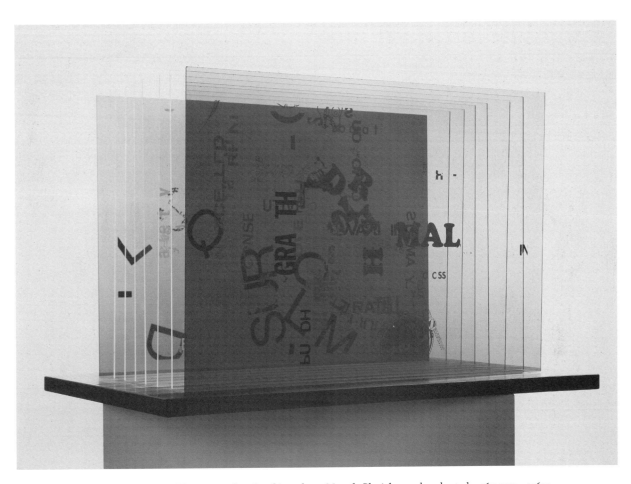

JOHN CAGE. *Not Wanting to Say Anything about Marcel*, Plexiglas and walnut, h. 365 mm, 1969; Nationalgalerie, Staatliche Museen, Berlin. PHOTOGRAPH BY JENS ZIEHE/COURTESY OF THE JOHN CAGE TRUST/ BILDARCHIV PREUSSISCHER KULTURBESITZ/ART RESOURCE, NY

visual works that have no musical connections. These are largely in the form of limited editions, mostly carried out in the etching studio of Crown Point Press in Oakland, CA, where he created 28 series of prints in the course of fairly regular visits between 1978 and his death in 1992. The earliest such work was *Not Wanting to Say Anything about Marcel* (1969), produced in collaboration with Calvin Sumsion (*b* 1942). It consists of eight parts (referred to as plexigrams), each comprising a base in which eight parallel Plexiglas sheets are fitted; fragments of printed text and images are silkscreened on to the sheets. Cage's etchings became increasingly complex as he used the *Yi jing* as a means of making formal decisions and of selecting a variety of printmaking techniques. In *Changes and Disappearances* (1979–82)

up to 45 different, irregularly shaped etching plates were used in each of the 35 etchings, with the final print containing 298 colors. Until 1982 most of his prints included reproductions of drawings by Thoreau in whole or in part; thereafter his images were inspired by the four elements of earth, air, fire and water, as well as the shapes of stones and rocks. In 1982, as part of his 70th birthday celebrations, the exhibition *John Cage: Scores and Prints* was mounted at the Whitney Museum of American Art, New York.

[*See also* Cunningham, Merce.]

WRITINGS

Silence: Lectures and Writings (Middletown, CT, 1961/R London, 1968)

A Year from Monday: New Lectures and Writings by John Cage (Middletown, CT, 1967/R London, 1968)

To Describe the Process of Composition Used in "Not Wanting to Say Anything about Marcel" (Cincinnati, 1969)

with C. Sumsion: "Plexigram IV: Not Wanting to Say Anything about Marcel," *Source: Music of the Avant-garde*, iv/7–8 (1970), pp. 1–20

M: Writings, '67–'72 (Middletown, CT, 1973/R London, 1973)

Empty Words: Writings, '73–'78 (Middletown, CT, 1979/R London, 1980)

X: Writings, '79–'82 (Middletown, CT, 1983/R London, 1987)

J.-J. Nattiez, ed.: *Pierre Boulez/John Cage: Correspondance et documents* (Winterthur, 1990) [bilingual text]; Fr. trans. (Paris, 1991); Eng. trans. as *The Boulez Cage Correspondence* (Cambridge, 1993) [exchange of letters between 1949 and 1954]

R. Kostelanetz, ed.: *John Cage, Writer: Previously Uncollected Pieces* (New York, 1993)

BIBLIOGRAPHY

Grove 6; Grove Amer. Music; Grove Instr.

C. Tomkins: "Figure in an Imaginary Landscape," *New Yorker* (28 Nov 1964), pp. 64–128; rev. as "John Cage" in *The Bride and the Bachelors* (New York, 1965); Eng. edn. as *Ahead of the Game: Four Versions of the Avant-garde* (London, 1965), pp. 69–138

R. Kostelanetz, ed.: *John Cage* (New York, 1970/R London, 1971); rev. as *John Cage: An Anthology* (New York, 1991) [incl. "Cage's Visual Art," p. 219, a list of graphic works to 1989]

D. Charles: "Cage et Duchamp," *L'Arc*, lix (Oct–Dec 1974), pp. 72–9; repr. in *Gloses sur John Cage* (Paris, 1978), pp. 183–96

Pour les oiseaux: Entretiens avec Daniel Charles (Paris, 1976; Eng. trans. London and Boston, MA, 1981) [based on interviews pubd. in *Rev. Esthét.*, xxi/2–4 (1968)]

H.-K. Metzger and R. Riehn, eds: *John Cage I* (Munich, 1978), pp. 65–91, 132–46 [well illus.; rev. 1990]

Tri-Quarterly, liv (Spring 1982) [issue ded. Cage], pp. 62–232; also as *A John Cage Reader*, ed. P. Gena and J. Brent (New York, London and Frankfurt, 1982) [illus., incl. 8 color pls. from *Changes and Disappearances*]

John Cage: Etchings, 1978–1982 (exh. cat., Oakland, CA, Crown Point Gal., 1982) [with introductory essay and chronology; incl. items by L. Toland and K. Brown originally pubd. in *Tri-Quarterly*, liv (Spring 1982)]

R. Kostelanetz, ed.: *Conversing with Cage* (New York, 1988/R London, 1989), pp. 173–90 [selections from interviews, esp. since 1965]

H.-K. Metzger and R. Riehn, eds: *John Cage II* (Munich, 1990) [well illus.; incl. M. Erdmann: "Chronologisches Verzeichnis," pp. 305–41, an annotated list (to 1988) of compositions, graphic works and writings]

R. Kostelanetz: "John Cage: The Development of his Visual Art," *Musicworks*, lii (Spring 1992), pp. 40–42 [graphic works to 1969, in special Cage issue]

D. Revill: *The Roaring Silence: John Cage, a Life* (London, 1992), pp. 261–5, 273–7, *passim* [first biography, incl. list of compositions (to early 1992) and "Chronology of Visual Works," pp. 367–8]

J. Pritchett: *The Music of John Cage* (Cambridge, 1993), pp. 180–89

D. W. Bernstein and C. Hatch, eds: *Writings through John Cage's Music, Poetry, and Art* (Chicago and London, 2001)

S. Shaw-Miller: *Visible Deeds of Music: Art and Music from Wagner to Cage* (New Haven and London, 2002)

D. Nicholls: *John Cage* (Urbana, IL, 2007)

Hugh Davies

Cahill, Holger

(*b* Snæfellsnessýsla, Iceland, 13 Jan 1887; *d* Stockbridge, MA, 8 July 1960), arts administrator and writer, of Icelandic birth. Cahill's parents emigrated to Canada, later moving to North Dakota. He moved to New York *c.* 1918, having changed his name from Sveinn Kristján Bjarnason, and became a journalist. At Columbia University he was exposed to John Dewey's theories of art and education, and at the New School for Social Research he learned to appreciate handicraft as art. In 1922 he went to the Newark Museum where he was responsible for educational program and the modern art collection. He organized influential exhibitions of American primitive painting and folk sculpture before moving to the Museum of Modern Art as director of exhibitions in 1932.

From 1935 to 1941 he was head of the Works Progress Administration's Federal Art Project (WPA/FAP), the US government's most extensive art program. By employing artists who were registered on relief rolls during the Depression, the FAP brought art to millions of Americans, commissioning murals, paintings, prints, posters, photographs and sculpture. From 1935 Cahill organized the Index of American Design, which recorded in 22,000 watercolor illustrations objects of American folk art from public and private collections. When the FAP ended in 1943, he returned to writing, mainly fiction.

[See also Ashcan school.]

WRITINGS

A Yankee Adventurer: The Story of Ward and the Taiping Rebellion (New York, 1930)

ed.: *Space*, vol. 1, nos. 1–3 (Jan–June 1930) [short-lived, quarterly journal, New York, NY]

Max Weber (exh. cat., New York, Downtown Gal., 1930)

American Painting and Sculpture, 1862–1932 (exh. cat., New York, MOMA, 1932)

American Folk Art: The Art of the Common Man in America, 1750–1900 (exh. cat., New York, MOMA, 1932)

American Sources of Modern Art (exh. cat., New York, MOMA, 1933)

ed., with A. H. Barr Jr.: *Art in America: A Complete Survey* (New York, 1933, rev. 1935)

New Horizons in American Art (exh. cat., New York, MOMA, 1936)

Masters of Modern Painting: Modern Primitives of Europe and America (exh. cat. with essays by H. Cahill and others, New York, MOMA, 1938)

A Museum in Action, Presenting the Museum's Activities (exh. cat., Newark, NJ, Newark Mus., 1944)

Look South to the Polar Star (New York, 1947)

BIBLIOGRAPHY

DAB

Holger Cahill Interview, 1960 Apr. 12 and 15, Archives of American Art, Smithsonian Institution [interviewed by J. Morse, New York; transcript available online at http://www.aaa.si.edu/collections/oralhistories/transcripts/cahill60.htm]

F. V. O'Connor, ed.: *The New Deal Art Projects: An Anthology of Memoirs* (Washington, DC, 1972)

R. D. McKinzie: *The New Deal for Artists* (Princeton, 1973)

W. M. Corn: *The Great American Thing: Modern Art and National Identity, 1915–1935* (Berkeley, 1999)

Drawing on America's Past: Folk Art, Modernism, and the Index of American Design (exh. cat. by V. T. Clayton and others, Washington, DC, N. G. A., 2003)

H. S. Bee and M. Elligott, eds.: *Art in Our Time: A Chronicle of the Museum of Modern Art* (New York, 2004)

Alan M. Fern

Cahokia

Site in East St Louis, IL, of a huge Pre-Columbian city. Founded *c.* AD 700, it was the largest prehistoric city ever built north of Mexico and was probably influenced by political and civic ideas from Pre-Columbian Mesoamerica. At its height, between *c.* AD 1050 and *c.* 1250, Cahokia encompassed *c.* 13 sq. km and had a population of *c.* 10–15,000. Although located in the northwest part of the middle Mississippi Southern Cult area, it was the political, economic and religious center for more than 50 towns. The exact nature of its power or rule, however, is uncertain. A potential rival in the southeast of the cult area was Moundville, AL, nearly as large. Cahokia began to decline after *c.* 1250, although some of its satellite towns, at such sites as Angel, Aztatlan, Dickson and Kinkaid, continued to flourish as local centers. A drastic population decline *c.* 1450 led to the abandonment or severe diminishment of many sites before European contact.

Cahokia lay in the American Bottomlands—the middle Mississippi Valley and confluence of the Mississippi, Missouri and Illinois rivers—a fertile alluvial valley region of light soils suitable for hoe-using agriculture. Archaeological evidence in the form of artifacts and skeletal remains (Springfield, IL, State Mus.) suggests that Mesoamerican influence began to penetrate this southeast woodlands region from *c.* AD 700. Later Mesoamerican influence brought about the construction of civic mounds. By *c.* 1200 Cahokia comprised a Central Plaza formed by 17 major mound structures of rammed earth and over 80 other mounds. Dominating the north side of the Central Plaza is Monks Mound, begun perhaps two centuries earlier and constructed in 14 stages to a height of more than 30 m. In its final configuration it comprised a complex rectangle with sloping sides (241×316 m at the base and more than 600,000 m^3 of earth). A ramp set slightly off-center on the south side led up to a wide platform across the south quarter. Higher stages were formed running north–south along the east and west sides, with two further platforms above these. Around the Central Plaza stood a four-sided timber palisade enclosing *c.* 120 ha. The ends of the long east and west sections of the stockade ended at the edge of Cahokia Creek, forming the north side of the ceremonial area. The two southern sections of the palisade formed an

offset point. Opinion differs as to whether the palisade was defensive or merely a ceremonial screen.

Groups of mounds formed further plazas immediately outside the palisade to the east (Ramey Plaza) and west (Merrell Plaza) and across Cahokia Creek (North Plaza). The mounds, also slope-sided, were flat-topped and square, rectangular or circular. In one case in the west plaza a truncated cone was set against the southwest corner of a square mound. When excavated, many mounds, including Monks Mound, bore traces of wooden structures presumed to be temples on their summits. Traces of ordinary longhouses built of upright logs were found scattered on the outskirts of the plazas.

Some mounds contained burials of elite citizens, while the cemeteries of non-elites formed several clusters around the Central Plaza and to the southwest of it. One elite burial contained two men surrounded by bundles of disarticulated bones. Another comprised an elite person wrapped in a robe of some 12,000 shell beads; around him were caches of polished stones, mica and arrowheads and six male retainers. A pit nearby contained the mass burial of 53 women, and in another pit were 4 decapitated men with amputated hands. The Wilson Mound, more than 1 km northwest of the Central Plaza, covered a mortuary chamber (4.25×5.50 m) containing hundreds of disarticulated bones grouped into bundles of several individuals each and a single dog skeleton. Scattered among the bundles were large whelk shells and disc-shaped marine shell beads.

[See also Native North American Art and Temple, Native North American.]

BIBLIOGRAPHY

M. L. Fowler: *Cahokia: Ancient Capital of the Midwest* (Menlo Park, CA, 1974)

J. Pfeiffer: "America's First City," *Horizon*, xvi/2 (1974), pp. 58–63

C. Hudson: *The Southeastern Indians* (Knoxville, 1976)

D. Snow: *The Archaeology of North America: American Indians and Their Origins* (London and New York, 1976/R 1980)

W. N. Morgan: *Prehistoric Architecture in the Eastern United States* (Cambridge, MA, 1980)

M. Coe, D. Snow and E. Benson: *Atlas of Ancient America* (Oxford, 1986), pp. 55–60

C. Scarre, ed.: *Past Worlds: The Times Atlas of Archaeology* (London, 1988), pp. 230–31

J. B. Stoltman, ed.: *New Perspectives on Cahokia: Views from the Periphery* (Madison, WI, 1991)

T. R. Pauketat: *The Ascent of Chiefs: Cahokia and Mississippian Politics in Native North America* (Tuscaloosa, AL, 1994)

M. Mehrer: *Cahokia's Countryside: Household Archeology, Settlement Patterns, and Social Power* (DeKalb, IL, 1995)

T. R. Pauketat and T. E. Emerson, eds., *Cahokia: Domination and Ideology in the Mississippian World* (Lincoln, NE, 1997)

T. E. Emerson: *Cahokia and the Archeology of Power* (Tuscaloosa, AL, 1997)

G. R. Milner: *The Cahokia Chiefdom: The Archeology of a Mississippian Society* (Washington, DC, 1998)

W. K. Moorhead: *The Cahokia Mounds*, ed. and intro. by J. E. Kelly (Tuscaloosa, AL, 2000)

S. A. Kitt Chappell and others: *Cahokia: Mirror of the Cosmos* (Chicago, 2002)

B. W. Young and M. L. Fowler: *Cahokia: The Great Native American Metropolis* (Urbana, IL, 2000)

R. A. Dalen and others: *Envisioning Cahokia: A Landscape Perspective* (DeKalb, IL, 2003)

T. R. Pauketat: *Ancient Cahokia and the Mississippians* (Cambridge and New York, 2004)

A. M. Byers: *Cahokia: A World of Renewal Cult Heterarchy* (Gainesville, FL, 2006)

David M. Jones

Cai Guo-Qiang

(*b* Quanzhou, 8 Dec 1957), Chinese installation artist, active in the USA. Cai studied at the Shanghai Drama Institute, completing his degree in stage design in 1985. He is best known for ephemeral, large-scale explosion-works using gunpowder, a medium he began to experiment with in China and often explained as a childhood reference to witnessing skirmishes between China and Taiwan along what was known as the Fujian Front.

In the 1980s he applied gunpowder to canvas, which he then lit to create bold, charred designs. When Cai emigrated to Japan in 1986, he began to use gunpowder for environmental installations. Since the early 1990s he called these works *Projects*

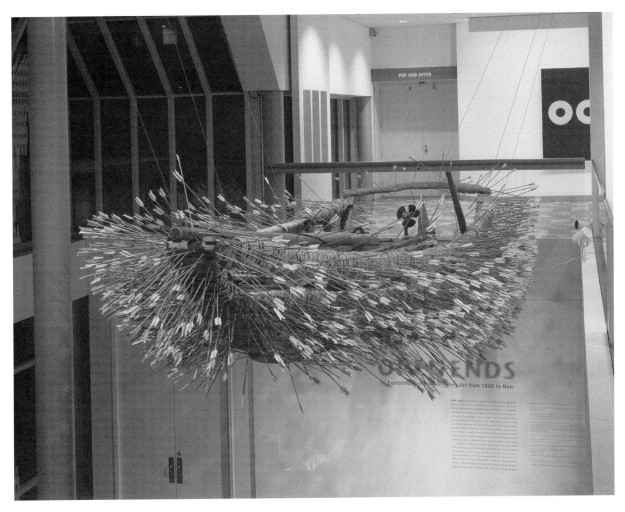

CAI GUO-QIANG. *Borrowing Your Enemy's Arrows*, wooden boat, canvas sail, arrows, metal, rope, Chinese flag and electric fan, 1998. GIFT OF PATRICIA PHELPS DE CISNEROS IN HONOR OF GLENN D. LOWRY. © CAI GUO-QIANG/ COURTESY OF CAI STUDIO © THE MUSEUM OF MODERN ART/LICENSED BY SCALA/ART RESOURCE, NY

for Extraterrestrials. Cai believed that most explosions visible from space have been related to war and that his work sends a non-violent message. A good example is *The Horizon from the Pan Pacific: Project for Extraterrestrials No. 14* (1994), executed off the coast of Iwaki, a small town in Japan, where Cai installed a 5000-m trail of gunpowder in the ocean that illuminated the horizon. The work evoked the experience of living in this small fishing village, where the ocean is a central part of everyday life. Such a conceptually charged yet rudimentary application of gunpowder characterizes Cai's works created in Japan.

Coinciding with his move to New York in 1995, Cai began to create installations using other materials and more direct references to his Chinese heritage, such as traditional Chinese medicine (*Bringing to Venice What Marco Polo Forgot*, 1995) and *fengshui* (*How Is Your Feng Shui?* 2000). These works reveal a desire to find new applications for Chinese cultural traditions outside China. For example, *Bringing to Venice What Marco Polo Forgot* consisted of a Chinese junk (boat) transported from the artist's hometown of Quanzhou and moored at Palazzo Giustinian-Lolin, a 17th-century merchant's home. Visitors could board the boat for the duration of the

exhibition and in the Palazzo were invited to self-prescribe Chinese medicinal tonics for various ills, which were dispensed from a vending machine. In this work Cai referred to Marco Polo's visits to China, suggesting that the explorer should have brought back Chinese traditional medicine, in addition to his observations of differences between Europe and 13th-century China.

Cai continued to create works using gunpowder, but they became much more ambitious in their application of pyrotechnic technology, sometimes involving collaboration with pyrotechnic companies. One such example is *Light Cycle* (2003), designed for New York's Central Park. The work consisted of three parts: *Signal Towers*, *Light Cycle* and *White Night*, each dependent upon different applications of gunpowder through the use of microchips inside firing shells and computer-operated remote controls. In conjunction with these ephemeral works, Cai also exhibited large-scale drawings made from burning gunpowder on paper.

WRITINGS

with Y. Jindong: "Painting with Gunpowder," *Leonardo*, xxi/3 (1988), pp. 251–4

BIBLIOGRAPHY

Silent Energy (exh. cat. of Cai Guo-Qiang and others, Oxford, MOMA, 1993)

Performance Anxiety: Angela Bullock, Cai Guo-Qiang [and others] (exh. cat., Chicago, Mus. Contemp. A., 1997)

Inside Out: New Chinese Art (exh. cat. with essays by Gao Minglu and others, San Francisco, MOMA, 1998)

Cai Guo-Qiang (exh. cat., Paris, Fond. Cartier A. Contemp., 2000)

Cai Guo-Qiang: Dragon or Rainbow Serpent—A Myth Glorified or Feared (exh. cat. by S. Raffel, Brisbaine, Queensland A. Gal., 2001)

D. Friis-Hansen and others: *Cai Guo-Qiang* (London and New York, 2002)

M. Chiu: "Light Cycle: An Interview with Cai-Guo-Qiang," *Cai Guo-Qiang: Light Cycle, Explosion for Central Park* (exh. cat., ed. M. Chiu, New York, Asia Soc. Gals, 2004)

X. Lin: "Globalism or Nationalism? Cai Guo-Qiang, Zhang Huan, and Xu Bing in New York," *Third Text*, 69 (July 2004), 279–95

D. Carrier: "Cai Guo-Qiang," *Artforum*, 43/6 (Feb 2005), pp. 176–7

S. Tanguy: "A Conversation with Cai Guo-Qiang," *Sculpture*, 24/4 (May 2005), pp. 32–7

M. Chiu: *Breakout: Chinese Art Outside China* (Milan, 2006)

J. K. Grande: "Shock and Awe: An Interview with Cai Guo-Qiang," *Yishu*, 6/1 (Spring 2007), pp. 39–44

M. B. Wiseman: "Submersive Strategies in Chinese Avant-Garde Art," *J. Aesth. A. Crit.*, 65/1 (Winter 2007), pp. 109–19

R. Vine: *New China, New Art* (Munich, 2008)

Cai Guo-Qiang: I Want to Believe (exh. cat. by T. Krens, A. Munroe and others, New York, Guggenheim, 2008)

D. Cohn: "Cai Guo-Qiang: The Art of War," *A. Asia Pacific*, 57 (March/April 2008), pp. 98–105

Melissa Chiu

Calatrava, Santiago

(*b* Benimamet, nr. Valencia, Spain, 28 July 1951), Spanish architect and engineer, active also in Switzerland and the USA. He studied architecture and urban planning at the Escuela Technica Superior de Arquitectura in Valencia (1969–74) and then civil engineering at the Eidgenössische Technische Hochschule (ETH), Zurich (1975–9). Between 1979 and 1981 he worked at the ETH and obtained a doctorate on the technology of space frames. After establishing an independent architectural and engineering practice in Zurich in 1981, he rapidly gained an international reputation for his integration of technology and aesthetics, producing dynamic structural forms that challenged traditional practice in both architecture and engineering. His approach to bridge design, for example, is based on the view that bridges can be used "to add energy to the landscape," as seen in the elegant, slender steel arch of his Lusitania Bridge (1988–91), Mérida, Spain, and the graceful continuous span of the tied steel arch projected for the East London River Crossing (1990; unexecuted). The single tilted steel arch of the small pedestrian La Devesa Bridge (1989–91), Ripoll, near Barcelona, the single inclined pylons with cable stays supporting the decks of the Alamillo Bridge (1987–92), Seville, and the pedestrian Trinity Bridge (begun 1993), Salford, Lancs, England, are dramatic, cantilevered designs that express the same view. Calatrava's most important building designs include the Stadelhofen Railway Station

(1983–90), Zurich, a long, curving, three-level structure that includes a basement underpass and upper-level walkway with connecting bridges. The nature of these spaces is emphasized by the structure: the basement is dominated by heavy, inclined concrete supports, and the upper walkway by the skeletal steel ribs of its cantilevered glazed roof. Lyon Airport Railway Station (1989–94) in France was designed with 500-m-long platform vaults of latticed concrete ribs; the station hall rising above them at the center has complex, angled roofs in the form of outstretched wings. Similar curved and skeletal forms feature in other projects, such as the Science Museum (1991), Valencia; the Kuwait Pavilion at Expo 92, Seville, with a roof formed of scimitar-shaped concrete ribs that could be hydraulically maneuvered to different angles; and a project (1991) for the completion of the cathedral of St John the Divine, New York, which includes an extraordinary, organic, skeletal structure for the transepts and a high-level garden under a glazed roof. Calatrava's work was exhibited widely in Europe and the USA in the 1980s and after, and he received several international awards, including the Gold Medal of the Institution of Structural Engineers, London (1992).

BIBLIOGRAPHY

W. Blaser, ed.: *Santiago Calatrava: Engineering-Architecture* (Basle, 1987)

F. Candela: "Calatrava's Graceful Shapes," *World Archit.*, xiii (1991), pp. 46–57

D. Sharp, ed.: *Santiago Calatrava* (London, 1992, rev. 1994)

K. Frampton and others: *Calatrava Bridges* (Zurich and London, 1993)

A. Tzonis: *Santiago Calatrava: The Poetics of Movement* (London, 1999)

A. Tzonis: *Santiago Calatrava: The Complete Works* (New York, 2007)

Valerie A. Clack

Calder, Alexander

(*b* Philadelphia, PA, 22 July 1898; *d* New York, 11 Nov 1976), sculptor, painter, illustrator, printmaker and designer, son of Alexander Stirling Calder. He graduated from Stevens Institute of Technology, Hoboken, NJ, with a degree in mechanical engineering in 1919. In 1923 he enrolled at the Art Students League in New York, where he was inspired by his teacher, John Sloan, to produce oil paintings. He became a freelance artist for the *National Police Gazette* in 1924, sketching sporting events and circus performances. His first illustrated book, *Animal Sketching* (New York, 1926), was based on studies made at the Bronx and Central Park Zoos in New York. The illustrations are brush and ink studies of animals in motion, with an accompanying text by the artist.

In 1926 Calder began his sojourns in Paris, where he attended sketching classes at the Académie de la Grande Chaumière. He was particularly influenced by the inventive collages of Joan Miró and by the whimsical art of Paul Klee, to which he was introduced by Miró. In Paris Calder made wood and wire animals with movable parts and designed the first pieces of his miniature *Circus* (1926–32; New York, Whitney). Performances of this hand-operated circus helped to introduce Calder to the Parisian avant-garde and to potential patrons. From 1927 to 1930 he constructed figures, animals and portrait heads in wire and carved similar subjects in wood.

After visiting Piet Mondrian's studio in 1930, Calder began to experiment with abstract constructions. He was invited to join Abstraction-Création in 1931 and was one of the few Americans to be actively involved with the group. In Paris in 1931 he exhibited his first non-objective construction, and in the following year he showed hand-cranked and motorized mobiles, marking the beginning of his development as a leading exponent of kinetic art. His major contribution to modern sculpture was the mobile, a kinetic construction of disparate elements that describe individual movements. *A Universe* (1934; New York, MOMA; see Constructivism) is an open sphere made of steel wire containing two smaller spheres in constant motion. With this motorized sculpture and related examples Calder demonstrated his indebtedness to astronomical

instruments of the past, including the armillary sphere and the mechanical orrery. In addition, he used his knowledge of laboratory instruments from his college training in kinetics.

Calder remained fully committed to abstraction during the 1930s and was encouraged by European modernists. After an initial involvement with geometric elements and machine imagery, he introduced biomorphic forms into his kinetic sculptures. Both the painted constructions and the brightly colored mobiles synthesized Constructivist methods and materials with abstract forms derived from Surrealist imagery. While his American contemporaries were only beginning to discover Constructivism, Calder was already exhibiting such work, both in the USA and in Europe. In 1938 he bought a farm in Roxbury, CT, and thereafter divided his time between visits abroad and longer periods of residence in the USA. He refined his wind-driven mobiles in subsequent years to produce elegant, space-encompassing abstractions of gracefully bending wires. *Lobster Trap and Fish Tail* (1939; New York, MOMA) is an example of the delicate balance that he achieved in deploying various forms from painted sheet metal and wire. His production of the 1930s included "plastic interludes," which were circles and spirals performing on an empty stage during the intermissions of Martha Graham's ballets. He also designed a mobile set for Erik Satie's symphonic drama, *Socrate* (1936), held at the Wadsworth Atheneum, Hartford, CT. In his later years he created costumes and set designs for various ballets and theatrical productions. Stabiles, large-scale constructions in cut and painted metal sheets, the first of which he created in the 1930s, appeared in substantial numbers from the 1950s. In his mature years his production included paintings, drawings, prints, book illustrations, jewelry and tapestries, all of which were composed of bold, abstract elements in primary colors. During the 1950s Calder continued to produce such mobiles as *Big Red* (1959; New York, Whitney) and *125* (1957; John F. Kennedy International Airport, New York), as well as producing new

forms, including the *Towers*, wire constructions attached to the wall, with moving elements, and *Gongs*, metal pieces intended to produce various sounds. In the spring of 1954 Calder established a new studio and remodeled a house in Saché, France, where his family settled.

During the 1960s and 1970s colossal stabiles were commissioned for public sites around the world. Calder's arching forms, dynamic surfaces and biomorphic imagery were the appropriate complement for the geometric regularity and severity of modern architectural complexes. *Teodelapio*, a stabile originally made for an exhibition in Spoleto, Italy, in 1962, served as a monumental gateway to the city. He designed *Man* for the World's Fair, Montreal, in 1967. Stabiles of 15 m and more were installed in many American and European cities. The frequent allusions to animal forms in these stabiles can be traced back to his formative years and his interest in Miró and Klee's fantastic imagery. One of the finest stabiles is *Flamingo* (1973), located at Federal Center Plaza in Chicago, IL. Positioned outside federal office buildings designed by Mies van der Rohe, it provides a visual transition between human scale and the colossal proportions of two monolithic skyscrapers that are adjacent. The red stabile complements the black steel and glass of the towers, and the curving forms counterpoise the severe geometry of the architect's design. Like a giant bird poised on spindly legs with beak lowered to the ground, it attracts the attention of pedestrians and encourages movement beneath the space it occupies. Shortly before his death Calder completed a colossal stabile, *La Défense*, at the Rond Point de La Défense Métro station in Paris. After Calder's death in 1976, a number of his public sculpture projects were installed with mixed results. Two notable examples are the giant mobile positioned in the atrium of the East Building at the National Gallery of Art, Washington, DC. This project had to be redesigned and modified so that the elements would move. However, the mobile has presented many problems since its installation. Another unfortunate installation is *Mountains and*

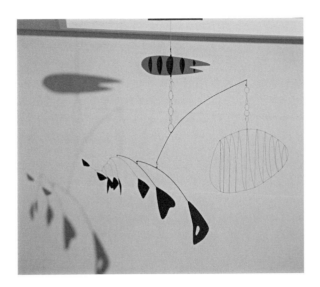

ALEXANDER CALDER. *Lobster Trap and Fish Tail*, painted sheet wire and sheet aluminum, 2.6 × 2.9 m, 1939. © 2010 CALDER FOUNDATION, NEW YORK/ARTISTS RIGHTS SOCIETY, NY © MUSEUM OF MODERN ART/LICENSED BY SCALA/ART RESOURCE, NY

Clouds in the Hart Senate Office Building, known only in a small maquette at the time of Calder's death. Calder's allusions to fantastic animal forms in brightly painted sheets of metal attracted the attention of sculptors interested in whimsical creatures in polychrome. As the first American artist to achieve international success for his Constructivist/Surrealist sculpture, he exerted a strong influence on younger artists committed to abstraction.

WRITINGS
An Autobiography with Pictures (New York, 1966)

BIBLIOGRAPHY
H. H. Arnason and U. Mulas: *Calder* (New York, 1971)
J. Lipman: *Calder's Universe* (New York, 1976)
J. Marter: "Alexander Calder: Cosmic Imagery and the Use of Scientific Instruments," *Arts* [New York], liii (1978), pp. 108–13)
J. Marter: *Alexander Calder* (Cambridge, New York and Melbourne, 1991 and 1997)
Alexander Calder (1898–1976) (exh.cat. by M. Prather, Washington, N. G. A., 1998).
Calder in Connecticut (exh.cat. by Eric M. Zafran, Wadsworth Athenum and Rizzoli, 2000).
Alexander Calder: The Paris Years, 1926–1933 (exh. cat. New York: Whitney Mus. f Amer. A., 2008)

Joan Marter

Calder, Alexander Milne

(*b* Aberdeen, Scotland, 23 Aug 1846; *d* Philadelphia, PA, 14 June 1923), sculptor. The son of a stonecutter, he studied carving at the Royal Institute of Arts in Edinburgh and also in Paris and in London, where he later worked on the carving of the Albert Memorial. In 1868 he went to Philadelphia and studied at the Pennsylvania Academy of the Fine Arts with Thomas Eakins. In 1873 he began a 20-year project to design and execute sculptural decorations for Philadelphia's new City Hall. This is his most significant work, and the elaborate reliefs, statues and panels of statesmen and early settlers form perhaps the most ambitious decorative program ever executed for a building by a single sculptor in the USA. The bronze statue of *William Penn* (over 11 m high), placed on top of City Hall in 1894, is a well-known landmark in Philadelphia and was until the 1980s the highest point in the city. Calder exhibited several figures and a carved stone panel (untraced) at the Centennial Exhibition in Philadelphia in 1876. Other notable works include a bronze portrait of *General George Gordon Meade* (Fairmount Park, Philadelphia) and the Hayden Memorial Geological Fund medal for the Academy of Natural Sciences (bronze, 1888).

BIBLIOGRAPHY
W. Craven: *Sculpture in America* (New York, 1968, rev. Newark, New York and London, 1984), pp. 483–6
Sculpture of a City: Philadelphia's Treasures in Bronze and Stone (New York, 1974), pp. 94–109
Philadelphia: Three Centuries of American Art (exh. cat., ed. G. Marcus and D. Sewell; Philadelphia, PA, Mus. A., 1976), pp. 432–3
M. Calder Hayes: *Three Alexander Calders: A Family Memoir* (Middlebury, VT, 1977)
S. Moore: "Billy Penn Gets a Scrubbing: Bronze Statue, Philadelphia City Hall," *Hist. Preserv.*, xl (1988), pp. 48–9

Abigail Schade Gary

Calder, Alexander Stirling

(*b* Philadelphia, PA, 11 Jan 1870; *d* New York, 6 Jan 1945), sculptor, son of Alexander Milne Calder. He studied at the Pennsylvania Academy of the Fine

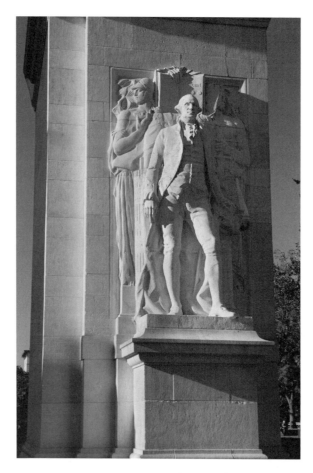

ALEXANDER STIRLING CALDER. *George Washington Accompanied by Wisdom and Justice*, marble, north side of Washington Arch, New York, 1918. Vanni/Art Resource, NY

Arts under Thomas Eakins and Thomas Anshutz and later in Paris at the Académie Julian and the Ecole des Beaux-Arts. Returning to Philadelphia in 1892, he won the gold medal of the Philadelphia Art Club and became an assistant instructor in modeling at the Pennsylvania Academy. His first commission, in 1893, was for a portrait statue in marble of the eminent surgeon *Dr. Samuel Gross* to go in front of the Army Medical Museum, Washington, DC (now Washington, DC, Armed Forces Inst. Pathology, N. Mus. Health & Medic., on loan to Philadelphia, PA, Thomas Jefferson U., Medic. Col.). In 1903 he began teaching at the Pennsylvania School of Industrial Art in Philadelphia. His first national recognition came after he won a silver medal for a statue of the explorer *Philippe François Renault* at the World's

Fair of 1904 in St Louis, MO. Moving to New York in 1910, he taught at the National Academy of Design and later the Art Students League. Calder was in charge of the sculptural decoration for the Panama–Pacific International Exposition of 1915 in San Francisco after the death of Karl Bitter. Although he was largely trained in the French academic tradition, he transcended its limits in some of his better pieces, such as the marble figure of *George Washington* (1918) for the Washington Arch in New York and the Swann Memorial Fountain (bronze, 1924) in Logan Circle, Philadelphia. Among his other notable works are the sculptures for Viscaya in Miami, FL, and the bronze statue of the Norse explorer *Leif Ericsson*, presented to Iceland by the USA in 1932 and placed on Skolavoeroduholt, the highest hill above Reykjavík.

BIBLIOGRAPHY

J. Bowes: "The Sculpture of Stirling Calder," *Amer. Mag. A.*, xvi (1925), pp. 231, 234–5

W. Craven: *Sculpture in America* (New York, 1968, rev. Newark, New York and London, 1984), pp. 570–73

Sculpture of a City: Philadelphia's Treasures in Bronze and Stone (New York, 1974), pp. 230–39

Philadelphia: Three Centuries of American Art (exh. cat., ed. G. Marcus and D. Sewell; Philadelphia, PA, Mus. A., 1976), pp. 525–6

M. Calder Hayes: *Three Alexander Calders: A Family Memoir* (Middlebury, VT, 1977)

P. Curtis: *Sculpture 1900–1945: After Rodin* (Oxford, 1999)

Abigail Schade Gary

Callahan, Harry

(*b* Detroit, 22 Oct 1912; *d* Atlanta, GA, 15 March 1999), photographer. Callahan took up photography in 1938, at the relatively late age of 26. Ansel Adams visited the Detroit Photo Guild in 1941, and Callahan was inspired by his emphasis on craftsmanship and his majestic images. Callahan's earliest works focused on the calligraphic details of landscape, such as the patterns of grass against snow or telephone wires against the sky, or explored the effects of multiple exposures. Later subjects included

studies of his wife Eleanor, a series of portraits made on Chicago's State Street in 1950, a series of houses at Providence, RI, and Cape Cod beachscapes begun in the 1960s. Whether working in black and white or, later, in color, as in *Harry Callahan: Color* (New York, 1980), Callahan was committed in all his work to what he called "the moment that people can't always see."

In 1946 Callahan joined the staff at the Institute of Design in Chicago. Colleagues such as the architect Mies van der Rohe, the artist Hugo Weber (1918–71) and fellow photographer Arthur Siegel brought him into contact with an innovative attitude toward art that emphasized the formal elements of composition and structure. He was acclaimed not only as a teacher at Chicago and later at the Rhode Island School of Design but also for the refinement and rigor of his vision.

[*See also* Chicago.]

WRITINGS
"Harry Callahan on Emmet Gowin," *Aperture*, 151 (Spring 1998), pp. 24–33

BIBLIOGRAPHY
Harry Callahan (exh. cat. with essay by P. Sherman, New York, MOMA, 1967)
J. Szarkowski, ed.: *Harry Callahan* (Millerton, NY, 1976)
P. C. Bunnell: *Harry Callahan* (New York, 1978)
Harry Callahan: Photographs (exh. cat., ed. K. F. Davis; Lawrence, KS, Spencer Mus. A.; Albuquerque, U. NM, A. Mus.; Durham, NC, Duke U., Mus. A.; 1981)
The Photography of Harry Callahan, 1941–1982 (exh. cat. with interview by S. Rice, Tokyo, Seibu Mus. A., 1983)
P. Booth, ed.: *Master Photographers: The World's Great Photographers on Their Art and Technique* (London, 1983)
C. Hagen: "Late Color," *Camera Arts*, 3/7 (July 1983), pp. 22–9, 72–3, 76–7 [interview]
J. Pultz: "Harry Callahan: The Creation and Representation of an Integrated Life," *History of Photography*, 15/3 (Autumn 1991), pp. 222–7
J. Pultz: *Harry Callahan and American Photography, 1938–1990* (Ph.D. dissertation, New York U., 1993)
J. Bell: "Harry Callahan," *Photographer's Forum*, 17/4 (Sept 1995), pp. 22–6, 28–9
Harry Callahan (exh. cat. by S. Greenough, Washington, DC, N. G. A., 1996)
J. Bell: "The Life and Times of Harry Callahan," *Rangefinder*, 45/4 (April 1996), pp. 12–4, 16
J. Williams: *Harry Callahan* (New York, 1999) [includes biblio.]
Elemental Landscapes: Photographs by Harry Callahan (exh. cat. by K. Ware, Philadelphia Mus. A., 2001)
Harry Callahan: The Photographer at Work (exh. cat. by B. Salvesen, forward by J. Szarkowski and contribution by A. Rule, Tucson, AZ, Cent. Creative Phot., 2006)
Eleanor/Harry Callahan (exh. cat. with essay and interview by J. Cox, intro. by E. Gowin, Atlanta, GA, High Mus. A., 2007)

MERRY A. FORESTA

Calzada, Humberto

(*b* Havana, 25 May 1944), Cuban painter, active in the USA. He moved to the USA in 1960, settling in Miami. Self-taught as an artist, he had his first solo show at the Bacardi Art Gallery in Miami in 1975. He is known principally for acrylic paintings showing architectural images or themes of the infinite in a hard-edge style, as in his series of the 1980s *A World Within* (e.g. *No. 14*, 1984; see 1988–9 exh. cat., p. 27), which employs a "painting-within-a-painting" technique. In his works he drew upon Renaissance perspective; the spaces of Giorgio de Chirico (1888–1978) and Luis Barragán (1902–88); the stained-glass images of Amelia Peláez (1896–1968); and colonial Caribbean architecture. The buildings that Calzada depicted are non-functional; they comprise detached façades and windows, labyrinthine walls and stairs, and portions of columns arranged in courtyards, with projections of shadow and perspective. Calzada exhibited throughout the Americas, and his work is held in a number of North American museums and in the Museo de Arte de Ponce, Puerto Rico.

BIBLIOGRAPHY
R. Pau-Llosa: "Calzada's Architecture of Memory," *Carib. Rev.*, xiii/2 (1984), pp. 38–9
R. Pau-Llosa: "Image du bâti," *Conn. A.*, 384 (1984), pp. 52–7
Outside Cuba (exh. cat. by I. Fuentes Pérez and others, New York, Mus. Contemp. Hisp. A.; Oxford, OH, Miami U., A. Mus.; Ponce, Mus. A.; and elsewhere; 1987–9), pp. 212–17
¡Mira! Canadian Club Hispanic Art Tour (exh. cat. by R. Pau-Llosa, S. Torruella Leval and I. Lockpez, Dallas, TX, S. Methodist U., Meadows Mus. & Gal.; and elsewhere; 1988–9)

D. D. Martinez: "Interview: Humberto Calzada," *A. Papers*, xv/1 (Jan–Feb 1991), pp. 6–9

Humberto Calzada: A Retrospective of Work, 1975–1990 (exh. cat. by R. Pau-Llosa, Miami Beach, FL, Bass Mus. A., 1991)

W. Navarrete and J. Rosado, eds.: *Visión crítica de Humberto Calzada* (Valencia, 2008)

Ricardo Pau-Llosa

Camera Work

Journal devoted to photography that was published from 1903 to 1917. *Camera Work* evolved from a quarterly journal of photography to become one of the most groundbreaking and influential periodicals in American cultural history. Founded in January 1903 by photographer Alfred Stieglitz as the official publication of the Photo-Secession, the journal originally promoted the cause of photography as a fine art. As Stieglitz, its editor and publisher, expanded the journal's scope to include essays on aesthetics, literature, criticism, and modern art, *Camera Work* fueled intellectual discourse in early 20th-century America.

Origins and the photographic cause, 1903–7. *Camera Work* mirrored the aesthetic philosophy of its founder Alfred Stieglitz. The journal resulted from his decade-long campaign to broaden and professionalize American photography. Serving for three years as editor of *American Amateur Photographer* (1893–6), Stieglitz championed the expressive potential of photography and advocated expanded exhibition opportunities comparable to those available in European photographic salons. In 1897, when the Society of Amateur Photographers merged with the New York Camera Club, Stieglitz convinced the enlarged organization to replace their modest leaflet with a more substantial quarterly journal, *Camera Notes*, which he edited until 1902. In editorial range and quality of photographic reproductions *Camera Notes* would become the prototype for *Camera Work*.

Chafing at the restraints inherent in a publication dedicated to a single organization, Stieglitz resigned as editor of *Camera Notes* in 1902 and began planning for a completely independent photographic journal. In March of that year he assembled an exhibition of leading progressive photographers for the National Arts Club in New York, and for that occasion he dubbed the incipient photographic movement the "Photo-Secession." He conceived of *Camera Work* as the "mouthpiece" of the Photo-Secession. To retain editorial independence, Stieglitz assumed control of *Camera Work* as both editor and publisher. He attracted more than 600 subscribers for the initial issue and enlisted the support of the wide circle of photographers and critics he had befriended in his role as photographer, editor and activist for the photographic cause. Dallett Fuguet, Joseph Keiley and John Francis Strauss joined him as associate editors of the new journal.

From its inception, *Camera Work* embodied Stieglitz's conviction that photography was an expressive visual medium as powerful and enduring as the traditional fine arts. His exacting design and production standards made *Camera Work* a compelling creative work of art in its own right. Each issue of the journal included a suite of photographic reproductions of exceptional quality. While many of the illustrations were half-tones or collotypes, a significant portion of the plates were printed in photogravure, which Stieglitz believed could equal the tonal value of an original photographic print. He engaged such firms as Photochrome Engraving Company, Manhattan Photogravure Company, the J. Craig Annan Company in Glasgow and the Bruckmann firm in Munich to print the journal. With such emphasis on craftsmanship, *Camera Work*'s typography and design reflected *fin-de-siècle* tastes, particularly the aesthetics of the Arts and Crafts Movement.

The early issues of *Camera Work* featured reproductions by leading photographers of the day including Gertrude Käsebier, Clarence White, Frank Eugene, Alvin Langdon Coburn and Stieglitz's close associate in the Photo-Secession movement, Edward Steichen. While Stieglitz published many of his own signature prints, including *The Hand of Man* (*Camera Work*, no. 1, 1903) and *The Flat Iron* (*Camera Work*, no. 4, 1903) in the pages of *Camera Work*, the photographer given greatest prominence was undoubtedly

Steichen. The photographic work of contributors to the journal ranged from Steichen's soft-focus pictorialism to the straight photographic approach favored by Stieglitz, Frederick Evans (1853–1943) and James Craig Annan (1864–1946).

The written commentary that accompanied the superb reproductive plates made *Camera Work* an intellectual force in American culture. Stieglitz enlisted accomplished critics such as Charles Caffin and Sadakichi Hartmann (who often penned essays under the pseudonym Sidney Allen) to contribute thoughtful essays on issues in photography. Articles on photographic technique and reviews of photography exhibitions appeared along with more speculative and philosophical pieces, such as an excerpt from painter James McNeill Whistler's "Ten O'Clock" lecture (*Camera Work*, no. 5, 1904), Maurice Maeterlinck's "I Believe" (*Camera Work*, special issue, April 1906) and playwright George Bernard Shaw's photographic commentaries (*Camera Work*, no. 14, April 1906). Moreover, in 1905, when Stieglitz opened the Little Galleries of the Photo-Secession at 291 Fifth Avenue, *Camera Work* began to chronicle its exhibition program and to republish critical commentary about the shows from the daily press. Notwithstanding its wide-ranging coverage, *Camera Work's* editorial content during its first five years reflected late 19th-century Symbolist aesthetics and the concerns of photographers for the cultural validation of their chosen medium.

Photography and the cause of modern art: 1908-17. Between 1908 and 1911, *Camera Work* began what would soon amount to an adventurous publication program promoting modern art as a foil to and catalyst for photography. In 1907, Stieglitz had presented an exhibition of watercolors by Pamela Colman Smith (1878–1951), the first non-photographic work featured at the 291 gallery. As he and Steichen arranged other shows of increasingly advanced visual art at 291, Stieglitz incorporated modern art into the editorial content of *Camera Work*. At first, only written commentary or reprints of reviews appeared, but in 1911, a double issue of

Camera Work featured reproductions of the diaphanous wash drawings by Auguste Rodin (1840–1917) along with essays on his art and that of Paul Cézanne (1839–1906) and Pablo Picasso (1881–1973). Although half the journal's subscribers cancelled subscriptions in protest over this departure from focus on photography, Stieglitz persisted in his belief that modern art represented a vital force that would invigorate American photography with what he and such critics as Charles Caffin and Sadakichi Hartmann regarded as an "anti-photographic" mode of vision. There followed historic issues of the journal with reproductions of the work of such modernists as John Marin (issue no. 38), Mexican caricaturist Marius De Zayas (nos. 29, 38, and 46), Henri Matisse (no. 32 and 39), Pablo Picasso (no. 39 and 41), Francis Picabia (no. 41) and Abraham Walkowitz (no. 44). Equally ground-breaking were the essays and articles that appeared in *Camera Work*, including extracts from the writings of Henri Bergson (no. 36, 1911), art historian Julius Meier-Graefe (no. 37, 1912) and Vasily Kandinsky (special issue, 1912). Gertrude Stein published her word portraits of Picasso and Matisse in 1912 in a special number of *Camera Work*. Painter Max Weber and De Zayas contributed important, provocative essays. American modernists Oscar Bluemner, Marsden Hartley and Elie Nadelman, who were featured in shows at 291, all were given voice in the pages of *Camera Work*.

By 1914, *Camera Work* transcended its original purpose as the "mouthpiece" for the Photo-Secession to rank as the premier American vanguard journal of its generation. Concurrently, the journal became inextricably identified with its publisher Stieglitz and his unprecedented exhibition program at 291. Aware of the historic impact of both his gallery and journal, Stieglitz solicited contributions from supporters for an extraordinary issue of *Camera Work* on the theme "What Is 291?" (no. 47, July 1914, published Jan 1915). The resulting anthology of opinions provided a memorable cross-section of the American avant-garde and served as a testament to the spiritual bonds that united Stieglitz's circle.

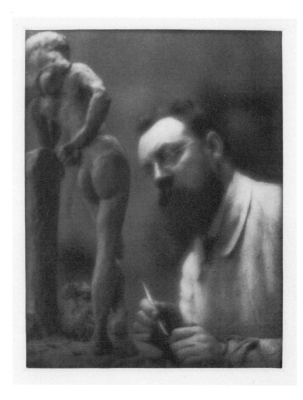

CAMERA WORK. *Henri Matisse* by Edward Steichen, from *Camera Work*, April–July 1913; Paris, Musée d'Orsay. © CAROUSEL RESEARCH/RÉUNION DES MUSÉES NATIONAUX/ART RESOURCE, NY

The elegiac spirit of issue no. 47 presaged the demise of *Camera Work*. Economic pressures from dwindling subscriptions and disruptions of World War I took their toll in the final two years of the journal's existence. Although Stieglitz published two additional issues of *Camera Work*, introducing Paul Strand's starkly geometric photographs in the final number of the journal, he was forced to cease publication in June 1917. Yet over a 15-year span, *Camera Work* succeeded in its dual role as a forum for the cause of fine art photography and as an exemplar of the creative intellectual spirit that transformed 20th-century American culture.

[*See also* Photo-Secession; Stieglitz, Alfred; *and* 291.]

BIBLIOGRAPHY

Camera Work: A Photographic Quarterly (New York, Jan 1903–June 1917); 50 issues repr. in 1950

P. C. Bunnell: "Alfred Stieglitz and *Camera Work*," *Camera*, xlviii (1968)

R. P. Hull: *Camera Work, an American Quarterly* (PhD thesis, Evanston, IL, Northwestern U., 1970)

J. Green, ed.: *Camera Work: A Critical Anthology* (New York, 1973)

Camera Work: Transformations in Pictorial Photography (exh. cat. by R. Wickstrom, Iowa City, U. IA Mus. A., 1975)

M. F. Margolis, ed.: *Camera Work: A Pictorial Guide* (New York, 1978)

Camera Work: Process and Image (exh. cat. by C. A. Peterson, Minneapolis, MN, Inst. A., 1985)

A. Porter, ed.: *Camera Work, Alfred Stieglitz*, trans. D. W. Portmann (Zurich, 1985)

A. Stieglitz: "*Camera Work* Introduces Gertrude Stein to America," and G. Stein: Stieglitz, 1934," *Literature and Photography Interactions, 1840–1990*, ed. J. M. Rabb (Albuquerque, 1995), pp. 184–8.

S. Philippi and U. Kieseyer: *Alfred Stieglitz, "Camera Work": the Complete Illustrations, 1903–1917* (Cologne and New York, [1997])

D. Cornell: "*Camera Work* and the Fluid Discourse of Pictorialism," *Hist. Phot.*, xxiii/3 (Autumn 1999), pp. 294–300

Camera Work: A Centennial Celebration (exh. cat. by S. Perloff, Doylestown, PA, Michener A. Mus., and elsewhere, 2003)

Judith Zilczer

Camouflage

To camouflage something is to interfere with its visibility, if only by making it more difficult to recognize. In the modern era, it was widely assumed that trained artists, by virtue of their knowing how to make things appear, had an equivalent knowledge of how to make things disappear, hence the historic connection between art and camouflage.

It is often said that American artist Abbott Handerson Thayer was the "father of camouflage," largely because of his writings about animal coloration, beginning in 1896. He also made proposals to the USA and other Allied governments, asserting that principles of natural concealment could be used for military purposes. In 1909, Thayer and his son Gerald produced a lengthy, elaborate book titled *Concealing Coloration in the Animal Kingdom*, which, during World War I, was used by both sides of the conflict. The Thayers' book was widely read, and it was partly because of their influence that American

artists as well as the public assumed that artists were well prepared to serve as camouflage specialists.

The USA was not the only country to use artists as camouflage experts during World War I, nor was it the first. The French army initiated the first *section de camouflage*, comprised mostly of artists, followed by the British. When civilian American artists were shown photographs of French camouflage, they formed their own unit, the New York Camouflage Society, jointly organized by muralist Barry Faulkner (1881–1966; Thayer's cousin and former student) and sculptor Sherry Edmundson Fry (1879–1966; a student of Augustus Saint-Gaudens). After the US entered the war in 1917, an Army camouflage section was established (with Faulkner and Fry as enlistees) in the grounds of the American University in Washington DC. Headed by theatrical designer Homer Saint-Gaudens (1880–1958; son of the celebrated sculptor Augustus), it was called the American Camouflage Corps, or Company A of the 40th Engineers.

No less important in World War I was the development of ship camouflage. Early in the war, it was widely assumed that the goal of both ground and naval camouflage was reduced visibility. In 1917, however, in response to a spike in the number of Allied ships destroyed by German submarines (U-boats), a British artist named Norman Wilkinson (1878–1971) called for a redefinition of the problem: since invisibility is all but impossible in an ocean setting, Wilkinson argued, the primary question is not "How can we make a ship less visible?" but "How can we make it harder to hit?" His solution was "dazzle painting" (Wilkinson's term) or "dazzle camouflage," in which ships were painted with bewildering geometric patterns, the purpose of which was not low visibility but confusion or "course deception," with the submarine captain uncertain about the speed and direction of an elusive moving target.

Dazzle ship camouflage was quickly adopted by other countries, especially for merchant ships, most notably in the US, where journalists gave it such curious names as "jazz painting," "razzle dazzle," "eccentric painting," and "crazy quilt painting."

In the last stages of World War I, a team of American artists (working under Everett L. Warner) were given the tasks of designing dazzle camouflage patterns, applying those designs to scale models of ships (for testing in a simulated ocean setting), and drawing up the blueprints used by other artists in painting the ships in the harbors. Still others, notably Thomas Hart Benton, were assigned to making drawings of camouflaged ships that entered the harbors, to make certain that the ship painters were correctly applying the schemes provided to them, and to document the camouflage of other Allied navies.

During World War II, the assumed alliance between art and military camouflage was revived and initially strengthened. Scores of American artists, architects, and designers functioned as instructors, consultants, or practitioners of various facets of camouflage, whether civilian or military, among them Arshile Gorky, Ellsworth Kelly, Jon Gnagy (1907–81), Ezra Jack Keats (1916–83), Harley Earl (1893–1969), Percival Goodman (1904–89), and Bill Blass (1922–2002). But as the war progressed, the unique contribution of artists declined, in large part because of developments in surveillance technology, especially radar, which fell outside the traditional range of artistic visual expertise.

Military surveillance technologies changed profoundly during the second half of the 20th century, as did the means of concealment or "stealth," less and less of which were based solely on unaided vision. By the end of that century, military camouflage was practiced more widely than ever before, but it was no longer considered to be the province of artists. In the flamboyant camouflage uniforms of military units throughout the world, as in fashionable street attire, camouflage patterns appeared to serve less for inconspicuousness than for "branding," as a way of distinctively standing apart from other groups or units.

In the postmodern era, there was renewed interest in camouflage among artists, but it was usually because, as civilians, they were using certain aspects

of camouflage in making experimental art, rather than using their knowledge of art to develop camouflage for the military. Among American artists whose artistic use of camouflage became well known were Andy Warhol, who produced a series of paintings and prints using motifs from camouflage fabric in the mid-1980s; William Anastasi (*b* 1933), who covered the entire interior of a New York art gallery with camouflage patterns in 2003; and Jeff Koons, who in 2008 designed a disruptive camouflage scheme for an art collector's yacht.

[*See also* Thayer, Abbott Handerson.]

BIBLIOGRAPHY

G. H. Thayer: *Concealing Coloration in the Animal Kingdom* (New York, 1909; 2/1918)

N. White: *Abbott H. Thayer: Painter and Naturalist* (Hartford, CT, 1951)

Andy Warhol: Camouflage (exh. cat. by B. Richardson, New York, 1999)

R. R. Behrens: *False Colors: Art, Design and Modern Camouflage* (Dysart, IA, 2002)

H. Blechman, ed.: *DPM [Disruptive Pattern Material]: An Encyclopedia of Camouflage* (London, 2004)

T. Newark: *Camouflage* (New York, 2007)

R. R. Behrens: *Camoupedia: A Compendium of Research on Art, Architecture and Camouflage* (Dysart, IA, 2009)

Roy R. Behrens

Campus, Peter

(*b* New York, 1937), sculptor. Campus studied experimental psychology at Ohio State University, Columbus (1955–60) and film at City College Film Institute, New York (1961–2). Campus was part of the first generation of artists who sought to investigate the formal possibilities of video and film technology. He brought to this an interest in behavioral psychology and the role of the viewer then current among contemporaries such as Bruce Nauman. Initially he was drawn to the blurred quality of low-grade images, such as those from CCTV cameras: *Optical Sockets* (1972–3; see 1979 exh. cat., p. 18) is typical of his early installations in its use of four video cameras and four monitors set up in a square in order to create four images of the viewer. This interest in doubling (in the Doppelgänger), the myth of Narcissus, and the dissolution of material reality continued as his formal concerns led him to settle on the use of static imagery. *Three Transitions* (1973; see 1979 exh. cat., pp. 55–60) is a famous example from this period in which he used camera trickery to create the illusion of him setting light to his own face. Toward the end of the 1970s he began to explore slide projection and black-and-white photography. In the 1980s he merged the two to examine how projected light alters our perception of images: *Murmur (Gemurel)* (1987; see 1990 exh. cat., p. 16), a monumental depiction of stones, is typical of his interest in natural imagery at the time. Throughout the 1990s he continued to move away from depiction of the human figure and toward natural imagery, while exploring the effects of combining and manipulating photographs. *Flutter* (1993; see Princethal, 1994, p. 125) is characteristic of this work: a color image depicts a butterfly in some grass, but the low resolution of the image produces a flatness that makes detail and space confusing.

BIBLIOGRAPHY

Peter Campus (exh. cat., essays by W. Herzogenrath, R. Smith, and the artist; Cologne, Kstver.; Berlin, Neuer Berlin. Kstver., 1979)

Peter Campus, Photographs, and David Deutsch, Paintings and Drawings (exh. cat., essay by K. Halbreich and K. Kline; Cambridge, MA, Hayden Gal., MIT, 1983)

Peter Campus (exh. cat., essay by H. Kersting; Mönchengladbach, Städt. Museen, 1990)

N. Princethal: "Peter Campus at Paula Cooper," *A. Amer.*, vol. lxxxii, no. 4 (April 1994), pp. 125–6

J. Hanhardt: "Peter Campus." *Bomb*, 68 (Summer 1999), pp. 66–73 [interview]

D. Joselit: "The Video Public Sphere," *A. J.*, 59/2 (Summer 2000), pp. 46–53

Peter Campus: Analog + Digital Video + Foto 1970–2003 (exh. cat. by B. Nierhoff, Bremen, Ksthalle, 2003)

J. Lageira: "Peter Campus: le corps en point de vue/Peter Campus: The Body in View," *Parachute*, 121 (Jan–Mar 2006), pp. 16–39

K. Mondloch: "Be Here (and There) Now: The Spatial Dynamics of Screen-Reliant Installation Art," *A. J.*, 66/3 (Fall 2007), pp. 20–33

P. Campus, D. Gordon and D. A. Ross: "The Expansive Lens," *Tate Etc.*, 14 (Autumn 2008), pp. 74–85

Y. Spielmann: *Video: The Reflexive Medium*, trans. with intro. by A. Welle and S. Jones (Cambridge, MA, 2008)

Morgan Falconer

Canyon de Chelly

Archaeological zone in northwest Arizona. Pre-Columbian sites in Canyon de Chelly are attributed to the Anasazi culture (*c.* 200 BC–*c.* AD 1350) and were built between the 12th and 14th centuries AD when the Anasazi began to abandon their scattered small hamlets on cliff tops for fewer but larger settlements of cliff dwellings. These were constructed in the steep-sided, stream-cut main and subsidiary canyons with numerous overhanging cliffs; on the shelves of such overhangs the Anasazi built blocks of apartment-like structures constructed of adobe bricks or stone blocks (e.g. White House ruins). The removal of the Anasazi from plateau dwellings to cliff

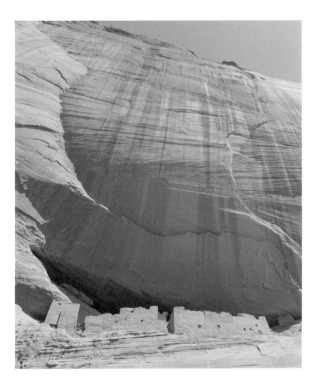

CANYON DE CHELLY. Anasazi cliff dwellings. WERNER FORMAN/ ART RESOURCE, NY

dwellings may have been for defense as aggression increased between groups. The earliest rooms often became storage rooms as later dwellings were built above and in front of them. The blocks were multi-story and terraced, with access between terraces by wooden ladders. Inter-story floors–ceilings were made with log rafters. Walls had keyhole and trapezoidal doorways and in some cases square windows. Open spaces in front of the blocks were excavated and filled to create level ceremonial areas, and circular, semi-subterranean *kivas* were dug for use as men's ritual meeting places. Society was matrilineal, and the houses were owned by women. Crop failure and possibly invasion by Navajo and Apache groups may have caused the abandonment of Canyon de Chelly *c.* 1350.

[*See also* Kiva; Mesa Verde; *and* Native North American Art.]

BIBLIOGRAPHY

P. S. Martin and F. Plog: *The Archaeology of Arizona: A Study of the Southwest Region* (New York, 1973)

C. Grant: *Canyon de Chelley: Its People and Rock Art* (Tucson, 1978)

A. Ortiz, ed.: "Southwest," *Hb. N. Amer. Ind.*, ix (1979) [whole vol.]

A. Ortiz, ed.: "Southwest," *Hb. N. Amer. Ind.*, x (1983) [whole vol.]

L. S. Cordell: *Prehistory of the Southwest* (New York, 1984)

L. S. Cordell: "Southwest Archaeology," *Annu. Rev. Anthropol.*, xiii (1984), pp. 301–32

M. Coe, D. Snow and E. Benson: *Atlas of Ancient America* (Oxford, 1986), pp. 68–79

G. Rink: "A Checklist of the Vascular Flora of Canyon de Chelley National Monument," *J. Torrey Botan. Soc.*, 132/3 (2005), pp. 510–32

David M. Jones

Capa, Cornell

(*b* Budapest, Hungary, 10 April 1918; *d* New York City, 23 May 2008), photographer. Brother of the photographer Robert Capa. Born Cornel Friedmann in Budapest in 1918, Capa moved to New York

in 1937 and became an American citizen in 1944, officially changing his name to Cornell Capa. He practiced and advocated a form of humanitarian documentary photojournalism that aimed to deepen people's awareness and concern about the social, economic and political issues that confronted individuals and groups of people around the world.

He worked as a staff photographer for *Life* magazine from 1946 to 1954, covering social and political conditions and events in the USA, England and Latin America. Some of his most notable contributions to the magazine during this period include his photo essays on Judaism and Israel, the education of mentally disabled children in the northeastern USA, and the 1952 presidential campaign of Democratic candidate Adlai Stevenson.

After Capa's older brother, the American war photographer Robert Capa, was killed in 1954 while on assignment in Indochina, Capa resigned from *Life* magazine and decisively assumed the task of promoting his brother's legacy through publications and exhibits. He also joined and later became the president of Magnum, the international photographic cooperative that his brother had co-founded in 1947.

In 1958, Capa traveled to the Soviet Union (now Russia) to photograph Russian Orthodox life, the Bolshoi Ballet School and the Nobel Prize-winning author Boris Pasternak. From the mid-1950s through the early 1970s, Capa also made numerous extensive trips to Latin America, documenting the political upheavals in Argentina, the activities of Christian missionaries in Ecuador and the destitute migrant agricultural laborers in Honduras and El Salvador. At home in the USA, Capa covered the 1956 and 1960 presidential elections, eventually producing a book that documented President John F. Kennedy's first 100 days in office.

In 1967 Capa organized an exhibition and a series of publications entitled *The Concerned Photographer* that emphasized the role of documentary photojournalism in addressing humanitarian concerns and its potential to effect social change. In 1974, Capa founded and became the first director of the International Center of Photography in New York City, an institution engaged in exhibiting, collecting and teaching photography.

[*See also* Magnum.]

PHOTOGRAPHIC PUBLICATIONS

with M. Pines: *Retarded Children Can Be Helped* (New York, 1957)

ed.: *Let Us Begin: The First 100 Days of the Kennedy Administration* (New York, 1961)

with M. Huxley and R. Russell: *Farewell to Eden* (New York, 1964)

with I. Morath and J. F. Stevenson: *Adlai Stevenson's Public Years* (New York, 1966)

ed.: *The Concerned Photographer* (New York, 1968)

Israel/The Reality (New York, 1969)

ed.: *The Concerned Photographer 2* (New York, 1972)

with J. M. Stycos: *Margin of Life: Population and Poverty in the Americas* (New York, 1974)

R. Whelan, ed.: *Cornell Capa: Photographs* (Boston, 1992)

Xiao Situ

Capa, Robert

(*b* Budapest, 22 Oct 1913; *d* Thai-Binh, Vietnam, 25 May 1954), photographer of Hungarian birth. Capa studied political science at Berlin University from 1931 to 1933. A self-taught photographer, as early as 1931 he worked as a photographic technician for the Ullstein publishing house and as a photographic assistant for Dephot (Deutscher Photodienst) cooperative photographic agency. In 1933 he emigrated to Paris, where he and his friend Gerda Pohorylles (1901–37) invented the American-sounding name Robert Capa, initially to publish photo-stories for which she wrote the text. This unsettled period in Paris offered numerous opportunities to work as a freelancer and to publish successfully. Although Lucien Vogel, the publisher of the magazine *Vu*, had revealed Capa's use of a pseudonym, he kept the name and flew to Spain as a reporter on the Spanish Civil War. With Pohorylles (using the pseudonym Gerda Taro) he published *Death in the Making*,

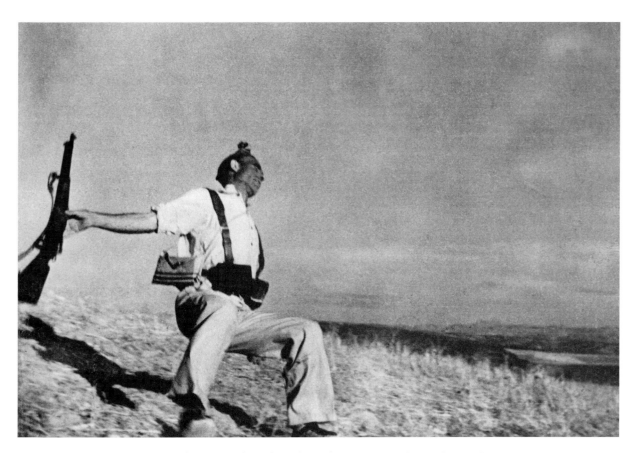

ROBERT CAPA. *Death of a Spanish Loyalist*, gelatin silver print, 1936. © 2001 CORNELL CAPA, COURTESY OF MAGNUM PHOTOS

which contained his most famous photograph, *Death of a Spanish Loyalist*, a soldier falling at the moment of being hit by a bullet. This picture made his reputation as a talented war reporter.

In 1938 Capa traveled to China and reported on the Japanese invasion; from 1941 to 1945 he was war correspondent for *Life* magazine, photographing in Italy, France, Germany and many other European countries. However, he intended to give up this occupation after World War II and lived in Paris for a time as part of a circle that included Pablo Picasso, Ernest Hemingway and John Steinbeck. During this period he also became friendly with Chim (David Seymour), Henri Cartier-Bresson, George Rodger (1908–95) and the *Life* photographer Bill Vandivert and joined them in founding the cooperative photographic agency Magnum in 1947. Membership of the agency was later to become a mark of high quality.

Between 1948 and 1950 he photographed the unrest surrounding the establishment of the state of Israel; in 1954 he traveled to Indo-China as a temporary war correspondent for *Life* and was fatally wounded in Vietnam. His death was the tragic consequence of his basic principle: "If your pictures aren't good enough, you aren't close enough."

Capa's ability to capture in one picture the feelings of a people in rebellion or at war brought him the great admiration of his contemporaries and later generations. Many world-famous photographs show this ability: the weeping child in an Israeli camp in *Israel, 1948*, swimming soldiers in *D-Day, Omaha Beach, June 6, 1944*, hysterical Neapolitan mothers weeping over their sons in *Italy, 1944* (all in Capa, 1969). A common feature is that the narrative moment does not predominate; they are imbued with humanity but also bear witness to Capa's

fascination with the human tight-rope walk between the will to live and the tendency to self-destruct.

Capa not only set new standards in photography, acting as a model for others, but also his work, full of commitment and human partisanship, is a manifesto against war, injustice and oppression. Numerous awards were established in his name.

PHOTOGRAPHIC PUBLICATIONS

Death in the Making, text by G. Taro (New York, 1937)

The Battle of Waterloo Road (New York, 1943)

Slightly Out of Focus (New York, 1947)

The Russian Journal, text by J. Steinbeck (New York, 1948)

Report on Israel, text by Irving Shaw (New York, 1950)

Images of War (New York, 1964)

BIBLIOGRAPHY

R. E. Hood: *Twelve at War* (New York, 1967)

A. Farova: *Robert Capa* (New York, 1968)

C. Capa, ed.: *The Concerned Photographer* (New York, 1969)

C. Capa, ed.: *Robert Capa, 1913–1954* (New York, 1974)

R. Martinez: *Robert Capa* (Milan, 1979)

G. Soria: *Les Grandes Photos de la guerre d'Espagne* (Paris, 1980)

C. Capa and R. Whelan, eds: *Robert Capa Photographs* (New York, 1985; Ger. edn., Cologne, 1985)

R. Whelan: *Robert Capa: A Biography* (New York, 1985)

Testimonois del fuego: retrospectiva de Robert Capa/Testimonies of Fire: Robert Capa Retrospective (exh. cat. by R. Whelan and J. Dorronsoro, Caracas, Mus. B. A., 1992)

Robert Capa: Photographs (exh. cat. with intro. by R. Whelan, forward by H. Cartier-Bresson, remembrance by C. Capa, Philadelphia Mus. A., 1996)

J. Friday: "Demonic Curiosity and the Aesthetics of Documentary Photography," *Br. J. Aesth.*, 40/3 (July 2000), pp. 356–75

R. Whelan: *Robert Capa: The Definitive Collection* (London, 2001)

A. Kershaw: *Blood and Champagne: The Life and Times of Robert Capa* (London, 2002)

Robert Capa—Retrospective (exh. cat. by L. Beaumont-Mailett, Berlin, Martin-Gropius-Bau, 2005)

H. Bresheeth: "Projecting Trauma: War Photography and the Public Sphere," *Third Text*, 20/1 (Jan 2006), pp. 57–71

Capa's World: The Works of Robert Capa and His Life (exh. cat., Tokyo, Fuji A. Mus., 2006)

This is War! Robert Capa at Work (exh. cat. with essay by R. Whelan, New York, Int. Cent. Phot., 2007)

Reinhold Misselbeck

Caponigro, Paul

(*b* Boston, MA, 7 Dec 1932), photographer. Caponigro studied music at Boston University College of Music (1950–51). In 1953 and again in 1956, when he also studied with Alfred W. Richter, Caponigro studied photography with Benjamin Chin, former student of Ansel Adams and Minor White at the California School of Fine Art. From 1957 to 1959 he was associated with Minor White, first as a student in Rochester, New York, at workshops in White's home, and then as an assistant during the summers of 1958 and 1959. His association with White provided the basis for his mature style. A delicate tonal balance and mystical view of nature typify black-and-white images such as *Running White Deer* and *County Wicklow, Ireland* (1967; see *Landscape: Photographs by Paul Caponigro*, New York, 1975). Throughout his career he repeatedly returned to the examination of particular forms in nature. Close-up views of sunflowers constitute one series (*Sunflower*, New York, 1974); another is devoted to the ancient stone monuments of England and Ireland, for example *Ardara Dolmen, County Donegal, Ireland* (1967; New York, MOMA, see Szarkowski, p. 193) and the later portfolio *Stonehenge* (Santa Fe, 1978).

PHOTOGRAPHIC PUBLICATIONS

M. White, ed.: *Aperture*, xiii/1 (1967) [issue devoted to Caponigro]; rev. as *Paul Caponigro: Photographs* (New York, 1972)

Seasons: Photographs and Essay (Boston: 1988)

BIBLIOGRAPHY

J. Szarkowski: *Looking at Photographs* (New York, 1973), pp. 192–3

9 Critics, 9 Photographs (exh. cat. ed. J. Alinder, Carmel, CA, Friends Phot., 1980 [incl. artist bio.]

Paul Caponigro Photography: 25 years (exh. cat., intro. P. C. Bunnell, ed. D. W. Mellor; Philadelphia, PA, Phot. Gal., 1981)

The Wise Silence: Photography of Paul Caponigro (exh. cat., essay M. Fulton, Rochester, NY, Int. Mus. Phot. at George Eastman House, 1983)

J. P. Caponigro: "Paul Caponigro" *View Camera* (May–June 1995), pp. 4–9 [interview]

American Photography, 1890–1965 (exh. cat. by P. Galassi, with essay by L. Sante, New York, MOMA, 1995)

New England Days (exh. cat. by Paul Caponigro, fore. A. Gallant, Portand, ME, Portland Mus. A., 2002)

J. Turner-Yamamoto: "Paul Caponigro: Meditations in Silver," *Phot Forum*, 31/1 (Dec 2008), pp. 22–30

Constance W. Glenn

Carles, Arthur B.

(*b* Philadephia, PA, 9 March 1882; *d* Philadelphia, PA, 18 June 1952), painter and teacher. As a student at the Pennsylvania Academy of the Fine Arts, Philadelphia, between 1900 and 1907, Carles won numerous prizes, including fellowships to travel abroad. Modern French art was Carles's primary source of inspiration; he lived in France between 1907 and 1910 and returned there in 1912, 1921 and 1929–1932. Cézanne and Matisse inspired his use of color for both structure and expression, as in *The Church* (1908–10; New York, Met.). Close to Edward Steichen and John Marin, Carles associated with Alfred Stieglitz's circle, and in 1912 he had the first of four solo exhibitions in New York at the 291 gallery. He showed at the Armory Show in 1913 and at annuals in Philadelphia and across the country. As an influential teacher he inspired students at the Pennsylvania Academy from 1917 to 1925 and then in private classes, opening their eyes to color and modern art.

Carles was one of the finest colorists among the early American modernists. His favorite subjects were the female nude, flower still lifes and French landscapes, treated in a variety of styles but with painterly color always dominant. In the late 1920s he began to break up forms with Cubist planes of color, as in *Arrangement* (1925–7; Chicago, IL, A. Inst.). *Abstraction (Last Painting)* (1936–41; Washington, DC, Hirshhorn), on which he was working when he was incapacitated by a fall and stroke in 1941, was prophetic of Abstract Expressionism. For illustration, see color pl. 1:XIII, 1.

[*See also* Philadelphia.]

BIBLIOGRAPHY

H. G. Gardiner: "Arthur B. Carles: A Critical and Biographical Study," *Bull. Philadelphia Mus. A.*, lxiv (1970), pp. 139–89

Arthur B. Carles: Painting with Color (exh. cat. by B. A. Wolanin, Philadelphia, PA, Acad. F.A., 1983)

Hollis Taggart Galleries: The Orchestration of Color: The Paintings of Arthur B. Carles (essay by Barbara Ann Boese Wolanin, New York, 2000)

Barbara A. Wolanin

Carlsen, (Soren) Emil

(*b* Copenhagen, Denmark, 19 Oct 1853; *d* New York, NY, 2 Jan 1932), painter of Danish birth. Soren Emil Carlsen immigrated to the USA in 1872 after studying architecture at the Kongelige Danske Kunstakademi in his native Copenhagen. In 1874 he worked under Danish painter Lauritz Holtz in Chicago. After six months of study in Paris (1875), he returned to Chicago to teach at the newly founded Academy of Design. Back in Paris (1884–6) for further study of the works of Jean-Siméon Chardin (1699–1779), he produced floral still lifes for New York dealer Theron J. Blakeslee. America's leading exponent of the Chardin Revival, Carlsen eventually became his adopted country's most famous depicter in paint of fish, game, bottles and related "kitchen" still-life subjects. A typical fish portrait recently hung in the National Gallery of Art, Washington, DC, near a similar piscean image by one of Carlsen's main competitors in the genre, William Merrit Chase, whose famous fish still life, *An English Cod* (1904; Washington, DC, Corcoran Gal. A.), also provides a revealing comparison.

Carlsen moved in 1887 to San Francisco, where he had been invited by portraitist Mary Curtis Richardson to succeed Virgil Williams (1830–86) as director of the California School of Design. He later taught at the San Francisco Art Students' League. During his four productive and influential years in California, he shared a Montgomery Street studio with Arthur F. Mathews. Unfortunately, exhibition and sales opportunities proved to be limited, and Carlsen, by then penniless, was forced in 1891 to relocate to New York, where his fortunes improved dramatically. *Still Life* (1891; Oakland, CA, Mus.) dates from the year of

his move east and is typical of the work that established his considerable reputation in New York and launched a long and successful career there. Despite the growing popularity of Impressionism, Carlsen's palette, which tended toward ivory, silver-gray and mauve, remained subdued, in a near monochromatic, realist manner close to that of the Munich-style Chase or Frank Duveneck. However, his massing of broad areas of color and reductive approach lends a modernist quality to many of his paintings. Works such as *Still Life, Pheasant* (1891; San Francisco, CA, priv. col.), in which a superbly painted dead pheasant is placed alone on a bare tabletop, reveal Carlsen's interest in formal construction and the abstract opportunities his chosen, traditional subjects provided him.

While in San Francisco, Carlsen exhibited regularly at the Bohemian Club, of which he was and remained a member. Other exhibitions during his lifetime included those at: the National Academy of Design, New York (1885–7, 1894–5, 1903, 1905–21, 1923–32); the Mechanics Institute, San Francisco (1887, 1888); the San Francisco Art Association, c. 1890–97; the Louisiana Purchase Exposition, St Louis (1904); Pennsylvania Academy of the Fine Arts, Philadelphia (1912); and the Panama–Pacific International Exposition, San Francisco (1915). The largest exhibition during the artist's lifetime was mounted at the Corcoran Gallery of Art, Washington, DC, in 1923, nine years before his death. At that time, Carlsen was described as "unquestionably the most accomplished master of still-life painting in America" (Arthur Edwin Bye).

BIBLIOGRAPHY
A. E. Bye: *Pots and Pans: Studies in Still-life Painting* (Princeton, NJ, 1921)
The Art of Emil Carlsen, 1853–1932 (exh. cat., San Francisco, CA, Wortsman-Rowe Gals, 1975)
G. Still: "Emil Carlsen, Lyrical Impressionist," *A. & Ant.*, iii/2 (1980), pp. 88–95
W. H. Gerdts: *Painters of the Humble Truth* (Columbia, MO, 1981)
H. L. Jones: *Impressionism: The California View* (Oakland, 1981)
W. H. Gerdts: *Art across America: Two Centuries of Regional Painting, 1720–1920*, iii (New York, 1990)
"Acquisitions of the Princeton University Art Museum 2004," *Rec. A. Mus., Princeton U.*, lxiv (2005), pp. 91–135
K. L. Jensen: *Søren Emil Carlsen: Skagensmaleren fra Manhattan* (Vældgungerne, 2008)

Paul J. Karlstrom

Carnegie, Andrew

(*b* Dunfermline, Scotland, 25 Nov 1835; *d* Lenox, MA, 11 Aug 1919), industrialist, philanthropist and patron of Scottish birth. Aged 11, Andrew Carnegie immigrated with his parents to Allegheny, near Pittsburgh, PA, where he educated himself while working as an office messenger and telegraph operator, before rising to enormous wealth through railroads, oil and the iron and steel industries. During his lifetime he gave more than $350 million to a variety of social, educational and cultural causes, the best known being his support for public libraries which he believed would provide opportunities for self-improvement without "any taint of charity." Here communities had to pay for the building site and the books, and to commit at least 10 percent of Carnegie's initial gift in annual support. As Carnegie struggled to give away money—for "to die rich was to die disgraced"—music, fine art, archaeology and technical schools also became beneficiaries, together with programs for the education of minorities in recognition of civilian heroism and world peace (still a central concern of the Carnegie Foundation).

Libraries formed the biggest program. Altogether about 3000 library buildings and neighborhood branches (half of them in the USA) were built with Carnegie grants throughout the English-speaking world from the 1890s to 1917 when America's entry into World War I curtailed non-essential building. Some big city libraries (New York Public Library by the architects Carrère & Hastings, and Cass Gilbert's libraries for Detroit and St Louis) remain significant architecturally. Large numbers of medium- and small-sized libraries (notably by specialist architects, such as Edward L. Tilton of New York, Patton & Miller of Chicago, Claude & Starck of Madison, WI,

Alden & Harlow of Boston and Pittsburgh, and McKim, Mead & White who designed many of New York's branches) provide buildings of distinction in the many styles of America's small towns and metropolitan suburbs.

Carnegie enjoyed "serious reading" with a particular admiration for William Shakespeare, Robert Burns, Charles Darwin and modern philosophers, such as Herbert Spencer, whose friendship he cultivated in later life. The choice of books for his libraries, however, was always left to the local committees. Carnegie's personal taste in music and fine art was also conventional. Carnegie Hall in New York (1890–91) and the Opera House which formed part of Pittsburgh's Carnegie Institute (1895–1907) presented "high" opera, lectures, public debates and community events as well as weekend "teaching concerts" conducted by Directors of Music on the Roosevelt concert organ (Carnegie's favorite instrument). Connecting with ordinary people was always a priority in Carnegie's philanthropy, even if he also enjoyed rubbing shoulders with political leaders and crowned heads. His New York residence and Scottish home, Skibo Castle, became veritable art galleries, but Carnegie never spent the large sums he could afford on paintings, preferring to support contemporary artists who had not yet achieved fame but who, he believed, would become "America's old masters." For his own walls he rejected what he termed "painfully serious" or "cold" art in favour of "comfortable" American Impressionists (J. Alden Weir and Alexander Roche), Pre-Raphaelites and landscapists (such as Edward Gay (1837–1928), an Irish–American immigrant). His fellow Scottish–American, Alexander Roche, sometimes advised on purchases, as did the bohemian critic, Sadakichi Hartmann, for European acquisitions.

For the major art, architecture and natural history collections in Pittsburgh's Carnegie Institute, however, Carnegie relied on professional curators, and he encouraged them to travel widely in pursuit of art and the sculptural and architectural castings that yielded full-size reproductions of Classical antiquities and architectural details, including entire façades of ancient, medieval or Renaissance buildings. What Carnegie liked to call "scientific philanthropy" (i.e. focused giving, which often also involved reciprocal contributions) embraced both technical education and natural history. The Pittsburgh Institute—rightly called an "American Palace of Culture"—also contains a remarkable collection of dinosaurs, many of which originated in Carnegie-funded digs in the far western USA, or had been exchanged for such finds with other great collections worldwide. The technical college which Carnegie founded in Pittsburgh (and deliberately focused on vocational students) has evolved into the prestigious Carnegie–Mellon University. Carnegie's cultural and educational ambitions knew few limits, and many of his foundations have taken on lives of their own. It was the tragedy of his late life that the International Peace Palace in The Hague was to open, inauspiciously, in 1914.

BIBLIOGRAPHY

J. F. Wall: *Andrew Carnegie* (1989)

D. Nasaw: *Andrew Carnegie* (New York, 2006)

Simon Pepper

Carrère & Hastings

American architectural partnership formed in 1885 by John Merven Carrère (*b* Rio de Janiero, 9 Nov 1858; *d* New York, 1 March 1911) and Thomas Hastings (*b* New York, 11 March 1860; *d* New York, 22 Oct 1929). Carrère studied in Lausanne and at the Ecole des Beaux-Arts, Paris (1877–82), in the atelier of Victor-Marie-Charles Ruprich-Robert. On his return to New York, Carrère worked in the office of McKim, Mead & White (1883–5) before setting up practice with his fellow employee Hastings. Hastings had studied more briefly at the Ecole des Beaux-Arts in 1884 in the atelier of Louis-Jules André.

The practice was launched with commissions from the developer Henry Morrison Flagler (1830–1913), for whom Carrère & Hastings designed the

Ponce de Leon Hotel (1885–8; later Flagler College), the Alcazar Hotel (1888–9), the Memorial Presbyterian Church (1889–90) and other Spanish–American Renaissance-style buildings in Palm Beach and St Augustine, Florida. For more northerly latitudes Carrère and Hastings developed the Renaissance classicism of McKim, Mead & White with great success, winning the competition for the New York Public Library in 1897 (built 1902–11). The clear, functional planning and refined use of stylistic ornament distinguished these buildings. Other works include the Russell Senate and Cannon House office buildings (1905–10), and the Carnegie Institution (1909), all in Washington, DC, and the New Theater (1911–12), New York. Both partners were involved in the movement toward urban planning that accompanied the American Beaux-Arts style. Carrère was architectural director for the Buffalo Exhibition (1901) and drew up plans for Ohio, Baltimore, MD, and Grand Rapids, MI (1909). He originated the Art Commission of the City of New York and was a notable campaigner for architectural education and the improvement of architectural ethics.

After Carrère's death in a car accident, Hastings, who had been the principal designer of the two, continued the practice, specializing in tall office buildings adapted to the New York zoning restrictions, for example the Cunard Building (1919–21), the Macmillan Building (1924) and the Standard Oil Building (completed 1926). He was an articulate advocate of American classicism and remained closely in touch with the design work of his office. Other works include the Memorial Amphitheater at Arlington Cemetery, VA, and the temporary Victory Arch (1918; destr.) in New York. In London, Hastings designed Devonshire House (1924–6), Piccadilly, a block of luxury apartments (now offices) for which the consultant architect was Charles H. Reilly. Hastings had had an association with Reilly and the Liverpool University School of Architecture since 1909. The firm's extensive oeuvre extended to some 600 projects in 30 states and nine countries.

[*See also* New York.]

WRITINGS

Carrère with A. W. Brunner: *Preliminary Report for a City Plan for Grand Rapids* (1909)

Hastings: "On the Evolution of Style," *Amer. Architect*, xcvii (1910), p. 71

BIBLIOGRAPHY

"The Work of Messrs Carrère & Hastings," *Archit. Rec.*, xxvii (1910), pp. 1–120

Obituary [Carrère], *RIBA J.*, xviii (1910–11), pp. p. 352

Obituary [Carrère], *Amer. Architect*, xci (1911), pp. 131–2

F. S. Swales: "John Merven Carrère, 1858–1911," *Archit. Rev.* [London], xxix (1911), pp. 283–93

E. Clute: "Master Draftsmen" [Hastings], *Pencil Points*, vi (1925), pp. 49–60, 88

Obituary [Hastings], *Amer. Architect*, cxxxvi (1929), p. 55

Obituary [Hastings], *Archit. Forum* (Dec 1929), p. 35

Obituary [Hastings], *Archit. Rec.*, lxvi (1929), p. 596

Obituary [Hastings], *RIBA J.*, xxxvi (1929–30), 24–5

D. Gray: *Thomas Hastings, Architect: Collected Writings* (Boston, 1933)

C. Condit: "The Pioneer Concrete Buildings of St Augustine," *Prog. Archit.* (Sept 1971), pp. 128–33

C. Aslet: "Nemours, Delaware, USA," *Country Life*, clxxxiii (1989), pp. 92–7

D. Cruickshank: "New York Public Library, New York, 1911–1998," *RIBA J.*, cv (1998), pp. 58–65

M. A. Hewitt and others: *Carrère & Hastings, Architects* (2 vols.) (New York, 2006)

Carson, Carol Devine

(*b* Nashville, TN, 30 Nov 1945), graphic designer. Carson studied fine art and art history at the University of Tennessee, Knoxville, graduating in 1966. She started her career as a graphic designer in 1967 working for United Methodist Publishing House, Nashville, TN, designing magazines and educational materials. Working with limited budgets and for readers ranging from children in kindergarten to adults, she learned to be resourceful and to communicate with varying age groups. Drawing on her magazine design skills, she began work for Color Productions in 1968. Producing international magazines gave her exposure to the full spectrum of design production, illustration and final press

production. When the company resources diminished in 1970, Carson took a position at Design Graphics, a Nashville art studio.

In 1973 she landed a job at Scholastic Publishing House designing their early childhood magazine *Let's Find Out*. Teaming up with editor Jean Marzollo, she worked with nationally known illustrators and photographers to make the children's stories and educational material come to life. This partnership lasted far beyond her tenure there, leading to collaboration on the *I Spy* book series in the early 1990s. In 1980 Carson began designing for *Savvy* magazine, a women's fashion magazine, and by 1982 she was working for another publisher on a new magazine concept. Between 1983 and 1987 she continued designing magazines as a freelance designer for such clients as Scholastic Publishing and Time, Inc., working on such magazines as *Sports Illustrated*, *Real Estate* and *Ms.*

In 1987 she accepted the position of art director of jacket designs for Alfred A. Knopf Publishers. Credited with creating a collaborative design laboratory, the core team of designers included herself, Barbara de Wilde, Chip Kidd (*b* 1964) and Archie Ferguson. Designing up to 180 book covers a year, the team produced visually challenging imagery for mainstream consumer products, something that was not being done at the time. In 1991 she became vice president, art director at Knopf, creating a system unique to the publishing industry whereby art directors collaborated directly with editors and authors. Works of note from her tenure at Knopf include *Midnight in the Garden of Good and Evil* by John Berendt, *Degree of Guilt* by Richard North Patterson, *Stardust, 7-Eleven, Route 57, A & W, and So Forth* by Patricia Lear, *The Bluest Eye* by Toni Morrison, *Lost Recipes* by Marion Cunningham and *A Venetian Affair* by Andrea Di Robilant. While she is able to translate obscure images into powerful book covers, her ability to use restraint and allow typography to carry the concept can also be seen in the book cover to Joan Didion's *The Year of Magical Thinking*. Using black lettering on a white background, there appears to be a random coloration of four letters, teasing readers' interest and subtly bridging the cover to the content— the letters highlight the content of the book. Carson has won numerous design awards, and her work is included in the Cooper-Hewitt National Design Museum and the American Institute of Graphic Arts (AIGA) Design Archive.

UNPUBLISHED SOURCES
Interview with A. Fox (Fall 2005)

BIBLIOGRAPHY
E. Baker: "The Art of the Borzoi," *Graphis*, l/293 (Sept–Oct 1994)

L. Haycock Makela and E. Lupton: "Underground Matriarchy," *Eye*, xiv (1994)

P. Terzian: "Kill your Darlings," *Print*, lxii/5 (Oct 2008), pp. 66–71

Amy Fox

Casebere, James

(*b* Lansing, MI, 17 Sept 1953), photographer and installation artist. Casebere made his first photographs of constructed models in 1975 while completing a BFA at the Minneapolis College of Art and Design. This method of image-making, a kind of no-man's land between reality and constructed fiction, became his trademark. By the time he graduated from the California Institute of Fine Arts in Valencia, CA, he was part of a generation of American artists, including Cindy Sherman and Richard Prince, that was redefining the use of photography in art. Casebere's early work directly referenced Hollywood films and television, depicting scenes in American domestic interiors or the popular conception of the Wild West. His primary concerns at that time were the exploration of personal and collective memories and the presentation of myths of a past that continue to inhabit the present. Always showing places without people in them, these images take on a charged atmosphere reminiscent of *film noir*, a sensation heightened by the use of stark contrasts and black-and-white imagery. The filmic quality was further emphasized through presentation of the photographs on lightboxes. By the end of the

1980s architectural references began to dominate Casebere's work, to such an extent that he also made occasional large-scale sculptural installations fusing a number of architectural forms such as the house or the tower, as in *Tree Trunk with Broken Bungalow and Shotgun Houses* (exh. Tampa, U. S. FL, A. Mus., 1989). During the 1990s the imagery in his photographs became more specific, if not more subtle in atmosphere, focusing in particular on architectural features of prisons and underground vaults. At this time also, he ceased to use lightboxes (choosing instead to display the images in conventional print form) while at the same time introducing color.

BIBLIOGRAPHY

James Casebere: Model Culture Photographs 1975–1996 (exh. cat. by A. Grundberg and M. Berger, San Francisco, CA, Ansel Adams Cent. Phot., 1996)

J. Rian: "James Casebere: The Architecture of Memory," *Flashart*, 31/203 (Nov–Dec 1998), pp. 82–5

D. Bate: "Surveillance and Solitude: James Casebere," *Portfolio Mag.*, 29 (June 1999), pp. 4–11, 50–1

James Casebere: New Photographs (exh. cat. by M. Tarantino and D. Lynas, Oxford, MOMA, 1999)

The Architectural Unconscious: James Casebere and Glen Seator (exh. cat., essays A. Weinberg, A. Vidler and M. Wigley, Andover, MA, Phillips Acad., Addison Gal., 2000)

James Casebere: The Spatial Uncanny (exh. cat. with contributions by A. Vidler, C. Chang, J. Eugenides, New York, Sean Kelly Gal., 2001)

J. Juarez: "James Casebere," *Bomb*, 77 (Fall 2001), pp. 28–35 [interview]

D. Frankel: "Portfolio: James Casebere," *Artforum*, 40 (March 2002), pp. 109–13

James Casebere (exh. cat. by D. Bohr, Montreal, Mus. A. Contemp., 2003)

Andrew Cross

Case study houses in California

Experimental architectural program that ran from 1945 to 1966 and involved the building of Modernist houses, largely in California. John Entenza (1903–84) hit upon the idea just after World War II of spreading the word of the Modern Movement in architecture through an actual building program. As editor of the left-leaning journal *California Arts and Architecture* (later *Arts and Architecture*), he was concerned that the aftermath of wars was usually a period of conservatism in which progressive ideas were set aside. He wished to keep the spirit of the New Deal of the 1930s alive in architecture.

Entenza used the journal to promote interest in a program in which he would choose a major Modernist architect to design a house which, when built, the general public would be invited to tour. After such exposure, he would sell the house and use the proceeds to build another house designed by a Modernist. It would also be open for inspection—and so on. Needless to say, his plan was based on faith alone. Surprisingly, the idea worked. Entenza's first six houses were toured by 368,554 people, all of them curious if not approving. Thirty-eight commissions were proposed and twenty-six were actually built, giving such architects as J. R. Davidson, Sumner Spaulding, John Rex, Thornton Abell (1906–84), Richard Neutra, Craig Ellwood, Raphael S. Soriano, Pierre Koenig and Charles and Ray Eames extraordinary publicity—and commissions.

For Entenza and many of his contemporaries, Modern architecture was a cause. However, at about the time the Case Study House program was abandoned (1966), the International Style came under attack, not from the right or the left, but from an aesthetic impulse. To Mies van der Rohe's assertion "Less is more," Robert Venturi answered that "Less is a bore." Various protests against the International Style arose: New Brutalism, Neo-Expressionism and so-called Post-modernism. While elements of these styles persist, there has also been a revival in the appreciation of the clean lines, order and spartan simplicity of the International Style. In that sense, Entenza's Case Study program has created enduring monuments.

BIBLIOGRAPHY

E. Mc Coy: *Case Study Houses, 1945–1962* (Los Angeles, 1977)

E. A. T. Smith: *Case Study Houses, 1945–1955: The California Impetus* (Hong Kong, 2007)

Robert Winter

Casey, Jacqueline

(*b* Quincy, MA, 20 April 1927; *d* Brookline, MA, 18 May 1992), graphic designer. Casey received a BFA and certificate in fashion design and illustration from the Massachusetts College of Art, Boston. Her first jobs included work in fashion illustration, advertising and interior decoration. In 1955 she was hired by fellow Massachusetts College of Art alumnus Muriel Cooper to design summer promotions material for MIT Summer Sessions. Subsequently Cooper offered her a position as a full-time designer at MIT's Office of Design Services. She learned the principles of graphic design from Cooper and the Swiss designer Theresa Moll, who worked in the Office of Publications during 1958. Moll was particularly influential for Casey and introduced her to elements of Swiss design. When Cooper left to join the MIT faculty in 1972, Casey became director of the Office of Publications (1972–89). Casey is best known for the posters she created to publicize MIT events and exhibitions during the 1960s and 1970s. Her high-contrast, type-heavy compositions were intended to stand out on the already cluttered university bulletin boards. She often used manipulated letterforms for primary text and set the supporting information in smaller type. Her compositions used color, proportion and proximity to create a visually and verbally effective typographic design. She repeatedly stated that her goal was to stop her audience, catch their interest and then educate them on her client's upcoming event or the poster's subject. For the 1972 poster advertising the MIT faculty-student exchange program, Casey used negative space created by red, blue and black triangles to form an area of white in the shape of an "X." The abstracted letter references the word "exchange," and the simply ordered title and supporting text compliment the stronger negative shapes that are the focal point of the composition, creating a blend of visual and verbal logic that is typical of Casey's style. In 1971, 17 posters by Casey and the staff at the Office of Publications were featured in *Print Magazine*'s competition *Poster USA: 1960–1970*. It was the second largest number by an individual or studio. In 1989 she retired as director of Design Services but stayed on at MIT as a visiting design scholar at the Media Laboratory. Casey's posters have been widely exhibited, and her work is in the permanent collections of the Library of Congress, Washington, DC, the Museum of Modern Art, New York and the Cooper-Hewitt Museum, New York. She served as guest lecturer at Massachusetts College of Art, Yale University, Carnegie-Mellon University and Simmons College.

BIBLIOGRAPHY

"Campus Publicity in America: Massachusetts Institute of Technology," *Graphis*, xxv (July 1971), pp. 402–9

F. H. K. Henrion: *Top Graphic Design: Examples of Visual Communication by Leading Graphic Designers* (Zurich, 1983)

R. Siegel: *American Graphic Designers: Thirty Years of Design Imagery* (New York, 1984)

L. McQuiston: *Women in Design: A Contemporary View* (New York, 1988)

A. Livingston and I. Livingston: *Thames and Hudson Encyclopedia of Graphic Design and Designers* (New York, 1992)

"Ellen Lupton and Jacqueline S. Casey, 1927–1992," *AIGA J. Graph. Des.*, x/3 (1992), pp. 14

Posters: Jacqueline S. Casey: Thirty Years of Design at MIT (Cambridge, MA, 1992)

A. Livingston and I. Livingston: "Jacqueline Casey," *The Thames and Hudson Dictionary of Graphic Design and Designers* (London, 2003/2006), p. 45

B. E. Resnick: "Women at the Edge of Technology," *Eye*, 17/68 (Summer 2008), pp. 26–8

Aaris Sherin

Casilear, John William

(*b* New York, 25 June 1811; *d* Saratoga Springs, NY, 17 Aug 1893), engraver, draftsman and painter. At 15 he was apprenticed to the engraver Peter Maverick (1780–1871) and then to Asher B. Durand. Casilear and his brother George formed a business partnership that eventually developed into the American Bank Note Co., the principal private bank-note engravers in America. He was perhaps the most fluent and accomplished draftsman of his generation,

and important collections of his landscape drawings are in the Detroit Institute of Arts and the Boston Museum of Fine Arts.

Casilear was an exponent of the Hudson River school of landscape painting. Such works as *Lake George* (1860; Hartford, CT, Wadsworth Atheneum) and his views of Genesee Valley, NY, and Niagara Falls manifest the refined color, restrained brushwork and ordered composition typical of that group. Casilear's compositions are firmly drawn and articulated through a subtle palette that explores the value and saturation of hues.

In 1833 Casilear was elected an Associate at the National Academy of Design, New York, based on his engravings and in 1851 an Academician based on his painting. In 1840 Casilear, Durand, John Frederick Kensett and Thomas Rossiter (1818–71) traveled to Europe to study, visiting London, Paris and Rome. Casilear was a regular exhibitor at the National Academy of Design (1833–90), the Apollo Association (1838–43), the American Art-Union (1847–51), the Pennsylvania Academy of the Fine Arts, Philadelphia (1855–65) and elsewhere.

BIBLIOGRAPHY

D. Stauffer: *American Engravers upon Copper and Steel* (New York, 1907)

American Paradise: The World of the Hudson River School (exh. cat. by J. K. Howat, New York, Met., 1987)

John Driscoll

Cassatt, Mary

(*b* Allegheny City [now in Pittsburgh], 25 May 1844; *d* Le Mesnil-Théribus, France, 14 June 1926), painter and printmaker, active in France. One of the great American expatriates of the later 19th century (along with Sargent and Whistler), Cassatt was an active member of the Impressionist group in Paris and carved out a lasting international reputation for her famous "modern" representations of the mother and child. Because of her success, her life and art have been closely examined to gain a better understanding of how gender affects artists during their lifetimes and afterward in historical perspective.

Life and work. Daughter of a Pittsburgh investment broker, Mary Stevenson Cassatt received a cultured upbringing and spent five years abroad as a child (1851–5). In 1860, at the age of 16, she began classes at the Pennsylvania Academy of the Fine Arts, Philadelphia, and in 1866 sailed again for Europe. During the next four years she studied in Paris with Jean-Léon Gérôme (1824–1904) and Charles Chaplin (1825–91), in Ecouen with Paul Soyer (1823–1903), in Villiers-le-Bel with Thomas Couture (1815–79) and in Rome with Charles Bellay (1826–1900). She concentrated mainly on figure painting, often posing her models in picturesque local costume. When she returned to Europe after 16 months in the USA (1870–71), she painted and copied in the museums of Parma, Madrid, Seville, Antwerp and Rome, finally settling in Paris in 1874. Until 1878 she worked mainly as a portrait and genre painter, specializing in scenes of women in Parisian interiors. She exhibited regularly in the USA, particularly in Philadelphia, and had paintings accepted in the Paris Salons of 1868, 1870 and 1872–6.

Cassatt's study of Diego Velázquez (1599–1660) and Peter Paul Rubens (1577–1640), coupled with her interest in the modern masters Couture, Gustave Courbet (1819–77) and Edgar Degas (1834–1917), caused her to question the popular Salon masters of the 1870s and to develop her own increasingly innovative style. This led to rejection of some of her Salon entries in 1875 and 1877 but also prompted Degas to invite her to exhibit with the Impressionists. She made her début with them at their fourth annual exhibition (1879), by which time she had mastered the Impressionist style and was accepted as a fully fledged member by artists and critics alike. She went on to participate in the Impressionist exhibitions of 1880, 1881 and 1886.

In 1877, when her parents and older sister Lydia arrived to settle with her in Paris, she exchanged her youthful lifestyle, living alone in her studio, for a more family-orientated existence. Their spacious

and comfortable accommodation also encouraged Cassatt's two brothers and their families to make frequent visits from Philadelphia. Family members often figure in Cassatt's Impressionist portraits and scenes of daily life during this period (e.g. *Lydia Crocheting in the Garden at Marly*, 1880; New York, Met.).

Cassatt began to revise her Impressionist style in the 1880s, and after the last Impressionist exhibition (1886) she developed a refined draftsmanship in her pastels, prints and oil paintings. After exhibiting with the new Société des Peintres-Graveurs in 1889 and 1890, she had her first individual exhibition of color prints and paintings in 1891 at the Galerie Durand-Ruel, Paris. In 1892 she was invited to paint a large tympanum mural, *Modern Woman*, for the Woman's Building at the World's Columbian Exposition (Chicago, 1893). Although the mural itself does not survive, many paintings (e.g. *Nude Baby Reaching for an Apple*, 1893; Richmond, VA, Mus. F.A.), prints (e.g. *Gathering Fruit*, drypoint with aquatint, *c.* 1895) and pastels (e.g. *Banjo Lesson*, 1894; Richmond, VA Mus. F.A.) based on Cassatt's mural designs reflect her concept of modern woman "plucking the fruits of knowledge or science." The monumental figures of women dressed in the current "aesthetic" style stood like goddesses in an orchard and passed down the fruits to the next generation of young girls and babies. She exhibited these in her first major retrospective exhibition in 1895 at Durand-Ruel's gallery in Paris and again in 1895 at his gallery in New York.

Cassatt's success in Europe and the USA was such that in 1894 she was able to purchase the Château de Beaufresne in Le Mesnil-Théribus (*c.* 90 km northwest of Paris) from the sale of her work. Thereafter she alternated between Paris and the country, with a few months every winter in the south of France. She increasingly concentrated on the mother-and-child theme and on studies of women and young girls, often turning to the Old Masters for inspiration. For this work she was recognized on both continents, and, in addition to receiving a number of awards, including the Légion d'honneur in 1904, she was called "the most eminent of all living American women painters" (*Current Lit.*, 1909, p. 167). She spent much of her time during these years helping her American friends build collections of avant-garde French art and works by Old Masters. Those she advised included Henry and Louisine Havemeyer, Mrs. Montgomery J. Sears, Bertha Honoré Palmer and James Stillman.

Cassatt painted until 1915 and exhibited her latest work that year in the *Suffrage Loan Exhibition of Old Masters and Works by Edgar Degas and Mary Cassatt* at the Knoedler Gallery, New York; but soon afterwards cataracts in both eyes forced her into retirement. She continued to be actively interested in art, however, and until her death she vigorously expressed her own views and opinions to the many young artists who visited her seeking advice.

Working methods, technique and subject matter. Cassatt's own experimentation and her openness to new ideas caused her style to change many times during her long career. In her early years (1860–78) she practiced a painterly genre style in dark, rich colors as in *A Musical Party* (1874; Paris, Carnavalet); during her Impressionist period (1879–86) she used a pastel palette and quick brushstrokes in such works as *Cup of Tea* (*c.* 1880; New York, Met.); in her mature period (1887–1900) she developed a style that was more finished and dependent on abstract linear design, for instance in *The Bath* (1893; Chicago, IL, A. Inst.) and *Mother and Child (The Oval Mirror)* (*c.* 1899; New York, Met.; see color pl. 1:XI, 2); and in her late period (1900–26) she often used color combinations with a somber cast, as in *The Caress* (1903; Washington, DC, Smithsonian Amer. A. Mus.).

As a student and young artist, Cassatt avoided the academic emphasis on drawing and concentrated instead on painting techniques. But as her career progressed, particularly after 1879 when she took up pastels and printmaking, she developed a refined and original drawing style that blended European and oriental effects. Her first efforts in printmaking were in a collaboration with Degas, Camille Pissarro

(1830–1903) and others to produce a journal combining art criticism and original prints. Although the journal, *Le Jour et la nuit*, never appeared, Cassatt went on to finish several complex prints in etching, aquatint and drypoint, such as *The Visitor* (softground, aquatint and drypoint, c. 1880; Breeskin, 1948, no. 34). In the late 1880s she turned to drypoint for a spare and elegant effect, as in *Baby's Back* (c. 1889; B. 128). Her greatest achievement in printmaking, however, was the group of 18 color prints she produced during the 1890s. The first ten were completed and exhibited as a set in 1891 and are highly prized for their skillful use of aquatint, etching and drypoint and for Cassatt's hand-inking and wiping of the plates for each print. Prints from this set, such as *The Letter* (drypoint and aquatint, 1890–91; B. 146), show her successful synthesis of the abstract design of Japanese color prints and the atmospheric qualities of Western art.

Cassatt's pastels are equally important to her development as an artist. Although she used pastel as a sketching tool from the first, it was not until she joined the Impressionist circle that she began to produce major finished works in this medium. Pastel became increasingly popular in both Europe and the USA in the 1870s and 1880s, and Cassatt was one of the first to exploit the properties of pastel in conveying the vibrancy of "modern" life. As in oil, she tailored her application of the pastel pigment to fit her changing style: exuberant strokes and rich colors during her Impressionist phase gave way to a calmer, more monumental style (exemplified by *Banjo Lesson*) as she matured. In the 1890s she returned often to the study of pastel techniques of 18th-century masters, particularly Maurice-Quentin de La Tour (1704–88).

In the late 1880s Cassatt began to specialize in the mother-and-child theme (e.g. *Mother and Child*, 1897; Paris, Mus. Orsay). This developed from her interest in the monumental figure and the depiction of modern life and was also in tune with late 19th-century Symbolism. She soon became identified with the theme and continues to be considered one of its greatest interpreters. The provocative contrast between Cassatt's own life as an ambitious professional artist and her sympathetic portrayal of the most traditional of female roles has led to much debate about gender restrictions and/or opportunities in the 19th century. But the fact that both her life and her art resist simplistic interpretation may explain why she continues to intrigue audiences and hold such an important place in the history of American art.

BIBLIOGRAPHY

J. K. Huysmans: *L'Art moderne* (Paris, 1883), pp. 6, 110, 231–4 [reviews of Salon of 1879, Impressionist exhibitions of 1880 and 1881]

Exposition Mary Cassatt (exh. cat., preface A. Mellério; Paris, Gal. Durand-Ruel, 1893)

W. Walton: "Miss Mary Cassatt," *Scribner's Mag.*, xix (1896), pp. 353–61 [review of Cassatt's exhibition in New York, 1895]

A. Segard: *Mary Cassatt: Une Peintre des enfants et des mères* (Paris, 1913) [first complete study of Cassatt's life and work, based on interviews with her]

A. D. Breeskin: *The Graphic Work of Mary Cassatt: A Catalogue Raisonné* (New York, 1948, rev. Washington, DC, 2/1979) [B.]

A. D. Breeskin: *Mary Cassatt: A Catalogue Raisonné of the Oils, Pastels, Watercolors, and Drawings* (Washington, DC, 1970)

Mary Cassatt, 1844–1926 (exh. cat., Washington, DC, N.G.A., 1970)

N. Hale: *Mary Cassatt* (New York, 1975)

Mary Cassatt at Home (exh. cat. by B. S. Shapiro, Boston, MA, Mus. F.A., 1978)

N. M. Mathews, ed.: *Cassatt and her Circle: Selected Letters* (New York, 1984)

Mary Cassatt and Philadelphia (exh. cat. by S. G. Lindsay, Philadelphia, PA, Mus. A., 1985)

N. M. Mathews: *Mary Cassatt* (New York, 1987)

Mary Cassatt: The Color Prints (exh. cat. by N. Mowll Mathews and B. Stern Shapiro, Washington, DC, N.G.A.; Williamstown, MA, Williams Coll. Mus. A.; Boston, MA, Mus. F.A.; 1989)

C. K. Carr: "Mary Cassatt and Mary Fairchild MacMonnies: The Search for their 1893 Murals," *Amer. A.*, viii (Winter 1994), pp. 52–69

J. Hutton: "Picking Fruit: Mary Cassatt's Modern Woman and the Woman's Building of 1893," *Fem. Stud.*, xx/2 (1994), pp. 318–48

N. M. Mathews: *Mary Cassatt: A Life* (New York, 1994)

M. E. Boone: "Bullfights and Balconies: Flirtation and Majismo in Mary Cassatt's Spanish Paintings of 1872–73," *Amer. A.*, ix (Spring 1995), pp. 54–71

Mary Cassatt, Modern Woman (exh. cat. by J. A. Barter, Chicago, IL, A. Inst.; Boston, MA, Mus. F.A.; Washington, DC, N.G.A.; 1998–9)

R. T. Clement, A. Houze and C. Erbolato-Ramsey: *The Women Impressionists: A Sourcebook* (Westport, CT, and London, 2000)

K. Ricci: *Mary Cassatt da Pittsburgh a Parigi* (Milan, 2002)

I. Pfeiffer and Max Hollein, eds.: *Women Impressionists* (Ostfildern, 2008)

Mary Cassatt: Friends and Family (exh. cat., ed. N. M. Mathews; Shelburne, VT, Mus., 2008)

Nancy Mowll Mathews

Castelli, Leo

(*b* Trieste, Austro-Hungarian Empire [now Italy], 4 Sept 1907; *d* New York City, 21 Aug 1999), dealer and collector. Castelli obtained a law degree from the University of Milan in 1924 and worked in insurance and banking in Italy, Romania and France. In 1939, with his first wife Ileana Shapira (later Sonnabend, 1914–2007), whom he had married in 1933, and the French architect and interior designer René Drouin, he opened a gallery in Paris specializing in Surrealist art. In 1941 the Castellis emigrated to New York, where they met Sidney Janis and artists such as Jackson Pollock and Willem de Kooning. In 1957, after serving in the US Army and working for his father-in-law, Castelli opened his first New York gallery, where in 1958 he presented influential solo exhibitions by Jasper Johns and Robert Rauschenberg. Through his involvement with them and others such as Roy Lichtenstein, James Rosenquist and Andy Warhol, he became the most influential promoter of Pop art; after giving Frank Stella his first solo exhibition in 1960 he also took up the cause of Minimalism, representing Donald Judd, Dan Flavin and Robert Morris, and of post-Minimalist and conceptual art by Richard Serra, Bruce Nauman and Keith Sonnier, among others.

Castelli's international success with these and other artists represented by him, including Lee Bontecou, John Chamberlain and Cy Twombly, soon allowed him to expand his operations, beginning in 1969 with Castelli Graphics, run by his second wife, Toiny Castelli (1928–87), and followed in the 1970s by two gallery spaces in the SoHo district of New York. His own collection included major works by some of his artists, notably Johns's *Target with Plaster Casts* (1955), Rauschenberg's *Bed* (1955) and Stella's *Black Adder* (1965).

[*See also* Collecting and dealing.]

BIBLIOGRAPHY

C. Tomkins: "A Good Eye and a Good Ear," *New Yorker*, 26 May 1980; also in C. Tomkins, *Post- to Neo-: The Art World of the 1980s* (New York, 1988), pp. 9–52

Castelli and His Artists: Twenty-five Years (exh. cat., Aspen, Cent. Visual A., 1982)

L. de Coppet and A. Jones, eds: *The Art Dealers* (New York, 1984), pp. 80–109

A Tribute to Leo Castelli (exh. cat. by C. Tomkins, London, Mayor Gal., 1985)

Leo Castelli y sus artistas (exh. cat., essays by N. Ortiz Garza and others, Mexico City, Cent. Cult. A. Contemp., 1987) [incl. interview with Castelli]

A. Hindry: *Claude Berri recontre Leo Castelli* (Paris, 1990) [interview]

M. Tschechne: "Ein Mann schenkt seinen Helden Charisma/A Man Gives His Heroes Charisma," *A.: Kunstmag.*, 3 (March 1992), pp. 48–55 [interview]

M. Casadio: "Leo Castelli," *Casa Vogue*, 251 (May 1993), pp. 86–91, 185, 195–6 [interview]

E. C. Baker: "Leo Castelli: 1907–1999," *A. Amer.*, 87/11 (Nov 1999), pp. 31, 33

M. Goldstein: *Landscape with Figures: A History of Art Dealing in the United States* (Oxford and New York, 2000)

T. Hulst: "The Leo Castelli Gallery," *Arch. Amer. A. J.*, 16/3–4 (Fall 2007), pp. 14–27

L. Kirwin: *Speaking of Art: Selections from the Archives of American Art Oral History Collection, 1958–2008* (Falls Village, CT, 2008)

Ruth Bass

Catesby, Mark

(*b* Castle Hedingham, Essex, 24 March 1682; *d* London, 23 Dec 1749), English naturalist, painter and graphic artist active in the American colonies. Catesby's scientific expeditions to the British colonies in North America and the Caribbean

(1712–19 and 1722–6) resulted in the first fully illustrated survey of the flora and fauna of the British Colonies in the Americas. *The Natural History of Carolina, Florida and the Bahama Islands* (1731–47) contains 220 hand-colored etchings. Catesby received lessons in etching from Joseph Goupy and executed most of the plates after his own drawings in graphite, gouache and watercolor. He also produced several plates after drawings by John White, Georg Dionysius Ehret, Everhard Kick and Claude Aubriet.

Catesby moved against the 18th-century trend in the natural sciences to portray Creation as a neatly ordered hierarchy of clearly definable parts. His pictures helped to promote a revolutionary view of the cosmos as a complex system of interdependent elements and forces. Instead of depicting organisms in the conventional manner as isolated specimens against an empty page, he produced tight compositional arrangements in which animals and plants from similar environments reflect one another's forms. Catesby's radical images of an integrated cosmos influenced eminent English and American naturalists, including George Edwards (1694–1773), William Bartram and John James Audubon.

Important drawings by Catesby are in the British Library and British Museum in London and the Royal Society, London. An almost complete set of preparatory drawings for the *Natural History* is in the Royal Library, Windsor Castle.

WRITINGS
The Natural History of Carolina, Florida and the Bahama Islands, 2 vols (London, 1731–47/R Savannah, 1979, rev. 3/1771)

"Of Birds of Passage by Mr. Mark Catesby F.R.S.," *Philos. Trans.*, xliv (1747), pp. 435–44

Hortus Britanno-Americanus (London, 1763, rev. 1767) [new title-page]

BIBLIOGRAPHY
G. Frick and R. Stearns: *Mark Catesby: The Colonial Audubon* (Urbana, 1961)

C. E. Jackson: *Bird Etchings: The Illustrators and their Books, 1655–1855* (Ithaca, NY, 1985), pp. 76–87

H. McBurney: "Painted from Nature," *Country Life*, clxxxix (14 Dec 1995), pp. 44–6

Mark Catesby's Natural History of America: The Watercolors from the Royal Library, Windsor Castle (exh. cat. by H. McBurney, San Marino, CA, Huntington Lib. & A.G. and elsewhere, 1997)

A. Myers and M. Pritchard, eds: *Empire's Nature: Mark Catesby's New World Vision* (Chapel Hill, 1998)

Amy Meyers

Catlett, Elizabeth

(*b* Washington, DC, 15 April 1915), sculptor, printmaker and art educator. One of the leading African American feminist and political artists of the 20th century and early 21st century, Catlett devoted her career of more than 60 years to expressing critical ideas in powerful visual form both in the USA and in her adopted country of Mexico. Her strong academic background began at Howard University, Washington, DC, where she studied under African American art luminaries James Porter, James Wells and Lois Jones. After graduating in 1937, she completed her MFA in 1940 at the University of Iowa.

In 1941 she married the artist Charles White. Visiting Mexico, they found the Mexican mural and printmaking tradition artistically and politically engaging. After her first marriage ended in 1946, she moved to Mexico in the wake of American postwar political repression. While working at the Taller de Gráfica Popular in Mexico City, she met the Mexican artist Francisco Mora (1922–2002), whom she married in 1947, becoming a Mexican citizen in 1962. In addition to creating her socially conscious sculptures of wood, stone, clay and bronze and prints including linocuts, lithographs and serigraphs, she taught at the Escuela Nacional de Bellas Artes in Mexico City from 1958 to 1976.

A major theme of her sculptures and prints is the dignified portrayal of African Americans, especially women. Her engaging depictions of anonymous black working women complement her portraits of such iconic historical figures as Sojourner Truth, Phyllis Wheatley, Harriet Tubman and Angela Davis. Her treatment of African American mothers and children

adds a welcome racial dimension to a universal artistic theme. Her widely reproduced color linocut, *Share-cropper* (1970), honoring an elderly black woman toiling in the fields, reflects Catlett's profound commitment to millions of similarly unheralded black females. Other works similarly honor male and female children of color, augmenting her stature as a major contemporary humanist artist.

Specific political commentary also pervades her prints and sculptures. Above all, her works provide striking visual support for the historic African American struggle for freedom and dignity. Such prints as *Civil Rights Congress* (1949) and *Malcolm Speaks For Us* (1969) join her sculptures, including *Homage to My Young Black Sisters* (1968) and *Black Unity* (1968), in revealing an enduring artistic commitment to the tradition of militant black social protest. Prints produced during the 1980s and 1990s express the continuing plight of black children in a racist

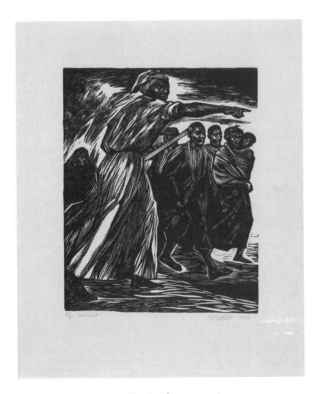

ELIZABETH CATLETT. *Harriet*, linocut, 316 × 257 mm, 1975. GIFT OF RALPH E. SHIKES FUND. © ELIZABETH CATLETT/LICENSED BY VAGA, NY © THE MUSEUM OF MODERN ART/LICENSED BY SCALA/ART RESOURCE, NY

environment in America that persists despite the advances of the modern civil rights movement.

As a naturalized Mexican, Catlett also used her art to provide critical commentary about Latin American political affairs. Such early 1980s linocuts as *Chile I* and *Chile II* (both 1980) call dramatic attention to the horrific human rights violations of the military regime in Chile following the overthrow of the lawful government there in 1973. *Central America Says No* (1986) similarly condemns American support of repressive military regimes there during the administration of President Ronald Reagan (1981–9). Cumulatively, Catlett's works establish an exemplary model of art combining excellent technique and trenchant social criticism.

BIBLIOGRAPHY

S. Lewis: *The Art of Elizabeth Catlett* (Los Angeles, 1984)

Elizabeth Catlett: Works on Paper, 1944–1992 (exh. cat., ed. J. Zeidler; Hampton, VA, U. Mus., 1993)

L. King-Hammond, ed.: *Gumbo Ya Ya: Contemporary African-American Women Artists* (New York, 1995)

C. A. Britton: *African American Art: The Long Struggle* (New York, 1996)

S. F. Patton: *African-American Art* (New York, 1998)

M. Herzog: *Elizabeth Catlett: An American Artist in Mexico* (Seattle, 2000)

S. Lewis: *African American Art and Artists* (Berkeley, 2003)

Swann Gallery: *The Golden State Mutual life Insurance Company African-American Art Collection* (New York, 2007)

C.-M Bernier: *African American Visual Arts: From Slavery to the Present* (Chapel Hill, NC. 2008)

Paul Von Blum

Catlin, George

(*b* Wilkes-Barre, PA, 26 July 1796; *d* Jersey City, NJ, 23 Dec 1872), painter and writer. Following a brief career as a lawyer, Catlin produced two major collections of paintings of Native Americans and published a series of books chronicling his travels among the native peoples of North, Central and South America. Claiming his interest in America's "vanishing race" was sparked by a visiting American Indian delegation in Philadelphia, he set out to

record the appearance and customs of America's native peoples. He began his journey in 1830 when he accompanied Gen. William Clark on a diplomatic mission up the Mississippi River into Native American territory. Two years later he ascended the Missouri River over 3000 km to Ft Union, where he spent several weeks among indigenous people still relatively untouched by European civilization. There, at the edge of the frontier, he produced the most vivid and penetrating portraits of his career (see color pl. 1:XIV, 2). Later trips along the Arkansas, Red and Mississippi rivers as well as visits to Florida and the Great Lakes resulted in over 500 paintings and a substantial collection of artifacts. In 1837 he mounted the first serious exhibition of his "Indian Gallery," published his first catalog and began delivering public lectures, which drew on his personal recollections of life among the Native Americans. Soon afterward he began a lifelong effort to sell his Native American collection to the US government. When Congress rejected his initial petition, he took the Indian Gallery abroad and in 1840 began a European tour in London.

In 1841 Catlin published *Letters and Notes on the Manners, Customs, and Condition of the North American Indians*, his major literary work, but only the first in a series of books documenting his travels and observations among the indigenous peoples of North and South America. When interest in the Indian Gallery waned in England, he took his collection to Paris, where it was praised by many, including Baudelaire, who found Catlin's colors "intoxicating." Confident that Congress would eventually purchase his Indian Gallery, Catlin borrowed heavily against it and in 1852 he suffered financial collapse. Dispersal of the Indian Gallery was avoided only when Joseph Harrison, an American manufacturer, reimbursed the artist's creditors and shipped the entire collection to Philadelphia, where it was stored until donated to the Smithsonian Institution, Washington, DC, six years after Catlin's death.

Following his bankruptcy, Catlin lived hand to mouth for two years before he secured funds to travel to South America. There he produced paintings of indigenous South Americans that, together with new paintings of Native Americans obtained on a trip up the Pacific Coast and copies of works from his original Indian Gallery, made up a second collection of over 500 pictures, which he called the "Cartoon Collection." The cartoons were first shown in Brussels in 1870 and in New York the following year, but the accolades of earlier years were not repeated. Discouraged and in ill health, he accepted an invitation to install his cartoons at the Smithsonian Institution in Washington, DC, while waiting for Congress to act on his latest petition. At his death Congress had failed to act and the Cartoon Collection passed to his family. In 1965, the National Gallery of Art, Washington, DC, acquired 351 cartoons. Taken together, the Indian Gallery, the Cartoon Collection and Catlin's supporting publications constitute the most comprehensive record of the life of indigenous people in North and South America during the period 1830–60. Catlin's paintings, long acknowledged as a key ethnographic resource, have only recently been discussed as compelling works of art. Often completed in haste and under adverse conditions, his finest works combine a refreshing immediacy of execution with a pervasive sympathy for the dignity of America's native peoples.

[*See also* New Orleans.]

WRITINGS

Letters and Notes on the Manners, Customs, and Condition of the North American Indians, 2 vols (London, 1841/R New York, 1973)

Catlin's Notes of Eight Years' Travels and Residence in Europe, 2 vols (London, 1848)

Life amongst the Indians (New York, 1857)

Last Rambles amongst the Indians of the Rocky Mountains and the Andes (New York, 1867)

O-Kee-Pa: A Religious Ceremony and Other Customs of the Mandans (London, 1867/R New Haven, 1967)

BIBLIOGRAPHY

T. Donaldson: "The George Catlin Indian Gallery," *Smithsonian Inst. Annu. Rep.*, v (1886)

L. Haberly: *Pursuit of the Horizon* (New York, 1948)

J. Ewers: "George Catlin, Painter of Indians and the West," *Smithsonian Inst. Annu. Rep.* (1956), pp. 483–528

M. Roehm, ed.: *The Letters of George Catlin and his Family* (Berkeley, 1966)

W. Truettner: *The Natural Man Observed: A Study of Catlin's Indian Gallery* (Washington, DC, 1979)

B. Dippie: *Catlin and his Contemporaries: The Politics of Patronage* (Lincoln, 1990)

E. C. Krebs: "George Catlin and South America: A Look at His Lost Years and His Paintings of Northeastern Argentina," *Amer. A. J.*, xxii/4 (1990), pp. 4–39

W. Rawls: "Audubon, Bodmer and Catlin: Facsimile Editions from the Editorial Side," *Imprint*, xvi/1 (1991), pp. 2–10

The West as America: Rethinking Western Art (exh. cat. by W. Truettner and others, Washington, DC, N. Mus. Amer. A., 1991); review by S. May in *Southwest A.*, xxi (1991), pp. 100–9

H. Wilderotter: "'*Sehet den schnellen Indianer an . . .*': Ideal und Stereotyp in den Indianerbildern George Catlins," *Mus. J.*, vi/3 (1992), pp. 4–8

The North American Indian Portfolios from the Library of Congress, intro. J. Gilreath (New York, 1993)

First Artist of the West: Paintings and Watercolors by George Catlin from the Collection of Gilcrease Museum (exh. cat. by J. C. Troccoli, Tulsa, OK, Gilcrease Mus., and elsewhere, 1993–6)

Latin American Art in Miami Collections and South American Indian Paintings by George Catlin (exh. cat., Miami, FL, Lowe A. Mus., 1995); review in *A. Nexus*, xvi (1995), pp. 123–4

R. Moore: *Native Americans: A Portrait, the Art and Travels of Charles Bird King, George Catlin, and Karl Bodmer* (New York, 1997)

George Catlin and His Indian Gallery (exh. cat. by B. Dippie and others, Washington, DC, Smithsonian Amer. A. Mus., 2002)

Nancy Anderson

Caudill, William W.

(*b* Hobart, OK, 25 March 1914; *d* Houston, TX, 25 June 1983), architect. Educated at Oklahoma State University, Stillwater (1933–7), and Massachusetts Institute of Technology, Cambridge (1937–9), he began his career as a design teacher at Texas A. & M. University, College Station, in 1939. By the time he founded the firm of Caudill, Rowlett and Scott in Houston in 1947 he had already established strong interests in the design of buildings for educational institutions and in a team approach to the design process that would inspire and distinguish the work of that firm and its successors, CRS Inc. and CRS Sirrine. Caudill described himself as a "professor/architect involved in theory and practice" and made a significant contribution as a researcher, philosopher and manager in addition to being a talented designer. His early research on elementary schools in Texas, first published in 1941, took an analytical, problem-solving approach to both functional and technological aspects of school design. Its pragmatic, commonsense arguments were influential in convincing communities to build modern schools in the 1950s and 1960s. Caudill's own firm designed many such schools, first in Texas and later throughout the USA.

The firm, based in Houston, eventually grew to an international practice with over 1000 employees under Caudill's leadership. Its innovative design methodology, rooted in reliance on interdisciplinary teams of architects, engineers, environmental specialists and user groups, became a pattern for many large architectural practices in the 1970s. The firm also developed techniques for group dynamics management and post-occupancy evaluation, which were broadly influential.

WRITINGS
Space for Teaching (College Station, TX, 1942)

Architecture by Team (New York, 1971)

P. Tombesi: "Capital Gains and Architectural Losses: The Transformative Journey of Caudill Rowlett Scott (1948–1994)," *J. Archit.*, xi/2 (April 2006), pp. 165–8

A. Sachs: "Marketing through Research: William Caudill and Caudill, Rowlett, Scott (CRS)," *J. Archit.*, xiii/6 (Dec 2008), pp. 737–52

Lawrence W. Speck

Cavallon, Giorgio

(*b* Sorio, Vicenza, 2 March 1904; *d*. 1989), painter of Italian birth. Cavallon studied in Provincetown, MA, at the National Academy of Design from 1925 to 1930 and then lived in Italy until 1933. From 1935 to 1936 he studied at Hans Hofmann's summer school in Provincetown, MA. Strongly influenced by Piet Mondrian and Jean Hélion and later by Arshile

Gorky and Willem de Kooning, he became associated with Abstract Expressionism and was a founding member of American Abstract Artists in 1936.

Cavallon's characteristic paintings, such as *Untitled* (oil on canvas, 1.42×2.03 m, 1956; Buffalo, NY, Albright–Knox A.G.), are constructed of irregularly shaped rectangular blocks in subtle and often pale colors; in later works the blocks are enclosed in small dark shapes. Seeking a harmonious balance of volume, shape and color, Cavallon structured his paintings so as to create an atmosphere of reverberating light around the apparently disintegrating shapes. Although his pictures consist of purely abstract elements, this sense of flooding light has led some viewers to interpret Cavallon's work as an equivalent to sunny Mediterranean landscapes.

BIBLIOGRAPHY

Artisti italo-americani: Cavallon, Nivola, Scanga (exh. cat. by F. Licht, Venice, Guggenheim, 1988)

G. Cavallon: *Giorgio Cavallon (1904–1989): Paintings/text by John Asbery* (New York, NY: Salander-O'Reilly Gals, 2005)

G. Cavallon: *Giorgio Cavallon: Paintings 1952–1989: 21 October–25 November 1989* (Los Angeles, CA: Manny Silverman Gal., c1989)

A. Bartos and others: *Giorgio Cavallon, 1904–1989: A Retrospective View* (exh. cat., U. of Connecticut: William Benton Mus. A., 1990)

Alberto Cernuschi

Celmins, Vija

(*b* Riga, Latvia, 25 Oct 1939), painter, sculptor, object-maker and draftsman of Latvian birth. In 1944 her

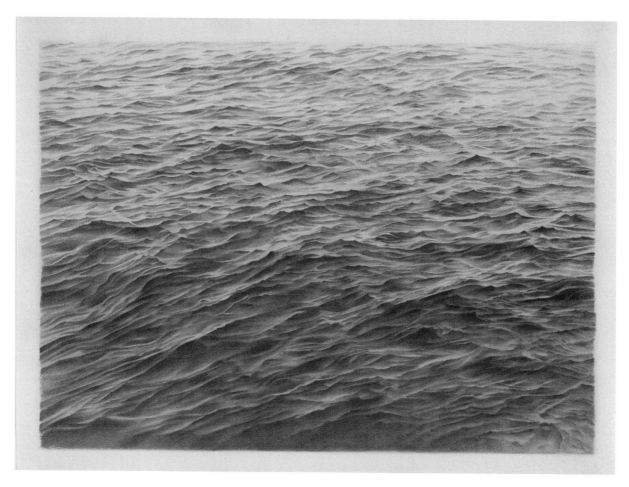

VIJA CELMINS. *Untitled (Ocean)*, graphite on acrylic ground on paper, 36 × 48 cm, 1970. © VIJA CELMINS. MRS. FLORENCE M. SCHOENBORN FUND, DIGITAL IMAGE © MUSEUM OF MODERN ART/LICENSED BY SCALA/ART RESOURCE, NY

family fled to eastern Germany, eventually settling near Esslingen am Neckar (Baden-Württemberg) in the west. In 1948 they moved to the USA, staying briefly in New York before resettling in Indianapolis. Celmins spent much time drawing and painting at school and at home, although she did not yet speak or write English. She studied painting at the John Herron School of Art in Indianapolis (1955–62) and regularly visited New York to see the work of the Abstract Expressionists. After attending the summer session at Yale University, New Haven, where she met a strong community of students and artists, she decided to become a painter (1961). She then attended the University of California, Los Angeles (1962–5). From 1966 Celmins took photographs as subjects for paintings. In painted and drawn works since 1968 she drew upon photographs from books, magazines and those taken by herself, including views of the sea, desert and constellations. In such works as *Moon Surface (Luna 9) No. 1* (1969; New York, MOMA) she carefully built up and layered marks to create a distance between photograph and painting, also calling attention to the paper surface. Her persistent attention to the psychological implications of the artistic process in relation to the formulation of images made the images objects for contemplation. One of her most visually and conceptually challenging works is *To Fix the Image in Memory 9* (1977–82), a series of 11 stones, both real and cast-bronze, painted with acrylic.

BIBLIOGRAPHY

Vija Celmins: A Survey Exhibition (exh. cat., intro. S. C. Larsen; Newport Beach, CA, Harbor A. Mus.; Chicago, IL, A. Club; New York, Hudson River Mus.; Washington, DC, Corcoran Gal. A.; 1980)

W. W. Bartman, ed.: *Vija Celmins (Interviewed by Chuck Close)* (New York, 1992)

Vija Celmins, Work 1964–96 (exh. cat. by J. Lingwood, London, ICA, 1996)

L. Relvea, R. Gober and B. Fer: *Vija Celmins* (London, 2004)

C. Whiting: *Pop L. A.: Art and City in the 1960s* (Berkeley, 2006)

C. Whiting: "'It's Only a Paper Moon': The Cyborg Eye of Vija Celmins," *Amer. A.*, xxiii/1 (Spring 2009), pp. 36–55

Cecile Johnson

Cemetery

Place, usually a ground but sometimes a structure, used for the entombment of the dead. The term derives from the Latin *coemeterium*, an adaptation of *koimetrion* (Gr: "dormitory"). The term was employed by Early Christian writers to describe underground burial places, also known as catacombs or *hypogea*, and it was later applied to the consecrated enclosure attached to a church or even extended to the church building itself. The term has since come to denote a burial ground, especially a large public park or land laid out for the interment of the dead, and in this form it has become distinguished from the "yard" of a church. This article is confined to cemeteries in the Western Christian tradition.

During the Middle Ages the parish graveyard and church were closely associated. In many cities arcaded, cloistered walks lined the perimeters of churchyards. Sometimes the arcades or colonnades were filled with ironwork, turning the cloisters behind into private tombs, as at St Peter in Salzburg (1627). The next development in this method was to fill the spaces between each column or pier so that each bay of the cloister became a family mausoleum; the churchyard of St Mary in Stockholm (first laid out in the 16th century) contains an 18th-century example of this.

The disposal of the dead in populous areas during the 16th, 17th and 18th centuries generally took place in churches and in burial grounds, with few architectural features. Overcrowding and insanitary conditions in many churchyards (especially during times of plague) led to proposals for their replacement. Significantly, some of the earliest attempts to improve conditions were made in Protestant countries, where traditional obligations owed to the dead were being weakened.

During the 18th century the perceived close connection between the living and the dead began to weaken. To enlightened minds the custom of entombing bodies in churches or in heavily populated districts was not only revolting but dangerous, and so numerous burial grounds, set apart from

populous areas, were enclosed. In some cases these were ornamented with built tombs (as at Old Calton Burying Ground in Edinburgh of 1718, where the tomb of *David Hume* has a great Roman drum, 1777–8, designed by Robert Adam), but more usually they were grounds with little or no architectural enrichment. Other cemeteries established outside crowded towns and cities included the Berlin-Kreuzberg cemetery (1735 onward); the Belfast Charitable Institution's Clifton Burying-Ground (opened in 1797); new cemeteries in Sweden that were formed when burial sites within churches were prohibited in 1783; and the St Louis cemetery (*c.* 1790), New Orleans, where the coffins were placed above ground in terraces of oven-like tomb recesses. Characteristic of cemetery design during this period were the regular (usually rectangular) plots of land that were enclosed within walls and laid out with paths and trees, which displayed numbered graves.

In 1799 the quarries of Montmartre were suggested as a site for a garden cemetery in the English landscape-garden style, with winding paths and trees, but the first great landscaped necropolis in modern Europe was Père-Lachaise, laid out in 1805 to designs by Alexandre-Théodore Brongniart. Set on a hill to the east of Paris, it soon became ornamented with house tombs, classical monuments, *stelae* and humbler memorials. By the second decade of the century Père-Lachaise had become the model for a whole generation of new European and American cemeteries in which monuments and mausolea were set off by natural landscape. The finest examples in North America include Mount Auburn (1831), Cambridge, MA, Laurel Hill (1836), Philadelphia, and Green-Wood (1838), Brooklyn, NY.

After 1843 the most influential ideas for cemeteries in English-speaking countries were by John Claudius Loudon, who in his *On the Laying Out of . . . Cemeteries* (1843) advocated what he called a "cemetery style" of planting, using evergreens; he also paid an almost obsessional attention to drainage and hygiene.

A particular 20th-century development was the war cemetery, created after the unprecedented death toll of World War I when the need arose for commemoration on a mass scale. In the war cemeteries of France and Flanders the British Imperial War Graves Commission used designs by some of the leading architects of the period, including Edwin Lutyens, Reginald Blomfield and Herbert Baker; only Classicism, it seemed, could rise to the occasion with dignity and without bathos. This tradition of simple, classical design was continued after World War II. Often names were simply added to existing memorials, for losses on the Allied side were not nearly so great as those of World War I, though the Soviet Union again used a stripped Neo-classicism to commemorate its dead.

In civilian cemeteries there have been two main trends. Lawn cemeteries, in which large mausolea or monuments are positively discouraged in favor of a uniform and anonymous type of commemoration, have become the dominant form in North America. This type has also been promoted elsewhere, largely owing to ease of maintenance and a modern distaste for extravagant show.

BIBLIOGRAPHY

J. C. Loudon: *On the Laying Out, Planting, and Managing of Cemeteries* (London, 1843); intro. by J. S. Curl (Redhill, 1981)

H. Acquier and A. Noel: *Les Cimetières de Paris: Ouvrage historique, biographique et pittoresque* (Paris, 1852)

W. Robinson: *God's Acre Beautiful, or the Cemeteries of the Future* (London, 1880)

A. A. Coussillan: *Les 200 Cimetières du vieux Paris* (Paris, 1958)

R. Auxelles: *Dernières demeures* (Paris, 1965)

P. Ariès: *L'Homme devant la mort* (Paris, 1977); Eng. trans. as *The Hour of our Death* (Harmondsworth, 1981)

J. S. Curl: *Mausolea in Ulster* (Belfast, 1978)

J. S. Curl: *A Celebration of Death: An Introduction to Some of the Buildings, Monuments and Settings of Funerary Architecture in the Western European Tradition* (London, 1980)

R. Etlin: *The Architecture of Death: The Transformation of the Cemetery in 18th-Century Paris* (Cambridge, MA, 1984)

C. Fischer and R. Schein, eds: "O Ewich is so lanck": *Die historischen Friedhöfe in Berlin-Kreuzberg* (Berlin, 1987)

J. S. Curl: *The Victorian Celebration of Death* (Stroud, Gloucestershire, 2000)

J. S. Curl: *Death and Architecture* (Stroud, Gloucestershire, 2002)

James Stevens Curl

Centennial Exposition

The 1876 International Exhibition of Arts, Manufactures and Products of the Soil and Mine, familiarly known as the "Centennial Exhibition," took place in Philadelphia's Fairmount Park from 10 May until 10 November 1876. Within the 236-acre fairgrounds, 249 buildings were erected to house exhibits from 36 participating nations, attracting nearly ten million visitors over the Exhibition's six-month duration. The first of such international exhibitions held in the USA, the Centennial Exhibition was commercial in nature, but was also intended to commemorate the 100th anniversary of the nation's birth. Held in the wake of the traumas of the Civil War, the failures of Reconstruction and the economic depression following the Panic of 1873, the Centennial Exposition offered a strategic opportunity to generate patriotic pride in the nation's triumphs and accomplishments as the country struggled to regain its economic and social health. Centennial officials generally agreed that the nation's history should be remembered as a groundswell of progress, a continuous movement culminating in a host of successes to be celebrated at the grand exhibition.

Among the most popular Centennial attractions was the art exhibition, housed in Memorial Hall, which was situated on what was arguably the finest space on the fairgrounds, and the Art Annex, immediately to its rear. Appropriately titled, Memorial Hall was distinguished as a permanent building intended to stand as a commemorative monument long after other exhibition buildings were dismantled following the close of the event. Designed by architect H. J. Schwartzmann, the highly ornamental Memorial Hall was designed around a core gallery nearly twice the size of any other hall in the country, and offered a total of 7000 sq. m of wall space and *c.* 1800 sq. m of floor space to display over 2500 paintings, prints and drawings, sculpture and applied art from 17 contributing nations.

The organization and management of Memorial Hall and the Art Annex fell under the direction of Philadelphia engraver John Sartain, Chief of the Bureau of Fine Art. Although he worked in conjunction with an Advisory Committee, a Committee on Selection, and a Committee on Arrangement composed of artists, collectors and museum officials from New York, Philadelphia and Boston, Sartain exercised liberal personal authority in his charge. Granting far more exhibition space to American artists than to any foreign contributor, Sartain devised an exhibition in which American art was highly privileged, resulting in the art exhibition as a whole being primarily an American venture. Filling more than one quarter of the available wall and floor space in Memorial Hall and almost the entire western side of the Art Annex, American contributions exceeded 1300 objects, more than half of the submissions from all other countries combined, and was the largest display of historic and contemporary American art ever before attempted.

The context within which the art exhibition was to be understood accorded with the official Centennial organizers' goals of celebrating the unity, strength and prosperity of the national community. Nationalism was a prominent concern in assessments of the American display, not only with the presence of subject matter that glorified the American past, such as Gilbert Stuart's renowned Lansdowne *George Washington* (1796; Washington, DC, N.P.G.) and Eastman Johnson's nostalgic *The Old Stagecoach* (1871; Milwaukee, WI, A. Mus.), but also with the vehement and relentless accusations of the impropriety of Peter Frederick Rothermel's antagonistic *The Battle of Gettysburg: Pickett's Charge* (*c.* 1868–70; Harrisburg, PA, State Mus.), a colossal painting (4.8×9.8 m) of unrestrained and violent Civil War combat, which served as the centerpiece in the American galleries. The most prevalent genre of American art was landscape, described as "national" in nature, which was championed by accomplished Hudson River school artists trained in the USA and associated with the conservative National Academy of Design in New York. These authoritative artists were challenged at the Centennial

by younger, European-trained American artists from Boston and Philadelphia who favored figurative subjects depicted with rich colorism and interpretive, loose brushwork over the precision and clarity of the nativist school landscapes. In response to this contest, the two factions of American artists initiated a dialog to define the parameters an American Art canon. By taking stock of their art historical past and determining the direction of its future, American artists and critics attempted to synthesize a coherent and inclusive narrative of American art history, which found its basis in the in the Centennial rhetoric of progress, advancement and national unity.

[*See also* Sartain, John, Emily and William.]

BIBLIOGRAPHY

E. Robey: "John Sartain and the Contest of Taste at the Centennial," *Philadelphia's Cultural Landscape: The Sartain Family Legacy*, ed. K. Martinez and P. Talbott (Philadelphia, 2000)

S. W. Gold: *Imaging Memory: Re-Presentations of the Civil War at the 1876 Centennial Exhibition* (PhD thesis., Philadelphia, U. PA, 2004)

K. Orcutt: *"Revising History": Creating a Canon of American Art at the Centennial Exhibition*, (PhD thesis, New York, City U.#, 2005)

S. W. Gold: "The Impediment of History: Building a National Memory at the 1876 Centennial Exhibition," *Many Things Forgotten: Collective Memory and the Rise of Americanism on Unstable Subjects: Practicing History in Unsettled Times: American Historical Association Annual Conference, Atlanta, GA, January 2007*

K. Orcutt: "H. H. Moore's Almeh and the Politics of the Centennial Exhibition," *Amer. A.*, xxi/1 (Spring 2007), pp. 50–73

S. W. Gold: "'Fighting the Battle over Again': *The Battle of Gettysburg* at the 1876 Centennial Exhibition," *Civil War History*, liv/3 (Sept 2008), pp. 277–310

Susanna W. Gold

Ceracchi, Giuseppe

(*b* Rome, 4 July 1751; *d* Paris, 30 Jan 1801), Italian sculptor, active also in England and the USA. He is best known for his portrait busts of the heroes of the American Revolution, executed during his two visits to the USA (1791–2 and 1794–5), where he made a significant contribution to the introduction of Neo-classicism. The son of a goldsmith, he studied in Rome with Tommaso Righi (1727–1802) and at the Accademia di S. Luca. Following his arrival in London in 1773, Ceracchi worked for Agostino Carlini (*c.* 1718–90) and modeled architectural ornament for Robert Adam (1728–92). He also taught Anne Seymour Damer (1748–1828) to model in clay, and *c.* 1777 he produced a life-size terracotta statue of her as the *Muse of Sculpture* (marble version, London, BM) holding one of her own works, a *Genius of the Thames*. His bust of *Admiral Keppel* (marble version, 1779; Mausoleum, Wentworth Woodhouse, S. Yorks) was considered "extremely like" by Horace Walpole when the terracotta model (1777; London, RA) was shown at the Royal Academy in 1777. Ceracchi produced the only bust of *Sir Joshua Reynolds* (1778; terracotta and marble versions, London, RA), modeled from life, although the finished marble may not be his work. The portrait is based on Roman busts of Emperor Caracalla. In 1778 Ceracchi also worked with Agostino Carlini on the sculptural decoration of Somerset House, London, producing figures of *Temperance* and *Fortitude* in Portland stone for the Strand façade.

The historical groups and busts that Ceracchi exhibited at the Royal Academy from 1776 to 1779 reflect high ambitions. In 1779 he exhibited a design for a monument to *William Pitt the Elder, Earl of Chatham*, which failed to win a commission. In the same year his second attempt to be elected an ARA proved unsuccessful. These setbacks probably prompted Ceracchi's departure for Vienna, where he made enquiries concerning the likelihood of employment in the USA. He then traveled to Rome via Amsterdam. In 1785 he was commissioned to execute a monument to *Baron Derk van der Capellen*, the Dutch champion of American liberty. Ceracchi had carved the group, comprising four colossal statues, in Rome by 1789, but was not paid; the figures eventually found a home in the gardens of the Villa Borghese. In Rome he made friends with Johann

Wolfgang von Goethe, who recorded that he carved a bust of *Winckelmann* (untraced).

Ceracchi left Europe in 1790, arriving in Philadelphia in 1791; he hoped to receive the commission for the monument to *George Washington* that Congress had resolved to erect as early as 1783. Although he produced models for an elaborate allegorical monument "perpetuating the memory of the American Revolution," the scheme was not realized. By way of soliciting support for the commission, however, Ceracchi began to model a series of portrait busts of prominent Americans, in Philadelphia, New York and Boston. Around 36 busts were eventually produced, notably marble portraits of *Benjamin Franklin* (Philadelphia, PA Acad. F.A.), *Alexander Hamilton* (New York, Pub. Lib.) and several of George Washington (e.g. New York, Met.). Other than that by Jean-Antoine Houdon (1741–1828), Ceracchi's bust of *George Washington* in New York is the only one to have been modeled from life.

In 1792 Ceracchi traveled to Amsterdam, Mannheim and Rome, where he began a monument to the unification of the Bavarian and Palatine states under the rule of the Elector Palatine (not completed). However, his Republican sympathies made him unpopular in Rome, and in 1794 he returned to Philadelphia, where he produced a revised version of his monument to Washington with the image of the statesman replaced by the Goddess of Liberty. In 1795 Ceracchi went to France. Around 1800 he received a number of official commissions for portrait busts (e.g. *General Massena* and *General Bernadotte*, both untraced). His unsteady career concluded in Paris when he joined an anti-Bonaparte conspiracy and was discovered and sent to the guillotine. J. T. Smith recorded a story, perhaps apocryphal, that Ceracchi rode to the scaffold dressed as a Roman emperor in a chariot he had designed for the occasion, having been disowned by the painter Jacques-Louis David (1748–1825) with whom he had apparently been living. His portrait, by John Trumbull, is in the Metropolitan Museum of Art, New York.

BIBLIOGRAPHY

Gunnis; Thieme–Becker

J. T. Smith: *Nollekens and his Times* (London, 1828), ii, p. 56

U. Desportes: "Giuseppe Ceracchi in America and his Busts of George Washington," *A.Q.* [Detroit], xxvi (1963), pp. 140–79

W. Craven: "The Origins of Sculpture in America: Philadelphia, 1785–1830," *Amer. A. J.*, ix/2 (Nov 1977), pp. 4–33

P. Potter-Hennessey: "The Italian Influence on American Political Iconography: The United States Capitol as Lure and Disseminator," *American Pantheon: Sculptural and Artistic Decoration of the United States Capitol* (Athens, OH, 2004), pp. 23–58

Julius Bryant

Ceramics

Although Native Americans had a long-established pottery tradition, Europeans brought their own techniques when they began to colonize North America after 1600. Small potteries in most Dutch, English, French and Spanish settlements successfully made bricks, roof tiles and utilitarian earthenware for kitchen, dairy and tavern use. However, little if any of this material can be classified as art in the academic sense.

1800–c. 1900. The American ceramics industry developed dramatically during the 19th century as the population grew and spread to the West and the demand for finer products increased. Artistic concerns also increased among the potteries, driven especially by the rise of exhibition venues such as the great world's fairs beginning in the 1850s. Annual regional fairs were also influential, especially those held in Boston, New York City and Philadelphia. By 1885 a variety of wares were produced, including industrial stoneware, decorative tiles, earthenware for kitchen, table and sanitary uses, art pottery and art porcelain.

Earthenware and stoneware. After 1800 red earthenware continued to be made, while an increasing number of potteries adopted salt-glazed stoneware as a viable product. For both wares greater competition engendered more decoration, and

regional characteristics can thus be more readily identified in wares made after 1800. Today, this material is routinely classified as folk art. New England redware, for example, displays colorful effects obtained by firing the wares in a reducing atmosphere that forced the lead glazes to "bloom" in contrasting colors around trace imperfections in the body or glaze. The region around New York Bay from coastal Connecticut to northeastern New Jersey produced wares with a distinctively bold use of trailed white slip on a bright red body. Decorations included geometric ornament, spirals, birds, names, mottoes and aphorisms. The same aesthetic was translated into brilliant cobalt blue slip trailed on to gray, salt-glazed stoneware made during the mid-19th century inland from the bay area in New Jersey, but especially north along the Hudson River and Erie Canal in New York state. A menagerie of animals, whimsical birds and human figures engaged in humorous activities were used on the pots and jugs from this region. Outside Philadelphia, in southeastern Pennsylvania, the use of highly stylized *sgraffito* and slip decoration of the previous century continued unabated in the German settlements until at least 1840, especially on presentation pieces made only for display.

Sculptural press-molding and Rockingham glaze treatment (wares with a brown mottled glaze) were introduced to American potteries by English potters coming from the overcompetitive industry in Staffordshire. In 1828 D. & J. Henderson purchased a pottery in Jersey City, NJ, and began making high-quality brown-glazed pottery, and later Rockingham, in molds for the first time in the USA. This operation, renamed the American Pottery Manufacturing Co. in 1833, is thought to have been the first true pottery factory in the USA in which a large number of skilled potters, semi-skilled workers and laborers were organized to mass produce good-quality tableware. Their modeler between 1839 and 1850 was the industry-trained Englishman Daniel Greatbach, who introduced the classic Hound-handle pitcher (e.g. Newark, NJ, Mus.; Trenton, NJ State Mus.) to the American potter's repertory, a form that was popular for the rest of the century. While in Jersey City, he also made large, fine Toby jugs, vine-covered tea sets and an "Apostle" jug. By 1852 he was employed by the United States Pottery Co. in Bennington, VT, to produce exhibition pieces for the Crystal Palace Exhibition of 1853 in New York. In Bennington, Greatbach used the "flint enamel" glaze developed by Christopher Webber Fenton (1806–65), as in the "Apostle" pattern water cooler (1849; New York, Brooklyn Mus. A.) attributed to him and made at Lyman, Fenton & Co.

The manufacture of press-molded wares provided the cornerstone for the development of America's two most important ceramic centers in the 19th and early 20th centuries: East Liverpool, OH, and Trenton, NJ. Manufacturers in each city were able to take advantage of water and rail transportation networks to serve highly populated areas. As capital investment increased so did the desire to produce finer wares capable of recognition at the great fairs.

Utilitarian stoneware was used throughout the later 19th century, although more for industrial applications than for homes, where such lighter materials as tin and glass were used for storage. After 1850 many of the stoneware potteries switched to industrial products (e.g. drainage tiles) as their mainstays. At these companies a folk tradition developed of making sculpture using the coarse stoneware clay. Subjects were generally idiosyncratic and humorous.

Some of the most imaginative stoneware was made in utilitarian potteries during the second half of the 19th century in Ohio and Illinois, at a time when the Renaissance and Rococo revival styles coincided with a decline in handcraft. This denouement generated some extravagant and original sculptural work; Wallace Kirkpatrick (1828–96) and Cornwall Kirkpatrick (1814–90) of Anna, IL, for example, made stoneware temperance jugs covered with writhing lifelike snakes. Their pig-shaped whisky flasks with railroad maps inscribed on the side were metaphors for corn production and consumption in

the Midwest. A distinctly different tradition in stoneware developed in the southern states, where potters preferred alkaline to salt glaze.

Wood ash was a commonly used flux in the mixtures with sand and clay that produced glassy green glazes ranging from clear pale celadon to dripping dark effects later called "tobacco spit." In the late 20th century North Carolina and Georgia continued to be known for the production of traditional alkaline-glazed stonewares. Jugs in the shape of heads with humorous faces continued to evolve as a form of folk art among these potters.

Art wares. The making of art ceramics in the USA received little encouragement until the 1880s: before 1800 Americans depended on English merchants to supply fine ceramics, and after the American Revolution, when trade conditions were more favorable to manufacturers, consumers already preferred wares from England, Europe and China. Porcelain was rarely produced with much commercial success until after the Civil War.

In 1849 Christopher Webber Fenton established the firm that would become the United States Pottery Co. in Bennington, VT, which made Parian figures, pitchers and vases. Charles Cartlidge & Co. in Greenpoint, NY (1848–56), made soft-paste porcelain doorknobs and buttons, but is best known for the Parian portrait busts and low-relief porcelain pitchers in his display in the New York Crystal Palace Exhibition of 1853. In 1863 William Boch and Bros' Union Porcelain factory became Thomas C. Smith's (1815–1901) Union Porcelain Works, where the first hard-paste porcelain was made c. 1865.

In Trenton, porcelain was produced at least as early as 1854 by William Young (1801–71), who had worked for Cartlidge, but his stock in trade remained hardware trimmings. In the 1860s William Bloor (1821–77) introduced parian manufacture to East Liverpool. Although this venture was a false start, his partnership in the late 1860s with Joseph Ott and John Hart Brewer in Trenton bore fruit. Ott & Brewer (1863–93) continued to make Parian portrait busts after Bloor's departure, and in 1875 they hired the sculptor Isaac Broome to prepare models for exhibition pieces to be shown at the Centennial International Exhibition of 1876.

In a similar move, Thomas Smith hired German sculptor Karl Müller (1820–87) for the Union Porcelain Works. Each sculptor produced several models for exhibition and sale, but for size and complexity Müller's "Century" vase (e.g. Atlanta, GA, High Mus. A.; New York, Brooklyn Mus. A.; New York, Met.; Trenton, NJ State Mus.) and Broome's "Baseball" vase (1875; Trenton, NJ State Mus.) were their principal contributions and rank as the USA's first major ceramic exhibition sculpture. Indeed, Broome's "Baseball" vase was the first piece of clay officially classified as art when it was moved from the industrial building to the art exhibit. In Broome's large covered vase, which honors contemporary sport, throwing, catching and batting are depicted by three figures arranged around a cone-shape faggot of bats topped by a baseball on which an American eagle sits. Müller's vase is historical in terms of both the modeled and the painted decoration, which celebrates the virgin land and early republic.

Ott & Brewer persisted in the development of American art porcelain by producing a version of Belleek beginning in 1883. This was decorated in the Aesthetic taste with gold encrustations, delicate flowers and flying cranes. In 1887, after his success as art director at Ott & Brewer, Walter Scott Lenox took the same concept for art porcelain to the Willets Manufacturing Co., a rival Trenton firm, where his famous nautilus-shell ewer (titled "The Cupid Jug") was first produced. In 1889 Lenox founded the Ceramic Art Co., which specialized exclusively in porcelain art wares, a radical idea in the American ceramics industry. Lenox hired leading painters from foreign factories and the large porcelain vases became three-dimensional canvases for painting portraits, beautiful heads, landscapes (both fanciful and real), and flowers. Unlike traditional canvasses, which have margins, the use of round forms allowed the painting to be horizontally continuous (and theoretically endless).

During the 1870s Maria Longworth Nichols, later Mrs. Storer (1849–1932), and Mary Louise McLaughlin (1847–1939), both from Cincinnati, OH, were learning to decorate china and were impressed with the painterly style of the slip-decorated pottery exhibited by Haviland & Co. of Limoges at the Centennial Exhibition of 1876, as well as with the art wares sent by Japan to the same exhibition. In 1878 McLaughlin successfully imitated the slip-decorated effect, although not the process, and in 1880 Nichols established the Rookwood Pottery in Cincinnati to produce the wares. Nichols later hired Japanese designers, such as Kataro Shirayamadani (1865–1948), to work at Rookwood. Rookwood's style was often copied by such later Ohio companies as the Weller Pottery (1888–1948) and the Roseville Pottery (1898–1954). The painterly slip decoration of Rookwood contrasted with the Chinese-style wares with monochromatic glazes that were produced by Hugh Cornwall Robertson in his family's Chelsea Keramic Art Works (1872–89) in Chelsea, MA. In 1895 a new pottery was established in Dedham, MA, using Robertson's distinctive crackled glaze for dinnerware, decorated in cobalt blue with stylized flowers and animals. Robertson used the dinnerware as the income-producing base for his continued experiments with glaze effects that are widely appreciated among connoisseurs today.

Other important American art wares of the late 19th century included those made by William Henry Grueby between 1894 and 1913. Inspired by the work of the French art potter Auguste Delaherche, Grueby's art wares combined monochromatic flowing matte glazes with organic low-relief designs. The Newcomb Pottery in New Orleans, LA, developed a distinctive regional style by rendering local flora in stylized patterns in a limited color palette. The pottery employed art graduates from the Newcomb College for Women, to which it was connected, from 1895 to 1940. Master potter George E. Ohr (1857–1918), of Biloxi, MS, produced artistic redwares of unusual character between 1890 and 1910.

His work was wheel-thrown to exquisite thinness and then adeptly altered with twists and frills. Many see his work as the beginning of expressionistic ceramic sculpture.

After c. 1900. American ceramics matured as both industry and art during the 20th century, and much of this development came from the institutionalization of ceramics education. Important ceramics and clayworking courses were established in the late 19th and early 20th centuries at such universities as Ohio State University, Columbus; Alfred University, Alfred, NY; Rutgers University, New Brunswick, NJ; and the University of Illinois, Urbana–Champaign. Such courses trained engineers, chemists and industrial designers as well as artist-potters. Independent potters began to think of themselves as artists in the same way as painters and sculptors; they were associated primarily with small, hand-production potteries, serving a giftware market created by the Arts and Crafts Movement, and later operated their own studios.

Production ceramics. Modernization of factory technology was necessary to meet increased demand profitably by the production potteries. At the same time these potteries began to give increased emphasis to design after World War I. The postwar environment required greater creativity in the potteries as arts organizations began to embrace design as an art form.

One of the most successful tableware firms to respond to these pressures was the Homer Laughlin China Co. In 1927 Frederick Hurten Rhead became its art director. He advocated the combination of formal industrial art education and factory apprenticeship and suggested that knowledge of advanced technology, design and marketing methods would help manufacturers create inexpensive, serviceable products for the American mass market. The success of Rhead's Fiesta ware, introduced by Homer Laughlin in 1936, continues today.

Rhead's advice was followed by many potteries that hired design-school graduates and/or consultant designers who created a single product or

product line that could be promoted for its artistic design qualities. The streamlined "American Modern" dinnerware line (1939) designed by Russel Wright for the Steubenville Pottery Co. (1879–1960), Steubenville, OH, is probably the best-known example of the latter type of relationship. Similarly, the "Museum" dinner service designed in 1942–3 by Eva Zeisel (*b* 1906) and produced by the Castleton China Co., New Castle, PA, for MOMA in New York had the added cachet of recognition by an arts institution.

Art wares. In the early 20th century art ceramics were still made largely by the small art potteries that were founded under the Arts and Crafts Movement. Such pioneering firms as the Rookwood Pottery, the Newcomb Pottery (1895–1931) and the Dedham Pottery (1896–1943) survived until at least the middle of the 20th century. In contrast a host of small art potteries were established and capitalized for a short time on the distinctive artistic inventions of their founders: Clewell Metal Art (1906–*c*.1920), Canton, OH, produced earthenwares covered in a patinated metal, a process developed by Charles Walter Clewell (*c*. 1876–1965); the Tiffany Pottery (1904–*c*. 1919), Corona, NY, of Louis Comfort Tiffany, made wares with matte, crystalline and iridescent glazes; the Clifton Art Pottery (1905–11), Newark, NJ, specialized in shapes and decorations modeled after early American Indian pottery; the Markham Pottery of Ann Arbor, MI (1905–13), and National City, CA (1913–21), produced redware vases with applied finishes that made them resemble archaeological relics; in 1909 the Fulper Pottery (1860–1935), Flemington, NJ, began using its 19th-century utilitarian stoneware body to make "Vasekraft" wares, created by the German designer J. Martin Stangl (*d* 1972), which were covered with colorful crystalline, flambé and monochromatic glazes.

Several art potteries founded during the early 20th century operated for many years because their products filled particular market niches. The work of the Van Briggle Pottery (1901) in Colorado Springs, CO, is based on the artistic concepts of Artus Van Briggle (1869–1904), who modeled Art Nouveau vases with designs adapted from American flora. Many of his original designs continued to be used after his death. The Pewabic Pottery (1903–61) was founded by Mary Chase Perry (1868–1961) in Detroit, MI, and specialized in the development of iridescent glazes on flat tiles or simply shaped vases. The firm's broad, flat, pictorial designs for tile installations were particularly popular with ecclesiastical customers. The vases appealed to collectors of American Impressionism, such as industrialist Charles Lang Freer (Freer Gallery, Washington, DC).

About 1920 Jacques Busbee and Juliana Busbee founded the Jugtown Pottery as a way of preserving the dying craft of pottery-making in rural North Carolina. Although most of this pottery's earthenware and stoneware was of a traditional American character, the potters also made elegant Chinese-inspired forms with white or transmutational turquoise and red glazes.

Several individual potters were important figures during the first quarter of the 20th century because of their roles in the market evolution that turned art potters into studio potters and in the recognition of clay as a legitimate medium for art. Charles Fergus Binns was the first director of the New York State School of Clayworking and Ceramics at Alfred University, which continues to be one of the foremost American schools for ceramic artists following its foundation in 1900; Adelaide Alsop Robineau (1865–1929) had a distinguished career as a potter, publisher, editor and teacher and in 1932 inspired the establishment of the Ceramic National Exhibitions; and R. Guy Cowan (1884–1957) believed that art and industry could be profitably united. In Cowan's Rocky River Pottery, near Cleveland, OH, such young ceramic artists as Waylande Gregory (1905–71), Viktor Schreckengost (1906–2008) and Edris Eckhardt (1910–98) designed limited edition vases and figures. After the firm closed in 1930 each of these artists continued to work in clay: Gregory worked as a sculptor in New Jersey, and his *Fountain of Atoms* for the World's Fair of 1939 in New York is considered the largest single work in modern ceramic sculpture; during the 1930s

Schreckengost was a designer for the production dinnerware potteries in Sebring, OH, but continued to produce small clay sculptures and important public tile installations; and Eckhardt, although later a glass artist, led a distinguished sculpture program (1933–41) for the Works Progress Administration in Cleveland, OH.

Prior to World War II American potters continued to draw from English and European models and aesthetic ideas. Vally Wieselthier (1895–1945) and Susi Singer (1891–1955) settled in the USA and brought with them a playful, colorful, figural style, which they had learned from Michael Powolny of the Wiener Werkstätte. Henry Varnum Poor (1888–1971) explored Cubism in ceramic decoration, using the *sgraffito* technique on earthenware. Charles M. Harder (1889–1959) at Alfred University and Arthur Eugene Baggs at Ohio State University adhered to the emphasis on a technically proficient vessel style that they had learned as students under Charles Fergus Binns at Alfred University. In 1939 the Austrian potters Otto Natzler (1908–2007) and Gertrude Natzler (1908–71) settled in Los Angeles and concentrated on combining elegant, classical forms with colorful and textural glaze effects. The Finnish potter Maija Grotell exerted a profound influence on American art ceramics as an experimental, vessel-oriented potter and as an instructor (1938–66) at the Cranbrook Academy of Art in Bloomfield Hills, MI. Her foremost students included Toshiko Takaezu (b 1929), Richard DeVore (1933–2006), John Glick (b 1938), Susanne Stephenson (b 1935) and John Stephenson (b 1929), who remained major figures in late 20th-century art ceramics as artists and teachers.

After World War II influences on ceramics were more varied. The group of young potters who were associated with Peter Voulkos at the Otis Art Institute in Los Angeles (1954–8) produced a large and diverse body of work that drew inspiration from Japanese ceramics, American Abstract Expressionist painting and improvisational jazz. As a result of the high level of expressive experimentalism that

Voulkos brought to his work, such as his stoneware stack pot, he was a very influential figure in postwar American ceramics. Many of his students, including Paul Soldner (b 1921), Jim Melchert (b 1930), Stephen De Staebler (b 1933), Kenneth Price, Michael Frimkess (b 1937) and Ron Nagle (b 1939), became successful potters in the late 20th century. Melchert and Price preferred to work in porcelain, exploiting its whiteness, fine texture and translucent nature. Porcelain was also preferred by such potters as Rudolf Staffel (1911–2002), Herbert Sanders (b 1909), Robert Hudson, Richard Shaw (b 1941) and Adrian Saxe (b 1943). David Gilhooly (b 1943) and Robert Arneson were the central force behind a ceramic genre called "Funk," which was inspired by Dada and Surrealist sculpture and was a protest against conventional notions of subject matter and propriety. Such potters as Robert Turner (1913–2005), Karen Karnes (b 1920), Val Cushing (b 1931), Kenneth Ferguson (b 1928), David Weinrib (b 1924) and Daniel Rhodes (1911–89), were trained at Alfred University and had a more reserved approach to the medium.

BIBLIOGRAPHY

E. A. Barber: *The Pottery and Porcelain of the United States: An Historical Review of American Art from the Earliest Times to the Present Day* (New York, 1893, rev. 3/1909/R New York, 1976)

E. A. Barber: *Tulip Ware of the Pennsylvania-Germans: An Historical Sketch of the Art of Slip-decoration in the United States* (Philadelphia, 1903)

L. W. Watkins: *Early New England Potters and Their Wares* (Cambridge, MA, 1950)

R. C. Barrett: *Bennington Pottery and Porcelain* (New York, 1958)

Abstract Expressionist Ceramics (exh. cat., Irvine, U. CA, 1966)

D. B. Webster: *Decorated Stoneware Pottery of North America* (Rutland, 1971)

P. Evans: *Art Pottery of the United States: An Encyclopedia of Producers and Their Marks* (New York, 1974, rev. 1987)

R. Kovel and T. Kovel: *The Kovels' Collector's Guide to American Art Pottery* (New York, 1974)

G. Clark: *A Century of Ceramics in the United States, 1878–1978: A Study of its Development* (New York, 1979)

American Decorative Tiles, 1870–1930 (exh. cat. by T. P. Bruhn, Storrs, U. CT, Benton Mus. A, 1979)

H. V. Bray: *The Potter's Art in California, 1885 to 1955* (Oakland, 1980)

G. H. Greer: *American Stonewares: The Art and Craft of Utilitarian Potters* (Exton, 1981)

A. K. Winton and K. B. Winton: *Norwalk Potteries* (Norwalk, 1981)

R. I. Weidner: *American Ceramics before 1930: A Bibliography* (Westport, 1982)

R. Anderson and B. Perry: *Diversions of Keramos: American Clay Sculpture, 1925–1950* (Syracuse, NY, 1983)

J. D. Burrison: *Brothers in Clay: The Story of Georgia Folk Pottery* (Athens, GA, 1983)

S. R. Strong: *History of American Ceramics: An Annotated Bibliography* (Metuchen, 1983)

J. Poesch: *Newcomb Pottery: An Enterprise for Southern Women, 1895–1940* (Exton, 1984)

E. Denker and B. Denker: *The Main Street Pocket Guide to North American Pottery and Porcelain* (Pittstown, 1985)

E. Denker: *"Forever Getting Up Something New": The Kirkpatricks' Pottery at Anna, Illinois, 1859–1896* (Champaign–Urbana, IL, 1986)

C. G. Zug III: *Turners and Burners: The Folk Potters of North Carolina* (Chapel Hill, 1986)

R. Blaszczyk: *Product Development in the American Tableware Industry, 1920–1945* (MA thesis, Washington, DC, George Washington U., 1987)

A. C. Frelinghuysen: *American Porcelain, 1770–1920* (New York, 1989)

S. J. Montgomery: *The Ceramics of William H. Grueby: The Spirit of the New Idea in Artistic Handicraft* (Lambertville, 1993)

N. Karlson: *American Art Tile, 1876–1841* (New York, 1998)

E. Denker: *Faces and Flowers: Painting on Lenox China* (Richmond, VA, 2009)

Ellen Denker

Cha, Theresa Hak Kyung

(*b* Busan, 4 March 1951; *d* New York, 5 Nov 1982), Korean artist and writer, active in the USA. Cha was born and raised in Busan, Korea, moving to Hawaii with her parents in the mid-1960s, and then later to San Francisco. Trained in French from early adolescence, she studied comparative literature at the University of California, Berkeley, including the works of Stéphane Mallarmé. As part of her theoretical studies, Cha also majored in visual art, first concentrating on ceramics and then moving to performance-based work under the tutelage of James Melchert (*b* 1930). After graduating in both disciplines in 1973 and 1975, respectively, Cha continued her studies in visual art at the University of California, Berkeley, receiving an MFA in 1978. During this time, she studied abroad in Paris at the Centre d'Etudes Américain du Cinéma in 1976, working with psychoanalytic theorists such as Christian Metz and Raymond Bellour. Works created during this time were based on symbols, the manipulation of language via experimentation with font, scale and the placement of words, and cinematic devices such as the fade.

Cha worked in a variety of media, including artist's books, performances and videos. The video *Mouth to Mouth* (1974) depicted a close-up of the artist silently mouthing the vowels of the Korean alphabet. In the performance *Aveugle Voix* (1975), Cha bound and gagged herself with white bands of material upon which were printed the words "aveugle" (blind) and "voix" (voice). Other crucial elements in Cha's work included sound and the variation of the speed of physical movement. Several works created during this time also had titles that played upon the relationship between similarities in pronunciation and differences in meaning such as *Amer* (1976). The word "amer" (bitter), is printed in ink on one side of an actual American flag. Although her work tended not to make explicit reference to specific political events, Cha was to continue her exploration of ideas of nationhood and national and ethnic identity for the remainder of her life. In 1979 Cha visited Korea for the first time since her departure and, partly motivated by her visit there, she made *Exilée*, a 50-minute film exploring various aspects of the state of exile through memory and language.

In 1981 Cha moved to New York to teach video art at Elizabeth Seton College. At this time she became increasingly interested in making sculptural works. She also completed work on *Dictée*, an artist's book that explores the most critical themes of Cha's work through the stories of several actual and fictional women, including the artist herself. The book incorporated a vast range of influences ranging from her

early training in semiotic theory to key characters in Korean history. Significant not only for its deconstructionist approach, it is also one of the first literary and artistic works to specifically address issues of memory and displacement as related to constructions of Korean and Asian-American identity. *Dictée* was published just prior to Cha's death in 1982.

WRITINGS
Étang (Berkeley, CA, 1979)

Dictée (New York, 1982)

BIBLIOGRAPHY
Theresa Hak Kyung Cha (1951–1982): Echoes (exh. cat., Oakland, CA, Mills Coll., 1982)

N. Alarcón and E. Kim, eds.: *Writing Self, Writing Nation: A Collection of Essays on* Dictée *by Theresa Hak Kyung Cha*, with essays by H. Y. Kang and others, design and artwork by Y. S. Min (Berkeley, CA, 1994)

J. Purdom: "Mapping Difference," *Third Text*, no. 32 (Autumn 1995), pp. 19–32 [with bibliography]

M. E. Vetrocq: "Conceptualism: An Expanded View," *A. Amer.*, 87/7 (July 1999), pp. 72–7, 14

Y. T. Lin: "Theresa Hak Kyung Cha (1950–1982)," *Asian American Novelists: A Bio-Bibliographical Sourcebook*, ed. E. S. Nelson (Westport, CT, 2000)

The Dream of the Audience: Theresa Hak Kyung Cha (1951–1982) (exh. cat., Berkeley, CA, Berkeley A. Mus., 2001)

D. Chong: "Korean American Views: On Exile, Travel and Belonging," *A. Asia Pacific*, no. 29 (2001), pp. 27–9 [with bibliography]

Art/Women/California 1950–2000: Parallels and Intersections (exh. cat., eds. D. B. Fuller and D. Salvioni, with numerous essays by others, San Jose, CA, San Jose Mus. A., 2002)

U. M. Probst: "Theresa Hak Kyung Cha: Der Traum des Publikums," *Kunstforum Int.*, 171 (July–Aug 2004), pp. 388–90

M. Yoshimoto: "Woomen Crossing the Borderlines," *A. Asia Pacific*, 44 (Spring 2005), pp. 42–44

R. Jennison: "Borderline Cases: 'For Women on the Borderlines,'" *N. Paradoxa*, 15 (2005), pp. 18–23

H. Kim: "Depoliticizing Politics: Readings of Theresa Hak Kyung Cha's *Dictée*," *Changing English*, 15/4 (Dec 2008), pp. 467–75

Joan Kee

Chaco Canyon

Archaeological zone of Pre-Columbian towns and roads in North America, in the San Juan Basin, northwestern New Mexico. Chaco Canyon was the center of Chacoan culture from *c.* AD 850–1150, one manifestation of the Anasazi tradition, and considered ancestral to contemporary Pueblo peoples of the Southwest. A community of at least 12 multistory, tiered "great houses" and hundreds of contemporaneous single-story "small house sites" were built within a 15-km sector of the canyon. Great houses were constructed with core walls with veneer masonry and ranged from 80 to 580 rooms. Small houses were of simpler masonry and averaged about 20 rooms each. Both types were domestic structures, but also contained round ceremonial rooms known as *kivas*. "Great *kivas*," up to 18 m in diameter, are restricted to great houses or occur as isolated buildings. Great houses are associated with elaborate water-control systems that collected and diverted rainfall runoff to gridded agricultural fields. Great houses in the canyon itself were linked to "outlier" communities on the peripheries of the San Juan Basin by wide (*c.* 9 m), relatively straight, cleared and often bordered roads. "Outliers" usually comprised one or more great houses, numerous small house sites and occasionally a great *kiva* and were located about 15 to 200 km from Chaco Canyon. Such attributes of Chacoan architecture as core and veneer masonry and square masonry columns, plus certain imported items, such as parrots and copper bells (Washington, DC, Smithsonian Inst.), are cited as evidence of Mesomerican influence or even domination of Chacoan culture, but most other data support indigenous development. Major collections of Chacoan artifacts are held by the American Museum of Natural History, New York, the Maxwell Museum, University of New Mexico, Albuquerque, and National Park Service, Santa Fe, New Mexico.

[*See also* Anasazi; Kiva; *and* Native North American Art.]

BIBLIOGRAPHY
L. S. Cordell: *Prehistory of the Southwest* (New York, 1984)

G. Vivian: *The Chacoan Prehistory of the San Juan Basin* (San Diego, 1990)

R. G. Vivian and B. Hilpert: *The Chaco Handbook: An Encyclopedic Guide* (Salt Lake City, 2002)

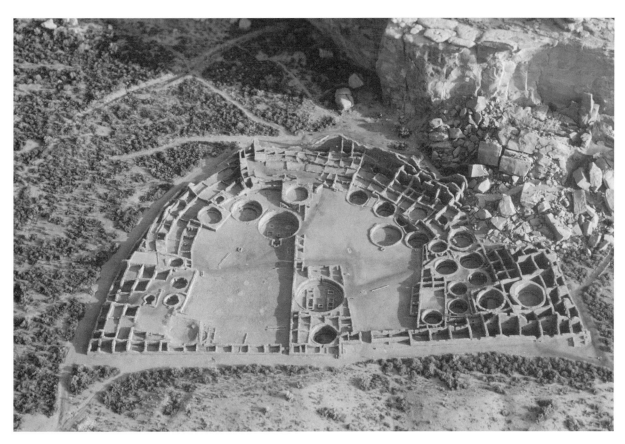

CHACO CANYON. Aerial view of Pueblo Bonito showing remains of rooms and circular *kivas, c.* AD 850–1150. R. Perron/Art Resource, NY

J. E. Neitzel, ed.: *Pueblo Bonito: Center of the Chacoan World* (Washington, DC, 2003)

D. G. Noble, ed.: *In Search of Chaco: New Approaches to an Archeological Enigma* (Santa Fe, NM, 2004)

B. M. Fagan: *Chaco Canyon: Archaeologists Explore the Lives of an Ancient Society* (Oxford and New York, 2005)

S. H. Lekson, ed.: *The Architecture of Chaco Canyon, New Mexico* (Salt Lake City, 2007)

J. M. Campbell: *The Great Houses of Chaco*, with contributions by T. C. Windes, D. E. Stuart, K. Kallestad (Albuquerque, NM, 2007)

R. M. Van Dyck: *The Chaco Experience: Landscape and Ideology at the Center Place* (Santa Fe, NM, 2008)

R. Gwinn Vivian

Chamberlain, John A.

(*b* Rochester, IN, 16 April 1927), sculptor, painter, printmaker and filmmaker. Chamberlain studied at the Art Institute of Chicago from 1950 to 1952 and from 1955 to 1956 at Black Mountain College, NC, where he was exposed to the modernist aesthetics of the poets Charles Olson (1910–70) and Robert Creeley (1926–2005), with whom he formed a lasting friendship. His early welded-iron sculpture was heavily influenced by Abstract Expressionism and by the sculpture of David Smith. In 1957 he moved to New York where he made his first works out of crushed car parts, such as *Shortstop* (1957; New York, Dia A. Found.), a practice for which he became immediately recognized and recognizable. During the mid-1960s he continued in this mode (see *Untitled*, 1965), expanding its formal vocabulary to include larger free-standing complexes and wall reliefs, always emphasizing fit and spontaneity. This work earned him instant critical association with the junk art movement.

In 1966 Chamberlain received a John Simon Guggenheim Memorial Fellowship. From 1967 he

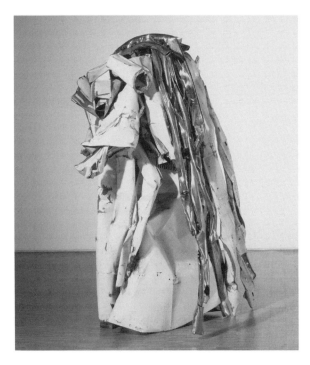

JOHN A. CHAMBERLAIN. *The Bride*, compressed and welded sheet metal, chrome-plated and lacquered, 1988. © 2010 JOHN CHAMBERLAIN/ARTISTS RIGHTS SOCIETY, NY CNAC/MUSÉE NATIONAL D'ART MODERNE, CENTRE GEORGES POMPIDOU, PARIS/ART RESOURCE, NY

constructions is an issue that harmonizes equally well with his perceived allegiance to modern American painting.

[*See also* Sculpture, *subentry on* After World War I.]

WRITINGS
Conversations with Myself (New York, 1992)

BIBLIOGRAPHY
D. Judd: "Chamberlain: Another View," *A. Int.*, vii/10 (1964), pp. 38–9

B. Rose: "How to Look at John Chamberlain's Sculpture," *A. Int.*, vii/10 (1964), pp. 36–8

E. C. Baker: "The Secret Life of John Chamberlain," *ARTnews*, lxviii/2 (1969), pp. 48–51, 63–4

John Chamberlain: A Retrospective Exhibition (exh. cat., ed. D. Waldmann; New York, Guggenheim, 1971)

John Chamberlain (exh. cat., ed. J. Gachnang; Berne, Ksthalle; Eindhoven, Stedel. Van Abbemus.; 1979)

John Chamberlain: Reliefs 1960–1982 (exh. cat. by M. Auping, Sarasota, FL, John and Mable Ringling Mus. A. Foundation, 1982)

G. Indiana: "John Chamberlain's Irregular Set," *A. Amer.*, lxxi/10 (1983), pp. 208–16

D. Smith: "In the Heart of the Tinman: John Chamberlain," *Artforum*, xxii/5 (1984), pp. 39–43

J. Sylvester: *John Chamberlain: A Catalogue Raisonné of the Sculpture, 1954–1985* (New York, 1986)

John Chamberlain (exh. cat. by B. O'Doherty, London, Waddington Gals, 1990)

F. Dawson: "Self-Portrait in Steel: A Talk with John Chamberlain," *A. Mag.*, 64/8 (Apr 1990), pp. 54–7

John Chamberlain (exh. cat. by J. Poetter, Staatliche Kunsthalle Baden-Baden, 1991) [with biblio. references]

J. Altabe: "John Chamberlain et sa méthode," *Art Press*, 163 (Nov 1991), pp. 24–8

DeKooning/Chamberlain: Influence and Transformation (exh. cat. by B. Rose, New York, PaceWildenstein, 2001)

John Chamberlain: Papier Paradiso: Drawings, Collages, Reliefs, Paintings (exh. cat. ed. D. Schwartz, intro. by C. Andre, with others, Kunstmus. Winterthur, 2005)

Derrick R. Cartwright

became interested in film and video, making his most ambitious cinematic project, *Wide Point*, in 1968. Around this time he returned to his crushed metal idiom after a brief fascination with a combination of stencil and Action painting, for which he used car spray paint. From that moment his materials began to include not only the familiar chassis, but also industrial rubber, plexiglass and polyurethane. Slightly later, near the height of the American fuel crisis, he made frequent use of oil barrels in such works as the *Socket* and *Kiss* series (1979; see Sylvester, nos 501–5 and 634–42). In addition to film and painting, Chamberlain produced and exhibited drawings and prints, for example *Time Goes By, Purple Disappears* (etching and aquatint, 1987; see *A. America*, lxxv/9, 1987, p. 90). Much discussion surrounding his work has centered upon his sympathy for the *objet trouvé* and his chance inventions, elements common to the art of Marcel Duchamp, John Cage and others. The relationship between his use of cultural waste and the implied violence of his

Chandler, Theophilus Parsons

(*b* Boston, MA, 1845; *d* Philadelphia, PA, 16 Aug 1928), architect and designer. After spending a year

at the Lawrence Scientific School of Harvard University, Cambridge, MA, Chandler is believed to have studied in the Atelier Vaudremer in Paris for a year, following this with European travel, which is documented by drawings (Philadelphia, PA, Athenaeum). Around 1872 Chandler set up practice in Philadelphia at the suggestion of landscape architect Robert Copeland, who involved him in the planning of a Bedford Park-like railroad suburb at Ridley Park. His mother's family had backed the Du Pont industrial empire, and in 1874 Chandler was involved with enlargements to Winterthur, Henry Francis Du Pont's mansion near Wilmington (now Winterthur, DE, Du Pont Winterthur Mus.). Through that connection Chandler married Sophie Madeleine Dupont, which provided him with a position in society and enabled him to practice architecture free from commercial considerations. Unlike his contemporaries in Philadelphia who regularly used brick, Chandler was committed to a stone architecture based rather closely on historical examples, which he adapted to large city and country houses and a significant group of churches. The most successful included the Philadelphia town houses for James Hutchinson (at 133 S. 22nd Street) and James Scott (at 2032 Walnut Street; both 1882), the suburban mansions for Edward Benson (1884; destr.) and William Simpson (Ingeborg, Wynnewood, PA, 1885) and the Swedenborgian Church (1882) at Chestnut Street and 22nd Street. A cluster of important Presbyterian church commissions reached as far west as Pittsburgh's First Presbyterian Church. These are finely detailed compositions that indicate the influence of Richard Morris Hunt and suggest an almost academic set of values in accord with the taste of the 1890s. He was, therefore, the logical choice to serve as the first Director of the School of Architecture of the University of Pennsylvania in 1890.

BIBLIOGRAPHY

Obituary, *Amer. A. J.*, xxv (1928), pp. p. 369

T. Sande: *Theophilus Parsons Chandler, jr, 1845–1928* (diss., Philadelphia, U. PA, 1971)

S. Tatman and R. Moss: *Biographical Dictionary of Philadelphia Architects, 1700–1930* (Boston, 1985), pp. 139–43

G. Thomas: "Theophilus Parsons Chandler, Jr.; FAIA," *Drawing towards Building: Philadelphia Architectural Graphics, 1730–1986* (exh. cat. by J. O'Gorman, J. Cohen, G. Thomas and G. Perkins, Philadelphia, PA Acad. F. A., 1986), pp. 166–8

George E. Thomas

Chandler, Winthrop

(*b* Woodstock, CT, 6 April 1747; *d* Woodstock, 29 July 1790), painter. Chandler was one of ten children of William Chandler, a farmer, and Jemima Bradbury Chandler of Woodstock, CT. After the death of his father in 1754 and on reaching the age for apprenticeship, Chandler pursued a career as a portrait and ornamental painter. While there is no proof of his presence in Boston, the *History of Woodstock* (1862) states that he studied portrait painting there. He may also have had the opportunity to view works by the major artist of the city, John Singleton Copley, as well as those of his lesser-known contemporaries, William L. Johnston and Joseph Badger. In the course of his career, Chandler worked in such diverse trades as gilding, carving and illustrating, as well as portraiture, landscape and house painting, suggesting that he received some instruction as an artisan–painter. He is best known for some 50 portraits, all of family and neighbors in the Woodstock area. Chandler adhered to a flat, linear manner of painting and realistic depictions of his subjects throughout his career. His style represented the work of a highly gifted folk painter.

In 1770 he was still in Woodstock, where he completed his first known signed portraits, of *Rev. Ebenezer Devotion* and his wife *Martha Lathrop Devotion* (e.g. in Brookline, MA, Hist. Soc. Mus.) of nearby Windham (now Scotland), CT. These monumental full-length portraits are painted in a highly realistic manner, including faithful likenesses of the subjects and accurate renderings of costumes and furnishings, for example bookshelves filled with worn leather volumes in the background.

In 1772 Chandler married Mary Gleason of Dudley, MA. Although he seems to have taken no part in the Revolutionary War, many members of his family did, fighting on both sides. Two of Chandler's most accomplished portraits are of his brother and sister-in-law, *Captain Samuel Chandler* and *Anna Chandler* (*c.* 1780; both Washington, DC, N.G.A.). The full-length portrait of Samuel, who commanded a regiment in the Revolutionary War, shows him in uniform with a detailed battle scene visible through the window.

A series of decorative landscapes in the form of overmantel paintings (*c.* 1770–90) for several houses in the Woodstock area are attributed to Chandler. These combine fanciful compositions that suggest elements taken from English prints with renderings of the New England landscape and its buildings. The *Homestead of General Timothy Ruggles* (*c.* 1770–75; priv. col., see Little, 1980, fig.) is a relatively accurate depiction of the Loyalist Ruggles's house and surrounding lands, framed by fanciful trees.

Chandler was often in financial difficulties. In 1785 he moved to Worcester, MA, perhaps in search of new patrons. There he did house painting and in 1788 regilded the weather-vane on the courthouse. A bust-length *Self-portrait* (Worcester, MA, Amer. Ant. Soc.) is thought to have been painted at that time. Chandler's obituary in the *Worcester Spy* (29 July 1790) alludes to the difficulties he and other rural painters of the era faced: "By profession he was a house painter, but many good likenesses on canvas show he could guide the pencil of the limner . . . The world was not his enemy, but, as is too common, his genius was not matured on the bosom of encouragement. Embarrassment, like strong weeds in a garden of delicate flowers, checked his enthusiasm and disheartened the man."

[*See also* Garbisch.]

BIBLIOGRAPHY
Obituary, *Worcester Spy* (29 July 1790)
N. F. Little: "Winthrop Chandler," *A. Amer.*, xxxv/2 (1947), pp. 77–168 [special issue]
N. F. Little: "Recently Discovered Paintings by Winthrop Chandler," *A. Amer*, xxxvi/2 (1948), pp. 81–97
N. F. Little: "Winthrop Chandler," *American Folk Painters of Three Centuries*, ed. J. Lipman and T. Armstrong (New York, 1980), pp. 26–35
Young America: A Folk-Art History (exh. cat. by J. Lipman, E. V. Warren, and R. Bishop, New York, Mus. Am. Folk Art and others, 1986)
Ralph Earl: The Face of the Young Republic (exh. cat. by E. Mankin Kornhauser and others, Hartford, CT, Wadsworth Atheneum, 1991), pp. 5–10, 102–4

Elizabeth Mankin Kornhauser

Chang, Patty

(*b* San Leandro, CA, 3 Feb 1972), performance and video artist of Chinese ancestry. Chang earned a Bachelor of Arts degree from the University of California, San Diego in 1994. She showed her first solo exhibition at Jack Tilton Gallery, New York, in 1999. Her body of work focused on how people can be deceived, either through sight—what one sees is not necessarily true—or through mainstream assumptions about such topics as Asia, sexuality and socially accepted behavior. Chang attributed her past stint in a cybersex company as the catalyst for exploring illusion as a theme. She realized that video flattened three-dimensional, live performances into a stream of two-dimensional images, enabling her to engage in visual deception.

Most of Chang's early works investigated problems of gender and sexuality, using her own body and elements suggesting violence or transgression. The photograph *Fountain* (1999) depicted her inside a cubicle of a public lavatory, with a urinal visible on the far wall. Wearing a business suit, she knelt on hands and knees, seemingly kissing herself but actually slurping water off a mirror on the floor. The accompanying video focused on Chang's face and her passionate interaction with her own reflection. While the photograph suggested female humiliation in a male world, the video complicated matters by implying that the act was motivated by narcissism.

Chang's subsequent works explored Asia and the Chinese woman as invented concepts. Her film

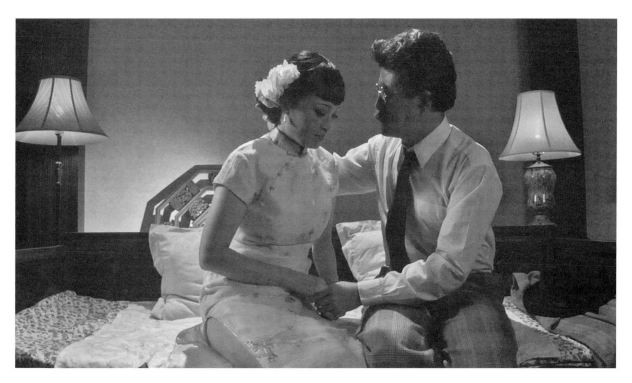

PATTY CHANG. *The Product Love*, two-channel digital video installation, 2009. © PATTY CHANG. COURTESY OF MARY BOONE GALLERY, NEW YORK

Shangri-La (2005) told the story of a town in south-central China, which attempted to boost tourism by marketing itself as the real Shangri-La, the mythical paradise popularized by James Hilton's 1933 novel *Lost Horizon* and a 1937 Hollywood film. *The Product Love* (2009) offered two interpretations of the 1928 meeting between Chinese American film actress Anna May Wong and the German critic Walter Benjamin. While the first part highlighted the difficulty of translating into English Benjamin's article about the interview, the second showed costumed actors enacting the meeting as a pornographic scene, made awkward by the mutual failure to understand each other's needs. These later works showed Chang moving in a new direction and looking beyond her own body as the locus of artistic expression.

BIBLIOGRAPHY

E. Leffingwell: "Patty Chang at Jack Tilton," *A. America*, lxxxvii (Nov 1999), p. 145

L. Wei: "Patty Chang at Jack Tilton/Anna Kustera," *A. America*, xc (June 2002), pp. 121–2

E. Arratia: "In Conversation: Patty Chang," *A. Asia Pacific*, xliv (Spring 2005), pp. 68–74

H. Cotter: "Patty Chang: Shangri-La," *NY Times* (29 July 2005)

H. Cotter: "Patty Chang," *NY Times* (12 June 2009)

Aileen June Wang

Chapman, John Gadsby

(*b* Alexandria, VA, 11 Aug 1808; *d* Staten Island, NY, 28 Nov 1889), painter and illustrator. Early encouragement and instruction from George Cooke (1793–1849) and Charles Bird King diverted Chapman from a career in law. In 1827 he began painting professionally in Winchester, VA, but quickly sought more training in Philadelphia at the Pennsylvania Academy of the Fine Arts. His desire to learn history painting soon took him to Italy to study the Old Masters. Returning to the USA in 1831, Chapman supported himself by painting portraits and occasional history subjects. Between 1837 and 1840 he executed the most important picture of his career,

the *Baptism of Pocahontas*, the fifth painting to decorate the Rotunda of the US Capitol Building in Washington, DC (*in situ*). In the mid-1830s Chapman began to illustrate texts, contributing to numerous magazines and gift-books. His most famous project was *Harper's Illuminated Bible* (New York, 1846), which contains over 1400 wood engravings in the style of Homer Dodge Martin and the later religious paintings of Benjamin West. Chapman's most lasting achievement was his instruction manual, *The American Drawing-book*, which went into numerous editions.

Constant debt, recurring illness and minimal success as a history painter prompted Chapman in 1848 to return to Italy, where he painted engaging scenes of the Roman Campagna. These panoramas and more portable colored etchings were very popular among American travelers. In 1884, however, Chapman returned to America physically and financially exhausted; his creative spark was all but extinguished. His sons, John Linton Chapman (1839 or 1840–1905) and Conrad Wise Chapman (1842–1910), were landscape painters of modest distinction.

WRITINGS

The American Drawing-book: A Manual for the Amateur (New York, 1847, rev. 1870)

BIBLIOGRAPHY

G. S. Chamberlain: *Studies on John Gadsby Chapman: American Artist, 1808–1889* (Alexandria, VA, 1962)

John Gadsby Chapman (exh. cat., ed. W. P. Campbell; Washington, DC, N.G.A., 1962)

P. C. Marzio: *The Art Crusade: An Analysis of American Drawing Manuals, 1820–1860*, Smithsonian Studies in History and Technology, 34 (Washington, DC, 1976)

E. B. Davis: "Fitz Hugh Lane and John Gadsby Chapman's American Drawing Book," *Antiques*, cxliv/5 (1993), pp. 700–07

L. Nelson-Mayson: "New in the Collection," *Cols* [Columbia, SC], v/3 (Summer, 1993), p. 3

E. B. Davis: "American Drawing Books and their Impact on Fitz Hugh Lane," *Cultivation of Artists in Nineteenth-century America* (1995), pp. 79–104

H. Nichols B. Clark

Charles, Michael Ray

(*b* Lafayette, LA, 1967), painter. Charles graduated from McNeese State University in Lake Charles, LA, in 1985, having studied advertising design, illustration and painting. He received his MFA from the University of Houston in 1993, and subsequently taught at the University of Texas at Austin. His paintings, which manipulate images of historical black stereotypes, have generated critical controversy and hostile reactions from viewers. Charles, however, saw himself as investigating these images and their place in American history, exploring and exposing their negativity. He typically signs his work with an actual copper penny, oriented to display the profile of Abraham Lincoln.

Charles also collected black memorabilia, such as Aunt Jemima dolls and other advertising ephemera, and has researched 19th-century blackface and minstrelsy performers. Some of his most controversial figures have been of childhood literary icons, including a black Sambo reminiscent of Mickey Mouse. Charles is interested in how these images remain in America's collective memory, and the different attitudes of Caucasians and African Americans when viewing them. He creates extreme caricatures, such as a sinister-looking black face with a watermelon slice for a mouth and black seeds instead of teeth—images meant to stimulate thought. The faces in his paintings confront the viewer with their oversized scale, some of them more than 1 m high. Charles felt that American advertising conditioned people of all types to pigeonhole blacks as representing the body (instead of the mind), and as entertainers—and that these stereotypical attitudes have been retained in the American psyche. To emphasize this point, Charles juxtaposed African American celebrities with advertising imagery, such as Oprah Winfrey as a cookie-jar mammy figure.

Many of Charles's paintings have an antique aura and resemble vintage posters, including a series of paintings on paper of black figures titled *Before Black* and *After Black*, with the former seemingly situated

in the 19th century and the latter in the present day. The figures in both are doomed by their blackness. Like Charles's work inspired by circus posters, this series has an antique source, the lithographs of Currier and Ives. This print shop's scenes of Americana offered several categories, including "Darktown" with racist depictions of blacks that were intended to be humorous.

Charles's paintings scathingly address issues of identity that concern postmodern art and society. Similar to the life-size silhouettes of Kara Walker, Charles's paintings ridicule the "romance" of the Old South and black subservience. By situating viewers in an historical continuum, Charles is able to emphasize the extreme nature of racist stereotypes, producing a sense of dissonance as viewers find themselves both repulsed and fascinated by the imagery. He has also worked in film, collaborating with Spike Lee on *Bamboozled* (2000), a version of Mel Brooks's film *The Producers* (1968) in which a producer pitches the worst possible idea for a television program—a modern-day minstrel show with African American performers in blackface. Charles's promotional poster featured a nappy-headed pickaninny.

The art market has favored African American artists such as Charles whose work "promotes" racial stereotypes even though the artists' purpose is ironic. As Richard Schur wrote,

Infused with humor and irony, the work of these artists question realism . . . they demonstrate how previous generations relied on overdetermined poses or models to create their art and question how traditional notions of art and beauty have perpetuated racial inequality. This ironic mode of representing black bodies has been popular with white collectors and thus has been problematic for African Americans because it frequently invokes stereotypes to de-bunk them, and such images have been a bit too popular with white audiences.

Charles has had solo exhibitions in the USA, France and Belgium, and has served as a juror on the Austin Arts in Public Places committee. His work is in the Museum of Modern Art in New York, the San Antonio Museum of Art, the Austin Museum of Art and other institutions.

BIBLIOGRAPHY
J. Cullum: "Stereotype This," *A. Papers*, xxii/6 (Nov–Dec 1998), pp. 16–21

P. Newkirk: "Pride or Prejudice?," *ARTnews*, xcviii/3 (March 1999), pp. 114–17

Art 21: Art in the Twenty-First Century, Season One (Alexandria, VA, 2001) [videodisc]

T. Barrett: "Interpreting Visual Culture," *A. Educ.*, lvi/2 (March 2003), pp. 6–12

K. J. Exum: "Charles, Michael Ray," *Current Biog.*, lxvi/10 (Oct 2005), pp. 14–18

R. Schur: "Post-Soul Aesthetics in Contemporary African American Art," *Afr. Amer. Rev.*, xli/4 (Winter 2007), pp. 641–54

Sandra Sider

Charleston

Charleston, SC, is among the most well-preserved historic cities in the USA. In spite of the city's many major fires in the 18th and 19th centuries, the city entered the 20th century with an extraordinary assemblage of pre-Civil War architecture. The emergence of the preservation movement in Charleston in the 1920s insured that a substantial percentage of that assemblage has survived to the present, and the city stands today as one of the densest and richest collections of 1750–1850 architecture in the USA.

Unlike most historic cities, Charleston has whole historic streetscapes that survive intact. Particularly important are the collections of 18th-century houses that line streets in the original walled portion of the city, including Tradd Street, Church Street and lower Meeting Street. Many of the houses in this district take the form of the single house, a distinctive urban form that incorporates urban English floor plans and back lots that emulate plantation workyards. In the closing years of the century, single and double piazzas—long porches that run the

depth of Charleston's narrow urban townhouses, often overlooking a side-yard garden—began to appear throughout the city. By the early 19th century, these were essential components of the Charleston single house, a form that persisted through the 19th century. Also evidenced in this district are substantial double-pile houses commonly found throughout the British colonies. The Heyward-Washington House on Church Street (c. 1772), owned and operated by the Charleston Museum, is an excellent example that is open to the public. The finest example of this type—and probably the finest example of 18th-century architecture in the city—is the Miles Brewton House (c. 1769) on lower King Street. Restored by its private owner, the house boasts a grand double portico overlooking the street. Major public buildings from this period include St Michael's Church (begun 1752), Charleston County Courthouse (begun 1753, originally the South Carolina Statehouse) and the Exchange Building (begun 1767). Begun in 1738, Drayton Hall, the spectacular Anglo-Palladian plantation house of the Drayton family, stands a short distance outside of the city. Owned and operated by the National Trust for Historic Preservation, Drayton Hall offers the most intensive investigation of early architecture and its preservation in Charleston.

The city is equally rich in Neo-classical and Antebellum architecture. Two major house museums—the Nathaniel Russell House operated by the Historic Charleston Foundation and the Joseph Manigault House (begun 1803) operated by the Charleston Museum—are among the city's best Neo-classical houses. The Aiken-Rhett House (begun in 1818 but extensively expanded in the 1830s and 1850s), also operated by the Historic Charleston Foundation, is the best surviving example of 19th-century workyard architecture and surviving urban slave quarters. This site gives the public some access to the substantial population of enslaved people who actually built the vast majority of Charleston's architecture and who sustained the way of life it represented. Important

19th-century public architecture include the Fireproof Building—now the home of the South Carolina Historical Society—begun in 1822 to the designs of Robert Mills, the city's most prominent 19th-century architect, and Market Hall, begun in 1840 to the designs of Edward Brickell White. The city also boasts a large number of early 19th-century churches, including Second Presbyterian (begun 1811), First Scots Presbyterian (begun 1814), St John's Lutheran (begun 1816), First Baptist (begun 1819), St Philips Episcopal (begun 1835), St Mary's Catholic (begun 1838), St Andrew's Lutheran (begun 1840), St Johannes Lutheran (begun 1842) and the Unitarian church (begun 1772, extensively remodeled 1852), among others.

While notable architecture of the late 19th and 20th centuries is less well represented, there are a few important examples. The Renaissance Revival Federal Courthouse and Post Office, designed by John Devereux and begun in 1896, is among the most prominent. Just down the street stands the 1892 Circular Congregational Church, designed by the New York firm of Stevenson and Green. One of the most important examples of recent architecture in the city is the much-acclaimed Inn at Middleton Place, designed by WG Clark Associates and the recently completed Ashley River Tower of the Medical University of South Carolina, designed by LS3P architects.

In addition to a rich architectural tradition, Charleston also has a deep tradition in the fine arts. The Gibbes Museum of Art has an extraordinary collection of fine art that ranges from the mid-18th century to the present, most with a Charleston or Southern connection. The Charleston Museum also has an extensive collection including fine arts, but extending also to cultural and natural artifacts from the region.

BIBLIOGRAPHY

B. St Julien Ravenel: *Architects of Charleston* (Charleston, SC, 1945)

M. Lane: *Architecture of the Old South: South Carolina* (Savannah, GA, 1984)

K. Severens: *Charleston Antebellum Architecture and Civic Destiny* (Knoxville, TN, 1988)

J. Poston: *The Buildings of Charleston: A Guide to the City's Architecture* (Charleston, SC, 1997)

C. Lounsbury: *From Statehouse to Courthouse* (Columbia, SC, 2001)

G. Waddell: *Charleston Architecture, 1670–1860*, 2 vols (Charleston, SC, 2003)

M. McInnis: *The Politics of Taste in Antebellum Charleston* (Chapel Hill, NC, 2005)

L. Felzer: *The Charleston Freedman's Cottage: An Architectural Tradition* (Charleston, SC, 2008)

L. Nelson: *The Beauty of Holiness: Anglicanism and Architecture in Colonial South Carolina* (Chapel Hill, NC, 2008)

Louis P. Nelson

Charlesworth, Sarah

(*b* East Orange, NJ, 29 March 1947), photographer and conceptual artist. Charlesworth received a BA in art history from Barnard College in New York in 1969. During her undergraduate years, she enrolled in a number of studio courses, including those taught by conceptual artist Douglas Huebler, and her work would be decisively shaped by late-1960s debates about conceptual art. In 1974–5, she joined with Joseph Kosuth and others to establish and edit the combative conceptualist journal *The Fox*, to which she made several contributions, including her well-known essay about the artist's place in the larger society "Declaration of Dependence." Her photo-conceptualist practice is often associated with the so-called "Pictures Generation" that included other photographers such as Barbara Kruger, Louise Lawler and Cindy Sherman, and in this context, she is often regarded as a key figure in the development of Appropriation art during the late 1970s and early 1980s. In 1992 she began teaching at the School of Visual Art in New York, and in 2000 began teaching at Rhode Island School of Design in Providence.

Charlesworth developed her characteristic tactic of appropriating details from existing photographic images in 1973 when she enlarged a small figure that was famously captured in an early daguerreotype image of the Parisian cityscape by Louis Daguerre. Her subsequent work has typically relied on images taken from both art history and contemporary popular culture, and it has often addressed both photography's signifying operations and its ideological effects. In her famous "Moro Trilogy," from her "Modern History" series, she displayed reproductions of the front pages of various newspapers covering the Red Brigade's kidnapping and reputed assassination of the former Prime Minister of Italy Aldo Moro. In each case, however, she eliminated the text and left the often-identical images of Moro isolated in the vacant space that opened up underneath the newspapers' masthead. In the last of these, entitled *April 21, 1978*, she reproduced the front pages of various newspapers that often featured identical images of Moro with a copy of the previous day's issue *La Repubblica* that reported his own death. Through these works, she called attention to both the evidential function and the questionable authority of the photograph, and she dramatized the mediating role of images in contemporary political and social life. In her *Arc of Total Eclipse, February 26, 1979*, from the same series, she charted an eclipse as it moved across the northwestern states through Canada to Greenland. Again, in this work, she employed front-page newspaper photographs from both local and national papers to highlight each town's mediated experience of the same event. In her subsequent series, entitled "Stills," she appropriated images of the falling bodies of people that leaped from skyscrapers, but through her appropriation, these disturbing images were radically decontextualized, and their subjects were rendered more or less anonymous. Through their designation as "stills," moreover, she called attention to the intersection between these tragedies and the conventions of film, implying that such radically individual events were always anticipated by and experienced through the conventions of cinema. In her 1992–3 series "Natural Magic," she furthered these investigations of the image by photographing

herself in the act of performing magic tricks and thereby presenting the viewer with a realistic image of an uncertain reality. During much of the 1990s, she was also preoccupied with the history of vision and the various devices that have mediated the act of seeing over the course of modern history. In many respects, these works represent an extension of her earlier efforts to address the veracity of the photographic image and its defining role in shaping experience in the contemporary world.

BIBLIOGRAPHY

U. Meyer, ed.: *Conceptual Art* (New York, 1972)

Art in the Crisis of Representation (exh. cat., ed. C. Gudis; Los Angeles, CA, Mus. Contemp. A., 1989)

Sarah Charlesworth: A Retrospective (exh. cat. by L. Grachos and S. F. Sterling; Santa Fe, NM, SITE, 1997)

Pictures Generation, 1974–1984 (exh. cat. by Douglas Eklund; New York, Met. 2009)

Tom Williams

Charlot, Jean

(*b* Paris, 8 Feb 1898; *d* Honolulu, 20 March 1979), French painter and printmaker, active in Mexico and the USA. As a child he was surrounded by the nostalgic presence of Mexico, as one of his great-grandmothers was Mexican, and one of his grandfathers had collected Pre-Columbian art. He specialized in murals, painting his first for the Exposition Saint Jean, an exhibition of liturgical art at the Louvre in 1920. In 1921 he settled in Mexico to take up an offer of work from Alfredo Ramos Martínez (1871–1946) at the open-air school in Coyoacán. He worked in Mexico City as an assistants to Diego Rivera (1886–1957) on the mural *The Creation* (1923), executing two important murals of his own in the city during the same period: the *Conquest of Tenochtitlán* (1922–3) in the Escuela Nacional Preparatoria, and *Porters and Washerwomen* (1923) in the building of the Secretaría de Educación Pública. Charlot collaborated on the magazine *Mexican Folkways* and from 1922 to 1927 worked with Sylvanus Morley (1883–1948) in

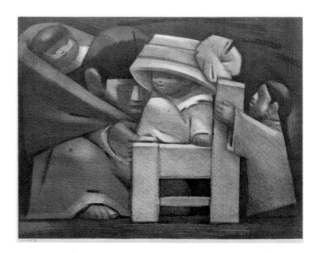

reproducing the Maya paintings from Chichén Itzá. He later settled in Hawaii and painted some murals in the USA.

WRITINGS

The Mexican Mural Renaissance, 1920–1925 (New York, 1979)

BIBLIOGRAPHY

O. S. Suárez: *Inventario del muralismo mexicano, siglo VII a.c.–1968* (Mexico City, 1972), pp. 120–21

P. Morse: *Jean Charlot's Prints: A Catalogue Raisonné* (Honolulu, 1976)

Jean Charlot y el renacimiento del grabado mexicano (exh. cat., Mexico City, Mus. N. Est., 1990)

México en la obra de Jean Charlot (exh. cat. by G. Estrada and others, Mexico City, Colegio Ildefonso and elsewhere, 1996)

A. H. Serrano: "The Latin American Left and the Contribution of Diego Rivera to National Liberation," *Third Text*, xix (2005), pp. 637–46

and others: *Mexico and Modern Printmaking: A Revolution in the Graphic Arts, 1920 to 1950* (exh. cat. by J. Ittmann and others, Philadelphia, PA, Mus. A., 2006)

Esther Acevedo

Chase-Riboud, Barbara

(*b* Philadelphia, PA, 26 June 1935), sculptor and writer. She was educated at the Tyler School of Art at Temple University, Philadelphia, graduating in

1957, and at Yale University, New Haven, CT, where she studied with Josef Albers from 1958 to 1960. After gaining her MFA at Yale in 1960, she lived in Paris with her husband, Marc Riboud (*b* 1923), a photo-journalist. Their extensive travels in Africa and Asia profoundly influenced Chase-Riboud's work. Her sculptures, which combine faceted, geometric bronze forms with braided silk and wool fibers, are often seen as an investigation of opposites—hardness and softness, masculinity and femininity—and how these qualities intersect. However, there are also striking connections apparent between her best-known sculptures (those of the 1970s) and African masks and artifacts. Her trait of disguising the plinth of her free-standing sculptures with hanging fibers, as for example in *Confessions for Myself* (1972; Berkeley, U. CA, A. Mus.), made in black bronze and black wool, gives another dimension to her work: behind the hanging braids and fibrous strands is a sense of something hidden—a supernatural element more obviously associated with the ritual and magic of Africa and of other non-Western cultures. A leading African American artist, Chase-Riboud also became known as a writer, publishing poetry and a novel.

BIBLIOGRAPHY

Chase-Riboud (exh. cat., Berkeley, U. CA, A. Mus., 1973)

C. Streifer Rubinstein: *American Women Artists from Early Indian Times to the Present* (Boston, 1982), pp. 114, 276, 423–5

P. Selz and A. F. Janson: *Barbara Chase-Riboud, Sculptor* (New York, 1999)

S. A. Spencer and C. A. Miranda, eds: "Barbara Chase-Riboud: A Special Issue," *Callaloo: A Journal of African Diaspora Arts and Letters*, xxxii/3 (Summer 2009), pp. 711–1026

Clair Joy

Chase, William Merritt

(*b* Williamsburg, IN, 1 Nov 1849; *d* New York, 25 Oct 1916), painter and printmaker. Chase received his early training in Indianapolis from the portrait painter Barton S. Hays (1826–75). In 1869 he went to New York to study at the National Academy of Design where he exhibited in 1871. That year he joined his family in St Louis, where John Mulvaney (1844–1906) encouraged him to study in Munich. With the support of several local patrons, enabling him to live abroad for the next six years, Chase entered the Königliche Akademie in Munich in 1872. Among his teachers were Alexander von Wagner (1838–1919), Karl Theodor von Piloty (1826–88) and Wilhelm von Diez (1839–1907). Chase also admired the work of Wilhelm Leibl (1844–1900). The school emphasized bravura brushwork, a technique that became integral to Chase's style, favored a dark palette and encouraged the study of Old Master painters, particularly Diego Velázquez and Frans Hals. Among Chase's friends in Munich were the American artists Walter Shirlaw, J. Frank Currier and Frederick Dielman (1847–1935), as well as Frank Duveneck and John H. Twachtman; the latter two accompanied him on a nine-month visit to Venice in 1877.

In 1878 Chase returned to New York to teach at the Art Students League. Despite his youth and his extended stay in Europe, Chase was not unknown to the American art world, for he had exhibited at the National Academy of Design in 1875, received a medal of honour at the 1876 Centennial Exposition in Philadelphia and won critical attention for his portrait *Ready for the Ride* (1877; New York, Un. League Club), shown at the inaugural exhibition of the Society of American Artists.

The 1880s were for Chase a period of intense activity, as well as artistic growth and maturity. He continued to teach at the Art Students League and to give private lessons in his studio in the Tenth Street Studio Building. In 1881 he won an honorable mention at the Paris Salon for a portrait of Duveneck entitled *The Smoker* (presumably destroyed by fire). That year he made the first of many trips to Europe, which brought him into contact with the Belgian painter Alfred Stevens (1823–1906) and the work of the French Impressionists. Their influence is apparent in the lighter palette of

the portrait of *Miss Dora Wheeler* (1883; Cleveland, OH, Mus. A.) and *Sunlight and Shadow* (1884; Omaha, NE, Joslyn A. Mus.). In 1885 Chase met James McNeill Whistler in London. The two agreed to paint each other's portrait, although only Chase's of Whistler was completed (1885; New York, Met.). Subsequently Whistler's influence can be seen in a remarkable group of large, full-length female portraits painted between 1886 and 1895: two portraits of Maria Benedict, *Lady in Black* (1888; New York, Met.) and *Lady in Pink* (1888–9; Providence, RI Sch. Des., Mus. A.), are characterized by a subtly modulated palette accented by shots of brilliant color, a simple, soft and atmospheric background and brushwork that is lively but not overbearing.

Chase, a member of many art groups, organized with Robert Frederick Blum in 1882 the American Society of Painters in Pastel, which presented four exhibitions between 1884 and 1890. Chase's work in pastel is among the most important in American art. Whether rendering a single figure as in *Back of a Nude* (c. 1888; New York, priv. col., see R. G. Pisano, 1979, p. 47) or creating a complex interior with figures as in *Hall at Shinnecock* (1893; Chicago, IL, Terra Mus. Amer. A.), Chase handled pastels with the same skill and panache as he did oils.

In 1883 Chase helped to select American paintings for the Munich Glaspalast exhibition and assisted with the organization of the Bartholdi Pedestal Fund Art Loan Exhibition which, while raising money for the base of the Statue of Liberty, brought important examples of modern European art to America. In 1886 the Boston Art Club held a major exhibition featuring 133 works by Chase. During the decade Chase also served as president of the Society of American Artists, for a one-year term in 1880 and, after his election in 1885, for ten years.

In 1891 Chase founded the Shinnecock Summer School of Art on Long Island near the village of Southampton. He conducted classes at this, the first important summer art school in America, until 1902. Chase was known primarily as a Realist, but landscapes that he produced at Shinnecock

during the 1890s, such as the *Fairy Tale* (1892; priv. col., see 1983–4 exh. cat., p. 315), capture the essence of American Impressionism. These works are more brilliantly colored and place greater emphasis on transient atmospheric effects than his earlier park and coastal scenes painted around New York and Brooklyn in the late 1880s. Teaching remained an important part of Chase's life. In addition to his classes at Shinnecock and those at the Art Students League (until 1896, and again 1907–12), Chase taught at the Brooklyn Art Association (1887, 1891–5), at the Chase School of Art (renamed the New York School of Art in 1899) between 1897 and 1907 and at the Pennsylvania Academy of Art (1896–1909). Except in 1906, he took students to Europe every summer from 1903 to 1912. Chase encouraged his pupils to work directly from nature and the model. He stressed technique over subject matter and advocated drawing directly on the canvas with a fully loaded brush, eschewing a preliminary sketch in pencil or charcoal. His students, who included Charles Demuth, Marsden Hartley, Georgia O'Keeffe, Charles Sheeler and Joseph Stella, developed very diverse styles, suggesting that Chase provided them with inspiration but did not insist on imitation.

Chase's prominence in the latter part of his life is reflected in the numerous honours he continued to receive. Although by the 1913 Armory Show his style of elegant realism was being superseded by modernist trends, a gallery was devoted to his work at the 1915 Panama-Pacific Exposition in San Francisco. For illustration, see color pl. 1:XI, 2.

BIBLIOGRAPHY
K. M. Roof: *The Life and Art of William Merritt Chase* (New York, 1917/R 1975)
Chase Centennial Exhibition: Commemorating the Birth of William Merritt Chase November 1, 1849 (exh. cat. by W. D. Peat, Indianapolis, IN, Herron Sch. A., 1949)
R. G. Pisano: *William Merritt Chase* (New York, 1979)
C. K. Carr: *William Merritt Chase: Portraits* (Akron, OH, 1982)
R. G. Pisano: *William Merritt Chase 1849–1916: A Leading Spirit in American Art* (Seattle, 1983)

D. C. Atkinson and N. Cikovsky jr: *William Merritt Chase: Summers at Shinnecock 1891–1902* (Washington, DC, N.G.A., 1987)

J. Treiman: *The Artists Series: Monotypes* (New York, 1990)

K. L. Bryant: *William Merritt Chase, A Genteel Bohemian* (Columbia, 1991)

A. Gordon: "Village Voice," *A. & Ant.*, viii/5 (1991), pp. 90–5

Photographs from the William Merritt Chase Archives at the Parrish Art Museum (exh. cat. by R. G. Pisano and A. G. Longwell, Southampton, NY, Parrish A. Mus., 1992–3)

R. G. Pisano: *Summer Afternoons: Landscape Paintings of William Merritt Chase* (Boston, 1993)

W. H. Gerdts: *Impressionist New York* (New York, London and Paris, 1994)

H. B. Weinberg: "Impressionists, Realists and the American City," *Mag. Ant.*, cxlv (1994), pp. 542–51

The Artist as Teacher: William Merritt Chase and Irving Wiles (exh. cat. by K. Cameron, East Hampton, NY, Guild Hall Mus., 1994)

B. D. Gallati: *William Merritt Chase* (New York, 1995)

L. J. Docherty: "Model Families: The Domesticated Studio Pictures of William Merritt Chase and Edmund C. Tarbell," *Not at Home: The Suppression of Domesticity in Modern Art and Architecture*, ed. C. Reed (London, 1996), pp. 49–64

H. G. Warkel: "William Merritt Chase: Works from the Permanent Collection," *Amer. A. Rev.*, viii/1 (1996), pp. 122–7, 160 [works by him in the Indianapolis Museum of Art]

R. G. Pisano, D. F. Baker, and M. Shelly: *The Complete Catalogue of Known and Documented Works by William Merritt Chase (1849–1916)*, vol. 1 (New Haven and London, 2006)

R. G. Pisano, C. K. Lane and D. F. Baker: *William Merritt Chase: Portraits in Oil*, vol. 2, (New Haven, 2007)

R. G. Pisano, C. K. Lane and D. F. Baker: *William Merritt Chase: Landscapes in Oil*, vol. 3 (New Haven, 2009)

Carolyn Kinder Carr

Chee, Robert

(*b* Utah, 1938; *d* 1972), Navajo painter. His mother recognized his artistic talents early on and strongly encouraged and cultivated his creative genius by enrolling him at the Intermountain Indian School in Brigham, UT, where he was a student of Chiricahua painter and sculptor, Allan Houser.

Enlisting in the US Army, from 1958 to 1961, Chee was assigned to paint several post building wall murals instead of regular duties. After his discharge, he began a full-time artistic career. A key post-World War II Southwestern painter, his work influenced other American Indian artists. His unique style depicts traditional subjects with a modern Navajo outlook in his favorite media, watercolor.

Chee's painting technique reflects the "Studio" style of Dorothy Dunn (1903–91). Flat backgrounds, American Indian-styled themes and bright colors characterize the Studio painting format. Expanding upon the Studio style, Chee began arranging his subjects in clustered groupings, only hinting at a background with a few suggestive, lively lines. Arranging his central figures with intimacy and detail, he sensitively portrayed and highlighted their character.

Chee collaborated with Mark Bahti, producing an instructional coloring book, *The Navajo–Robert Chee*, showcasing his energetic drawing skills and abilities with line. Chee's aim was to teach his artistic perspective and impressions of historic Navajo ways of life and optimistically influence other people's view of his tribe.

The Smithsonian Institution in Washington, DC, the Philbrook Art Center in Tulsa, OK, and the Southwest Museum in Los Angeles, CA, among others, contain his work. Garnering honors and recognition, he won awards at the Navajo Tribal Fairs and at Inter-Tribal Indian ceremonies as a preeminent artist.

His trademark painting style was active and dreamlike, but also cheerfully playful and emotionally honest. Some paintings are lyrically sentimental, while others are dark and evocative. He adhered to only painting subjects personally understood from within his culture. He remained faithfully Navajo, but welcomed the forthcoming modernist Navajo outlook.

WRITINGS
with M. Bahti: *The Navajo–Robert Chee* (Tucson, AZ, 1975)

BIBLIOGRAPHY
D. Dunn: *American Indian Painting of the Southwest and Plains Areas* (Albuquerque, NM, 1968)

R. Henkes: *Native American Painters of the Twentieth Century: The Works of 61 Artists* (Jefferson, NC, 1995)

P. Lester: "Robert Chee," *The Biographical Directory of Native American Painters* (Tulsa, OK, 1995)

C. S. Kidwell and A. Velie: "Aesthetic," *Native American Studies* (Lincoln, NE, 2005)

G. Lola Worthington

Chermayeff, Serge

(*b* Groznyy, Azerbaijan, 8 Oct 1900; *d* Wellfleet, MA, 8 May 1996), British American architect of Russian birth. Chermayeff was educated in Moscow before emigrating to England in 1910 and completing his education at Harrow. In 1917 he served briefly as an interpreter to General Maynard in Murmansk and from 1918 to 1923 worked as a journalist for Amalgamated Press in London, where, because of his taste for jazz and ballroom dancing, he obtained the editorship of *Dancing World* magazine. Chermayeff studied art and architecture at various schools in Europe (1922–5), and in 1924 he became chief designer for the decorators E. Williams Ltd, doing "period" rooms.

In 1928 Chermayeff was naturalized as a British citizen and became director of the Modern Art Department of Waring & Gillow, collaborating with the French designer Paul Follot; here he organized the first exhibition of modern furnishings in England, *Modern Art in French and English Furniture and Decoration*. From 1930 to 1932 he ran his own architectural practice in London and undertook interior design commissions that established his name as a Modernist designer, albeit with somewhat Art Deco beginnings. Notable work included the dramatically plain interior of the Cambridge Theater (1930) in London and the interiors for Broadcasting House (1930–33), London, where he worked as part of a team under Raymond McGrath. He also designed a prototype weekend house, including "Plan" modular furniture, for the Exhibition of British Industrial Art (1933) at Dorland Hall, London; a small concrete house (1934) at 116 Dunchurch Road, Rugby, Warwicks; and the interiors of an elegant flat at 42 Upper Brook Street, London (1935).

From 1933 to 1936 Chermayeff was in partnership with Erich Mendelsohn; together they won the competition (1934) for the De La Warr Pavilion, Bexhill, Sussex, with a design that produced one of the finest modern buildings of the decade in Britain (completed December 1935). Distinguished work of the partnership included houses at Chalfont St Giles, Bucks (1935), and 64 Old Church Street, Chelsea, London (1936). After Mendelsohn's departure for the USA, Chermayeff continued in private practice and designed some large commercial buildings including offices for Gilbeys in Camden Town, London (1937), and buildings for Imperial Chemical Industries at Blackley, Manchester (1938). He also designed his own country house at Bentley Wood, Halland, Sussex, in 1938, a Modernist timber building with an elegant relationship to the landscape. During the 1930s, Chermayeff wrote extensively on issues of Modern architecture and decoration, calling for a clear unselfconscious approach to design with an awareness of contemporary art.

In 1940 Chermayeff emigrated to the USA and settled initially in California, where he designed houses at Piedmont, CA (1946), and Redwood, CA (1947). He became a naturalized US citizen in 1946. His subsequent career was primarily as a teacher, first at Brooklyn College, New York (1942–6) and then at the Chicago Institute of Design (1946–51), where he presided over a brilliant phase of creative activity before resigning as Principal in protest at the Institute's loss of autonomy. As Professor of Architecture at the Harvard Graduate School of Design, Cambridge (1953–62), and finally as Professor of Architecture at Yale University, New Haven, CT (1962–9), he encouraged interdisciplinary studies and was particularly concerned with evolving solutions to urban design and housing problems. He also maintained a small private practice and designed two studios for himself and a number of other houses at Wellfleet, MA (1952–72). The Chermayeff house at 28 Lincoln Street, New Haven (1962), a series of one-story pavilions and courtyards, was an important demonstration of a prototype for

high-density housing, a subject that Chermayeff had studied with his pupil Christopher Alexander.

WRITINGS

with C. Alexander: *Community and Privacy* (New York, 1963)

with A. Tzonis: *The Shape of Community: Realization of Human Potential* (New York, 1970)

R. Plunz, ed.: *Design and the Public Good, Selected Writings, 1930–1980, by Serge Chermayeff* (Cambridge, MA, and London, 1982)

BIBLIOGRAPHY

B. Tilson: "The Modern Art Department, Waring and Gillow, 1928–31," *J. Dec. A. Soc. 1890–1940*, viii (1984), pp. 40–47

B. Tilson: "Serge Chermayeff and the Mendelsohn/Chermayeff Partnership," *Erich Mendelsohn, 1887–1953*, ed. J. Brook and others (London, 1987), pp. 59–67

A. Powers: *Serge Chermayeff: Designer, Architect, Teacher* (London, 2001)

Alan Powers

Chicago

City and seat of Cook County in the state of Illinois. Located at the southwestern corner of Lake Michigan, Chicago is the most important inland city in North America as well as the third largest, with a population of nearly 9.6 million (Census Bureau 2007). Beginning in the late 19th century the city was at the center of important innovations in the development of modern architecture.

History and urban development.

Before c. 1930. The first European settlement on the site of Chicago was Fort Dearborn, established in 1803 to protect the portage route between the south branch of the Chicago River and the Des Plaines River, which flows southwest into the Illinois and thence the Mississippi. The fort was abandoned following the massacre of the garrison by Native Americans in 1812 but re-established in 1816. The strategic situation of the site stimulated further settlement, and the area at the junction of the north and south branches of the Chicago River was planned in 1830 with a rectangular pattern conforming to the federal Northwest Territories Ordinance of 1787. Following the opening of the Erie Canal (1825), which lowered transportation costs to the eastern seaboard, and with the evacuation of the Native American population after the Black Hawk War (1832), there was rapid population growth in the settlement and a speculative land boom. Notable early buildings included those in Neo-classical and Greek Revival styles by John Mills Van Osdel, for example the first Chicago City Hall (1844; destr.). In 1848 the Illinois and Michigan Canal connected Chicago with steamboat navigation on the Illinois River and hence the Mississippi, and the first railway to the west was begun. By 1856 Chicago was the most important inland rail center, a position it maintained. In the next two decades the city's population increased from 30,000 to 300,000; more than half the newcomers were immigrants. Numerous suburban communities became established along the railways radiating from the city. Notable were those along the north lake shore and Riverside, designed by Frederick Law Olmsted and Calvert Vaux in 1869. In the same year Olmsted and Vaux laid out South Park (now Washington and Jackson parks).

In October 1871 a fire spread across much of the city, including the central business district and extensive residential areas; an unknown number of lives were lost; property damage was estimated at $200 million; and nearly 100,000 people were made homeless. Rapid suburban development followed, however, and much of the city was rebuilt. During the two decades following the fire the population grew to 1.1 million. This rapid growth and rebuilding program provided ample opportunity for a large number of architects, many of whom achieved international reputations. In the 1880s the construction and engineering innovations in the development of high-rise buildings came to be associated with the Chicago school of architecture. Analogous to the introduction of the balloon frame (invented by Chicago carpenters in the 1930s using light milled pine lumber and factory-produced nails in a quick, efficient construction system based on walls as whole

units rather than on a separate heavy braced frame), an iron and steel skeleton was first used in 1883–5 by William Le Baron Jenney (with the engineer George B. Whitney) in the Home Insurance Building (destr. 1931). Jenney's solution to the problem of height, using the skeletal metal frame clad with masonry, became the model for buildings in Chicago. The steel skeleton was used notably in the Reliance Building by D. H. Burnham & Co. (1889–95; since 1999 Hotel Burnham), designed by John Wellborn Root (1890) and Charles B. Atwood (1894–5). Louis Sullivan was another a leading designer of high-rise buildings, producing, with Dankmar Adler, the Auditorium Building (1886–9), a ten-story block that at the time was the largest building in Chicago; it is now part of Roosevelt University. Frank Lloyd Wright, then working in Sullivan's practice, also collaborated on this project.

In the late 19th century Chicago's wealth was reflected in the generous contributions to the city's cultural life made by its business leaders and in the construction of many commercial buildings, including the Marshall Field Wholesale Store (1885–7; destr.) by H. H. Richardson, which was particularly influential; the Montgomery Ward (later Fair) Store (1891–2; destr.) by Jenney; and Sullivan's Schlesinger and Mayer Department Store (1898–1904; now Carson Pirie Scott & Co.), a steel structure noted for its cast-iron ornament. Such works became architectural landmarks. Further technical innovation was introduced in the 1890s by the firm of Holabird & Roche, who used portal wind bracing for the first time in the 17-story Old Colony Building (1893–4; with the engineer Corydon T. Purdy). Around this time Frank Lloyd Wright was also undertaking commissions of his own in Chicago, including houses for Isidore Heller (1897–8) and Joseph Husser (1899), and, most notably, the Fred Robie House (1908–10), the last being one of the best-known examples of the style that came to be associated with the Prairie school. There were improvements to the city's infrastructure before the end of the 19th century: street railways were electrified after 1885, and elevated railways were built from 1893. The first multiple-unit electric trains operated on the South Side elevated line, and in 1897 the radiating lines were joined in a city-center loop, which is the source of the name "the Loop" for the city's commercial district.

To commemorate the 400th anniversary of Christopher Columbus's discovery of America and to celebrate the city's rapid recovery from the fire, the World's Columbian Exposition was held (a year late) in 1893 in Jackson Park. The general site plan was initially drawn up by Daniel H. Burnham, later the director of construction, and John Wellborn Root, with Olmsted and Henry Codman (1867–93). Pavilions were designed by, among others, Adler & Sullivan, Jenney & Mundie, Richard Morris Hunt, Solon S. Beman and Henry Ives Cobb. The fair, which had record attendances, stimulated worldwide interest in comprehensive planning, not only of individual buildings but also of their spatial, functional and aesthetic interrelations, and furthered interest in the ideals of the City Beautiful Movement for the enhancement of the urban environment. Another effect of the Exposition was, however, its negative impact on developments in skyscraper technology in Chicago, since height limitations were imposed in the city. New York took over as the center for innovations in high-rises.

As a direct result of the Exposition, Burnham and Edward H. Bennett (1874–1954) were commissioned (1906) by the City Club of Chicago to prepare a comprehensive plan for the city and its environs. Published in 1909, the *Plan of Chicago* was a prototype for comprehensive plans for many other cities, although, as in the plans of the City Beautiful Movement, the absence of skyscrapers, elevated railways and other features of the modern city was in many ways unrealistic. The Chicago Plan Commission, a forerunner of the American Planning Association and a quasi-official organization, was instrumental in spreading interest in urban planning. It conducted educational programs, introduced planning into the American public school curriculum and promoted many of the outstanding infrastructure

improvements in Chicago during the following 30 years. These included the almost continuous lake-front parks; the widening of arterial streets; numerous bridges across the Chicago River and its branches; the North Michigan Avenue boulevard development (which a century later became the axis for a new retail, hotel, office and residential area complementing the older Loop district); a new Union Station (1913–25) by Graham, Burnham & Co. (1913–17) and Graham, Anderson, Probst & White (after 1917); and an outer belt of forest areas, principally along the suburban corridors. In retrospect, the Burnham and Bennett plan had many shortcomings. It treated such social problems as poverty and housing very lightly, implying that physical improvements would stimulate the mitigation of social problems; this proved not to be the case.

After c. 1930. By the late 1930s it was realized that a continuous planning operation, with more official status, was needed to deal not only with the city's physical infrastructure but also with basic problems of economic and social welfare. The Chicago Plan Commission was reconstituted: it acquired a professional staff that prepared many studies and plans, some of which were implemented. One study indicated that a predominantly residential area of *c.* 37 sq. m, located primarily close to the central business district, was so blighted that complete demolition and rebuilding would be necessary before living conditions met acceptable standards. Another plan prepared in the 1930s was for a series of "superhighways" designed to carry a high proportion of the city and suburban traffic, and for two rapid-transit underground rail systems. The latter were built from 1943, and by the 1960s the superhighways were also in place, facilitating rapid expansion of the suburban areas. Suburban land-use patterns were transformed: vast areas were rapidly filled with single-family detached houses; huge, enclosed shopping malls offered effective competition to the older commercial areas within the city and inner suburbs; office and industrial parks induced relocation of businesses to the urban periphery and

beyond. Decline of the city's tax base inevitably followed, at the same time that the increasing demands for social services and physical rehabilitation and maintenance accentuated the need for expenditure.

During the 1950s and 1960s huge clusters of high-rise blocks of flats were constructed in the older city areas, consisting of public housing for the poor (often from ethnic minorities) and privately built (but publicly assisted) housing for the wealthier population. A pioneering example was set by the pair of 24-story apartment towers at 860 Lake Shore Drive), built in 1951 by Ludwig Mies van Der Rohe in glass and steel. Even these massive housing projects represented only a small part of the demand, however. Furthermore, many residents of the poorer areas were victims of social and economic problems. After inter-racial conflict erupted in many areas, notably in 1968, the courts ordered that concentrated public housing could no longer be built in areas in which a given ethnic minority predominated; public housing had to be on scattered sites.

Mies van der Rohe's career in Chicago was of seminal importance to the appearance of the city in the mid-20th century. He produced many low-rise buildings over a 20-year period for the Illinois Institute of Technology, and for other institutions, such as the School of Social Service Administration (1952–5) for the University of Chicago. From the 1960s skyscrapers increasingly characterized the center of Chicago: about 75 were built in the 1970s and 1980s. Indeed two buildings by the practice of Skidmore, Owings & Merrill (SOM) are among the tallest in the world: working in association with the SOM practice, Bruce Graham (1925–2010) built the multi-purpose John Hancock Center, standing at 344 m, in 1969, and five years later he worked with Fazlur Khan and SOM to produce the Sears Tower (443 m; now Willis Tower) using a tubular steel frame. A major figure of the late 20th century associated with Chicago was Helmut Jahn, whose buildings are characterized by a pastiche of historical and

exotic styles. Examples of his skyscrapers include One South Wacker Drive (1984) and the Art-Deco style Northwestern Terminal Building (1987).

The multi-functional high-rise building became increasingly common in the 1980s, combining retail establishments, offices, shops, flats and sometimes hotels. Examples include the River City Building (1985) by Bertrand Goldberg (1913–97). Many were built in response to the "Century 21" plan of the 1970s, developed by private venture capital in collaboration with public agencies. Several more were proposed in the early 1990s but were deferred because of the decline of the property market. Major additions to the metropolitan infrastructure proposed for construction before the end of the 20th century included additional express highways and rapid-transit lines, another large airport, completion of a deep-tunnel sewerage system and additions to the park and forest systems.

In the first decade of the 21st century, the development of Millennium Park (1998–2004) transformed an abandoned lakefront industrial site into a vibrant downtown city park, extending over 24.5 acres. Two of its prominent architectural features are Frank Gehry's signature swirling steel forms that make up the Jay Pritzker Pavilion's outdoor bandstand (1999–2004), and the five-acre Lurie Garden, designed by Kathryn Gustafson, Piet Oudolf and Robert Israel, to refer to the city's history and culture, with 5-m "shoulder" hedges outlining expanses of native plantings. To the south is the Modern Wing of the Chicago Art Institute (completed 2009), the c. 22,000 sq. m addition designed by Renzo Piano as a natural light-filled complement to the museum's 1893 Beaux-Arts structure. Its distinctive steel and glass façade, floating roof and staircase suspended on slender, glass columns carries forward the industrial aesthetic imprinted on the city by Mies van der Rohe.

Art life and organization.

Before World War II. The city's first major cultural development was the founding by a group of artists in 1866 of the Chicago Academy of Design, a professional art school. Chicago's cultural needs began to be more broadly addressed, however, after the fire of 1871, when the city was rebuilt and became a center for modern architecture (see above). The great philanthropists Edward E. Ayer, Marshall Field, Charles L. Hutchinson, Potter Palmer, Lambert Tree and Martin A. Ryerson, whose wealth was generated through the city's successful commerce and manufacturing, envisaged art as a means of social improvement for the "brawling masses." They firmly believed in John Ruskin's notions of the ennobling and purifying effects of art. Their first project was to take over the financially troubled Academy of Design, which they reorganized and renamed the Art Institute of Chicago (AIC) in 1882. The donation of these patrons' collections formed the core of the AIC's renowned Impressionist and Post-Impressionist holdings and established a continuing tradition of high-level collecting by private individuals in the city. The AIC retained its teaching center as the School of Art Institute, which rapidly became a regional magnet for aspiring artists.

The World's Columbian Exposition, held in Chicago in 1893, provided the second major impetus for cultural growth. The AIC's Beaux-Arts style building located between Lake Michigan and Michigan Avenue was originally an exhibition hall for the Exposition; the central building was later significantly extended. The Fine Arts Building, erected in 1893 on Michigan Avenue, was not primarily an exhibition space, but a commercial studio, recital and office building providing a forum for artists, writers, musicians, craftsmen and other creative people. After the Exposition, an artists' colony grew up, based on 57th Street in housing built for workers employed on construction of the Exposition and then abandoned, and focused on the newly established University of Chicago (founded 1890). The colony thrived until the outbreak of World War II. Also in the late 19th century, the strong following in Chicago of the Arts and Crafts Movement was indicated by the founding in 1897 of the

Chicago Society of Arts and Crafts at Hull House, a settlement house, where immigrants practiced such crafts as spinning and weaving.

By the early 20th century the AIC had amassed a significant collection through donations and purchases. In 1913 the landmark Armory Show traveled to Chicago from New York, causing great controversy but drawing huge crowds; several important works, including Vasily Kandinsky's *Improvisation with Green Center (No. 176)* (1913) were bought from the show and eventually donated to the AIC. In 1926 it acquired the Helen Birch Bartlett Memorial Collection, which included Georges Seurat's *Sunday Afternoon on the Island of La Grande Jatte* (1884–6), now a signature work along with Grant Wood's *American Gothic*, executed and acquired in 1930. The art life of the city was augmented by the Renaissance Society at the University of Chicago, which began holding exhibitions of avant-garde art in 1915. The following year the Arts Club of Chicago was founded, exhibiting Post-Impressionist works (so favored by Chicago collectors) and providing venues for such important modern artists as Constantin Brancusi (1876–1957). Local artists began to organize against what they perceived as an increasingly antiquated and hostile Art Institute; the AIC's venerable Annual Exhibition of Artists of Chicago and Vicinity (now defunct), conceived to highlight local talent, became a focus for rallying cries for change by Chicago artists, who, despite generally practicing figurative styles, were still consistently rejected as "too modern." A *salon des refusés* formed in 1920 by the abstract artist Rudolph Weisenborn (1891–1973) and the art dealer Increase Robinson became a model for much subsequent activity by local artists.

Artists' groups proliferated in Chicago in the 1920s but dwindled with the Great Depression of the 1930s. There was little artistic activity outside the Works' Progress Administration's Federal Arts Program, through which mural decoration was undertaken for some post offices and libraries. In 1933, however, the *Century of Progress Exposition*, a world's fair to commemorate the 100th anniversary of Chicago's founding, brought badly needed stimulation to the city's depressed economy. Funded largely by Chicago's business community, it was the first world's fair to make a profit, and its modernistic presentation of cultural, ethnographic and technological exhibits set a standard for many subsequent world's fairs. In 1937 the New Bauhaus (from 1939 the School of Design, and from 1944 the Institute of Design) was founded by László Moholy-Nagy, who came to the USA because of growing political unrest in Europe. The Hyde Park Art Center, a pioneering community-based teaching and exhibition center was founded in 1939 by veterans of the 57th Street artists' colony.

After World War II. Many war veterans took advantage of the government-sponsored GI Bill to obtain professional art education, including Leon Golub and H. C. Westermann. With modern art increasingly accepted by cultural institutions in Chicago, several commercial galleries (Fairweather Hardin and Allan Frumkin galleries, and Richard L. Feigen and Co.) began showing national and international contemporary art, as well as local painting and sculpture. A new generation of collectors (including Joseph and Jory Shapiro and Mr. and Mrs. Edwin A. Bergman) began to amass important holdings of Surrealist art, in addition to supporting local artists. Shapiro works on paper are now in the AIC; paintings and sculpture are in the Museum of Contemporary Art; pre-1945 material from the Bergman collection is in the AIC. In 1948 artists once again banded together against the increasingly staid Chicago and Vicinity shows at the AIC; their protests resulted in the Exhibition Momentum series of alternative shows, which continued throughout the 1950s and 1960s.

Chicago's first nationally recognized style was the Monster Roster, of which Golub was a major exponent, although characteristic works also include Richard Hunt's Surrealist-influenced abstract sculpture *Construction E* (1955; Chicago, David C. Ruttenberg priv. col.) and Westermann's

idiosyncratic wood construction *Mad House* (1957; Chicago, IL, Mus. Contemp. A.). There was, however, still a small community of artists practicing the figuration historically associated with the city, which critics sought to justify. Important in this justification was the lecture "Anticultural Positions" (1951), given at the Arts Club by Jean Dubuffet (1901–85), whose message of looking inward to a primitive well-spring of creativity held great appeal for Chicago's artists, who felt isolated by a mainstream art world captivated by the Abstract Expressionism of the New York school.

In the early 1960s Black Expressionism gave rise to the Black Neighborhood Mural Movement. In 1961 the Du Sable Museum was founded as the first museum in the Midwest dedicated to African American culture, collecting the work of such artists as Archibald Motley Jr. By the mid-1960s a group of AIC-trained artists, who had first exhibited together at shows at the Hyde Park Art Center organized by artist–impresario Don Baum (1922–2008), came to prominence and eventually became known as the Imagists. They included Roger Brown, Jim Nutt, Gladys Nilsson (*b* 1940) and Ed Paschke. While continuing the historical interest in figurative art, they drew upon such sources as Surrealism, ethnic art, folk art, *art brut*, comics and advertising. In 1967 the Museum of Contemporary Art was founded to show developments in international art that were otherwise unrepresented in Chicago. With controversial early projects, including Christo and Jeanne-Claude's wrapping of the building, the museum brought long-overdue excitement to the city's contemporary art scene.

A tradition of public sculpture that had been established in the late 19th century was enhanced in 1967 with the gift to the city by Pablo Picasso (1881–1973) of his monumental steel portrait of Jacqueline Roque: *Chicago Picasso* (1967; Daley Plaza) became an emblem of the city. Other public works erected in the second half of the 20th century include Alexander Calder's *Flamingo* (1974; Federal Plaza), the massive five-sided architectural mosaic,

the *Four Seasons* (stone and glass, 21.34×4.27×3.04 m, 1974; First National Plaza) by Marc Chagall (1887–1985), Claes Oldenburg's *Batcolumn* (1977; Social Security Administration Building Plaza) and Dubuffet's *Monument to the Standing Beast* (1982; State of Illinois Building Plaza). Two of the most popular public works are found in Millennium Park: Crown Fountain (2004) by Jaume Plensa (*b* 1955), whose two glass block towers (*c.* 15 m high) light up with the projected faces of city residents at each end of a shallow reflecting pool; and the 110-ton elliptical Cloud Gate sculpture (2004–6)—popularly known as "The Bean"—by Anish Kapoor (*b* 1954) with its surface of polished stainless steel that reflects the clouds above and the surrounding city skyline.

Chicago's progressive Percent for the Arts Program, which requires that 1% of the cost of each new building built for or by the city is used to purchase art for the site, has contributed to the placement of substantial art works throughout the city. The foundation in 1970 of the Chicago Mural Group, which works with different communities, stimulated public art further. Explosive growth in the arts occurred in the 1970s. Artists' cooperative galleries led by N.A.M.E. and the feminist-oriented ARC and Artemisia enabled a new generation of conceptual, installation and performance artists, as well as painters and sculptors, to exhibit. Computer and video art flourished at the University of Illinois. The tradition of excellence in fine art photography established at the Institute of Design blossomed through the teaching of such figures as Aaron Siskind and Harry Callahan, and in 1984 Columbia College Chicago's Museum of Contemporary Photography replaced the Chicago Center for Contemporary Photography. Also, the School of the Art Institute expanded.

From the 1980s fewer artists left Chicago for New York, and commercial galleries boomed. A tendency toward installations and performance art was particularly strong, the latter centered around the Randolph Street Gallery (1979–98), along with an

expanding, active underground art scene driven by independent and cooperative galleries. In 1991 the Chicago Cultural Center opened with exhibition spaces in the restored downtown public library building (1893), itself an architectural landmark featuring a Tiffany dome.

[*See also* Adler, Dankmar; Brown, Roger; Burnham, Daniel H.; Callahan, Harry; Chicago school; Holabird & Roche; Jenney, William Le Baron; Mies van der Rohe, Ludwig; Nutt, Jim; Olmsted, Frederick Law; Paschke, Ed; Prairie school; Richardson, H. H.; Skidmore, Owings & Merrill; Siskind, Aaron; Sullivan, Louis; *and* Wright, Frank Lloyd.]

BIBLIOGRAPHY

I. Bach and M. L. Gray: *A Guide to ChicagO's Public Sculpture* (Chicago and London, 1983)

J. A. Barter, ed.: *Apostles of Beauty: Arts and Crafts from Britain to Chicago* (Chicago, 2009)

D. Bluestone: "Preservation and Renewal in Post-World War II Chicago," *J. Archit. Educ.*, xlvii/4 (May 1994), pp. 210–23

R. Bruegmann: *The Architects and the City: Holabird & Roche of Chicago, 1880–1918* (Chicago, 1997)

D. H. Burnham and E. H. Bennett: *Plan of Chicago* (Chicago, 1909/R 1960)

C. W. Condit: *The Chicago School of Architecture: A History of Commercial and Public Building in the Chicago Area, 1875–1925* (Chicago, 1964)

W. Cronon: *Nature's Metropolis: Chicago and the Great West* (New York and London, 1991)

I. Cutler: *Chicago: Metropolis of the Mid-continent* (Dubuque, IA, 3/1982)

M. L. Gray: *A Guide to Chicago's Murals* (Chicago, 2001)

J. R. Grossman, A. D. Keating and J. L. Reiff, eds.: *The Encyclopedia of Chicago* (Chicago, 2004)

Z. L. Jacobson: *Art of Today: Chicago, 1933* (Chicago, 1932)

H. Hoyt: *One Hundred Years of Land Values in Chicago: The Relationship of the Growth of Chicago to the Rise in its Land Values, 1830–1933* (Chicago, 1933)

Master Paintings in the Art Institute of Chicago (exh. cat. by J. Wood, Chicago, IL, A. Inst., 1988)

H. M. Mayer and R. C. Wade: *Chicago: Growth of a Metropolis* (Chicago, 1969)

J. Merwood-Salisbury: *Chicago 1890: The Skyscraper and the Modern City* (Chicago, 2009)

D. A. Pacyga: *Chicago: A Biography* (Chicago, 2009)

D. A. Pacyga and E. Skerett: *Chicago: City of Neighborhoods. History & Tours* (Chicago, 1986)

B. L. Pierce: *A History of Chicago*, 3 vols. (New York, 1937–57)

Residential Land Use: Master Plan of Chicago, chicago Plan Commission (Chicago, 1943)

S. A. Prince: *The Old Guard and the Avant-Garde: Modernism in Chicago, 1910–1940* (London and Chicago, 1990)

J. F. Roche: "Louis Sullivan's Architectural Principles and the Organicist Aesthetic of Friedrich Schelling and S. T. Coleridge," *19th C. Stud.*, vii (1993), pp. 29–55

F. Schulze: *Fantastic Images: Chicago Art since 1945* (Chicago, 1972)

C. Smith: *The Plan of Chicago: Daniel Burnham and the Remaking of the American City* (Chicago, 2006)

K. Solomonson: *The Chicago Tribune Tower Competition, Skyscraper Design and Cultural Change in the 1920s* (Chicago, 2001)

T. Suhre: *Moholy-Nagy: A New Vision for Chicago* (Springfield, 1990)

The Arts Club of Chicago: Seventy-fifth Anniversary Exhibition (Chicago, 1992)

D. van Zanten: "Chicago in Architectural History," *Architectural Historian in America: A Symposium in Celebration of the Fiftieth Anniversary of the Founding of the Society of Architectural Historians*, ed. E. B. MacDougall (Washington, DC, 1990), pp. 91–9

Visions: Painting and Sculpture. Distinguished Alumni, 1945 to the Present (exh. cat. by D. Adrian, Chicago, IL, Sch. A. Inst., 1976)

C. Waldheim and K. Rüedi Ray, eds.: *Chicago Architecture: Histories, Revisions, Alternatives* (Chicago, 2005)

R. G. Wilson: "Prairie School Works in the Department of Architecture at the Art Institute of Chicago," *Mus. Stud.*, xxi/2 (1995), pp. 92–111

Who Chicago? (exh. cat. by D. Adrian, Sunderland, A. Cent., 1980)

J. Zukowsky, ed.: *Chicago Architecture, 1872–1922: Birth of a Metropolis* (Munich, 1987)

J. Zukowsky, ed.: *Chicago Architecture and Design, 1923–1993: Reconfiguration of an American Metropolis* (Chicago, 1993)

Harold M. Mayer and Lynne Warren
Revised and updated by Margaret Barlow

Chicago, Judy

(*b* Chicago, IL, 20 July 1939), installation artist, activist, feminist, author and educator. Chicago became involved in the art world in the 1960s and is one of the originators of feminist art education in the USA. Born Judy Cohen and brought up in Chicago by socialist Jewish parents, she studied at University of California, Los Angeles, where she

became a member of Phi Beta Kappa, and received a Bachelor of Art in 1962 and a Masters of Art in 1964. She remained in California where she began working in the Los Angeles-based "Finish Fetish" style, a variation of West Coast Minimalism, and her piece *Rainbow Pickett* (destr. by the artist but recreated in 2004) was included in *Primary Structures*, the 1966 exhibition curated by Kynaston McShine at the Jewish Museum in New York City, which introduced Minimalism. In 1969, she started the first feminist art education program at California State University, Fresno, where she remained until 1971; in 1970 she changed her last name to Chicago to remove the patronym and celebrate her independence from patriarchy. Then, she co-founded the Feminist Art Program with artist Miriam Schapiro at the California Institute of the Arts (CalArts), in Valencia, which ran from 1971 until 1973. With their students, they created the massive *Womanhouse*; a series of feminist installations and performances inside of a soon-to-be demolished mansion, on view from 30 January through 28 February 1972, which had a broad and lasting impact on feminist art. Chicago, alongside art historian Arlene Raven and graphic designer Sheila de Bretteville, co-founded the Los Angeles Woman's Building in 1973, an influential center for feminist art activities, where she co-founded the Feminist Studio Workshop. From 1974 through 1978, she focused her energies on producing *The Dinner Party* (San Francisco, CA, MOMA), a large sculptural installation requiring hundreds of volunteer hours to create a triangular table with embroidered place settings and ceramic plates for 39 famous historical women (including artist Georgia O'Keeffe as the one living guest). The installation became the centerpiece in 2007 of the Elizabeth A. Sackler Center for Feminist Art at the Brooklyn Museum. In 1978, she founded Through the Flower, a non-profit arts organization to support her work. Chicago's *The Birth Project* (1980–85), and *The Holocaust Project* (1987–93), which she created with her husband, photographer Donald Woodman, are also large-scale installations.

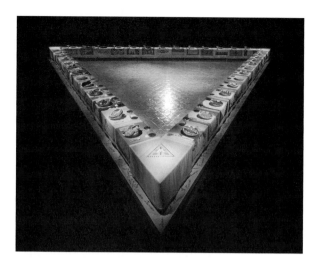

JUDY CHICAGO. *The Dinner Party*, mixed media, 1979. © JUDY CHICAGO, 1979/ELIZABETH A. SACKLER CENTER FOR FEMINIST ART, COLLECTION OF THE BROOKLYN MUSEUM OF ART/PHOTOGRAPH BY DONALD WOODMAN

[*See also* Primary Structures *and* Womanhouse.]

BIBLIOGRAPHY

J. Chicago: *Through The Flower: My Struggle As a Woman Artist* (New York, 1993)

J. Chicago: *The Dinner Party* (New York, 1996)

G. Levin: *Becoming Judy Chicago: A Biography of the Artist* (New York, 2007)

Anne K. Swartz

Chicago school

Term applied today to an informal group of architects, active mainly in Chicago in the late 19th and early 20th centuries. The architects whose names have come to be associated with the term include Dankmar Adler, Daniel H. Burnham, William Holabird, William Le Baron Jenney, Martin Roche and Louis Sullivan. All these architects were linked by their use of the new engineering and construction methods developing in high-rise buildings from the 1880s (sometimes described as "Chicago construction") and by a new approach to the articulation of facades. In its original use, however, as defined in 1908 by the architect and writer Thomas E. Tallmadge (1876–1940), the term was applied to the work of architects of the next generation.

First generation. In the more general use of the term "Chicago school," the first common and uniting element for the architects concerned was their use of the steel skeleton for constructing buildings. In the aftermath of the Great Fire of 1871, which devastated Chicago, rapid expansion took place. The high cost and limited availability of sites meant that architects developed high-rise buildings and sought new ways to make buildings fireproof; even cast-iron frame buildings had been vulnerable. William Le Baron Jenney pioneered the use of an iron and steel skeleton clad with masonry, which rendered it more heat resistant, in the Home Insurance Building (1883–5; destr. 1931). Five years later Burnham and Root built the Rand–McNally Building, for which they employed the steel skeleton.

The second identifying characteristic of "Chicago construction" is simple exterior decoration, often in red brick or terracotta, and the use of blocky volumes. It was the Bostonian H. H. Richardson who provided the influential model for the stylistic development and the move away from decorative eclecticism, in his massive Marshall Field Wholesale Store (1885–7; destr. 1930), with its plain, rusticated facade and windows grouped under round arches. In 1886–9 Richardson's approach was echoed in the exterior of Sullivan and Adler's Auditorium Building; it was Sullivan who was responsible for the design and ornament. By contrast, Burnham and Root in their brick Monadnock Building (1889–91), the most celebrated example, avoided ornament.

These two characteristics did not necessarily occur together: the Monadnock Building has no skeleton; the Home Insurance Building is disappointingly overdecorated. They might, however, coincide, and at that moment the masterpieces of the moment appeared, such as the steel and terracotta Reliance Building (1891–5) by Burnham and Charles Atwood (with John Wellborn Root) or the skyscrapers of Adler and Sullivan, beginning with the Wainwright Building (1890–91) in St Louis.

In 1893 the World's Columbian Exposition was held in Chicago, re-establishing the popularity of classicism; in addition, restrictions were placed on the height of buildings in the city. Some critics consider this the effective end of the Chicago school, although for others this era is considered its beginning.

Second generation. When Tallmadge first self-consciously defined the term "Chicago school" in 1908, he characterized the school's style as the avoidance of historical forms, the invention of original ornament based on real botanical species and acceptance of boxy, geometric massing. He located the formulation of these ideas among the younger Chicago draftsmen gathering at the Chicago Architectural Club, which organized design competitions and exhibitions, and identified its leaders as George W. Maher, Richard E. Schmidt (1865–1958), Hugh M. G. Garden, George C. Nimmons (1869–1947), Robert C. Spencer, George R. Dean (1864–1919), Dwight H. Perkins (1867–1941), Myron Hunt (1868–1962) and especially Frank Lloyd Wright. Important examples of their work include Maher's Patten House (1901; destr.), Evanston, IL; Schmidt and Garden's Madlener House (1902), Chicago; and Perkins's work as architect of the Chicago School Board (1905–10), especially his Carl Schurz High School (1908).

This self-conscious, second-generation "Chicago school" was of short duration, having emerged c. 1895 when most of the members first set up practice, and was already showing signs of dissolution when Tallmadge wrote in 1908. It was a basically unsuccessful attempt to make a system of the intensely personal contribution of Sullivan, who had been recognized as the creator of a new, antihistorical manner by influential critics Barr Ferree and Montgomery Schuyler early in the 1890s on the basis of his Wainwright Building (1890–91), St Louis, and in Chicago the Schiller Building (1891–3) and the Transportation Building (1891–3) at the World's Columbian Exposition (1893). By 1900, however, Frank Lloyd Wright, in what he called his "Prairie Houses," was already developing a very different and equally personal style and, like Sullivan, was soon proclaimed the founder of another and equally ephemeral school, christened in the 1960s the Prairie

School. This included Walter Burley Griffin and Marion Mahony Griffin, William E. Drummond and John S. Van Burgen (1885–1969).

The flaw in the formulation of these schools would seem to lie in their effort to reduce to systems the manner of two individualists, when what was most fertile was the mentality and technology of the locality. In the 1830s Chicago carpenters had invented the balloon frame. The city had also been at the forefront of the development of fireproof commercial buildings following the Great Fire of 1871. The architects themselves were aware of their accomplishment (Root in particular), and visitors and writers saw these structures as powerful and characteristic expressions of the city's spirit: Henry Blake Fuller in *The Cliff Dwellers* (1893); Achille Hernant in the *Gazette des Beaux-Arts* (1893–4); Paul Bourget in *Outre-Mer* (1895); and Theodore Dreiser in *Sister Carrie* (1900). When in the 1930s advocates of the European International Style, such as Henry-Russell Hitchcock, Richard Neutra, Nikolaus Pevsner and Sigfried Giedion, evoked Chicago, it was in these terms, and Sullivan and Wright were presented as emanations of a broader Chicago mentality. Between the two World Wars more insular American critics, such as Fiske Kimball (*American Architecture*, 1928) and Tallmadge (*The Story of Architecture in America*, 1927), depicted Sullivan and Wright as romantics attempting (but failing) to create an "American" style, while Lewis Mumford saw them in the same terms in his *Sticks and Stones* (1924) and *Brown Decades* (1931) but believed that their cause would succeed.

The consequence of seeing Sullivan and Wright as the products of a technological Chicago was to denigrate the aesthetic, humane element in their work: Sullivan's exuberant ornament; Wright's effort to blend his houses with their environment. In his *Space, Time and Architecture* (1941), Giedion argued that Sullivan's skyscrapers should be seen as a particularly frank expression of their inner-steel skeletons and that Wright's houses should be appreciated as compositions of geometric forms in space, thus summing up 50 years of critical interpretations of

Chicago's contribution beginning with: H.-R. Hitchcock, *The Buildings of Frank Lloyd Wright* (1928) and *Modern Architecture: Romanticism and Reintegration* (1929); R. Neutra, *Amerika* (Vienna, 1930); H. Morrison, *Louis Sullivan: Prophet of Modern Architecture* (1935); and N. Pevsner, *Pioneers of the Modern Movement* (1936). The final result was the doctrine of Carl Condit's *Chicago School of Architecture* (1964), namely that there is a consistent, almost inevitable, Chicago tradition of industrial architecture extending from Jenney to Mies van der Rohe, in which Sullivan and Wright are mere incidents. Other art historians have held that the intentions of Sullivan and Wright should be seen in their immediate historical context, an attitude initiated by Vincent Scully, who treated Sullivan as a humane ornamentalist (*Perspecta*, v, 1959) and Wright as a symbolist (*Frank Lloyd Wright*, New York, 1960). Since then have come Sherman Paul's *Louis Sullivan: An Architect in American Thought* (1962), Narciso Menocal's *Architecture as Nature* (1981) and Lauren Weingarden's essays on Sullivan, as well as Norris Kelly Smith's *Frank Lloyd Wright: A Study in Architectural Content* (1966) and Neil Levine's *The Architecture of Frank Lloyd Wright* (1996). What remains to be addressed, once a more subtle and historically accurate definition of these men's enterprise has been arrived at, is an expansion of the idea of a "Chicago school" to embrace Daniel H. Burnham with his World's Columbian Exposition work of 1893, as well as his Chicago plan of 1909, and thus to include popular imagery as well as technique in the conception. Chicago's role in the emergence of an unprecedented and revolutionary American visual culture in the late 19th and early 20th centuries was pervasive and complex; more exploration of this cultural phenomenon is still needed.

[*See also* Chicago; Prairie school; Sullivan, Louis; *and* Wright, Frank Lloyd.]

BIBLIOGRAPHY
Industrial Chicago, 6 vols (Chicago, 1891–6)
Catalogues of Annual Exhibitions, Chicago Architectural Club (Chicago, 1894–1923)

T. E. Tallmadge: 'The Chicago School', *Archit. Rev. [Boston]*, xv (1908), pp. 69–74

S. Giedion: *Space, Time and Architecture* (Cambridge, MA, 1941)

F. A. Randall: *History of the Development of Building Construction in Chicago* (Urbana, 1949)

C. Condit: *The Rise of the Skyscraper* (Chicago, 1952)

C. Condit: *The Chicago School of Architecture* (Chicago, 1964)

M. Peisch: *The Chicago School of Architecture: Early Followers of Sullivan and Wright* (New York, 1965)

H. A. Brooks: *The Prairie School: Frank Lloyd Wright and his Midwest Contemporaries* (Toronto, 1972)

G. Wright: *Moralism and the Model Home* (Chicago, 1980)

C. S. Smith: *Chicago and the American Literary Imagination, 1880–1920* (Chicago, 1984)

K. Sawislak: *Smoldering City* (Chicago, 1995)

J. Merwood-Salisbury: *Chicago, 1890: The Skyscraper and the Modern City* (Chicago, 2009)

DAVID VAN ZANTEN

Chicago Tribune Competition

Architectural competition held in 1922 by the *Chicago Tribune* newspaper for its new corporate headquarters. The competition changed American views of European modernism and the course of American skyscraper architecture. The 1922 *Chicago Tribune* Competition's call for competitors attracted more than 260 architects from 23 countries with the offer of a $50,000 prize for the winning design. Although the company may have issued this competition as a way of attracting attention to its newspaper, competitors from around the world, drawn by what was in 1922 an astronomical sum, submitted entries that varied from the very traditional revival styles to cutting-edge European modernism. In the end, the winners were Americans John Mead Howells and Raymond Hood (Howells & Hood) with their neo-Gothic skyscraper influenced by the Tour de Beurre in Rouen Cathedral. However, the second place entry from Eliel Saarinen of Finland took America by storm, encouraging the architect to immigrate to the USA. In fact, some American architects and critics, such as Louis Sullivan, preferred the Saarinen design to the Howells & Hood tower, and

Saarinen's stepped-back tower with little applied decoration certainly influenced later skyscraper design.

Perhaps the fact that a revival-style design won the competition makes entries by the European architects even more interesting. Adolf Loos (1870–1933), whose drawing arrived too late to be considered, submitted a play on the idea of the newspaper column, surmounting his modern 12-story base with a Doric column. Walter Gropius and Adolf Meyer (1881–1929), both destined to become directors of the German Bauhaus, submitted a design which clad the building in glass and emphasized the horizontal plane, a far cry from the winning neo-Gothic design with its upward motion.

Not every architect seemed to take the competition seriously, however. The German Heinrich Mossdorf presented a tower topped by a befeathered Native American wielding a tomahawk, and even some American architects such as Jens Frederick Larson (*b* 1893), later the architect for Dartmouth College, Hanover, NH, presented a variation on Philadelphia's Independence Hall, rendered as a skyscraper.

So striking were the entries that a number of Honorable Mentions were distributed, including one for New Yorkers Albert Fellheimer (1875–1959) and Steward Wagner, who employed the setback, but in the general shape of an obelisk. Another Honorable Mention went to Japanese–American Richard Yoshijiro Mine (1894–1981), whose neo-Gothic design now resides in the collections of the Chicago Art Institute, one of few drawings from the competition that has survived.

In 1923 the *Chicago Tribune* published *The International Competition for a New Administration Building*, capping its achievement of a year earlier with a compendium of the designs submitted. If the American critical public had missed or forgotten the many designs which exemplified European modernism, they could then ruminate over each, argue about the best and even, in the case of architects, use the volume as a primer for their own work, a kind of skyscraper pattern book. Certainly Raymond

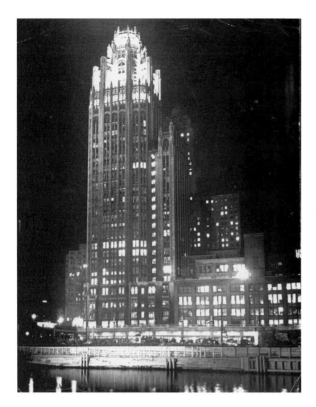

CHICAGO TRIBUNE COMPETITION. *Chicago Tribune* Building by Raymond Hood and John Mead Howells, Chicago, Illinois, 1922–5. (Photo by George Skadding//Time Life Pictures/Getty Images)

Hood, whose winning design had represented a collaboration with the more traditional John Mead Howells, went on to some glory for his skyscraper designs, taking to heart the lessons that he had gleaned from the losing entries in the competition; and skyscraper design was forever more changed in the USA. Hood's American Radiator Building (1924) and New York Daily News Building (1929) both in New York City, appear to discard the historical references that won the *Chicago Tribune* Competition in favor of a more European, stripped-down approach.

Did the *Chicago Tribune* Competition open the door in the USA to the International Style in architecture? It certainly introduced some of the practitioners to an American audience, made up not just of the general public but of the population of American architects as well. It was a wake-up call to many architects who had comfortably designed tall office buildings in revival styles, especially the favored Gothic Revival, to think about how a modern structure should be designed and what style should be applied, if any. Certainly with the immigration of a number of architects who participated in the competition, including Saarinen and Gropius, the floodgates were opened to European modernism.

UNPUBLISHED SOURCES
Chicago, IL, A. Inst. [Chicago Tribune Tower Competition]

BIBLIOGRAPHY
The International Competition for a New Administration Building for the Chicago Tribune (Chicago, 1923)

K. Solomonson: *The Chicago Tribune Tower Competition: Skyscraper Design and Cultural Change in the 1920s* (Chicago, 2003)

K. Solomonson: "The Chicago Tribune Tower Competition: Publicity", *The American Skyscraper—Cultural Histories*, ed. R. Moudry (Cambridge, 2005), pp. 147–64

Sandra L. Tatman

Childs, Lucinda

(*b* New York, NY, 26 June 1940), dancer and choreographer. Born in 1940, Childs grew up in New York City. In her teens she studied with such dancing legends as Hanya Holm and Helen Tamiris. Childs majored in dance at Sarah Lawrence College, where she received a Bachelor's degree. There she studied with Judith Dunn, Bessie Schonberg and Merce Cunningham, whose iconoclastic approach to dance was of particular importance. In 1963, at Cunningham's studio, she met Yvonne Rainer, another dancer who became a renowned choreographer, who told her about the dance, performance and art activities at the Judson Church in New York City. Childs became one of the founding members of the Judson Dance Theater. There she had the opportunity to investigate and experiment. As an original member of the troupe, she performed with Robert Morris and Yvonne Ranier. She would incorporate elements from everyday life, evident in such works as *Pasttime* of 1963 where she performed a solo in three parts showcasing the movements of the body. By 1968, she

took a break from choreography to focus on developing her individual style, which has strong conceptual elements. By 1973, she had formed The Lucinda Childs Dance Company. Starting in 1979, she began collaborations with experimental visionaries including director Robert Wilson and composer Philip Glass, Steve Reich, Frank Gehry and Robert Mapplethorpe. With them, she performed and choreographed their breakthrough opera, *Einstein on the Beach,* and participated in the 1984 and 1992 revivals. Childs has subsequently worked with each separately, as well as choreographing for many other avant-garde composers and directors. She is considered one of the foremost proponents of postmodern dance because of her embrace of alternative approaches to the integration of movement and sound. Her commissions from important ballet companies include Pacific Northwest Ballet and Les Ballets de Monte-Carlo, among many others. In recent years Childs turned her attentions to choreographing for the opera for such directors as Peter Stein, Peter Sellers and Luc Bondy. In 1995, she directed her first opera, Mozart's *Zaide,* which she debuted in Belguim. Childs received the rank of Commandeur dans l'Ordre des Arts et des Lettres from the French Government in 2004.

BIBLIOGRAPHY

Tracking, Tracing, Marking, Pacing (Moving Drawings) (exh. cat., Pratt Manhattan Center Gallery, 1982) [with essay by E. Schwartz]

S. Barnes: *Democracy's Body: Judson Dance Theater, 1962–1964* (Durham, 1993)

F. Bertoni: *Minimalist Design* (London, 2004)

J. Morgenroth: *Speaking of Dance: Twelve Contemporary Choreographers on Their Craft* (New York, 2004)

Anne K. Swartz

Chim

(*b* Warsaw, 20 Nov 1911; *d* Suez, 10 Nov 1956), photographer of Polish birth. Chim studied printing at the Akademie für Graphische Kunst, Leipzig (1929–31), and then at the Sorbonne, Paris (1931–3), with the intention of working for his father, a prominent publisher of Hebrew and Yiddish books. By 1933 he had converted the bathroom of his flat into a darkroom, which he shared with his friends Robert Capa and Henri Cartier-Bresson. At this time he took the name Chim, adapted from his surname. In 1939 Chim emigrated to the USA and changed his surname to Seymour.

In 1934 Chim began to contribute photographs to *Regards,* a large-format illustrated magazine devoted to the ideals of the Popular Front, for which he eventually became the staff photographer. In July 1936 Chim was sent by *Regards* to be a correspondent for the Spanish Civil War, recording such images as *Loyalist Rally, Spain, 1936* (see Friedberg, pp. 36–7). Some of these and later photographs were published in *Life,* for example a report on Barcelona (*Life,* 28 Nov 1938, pp. 48–55). In 1947 Magnum, a cooperative photographic agency, was founded by Chim with Robert Capa, Cartier-Bresson, George Rodger (1908–95) and Bill Vandivert (*b* 1912); Chim was president when he died. In 1948 he was commissioned by UNESCO to produce a photographic report, which was published as *Children of Europe* (1949). One of his most famous images is *Terezka: A Disturbed Child in an Orphanage. The Scrawls on the Blackboard Are Her Drawing of "Home"* (1948, see Friedberg, p. 44). He undertook his last project in 1956, photographing the occupied Port Said in Suez, where he died under Egyptian machine-gun fire.

Chim combined a publishing background, an interest in politics and his knowledge of photography to become a photojournalist. In his work he usually collaborated with a writer, and he made photographs only after researching the subjects and situations he was representing. His importance to the development of photojournalism inspired the creation of the International Center of Photography in New York. His best known work was that documenting the effects of the horrors of war on children, a theme to which he often returned.

[*See also* Capa, Robert, *and* Magnum.]

PHOTOGRAPHIC PUBLICATIONS

Contributions to *Regards* (1934–)

Children of Europe (Paris, 1949)

The Vatican (New York, 1950)

The Little Ones (Tokyo, 1957)

BIBLIOGRAPHY

P. Pollack: *The Picture History of Photography* (New York, 1958, rev. 1969)

J. Friedberg: *David Seymour—"Chim"* (New York, 1966)

C. Capa, ed.: *The Concerned Photographer* (New York, 1968)

C. Capa and B. Karia, eds: *David Seymour—"Chim," 1911–1956* (New York, 1974)

C. Beaton and G. Buckland: *The Magic Image* (London, 1975)

I. Bondi: *Chim: The Photographs of David Seymour* (Boston, 1996)

Close Enough: Photography by D. Seymour Chim (exh. cat. by T. Gipps, College Park, MD, U. of Maryland A. Gal., 1999)

David Seymour: Chim (exh. cat. by K. de Baranano, H. Cartier-Bresson and others, Valencia, IVAM Centre Julio Gonzales, 2003)

T. Beck: *David Seymour Chim* (London, 2005)

O. Laurent. "Lost Photographs Brought to Light," *Br. J. Phot.*, 156/7735 (May 2009), pp. 4–5

Mary Christian

Chin, Mel

(*b* Houston, TX, 1951), sculptor, installation and conceptual artist. Chin's multimedia works investigate the pathology of contemporary culture. Mel Chin was born and raised in Houston, TX, to parents of Chinese birth and received his BA in 1975 from the Peabody College in Nashville, TN. The works in Chin's oeuvre are diverse in both medium and subject, but a consistent undercurrent of social, political and environmental responsibility runs throughout. Whether a sculpture, film, video game, installation, public project or earthwork, Chin's artworks consistently targeted a broad spectrum of pressing cultural and ecological interests and spread their message in subtle, if not viral ways.

In the 1980s, Chin produced a number of sculptures that set the stage for his ever evocative artistic journey. *The Extraction of Plenty from What Remains: 1823–* (1988–9) is a frequently referenced piece from this period. It is a symbolic encapsulation of the effects of the Monroe Doctrine, referencing the complicated dealings between the US (represented by truncated replicas of White House columns) and Central America (represented by a cornucopia of mahogany branches, woven banana-tree fiber, and a surface layer of hardened blood, mud and coffee grinds). From the 1990s, however, Chin moved away from strictly gallery-based installations and began creating works that directly engaged contemporary culture in a variety of physical and theoretical landscapes.

This transition is evidenced in *Revival Field*, which Chin began in 1991 at the Pig's Eye landfill outside St Paul, MN, as part of his residency at the Walker Art Center (for illustration, see Environmental art). Together with local scientists, Chin created a garden of hyperaccumulators—plants that leach the metal toxins from polluted soil and slowly clean contaminated earth. Once the plants reached their limits, they were burned; the extracted metals were sifted and recycled, and the harvested plants replaced by new ones. While Chin's work owes a great deal to its earthwork predecessors, *Revival Field* is more involved with restoring something back to its most natural state than making an aesthetic mark on the landscape.

With *In the Name of the Place* (a collaborative effort with members of the University of Georgia and the California Institute of Art, known as the GALA Committee), Chin targeted a very different medium: the plot and props within the 1990s television drama *Melrose Place*. Chin arranged for his GALA Committee to receive secret copies of the show's script and suggest set designs that would subtly reinforce controversial moments in the story arc while remaining below the radar of the Federal Communications Commission. Examples included a RU486 patterned comforter, a Chinese take-out box alluding to the Tiananmen Square tragedy and a set of bed linens with the abstract outline of unrolled condoms.

Other works in Chin's eclectic oeuvre include *Home y Sew 9* (1994), a Chin-retrofitted Glock 9mm handgun that—instead of bullets and a magazine—contained the surgical supplies and painkillers to

treat a trauma wound. With *WMD* (2004), Chin and his students at East Tennessee State University fitted out a mobile home to look like a weapon of mass destruction on the outside and a warehouse of mass distribution on the inside—a one-stop shop for those in need of clothes, food and books.

With each of the works in his politically conscious oeuvre, Chin succeeds in transforming facets of our culture from the inside out, while laying the framework for that change to continue long after the artist has moved on.

BIBLIOGRAPHY

Visions of America: Landscape as Metaphor in the Twentieth Century (exh. cat., Denver, CO, A. Mus.; Columbus, OH, Mus. A.; 1994)

L. Weintraub: *Art on the Edge and Over: Searching for Art's Meaning in Contemporary Society, 1970s–1990s* (Litchfield, CT, 1996)

Inescapable Histories: Mel Chin (exh. cat., Kansas City, MO, Exhibits USA, 1996)

M. Cieri and C. Peeps, eds.: *Activists Speak Out: Reflections on the Pursuit of Change in America* (New York, 2000), pp. 147–62

Mary M. Tinti

Chinese Revolutionary Artists' Club (Chinese Academy of Art)

Artists' club formed in 1926 in San Francisco's Chinatown. The club was composed of Guangdong immigrants in their late teens and early 20s. Its headquarters, which also served as a studio, teaching center, exhibition space and quite possibly a shared bedroom, was located in an upper room at 150 Wetmore Place, an alley on Chinatown's western fringe. The exact membership is unknown—probably a dozen members at any given time—and its composition fluctuated greatly during its 15 or so years of existence. Its most famous members were Yun Gee, a co-founder and leader, and Eva Fong Chan (1897–1991) who was granted membership in the early 1930s and was the only woman known to belong. Unlike Fong, a former beauty queen who was a piano teacher married to a prominent Catholic

businessman and privileged with an education, the young men were working-class and probably held the menial jobs reserved for most Chinese of their era, as servants, cooks, dishwashers and launderers.

The club was devoted to learning and teaching the techniques of modernist oil painting "that is essentially Chinese," as their friend and longtime San Francisco painter Otis Oldfield explained. This primarily meant paintings with local subject matter—the street scenes, people and goods of Chinatown—rendered in a style reminiscent of Salon Cubism. The membership had a preference for thick, loaded, choppy brush work and the juxtaposition of hot and cold colors. With few exceptions, their paintings are modestly sized, often on hardboard or paper, and dominated by figures. Considering that most schools and painters in the city were preoccupied with more conservative modes of expression, including variants of California Impressionism and Tonalism, the club was one of the few collectives to experiment, and teach, in the latest Parisian styles.

The club's major achievements are twofold. It tried to broker experiments in the studio with a larger social agenda, informed very loosely by Sun Yat-sen and Chinese republicanism. In this sense, the word "revolutionary" in the club's official name had a dual aspect: artistic and social. Secondly, although San Francisco was witnessing the rise of art clubs and small, independently run galleries throughout the 1920s, the Chinese club represented a unique space for a disenfranchised and mistreated population that continued to suffer the humiliation of the 1924 Immigration Act, which forbade the immigration and naturalization of Chinese.

[*See also* Gee, Yun.]

BIBLIOGRAPHY

A. Lee: *Picturing Chinatown: Art and Orientalism in San Francisco* (California, 2001)

A. Lee, ed.: *Yun Gee: Poetry, Writings, Art, Memories* (Washington, 2003)

Anthony W. Lee

Christenberry, William

(*b* Tuscaloosa, AL, 5 Nov 1936), painter, photographer and sculptor. Born and raised in Tuscaloosa, Alabama, Christenberry received his bachelor's degree in fine arts in 1958 and his master's degree in painting in 1959, both from the University of Alabama. He began his artistic career by painting in an Abstract Expressionist style, but soon turned his attention to the landscape of his native Alabama as the primary subject of his art. His photographs, paintings and sculptures focus on the vernacular architecture, rural roads, commercial signs and decorative gravesites that characterize the region. As an entirety, his works address themes such as the personal attachment to place and culture, the effects of the passage of time and the simultaneous fragility and endurance of memory.

After teaching art for six years at Memphis State University (now the University of Memphis), Christenberry moved to Washington, DC, in 1968 to accept a professorship at the Corcoran College of Art and Design. He continued making annual summer pilgrimages to Alabama to photograph local sites and structures such as *Palmist House*, *Sprott Church* and *Bar-B-Q Inn*. Over the course of years, his accumulating photographs of these sites became visual documents of the effects of time, age and circumstance on the local landscape and its architectural structures. In the 1970s the inclusion of Christenberry's photographs in exhibitions at the Rochester Institute of Art, the Baltimore Museum of Art and the Art Institute of Chicago helped herald the art world's acceptance of color photography as fine art.

In the 1970s Christenberry also began drawing upon the architectural forms in his photographs to make small-scale, mixed-media sculptures called *Building Constructions*. His sculptures became increasingly abstract in the 1980s and 1990s, influenced more and more by his memories and personal responses to buildings and sites rather than by actual structures. Christenberry called these more abstract constructions *Southern Monuments*, *Dream Buildings* and *Memory Forms*. Throughout his career, Christenberry also confronted the darker side of Southern history by exploring the visual culture of the Ku Klux Klan through drawings, paintings, costumed dolls and constructed tableaux that together comprise an installation entitled *The Klan Room*.

BIBLIOGRAPHY
R. H. Cravens: *William Christenberry: Southern Photographs* (New York, 1983)
T. W. Southall: *Of Time and Place: Walker Evans and William Christenberry* (San Francisco, 1990)
J. R. Gruber: *William Christenberry: The Early Years, 1954–1968* (Augusta, 1996)
T. W. Stack: *Christenberry Reconstruction: The Art of William Christenberry* (Jackson, MS, 1996)
A. Timpano: *William Christenberry: Architecture/Archetype* (Cincinnati, 2001)
R. Hirsch: "The Muse of Place and Time: An Interview with William Christenberry," *Afterimage*, xxxiii/3 (Nov–December 2005), pp. 29–36
W. Hopps: *William Christenberry* (New York and Washington, DC, 2006)
William Christenberry's Black Belt (Tuscaloosa, 2007)

Xiao Situ

Christo and Jeanne-Claude

Artistic partnership. Christo [Christo Javacheff] (*b* Gabrovo, Bulgaria, 13 June 1935), an artist of Bulgarian birth, studied at the Fine Arts Academy in Sofia (1953–6), after which he spent six months in Prague. There he encountered Russian Constructivism, which impressed him with its concern for monumental visionary structures. He escaped first to Vienna, studying briefly in 1957 at the Akademie der Bildenden Künste, and in 1958 to Paris. Like his contemporaries, Christo rebelled against abstraction, seeing it as too theoretical and proposing in its place a manifestly physical art composed of real things. Christo began by wrapping everyday objects, including tin cans and bottles, stacks of magazines,

furniture (e.g. *Wrapped Chair*, 1961; New York, Jeanne-Claude Christo priv. col., see 1990–91 exh. cat., p. 54), automobiles or various objects such as *Wrapped Luggage Rack* (1962; New York, Jeanne-Claude Christo priv. col., see 1990–91 exh. cat., p. 56). From 1961 he collaborated with his wife, Jeanne-Claude [née de Guillebon] (*b* Casablanca, 13 June 1935; *d* New York, 18 Nov 2009). Industrial materials, usually polypropylene sheeting or canvas tarpaulins held in place with irregularly tied ropes, were used for the wrappings. The use of fabric sometimes involved wrapping an object, sometimes a bundle; these coverings partly obscured the object's contours and hampered its function, thus transforming it into an aesthetic presence. In 1964, just after moving to New York, this repertory of forms was augmented by a series of life-sized store fronts, for example *Store Front* (1964; New York, Jeanne-Claude Christo priv. col., see 1990–91 exh. cat., p. 67), the view through their plate-glass windows blocked by hanging fabrics or by sheets of paper stretched across their fronts, again rendering their function uncertain.

Working on the principle that the alteration of one element in a context affected all of its parts, in 1961 the first *Project for a Wrapped Public Building* (collaged photographs and typed text; New York, Jeanne-Claude Christo priv. col., see 1990–91 exh. cat., p. 73) was conceived. With its normal interior function unimpeded, the obscured structure would become a disquieting presence in its urban setting. A related contextual intrusion was realized on the Rue Visconti in Paris on 27 June 1962 with the blocking of a small street by a stack of oil drums; the brightly colored drums in this temporary work, *Iron Curtain—Wall of Oil Barrels, 1961–1962* (see Laporte, p. 16), formed an unexpected and impenetrable street presence. In 1968 Christo and Jeanne-Claude produced the first of a number of temporary full-scale realizations, *Wrapped Kunsthalle, Berne, Switzerland* (see Laporte, p. 68), which enshrouded the museum in a pale fabric and ropes so that it became a ghostly presence in its urban environment.

Subsequently they directed their energies primarily to the realization of temporary projects in which they varied the notions of obscuring through wrapping, blocking and the altering of context by the intrusion of an unexpected element, accompanied by an increasingly large scale made possible by the use of industrial technique and engineering. With such works Christo and Jeanne-Claude helped establish the terms of a new art form known as environmental art.

The partnership's most celebrated realizations include *Wrapped Coast—One Million Square Feet, Little Bay, Sydney, Australia* (1969; see 1990–91 exh. cat., pp. 120–21), the wrapping of a mile of Australian ocean shore; *Valley Curtain, Rifle, Colorado, 1970–72*, in which an orange nylon curtain 417 m wide was suspended across a valley; *Running Fence, Sonoma and Marin Counties, California, 1972–6* (see 1990–91 exh. cat., pp. 154–5), a meandering intrusion of white nylon, 5.5 m high and 39.5 km long, across the northern California landscape that ultimately disappeared into the Pacific Ocean; *The Pont Neuf Wrapped, Paris, 1975–85* (see 1990–91 exh. cat., pp. 180–81), enshrouding the oldest bridge in Paris; and *Surrounded Islands, Biscayne Bay, Greater Miami, Florida, 1980–83* (see 1990–91 exh. cat., pp. 169–71), in which an expanse of 600,000 sq. m of bright pink fabric placed around 11 islands mysteriously isolated them from the surrounding water. One of the most discussed and symbolically rich later projects was the *Wrapped Reichstag, Berlin, 1971–95* (see 1990–91 exh. cat., pp. 188–97), first proposed in 1976 and realized finally in 1995. Similarly long in the making was *The Gates, Central Park, New York City, 1979–2005*. For 16 days in February 2005, more than 7500 saffron-colored fabric panels of varying sizes floated on metal "gate" frames above the many entrances and paths that traverse New York's Central Park. The large sums of money required to realize such proposals were raised through the sale of original drawings and collages in which Christo and Jeanne-Claude visualized various aspects of the project in question, as well as earlier works. They regarded the

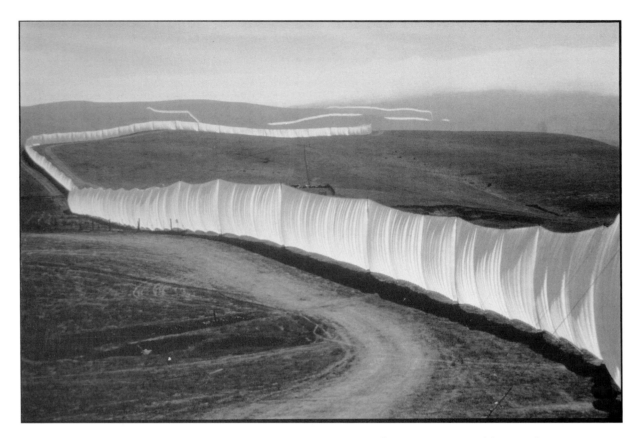

CHRISTO AND JEANNE-CLAUDE. *Running Fence*, Sonoma and Marin Counties, California, nylon, 1972–6. Photograph by Wolfgang Volz © Christo, 1976/Centre Georges Pompidou, CNAC/MNAM/Dist. Réunion des Musées Nationaux, Paris/Art Resource, NY

public endeavor, generally involving large numbers of people and directed to the often stubborn and difficult process of procuring permissions and rights of way, as an essential element in the realization of the work. Although they remained residents of New York, Christo and Jeanne-Claude, more than perhaps any artists of their generation, continued to conceive of the entire world as the platform for their extraordinary schemes.

[*See also* Environmental art.]

BIBLIOGRAPHY

D. Bourdon, O. Hahn, and P. Restany: *Christo* (Milan, 1965)

Christo: Monuments and Projects (exh. cat. by S. Prokopoff, Philadelphia, U. PA, Inst. Contemp. A., 1968)

L. Alloway: *Christo* (New York, Stuttgart and London, 1969)

D. Bourdon: *Christo* (New York, 1970)

W. Spies: *Christo: The Running Fence* (New York and Paris, 1977)

Christo: Urban Projects (exh. cat., essays P. Allara and S. Prokopoff; Boston, MA, ICA; Austin, TX, Laguna Gloria A. Mus.; Washington, DC, Corcoran Gal. A.; 1979)

P. Hovdenakk: *Christo: Complete Editions, 1964–82* (Munich, 1982; Eng. trans., New York, 1982)

D. G. Laporte: *Christo* (Paris, 1985; Eng. trans., New York, 1985)

M. Vaizey: *Christo* (New York, 1990)

Christo: Works from 1958–1990 (exh. cat., essays A. Bond, D. Thomas, and N. Baume; Sydney, A.G. NSW; Perth, A.G. W. Australia; 1990–91)

B. Chernow: *Christo and Jeanne-Claude: A Biography* (New York, 2002)

J. D. Fineberg: *On the Way to the Gates: Central Park, New York City: Christo and Jeanne-Claude* (New Haven and New York, 2004)

Stephen S. Prokopoff
Revised and updated by Margaret Barlow

Chromolithography

Planographic color printing process. Chromolithography was developed in the early 19th century and came to the USA in 1840. After the Civil War, chromolithography became the means of making color printed images available to a wide audience for the first time. The two most important applications for chromolithography were advertising and reproducing paintings.

Chromolithography was distinct from single-color lithography, tinted lithography and hand coloring. Most single-color lithographs were printed in black. Tinted lithographs added another printed color, usually with minimal drawing, to create a sense of atmosphere. Colored lithographs, like those for which Currier & Ives were well known, were printed in black and then had watercolor added by hand to each copy. In chromolithography, by contrast, there was a fairly full range of colors, and all of it was printed.

The chromolithographic process involved printing a series of layers of transparent ink from separate slabs of limestone (the traditional material) or metal (usually zinc) plates. Accurate registration of one color on top of another was crucial. Cheaper chromolithographs used only a few colors, while the most elaborate ones required dozens. If reproducing an existing color image, such as an oil or watercolor painting, the chromolithographer made color separations by eye, having the original in sight while drawing, using a key tracing as a guide. Simple, generic commercial work might require only taking existing stones off the shelf. Complicated new images could take months to complete.

Though Alois Senefelder (1771–1834), the inventor of lithography, himself experimented with and described techniques for printing lithographs in color, it was not until the 1830s that major works using chromolithography appeared. The first chromolithograph made in the USA was a portrait of *F. W. P. Greenwood* (1840) by William Sharp. American chromolithography continued to depend on the technical expertise and craft skills of European immigrants. Early examples of chromolithographic illustration appeared in books on architecture and design (notably those by Owen Jones), medieval art and natural history (such as the unfinished chromolithographic version of Audubon's *Birds of America* by Julius Bien [1826–1909]). By the 1860s, aided by the introduction of steam-powered presses, chromolithography became the dominant method of printing color images, and it remained so until the end of the 19th century.

The vast majority of chromolithographic images were commercial. These included trade cards, product labels, advertising broadsides and posters. Chromolithography also allowed for the creation of the greeting card industry, beginning in the 1870s. Chromolithographic publishing was an example of the emergence of commercial mass culture, a hybrid of commercial art and popular culture that redefined the nature, creation and use of art.

The most significant and controversial use of chromolithography was making "chromos," full-color reproductions of paintings. Louis Prang of Boston was the leading chromo publisher. Unlike Britain's Arundel Society, which concentrated on the reproduction of Renaissance masterworks, Prang and other American chromo publishers selected for reproduction mostly contemporary art likely to prove popular. While Prang championed chromos as the democratization of art, skeptical critics charged that they were mechanical, deceptive and commercial. Machine production, which allowed chromos to be produced at a cost affordable to the middle class, also jeopardized their artistic worth. So that chromos might substitute effectively for more expensive original paintings, they were often embossed with a canvas-like texture, varnished and framed. To conservative cultural critics concerned with policing aesthetic and social boundaries, this seemed like trickery. The fact that producing chromos was a commercial venture cast doubt on the purported altruism of chromo publishers like Prang, who claimed an interest in edifying the public.

Underlying debates about chromolithography were anxieties about industrialization and social flux. In the second half of the 19th century, technological advances and economic expansion and consolidation brought about rapid and unsettling changes in daily life and social structure. Nostalgic, sentimental art was one way of assuaging such apprehensions, but paradoxically it was only through such processes of mass reproduction as chromolithography that art could become inexpensive enough for large numbers of people to be able to afford it. At the other end of the social hierarchy, members of a traditional cultural elite felt threatened by the possibility that their judgment, standards and position might be called into question or ignored. Chromolithography thus became a battleground, signifying to some aesthetic satisfaction and cultural democracy and to others crass debasement of standards and taste.

[*See also* Prang, Louis.]

BIBLIOGRAPHY

P. Marzio: *The Democratic Art; Chromolithography 1840–1900: Pictures for a 19th-Century America* (Boston, 1979)

M. Clapper: "'I Was Once a Barefoot Boy!': Cultural Tensions in a Popular Chromo," *Amer. A.*, 16 (2002), pp. 16–39

J. Last: *The Color Explosion: Nineteenth-Century American Lithography* (Santa Ana, CA, 2005)

Michael Clapper

Chrysler, Walter P., Jr.

(*b* Oelwein, IA, 27 May 1909; *d* Norfolk, VA, 17 Sept 1988), industrialist and collector. He began collecting at the age of 14 with the purchase of a small landscape by Auguste Renoir. In 1919 he traveled to Europe, where he met Pablo Picasso, Georges Braque, Juan Gris, Henri Matisse, Fernand Léger and other avant-garde artists in Paris, whose work he began to acquire. In 1935 he became Director of the Chrysler Corporation and participated in the development of the Museum of Modern Art in New York, serving as the first Chairman of the Library Committee and donating significant material on Dadaism and Surrealism. Among the paintings acquired from him by the Museum were Matisse's *Dance* (1909) and Picasso's *Charnel House* (1944–5/8). During the 1930s he assembled one of the largest private collections of modern painting and sculpture in the USA. He also owned an eclectic mixture of antiquities, 17th- and 18th-century French and Italian paintings and drawings, 19th- and 20th-century European and American decorative arts (including a comprehensive collection of glass, especially Art Nouveau), stamp collections, rare books and musical instruments. In 1958 he founded the Chrysler Art Museum in Provincetown, MA, and opened his collection to the public. He made shrewd purchases of works of art at bargain prices, but in the 1960s some were found to be forgeries, which led to a certain amount of denigration of his vast collection as a whole. In 1971 he donated his collection to the Norfolk Museum of Arts and Sciences in Norfolk, VA, (now the Chrysler Museum). At his death in 1988, the Chrysler Museum was beneficiary of over three-quarters of the Chrysler family trust, and the value of his works of art was estimated at £100 million. Those that had remained in his private collection were auctioned in 1989 (New York, Sotheby's, 1 June).

BIBLIOGRAPHY

The Chrysler Museum: Selections from the Permanent Collection (exh. cat., Norfolk, VA, Chrysler Mus., 1982)

French Paintings from the Chrysler Museum (exh. cat. by J. Harrison, Norfolk, VA, Chrysler Mus., 1986)

A Concise History of Glass Represented in the Chrysler Museum Glass Collection (exh. cat. by N. Merrill, Norfolk, VA, Chrysler Mus., 1989)

The Chrysler Museum: Handbook of the European and American Collections (exh. cat. by J. Harrison, Norfolk, VA, Chrysler Mus., 1991)

Collecting with Vision: Treasures from the Chrysler Museum of Art (exh. cat. by W. J. Hennessy and others, Norfolk, VA, Chrysler Mus., 2007)

P. Earle: *Legacy. Walter Chrysler Jr. and the Untold Story of Norfolk's Chrysler Museum of Art* (Charlottesville, VA, 2008)

Martha Hamilton-Phillips

Chryssa

(*b* Athens, 31 Dec 1933), sculptor and painter of Greek birth. Chryssa [Vardea-Mavromichaeli] studied at the Académie de la Grande Chaumière in Paris (1953–4) and at the California School of Fine Arts in San Francisco (1954–5). Her first works were paintings and metal reliefs (e.g. the *Cycladic Book* series, 1955–6) depicting Japanese calligraphy and letters from the Roman alphabet, along with other images, such as arrows, as signs of human communication. Related to these concerns were paintings and sculptures that made use of typography and newsprint collages.

Chryssa settled in New York in the mid-1950s and began to explore the material products of modern technology, partly in reaction against abstraction, finding in the neon signs of advertising and mass communication a symbol of urban American culture. Her first works made of brilliantly colored neon tubing, with which she continued to be most closely identified, date from 1962. They include *The Gates to Times Square* (1964–6; Buffalo, NY, Albright–Knox A.G.), a gigantic letter A symbolizing America or as the first letter of the alphabet, and *Clytemnestra* (1966; Washington, DC, Corcoran Gal. A.), in the shape of a double S, the first of her sculptures in which the neon tubes were not encased in Plexiglas; in the latter work the letters also suggest the outline of a screaming mouth as a representation of the emotions alluded to by Euripides. From the early 1970s she combined light, paint and various sculptural materials to create alphabetical signs and more abstract shapes.

BIBLIOGRAPHY

S. Hunter: *Chryssa* (London and New York, 1974)

P. Restany: *Chryssa* (New York, 1977)

Chryssa: Urban Icons (exh. cat., intro. D. G. Schultz; Buffalo, Albright–Knox A.G., 1982)

D. Schultz: *Chryssa: Cityscapes* (London and New York, 1990)

Chryssa: Cycladic Books, 1957–1962 (exh. cat. by D. Kuspit; Athens, Mus. Cyclad. & Anc. Gr. A., 1997)

Athena S. E. Leoussi

Chu, Ken

(*b* Hong Kong, 1953), mixed-media and installation artist, and cultural activist. Ken Chu came to the USA from Hong Kong in 1971, settling in California where he received a BFA in film studies from San Francisco Art Institute (1986). Relocating to New York City after graduation, his encounters with local Asian American artists, activists and cultural organizations supported his artistic efforts, in which he often drew upon subjects that emerged organically from personal experience in the US as a gay Asian man. Adopting popular cultural idioms from film and comics, while also drawing upon symbols and motifs from Chinese and other Asian cultures, his imagery from this pivotal period featured Asian men cast as prototypically American masculine figures, such as California surfers and cowboys, who populate colorful, imaginary scenarios of cross-cultural contact, mixing and desire. In Western societies, where the dominant norms are non-Asian and few viable role models for Asian men exist, Chu's art strongly asserted their collective presence and place. His socially inspired work has since also engaged matters of anti-Asian violence, internalized racism, stereotyping, homophobia and the impact of AIDS on Asian diasporic communities.

Through painted mixed-media sculptures, room-sized installations, public art projects and exhibitions curated by the artist, including *Dismantling Invisibility: Asian & Pacific Islander Artists Respond to the AIDS Crisis* (1991), Chu addressed inter-related issues of ethnic, cultural and sexual identification. His interests also led him to co-organize the influential pan-Asian art group, Godzilla: Asian American Art Network (1990–2001), and to work in arts philanthropy, providing grants to fellow artists. Chu's work has been exhibited in Great Britain, Germany, Canada and venues across the US such as the San Diego Museum of Art, the New Museum of Contemporary Art, the Asia Society Galleries, Clocktower Gallery, Creative Time and the Museum of Chinese in America, all in New York, the Walker Art Center in

KEN CHU. *Café Cure* (detail), mixed media, New York, 42nd Street Art Project, 1994. Photograph by Becket Logan © Ken Chu

Minneapolis, MN, the Yerba Buena Center for the Arts in San Francisco, CA, and Real Art Ways in Hartford, CT. He has received grants and awards from New York State Council for the Arts, Artists Space, Art Matters, P.S.1 National Studio Program and Chinese Arts Centre in Manchester, UK.

[*See also* Godzilla: Asian American Art Network.]

BIBLIOGRAPHY

L. Lippard: *Mixed Blessings* (New York, 1990), p. 231

M. Machida: "Seeing 'Yellow': Asians and the American Mirror," *The Decade Show* (exh. cat., New York, Mus. Contemp. Hisp. A., 1990), pp. 118–20

M. Machida: "Ken Chu's Clash of Symbols," *A. Mag.* (Spring 1991), pp. 44–5, 53

K. Sakamoto: "Dismantling Invisibility: Asian and Pacific Islander Artists Respond to the AIDS Crisis," *Godzilla: Asian American Art Network*, ii/1 (Summer 1992), pp. 1, 5

J. Borum: "Asia/America," *Artforum* (Sept 1994), p. 108

M. Machida: "Out of Asia: Negotiating Asian Identities in America," *Asia/America: Identities in Contemporary Asian American Art* (New York, 1994), pp. 50, 84, 85, 90

P. Karmel: "Expressing the Hyphen in 'Asian-American,'" *NY Times* (23 April 1995), p. 37

G. Marchetti: "Romance and the 'Yellow Peril': Race, Sex, and Discursive Strategies in Hollywood Fiction," *Amerasia Journal*, xxi/3 (Winter 1995–6), p. 219

S. Cahan and Z. Kocur, eds.: *Contemporary Art and Multicultural Education* (New York, 1996)

D. Eng and A. Hom, eds.: *Q&A Queer in Asian America* (Philadelphia, 1998), p. 367

H. Cotter: "When East Goes West, The Twain Meet Here," *NY Times* (23 March 2001)

E. Guffey: "Ken Chu: Tong Zhi/Comrade: Out in Asia America," *A. Pap.*, v/5 (May–June 2001), pp. 89–90

E. H. Kim, M. Machida and S. Mizota, eds.: *Fresh Talk/Daring Gazes: Conversations on Asian American Art* (Berkeley, 2003)

K. Hallmark: *Encyclopedia of Asian American Artists* (Westport, 2007), pp. 42–5

A. Pasternak: *Creative Time, The Book: 33 Years of Public Art in New York City* (New York, 2007), pp. 77, 264, 273

A. Chang: *Envisioning Diaspora* (Beijing, 2008)

M. Machida: *Unsettled Visions: Contemporary Asian American Artists and the Social Imaginary* (Durham, 2008), p. 260

Margo Machida

Church, Frederic Edwin

(*b* Hartford, CT, 4 May 1826; *d* New York, 7 April 1900), painter. Church was a leading representative of the second generation of the Hudson River school, who made an important contribution to American landscape painting in the 1850s and 1860s. The son of a wealthy and prominent businessman, he studied briefly in Hartford with two local artists, Alexander Hamilton Emmons (1816–84) and Benjamin Hutchins Coe (1799–1883). Thanks to the influence of the Hartford patron Daniel Wadsworth, in 1844 he became the first pupil accepted by Thomas Cole. This was an unusual honor, although Cole probably offered little useful technical instruction—he once observed that Church already had "the finest eye for drawing in the world." However, Cole did convey certain deeply held ideas about landscape painting, above all the belief that the artist had a moral duty to address not only the physical reality of the external world but also complex and profound ideas about mankind and the human condition. Church eventually abandoned the overtly allegorical style favored by his teacher, but he never wavered from his commitment to the creation of meaningful and instructive images.

Church began exhibiting works in New York at the National Academy of Design and American Art-Union while he was still under Cole's instruction. His first success, the *Rev. Thomas Hooker and Company Journeying through the Wilderness from Plymouth to Hartford, in 1636* (1846; Hartford, CT, Wadsworth Atheneum), was a historical landscape that celebrated the founding of his hometown. Although the painting was somewhat contrived in composition and still heavily dependent on Cole,

details of foliage, branches and rocks were handled with extraordinary precision, and the radiant, all-encompassing light indicated how carefully the young artist had studied natural phenomena.

After settling in New York in 1847, Church followed a routine of sketching in oil and pencil during summer trips in New York State and New England and painting finished pictures in his studio during the autumn and winter. Most of his works were straightforward American landscapes painted with a crisp realism indicative of his interest in John Ruskin's aesthetics, but he also exhibited, almost every year until 1851, imaginary or allegorical works reminiscent of Cole with such themes as the *Plague of Darkness* and *The Deluge* (both untraced).

In the summer of 1850 Church made his first visit to Maine, beginning a lifelong association with that state. A number of fine marine and coastal pictures resulted, such as *Beacon, off Mount Desert Island* (1851; priv. col., see 1989–90 exh. cat., p. 26). About this time he started to read the German naturalist Alexander von Humboldt's *Cosmos* (1845–62), paying particular attention to the chapter on landscape painting and its relationship to modern science. He began to produce compositions that fused panoramic scope with intricate, scientifically correct detail, such as *New England Scenery* (1851; Springfield, MA, Smith A. Mus.). Although the didactic emphasis of these works recalled Cole's moralizing landscapes, their strongly nationalistic tone and promise of revelation through scientific knowledge made them especially appealing to Church's contemporaries.

Humboldt's description of the tropics of South America as a subject worthy of a great painter inspired Church to travel there in the spring of 1853. He returned to New York with numerous pencil drawings and oil sketches of South American scenery. The first finished pictures based on these studies, such as *La Magdalena* (1854; New York, N. Acad. Des.), appeared in the spring of 1855 at the National Academy, where they caused a sensation. Even more successful was the *Andes of Ecuador*

(1855; Winston-Salem, NC, Reynolda House), a sweeping view across miles of mountainous landscape animated by a luminous atmosphere.

In 1857 Church unveiled *Niagara* (1857; Washington, DC, Corcoran Gal. A.), the work that made him the most famous painter in America. This *tour de force* of illusionistic painting brought the spectator to the very brink of the falls, capturing the effect of North America's greatest natural wonder as had no previous work. Exhibited by itself in America and England between 1857 and 1859, *Niagara* was seen and admired by thousands. In the spring of 1857 Church returned to South America to gather material for a new series of major tropical landscapes. The first to appear was his masterpiece, the *Heart of the Andes* (1859; New York, Met.), which was displayed in the Tenth Street Studio Building in New York in a darkened room with carefully controlled lighting. Surrounded by molding designed to resemble a window-frame, the painting overwhelmed contemporaries with its intricately painted foreground of tropical plants and its breathtaking vistas along lines leading to several vanishing points in the mountainous distance. Like *Niagara*, the *Heart of the Andes* toured cities in the USA and England, receiving enthusiastic critical and popular acclaim.

During the late 1850s and early 1860s Church was at the height of his powers, painting large-scale exhibition pieces, such as *Twilight in the Wilderness* (1860; Cleveland, OH, Mus. A.), *The Icebergs* (1861; Dallas, TX, Mus. A.), *Cotopaxi* (1862; Detroit, MI, Inst. A.) and *Aurora Borealis* (1865; Washington, DC, N. Mus. of Amer. A.). He continued to paint major works in the years immediately after the Civil War but with an increasing emphasis on visionary atmospheric effects reminiscent of J. M. W. Turner, as in *Rainy Season in the Tropics* (1866; San Francisco, CA, de Young Mem. Mus.), *Niagara Falls, from the American Side* (1867; Edinburgh, N.G.) and the *Vale of St Thomas, Jamaica* (1867; Hartford, CT, Wadsworth Atheneum).

Church continued to travel widely, visiting Jamaica in 1865 and Europe and the Near East in 1867–9. On the journey home, in June 1869, he took advantage of a brief stay in London to study works by Turner. Although a number of important works by Church subsequently appeared in the late 1860s and the 1870s, only a few, such as *Jerusalem* (1870; Kansas City, MO, Nelson–Atkins Mus. A.), approached the power of his earlier works. Similarly, his late South American scenes gradually became less convincing as his memory of the tropics dimmed. Perhaps his last successful full-scale work was *Morning in the Tropics* (1877; Washington, DC, N.G.A.), which has a poetic, introspective quality.

Church spent most of the last years of his life at Olana, the house he built on top of a hill overlooking the Hudson River, just across from Catskill, NY. From there he made numerous trips in the last decades of his life, especially to Maine and Mexico. Although few finished works of note date from these years, Church did paint dozens of superb oil sketches, often of the sky seen from Olana. These sketches, now in Olana and the Cooper-Hewitt Museum of Design in New York, are among his most beautiful creations. Olana survives with many of its original furnishings intact. It contains a collection of Church's works in all media, as well as an important archive of documentary material.

[*See also* Hudson River school *and* Wadsworth, Daniel.]

BIBLIOGRAPHY

D. C. Huntington: *Frederic Edwin Church, 1826–1900: Painter of the New World Adamic Myth* (diss., New Haven, Yale U., 1960)

D. C. Huntington: *The Landscapes of Frederic Edwin Church: Vision of an American Era* (New York, 1966)

Frederic Edwin Church (exh. cat., Washington, DC, N. Col. F.A., 1966)

Frederic Edwin Church: The Artist at Work (exh. cat. by B. Hanson, West Hartford, U. Hartford, Joseloff Gal., 1974)

Close Observation: Selected Oil Sketches by Frederic Edwin Church (exh. cat. by T. E. Stebbins, Washington, DC, Smithsonian Inst. Traveling Exh. Service, 1978)

Frederic Edwin Church: The Icebergs (exh. cat. by G. L. Carr, Dallas, Mus. A., 1980)

D. C. Huntington: "Church and Luminism: Light for America's Elect," *American Light: The Luminist Movement, 1850–75* (exh. cat., Washington, DC, N.G.A., 1980), pp. 155–90

To Embrace the Universe: The Drawings of Frederic Edwin Church (exh. cat. by E. Dee, Yonkers, Hudson River Mus., 1984)

Creation and Renewal: Views of Cotopaxi by Frederic Edwin Church (exh. cat. by K. Manthorne, Washington, DC, N. Mus. Amer. A., 1985)

G. L. Carr and F. Kelly: *The Early Landscapes of Frederic Edwin Church, 1845–1854* (Fort Worth, 1987)

F. Kelly: *Frederic Edwin Church and the National Landscape* (Washington, DC, 1989)

Frederic Edwin Church (exh. cat., ed. F. Kelly and others; Washington, DC, N.G.A., 1989–90); review by C. French in *J. A.* [USA], ii/3 (Dec 1989), pp. p. 14

G. L. Carr: *Frederic Edwin Church: Catalogue Raisonné of Works of Art at Olana State Historic Site* (Cambridge, 1994); review by R. P. Wunder in *Drawing*, xvi/6 (1995), pp. 134–5

Franklin Kelly

Church, Thomas D.

(*b* Boston, MA, 27 April 1902; *d* San Francisco, CA, 30 Aug 1978), landscape designer and writer. Thomas Dolliver Church was educated at the University of California, Berkeley (1918–23), and at the Harvard Graduate School of Design (1923/4–6) before opening his office in San Francisco in 1932. Most of his work was in residential districts. In San Francisco he was faced with small plots and steep, hillside sites. Here and in the suburban and central valley areas, where he also worked, he confronted the postwar reality of a changing, often intensive use of the garden and a reduced level of maintenance. Whereas Church's traditional training in the Italian Renaissance and Baroque had presented him with pergolas and fountains, the California lifestyle demanded swimming pools and barbecues. Influenced by the Modern Movement in art and architecture, he visited Alvar Aalto in Finland and the International Exhibition in Paris, both in 1937. Church applied the new ideas of multiple perspective and fluid composition to his practice. Cut on the bias, the Jerd Sullivan garden (1935), San Francisco, proved one of his most influential compositions. In the Sullivan garden he used a zigzag path to divide a slanted border of shrubbery from the lawn, leading to a small brick terrace in a far corner. As his

jobs got larger and his design more assured, he introduced curvilinear forms, most memorably at the Donnell garden (1947–9) at Sonoma, CA, designed on a hilltop around existing mature oaks. The garden, with its kidney-shaped swimming-pool echoing the surrounding hills and salt-marshes of the Sonoma Valley below, extends into the surrounding countryside. Here, as in his other work, a "functional plan and the artistic composition" are the primary factors. Major public projects in California included the Park Merced (1941–50), San Francisco, and master plans for the University of California at Berkeley (1961) and Santa Cruz (1963), Harvey Mudd College (1963) at Claremont, Stanford University (1965) at Palo Alto, and Scripps College (1969), Claremont. Church produced over 2000 designs in almost 50 years of private practice, and his influence was spread by his writings as well as by his former employees, including Lawrence Halprin and Garrett Eckbo (1910–2000).

[*See also* Halprin, Lawrence.]

WRITINGS

Gardens Are for People (New York, 1955, 2/1983)

Your Private World: A Study of Intimate Gardens (San Francisco, 1969)

Regular contributions to *House Beautiful* (1947–55) and *Bonanza* (late 1950s–early 1960s)

BIBLIOGRAPHY

Contemp. Architects

D. C. Streatfield: "Thomas Church," *American Landscape Architecture: Designers and Places* (Washington, DC, 1989)

Stud. Hist. Gdn & Des. Landscapes, xx/2 (April–June 2000) [entire issue is devoted to Church]

Phoebe Cutler

Chwast, Seymour

(*b* New York, 18 Aug 1931), graphic designer and illustrator. Chwast drew prodigiously in comic-book fashion as a child. From 1948 to 1951 he studied design, illustration, painting and woodcut at the Cooper Union for the Advancement of Science and

Art, New York, and was influenced by the work of such artists as Paul Klee, Georges Rouault and Ben Shahn. He worked as a junior designer in the advertising department of the *New York Times* and then for *House and Garden* and *Glamour* magazines. In his spare time, together with Edward Sorel (*b* 1929) and Reynold Ruffins (*b* 1930), he published the *Push Pin Almanack*, a promotional brochure that led to numerous freelance commissions. In 1954, with Sorel, Ruffins and Milton Glaser, Chwast founded the Push Pin Studios, New York. Both Chwast and Glaser sought to bring a new vitality to graphic design with a return to hand-drawn lettering and illustration in contrast to the then-standard use of photomontage and Bauhaus-derived, abstract forms. In the 1950s they each created elastic new alphabets based on Victorian typography, which they manipulated to the verge of illegibility. In 1955, with Glaser and Ruffins, Chwast founded *Push Pin Graphics* magazine, which he edited until 1981. As well as lithography, Chwast frequently worked in woodcut and monoprint, using thick, bold outlines (e.g. *End Bad Breath* poster, woodcut, 1976; artist's col., see Ades, p. 187). He designed posters, packaging and record-sleeves, illustrated magazines and books, particularly children's books, and drew animated films. Throughout the 1960s and into the 2000s the Push Pin Studios was responsible for an enormous body of work, and its graphic style was a major influence in the USA and abroad. In 1970 the Musée des Arts Décoratifs, Paris, held a retrospective exhibition, and in 1973 the group's work was included in the exhibition *A Century of American Illustration* at the Brooklyn Museum, New York. Chwast's fluency as a draftsman allowed him to work quickly and in many different styles, often with a satirical edge. He drew extensively on 19th-century illustration and circus and theatrical poster art (e.g. the *Sensational Houdini* poster, lithograph, 1973; artist's col., see Heller and Chwast, p. 203). He was a visiting lecturer at art schools in New York and vice-president of the American Institute of Graphic Arts (1974–8), New York. He established the Push Pin Press

(1976–81), New York, and co-authored several books on graphic design. In 1982 the studio and its affiliates became the Pushpin Group Inc. In 2005 the American Institute of Graphic Arts staged a major exhibition of the group's early work. The style of his posters and design projects through the 1990s and 2000s remained colorful, playful and edgy.

[*See also* Glaser, Milton.]

WRITINGS

with S. Heller: *Graphic Style: From Victoriana to Post-Modern* (London and New York, 1988)

The Push Pin Graphic: A Quarter Century of Innovative Design and Illustration (ed. S. Heller and M. Venezky; San Francisco, 2004).

BIBLIOGRAPHY

The Push Pin Style (exh. cat., intro. J. Snyder; Paris, Mus. A. Déc., 1970) [bilingual text]

A Century of American Illustration (exh. cat. by L. S. Ferber, New York, Brooklyn Mus., 1972)

D. Ades: *The 20th-century Poster: Design of the Avant-Garde* (New York, 1984)

The Left-Handed Designer (New York, 1985)

S. Heller, ed.: *Innovators of American Illustration* (New York, 1986), pp. 40–49

S. Chwast: S. Heller and P. Scher, eds.: *Seymour: The Obsessive Images of Seymour Chwast* (New York, 2009)

Cincinnati

City in Ohio. From the beginning, Cincinnati was favored by its location on the Ohio River and by an abundance of building material, especially clay for brickworks. During the early 19th century, with the economy prospering as a result of the War of 1812, the city became known as "Queen of the West." Although the Civil War halted most new building, in 1865 the city was able to resume construction of John Augustus Roebling's suspension bridge (1856–67) over the Ohio River linking Cincinnati to Kentucky—the longest suspension span in the world at the time (322 m). Cincinnati experienced tremendous development following the American Centennial, including H. H. Richardson's powerful

Romanesque design for the Chamber of Commerce (1885–8; destr. 1911), with its monumental circular corner tower. The Hannaford firm designed several important buildings between the 1870s and early 1900s, such as the Music Hall (1876) and City Hall (1887–93). Church architecture also flourished during this boom period, and by the early 20th century, schools and universities were being founded or expanded. Joseph G. Steinkamp's designs for Xavier University (c. 1915) successfully mingled medieval elements, such as octagonal towers, with accents in the Tudor style. J. Walter Stevens was also inspired by Tudor architecture in his design for Hughes Hill School (1910). Cincinnati pioneered a comprehensive city plan in 1925, including an innovative zoning code that targeted the downtown basin area as a focus for business development. Skyscrapers began appearing in the 1930s, and public works projects improved city services. In 1964, the city developed a Downtown Plan that resulted in several massive modernistic structures before preservation efforts were able to focus attention on maintaining a more human scale. Since the 1980s, post-modern buildings, notably the Procter & Gamble Headquarters' addition (1985) by Kohn Pederson Fox, have been more in tune with the city's historic styles. More recent noteworthy projects include Frank Gehry's sculptural Vontz Center for Molecular Studies (1999) at the University of Cincinnati, the Paul Brown Stadium (2002) by NBBJ featuring cantilevered canopies and the new Center for Contemporary Art (2001–3) by Zaha Hadid (b 1950).

The Cincinnati Art Museum, designed by James W. McLaughlin (1834–1923) with Italian Romanesque emphasis, opened in 1886 on a hilltop in Eden Park. Subsequent additions, such as the 1907 Schmidlapp wing by Daniel H. Burnham in Beaux-Arts style, have rendered the complex into an eclectic conglomerate. In 2008, museum officials began working with the Dutch firm Neutelings Riedijk to expand the facilities in a further architectural transformation. The Taft Museum of Art (formerly the Baum–Longworth–Taft House) opened in 1932.

Constructed c. 1820, the Federal-style Baum house is the city's oldest extant wooden residence of note. The museum's renovation and expansion (2002–4) by Ann Beha Architects paid homage to the original building, which has been accurately restored. The Lois and Richard Rosenthal Center for Contemporary Art of the Contemporary Arts Center (2003), is the first major American museum designed by a woman. Working with Markus Dochantschi (New York) and the local firm KZF Design, Pritzker-award-winning Zaha Hadid created a Postmodern marvel that "appears to defy gravity" (Painter, 2006). Constructed on a challenging corner lot, the building provides over 8000 sq. m of space. The galleries have been described as a jigsaw puzzle, connected by a series of ramps, with these irregular shapes projecting as dynamic slabs and boxes on the exterior. One exterior wall is a curving, translucent skin through which interior activities can be observed, and which filters light into the galleries.

Cincinnati boasts nine buildings categorized as National Historic Landmarks, including the Taft Museum, Carew Tower–Netherland Plaza Hotel, Cincinnati Union Terminal and Plum Street Temple, located across from City Hall. James K. Wilson (1828–94), who trained in Europe and in New York with James Renwick Jr., brought his idea of High Victorian Gothic to Cincinnati. In the mid-1860s, Wilson conceived the Plum Street Temple (at that time the B'nai Yesurun synagogue) as a brick Gothic-style cathedral with a tracery rose window, but also with twin minarets and Moorish ornamentation in stone trim. Exterior decoration includes Hebrew inscriptions and symbolic friezes. Union Terminal was completed in 1933 from designs by Steward Wagner and Alfred Fellheimer (1875–1959), the latter having worked on Grand Central Terminal in New York. Cincinnati's terminal was constructed with the highest half-dome to date, supported by eight arched trusses—a lofty gateway to the city. The modernistic style most likely was influenced by Eliel Saarinen's Helsinki Railroad Station (1914). The Carew Tower-Netherland Plaza Hotel was part of downtown

development during the late 1920s and early 1930s. Walter W. Ahlschlager (d 1965), advised by William Delano (designer of the geometric exterior) and developer John J. Emery Jr., created a streamlined, modernistic Beaux-Arts exterior with a luxurious Art Deco interior. More than 152 m high, the complex remains the tallest skyscraper in the city.

BIBLIOGRAPHY

The Allen Temple, formerly the B'nai Israel Synagogue, Cincinnati, Ohio, 1852–1979 (Cincinnati, 1979)

A. G. White: *The Architecture of Cincinnati: A Selected Bibliography* (Monticello, IL, 1982)

Architecture and Construction in Cincinnati: A Guide to Buildings, Designers, and Builders (Cincinnati, 1987)

J. Clubbe: *Cincinnati Observed: Architecture and History* (Columbus, OH, 1992)

A. Weston and W. E. Langsam: *Great Houses of the Queen City: Two Hundred years of Historic and Contemporary Architecture and Interiors in Cincinnati and Northern Kentucky* (Cincinnati, 1997)

W. E. Langsam and A. Weston: *Architecture Cincinnati: A Guide to Nationally Significant Buildings and their Architects in the Greater Cincinnati Area* (Cincinnati, 1999)

L. C. Rose and P. Rose: *Cincinnati Union Terminal: The Design and Construction of an Art Deco Masterpiece* (Cincinnati, 1999)

P. Bennett: *University of Cincinnati: An Architectural Tour* (New York, 2001)

S. Litt: "Touchdown Cincinnati: The Bengals Make a Bold Play with their New Riverfront Stadium," *Architecture*, xci/4 (April 2002), pp. 98–103

Z. Hadid and M. Dochantschi: *Zaha Hadid: Space for Art—Contemporary Arts Center, Cincinnati. Lois and Richard Rosenthal Center for Contemporary Art* (Baden, 2004)

S. A. Painter with J. Merkel and B. Sullebarger: *Architecture in Cincinnati: An Illustrated History of Designing and Building an American City* (Athens, OH, 2006)

U. Greinacher: *50 from the 50s: Modern Architecture and Interiors in Cincinnati* (n.p., 2008)

K. Olson: "The Temporal Nature of Zaha Hadid's Ramps at the Center for Contemporary Art in Cinncinati," *S.-E. Coll. Rev.*, xv/3 (2008), pp. 338–45

Sandra Sider

Cinema

Building for the projection and viewing of films. The term derives from *cinématographie*, the equipment devised for showing moving pictures patented by the Lumière brothers in France in 1895. Significant forerunners of this development include the diorama, invented by Louis Daguerre in 1822, and the Kinetoscope, a machine for running a film-reel, invented by Thomas Edison's assistant William Dickson and introduced by Edison in the USA in 1891. The Kinetoscope was one of a variety of solutions produced in Europe and the USA in the last decade of the 19th century to the challenge of presenting moving pictures to an audience. Pressure for improvements in technology and comfort was probably at its most intense in the USA, and the first permanent, purpose-built cinema, the Electric Theater, was opened in Los Angeles, CA, by Thomas L. Tally in 1902.

The early cinema was typically a simple rectangular auditorium fronted by an ostentatious façade; this derived in part from fairground booths and shops, in the recesses of which picture shows were held during the 1890s. Music halls and theaters were often used for projecting moving pictures in conjunction with other forms of entertainment, and their decoration and plan were emulated in the design of early cinemas, many of which had stages. A few cinemas built before World War I had simple balconies and, occasionally, side-boxes, despite the limited vision these usually provided. From 1909 cinema building became more widespread, partly as a result of the safety requirements of the British Cinematograph Act, which include the provision of fire-resistant projection rooms separate from the auditorium. These requirements prompted the construction of such buildings as the Electric Cinema (c. 1910), Portobello, London. One of the most prolific cinema designers in Britain at this time was Frank Verity (1867–1937). However, although technical sophistication in filmmaking was considerable by the outbreak of World War I, this was not matched by innovations in cinema design. It was some years before the function of the cinema had much influence on its plan. The advent of "talking pictures" (*The Jazz Singer* in 1927) made a fan-shaped auditorium acoustically desirable, but it was not adopted for the plan of every new cinema.

By the 1920s, American-style distribution methods, especially the block booking of cinemas (which created "circuits" and eventually cinema chains), had been introduced into Europe. It was also in the USA that the two main strains of cinema design emerged, known as "hard top" and "atmospheric." The "hard-top" type, whose principal architect was the Scottish émigré Thomas W. Lamb (1871–1942), was classical in type (e.g. Loew's State, St Louis, MO, 1924; designed like a theater with boxes, in a style reminiscent of Robert Adam (1728–92)). The "atmospheric" type, pioneered by the Austrian émigré architect John Eberson, led to the creation of a fantasy environment with "scenery" and lights. An early example of this was the Majestic (1923; destr.), Houston, TX, which created the illusion of an open-air Italian garden. Lamb, in partnership with the celebrated showman of the cinemas, Samuel L. "Roxy" Rothafel created a number of cinemas, such as the lavish Strand Theater (1914), New York, which had a 30-piece orchestra and a powerful Wurlitzer organ. This was surpassed, however, by the Baroque-style Roxy Cinema (1927; destr.) in New York, which Walter W. Ahlschlager designed and which seated 5800 people. Lamb also designed the Fox (1929; destr.), San Francisco, which seated 5000; this was built for the promoter William Fox, Roxy's main rival. The "atmospheric" cinemas of Eberson were pretty, colorful and rampantly eclectic, showing the influence of Egyptian, Persian, Spanish, Italian and other styles. His work was particularly influential in Britain, where a number of cinemas were built in the Egyptian style, such as the Carlton (1930), Islington, London, designed by George Coles (1884–1963). In the Astoria (1930), Finsbury Park, London, there was a Moorish-style interior by Tommy Somerford and Ewen Barr. This was one of several Astoria cinemas designed by Edward A. Stone. These designs culminated in the 1930s in the fantastic interiors by Theodore Komisarjevski (1882–1954) in the suburban London cinemas of the Granada chain, for example at Tooting (1937), where the auditorium takes the form of a Gothic fantasy, behind a conventional classical façade by Masey & Uren.

The influence of the Modern Movement on cinema design was strongest in Germany. Several of Germany's most famous architects designed cinemas; among these were Erich Mendelsohn's dynamic, rounded and balconied Universum/Luxor-Palast (1926–9; interior destr.) and the simple Babylon Cinema (1928; destr.) by Hans Poelzig (1869–1936), both in Berlin. One leading cinema architect was Fritz Wilms (1886–1958), who designed several clean-lined cinemas for the UFA Company, including the UFA-Schauberg, Magdeburg, and the UFA, Turmstrasse, Berlin. He was a supporter of "night architecture," a style of building in which cinemas were designed to be illuminated and to have glazed facades, so as to allow views within in the evenings, when it was intended that the largest possible audiences be drawn in. Another exponent of "night architecture" was Friedrich Lipp, whose Capitol Cinema at Breslau (now Wrocław, Poland) is an outstanding example of the type, later emulated in Great Britain in such cinemas as the Odeon, Leicester Square, London. In the Netherlands an influential cinema was the Art Deco Tuschinski (1918–20), a building by H. L. de Jong in Amsterdam. Art Deco became the common style for the 1930s, typified by the impresario Oscar Deutch's chain of Odeon cinemas in Britain. One of the most elegant cinemas in Europe, however, was the Skandia (1922), Stockholm, designed by Gunnar Asplund (1885–1940). In most other parts of the world cinema design followed the American "atmospheric" style. Examples include the Civic, Auckland, New Zealand, in the Hindu style, and the State, Melbourne, Australia, in the Moorish style, both designed by Bohringer, Taylor & Johnson in 1929.

As cinema building escalated in the 1930s, many designs were for whole complexes, comprising a foyer, ticket booth, an auditorium with an organ by Wurlitzer or Compton, a projection room, a manager's office, and often a cafe or restaurant and even a ballroom. Usually their frames were of steel. Many facades were clad in easy-clean materials, such as

faience tiles, to enable them to look perennially gleaming. Novel advances in film presentation in the 1950s, such as Cinemascope (1953) and Cinerama (1954), did not reverse declining attendances, which by c. 1960 had led to the closure or change of use of many cinemas. By the late 1960s cinemas were being subdivided, allowing a variety of films to be shown within one complex. This initiative, continued in subsequent decades, has attracted reasonable rates of attendance. The division of large auditoria is usually achieved by blocking off the area beneath the circle; a medium-sized cinema can be formed within the seating area of the original circle, while the lower (stalls) area can be divided down its center to create two small cinemas. Few serious attempts at lavish architectural or decorative embellishment are undertaken, however.

[See also Eberson, John.]

BIBLIOGRAPHY

D. Sharp: The Picture Palace (London, 1969)

D. Atwell: Cathedrals of the Movies (London, 1980)

J. Mayne: Cinema and Spectatorship (London, 1993)

S. Kracauer: "Cult of Distraction: On Berlin's Picture Palaces," Mass Ornament: Weimar Essays, trans. and ed. Thomas Y. Levin (Cambridge, 1995), pp. 323–8

D. Welling: Cinema Houston: From Nickelodeon to Megaplex (Austin, TX, 2007)

The Cinema Effect: Illusion, Reality, and the Moving Image (exh. cat. by K. Brougher and others, Washington, DC, Hirshhorn, 2008)

Priscilla Boniface

City Beautiful Movement

Urban planning movement directed toward achieving a cultural parity with the cities of Europe, led by architects, landscape architects and reformers. The movement began in the 1850s with the founding of improvement societies in New England towns, but it gathered momentum and secured a national identity in the 1890s under the stimulus of the Beaux-Arts-inspired World's Columbian Exposition, Chicago (1893), the development of metropolitan park and boulevard systems and the founding of municipal art societies in major cities. National interest in the movement intensified with the publication of the comprehensive McMillan Plan for Washington, DC (1901–2), designed by the Exposition participants Daniel H. Burnham, Charles F. McKim, Augustus Saint-Gaudens and Frederick Law Olmsted Jr., a watershed event in which the Exposition's principles of composition came together with park and boulevard design to create a comprehensive system of city planning.

Charles Mulford Robinson (1869–1917), journalist and author, emerged shortly after 1900 as the movement's chief spokesperson and advised municipalities to enlist experts. Politicians, art commissions and businessmen's clubs nationwide called on consulting architects, landscape architects and designers. Their objective was not social reform, but municipal reform and beautification, believed to elevate the prestige of cities and thus attract wealth. The City Beautiful projects, many unrealized, ranged in scale from Cass Gilbert's design for the surroundings of the Minnesota State Capitol in St Paul (1903–6) to the ambitious plan of Daniel H. Burnham and Edward H. Bennett (1874–1954) for San Francisco, CA (1904–5). The movement culminated in Burnham and Bennett's plan for Chicago (1906–9), which encompassed a 95-km radius and proposed a crowning civic center, radial avenues and ring roads, a rearranged rail network and an extensive system of parks and parkways. A significant legacy of the movement are more than 70 civic center proposals, a few of which were built, distinctive among them those of Cleveland, OH (Daniel Burnham, John M. Carrère, Arnold W. Brunner, 1902–35), Springfield, MA (Pell & Corbett, 1909–15), and San Francisco (John Galen Howard, Frederick Meyer, John Reid Jr., 1912–32). San Francisco's civic center, built virtually as designed, comprises five major buildings organized on cross axes around a central plaza commanded by the City Hall (Bakewell & Brown, 1913–6). By the end of World War I most of the movement's major personalities had completed their careers, but their goals remained an animating force in American urban planning.

[*See also* Chicago; Hamlin, A. D. F.; *and* Washington, DC.]

WRITINGS

C. M. Robinson: *Modern Civic Art or the City Made Beautiful* (New York, 1903)

D. H. Burnham and E. H. Bennett: *Plan of Chicago* (Chicago, 1909/R New York, 1970)

BIBLIOGRAPHY

T. Kimball, ed.: *Municipal Accomplishment in City Planning and Published City Plan Reports in the United States* (Boston, 1920)

J. Reps: *Monumental Washington: The Planning and Development of the Capital Center* (Princeton, 1967)

M. Scott: *American City Planning since 1890* (Berkeley, 1969)

T. S. Hines: *Burnham of Chicago: Architect and Planner of Cities* (New York, 1974)

J. Kahn: *Imperial San Francisco: Politics and Planning in an American City, 1897–1906* (Lincoln, 1979)

A. Sutcliffe: *Towards the Planned City: Germany, Britain, the United States, and France 1870–1914* (New York, 1981)

W. H. Wilson: *The City Beautiful Movement* (Baltimore, 1989)

T. S. Hines: "The Imperial Mall: The City Beautiful Movement and the Washington Plan of 1901–1902." *Stud. Hist. A.* [Washington, DC], xxx (1991), pp. 78–99

J. A. Peterson: "The Mall, the McMillan Plan and the Origins of American City Planning," *Stud. Hist. A.* [Washington, DC], xxx (1991), pp. 100–15

K. C. Schlichting: "Grand Central Terminal and the City Beautiful in New York," *J. Urban Hist.*, xxii/3 (March 1996), pp. 332–49

R. Longstreth, ed.: *The Mall in Washington, 1791–1991* (Washington, DC, 2003)

J. A. Peterson: *The Birth of City Planning in the United States: 1840–1914* (Baltimore, 2003)

Gail Fenske

Civil War monuments

The Civil War (1861–5) provided impetus for the creation of hundreds of sculptural monuments in the late 19th century and early 20th. Most major American sculptors of the period were called upon to provide memorials to those who fought and died, those who led the country and those who suffered through the largest and most deadly conflict the nation had ever experienced. Two main types emerged: the "common soldier" monument, most often a single soldier standing atop a plinth, and the "great man" monument dedicated to a military or political leader. Other types, much smaller in number though of significance, are monuments to emancipation and to women. The North began putting up memorials as soon as the war was over. The South, more impoverished, had a slower start, but by the end of Reconstruction seemed to surpass the North in enthusiasm for monument building. The North had the more gifted talent in sculptors such as Augustus Saint-Gaudens and Daniel Chester French, but the South had its own artists such as Edward Valentine (1838–1930) and Moses Ezekiel. Some have argued that the act of commemoration itself provided a forum for reconciliation between the two sides.

As has often been noted, history is told by the winners and in the case of public monuments those determining the program were usually those with the resources to afford such displays. Though public, the monuments were rarely paid for by the government. Most were funded by veterans' organizations or their families or by civic-minded women's groups who presented them to the community. In the North, it was most commonly the Grand Army of the Republic, the Union's major veterans' group. In the South it was either the Confederate Veterans or the United Daughters of the Confederacy (UDC). The sculpture they sponsored supported their points of view on the conflict.

The very first impulses at commemoration focused on cemeteries and the need to re-bury, identify and organize gravesites, but soon there were commissions for monuments to honor the dead. Three early examples are Randolph Rogers's standing soldier for Spring Grove Cemetery in Cincinnati (1863–6), Martin Milmore's for Boston's Forest Hills Cemetery (*c.* 1867) and John Quincy Adams Ward's 7th Regiment Memorial for Central Park in New York (1869–74). They are early examples of the type that would appear repeatedly across the country: a soldier stands in a relaxed pose, leaning on his

rifle. It was not only noted sculptors who provided this type, but also mail order companies, especially after 1880, as a monument industry rose to meet the enormous demand for the subject. Countless small towns across the country still possess a standing soldier monument. Art Historian Kirk Savage suggests the figure embodies a new type for American sculpture, that of the common man, a citizen–soldier, not a professional one, whose parade-rest pose depicts the ideal of the white, male civilian who takes up arms prepared to defend his country. It was a type readily adopted by both Northern and Southern audiences. Only the details of the uniform were changed. In big cities a more elaborate variation involved an allegorical female figure (Union/Republic/South) at the top with the standing soldier types below representing both the army and the navy. Rogers executed one (c. 1870) for Providence, RI. Milmore designed one for the Boston Commons (c. 1870–74) and Franklin Simmons (1842–1913) made another (c. 1891) for Portland, ME. Moses Ezekiel's Arlington Memorial (1914) is a Southern version. But most audiences preferred the simple realism of the soldier on the plinth.

The "great man" monument type has a longer tradition in sculptural history and was quickly adopted to celebrate the heroes of the conflict. In the North there were favorite military heroes from Admiral Farragut and General Sherman (Augusts Saint-Gaudens, c. 1881 and 1903, both in New York) to General Meade (Charles Grafly, 1915–25, Washington, DC). They are also abundantly present in major battlefields such as Gettysburg. Political figures included abolitionist Henry Ward Beecher (John Quincy Adams Ward, c. 1891, Brooklyn) and, of course, Abraham Lincoln. There are numerous examples of Lincoln memorials, the best known being Daniel Chester French's on the Mall in Washington, DC (1915–22). For the South, the major figures were Robert E. Lee, Stonewall Jackson and Jefferson Davis. There are numerous examples of memorials to all three, but perhaps the most important is the elaborate city-planning project carried out in Richmond, VA, on Monument Avenue between the 1880s and 1920s. There a 42-m wide divided street, planted with rows of trees and studded with Confederate monuments, stretches for 14 blocks. The centerpiece is the equestrian statue of *Robert E. Lee* (1890) by Antonin Mercié (1845–1916). The monument to *J. E. B. Stuart* by Frederick Moynihan (1843–1910) followed in 1907, and one to *Stonewall Jackson* by Frederick William Sievers (1872–1966) in 1919. All of these were equestrian figures. The Jefferson Davis Memorial, sponsored by the UDC and designed by the architect William C. Noland (1865–1951) and sculptor Edward V. Valentine, was dedicated in 1907. A 13-columned Doric exedra frames the Davis statue while a colossal column looms behind him, topped by an allegorical figure of *Vindicatrix*, the "Spirit of the South."

The third type of public monument celebrates emancipation itself. Thomas Ball's Freedman's Memorial (1876) for Lincoln Park, Washington, DC, is perhaps the best known. While supported by the donations from freed African Americans, it was a group of white abolitionists who had control over the sculptural program. Harriet Hosmer proposed an elaborate, multi-figural composition, but it was Thomas Ball's simpler image that was chosen: a standing figure of Lincoln unrolls the Emancipation Proclamation as he gestures to a kneeling slave who is about to rise, his bonds having just been broken. Another monument that combines the "great man" and the "common soldier" type is Saint-Gauden's Shaw Memorial (c. 1897) in Boston, MA. Moreover, it does so to commemorate not only the "great man," Robert Gould Shaw, and his "common solders," the black troops of the 54th Massachusetts Regiment, it also commemorates the reason they were fighting, emancipation. But it is one of the few public monuments of the 19th century to include an active black presence seeking its own liberation. One example of a public emancipation monument done by an African American sculptor is Meta Vaux Warrick Fuller's 1913 piece created for W. E. B. Dubois's Emancipation Celebration, which took

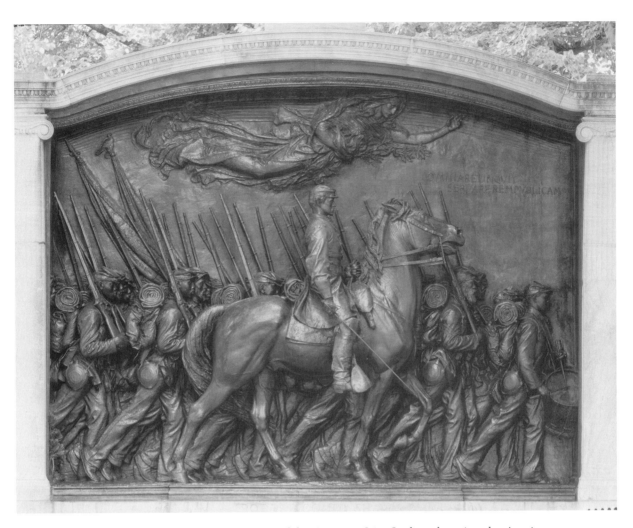

CIVIL WAR MONUMENTS. *Shaw Memorial* by Augustus Saint-Gaudens, honoring the American commander Robert Gould Shaw, Boston Common, 1884–97. JERRY L. THOMPSON/ART RESOURCE, NY

place in New York that year. It would not be until 2000 that it was finally cast in bronze and erected in Boston. It depicts two semi-nude African Americans, male and female, emerging from a tree with the hand of fate above them as they step forward into the future.

The final type is the monument devoted to women who sacrificed so much during the war. This was a particularly prominent form in the South where Confederate veterans placed seven of them between 1912 and 1926. While the designs vary widely, most place the Southern woman firmly on a pedestal where she is either crowned with a laurel

wreath (F. Wellington Ruckstuhl, 1912, Columbia, SC); reads to her children (Augustus Lukeman, 1914, Raleigh, NC, and Allen G. Newman, 1915, Jacksonville, FL); or accompanies a fallen soldier (Belle Kinney, 1917, Jackson, MS).

While the aftermath of wars often provides opportunities for sculptural monuments, the need for Civil War memorials came at a time when American sculpture seemed particularly ready to meet the public's demand and taste. Today the memorials line the country's streets, parks, battle-fields and cemeteries and provide one of the most visible displays of the period's sculptural art.

BIBLIOGRAPHY

W. Lewis Waldron: *Commercially Produced Forms of American Civil War Monuments* (MA thesis, U. IL, 1948)

W. Craven: *Sculpture In America* (New York, 1968)

M. Baruch and E. Beckman: *Civil War Union Monuments: A List of Union Monuments, Markers, and Memorials of the American Civil War* (Washington, DC, 1978)

R. Widener: *Confederate Monuments: Enduring Symbols of the South and War Between the States* (Washington, DC, 1982)

M. Panhorst: *Lest We Forget: Monuments and Memorial Sculpture in National Military Parks on Civil War Battlefields, 1861–1917* (PhD thesis, Newark, U. DE, 1988)

M. D. Peterson: *Lincoln in American Memory* (Oxford, 1994)

D. Gelbert: "Civil War Sites," *Memorials, Museums, and Library Collections: A State-by-state Guidebook to Places Open to the Public* (Jefferson, NC, 1997)

K. Savage: *Standing Soldiers, Kneeling Slaves: Race, War and Monument in Nineteenth-Century America* (Princeton, 1997)

S. Driggs, R. G. Wilson and T. Prawl: *Monument Avenue: History and Architecture* (Chapel Hill, 2001)

T. Desjardin: *These Honored Dead: How the Story of Gettysburg Shaped American Memory* (Cambridge, 2003)

C. Mills and P. Simpson: *Monuments to the Lost Cause* (Knoxville, 2003)

K. Savage: *Monument Wars, Washington, D. C., the National Mall, and the Transformation of the Memorial Landscape* (Berkeley, 2009)

Pamela H. Simpson

Clark, Alfred

(*b* New York, 1873; *d* Fulmer, Bucks, England, 16 June 1950), naturalized British radio-industry innovator and executive, collector and patron of American birth. He was educated at the College of the City of New York and the Cooper Union School of Art and Science, New York. In 1889 he joined an organization set up by Thomas Edison to develop the phonograph, and in 1895 at the Edison Laboratory at Orange, NJ, he produced the first moving-picture films with continuity or plot. In 1896 he worked in Washington, DC, at the laboratory of Emile Berliner, inventor of the gramophone, then joined the Gramophone Company of London and in 1899 founded the French Gramophone Company in Paris. In 1907 he went on to establish the Musée de la Voix in the archives of the National Opera in Paris. From 1909 to 1931 he was Managing Director of the Gramophone Company and became a British subject by naturalization in 1928. From 1896 he also patented several inventions in sound reproduction.

Clark was also a supporter of the arts. He was the most important patron of the American sculptor George Gray Barnard. His collection of Chinese ceramics, which was formed between the mid-1920s and the year of his death, was his pastime. It embraced Tang (AD 618–907), Song (960–1279), blue-and-white wares and a fine group of polychrome enameled porcelains. He participated in the activities of the Oriental Ceramic Society in London, serving on the Council and on the Management Committee almost continuously from 1934 to 1948. He also lent his ceramics to a number of important exhibitions, including the International Exhibition of Chinese Art in London in 1935 and the exhibitions of the Oriental Ceramic Society. A handwritten catalog of his collection, complete with photographs of the pieces, was compiled by R. L. Hobson in 1939. In 1956 some of his Yuan (1279–1368) pieces and a large group of 16th-century blue-and-white and polychrome wares were sold.

BIBLIOGRAPHY

E. E. Bluett: "Chinese Pottery and Porcelain in the Collection of Mr and Mrs Alfred Clark," *Apollo*, xviii/105 (Sept 1933), pp. 164–75; xviii/107 (Nov 1933), pp. 301–12; xix/111 (March 1934), pp. 135–43; xix/113 (May 1934), pp. 235–43

Blue and White Porcelain from the Collection of Mrs Alfred Clark (sale cat., London, Spink & Son, 16–31 Oct 1974)

S. J. Vernoit

Clark, Edward

(*b* New Orleans, LA, 6 May 1926), painter. Edward Clark experienced the excitement of being part of the younger generation of Abstract Expressionists and over a period of 50 years built up a solid body of

work that has made something both unique and original out of his commitment to Jackson Pollock's principles of action and spontaneity.

Born in New Orleans in 1926, Clark grew up in Chicago and, after studying at the Chicago Art Institute, took advantage of the GI Bill and went to Paris. There, he enrolled in the Académie de la Grande Chaumière in 1951 and by 1952 came under the influence of Paul Cézanne (1839–1906) and of Cubism. In 1954, the American Center for Students and Artists became interested in the artistic activity in Montparnasse studios and presented an exhibition titled *Grandes Toiles de Montparnasse*, in which Clark participated and was described in a review in *Le Monde* as a "noir de grand talent" (a black man of great talent).

Clark subsequently returned to New York to join a younger generation of Abstract Expressionist artists and, in 1957, became a member of the Brata Gallery artist cooperative on 10th Street. Also in that year, Clark made one of the first shaped paintings done in America—a painting "on which painted canvas was intermingled with painted fragments of paper that overlapped and went beyond the rectangular frame of the canvas."

In 1963, Clark began to divide his canvas into three parts and, hitting upon the idea of making his paintings on the floor, he began to use, in place of brushes, push brooms guided by wooden tracks to increase the speed and scope of his line. In 1966, after ten years in New York, Clark returned to Paris. Subsequently, throughout a career encompassing many stylistic changes, Clark chose to share his time and creative energies by alternately living and exhibiting in both Paris and New York.

Passion is an integral element in Clark's painting, and is the basis of his relationship to the brush strokes of Willem de Kooning and Franz Kline, his Abstract Expressionist forebears. In 1972, Clark took a trip across the African continent. At the University of Ife, in Nigeria, he shut himself up for ten days and made a series of pastel and pencil drawings that reflected his experience of the color of the world through which he was traveling. This, in turn, became the basis for a series of large paintings (ranging from 3.6 m to 4.8 m across and 2.4 m to 2.7 m high) that he made upon his return to New York. Influenced by his experience of the African landscape, Clark's colors included umbers, tans and terracotta reds moving in a series of approaching and retreating lines like a horizon. By this time, the Black Power Movement of the 1960s had spread to the art world bringing belated recognition to many black artists. For example, in 1972, Clark won an award from the National Endowment for the Arts and was included in the 1973 Whitney Museum "Biennial" of American Art. In 1974, the Ife paintings were extremely well received in Clark's solo exhibition at the South Houston Gallery in SoHo, and it was in this context that one of Clark's Ife paintings was included in a 1980 exhibition called *Afro-American Abstraction* organized by April Kingsley at P.S. l, an alternative space in Long Island, New York. From this time on, appreciation of Clark's contribution to American abstract art was on the rise. His subsequent shows were reviewed in such journals as *ARTnews*, *Arts* and *Art in America*. His work is in the permanent collection of the Art Institute of Chicago, the Studio Museum in Harlem, New York, Chase Manhattan Bank and other distinguished public collections.

BIBLIOGRAPHY

J. Wilson: "Edward Clark: Directions," *A. America*, lxix/1 (Jan 1981), p.119

C. Robins: *The Pluralist Era: American Art, 1968–1981* (New York, 1984), pp. 44–5

Explorations in the City of Light: African-American Artists in Paris, 1945–1965 (exh. cat. by K. Conwill, New York, Studio Mus. Harlem, 1996)

Corinne Robins

Clark, Larry

(*b* Tulsa, OK, 19 Jan 1943), photographer and film-maker. He studied photography at Layton School of Art, Milwaukee, WI (1960–63), and later came under

the tutelage of Walter Sheffer (1918–2002) and Gerard Bakker. Clark first garnered attention in 1971 with the publication of *Tulsa*, a book whose graphic and uncensored view of the youth subculture of the Midwest resulted in a lawsuit, bringing Clark notoriety but also recognition as a photographer. In 1973 Clark was awarded a National Endowment of the Arts Photographers' Fellowship. His later books, *Teenage Lust* (1982) and *Perfect Childhood* (1992), continued to be centered on the rituals and obsessions of drug culture and youths dominated by sex, the hypodermic needle and the gun. A heightening of the voyeuristic element as a result of the growing difference in ages between the subjects and the photographer was particularly apparent in later photographs of young people in New York and by the depiction of teens in his debut feature film *Kids* (1995).

Kids drew an equal amount of praise and criticism for its unflinching portrayal of disaffected urban teens. Its graphic imagery and frank dialogue fueled a national discussion regarding the influence of sex and drugs on an increasingly disenfranchised and amoral youth subculture. In spite of, or perhaps because of, the firestorm of controversy *Kids* generated, it became one of the first unrated films to see wide release. Clark's next project, the more conventional Hollywood production *Another Day in Paradise* (1998), received less attention than *Kids*, and Clark returned to familiar thematic territory for *Bully* (2001). In 2002 Clark reunited with *Kids* screenwriter Harmony Korine for *Ken Park*. This was followed by *Wassup Rockers* (2005), a brutally realistic story of young people from the wrong side of the tracks engaging in adult behavior in Beverly Hills.

Clark mounted several US and international exhibitions (both solo and group) over the decades between *Tulsa* and his later film work. In 2005, Clark received the International Photography Lucie Award for Achievement in Documentary Photography. Clark's work in photographs and on film challenged social standards and preconceptions regarding the priorities and proclivities of adolescence.

BIBLIOGRAPHY

Contemp Phots.

3 *New Yorker Fotografen: Peter Hujar, Larry Clark, Robert Mapplethorpe* (exh. cat. by D. Hall, J.-C. Ammann and S. Wagstaff, Basel, Ksthalle, 1982)

Jeff Stockton

Clark, Robert Sterling

(*b* New York, 25 June 1877; *d* Williamstown, MA, 29 Dec 1956), collector. Clark was educated at Sheffield Scientific School, Yale University, and served in the US Army from 1899 to 1905. He led an expedition to northern China in 1908–9 and published an account of it, *Through Shen Kan*, with Arthur Sowerby in 1912. He settled in Paris in 1912 and married Francine Clary in 1919. After 1920 the couple lived mainly in New York, with residences in Cooperstown, NY (until 1933), Upperville, VA, and Paris. Using Clark's inherited fortune, they founded and endowed the Sterling and Francine Clark Art Institute (opened 1955) in Williamstown, MA, to house Clark's collection.

Clark purchased art between 1912 and 1954, principally from the firms of Colnaghi, Knoedler and Durand-Ruel. He began primarily with the Old Masters, acquiring paintings by Piero della Francesca, Hans Memling, Jan Gossart and Claude Lorrain, but after 1920 he concentrated on 19th-century French painting. He had several favorites: Auguste Renoir (represented by more than 30 paintings including *At the Concert*), Claude Monet, Camille Pissarro, John Singer Sargent and Winslow Homer (e.g. *Sleigh Ride*). Such academic painters as William-Adolphe Bouguereau (e.g. *Nymphs and Satyr*), Jean-Léon Gerôme, Alfred Stevens and Giovanni Boldini are also well represented. The drawings collection includes works by Albrecht Dürer (e.g. *Sketches of Animals and Landscapes*), Peter Paul Rubens, Rembrandt, Antoine Watteau (e.g. *Woman in Black*), Jean-Honoré Fragonard and Edgar Degas; the silver collection is especially strong in English domestic wares of the 17th and 18th centuries, with Paul de

Lamerie a particular favorite. Clark was a very private collector and had no advisers. Few of his pictures were exhibited during his lifetime. His brother, Stephen Clark (1882–1960), was also a notable collector, acquiring works by artists such as Cézanne (*Card Players*, New York, Met.) and van Gogh (*Night Café*, New Haven, CT, Yale U. A.G.).

BIBLIOGRAPHY

Drawings from the Clark Art Institute, intro. E. Haverkamp-Begemann (New Haven and London, 1964), pp. vii–xi

List of Paintings in the Sterling and Francine Clark Art Institute, intro. D. S. Brooke (Williamstown, 1992)

D. S. Brooke. "The Collection of Sterling and Francine Clark in Williamstown," *Drawing*, 17/2 (July–Aug 1995), pp. 25–9

S. Kern and others. *A Passion for Renoir: Sterling and Francine Clark Collection, 1916–1951* (New York, 1996)

K. Wilkin. "What an Eye!," *ARTnews*, 96/3 (Mar 1997), pp. 102–4

M. Conforti. "An Art Institute in the Berkshires," *Antiques*, 152/4 (Oct 1997), pp. 494–9

D. S. Brooke and others. "The Clarks as Collectors," *Antiques*, 152/4 (Oct 1997), pp. 500–3, 522–35, 546–57

The Clark Brothers Collect: Impressionist and Early Modern Paintings (exh. cat. by M. Conforti, Williamstown, MA, Sterling and Francine Clark A. Inst., 2006)

N. F. Weber: *The Clarks of Cooperstown* (New York, 2007)

David S. Brooke

Clarke, Thomas B.

(*b* New York, 11 Dec 1848; *d* New York, 18 Jan 1931), businessman, collector, patron and dealer. Clarke began collecting art in 1869 with paintings by American Hudson River school artists and conventional European works, Chinese porcelain, antique pottery and 17th- and 18th-century English furniture. By 1883 his taste was focused entirely on American works, especially on paintings by George Inness and Winslow Homer. By dealing in such works and by giving frequent exhibitions, Clarke enhanced the popularity of these artists, while also realizing large profits for himself. His founding of Art House, New York, in 1890 confirms the profit motive behind his collecting practices. The most notable sale of his paintings took place in 1899, when he sold at auction 373 contemporary American works at a profit of between 60 and 70%. Four landscapes by Inness—*Grey, Lowery Day* (c. 1876–7; untraced), *Delaware Valley* (1865; New York, Met.), *Clouded Sun* (1891; Pittsburgh, Carnegie Mus. A.) and *Wood Gatherers: Autumn Afternoon* (1891; Williamstown, MA, Clark A. Inst.)—received higher prices than any hitherto realized by American paintings. Also sold at this auction were Winslow Homer's *Eight Bells* (1886; Andover, MA, Phillips Acad., Addison Gal.) and Albert Pinkham Ryder's *Temple of the Mind* (c. 1885; Buffalo, NY, Albright–Knox A.G.).

Clarke's taste in American art was conventional. He tended to emphasize landscape and genre but also favored less popular still life. After the sale of 1899, he collected early American portraits, perhaps partly in response to the Colonial Revival movement in America and the increased interest in historic American art. Although some of the portraits he collected were misattributed, many of those by John Singleton Copley and Gilbert Stuart, such as *Joseph Coolidge* (1820) in his collection, subsequently given to the National Gallery of Art, Washington, DC, have become national icons. Clarke was admired by his contemporaries for his philanthropy, but a report issued in 1951–2 for the National Gallery of Art in Washington, DC, revealed him as a fraudulent dealer in 18th-century art portraits. Clark's encouragement of art did not extend beyond his lifetime. He did, however, establish a fund at the National Academy of Design, New York, the proceeds of which provide an annual prize of $300 to the best figure painting by a non-academician.

UNPUBLISHED SOURCES

Washington, DC, Smithsonion Inst., Archivs Amer. A.

BIBLIOGRAPHY

DAB

Catalogue of the Private Collection of Thomas B. Clarke (exh. cat., New York, Amer. A. Gals, 1899)

H. B. Weinberg: "Thomas B. Clarke: Foremost Patron of American Art from 1872 to 1899," *Amer. A. J.*, viii/1 (1976), pp. 52–83

R. H. Saunders: "The Eighteenth-century Portrait in American Culture of the Nineteenth and Twentieth Centuries," *The Portrait in Eighteenth-century America*, ed. E. G. Miles (Newark, 1993), pp. 138–52

Lillian B. Miller
Revised and updated by Gregory Gallagan

Claypoole, James

(*b* Philadelphia, PA, 2 Feb 1721; *d* Philadelphia, PA, 1784), painter. Claypoole was among the earliest native-born artists in Pennsylvania and painted a number of portraits before 1750 in the Philadelphia area (although none can be identified with certainty). Documents preserved at the Historical Society of Pennsylvania show that, around 1741, he was working for (possibly apprenticed to) Gustavus Hesselius. His students, James Claypoole Jr. (*c*. 1743–1800) and Matthew Pratt, became noted artists at the time of the American Revolution. Claypoole gave up painting for politics later in life and served as High Sheriff of Philadelphia from 1777 to 1780. He is usually remembered, however, for being related to many of the artistic and political leaders of 18th-century Philadelphia. He was the father-in-law of the miniature painter James Peale and the activist Timothy Matlack. His cousin married Betsy Ross (1752–1836), who is thought to have sewn the first American flag. A portrait of Claypoole by Charles Willson Peale is in the Pennsylvania Academy of Fine Arts in Philadelphia.

[*See also* Hesselius, Gustavus *and* Pratt, Matthew.]

BIBLIOGRAPHY

C. Sellers: "James Claypoole: A Founder of the Art of Painting in Pennsylvania," *PA Hist.*, xvii (1950), pp. 106–9

Mark W. Sullivan

Clayton, Nicholas J.

(*b* Ireland, ?1840; *d* Galveston, TX, 9 Dec 1916), architect of Irish birth. According to family tradition, Clayton was taken to the USA by his recently widowed mother when he was a child. They settled in Cincinnati, OH, where Clayton, after serving in the US Navy, was listed in the city directory as a stone-carver. His architectural apprenticeship may have been with the firm of Jones & Baldwin of Memphis, TN. By 1872 Clayton was in Galveston, TX, as the supervising architect for the First Presbyterian Church, a building thought to have been designed by Jones & Baldwin. In 1875 Clayton was practicing in Galveston under his own name and listed himself in the *Galveston City Directory* as "the earliest-established professional architect in the state." He took an active role in the establishment of a professional organization for architects, the forerunner of the present Texas Society of Architects. For his work in promoting the profession, as well as for the quality of his architecture, he was made a Fellow of the American Society of Architects. He enjoyed a successful practice, patronized by leaders in Galveston's business, religious and civic establishments. He worked mainly in the prevailing High Victorian styles, particularly in those of the Gothic and Romanesque revivals, and was admired for his elaborate, inventive and colorful brick detail. Among his most notable works in Galveston are the Gresham House (or Bishop's Palace; 1888), the University of Texas Medical School (or Ashbel Smith Hall; 1889–90) and the Ursuline Convent (1891–4; destr.).

BIBLIOGRAPHY

D. B. Alexander: *Texas Homes of the Nineteenth Century* (Austin, 1966)

H. Barnstone: *The Galveston That Was* (New York, 1966)

W. E. Robinson: *Texas Public Buildings of the Nineteenth Century* (Austin, 1974)

R. L. Good: "Modern Texas Architecture: In the Details," *Texas Archit.*, 41/8 (Nov–Dec, 1991), pp. 34–43

B. Scardino and D. Turner: *Clayton's Galveston: The Architecture of Nicholas J. Clayton and His Contemporaries*, foreword P. Brink, afterword by S. Fox (College Station, TX, 2000)

D. T. Rulton: "Faithful Addition" [Cathedral Santuario Guadalupe Towers, Dallas], *Texas Archit.*, 57/6 (Nov–Dec 2007), pp. 28–31

Drury B. Alexander

Clegg & Guttman

Photographers and conceptual artists of Irish and Israeli birth. Collaborating under a corporate-sounding name, Michael Clegg (*b* Dublin, 1957) and Martin Guttman (*b* Jerusalem, 1957) began making photographs together in 1980. Using corporate group portraits as their resource material, they made constructed photographs in the manner of 17th-century Dutch paintings. *A Group Portrait of the Executives of a World Wide Company* (1980; see 1989 exh. cat., p. 33) shows five suited men seated in a brooding darkness, their heads and hands illuminated in a chiaroscuro effect. The reference to historical paintings is made particularly explicit in *The Art Consultants* (1986; see 1989 exh. cat., p. 37): the figures are posed directly in front of a canvas so as to mirror the painted figures, illustrating Clegg & Guttman's proposition that within the hierarchies of power, the essential nature of pose, emblems and dress have remained relatively unchanged for centuries. Pushing these images to the point of indetermination, Clegg & Guttman also occasionally carried out actual commissions (although not always successfully), as well as creating collaged and altered portraits such as *The Art Foundation: A Rejected Commission* (1988; see 1989 exh. cat., p. 45). They went on to create works that involved the participation of communities, such as a series of *Open Library* projects made in several sites in Germany (1993; see 1993 exh. cat., p. 31). Installing a selection of books in a public space in housing estates, the artists encouraged the local residents to use this facility on an honor system, heightening a sense of collective identity and responsibility.

BIBLIOGRAPHY

Clegg & Guttman: Collected Portraits (exh. cat., essays T. Ostenwald and others, Stuttgart, Württemberg. Kstver., 1988) [includes text by the artists]

Clegg & Guttman: Group Portraits (exh. cat., essay R. Durand, Bordeaux, Mus. A. Contemp., 1989)

Kant Park (exh. cat., essay R. H. Heller, Duisburg, Lehmsbruck-Mus., 1993)

Clegg & Guttman (exh. cat., Basle, Ksthalle, 1997)

R. Rosenblum: "Post Human," *Artforum*, xliii (2004), pp. 121, 284

M. Vincent: "Clegg & Guttman," *A. Mthly*, ccc (2006), pp. 30–1

Francis Summers

Clemente, Francesco

(*b* Naples, 23 March 1952), Italian painter. In 1970 Clemente began studying architecture in Rome at the Università degli Studi "La Sapienza," establishing a studio where he made drawings, many based on childhood memories and dreams (e.g. collection of untitled ink drawings, 1971; Basle, Kstmus.). He became involved in Roman avant-garde art circles and befriended the Italian painter Alighiero Boetti (*b* 1940), whose work, together with that of Joseph Beuys and Cy Twombly, was an early influence. Clemente's first solo exhibition of collages was held at the Galleria Giulia, Rome, in 1971. His interest in the art, folklore and mysticism of India began with yearly visits from 1973 (e.g. *Francesco Clemente Pinxit*, series of 24 paintings in gouache on handmade paper, 1980–1; Richmond, VA Mus. F.A.). In 1974 he traveled with Boetti to Afghanistan, producing a series of pastel drawings. Clemente came to prominence in the mid-1970s with his intensely subjective, erotic imagery of frequently mutilated body parts, skewed self-portraits and gesturing, ambivalent figures, often depicted in rich colors. He was part of the revolt against formalism and the detached qualities of much conceptual art, which linked him with such painters as Sandro Chia, David Salle and Georg Baselitz. The eclecticism and highly personal symbolism in his work is evidence of an itinerant life spent among three homes: in Madras, New York and Rome. Clemente's first large-scale oil paintings were executed during a stay in New York (1981–2) and subsequently shown first at the Whitechapel Gallery, London, and then in Germany and Stockholm (1983). The violent, expressionist style and arcane, quasi-religious content of these and later paintings defied easy definition as his work grew more surreal (e.g. *2 Seeds*, oil on canvas, 1983; Chicago, IL, A. Inst.).

In 1984 in New York he worked on collaborative projects with the American painter Jean Michel Basquiat and Andy Warhol.

WRITINGS
The Pondicherry Pastels (London and Madras, 1986)

BIBLIOGRAPHY
M. McClure: *Francesco Clemente: Testa coda* (New York, 1985) [essay and interview]

E. Avedon, ed.: *Clemente: An Interview with Francesco Clemente by Rainer Crone and Georgia Marsh* (New York, 1987)

Francesco Clemente: Three Worlds (exh. cat. by A. Percy and R. Foyle, Philadelphia, PA, Mus. A.; Hartford, CT, Wadsworth Atheneum; San Francisco, CA, MOMA; London, RA; 1990–91)

Francesco Clemente, Bestiarium (exh. cat. by J.-C. Ammann, Frankfurt am Main, Mus. Mod. Kunst, 1991)

V. Katz: *Life Is Paradise: The Portraits of Francesco Clemente* (New York, 1999) [essay and interview]

Clemente (exh. cat. by L. Dennison, New York, Guggenheim, 1999)

M. Auping: *Francesco Clemente* (Milan, 2000)

Clemente (exh. cat., Guggenheim, New York and Bilbao, 2000)

A. B. Oliva: *Francesco Clemente* (Milan, 2000)

B. Adams: "80s Then: Francesco Clemente Talks to Brooks Adams," *Artforum*, 41/7 (Mar 2003), pp. 58–9, 260

Francesco Clemente: Paintings 2000–2003 (exh. cat. with essay by D. Rimanelli, Gagosian Gal., New York, 2003)

Francesco Clemente: New Works (exh. cat. by E. Juncosa, Irish MOMA, Dublin, 2004)

Francesco Clemente: Works 1971–1979 (exh. cat. by J. C. Ammann, Deitch Projects, New York, 2007)

Cleveland

City and seat of Cuyahoga County in the state of Ohio. Located on the southern shore of Lake Erie, it is an industrial metropolis and a Great Lakes port (population *c.* 500,000). The city was founded in 1796 as part of the Western Reserve lands of the old colony of Connecticut. Growth was spurred by the Ohio Canal, the development of the railways, industry and manufacturing, and by 1910 the city was the sixth largest in the USA.

Cleveland's architecture during the first half of the 19th century was typical of a transplanted New England village, with classical and Greek Revival timber houses and churches. In the last quarter of the century the city's most impressive architecture was concentrated on Euclid Avenue, lined with great mansions in every revival style built by the barons of steel, shipping, oil, electricity and the railways (e.g. the Gothic Revival Rufus K. Winslow House by Levi T. Schofield, 1878; destr.). The opportunities for building in a growing and wealthy industrial city attracted many exceptional architects to Cleveland. Several achieved regional, if not national, reputations, including Charles F. Schweinfurth, whose works included the Romanesque Revival Calvary Presbyterian Church (1887–90), and later J. Milton Dyer (1870–1957) and the firm of Walker & Weeks. Cleveland also participated in the commercial architecture revolution that evolved simultaneously in Chicago, New York, and other large American cities, which was particularly characterized by the evolution of iron and steel skeletal-frame structures. The most significant example of this development in Cleveland is the Arcade (1890) by John Eisenmann (1851–1924) and George H. Smith (1849–1924), a 91-m long, five-story commercial shopping street connecting two nine-story office buildings, enclosed in iron and glass with an innovative trussed roof.

In 1903 a commission headed by Daniel H. Burnham produced the "Group Plan" for Cleveland, in which federal, county, and city buildings were built between 1903 and 1936 in a monumental Beaux-Arts ensemble around a mall; it was one of the most fully executed of Burnham's urban plans. Greater Cleveland also developed the first comprehensive modern building code (1904), the first industrial research campus (Nela Park, 1911) by Frank E. Wallis and the most spectacular realization of the garden city suburb, Shaker Heights (1906–30), planned by Oris P. van Sweringen (1879–1936) and Mantis J. van Sweringen (1881–1935). The complex of Union Terminal buildings (1925–30) by Graham, Anderson, Probst & White anticipated many of the features of New York's Rockefeller Center, and its Terminal Tower (h. 216 m) was the tallest building outside New York City between 1927 and 1967.

At University Circle, centered on a lagoon and planned by Frederick Law Olmsted's practice, a unique cluster of cultural institutions was established from the 1880s, some housed in such notable buildings as the Cleveland Orchestra's Severance Hall (1931) by Walker & Weeks. The art life of the city became centered on two institutions housed in the Circle, the Cleveland Institute of Art (founded in 1882 as the Cleveland School of Art) and the Cleveland Museum of Art. Established in 1913, the Museum occupies a notable Beaux-Arts building, designed by Benjamin S. Hubbell (1867–1953) and W. Dominick Benes (1857–c. 1935), completed in 1916. The Museum attained national status, especially in view of its oriental collections, which were acquired following the Leonard Hanna bequest of $30 million in 1958. Projects to increase space for the Museum's collections and programs included a 1971 modernist "fortresslike" west wing designed by Marcel Breuer and a sprawl of additions (1983–93). The first stage of a long-term renovation–expansion program (begun 2000) was a two-story addition by Rafael Viñoly Architects designed to unify the classical original building and Breuer addition, incorporating glazed walkways and galleries, stonework bands to reflect the earlier architects' aesthetics, and a planned glass and steel canopy to bring all the parts together.

During the Depression of the 1930s, the first three federal public housing projects in the USA were authorized and begun in Cleveland in 1935–7; one of them, Lakeview Terrace, designed by Joseph L. Weinberg, William H. Conrad, and Wallace S. Teare, was recognized internationally as a landmark in public housing because of its adaptation to a difficult lake-front site and its early use of the European International-Style idiom. Following World War II, Cleveland embarked on one of the most ambitious urban renewal plans undertaken under the Federal Urban Redevelopment Program. The Erieview plan (1960) by I. M. Pei designated sites for new public, commercial and residential development around planned axes and facilitated the construction of a number of important new central office buildings by both national and local architects, including the Cleveland Trust Company Tower (1971) by Marcel Breuer and Hamilton P. Smith (b 1925). The plan's concentration of urban renewal efforts in one inner city district did little to staunch the decay of other inner city areas such as Hough and University-Euclid. Significant architectural projects of the 1980s and 1990s included the BP America Building by HOK (1985) and Key Tower by Cesar Pelli & Associates (1991), as well as I. M. Pei's International Rock Hall of Fame and Museum (1995), and the Main Library's Louis Stokes Wing, designed by Hardy Holzman Pfeiffer Associates (1996), both of which also contributed to the city's cultural development.

BIBLIOGRAPHY

E. H. Chapman: *Cleveland: Village to Metropolis* (Cleveland, 1964)

C. F. Wittke: *The First Fifty Years: The Cleveland Museum of Art* (Cleveland, 1966)

The Architecture of Cleveland: Twelve Buildings, 1836–1912 (Cleveland and Washington, DC, 1973)

M. P. Schofield: *Landmark Architecture of Cleveland* (Pittsburgh, 1976)

E. Johannesen: *Cleveland Architecture, 1876–1976* (Cleveland, 1979)

S. Lee: *Eight Dynasties of Chinese Painting: The Collections of the Nelson Gallery-Atkins Museum, Kansas City, and Cleveland Museum of Art* (Cleveland, 1981)

N. C. Wixom: *Cleveland Institute of Art* (Cleveland, 1983)

R. C. Gaede: *Guide to Cleveland Architecture* (Cleveland, 1997)

G. G. Deegan and J. A. Toman: *The Heart of Cleveland: Public Square in the 20th Century* (Cleveland, 1999)

S. P. Hoefler: *Cleveland's Downtown Architecture* (Chicago, 2003)

M. Iacono, ed.: *Masterpieces of European Painting from the Cleveland Museum of Art* (Cleveland, 2007)

Eric Johannesen
Revised and updated by Margaret Barlow

Cleveland, Horace William Shaler

(b Lancaster, MA, 16 Dec 1814; d Hinsdale, IL, 5 Dec 1900), landscape architect and writer. He was a descendant of Moses Cleveland, who came from Ipswich, England, in 1635, and his father, Richard

Jaffry Cleveland, was a sea captain. Cleveland gained early agricultural experience in Cuba while his father served as Vice-Consul in Havana. On his return to the USA after 1833, Horace studied civil engineering in Illinois and Maine, settled afterward on a farm near Burlington, NJ, and became corresponding secretary of the New Jersey Horticultural Society. In 1854 he moved with his family to the vicinity of Boston, spending three years in Salem and ten years in Danvers. During this early phase of his career he formed a partnership with Robert Morris Copeland (1830–74), a landscape architect of Lexington, MA, and designed several rural cemeteries near Boston, including Oak Grove (1854) in Gloucester, MA, and the celebrated Sleepy Hollow (1855) in Concord, MA. In 1856 Cleveland and Copeland entered the competition for the design of the newly acquired Central Park in New York but lost to Frederick Law Olmsted and Calvert Vaux. Cleveland's design bore many of the features of the Olmsted–Vaux design. In a pamphlet accompanying his design Cleveland wrote, "The tract of land selected for the Central Park comprises such an extensive area and such variety of surface as to afford opportunity for the construction of a work which shall surpass everything of its kind in the world. . . . Cleveland, like Olmsted, prescribed broad lawns, undulating surfaces, "clothed with the rich verdure, dotted here and there with graceful trees and bounded by projecting capes and islands of wood. . . ."

Very little is known of Cleveland's work from 1857 until 1869, when he moved to Chicago. In 1871 he formed a new partnership there with William Merchant French (1843–1914), the architect and civil engineer who later helped to found the Art Institute of Chicago. A professional pamphlet issued by Cleveland and French in 1871 broadly defined landscape architecture as "the art of arranging land so as to adapt it most conveniently, economically and gracefully, to any of the varied wants of civilization." In 1873 Cleveland published *Landscape Architecture as Applied to the Wants of the West*, in which he stressed the need for creating broad, tree-lined

boulevards to relieve the monotony of the straight lines of Midwestern city grids. In 1876 Cleveland was asked to design Roger Williams Park in Providence, RI. He had earlier been associated with the design there of Swan Point Cemetery and of the grounds of the Butler Hospital. His approach to the design of Roger Williams Park was characteristically bold as well as sensitive to the site's topography and natural features. Within ten years he transformed what had been a swampy, unpromising site into one of the finest Picturesque parks in the USA. He created a series of three interconnected lakes, unified by a system of encircling drives and paths. Adjacent lawns were planted with native trees and shrubs, and the whole composition was designed to produce a progression of varying scenes and to give the illusion of naturalness. Cleveland, like Olmsted, with whom he was earlier associated in the design of Prospect Park (1865), Brooklyn, New York, and in the design of South Park (now Washington and Jackson Parks) and Drexel Boulevard (1872–6) in Chicago, perceived the park as an instrument of social change and as a work of art. Cleveland moved again in 1886 to Minneapolis, MN. There he made important contributions to civic improvement, fought for the preservation of Minnehaha Falls and designed the regional St. Paul–Minneapolis Park system. He contributed a paper on the *Influence of Parks on the Character of Children* to the Chicago Outdoor Art Association in 1898.

[*See also* Providence.]

WRITINGS

A Few Words on the Central Park (Boston, 1856)

Public Parks, Radial Avenues and Boulevards (24 June 1872) [address given before the Common Council and Chamber of Commerce of St Paul]

Landscape Architecture as Applied to the Wants of the West (Chicago, 1873/R Pittsburgh, 1965)

Report upon the Improvements of Roger Williams Park (Providence, 1878)

Outline of a Plan of a Park System for the City of St Paul (19 June 1885) [address given before the Common Council and Chamber of Commerce of St Paul]

Park Systems of St Paul and Minneapolis (St Paul, 1887)

BIBLIOGRAPHY

DAB

T. Kimball: "H. W. S. Cleveland, an American Pioneer in Landscape Architecture and City Planning," *Landscape Archit.*, xx (1929), pp. 99–110

E. M. McPeck: *H. W. S. Cleveland in the East* (paper, Cambridge, MA, Harvard U., Grad. Sch. Des., 1973)

E. M. McPeck: *Report to the Roger Williams Park Commission: Historic Factors* (Providence, 1984)

D. J. Nadenicek: "Civilisation by Design: Emerson and Landscape Architecture," *19th C. Stud.*, x (1996), pp. 33–47

R. A. Bosco, J. Myerson and R. W. Emerson: "In the Palm of Nature's Hand: Ralph Waldo Emerson's Address at the Consecration of Sleepy Hollow Cemetery," *Markers: The Annual Journal of the Association for Gravestone Studies*, xxi (2004), pp. 148–73

P. G. Koski: "Urban Remedy," *Archit. MN*, xxx/1 (2004), pp. 21, 60, 62

Eleanor M. McPeck

Climent, Elena

(*b* Mexico City, 6 March 1955), Mexican painter, active also in the USA. An autodidact, at the age of 16 Climent decided to pursue a career as a painter. Her mother was born in New York, and her father, Enrique Climent (1897–1980), was a celebrated painter who had come to Mexico as an exile from the Spanish Civil War. Her parents' intimate social circle was made up of expatriate Spanish artists, musicians and writers. Climent's decision not to enter art school in Mexico was influenced by her father, whose negative view of formal education stemmed from his own conservative training in early 20th-century Valencia.

Climent's early works in watercolor were exhibited at a series of solo exhibitions in Mexico City from 1972 until 1984, when she took a two-year break from professional practice. In 1986 the direction and medium of Climent's work changed. Exploring the streets of Mexico City with her camera, she took snapshots of windows, doors and balconies, detailing the overlapping margins between exterior and interior spaces. From these photographs she produced her first series of oil paintings. In 1988 the series was exhibited at the Palácio de Bellas Artes, Mexico City, and the widespread popularity of her new work marked a personal breakthrough. Previously her work had drawn from her own imagination, and her move away from such interior musings was motivated by a need to engage with contemporary Mexico, a reality placed at a distance from the family home by her father's preservation of an expatriate Spanish identity.

In 1988 Climent moved to New York where her husband, an anthropologist, held a position at New York University. In the USA she continued to explore the urban landscape of Mexico City, using her snapshots as a visual dictionary from which she described a city in a constant state of change, its capricious urban geography composed of individual, personalized alterations of space. Her first solo exhibition in the USA was held in 1992 (*In Search of the Present*; New York, Mary-Ann Martin/Fine Art) and traveled to the Galería de Arte Mexicano, Mexico City, in 1993. Her second exhibition, *Re-encounters* (1995; New York, MAM/FA), marked a new emphasis on intimate still lifes; she continued to draw inspiration from the homes and streets of Mexico City, but her intervention in the choice and placement of particular objects became more explicit. Some still lifes were composed in her New York studio, from objects selected for their personal associations, while domestic settings were drawn from photographs taken on a recent visit to her family home in Mexico shortly after her mother's death in 1994. This brief inhabitation of her childhood home, where the lingering presence of her parents was reflected by the objects that they had collected over a lifetime, resulted in a second exhibition, *To My Parents* (1997; New York, MAM/FA). While fragments of the household were recorded in carefully composed detail, Climent also inserted elements that indicate her own presence, reconciling a long-held sense of difference from the Europeanized world of her family home. In *Dresser with Doll and Old Studio Photograph*, for example, Climent respectfully reproduces a photograph of her father's former studio in Spain on a shelf, but repaints the wall in the background a vivid yellow; this color suggests the

Mexico outside the family enclave and is one that would not have been permitted by her parents' preference for sober and tasteful color.

Climent continued to show series of paintings at MAM/FA, using material drawn from regular visits to Mexico and maintaining a focus on the arrangement of possessions. Informally ordered and including objects that evoke an active human presence, such as lit candles and half-consumed beverages, her self-styled "unstill lifes" aim to reconcile the undisciplined and unpredictable exigencies of the present with the need to create meaning and personal narrative from the past.

BIBLIOGRAPHY

Elena Climent: El tiempo detenido (exh. cat. by J. Torres Martinez; Mexico City, Gal. Met., 1982)

Elena Climent: Flor de asfalto (exh. cat. by M. Saavdra; Mexico City, Pal. B.A., 1988)

Elena Climent: In Search of the Present (exh. cat. by E. J. Sullivan; New York, MAM/FA, 1992)

E. J. Sullivan: "Fantastic Voyage: The Latin American Explosion," *Artnews*, 92/6 (Summer 1993), pp. 134–7

Re-encounters (exh. cat. by S. M. Lowe; New York, MAM/FA, 1995)

To My Parents (exh. cat. by H. Herrera; New York, MAM/FA, 1997)

Latin American Still Life: Reflections of Time and Place (exh. cat. by C. C. Kirking and E. J. Sullivan, Katonah Mus. A., New York, and Mus. Barrio, New York, 1999)

R. P. Horcasitas: *Elena Climent* (Mexico, 2000)

Latin American Still Life (exh. cat., Mus. Barrio, New York, 2000)

Elena Climent: Windows from Here to Then (exh. cat. with essays by C. I. Bach and E. Climent, New York, Mary-Anne Martin/ F. A. Gal., 2000)

Elena Climent: La hora de la siesta; obra reciente: 23 de octubre (exh. cat. with essays by A. R. de Yturbe, Mexico, Gal. A. Mex., 2001)

C. Bravo: *Claudio Bravo, Elena Climent* (Mexico, 2003)

Elena Climent: Lateral Altars (exh. cat. with essays by E. Climent, S. Vollmer, C. A. Vicuña, New York, Mary-Anne Martin/F. A. Gal., 2004)

Isobel Whitelegg

Cling, Alice

(*b* Cow Springs, AZ, 21 March 1946), potter. The daughter of famed Navajo potter Rose Williams, Cling broke with tradition by creating highly polished, red-hued decorative ware in a contemporary style that ushered in a new generation of Navajo art potters (including her two sisters).

After graduating from the Intermountain Indian School in Brigham City, UT, she married Jerry Cling and worked as a teacher's aide at the Shonto Boarding School. Initially learning to pot from her mother while a young girl, she became interested in the craft in the 1970s and over time developed an innovative style that reflected her own individual vision.

Cling used the traditional method of coiling and pinching clay into the desired form, then sanded, polished and coated her pottery with piñon pitch. She worked in the small communal room of her home in the Shonto-Cow Springs region of Arizona, watched by her mother, who lived across the highway. Her pots were fired outdoors in an open pit with juniper wood (and sometimes sheep manure) for fuel.

The distinctive sheen of her work is the result of her pots being polished to a high gloss before they are fired. The rich color is achieved by using a red-clay slip, originally acquired from the Hualapai Indians and later located and dug up by Cling herself. Occasionally she applied appliquéd decoration, but generally her pots remain plain. Her clay surfaces are further enhanced by the dark-colored blushes (or fire clouds) that are created by the wood ash that falls onto her pots during the firing process.

Cling broke with the Navajo pottery tradition by developing her own graceful, artfully shaped forms; by discarding the typical *biyo'* (or beaded necklace) around the rim; and by polishing her ware with a smooth river stone (and sometimes Popsicle sticks) instead of the usual burnished corncob. Cling was one of the first Navajos to sign her name on her pots.

Highly sought after by collectors and museums, her work has won awards at Native American craft fairs, including the annual markets held at the Heard Museum, Phoenix, AZ, in Santa Fe, NM, and at the Museum of Northern Arizona, Flagstaff.

BIBLIOGRAPHY

R. Hartman: *Navajo Pottery: Traditions & Innovations* (Flagstaff, 1987)

H. D. Wright: "Navajo Pottery, Contemporary Trends in a Traditional Craft," *Amer. Ind. A.*, ii (Spring 1987), pp. 27–35

Pottery by American Indian Women (exh. cat. by S. Peterson, Washington, DC, N. Mus. Women A., 1997)

C. Rosenak and J. Rosenak: *Navajo Folk Art* (Arizona, 2008)

Margaret Moore Booker

Clinton & Russell

Architectural partnership formed in 1894 by Charles William Clinton (*b* New York, ?1838–9; *d* New York, 1 Dec 1910) and William Hamilton Russell (*b* New York, ?1854–6; *d* New York, 23 July 1907). Around

1854 Charles Clinton was apprenticed to Richard Upjohn before forming a partnership with Anthony B. McDonald from 1857 to 1862. Clinton then became associated for about ten years with William A. Potter. Thereafter he practiced alone for two decades before forming a partnership with William Russell in 1894. Russell had graduated from the School of Mines at Columbia College in 1878 and then joined the office of his great uncle, James Renwick, becoming a partner in 1883.

Clinton & Russell designed a number of armories, such as the 71st Regiment Armory, New York (1905; destr.), a brick building crowned by an Italianate medieval tower. They also specialized in large commercial buildings of essentially classical design, notably the 19-story Hudson Terminal (1908) and the Mercantile

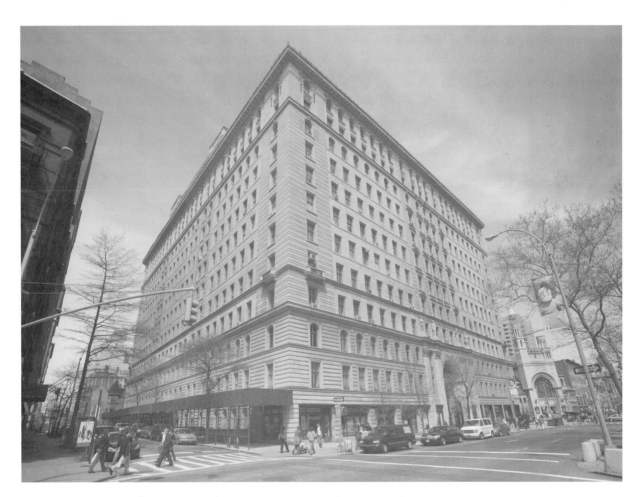

CLINTON & RUSSELL. Apthorp Apartments, New York, 1908. VANNI/ART RESOURCE, NY

Building (1901), both of which were pioneering efforts in the direct linking of lofty commercial developments with rail transportation. The Mercantile Building, for example, was one of the earliest structures to include a subterranean pedestrian link leading directly to the subway. The firm executed more than a score of mid-rise buildings in lower Manhattan, helping to create the financial district's canyon-like streetscape during the era of New York's emergence as a world financial center. Clinton & Russell were also responsible for major Beaux-Arts commissions around upper Manhattan, many of which were sponsored by the real estate magnate William Waldorf Astor. Most notable were the Hotel Astor (1904–9; destr. 1966), a nine-story French Renaissance style building of brick and limestone noted for its marble and gold lobby arcade and large ballroom; the fashionable Graham Court Apartments (1899–1901); the Astor Apartments (1905); and the sprawling Apthorp Building (1908), said to be, of its time, the largest apartment building in the world.

[*See also* Potter, William A.; Renwick, James; *and* Van Alen, William.]

BIBLIOGRAPHY

Macmillan Enc. Archit.

R. Sturgis: "A Review of the Work of Clinton and Russell," *Archit. Rec.*, vii (1897), pp. 1–61

R. A. M. Stern: "With Rhetoric: The New York Apartment House," *Via*, 4 (1980), pp. 78–111

R. A. M. Stern, G. Gilmartin and J. Massengale: *New York, 1900: Metropolitan Architecture and Urbanism, 1890–1915* (New York, 1983)

J. Shockley: "Graham Court Designation Report," *Landmarks Preservation Commission* (New York, 1984)

D. Cosper: "Notes from the Underground: The Vine Vaults," *Interiors*, 159/6 (June 2000), p. 34

M. W. Berger: "The Rich Man's City: Hotels and Mansions of Gilded Age New York," *J. Dec. Prop. A.*, 25 (2005), pp. 46–71

Janet Adams

Clonney, James Goodwyn

(*b* ?Liverpool, 28 Jan 1812; *d* Binghamton, NY, 7 Oct 1867), painter. Clonney was one of the first generation of American genre painters. His earliest datable work includes two lithographs of urban views and images of birds and animals published in New York between 1830 and 1835. He studied at the National Academy of Design, New York, and exhibited there periodically between 1834 and 1852. The first genre painting he exhibited at the National Academy was *Militia Training* (1841; Philadelphia, PA Acad. F.A.), although another example, *In the Woodshed* (1838; Boston, MA, Mus. F.A.), predates it. He also exhibited at the Pennsylvania Academy of Fine Arts (1845 and 1847) and at the Apollo Association and American Art-Union (1841–50).

Clonney worked in watercolors as well as oils and was a prolific draftsman. Stylistically, his genre paintings indicate an awareness of English precedents and of contemporary American genre painters, especially William Sidney Mount. Clonney's scenes of quiet rural life are typical of the period, but his work is notable for its gentle humor and lack of sentimentality.

[*See also* Karolik, Maxim.]

BIBLIOGRAPHY

L. H. Giese: "James Goodwyn Clonney (1812–1867), American Genre Painter," *Amer A. J.*, xi/4 (1979), pp. 4–31

Lucretia H. Giese

Close, Chuck

(*b* Monroe, WA, 5 July 1940), painter and printmaker. He studied (1960–65) at the University of Washington, Seattle, at Yale University and at the Akademie der Bildenden Künste in Vienna. During this period he painted biomorphic abstract works, influenced by the avant-garde American art of the previous two decades. After a brief experiment with figurative constructions, he began copying black-and-white photographs of a female nude in color on to canvas. After abandoning this approach he used a black-and-white palette, which resulted in the 6.7 m long *Big Nude* (1967–8; artist's col., see Lyons and Storr, p. 14). Finding this subject too

"interesting," he turned to neutral, black-and-white head-and-shoulder photographs as models, which he again reproduced in large scale on canvas, as in *Self-portrait* (1968; Minneapolis, MN, Walker A. Cent.). He incorporated every detail of the photograph and allowed himself no interpretative freedom. Working from photographs enabled him to realize the variations in focus due to changing depth of field, something impossible when working from life. He continued in the black-and-white style until 1970, when he began to use color again. With a similarly limited range of model photographs, he experimented with various types of color marking. The pencil and ink *Robert/104,072* (1973–4; New York, MOMA), for example, is made from 104,072 separate color squares. Other techniques included the use of fingerprint marks and pulp paper fragments. This concern with modes of representation links him to conceptual art as well as, more obviously, to Photorealism. For the color paintings such as *Linda* (1975–6; Akron, OH, A. Mus.) he used acrylic, ink and watercolor among other media, and built the works up using only cyan, magenta and yellow, thus imitating mechanical reproduction techniques. Close also made occasional prints, such as the mezzotint *Keith/Mezzotint* (1972; see Lyons and Storr, p. 162). In the 1980s he worked with handmade papers and also produced images pieced together from huge Polaroid photographs, such as *Bertrand II* (1984; artist's col., see Lyons and Storr, pp. 156–7).

In 1988 Close suffered from a spinal blood clot that left him paralyzed. Confined to a wheelchair and with severely limited movement, he continued painting. Using a brush strapped to his hand, he painted small abstract "tiles" that were assembled on a grid to create large-scale portraits such as *Big Self-Portrait* (2001–2; San Francisco, CA, MOMA). His fascination with printmaking continued through the 1990s and 2000s as he employed collaborative processes to create woodblock, reduction block and other large reproductive portrait images, including many self-portraits. Continuing as well his large-scale photographic experimentation, in the later 1990s he created a series of large portrait heads

based on the 19th-century daguerreotype. For illustration, see color pl. 1:XII, 1.

[*See also* Photorealism.]

BIBLIOGRAPHY

Chuck Close (exh. cat. by H. Kern, Munich, Kstraum, 1979)

Close Portraits (exh. cat. by M. Friedman and L. Lyons, Minneapolis, MN, Walker A. Cent., 1980)

L. Lyons and R. Storr: *Chuck Close* (New York, 1987)

R. Storr: *Chuck Close* (New York, 1998)

D. Paparoni, ed.: *Chuck Close: Daguerreotypes* (Milan, 2002)

Chuck Close Prints: Process and Vollaboration (exh. cat. by T. Sultan, Houston, TX, U. Houstonm, Sarah Campbell Blaffer Gal., 2003)

Chuck Close: Self-portraits 1967–2005 (exh. cat., San Francisco, CA, MOMA; Minneapolis, MN, Walker A. Cent.; 2005) (essays by S. Engberg, M. Grystejn and D. R. Nickel)

Chuck Close: Paintings, 1968–2006 (exh. cat. by K. Kertess and R. Storr, Madrid, Mus. N. Cent. A. Reina Sofía, 2007)

Cobb, Henry Ives

(*b* Brookline, MA, 19 Aug 1859; *d* New York, 27 March 1931), architect. Cobb spent one year at the Massachusetts Institute of Technology before enrolling in the Lawrence Scientific School of Harvard University, Cambridge, MA, in 1877. He studied there until 1880 and was awarded a degree in 1881. Cobb worked first for the Boston architectural firm of Peabody & Stearns. Having won the competition of 1881 to design a building for the Union Club in Chicago, Cobb moved to the city in 1882 and began an association with Charles Sumner Frost (1856–1931), who had also worked for Peabody & Stearns. Cobb & Frost's most notable early commission, a castellated Gothic mansion (1882–3; destr. 1950) for Potter Palmer, led to a number of sizeable residential jobs in Chicago. Cobb's popularity rested on his willingness to "work in styles," as Montgomery Schuyler observed. The Shingle style was used in the Presbyterian Church (1886), Lake Forest, IL, while Romanesque Revival was favored for the Dearborn Observatory (1888–9), Northwestern University, Evanston, IL, and the Chicago and Alton Railway Station (1885), Dwight, IL. The two major commercial buildings designed by the partnership are the

Opera House (1884–5; destr.), which incorporated offices to support the theater, and the Owings Buildings (1888; destr.), both in Chicago.

Working independently after his partnership with Frost ended (1888), Cobb became one of Chicago's most successful architects. In 1891 he proposed the initial campus plan for the University of Chicago. Tudor Gothic in their detailing and arranged in quadrangles, the 17 buildings designed by Cobb's firm between 1892 and 1899 represent an early adoption of the collegiate Gothic in American campus design. In 1891 Cobb joined the National Board of Architects in planning the World's Columbian Exposition in Chicago (1893). Of the seven buildings that his office designed for the Exposition, the Fisheries Building received high praise since its design diverged from the classicism and formality of the exposition's principal buildings and used instead Romanesque forms and ornamental details based on marine life.

Cobb had more than 100 office staff in the early 1890s, when he received many of Chicago's most prestigious public and commercial commissions. For the Durand Art Institute (1891), Lake Forest College, Chicago Historical Society (1892) and the Newberry Library (1892), Chicago, he favored rugged masonry forms characteristic of H. H. Richardson's Romanesque Revival style. Tall commercial buildings included the Chicago Title & Trust Company Building (1892; destr.), where he had his offices, and the Chicago Athletic Association Club (1893), with a façade inspired in its color, texture and forms by Venetian Gothic palaces.

By the turn of the century, Cobb had secured a national reputation. He designed the vast Yerkes Observatory (1892–7), Williams Bay, WI, with its Romanesque style detailing, the City Hall (1898), Lancaster, PA, and the Capitol Building (1898) at Harrisburg, PA, and he was the architect of the Chicago Federal Building and Post Office (1897–1905). Cobb practiced in Washington, DC, from 1898 to 1902, moving there apparently for personal and professional reasons, particularly the prospect of becoming the architect for the American University. He proposed an extensive campus plan for the University in 1898, but only the McKinley-Ohio Hall of Government (1902) was executed. Cobb finally settled in New York in 1902 and practiced there until his death. The New York skyscrapers designed by his office include an office building at 42 Broadway (1902–4), the Liberty Tower Building (1909), the Harriman Bank Building (1910) and an apartment house at 666 Park Avenue (1926).

[*See also* Burnham, Daniel H.]

BIBLIOGRAPHY

"Description of Offices of Henry Ives Cobb, Architect," *Inland Archit. & News Rec.*, xxv (May 1895), p. 39

M. Schuyler: "Henry Ives Cobb," *Archit. Rec.*, v (1895), pp. 72–110 [Gt. Amer. Architects Ser., no. 2, pt iii]

"The Chicago Post Office and Its Architect," *Inland Archit. & News Rec.*, xxxi (1898), pp. 25–6

"Henry Ives Cobb, 1859–1931," *Pencil Points*, xii (1931), p. 386

J. Lewis: "Henry Ives Cobb and the Grand Design," *U. Chicago Mag.*, lxix (1977), pp. 6–15

K. Alexis: "Henry Ives Cobb: Forgotten Innovator of the Chicago School," *Athanor*, iv (1985), pp. 43–53

D. Bluestone: *Constructing Chicago* (New Haven and London, 1991)

Kathleen Roy Cummings

Coburn, Alvin Langdon

(*b* Boston, MA, 11 June 1882; *d* Colwyn Bay, 23 Oct 1966), photographer, active also in Britain. Coburn was greatly influenced by his mother, a keen amateur photographer, and began taking photographs at the age of eight. He traveled to England in 1899 with his mother and his cousin, F. Holland Day. Coburn developed substantial contacts in the photography world in New York and London, and in 1900 he took part in the *New School of American Pictorial Photography* exhibition (London, Royal Phot. Soc.), which Day organized. In 1902 he was elected a member of the Photo-Secession, founded by Alfred Stieglitz to raise the standards of pictorial photography. A year later he was elected a member of the Brotherhood of the Linked Ring in Britain.

Some of Coburn's most impressive photographs are portraits. He worked for a year in the studio of the leading New York portrait photographer Gertrude Käsebier and became friendly with George Bernard Shaw, who introduced him to a number of the most celebrated literary, artistic and political figures in Britain, many of whom, including Shaw, he photographed (for example see Gernsheim and Gernsheim, p. 13). Shaw also wrote the preface to the catalogue for the exhibition of Coburn's work at the Royal Photographic Society, London, in 1906, and regarded Coburn and Edward Steichen as "the two greatest photographers in the world." Coburn produced two books of portraits: *Men of Mark* (1913) and *More Men of Mark* (1922). As a photographer of cities and landscapes (1903–10), he concentrated on mood, striving for broad effects and atmosphere in his photographs rather than clear delineation of tones and sharp rendition of detail. He was influenced by the work of Japanese painters, which he referred to as the "style of simplification." He considered simple things to be the most profound. Coburn produced two limited-edition portfolios, *London* (1909) and *New York* (1910), in photogravure form, which he produced on his own printing press. He claimed that in his hands photogravure produced results that could be considered original prints and signed them accordingly. In 1908 he learned from Steichen the refinements of the Autochrome color process in New York, although on his return to London he himself claimed to be an innovator and pioneer of color photography.

Between 1910 and 1911 Coburn spent an extended period in the wilder regions of California, photographing places of great natural beauty, including the Grand Canyon, AZ. Strong design featured in these photographs and in those taken from the top of New York's skyscrapers, such as *House of a Thousand Windows* (1912; see Gernsheim and Gernsheim, p. 109), which was part of the series *New York from Its Pinnacles*, exhibited later at Goupil Galleries, London (1913). He defended his right to manipulate photographic perspective to achieve

ALVIN LANGDON COBURN. *Ezra Pound*, photograph, 1913. PRIVATE COLLECTION. ADOC-PHOTOS/ART RESOURCE, NY

interesting designs, as the Cubists had done in painting. He settled permanently in Britain in 1912 and became involved in Vorticisim from its inception in 1914, although his continued interest in pictorial photography led him in 1915 to form the Pictorial Photographers of America with Gertrude Käsebier, Karl F. Struss and Clarence H. White. In 1916 he made a Vortoscope (a triangle of mirrors attached to the lens), with which he was able to take abstract photographs known as Vortographs, which he exhibited (together with a number of paintings) in London at the Camera Club in 1917. From 1918 he dedicated himself to freemasonry, taking photographs only when on holiday (as in 1947); he spent most of his time at his home in North Wales, where he derived great happiness from his study of freemasonry and spiritual subjects. He became a naturalized British citizen in 1932. A one-man exhibition of his work was held at the Royal Photographic

Society in London in 1957 to celebrate his 50 years of membership, and his works continued to be exhibited long after his death.

[*See also* Day, F. Holland *and* Photography.]

PHOTOGRAPHIC PUBLICATIONS
London, text by H. Belloc (London and New York, 1909)

New York, foreword by H. G. Wells (London and New York, 1910)

Men of Mark (London and New York, 1913)

More Men of Mark (London, 1922)

WRITINGS
H. Gernsheim and A. Gernsheim, eds: *Alvin Langdon Coburn: An Autobiography* (London and New York, 1966; reprint avail. with new intro. by H. Gernsheim and five supplemental plates, New York, 1978)

BIBLIOGRAPHY
Alvin Langdon Coburn: Photographs (exh. cat., preface G. Bernard Shaw; London, Royal Phot. Soc., 1906)

Vortographs and Paintings by Alvin Langdon Coburn (exh. cat. by E. Pound, London, Cam. Club, 1917)

M. F. Harker: *The Linked Ring: The Secession Movement in Photography in Britain, 1892–1910* (London, 1979)

R. F. Bogardus: *Pictures and Texts: Henry James, A. L. Coburn and New Ways of Seeing in Literary Culture* (Ann Arbor, 1984)

Pound's Artists: Ezra Pound and the Visual Arts in London, Paris and Italy (exh. cat. by R. Humphrey's and others, London, Tate Gal., 1985)

M. Weaver: *Alvin Langdon Coburn, Symbolist Photographer (1882–1966): Beyond the Craft* (New York, 1986) [with biblio.]

F. DiFederico: "Alvin Langdon Coburn and the Genesis of Vortographs," *Hist. Phot.*, 11/4 (Oct–Dec 1987), pp. 265–96 [with biblio.],

J. Schriver: "Alvin Langdon Coburn: The Silent Bard," *Hist. Phot.*, 17/3 (Autumn 1993), pp. 299–301

Alvin Langdon Coburn: Photographs 1900–1924 (exh. cat. by N. Newhall and others, ed. K. Steinorth, Rochester, NY, Int. Mus. Phot., 1998)

N. Newhall: *From Adams to Stieglitz: Pioneers of Modern Photography* (New York, 1999)

M. Frizot, intro.: *Alvin Langdon Coburn* (Arles, 2004)

Margaret Harker

Codman, Ogden

(*b* Boston, MA, 19 Jan 1863; *d* Gregy-sur-Yerres, France, 8 June 1951), architect. Codman's name has been associated primarily with that of the novelist Edith Wharton as the co-author of *The Decoration of Houses* published in New York in December 1897. Both as architect and decorator, he is known for his classical interiors adapted from 18th-century models of French, English and American houses, particularly those built on an intimate scale. Born into a distinguished New England family, Codman spent much of his youth in France and returned to Boston to live with his uncle, the architect John Hubbard Sturgis, in 1882. He trained for a year in architecture at the Massachusetts Institute of Technology, Boston, and had several years of practical experience with local architectural firms. An early interest in measured drawing and the study of 18th-century buildings in Boston were important factors in his education.

In 1891 Codman opened an office in Boston, followed by a branch in Newport and a permanent one in New York. During the next 30 years his office specialized in residential commissions, handling approximately 120 projects, 31 of which involved the complete design and remodeling of houses for well-to-do families in the northeast of the USA. These projects included the alteration, interior decoration and landscape design of Edith Wharton's house, Land's End, Newport, RI, in 1893; the decoration (1894–5) of the two upper floors of The Breakers, Newport, RI, for Cornelius Vanderbilt II (1843–99); the interior design (1908) of Kykuit, Pocantico Hills, NY, for John D. Rockefeller; and the building design and interior decoration (1913–15) of 1083 Fifth Avenue (now the National Academy of Design) and 3 East 89th Street, New York, for Archer M. Huntington.

Disillusioned by social changes brought about by World War I, Codman closed his office in 1920 and moved to France. In 1929–31 he created a classical villa for himself, La Leopolda at Villefranche-sur-Mer, on the Mediterranean, restored the 17th-century château of Gregy-sur-Yerres, Brie-Comte-Robert, in 1926 and continued to be an architectural and decorating consultant in Europe to such figures as Cole Porter, Amos Lawrence and Seton Henry.

His last and most extensive commission was for the alteration and decoration of Godmersham Park, Kent, for Mr and Mrs Robert Tritton in 1936.

Codman was also an antiquarian especially interested in architectural history and genealogy. His most enduring architectural legacy is as an interpreter of the traditional style of interior decoration as popularized by the interior decorator Elsie De Wolfe.

[*See also* Roth, Emery.]

BIBLIOGRAPHY

E. Wharton and O. Codman Jr.: *The Decoration of Houses*, rev. and exp. classical American ed. (orig. 1897; New York, 1997)

F. Codman: *The Clever Young Boston Architect* (Augusta, ME, 1970)

P. C. Metcalf: "The Interiors of Ogden Codman, Jr., in Newport," *Antiques*, cviii (1980), pp. 486–97

P. C. Metcalf: "Ogden Codman and The Grange," *Old-Time New England*, xvii (1981), pp. 68–83

P. C. Metcalf: "Restoring Interiors: The Work of Ogden Codman at The Breakers," *House & Gdn* (September, 1984)

Ogden Codman and the Decoration of Houses (exh. cat., ed. P. C. Metcalf; Boston, MA, Athenaeum, 1988)

P. F. Miller: "Newport in the Guilded Age," *Antiques*, 147/4 (Apr 1995), pp. 598–605

N. Gray and P. Herrick: "Decoration in the Gilded Age: The Frederick W. Vanderbilt Mansion, Hyde Park, New York," *Stud. Dec. A.*, 10/1 (Fall 2002–Winter 2003), pp. 98–141

A. Boyd: "The Decoration of Houses: The American Homes of Edith Wharton," *J. Dec. A. Soc.* 30 (2006), pp. 74–91

Pauline C. Metcalf

Coe, Sue

(*b* 1951 Tamworth, Staffs), English illustrator, draftsman, author, activist, painter and mixed media artist, active also in the USA. Her drawings profile the contemporary social and political hypocrisies she made it her life's work to expose. Born in England, Sue Coe spent her formative years in her native country where she trained at London's Chelsea School of Art and the Royal College of Art before moving to New York in 1972. Shortly thereafter, Coe landed a job as an illustrator for *The New York Times* and her works were regular features on the op-ed page. (Throughout her career she illustrated for such publications as *The New Yorker*, *National Lampoon*, *Newsweek*, *Rolling Stone*, and *Time*.) At this time, she also began associating with the Workshop for People's Art, a volunteer artist group who created advertisements and graphic literature for community organizations.

Coe soon realized that her passion for the causes she believed in, and the artistic and ideological issues she wanted to probe, could not be contained on the more conservative editorial pages of mainstream print media. She began producing her own unflinching series of paintings, etchings, and collected illustrations that directly challenged, the injustices she thought deserved more attention than they received in the popular press. Early causes ranged from outrage against racial prejudice, the Ku Klux Klan, and urban violence, to advocacy for women's rights. Over the next two decades, she dedicated herself to creating graphically journalistic protests against apartheid, US foreign policy, labor rights, animal cruelty, war and capitalist greed. Her works were powerfully but uncomfortably charged, and over the course of her career she managed to target an impressive range of hard to swallow social truths.

Coe's style ranged from an almost cartoonish, gray-toned realism to a darker, more haunting one in which she interchangeably employed collage, sketches, text and painting. Parallels with the social realist works of such varied artists as George Bellows, Otto Dix (1891–1969), John Heartfield (1891–1968), George Grosz (1893–1969), Francisco de Goya (1746–1828), Käthe Kollwitz (1867–1945), and José Clemente Orozco (1883–1949) have often been noted. Like theirs, her works are at once raw, gritty, gruesome, honest, unsettling and exaggerated renderings of reality. Her drawings were almost always paired with text (which she occasionally authored herself), and were the result of intense behind the scenes investigations and vociferous research on the subject at hand. Coe's notepad could go where cameras could

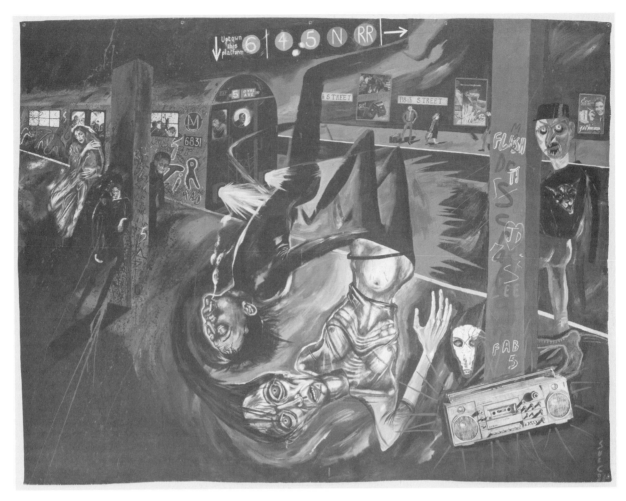

SUE COE. *Breaking*, mixed media on canvas, 2311 × 3073 mm, 1984. © Courtesy of the artist/Gift of Edward R. Broida/The Museum of Modern Art/Licensed by SCALA/ Art Resource, NY

not, and thus her sketches provided an immediate visual translation of her experiences.

Politically prescient and critically important publications include: *How to Commit Suicide in South Africa* (1983), a reaction to the immorality of apartheid, *X* (1986), a tribute to Malcolm X, *Dead Meat* (1995), Coe's multi-year account of the slaughterhouse industry, and *Bully! Master of the Global Merry-Go-Round* (2004), a dark commentary on politics in the era of President George W. Bush. Coe believed that knowledge and education are the keys to bringing about social change, and thus used her talents as an artist to illustrate injustice and, through printed media, share them with a broad public. Though dark, serious, wry, and often grotesque in appearance, her works are created from a place of hope and a belief that art can inspire acts of justice.

WRITINGS

with H. Metz: *How to Commit Suicide in South Africa* (London, 1983)

Dead Meat (New York, 1995)

with J. Brody: *Bully! Master of the Global Merry-Go-Round* (Washington, DC, 2004)

BIBLIOGRAPHY

J. Moore: *X* (New York, 1986)

M. Scala: "The Dictates of Conscience: An Interview with Sue Coe," *New A. Examiner*, xiv (April 1987), pp. 121–3

S. Gill: "Sue Coe's Inferno," *A. News*, lxxxvi (Oct 1987), pp. 110–15

B. Adams: "The Coldest Cut: Sue Coe's Porkopolis, *A. Amer.*, lxxviii (Jan 1990), pp. 126–9

T. Luke: *Shows of Force: Power, Politics, and Ideology in Art Exhibitions* (Durham, 1992)

Porkopolis: Sue Coe's Jungle (exh. cat., ed. J. Barter and A. Mochon; Amherst, MA, Amherst Coll., Mead A. Mus., 1993)

Mary M. Tinti

Cohen, Elaine Lustig

(*b* Jersey City, NJ, 26 March 1927), graphic designer and painter. Cohen received her MFA in art at Tulane University, New Orleans, LA (1945–6) and a BFA from the University of Southern California, Los Angeles (1947–8). Her professional experience with design began when she married the graphic designer Alvin Lustig (1915–55) in 1948 and began working in his office as secretary, production assistant and draftsman. Her duties increased and became more design related as Lustig's health, particularly his sight, deteriorated due to chronic diabetes. Cohen did not begin doing independent work until clients asked her to complete jobs that were still in progress at the time of Lustig's death. Although her early work was influenced by her late husband, she quickly developed her own distinct visual language and style.

Cohen received widespread acclaim for the book covers she designed as art director for Meridian Books, which published reprints and contemporary works in paperback that were intended for a college-age audience. Cohen's cover designs were fresh and appealed to this young market. Although heavily influenced by modernism, her work has a playfulness and humor that is often characterized by a willingness to experiment with composition and materials. For the cover of the journal *The Noble Savage* (Meridian, 1959, issue 4), she used an image of a classical stone statue and added type in the shape of a moustache and a cutout shape like a starburst with a quote from Charles Darwin. For the cover of Yvor Winters's book *On Modern Poets* (1959), she photographed jumbled plastic letters to spell out the title. For Tennessee Williams's *Hard Candy* (Meridian, 1959), she used oversized candies paired with elegant type. These simple changes and placement of text and color gave the designs a light-hearted feel.

While most of her design work was done for Meridian Books and New Directions, she also worked for other companies, including General Motors, the Home Security Life Insurance, the Museum of Modern Art, New York, the Jewish Museum, New York, the American embassies in London and Oslo and Trans-World Airways. One of her largest projects was creating lettering, signs and symbols for the Seagram Building in New York. Her work in architectural type design was particularly valued as she was one of the first designers to work alongside architects such as Philip Johnson and Eero Saarinen to give buildings visually coherent signage and symbol systems that matched their overall design. In 1969 Cohen stopped working professionally in design and began to exhibit her paintings. Both this work and her later collages are widely collected in museums and galleries. In 1973 she established Ex Libris gallery and bookstore with her second husband Arthur A. Cohen, the publisher of Meridian Books. The Manhattan shop specialized in rare books and ephemera of the European avant-garde.

BIBLIOGRAPHY

Elaine Lustig Cohen: Paintings, Wood Constructions, Works on Paper, 1979–1985 (exh. cat. by P. Frank and D. Barthelme, New York, Exit Art, 1985) S. Heller: "Lustig's Legacy", *ID* (Nov 1994)

M. Ogundehin: "The Doyenne of Graphics," *Blueprint*, cxv (March 1995), pp. 40–41

S. Heller: "A Place On The Map," *ID* (May–June 1995), pp. 51–5

E. Lupton: "Elaine Lustig Cohen," *Eye*, xvii (Summer 1995), pp. 151

D. S. Greben: "Elaine Lustig Cohen," *A. News*, xciv (Oct 1995), pp. 151

P. Kirkham, ed.: *Women Designers in the USA 1900–2000: Diversity and Difference* (New Haven, 2000)

Aaris Sherin

Cole, Thomas

(*b* Bolton-le-Moor, Lancs, 1 Feb 1801; *d* Catskill, NY, 11 or 12 Feb 1848), painter and poet of English birth.

Cole was the leading figure in American landscape painting during the first half of the 19th century and had a significant influence on the painters of the Hudson River School, among them Jasper Cropsey, Asher B. Durand and Frederic Church (Cole's only student). In the 1850s these painters revived the moralizing narrative style of landscape in which Cole had worked during the 1830s. From the 1850s the expressive, Romantic landscape manner of Cole was eclipsed by a more direct and objective rendering of nature, yet his position at the beginning of an American landscape tradition remained unchallenged.

Early career, 1801–29. He spent his first 17 years in Lancashire. Industrialized since the 18th century, Lancashire provided a stark contrast to the wilderness Cole encountered when he followed his family to Steubenville, OH, via Philadelphia, in 1820. To a greater extent than his American contemporaries, therefore, Cole sensed the fragility of the American wilderness, threatened by settlement and industry. Coming of age on a frontier, Cole was largely self-taught as an artist. The somewhat mythologized account of his life set forth by his friend, the minister Louis Noble, describes a youthful romantic in spiritual communion with nature, finding his vocation amid "the form and countenance, the colors, qualities and circumstances of visible nature" (Noble, p. 12).

Cole's earliest views of the American wilderness were fresh and direct, reinvigorating the worn conventions of the Picturesque and the Sublime that shaped the work of the nation's first landscape painters, Joshua Shaw, Alvan Fisher and Thomas Doughty. He surpassed the topographical tradition represented by British emigrant artists such as William Guy Wall, William James Bennett (1787–1844), William Birch (1755–1834) and his son Thomas Birch. Cole's landscapes, exhibited for the first time in New York in 1825, brought him to the immediate attention of John Trumbull, the patriarch of American history painting, and Asher B. Durand, who succeeded Cole as the most influential spokesman for landscape as a genre. The patronage of men such as Daniel Wadsworth of Hartford, CT, also helped establish Cole as an artist.

Cole's early landscapes, such as *Landscape with Tree Trunks* (1827–8; Providence, RI Sch. Des., Mus. A.) or *The Clove, Catskills* (1827; New Britain, CT, Mus. Amer. A.), were suffused with the drama of weather and seasonal cycles and of natural flux, conditions through which the artist explored his own changing emotional states. Such concerns are evident not only in his painting, but also in the poetry that he wrote throughout his life. His verse and his diaries provide an essential gloss on his art and reveal in his thinking a strong literary and moralizing component that bound nature and imagination together in a complex and unstable unity.

In the late 1820s Cole turned to biblical themes, producing such paintings as *St John the Baptist Preaching in the Wilderness* (1827; Hartford, CT, Wadsworth Atheneum), the *Garden of Eden* (1828; Fort Worth, TX, Amon Carter Mus.), the *Expulsion of Adam and Eve from the Garden of Eden* (1827–8; Boston, MA, Mus. F.A.) and the *Subsiding of the Waters after the Deluge* (1829; Washington, DC, Smithsonian Amer. A. Mus.). Among the influences on these works were the recently published mezzotints of John Martin. Cole's early mode of landscape painting was frequently associated with Salvator Rosa, with whose landscapes he was probably familiar. His *Scene from "Last of the Mohicans"* (1827; Hartford, CT, Wadsworth Atheneum), of which there are several versions, was based on James Fenimore Cooper's novel and was one of the earliest works of art inspired by American literature.

While Cole prepared the way for the *plein-air* naturalism that overtook American landscape painting of the 1850s, his own working methods were grounded in older attitudes. He frequently made precise outline drawings and studies carrying observations about distance and color from nature and employed these as the sources for his studio compositions, modifying them to produce a synthetic approach to landscape. In certain instances Cole made preparatory oil sketches for such ambitious

later series as *The Voyage of Life*. His palette varied from the dark, brooding effects of his early Romantic landscapes to the more strident colors of certain works of the 1840s.

Later career, 1829–48. Cole spent the years from 1829 to 1832 in England and Italy. During this period he painted the Roman Campagna in a manner suggestive of J. M. W. Turner's influence. In Rome, however, while occupying the studio that, according to tradition, had been that of Claude Lorrain, Cole formulated the idea for his most ambitious series, *The Course of Empire* (1833–6; New York, NY Hist. Soc.). The generous patronage and friendship of Luman Reed, a newly wealthy New York merchant, made such an extended effort possible for Cole, and the cycle of five paintings, exhibited in New York in 1836, did much to broaden his reputation.

A dramatic allegory, *The Course of Empire* traced the history of a great nation from its origins in nature and rise to imperial power through its subsequent conquest by invaders and final decline into oblivion. In constructing his series, Cole drew an analogy between ancient and modern republics that had been explored by such works as Edward Gibbon's *Decline and Fall of the Roman Empire* (1776–88) and later by English Romantic works such as Byron's *Childe Harold's Pilgrimage* (1812–18). The implied analogy with ancient Rome reflected Cole's growing disillusionment with America's cultural arrogance and what he felt was its unwitting re-enactment of previous historical cycles. The series also drew on diverse visual sources; for example, on popular panoramas such as *Pandemonium* by Robert Burford (1792–1861) and perhaps on catastrophic themes in the work of Turner, particularly in *The Fifth Plague of Egypt* (exh. RA, 1800; Indianapolis, IN, Mus. A.; engraved 1808).

Such didactic serial allegories consumed a large part of Cole's energies during the remainder of his career, expressing his frustrations with the limits of pure landscape. In works such as *Oxbow on the Connecticut River* (1836; New York, Met. see color pl. 1:XIII, 3), Cole infused pure landscape with a

dynamic sense of historical change. His increasing awareness of the clash between nature and culture is evident not only in his art, but also in his journals, poetry and correspondence. Such landscape views as *Mt Aetna from Taormina* (1843; Hartford, CT, Wadsworth Atheneum) sounded a characteristic note in Cole's later work: culture's impermanence measured by the standards of natural time. Pendant works such as *The Departure* and *The Return* (both 1837; Washington, DC, Corcoran Gal. A.) and *The Past* and *The Present* (both 1838; Amherst Coll., MA, Mead A. Mus.) express a sense of Romantic belatedness, as well as a fascination with the Middle Ages (an interest that linked Cole to the Gothic Revival movement in America during the 1830s and 1840s). These works also furnished the source for later allegorical or literary landscapes, such as Jasper Cropsey's *Spirit of War* (1853; Washington, DC, N.G.A.). Such "medieval" themes constituted only half of Cole's fascination with the past; equally compelling was the arcadian landscape of the Mediterranean world, evident in such works as *Roman Campagna* (1843; Hartford, CT, Wadsworth Atheneum), *The Dream of Arcadia* (1838; Denver, CO, A. Mus.) and *L'Allegro* (1845; Los Angeles, CA, Co. Mus. A.). In *The Architect's Dream* (1840; Toledo, OH, Mus. A.), commissioned by the architect Ithiel Town, Cole juxtaposed Classical, Gothic and Egyptian styles in a fantastic architectural amalgam recalling the work of the English artist Joseph Michael Gandy.

In 1839, under the patronage of Samuel Ward, a prominent New York banker, Cole undertook another ambitious series, *The Voyage of Life* (1839–40; Utica, NY, Munson–Williams–Proctor Inst.; second version, 1841–2; Washington, DC, N.G.A.). A four-part allegory painted in the period of Cole's conversion to the Episcopal Church, *The Voyage of Life* was a highly accessible series whose Christian theme of resignation appealed to popular sentiments. Engraved by the American Art-Union, it enjoyed a wide national circulation. Cole's tale of youthful imperial visions followed by the sobering setbacks

of maturity placed him once again at a philosophical remove from the aggressive expansionism of his contemporaries.

Following a second trip to Europe in 1841–2, Cole was drawn increasingly to Christian subjects; the most ambitious of these works, *The Cross and the World*, remained unrealized at his death. During these years his landscape style shifted toward more domesticated scenes, evident in such works as the *Old Mill at Sunset* (1844) and *The Picnic* (1846; both New York, Brooklyn Mus. A.). During the mid-1840s he also produced a series of paintings on the theme of the home in the woods, which nostalgically evoked the pioneer's earlier, more direct association with nature. Although he continued to paint occasional works reminiscent of his wilderness views of the 1820s (e.g. *Notch of the White Mountains*, 1839; Washington, DC, N.G.A.; and *Mountain Ford*, 1846; New York, Met.), the pastoralized scenes he executed in the 1840s became the touchstone for American landscape painting over the next decade, as nature came to symbolize communal rather than spiritual and personal values.

Although Cole's work showed no loss of artistic conviction in these years, such stylistic and thematic changes betoken his withdrawal from what he called "the daily strife" of America in the 1840s into a religiously inspired vision of personal salvation. While he looked to art as an antidote to the rampant materialism of Americans, he nonetheless felt discouraged over the social role of artists and the opportunities for patronage available to them in a democratic culture. Cole remained at root culturally disenchanted, in search of a stability that he found only in private withdrawal and religion. Although he occasionally produced works with a broader cultural significance, such as his *Prometheus Bound* (1846–7; priv. col.), which symbolizes the subjugation of hubris by a transcendent power, Cole's later career was dominated by a largely personal symbolism. Yet his friendships in the artistic and literary community were strong, and his sudden death in 1848 left a void in the artistic life of the nation.

[*See also* Hudson River school.]

UNPUBLISHED SOURCES
Albany, NY, New York State Library [Cole papers; also available on microfilm, Archives of American Art]

WRITINGS
M. Tymn, ed.: *Thomas Cole's Poetry* (York, PA, 1972)

M. Tymn, ed.: *The Collected Essays and Prose Sketches of Thomas Cole* (St Paul, MN, 1980)

BIBLIOGRAPHY
L. L. Noble: *The Course of Empire, Voyage of Life and Other Pictures of Thomas Cole, N.A.* (New York, 1853); ed. E. Vesell as *The Life and Works of Thomas Cole* (Cambridge, MA, 1964)

H. Merritt, ed.: "Studies on Thomas Cole: An American Romanticist," *Baltimore Mus. A. Annu.*, ii (1967) [whole issue]

Thomas Cole (exh. cat. by H. Merritt, U. Rochester, NY, Mem. A. G., 1969)

E. Powell: "Thomas Cole and the American Landscape Tradition," *A. Mag. [prev. pubd as Arts [New York]; A. Dig.]*, lii (Feb 1978), pp. 114–23; (March 1978), pp. 110–17; (April 1978), pp. 113–17 [a series of articles with this general title]

A. Wallach: "Thomas Cole and the Aristocracy," *A. Mag.*, lvi/3 (1981), pp. 94–106

"The Brushes He Painted with That Last Day Are There: Jasper F. Cropsey's Letter to His Wife, Describing Thomas Cole's Home and Studio, July 1850," *Amer. A. J.*, xvi (Summer 1984), pp. 78–83

E. C. Parry: *The Art of Thomas Cole: Ambition and Imagination* (Newark, NJ, 1988)

E. A. Powell: *Thomas Cole* (New York, 1990)

Fair Scenes and Glorious Wonders: Thomas Cole in Italy, Switzerland and England (exh. cat., Detroit, MI, Inst. A., 1991)

A. Miller: *The Empire of the Eye: Landscape Representation and American Cultural Politics, 1825–1875* (Ithaca, NY, 1993)

Thomas Cole: Drawn to Nature (exh. cat., ed. C. T. Robinson; Albany, NY, Inst. Hist. & A., 1993)

E. Licata: "Spirit of the Valley: Landscape into History," *Art & Ant.*, xvii (1994), pp. 44–8

M. P. Sharpe: "Thomas Cole: Landscape into History," *Amer. A. Rev.*, vi (1994), pp. 122–9

Thomas Cole: Landscape into History (exh. cat., ed. A. Wallach and W. Truettner; Washington, DC, N. Mus. Amer. A.; Hartford, CT, Wadsworth Atheneum; New York, Brooklyn Mus.; 1994–5); review by W. H. Gerdts in *Apollo*, cxli/398 (1995), pp. 56–7, and by A. L. Miller in *Oxford A. J.*, xviii/2 (1995), pp. 93–6

Thomas Cole's Paintings of Eden (exh. cat. by F. Kelly with C. M. Barry, Fort Worth, TX, Amon Carter Mus., 1994–5)

C. Nadelman: "Thomas Cole: Blending William Wordsworth and James Fenimore Cooper," *ARTNews*, xciv (1995), p. 82

M. Baigell: *Thomas Cole* (New York, 1998)

The Painted Sketch: American Impressions from Nature, 1830–1880 (exh. cat. by E. J. Harvey, Dallas Mus. A., 1998)

Intimate Friends: Thomas Cole, Asher B. Durand, William Cullen Bryant (exh. cat. by E. Foshay and B. Novak, New York, Hist. Soc., 2000)

M. J. Lewis: "American Sublime," *New Criterion*, 21/1 (Sept 2002), pp. 27–33

Along the Juniata: Thomas Cole and the Dissemination of American Landscape Imagery (exh. cat. by N. Siegel, Huntingdon, PA, Juniata Coll. Mus. A., 2003)

Angela L. Miller

Cole, Timothy

(*b* London, 16 April 1852; *d* Poughkeepsie, NY, 17 May 1931), wood engraver of English birth. Walter Sylvanus Timothy Cole was one of the most renowned reproductive wood engravers of his generation. Cole was apprenticed in his early teens to a Chicago firm of commercial wood engravers and spent several years in New York, working for such periodicals as *Scientific American* and the *Illustrated Christian Weekly*. In 1875 he began an association with *Scribner's Illustrated Monthly Magazine* (later the *Century Magazine*), which continued for the greater part of his career. The magazine was a leader in "the golden age of American illustration," and its reputation derived in part from the excellence of its engravings, to which Cole made a decisive contribution. He was in the forefront of the "new school" of wood engraving, which sought to reproduce more faithfully the textures and tonal values of painting and opposed the prevailing doctrines of such conservative engravers as William James Linton (1812–98), who was attempting to retain some artistic license for the engraver.

In recognition of Cole's extraordinary technical skill and his sensitivity to works of art, the *Century Magazine* commissioned from him a series of engravings after masterpieces owned by leading European museums. Cole spent 27 years on the project,

returning to the USA in 1910 to undertake a similar commission in American museums. In addition to appearing regularly in the *Century Magazine*, Cole's engravings were published separately in portfolios and were used to illustrate such books as William James Stillman's *Old Italian Masters* (New York, 1892), J. C. Van Dyke's *Old Dutch and Flemish Masters* (New York, 1895) and Charles H. Caffin's *Old Spanish Masters* (New York, 1902).

WRITINGS
"Some Difficulties of Wood Engraving," *Prt. Colr Q.*, i (1911), pp. 335–43

Considerations on Engraving (New York, 1921)

BIBLIOGRAPHY
R. C. Smith: *The Engraved Work of Timothy Cole* (Washington, DC, 1925)

Timothy Cole Memorial Exhibition (exh. cat., Philadelphia, PA, Prt Club Mus., 1931)

A. P. Cole and M. W. Cole: *Timothy Cole: Wood Engraver* (New York, 1935)

Anne Cannon Palumbo

Cole, Willie

(*b* Somerville, NJ, 1955), sculptor, printmaker and conceptual artist. He grew up in New Jersey and attended the Boston University School of Fine Arts, the School of Visual Arts and the Art Students League of New York City. Cole is best known for assembling and transforming ordinary domestic objects, such as irons, ironing boards, high-heeled shoes, lawn jockeys, hair dryers, bicycle parts, and other discarded appliances and hardware, into imaginative and powerful configurations and installations embedded with references to the African American experience and inspired by West African religion, mythology, and culture. Visual puns and verbal play characterize his works, thereby creating layered meanings. The objects he chooses are often discarded mass-produced American products that have themselves acquired an alternate history through their previous handling and use.

In 1989, he became attracted to the motif of the steam iron both for its form and for its perceived

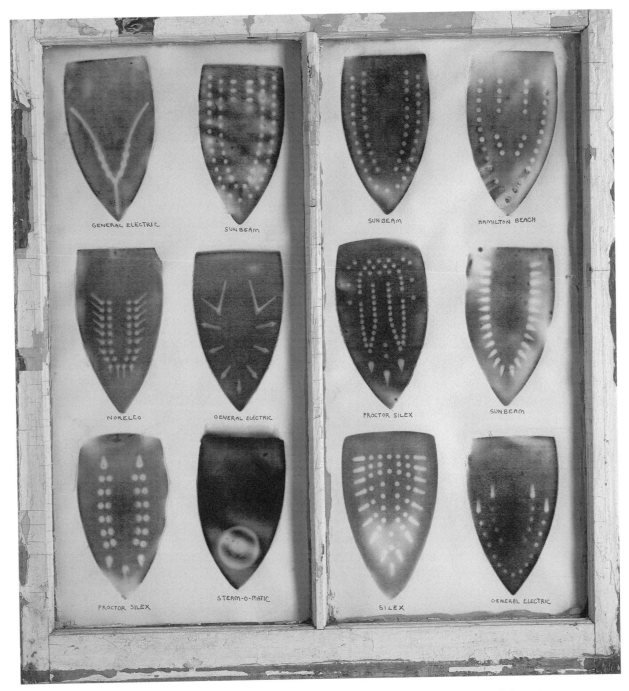

WILLIE COLE. *Domestic I. D. IV*, steam iron scorch and pencil on paper, mounted in recycled wooden window frame, 889 × 813 mm, 1992. Acquired through the generosity of Agnes Gund. © The Museum of Modern Art/ Licensed by SCALA/Art Resource, NY

embodiment of the experience and history of the unknown persons who had previously used it. He referred to the earliest versions of these irons as "Household Gods" and "Domestic Demons." With them, he engaged with ideas utilizing not only the found object but also the repetitive scorch mark of the iron arranged in either purely decorative patterns or in such ways as to suggest a face or African

mask. The shape of the iron itself was not only transformed into human form reminiscent of an African sculpture, but also was manipulated to suggest boats and the Middle Passage, the trade route used by slave ships. Scorched ironing boards can be seen as African warrior shields or are suggestive of patterns that recall Ghanaian Adinkra cloth. The symbolism of the steam iron and its scorch mark extend from the domestic role of black women to the Yoruba god of iron and war, Ogun. Moreover, the scorch mark is suggestive of the branding of slaves and the intertwined histories of slavery and plantation culture.

Through his creative configurations, Cole draws on his personal experience and on collective cultural histories. His works constitute a playful and inquisitive approach to synthesizing the physical and spiritual worlds. His appropriated, reassembled, and resituated objects explore issues of identity, race, consumerism and the environment. They also suggest a postmodern eclecticism in their strategies of combining and seizing African forms. Through the process of assemblage, Cole gives these objects a new and vibrant meaning, evoking associations ranging from domestic labor to religious ritual. They also reference and critique both consumer culture and the Western appropriation of African forms. In many of his works, Cole chooses single objects and repeats them in multiples. As assembled pieces they acquire a transcendent quality and a renewed metaphorical signification through their transformation.

Willie Cole is the recipient of many awards, and his sculptures can be found in various public and private museum collections in America.

BIBLIOGRAPHY

M. Harris: *Colored Pictures: Race and Visual Representation* (Chapel Hill, NC, 2003)

Afterburn: Willie Cole—Selected Works 1997–2004 (exh. cat., Laramie, U. WY A. Mus. and elsewhere, 2004)

Anxious Objects: Willie Cole's Favorite Brands (exh. cat. by P. Sims; Montclair, NJ, A. Mus., 2006)

James Smalls

Colescott, Robert

(*b* Oakland, CA, 26 Aug 1925; *d* Tucson, AZ, 4 June 2009), painter, printmaker and teacher. Colescott produced highly expressive and gestural paintings that addressed a wide range of social and cultural themes and challenged stereotypes. Interested in issues of race, gender and power, his work critiqued the representation of minorities in literature, history, art and popular culture. Stylistically, his work is indebted to European modernism, particularly Cubism and Expressionism, but also makes references to African sculpture, African American art and post–World War II American styles.

Colescott was introduced to art at an early age. His mother was a pianist and his father was a classically trained violinist and jazz musician. Through his parents' social circles, he often found himself surrounded by creative individuals as he was growing up, like his artistic mentor, the sculptor Sargent Johnson (1888–1967). Colescott received his BA in 1949 and later his MFA in 1952 from the University of California, Berkeley. He also studied with Fernand Léger (1881–1955) in Paris from 1949 to 1950. Although Colescott's training focused on European abstraction, he was inspired by Léger's emphasis on the human figure. After his return to Berkeley in 1950, Colescott's new interest in representation was supported by other Bay Area artists who depicted figurative subjects with expressive gestures, even though the Abstract Expressionists in New York were moving toward non-objective art.

Colescott moved to the Pacific Northwest in 1951, teaching art in public schools in Seattle and later at Portland State University. His first solo exhibition occurred in 1963 at Fountain Gallery in Portland. A year later, he traveled to Cairo, Egypt—serving first as a fellow at the American Research Center (1964–5) and then as a professor at American University (1966–7). He absorbed the graphic quality, monumentality and color of the ancient art he encountered, but his stay in Egypt also influenced his subject matter and caused him to reflect on race in America. Due to the outbreak of the Arab–Israeli War, Colescott left

Egypt in 1967 and moved to Paris for three years. During this period, he witnessed the social unrest of the Civil Rights Movement in America, but from afar. Upon his return to the USA, he embarked on a critique of contemporary American culture through the use of irony and satire, which became the defining characteristic of his mature work.

Colescott's appropriation of images predated the emergence of multiculturalism, Post-modernism and Neo-Expressionist painting of the 1980s. Due to the controversial and sensitive issues that Colescott addressed, his paintings were not always initially well-received. It was not until revisionist strategies became dominant in the 1980s that Colescott's work earned critical acclaim. Colescott was particularly focused on rewriting African American history by inserting black figures into narrative scenes, often using images from the history of Western art as his starting point. In his reinterpretations, he exaggerated and distorted racial types to expose the denigrated position of non-whites in Western art and imagined an alternate history of art. For example, in *George Washington Carver Crossing the Delaware: Page from an American History Textbook* (1975; priv. col.), Colescott quoted Emmanuel Leutze's painting (1851; New York, Met.), but restaged the historical event with the scientist Carver at the helm, accompanied by historical black stereotypes, such as cooks, mammies and banjo players. Colescott's similarly altered art history paintings include Jan van Eyck's *Giovanni Arnolfini and his Wife* (1434; London, N.G.), Edouard Manet's *Dejeuner sur l'herbe* (1863; Paris, Mus. Orsay) and Willem de Kooning's *Woman I* (1950–2; New York, MOMA).

In the mid-1980s, Colescott continued to utilize a figurative–narrative style infused with humor, but his paintings became more gestural. Additionally, the content of his work moved toward universal concepts of beauty and power, and allegorical subjects based on religion, mythology and literature. Colescott's paintings from the late 1980s and 1990s turned toward the moral and ethical issues surrounding artistic production with particular attention to race, gender and power. In 1997, Colescott was selected to represent the USA at the 47th Venice Biennale, making him the first African American artist to have a solo exhibition at the Biennale and also the first painter since Jasper Johns in 1988. He was an Emeritus Professor of Art at the University of Arizona, where he taught from 1983 to 1995. For illustration, see color pl. 1:XII, 3.

WRITINGS

"Cultivating a Subversive Palette," *Reimaging America: The Art of Social Change*, ed. M. O'Brien and C. Little (Philadelphia, 1990)

BIBLIOGRAPHY

Robert Colescott: The Artist and the Model (exh. cat. by G. Silk, Philadelphia, U. PA, ICA, 1984)

Robert Colescott: Another Judgment (exh. cat. by K. Baker and A. Shengold, Charlotte, NC, Spirit Square Arts Center, Knight Gallery, 1985)

Robert Colescott: A Retrospective 1975–1986 (exh. cat. by L. S. Sims and M. D. Kahan, San Jose, CA, Mus. A., 1987)

The Eye of the Beholder: Recent Work by Robert Colescott (exh. cat. by S. Arnold, Richmond, VA, U. Richmond, Marsh Gallery, 1988)

K. Johnson: "Colescott on Black & White," *A. America*, lxxvii (June 1989), pp. 148–53, 197

F. Hirsch: "L'Ecole de Paris is Burning: Robert Colescott's Ironic Variations," *A. Mag.*, lxvi (Sept 1991), pp. 52–7

Robert Colescott: The One-Two Punch (exh. cat. by R. Knight, Scottsdale, AZ, Cent. A., 1995)

S. Euaclaire: "One-Two Punchinello," *ARTnews*, xcvi (June 1997), pp. 104–7

Robert Colescott: Recent Paintings (exh. cat. by M. Roberts, Sante Fe, NM, SITE, 1997)

J. Cutler: *The Paintings of Robert Colescott: Race Matters, Art and Audience* (PhD thesis, Stony Brook, SUNY, 2001)

S. M. Atkins: *Art Appropriation and Identity Since 1980* (PhD thesis, New Brunswick, NJ, Rutgers U., 2004)

M. Lobel: "Black into Front: Robert Colescott," *Artforum*, xliii/2 (Oct 2004), pp. 266–9, 306, 310

Sharon Matt Atkins

Collaborative Projects (Colab)

Avant-garde, mix-gendered artist group formed in New York City in 1977. Colab engaged in open arts and political dialogue across disciplines, collaborated on new media community projects and changed the

way artists could apply for and receive state and federal funding. While driven by the potential for cutting-edge collaborations, the initial motives behind Colab's formation were financial. In an era when state and national arts grants were distributed according to the discretion of arts administrators and existing alternative spaces, rather than directly to the artists, a group of like minded visual artists, filmmakers, writers and musicians pooled their talents to beat the system. Declaring themselves a collective (Colab became an official non-profit organization in 1978), Colab crafted creative applications to such funding bodies as the National Endowment for the Arts and democratically divided up the grant monies they received. Over the course of a decade, membership grew and changed with more than 40 artists having participated in critically noteworthy, overlapping collaborations in spaces of their own choosing throughout the city. The fellowship included such artists as John Ahearn (b 1951), Diego Cortez (b 1946), Colen Fitzgibbon (b 1950), Bobby G, Jenny Holzer, Tom Otterness, Kiki Smith, Tom Warren (b 1954) and Robin Winters (b 1950).

Colab created challenging exhibitions in a variety of unusual locations. *The Real Estate Show* dealt with issues of New York tenants' rights in an illegal Colab-retrofitted abandoned storefront on Delancey Street, while *The Times Square Show* was a collaboration with the Bronx-based Fashion Moda group and took place in a seedy former 7th-Avenue massage parlor–sex shop, filling the two-story space with graffiti art, posters, advertisements, videos, installations, break dance, and rap performances—all in keeping with the Times Square theme. In addition to these well-known rogue exhibitions, and their open-invitation studio exhibitions, the fellowship also made serious contributions in the field of new media.

Colab's members believed in well-rounded experimentation and expanded their artistic exploration to include film and video editing, TV production and cable broadcasts, performance art and all of the above combined. They also believed in cross-disciplinary collaboration and thus any given artist could be part of any number of projects at the same time. Their foray into film led them to open their own movie house, the New Cinema, on St Mark's Place where they featured punk and new wave Super-8 films by Tina Lhotsky, James Nares (b 1953), Eric Mitchell and Michael McClard, to name a few. *All Color News* (Colab's cable television show) was a one-hour community news and activist report that ran for 12 weeks in 1977 and documented important stories and local events that were not a part of mainstream media programs. The show was an outgrowth of their short-lived publication, *X Motion Picture Magazine*, both of which were created to explore how new media and emerging communications systems could be used to reach broader audiences and suggest that the pressing needs of any given New York community were not unique to this one place, but part of larger societal problems. Theirs was an activist collective that did not focus mainly on critiques of the art world or its institutions, but rather on the merits of collaboration, independent, renegade artist spaces, and the use of new media to activate, involve and inform the public.

[*See also* Holzer, Jenny; Otterness, Tom; *and* Smith, Kiki.]

BIBLIOGRAPHY

S. Webster: *A Report: Alternative Spaces and the Crises Threatening Their Survival* (New York, 1982)

J. Ault, ed.: *Alternative Art, New York, 1956–1985: A Cultural Politics Book for the Social Text Collective* (Minneapolis and New York, 2002)

D. Little: "Colab Takes a Piece, History Takes It Back: Collectivity and New YorkAlternative Spaces," *A. J.*, lxvi (Spring 2007), pp. 60–74

Mary M. Tinti

Collage

Composition consisting of relatively flat materials, usually paper and cloth, glued onto a surface (Fr. *coller*: "to glue"). Another approach to collage is *décollage*, in which layers are built up, then one or more layers are torn away or cut through to reveal

the layer(s) beneath. When only photographs are used, the technique is photocollage, with images glued to a support; in photomontage, they are combined via a photographic or digital process. Assemblage is related to the collage process, but the various elements are mostly three-dimensional. Many contemporary artists stretch the boundaries of collage, incorporating quasi-flat materials such as melted plastic bottles and metal into their compositions.

As a form of modern art, collage began in the early 20th century when European artists Pablo Picasso (1881–1973) and Georges Braque (1882–1963), transferring the idiom of Cubist painting into mixed media compositions, glued paper fragments to drawings and paintings. By applying scraps of newspaper and other ephemera, the artists weakened the boundary between art and life, a recurring theme in modern culture. European Dada artists such as Max Ernst, Hannah Höch (1889–1978), and Kurt Schwitters (1887–1948) also manipulated text and image via collage, including photocollage. Much of their work was vehemently political. American collage art in the 21st century is political, conceptual, satirical and thriving.

One of the early collage exhibitions in the USA was a Kurt Schwitters's solo show in 1948 at the Rose Fried Gallery in New York. After viewing the exhibition, Anne Ryan (1889–1954) became fascinated with the process and created hundreds of pieces. The 1953 Dada exhibition curated by Marcel Duchamp at the Sidney Janis Gallery presented a plethora of collage art to New York artists, and Duchamp designed parts of the installation in collage style. Collage also entered the American art scene via Pop art. Some of the earliest exhibitions in New York were at the Judson Gallery in the mid-1960s. Marc Ratliff and Tom Wesselmann exhibited small-format collages there. The collage aesthetic of fragmentation influenced many painters and printmakers, such as Jim Dine, Alex Katz, Robert Rauschenberg, Larry Rivers, and James Rosenquist, whose shifts in scale are like those in collage art. Some of Rivers's installations were monumental, with collage only a part of his rambling mixed-media surfaces. Robert Motherwell was working with collage

early in his career, having first experimented with the technique in Jackson Pollock's studio. In California, San Francisco artist Jess pioneered collage during the mid-1950s, combining photographs, images from magazines, and watercolor. He approached collage ("paste-ups") as a game of visual puns, often with homosexual erotic overtones.

During the 1980s, David Hockney in southern California experimented with photocollage, creating some dizzying visual effects in both portraiture and landscape, in what he called "joiners." Although artists working in photocollage often cut the prints into sections or silhouettes, Hockney overlapped the rectangular photographs without cutting them, maintaining the integrity of each image. Tony Berlant (*b* 1941) ranks among the top collage artists of the late 20th century, working with pieces of metal fastened to plywood with metal studs or nails in a Neo-Expressionist mode. Conceptual artist Amanda Ross-Ho (*b* 1975) has produced works in a different vein, suggesting implied relationships, or the impossibility of relationships, in works such as *Untitled Proximity Collages* (2007).

African American artists Romare Bearden and Reggie Gammon (1921–2005), both members of the 1960s Spiral group, used collage in much of their work. While Bearden's vocabulary in the mid-1960s resembled that of Pop artists, it was used to different purposes. His concerns were different from the artistic mainstream of his time, in particular in his embrace of narrative during a period when abstraction was in the ascendant. Turning away from Abstract Expressionism, Bearden created jaggedly representational imagery depicting life in Harlem, with shifts in scale and points of view creating visual rhythms like those in jazz. Gammon began experimenting with collage in the 1970s, working with dental floss to introduce "scarification" patterning over two painted figures in a large painting. Kara Walker, among others, has continued the collage tradition in African American art, for example in *Negress Notes* (1995).

Feminist artists of the 1960s and 1970s found collage to be a powerful vehicle for their political

COLLAGE. *Robert Rauschenberg Self-portrait*, photographs on board, 254 × 203 mm, 1976. © ESTATE OF ROBERT RAUSCHENBERG/ LICENSED BY VAGA, NY/NATIONAL PORTRAIT GALLERY, SMITHSONIAN INSTITUTION/ART RESOURCE

agendas, the most notorious example being Mary Beth Edelson's interpretation of Leonardo da Vinci's *Last Supper*. Martha Rosler's work has incorporated collage with devastating effects, and Miriam Schapiro coined a new term, femmage, for her paintings layered with fragments of fabric. As a founding member of the Pattern and Decoration movement, Schapiro has celebrated domestic decoration and women's work for nearly four decades. Instead of paper, she has layered her paintings with handkerchiefs, aprons, doilies, and motifs cut from floral fabric. Collage bore the personal messages of another female artist, weaver Lenore Tawney, who began mailing collaged postcards to friends in the 1960s and continued to do so for many years.

In canvas collage, patches of cut-up painted canvas are applied to another painting. During the 1960s, Jane Frank (1918–86) and Lee Krasner both used this technique, Krasner often cutting up her own paintings to reassemble them. She also glued fragments of her husband Jackson Pollock's drip paintings onto her work. The collage aesthetic extends to contemporary quilt art, in which the fragments and layers are usually stitched instead of glued.

Many collage artists work with found objects and images, a tradition that continues today in digital collage (technically photomontage). Artists sift through the internet, culling disparate imagery, sometimes randomly, to create fragmented sites and interactive experiences. This process harkens back to the Surrealists, whose exercises such as the "Exquisite Corpse" (a work consisting of words or images contributed from various sources) functioned arbitrarily. The collage aesthetic seems especially appropriate for the sound bytes of contemporary culture.

[*See also* Bearden, Romare; Duchamp, Marcel; Edelson, Mary Beth; Ernst, Max; Femmage; Hockney, David; Jess (Collins, Burgess); Krasner, Lee; Motherwell, Robert; Photomontage; Rosler, Martha; Schapiro, Miriam; Tawney, Lenore; Walker, Kara; *and* Wesselmann, Tom.]

BIBLIOGRAPHY

A. G. Dove and D. R. Johnson: *Arthur Dove: The Years of Collage* (College Park, MD, 1967)

Tom Wesselmann: The Early Years: Collages, 1959–1962 (exh. cat., Long Beach, CA State U., and elsewhere, 1974)

R. Motherwell: *Robert Motherwell: Paintings and Collages from 1941 to the Present* (London, 1978)

M. Schwartzman: *Romare Bearden: His Life & Art* (New York, 1990)

D. Waldman: *Collage, Assemblage, and the Found Object* (New York, 1992)

M. Auping, R. J. Bertholf and M. Palmer: *Jess, a Grand Collage, 1951–1993* (Buffalo, NY, 1993)

L. Tawney and H. Cotter: *Lenore Tawney: Signs on the Wind— Postcard Collages* (San Francisco, 2002)

B. Taylor: *Collage: The Making of Modern Art* (New York, 2004)

D. Cohen: *Alex Katz: Collages [1954–1960]* (Waterville, ME, 2005)

G. E. Jefferson: "Bridging Generations: Reminiscing with Reggie [Gammon]," *Int. Rev. Afr. Amer. A.*, xx/3 (2005), pp. 38–45

R. Bearden: "Rectangular Structure in my Montage Paintings," *Leonardo*, xl/3 (2007), pp. 291–300

R. Flood, M. Gioni and L. J. Hoptman: *Collage: The Unmonumental Picture* (London and New York, 2007)

Sandra Sider

Collecting and dealing

Apart from isolated collections of prints, drawings and copies, such as that of John Smibert, in Colonial times the furnishings of the houses of the wealthy constituted the only significant artistic collections. The only paintings commonly owned were family portraits, which functioned as likenesses rather than works of art. Even after the Revolution, a concern for the sciences was at first more apparent than any interest in the fine arts, and collections of art were extremely rare, despite the efforts of such artists as Charles Willson Peale and Rembrandt Peale. It was not until the early 19th century that there were the first signs of collecting activity by such figures as James Bowdoin III, who acquired much of Smibert's collection. Collections formed at this time generally included either Dutch and Flemish art and/or works by contemporary local artists, a pattern similar to that in England in the same period. Because opportunities to buy European work in the USA were generally restricted to rather questionable auction sales, such art was generally acquired in Europe by the collectors concerned, or by artists acting as agents, while American art was acquired directly from the artists responsible.

Despite the occasional notable collection, such as those of grocer Luman Reed and Thomas Jefferson Bryan (1802–70) in New York, the ownership of art works was still regarded as eccentric in the mid-19th century. A landmark in efforts to counter this prejudice, particularly with regard to local artists, was the American Art-Union (1844–51), based in New York. This organization, by holding regular exhibitions of works by American artists and distributing over 150,000 engravings and paintings to its members by means of a lottery, introduced original art into many districts and made ownership of art works more widespread. Other organizations such as the Dusseldorf Art Union attempted to stimulate interest in foreign artists in a similar manner. Art collecting in the USA continued, however, to be circumscribed by the dearth of outlets where potential collectors could obtain works until after the 1850s, when a number of knowledgeable dealers, the most notable of whom were connected with galleries in Paris (e.g. Michael Knoedler), began to appear in New York and a few other East Coast cities. The success of John Rogers in selling plaster copies of his statuette groups by mail order is indicative of the expanding market in the second half of the 19th century, but it was not until just after the Civil War that there was significant collecting and dealing in the USA, partly stimulated by the emergence of a new class of wealthy industrialists.

In the third quarter of the 19th century the standard of American collecting underwent a qualitative change as the first American collections to contain works of real art-historical significance began to appear. The new collectors of the time did not share their predecessors' reservations about buying art; instead they wished to advertise their wealth and status by living in opulent surroundings, accompanied by large, dramatic works of art. The works they collected were also very different from those previously sought after, as the dubious Old Masters (mainly of the Italian and northern European Renaissance) or contemporary American works of earlier collections were replaced by contemporary French painting, particularly by such established French Salon favorites as Rosa Bonheur (1822–99), William Bouguereau (1825–1905), whose work was promoted by Samuel P. Avery, or, from the 1870s, the Barbizon painters, whose work was introduced to the New York public largely by Michael Knoedler. This shift was stimulated partly by a number of European-minded American artists who acted as advisers to collectors, and despite the introduction in 1883 of a heavy import duty on works of art, contemporary American art declined in relative

popularity with collectors in the late 19th century. (Duty on works more than 20 years old was only repealed in 1909; in 1913 works less than 20 years old were exempted.) It was not until 1892 that the first gallery specializing in American art opened in New York.

In the mid-1880s Impressionism was introduced to the USA by such dealers as Paul Durand-Ruel and, with the added encouragement of Mary Cassatt, a number of collectors such as Bertha Honoré Palmer and Henry and Louisine Havemeyer acquired notable groups of Impressionist paintings. However, although these collectors acquired substantial amounts of contemporary art, their collections still also included art of the past. By the 1890s the taste of such tycoons as Andrew W. Mellon, J. Pierpont Morgan and Samuel H. Kress, on the other hand, had become synonymous with accredited Old Masters and 18th-century works. Typically these collections were large and historical, including works from the early Renaissance to the 18th century; some were almost encyclopedic, or even acquired in bulk. The USA's new economic and cultural strength was the stimulus behind such collections, which were characterized by an enthusiasm for the most prestigious works and by the remarkably high prices paid for their masterpieces. Another important element was the intention of collectors such as Isabella Stewart Gardner, William T. Walters and others to leave their collections to the public as memorials to their achievements. The shift in emphasis from contemporary to past art was made possible by improvements in art scholarship and the appearance of the first expert advisers. A number of prestigious European dealers, including Joseph Duveen (1869–1939) and Nathan Wildenstein (1851–1934), established themselves in New York and played a crucial part in building these collections. The era of such collections lasted until the late 1920s, when it was curtailed by the Stock Market Crash and the subsequent Depression.

On the whole, American collectors ignored subsequent developments in European art such as Post-Impressionism. Before World War I the only American collectors who showed any enthusiasm for modern art from Post-Impressionism onward were distinguished by their strong ties to Europe, such as the Stein family and the Cone sisters, who bought works from European dealers or from the artists themselves. In the early 20th century the Madison Gallery and the 291 gallery of Alfred Stieglitz were among the first few galleries handling modern European art and contemporary American artists in New York. It was the Armory Show of 1913, which introduced the American public to European avant-garde art, that was most effective in stimulating American collectors in this direction. Among the collectors who built significant holdings of the most radical and recent European and American art in the years immediately after were Walter Arensberg, A. E. Gallatin (who subsequently exhibited his collection as the Gallery of Living Art), John Quinn, Albert C. Barnes and Katherine S. Dreier. American taste during the 1920s continued to be dominated by the Old Masters, however, and although there was more interest in modern art, the number of those buying it remained tiny, as did the number of galleries exhibiting such work. American art also had few notable buyers at this time, except such dedicated patrons as Gertrude Vanderbilt Whitney. Largely as a consequence of the increasing activity of museums, however, this situation began to change from the mid-1930s.

After World War II there was an unparalleled increase in the number, variety and quality of American collections. Whereas before the war American collectors of any note could be counted in tens, by the 1960s it was possible to talk of hundreds. Moreover, collecting and dealing became truly nationwide for the first time. The nature of these collectors also underwent a change: whereas in the past collectors had traditionally been of the wealthy social élite, increasingly they were much younger, newly wealthy, well-educated professionals. The range of such collections also diversified considerably, but two notable trends were the increasing scarcity of large, eclectic, historical collections (Norton Simon being a notable exception) and a greater

willingness to acquire works representing new developments in art. For the first time very large collections of modern art appeared, such as those of Joseph H. Hirshhorn and Nelson Aldrich Rockefeller, and shifts were influenced by a number of factors, the most significant of which was the heightened critical standing of American art in the postwar era. While such galleries as Peggy Guggenheim's Art of This Century and the Sidney Janis Gallery initially promoted European artists who had fled from the war, they and such other dealers as Betty Parsons were also important in promoting Abstract Expressionism. The acclaim with which such artists as Jackson Pollock were greeted in turn helped establish New York in particular as a center of the art market, a trend that continued in the 1960s with the commercial success of many Pop artists and the establishment of such galleries as that of Leo Castelli. Whereas in the early 1940s there were *c.* 70 galleries of all types in New York, 20 years later this number had nearly quadrupled, and by the mid-1970s it had doubled again. Another significant factor was the American taxation system, which encouraged private collectors to give their holdings to museums; this institutional drift in turn created increasing shortages of certain kinds of works, such as major Old Masters or Impressionist paintings, and forced collectors into new fields. A further important development was the growth of corporate art collecting, which in the 1940s was still quite rare, but which became increasingly common from the early 1960s, with corporations such as the Chase Manhattan Bank building up extensive collections of contemporary art. The economic recession of the mid-1970s brought to an end this great era of expansion, and with some artists experimenting with new media and skeptical of the gallery system, collecting and dealing became less prominent.

[*See also* Arensberg; Avery, Samuel P.; Barnes, Albert C.; Bowdoin, James, III; Castelli, Leo; Cone; Dreier, Katherine S.; Gallatin, A. E.; Gardner, Isabella Stewart; Guggenheim, Peggy; Havemeyer, Louisine; Hirshhorn, Joseph H.; Janis, Sidney; Kress, Samuel H.; Morgan, J. Pierpont; Palmer, Bertha Honoré; Parsons, Betty; Quinn, John; Reed, Luman; Rockefeller, Nelson Aldrich; Simon, Norton; Stieglitz, Alfred; Walters, William T.; *and* Whitney, Gertrude Vanderbilt]

BIBLIOGRAPHY

R. Brimo: *L'Evolution du goût aux Etats-Unis* (diss., Paris, Inst. A. & Archéol., 1938)

A. B. Saarinen: *The Proud Possessors* (London, 1959)

W. G. Constable: *Art Collecting in the United States* (London, 1964)

J. Lipman, ed.: *The Collector in America* (New York, 1970)

W. Towner: *The Elegant Auctioneers* (New York, 1970)

F. V. O'Connor: "Notes on Patronage: The 1960s," *Artforum*, xi/1 (1971) M. N. Carter: "The Magnificent Obsession: Art Collecting in the '70s," *ARTnews*, lxxv/5 (1976), pp. 39–45

Art Inc.: *American Paintings from Corporate Collections* (exh. cat. by M. D. Kahan, Montgomery, AL, Mus. F.A., 1979)

L. Skalet: *The Market for American Painting in New York, 1870–1915* (diss., Baltimore, MD, Johns Hopkins U., 1980)

S. N. Platt: *Responses to Modern Art in New York in the 1920s* (Ann Arbor, 1981)

L. de Coppet and A. Jones, eds: *The Art Dealers: The Powers behind the Scene Talk about the Business of Art* (New York, 1984)

A. D. Robson: *The Market for Modern Art in New York in the 1940s and 1950s* (diss., U. London, 1988)

T. A. Carbone: "At Home with Art: Paintings in American Interiors, 1789–1920," *Amer. A. Rev.*, vii/6 (1995–6), pp. 86–93

S. Guilbaut: *How New York Stole the Idea of Modern Art: Abstract Expressionism, Freedom, and the Cold War*, trans. A. Goldhammer (Chicago and London, 1983)

T. Crow: "Modernism and Mass Culture in the Visual Arts," *Pollock and After: The Critical Debates*, ed. F. Frascina (New York, 1985), pp. 233–66

C. Greenberg: "Avant-Garde and Kitsch [1939]," and "Towards a Newer Laocoon [1940]," *Clement Greenberg: The Collected Essays and Criticism: Vol. 1 Perceptions and Judgments 1939–1944* (Chicago, 1986), pp. 5–36

G. Debord: *The Society of the Spectacle*, trans. D. Nicholson-Smith (New York, 1995)

T. J. Clark: "In Defense of Abstract Expressionism," *Farewell to an Idea: Episodes from a History of Modernism* (New Haven and London, 1999), pp. 370–403

J. Baudrillard: *The Conspiracy of Art*, trans. A. Hodges (New York, 2005)

Collins, Jess

See Jess (Collins, Burgess).

Colman, Samuel

(*b* Portland, ME, 4 March 1832; *d* New York, 26 March 1920), painter, interior designer and writer. Colman grew up in New York, where his father, Samuel Colman, ran a successful publishing business. The family bookstore on Broadway, a popular meeting place for artists, offered Colman early introductions to such Hudson River School painters as Asher B. Durand, with whom he is said to have studied briefly around 1850. Having won early recognition for his paintings of popular Hudson River School locations, he was elected an Associate of the National Academy of Design in New York in 1854. Most of Colman's landscapes of the 1850s, for example *Meadows and Wildflowers at Conway* (1856; Poughkeepsie, NY, Vassar Coll., Frances Lehman Loeb A. Cent.), reveal the influence of the Hudson River School. An avid traveler, he embarked on his first European tour in 1860, visiting France, Italy, Switzerland and the more exotic locales of southern Spain and Morocco. His reputation was secured in the 1860s by his numerous paintings of romantic Spanish sites, notably the large *Hill of the Alhambra, Granada* (1.2×1.8 m, 1865; New York, Met.)

In 1862 Colman was elected a full member of the Academy. Four years later he was a founder-member of the American Society of Painters in Water Colors, serving as its first President until 1870. He journeyed to California in 1870 and a year later began another extensive European tour, this time to Egypt, Algeria, Morocco, Italy (recorded in the watercolor sketch *On the Tiber, Rome*, 1874; priv. col.) France, the Netherlands and England. He was a founder-member of the Society of American Artists, established in 1877 as an alternative to the increasingly conservative National Academy of Design. A passionate collector of oriental art and artifacts, Colman expressed his strong interest in the decorative arts through his involvement with the firm of Louis C. Tiffany & Associated Artists, which the two founded with Lockwood de Forest and Candace Wheeler in 1879; they collaborated on interior design projects, including the redecoration of the White House, Washington, DC, in 1882. From the mid-1880s Colman made regular sketching trips through the American and Canadian West, producing such vivid and atmospheric watercolors as *Yosemite Valley, California* (c. 1888) and *Banff, Canada* (1892; both New York, Kennedy Gals). In the early 1900s he curtailed most of his artistic activities, preferring to devote attention to writing his esoteric theories of art. For illustration, see color pl. 1:XVI, 3.

[*See also* Hudson River School *and* Tiffany, Louis Comfort.]

WRITINGS
Nature's Harmonic Unity (New York and London, 1912)
Proportional Form (New York and London, 1920)

BIBLIOGRAPHY
"American Painters: Samuel Colman, N.A.," *Appleton's J.* [New York], ii (1876), pp. 264–6
G. W. Sheldon: *American Painters: With Eighty-three Examples of their Work Engraved on Wood* (New York, 1876), pp. 71–6
W. Faude: "Associated Artists and the American Renaissance in the Decorative Arts," *Winterthur Port.*, x (1975), pp. 101–30
W. Craven: "Samuel Colman, 1832–1920: Rediscovered Painter of Far-away Places," *Amer. A. J.*, viii/1 (1976), pp. 16–37
The Romantic Landscapes of Samuel Colman at Kennedy Galleries (exh. cat., New York, Kennedy Gals, 1983)
The Poetic Landscapes of Samuel Colman (1832–1920) (exh. cat. with text by M. Flynn, New York, Kennedy Gals, 1999)

Merrill Halkerston

Colonial Revival

Term applied to an architectural and interior design style prevalent in the late 19th and early 20th centuries in the USA and Australia, countries formerly colonized by Britain. The style, used mostly for domestic architecture, was based on buildings of early colonial periods and had much in common with the contemporary Neo-Georgian tendency in Britain; later developments on the west coast of the USA drew on Spanish styles. It became popular in response to a reaction against the ornate eclecticism of late 19th-century architecture and the search for a new esthetic: Colonial Revival was promoted

as a "national" style, rooted in the foundations of the nations and suited to their environment and culture. A similar stimulus produced revivals of colonial styles in other countries, such as South Africa, where the Cape Dutch style was revived in work by Herbert Baker around the end of the 19th century, and Brazil, where features of Portuguese colonial architecture appeared in the work of Lúcio Costa.

In the USA scattered praise of Colonial architecture had appeared in architectural publications from the 1840s, and from the 1870s such architects as Robert Swain Peabody and Arthur Little emphasized the appropriateness and picturesque qualities of colonial architecture and advocated its revival. Such views were consolidated by the Centennial International Exhibition (1876) in Philadelphia, which crystallized national aspirations toward a simpler way of life, with nostalgia for the values of a pre-industrial society becoming associated with a revival of the building and furnishing styles adopted by the colonists. Two buildings at the exhibition attracted particular attention: the Connecticut House by Donald G. Mitchell, which was intended to suggest a Colonial farmstead, and the New England Log House, which had a kitchen with a low-beamed ceiling and Colonial furniture, where traditional boiled dinners—advertised as the kind "the old Puritans grew strong on"—were served. Two British buildings in a half-timbered style by Thomas Harris were influential in validating the use of a vernacular style. Colonial Revival also drew inspiration from the contemporary resurgence of academic classicism. During the next decades a trend toward greater historical accuracy emerged, with the publication of many illustrated articles and measured drawings of colonial buildings.

The development of resorts in New England provided the opportunity for the Colonial Revival style to be used in settings similar to those experienced by the colonists. Early examples in Newport, RI, include the remodeling (1872) of the Robinson House, Washington Street, by Charles Follen McKim and other buildings by McKim, Mead & White,

and Richard Morris Hunt's own house (1870–71); the latter combined elements from Colonial architecture and the Shingle style, as did the F. W. Andrews House (1872; destr.) at Middletown, RI, by H. H. Richardson, which had shingles on the upper story and clapboard below. In Litchfield, CT, the Mary Perkins Quincy House (1904) by Howells and Stokes is a clapboard building with green shutters, which harmonizes with its colonial neighbors.

Colonial Revival was adopted for both large and small houses. The simplicity of the New England prototypes and the use of timber as a building material made it a popular, inexpensive choice and led to its widespread use for suburban housing, with several characteristics in common with the late 19th-century Queen Anne Revival style. From the late 1880s, architects in Philadelphia turned to regional models, such as old Pennsylvania farmhouses, and they employed undressed local stone, often whitewashed, as a building material. Among them were Wilson Eyre, Walter Cope (1860–1902) and the practice of Duhring, Okie & Ziegler, whose William T. Harris House (completed by 1915) in Villa Nova, PA, is a sturdy two-story building of local stone combining a simple vernacular exterior with a sophisticated interior layout. Colonial Revival developed later in the southern states, where local models were again adopted; the J. H. Boston House (c. 1913), Marietta, GA, by Joseph Neel Reid, for example, evokes an ante-bellum mansion. The style was also used for other building types. Examples include additions (1870) to Harvard Hall, Harvard University, Cambridge, MA, by Ware & Van Brunt; the Post Office (1902), Annapolis, MD, by James Knox Taylor; and the Unitarian Meeting House (before 1914), Summit, NJ, by John Wheeler Dow, a white clapboard structure with a wooden portico and tower.

Two distinctive variants of American Colonial Revival developed on the west coast of the USA: Mission Revival (from the 1890s) and Spanish Colonial Revival (from the early 1920s). Mission Revival drew freely on the old Roman Catholic mission

buildings of California and was first popularized after the success of the California Building by A. Page Brown (1859–96) at the World's Columbian Exposition (1893) in Chicago. Typical features included balconies, verandahs and arcades, towers and courtyards. Walls were plastered and roofs pantiled, and there was an almost complete absence of architectural moldings. Examples of this approach include John Kremple's Otis House (1898), Wilshire Boulevard, Los Angeles, and the Union Pacific Railroad Station (1904), Riverside, CA, by Henry Charles Trost. Spanish Colonial Revival is distinguished from Mission Revival by the considerable use of carved or cast ornament, classically derived columns, window grilles and elaborate balcony railings of wrought iron or turned spindles, all elements that are found in Spanish colonial architecture in Mexico. Popularized after its appearance at the Panama–California Exposition (1915) at San Diego, the style had become a craze within ten years. One of its most notable practitioners was George Washington Smith, who designed Sherwood House (1925–8), La Jolla, CA.

In Australia the Colonial Revival resulted from a new sense of national identity that followed federation of the states in 1901 and led to a search for a "national style." The movement was based in Sydney, and its main practitioners included W. Hardy Wilson, Robin Dods (also active in Brisbane), John D. Moore (1888–1958) and Leslie Wilkinson, Australia's first professor of architecture (1918–47) at the University of Sydney. Wilson made the first scholarly studies of colonial Georgian architecture and incorporated such features as sash windows, shutters, fanlights and columned verandahs in his simply planned houses (e.g. Eryldene, 1913–14, Gordon, Sydney). A notable variation was seen in the work of Wilkinson, who combined Australian colonial elements with loggias inspired by Mediterranean architecture (e.g. Greenway, 1923, Vaucluse, Sydney).

While other styles became popular in the 1920s and 1930s, the Colonial Revival remained part of the

COLONIAL REVIVAL. Annie Longfellow Thorpe House, Cambridge, Massachusetts, 1887. Historic American Buildings Survey, Library of Congress Prints and Photographs Division

domestic vernacular in both the USA and Australia and was reinterpreted in later housing projects, particularly toward the end of the 20th century.

[*See also* Eyre, Wilson; Little, Arthur; McKim, Mead & White; Peabody, Robert Swain; Richardson, H. H.; Shingle style; *and* Smith, George Washington.]

BIBLIOGRAPHY

C. F. McKim: *New York Sketch Book of Architecture* (Montrose, NJ, 1874)

R. S. Peabody: "Georgian Houses of New England," *Amer. Architect*, 2 (1877), pp. 838–9

W. B. Rhoades: *The Colonial Revival*, 2 vols (New York and London, 1977)

P. Cox and C. Lucas: *Australian Colonial Architecture* (East Melbourne, 1978), pp. 227–55

K. J. Weitze: *California's Mission Revival* (Santa Monica, 1984)

A. Axelrod: *The Colonial Revival in America* (Winterthur, DE, 1985)

K. A. Marling: "Parades, Pageantry and the Colonial Revival: The Influence of Popular Culture on the Evolution of Style, 1876–1932," *World Art: Themes of Unity in Diversity*, ed. I. Lavin (University Park, PA, 1989), pp. 686–97

W. B. Rhoades: "The Discovery of America's Architectural Past, 1874–1914," *Architectural Historian in America: A Symposium in Celebration of the Fiftieth Anniversary of the Founding of the Society of Architectural Historians*, ed. E. B. MacDougall (Washington, DC, 1990), pp. 23–39

W. B. Rhoades: "Colonial Revival in American Craft: Nationalism and the Opposition to Multicultural and Regional Traditions," *Revivals!: Diverse Traditions, 1920–45: The History of*

Twentieth Century American Craft, ed. J. Kardon (New York, 1994), pp. 41–54

M. B. Woods: "Viewing Colonial America through the Lens of Wallace Nutting," *Amer. A.*, viii/2 (1994), pp. 66–86

T. A. Denenberg: *Wallace Nutting and the Invention of Old America* (New Haven, 2003)

P. S. Kropp: *California Vieja: Culture and Memory in a Modern American Place* (Berkeley, 2006)

Betzy Dinesen

Color field painting

Term referring to the work of such Abstract Expressionists as Barnett Newman, Mark Rothko and Clyfford Still and to various subsequent American painters, including Morris Louis, Kenneth Noland, Frank Stella, Jules Olitski, and Helen Frankenthaler. The popularity of the concept stemmed largely from Clement Greenberg's formalist art criticism, especially his essay "American-type Painting," written in 1955 for *Partisan Review*, which implied that Still, Newman and Rothko had consummated a tendency in modernist painting to apply color in large areas or "fields." This notion became increasingly widespread and doctrinaire in later interpretations of Abstract Expressionism, until the movement was effectively divided into "gesturalist" and "color field" styles despite the narrow and misleading overtones of each category.

Among the main characteristics of Abstract Expressionist color field painting are its use of hues close in tonal value and intensity, its radically simplified compositions and the choice of very large formats. From the later 1950s onward, Louis, Stella, Noland and others developed these tendencies (see color pl. 1:XIV, 1), although their art avoided the overt symbolic or metaphysical drama of the Abstract Expressionists. American color field painting of the 1960s and 1970s often employed geometric motifs such as Louis's stripes and Noland's chevrons to emphasize the chromatic intensity between areas. These emblematic elements, alongside, for example Olitski's sexy titles and sensual surfaces, sometimes bring the movement closer to Pop art than is commonly recognized. Synthetic media such as acrylics and Magna paint were allied to techniques such as spraying and soaking paint onto unprimed canvas without a brush. These procedures produced extraordinary refinements of texture, luminosity and coloristic inflection, whose visual complexity was matched by the conceptual intricacies of formalist criticism of the period. Through the work of Ellsworth Kelly, Ad Reinhardt and Larry Poons, color field painting also established links with other contemporary departures, including hard-edge painting, Minimalism and Op art.

[*See also* Abstract Expressionism *and* Noland, Kenneth.]

BIBLIOGRAPHY

C. Greenberg: "American-type Painting," *Partisan Rev.*, xxii/2 (1955), pp. 179–96; also in *A. Cult.* (Boston, 1961), pp. 208–29

C. Greenberg: "After Abstract Expressionism," *A. Int.*, vi/8 (1962), pp. 24–32

Three American Painters (exh. cat. by M. Fried, Cambridge, MA, Fogg, 1965)

I. Sandler: *The New York School* (New York, 1978), pp. 214–55

K. Wilkin: *Color as Field: American Painting, 1950–1975* (New Haven, 2007)

David Anfam

Colter, Mary

(*b* Pittsburgh, PA, 4 April 1869; *d* Santa Fe, NM, 8 January 1958), architect and designer. Raised in St Paul, MN, Mary (Elizabeth Jane) Colter graduated in 1890 from the California School of Design in San Francisco, then taught mechanical drawing at a St Paul high school and contributed to local Arts and Crafts societies as lecturer and craftswoman. These pursuits nourished Colter's love of Native American art and the Southwest, interests also fostered by her first professional projects—the interior of the Indian Building at the Santa Fe Railway's Albuquerque station (1902) and the Grand Canyon's Hopi House (1904), modeled on an Indian village. She completed both for her lifelong employer, the

Fred Harvey Co., the famous purveyor of travel services, which hired her full-time in 1910.

Colter designed hotels, train stations, tourist attractions, restaurants and shops—at the Grand Canyon and along the Santa Fe line. She based her designs on Native American and Hispanic cultures and on the western landscape, and, through rigorous research, fashioned environments to charm the leisure traveler. The most dramatic is the Watchtower (1933) at the Grand Canyon, based on ancient Indian stoneworks in the region. The tower crowned a series of works at the canyon, beginning in 1914 with Lookout Studio and Hermit's Rest, freeform structures that seem at one with their rocky surrounds. Phantom Ranch (1922) and Bright Angel Lodge (1935) similarly show her use of rugged local materials, an approach that helped launch the style later called "National Park Service rustic."

Colter showed modernist flair with El Navajo (1923) in Gallup, NM, a hotel and train station decorated inside with sand paintings (their first commercial use). Her most lavish project was the last of the Harvey Houses, La Posada (1930) in Winslow, AZ, a Spanish Colonial Revival hotel for which—with Arts and Crafts breadth—she designed structure, interiors, furnishings and landscape. Like most of her works, La Posada tells a story, that of the hacienda of a wealthy ranching family. Colter also designed shops and restaurants for the union stations of Kansas City (1914), Chicago (1925) and Los Angeles (1939). Two station dining rooms—Kansas City's Westport Room (1937) and the restaurant at Los Angeles—are sleekly modern but integrate historical allusion. Colter helped American architecture become more American.

BIBLIOGRAPHY

A. H. Good: *Park and Recreation Structures* (Washington, 1938/R New York, 1999)

V. Grattan: *Mary Colter: Builder Upon the Red Earth* (Grand Canyon, AZ, 1992)

M. Weigle and B. A. Babcock, eds: *The Great Southwest of the Fred Harvey Company and the Santa Fe Railway* (Phoenix, 1996)

A. Berke: "Drawing From the Desert," *Preservation*, (July–August 1997), pp. 34–43

H. Kaiser: *Landmarks in the Landscape: Historic Architecture in the National Parks of the West* (San Francisco, 1997)

L. Flint McClelland: *Building the National Parks: Historic Landscape Design and Construction* (Baltimore, 1998)

A. Berke: *Mary Colter: Architect of the Southwest* (New York, 2002)

Arnold Berke

Columbian Society of Artists

Artists' society, active in Philadelphia from 1810 to 1820. The Columbian Society of Artists (CSA) was a professional association founded by a group of Philadelphia artists in response to the perceived inadequacies of the foremost art institution of the day, the Pennsylvania Academy of the Fine Arts (PAFA). Established by leading members of Philadelphia's art community in 1805, the PAFA had existed largely as a space for the display of works by major American artists, such as Benjamin West, and a collection of plaster casts of Classical sculptures. It was also intended to help cultivate the education and patronage of American artists, although within a few years local artists began complaining that the PAFA was doing little to support their careers. In 1810 artists including Charles Willson Peale, Rembrandt Peale, Benjamin Henry Latrobe, and William Birch founded the Society of Artists of the United States; six months later the membership had swelled to number 100 painters, engravers, sculptors, and architects. The organization changed its name to the Columbian Society of Artists in 1814.

Established during a period when American artists often had to prove their social value through a commitment to political ideals, the CSA articulated its intent to uphold the ideals of simplicity and plainness associated with republican political culture. Thus the Society criticized the PAFA for its display of antique casts on the grounds that nude sculptures corrupted public morals. It also objected to the PAFA's custom of admitting men and women

separately to the cast collection, suggesting that any exhibition requiring gender-segregated admission was inappropriate. Its strongest charge, though, was that the PAFA had denied artists access to the casts for study purposes and had excluded them from membership.

In response, the CSA outlined several goals. It intended to hold annual public exhibitions; to establish a fine arts school; to improve the public taste; and to raise funds for the relief of deceased members and their families. It proved most successful in the first of these objectives, sponsoring annual exhibitions jointly with the PAFA through the second decade of the 19th century. The inaugural exhibition in 1811 featured over 500 works of art, approximately half of which were by living American or immigrant artists, and it attracted an audience large enough to gross $1860 in admission fees. Although the CSA was absorbed into the PAFA in 1820, during its brief existence it obtained greater visibility for artists and encouraged the development of American art criticism in the foremost literary journal of the era, *The Port-Folio*. It also helped stimulate the establishment of other venues in Philadelphia for the display of art, including commercial galleries and, in 1836, the Artists' Fund Society.

[*See also* Latrobe, Benjamin Henry; Peale, Charles Willson; Peale, Rembrandt; *and* Pennsylvania Academy of the Fine Arts.]

UNPUBLISHED SOURCES

Philadelphia, PA Acad. F.A. Archvs and Washington, DC, Smithsonian Inst., Archvs Amer. A. [Columbian Society of Artists records, 1810–49]

BIBLIOGRAPHY

N. Harris: *The Artist in American Society: The Formative Years, 1790–1860* (New York, 1966)

L. B. Miller: *Patrons and Patriotism: The Encouragement of the Fine Arts in the United States, 1790–1860* (Chicago and London, 1966)

In This Academy: The Pennsylvania Academy of the Fine Arts, 1805–1976: A Special Bicentennial Exhibition (exh. cat., Philadelphia, PA Acad. F.A., 1976)

Wendy Bellion

Columbianum Academy and Columbian Exhibition

Academy of fine arts active in Philadelphia, PA from 1794 to 1795. The Columbianum Academy, also known to its founders as the American Academy of the Fine Arts, was the first art academy established in the USA. Founded in Philadelphia on 29 December 1794, survived only six months before succumbing to political infighting among its members. Before dissolving, however, it succeeded in holding the nation's first major public art exhibition. It also provided an important impetus to the emergence of the Pennsylvania Academy of the Fine Arts a decade later.

The Columbianum Academy was organized by 16 men, including engravers, immigrant British painters, and Charles Willson Peale, Philadelphia's leading portraitist. Pledging to encourage the development of art in the USA, the group soon attracted another 14 members, including Peale's sons Raphaelle and Rembrandt; William Groombridge (1748–1811), an English landscape artist; John Eckstein (1735–c. 1817), a former painter to the Prussian court; the American sculptor William Rush; and the Italian sculptor Giuseppe Ceracchi. Additional founders included two physicians, an amateur architect, and a Baptist clergyman who belonged to the American Philosophical Society.

The academy devised an ambitious curriculum for itself, aspiring to teach all branches of the fine arts in addition to engraving and anatomy, with its founding members serving as instructors. According to the Columbianum's constitution created in April 1795, artists could join the academy pending a review of their work. Membership was also extended to patrons of the arts. An annual fee was established to help support lectures, a library, and a gallery of plaster casts of Classical sculptures.

Within two months of its establishment, the Columbianum divided into two competing organizations, one of which was headed by Peale and the other centered around Groombridge. The split was occasioned by several factors. Based on anecdotal

evidence, scholars long assumed that a difference of opinion concerning the use of nude models in life drawing classes led to the Columbianum's demise, but contemporary newspapers suggest a different cause, demonstrating that members disagreed in part over the extent to which the academy should be modeled upon Britain's Royal Academy. Groombridge and his supporters envisioned a national school for the arts and hoped that President George Washington would become as its honorary patron, much as the British king served as the titular head of the Royal Academy. Peale and his friends objected to this idea on political grounds, fearing that it implied a fondness for aristocracy inappropriate for a republican nation that had just won its independence from a monarchy. They also argued that the idea of a national academy was too ambitious and contradictory to republican values. Echoing the language of Anti-Federalist political rhetoric, which valued direct and local forms of political representation over the anonymity of a national electoral system, they maintained that the Columbianum academy should aspire to represent and serve only the interests of Pennsylvania artists. These disputes led Groombridge and seven other artists to resign from the original Columbianum and establish a separate one with the same name. The breakup sparked a long, angry standoff in Philadelphia newspapers that echoed the deeply partisan political divides of the 1790s.

The Columbianum Academy never recovered from its internal bickering. It attracted few students—among them, Rembrandt Peale and Jeremiah Paul—and ceased to exist entirely after summer 1795. Its major accomplishment, before folding, was the large exhibition it staged in the second-floor Assembly Room of the Pennsylvania State House (Independence Hall) during May and June 1795. The Columbianum exhibition attracted the participation of approximately forty professional and amateur artists, including four members of the Peale family, the British enamel painter William Birch (1755–1834) and his son Thomas Birch, the Carolina painter Henry Benbridge, and the theatrical scene painter Hugh Reinagle (1790–1834). Benjamin West

and John Singleton Copley, who were celebrated by early national Americans as the country's leading painters, were also represented. Together, artists contributed over 150 objects ranging from traditional genres of the fine arts—mainly portraiture, landscape, and still life—to the mechanical arts, such as model ships and architectural drawings. The many portraits displayed included likenesses of George Washington, Thomas Jefferson, the African American poet Phillis Wheatley, the Swiss painter Angelica Kauffman, and the Philadelphia scientist David Rittenhouse. Other works included a sculptural model of the "protecting Goddess of America" prepared by John Eckstein and his son Frederick, and Charles Willson Peale's canonical *trompe l'oeil* painting, *The Staircase Group: Raphaelle and Titian Ramsay Peale* (1795; Philadelphia, PA, Mus. A.), which was specifically designed for exhibition in the State House.

[*See also* Ceracchi, Giuseppe; Peale, Charles Willson; *and* Rush, William.]

BIBLIOGRAPHY

The Exhibition of the Columbianum, or American Academy of Painting, Sculpture, Architecture, &c. Established at Philadelphia, 1795 (Philadelphia, 1795)

W. Dunlap: *History of the Rise and Progress of the Arts of Design in the United States*, i (New York, 1834), pp. 418–19

R. Peale: "Reminiscences: Exhibitions and Academies," *The Crayon*, i/19 (9 May 1855), p. 290

J. Flexner: "The Scope of Painting in the 1790's," *PA Mag. Hist. & Biog.*, lxxiv/1 (Jan 1950), pp. 74–89

L. B. Miller and others, eds: *The Selected Papers of Charles Willson Peale and his Family*, i (New Haven and London, 1983–2000), pp. 103–9

W. Bellion: "Illusion and Allusion: Charles Willson Peale's Staircase Group at the Columbianum Exhibition," *Amer. A.*, xvii/2 (Summer 2003), pp. 18–39

D. Steinberg: "Educating for Distinction? Art, Hierarchy, and Charles Willson Peale's Staircase Group," *Seeing High & Low: Representing Social Conflict in American Visual Culture*, ed. P. Johnson (Berkeley, 2006), pp. 25–41

W. Bellion: *Citizen Spectator: Art, Illusion, and Visual Perception in the Early United States* (Chapel Hill, NC, 2010)

Wendy Bellion

Comic-strip art

Since the 1990s dramatic developments in the production, dissemination and scholarship of comic strips and graphic novels have propelled these provocative artistic forms into the forefront of visual popular culture. These closely related genres have become an increasingly recognized feature of contemporary art historical inquiry—a long overdue recognition after centuries of critical marginality. As Paul Buhle, a key figure in the comic strip scholarly renaissance in the early 21st century, noted in 2008, "more published volumes about comic art, of both the scholarly and picture book variety (the latter often boasting the superior research), have been produced than in all the previous history of the subject."

Buhle identified some of the key developments in this renaissance. The groundbreaking two-volume Holocaust graphic novel *Maus* by Art Spiegelman (*b* 1948)—a story of his father's harrowing ordeal in Nazi concentration camps and his subsequent life as a troubled Jewish survivor in America—received a Pulitzer "Special Awards and Citations" recognition in 1992. Spiegelman's editorial leadership with Françoise Mouly of the magazine *Raw* from 1980 to 1991, moreover, was the major catalyst for the alternative comics movement of the late 20th century. In 2000, graphic novelist Ben Katchor (*b* 1951) received a MacArthur "genius grant," further elevating this talented comic artist to major visibility in popular and critical circles. Two well-received films also added strongly to public recognition about comic artists and their work. *Crumb*, released in 1994, highlighted the life and work (as well as the psychopathological family history) of Robert Crumb, one of the iconic figures of comic art, especially his role as the founder of "underground comics" in the USA. The 2003 film *American Splendor* focused on Harvey Pekar (*b* 1939), another iconic figure in contemporary comic-strip art.

Moreover, various museum exhibitions provided further validation for the legitimacy of comics as an artistic form. A major example was the *Masters of Comics* show held jointly at the Armand Hammer Museum and the Museum of Contemporary Art in Los Angeles (2005–6) and subsequently in New York's Jewish Museum and the Newark Art Museum. The exhibition and its lavish catalog provided audiences with extensive visual materials, including the artists' rarely seen prepublication sketches and drawings. Although the exhibition generated controversy, including among comic artists themselves, it helped foster increased public awareness of this engaging artistic medium, reinforcing its growing critical stature.

Finally, many colleges and universities began offering courses on comic art and literature throughout the USA in the early 21st century, as part of traditional curricular offerings or as entirely new innovations. The University of Mississippi Press created its own comic series, a radical departure in scholarly publishing. Academic journals, magazines and newspapers, and internet sites and publications began offering more articles about comics and graphic novels. These developments further increased the growing visibility of comics as an integral feature of contemporary visual art.

The growing body of graphic novels represents a striking contemporary development. Every large bookstore carries a growing body of graphic novels, many resulting from the critical and popular success of Spiegelman's *Maus* and the earlier pioneering efforts of Will Eisner (1917–2005). Some graphic novels are primarily entertainment, offering science fiction, adventure, romance, erotica and other genres for readers of all ages. Others, however, are strongly political in content, providing readers with powerfully critical views of various international and domestic controversies. Key figures include Joe Sacco (*b* 1960), author of *Palestine* and *Safe Area Gorazde*, and Eric Drooker (*b* 1958), author of *Flood* and *Blood Song*, which are among the most compelling examples of contemporary political art.

Political expressions have generally made powerful contributions to the contemporary comic-strip

renaissance. *Doonesbury* by Garry Trudeau (*b* 1948) remains the qualitative standard; his biting social commentary for four decades critiqued bumbling politicians, social misconduct and institutional corruption for millions of viewers both in daily newspapers and in anthologies of his works. Other contemporary progressive comic-strip artists include Lloyd Dangle (*b* 1961), Tom Tomorrow (*b* 1961), Peter Kuper (*b* 1958), Tim Eagan, Eric Bezdek, Jen Sorensen (*b* 1974), Scott Bateman (*b* 1964), Ruben Bolling, Ward Sutton, Stephanie McMillan, Ted Rall (*b* 1963), Matt Wuerker, among many others. These talented comic artists often publish their works in underground sources and on the internet, although their works also appear occasionally in mainstream publications.

Conservative comics likewise contribute to the modern proliferation, most notably *Mallard Fillmore* by Bruce Tinsley (*b* 1958). Others are available on conservative websites, but in general comic strips and cartoons as a critical artistic medium are largely identified with the political left. More general satirical strips, such as *Dilbert* by Scott Adams (*b* 1957), provide viewers with comfortably familiar tales of workplace frustrations and aggravations without a deeper critique of capitalism and bureaucracy.

Ethnic consciousness in comic-strip art is a huge feature of contemporary developments in the genre. Paul Buhle has comprehensively surveyed the tradition of Jewish comic strip art in his various publications. His surveys of Jewish comic art for the past 100 years are a definitive account of that tradition. In addition to his treatment of such iconic artists as Will Eisner, Jules Feiffer (*b* 1929), Art Spiegelman, Harvey Pekar, Ben Katchor and many others, he has critically examined the works of many early 21st-century Jewish comic artists, persuasively establishing the primacy of Jewish participation in the American comic-strip artistic tradition generally.

African American contributions to American comic-strip art are likewise crucial but rarely acknowledged. The seminal historical figure was Oliver Harrington (1912–95), whose trenchant visual imagery shed a sharply critical light on American race, politics and culture for many decades. Following in Harrington's anti-racist visual tradition, Aaron McGruder (*b* 1974) created the comic strip *Boondocks*, a controversial effort that bitingly critiques dominant American culture and leading American political figures. McGruder's chief character is named Huey, after Black Panther leader Huey Newton; like his namesake, Huey is an outspoken militant, quick to condemn white racism and black complicity and passivity. Another significant contemporary African American comic artist is Jerry Craft, whose *Mama's Boyz* strip also addresses American racism, although less truculently than *Boondocks*. Craft also uses his art to provide more general commentary about African American teenage and family life and culture.

The premier Chicano comic-strip artist of the 21st century is Lalo Alcaraz (*b* 1964). His syndicated comic strip *La Cucaracha*, reflects a tradition of biting Latino satire, reminiscent of a strain of 20th-century Mexican mural and graphic art. Alcaraz uses his work to call sharp attention to American xenophobia, especially the wave of anti-immigrant sentiment in the early 21st century. At the same time, he occasionally casts a gently critical eye on his own Chicano community. His strip is a powerful voice for the disenfranchised Latino community in the USA, adding to the burgeoning tradition of contemporary ethnic comic-strip art.

Asian Americans are rarely acknowledged as comic-strip artists, but their contemporary efforts are available on the internet and in Asian American publications. Examples, including *Secret Asian Man* by Tak Toyoshima (*b* 1971) and *Asian Americana* by Ian Liu, address issues of serious concern to various Asian American communities; in the process, these comic artworks add a valuable dimension to the recent body of comic art. A major representative of this tradition is Korean–American Lela Lee (*b* 1974). When she created her comic strip *Angry Little Girls*, she sought to counter the widespread myth of Asian Americans as the "model minority." Instead of being

passive, studious and obedient to authority, her angry female characters were defiant and even profane, revealing to her audiences a vastly different view of various young women of Asian descent. Lee too joins a longer tradition of visual satire expressed through comic-strip visual art.

The days of comic-strip marginalization are gone forever. With the proliferation of new electronic means of dissemination, this medium will grow to even greater visibility in coming decades. The contemporary comic strip has earned comparable recognition with painting, sculpture, printmaking, performance and video art in contemporary art history.

BIBLIOGRAPHY

B. Wright: *Comic Book Nation: The Transformation of Youth Culture in America* (Baltimore, 2001)

T. Rall, ed.: *The New Subversive Political Cartoons* (New York, 2002)

S. Weiner: *The Rise of The Graphic Novel* (New York, 2003)

P. Buhle: *Jews and American Comics* (New York, 2008)

P. Buhle: *Comics in Wisconsin* (Madison, 2009)

Paul Von Blum

Computer art

Term formerly used to describe any work of art in which a computer was used to make either the work itself or the decisions that determined its form. Computers became so widely used, however, that in the late 20th century the term was applied mainly to work that emphasized the computer's role. It can include artworks that use computers or other digital technology not only for their creation but for their display or distribution. It can also include interactive works, installation art and art created for the internet.

Calculating tools such as the abacus have existed for millennia, and artists have frequently invented mathematical systems to help them to make pictures. The golden section and the formulae used by Leon Battista Alberti (1404–72) for rendering perspective were devices that aspired to fuse realism with idealism in art, while Leonardo da Vinci (1452–1519) devoted much time to applying mathematical principles to image-making. After centuries of speculations by writers, and following experiments in the 19th century, computers began their exponential development in the aftermath of World War II, when new weapon-guidance systems were adapted for peaceful applications, and the term "cybernetics" was given currency by Norbert Wiener. After the war, "mainframe" computers, which first used vacuum tubes and later transistors and silicon chips, became widespread. Their prohibitive size and cost, however, restricted their use to government agencies, major corporations, universities and other large institutions. It was at these institutions that early attempts at using computers to create simple geometric visual images were carried out. Artists exploited computers' ability to execute mathematical formulations or "algorithms" from 1950, when Ben F. Laposky (*b* 1930) used an analog computer to generate electronic images on an oscilloscope. Once it was possible to link computers to printers, programmers often made "doodles" between their official tasks. From the early 1960s artists began to take this activity more seriously and quickly discovered that many formal decisions could be left to the computer, with results that were particularly valued for their unpredictability.

The first exhibition of computer art as such appears to have been an exhibition called *The World of Computer Graphics* held at the Howard Wise Gallery, New York, in 1965. Throughout the 1960s and 1970s, as computer graphics programs were developed for industrial and broadcast-television uses, increasing numbers of artists began to take advantage of these technologies. From the mid-1970s the painter Harold Cohen (*b* 1928) developed a sophisticated program, AARON, which generated drawings that the artist then completed as colored paintings. Although the computer became capable of that task as well, Cohen continued to hand-color computer-generated images (e.g. *Socrates' Garden*, 1984; Pittsburgh, PA, Buhl Sci. Cent.).

Until *c.* 1980 graphic output was relatively slow: the artist entered instructions, and a line plotter would eventually register the computer's calculations as a visual depiction of mathematical formulae. Alternatively, drawings, photographs or video pictures could be "digitized": tones broken down into patterns of individual units or "pixels," and lines rendered as sine-curves. These elements could then be manipulated by the computer as sets of digits. Using complex algorithms known as "fractals," artist—programmers have since evolved spectacular depictions of realistic and fantastic objects and scenes. It eventually became possible for artists to work interactively in real time with a display screen, using a "light pen" or stylus. In the USA in the mid-1970s David Em (*b* 1952) made contact with computer programmers developing this technology. He developed both geometric patterns and illusionistic images. In Europe related developments included the patterns of forms and colors produced by such artists as the German Jürgen Lit Fischer (*b* 1940). The Quantel Paintbox was an early example of a sophisticated interactive graphic computer, designed to generate captions for television, as video images or as color prints. Such artists as Richard Hamilton (*b* 1922) and David Hockney, both keenly interested in technical innovations, worked with it, and the painter Howard Hodgkin (*b* 1932) used it to produce stage designs.

Computers also became part of works created for other media. Some artists used computers to create film animation (e.g. *Poem Fields* (1964) by Stan Vanderbeek (1927–84)); others used computers to control video displays in interactive works (e.g. *The Erl King* (1982–5) by Grahame Weinbren (*b* 1947) and Roberta Friedman) and non-interactive installations, (e.g. *Video Flag* (1985–) by Nam June Paik). Artists also used computer programs to control complex movements in kinetic sculpture, to compose and perform music and to choreograph dance works. For makers of film and video, the computer offers unlimited possibilities in generating and transforming images and movement. From 1986 the artist Tom Phillips (*b* 1937) and the film director Peter Greenaway (*b* 1942) collaborated on a television version of Dante's *Inferno* in which elaborate visual effects were achieved using a computer.

By the 1990s personal computers could perform tasks that once required large, expensive items of hardware, while computer skills became a standard element in art and design education. The personal computer (PC) revolution of the 1980s, which brought computers within financial reach of many individuals, also revolutionized the world of computer art. From that point forward, the field of computer-based art became overwhelmingly diverse. The growth of the internet in the late 1990s added another component to the field—the ability to deliver works remotely to audiences around the world. As the capacity of computers increases continuously, it would be unwise to predict the kinds of computer art that may evolve. However, it is clear that in the culture that computers help to create, many things will become commonplace that were previously assumed to be impossible.

BIBLIOGRAPHY

J. Reichardt, ed.: *Cybernetics, Art and Ideas* (London, 1971)

M. L. Prueitt: *Art and the Computer* (1984)

Digital Visions: Computers and Art (exh. cat. by C. Goodman, Syracuse, NY, Everson Mus. A., 1987)

Art and Computers: A National Exhibition (exh. cat., intro. J. Lansdown; Middlesborough, Cleveland Gal., 1988)

The Second Emerging Expression Biennial: The Artist and the Computer (exh. cat., intro. L. R. Cancel; New York, Bronx Mus. A., 1988)

C. Giloth and L. Pocock-Williams: "A Selected Chronology of Computer Art Exhibitions, Publications, and Technology," *A. J.*, xlix/3 [Computers and Art: Issues of Content] (Autumn 1990), pp. 283–97

P. Hayward, ed.: *Culture, Technology & Creativity in the Late Twentieth Century* (London, 1990)

F. Popper: *Art of the Electronic Age* (London, 1993)

L. Manovich: *The Language of New Media* (Cambridge, MA, 2001)

R. Greene: *Internet Art* (London and New York, 2004)

M. Rush: *New Media in Art* (London, 2/2005)

T. Corby, ed.: *Network Art: Practices and Positions* (New York, 2006)

J. Raimes: *The Digital Canvas: Discovering the Art Studio in Your Computer* (New York, 2006)

F. Popper: *From Technological to Virtual Art* (Cambridge, MA, 2007)

Mick Hartney
Revised and updated by Jeffrey Martin

Computer imaging

Term used to describe pictorial representations of objects and data using a computer. The term also implies the creation of and subsequent manipulation and analysis of computer-generated imagery and graphics. Computer-generated imagery was developed shortly after the introduction of the Electronic Numerical Integrator and Computer (ENIAC) in 1946. In 1950, a mathematician and artist from Iowa named Ben Laposky produced computer-generated graphic images using an electronic oscilloscope and photographed the results using high-speed film. The first interactive man-machine graphics program was Sketchpad, invented by Ivan Sutherland, a graduate student at the Massachusetts Institute of Technology. Developed for the TX-2 computer, Sketchpad allowed one to draw on the computer screen using a light pen and processed image manipulation functions through a series of toggle switches.

In 1965, scientists from the USA and Germany organized concurrent computer art exhibitions entitled *Computer-Generated Pictures* at the Howard Wise Gallery in New York and the Galerie Niedlich in Stuttgart. The American scientists, Bela Julesz and A. Michael Noll worked at Bell Laboratories in Murray Hill, NJ, a center of computer graphic development and in 1966 Bell engineer Billy Klüver formed Experiments in Art and Technology (EAT) to encourage collaboration between artists and engineers. In 1968, the Museum of Modern Art, New York, organized the traveling computer-art exhibition *The Machine as Seen at the End of the Mechanical Age*. Also in the 1960s, Bell Laboratories demonstrated that electronic digital processing could be coupled with electronic film recording to create high-resolution images.

By 1970, the Xerox Corporation had established the Palo Alto Research Center (now PARC), with a directive to further develop computer graphics applications. In 1970, General Electric introduced Genigraphics, the first high-resolution color graphics system and, in 1973, the Association for Computing Machinery's Special Interest Group on Graphics and Interactive Techniques (SIGGRAPH) was formed. The Apple II computer, which was introduced in 1979, was the first personal computer issued with computer graphics capabilities. In the 1980s, the School of Visual Arts in New York established the first Master of Fine Arts in Computer Art.

Released in 1982, Autodesk's AutoCAD was the first computer-aided drafting program for a personal computer. In 2005, Autodesk acquired Alias Systems Corporation's Maya, the most commonly used computer software application for three-dimensional modeling, animation, rendering and visual effects. Adobe Systems, founded in 1982, launched Adobe Photoshop in 1990, which allowed for the creation and editing of pixel-based images, such as a digital camera capture and vector artwork. At the 1990 Photoshop Invitational, Adobe Systems sought input from renowned artists such as David Hockney. In 2001, the San Francisco Museum of Modern Art inaugurated *010101*, a digital-technology initiative showcasing developments in contemporary art, architecture and design altered by computer-based media. As computer-imaging technologies continue to advance, computer-based tools and applications have become standard and replaced traditional practice in certain fields; however, their critical analysis remains connected to long-standing artistic qualities and aesthetics.

[*See also* Experiments in Art and Technology (EAT).]

BIBLIOGRAPHY

S. Coons: "Design and the Computer," *Des. Q.*, lxvi–lxvii (1966), pp. 6–13

F. Dietrich: "The First Decade of Computer Art," *Leonardo*, xix/2 (1986), pp. 159–69

010101 Art in Technological Times (exh. cat., San Francisco, CA, MOMA, 2001)

B. Wands: *Art of the Digital Age* (New York, 2006)

"About Adobe," http://www.adobe.com/aboutadobe/ [Adobe Systems] (accessed 2 Feb. 2010)

"The Autodesk Story," http://usa.autodesk.com/company/ [Autodesk] (accessed 2 Feb. 2010)

Anne Blecksmith

Conceptual art

Term applied to work produced from the mid-1960s that either markedly de-emphasized or entirely eliminated a perceptual encounter with unique objects in favor of an engagement with ideas. Although Henry Flynt of the Fluxus group had designated his performance pieces "concept art" as early as 1961 and Edward Kienholz had begun to devise "concept tableaux" in 1963, the term first achieved public prominence in defining a distinct art form in an article published by Sol LeWitt in 1967. Only loosely definable as a movement, it emerged more or less simultaneously in North America, Europe, Latin America and Asia and had repercussions on more conventional spheres of artistic production spawning artists' books as a separate category and contributing substantially to the acceptance of photographs, musical scores, architectural drawings and performance art on an equal footing with painting and sculpture. Moreover, conceptual art helped spawn the move toward multi-media installations that has emerged to such prominence since the 1980s.

Precedents. In the mid-17th century, the painter Nicolas Poussin defined classicizing painting as "nothing but an idea of incorporeal things" (see Holt). Only in the early 20th century, however, did artists question the traditional emphasis on perception and on finished objects. The Dadaists, particularly Marcel Duchamp with his invention of the ready-made in 1913, countered the "retinal" qualities of beautifully made, unique objects whose status was linked to a monetary value with an art consciously placed "at the service of the mind."

Duchamp's ready-mades, intellectually rather than manually conceived by ascribing a new use to old objects, demonstrated how art was defined by means of ideological mediation and institutional presentation within a determined historical context. He stressed the role of the spectator in constituting the meaning of these works and by placing them in conventional exhibition spaces sought to destroy their atmosphere of cultural sanctification. Moreover, by rejecting the assumed link between aesthetic and monetary worth Duchamp emphasized in 1961 that his choice had been based on "visual indifference with, at the same time, a total absence of good or bad taste" (Sanouillet and Peterson, p. 141).

The position formulated by the Dadaists in response to the mood of crisis that emerged in Europe after World War I was resuscitated in the 1950s and 1960s, another time of social upheaval, particularly by American artists sometimes referred to as Neo-Dadaists. Robert Rauschenberg, for example, literally effaced the Western view of the heroic individual creating precious objects when in 1953 he acquired a drawing from Willem de Kooning, erased it and then exhibited the result as *Erased de Kooning Drawing*; when invited in 1960 to participate in a show featuring 40 portraits of dealer Iris Clert he sent a telegram to the gallery stating, "This is a portrait of Iris Clert if I say so." Robert Morris also anticipated notions central to conceptual art in works such as *Document* (1963; New York, MOMA), a relief construction from which he had removed "all aesthetic quality and content" in a notarized "Statement of Esthetic Withdrawal"; its acquisition by an esteemed cultural institution further highlighted its ironic stance. A related anticipation of conceptual art in Asia occurred in 1956 when Iqbal Geoffrey of Lahore, Pakistan, declared that a live tree was his "sculpture."

The Late 1960s. Conceptual art emerged in the mid-1960s as a probing critique of Western art and of the political and economic systems that sustain it. As defined by its most important practitioners, for example by Joseph Kosuth in two

influential articles published in 1969 as "Art after Philosophy" (see Meyer, pp. 155–70), it examined the role of artistic intention in relation to the meanings ascribed to the resulting objects; the communicative limits and internal coherence of existing visual languages; and the degree to which the impact of art is visual rather than intellectual. In ascribing more importance to communicating an idea than to producing a permanent object, conceptual artists questioned labor itself as a potentially alienating process. They also drew attention to the institutional framing of art, especially the avenues whereby it reaches and comes to have meaning in the public domain, the extent to which art production is a manifestation of commodity fetishism, the role of the market as a mediating agent for art in the public sphere, the hierarchical social structures that regulate who becomes an artist, the function of the culture industry in "producing" spectators, and the institutionalized rules by which a particular medium is given its value.

As a definable and international movement, conceptual art made a sudden appearance *c.* 1966 with works such as Joseph Kosuth's series *Titled (Art as Idea as Idea)* (1966–7), dictionary definitions of words presented as photographic enlargements; *Air Show/Air Conditioning* (1966–7), a proposal for the exhibition of an unspecified "column" of air by two English artists, Terry Atkinson and Michael Baldwin, who in 1969 became founder-members of the group Art and Language; and an exhibition in 1968 (Los Angeles, CA, Molly Barnes Gal.) of word paintings by John Baldessari, such as a canvas bearing the sentence "Everything is purged from the painting but art." A group exhibition devoted exclusively to the work of conceptual artists, *January 1–31: O Objects, O Painters, O Sculptors*, mounted by the New York dealer Seth Siegelaub in 1969, featured Kosuth, Robert Barry (b 1936), Douglas Huebler (1924–97) and Lawrence Weiner; later that year Siegelaub followed this with *March 1–31*, an exhibition that existed only in catalogue form, in which he included 31 conceptual artists, among them LeWitt, Atkinson,

Baldwin and Kosuth. Other group exhibitions soon followed, helping to define the terms of the movement. These included *When Attitudes Become Form* (Berne, Ksthalle; Krefeld, Kaiser Wilhelm Mus.; London, ICA; 1969); *Conceptual Art, Arte Povera, Land Art* (Turin, Gal. Civ. A. Mod., 1970), which presented conceptual art in relation to two movements emerging at the same time, and *Information* (New York, MOMA, 1970).

A prime concern of certain conceptual artists was with the context in which the work was exhibited. From the time of his first exhibition at the Galerie Fournier in Paris (March 1966), for example, Daniel Buren showed only striped paintings to focus the viewer's attention on their specific location rather than on their physical attributes. One phase of the *Street Work* made in New York in 1969 by Marjorie Strider (b 1934) consisted of 30 empty picture frames presented as "instant paintings" and installed to make passers-by aware of their environment. In late 1969 Jan Dibbets invited recipients to return one page of his *Art and Project Bulletin* to him by post; he then used their addresses to construct a world map on which he noted their locations in relation to his own studio in Amsterdam. On a much smaller but equally exact scale Mel Bochner in his *Measurement Series* (Munich, Gal. Heiner Friedrich, 1969) displayed the precise measurements of the exhibition space on its walls. Other artists were more concerned with the political, rather than purely physical, ramifications of the context, as in the case of the Rosario group's extended street "exhibition" throughout northwest Argentina in November 1968, which consisted solely of the name Tucumán, an allusion to public protests over work conditions by workers from that province. In New York in May 1970, during the insurrectional period surrounding the Vietnam War and the Civil Rights movement, Adrian Piper presented a work that stated simply that it had been withdrawn "as evidence of the inability of art expression to have meaningful existence under conditions other than those of peace, equality, truth, trust, and freedom."

Elevating the conception of the work of art above its execution, conceptual artists were keen to demystify the creative act and to democratize the role of the artist and public alike by decentralizing control away from institutions such as commercial galleries. For many this could be achieved simply by not producing works as saleable commodities; hence, the preference for temporary installations, performances or written texts over finite objects. Part of the *Experimental Art Cycle* presented by the Rosario group in 1968 consisted of an empty room with a square drawn on the floor, accompanied by a page of instructions exhorting the spectator to construct a similar work elsewhere. Wiener, who stated that it was enough to know about his works to possess them, felt that any conditions imposed on the spectator constituted "aesthetic fascism" (see Meyer, p. 218). As a corollary to this attack on the monopoly control of the artist, Huebler advocated the supercession of art as object-making or commodity production, since "the world is more or less full of objects, more or less interesting; I do not wish to add any more" (Meyer, p. 137). Similarly, it was to the ICA of London in 1968 that Rasheed Araeen of Pakistan submitted a proposal for the conceptual deconstruction of his own minimalist sculpture there (100 cubes, 18×18" each), so that the audience would continually dismantle and reassemble this sculpture during the duration of the show. Another, sometimes countervailing tendency of conceptual art concentrated on the self-referentiality of art, in order to address it as a language or as a form of logic. This position was represented in its most single-minded form by Kosuth, for whom art was merely a self-validating tautology, and in its most wide-ranging sense by *Art & Language*, which saw art in more expansive terms.

Evolution in the 1970s and 1980s. The theoretical impasse brought about in particular by Kosuth's insistence on the primacy of an artist's intentions was broken only by the ascendancy in the early 1970s of conceptual artists such as Buren and Hans Haacke, who recognized that the formative idea was

only one aspect of the systemic process whereby the work of art acquired signification or "completion" in society. Haacke in particular created works that deftly disclosed the conceptual role of institutions in framing all art, so that its meaning went far beyond the artist's original conception. Such works can be referred to as "meta-conceptual," since they address the conditions preceding the production of all works of art and later influencing their public reception. Haacke neither privileged his own concepts as art nor resorted to an anti-art assault on the aura in which high art is institutionally encased. He instead presented works as so formally cool and so reticent with regard to his intention that their most obvious characteristic became their aura as art, as evoked by corporate patrons in remarks photo-engraved on the six plates of the series *On Social Grease* (e.g. *On Social Grease, No. 2*, 1975; Detroit, MI, Mr. and Mrs. Gilbert Silverman priv. col.). Haacke's self-conscious removal from the opinions he quoted enabled him to force cultural institutions to face the fallacy of their own modes of appropriating art, since they were shown saluting art's "purity" and purported detachment within the "impure" context of social manipulation. Ironically, then, art was shown to be useful to corporate patrons precisely because of the myth of art's "uselessness." Haacke and other conceptual artists such as Victor Burgin demonstrated that the context of art was ideologically evasive in that it could be identified only to the extent that the institutions framing it allowed it to be.

In the 1980s there emerged a new generation of artists who were indebted to conceptual art, particularly to the critical mode formulated by artists such as Haacke and Buren. These artists, along with the Americans Sherrie Levine, Barbara Kruger, Jenny Holzer and Rudolf Baranik, extended the critical focus to include the intersection between the institutional concerns of the art world and other social and political matters such as those pertaining to gender or race. The subtitle of a photograph of two classical statues by the American artist Louise

CONCEPTUAL ART. *Art as Idea as Idea, The First Investigation* by Joseph Kosuth, 1.2 × 1.2 m, 1967; Hamburger Kunsthalle, Hamburg. © DACS/THE BRIDGEMAN ART LIBRARY

Lawler, *Sappho and Patriarch* (1984; see Foster, p. 98), consists of a question that in many ways encapsulates a major concern of this particular generation of conceptual artists: "Is it the work, the location or the stereotype that is the institution?" Over the past decade and a half, Hans Haacke has taken conceptual art into yet other, equally prominent directions on the international stage. In 1993, Haacke represented Germany at the Venice Biennial and his work there, *Germania*, consisted in part of the systematic destruction of the marble floor in the national pavilion that had been added to the building by the Nazis in the 1930s. With this piece the dematerialization of the art object became synonymous with the demolition of part of the art institution in which the work was exhibited. In 2000, Haacke received another public commission from the German government that allowed him to temporarily propose the renaming of the text on the Reichstag's façade, from "To the Folk (VOLK)" to "The People or Citizens" (Der Bevölkerung), thus shifting the dedication to be based on citizenship, not race, as a defining feature of the German state. In this case, Haacke's piece was debated on the floors of the German Parliament—and on television—before execution of it was allowed.

WRITINGS

U. Meyer, ed.: *Conceptual Art* (New York, 1972)

D. Buren: "Function of the Museum," *Artforum*, xii/1 (1973), p. 68

M. Sanouillet and E. Peterson, eds: *Salt Seller: The Writings of Marcel Duchamp* (New York, 1973)

H. Haacke: *Framing and Being Framed: Seven Works* (Halifax, NS, 1975)

D. Buren: *Reboundings* (Brussels, 1977)

General Idea (exh. cat., New York, 49th Parallel Gal., 1981)

H. Haacke: "Museums, Managers of Consciousness," *A. Amer*, lxxii/2 (1984), pp. 9–16

BIBLIOGRAPHY

E. Holt, ed.: *Documentary History of Art*, ii (New York, 1947), p. 145

G. Celant: *Arte Povera* (New York, 1969)

A. Schwarz: *The Complete Works of Marcel Duchamp* (New York, 1969)

Conceptual Art and Conceptual Aspects (exh. cat., New York, Cult. Cent., 1970)

K. Honnef: *Concept Art: Versuch einer Concept Art Theorie* (Cologne, 1971)

P. Maenz and G. de Vries, eds: *Art and Language* (Cologne, 1972)

E. Migliorini: *Conceptual Art* (Florence, 1972)

H. Rosenberg: *The De-definition of Art* (New York, 1972)

G. Battock, ed.: *Idea Art: A Critical Anthology* (New York, 1973)

L. Lippard: *Six Years: The Dematerialization of the Art Object from 1966–1972* (New York, 1973)

R. Wollheim: *On Art and the Mind* (Cambridge, MA, 1974)

Art and Language: 1966–1975 (exh. cat., Oxford, MOMA, 1975)

C. Russell: "Towards Tautology: The Nouveau Roman and Conceptual Art," *Mod. Lang. Notes*, xci/5 (1976), pp. 1044–60

W. Fowkes: "An Hegelian Critique of Conceptual Art," *J. Aesth. & A. Crit.*, xxxviii/2 (1978), pp. 157–67

D. Kuspit: "Sol LeWitt the Wit," *A. Mag.* [prev. pubd as Arts [New York]; A. Dig.], lii/8 (1978), pp. 118–25

R. Morgan: "Conceptual Art and the Continuing Quest for a New Social Context," *J. S. CA A. Mag.*, 23 (1979), pp. 30–6

H. Osborne: "Aesthetic Implications of Conceptual Art, Happenings, etc.," *Brit. J. Aesth.*, xx/1 (1980), pp. 6–20

R. Smith: "Conceptual Art," *Concepts of Modern Art*, ed. N. Stangos (London, 1981), pp. 256–72

D. Craven: "Hans Haecke's Cunning Involvement," *The Unnecessary Image*, eds P. D'Agostino and A. Muntadas (New York, 1982), pp. 21–5

C. Harrison and F. Orton: *A Provisional History of Art and Language* (Paris, 1982)

C. Robins: *The Pluralist Era: American Art, 1968–1981* (New York, 1984)

H. Foster: *Recordings* (Port Townsend, WA, 1985)

D. Craven: "Hans Haacke and the Aesthetics of Dependency Theory," *A. Mag.* [prev. pubd as Arts [New York]; A. Dig.], lxi/7 (1987), pp. 56–8

I. Sandler: *American Art of the 1960s* (New York, 1988), pp. 343–58

Art conceptuel formes conceptuelles/Conceptual Art Conceptual Forms (exh. cat., Paris, Gal. 1900–2000, 1990)

L'Art conceptuel, une perspective (exh. cat., Paris, Mus. A. Mod. Ville Paris, 1990)

R. Morgan: *Art into Ideas: Essays on Conceptual Art* (Cambridge, 1996)

A. Alberro and B. Stimson: *Conceptual Art: A Critical Anthology* (New York, 1999)

Global Conceptualism: Points of Origin, 1950s-1980s (exh. cat., New York City, Queens Mus. A., 1999)

R. Araeen: "A Suspressed History of Conceptual Art in Post-War Britain" (21 April 1999), personal papers of Rasheed Araeen, London

A. Alberro: *Conceptual Art & the Politics of Publicity* (New York, 2003)

D. Kuspit: *The End of Art* (Cambridge, 2004)

A. Alberro and S. Buchmann: *Art after Conceptual Art* (New York, 2006)

David Craven

Concrete poetry

Art form developed in the 1950s and 1960s based on the visual aspects of words. In contrast to "shaped" poetry, in which the meaning of a text is enhanced by the relationship between a sequence of lines and the overall pattern or silhouette that these lines create on a page (as in George Herbert's "Easter-Wings," 1633, and Guillaume Apollinaire's *Calligrammes*, 1918), Concrete poetry largely dispenses with conventional line and syntax. It may bring into use not only a wide range of typefaces but also other elements derived from calligraphy, collage, graphics and computer-generated shapes. It can appropriately be considered a visual art, although it is also a literary one.

The term Concrete poetry as a designation for words in a spatially inventive context was devised in 1955 by Eugen Gomringer (*b* 1925), then working in Ulm as secretary to Max Bill, and Decio Pignatari (*b* 1927), a Brazilian teacher of industrial design. Pignatari had been a founder-member of the Noigandres group of experimental poets in 1952, and Gomringer had published a volume of *Konstellationen* (Berne) in 1953. From this period onward Pignatari, together with his Noigrandes colleagues Augusto de Campos (*b* 1931) and Haroldo de Campos (*b* 1929), viewed a range of references in avant-garde music and literature as relevant to their work, which was lyrical, exuberant, literally colorful and often socially pointed. Gomringer, in common with other German-speaking poets, preferred the sobriety of Bauhaus typography and looked up to the rigorous example of Swiss Concrete art. His poems involved words and phrases repeated and permuted as in a litany, and one collection took the devotional form of a Book of Hours (*Das Stundenbuch*, Munich, 1965).

From *c.* 1965 Concrete poetry was being celebrated throughout Europe and America in little magazines, exhibitions and anthologies. Its rise coincided with a revival of interest in the Modern Movement, which also found expression in the popularity of Op art and kinetic art. In the 1970s it suffered an eclipse. Nevertheless, several important poets, besides the original group, continued to publish work that identified closely with the movement, notably Robert Lax (1915–2000), an American living in Greece, and Pierre Garnier (*b* 1928), pioneer of Concrete poetry in France, as well as John Cage. The foremost Concrete poet in Britain is Ian Hamilton Finlay, who expanded his range to include poem-prints, cards and booklets published through his Wild Hawthorn Press (founded 1961). His concern with inscription and his fame as a garden designer can be traced back to the catalytic effect of Concrete poetry.

[*See also* Cage, John.]

BIBLIOGRAPHY

S. Bann: *Concrete Poetry: An International Anthology* (London, 1967)

J. Hollander: *Types of Shape* (New Haven, 1967, rev. 1991)

E. Williams: *An Anthology of Concrete Poetry* (New York, 1967)

P. Garnier: *Spatialisme et poésie concrète* (Paris, 1968)

E. Gomringer: *Worte sind Schatten* (Hamburg, 1969)

M. E. Solt: *Concrete Poetry: A World View* (Bloomington, 1970)

S. Bann: "Constructivisme," *Les Avant-gardes littéraires au XXe siècle*, ed. J. Weisgerber (Budapest, 1984), pp. 1010–24

C. A. Taylor: *A Poetics of Seeing: The Implications of Visual Form in Modern Poetry* (New York, 1985)

E. Bollobás: "Poetry of Visual Enactment: The Concrete Poem," *Word & Image*, 2/3 (July–Sept 1986), pp. 279–85

R. Grimm and J. Hermand, eds: *From Ode to Anthem: Problems of Lyric Poetry* (Madison, WI, 1989)

W. Haas: *Sprachtheoretische Grundlagen der Konkreten poesie* (Stuttgart, 1990)

C. Espinosa, ed., *Corrosive Signs: Essays on Experimental Poetry (Visual, Concrete, Alternative)* (Washington, DC, 1990)

V. Pineda: "Speaking about Genre: The Case of Concrete Poetry," *New Lit. Hist.*, 26/2 (Spring 1995), pp. 379–93

E. Gomringer and others: *Theorie der konkreten Poesie: Texte und Manifeste, 1954–1997* (Vienna, 1997)

J. Morrison and F. Krobb, eds: *Text into Image: Image into Text* (Amsterdam, 1997)

S. Scobie: *Earthquakes and Explorations: Language and Painting from Cubism to Concrete Poetry* (Toronto: 1997)

C. Clüver, ed. and others: *The Pictured Word:* (Amsterdam, Netherlands, 1998)

J. Linschinger, ed.: *Poesie: Konkret, Visuell, Konzeptuell* (conf. proceedings, Vienna, 1999)

W. Bohn: *Modern Visual Poetry* (Newark and London, 2001)

R. Krüger: "Concrete Poetry," *Brazilian Writers*, eds: M. Rector and F. M. Clark (Detroit, MI, 2005), pp. 405–15

A. K. Schaffner: "Inheriting the Avant-Garde: On the Reconciliation of Tradition and Invention in Concrete Poetry," *Neo-Avant-Garde*, ed. and introd. by D. Hopkins (Amsterdam, Netherlands, 2006), pp. 97–117

B. Spatola. *Toward Total Poetry*, trans. from the Italian by B. W. Hennessey and G. Bennett, (Los Angeles, 2008)

Stephen Bann

Condo, George

(*b* Concord, NH, 10 Dec 1957), painter and draftsman. He emerged in the mid-1980s with figurative paintings in an often expressive but mannered style. The figures generally had comical features bordering on the caricatural, such as large noses or bulbous eyes, and they seemed to parody earlier styles and genres of painting. *Italian Still Life* (1985; see W. Dickhoff) employs the image of a painter's palette to make a clown's head, which stands against a broadly described landscape background. Condo's interest in bringing a Pop sensibility to bear on earlier, canonical art was also echoed around this time in his drawings, many of which display a rather parodic affinity with the work of Picasso. In the late 1980s and early 1990s Condo produced a series of nudes and portraits in a style resembling Picasso's late work; during the same period he evolved a kind of fusion between Cubism and biomorphic abstraction in pictures depicting muscular forms erupting from fissures in the surface. *Infinite and Exfinite* (1986; see Dickhoff) demonstrates a development of this disjunctive style, in which Condo presented elements reminiscent of the work of Picasso and Joan Miró in a series of small drawings combined with gold leaf. Around the late 1980s Condo began to introduce figures from 17th-century Spanish court portraiture into fantastical backdrops, ushering in a new interest in the history of flattering depictions of rich patrons. *The Gardener's Dream* (1995; see 1995 exh. cat., p. 29) demonstrates a typical subject that evolved out of this series: an image set in a lush green landscape of a woman with an ovoid head and jewel-like baubles for features clutches a branch and a bird as an obscure symbolic attribute.

BIBLIOGRAPHY

W. Dickhoff: *George Condo: Paintings and Drawings 1985–7* (Zurich, 1987)

George Condo (exh. cat., essay W. Dickoff, New York, Pace Gal., 1991)

George Condo (exh. cat., essay W.S. Burroughs, New York, Pace Gal., 1994)

George Condo: Paintings and Drawings (exh. cat., essay D. Kuspit, New York, Pace Gal., 1995)

P. Plagens: "Fake Tiepolos and the Cabbage Patch Queen," *ARTnews*, 106/7 (July 2007), pp. 182–5

M. Falconer and G. Condo: "George Condo," *Art World* 5 (June–July 2008), pp. 62–7

Morgan Falconer

Cone

Family of collectors. Claribel Cone (*b* Jonesboro, TN, 14 Nov 1864; *d* Lausanne, 20 Sept 1929) studied medicine at Johns Hopkins University, Baltimore, MD, and her friendship with fellow student Gertrude Stein led to close contact between the two families from the 1890s. Claribel's sister Etta Cone (*b* Jonesboro, TN, 30 Nov 1870; *d* Blowing Rock, NC, 31 Aug 1949) was the first to travel to Europe in 1901, and she was there again from June 1904 to April 1906, meeting Picasso through Gertrude Stein in November 1905 and Matisse in January 1906 through Sarah Stein. After these two studio visits, the Cone sisters began collecting work by both artists and by those artists Matisse and Picasso had led them to admire, including Corot, Cézanne, Renoir, Manet, Degas and Gauguin.

Among the important Picasso works owned by the Cones, some were acquired from the Steins, such as the portrait of *Allan Stein* (1906; Baltimore, MD, Mus. A.). It was Matisse's work, however, that rapidly became the focus of their collection. Their works by Matisse, including a concentration of odalisques and interiors from the 1920s and 1930s, eventually included 42 paintings, 18 sculptures, 36 drawings, 155 prints and 7 illustrated books.

After Claribel's death, Etta continued adding to the collection. She visited Matisse annually to buy key works reserved for her and commissioned him to make a posthumous portrait of her sister. He sent her ten superb drawings (six of Claribel, four of Etta) made between 1931 and 1934. In 1932, at the artist's suggestion, she bought Matisse's 250 original designs for Mallarmé's *Poésies* (in effect, all his work for the whole of 1931). Etta bequeathed the full collection of more than 3000 items—mostly paintings, drawings and sculptures but also fabrics and *objets d'art*—to the Baltimore Museum of Art.

BIBLIOGRAPHY

B. Richardson: *Dr Claribel and Miss Etta: The Cone Collection of the Baltimore Museum of Art* (Baltimore, MD, 1985)

M. Gabriel: *The Art of Acquiring: A Portrait of Etta and Claribel Cone* (Baltimore, 2002)

C. K. Snay: "Acquiring Minds: The Early Patrons of Nineteenth-Century French Drawings in Baltimore," *Master Drawings*, 42/1 (Spring 2004), pp. 68–77

Isabelle Monod-Fontaine

Coney, John

(*b* Boston, MA, 5 Jan 1656; *d* Boston, 20 Aug 1722), silversmith, goldsmith and engraver. The son of a cooper, Coney probably served his apprenticeship with Jeremiah Dummer (1645–1718) of Boston. Coney may have engraved the plates for the first banknotes printed in the Massachusetts Bay Colony in 1690 and certainly engraved the plates for those issued in 1702. His patrons included important citizens of Boston, churches throughout New England, local societies and Harvard College. Active as a silversmith and goldsmith for 45 years, he produced objects in three distinct styles—that of the late 17th century (characterized by engraved and flat-chased ornament and scrollwork), the early Baroque and the late Baroque (or Queen Anne)—and introduced specialized forms to New England, for example the monteith and chocolatepot. Although derived directly from the English silversmithing tradition and thus not innovative in design, Coney's work exhibits excellent craftsmanship in all technical aspects of gold- and silversmithing. Two lobed sugar-boxes (Boston, MA, Mus. F. A., and Manchester, NH, Currier Gal. A.), a large, gadrooned, two-handle cup (1701; Cambridge, MA, Fogg) made for William Stoughton (*d* 1701), the earliest New England chocolatepot (Boston, MA, Mus. F. A.) and a monteith made *c.* 1705–15 for John Colman (New Haven, CT, Yale U. A.G.) are among the objects he made in the Baroque style. His pear-shape teapot of *c.* 1710 made for the Mascarene family (New York, Met.) and a two-handle covered cup (1718; Shreveport, LA, Norton A.G.) and a monteith (1719) made for the Livingston family (New York, Franklin D. Roosevelt Lib.) are superb examples of the curvilinear Queen Anne style that was never widely popular in Boston. The more than 100 surviving

objects bearing his mark illustrate the Rev. Thomas Foxcroft's observation that Coney was "*excellently talented* for the Employment assign'd Him, and took a peculiar Delight therein."

[*See also* Boston.]

BIBLIOGRAPHY

T. Foxcroft: *A Funeral Sermon Occasion'd by Several Mournful Deaths, and Preach'd on the Decease of Mr. John Coney, Late of Boston, Goldsmith* (Boston, 1722), p. 63

H. F. Clarke: *John Coney, Silversmith, 1655–1722* (Boston and New York, 1932/R New York, 1971)

H. N. Flynt and M. Gandy Fales: *The Heritage Foundation Collection of Silver, with Biographical Sketches of New England Silversmiths, 1625–1825* (Old Deerfield, MA, 1968), pp. 188–9

B. McLean Ward: *The Craftsman in a Changing Society: Boston Goldsmiths, 1690–1730* (diss., Boston U., 1983), pp. 169–75, 350

P. E. Kane and others: *Colonial Massachusetts Silversmiths and Jewelers: A Biographical Dictionary* (New Haven, 1998), pp. 315–34

B. L. Scherer: "Silver," *A. & Auction*, xxiv/4 (April 2002), p. 108

J. Falino and G. W. R. Ward, eds: *Silver of the Americas, 1600–2000* (Boston, 2008), pp. 39–54

Gerald W. R. Ward

Congdon, Henry Martyn

(*b* New Brighton, NY, 10 May 1834; *d* New York, 28 Feb 1922), architect and designer. Congdon's father was a founder of the New York Ecclesiological Society, giving Congdon a propitious beginning to his career as a preferred Episcopal church architect. In 1854 he graduated from Columbia College and was then apprenticed to John W. Priest (1825–59), a leading ecclesiological architect in New York. When Priest died five years later, Congdon inherited the practice. He then moved to Manhattan where he collaborated, from 1859 to 1860, with Emlen T. Littel and later, from around 1870 to 1872, with J. C. Cady (1837–1919). Congdon otherwise practiced alone until 1901, when he was joined by his son, Herbert Wheaton Congdon.

Throughout his career Congdon adhered to the ecclesiological tenets he had adopted in his youth.

Aside from an occasional deviation, such as his robust Romanesque St James's Episcopal Church, Cambridge, MA (1888), he worked most often in the English Gothic Revival style but treated it in a personal, less archaeologically correct manner. His richly textured churches are often distinguished by prominent towers, compact picturesque massing and a wealth of painstaking detail. His St Andrew's Church, New York (1889–91), is a ruggedly picturesque Gothic Revival building with rock-face granite walls, a lofty spire off the south transept, a projecting gabled entrance porch on the southwest, a steeply pitched slate roof and deeply set portals, reveals and buttresses. He frequently assumed responsibility for all interior furnishings, including stained glass, pastoral staves and plate.

Most of Congdon's churches are located in the northeast of the USA, particularly in Connecticut and New York. However, he also carried out numerous ecclesiastical commissions in the Midwest, most notably St Michael's Episcopal Cathedral, Boise, ID (1899).

UNPUBLISHED SOURCES

H. W. Congdon: "Autobiography," *Eugene, U. Oregon*, Special Cols [typescript]

BIBLIOGRAPHY

Macmillan Enc. Archit.

G. W. Shinn: *King's Handbook of Notable Episcopal Churches in the United States* (Boston, 1889)

Obituary, *Amer. Archit.*, 121 (12 April 1922), p. 16

Obituary, *Amer. Inst. Archit. J.*, 10 (1922), p. 134

Obituary, *New York Times* (2 March 1922), p. 18

P. B. Stanton: *The Gothic Revival and American Church Architecture: An Episode in Taste, 1840–56* (Baltimore, 1986), pp. 187, 286, 301

Janet Adams

Conner, Bruce

(*b* McPherson, KS, 18 Nov 1933; *d* San Francisco, 7 July 2008), sculptor, collagist, draftsman and filmmaker. Conner attended the University of Nebraska, Lincoln, finishing his studies in 1955. Soon after he moved to San Francisco, where he immersed himself

also made strange, disquieting sculpture that paid homage to Marcel Duchamp, such as *The Bride* (1960; Minneapolis, MN, Walker A. Cent.) and *The Marcel Duchamp Travelling Box* (1963; New York, Guggenheim Mus.), showing his interest in morbid erotic desire. In the mid-1960s, Conner abandoned his collage technique and made drawings that reflected his interest in altered perceptions, as in the *Mandala Series*, such as *Untitled* (1965; Berkeley, U.CA, A. Mus.). Conner continued to make films into the late 1970s, and at the beginning of the 1980s he embarked on a series of collages that juxtapose motifs from 18th- and 19th-century etchings with modern technical drawings. The effect of works such as *Christ Casting out the Legions of Devils* (1987; see 1999 exh. cat., p. 36) recalls the surrealist collages of Max Ernst, but with a dark, psychedelic inflection.

BIBLIOGRAPHY

Bruce Conner: Sculpture, Assemblages, Collages, Drawings, Films (exh. cat., essay by J. C. Siegfried, Philadelphia, U. PA, ICA, 1967)

Angels: Bruce Conner (exh. cat., essay by J. Cizeck, San Francisco, CA, MOMA, 1992)

2000 BC: The Bruce Conner Story Part II (exh. cat., essays by P. Boswell, J. Rothfuss and B. Jenkins, Minneapolis, MN, Walker A. Cent., 1999)

B. Jenkins: "Bruce Conner's Report: Contesting Camelot," in *Masterpieces of Modernist Cinema* (Ed. T. Perry; Bloomington, IN, 2006), pp. 236–51

B. Jenkins: "A Life in Two Parts: On Bruce Conner (1933–2008)," *Artforum* 47/2 (2008), pp. 85–8

K. Hatch: "'It has to do with the Theater': Bruce Conner's Ratbastards," *October* 127 (2009): 109–32

J. McKinnon: "End Notes: Bruce Connor, 1933–2008," *X-TRA: Contemp. A. Quart.* 11/4 (2009), pp. 66–9

Francis Summers

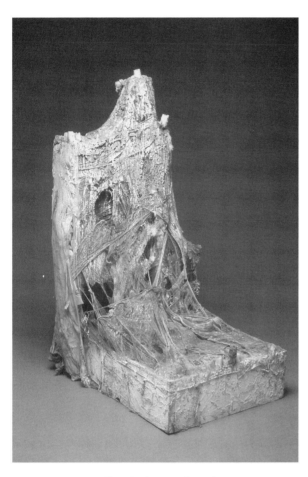

BRUCE CONNER. *The Bride*, wood, nylon, string, wax, paint, candles, costume jewelry, marbles and paper doily, h. 965 mm, 1960–61; Minneapolis, MN, Walker Art Center. Braunstein Quay Gallery and T. B. Walker Acquisition, Fund, 1987 © 2010 CONNER FAMILY TRUST, SAN FRANCISCO/ARTISTS RIGHTS SOCIETY, NY

in its prevalent Beat culture. His early work was principally a form of collage or assemblage, as in *Spider House Lady* (1959; Oakland, CA, Mus.) in which he gathered together decayed print and other fetid matter, wrapped in string nylon, an effect that gave his work a mummified, funereal pallor. Conner also made films reflecting his practice of recycling images from America's media culture. Using film stock from movies intended to be projected at home, Conner created a collage of various Hollywood stereotypes in *A Movie* (1958; see 1999 exh. cat., p. 189), a work that established him as an important underground filmmaker. Conner

Constructivism

Twentieth-century art movement that originated in Russia in 1921 and spread internationally during the 1920s. Constructivists sought to extend their abstract, geometric art into the realm of practical design work, while being inspired by modern

technology and engineering. In a more general sense, the term Constructivism can also be applied to works "constructed" of geometric and linear elements, with clear, simple designs and often made of modern materials. American artists became interested in Constructivist principles in the late 1920s. The theoretical basis for this involvement in Constructivism by a few American modernists was their knowledge of innovations at the Bauhaus, those of Russian Constructivists and artists of the Dutch group De Stijl. These young progressives, attuned to the achievements of Constructivists abroad, responded to the call for a "truly American" art.

While direct carving of the figure occupied most modernists among American sculptors of the late 1920s and 1930s, a few were inspired by the European vanguard to explore new aesthetic concepts and materials. Such artists as Alexander Calder, Theodore Roszak, Ibram Lassaw, Jose De Rivera and others assimilated Constructivist principles and created non-objective works that acknowledged modern technology, industrial methods and scientific discoveries. Although these pioneers had limited critical attention and public acclaim in this decade, they were the American precedents for a younger generation of sculptors who created large-scale constructions in industrial materials during the postwar years. Only Calder received recognition for his invention of the mobile and the stabile: his painted metal works based on Constructivist principles which he combined with his practical skills in mechanical engineering. The other vanguard sculptors, several of whom were active on the Federal Arts Project of the Works Progress Administration (WPA) had no solo exhibitions in the period, few if any sales and virtually no critical attention. Calder's motorized *Universe* was purchased by the Museum of Modern Art, New York, in 1934.

The achievement of these few American artists who explored new approaches to sculpture based on International Constructivism has not received attention in art historical literature. These works represent an attempt to create a machine-age art

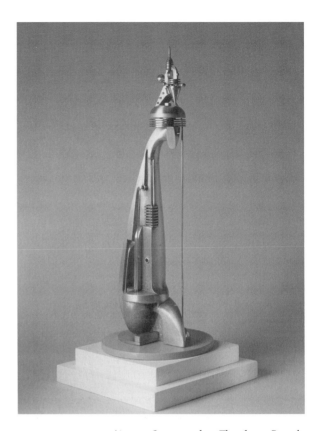

CONSTRUCTIVISM. *Airport Structure* by Theodore Roszak, copper, aluminum, steel and brass, h. 486 mm, 1932. © ESTATE OF THEODORE ROSZAK/LICENSED BY VAGA, NY/THE NEWARK MUSEUM/ART RESOURCE, NY

and to establish an indigenous style derived from the industrial technology that was the promise of a better life in America. At a time when many American painters turned to regionalism and the extolling of homespun American values, and some American sculptors explored social protest, these artists took a more idealistic view of the world. Roszak was among the most dedicated in his involvement with the machine as a means to create ideal and fantastic forms. But other artists shared his views that their art should be directly related to contemporary life, to the rhythms and forces of a technological age. In the early 1930s these artists created works that adhered to concepts and the physical appearances of their European counterparts. In the "Americanization of Art," which appeared in the catalogue for the *Machine-Age Exposition* held in New York in 1927, Louis Lozowick, a Russian immigrant, observed that

America had new material for creative activity: "The history of America is a history of gigantic engineering feats and colossal mechanical construction." Alexander Archipenko, born in the Ukraine and steeped in Cubism and Futurism from his years in Paris, published an essay entitled "Machine and Art" in the same catalogue: "Let us take the present epoch—the Machine Age. . . . Since Art is the reflection of life, it is evident that the art of today must be bound to Action." Despite his frequent use of industrial materials and his acknowledged inspiration from science and the modern city, Archipenko's works remain figurative. But he was an important teacher in the USA, introducing progressive ideas.

By the early 1930s there was a growing awareness of the link between American technology and art in such shows as *The Machine Art Exposition*, held in New York in 1927, the *Machine Art* show at the Museum of Modern Art in 1934 and *Dynamic Design* at the Philadelphia Art Alliance also in 1934. The *Machine Art Exposition* was the most ambitious in incorporating the work of artists, industrial designers and architects. Louis Lozowick published *Modern Russian Art* in 1925. This book was made available through the Société Anonyme and was an acknowledged source of information about the Russian avant-garde for American artists. In his text, Lozowick introduced the concepts of Russian Constructivism and illustrated them with some examples. After mentioning the names of the gifted Russian artists and theorists who supported this doctrine, Lozowick made the distinction between the Productivists and those who "grant the legitimacy of artistic activity but would transform it in harmony with the new age." Lozowick outlined the aesthetic concepts of the Constructivists:

> Arts should have its roots in the weightiest realities of our day. These are science and industry. The constructivists, therefore, go for instruction to science and borrow an example from industry. Like science, they aim at precision, order, organization; like industry, they deal with concrete materials: paper, wood, coal, iron, glass. Out of these new objects—not pictures—are created, not imitative of reality, but built with a structural logic to be utilized eventually, just as steam was utilized long after its discovery . . .

Lozowick commented on the sensitivity shown by Vladimir Tatlin (1885–1953) to the properties of materials, allowing the forms to be dictated by the individuality of each element. The author also discussed Naum Gabo who "introduces dynamics into his work and seeks to establish in his sculpture an interrelation of forces rather than of masses." Through this publication American artists could gain basic information about the tenets of Constructivism. Through exhibitions in New York and elsewhere in the 1920s, artists had opportunities to study related works by Russian, German and Dutch artists. The Société Anonyme, the first museum of modern art, was instrumental in informing American artists and the public about vanguard European art, as well as providing opportunities for the exhibition of progressive American artists. In 1923, an exhibition of Russian art was held at the Brooklyn Museum, and in the following years works by Kazimir Malevich (1878–1935), Konstantin Medunetsky (1899–c. 1935), Tatlin, Vladimir Stenberg (1899–1982), Georgy Stenberg (1900–33) and others were presented. In 1926 the International Exhibition of Modern Art sponsored by the Société Anonyme included works from 23 countries and the first America presentation of Constructivists such as Carl Buchheister (1890–1964), César Domela (1900–92), Georges Vantongerloo (1886–1965) and others. The Little Review Gallery, co-sponsor of the *Machine-Age Exposition*, also showed works by Gabo, Antoine Pevsner (1886–1962) and other Constructivists on a regular basis. In the 1920s, the quarterly journal, *Little Review*, featured articles on Constructivism and De Stijl artists.

In addition to the exhibitions and publications of the 1920s, American Constructivists acknowledged the importance of a single book to their personal development during the following decade: László

Moholy-Nagy's *The New Vision*. Many of the ideas advanced by the Russian Constructivists found acceptance at the Bauhaus, and Moholy-Nagy, instructor in three-dimensional design at the Bauhaus, developed his own concepts for sculpture in the machine age. *The New Vision*, originally a Bauhaus book entitled *Von Material zu Architektur*, was first published in an English edition in 1930, and included reproductions of recent works by Moholy-Nagy, his Bauhaus students and other progressive artists.

Moholy-Nagy wrote specifically of the new possibilities for sculpture, outlining five stages of development of three-dimensional pieces on the basis of the working of materials. He gave particular attention to "equipoised and kinetic sculpture." Studies in balance were reproduced and Moholy-Nagy proposed that sculptors could benefit from more knowledge of engineering problems. Kinetic sculpture was designated by the author as "the highest sublimation of volume content." Illustrating his *Space-Light Modulator*, Moholy-Nagy proposed light as spatial projection and as an excellent means for attaining virtual volumes. Scientific models are also presented as a basis for Constructivist exploration.

Knowledge of the tenets of Constructivism, machine aesthetics and the extolling of contemporary industrial technology were important factors in the creation of vanguard sculpture by Americans during the 1930s and after. Generally, the work of these artists shares some characteristics, although each modernist did develop a personal style. Their works are constructed or assembled of disparate materials, often metals combining planar elements rather than joining solid sculptural masses. The works are open-space constructions, relying on linear elements as well as solid forms, and often new materials are used, for example metals, particularly those with highly polished surfaces such as those chosen for industrial design in the period.

Alexander Calder, for example, continued the exploration of concepts of the universe that initially appeared in the works of Moholy-Nagy, Vasily

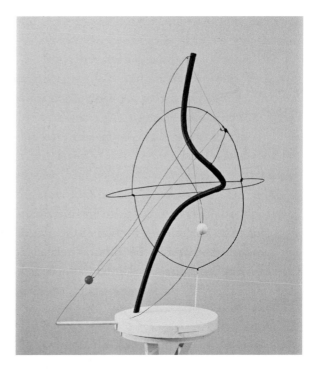

CONSTRUCTIVISM. *A Universe* by Alexander Calder, motor-driven mobile painted iron pipe, wire and wood with string, h. 1.03 m, 1934. GIFT OF ABBY ALDRICH ROCKEFELLER [BY EXCHANGE] © ARTISTS RIGHTS SOCIETY, NY/IMAGE 9C/THE MUSEUM OF MODERN ART/LICENSED BY SCALA/ART RESOURCE, NY

Kandinsky (1866–1944) and other Bauhaus artists, as well as expanding the study of forms in notion begun by Naum Gabo. Among American sculptors of the 1930s, Calder was one of the major innovators and a pioneer in the assimilation of Constructivist principles. His education in engineering at the Stevens Institute of Technology assured his facility with mechanical devices. He took courses in applied kinetics and physics and worked for four years as an engineer before enrolling at the Art Students League. Calder was the first American artist to develop a sculptural idiom based on disparate components freely arranged in space. Ultimately Calder was able to expand the concept of moving sculpture beyond the conclusions drawn by Gabo, Aleksandr Rodchenko (1891–1956), Moholy-Nagy and others. By 1933 Calder had determined to "compose motions" in addition to arranging shapes and varying colors in space.

By the mid-1930s biomorphic shapes related to the imagery of Joan Miró (1893–1983) and Hans Arp (1886–1966) joined the biotechnical forms previously used in Calder's mobiles, but Constructivist principles continued to be the basis for his kinetic and static works. Calder's innovations had an impact on his American contemporaries when his constructions were exhibited in New York, beginning in 1932. Ibram Lassaw acknowledged the influence of Calder on his own development of open-space constructions. Theodore Roszak's constructions of the 1930s form a significant portion of the innovative production that can be directly related to Constructivist principles. In addition to the undeniable "machine-made" appearance of his constructions, his works seem equivalent to machines: turbines, engines related to aviation, or even fantastic rockets intended for travel in outer space. Charles Biederman created relief constructions and a few examples of non-objective sculpture during the 1930s. Jose De Rivera made constructions based on the concepts of space and time developed by the Constructivists. His *Flight*, commissioned for Newark Airport in 1938, is a machine form that seems to describe airborne velocity. The emergence of Constructivism in the work of a few Americans during the 1930s assured the viability and continuity of the achievements of the Bauhaus and their survival into the postwar period. These artists carried the principles of Constructivism through the 1940s. Subsequently other artists, such as George Rickey, Richard Lippold, Sidney Gordin (1918–96) and others assured that the legacy of Constructivism would continue in American art.

[*See also* Archipenko, Alexander; Biederman, Charles; Calder, Alexander; Kineticism; Lassaw, Ibram; Lippold, Richard; Moholy-Nagy, László; Rickey, George; Roszak, Theodore; *and* Société Anonyme, Inc.]

BIBLIOGRAPHY
L. Lozowick: *Modern Russian Art* (New York, 1925)

A. Archipenko: "Machine and Art," *Machine-Age Exposition* (exh. cat., New York, 1927)

L. Lozowick: "The Americanization of Art," *Machine-Age Exposition* (exh. cat., New York, 1927)

L. Moholy-Nagy: *The New Vision* (New York, 1930)

Machine Art (exh. cat., New York, MOMA, 1934)

G. Rickey: *Constructivism: Origins and Evolution* (New York, 1968)

S. Bann, ed.: *The Tradition of Constructivism* (New York, 1974)

J. Marter: "The Machine as Creator of Fantastic and Ideal Forms," *A. Mag.*, liv (Nov 1979), pp. 110–14

J. Marter: "Constructivism in America: The 1930s," *A. Mag.*, lvi (June 1982), pp. 73–80

Joan Marter

Cook, Walter William Spencer

(*b* Orange, MA, 7 April 1888; *d* 30 Sept 1962), art historian. Cook was educated at Philips Exeter Academy and graduated from Harvard University in 1913, taking his MA in 1917. He taught there from 1915, served in the US Army from 1917 to 1919 and was an assistant in the Fine Arts Department until 1920. From 1920 to 1921 he was Fellow of Medieval and Renaissance Studies, and he was awarded a PhD in 1924. Moving to New York University, he became Professor of Fine Arts in 1932 and Emeritus Professor in 1956 and was largely responsible for the establishment of its Institute of Fine Arts. He acted as adviser on Spanish art, a particular enthusiasm of his, to the Philadelphia Museum of Art and was Director of the Spanish Institute in New York. He also built up the photographic archive of Spanish manuscripts at the Frick Art Reference Library, New York. In 1953–4 he was the Fulbright Lecturer in Italy. He was a Fellow of the Medieval Academy of America and President of the College Art Association from 1938, becoming its Honorary Director in 1947. He also served on the editorial board of *Art in America*. Other awards included the Gold Order of Isabella la Catolica and the Medal of the Hispanic Society of America. It was said that "he belonged to that generation who blocked out the main outlines of medieval art, and his devotion to Spain never wavered" (Craig Hugh Smyth).

WRITINGS

with J. Gudiol Ricart: *Pintura e imaginería románicas*, A. Hisp., vi (Madrid, 1950)

La pintura mural romanica en Catalunia (Madrid, 1956)

Spain: Romanesque Paintings, pref. by W. W. S. Cook, intro. by Juan Ainaud (Greenwich, CT, 1957)

La pintura romanica sobre table en Catalunia (Madrid, 1959)

BIBLIOGRAPHY

Who Was Who in America (Chicago, 1960–)

In Memory of Dr. Walter W. S. Cook: Tributes Delivered at a Gathering of the Institute of Fine Arts, New York University, on Thursday, Sept 27, 1962 (New York, 1962)

C. H. Smyth: Obituary, *A. J. [New York]*, xxii/3 (1963), p. 167

Jacqueline Colliss Harvey

Coomaraswamy, Ananda Kentish

(*b* Colombo, 22 Aug 1877; *d* Needham, MA, 9 Sept 1947), Anglo-Sinhalese writer and curator, active also in India and the USA. More than those of any other scholar of Indian art, culture and aesthetics, Coomaraswamy's vision and views have dominated and molded the current understanding of Indian art. He began his career at the start of the 20th century as a champion of an aesthetic revaluation of Indian art. His powerful defense of Indian art and Eastern aesthetics was motivated on one hand by a cultural nationalism that resented the intrusion of British colonial rule in India and Ceylon (now Sri Lanka) and on the other hand by a utopian ideal of a medieval village civilization that rejected the materialism of the modern, industrial West. This ideal of an alternative socio-cultural order, discovered in traditional Sri Lanka and India, generated in time a more specific quest for an alternative aesthetic of Indian art. From the active mission of the cultural regeneration of Asia, Coomaraswamy retreated, with age, into the more aloof world of iconography, Eastern religions and metaphysics.

Born to an eminent Sinhalese father and an English mother, Coomaraswamy moved to England at the age of two, following his father's death. A primarily English upbringing led up to his training as a geologist and botanist at University College,

London. It was as director of the newly founded Mineralogical Survey of Ceylon that the young geologist, steeped in the anti-industrial ethics of William Morris and John Ruskin, returned to his native land in 1903. The years in Ceylon (1903–7) became the great turning point of Coomaraswamy's career, radically altering the thrust of his intellectual preoccupations, filling him with a reformist zeal to recover the lost traditions and culture of a colonized people.

The art historian in him also emerged during these years. Perceiving the most destructive impact of colonial rule in the disappearance of the age-old arts and handicrafts of Sri Lanka, he was driven by the urge for national reform to study the dying craft traditions of the Kandyan period (17th–19th centuries). The results materialized in Coomaraswamy's first monumental work, *Medieval Sinhalese Art* (1908). Published by Morris's Kelmscott Press in England, this book vividly reflects the author's close involvement with the last phase of the English Arts and Crafts Movement. The Arts and Crafts nostalgia for a pre-industrial past and its apparently idyllic world of craftsmanship found a model in the medieval Kandyan kingdom, with its wealth of handicrafts, system of craftsmen's guilds, royal and religious patronage and centrality of art and religion in daily life. In England between 1907 and 1909 Coomaraswamy shared in the work of the Chipping Campden Guild and School of Handicraft established by C. R. Ashbee. His next book, *The Indian Craftsman* (1909), projects a more concentrated assemblage of Arts and Crafts ideas but in an Indian context.

As he shifted his attention to India, Coomaraswamy's preoccupations with craft were overshadowed by an increasing concern with the spiritual ideals of Indian art and religion and by a desire to mobilize these ideals in the cause of India's "national awakening." Traveling frequently between England and India during 1909–13, he spent long periods with the influential Tagore family in Calcutta, where the influence of the Swadeshi movement, involving the boycotting of British goods and terrorist tactics, was

still strong. Focusing his nationalist sympathies in the realm of art and culture, he picked on Indian art as the main vehicle of India's "higher wisdom," arguing that the true significance of Indian nationalism was as an idealistic movement that could best seek fulfillment in art. He now also attacked the entrenched Western theory that posited formative Greek influence on the development of Indian Buddhist art. Challenging what he saw as the misplaced emphasis on Gandharan sculpture in Indian art history, he asserted instead the notion of the totally independent evolution of the "Indian ideal" in art since the 2nd and 3rd centuries AD, long after contact with the Greeks. Much of Coomaraswamy's writing of this period came together in two volumes, *Essays in National Idealism* (1909) and *Art and Swadeshi* (1911). These books contain the seeds of his entire aesthetic and spiritual construct of the Indian art tradition.

His visits to India also highlighted Coomaraswamy's initiatives in primary research and the discovery of examples of traditional Indian art and aesthetic treatises. In Calcutta in 1909–10, as an enthused supporter of the school of Indian-style painting founded by Abanindranath Tagore, he was active in the newly established Indian Society of Oriental Art. He found a major opportunity for field research when he was entrusted by the society with the collecting of old north Indian drawings and paintings for display at the United Provinces Exhibition at Allahabad in 1910–11. The travels, survey and collection he began at this time culminated in his pioneering study *Rajput Painting* (1916). A systematic, historic classification of the then practically unknown 16th- to 19th-century schools of painting of Rajasthan and the Punjab Hills was accompanied by an in-depth study of the *Kṛṣṇalīlā* and *Rāgamālā* iconographies. One of the main purposes of this work was to discover a "Hindu" and "religious" tradition of miniature painting and to differentiate it sharply from the "secular" school of Mughal court painting as the more authentic representative of the Indian tradition.

By 1916 Coomaraswamy had emerged as one of the most discerning collectors of Indian art, particularly of Rajput painting, and was attracting the attention of Western museums. He offered his collection to India to boost his proposal for setting up a museum of national art in Varanasi (Banaras), trying at the same time to secure a post as professor of Indian art and culture at Banaras Hindu University. But war and a disappointing lack of response prevented this. In 1916 he moved, with his collection, to the Museum of Fine Arts, Boston, which had already amassed an extraordinary collection of Far Eastern art. Coomaraswamy was appointed curator of the museum's newly created Indian section.

The American phase of his career inaugurated his most thorough and solid scholarship on Indian art history and aesthetics. Coomaraswamy's parallel studies of Indian classical music and dance and other aspects of traditional culture took shape, soon after his arrival, in two important books, *The Mirror of Gesture* (1917) and *The Dance of Shiva* (1918). However, the main symbol of this period of his work is the encyclopedic, serialized *Catalogue of the Indian Collection in the Museum of Fine Arts, Boston* (1923–30). This was, to date, the most professional and exhaustive printed work on Indian art. It was accompanied by Coomaraswamy's other definitive work, the *History of Indian and Indonesian Art* (1927), a richly illustrated and documented survey.

In a sense Coomaraswamy went as far as he wished to go with the writing of history in the latter book. The issue of defending Indian art against theories of foreign influence had also, by then, subsided in importance. In 1927 his authoritative essay "The Origin of the Buddha Image" forcefully established the Mathura sculptures of the 1st and 2nd centuries AD as the genuine "Indian" type. Replacing Gandhara, Mathura now provided the key to an alternative vision of Indian art history, one that revolved around a "golden age"—the Gupta period—and the diffusion of Indian Buddhist art throughout South and Southeast Asia. Henceforth Coomaraswamy's work was concerned

primarily with iconography and religious symbolism and with Indian philology, scripture and philosophic texts. The transition is marked by his major two-volume work, *Yakṣas* (1928, 1931), in which he tapped a large body of iconographic and literary material to reconstitute a pre-Vedic water cosmology with which the worship of nature gods (*yakṣas*) and many other non-Vedic divinities was closely associated.

His famous collection of essays *The Transformation of Nature in Art* (1934) bears testimony to the new depth and range of Coomaraswamy's comparative studies on art, aesthetics and religion. His *Elements of Buddhist Iconography* (1935) even more strongly demonstrates his erudition, which balanced a close analysis of principal Buddhist artistic symbols with a knowledge of all of the religious and metaphysical traditions underlying these motifs and of parallels in Islamic and Christian iconography. During this period Coomaraswamy also carried on rigorous textual work, translating and interpreting Sanskrit and Pali scriptures in a series entitled *A New Approach to the Vedas* (1932–47). Simultaneously, the ethical polemicist in him surfaced in many of his late essays, such as "What Is the Use of Art, Anyway?" (1937), which appeared in *Why Exhibit Works of Art?* (1941), a collection that contained a pertinent discussion on the educational and aesthetic functions of modern museums. Nonetheless the majority of his late writings show Coomaraswamy traversing an esoteric "universe of discourse," comparing the metaphysics, phraseology, aesthetics and iconographies of Hinduism, Buddhism, Christianity and Islam. Coomaraswamy lived in the USA for the last 30 years of his life; his desire to retire and settle in newly independent India remained unfulfilled.

UNPUBLISHED SOURCES
Princeton, U. NJ, Firestone Lib. [extensive col. of research notes, drafts of articles and correspondence]

SELECTED WRITINGS
Many of these works exist in later reprints. Coomaraswamy's later writings, some previously unpublished, are brought together in R. Lipsey, ed.: *Selected Papers: Traditional Art and Symbolism and Selected Papers: Metaphysics*, i and ii of *Coomaraswamy*, 3 vols (Princeton, 1977, New Delhi, 2/1986)

Borrowed Plumes (Kandy, 1905)

"Anglicisation of the East," *Ceylon N. Rev.*, i/2 (1906), pp. 181–95

Handbook to the Exhibition of Arts and Crafts in Connection with the Ceylon Rubber Exhibition (Colombo, 1906)

Medieval Sinhalese Art (Broad Campden, 1908)

The Message of the East (Madras, 1908)

Essays in National Idealism (Colombo, 1909)

The Indian Craftsman (London, 1909)

Indian Drawings, 2 vols (London, 1910–12)

Art and Swadeshi (Madras, 1911)

"The Modern School of Indian Painting," *Catalogue to the Festival of Empire Exhibition: Indian Section* (London, 1911), pp. 105–6

The Arts and Crafts of India and Ceylon (Edinburgh, 1913)

with Sister Nivedita: *Myths of the Hindus and Buddhists* (London, 1913)

Visvakarma: Examples of Indian Architecture, Sculpture, Painting, Handicrafts (London, 1914)

Buddha and the Gospel of Buddhism (London, 1916)

Rajput Painting, 2 vols (London, 1916)

The Mirror of Gesture: Being the Abhinaya Darpan of Nandikesvara (New York, 1917)

The Dance of Shiva: Fourteen Indian Essays (New York, 1918)

Portfolio of Indian Art: Objects Selected from the Collections of the Museum, Boston, MA, Mus. F.A. cat. (Boston, 1923)

Catalogue of the Indian Collections in the Museum of Fine Arts, Boston, 5 vols (Boston, 1923–30)

Bibliographies of Indian Art (Boston, 1925)

History of Indian and Indonesian Art (Leipzig, London and New York, 1927)

"The Origin of the Buddha Image," *A. Bull.*, ix (1927), pp. 1–42

Yakṣas, 2 pts (Washington, DC, 1928, 1931/R New Delhi, 1971)

A New Approach to the Vedas: An Essay in Translation and Exegesis (London, 1932–47)

The Transformation of Nature in Art (Cambridge, MA, 1934)

Elements of Buddhist Iconography (Cambridge, MA, 1935)

Asiatic Art (Chicago, 1938)

Why Exhibit Works of Art? (London, 1941)

Figures of Speech or Figures of Thought: Collected Essays on the Traditional or "Normal" View of Art (London, 1946)

Christian and Oriental Philosophy of Art (New York, 1956)

BIBLIOGRAPHY
K. Bharata Iyer: *Art and Thought* (London, 1947)

S. Durai Raja Singam: *Ananda Coomaraswamy: Remembering and Remembering Again and Again* (Kuala Lumpur, 1974)

R. Lipsey: *His Life and Work*, iii of *Coomaraswamy*, 3 vols (Princeton, 1977, New Delhi, 2/1986)

Paroksa: Coomaraswamy Centenary Seminar: New Delhi, 1977

P. Chandra: *On the Study of Indian Art* (Cambridge, MA, 1983)

D. M. Stadtner: "New Approaches to South Asian Art," *A. J.*, 49/4 (Winter 1990), pp. 359–62

T. Herrod: "Ananda Coomaraswamy," *Crafts*, 143 (Nov–Dec 1996), pp. 20–3

A. Antliff: *Anarchist Modernism: Arts, Politics, and the First American Avant-Garde* (Chicago and London, 2001)

B. A. Antliff and B. Croswell: "Beauty Is a State of Mind," *Artichoke*, 16/1 (Spring 2004), pp. 18–9 [with biblio]

Tapati Guha-Thakurta

Cooper, Muriel

(*b* 1925; *d* Brookline, MA, 26 May 1994), graphic designer, art educator and researcher. Cooper received a BSc in education from Ohio State University in Columbus (1948) and a BFA in design (1948) and BSc in education (1951) from Massachusetts College of Art in Boston. In 1952 she became design director of the Massachusetts Institute of Technology's Office of Publications (later renamed Design Services), but left MIT in 1958 and founded her own design studio, Muriel Cooper Media Design. The majority of her work still came from MIT and in 1966 she returned as the first design and media director of the MIT Press (1966–74). Her design for *Learning from Las Vegas* (MIT Press, 1972) was important to the evolution of printed media and computer-assisted design. Cooper used an IBM composer for the typesetting and although the machine was still manually driven it allowed her to interchange typefaces at will, a fact that she found liberating. She continued to experiment as the power and flexibility of technology increased. The book won awards for its design, but her clients were not particularly pleased with the innovative work: "They wanted a duck, and I gave them a monument."

In 1973 she co-founded the Visible Language Workshop (later part of the MIT Media Lab) with physicist and photographer Ron MacNeil.

A modernist, Cooper based the VLW on Bauhaus principles and focused on experimental printing and book arts. The VLW went on to become a pioneer in the area of computer-aided interaction design. "We were creating a vocabulary of 'geometric primitives'—relationships of color size, transparency, proximity, etc—that change according to the users position in the document." Although not a programmer herself, Cooper excelled at thinking around and finding pathways through problems. Cooper's work with computer-aided design was fully realized in 1994 when she presented work from the VLW at the TED5 conference. Although the highly conceptual work done at the VLW had previously drawn some criticism, the material she presented at TED5 was met with resounding praise from both programmers and designers alike.

During her career as a print designer Cooper designed over 500 books, 150 of which won awards. She was the recipient of numerous professional awards including the American Institute of Graphic Arts Design Leadership Award (to MIT Design Services, MIT Press and the Visual Language Workshop) 1982 and the Grand Prix d'Arles Design of Best Photographic Book, 1974. Her work is reproduced in books on graphic design and design annuals. Cooper was an associate professor of visual studies, MIT Department of Architecture, Media Laboratory from 1981 until her death in 1994.

WRITINGS

"Computers and Design," *Des. Q.*, cxlii (1989), pp. 1–32

BIBLIOGRAPHY

R. Siegel: *American Graphic Designers: Thirty Years of Design Imagery* (New York, 1984)

L. McQuiston: *Woman in Design a Contemporary View* (New York, 1988)

A. Livingston and I. Livingston: *Thames and Hudson Encyclopedia of Graphic Design and Designers* (New York, 1992)

J. Abrams: "Muriel Cooper's Visible Wisdom," *ID*, xli/5, (1994), pp. 48–55, 96–7

E. Lupton: "In Memory of Muriel R. Cooper," *AIGA J. Graph. Des.*, xii/2, (1994), pp. 42

E. Lupton: "Interview with Muriel Cooper," *Des. Statements*, ix/2, (1994), 11–3

W. Richmond: "Muriel Cooper," *Communic. A.*, xxxvi/4 (1994)

"Pioneers: Muriel Cooper," *Communic. A.*, xli/1 (1999), pp. 174–5, 242

M. Golec: "Doing It Deadpan: Venturi, Scott, Brown and Izenour's Learning from Las Vegas," *Visible Lang.*, 37/3 (2003), pp. 266–87

D. Rienfurt: "This Stands as a Sketch for the Future," *Dot Dot Dot*, 15 (Oct 2007), pp. 33–48

Aaris Sherin

Cope & Stewardson

Architectural partnership. It was formed in July 1885 by Walter Cope (*b* Philadelphia, PA, 20 Oct 1860; *d* Philadelphia, 1 Nov 1902) and John Stewardson (*b* Philadelphia, 21 March 1858; *d* Philadelphia, 6 Jan 1896). The firm's early works are typical of the loose eclecticism of the late 1880s; they worked in several modes, from a refined version of the Romanesque Revival of H. H. Richardson in their Young Men's Christian Association (YMCA) building, Richmond, VA (1885; destr.), to the Shingle style of their Edmund Crenshaw House, Germantown, PA (1891), the Netherlandish stepped-gabled fantasy of their Logan Offices, Philadelphia (1888; destr.), and the free broad-eaved Italianate seen in their Harrison Caner House, Philadelphia (1890; destr.), and their Foulke-Long Institute for Orphan Girls, Philadelphia (1890). In each, their invocation of history was blended with the lithe compositional and ornamental goals of their own generation.

Toward the mid-1890s Cope & Stewardson began to garner larger commissions, and their mature work shows a more academic approach to style. Such work also ranged widely, touching on the Spanish Renaissance in their Pennsylvania Institution for the Blind (1897–1900), Overbrook, PA; on the American Colonial in their James B. Markoe House (1900), 1630 Locust Street, Philadelphia; and on the English Perpendicular Gothic in their Lady Chapel at St Mark's Episcopal Church (1899–1902), 1625 Locust Street, Philadelphia. The firm is most widely remembered, however, for its lively evocations of 17th-century English collegiate buildings at Oxford and Cambridge for American campuses at Bryn Mawr College (begun 1886), PA, the University of Pennsylvania (begun 1895), Philadelphia, Princeton University (begun 1896), NJ, and, further afield at Washington University (begun 1899) in St Louis, MO. In these late works Cope & Stewardson's planning effectively combined order and incident, while their sense of stylistic authenticity revealed the spirit of each place and articulated the intention of the clients. The early deaths of both John Stewardson and Walter Cope left the firm in the hands of Emlyn Lamar Stewardson (1863–1936), brother of John, who continued the firm, changing its name in 1912 to Stewardson & Page.

BIBLIOGRAPHY

R. A. Cram: "The Work of Cope and Stewardson," *Archit. Rec.*, xv (1904), pp. 407–31

G. B. Tatum: *Penn's Great Town* (Philadelphia, 1961), pp. 118–22

S. Tatman and R. Moss: *Biographical Dictionary of Philadelphia Architects, 1700–1930* (Boston, 1985), pp. 165–70, 759–62

J. Merkel: "Washington University: Campus Architecture as Suburban Prototype," *Inland Archit.*, 30/4 (July–Aug 1986), pp. 45–50

R. Lemore: "Tudor Gothic in Downtown Montréal 1900–1929," *Soc. Study Archit. Canada J.*, 12/1 (March 1987), pp. 13–20

Jeffrey A. Cohen

Copley, John Singleton

(*b* ?Boston, 3 July 1738; *d* London, 9 Sept 1815), painter. He was the greatest American artist of the Colonial period, active as a portrait painter in Boston from 1753 to 1774. After a year of study in Italy and following the outbreak of the American Revolution, in 1775 he settled in London, where he spent the rest of his life, continuing to paint portraits and making his reputation as a history painter.

America, 1738–73. Copley's parents, Richard and Mary Copley, probably emigrated from Ireland shortly before he was born. Following the death of his father, a tobacconist, Copley's mother in 1748

married Peter Pelham, an engraver of mezzotint portraits. Copley was undoubtedly influenced by Pelham and through him would have had contact with other artists working in Boston, including John Smibert, whose collection of copies of Old Master paintings and casts after antique sculpture constituted the closest thing to an art museum in Colonial America.

Copley began to produce works of art by 1753, when he was only 15. He painted a few early history paintings, largely copied from engravings, but there was no demand for such pictures in Boston. From the beginning he painted primarily portraits. His early style reflects the technical influence of Smibert and the formal influence of a younger artist active in Boston in the late 1740s, Robert Feke. Working in relative isolation, he also relied on English prints for compositional ideas. The portrait of *Mrs Joseph Mann* (1753; Boston, MA, Mus. F.A.), for example, exactly reverses the composition of an English mezzotint of *Princess Anne* by Isaac Beckett after Willem Wissing (*c.* 1683).

The death of Smibert and Pelham in 1751, and the departure of Feke and John Greenwood, left Copley little competition in Boston at the start of his career. In 1755, however, a more polished British painter, Joseph Blackburn, arrived, whose work made Copley's paintings seem pedestrian. Copley quickly absorbed Blackburn's Rococo style of color, composition and elaborate drapery, but he retained a strong sense of the physical individuality and presence of his sitters that differs from Blackburn's sweet, sometimes cloying, characterizations.

Whereas Copley's portraits of the 1750s were based on mezzotints after late 17th- and early 18th-century English paintings by Godfrey Kneller and others, in the early 1760s Copley became indebted via mezzotints to the later English artist Thomas Hudson. He painted in an English style that was about 15 years out of date, enhanced by characteristics that were fundamental to his developing personal style—simplicity of design, fidelity of likeness, restrained but bold use of color (Copley was a superb colorist throughout his career), strong tonal contrasts (the mark of an artist trained more through the study of black-and-white prints than of subtly modulated paintings) and a concern more with two-dimensional surface pattern than with the illusionistic representation of masses in space. He painted a few full-length portraits, but most were standard half-lengths (50×40 in.), kit-cats (36×28 in.) or quarter-lengths (30×25 in.). He was an excellent craftsman, preparing his materials with care, and his pictures have stood up well to the passage of time. He was fastidious in the studio and, to the annoyance of some sitters, worked slowly, although he could turn out one half-length or two quarter-length pictures per week. By the mid-1760s Copley was influenced by more recent sources, notably by Joshua Reynolds; Copley's portrait of *Mrs Jerathmael Bowers* (1767–70; New York, Met.) was based on James McArdell's mezzotint of Reynolds's portrait of *Lady Caroline Russell* (1759).

Copley prospered by satisfying the taste of his American Colonial sitters for accurate likenesses. But wealth was not sufficient. Aware that he was the best artist in Boston, and perhaps in all of America, Copley yearned to know how good his art was by European standards. In 1765 he painted a portrait of his half-brother Henry Pelham, the *Boy with a Squirrel* (Boston, MA, Mus. F.A.), and sent it to London to be exhibited at the Society of Artists the following year. Reynolds and Benjamin West were favorably impressed, but some criticism was directed at the picture's flatness, and Copley was urged to come to England to perfect his art. He was reluctant, however, to give up a flourishing and profitable business in Boston. During the next few years he painted some of the most brilliant and penetrating portraits of his career. The portrait of *Paul Revere* (1768; Boston, MA, Mus. F.A.) shows a shirt-sleeved silversmith with his engraver's tools spread on the table before him, contemplating the decorative design he will incise into the surface of a teapot. This portrait is a splendid example of the way in which Copley exercised control of light and color to achieve a triumph of realistic portraiture.

In 1769 Copley, by then quite prosperous, married Susanna Clarke, the daughter of Richard Clarke, the agent of the British East India Company in Boston. He purchased a 20-acre farm with three houses on it next to John Hancock's house on Beacon Hill. To mark the marriage, Copley painted a pair of pastel portraits of himself and his wife (1769; Winterthur, DE, Du Pont Mus.). Although self-taught, Copley was a superb pastellist, one of the best in a century in which the pastel portrait was very popular in England and on the Continent. Many of Copley's wealthiest sitters, especially those who were young and socially prominent, opted for pastels rather than oils. Copley was also a first-rate painter of miniatures, both in watercolor on ivory and in oil on copper (e.g. *The Rev. Samuel Fair-weather*, c. 1758; New Haven, CT, Yale U. A.G.).

The political events of the late 1760s and early 1770s split Copley's clientele into opposing camps. Some of his friends and patrons became ardent Whigs and others intractable Tories. Copley was divided in his sympathies. He was a long-time friend of many radicals, including Paul Revere, John Hancock and Sam Adams. On the other hand, he now moved in prominent social circles, and all of his merchant in-laws were Loyalists. Copley also found his business in Boston falling off. In 1771 he took his only extended professional trip in Colonial America, spending over six productive months painting in New York. Copley had by then achieved a powerful, restrained, sophisticated and austere style that had no precise English counterpart; he had, in fact, created an original American style. Somber in hue and deeply shadowed, his late American portraits, such as that of *Mrs Humphrey Devereux* (1770–71; Wellington, Mus. NZ, Te Papa Tongarewa) and *Mrs John Winthrop* (1773; New York, Met.), are among his most impressive achievements. In the 1770s they directly influenced younger American artists, especially John Trumbull, Gilbert Stuart and Ralph Earl, generating the first definably American style—a development that was unfortunately cut short by the outbreak of the American

Revolution and the departure of all these artists for England for the duration of the war.

The political situation in Boston worsened after the Boston Tea Party (1773). The tea had been consigned to Copley's father-in-law, and Copley unsuccessfully attempted to conciliate both his Tory in-laws and his radical friends. Reluctant to offend either party by taking sides, he decided to go to Europe to improve his art.

Europe, 1774–1815. Copley left Boston early in 1774. After a brief stay in England, where he finally met and was befriended by Benjamin West, Copley traveled via France to Italy, where he studied for a year. Exposed to works of Classical antiquity and the Old Masters, he overcame earlier apprehensions regarding multi-figure compositions. His new assurance is manifest in the *Ascension* (1775; Boston, MA, Mus. F.A.), inspired by Raphael's *Transfiguration*. By the end of 1775 Copley was back in England and reunited with his family, who had left Boston after the outbreak of hostilities. A large group portrait of *The Copley Family* (1776–7; Washington, DC, N.G.A.) commemorates the reunion.

At the age of 37 Copley launched a second career in England. He hoped that he would be able to concentrate on history painting, fulfilling an early ambition stimulated by reading books on art theory to work in the highest branch of art, although he continued to paint portraits to support his family. His English portrait style, as in *Richard Heber* (1782; New Haven, CT, Yale Cent.) or in the portrait tentatively identified as that of *Mrs Seymour Fort* (c. 1778; Hartford, CT, Wadsworth Atheneum), was influenced by West, Reynolds and George Romney and appears looser than his American manner. Supple brushwork applied the paint fluidly to the canvas, dissolving detail in favor of more flamboyant visual effects. Strong contrasts of light and dark continued to be important but were used to open up space as well as to enliven the surface.

Watson and the Shark (1778; Washington, DC, N.G.A.), Copley's first English history painting, drew favorable attention when it was exhibited at

the Royal Academy in 1779, the year in which he was elected RA. The painting reflected Copley's admiration for what Edgar Wind later called "the revolution of history painting" (*J. Warb. & Court. Inst.*, ii (1938–9), pp. 116–27), a break with tradition that had been initiated by Benjamin West's *Death of General Wolfe* (1771; Ottawa, N.G.) through portraying recent events in contemporary rather than classical terms. Copley's next history painting, the *Death of the Earl of Chatham* (1779–81; London, Tate), carried the innovations in history painting a step further, combining history painting and portraiture (genres that had traditionally been separate) and incorporating portraits of 55 of England's most prominent noblemen. Viewing himself as a historian as well as an artist, Copley was trying to record an important event for posterity.

While the *Death of Chatham* was being exhibited, Copley began to work on another large history picture, the *Death of Major Peirson* (1782–4; London, Tate; see color pl. 1:XV, 2). On 5–6 January 1781 a detachment of 900 French troops had invaded the island of Jersey, seizing the capital city of St Helier and most of the island. Inspired and led by a 24-year-old major, Francis Peirson, the remaining British troops and local militia launched a brisk counterattack that swept back into St Helier and won the day. Peirson was shot and killed at the moment of his triumph. That event, and the revenge exacted by Peirson's black servant, is the primary subject of the picture. The *Death of Major Peirson* is Copley's finest history painting, notable for its vigorous composition, brilliant color and flickering contrasts of light and dark. Like *Watson and the Shark*, it contains a topographically accurate townscape, the portrait of a black as a central figure and the representation of a dramatic event. Like the *Death of Chatham*, it is centered on a death group and includes actual portraits of key figures. Although Copley had no pupils and founded no school, such paintings influenced John Trumbull's series of American Revolutionary War scenes (New Haven, CT, Yale U. A.G.). Thus the large English history

paintings that Copley regarded as his major achievement did have some impact, albeit not profound or durable, on the subsequent course of American art. It is also possible that through engravings his history paintings may have had some influence on later French Neo-classicism, particularly such portrait-filled recordings of contemporary history as Jacques-Louis David's *Oath of the Tennis Court* (1790–91; Paris, Louvre) with its echoes of the *Death of Chatham*.

In 1783, while at work on the *Death of Major Peirson*, Copley and his family moved from Leicester Square to an elegant house in George Street, where he lived for the rest of his life, as did his son John Singleton Copley Jr., later Lord Lyndhurst, three times Lord Chancellor under Queen Victoria. Unfortunately, the quality of his art and indeed of his life deteriorated after the triumph of the *Death of Major Peirson*. In 1783 he won a commission from the Corporation of the City of London to paint the *Siege of Gibraltar* (London, Guildhall A.G.), an enormous canvas (5.5×7.6 m) celebrating a victory over the Spanish (1782). Shortly thereafter he also received his first major royal commission, the *Daughters of George III* (London, Buckingham Pal., Royal Col.). But when this work was exhibited at the Royal Academy in 1785, it was ridiculed by a rival artist, John Hoppner (review repr. in W. T. Whitley, *Artists and their Friends* (Cambridge, 1928), ii, p. 49), and Copley subsequently received little royal or aristocratic patronage. Another blow in 1785 was the sudden illness and death of his two youngest children. The *Siege of Gibraltar*, long delayed in its completion, was not a critical success when it was finally exhibited in 1791.

During the 1790s Copley attempted to apply his realistic history-painting techniques to scenes of 17th-century English history, but the results failed to capture the public imagination. He did produce one final impressive modern history picture, the *Victory of Lord Duncan* (1798–9; Dundee, Spalding Golf Mus.), but thereafter his powers declined rapidly. In the early years of the 19th century he became

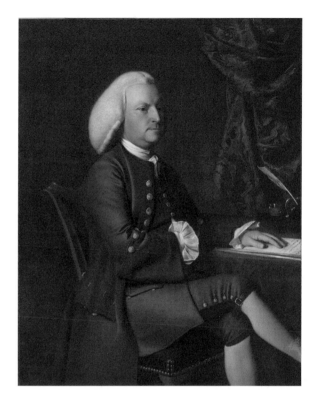

JOHN SINGLETON COPLEY. *Isaac Smith*, oil on canvas, 1273 × 1019 mm, 1769. GIFT OF MAITLAND FULLER GRIGGS/YALE UNIVERSITY ART GALLERY/ART RESOURCE, NY

enmeshed in squabbles with patrons and fellow artists, especially during an unfortunate campaign to unseat West as PRA. He sank into debt in attempting to maintain his elegant house and grew increasingly feeble in both mind and body until, following a stroke, he died at the age of 77.

WRITINGS

G. Jones, ed.: *Letters and Papers of John Singleton Copley and Henry Pelham, 1739–1776*, MA Hist. Soc. col., lxxi (Boston, 1914)

BIBLIOGRAPHY

A. T. Perkins: *A Sketch of the Life and a List of the Works of John Singleton Copley* (Boston, 1873)

Supplementary List of Paintings by John Singleton Copley (Boston, 1875)

M. B. Amory: *The Domestic and Artistic Life of John Singleton Copley, RA* (Boston, 1882/R New York, 1970)

An Exhibition of Paintings by John Singleton Copley (exh. cat. by H. B. Wehle, New York, Met., 1936–7)

B. N. Parker and A. B. Wheeler: *John Singleton Copley: American Portraits in Oil, Pastel and Miniature, with Biographical Sketches* (Boston, 1938)

John Singleton Copley, 1738–1815 (exh. cat., Boston, Mus. F.A., 1938)

J. T. Flexner: *John Singleton Copley* (Boston, 1948)

J. D. Prown: "An 'Anatomy Book' by John Singleton Copley," *A. Q.*, xxvi (1963), pp. 31–46

John Singleton Copley, 1738–1815 (exh. cat. by J. D. Prown, Washington, DC, N.G.A., 1965–6)

J. D. Prown: *John Singleton Copley*, 2 vols (Cambridge, MA, 1966)

A. Frankenstein and others: *The World of Copley, 1738–1815* (New York, 1970)

T. J. Fairbrother: "John Singleton Copley's Use of British Mezzotints: A Reappraisal Prompted by New Discoveries," *A. Mag. [prev. pubd as Arts [New York]; A. Dig.]*, lv (1981), pp. 122–30

A. Boime: "Blacks in Shark-Infested Waters: Visual Encodings of Racism in Copley and Homer," *Smithsonian Stud. Amer. A.*, iii/1 (1989), pp. 19–47

John Copley: 1875–1950 (exh. cat. by G. Cooke and J. R. Taylor, New Haven, CT, Yale Cent. Brit. A., 1990)

C. Rebora: "Transforming Colonists into Goddesses and Sultans: John Singleton Copley, his Clients and their Studio Collaboration," *Amer. A. J.*, xxvii/1–2 (1995–6), pp. 4–37

C. Troyen: "John Singleton Copley and the Heroes of the American Revolution," *Mag. Ant.*, cxlviii (1995), pp. 84–93

John Singleton Copley in America (exh. cat. by C. Rebora and others; Boston, MA, Mus. F.A.; New York, Met.; Houston, TX, Mus. F.A.; 1995–6)

John Singleton Copley in England (exh. cat. by E. B. Neff; Houston, TX, Mus. F.A.; Washington, DC, N.G.A.; 1995–6) [entry by W. L. Pressley]; review by J. Wilson in *Burl. Mag.*, cxxxviii (1996), 35–45

E. B. Neff: "John Singleton Copley's 'Native' Realism and his English 'Improvement'," *Amer. A. Rev.*, viii/1 (1996), pp. 78–85

S. Rather: "Carpenter, Tailor, Shoemaker, Artist: Copley and Portrait Painting around 1770," *A. Bull.*, cxxix (1997), pp. 269–90

M. Lovell: "Mrs. Sargent, Mr. Copley, and the Empirical Eye," *Winterthur Port.*, 33/1 (Spring 1998), pp. 1–39

M. D. McInnis: "Cultural Politics, Colonial Crisis, and Ancient Metaphor in John Singleton Copley's Mr. and Mrs. Ralph Izard," *Winterthur Port.*, 34/2–3 (Summer–Autumn 1999), pp. 85–108

S. L. Webber: "The Discovered Hand: John Singleton Copley's Underdrawing Techniques," *Porticus*, 20 (2001), pp. 48–58

I. Breskin: "'On the Periphery of a Greater World': John Singleton Copley's Turquerie Portraits," *Winterthur Port.*, 36/2–3 (Summer–Autumn 2001), pp. 97–123

J. Bonehill: "Exhibiting War: John Singleton Copley's the Siege of Gibraltar and the Staging of History," in *Conflicting Visions: War and Visual Culture in Britain and France,*

c. *1700–1830* (J. Bonehill and G. Quilley, eds; Aldershot, England; Burlington VT: Ashgate, 2005)

J. Roberts: "Copley's Cargo: *Boy with a Squirrel* and the Dilemma of Transit," *Amer. A.*, 21/2 (Summer 2007), pp. 20–41

Jules David Prown

Copley, William Nelson

(*b* New York, 24 Jan 1919; *d* 1996), dealer, patron and painter. Born into a newspaper-publishing family, Copley responded to his upper-class establishment upbringing by seeking out ambivalence in art and life. Copley established the Copley Galleries in Los Angeles in 1948 with John Ployardt as partner and showed Magritte, Max Ernst, Roberto Matta, Man Ray, Yves Tanguy and Joseph Cornell, as well as younger local artists. He regularly purchased a work from each show and built up his collection. Self-taught as a painter, in 1951 he closed the gallery to paint and moved to Paris, where he bought directly from the Surrealists. He returned to the USA in 1963, living and working in Roxbury, CT. He regularly exhibited at the Phyllis Kind Gallery, New York, and elsewhere in the USA and Europe. He used Magritte's method of "assembling images" in his own narrative figurative paintings. As in some Surrealist works, eroticism is the guiding force in brightly colored and witty paintings. He compared *Tomb of the Unknown Whore*, his installation of 1986 at the New Museum of Contemporary Art, New York, to Duchamp's *Large Glass* (1915–23) and *Etant donnés* (1944–6). The range and quality of Copley's collection were confirmed by the high prices it drew when it was auctioned at Sotheby–Parke–Bernet, New York, in November 1979. Among the works were Man Ray's *Observatory Time: The Lovers* (1932–4; priv. col.), Max Ernst's *Surrealism and Painting* (1942) and Magritte's *The Sense of the Night* (1928).

BIBLIOGRAPHY

F. du Plessix: "William Copley: The Artist as Collector," *A. Amer.*, liii/6 (1965–6), pp. 67–75

The William Nelson Copley Collection: Surrealism (sale cat., New York, Sotheby–Parke–Bernet, 5 Nov 1979)

A. Jones: "William Copley, 'Being an Artist Is the Closest Thing to Being a Criminal That Exist,'" *Flash A.*, cxl (May/June 1988), pp. 94–6

Diane Tepfer

Coram, Thomas

(*b* Bristol, England, 1756; *d* Charleston, SC, 2 May 1811), painter and engraver. Born in England, Coram immigrated to America on 1 March 1769 following an older brother who was established as a merchant in Charleston, SC. He eventually took over his brother's business and also advertised himself as an engraver by 1778. He engraved a wide variety of cards and shop bills as well as currency for the state of South Carolina. He referred to himself as "self-taught," which he was initially, but he also received instruction after 1772 from the portrait painter Henry Benbridge. In turn, Coram instructed the painter Charles Fraser.

At least as early as 1791, Coram began a sketchbook of landscape scenes entitled *Sketches, Taken from W. Gilpin's Observations on the River Wye and Several Parts of South Wales* (priv. col.). These sketches demonstrate that Coram was studying the engraved images from the works of the immensely popular English author the Reverend William Gilpin whose numerous volumes published in the mid-18th century helped to disseminate an understanding of the picturesque. Another sketchbook entitled *Sketches from Nature* and dated 1792 (Charleston, SC, Gibbes Mus. A.), shows how he applied the lessons of the English picturesque to the Lowcountry plantation landscape.

His early student exercises resulted in an approach to the American landscape that was largely based on English precedent. Coram's surviving landscape paintings of the South Carolina Lowcountry are some of the earliest works of American landscape painting. These small works of oil on paper include multiple views of an individual property to encompass different and varied features of the plantation and its environment. The most famous is the *View of Mulberry House and Street* (c. 1800; Charleston, SC,

Gibbes Mus. A.) that depicts the main house and a street of slave cabins immediately before it. Most works did not, however, include images of enslaved persons. Coram also painted portraits and gave to the Charleston Orphan House a large work called *Jesus Said Suffer Little Children* (on deposit Charleston, SC, Gibbes Mus. A.).

BIBLIOGRAPHY

M. S. Middleton: "Thomas Coram, Engraver and Painter," *Mag. Ant.*, xxix (June 1936), pp. 242–4

W. Batson: "Thomas Coram: Charleston Artist," *J. Early S. Dec. A.*, i/2 (Nov 1975), pp. 35–47

R. Kefalos: "Landscapes of Thomas Coram and Charles Fraser," *Amer. A. Rev.*, x/3 (June 1998), pp. 1227

R. Sokolitz: "Picturing the Plantation," *Landscape of Slavery: The Plantation in American Art* (exh. cat., ed. A. D. Mack and S. Hoffius; Charleston, SC, Gibbes Mus. A., 2008), pp. 30–57

A. O. Marley: *Rooms with a View: Landscape Representation in the Early National and Late Colonial Domestic Interior* (PhD thesis, Newark, U. DE, 2009)

Maurie D. McInnis

Corbett, Harvey Wiley

(*b* San Francisco, 8 Jan 1873; *d* New York, 21 April 1954), architect, teacher and writer. Corbett studied engineering at the University of California, Berkeley, graduating in 1895, and then went to the Ecole des Beaux-Arts, Paris (1896), where he entered the atelier of Jean-Louis Pascal and received his diploma in 1900. In 1901 he joined the New York office of Cass Gilbert as a draftsman, later going into partnership (1903–12) with F. Livingston Pell and, until 1922, with Frank J. Helmle. His earliest major commissions were won in competitions, including those for the Maryland Institute (1908–13) in Baltimore, a variation on a Florentine palazzo, and the classical Municipal Group building (1908–13) in Springfield, MA. From 1907 to the mid-1930s he lectured at the Columbia School of Architecture, which followed the Beaux-Arts educational system. The vertically expressive Bush Terminal Tower (1916–18) on 42nd Street, New York, with its prominent position and slight setbacks in buff, white and black brick, marked his début as an influential skyscraper designer and he maintained his leading position through the 1920s and 1930s. Both in his work and writing for the media, Corbett explored the creative potential of the "setback" restrictions of the New York zoning laws of 1916 affecting the design of the skyscraper and its environment.

In a search for a modern style free of historical allusion, Corbett collaborated with the architectural illustrator Hugh Ferriss on drawings of skyscrapers as simplified sculptural masses rendered in chiaroscuro, in particular the influential "zoning envelope studies" of 1922, which he published in the magazine *Pencil Points*. The Titan City department store exhibition mounted in October 1925 with Ferriss and the muralist Willy Pogany, with its host of large-scale drawings by these two artists of Corbett's ideas for a three-level metropolis, provided the public with a glimpse of the urbanism of the future. Corbett also believed that by creating tiered streets and multi-level "tube" transport systems to facilitate the fast movement of traffic, urban congestion could be reduced and airports reached more easily. His schemes were based on formal concerns rather than social ones, linking him with a tradition of such French academic urban planners as Eugène Alfred Hénard.

In 1925 Helmle & Corbett designed Bush House, Aldwych, their only London project. It is an accomplished classical building that respects the existing scales of Kingsway to the north and James Gibbs's St Mary-le-Strand to the south. In 1926 Corbett paid the Viennese designer Frederick Kiesler a £1000 retainer to join his office; their association was somewhat incongruous and ultimately proved fruitless. The following year, Helmle & Corbett took on as a partner Wallace Kirkman Harrison (*see* Harrison and Abramovitz), and on Helmle's retirement in 1927 he was replaced by William MacMurray (1886–1941), with the firm becoming Corbett, Harrison & MacMurray. Meanwhile, Helmle, Corbett & Harrison designed the Master apartment building, New York (built 1928–9), containing the Roerich Museum in its base, an early example of a popular hybrid

building type, designed in shaded brick as an optical device with public facilities subsidized by an income-generating tower.

Corbett, Harrison & MacMurray were one of the three architectural teams responsible for the design of the Rockefeller Center in New York (1929–34; built 1931–40 on 5th–6th Avenue), the other two being Reinhard & Hofmeister and Hood, Godley & Fouilhoux. Conceived in the affluent 1920s, it was realized in the Depression only when John D. Rockefeller Jr. resuscitated the project after financial support collapsed in 1929. Its Art Deco skyscrapers in limestone, embellished with terraces and fountains, were uniquely planned as a unit above a sunken plaza, with Radio City Music Hall and a theater. The complex's primary purpose was commercial, and it included more office space than ever before on a mid-town site. Although completed to mixed reviews, it set standards for other urban business centers in the USA.

In 1935 Harrison left the firm, which then became Corbett & MacMurray. Corbett's last great commission before World War II was the New York Criminal Courts Building and Prison, also known as the "Tombs," at 100 Center Street (1939), a 17-story building of dense mass with subtle fenestration culminating in an underscaled ziggurat. Inside, a series of U-shaped courtyards opens to the street to provide light and air; the elusive character of its exterior suggests an office building. On MacMurray's death in 1941 the firm became Harvey Wiley Corbett Associates. Corbett's wide-ranging activities included membership of the planning committees of the Chicago and New York world fairs of 1933 and 1939. He was active in many professional and civic organizations and wrote frequently in the architectural and popular press. As his career developed, his attempts to define a modern American architectural aesthetic appropriate for commercial or public buildings, typified by the "Tombs," were increasingly influenced by the more polemically charged International style advocated by Henry-Russell Hitchcock and Philip Johnson.

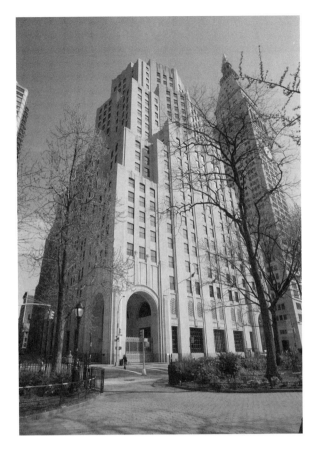

HARVEY WILEY CORBETT AND D. EVERETT WAID. Metropolitan Life Insurance Company, New York, 1932–50. VANNI/ART RESOURCE, NY

[See also Kiesler, Frederick.]

WRITINGS

"The Influence of Zoning on New York's Skyline," *Amer. Archit.*, cxxiii (1923), 1–4

"Zoning and the Envelope of the Building," *Pencil Points*, iv (1923), 15–18

"The Effect of New York Zoning Resolutions on Commercial Buildings," *Amer. Archit.*, cxxv (1924), pp. 547–51

"New Stones for Old," *Sat. Eve. Post* (27 March 1926), pp. 6–7; (8 May 1926), 26–7; (15 May 1926), 16–17

"The Skyscraper and the Automobile Have Made the Modern City," *Stud. A. Archit.*, ed. E. L. Morgan (Philadelphia, 1941)

BIBLIOGRAPHY

C. Krinsky: *Rockefeller Center* (New York, 1978)

R. A. M. Stern, G. Gilmartin and T. Mellins: *New York, 1930: Architecture and Urbanism between the Two World Wars* (New York, 1987)

Corcoran, William Wilson

(*b* Washington, DC, 27 Dec 1798; *d* Washington, DC, 24 Feb 1888), financier, collector and museum founder. The success of the Corcoran & Riggs Bank (now Riggs National Bank) permitted Corcoran to retire in 1854 and devote the remainder of his life to art and philanthropy. His first significant purchase, the *Adoration of the Magi* by Anton Raphael Mengs, was made in 1846. (All works mentioned are in the Corcoran Gallery of Art, Washington, DC.) He began to focus on contemporary American artists from the 1840s with such purchases as the *Greek Slave* by Hiram Powers (1841) and *Mercy's Dream* by Daniel Huntington (1850). Further interests were the artists of the Hudson River school, including Thomas Doughty, Thomas Cole and John Frederick Kensett, in addition to genre painters such as Seth Eastman, William Tylee Ranney and John Mix Stanley. His determination to acquire major works led to costly purchases such as the pair of paintings by Thomas Cole, *The Departure* and *The Return* (both 1837), for which he paid $6000. After trips to Europe in 1849 and 1850, he bought works by contemporary European painters, but they never fully commanded his attention.

In 1848 Corcoran bought the former residence of Daniel Webster and furnished it with his collection. James Renwick renovated the building and designed new wings, while the grounds were landscaped by A. J. Downing. Even at this early date, a public commitment can be discerned; he loaned paintings to exhibitions, provided space for artists' studios and made donations to local arts organizations. In 1851 he opened his home to the public, and around 1855 Renwick began to design and build a gallery in the Second Empire style to house the collection. Construction was interrupted by the Civil War in 1861. Corcoran was accused of Confederate sympathies, his property was partially confiscated and he fled to Europe the same year. On his return in 1865, he sought to redeem his position in Washington by completing the gallery. His plans for the museum, founded in 1869, were threefold: an institution to collect and exhibit American art, a national portrait gallery, and an art school. Between 1874 and 1885 he purchased for the gallery portraits of all the American presidents, including *Andrew Jackson* (1845) by Thomas Sully. He left a bequest of $100,000 to be used by the art school. In 1897 the Corcoran Gallery moved to 17th St, Washington, DC, and is now one of the largest and most extensive collections of 19th-century American painting in the USA.

WRITINGS
A Grandfather's Legacy: Containing a Sketch of his Life and Obituary Notices of some Members of his Family Together with Letters from his Friends (Washington, DC, 1878)

UNPUBLISHED SOURCES
Washington, DC, Lib. Congr. [Papers of William Wilson Corcoran]

BIBLIOGRAPHY
D. W. Phillips: *DAB A Catalogue of the Collection of American Paintings in the Corcoran Gallery of Art*, 2 vols (Washington, DC, 1966–73)

Corcoran (exh. cat. by D. Spiro, Washington, DC, Corcoran Gal. A., 1976)

R. T. Carr: *32 President's Square, The Riggs Bank and its Founders* (Washington, DC, 1980)

A. Wallach: "On the Problem of Forming a National Art Collection in the United States: William Wilson Corcoran's Failed National Gallery," *Stud. Hist. A.*, xlvii (1994), pp. 113–25

A. Wallach: *Exhibiting Contradiction: Essay on the Art Museum in the United States* (Amherst, 1998)

E. Heartney: *A Capital Collection: Masterworks from the Corcoran Gallery of Art* (with essays by F. O. Gehry . . . [et al.]; Washington, DC: Corcoran Gal. A.; London: in association with Third Millennium Pub., 2002)

Linda Crocker Simmons

Cordero, Helen

(*b* Cochiti Pueblo, NM, 1915; *d* Cochiti Pueblo, NM, 24 July 1994), Cochiti potter. Best known as inventor of the "Cochiti Pueblo Storyteller figure," Cordero is credited with innovation and regarded as a true folk artist. Unable to master traditional pottery forms such as bowls and vases, she produced other

craftworks, such as leather and beadwork for sale, later turning to pottery as an alternative income source. Dissatisfied and frustrated with her clay skills, her cousin suggested she try to create figures. She recalled it was "like a flower blooming."

Always living and following the Cochiti way of life, she dug and prepared natural clay and pigments. Not working from a studio, she preferred to work outdoors in all weather conditions. She created tiny bird and animals, and produced numerous figures for sale. Eventually she created the Cochiti Storyteller figure. Considered debased idol worship by the Spanish, the Pueblo figurative pottery tradition had been repressed. Cordero created her first small Storyteller figure in 1964 based upon memories of her grandfather Santiago Quintana. Breaking the moratorium, her figurative work reflects her family history and a renewal of Cochiti figurative forms. This innovative and crucial return to traditional forms commenced a resurgence and influence in modern Pueblo ware across the Southwest.

Making three major changes in the Storyteller form, Helen changed the Cochiti Storyteller tradition. The Storyteller became male, based on a real individual, her grandfather, and finally, a personal innovation, she expanded the number of children accompanying the Storyteller up to 20. As her technical style improved, she changed her repertory to suit her personal artistic view rather than retain traditional Cochiti forms. Eventually her figure variations enlarged to include the Navajo Storyteller, the Singer, the Nightcryer, Praying and Children's Hour.

Not seriously accepted until the 1970s, her figurative work was supported by her patron, Alexander Girard, a folk art collector. Recognizing her exceptional pieces, he purchased and promoted her unconventional work. Adapting to collectors' tastes, her works eventually became valued collectables. In 1984, the National Endowment of the Arts awarded her the National Heritage Fellowship Lifetime Honors for her Storyteller figurative work, which transformed the Pueblo pottery tradition.

BIBLIOGRAPHY

B. Babcock and D. Monthan: *The Invention of the Storyteller: Development of a Figurative Tradition* (Tucson, AZ, 1986)

A. Hirschfelder: *Artists and Craftspeople* (New York, 1994)

N. Shroyer Howard: *Helen Cordero And The Storytellers of The Cochiti Pueblo* (1995)

G. Lola Worthington

Cornè, Michele Felice

(*b* Elba, 1752; *d* Newport, RI, 1845). Michele Felice Cornè arrived in Salem, MA, from Naples, Italy, in August 1800. On board the *Mount Vernon*, a ship owned by the prominent Derby family, Cornè launched his career as an American artist, with greatest success as a marine and landscape painter. Born of French ancestry on the Italian island of Elba, Cornè became embroiled in the political upheavals of Naples in the closing years of the 18th century. Whether Cornè sympathized with the monarch or the French republican movement is not clear; however, Cornè corresponded for many years with his brother who remained in the service of the King of Naples.

Little is known of Cornè's Italian art training; it may be that he was trained as a decorative or sign painter, since his figures sometimes lack classical proportions and graceful poses. Despite his periodic awkwardness, Cornè demonstrated working knowledge of European conventions of history painting. It is said that on several occasions he drew classical designs of nymphs and the Graces with charcoal, colored chalk and crayons on a floor, then dancers swept them away during elegant balls.

In Salem, with introductions provided by the Derbys, Cornè became well established as a painter of ship portraits for the town's merchant élite; the Peabody Essex Museum now holds over 50 ship portraits done during his brief sojourn in Salem from 1800 to 1806. In addition to marine scenes and portraits of prominent individuals, Salem supported a vibrant art market for landscapes and subject pictures incorporated into domestic interiors. Cornè painted

fireboards, overmantels, wallpaper and even a ceiling with local, classical and imaginary views.

The East India Marine Society became a significant patron, commissioning global views. For instance, Cornè painted a trio of fireboards symbolizing the sea captains' worldwide trading experience through scenes of the Cape of Good Hope, Cape Horn and Canton. The Society also commissioned portraits of nautical and military heroes, such as Captain Cook and Admiral Nelson.

American history provided Cornè with other favored subjects for Salem patrons including the *Landing of the Pilgrims* and *Columbus and The Egg*. The Pilgrims and Columbus both served as important metaphors for the foundation of the American republic and emerging American nationalism, as well as symbols for New England regional identity and the Federalist party. Multiple patrons commissioned them: Cornè painted at least five versions of the *Landing of the Pilgrims* and two of *Columbus and The Egg*. Cornè usually based his historical scenes on pre-existing sources, typically engravings.

Though Cornè's time in Salem was brief, he made a major impact on the arts of the city. Artists George Ropes (1788–1819), Hannah Crowninshield (1789–1834) and Anstis Stone studied with him. The Reverend William Bentley commented in his diary, "In every house we see the ships of our harbour delineated for those who have navigated them. Painting before unknown, in its first efforts, is now common among our children."

Cornè moved to Boston by 1807, where city directories list him as a "limner." In the larger capital city he gained attention for naval battle scenes in large-scale formats. His panorama of the *Bombardment of Tripoli*, done in collaboration with William King and exhibited in Boston, Salem and Providence, was reportedly 18 m long and 3 m high. While the panorama is lost, smaller versions are held at the Naval Academy and the Maine and Rhode Island Historical Societies.

Cornè gained greater fame with his series of paintings of battles in the War of 1812, including a series of scenes of the major engagement between the *Constitution* and the *Guerriere*, which were engraved by Abel Bowen (1790–1850) for the book *The Naval Monument* and later frequently copied as decorations on English ceramics for the American market. The *North American Review* in May 1815 called him "one of the best painters of ships alive." Cornè moved to Newport in 1822 and died there in 1845.

BIBLIOGRAPHY

W. Bentley: *The Diary of William Bentley, D.D., Pastor of the East Church, Salem, Massachusetts*, 4 vols. (Salem, MA, 1905)

Michele Felice Cornè, 1752–1845; Versatile Neapolitan Painter of Salem, Boston, & Newport (exh. cat. by P. C. F. Smith and N. F. Little (Salem, MA, Peabody Essex Mus., 1972)

A. O. Marley: *Rooms with a View: Landscape Representation in the Early National and Late Colonial Domestic Interior* (PhD thesis, Newark, U. DE, 2009)

Patricia Johnston

Cornell, Joseph

(*b* Nyack, NY, 24 Dec 1903; *d* Flushing, NY, 29 Dec 1972), sculptor, filmmaker and writer. Cornell studied from 1917 to 1921 at Phillips Academy in Andover, MA. After leaving the Academy he took a job as a textile salesman for the William Whitman Company in New York, which he retained until 1931. During this time his interest in the arts developed greatly. Through art reviews and exhibitions he became acquainted with late 19th-century and contemporary art; he particularly admired the work of Odilon Redon. He also saw the exhibitions of American art organized by Alfred Stieglitz and became interested in Japanese art, especially that of Andō Hiroshige and Katsushika Hokusai. Following a "healing experience" in 1925 he became a convert to Christian Science.

In 1931 Cornell lost his job as a salesman. In November 1931 he discovered Julien Levy's newly opened gallery in New York and showed Levy some of his collages. Employing curious juxtapositions, these were composed from cut-out fragments of engravings as in *Untitled* (1931; artist's estate, see

1980–81 exh. cat., pl. 5). They closely resembled the collages of Max Ernst, which Cornell had seen at Levy's gallery, although he had probably been experimenting with collage before this. Through Levy, Cornell became acquainted with a wide range of Surrealist art as well as with various artists in New York, including Marcel Duchamp, whom he first met in 1934. In January 1932 he was included in the *Surrealism* exhibition at the Julien Levy Gallery, the first survey of Surrealism in New York, to which he contributed a number of collages and an object. By the time of his first one-man show at the same gallery in November 1932 he had begun producing his shadow boxes. These were small circular or rectangular found boxes containing mounted or unmounted engravings and objects. At the same show, which was concurrent with an exhibition of engravings by Picasso, Cornell displayed *Jouets surréalistes* and *Glass Bells*. The former (*c.* 1932; Washington, DC, Smithsonian Amer. A. Mus.) were small mechanical and other toys altered by the addition of collage, this use of toys suggesting the relationship between art and play. The *Glass Bells* contained assemblages of collage and other objects.

From 1932 to 1935 Cornell learned woodworking techniques from a neighbor in order to custom-build the wooden boxes for his assemblages, and from 1936 this became his preferred method, although he still occasionally used found boxes. Having been largely unemployed since 1931, *c.* 1934 he found a job through his mother's friend, Ethel Traphagen, designing textiles for the Traphagen Commercial Textile Studio in New York; he continued working there until 1940. He made his first film, *Rose Hobart*, *c.* 1939, which was essentially a drastically re-edited version of a film called *East of Borneo* (1931) in which Rose Hobart had starred. By incorporating sudden incongruous transitions from one scene to another and breaking up the original narrative sequence, Cornell effected a startling transformation of the undistinguished original. He screened the film without any soundtrack in December 1936, and it was shown officially in 1939 at the Julien Levy Gallery.

The earliest of Cornell's handmade box assemblages is *Untitled (Soap Bubble Set)* (1936), which formed part of a larger installation at the *Fantastic Art, Dada, Surrealism* exhibition organized by Alfred H. Barr Jr. at MOMA, New York. The work incorporates the hallmarks of much of Cornell's work: a series of compartments containing objects together with arcane engraved images, the whole work being unified by various conceptual and visual associations. The objects in this box include four cylindrical weights, an egg in a wine glass, a cast of a child's head, a clay pipe and a map of the moon. The clay pipe, with which soap bubbles can be made, has a clear relationship to childhood and hence the child's head. For Cornell the soap bubble also symbolized the contemplation of the cosmos as suggested by the lunar map. Visual associations are presented by the circular forms of the egg, the moon, the implied soap bubbles and even the child's head. Such associative networks clearly bear an affinity with Surrealist art, and this was reflected by the discussion of his works in this context in much contemporary criticism. Despite sharing the Surrealists' similar literary tastes for such 19th-century writers as Arthur Rimbaud and Gérard de Nerval, Cornell did not have their interest in psychology and the subconscious. Before the exhibition at MOMA (1936) he wrote to Barr in an attempt to distance himself from mainstream Surrealism. Cornell was furthermore unconcerned with the erotic themes favored by the Surrealists and it seems therefore that the French movement acted more as a catalyst in Cornell's development rather than as a rigid framework.

After finishing his work for Traphagen's in 1940, Cornell was able to devote himself more fully to his art, although he also undertook freelance work producing illustrations and designing layouts for magazines such as *Vogue* and *House and Garden* until 1957. In the 1940s he paid more serious attention to his writing, which had earlier appeared only in notes and correspondence. From 1941 to 1947 he contributed articles to *View* and *Dance Index*. Concentrating largely on his box works, in the 1940s

Cornell tended to work in thematic series. He made further *Soap Bubble Set* boxes and created series such as *Pharmacy* that extended into the 1950s. *Untitled (Pharmacy)* (*c.* 1942; Venice, Guggenheim), for example, is characteristic of these, consisting of a shallow box lined with rows of small glass drug bottles, each filled with an assortment of materials and objects. Birds were recurring motifs, particularly parrots, cockatoos and owls, which appeared in a number of boxes throughout the 1940s. Some used stuffed birds, for example *Parrot Music Box* (*c.* 1945; Venice, Guggenheim), in which the parrot is claustrophobically enclosed in an overtly alien environment in a parody of the bird and animal cases of the 19th century. In *Untitled (Owl Box)* (1945–6; Paris, Pompidou) Cornell incorporated a cut-out owl into a near "natural" woodland habitat, relying on the traditional variety of the bird's connotations for the work's suggestive effect: the owl as a premonition of death, Devil's accomplice, embodiment of wisdom and so on. From the late 1940s and into the 1950s he also produced a number of austere white abstract boxes inspired by Mondrian's work, such as *Untitled (Window Façade)* (*c.* 1953; New York, priv. col., see 1980–81 exh. cat., pl. 223), the top of which is covered by a rectilinear network of white, wooden strips.

In the 1950s Cornell resumed his film-making but this time in the role of director and editor of original rather than found footage, using such cameramen as Rudy Burckhardt and Stan Brakhage. This led to several short films in both black and white and color, such as *GniR RednoW* (1955), filmed by Brakhage, and *Nymphlight* (1957), filmed by Burckhardt. From 1955 Cornell again started to produce collages as an independent medium, producing works such as *Allegory of Innocence* (*c.* 1956; New York, MOMA). Many of his boxes of the mid to late 1950s included references to the constellations, as in *Untitled (Space Object Box)* (*c.* 1958; New York, Guggenheim), although this theme had appeared earlier as well. Due to declining health and the grief caused by the death of his brother and mother, from the 1960s Cornell produced few boxes, although he continued to make

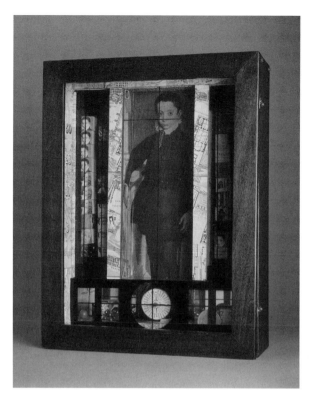

JOSEPH CORNELL. *Medici Slot Machine*, construction, h. 394 mm, 1942. Collection of the Reis Family © THE JOSEPH AND ROBERT CORNELL MEMORIAL FOUNDATION/LICENSED BY VAGA, NY/ EDWARD OWEN/ART RESOURCE, NY

collages such as *Sorrows of Young Werther* (1966; Washington, DC, Hirshhorn).

BIBLIOGRAPHY

Joseph Cornell (exh. cat. by F. Porter, Pasadena, A. Mus., 1966–7)

D. Ashton: *A Joseph Cornell Album* (New York, 1974)

Joseph Cornell (exh. cat. by J. B. Myers, New York, ACA Gals, 1975)

D. Waldman: *Joseph Cornell* (New York, 1977)

Joseph Cornell Retrospective (exh. cat., ed. K. McShine; New York, MOMA; Paris, Mus. A. Mod. Ville Paris; Düsseldorf, Städt. Ksthalle; London, Whitechapel A.G.; 1980–81)

Joseph Cornell: Art and Metaphysics (exh. cat. by S. L. Starr, New York, Castelli, Feigen, Corcoran, 1982)

Joseph Cornell: An Exploration of Sources (exh. cat. by L. R. Hartigan, Washington, DC, N. Mus. Amer. A., 1983)

Joseph Cornell (exh. cat. by F. Huici, Madrid, Fund. Juan March, 1984)

Joseph Cornell (exh. cat. by B. O'Doherty, New York, Pace Gal., 1986–7)

Joseph Cornell (exh. cat. by E. Jaguer, Paris, Gal. 1900–2000, 1989)

Special dossier on Joseph Cornell: *Mizue* (Japan), no. 954 (Spring 1990)

Joseph Cornell (exh. cat. by K. McShine, D. Ades. and others, New York, MOMA, 1990)

D. Tashjian: *Joseph Cornell: Gifts of Desire* (Miami Beach, 1992)

M. A. Caws: *Joseph Cornell's Theatre of the Mind: Selected Diaries, Letters and Documents*, with pref. by J. Ashbery and a text by R. Motherwell (London, 1993)

Special Dossier on Joseph Cornell: *Arte y Parte* (Spain), no. 2 (Apr–May 1996)

D. Solomon: *Utopia Parkway: The Life and Work of Joseph Cornell* (New York, 1997)

J. Hauptman: *Joseph Cornell: Stargazing in the Cinema* (New Haven, 1999)

Joseph Cornell/Marcel Duchamp–In Resonance (exh. cat. by E. Bonk and others, intro. A. D'Harnoncourt, Philadelphia Mus. A., 1999); review by D. Ades, "Cornell and Dechamp," *Burlington Mag.*, 141/1152 (Mar 1999), pp. 195–8; and B. Hainley, "Joseph Cornell/Marcel Duchamp in Resonance," *Artforum*, 37/10 (Summer 1999), pp. 150–1

J. Mundy: "An 'overflowing, a richness & poetry': Joseph Cornell's Planet Set and Giudita Pasta," *Tate Papers*, 1 (Spring 2004), unpaginated

J. Sommers and A. Drake: *The Joseph Cornell Box: Found Objects, Magical Worlds from the Collection of the Art Institute of Chicago* (Kennebunkport, ME, 2006)

Joseph Cornell: Navigating the Imagination (exh. cat. by L. R. Hartigan, Washington, DC, Smithsonian Amer. A. Mus., 2006); review by D. Carrier, "Joseph Cornell," *Artforum*, 45/6 (Feb 2007), pp. 298–9

C. Corman, ed.: *Joseph Cornell's Dreams* (Cambridge, MA, 2007) [with intro. and appendices]

K. A. Hoving: *Joseph Cornell and Astronomy: A Case for the Stars* (Princeton, NJ, 2009)

Philip Cooper

Cornish

American town and former artists' colony in the state of New Hampshire. Situated on a line of hills near the eastern bank of the Connecticut River *c.* 100 miles northwest of Boston, Cornish looks across to Windsor, Vermont and Mt Ascutney. It was settled in 1763 as an agrarian community, but its population was rapidly reduced during the migration to the cities in the second half of the 19th century. From 1885 until around the time of World War I, Cornish was the summer home of a group of influential sculptors, painters, architects, gardeners and writers. For this coherent group, the Cornish hills symbolized an ideal natural environment that reflected the classical images so important in their work. The sculptor who first spent a summer in Cornish in 1885, Augustus Saint-Gaudens, bought his summer residence there in 1891, and he was soon followed by the painters Henry Oliver Walker (1843–1929), George de Forest Brush, and Thomas Wilmer Dewing and his wife Maria Oakey Dewing. While the Dewings became the most enthusiastic promoters of the colony, Saint-Gaudens, who made Cornish his permanent home from 1900 onward, clearly established it as a domain for sculptors, attracting Daniel Chester French, who worked there in the summers of 1892 and 1893, and Herbert Adams, who joined the community in 1894. Paul Manship, and William Zorach and his wife, Marguerite Zorach, came in 1915, but the last two soon found their modernist interests out of step with those of the other colonists.

While the colony in Cornish was not dominated by a major figure, painters formed the largest group of artists. Most of them had trained in New York and in Paris at either the Académie Julian or the Ecole des Beaux-Arts. They shared a common belief in traditional subjects as influenced by the art of antiquity and the Renaissance. The figural tradition was pursued by mural painters, for example Kenyon Cox and John Elliott (1858–1925), and by book and magazine illustrators such as Maxfield Parrish and William Howard Hart (1863–1937). A larger group focused on the local landscape: Willard Leroy Metcalf, Arthur Henry Prellwitz (1865–1940), Stephen Parrish (1846–1938) and Charles A. Platt depicted scenes of the Connecticut River Valley and New Hampshire hills, while Thomas Dewing created a more mythical landscape in haunting canvases populated by ethereal maidens in flowing gowns. Platt also became the resident architect of the Cornish colony after designing nine houses and

several gardens for himself and his fellow colonists in the 1890s. While others, including Joseph Wells (1853–90), George Fletcher Babb, Wilson Eyre and Harrie T. Lindeberg (1880–1959), also designed houses in Cornish, Platt established the model for the urban artist's summer retreat in his combination of the Italian Renaissance villa and local building materials (clapboard, stucco on wooden frame and brick).

Landscape architects also emerged in the colony: many of the artists were amateur gardeners, but Platt, Ellen Shipman and Rose Standish Nichols (1872–1960) began their professional careers as landscape designers in their work on Cornish gardens. All three espoused an interest in the formal gardens of the Renaissance, with clear geometry and axial interrelationships providing the basis of their designs. Collaboration was characteristic of the Cornish community, and many artists worked in more than one medium. The architects designed settings for the sculptors, the muralists incorporated gardens modeled on local examples, and the sculptors derived inspiration from the landscape painters. Emblematic of this communal interaction and of the spirit of Cornish at large is the bronze medal cast by Saint-Gaudens in 1905–6 to commemorate the *Masque of the Golden Bowl*, a classically inspired pageant written, acted and staged by the colony to celebrate Saint-Gaudens's 20th summer at Cornish.

Following World War I, few new artists joined the colony. However, its original members continued to spend summers there until the 1960s, and the descendants of many of them still maintain houses there. In 2006 the population of Cornish was about 1779.

[*See also* Platt, Charles A.]

BIBLIOGRAPHY

H. M. Wade: *A Brief History of Cornish, 1763–1974* (Hanover, NH, 1976)

S. Faxon Olney, ed.: *A Circle of Friends: Art Colonies of Cornish and Dublin* (Durham, NH, 1985), intro. and pp. 33–137

K. N. Morgan: *Charles A. Platt: The Artist as Architect* (New York, 1985); ed., *Shaping an American Landscape: The Art and Architecture of Charles A. Platt* (Hanover, NH: 1995)

D. van Buren: *The Cornish Colony: Expressions of Attachment to Place, 1885–1915* (diss., Washington, DC, George Washington U., 1987)

K. McCormick: "A Sculptor's Retreat," *Hist. Preserv.*, xlvi (1994), p. 68

J. B. Tankard and A. M. Gilbert: *Place of Beauty: The Artists and Gardens of the Cornish Colony* (Berkeley, 2000).

Keith N. Morgan

Correspondence art

Term applied to art sent through the post rather than displayed or sold through conventional commercial channels, encompassing a variety of media including postcards, books, images made on photocopying machines or with rubber stamps, postage stamps designed by artists, Concrete poetry and other art forms generally considered marginal. Although Marcel Duchamp, Kurt Schwitters and the Italian Futurists have been cited as its precursors, as a definable international movement it can be traced to practices introduced in the early 1960s by artists associated with Fluxus, Nouveau Réalisme and the Gutai group and most specifically to the work of Ray Johnson. From the mid-1950s Johnson posted poetic mimeographed letters to a select list of people from the art world and figures from popular culture, which by 1962 he had developed into a network that became known as the New York Correspondence School of Art.

Correspondence artists sought, among other things, to circumvent the commercial exploitation of their work, and in this respect their work can be linked to conceptual art, performance art and other developments of the 1960s and 1970s that elevated ideas over the production of finished objects. As for these other art forms, however, exhibitions played an important role in making public the results of an otherwise essentially private and intimate activity. Among the exhibitions that helped set the standards for subsequent shows, following the first

Correspondence Art exhibition at the Whitney Museum in New York in 1970, were a special section curated by Jean-Marc Poinsot of the seventh Paris Biennale in 1971 and *Omaha Flow Systems* (1972; Omaha, NE, Joslyn A. Mus.), organized by Fluxus artist Ken Friedman (*b* 1949). These were conducted without entry fees or juries, and participants were provided with documentation.

In addition to organizing exhibitions, correspondence artists published magazines, established archives and conducted research, in each of these ways stimulating international interaction among contemporary artists. Their role was especially important in establishing links between North America and Western Europe on the one hand and Eastern Europe and the Soviet Union on the other. The Decentralized Worldwide Mail Art Congress held in 1986, which attracted over 500 artists, consisted of more than 80 meetings in 25 countries.

BIBLIOGRAPHY

J.-M. Poinsot: *Mail Art: Communication a Distance Concept* (Paris, 1971)

H. Fischer: *Art et communication marginale: Tampons d'artistes* (Paris, 1974)

Lightworks Envelope Show: An Exhibition of Correspondence Art (exh. cat. by F. Friedman and others, Ann Arbor, MI, 1978)

Mail, Etc., Art: A Travelling Correspondence Art Exhibition (exh. cat. ed. B. Donahue and others, Boulder, CO, Fine Arts Gallery, U. of Colorado at Boulder, 1980); review by K. S. Friedman, "Mail Art Exhibitions and Competitions," *Umbrella*, 3/3 (May 1980), pp. 56–8

R. H. Cohen: "Art and Letters: Please Mr. Postman Look and See … Is There a Work of Art in Your Bag for Me?," *ARTnews*, lxxx/10 (1981), pp. 80–7

M. Crane and M. Stofflet: *Correspondence Art: Source Book for the Network of International Postal Art Activity* (San Francisco, 1984)

Mail Art Then and Now (exh. cat. by R. Cohen, New York, Franklin Furnace, 1984)

S. Home: *Assault on Culture: Utopian Currents from Lettrisme to Class War* (London, 1988)

J. Held Jr.: *Mail Art: An Annotated Bibliography* (Metuchen, NJ, 1991)

C. Welch: "Mail Art Network: Source and Flow," *Art Papers*, 15/3 (May–June 1991), pp. 2–7

R. C. Morgan: *Commentaries on the New Media Arts: Fluxus and Conceptual Art, Artists' Books, Correspondence Art, Audio and Video Art* (Pasadena, CA, 1992)

K. Friedman, ed.: *The Fluxus Reader* (Chichester, West Sussex and New York, 1998)

M. Bloch: "Communities Collaged: Mail Art and the Internet," *New Observations*, 126 (Summer 2000), pp. 4–6 [incl. biblio]

John Held Jr.

Cortor, Eldzier

(*b*. Richmond, VA, 10 Jan 1916), painter and printmaker. Cortor's signature form is the attenuated black female nude presented as the personification of the African Diaspora's cultural richness and beauty. Born in the American South, Cortor left the region as a child and was raised in Chicago. After finishing high school, he studied painting and drawing at the School of the Art Institute of Chicago from 1936 to 1938. In 1938, Cortor joined the easel painting division of the Federal Art Project and worked in this Works Progress Administration program for five years, producing heroic, social realist genre pictures.

In 1944–5, Cortor was awarded successive Julius Rosenwald Foundation Fellowships that funded travel to the Sea Islands off the Georgia and South Carolina coasts. There, Cortor studied and painted the Gullah people, African Americans well-known for their retention of African cultural ways and languages.

By the late 1940s Cortor had developed a romantic realist style that generated widespread notice and praise. His painting *Americana* (1946; untraced) won an honorable mention at the Carnegie Institute's annual exhibition of 1947. *Life* magazine named Cortor among the best young painters in the USA in 1950, a year after he won a Guggenheim Fellowship to study and paint in Cuba, Haiti, and Jamaica. Cortor subsequently added Caribbean flora and fauna to his canvases, drawings, and prints, some of which are lyrical interpretations of West Indian dance and musical cultures. In 1952 Cortor moved to New York.

A notable departure from these poetic representations is Cortor's *L'Abbatoire (The Slaughterhouse)*, a series of prints done in 1955, 1967, and 1980. With its graphic title and haunting imagery of hanging, flayed muscles, *L'Abbatoire* alludes to the history of political violence in Haiti during the 20th century.

BIBLIOGRAPHY

Three Masters: Eldzier Cortor, Hughie Lee-Smith, Archibald John Motley, Jr. (exh. cat., essay by C. L. Jennings; New York, Kenkeleba Gallery, 1988)

Black Spirit: Works on Paper by Eldzier Cortor (exh. brochure, essay by M. Backer; Bloomington, IN U. A. Mus., 2006)

Jacqueline Francis

Cosindas, Marie

(*b* Boston, MA, 1925), photographer. Cosindas studied painting at the Boston Museum School and worked as a designer from 1944 to 1960. Her Boston studio was in the same building as the Carl Siembab Gallery; she gradually became part of the circle of photographers that made up his stable of artists. She attended photography workshops with Ansel Adams in 1961 and Minor White in 1963 and 1964. In 1962 she was one of about a dozen photographers who were invited by Polaroid to test Polacolor film. Since that time she worked extensively with Polaroid film and exclusively in color, manipulating various components of the process to produce the warm tones she preferred. Cosindas created sensuous portraits of figures and objects, using a view camera, natural light and color filters and working in the same way whether the images were personal or commissioned. Her color is muted, harmonious and atmospheric and infuses her images with romance and nostalgia.

PHOTOGRAPHIC PUBLICATIONS

Color Photographs (Boston, 1976)

BIBLIOGRAPHY

Marie Cosindas: Polaroid Color Photographs (exh. cat., New York, MOMA, 1966)

Color Photographs by Marie Cosindas (exh. cat. by Kristin L. Spangenberg, Cincinnati, Cincinnati A. Mus., 1981)

Sheryl Conkelton

Cosmopolitan Art Association

Organization for the cultivation of art and literature that was active in Sandusky, OH, and New York from 1854 to 1861. The Cosmopolitan Art Association was founded in 1854 to encourage the appreciation of fine art and to promote quality literature. Started by the book and periodical publisher Chauncey Lyman Derby (*b c.* 1821) in Sandusky, OH, the organization moved in 1855 to New York City and established a presence on Broadway. For an annual payment of three dollars, the Association offered its members a one-year subscription to a nationally distributed periodical such as *Godey's Lady's Book* or *Graham's Magazine*, among others, and a chance to win an original work of art in the Association's yearly art lottery. The first lottery included a version of the *Greek Slave* by American sculptor Hiram Powers, European genre paintings and landscapes by Ohio and New England artists. During its first full year of operation, the Association attracted over 22,000 members, including schools, libraries, social clubs and individuals.

The Cosmopolitan Art Association's most prominent predecessor was New York's American Art-Union, which had closed its doors in 1851. In 1856, following in the tradition of the Art-Union, the Association began publishing large engravings as an additional benefit for members. The engravings depicted scenes from poetry and the writings of Shakespeare. In 1857 the Association's directors, encouraged by expanding membership, purchased Broadway's renowned Dusseldorf Gallery where they exhibited European and American art. Through the gallery, the engravings, the annual lotteries and a monthly magazine called the *Cosmopolitan Art Journal*, the Cosmopolitan Art Association promoted such American painters as Lilly Martin Spencer and Albert Fitch Bellows (1829–83), and also the work of writers such as Metta Victoria Fuller Victor (1831–85) and Lydia Sigourney (1791–1865). The grand plans of the organization for "disseminating throughout the country a taste for the true, the beautiful, the good" came

to an end in 1861 with the start of the Civil War, and the books were officially closed in April of that year. During the seven years of its existence, the Cosmopolitan Art Association distributed more than 75,000 engravings, innumerable copies of their heavily illustrated periodical and nearly 2000 original works of art to Americans across the continent.

BIBLIOGRAPHY

The Cosmopolitan Art Association Illustrated Catalogue (Sandusky, OH, 1854)

"Sketchings, The Cosmopolitan Art Association," *The Crayon*, viii (Aug 1857), pp. 252–3

Cosmopolitan A. J., i–v (July 1856–March 1861)

The Cosmopolitan Almanac & Diary for 1861 (New York, 1861)

W. Sutton: "The Derby Brothers: Nineteenth-century Bookmen," *U. Rochester Lib. Bull.*, iii/2 (Winter 1948), pp. 21–9

L. B. Hewes: "The Cosmopolitan Art Association Engravings, 1856–1861," *Imprint*, xxxi/2 (Autumn 2006), pp. 2–17

Lauren B. Hewes

Cosmorama

Darkened room (or rooms), with lenses set into the walls, through which the viewer could inspect magnified, brightly lit and minutely delineated pictures placed at the end of a screened black tunnel. The cosmorama was mainly in use in 19th-century Europe and America. The pictures were painted in oils, in an ultra-realistic manner. Some paintings were perforated so as to create the effect of lit windows or a star-spangled sky, or they incorporated transparencies so that sequences of scene transformations could be produced. The paintings were generally of spectacular subjects—far-off cities, storms at sea, dramatic conflagrations, pyramids, great waterfalls or volcanoes. Visits to cosmoramas provided a substitute for arduous foreign travel, and they were often used to divert and educate children.

The first cosmorama was opened in 1808 by the Société des Voyageurs et des Artistes at the Palais-Royal, Paris. The invention reached New York in 1815, while a Cosmorama Room, exhibiting the Paris paintings, was established at 29 St James's Street, London, in May 1821, transferring to 209 Regent Street two years later. It continued in business until 1861. Other cosmoramas (sometimes called physioramas, naturoamas and poeciloramas) in London were in the Lowther Bazaar, the St James's Bazaar, the Royal Bazaar, the Queen's Bazaar, the Saville House Bazaar, the Grand Oriental Bazaar and the Waterloo Rooms. In the English provinces cosmoramas were established at Bristol, Manchester, Exeter, Derby and other major cities. Many of the paintings shown were by French artists, although a few were by Clarkson Stanfield, Frederick Nash (1782–1896) and Kenny Meadows. John Martin's paintings provided an occasional source.

In Europe the principal cosmorama artist was Hubert Sattler (1817–1904). He was the son of the panoramist Johann Michael Sattler (1786–1847), who from 1829 toured Europe exhibiting a panorama of Salzburg in a transportable rotunda, which he set up in the marketplace of each town visited. Hubert Sattler's cosmoramas were displayed either in the corridor beneath the panorama or in a separate "art hut." In his search for subjects Sattler traveled widely, to Italy, Greece, Turkey, Syria, Egypt, the east coast of the USA, Mexico and the West Indies. He visited New York in 1850, exhibiting his cosmoramas in an iron hut on Broadway at 13th Street. In 1870 he presented the city of Salzburg with his father's panorama and over 100 cosmoramas. Sattler's cosmoramas are preserved in the Salzburger Museum.

BIBLIOGRAPHY

A. Adburgham: *Shops and Shopping* (London, 1964)

B. Stopfer: "Hubert Sattler (1817–1904): Materialien zur Monographie eines Reisemalers," *Jschr. Salzburg. Mus. Carolino Augusteum*, xxii (1976), pp. 103–48

S. B. Wilcox: *Panoramas and Related Exhibitions in London* (diss., U. Edinburgh, 1976)

Sattler & Sattler: Ölgemälde Graphik (exh. cat., Salzburg, Mus. Carolino Augusteum, 1977)

R. D. Altick: *The Shows of London* (Cambridge, MA, 1978)

F. Robichon: *Les Panoramas en France au XIX siècle* (diss., U. Paris, 1982)

Panoramania! (exh. cat. by R. Hyde, London, Barbican A.G., 1988)

Sehsucht: Das Panorama als Massenunterhaltung des 19. Jahrhunderts (exh. cat., Bonn, Kst- & Ausstellhal., 1993)

S. Oettermann: *The Panorama: History of a Mass Medium*, trans. D. L. Schneider (New York, 1997)

B. Comment: *The Panorama* (London, 1999)

Devices of Wonder: From the World in a Box to Images on a Screen (exh. cat. by B. M. Stafford and F. Terpak, Los Angeles, Getty Mus., 2001)

Ralph Hyde

Cox, Kenyon

(*b* Warren, OH, 27 Oct 1856; *d* New York, 17 March 1919), painter, illustrator and writer. He was a member of a prominent Ohio family who fostered in him a strong sense of moral responsibility. From an early age he wished to be a painter and despite severe illnesses studied at the McMicken School in Cincinnati, OH, and at the Pennsylvania Academy of Fine Arts, Philadelphia (1876–7). From 1877 to 1882 he was in Paris, where he worked first with Carolus-Duran (1837–1917), then with Alexandre Cabanel (1823–99) and Jean-Léon Gérôme (1824–1904) at the Ecole des Beaux-Arts. He considered Gérôme his master, though he did not adopt his style or subject matter. In the autumn of 1878 Cox traveled to northern Italy, where he imbibed the spirit of the Italian Renaissance. As a student he gravitated steadily toward the reigning academic ideal of draftsmanship, especially of the figure, that was to persist throughout his career (e.g. *An Eclogue*, 1890; Washington, DC, N. Col. F.A.). He did paint outdoors, both landscapes and genre, and attained a sense of spontaneity and charm in many such works, but he always insisted on careful composition and interpreted form. He exhibited at the Salon in Paris between 1879 and 1882.

Cox returned to Ohio in the autumn of 1882 and moved to New York a year later. He made a living illustrating magazines and books and writing occasional art criticism. In 1892 he began his career as a mural painter with four mural decorations for the Manufactures and Liberal Arts Building at the World's Columbian Exposition of 1893 in Chicago, IL. He painted a lunette, *Venice* (1894), at Bowdoin College, Brunswick, ME, and in 1896 finished two large lunettes for a gallery in the Library of Congress, Washington, DC. A steady flow of commissions for public buildings followed, providing what he called "a precarious living." Among these were a mural for the Public Library, Winona, MN (the *Light of Learning*, 1910; *in situ*), and the sculpture *Greek Science* for the Brooklyn Institute of Arts and Sciences, NY (1907–9).

Cox believed that works of art should speak a universal language based on Classical and Renaissance precedents and promote in the viewer a unified experience of expanded imagination and attachment to tradition. He ardently believed that art is a unifying force in society. Thus in his murals he used idealized, usually female, figures to symbolize abstract ideas such as Truth or Beauty. He was a skillful academic draftsman and a strong colorist, and he adopted elements of the simplified, decorative style of Pierre Puvis de Chavannes (1824–98) and of the Italian Renaissance masters. However formal, at their best Cox's works are beautifully crafted and impressive. They represent his conception of the artist as a special person with unusual perception who should express ideals in a lofty but comprehensible way.

In his later years, Cox, while not opposed to change, was an outspoken opponent of modernism. Though skeptical of the claims of Impressionism, which dissolved the palpable form and design he thought necessary for artistic expression, he nonetheless approved of the new emphasis on color and, to a lesser extent, on light in painting. He viewed the most radical aspects of modern art that tended towards abstraction as divisive and particularly disliked the new emphasis on self-conscious individual expression, or "egotism," because he feared that the artist would ultimately communicate only to a handful of devotees rather than act as a unifying

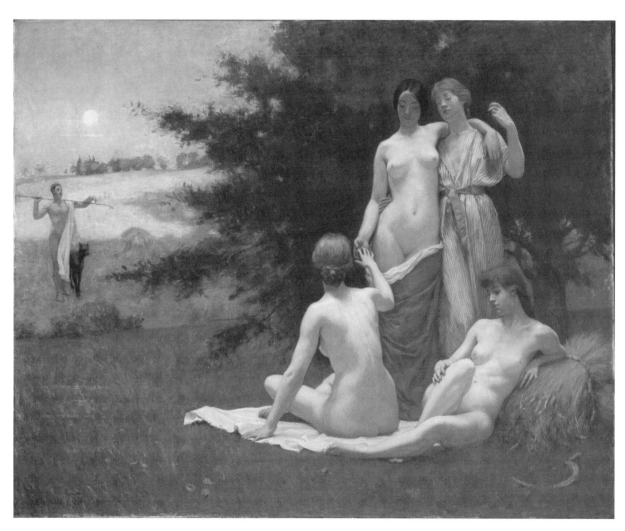

KENYON COX. *An Eclogue*, oil on canvas, 1.2 × 1.5 m, 1890. Smithsonian American Art Museum, Washington, DC/Art Resource, NY

social force. He taught at the Art Students League in New York from 1884 until 1909. In 1892 he married a pupil, Louise King (1865–1945), who also attained some reputation as a painter.

UNPUBLISHED SOURCES
New York, Columbia U., Avery Archit. Mem. Lib. [Cox's papers]

WRITINGS
Old Masters and New: Essays in Art Criticism (New York, 1905)
Painters and Sculptors (New York, 1907)
The Classic Point of View (New York, 1911)
Artist and Public (New York, 1913)
Concerning Painting: Considerations Theoretical and Historical (New York, 1917)

H. W. Morgan, ed.: *An American Art Student in Paris: The Letters of Kenyon Cox, 1877–1882* (Kent, OH, 1986)

H. W. Morgan, ed.: *An Artist of the American Renaissance: The Letters of Kenyon Cox, 1883–1919* (Kent, OH, 1995)

BIBLIOGRAPHY
M. C. Smith: "The Works of Kenyon Cox," *Int. Studio*, xxxii (1907), pp. i–xiii

H. W. Morgan: *Keepers of Culture: The Art-thought of Kenyon Cox, Royal Cortissoz and Frank Jewett Mather, Jr.* (Kent, OH, 1989)

H. W. Morgan: *Kenyon Cox, 1856–1919: A Life in American Art* (Kent, OH, 1994)

H. Wayne Morgan

Cox, Renee

(*b* Colgate, Jamaica, 16 Oct 1960), photographer of Jamaican birth. Although born in Jamaica, Cox was raised in an upper–middle-class neighborhood in Scarsdale, NY. Interested in both film and photography, Cox favored the latter for its immediacy and began her study of the craft while at Syracuse University. After a brief stint as a fashion photographer, Cox received her MFA from the School of Visual Arts in 1992 photographer and participated in the Whitney Museum of American Art Independent Study Program from 1992–3.

Cox became a household name in 2001 when New York City mayor Rudolph Giuliani took great offense at *Yo Mama's Last Supper* (1996), a controversial photographic reinterpretation of Leonardo's *Last Supper*, unveiled at the Brooklyn Museum exhibition, *Committed to the Image: Contemporary Black Photographers*. (The photo featured a nude Cox, with arms outstretched, flanked by 11 black, dreadlocked apostles and a white Judas.) Outraged at the image's supposedly irreverent, anti-Catholic overtones, Giuliani called for a special commission on decency to oversee organizations whose exhibitions benefited from public funds. The subsequent media frenzy earned Cox (who was raised Catholic) much publicity in the popular press, which in turn brought new critical attention to her works.

Yo Mama's Last Supper is representative of the kind of antagonistic complexity and friction so evident in Cox's carefully posed self-portraits. Her photos are a re-envisioning of familiar biblical, historical, and stereotypical narratives in which women and blacks often have been excluded, and take aim at the always culturally, sexually, and racially charged terrain of the black female nude. They also are a commentary on contemporary social norms and place Cox—an African American female—at the center of that discourse, quite literally.

Her body displayed in various states of nudity, Cox is ever the consummate beauty. Whether portraying a sexy dominatrix, an expectant or nursing mother,

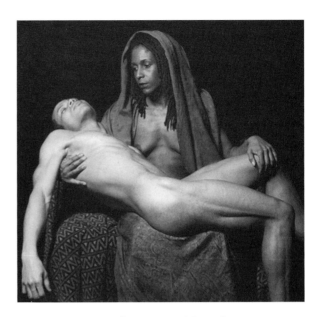

RENEE COX. *Yo Mama's Pieta*, 1996. © Renee Cox, courtesy of the artist

a canonical religious figure, a fictitious female superhero named "Raje" who comes to the rescue of Aunt Jemima and Uncle Ben, a pampered suburban house wife or a Jamaican national heroine, since the early 1990s Cox has fought female stereotypes. Through such series as *Flippin the Script* (1992–7), *Yo Mama* (1979–96), *Raje* (1998), *American Family* (2001), *Queen Nanny of the Maroons* (2004; for which she won the 2006 Jamaican Biennial Aaron Matalon Award) and *The Discrete Charm of the Bougies* (2008), Cox aimed to portray her subjects as visibly empowered women and, when necessary, to reclaim the lives, histories and dignity of her characters.

Cox used her photography not only as a means through which to grapple with evolving stereotypical narratives but also a mode through which to untangle her personal navigation of the roles of woman, daughter, wife, mother and artist. Acutely aware of her own complex, multi-textured identity, Cox's rich works represent a woman on a constant quest to understand her place in a world that has yet to catch up with her; a world that is still a long way away from coming to terms with its perpetuation of social, cultural and racial prejudices and gender biases.

BIBLIOGRAPHY

Bad Girls (exh. cat., New York, New Mus. Contemp. A., 1994)

A. Liss: "Black Bodies in Evidence: Maternal Visibility in Renee Cox's Family Portraits," *Familial Gaze*, ed. M. Hirsch (Hanover and London, 1999), pp. 276–92

Committed to the Image: Contemporary Black Photographers (exh. cat., ed. B. Head Millstein, New York, Brooklyn Mus., 2001)

Renee Cox: American Family (exh. cat., ed. J. Isaak; New York, Robert Miller Gallery, 2001)

L. Farrington: "Reinventing Herself: The Black Female Nude," *Woman's A. J.*, xxiv (2004), pp. 15–23

L. Farrington: *Creating Their Own Image: The History of African-American Women Artists* (Oxford 2005)

Mary M. Tinti

Coxe-DeWilde Pottery

Pottery in Burlington, NJ. Coxe-DeWilde Pottery was founded in 1688 by Dr. Daniel Coxe (*b* ?Stoke Newington, England, 1640/41; *d* ?London, 19 Jan 1730) and John DeWilde (*b c.* 1665; *d* Doctor's Creek, NJ, 1708). A Cambridge-trained physician, Dr. Coxe had extensive interests in the American colonies and was Governor of East and West Jersey from 1688 to 1692. His contract with DeWilde for a pottery "for white and Chiney ware" was only one of the many ways in which he profited from his colonial holdings. From 1675 DeWilde had trained in London delftware potteries and by the time of his association with Coxe was a master potter and maker of delftware. Documents show that tin-glazed earthenwares were sold in the Delaware River Valley, Barbados and Jamaica, although no pieces from this pottery survive. The pottery was probably disbanded when Coxe sold his Jersey holdings to the West Jersey Society in 1692.

BIBLIOGRAPHY

B. L. Springsted: "A Delftware Center in Seventeenth-century New Jersey," *Amer. Cer. Circ. Bull.*, iv (1985), pp. 9–46

Ellen Denker

Coxhead, Ernest

(*b* Eastbourne, Sussex, 1863; *d* Berkeley, CA, 27 March 1933), English architect, active in the USA. Coxhead was trained in the offices of several English architects and attended the Royal Academy Schools, London. In 1886 he moved with his older brother, Almeric Coxhead (1862–1928), to Los Angeles, CA, where he established an independent practice. The Coxheads moved to San Francisco four years later and soon formed a partnership that lasted until Almeric's death. Ernest Coxhead appears to have retained charge of designing. Until the early 1890s the firm specialized in churches; thereafter, most executed projects were for houses in San Francisco and its suburbs. Coxhead's building schemes of the 1890s were highly inventive, sometimes eccentric, drawing on both the classical tradition in England and the contemporary English Arts and Crafts work. He was adept at developing complex, dramatic spatial sequences and creating mannerist plays with form, scale and historical allusions. Like his friend Willis J. Polk, Coxhead excelled in the design both of modest, informal dwellings such as his own house (1893) in San Francisco and of large, elaborate ones such as the Earl House (*c.* 1895–8; destr. 1957), Los Angeles. Among his most original designs was an unsuccessful entry to the Phoebe Hearst architectural competition for the University of California, Berkeley (1898). Here, grand classical elements are interspersed among others more suggestive of a northern Italian hill town, to form an intricate collage that is a pronounced departure from most planning projects of the period.

After 1900 Coxhead's career declined, the reasons for which are difficult to pinpoint. He continued to practice for another 30 years; however, most of this work fails to match the vital, ingenious spirit that marked earlier efforts.

[*See also* San Francisco *and* Shingle style.]

BIBLIOGRAPHY

A. Coxhead: "The Telephone Exchange," *Archit. & Engin. CA*, xviii/1 (1909), pp. 34–46

"An Echo of the Phoebe Hearst Architectural Competition for the University of California," *Archit. & Engin. CA*, xxx/2 (1912), pp. 97–101

J. Beach: "The Bay Area Tradition, 1890–1918," *Bay Area Houses*, ed. S. Woodbridge (New York, 1976), pp. 23–98

R. Winter, ed.: *Toward A Simpler Way of Life: The Arts & Crafts Architects of California* (Berkeley, CA, 1997)

R. Longstreth: *On the Edge of the World: Four Architects in San Francisco at the Turn of the Century* (New York, 1983/R Berkeley, 1998)

Richard Longstreth

Craftsman Movement

Early 20th-century American manifestation of the late 19th-century international Arts and Crafts movement and similarly grounded on the ideas of John Ruskin and William Morris. The Craftsman Movement married Ruskin's concept of an architectural morality with Morris's ideal of art as quintessentially "doing a right thing well," and called for artists to embrace the idea that the worth of an object is inherent in the pleasure in its making. Led in America by furniture maker Gustav Stickley, the movement preached honesty in materials, elimination and simplification in design (as a reflection of a simpler life) and an integration of art and beauty into domestic life. A non-elitist craft of building embodying values of handiwork and "pleasure in labor" would result in a democratic architecture of good character available to Everyman.

Stickley designed and manufactured furniture, and published designs for houses as appropriate settings for his honest and straight-forward oak tables and chairs and built-in bookcases. He illustrated his work and point of view in *The Craftsman Magazine*, which ran from 1901 to 1916. Articles offered readers numerous images of Craftsman homes, including sketches of living rooms and dining rooms with inglenooks, built-in bookcases, window seats, ceiling beams, cozy stone fireplaces and Craftsman furniture. Stickley's empire grew to a network of factories and workshops, the Craftsman Farms (1908) in Morris Plains, NJ, and ultimately a twelve-story New York skyscraper (1913), known as the Craftsman Building. Here, model-home shows and exhibits offered visitors examples of Stickley's furnishings in their Craftsman settings (e.g. *The Craftsman Permanent Homebuilders' Exposition*), and here also were located his magazine's editorial offices. Stickley furniture was collected notably by Frank Lloyd Wright to furnish his Oak Park house, before Wright himself effectively joined the movement as a designer of "Prairie" furniture, leaded glass, and other arts and crafts. Wright was also a member of the Chicago Arts and Crafts Society.

Stickley's greatest rival was "Fra" Elbert Hubbard, whose Roycrofter group gathered as an artists' colony in East Aurora, NY. Hubbard designed competing domestic furnishings, edited a rival magazine, *The Philistine*, and published hand-bound and beautifully printed books. A notable collection of Roycrofter furniture survives at the Grove Park Inn in Asheville, NC. Hubbard's *Note Book* is full of aphorisms and favorite collected quotations, advancing ideas about art and life which generally conformed to the Craftsman movement at large. His *Little Journeys to the Homes of the Great* was a series of short biographies of famous individuals, whose character was conveyed through descriptions of Hubbard's visits to their homes.

That architecture was perceived as an embodiment of an individual's character was implicit in such writings by both Hubbard and Stickley. This view underscored a lasting legacy of the Craftsman Movement: the idea that by improving art and craft, both the artist and the user of well-crafted objects, including homes, can bring about improvements in society—a simple art and a simpler life.

In California, the Craftsman Movement spread from San Diego to San Francisco with distinctive traits characterizing the architecture of each region. Irving Gill produced restrained, almost proto-Modernist architecture, whose cubic forms, clean surfaces, and white abstraction have been compared to the work of Adolf Loos in Vienna, but whose roots are more directly in the simple forms of Spanish Colonial

architecture. In Pasadena, CA Greene & Greene produced the so-called "ultimate bungalows" of the Arroyo region, notably the Blacker House (1906) and Gamble House (1907–8), two hand-crafted homes that are unsurpassed in refined joinery and artistry. The brothers and their artisans display an almost reverential respect for carpentry and handicraft in wood, softening and polishing fine hardwoods (teak and mahogany) into exquisitely crafted objects, including tables and chairs, architectural paneling, wall sconces and chandeliers. Doors and windows are trimmed and filled with stained glass, transforming the entire house into an *objet d'art*. In the Berkeley and San Francisco area, Bernard Maybeck designed what contemporary poet Charles Keeler called "simple homes," characterized by unpainted redwood inside and out. Through works such as the R. H. Matheuson House, Berkeley (1915), Maybeck became the mentor for a generation of California architects who formed what has been called the Bay Region tradition.

In cities throughout America, the "Craftsman bungalow" became the domestic style of choice during much of the first quarter of the century. Pattern-book houses offered by such local designers as Leila Ross Wilburn in Atlanta, mail-order houses available nationally from Sears Roebuck and other companies, and anonymous local developer- and contractor-houses created neighborhoods of Craftsman-inspired homes, today constituting "historic districts" now being reclaimed by residents who are rediscovering the artistic home life and simpler lifestyle which the movement originally inspired.

[*See also* Arts and Crafts movement; Gill, Irving; Greene & Greene; Maybeck, Bernard; Stickley, Gustav; Wilburn, Leila Ross; *and* Wright, Frank Lloyd.]

BIBLIOGRAPHY

E. Hubbard: *Little Journeys to the Homes of the Great* (1894–; 1895–1909 in booklet form)

The Craftsman Magazine (1901–16)

C. Keeler: *The Simple Home* (San Francisco, 1904)

G. Stickley: *Craftsman Homes* (New York, 1909); rev. as *Craftsman Homes: Architecture and Furnishings of the American Arts and Crafts Movement* (New York, 1979)

G. Stickley: *More Craftsman Homes* (New York, 1912)

L. R. Wilburn: *Southern Homes and Bungalows* (Atlanta, 1914)

F. Champney: *Art & Glory: The Story of Elbert Hubbard* (New York, 1968)

T. J. Anderson, E. M. Moore, and R. Winter, eds: *California Design 1910* (Salt Lake City, 1974)

G. Stickley: *The Best of Craftsman Homes* (Santa Barbara and Salt Lake City, 1979)

L. Lambourne: *Utopian Craftsmen: The Arts and Crafts Movement from the Cotswolds to Chicago* (Salt Lake City, 1980)

M. A. Smith: *Gustav Stickley: The Craftsman* (New York, 1983)

C. Lancaster: *The American Bungalow, 1880–1930* (New York, 1985)

W. Kaplan: *"The Art that is Life": The Arts and Crafts Movement in America, 1875–1920* (Boston, MA, 1987)

K. R. Trapp: *The Arts and Crafts Movement in California: Living the Good Life* (New York, 1993)

M. Via and M. Searl: *Head, Heart, and Hand: Elbert Hubbard and The Roycrofters* (Rochester, NY, 1994)

R. Winter, ed.: *Toward a Simpler Way of Life: The Arts and Crafts Architects of California* (Berkeley, 1997)

Robert M. Craig

Cram, Ralph Adams

(*b* Hampton Falls, NH, 16 Dec 1863; *d* Boston, 22 Sept 1942), architect and writer. Cram was the leading Gothic Revival architect in North America in the first half of the 20th century, at the head of an informal school known as the Boston Gothicists, who transformed American church design.

In 1881 Cram was apprenticed to the firm of Rotch & Tilden in Boston. His letters on artistic subjects to the *Boston Transcript* led to his appointment as the journal's art critic by the mid-1880s. In 1886 he began his first European tour. In 1888 he founded the firm of Cram & Wentworth with Charles Wentworth (1861–97). With the arrival of Bertram Goodhue, the firm became Cram, Wentworth & Goodhue in 1892, and in 1899 Cram, Goodhue & Ferguson, with Frank Ferguson (1861–1926) having joined the office as business and engineering partner following the death of Wentworth.

Cram was strongly influenced both by the philosophies of John Ruskin and William Morris and by

the architectural images of H. H. Richardson, Henry Vaughan (1846–1917) and, behind Vaughan, the English Gothic Revival architects J. L. Pearson, G. F. Bodley and J. D. Sedding. Cram became an ardent Anglican, following the precepts of the Oxford Movement. He believed that the development of Gothic had been sundered prematurely at the Renaissance and argued that Gothic Revival should continue the Gothic style. His first work, All Saints (1891), Ashmont, Boston, built of irregular brown granite, is a powerful adaptation of the English Perpendicular style.

Cram's most successful designs were for small village churches and chapels that combined overall strength and simplicity while nonetheless including some rich detail. Examples include Our Saviour's (1897), Middleborough, MA, and the Day Chapel (1902), Norwood, MA. Among his large urban churches is the House of Hope (1912), St Paul, MN. His output was prolific, and he undertook commissions for many denominations in a wide variety of styles. For the stained glass and fittings of his churches, he secured exceptionally talented collaborators, including the stained-glass makers Charles Connick, Wilbur Burnham and Joseph Reynolds, Francis & Rohnstock and the architectural sculptor and carver Johannes Kirchinayer.

Two of Cram's most outstanding contributions to Gothic Revival are in New York: St Thomas (1905–14), Fifth Avenue, and work on the Cathedral of St John the Divine (1912–41), Amsterdam Avenue. At St Thomas he showed how, even without a tall tower, a Gothic Revival church could still dominate its surroundings, with a majestic and elegant massing of strong forms.

St John the Divine was begun by Heins & La Farge in 1892–1911 in a Romanesque style. Cram took over in 1912 with a new Gothic design. He remodeled the chancel and was responsible for the nave, west front, baptistery and synod house. His intended towers were not built, but the awkward façade is nonetheless imposing. The impressive, spacious nave is tall and narrow, with the aisles rising to the height of the nave itself.

Cram was also an important college architect. His educational commissions include the campuses at Wheaton College (1900), Norton, MA, and Sweet Briar College (1902), VA. The magnificent Gothic Revival ranges at the US Military Academy (1903) at West Point, New York, were the result of the winning competition entry that brought the firm national fame. His Graduate College at Princeton University (1910) is an important work in the tradition of the Anglo-American residential college.

Other significant work by Cram includes Richmond Court (1899), Brookline, MA, possibly the first courtyard apartment house in the eastern USA; Harbourcourt, the John Nicholas Brown House (1904, Newport, RI); and the Japanese Garden Court and Temple Room of the Museum of Fine Arts (1910), Boston, MA, which shows his interest in Japanese architecture.

The initial plans for the firm's commissions were prepared by Cram; he outlined the mass, scale and proportions and left the detail to his partners. From 1902 to 1913, when Cram and Goodhue dissolved their partnership, the firm maintained a New York office under Goodhue's charge, with Cram remaining in Boston. After 1913 the firm became Cram & Ferguson, with Frank Cleveland (1878–1950) and Alexander Hoyle (1881–1969) becoming Cram's designing partners. The firm continued after Cram's death, with John Doran and Maurice Berry, and Hoyle, Doran & Berry remains one of few American architectural firms to have lasted more than 100 years, continuing work on St John the Divine.

Cram was the author of nearly two dozen books and many articles on various subjects, including art criticism and Japanese architectural history, on which he was an authority. He was Professor of the Philosophy of Architecture and Head of the School of Architecture at the Massachusetts Institute of Technology. His work was eclectic but his passionate

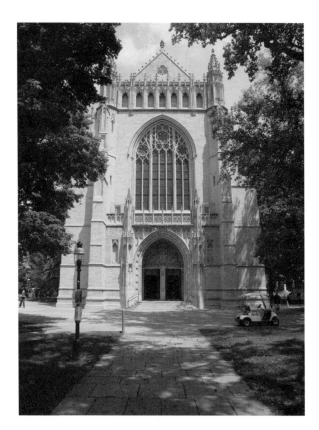

RALPH ADAMS CRAM. Princeton University Chapel, Princeton, New Jersey, 1928. COURTESY OF ROBERT M. CRAIG

The Substance of Gothic (Boston, 1917)

The Catholic Church and Art (New York, 1930)

The End of Democracy (Boston, 1935)

My Life in Architecture (Boston, 1936/R New York, 1969)

BIBLIOGRAPHY

M. Schuyler: "The Works of Cram, Goodhue and Ferguson," *Archit. Rec.*, xxix (1911), pp. 1–112

The Work of Cram and Ferguson (New York, 1929)

R. Muccigrosso: *Ralph Adams Cram* (New York, 1931)

D. Shand-Tucci: *Ralph Adams Cram: American Medievalist* (Boston, 1975)

A. M. Daniel: *The Early Architecture of Ralph Adams Cram, 1889–1902* (diss., U. North Carolina, 1978)

R. Muccigrosso: *American Gothic: The Mind and Art of Ralph Adams Cram* (Washington, DC, 1980)

F. S. Boos, ed.: *History and Community: Essays in Victorian Medievalism* (New York, 1992)

D. Shand-Tucci: *Ralph Adams Cram: Life and Architecture* (Amherst, 1994)

D. Shand-Tucci: *Ralph Adams Cram: Life and Architecture* (Amherst, MA, 1995)

Ralph Adams Cram: The University of Richmond, and the Gothic Style Today (exh. cat. by E. J. Slipek Jr., with essays by S. L. Wheeler and V. Mays, Richmond, VA, Marsh A. Gal., U. of Richmond, 1997)

D. Shand-Tucci: *Built in Boston: City and Suburb, 1800–2000*, with foreword by W. M. Whitehill (Amherst, MA, 1999)

M. D. Clark: *The American Discovery of Tradition, 1865–1942* (Baton Rouge, 2005)

E. Anthony: *The Architecture of Ralph Adams Cram and His Office* (New York, 2007)

Douglass Shand-Tucci

medievalism was the sphere of his greatest influence. He persuaded Henry Adams (1838–1918) to publish privately his *Mont Saint–Michel and Chartres* (1904) and wrote the introduction to it. He also played a leading role in inspiring Kenneth Conant's work on Cluny at Harvard. A founder of the Medieval Academy of America, Cram was also led by his medievalism to an interest in conservative social philosophy, about which he wrote widely. His influence in this field alone has generated considerable scholarship since World War II.

[*See also* Boston *and* Goodhue, Bertram.]

WRITINGS
Church Building (Boston, 1901–2, 2/1914, 3/1924)

Impressions of Japanese Architecture (New York, 1905/R 1966)

Ministry of Art (Boston, 1914/R Freeport, NY, 1967)

Heart of Europe (New York, 1915)

Crawford, Ralston

(*b* St Catharines, nr Niagara Falls, 5 Sept 1906; *d* New York, 27 April 1978), painter, printmaker and photographer of Canadian birth. After attending high school in Buffalo, NY, Crawford worked on tramp steamers in the Caribbean. In 1927 he enrolled at the Otis Art Institute in Los Angeles, CA, and worked briefly at the Walt Disney Studio. Later that year he moved to Philadelphia, PA, where he studied at the

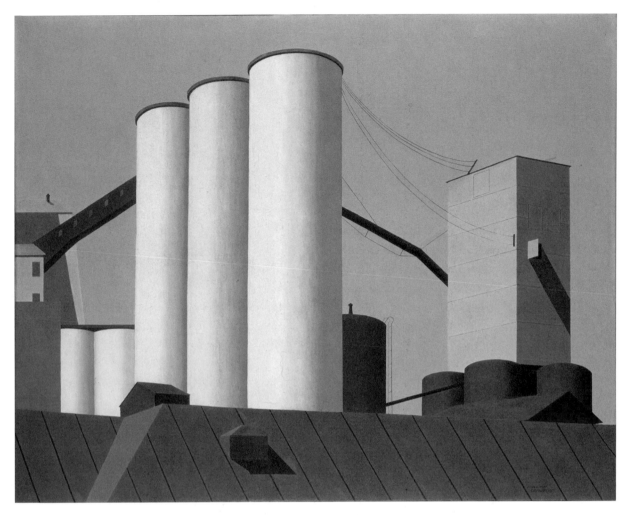

RALSTON CRAWFORD. *Buffalo Grain Elevators*, oil on canvas, 1021 × 1276 mm, 1937. Smithsonian American Art Museum, Washington, DC/Art Resource, NY

Pennsylvania Academy of the Fine Arts and at the Barnes Foundation in Merion Station until 1930. Crawford's paintings of the early 1930s, such as *Still-life on Dough Table* (1932; artist's estate, see 1985 exh. cat., p. 19), were influenced by the work of Cézanne and Juan Gris, which he had studied at the Barnes Foundation. He was also attracted to the simplified Cubism of Stuart Davis, with its restricted primary color schemes. After a trip to Paris in 1932–3, where he studied at the Académie Colarossi and the Académie Scandinave, Crawford's flat, geometric treatment of architectural and industrial subjects in paintings such as *Vertical Building* (1934; San Francisco, CA, MOMA) led him to be associated with Precisionism. After 1940 he almost eliminated modeling from his work in favor of flat and virtually abstract architectural renderings, for example *Third Avenue Elevated* (1949; Minneapolis, MN, Walker A. Cent.). He taught at several schools in the USA and worked extensively in lithography and photography, in many cases using his highly formal black-and-white photographs as source material for his paintings.

BIBLIOGRAPHY

R. B. Freeman: *Ralston Crawford* (Tuscaloosa, AL, 1953)

R. B. Freeman: *The Lithographs of Ralston Crawford* (Lexington, KY, 1962)

H. H. Arnason: *Ralston Crawford* (New York, 1963)

W. C. Agee: *Ralston Crawford* (Pasadena, CA, 1983)

Ralston Crawford: Photographs/Art and Process (exh. cat. by E. A. Tonelli, College Park, U. MD A.G., 1983)

Ralston Crawford (exh. cat. by B. Haskell, New York, Whitney, 1985)

R. Crawford: "A Comment on Ralston Crawford and his Works at the Kresge Art Museum," *Kresge A. Mus. Bull.* 7 (1992), pp. 10–23

Andrew Kagan

Crawford, Thomas

(*b* New York, ?1813; *d* London, 10 Oct 1857), sculptor. One of the major American Neo-classical sculptors, Crawford learned wood-carving in his youth. In 1832 he became a carver for New York's leading marble shop, operated by John Frazee and Robert E. Launitz (1806–70). He cut mantelpieces and busts and spent his evenings drawing from the cast collection at the National Academy of Design. In 1835 Crawford became the first American sculptor to settle permanently in Rome. Launitz provided Crawford with a letter of introduction to Bertel Thorvaldsen (1768/70–1844), who welcomed Crawford into his studio, gave him a corner in which to work and provided occasional criticism, including the advice to copy antique models and not his (i.e. Thorvaldsen's) own work. It is not known precisely how long Crawford remained under Thorvaldsen's tutelage, but it was probably less than a year. Crawford always esteemed Thorvaldsen's sculpture and continued friendship.

Once in his own studio, Crawford at first eked out a living by producing portraits, such as his bust of *Mrs. John James Schermerhorn* (1837; New York, N-Y Hist. Soc.). By 1839 he had executed a full-scale plaster of his first major ideal work, *Orpheus* (Boston, MA, Mus. F.A.). Charles Sumner, the future US senator and abolitionist, persuaded a group of literati to present an over life-sized marble version of *Orpheus* to the Boston Athenaeum, where it was unveiled in 1844 with other sculpture by Crawford: the first solo exhibition by an American sculptor. With its touching subject, careful nudity and echoes

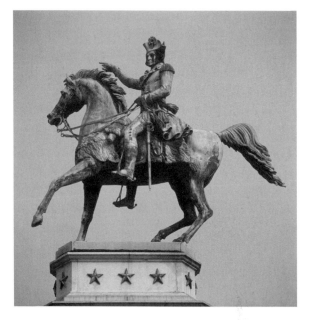

THOMAS CRAWFORD. *George Washington*, bronze, Richmond, Virginia, 1850. © SEF/Art Resource, NY

of the *Apollo Belvedere* (Rome, Vatican, Cortile Belvedere)—the statue most revered by Neo-classical artists—*Orpheus* won Crawford a reputation in Roman, British and, most importantly, American art circles. His rise to eminence was steady, and he found ready American patronage for ideal sculptures. Crawford attained particular success with figures of children, such as the *Genius of Mirth* (1842; New York, Met.).

Crawford was singular among the first generation of American Neo-classical sculptors in his success with public statuary. In 1850 he won a competition in Richmond, VA, for his bronze equestrian *George Washington*. Crawford's pediment design of the *Progress of Civilization* was commissioned for the Senate of the US Capitol in 1854. This pediment, composed of figures from America's past and present, dressed in contemporary costume, was thought eminently suitable for public statuary, and Crawford received subsequent Capitol commissions, including *History and Justice* (a pediment); bronze doors for the House of Representatives and Senate; and the colossal bronze *Armed Freedom* for the dome (all begun 1855). Crawford continued

to execute ideal figures such as *Flora* (1847; Newark, NJ, Mus.) and *Peri* (1854; versions at Washington, DC, Corcoran Gal. A., and Philadelphia, PA Acad. F.A.), in which his earlier severe Neo-classicism was sweetened by sentimentality, but his career was cut short by his death from cancer at the age of 44. Many of his projects were completed by colleagues in Rome under the supervision of his widow. His plaster models were presented to the New York Central Park Commissioners in 1860 and were exhibited until 1881, when a fire destroyed many of them.

UNPUBLISHED SOURCES

Washington, DC, Smithsonian Institution, Archives of American Art, [Crawford archives] microfilm reels D181, 3023, and 3667)

BIBLIOGRAPHY

R. L. Gale: *Thomas Crawford, American Sculptor* (Pittsburgh, 1964)

W. Craven: *Sculpture in America* (New York, 1968, rev. Newark, 2/1984), pp. 123–35

L. Dimmick: *The Portrait Busts and Ideal Works of Thomas Crawford (1813?–1857), American Sculptor in Rome* (diss., U. Pittsburgh, 1986)

L. Dimmick: "Thomas Crawford's *Orpheus*: The American *Apollo Belvedere*," *Amer. A. J.*, xix/4 (1987), pp. 47–79

L. Dimmick: "Veiled Memories, or, Thomas Crawford in Rome," *The Italian Presence in American Art, 1760–1860*, ed. I. Jaffe (New York, 1989), pp. 176–94

L. Dimmick: "'An Altar Erected to Heroic Virtue Itself': Thomas Crawford and his *Virginia Washington Monument*," *Amer. A. J.*, xxiii/2 (1991), pp. 4–73

M. G. Muller: "Die Obszönität der Freiheit: Politische Ästhetik und Zensur in den USA des 19. Jahrhunderts," *Krit. Ber.*, xxiii/4 (1995), pp. 29–39

L. Dimmick: "Thomas Crawford," *American Sculpture in the Metropolitan Museum of Art, Volume I.*, ed. T. Tolles (New York, 1999), pp. 34–40

Lauretta Dimmick

Crayon, The

Art periodical published in New York from 3 January 1855 to July 1861, spanning 8 volumes. Co-founded by William James Stillman, a painter and devotee of art critic John Ruskin (1819–1900), and John Durand, son of landscape painter Asher B. Durand, *The Crayon* sought to elevate America's artistic production by presenting concepts of beauty and nature as a means of reform to an overly materialistic and uncultured nation. *The Crayon* counted an eclectic mix of artists, literati, ministers, women, philosophers and foreigners as its contributors and subscribers.

At first a weekly paper, and then in 1856, a monthly, *The Crayon* ironically remained virtually devoid of illustrations and decorative designs. Stillman wrote many of the articles (often unsigned or with a pseudonym) including editorials, notices called "Sketchings," book reviews, nature adventures, art exhibition reviews and even poetry. When Stillman resigned in June 1856, Durand became sole proprietor. Subsequently, the periodical's content became sociologically broader in its offerings, including excerpts from the American Association of Architects, German philosophers, histories of Greek, Roman and Medieval art, Chinese history, landscape gardening and woman's place in society. By 1859 excerpts from Ruskin were supplanted by Georg Wilhelm Friedrich Hegel's *Aesthetics*, affirming the journal's increasing de-emphasis on the eye's truth to nature and its favoring of a subjective intuition of nature's beauty.

The Crayon's importance for the history of American art is twofold. First, it is a rich archival repository of artistic, literary, social and cultural antebellum America. Secondly, its overarching goals of cultivating a love of nature while affirming beauty as "the Ideal of the Actual" by which one "discovers the Beautiful in the spirit—the Ideal of the Immortal" led to an essentially Unitarian–Transcendentalist aesthetic discourse that sanctioned a new Romantic classicism and with it a new ideal of landscape painting. Its litany of favored qualities in art and nature, including light, breadth, simplicity, silence, delicacy, modesty, harmony, beauty and repose, elevated such artists as John Frederick Kensett and Sanford Robinson Gifford above Frederic Edwin Church, Albert Bierstadt and even Asher B. Durand. *The Crayon* created a critical foundation

for the rise of Luminist and Tonalist aesthetics in the wake of the Civil War.

[*See also* Stillman, William James.]

BIBLIOGRAPHY

W. J. Stillman: *The Autobiography of a Journalist* (Boston and New York, 1901)

J. P. Simoni: *Art Critics and Criticism in Nineteenth Century America* (PhD diss., Columbus, OH State U., 1952)

R. B. Stein: *John Ruskin and Aesthetic Thought in America 1840–1900* (Cambridge, MA, 1967)

J. Simon: *The Crayon 1855–1861: The Voice of Nature in Criticism, Poetry, and the Fine Arts* (PhD diss., Ann Arbor, U. MI, 1990)

J. Simon: "Imaging a New Heaven on a New Earth: The Crayon and Nineteenth-Century American Periodical Covers," *American Periodicals*, i (1991), pp. 11–24

The Crayon and the American Landscape (exh. cat. by M. Grzesiak, Montclair, NJ, A. Mus., 1993)

D. Raverty: "Art Theory and Psychological Thought in Mid-19th-Century America: The Case of The Crayon," *Prospects*, xxiv (1999), pp. 285–96

Janice Simon

Creeft, José de

(*b* Guadalajara, Spain, 27 Nov 1884; *d* New York, 11 Sept 1982), sculptor, painter and draftsman of Spanish birth. After being apprenticed to a religious figure-carver and then in a foundry, in 1900 Creeft moved to Madrid, where he became a student of Augustín Querol y Subirats. He also studied with Ignacio Zuloaga before acquiring his own studio in Madrid in 1902. In 1903 he had his first one-man show at the Círculo de Bellas Artes in Madrid and in 1905 moved to Paris. Shortly afterward he settled in the Bateau-Lavoir in Paris, where Picasso, Braque and Gris lived. On the advice of Auguste Rodin he studied sculpture at the Académie Julian from 1905 to 1906. He learned the techniques of copying models into stone at the Maison Gréber workshop in Paris from 1911 to 1914 but in 1915 turned to direct carving in stone. This was to be his main technique thereafter, leading to such works as *Fetish* (*c.* 1916; Washington, DC, Hirshhorn), which showed the influence of non-Western sculpture. Some of his early sculptures molded the female figure into near abstract forms, as in *Orchid* (1919; New York, Lorrie Goulet priv. col., see Campos, pl. 217).

During the 1920s de Creeft made a number of otherwise rare experiments using avant-garde techniques, producing several sculptures using junk metal elements, for example *Picador* (1925; Barcelona, Fund. Miró). Representing a horse and rider, *Picador* is 2.4 m high and made largely from stove pipes. He also made several abstract sculptures, such as *Abstract* (1928; Leesburg, VA, Mr. and Mrs. Edward Marks priv. col., see Campos, pl. 249), but found this aesthetic uncongenial. In 1929 he settled in New York, becoming an American citizen in 1940. After the move he returned to carved works of the female figure. These were invariably squat and often used in a symbolic role, as in *The Cloud* (1939; New York, Whitney) or *Metamorphosis* (1958; Washington, DC, Hirshhorn). He also used beaten metal as in *Himalaya* (beaten lead, 1942; New York, Whitney) and produced portraits, such as *Rachmaninoff* (1943; Philadelphia, PA Acad. F.A.). From 1932 to 1948 de Creeft taught at the New School for Social Research, New York. In 1955 he was commissioned to design the bronze tableau *Alice in Wonderland* (unveiled 1959) for Central Park in New York. He continued working well into later life, producing such works as *Maternity* (silver, 1973; New York, Lorrie Goulet priv. col., see 1983 exh. cat., p. 55).

BIBLIOGRAPHY

J. Campos: "About the Sculptor," *José de Creeft* (Athens, GA, 1950), pp. 61–2

José de Creeft (exh. cat. by C. Devree, New York, Amer. Fed. A., 1960)

J. Campos: *The Sculpture of José de Creeft* (New York, 1972) [with a statement on sculpture by the artist]

José de Creeft: A Retrospective Exhibition (exh. cat., New York, New School A. Cent., 1974)

José de Creeft: Recent Sculpture (exh. cat., New York, Kennedy Gals., 1975)

L'aventura humana de José de Creeft (exh. cat. by C. Fontsere, Barcelona, Fund. Miró, 1980)

José de Creeft: Sculpture and Drawings (exh. cat. by A. D. Breeskin and V. M. Mecklenburg, Washington, DC, N. Mus. Amer. A., 1983)

José de Creeft, 1884–1982: Works from the Collection of Nina De Creeft Ward and William De Creeft (exh. cat. by D. E. Stetson, Cedar Falls, IA, Gal. A., U. of Northern Iowa, 1983)

D. Halpern, ed.: *Writers on Artists* (San Francisco, 1988)

José de Creeft: Sculpture & Drawing, 1917–1940: Paris, Mallorca, New York (exh. cat., New York, Childs Gal., 1990)

Kenneth W. Prescott

Cret, Paul

(*b* Lyon, 23 Oct 1876; *d* Philadelphia, PA, 8 Sept 1945), French architect, active in the USA. He first studied architecture at the Ecole des Beaux-Arts in Lyon and then at the Ecole des Beaux-Arts in Paris (1897–1903), where he was in the atelier of Jean-Louis Pascal (1837–1920). After receiving his diploma in 1903 he immigrated to the USA to teach architectural design in Philadelphia at the University of Pennsylvania. He taught there until 1937, when he retired due to ill health, and gained a national reputation as a teacher; Louis I. Kahn was his best-known student. A number of influential French critics taught in the USA in the late 19th century and early 20th, but Cret also achieved prominence as a practicing architect and received the Gold Medal of the American Institute of Architects in 1938. His designs, even for those competitions that he entered but did not win, such as for the Nebraska State Capitol (1920), Lincoln, NE, the Kansas City Liberty Memorial (1921) and the Smithsonian Gallery of Art (1939), Washington, DC, furthered his distinctive ideas about typology and style. His writings about the Beaux-Arts method of design and about the possibilities of achieving a modern classicism complement and explicate his buildings and teaching.

Cret's civic buildings, for example the Indianapolis Public Library (1913–17), the Detroit Institute of Arts (1919–27) and the Pan American Union Building (1907–10) in Washington, DC, are all notable for the hierarchical lucidity of their designs. Following Beaux-Arts conventions, he composed his buildings as a succession of volumes organized on an armature of major and minor axes. He created legible sequences of rooms with subtly varying light, ornament and proportions that prepared visitors for the most important space in the building, the one that characterized each institution.

In keeping with Beaux-Arts theory, Cret saw architectural design as a process in a dialectical evolution of building types. He felt that it was the architect's responsibility to penetrate the complex and contradictory programs of modern civic clients in order to understand and to make architecturally legible the present state of an institution's development. For example, although American public libraries had formerly been characterized by the prominence of their reading rooms, at the Indianapolis Public Library Cret displaced the reading rooms to the sides of the building and placed, in the central location, a double-story book delivery room. The giant Doric order of the main façade not only deferred to contemporary American stylistic preferences but, more importantly for Cret, emphasized further the importance of this space, giving it a new prominence that articulated the shift in function of public libraries from reading to lending institutions.

The problem of the appropriate architectural representation for modern public institutions occupied Cret throughout his career, but in the mid-1920s he began to focus equal attention on the issue of the appropriate stylistic language for his time. In response to the argument that new materials and methods of construction had made the historical styles obsolete, Cret proposed the viability of a modern classical style. In bridges, such as the Delaware River Bridge (1920–26), Philadelphia, which he designed with the engineer Ralph Modjeski (1861–1940), he rationalized the form of the stone piers in terms of the forces of tension and compression. In the County Building, Hartford, CT, he developed

a modern classicism of unfluted piers to signify the steel frame, thus emphasizing the congruence between modern structure and classical form. His much-publicized Folger Shakespeare Library, Washington, DC, however, addressed the conventionality of the classical language; the fluted pilaster strips set into the plane of the walls read, like the sculptural plaques beneath them, as independent symbolic elements. In this building the issue is classicism as symbol rather than as structure. Cret's modern classicism may thus be understood as participating in the continuing debate about the origin and cultural function of classicism.

BIBLIOGRAPHY
Macmillan Enc. Architects

J. Harbeson: "Paul Cret and Architectural Competitions," *J. Soc. Archit. Hist.*, xxv (1966), pp. 305–6

T. B. White: *Paul Philippe Cret: Architect and Teacher* (Philadelphia, 1973)

J. Esherick: "Architectural Education in the Thirties and Seventies: A Personal View," *The Architect*, ed. S.Kostof (New York, 1977)

D. Van Zanten: "Le Système des beaux-arts," *Archit. Des.*, xviii (1978), pp. 11–12, 66–79

E. Grossman: "Paul P. Cret and the Pan American Union Competition," *Modulus* (1982), pp. 30–39

C. McMichael: *Paul Cret at Texas* (Austin, 1983)

E. Grossman: "Architecture for a Public Client: The Monuments and Chapels of the American Battle Monuments Commission," *J. Soc. Archit. Hist.*, xliii (1984), pp. 119–43

E. Grossman: "Two Postwar Competitions: The Nebraska State Capitol and Kansas City Liberty Memorial," *J. Soc. Archit. Hist.*, xlv (1986), pp. 244–69

E. G. Grossman: *The Civic Architecture of Paul Cret* (Cambridge, 1996)

J. E. Farnham: "Staging the Tragedy of Time: Paul Cret and the Delaware River Bridge," *J. Soc. Archit. Hist.*, lvii/3 (Sept 1998), pp. 258–79, 362

A. T. Shulman: "Paul Philippe Cret: Modern Classicism and Civic Art," *The Modernism Magazine*, i/3 (Winter 1999), pp. 16–22

Elizabeth Grossman

Crewdson, Gregory

(*b* New York, 26 Sept 1962), photographer. Crewdson obtained a BFA from the State University of New York Purchase, NY, and an MFA from Yale University, New Haven, CT, where he completed his studies in 1988. Creating highly constructed photographs that deal with the duality of culture and nature, Crewdson presented his first major cycle of untitled photographs within the tradition of pictorial dioramas, under the heading *Natural Wonder* (1992–7). Working with installations he had made in his studio from backdrops and stuffed animals, Crewdson created open-ended ambiguous narratives that took the American suburban landscape as a model for anxiety and desire. Typically, animals are posed in uncanny and unnatural roles; one such work has a ring of eggs (mirroring monolithic structures) surrounded by a gathering of birds in some unknowable ritual (see 1999 exh. cat., p. 34). Taxidermy featured less in Crewdson's later work, but he continued to explore his interest in pictorial framing. His *Hover* series of 1996–7 uses real suburban spaces where the strange incidents occur in a definite human context. Such incidents as fires, crop circles in back yards and neighborly insanity are coolly observed, as if the inhabitants were occupying a para-normal goldfish bowl. A subsequent series, *Twilight* (1998), continues this theme, using a more filmic language. Such photographs as one featuring a woman kneeling in the center of a soil- and flower-filled living room (see 1999 exh. cat., p. 108) directly relate to a scene from Steven Spielberg's movie *Close Encounters of the Third Kind* and create a sense of familiar unease.

BIBLIOGRAPHY
C. Schorr: "Close Encounters," *Frieze*, (March/April 1995), pp. 44–7

"Gregory Crewdson at Luhring Augustine," *A. America* (June 1995), pp. 107–8

Dream of Life: Gregory Crewdson (exh. cat., essay D. Steinke, interview by B. Morrow, Salamanca, U. Salamanca, 1999)

Beneath the Roses (with an essay by Russell Banks; New York, 2008)

D. Green and J. Lowry: "Photography, Cinema and Medium as Social Practice," *Vis. Stud.*, 24/2 (Sept. 2009), pp. 132–42

Francis Summers

Crolius and Remmey

Pottery established by William Crolius [Johan Willem Crollius] (*b* Neuwied, near Koblenz, *c.* 1700; *d* New York, *c.* 1776) and John Remmey [Remmi] (*d* New York, Nov 1762). Crolius arrived in New York *c.* 1718 and established a stoneware pottery on Pot-Bakers Hill. Bound by intermarriage to the Corselius and Remmey families, who were also in the pottery business, the Crolius family figured prominently in Manhattan pottery history until about 1850. From *c.* 1735 William Crolius and John Remmey were in business together. Although salt-glazed stoneware was the principal product, lead-glazed earthenware was also made in the early years of the Crolius and Remmey potteries. Before the American Revolution, their stoneware closely resembled Rhenish stoneware with incised decoration filled in with a blue cobalt oxide glaze, but subsequent generations usually painted simple blue embellishments (e.g. pitcher, 1798; New York, NY Hist. Soc.). Remmey's grandson Henry Remmey Sr. (*b c.* 1770; *d c.* 1865) and great-grandson Henry Remmey Jr. left New York in 1812 and set up a workshop in Baltimore. In 1827 the latter purchased a pottery in Philadelphia and established the Remmey name there.

BIBLIOGRAPHY

W. C. Ketchum Jr.: *Early Potters and Potteries of New York State* (New York, 1970); rev. as *Potters and Potteries of New York State, 1650–1900* (Syracuse, 1987)

L. Zipp: "Henry Remmey and Son, Late of New York: A Rediscovery of a Master Potter's Lost Years," in R. Hunter, ed., *Ceramics in America* (Milwaukee, WI: The Chipstone Foundation, 2004), pp. 143–56

M. F. Janowitz: "New York City Stonewares from the African Burial Ground," in R. Hunter, ed., *Ceramics in America* (Milwaukee, WI: The Chipstone Foundation, 2008), pp. 41–66

Ellen Denker

Cropsey, Jasper F.

(*b* Rossville, Staten Island, NY, 18 Feb 1823; *d* Hastings-on-Hudson, NY, 22 June 1900), painter and architect. Cropsey was a practicing architect by 1843, but in that year he also exhibited a landscape painting, to favorable reviews, at the National Academy of Design in New York. He greatly admired Thomas Cole for his dramatic use of the American landscape, but Cropsey brought to his panoramic vistas a more precise recording of nature, as in *View of Greenwood Lake, New Jersey* (1845; San Francisco, CA, de Young Mem. Mus.). Such vastness and detail impressed the viewer with both the grandeur and the infinite complexity of nature and indicated a universal order. In 1847 Cropsey made his first trip to Europe, settling in Rome among a circle of American and European painters. His eye for detail in recording nature was encouraged by the Nazarenes, and his American sympathy for historical and literary subjects was sharpened by the antiquities of Italy. In 1848 Cropsey was in Naples, where the work of contemporary painters may have inspired the bold massing, deep space and brilliant lighting in *View of the Isle of Capri* (1848; New York, NY, Alexander Gal.)

After his return to America in 1848, Cropsey painted landscape subjects, including a keenly observed view of a serene and sun-drenched harvest scene, *Bareford Mountains, West Milford, New Jersey* (1850; New York, Brooklyn Mus. A.), and a dramatic thunderstorm and waterfall in *Storm in the Wilderness* (1851; Cleveland, OH, Mus. A.). He also painted canvases after sketches made in Europe, one of the largest being *The Coast of Genoa* (1854; Washington, DC, N. Mus. Amer. A.). The strain of idealism characteristic of America found expression in such allegories as *Spirit of War* (1851; Washington, DC, N.G.A.).

Cropsey spent 1856 to 1863 in England, painting American and Italian subjects as well as the English landscape. He provided 16 scenes of America for lithography by Gambart & Co., drew the rugged coast at Lulworth, Dorset, and captured the charm of the Isle of Wight in *Beach at Bonchurch* (1859; Hastings-on-Hudson, NY, Newington Cropsey Found.). The detailed clarity and intense color of

the pre-Raphaelites impressed Cropsey, and his inclination toward truth to nature was encouraged by his personal acquaintance with John Ruskin. Cropsey portrayed, for an enthusiastic English public, the blazing colors of New England autumn in the vast painting called *Autumn—On the Hudson River* (1860; Washington, DC, N.G.A.). Returning to America in 1863, Cropsey repeated his success with such large, crisply drawn and vigorously painted scenes of America as *Indian Summer* (1866; Detroit, MI, Inst. A.; see color pl. 1:XV, 1.). Many of his paintings were modest in size, peopled with boaters or fishermen, sharp in detail but with a serene, burnished atmosphere, as in *Autumn Greenwood Lake* (1866; Hastings-on-Hudson, NY, Newington Cropsey Found.). During the 1860s and 1870s Cropsey became increasingly concerned with depicting the appearance of landscape strongly modified by sun and atmosphere. Air and light became chief elements in his Luminist pictures, such as *Lake Wawayanda* (1874; Amherst Coll., MA, Mead A. Mus.).

Cropsey revived his architectural practice soon after 1863 and built his own house, Aladdin, Warwick, NY (completed by 1869), in a Gothic Revival style. His scheme (1867) for a five-story apartment house was one of the first in America without shops on the ground floor. He also designed the 14 stations of New York's Sixth Avenue Elevated Railway (1876; destr. 1939), with much curving ironwork.

In later years Cropsey turned increasingly to watercolor, often with highlights in white gouache and solidly painted darks. An inclination toward the dramatic and imaginative rather than the calm and lyrical is evident in such watercolors as *Under the Palisades* (c. 1891; San Francisco, CA, de Young Mem. Mus.). Despite the growing Tonalist concern for projection of individual temperament and the Impressionist preoccupation with perception of light in the second half of the 19th century, Cropsey's descriptive clarity, spirited handling of paint and expansive vistas brought great vigor to American painting.

BIBLIOGRAPHY

Jasper F. Cropsey, 1823–1900 (exh. cat. by W. S. Talbot, Cleveland, OH, Mus. A.; Utica, NY, Munson–Williams–Proctor Inst.; Washington, DC, N. Col. F.A.; 1970–71)

W. S. Talbot: *Jasper F. Cropsey, 1823–1900* (New York, 1977) [catalogues 245 works]

"The Brushes He Painted with That Last Day Are There: Jasper F. Cropsey's Letter to His Wife, Describing Thomas Cole's Home and Studio, July 1850," *Amer. A. J.*, xvi (Summer 1984), pp. 78–83

Jasper Cropsey Watercolors (exh. cat. with essay by C. Rebora, intro. A. Blaugrund, New York, N. Acad. Des., 1985)

A Man for All Seasons: Jasper Francis Cropsey (exh. cat. by N. Hall-Duncan, Greenwich, CT, Bruce Mus., 1988)

C. Rebora: "Jasper Cropsey," *American Paradise: The World of the Hudson River School* (exh. cat. with intro, by J. K. Howat and essays by K. J. Avery and others, New York, Met., 1987), pp. 200–16

S. May: *Jasper Francis Cropsey: An Artist for all Seasons* (Hastings-on-Hudson, NY, 1994)

The Painted Sketch: American Impressions from Nature, 1830–1880 (exh. cat. by E. J. Harvey, Dallas, Mus. A., 1998)

Scenes from a Century Past: Reflections of the Spirit: Vibrant Forces for Rebirth as We Enter the New Millennium (exh. cat. by A. C. Rasines, with essays by K. Maddox and A. Speiser, Hastings-on-Hudson, NY, Newington Cropsey Found., 2000)

William S. Talbot

Crumb, R.

(*b* Philadelphia, PA, 30 Aug 1943), illustrator and cartoonist. Crumb became prominent during the 1960s as one of the key figures in the development of the Underground Comix movement, which was comprised of a number of different artists who self-published comic books that addressed distinctly personal and often controversial themes. His work is frequently associated with the counterculture of that period and is notable for his candid depictions of drug use and sex. Although he was self-trained, he spent much of the early 1960s working as a greeting card illustrator in Cleveland, and he later went to work for the former *Mad* magazine illustrator Harvey Kurtzman's *Help!* In 1967, he moved to San Francisco where he began to self-publish such

comic books as *Zap Comix*, *Despair*, and *The People's Comics* that often featured characters such as Mr. Natural and Fritz the Cat. Many of these comics also included contributions by other significant cartoonists of the period such as S. Clay Wilson (*b* 1941), Victor Moscoso (*b* 1936), Gilbert Shelton (*b* 1940) and Robert Williams (*b* 1943).

His comics are best known for their salacious narratives and their satirical accounts of mainstream American culture. He was particularly well known for his signature *Keep on Truckin'* image that features a swaggering chorus line of four smiling men in suits that stretches from the foreground to the horizon. As with this comic, much of his work displays the stylistic influence of 1930s animated characters such as Betty Boop, but he interprets this style according to the demands of his scandalous and often personal subject matter. Many of the comics that he published during the late 1960s also became renowned as aspects of the emerging counterculture, and his work frequently celebrated this burgeoning anti-establishment sensibility. Crumb himself often claimed that much of his work was inspired by his experiences taking LSD during the mid-1960s, and his comics during this period openly chronicled these experiences.

In the late 1960s, his cast of characters also addressed the cultural developments of the moment. Indeed, to many commentators, his scam-artist-cum-sage Mr. Natural perfectly captured the Bohemian sensibility of the moment by living on the margins of society and exchanging his sham wisdom for a meager existence on the street. In many narratives, he acts as a kind of would-be professional guru to disciples such as Flakey Foont and Schuman the Human, and he shares with them his dubious lessons about spiritualism and living naturally. Fritz the Cat, on the other hand, was a freewheeling, thrill-seeking college student who was perpetually looking for sex and drugs. Like Mr. Natural, however, Fritz was as much a parody of the pseudo-intellectualism and pretentiousness of the counterculture as a reflection of its

values. This ambivalence was typical of Crumb's own uncertainty about the trends that he was often called on to represent. In 1972, Fritz the Cat's popularity as an icon of hip culture prompted a feature-length film, but Crumb controversially disavowed it and subsequently killed the character off.

Crumb remained in California during the 1970s and 1980s, but in 1991, he moved to France with his wife. The move is discussed in Terry Zwigoff's 1994 feature-length documentary *Crumb*. This highly acclaimed film addresses his work, his personal relationships (particularly with his brother and his wife), and it chronicles both his artistic origins and the overall course of his career.

WRITINGS
with P. Poplaski: *The R. Crumb Handbook* (London, 2005)

COMIC BOOK PUBLICATIONS
G. Groth, R. Fiore, and R. Boyd, eds: *The Complete Crumb*, 17 vols. (Seattle, 1987–)

BIBLIOGRAPHY
M. Estren: *A History of Underground Comics* (San Francisco, 1974)
G. Groth and R. Fiore, eds: *The New Comics* (New York, 1988)
P. Rosencranz: *Rebel Visions: The Underground Comix Revolution, 1967–1972* (Seattle, 2002)
D. K. Holm, ed.: *R. Crumb: Conversations* (Jackson, MS, 2004)

Tom Williams

Cruz Azaceta, Luis

(*b* Havana, 5 April 1942), Cuban painter, active in the USA. He left Cuba in 1960 and settled in New York, where from 1966 to 1969 he studied at the School of Visual Arts. He was a protagonist of the Neo-Expressionist movement that emerged in New York in the 1970s. His work of this date is characterized by a humor lacking in some of the work by European exponents, for example the *Dance of Latin America* (acrylic on canvas, 1.96×2.34 m, 1983; New York, Met.). In 1985 he won a Guggenheim Fellowship in painting. Works by Cruz Azaceta

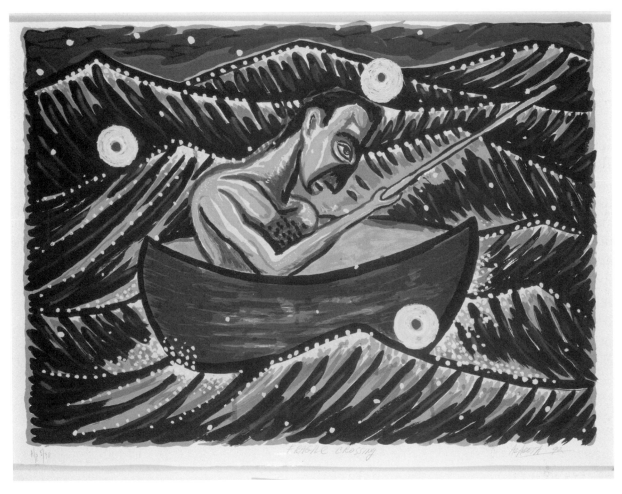

LUIS CRUZ AZACETA. *Fragile Crossing*, serigraph on paper, 533 × 762 mm, 1992. COURTESY OF THE ARTIST/ SMITHSONIAN AMERICAN ART MUSEUM, WASHINGTON, DC/ART RESOURCE, NY

are in a number of collections (e.g. *A Question of Color*, acrylic on canvas, 3.05×3.66 m, 1989; Houston, TX, Mus. F.A.) including those of the Metropolitan Museum of Art, New York; Rhode Island School of Design, Providence; Boston Museum of Fine Arts, MA; and the Houston Museum of Fine Arts, TX.

BIBLIOGRAPHY

Azaceta's Tough Ride around the City (exh. cat., New York, Mus. Contemp. Hisp. A., 1986)

The Art of the Fantastic: Latin America, 1920–1987 (exh. cat. by H. T. Day and H. Sturges, Indianapolis, Mus. A., 1987)

Luis Cruz Azaceta: The AIDS Epidemic Series/Serie epidemica del SIDA (exh. cat. by S. Torruella Leval, P. Yenawine, and I. Sheppard, New York, Queens Mus. A., *c.* 1990)

C. Damian: "Cruz Azaceta," *Lat. Amer. A.*, iii/3 (1991), pp. 46–8

J. Yau: *Luis Cruz Azaceta* (exh. cat., New York, Frumkin/Adams Gal., 1991)

Hell: Luis Cruz Azaceta, Selected Works, 1978–1993 (exh. cat., New York, Alternative Museum, [1994])

Memoria de una ciudad: Estudio fotográfico Courret Hnos, 1863–1935 (exh. cat. by J. Deustua, Lima, Mus. N. Lima, 1994)

Ricardo Pau-Llosa

Cumming, Robert

(*b* Worcester, MA, 7 Oct 1943), photographer and conceptual artist. He studied painting at the Massachusetts College of Art, Boston (1961–5), and the

University of Illinois, Urbana (1965–7). He first won recognition for his 8 × 10 view camera photographs, for example *Chair Trick* (1973; see Alinder, pl. 12). In such works as these, where he constructed the objects and their settings and then photographed them, Cumming explored perception, illusion, logic, time and motion. In the 1980s he began using drawing, printmaking and color photography, for example *X-ray Crystallography Mounts (DNA Molecule Research) MIT* (photograph, 1986; Cambridge, MA, MIT; see 1988 exh. cat., pl. 24), with the same attention to pragmatic detail and often magical humor. His interest in narrative fantasies first provided storylines for photo-sequences and later led him to write, illustrate, and publish five books including *Discourse on Domestic Disorder* (Orange, CA, 1975).

BIBLIOGRAPHY

J. Alinder: *Cumming Photographs: Untitled 18* (Carmel, 1979)

Three on Technology: New Photographs by Robert Cumming, Lee Friedlander, Jan Groover (exh. cat., essay by A. Trachtenberg; Cambridge, MA, MIT, List Visual A. Cent., 1988)

Robert Cumming: Cone of Vision (exh. cat., essay by H. M. Davies and L. Forsha; San Diego, CA, Mus. Contemp. A.; Houston, TX, Contemp. A. Mus.; 1993)

Robert Cumming: L'oeuvre Photographique 1969–80 (with texts by R. Armstrong, R. Cumming, F. Paul; Limoges, France; New York, Distribution, DAP/Distributed Art Publishers, 1994)

M. Collings: "Introspection," *Mod. Paint.*, 14/4 (Winter 2001), pp. 76–9

Constance W. Glenn

Cummings & Sears

Architectural partnership formed in 1857 by Charles A. Cummings (*b* Boston, MA, 26 June 1833; *d* Northeast Harbor, ME, 11 Aug 1905) and Willard T. Sears (*b* New Bedford, MA, 15 Nov 1837; *d* Boston, MA, 21 May 1920). Charles A. Cummings graduated from the Rensselaer Polytechnic Institute, Troy, NY, in 1853. Following a two-year tour of Europe and Egypt, he returned to Boston and began work in the office of Gridley J. F. Bryant. There he met Willard T.

Sears, and the two set up in practice together. The partnership lasted until Cummings retired in 1889. Like most Boston architects of the time, Cummings & Sears profited from the destruction caused by the Great Fire of 1872 and from the new land being created by the filling of Boston's Back Bay. They built commercial blocks, apartment hotels and houses throughout the 1870s and 1880s. They also undertook many suburban house commissions. Cummings, who did most of the firm's design work, was strongly influenced by his travels in Italy. His style can best be seen in the New Old South Church (1876), Boston, with its pointed arches, polychromatic stonework, fine floral and foliate decoration and tall Italian campanile. This free Italianate Gothic is typical of most of the firm's work.

Cummings was a prominent member of the Boston Society of Architects. He retired from architectural practice in 1889 in order to devote himself full time to writing, particularly on Greek and Italianate architecture. Sears continued to practice alone after 1889, with the Italian Gothic bent of his practice culminating in Fenway Court (now the Isabella Stewart Gardner Museum), Boston, a mansion built in 1901–3 for Mrs. Isabella Stewart Gardner, which housed her important collection consisting largely of Renaissance paintings, sculpture and decorative art. The house, a four-story stuccoed building with a covered interior courtyard, utilized European architectural fragments throughout its vast interiors.

[*See also* Boston *and* Sturgis, John Hubbard.]

WRITINGS

C. A. Cummings and W. P. P. Longfellow: *Cyclopaedia of Works of Architecture in Italy, Greece and the Levant* (New York, 1895)

C. A. Cummings: *A History of Architecture in Italy*, 2 vols (Boston, 1901)

C. A. Cummings: contributions to Winsor and Sturgis

BIBLIOGRAPHY

J. Winsor: *The Memorial History of Boston*, 4 vols (Boston, 1881)

R. Sturgis, ed.: *A Dictionary of Architecture and Building* (Boston, 1901)

W. P. P. Longfellow: "Charles A. Cummings," *Q. Bull. Amer. Inst. Archit.*, vi/10 (1905), pp. 169–73

<div align="right">Jean A. Follett</div>

Cunningham, Imogen

(*b* Portland, OR, 12 April 1883; *d* San Francisco, CA, 23 June 1976), photographer. Cunningham studied at the University of Washington, Seattle, where she became interested in photography. She had been inspired by the work of Gertrude Käsebier, whose Pictorial images were reproduced in Alfred Stieglitz's *Camera Work* and in *The Craftsman*. Cunningham took her first photographs about 1906 and became a professional photo-technician at the Edward Curtis Studio in Seattle from 1907 to 1909, where she printed Curtis's negatives of North American Indians. She was awarded a scholarship to study with Robert Luther (1868–after 1932) at the Technische Hochschule, Dresden (1909–10), where she studied platinum printing, art history and life drawing. In late 1910 Cunningham returned to Seattle and opened a portrait studio. From 1910 to 1915, in addition to her commercial portraiture, she produced a body of Pictorial, Symbolist works inspired by the poetry and prose of William Morris. These depict her friends dressed as mythical characters in bucolic settings. She married the etcher Roi Partridge (1888–1984) in 1915. (They were divorced in 1934.) Her nude photographs of her husband on Mt Rainier, WA, caused a local scandal when they were published in a Seattle periodical that same year. Cunningham moved to San Francisco in 1917, and in 1918 she worked with Francis Bruguière in his local studio.

Cunningham became an innovator in West Coast photography. By 1921 she discovered her interest in detailing natural forms, such as trees at Point Lobos, as well as poised snakes, zebra stripes and close-up botanical studies. She also experimented with pure light abstractions and double exposures. During the 1920s she produced her famous images of magnolia blossoms and calla lilies. Her work was

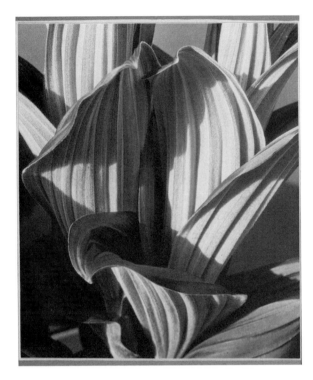

IMOGEN CUNNINGHAM. *Glacial Lily*, gelatin silver print, 213 × 184 mm, 1927. COURTESY OF THE IMOGEN CUNNINGHAM TRUST/GIFT OF ALBERT M. BENDER © MUSEUM OF MODERN ART/LICENSED BY SCALA/ ART RESOURCE, NY/© 1927, 2010 IMOGEN CUNNINGHAM TRUST. WWW. IMOGENCUNNINGHAM.COM

prominent in the exhibition *Film und Foto* held at the Deutscher Werkbund, Stuttgart, in 1929. She was one of the seven original members of Group f.64 who created a corpus of sharply focused, unmanipulated imagery. She photographed for *Vanity Fair* in the early 1930s and after that time became increasingly interested in portraiture integrating subject and setting. She became a popular San Francisco figure over the decades, especially among student photographers.

[*See also* Photography.]

BIBLIOGRAPHY

E. T. Daniel: *Imogen Cunningham: Portraits, Ideas and Design* (Berkeley, 1961)

G. M. Craven: "Imogen Cunningham," *Aperture*, xi/4 (1964), pp. 134–74

Imogen Cunningham: Photographs, 1921–1967 (exh. cat., intro. B. Newhall; Stanford, CA, U. A.G. & Mus., 1967)

Imogen Cunningham: Photographs, intro. M. Mann (Seattle, 1970)

Imogen! . . . Imogen Cunningham Photographs, 1910–1973 (exh. cat., intro. M. Mann; Seattle, U. WA, Henry A.G., 1974)

J. Dater: *Imogen Cunningham: A Portrait* (Boston, 1979)

R. Lorenz: *Imogen Cunningham: Frontiers, Photographs, 1906–1976* (Washington, DC, 1987)

A. Rule, ed.: *Imogen Cunningham: Selected Texts and Bibliography* (Oxford, 1992)

M. Heiting, ed.: *Imogen Cunningham: 1883–1976* (Cologne, London and New York, 2001) [Eng., German]

A. Shumard: "Shear Energy," *ARTnews*, 101/7 (Summer 2002), p. 200

B. Savedoff, J. Szarkowski and C. Chiarenza: "Abstract Photography: Identifying the Subject," *Exposure*, 37/2 (2004), pp. 25–34 [with biblio.]

Richard Lorenz

Cunningham, Merce

(*b* Centralia, WA, 16 April 1919; *d* New York, NY, 26 July 2009), choreographer. Merce [Mercier Philip] Cunningham merged dance and theater to formulate a new art form and reinvented both choreography and dance in the 21st century. Cunningham is renowned internationally for the revolutionary achievement of creating dance and music independently of each other. A performance by the Kurt Jooss Company introduced Cunningham to choreography in his first year of study at George Washington University in 1936 and in 1937 he began to blend theater with dance studies at the Cornish School in Seattle, WA. In 1939 he accepted Martha Graham's invitation to join her dance company; staying six years, he moved to create his first choreographed dance collaborating with music composer John Cage in 1944. Cage became a lifetime collaborator and partner.

Cunningham's artistic exploration and experiments were inspired by Abstract Expressionism, classicism, West Coast Native culture, anthropology, theater and music. Early artistic influences were Jerome Robbins and Paul Taylor, both New York choreographers who aimed to redefined dance as an art form beyond ballet and modern dance.

Cunningham has worked extensively in film and video and documentary film projects such as *Merce Cunnigham: A Lifetime of Dance* (2005), *Views on Camera Views on Video* (2004/2005), *Split Sides* (2003) and *Ocean* (1994, revived 2005). In April 2009 Cunningham performed his newest and last performances titled *Nearly Ninety* at the Brooklyn Academy of Music.

In 1953 the Merce Cunningham Dance Company (MCDC) was formed at Black Mountain College, creating nearly 200 choreographed dances by Cunningham. Since 1991 Cunningham has worked with the computer program *DanceForms* to compose his dances. Intellectually Cunningham approached choreography as a precise science and language, deconstructing the temporal or syntactical structure to create chance as continuity. Numerous artists have collaborated with MCDC such as Robert Rauschenberg, Bruce Nauman, Frank Stella, Andy Warhol, Ernesto Neto and Bernadetta Tagiabul.

Cunningham received numerous awards and honorary doctorates in Fine Arts from Bard College Annandale-on-Hudson, NY (2008), Cornish College of the Arts, Seattle (2006) and Honorary Doctorate in Human Letters, University of Minnesota (2005). In 2004, he was inducted as an officer of the Legion d'Honneur, France and in 2000 was named a living legend by the Library of Congress, Washington DC.

BIBLIOGRAPHY

J. Adam: *Dancers on a Plane/Cage Cunningham Johns* (in assoc. with Anthony D'offay Gallery; New York, 1990)

S. Barnes: *Writing Dance in the Age of Postmodernism* (Middletown, CT, 1994)

R. Kostelanetz: *Merce Cunningham/Dancing in Space and Time* (Cambridge, MA, 1998)

M. Cunningham: *Other Animals* (New York, 2002)

Deborah A. Middleton

Currier & Ives

Firm of printmakers. Currier & Ives was founded in New York in 1834 by Nathaniel T. Currier (1813–88),

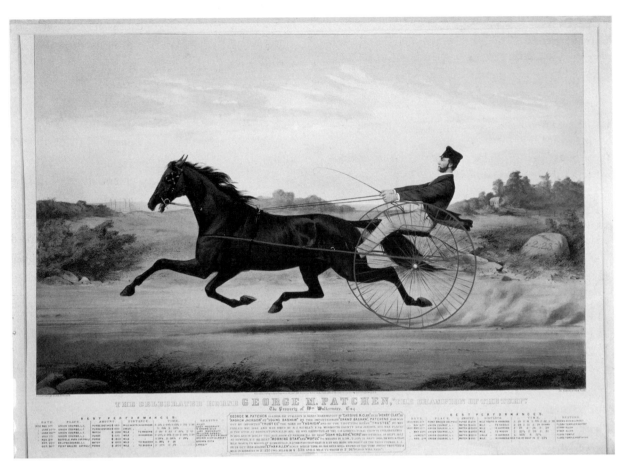

CURRIER & IVES. *The Celebrated Horse George M. Patchen, "The Champion of the Turf,"* colored print, 1860; New York, Museum of the City of New York. SCALA/ART RESOURCE, NY

who had been apprenticed as a youth to the Boston lithographic firm of William S. & John Pendleton. Currier & Ives lithographs initially appeared under Currier's imprint (his earlier lithographs had been issued in 1834 under the name of Stodart & Currier), and the name Currier & Ives first appeared in 1857, when James Merritt Ives (1824–95) was made partner. Ives was the company's bookkeeper and the brother-in-law of Nathaniel Currier's brother, Charles. Currier supervised production while Ives handled the business and financial side. In 1840 the firm began to shift its focus from job printing to independent print publishing, to which it was exclusively devoted from 1852 to 1880.

Currier & Ives prints were decorative and inexpensive, ranging in price from 20¢ to $3.00. Their subject matter ranged from rural life, ships, trains, animal and sporting scenes to religious images and spectacular news events. The firm produced more than 7000 titles, many in runs of hundreds of thousands, and became the largest and most successful American lithographic publishing company of the 19th century. Vigorous marketing through published catalogues, a sales staff and agents throughout the USA, as well as in London, enabled Currier & Ives to capture approximately three quarters of the American print market in the peak years of the firm's popularity. Both black-and-white and colored prints were sold; color was usually applied by a staff of women working in a production line from a model, although some prints were sent out for hand coloring. Chromolithographs were also

published by the firm, but color-printing was not done on the premises.

Although many of the large number of artists employed by Currier & Ives simply copied the designs of others onto the stone, original works were also commissioned. These occasionally included pictures by well-known artists, such as Arthur Fitzwilliam Tait's *A Tight Fix: Bear Hunting in Early Winter* (pubd 1861) and George Henry Durrie's *New England Winter Scene* (pubd 1861), but more often commissions went to artists closely associated with the firm. Significant among these were Frances Palmer; Thomas Worth (1834–1917), whose specialty was comic scenes; Charles Parsons (1821–1910), noted for his sailing ships and steam vessels, for example *A "Crack" Sloop in a Race to Windward* (pubd 1882); and Louis Maurer (1832–1932), creator of the series *Life of a Fireman* and of a popular group of prints featuring trotting horses.

By the time Currier retired in 1880 in favor of his son Edward West Currier, chromolithography and photography had already begun to challenge the Currier & Ives market. Broader cultural changes also hastened the decline in appeal of the company's products: exuberant self-confidence and belief in the simple values and homely virtues that the Currier & Ives image had come to symbolize had largely passed from the scene. Ives stayed with the firm until his death, succeeded by his son Chauncey Ives, who purchased the firm in 1902 and sold it in 1907. For illustration, see also Sporting scenes.

[*See also* Palmer, Frances; Stanford, Leland; and Tait, Arthur Fitzwilliam.]

BIBLIOGRAPHY

H. T. Peters: *Currier & Ives: Printmakers to the American People*, 2 vols (New York, 1929–31)

F. A. Conningham: *Currier & Ives* (Cleveland, 1950)

W. Rawls: *The Great Book of Currier & Ives' America* (New York, 1979)

F. A. Conningham: *Currier & Ives Prints: An Illustrated Check List*, new updated ed., foreword by R. L. Searjeant (New York, 1983)

Currier & Ives Navy: Lihographs from the Beverley R. Robinson Collection (exh. cat., US Nav. Acad. Mus., 1983)

C. Carter Smith and C. Coshion, eds: *Currier & Ives: A Catalogue Raisonné* (Detroit, 1984)

K. O'Rourke: *Currier and Ives: The Irish and America* (New York, 1995)

A. Bonfante-Warren: *Currier & Ives: Portraits of a Nation* (New York, 1998)

B. F. Le Beau: *Currier & Ives: American Imagined* (Washington, DC, 2001)

The Legacy of Currier & Ives: Shaping the American Spirit (exh. cat. Springfield, MA Art Museums, Sept 2010)

Anne Cannon Palumbo

Currier, J. Frank

(*b* Boston, MA, 21 Nov 1843; *d* Waverley, MA, 15 Jan 1909), painter. Currier first studied art in the late 1860s after working briefly as a stone-cutter (his father's profession) and as a banking apprentice. In 1869, after a short stay in England, he arrived in Antwerp, where he studied at the Koninklijke Academie and benefited especially from the example of Antoine Wiertz. Currier visited Paris in the spring of 1870, perhaps intending to undertake a lengthy period of study. With the outbreak of the Franco-Prussian War in August 1870, however, he moved to Munich, where he studied at the Akademie der Bildenden Künste until 1872. He became part of the American contingency of Munich painters, which included Frank Duveneck, Walter Shirlaw and William Merritt Chase. Like them, he became a notable practitioner of Munich realism as taught by Wilhelm Leibl and others. To this style, based on the chiaroscuro and dramatic brushwork of Frans Hals, Currier brought an expressionistic, individual manner, bolder in technique and more emotional and visionary in character. The *Head of a Boy* (1873; New York, Brooklyn Mus. A.) and *Peasant Girl* (*c.* 1878; Waterford, CT, Mr. & Mrs. Henry C. White priv. col., see Neuhaus, p. 126, fig.) are representative of his Munich style at its best. In 1877 Currier moved to the Bavarian town of Polling. There, as in Dachau and Schleissheim (located a few miles west of Dachau) in the early 1880s, he assumed leadership of the American art colony after the departures

of Duveneck and Chase. Currier returned to Boston in 1898 and subsequently gave up painting entirely. In 1909 he took his own life.

BIBLIOGRAPHY

N. C. White: *The Life and Art of J. Frank Currier* (Cambridge, MA, 1936)

M. Quick: "Munich and American Realism," *Munich and American Realism in the 19th Century* (Sacramento, CA, 1978), pp. 21–36R. Neuhaus: *Unexpected Genius: The Art and Life of Frank Duveneck* (San Francisco, CA, 1987)

J. Frank Currier, 1843–1909: A Solitary Vision (exh. cat., New York, Babcock Gals, 1994)

J. Frank Currier (1843–1909), A Natural Colorist (exh. cat., New York, Babcock Gal., 1995)

T. Carbone and others: *American Paintings in the Brooklyn Museum: Artists Born by 1876* (New York, 2006)

American Still-Life Painting of the Nineteenth Century (exh. cat., essay by T. Quick, New York, Godel & Co., 2008)

James C. Cooke

Currin, John

(*b* Boulder, CO, 19 Sept 1962), painter. Currin completed a BFA at the Carnegie Mellon University in Pittsburgh (1984) and an MFA at Yale University (1986). His subjects include adolescent girls, middle-aged women and couples, all of which are the focus of his compositions. His work has been described as provocative, pornographic, misanthropic, grotesque and misogynistic. Currin presents fictional portraits that are disturbing because they meld the idealized nude with the crudity of the pin-up. Currin exaggerates the male objectifying gaze by focusing on the portrayal of the young and naked female body as the site for male desire, while also satirizing this art historical tradition. However, he is also deeply indebted to art historical references, for example his convention of working to the small dimensions of easel painting, the use of Renaissance prototypes and his appropriation of the Mannerist style.

His work can be divided into phases. The early body of work, 1989–90, depicts "yearbook"

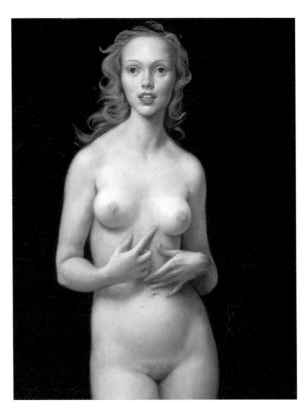

JOHN CURRIN. *Honeymoon Nude*, oil on canvas, 1168 × 915 mm, 1998. Purchased with assistance from Evelyn, Lady Downshire's Trust Fund, 1999, Tate Gallery, London/Art Resource, NY © John Currin, courtesy Gagosian Gallery

style portraits of girls presented in a classical manner. From 1991 his subject matter is more contentious: middle-aged desexualized women, effeminate insecure men and couples that tended to be of middle-aged men and young women. From 1998 to 1999 his work changed attitude as he became less antagonistic and controversial in his depictions and sought to develop the technicalities of style. *Honeymoon Nude* (1998; London, Tate) is modeled according to the classical nude genre, and allusions are made to the nudes of Lucas Cranach (1472–1553) and Sandro Botticelli's *Birth of Venus* (c. 1484; Florence, Uffizi).

Currin's work has undergone a recent appraisal and is regarded more from his social observations and insights into contemporary culture, particularly his involvement with social anxieties with aging and body image.

BIBLIOGRAPHY

John Currin: Works 1989–1995 (exh. cat., essays by K. Seward and F. Paul, Limoges, 1995)

R. Rosenblum: *John Currin* (New York, 2003)

John Currin (exh. cat., essays by N. Bryson, A. Gingeras and D. Eggers, New York, Gagosian Gal., 2006)

Rina Arya

Curry, John Steuart

(*b* nr Dunavant, KS, 14 Nov 1897; *d* Madison, WI, 29 Aug 1946), painter and illustrator. As one of the "Regionalist triumvirate," with Thomas Hart Benton and Grant Wood, he has been most often characterized as a faithful chronicler of rural life in Kansas. From 1916 to 1918 he was at the School of the Art Institute of Chicago. In 1919 he began study in the studio of Harvey Dunn (1884–1952) in Tenafly, NJ. After seven years as an illustrator in and around New York, he went to Paris in 1926 to study with the Russian Academician Vasily Shukhayev (1887–1973). Ironically, it was on Curry's return to the East Coast the following year that he began to earn his reputation as a Regionalist by painting memories of Kansas from his studio in the fashionable art colony of Westport, CT. *Baptism in Kansas* (1928; New York, Whitney) shows a country child being baptized in a cattle trough. Such paintings of early American life appealed to certain East Coast urban viewers seeking to recover a lost past.

From 1936 to 1946 Curry was artist-in-residence at the University of Wisconsin, Madison. From 1936 to 1938 he executed mural cycles for the Departments of Justice and of the Interior (Washington, DC) under New Deal patronage. In 1937 he was commissioned to paint murals for the Kansas State Capitol building, but Kansas gave its truant Regionalist such a hostile reception that the ambitious cycle (featuring John Brown and the history of settlement on the plains) was never fully completed. For illustration, see color pl. 1:IX, 1.

[*See also* Regionalism.]

BIBLIOGRAPHY

L. E. Schmeckebier: *John Steuart Curry's Pageant of America* (New York, 1943)

John Steuart Curry (exh. cat., ed. B. Waller; Lawrence, U. KS, Spencer Mus. A., 1970)

M. S. Kendall: *Rethinking Regionalism: John Steuart Curry and the Kansas Mural Controversy* (Washington, DC, 1986)

P. Junker: *John Steuart Curry: Inventing the Middle West* (New York, 1998)

M. Sue Kendall

Curtis, Edward S.

(*b* White Water, WI, 1868; *d* Los Angeles, CA, 21 Oct 1954), photographer. A self-taught photographer, in 1887 Curtis became a partner in a portrait studio in Seattle, where he experimented with new subject matter. He decided to make the photography of native peoples his specialty and accompanied anthropologists on the Harriman Expedition to Alaska in 1899 and to Montana in 1900. In 1901 he conceived a vast project to document photographically the lives, customs and folklore of the Native American tribes and to record their customs. President Theodore Roosevelt introduced him to J. Pierpont Morgan, who sponsored Curtis's work and his publication of the luxurious 20-volume compendium *The North American Indian* (1907–30).

Curtis's photographs in *The North American Indian* reflected the contemporary view of American Indians as "noble savages." He judged his methods to be far superior to those of his predecessor, George Catlin. In wishing to document the vanishing culture of the rapidly Europeanized American Indian, he romanticized the settings of his photographs, sometimes adding props consisting of "scalps," head-dresses and ceremonial costume, suggesting, for example, the inherent warrior nature of the men and the promiscuity of the young women. To reduce the intervention of contemporary settings, he freely altered negatives and reduced the depth of field using a large aperture to soften the surroundings of his subject. His portraits adopted the tight cropping and full-face or

profile formats characteristic of ethnographic photography. His formal mastery and his concern with creating works of art as well as documents of a culture distinguished him from other contemporary photographers of the "vanishing race." He also made a film of the Kwakiutl people called *In the Land of the Headhunters*, first presented in 1914.

[*See also* Dat So La Lee.]

PHOTOGRAPHIC PUBLICATIONS

The North American Indian; The Complete Portfolios, intro. T. Roosevelt, 20 vols (Norwood, 1907–30; reissued with additional photographs and additional intro. H. C. Adam, Cologne, 1997)

Native Nations: First Americans as Seen by Edward S. Curtis, ed. C. Cardozo (Boston, MA, *c*. 1993)

The North American Indian, intro. C. Cardozo, 2 discs, CD-ROM (Denver, *c*. 1994)

C. Worswick, D. L. Monroe and T. Haukaas: *Edward Curtis: The Master Prints* (Santa Fe, NM, with the Peabody Essex Mus., 2001)

FILMS

In the Land of the Headhunters (1914)

BIBLIOGRAPHY

F. C. Graybill and V. Boesen: *Edward Sheriff Curtis: Visions of a Vanishing Race* (New York, 1976)

The Vanishing Race and Other Illusions: Photographs of Indians by Edward S. Curtis (exh. cat. by C. M. Lyman, intro. V. Deloria, Washington, DC, Smithsonian Inst., 1982)

B. Davis: *Edward S. Curtis* (San Francisco, 1985)

McRae, W. E.: "Images of Native Americans in Still Photography," *Hist. Phot.*, xviii (Oct/Dec 1989)

Fergus, C.: "Shifting Shadows: Was Edward S. Curtis a Huckster or an Artist of Genius?" *A. & Ant.*, viii (Nov 1991), pp. 46–53

To Image and to See: Crow Indian Photographs by Edward S. Curtis and Richard Throssel (exh. cat. by T. Northern and W.-S. Brown, Hanover, NH, Hood Mus. A., Dartmouth College, 1993)

Faris-James, C.: "The Navajo Photography of Edward S. Curtis," *Hist. Phot.*, xvii (Winter 1993), pp. 377–87

The Wild West (exh. cat., London, Hamilton Gals, 1994)

Edward Sheriff Curtis: Die Schattenfänger: Das Bild der Indianer Nordamerikas 1900 bis 1930 (exh. cat., ed. D. Byer, Vienna, Mus. Vlkerknd., 1994)

To Image and To See: Crow Indian Photographs by Edward S. Curtis and Richard Throssel, 1905–1910 (exh. cat., Casper, WY, Nicolaysen A. Mus., 1994)

Shadowy Evidence: The Photographs of Edward S. Curtis and His Contemporaries (exh. cat., Boston, MA, Photo. Res. Cent., 1995)

M. Gidley: *Edward S. Curtis and the North American Indian, Incorporated* (Cambridge and New York, 1998)

C. Cardozo, ed.: *Sacred Legacy: Edward S. Curtis and the North American Indian*, with foreword by N. S. Momaday and essays by C. Cardozo and J. D. Horse Capture, afterword by A. Makepeace (New York and London, 2000)

A. Makepeace: *Edward S. Curtis: Coming to Light* (Washington, DC, 2001)

M. Gidley, ed. and intro.: *Edward S. Curtis and the North American Indian Project in the Field* (Lincoln, NB, 2003)

Edward Sheriff Curtis: The North American Indian (exh. cat. ed. E. Mittler, with intro. H.-C. Adam, Göttingen, Ausstellung in der Niedersächsischen Staats- und Universitätsbibliothek, 2004)

J. C. Scherer: *Edward Sheriff Curtis* (London, 2008)

Mary Christian

Curtis and Davis

Architectural partnership formed in 1946 by Nathaniel (Cortlandt) Curtis Jr. (*b* Auburn, AL, 29 Nov 1917; *d* New Orleans, LA, 10 June 1997) and Arthur Quentin Davis (*b* New Orleans, LA, 1920). Curtis and Davis was the most prominent early modern architecture and planning firm in New Orleans, designing some of that city's most notable modernist landmarks, including the Rivergate (1968; Port of New Orleans Exposition Center, destr. 1995), the Louisiana Superdome (1971–5), the Hyatt Regency (1976) and Marriott (1972) hotels, and the Milton K. Latter Library. Curtis was the son of noted architect, artist and writer, Nathaniel Cortlandt Curtis Sr. (1881–1953), who was head of the architecture schools first at Auburn and later at Tulane University, New Orleans. Curtis Jr. and Davis were classmates at Tulane during the late 1930s when Beaux-Arts education was giving way to Bauhaus design methodologies there. After graduation, Davis was apprenticed to Albert Kahn and received a Masters degree (1946) from the Harvard School of Design, studying under Walter Gropius.

The partnership of Curtis and Davis (1946–78) was formed in 1946 in New Orleans, intending from the start to bring contemporary design to an essentially 19th-century city; a dozen years later, at the age of 38, Davis became the youngest architect to be honored as a Fellow of the American Institute of Architects. After the firm was acquired in 1978 by an engineering firm in California, both partners continued to practice independently. Davis culminated his career with an exhibit and retrospective of his life work, organized by the Ogden Museum of Southern Art, New Orleans, in 2009.

Curtis and Davis designed public and private buildings throughout the USA, as well as in Saudi Arabia, Egypt, Vietnam, Aruba, Indonesia, Germany and the UK. Many projects set notable records: the Teaching Hospital for the Free University of Berlin (1969, largest hospital in Europe), James Forrestal Building (1969) for the Defense Department (first modern building to be approved by the Fine Arts Commission), Louisiana State Penitentiary, Angola (1952–56, first penitentiary designed to house a rehabilitation program), the Louisiana Superdome (1971–75, largest enclosed stadium) and Rivergate (1968, longest span pre-stressed post-tensioned concrete barrel vault roof ever built). Curtis emphasized site, program, budget, climate, materials and client needs as the key determinants in design. In projects that Davis characterized as "regional modern," he sought to synthesize Creole and Beaux-Arts design elements and ideas, merging modern aesthetics while preserving historic memory.

BIBLIOGRAPHY
A. Q. Davis and J. R. Gruber: *It Happened by Design: The Life and Work of Arthur Q. Davis* (Jackson, MS, 2009)

Robert M. Craig

Cushing, Frank Hamilton

(*b* northeastern Erie County, PA, 22 July 1857; *d* 10 April 1900), ethnologist and writer. Cushing was of frail health, and his schooling was irregular; he was briefly enrolled at Cornell University, NY, in 1875, but was enlisted as an assistant to Charles Rau to help with the Philadelphia Centennial in 1876 and served as curator until it closed. In 1879 he went to the Zuni Pueblo of the US Southwest, where he remained for four and a half years, moving into the governor's house and becoming an accepted member of the Zuni tribe. He learned their language and customs to the extent that he was able to call himself "War Chief" and to act as an aide to the governor and the tribe in its many quarrels with the US Army and the Bureau of Indian Affairs. He won the Zuni name Tenatsali or "Medicine Flower," a reference to the curative powers of the jimson weed. He fell foul of Senator John A. Logan, who forced him to leave the Zunis in 1884 and return to Washington, DC. From 1887 to 1889 he was co-director of the Hemenway Southwestern Archaeological Expedition with Adolph Bandelier, Hermann F. C. ten Kate and Frederick Webb Hodge in southern Arizona and New Mexico, but his health continued to afflict him and he returned to the east. In 1895–6 he began to conduct explorations at Key Marco, FL, but died at the age of 42. His major ethnological writings include an account of his life in the Zuni village (1882), one of the first books of Indian mythology (1901) and a rare inside account of life in the Southwest Pueblos at the turn of the century (1920).

[*See also* Native North American Art.]

WRITINGS
My Adventures in Zuni (Santa Fe, NM, 1882, 2/1951)
Zuni Folk Tales (New York, 1901, 2/1931)
Zuni Breadstuff, contributions from the Museum of the American Indian, Heye Foundation, viii (New York, 1920)

BIBLIOGRAPHY
J. Green: *Cushing at Zuni: the Correspondence and Journals of Frank Hamilton Cushing 1879-1893.* (Albuquerque, 1990)
C. M. Hinsley and D. R. Wilcox: *The Southwest in the American Imagination: The Writings of Sylvester Baxter, 1881–1889* (Tucson, AZ, 1996)
C. M. Hinsley and D. R. Wilcox: *The Lost Itinerary of Frank Hamilton Cushing* (Tucson, AZ, 2002)
P. E. Kolianos and B. R. Weisman, eds: *The Lost Florida Manuscript of Frank Hamilton Cushing.* (Gainesville, FL, 2005)

P. E. Kolianos and B. R. Weisman, eds: *The Florida Journals of Frank Hamilton Cushing*. (Gainesville, FL, 2005)

Frederick J. Dockstader
Revised and updated by Margaret Barlow

Cushman, Charlotte

(*b* Boston, MA, 23 July 1816; *d* Boston, MA, 16 Feb 1876), actress and patron. Charlotte Cushman played a significant role in the careers of numerous female visual artists. During her lifetime, Cushman was considered the greatest and most successful actress in the English-speaking world and served as a role model for many women.

When Cushman initially chose to retire from the stage and live abroad, she divided her time between London, where she had established a home, and Rome. While performing in Boston, MA, in 1852, prior to her first trip to Italy, Cushman and her then-partner, British novelist and translator Matilda Hays, made the acquaintance of young American sculptor, Harriet Hosmer. Hosmer accompanied Cushman and Hays to Italy and, for several years, resided with them in Rome. From the start, Cushman envisioned setting up a residence and salon for expatriate female artists from the USA. Just as Cushman had competed openly and aggressively with male actors and insisted upon receiving remuneration equal to theirs, she also encouraged the female artists she supported to compete openly with male sculptors for commissions. She was their fierce advocate in what Hosmer described as "rivalry in the clay" with male sculptors.

From the mid-1850s to 1870, Cushman's immediate social circle in Rome included cameo maker Margaret Foley and sculptors Edmonia Lewis, Anne Whitney and Florence Freeman (1825–76). Like Cushman, these American artists became expatriates, finding in Italy—with Cushman's patronage and material support—professional opportunities not available to them in the USA. Henry James wrote dismissively about the "strange sisterhood of American 'lady' sculptors" who, he claimed, had settled upon the seven hills of Rome "in a white marmorean flock."

While Cushman was a decided champion of a number of female artists, her most significant efforts were focused on securing commissions for and supporting the work of sculptor Emma Stebbins, who in 1857, became Cushman's life partner. Cushman's unpublished correspondence establishes her personal efforts to secure for Stebbins the commission for a commemorative sculpture of Horace Mann in Boston, and the funding for the casting of Stebbins's most significant work, *Angel of the Waters* (1873) at Bethesda Fountain in New York's Central Park. Cushman drew upon her own professional acclaim and social status, offering to return to Massachusetts and do dramatic readings if sufficient funds were not secured for casting Stebbins's monument to Horace Mann. In this way, Cushman claimed, "women would raise the statue." The work now stands before the State House in Boston.

[*See also* Foley, Margaret; Hosmer, Harriet; Lewis, Edmonia; Stebbins, Emma; *and* Whitney, Anne.]

UNPUBLISHED SOURCES
Washington, DC, Libr. Congress, Charlotte Cushman Papers

BIBLIOGRAPHY
H. James: *William Wetmore Story and His Friends*, i (London, 1903), p. 257
L. Merrill: *When Romeo was a Woman, Charlotte Cushman and Her Circle of Female Spectators* (Ann Arbor, 1999)
L. Merrill: "Old Maids, Sister-Artists, and Aesthetes: Charlotte Cushman and Her Circle of 'Jolly Bachelors' Construct an Expatriate Women's Community in Rome," *Women's Writing*, x/2 (2003), pp. 367–83

Lisa Merrill

Cutrone, Ronnie

(*b* New York, 10 July 1948), painter, draftsman, printmaker and sculptor. From 1966 to 1970 he studied at the School of Visual Arts in New York, where he made large figurative paintings around themes

such as rescue and survival. He stopped painting in 1970 but continued to make drawings and sculptures, including a series of large iron cages such as *The Getting To Know You Cage* (1979; USA, priv. col.), in which the reactions between two people inside a confined space could be observed by spectators. Several of Cutrone's cages were shown at The Mudd Club, a combined music venue and gallery in New York which he ran between 1979 and 1982. From 1972 to 1982 Cutrone worked as a studio assistant to Andy Warhol, also briefly co-editing Warhol's *Interview* magazine (1972–3). He resumed painting in the early 1980s and began incorporating Biblical imagery into his work, linking it with favorite American cartoon characters in ways that deliberately courted controversy. He established his reputation around the same time as such graffiti artists as Jean-Michel Basquiat and Keith Haring who were coming to prominence, as well as other painters using cartoon imagery, such as Kenny Scharf. Works such as *Hot Cross* (1981; artist's priv. col.), an American flag with a cross shape burned out of the center and a velvet backing attached, or *Fruits of the Spirit* (1982; artist's priv. col.), a flag overpainted with an image of a cornucopia and the cartoon character Woody Woodpecker, were considered offensive and unpatriotic by many and caused considerable public outrage. In the 1990s Cutrone made a series of satirical paintings on the theme of archangels. *Michael* (1993; Belgium, priv. col., see 1994 exh. cat.), fused references to Renaissance drapery and traditional American quilting with a skull and crossbones, a stripe of army camouflage fabric, the Death of Superman insignia and the US flag to create a typically provocative reflection on public perceptions of good and evil in contemporary America.

BIBLIOGRAPHY
T. Trini: "Ronnie Cutrone," *Flash A.* (Feb 1982), pp. 62–3
Ronnie Cutrone (exh. cat., New York, Tony Shafrazi Gal., 1985)
Ronnie Cutrone: "Archangels" (exh. cat., essay M. McKenzie, Knokke, Gal. Cotthem, 1994)

Sophie Howarth